*TEXAS
LITHOGRAPHS*

CHARLES N. PROTHRO
TEXANA SERIES

RON TYLER

TEXAS

LITHOGRAPHS

A CENTURY OF

HISTORY IN IMAGES

UNIVERSITY OF TEXAS PRESS ᗵ AUSTIN

The author and publisher wish to acknowledge the generous support of the Summerlee Foundation in the publication of this book.

The author and publisher wish to acknowledge the generous support of Morris Matson in the publication of this book.

Copyright © 2023 by Ron Tyler
All rights reserved
Printed in China
First edition, 2023

Requests for permission to reproduce material from this work should be sent to:
 Permissions
 University of Texas Press
 P.O. Box 7819
 Austin, TX 78713-7819
 utpress.utexas.edu/rp-form

♾ The paper used in this book meets the minimum requirements of ANSI/NISO Z39.48-1992 (R1997) (Permanence of Paper).

Library of Congress Cataloging-in-Publication Data

Names: Tyler, Ronnie C., 1941– author.
Title: Texas lithographs : a century of history in images / Ron Tyler.
Description: First edition. | Austin : University of Texas Press, 2023. | Includes bibliographical references and index.
Identifiers: LCCN 2021054880 | ISBN 978-1-4773-2608-4 (hardcover)
Subjects: LCSH: Palm, Swante, 1815–1899—Art collections. | Lithography—Texas—19th century. | Texas—History—19th century—Pictorial works. | Texas—Description and travel—History—19th century—Pictorial works. | LCGFT: Lithographs.
Classification: LCC F387 .T95 2023 | DDC 976.4/0500222—dc23/ eng/20211214
LC record available at https://lccn.loc.gov/2021054880

doi:10.7560/326084

FOR

WILLIAM S. REESE (1955–2018)
AND
DOROTHY SLOAN (1943–2021),
Friends, colleagues, and extraordinary dealers

It has seemed to me that separately published lithographs and engravings of Texas scenes and of men of the period . . . are entitled to a monograph of their own.

THOMAS W. STREETER, *BIBLIOGRAPHY OF TEXAS*, 1983, 330

CONTENTS

INTRODUCTION: "WE CAN READ THE PICTURES" 1

1. "Really a Kind of Paradise"
 HISPANIC AND MEXICAN TEXAS 11

2. "A More Perfect *Fac-simile* of Things"
 THE REPUBLIC OF TEXAS 41

3. "Illustrations of a Cheap Character"
 ANNEXATION AND WAR WITH MEXICO 91

4. "A Perfect *Terra Incognita*"
 SURVEYS OF TEXAS 133

5. "Pretty Pictures . . . 'Candy' for the Immigrants"
 ILLUSTRATING THE STATE 187

6. "The Dark Corner of the Confederacy"
 CIVIL WAR AND RECONSTRUCTION IN TEXAS 245

7. "The Enterprise Was Not Properly Appreciated"
 THE GROWTH OF LITHOGRAPHY IN TEXAS 263

8. "The 'Image Breakers'"
 MENDING THE REPUTATION 337

9. "The Truth Is Texas Is What Her Railroads Have Made Her" 385

EPILOGUE: "MISTAKEN . . . FOR LITHOGRAPH WORK" 459

ACKNOWLEDGMENTS 463

NOTES 467

INDEX 507

TEXAS LITHOGRAPHS

INTRODUCTION

"WE CAN READ THE PICTURES"

In the winter of 1882–1883, twenty-seven-year-old Charlie Siringo found himself on a lonely ranch in the northern part of Indian Territory along with eight other cowboys. He was a literate Matagorda County fellow who had attended public school through age fifteen and proposed that to help pass the time, they pool their money by paying a dime for every curse word they uttered or if they were "caught picking grey backs off and throwing them on the floor without first killing them." The pooled money would be used to subscribe to some "choice literature—something that would have a tendency to raise us above the average cow-puncher." Everyone agreed, and within twenty-four hours they had collected enough money for a subscription. But Siringo was surprised when the group, including two illiterate young Texans, voted for the *Police Gazette*, the sex/crime, girly/pinup magazine of the day. Why would you want to buy that "wicked Sheet?" he asked them. "Cause we can read the pictures," the Texans shouted in unison, a testament to the impact that mass-produced images had in nineteenth-century America, when Texas came of age.[1]

The *Police Gazette* was but one of many pictorial magazines, newspapers, books, and separately issued prints that increasingly made pictures inescapable as the nineteenth century became the age of the illustrated press. Images of the American West, including Texas, poured from the federal government and other publishers as part of the effort to explore, publicize, and settle the newly acquired territory. One correspondent noted in a widely published essay that the pictorial press provided

> a series of truthful representations of various points . . . which afford, probably, a better idea of the lay of the land, the general appearance and characteristic of the country, than is to be had from the most elaborate written description. These are finely engraved, and will, doubtless, soon adorn the table of every farmer in the land, and exert an important influence in giving direction to many who are looking to the West for their future home.[2]

And an unnamed commentator for *The Churchman* concluded that "it is no disparagement to their brilliant literary quality to suggest that the publishers find their account rather in the burin of the engravers than in the brains of their contributors." Currier & Ives were in their prime, Boston lithographer Louis Prang returned from research into new lithographic techniques in Europe to introduce the Christmas card to America in 1874, and tobacco and coffee companies blanketed the country with

various full-color, collectable cards, from baseball players to policemen to cowboys.[3]

The "ubiquitous chromo" became so common and cheap that the influential and elitist editor of *The Nation*, E. L. Godkin, confronted with the high-profile society scandals of the day, condemned the age as a "chromo-civilization." And Texas was no exception. In 1865, offended because the state was "deluged with worthless pictorial publications from the North," a *Galveston Daily News* editor urged that parents shield their children from "the imperfect wood-cut or the colored lithograph."[4] But the pictures continued to come, many of them of Texas itself, and this study examines the composite image of the state that emerged as lithography, a new method of printing discovered at the onset of the nineteenth century, greatly multiplied the number and quality of pictures available to the public.

When I set out to organize the Amon Carter Museum's sesquicentennial exhibition in 1986, my intention was to catalogue and exhibit all the lithographs relating to Texas, something similar to what Dr. Mavis Kelsey and Robin Brandt Hutchison produced in *Engraved Prints of Texas, 1554–1900*. I had hoped to show the importance as well as the ubiquity of the lithographic record in documenting the history of the state. But I soon realized that, unlike engravings, which were usually included in publications, lithographs were frequently issued separately, and a catalogue would be virtually impossible given the large number of images produced, their ephemeral nature, their rarity today, and the fact that few institutions have seriously collected Texas-related lithographs on a national scale.[5] As I continued to gather information, it became apparent that the story of Texas-related lithographs is also the story of Texas, and I have attempted to pursue that premise through the nineteenth century, to place them in their proper context, to add their perspective to that story.

Pictures of early Texas are quite scarce. The 1554 woodcut of a buffalo (fig. 0.1), perhaps based on accounts from Francisco Vázquez de Coronado's expedition through the Southwest, might be tenuously associated with Texas, but the imaginary illustrations of La Salle's ill-fated 1685 landing on the Gulf Coast that first appeared in 1698 in Fr. Louis Hennepin's *A New Discovery of a Vast Country in America* are the earliest published pictures to be clearly based on Texas events and purporting to be scenes of Texas (fig. 0.2).[6] With the invention of lithography a century later, however, inexpensive reproduction of pictures became possible just as Texas was beginning to attract international attention. Because Texas was remote

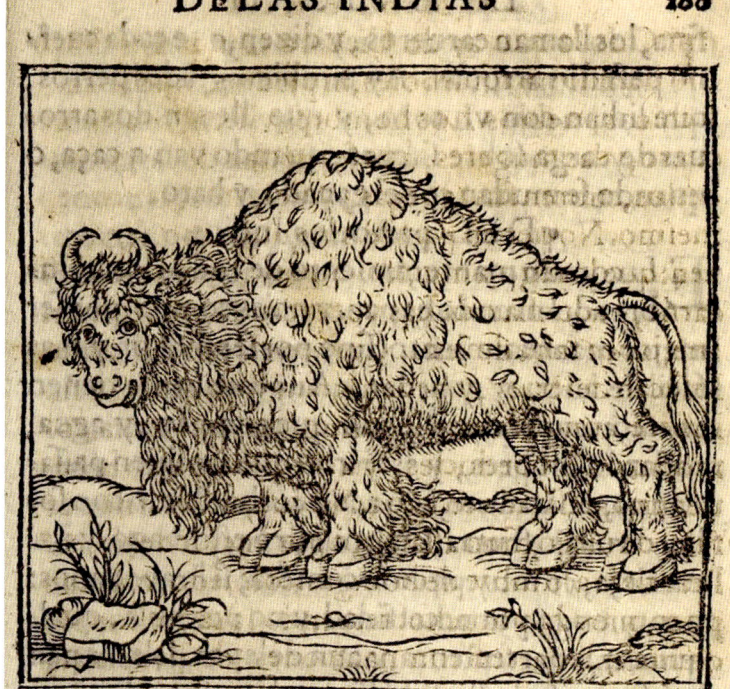

FIGURE 0.1 Unknown artist, [Buffalo], 1554. Woodcut, 2.25 × 2.5 in. (image). From Francisco López de Gómara, *La historia general de las Indias* (1554), 288. Courtesy DeGolyer Library, Southern Methodist University.

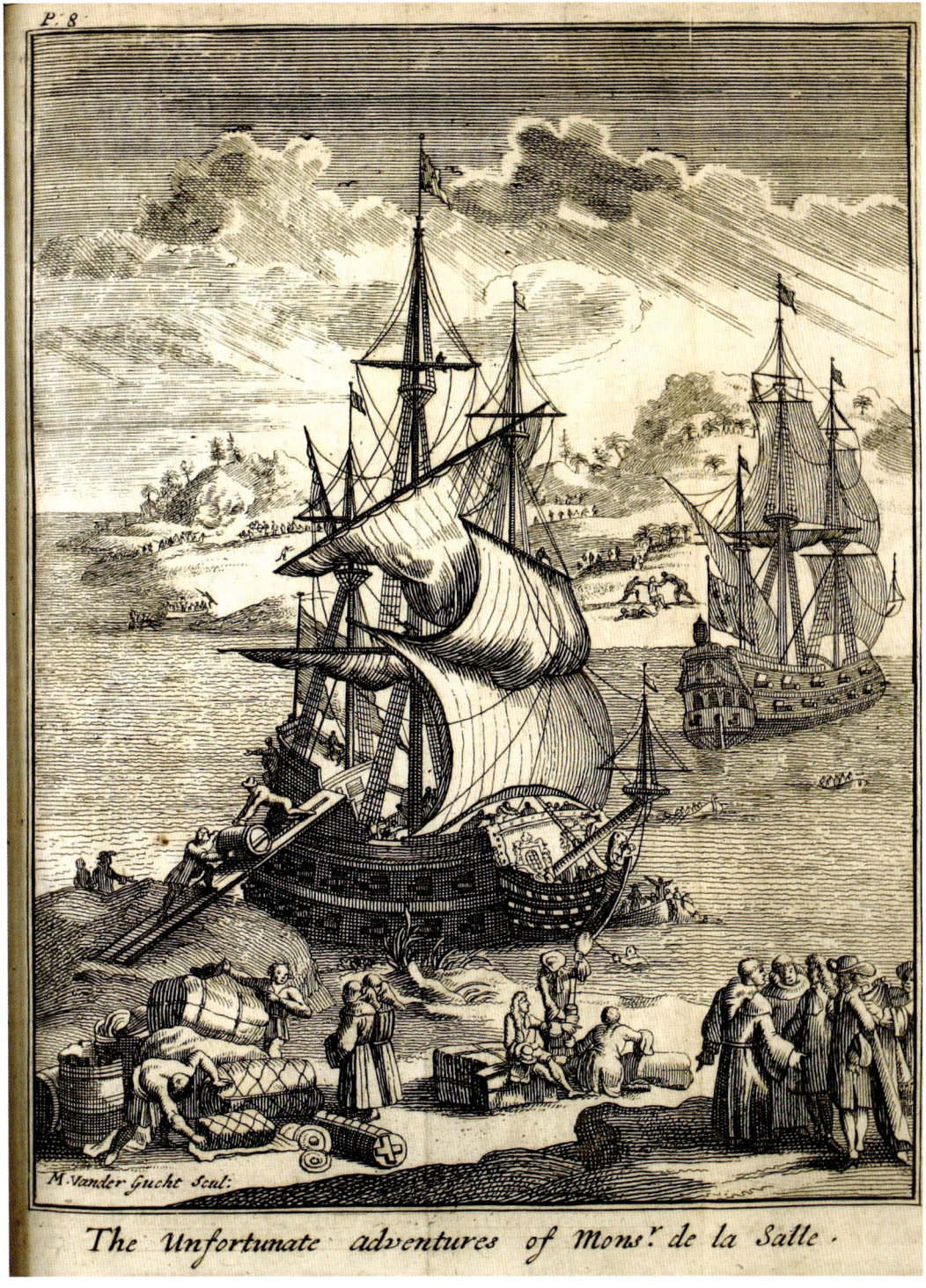

FIGURE 0.2 M. Vander Gucht, *The Unfortunate Adventures of Monsr. de la Salle*, 1698. Woodcut, 20 cm. From Louis Hennepin, *A New Discovery of a Vast Country in America* (1698), vol. 2, between 8–9. Courtesy Newberry Library, Chicago.

from centers of commerce and information, few artists visited before independence in 1836 and not that many more printers and lithographers, although, by one count, there were twenty-one printers in the Texas army at the battle of San Jacinto.[7]

Still, although no lithographer was able to establish a successful presence in Texas until after the Civil War, lithographic images purporting to depict the region lack only two decades in spanning the history of the medium itself. Most of the early prints came from well-publicized events combined with the artist's imagination, casual trips to the region, or from the desire to illustrate a text, usually by an artist who had never seen Texas. Horace Vernet, a well-known European military painter who provided the cover for an 1818 song sheet with an imaginary image of Champ d'Asile, the short-lived French settlement on the Trinity River, is one of the most famous artists included in this study, but he conceived the picture from his cosmopolitan Paris studio rather than the Trinity River wilds. The first published eyewitness images of Texas probably are the four engraved scenes included, along with the "fresh and lively narrative" of an anonymous author in *A Visit to Texas; Being the Journal of a Traveller through Those Parts Most Interesting to American Settlers . . .*, published in 1834, but lithographic scenes from other visitors soon followed. The most famous artist to visit the Republic was, no doubt, the ornithologist John James Audubon, who arrived in 1837 in the process of finishing his magnificent *The Birds of America* and planning his book on quadrupeds.[8] After statehood in 1845, artists and trained lithographers settled among the German and French villages in the Hill Country and at La Réunion near Dallas, while federal

explorers—heirs to the eighteenth-century tradition from enlightened Europe of scientific examination and documentation—crisscrossed the state.[9] Wilhelm Thielepape, a surveyor and recent immigrant with no printing experience, pulled the first lithograph from a Texas press in 1855 (a rather crude caricature of Sam Houston), and French immigrant Joseph Paul Henry, who had set up his press in the North Texas communal settlement of La Réunion, printed a cartoon in 1860 predicting that Texas would be the first Southern state to secede from the Union. Finally, in 1868, the Galveston firm of M. Strickland & Co. added lithography to its stationery and bookbinding business, becoming the first established lithographic house in the state. Five years later Strickland imported a steam lithographic press and European crew from the East Coast.[10]

While Americans readily embraced this new printing process as a means of disseminating art in a democratic society, the methodology came directly from aristocratic Europe. Alois Senefelder was but a twenty-seven-year-old youth when he invented a revolutionary process that he called chemical printing, and craftsmen in Germany, France, and England had worked out its basic elements by 1819, when an American artist named Bass Otis printed the first lithograph in the United States. The older methods of etching and engraving require that the ink reside either in a groove or on a raised surface, and images are printed by pressing a sheet of paper against that surface. The former curator of photography at the Museum of Modern Art in New York, John Szarkowski, offered a simple explanation of the difference between the two processes: if you press your finger onto an ink pad and then press it onto paper, the ink from the raised surfaces of your finger touches the paper and makes a relief print. But if you put ink on your hand and then wipe if off, leaving ink only in the depressions (or grooves) of your hand, and then press it firmly to paper, that would produce an intaglio print, with ink transferring to the paper from your hand's recessed surfaces rather than the raised surfaces.[11]

By contrast, lithography is a planographic medium—it prints from a flat surface, based on the principle that oil and water do not mix. It became widespread because it offered the artist and printer techniques and opportunities not shared by any other printing medium: ease of drawing on the stone, freedom of expression not easily obtained in engraving or etching, speed of printing, many more reproductions (each one identical to the original), and the ability to reproduce tones and shades rather than having to simulate them by cross-hatching or otherwise working the surface of a metal plate or woodblock.[12] Senefelder claimed to have discovered the lithographic process when he used a grease pencil to jot down his laundry list on a smooth, Bavarian limestone, and Napoleon is said to have been attracted to it because multiple copies of his orders could be rapidly produced and distributed.[13]

To make a lithograph, the artist draws with a greasy or soapy substance, such as a tallow, resin, or wax crayon, directly onto the surface of a limestone that has been ground flat and smooth (fig. 0.3). As printers became more proficient, they learned to mix grease-based inks to the consistency that could be applied to the stone with a brush or a pen. The fatty acids in the crayon or ink react with the limestone to produce an insoluble lime soap that sticks to an oil-based ink but repels water. When the drawing is finished, the entire stone is bathed in gum arabic and dilute nitric acid to "fix" the drawing and prevent it from spreading during printing, then washed with water. When the oily ink is applied to the surface of the stone with a roller, it sticks to the greasy drawing but is repelled by the wet stone. Paper is then laid over the stone and appropriate pressure applied, resulting in a mirror image being transferred to the paper. The stone may be re-inked and the process repeated. In the hands of a skilled printer, hundreds and even thousands of copies might be made before the image deteriorates.[14]

Since the process is autographic (i.e., an artist draws directly on the stone with the work mirrored on the paper), Senefelder advertised it as a way for the artist to "multiply his originals," whether a picture or a business or legal document. Because it is also relatively inexpensive, one editor predicted in 1826 that "the cheapness and facility of the lithographic process, the number and goodness of the impressions to be obtained from a single plate, the spirit of these impressions, they being *fac-similes* of the original drawing, show that it is a most valuable substitute for copper-plate printing in all but the highest branches of the art." Six years later another scribe claimed, "The cheapness of lithographic prints brings them within the reach of all classes of society, and the works of authors which require embellishment, are by this art reduced in price." And by 1846, Nathaniel Currier, who would achieve much greater fame as partner with James Merritt Ives, advertised that he was "prepared to supply orders for *Lithographic Prints* from 1 to 250,000 at 24 hours notice."[15]

There was also another advantage. Uninhibited by the rigid lines and columns of metal type in books, newspapers, and magazines, lithographers freely exercised their imaginations to create designs,

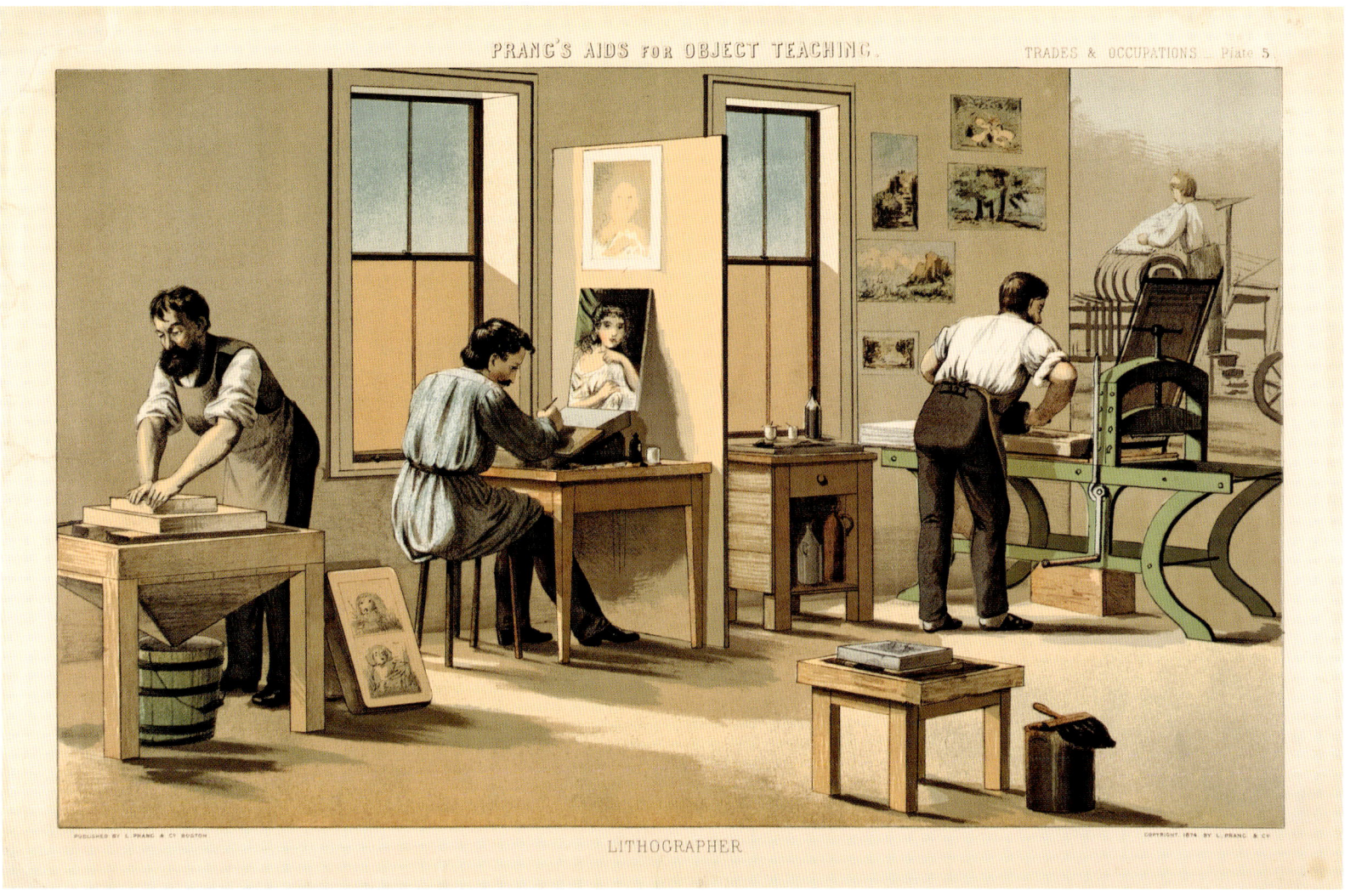

FIGURE 0.3 Unknown artist, *Lithographer*, 1874. Chromolithograph, 12 × 30 in. From *Prang's Aids for Object Teaching, Trades and Occupations*, plate 5, by L. Prang and Co., Boston. Courtesy Amon Carter Museum of American Art, Fort Worth (1978.26). Prang illustrates the various steps (from left to right) in producing a lithograph. First, a worker smooths the stone by grinding it against another stone. Then the artist copies an image on the stone. In the third stage, a worker is inking a stone on a hand-operated proofing press, and, at the top right, a worker is tending a steam-powered press.

alphabets, and color combinations that could be printed in any format within the size of the stones. The change was so radical that traditionalists often objected to the increasingly intricate scrollwork and sometimes garish colors of chromolithographs. English printer and author Andrew J. Corrigan complained that lithographers "had no traditions.... They were not bound by any limitations, and could run their degeneracies in a diagonal or double diagonal, circle, pyramid, oval, or triangle as they pleased." But such had been the case for decades, and the practices became ubiquitous as colorful posters and advertisements lured customers away from the more traditional letterpress products as the century progressed.[16]

Senefelder had intended to invent a scientific method of printing, a precise procedure that could be described and duplicated by others. But differences in ink and stones made it a highly individualistic process based on general formulas adapted to the characteristics of each stone and even subject to variables such as atmospheric conditions. These techniques immediately became trade secrets of each printer and were not readily shared with competitors, except

through apprenticeships and the tendency of printers to move from one establishment to another. The best stones still come from the Solenhofen quarry in Bavaria, but Americans soon found usable stones in Kentucky, Ohio, New Mexico, and, according to one experiment, Texas.[17]

Because of the variations and expense of the stones, Senefelder also had experimented with zinc plates, which can be grained or polished with sand and water like a lithographic stone, and American lithographers were experimenting with zinc plates by 1849. By December 1884 a writer for the *Inland Printer* reported that "zinc plates as substitutes for lithographic stones are now in common use"; in 1888 the *Waco Evening News* reported on the use of "zincography as a refuge and substitute for the Bavarian lithographic stone."[18] Many of the larger lithographs considered in this study, such as some of the bird's-eye views of cities, probably were printed from zinc plates rather than stones.[19]

This abbreviated description makes lithography sound simple, but there are numerous pitfalls, as the would-be lithographers of early Texas discovered. First, the print is reversed from the image drawn on the stone, so if the artist wants to produce an exact replica of a picture, he must draw the image on the stone in reverse or transfer it to the stone (by placing the drawing face-down on the stone and rubbing the back with enough pressure that the image offsets onto the stone). Nor will he know precisely what the finished image will look like, because the color of the crayon or ink used to draw on the stone does not necessarily relate to the tonal qualities of the finished print, which must be worked out through experience. Lampblack or some other coloring agent is usually added to the crayon to make the drawing visible, but the amount of ink that will adhere to the drawing and be offset to the paper is in direct proportion to the amount of grease in the crayon, not the amount of lampblack. Early lithographic manuals instructed printers to strive for an equal amount of grease throughout the drawing and to achieve tonality by the same techniques they used in engravings or etchings. Eventually, however, as lithographic artists gained experience with the medium, they learned to vary the amount of grease in the crayon or ink, thereby managing the tonality in the finished print from the lightest gray to the darkest black.[20]

The ability to control the tonality proved to be one of lithography's great advantages over earlier forms of printing, but it required a sophisticated knowledge of the process and deft workmanship. Imagine the challenge that forty-one-year-old German immigrant Wilhelm Thielepape faced in San Antonio in 1855: trained as a surveyor and a draftsman but with no printing experience, with a lithographic manual in hand and a used and faulty press purchased in New Orleans, "he practically reinvented the art of lithography," according to Dr. Adolph Douai, editor of the San Antonio *Staats Zeitung*, to produce a few crude images that probably are the earliest lithographs printed in Texas.[21] This new process was slow in coming to Texas, but when it did, it created and helped spread the region's visual imagery throughout the country—in book illustrations, sheet music, maps, advertisements, letterheads, and separately issued prints.

It is generally easy to identify a lithograph: the distinctive quality is the graininess of the stone that is mirrored in the image (fig. 0.4). But some lithographs—especially those composed only of lines, as recommended in some early manuals—are difficult to distinguish from engravings or etchings. In addition, editors frequently used "lithograph" and "engraving" as interchangeable terms and often did not know the difference, as exemplified in 1869 when editor Ferdinand Flake took his counterpart at the *Galveston News* to task for mistaking "the very commonest of woodblock printing" for a lithograph. In its simplest form, a lithographic line, because it is made by a planographic process, will often appear under magnification to be evenly inked with smooth edges. Sometimes the graininess of the stone will be evident, even in the lines and dark areas of the print, but some of the finer-grained stones combined with the best craftsmanship yield velvety blacks in which grain is often difficult to detect. By contrast, the edges of an etched or engraved line will sometimes appear to be rough under magnification, because it will

FIGURE 0.4 Detail from Carl Nebel, *Battle of Palo-Alto*. Lithograph, 27.8 × 42 cm, by Adolphe-Jean-Baptiste Bayot. From George Wilkins Kendall and Carl Nebel, *War between the United States and Mexico, Illustrated* (1851), showing the grain of the lithographic stone as well as the paint strokes (in the right margin) of the colorist. Amon Carter Museum of American Art, Fort Worth.

have been made by a physical process that began with either scratching or chemically etching a metal plate and then was printed under great pressure. Woodcuts, wood or metal engravings, metal cuts, and other forms of relief printing sometimes show signs of what printers call "squeeze," in which the pressure of the press forces ink from the middle of the line toward the edge. The darker edges of such a line may sometimes be seen under magnification.[22]

As printmakers continued to experiment and developed increasingly sophisticated techniques, the obvious differences among printing methods blurred. Senefelder had explained another process of drawing on the stone that resembles the use of a wax ground in etching. In what Senefelder called stone engraving, the lithographer coats the stone with a water-soluble ground, then incises the image in the ground with a fine needle. Grease reaches the stone only where the lines have cut through the wax, resulting in thin but consistent lines and making the process ideal for producing maps. Others chose to draw on the stone with a pen or an extremely fine brush in the same hardline manner that they had used for intaglio prints or to transfer extremely fine-lined drawings from paper to the stone. Many lithographers intentionally tried to imitate etchings or engravings, which were considered by many to be superior artistic techniques. Greene & Fishbourne of New Orleans, for example, advertised that they had "at length brought Lithography on a par with Copper-plate printing" and claimed that the result "imitates copperplate printing so well that the most critical eye cannot distinguish the difference." Although by 1873 the *Daily Graphic* in New York printed its entire newspaper by lithography, including the type, the illustrations still appear to possess all the characteristics of engraving.[23] It is no surprise that the first successful lithographer in Texas, Miles Strickland, testifying in court regarding some counterfeit stock certificates, explained that "I can not say where nor by whom the work was done." He explained that "a portion of these certificates is set up in type, a portion engraved, and the whole transferred to a lithographic stone and an impression taken therefrom."[24] Strickland described a common practice in nineteenth-century printing. The final product was a lithograph, but its production involved letterpress printing and engraving.

Therefore, it is difficult to determine whether the Joshua Lowe after Edward Hall view of Austin (see fig. 2.25) is a lithograph; fortunately, Lowe labeled it as such. Even the grainy appearance of a print is sometimes difficult to interpret; mezzotint (a form of engraving that appears to have tonal ranges) and aquatint (which achieves a similar effect by dusting the plate with powdered rosin, heating it, then etching it with acid) simulate the grainy qualities of a lithograph and were generally favored for fine-art prints such as those in Audubon's heroic *The Birds of America* (1827–1838) and Karl Bodmer's stunning Plains Indian portraits accompanying Prince Maximilian of Wied-Neuwied's *Die Reise in das innere Nord-America in den Jahren 1832–34* (*Travels in the Interior of North America 1832–34*) (1839–1841). But with most lithographs the question of medium is easily answered because of the grainy and tonal qualities, even in works as beautifully printed as Audubon's *Viviparous Quadrupeds of North America* (the finest work lithographed in the United States prior to the Civil War) and George Wilkins Kendall and Carl Nebel's *The War between the United States and Mexico, Illustrated* (1850), which was lithographed and hand-colored in France.[25]

The question of medium is further complicated by the addition of color. Initially, lithographers printed in only one color, usually black. Sometimes they added a colored tint from a second stone, brown or green for the foreground or blue for the sky.[26] When additional color was needed, the artist applied watercolor or, in some instances, oil-based paints by hand. Finally, lithographers got to the point that they could print all the colors from stones in an extremely complicated mental and mechanical process. Senefelder had conducted experiments with color printing, and German lithographer Godefroy Engelmann took out a French patent on what he called chromolithography in 1837. Two years later English lithographer Charles Hullmandel printed the first color lithographs in England, and in 1840 English immigrant William Sharp brought the process to America.[27] The need for mechanized production of color plates is apparent when considering the octavo edition of Audubon's *The Birds of America* (1840–1844), which lithographer J. T. Bowen produced in Philadelphia as Sharp was conducting his experiments. Audubon's seven volumes contain five hundred hand-colored plates. By the time he finished the project, he was printing 1,050 copies of each print. Simple multiplication requires that Bowen's colorists would have had to color more than half a million plates (1,050 × 500 = 525,000) during that five-year period.[28] Miles Strickland introduced color printing to Galveston in 1873, and by the 1880s the Dallas Lithograph Co. was producing "chromos" such as the *Diploma Awarded by the Texas State Fair and Dallas Exposition* (see fig. 7.71).[29]

A chromolithograph is generally defined as an image composed of at least three printed colors, in which the colors themselves make

up the picture. Printing a chromolithograph is considerably more complicated than a lithograph. First, a skilled colorist had to decide how, printing one color at a time, to achieve the final color combination. Surviving proofs indicate that there was no generally accepted theory as to how this was to be accomplished, but standard references suggest that bronzing was done first followed by blue, red, yellow, outline, and, perhaps, a final color. For the most sophisticated images, lithographers might have used as many as twenty or thirty stones, each printing a different color or different area of the image. New technology was also involved, for most chromolithographs were printed on steam-powered presses. A number of chromolithographs are included here, including Seth Eastman's view of Mission San José (fig. 4.7), Strickland's Mardi Gras invitations (figs. 7.24–7.28, and 7.30–7.36), the new capitol (figs. 8.34 and 9.59–9.61), the frontispiece to Charles Siringo's book (fig. 8.8), the Spring Palace poster (fig. 9.56), Texas-related trading cards (figs. 8.13–8.20 and 8.22), and various advertising posters (figs. 7.70 and 9.47); but only Strickland's Mardi Gras invitations (see chapter 7), W. H. Coyle's cover for the *Grand Inter-State Drill and Encampment* (fig. 7.61), several of Dallas Lithograph's works (figs. 7.67–7.68, 7.70–7.73), and, perhaps, the frontispiece to William W. Dunn's *Evolution and True Light* (fig. 7.82) were printed in Texas.[30]

Examples of each of the various kinds of lithographs appear here, and, while there are no universally accepted definitions, I have referred to a single-color print as a lithograph, a lithograph containing one or two additional colors as a tinted or toned lithograph, and a print of three additional colors or more as a chromolithograph. I have also noted the presence of hand-coloring.

Print historians have long been interested in the development of lithography, beginning with Senefelder himself and his book *Vollständiges Lehrbuch der Steindruckerey* (1818; published in English in 1819 as *A Complete Course of Lithography*). The great collector of American lithography was Harry T. Peters, partner in a coal company and avocational sportsman and print collector. In *Currier & Ives: Printmakers to the American People* (1929), he provides a detailed history of that firm and its artists, along with a checklist of their prints. Most of this collection is now housed in the Museum of the City of New York. His monumental *America on Stone* (1931) deals with other nineteenth-century lithographers (collection now in the Smithsonian National Museum of American History) and was followed by *California on Stone* (1935), in which he provides a survey of what he called the "fourth geographical school" of American lithography after Boston, New York, and Philadelphia.[31] Scholars soon readdressed those areas: Sally Pierce and Catharina Slautterback (Boston), Nicholas B. Wainwright and Erika Piola (Philadelphia), and David Tatham and many others (New York). There are also specific volumes on other cities, such as New Orleans and Cincinnati.[32]

All this to say that there is almost a century-long tradition of lithographic scholarship relating to various areas of the country, so it is not unusual that a volume should address lithographs relating to Texas. The main difference between this study and the others, however, is that the others deal with lithographs produced in the cities (or states) being discussed, while this volume includes lithographs that were printed in many different places—France, Germany, the Czech Republic, England, Mexico, various American cities, and, finally, after several decades of growth and immigration, Texas itself—but that all relate to Texas.

This collection, then, presents a fresh and fascinating perspective on Texas as it developed in less than a century from a Spanish colonial wilderness into a Mexican state, a republic, an American state, and a Confederate state, before joining the Union again. Bringing together these historic images for the first time tells a composite truth about the state than has gone unexamined over the years, the whole of which few contemporaries would have seen, with the possible exception of Swen Jaensson, known as Swante Palm (1815–1899), a twenty-four-year-old Swede who immigrated to Texas in 1844. Over the years, Palm gathered a large collection of prints and travel books in his Austin home, and in 1897 he donated most of his twelve thousand volumes to the University of Texas, including works on "comparative history . . . , exploration, travel, geography, science, climate and life statistics," and pictures of every kind, which are now scattered among the various libraries at the university. "Had his plan been completed," wrote bibliophile Harry Ransom, first chancellor of the University of Texas system and founder of the Harry Ransom Center, "he would have acquired every early print of Texas and the Southwest."[33] Gathered in his library, and in this study for the first time, is perhaps the most complete visual record of nineteenth-century Texas—the record of a nineteenth-century myth on the make.

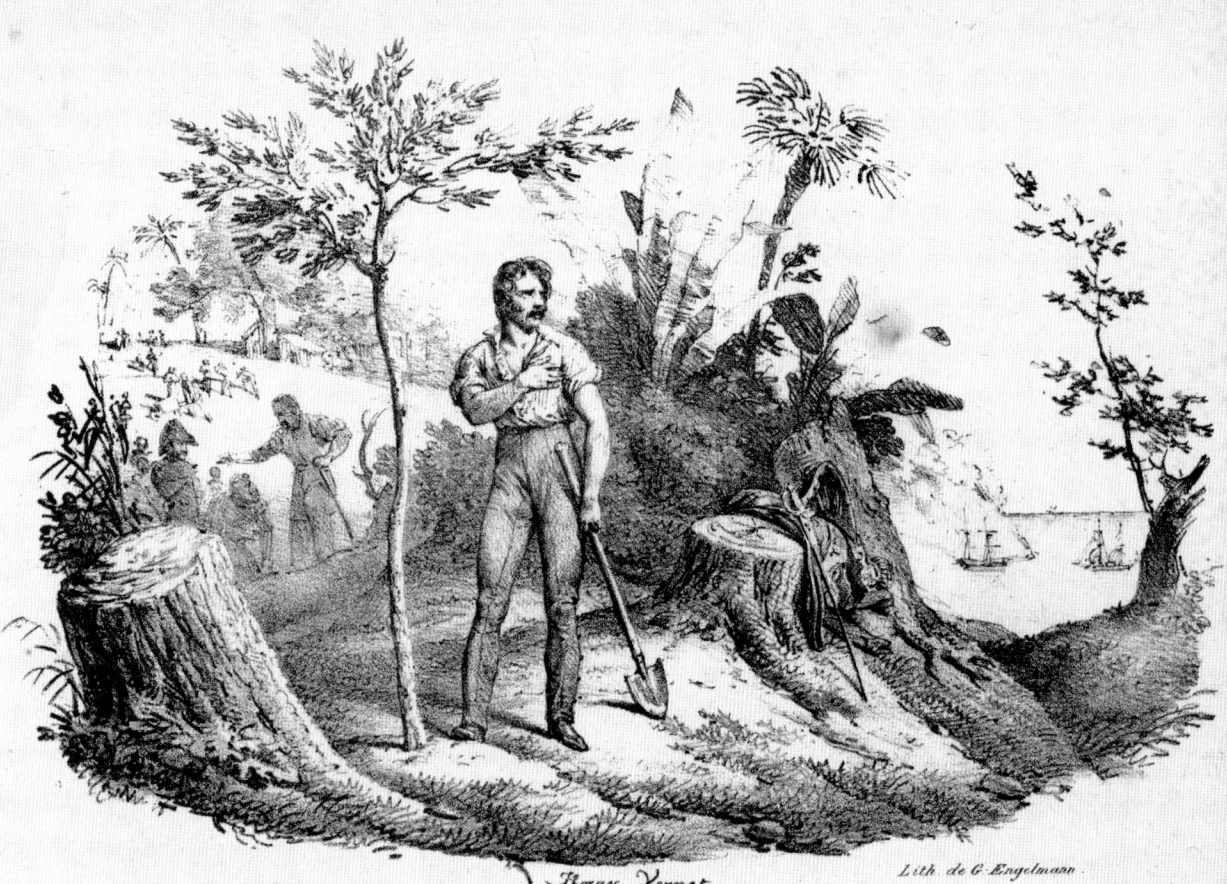

FIGURE 1.1 Horace Vernet, "Le Champ d'Asile Romance," 1818. Sheet music. Lithograph, 11 × 9.38 in. (sheet), by Godefroy Engelmann. Published by Bressler, Paris. Signed on the stone l.c., Vernet; l.r., Lith. de G. Engelmann. Courtesy Special Collections, University of North Texas Library, Denton.

CHAPTER 1

"REALLY A KIND OF PARADISE"

HISPANIC AND MEXICAN TEXAS

Standing on the bank of a New World river, the valiant Frenchman, a veteran of Napoleon's campaigns, places his right hand over his heart, his fingers forming what may be a Masonic sign evoking international brotherhood (fig. 1.1). Scorned at home, he has sought refuge in an alien wilderness. His comrades are at work behind him at the left; one of them, probably a former officer, still wears his uniform and bicorne hat. They are literally transforming the dense thicket into a fortified home. The tree stumps in the foreground and center mark their progress, the timber used to build the cabin on the hill at the left. In his left hand the refugee holds a shovel, signifying his peaceful intentions, but he secures it as he would his rifle at ease, and his sword and military uniform are lying on the nearby tree stump should he need them. He looks longingly over his left shoulder toward the two ships at anchor in the river at the right, the only connection with his homeland. This is Champ d'Asile on the Trinity River in Spanish Texas in 1818, as drawn by the well-known French painter Horace Vernet and printed in Paris by Godefroy Engelmann, one of the pioneers of lithography. It is the first Texas lithograph.

The remote Hispanic and Mexican province inspired few lithographs, and it is remarkable to have more than one appear as early as 1818, when the region was still "a distant, unimportant hinterland," an "ungovernable appendage" as far as the Spanish crown was concerned.[1] Each lithograph resulted from extraordinary and sometimes fascinating circumstances. The first appeared just three years after the battle of Waterloo, after former French general Charles-François Antoine Lallemand (fig. 1.2), led a group of Napoleonic veterans to establish a settlement in southeast Texas near the mouth of the Trinity River, a disputed region that for decades had been home to Indians, illegal settlers, bandits, invaders, revolutionaries, and a few Spanish colonists. Lallemand claimed that the colony was a peaceful agricultural settlement for veterans of Napoleon's Grand Armée, but Champ d'Asile (Field of Asylum) was, in fact, a provocative, armed effort that impinged briefly—and recklessly—on the fringes of Spanish Texas at a sensitive time, as the United States and Spain were negotiating the boundary of the Louisiana Purchase. Six months later Lallemand had abandoned the effort, and a Spanish army had razed the site so efficiently that archeologists still have found no trace of it.[2] Its purpose remains shrouded in obfuscation, but this disorganized, wildly romantic, and doomed invasion of Spanish territory inspired a flurry

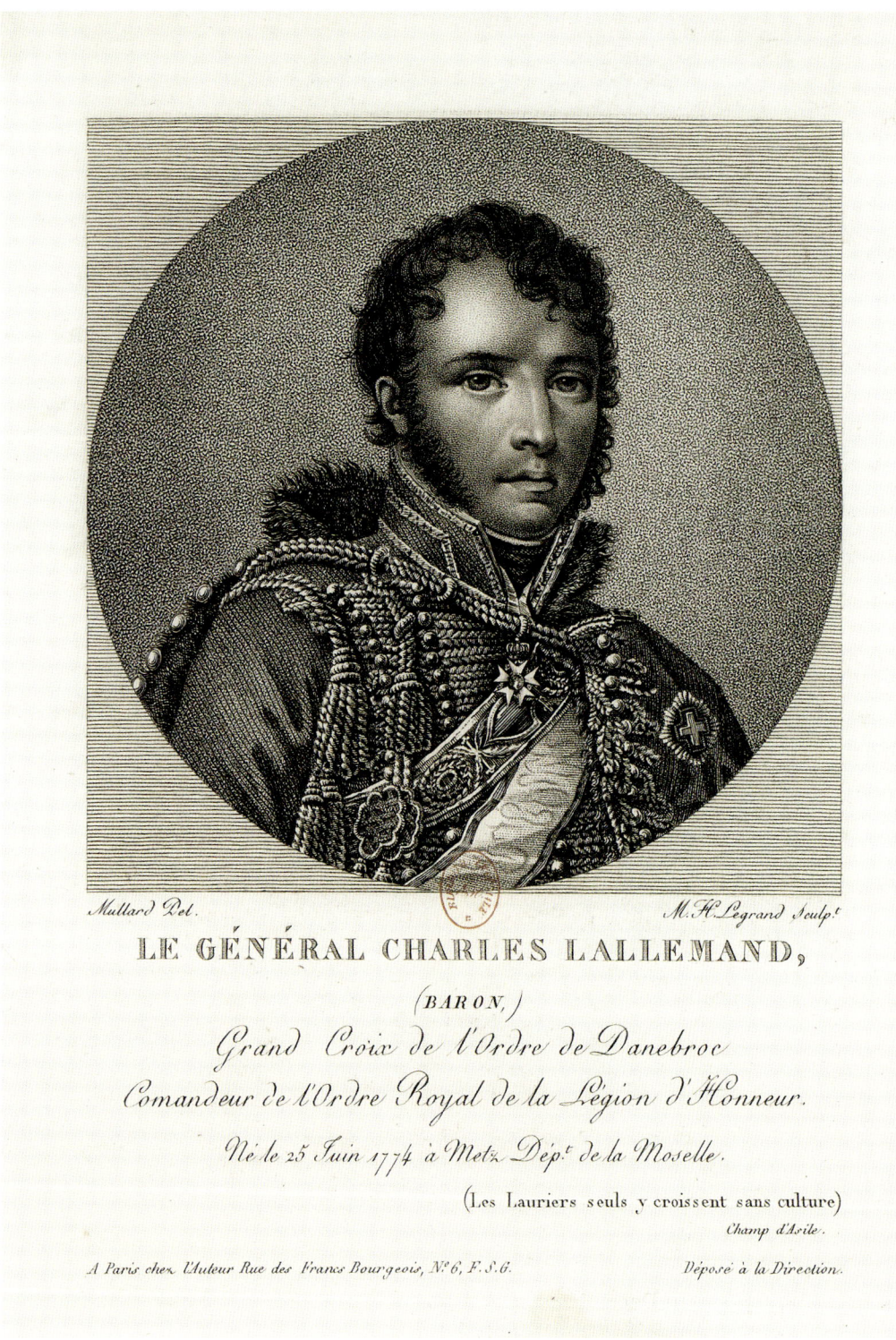

FIGURE 1.2 François-Henry Mullard, *Général Charles Lallemand*, 1819. Single sheet. Engraving, 11 × 8 in. (sight), by M. H. Legrand. Courtesy Collection Générale des portraits, Bibliothèque nationale de France.

of imaginary lithographs set in Texas, just two decades after Senefelder had invented the process and before the first lithograph was printed in the United States.

Following Napoleon's defeat in 1815 and exile on the island of Saint Helena in the South Atlantic Ocean, his officer corps had scattered to the four winds. Many of them took refuge in the United States, where their presence spawned various rumors, from a plan to rescue Napoleon, to a military expedition to liberate Mexico from the Bourbon domination of Spain's King Ferdinand VII and install Napoleon's brother Joseph as king, to the overthrow of the French monarchy itself. While the Americans generally welcomed the veterans, their presence also caused concern, and, seeking to encourage them to settle and occupy recently seized Indian lands in western Alabama, Congress granted a group of them, organized as the Society for the Cultivation of the Vine and Olive, four townships near present-day Demopolis. Charles Lallemand managed to take over the society and raised money for his Texas venture by selling some of the Alabama townships to Philadelphia speculators.[3]

While Lallemand's "splendid idea" inspired dreams of a New World empire, novelist and playwright Honoré de Balzac, a close observer of the French political scene, pointed out that both the restored Bourbon monarch Louis XVIII and the Bonapartists recognized the project as a possible solution to one of their most vexing problems—how to deal with as many as twenty-five thousand former imperial soldiers, forcibly retired on half-pay (which seldom arrived) and legally prohibited from working anywhere but their family farms. Many of the battle-scarred, desperate men "knew no other life than war making."[4]

The veterans—French, Polish, Dutch, and Belgian, as well as other nationalities—arrived in two armed groups, one under Brigadier General Antoine Rigaud, fleeing a death sentence because of his rebellious activities, and the other under Lallemand, who had escaped a British jail in Malta. The groups rendezvoused on Galveston Island in February 1818. With the assistance of the notorious smuggler and pirate Jean Laffite, who was operating as a Spanish informant but had little choice but to assist such a large military contingent, the group departed on March 10 for the mouth of the Trinity River. One of their flotilla of tiny boats capsized in Galveston Bay, and six veterans drowned, but the remainder made it safely to the selected site. Lallemand and his brother Henri Dominique purposely chose a defensive position on a bluff overlooking the river a few miles south of present-day Liberty/Moss Bluff.

Fewer than 150 officers and soldiers—along with four women and four children, including Rigaud's adult son Narcisse and his daughter Antonia as well as a few servants and laborers—finally reached the chosen site. The so-called colonists spent most of their time building a fortress and manufacturing munitions, so lack of food was an immediate problem. Every plant in the area seemed to stick or sting, and one that looked like lettuce, probably Jimson weed, proved to be poisonous and made the poorly provisioned and starving veterans quite ill—until a friendly Indian provided them with the antidote. Initially well organized along military lines, the colonists soon fell into disagreement, and the leaders apparently suffered from the delusion that they were so far from the settled areas of Texas that the few Spaniards there would not bother them.[5] While rumors spread internationally, Lallemand issued a proclamation on May 11 claiming that he had established an agricultural colony for deserving veterans, armed only for self-preservation and defense. But rumors of other purposes swirled and spread. A deserter later divulged that he had overheard the general describing how the wealth from Mexican silver mines would finance the rescue of the emperor.[6]

The Spaniards had known about Champ d'Asile from its inception—Lallemand had tried to convince the Spanish minister to the United States that his settlement would serve as a barrier against filibusters from the United States—and Viceroy Juan José Ruiz de Apodaca y Eliza in Mexico City had warned Antonio Martínez, governor of Texas, of the colonists' presence as early as April. Fearing that the Americans would use the French intrusion as an excuse to invade Texas as they had Spanish Florida, Apodaca ordered land and sea expeditions to oust the French from Spanish territory. But the Spanish naval squadron could not navigate the treacherous and shallow Galveston Bay, and the overland expedition from San Antonio suffered worse than the onerous conditions that beset the occupants of Champ d'Asile because they had to travel over 250 miles of wilderness and cross seven rain-swollen rivers.[7] But when Lallemand learned from Laffite that a Spanish military expedition was en route, he and his dispirited followers struck camp in less than two hours. Once the French were back at Galveston, a US federal agent notified them that Congress wanted everyone to leave—settlers and pirates alike—and they scattered. Several, including Lallemand, departed immediately for New Orleans. Others joined the pirates. Hezekiah Niles, one of the most widely read American journalists, reported in December that "Gen. Lallemand's establishment on the Trinity River, it seems, has been broken up, root and branch, by a petty party of 200 Spaniards from the interior." In fact, Champ d'Asile had collapsed ignominiously on July 23, 1818, two and a half months before the Spaniards arrived, a circumstance that the Spanish commander, Juan de Castañeda, appreciated, reporting that "the taking and destruction [of the fort] would surely have cost a great deal of blood because of its location and because the fortifications were constructed with all the rules of the profession."[8]

The most successful aspect of the endeavor was the propaganda campaign carried out in France by a broad coalition of liberals opposed to the monarchy. Benjamin Constant led the effort, and he and other Bonapartist friends established a journal, *La Minerve Française*, and pushed their interpretation of the events to mythic proportions. Champ d'Asile, as the Bonapartists called the settlement, captured widespread attention in France because of the association of former officers of Napoleon's Grande Armeé and the French idealization of New World exoticism and wilderness. In August, a month after the colony had disbanded, Constant published Lallemand's May 11 proclamation claiming that Champ d'Asile was an agricultural settlement with a code of laws "founded on justice, friendship, and disinterestedness" and immediately blamed the Bourbon monarchy for its failure. *Niles' Weekly Register* suggested a less benign purpose the following month: the colony was said to "gather strength very fast, by volunteers—and it is intimated, will soon be able to 'strike at once for the liberation of Mexico.'" In December the newspaper repeated the *London Courier* rumor that the rogue British naval captain Lord Thomas Cochrane had a steamship that could navigate the coast of a windward island such as Saint Helena. "Few things would gratify him more than to become

the liberator of Napoleon," the *Courier* had ventured, and "the Bonapartists in the province of Texas on the Trinity river . . . may probably supply the resources" for such an expedition.[9]

Despite the fact that Lallemand and his followers had already departed Texas, the Bonapartists rallied poets, musicians, artists, and publishers to the cause of aggrieved veterans, whom they depicted in illustrated sheet music covers, books, pamphlets, and prints as having been hounded from their own country by an overreaching monarch only to have their "field of asylum" in the Texas wilderness denied them (fig. 1.3). Theatrical producers staged special performances, and sponsors organized at least one banquet on behalf of the exiles.

Parisian artists knew nothing of Texas, so as they prepared their imaginary images of this field of asylum they relied on the visual props and symbols from their culture—romantic works such as Chauteaubriand's *Atala* (1801), with its descriptions of the lush Mississippi River valley, and elements of heroic poses and figures from Jacques-Louis David's most famous paintings. Lithographers set scenes of well-known and valiant former imperial officers in their new home in the Texas wilderness alongside the "noble savage," which even the largely illiterate French populace could understand. "Texas has become a rich field for literature and anyone may exploit it," a French critic explained.[10]

The first to exploit this theme visually was Godefroy Engelmann, one of the foremost lithographers in France. Trained in business as well as art, Engelmann had recognized the potential of lithography and set up his own press in 1815. In the fall of 1818 he printed the cover for "Le Champ d'Asile Romance" (see fig. 1.1), a piece of illustrated sheet music composed by A. Romagnesi, who was associated with the Italian Opera in Paris, with lyrics by Alphonse Naudet and the cover picture by artist Horace Vernet, best known for his military paintings but also among the first to introduce lithography into France. Henri Bressler, a well-known publisher, pledged that the proceeds from the first one thousand copies would go to the refugees. *La Minerve Française* publicized the print and urged its readers to support the veterans.[11]

The soldier-laborers, the sad but proud former comrades in the emperor's campaigns now returned to their fields, became a popular symbol in France. Shown honorably tilling the soil, but with the accoutrements of war close at hand, these beaten warriors symbolized France itself, still occupied by the foreign armies that guaranteed the Bourbon king's authority. Now, in Vernet's image, the *soldat-laboureurs* of Champ d'Asile, who had crossed the ocean to establish their refuge in the wilds of Texas, became representative of these abandoned veterans.[12] Of course, implicit in these images is a critique of the Bourbon king for not taking better care of those who had served the country, but the criticism had to be sufficiently benign to pass the censor. According to the royal ordinance of October 8, 1817, all lithographic printers had to be licensed by the government, and all lithographic prints had to be deposited with the government before publication, so the implications had to be subtle.[13] But both Spain and France were ruled by members of the Bourbon family, and Napoleon had replaced the Spanish kings with his brother Joseph, which imbued this seemingly modest affair with possibly global consequences.

Engelmann registered the image *Le Champ d'Asile Romance* on November 18, 1818, almost four months after the settlement had been abandoned and less than three weeks after Spanish troops had destroyed the fortifications, commander's lodge, and cabins. It was the first of several publications—prints, books, and sheet music—devoted to Champ d'Asile between 1818 and 1820, all heavily influenced by the patriotism and politics of the moment. The image is a highly romantic and unrealistic, but symbolic, view depicting the *soldat-laboureur*, by then a familiar character in France.[14] He stands in the foreground with his right hand over his heart and looking over his left shoulder toward what is presumably the Trinity River, with two apparently ocean-going vessels at anchor. The careful Bourbon censor might have interpreted this gesture as a sign of his yearning to return home, but the more subversive suggestion was that this new colony possessed the means necessary to rescue the emperor from his Saint Helena imprisonment and help the Mexicans throw off this New World extension of the Bourbon yoke. The leaves and shrubs at the right center of the image seem to form the face of an Indian, which might have been a veiled taunt of the censor for shutting down a newspaper the previous year for suggesting that one of Jean-Baptiste Isabey's drawings might have contained a similarly concealed depiction of Napoleon's son.[15] The publication stirred patriotic pride even half a century later, when Pierre Larousse, who was of liberal persuasion himself, published his *Larousse Grand Dictionnaire universel du XIXème siècle* and recalled how "Béranger excited public interest with his beautiful song about Champ d'Asile."[16]

Engelmann's second sheet music cover, for "Le Champ d'Asile Romance Tirée de la Minerve française," registered on December 26, 1818, pursues the same theme, with a veteran facing the viewer

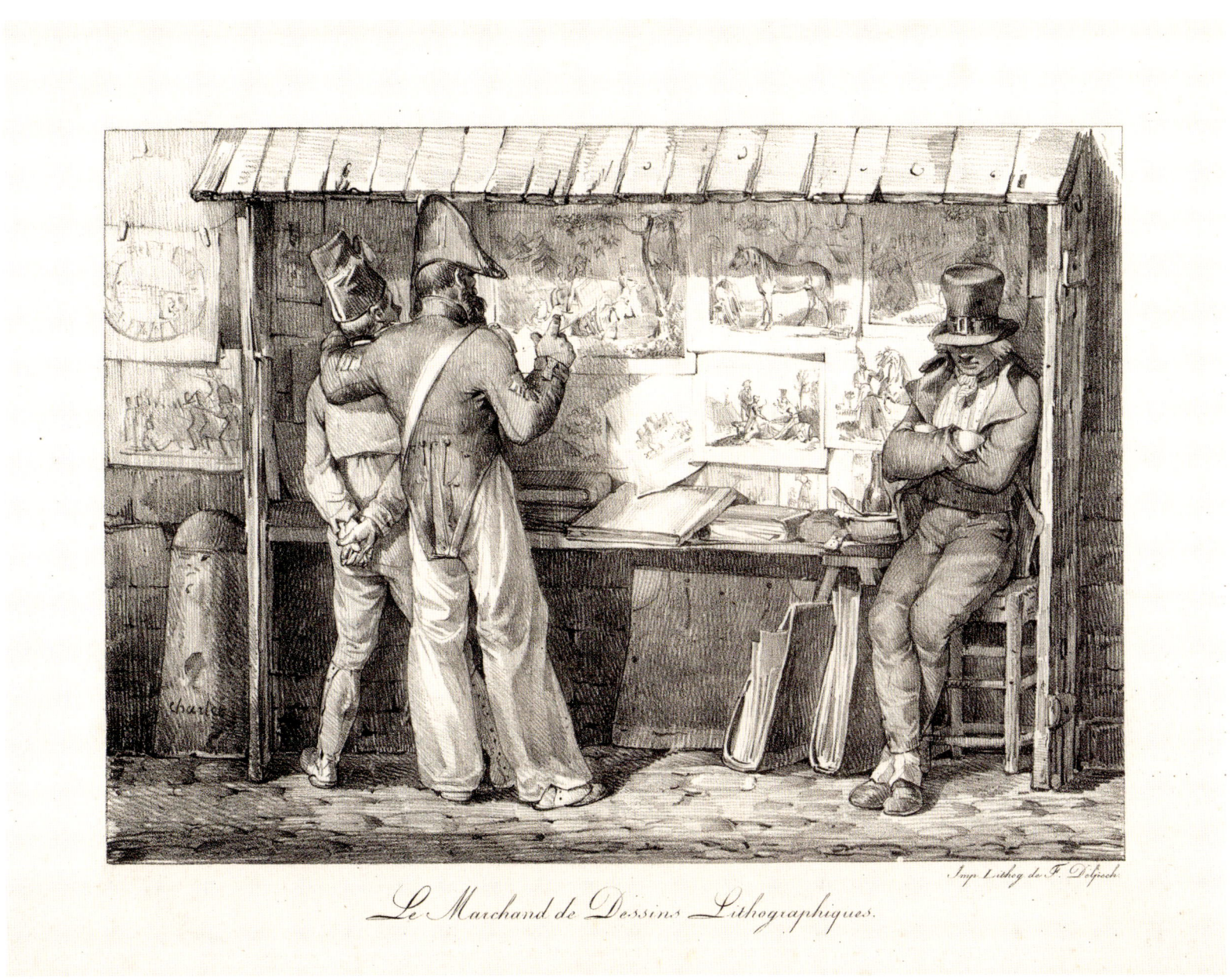

FIGURE 1.3 Nicolas Toussaint Charlet, *Le marchand de dessins lithographiques* [The seller of lithographic drawings], c. 1819. Crayon lithograph on wove paper, 8.5 × 12.12 in., by F. Delpech. Courtesy Museum of Fine Arts, Boston, gift of W. G. Russell Allen. French veterans pause to examine the print seller's offerings.

with his arms folded over the handle of his shovel, as he would a rifle, in what is clearly a new campsite with the Trinity River in the background (fig. 1.4). Others behind him on the hillside are working, while another, in a tricorne hat, converses with a Native American in front of the only structure within view, a lean-to adjacent to the tree at left. The camp is a bit more primitive than the one depicted in his first print and may be the most convincing of all the Champ d'Asile images, because it is clearly an area of construction rather than the idyllic scene portrayed in the other prints.[17] The song was taken from *La Minerve Française*; Antony Béraud provided the lyrics, G. Kuhn the music, and Auguste D. the cover illustration, and M. Ladvocat published it.

The painter Ludwig Rullmann, a German who had studied in Paris with Jacques-Louis David, moved the focus from the individual to the community and to scenes of "liberty, equality, and fraternity" with two images registered within days of each other in January 1819: *Les Lauriers Seuls y Croitront Sans Culture* (The laurels only grow wild, fig. 1.5) and *Colonie du Texas* (fig. 1.6). Rullmann, perhaps intentionally, confused the French refugee settlement of Demopolis on the Tombigbee River in Alabama with the Texas settlement to imply that the Texas settlement was also a legitimate colony. In both prints he depicts a French military officer shaking hands with an individual who has stopped working—a veteran chopping trees in *Les Lauriers* and a farmer plowing in *Colonie du Texas*.[18] Author Betje Klier has identified *Colonie du Texas* as an Alabama scene: the farmer is George Strother Gaines, who owned the local trading post near the Demopolis settlement, and the two military figures are General Charles

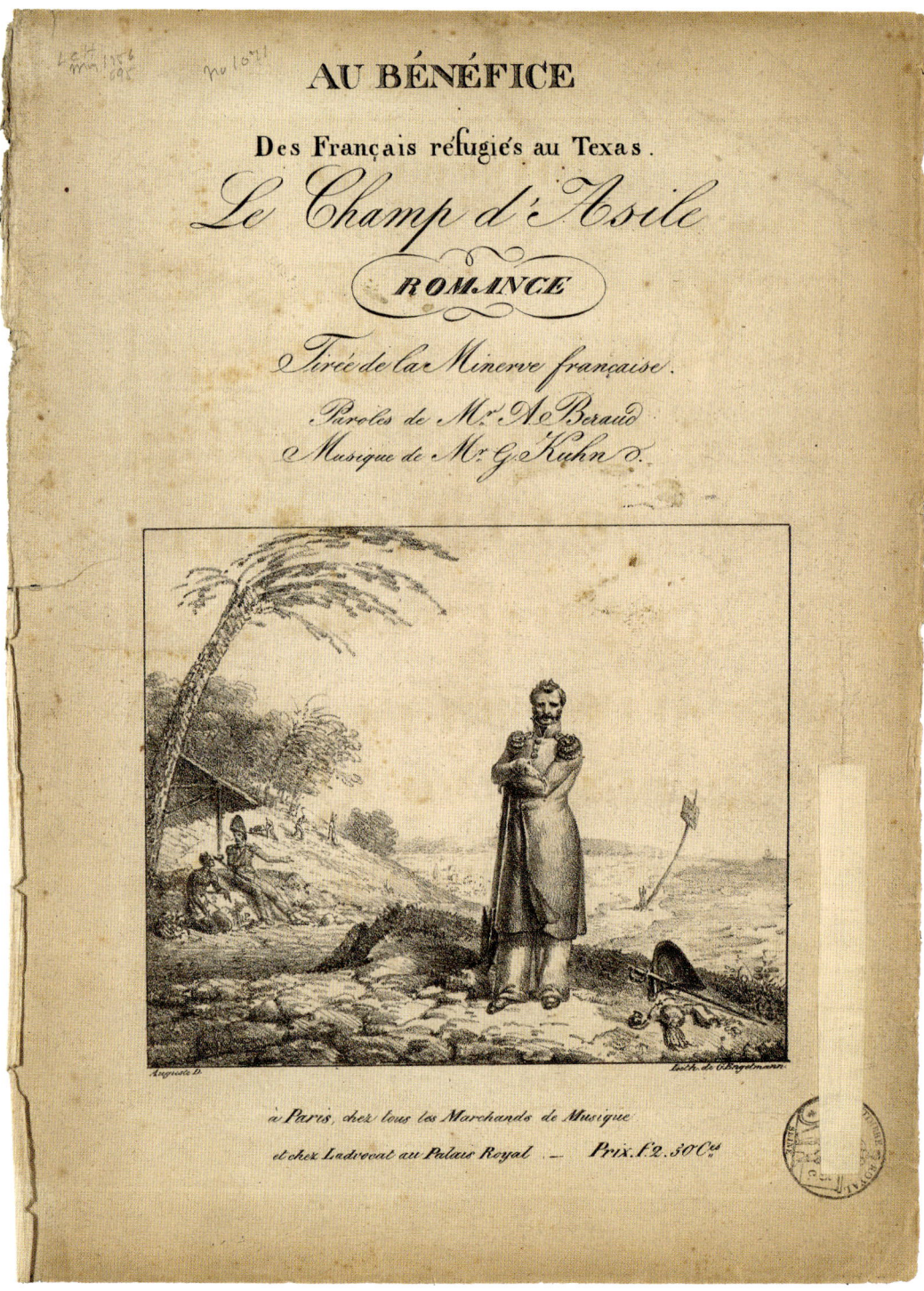

FIGURE 1.4 Auguste D., "Le Champ d'Asile Romance Tirée de la Minerve française," 1818. Sheet music. Lithograph, 14.3 × 17.5 cm (image), 29.4 × 17.5 cm (comp.), by Godefroy Engelmann. Paroles de Mr. A. Béraud. Musique de Mr. G. Kuhn. Published by Marchands de Musique dt chez Ladvocat au Palis Royal, Paris. At the head of the title: Au Bénéfice des Français refugiés au Texas. Courtesy Beinecke Rare Book and Manuscript Library, Yale University.

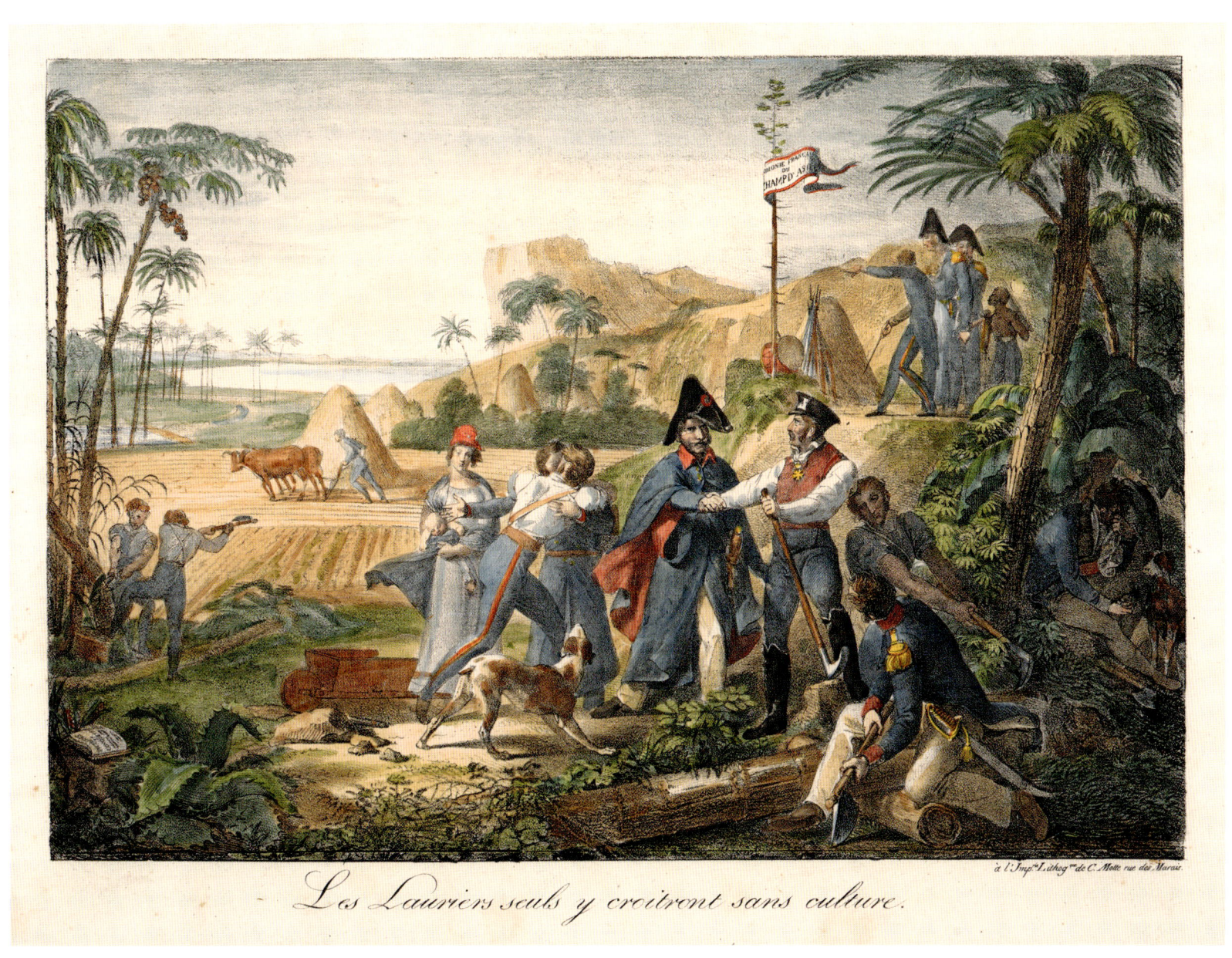

Les Lauriers seuls y croitront sans culture.

FIGURE 1.5 Ludwig Rullmann after Arsène Lacarrièr-Latour (attrib.), *Les Lauriers Seuls y Croitront Sans Culture*, 1819. Single sheet. Hand-colored lithograph, 9.12 × 13.31 in. (image), by C[harles Etienne Pierre] Motte. L.r., à l'Imp.rie Lithogque de C. Motte, rue des Marais [Paris]. Courtesy Amon Carter Museum of American Art, Fort Worth.

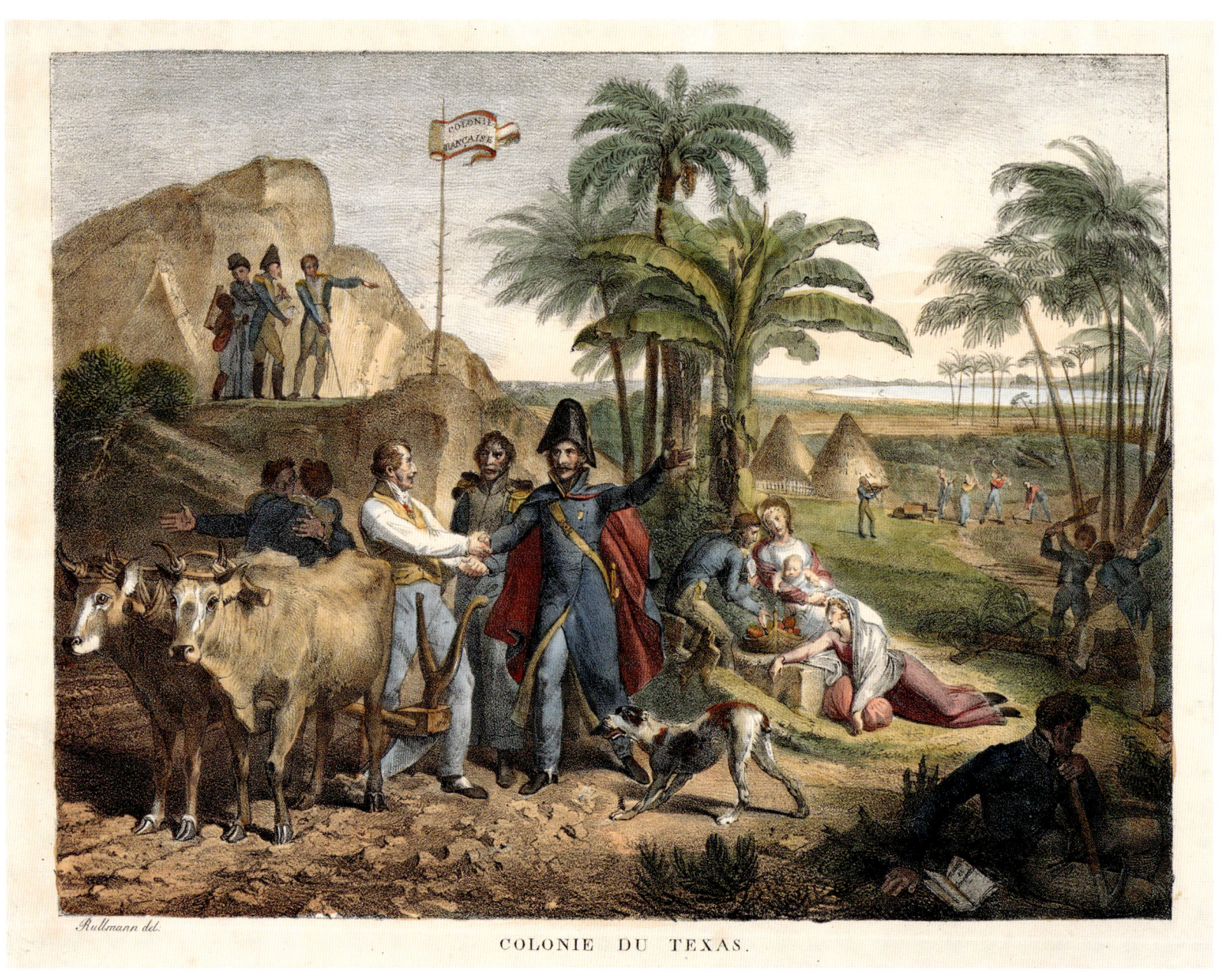

FIGURE 1.6 Ludwig Rullmann after Arsène Lacarrière-Latour (attrib.), *Colonie du Texas*, 1819. Single sheet. Hand-colored lithograph, 9.94 × 13.25 in. (image). Published by chez (Motte), 13 rue des Marais, Paris. Courtesy Amon Carter Museum of American Art, Fort Worth. The print might have been issued colored and uncolored since the copy in the Cabinet des Estampes in the Bibliothèque nationale de France is uncolored.

Lefebvre-Desnouëttes and Victor, the son of Marshal Emmanuel Grouchy. Other settlers are clearly soldiers but are engaged in home-building and agricultural pursuits. In *Les Lauriers*, Rullmann depicts men felling trees, while a farmer plows with an ox team in the middle ground, acquaintances and friends embrace, and officers (two in tricorne hats) survey the settlement from a promontory. In the lower right-hand corner, a soldier sitting under the tree appears to weep, comforted only by a dog; another has stopped his work to look at the central pair. The pennant that waves over the scene says "Colonie française du Champ d'Asile," but the theme of this composition, like *Colonie du Texas*, shares characteristics that are more likely associated with events that occurred at Demopolis.

In *Colonie du Texas*, the central scene is quite similar. Lefebvre-Desnouëttes greets Gaines, while, to the left (behind the oxen), two veterans greet each other. In the right-hand corner, another rests with his pick and has laid aside his book while he relaxes; and still others, at the foot of the trees in the right center of the composition, tend to a child, which might suggest the growth of the colony. On a hill, in the upper left portion of the picture, three figures stand, one appearing to look at a map or a plan, under a banner labeled "colonie française." At least one scholar has suggested that the diminutive figure in the tricorne hat may represent Napoleon, a none-too-subtle reference to the fact that the Bonapartists hoped he would rule again, even if only in the New World.[19]

There is a shadowy figure between Lefebvre-Desnouëttes and Gaines who may be a key to a fuller understanding of Rullmann's prints. Young Victor Grouchy had accompanied Lefebvre-Desnouëttes to Demopolis, but late in life Gaines recalled that there was another French officer present in the meeting, one whom Lefebvre-Desnouëttes called "the engineer" and who "sketched continuously." This was probably Major Arsène Lacarrière-Latour, an artist and cartographer as well as an engineer. He was a member of the French Army, had served as Gen. Andrew Jackson's chief military engineer during the battle of New Orleans, and had published his memoirs of the war in Philadelphia in 1816.[20] Dr. Klier suggests that Rullmann might have portrayed him as an acknowledgment that he had received Latour's sketches from Major Grouchy, who had returned to Paris in December 1818. So, while highly idealized, Rullmann's scenes of the French colony in Alabama (which he labeled as Texas) may actually have had Latour's eyewitness sketches as a source and therefore contain some visual elements of the actual camp. He chose from the artist's inventory of heroic poses and romantic symbols to finish out the scenes, which Dr. Klier further suggests were probably intended as pendants, for they almost mirror each other when placed side by side. They are quite similar to another pair of engravings done a year later by artist Ambrose Louis Garneray, and Dr. Klier proposes that by pairing the two settlements, both artists intended to blur the distinction between a legal agricultural colony and an illegal military outpost.[21]

"Le Champ d'Asile" was the talk of cafe society for months, and *La Minerve Française* announced in May 1819 that almost 100,000 francs (approximately $15,000) had been collected. Even the eight hundred students at the College of Louis le Grand, a prestigious academy, staged an "open revolt" over their subscriptions intended for the exiles, and the principal temporarily closed the school and called the police to restore order.[22]

The fate of the subscription money is the subject of perhaps the last lithograph concerning the by-now-legendary colony, *Compte Rendu* (fig. 1.7). The image seems to support accusations from no less popular a figure than Balzac that the entire effort was a "gigantic fraud" perpetrated by "those who paraded a sympathy" for the old guard but, in fact, had "joined hands with the partisans of the restored Bourbons in 'sending away the glorious remnant of the French Army.'" The anonymous artist and publisher who produced *Compte Rendu*, probably issued after the fate of the colony and the effort to disperse the funds had become known, no doubt agreed with him. *Compte Rendu* shows five men gathered around a table. As one begins to carve a pie labeled "revenus Champ d'Asile," another stands and offers a toast: "À la sante des habitants du Champ d'Asile." The satire may also be directed at Lallemand, who by then had obtained and mortgaged a farm on Bayou St. Jean, near New Orleans, victimizing several of his friends as he endeavored to become a capitalist and leading to speculation that he would try to keep all the money himself. In fact, the Louisiana governor appointed a committee, presided over by a respected planter, to distribute the money and asked Lallemand for a list of men who had participated in the foray. Lallemand delayed but finally produced the list, ostentatiously declining to take any of the money himself. That left two shares for the embattled General Rigaud; the rest was distributed in 1820 among the participants (more than half) who had settled in the New Orleans area.[23]

Ultimately, Champ d'Asile must be considered a confused and supremely misguided effort that was "cloaked in a profound darkness" but wonderfully representative of the spirited Romanticism

of the era that stimulated the earliest and, in many ways, the most fascinating lithographs relating to early Texas.[24] By calling attention to the Texas coast, the episode played a role in ousting Laffite from Galveston Island and in encouraging the United States and Spain to settle the boundary of Louisiana in the Adams-Onís Treaty of 1819. The ensuing goodwill on the part of the French people toward Texas perhaps encouraged France to intervene in the affairs of Mexico in the so-called Pastry War in 1839, at a precarious time for Texas, and in Rear Admiral Charles Baudin's triumphant visit to Galveston a few months later as he was returning from having pummeled Veracruz and the fortress of San Juan de Ulúa.[25] France became the first European country to recognize Texas independence in September 1839.[26] No wonder the great Texas collector and bibliographer Thomas W. Streeter concluded his discussion of the various Champ d'Asile publications by commenting, "If this note were not already very long I would include in it a description of contemporary prints on the Champ d'Asile. They are an interesting lot."[27] An understatement, to be sure.

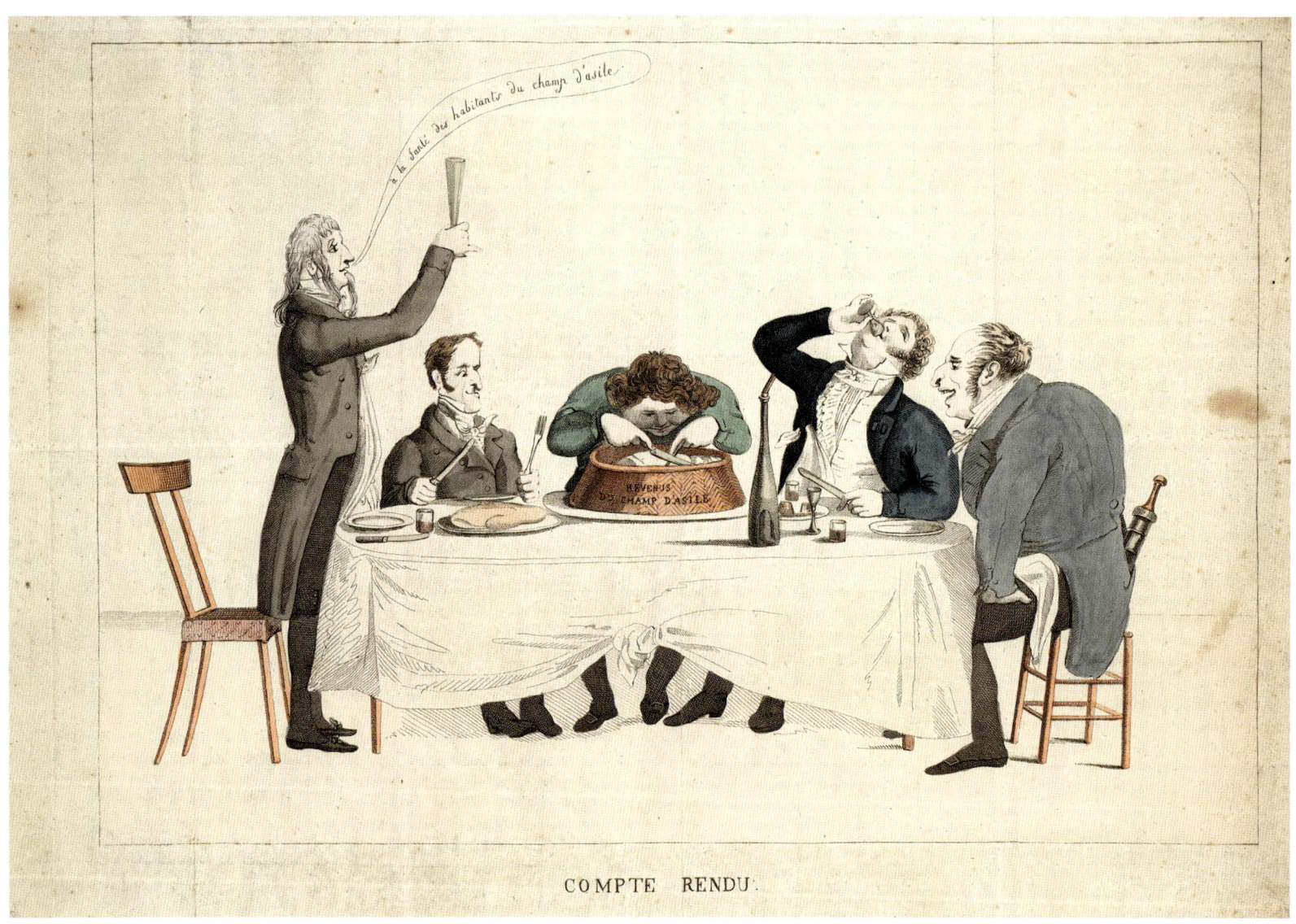

FIGURE 1.7 Unknown artist, *Compte Rendu* (Accounts rendered), c. 1819. Single sheet. Hand-colored lithograph, 32 × 48 cm (comp.), lithographer unknown. Courtesy Beinecke Rare Book and Manuscript Library, Yale University.

JOHN DUNN HUNTER, A LOST SOUL

All remnants of Champ d'Asile were apparently gone by the time twenty-nine-year-old John Dunn Hunter arrived in East Texas in the fall of 1825. A striking character, especially on the wilderness frontier, Hunter had been orphaned and raised by Kickapoo, Kansas, and Osage Indian tribes, as he explained in an autobiography published in Philadelphia in 1823. The Osage had named him "Hunter" because of his prowess in the chase, and during one summer he migrated all the way to the Pacific Ocean with his adopted tribe. He left the Indians in about 1816 to go to school to learn (or relearn) English and became an enthusiastic reader, later adopting the name of a Missourian whom he esteemed, John Dunn. After his autobiography was published, he traveled to England, where the British publisher Longman, Hurst, Rees, Orme, and Brown reprinted his book, retitling it *Memoirs of a Captivity among the Indians of North America, From Childhood to the Age of Nineteen . . .* , and adding a handsome lithographic portrait as the frontispiece (fig. 1.8), after artist Charles Robert Leslie, born in London of American parents. Even before Hunter returned to the United States to try to help the Indians, Longman issued a third edition of the book with a second lithographed portrait, also by Leslie.[28]

The same Romanticism that had enveloped Champ d'Asile also rendered Hunter's life story high adventure for the English elite, who saw him as a figure straight from the Rousseauian wilderness of the New World, a serious young man with an idealistic plan to save the doomed Indians from extinction. He was a friend of the Welsh utopian socialist philanthropist Robert Owen, who founded New Harmony, Indiana, and of former president Thomas Jefferson. His book initially attracted favorable attention, but when the English edition became the subject of an approving review in the *London Quarterly Review*, which blamed the American government for its treatment of Native Americans, critics attacked Hunter as a charlatan and characterized his book as "vapid descriptions and ill-digested theories." They included men such as Lewis Cass, governor of Michigan Territory; William Clark, of Lewis and Clark fame; linguist Peter Stephen Duponceau; and ethnologist Henry Rowe Schoolcraft. A reviewer for the *North American Review*, probably Cass himself, called the book "a Jeremiad upon the savage treatment of the aborigines of this continent, by their barbarous Anglo American neighbors" and named Hunter himself "one of the boldest imposters that has appeared in the literary world since the days of Psalmanazar."[29] These critics had

FIGURE 1.8 Charles Robert Leslie (1794–1859), *John D. Hunter*, 1823. Lithograph, 11.8 × 8 cm (image), by Charles Joseph Hullmandel, London. From John D. Hunter, *Memoirs of a Captivity among the Indians* (2nd ed., 1823). Courtesy the Wellcome Collection, London.

interests in the West, to be sure, but they were also some of the most knowledgeable American students of the Indians.

Hunter, meanwhile, probably never saw the vicious attacks on him and his book, for he had made his way to East Texas, intent upon implementing his dream of helping displaced Indians enjoy "the benefits of civil life." "His countenance and demeanor, before I knew who he was, drew my attention," wrote one who met him in Nacogdoches, "and . . . I was aware, and notwithstanding the plainness of his dress, & the simplicity of his manners, that I was in the society of a highly intelligent man, and a gentleman." The Cherokees, under Chief Bowl, also recognized in him an able spokesman who could assist in their efforts to acquire a land grant and authorized him to go to Mexico City with their petition to settle thousands of Indians in Texas. Despite such apparent abilities, Mexico City officials would not treat with him, perhaps because the new federal system in Mexico assigned responsibility for land grants to the states, and he returned empty-handed. The proposal had also aroused opposition from *empresario* Stephen F. Austin and Mexican officials in Bexar,

who did not want thousands of what they considered to be ungovernable Indians on their eastern border.³⁰

Those concerns turned out to be prescient, for Hunter and the opportunistic Richard Fields, a frontiersman who was part Cherokee, soon convinced the Indians to align themselves with Haden and Benjamin Edwards in their effort to establish the Republic of Fredonia. Haden had received an *empresario* grant to settle families in East Texas but had encountered opposition from squatters and settlers with preexisting grants. When the rebellion collapsed, Edwards and his supporters fled across the border to the United States, leaving the Cherokees to explain themselves to the Mexican authorities. Meeting in council, the Cherokees concluded that both Fields and Hunter had acted against the interests of the tribe and condemned them to death. Both men fled but were quickly apprehended and killed.³¹

Hunter's execution was widely reported, according to the *Times*. Many continued to characterize him as a charlatan, but others, including the artist George Catlin, who held sympathetic views, were more tolerant and supportive of his goal. Had he lived, the editor concluded, he "might have descended among those philanthropists who have sought to improve the condition of the savages."³² Hunter's book went through eight editions before the Civil War, including translations into German, Dutch, and Swedish, and it probably influenced the subsequent writings of James Fenimore Cooper, among others. Apparently the first two English editions are the only ones containing lithographic portraits of this most extraordinary man.³³

Stories of Indian captivities such as Hunter's were among the most popular literature in colonial America and had lost little of their appeal during the first half of the nineteenth century.³⁴ Not long after Hunter's death, Barbara Hofland, a well-known English writer of children's books, set her 1820s story of a young Spanish boy who was captured near San Antonio and carried into captivity by the Comanches in Mexican Texas.³⁵ Although a later critic concluded that Mrs. Hofland's story read more like fiction, she claimed that her portrayal of the capture and escape of young Manuel del Perez was true and based on the account of a Mr. Parker, who was living in Natchitoches when Perez arrived there. *The Stolen Boy. A Story, Founded on Facts* (c. 1830) contained an engraved frontispiece showing the boy tied to a tree as Comanche teenagers amused themselves by throwing tomahawks as close to him as they could without hitting him. The moment depicted is that of the eleventh

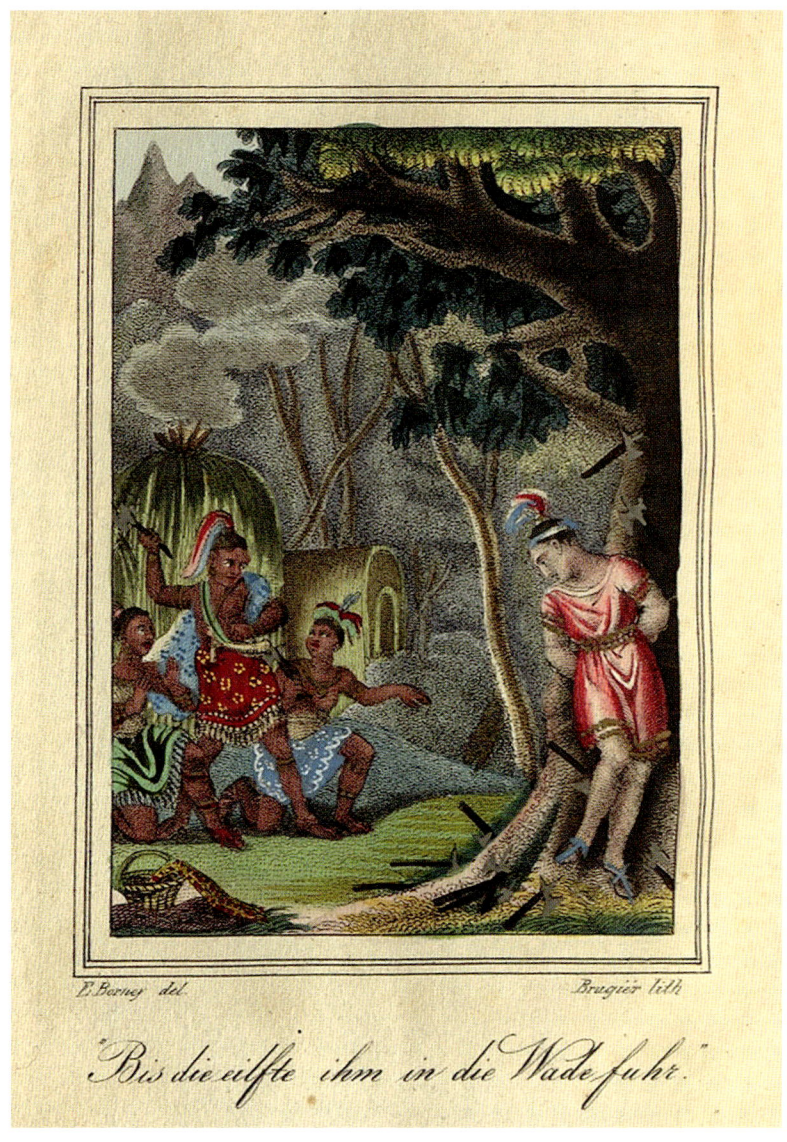

FIGURE 1.9 E. Borney [*sic*, should be Burney], "*Bis die eilfte ihm in die Wade fuhr*" (Until the eleventh struck him in the calf), 1842. Hand-colored lithograph, 15 × 10 cm (image) by Brugier. From Barbara Hofland, *Der geraubte* (*The Stolen Boy*) (1842). Courtesy Galerie Bassenge, Berlin.

throw, which wounded him in the calf. Mrs. Hofland claimed that Perez later escaped and made his way to Natchitoches and then back to his family. Her book enjoyed brisk sales and was rapidly reprinted both in England and in the United States, with translations appearing in French, Spanish, and German. A hand-colored lithograph of the tomahawk scene is included in the German edition, published in 1842 (fig. 1.9).³⁶

LITHOGRAPHY IN MEXICO

Claudio Linati de Prévost, who had fled his native Italy because of his revolutionary activities, established and operated the first lithographic press in Mexico in 1826 and taught lithography at a small workshop in Mexico City. One of his early prints was the map of Texas that General Manuel de Mier y Terán would carry with him into Texas in 1828 (fig. 1.10).[37] Linati had studied in the studio of Jacques-Louis David in Paris before fleeing a death sentence brought on by his political activism. Nor did his time in Mexico

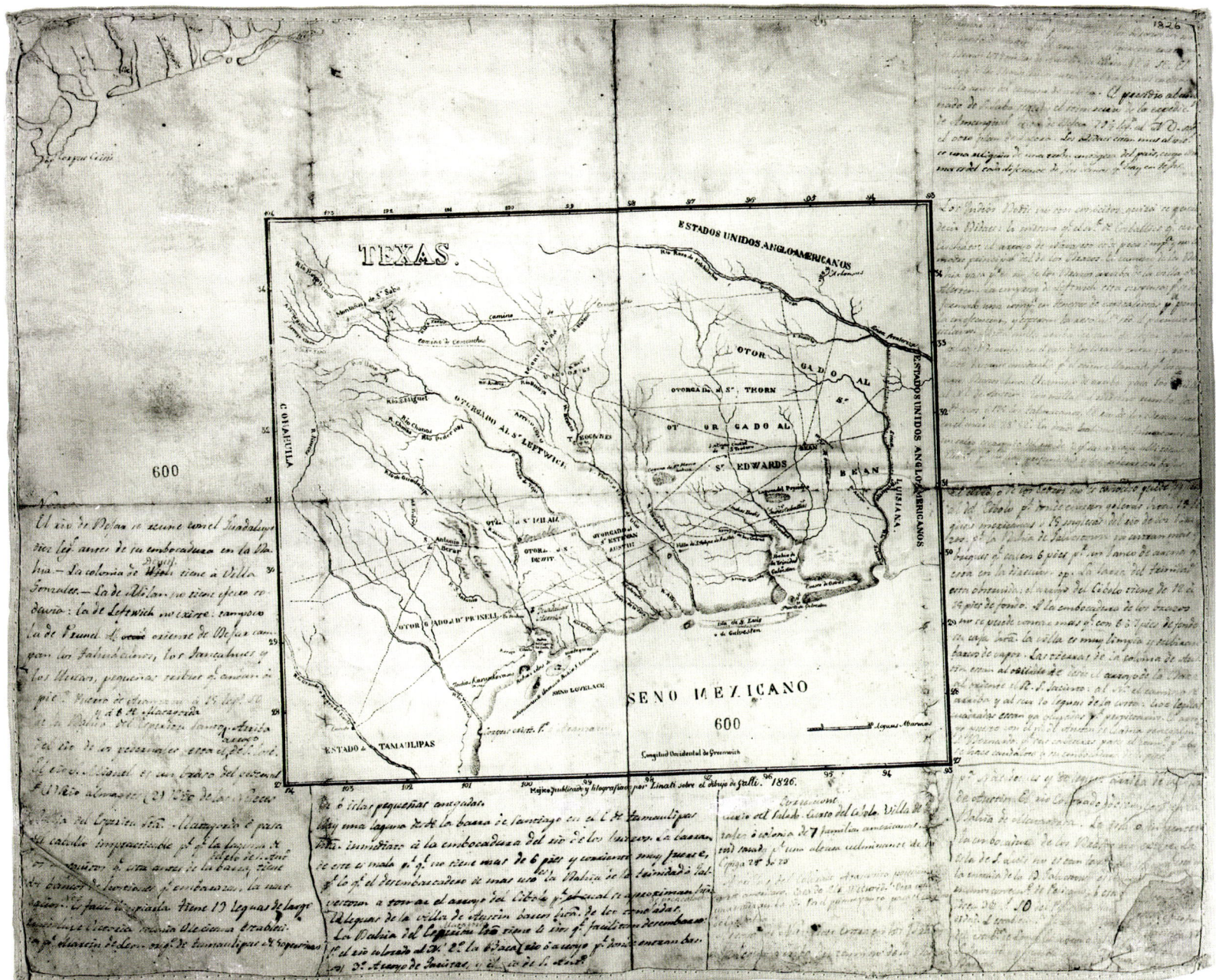

FIGURE 1.10 Fiorenzo Galli after Stephen F. Austin, *Texas*, 1826. Map. Lithograph, 22.8 × 28 cm, by Claudio Linati, Mexico. Courtesy Briscoe Center for American History, UT Austin.

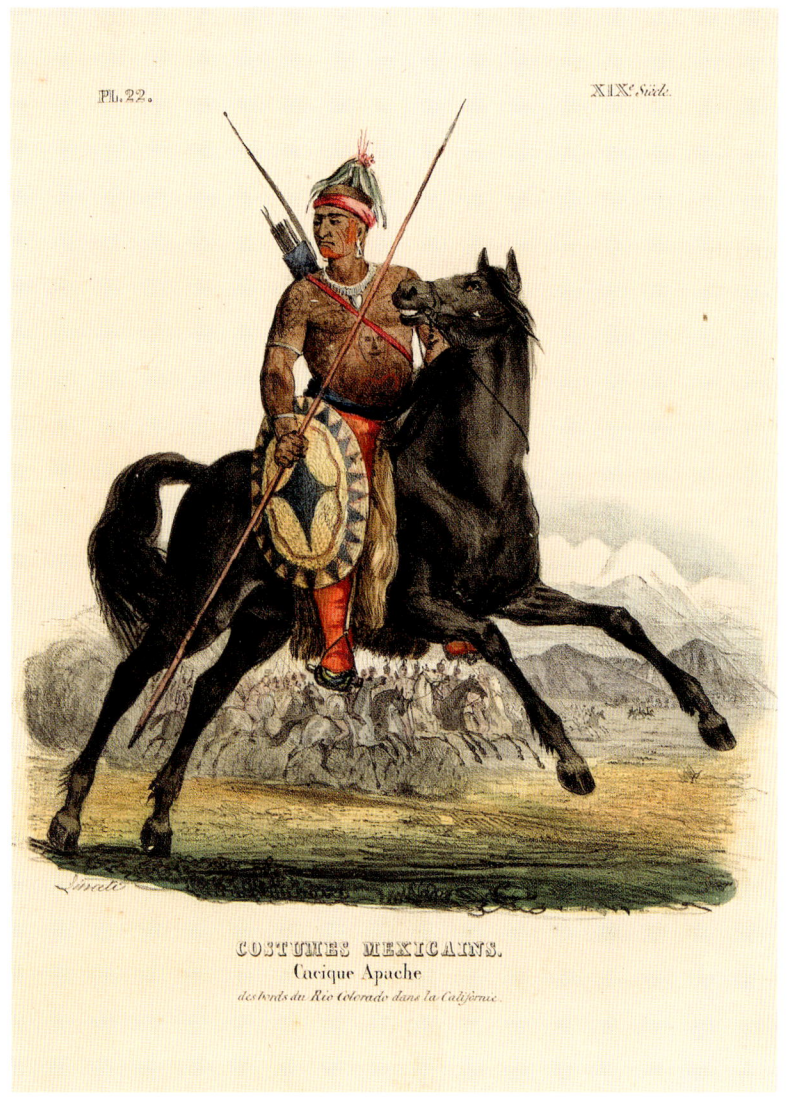

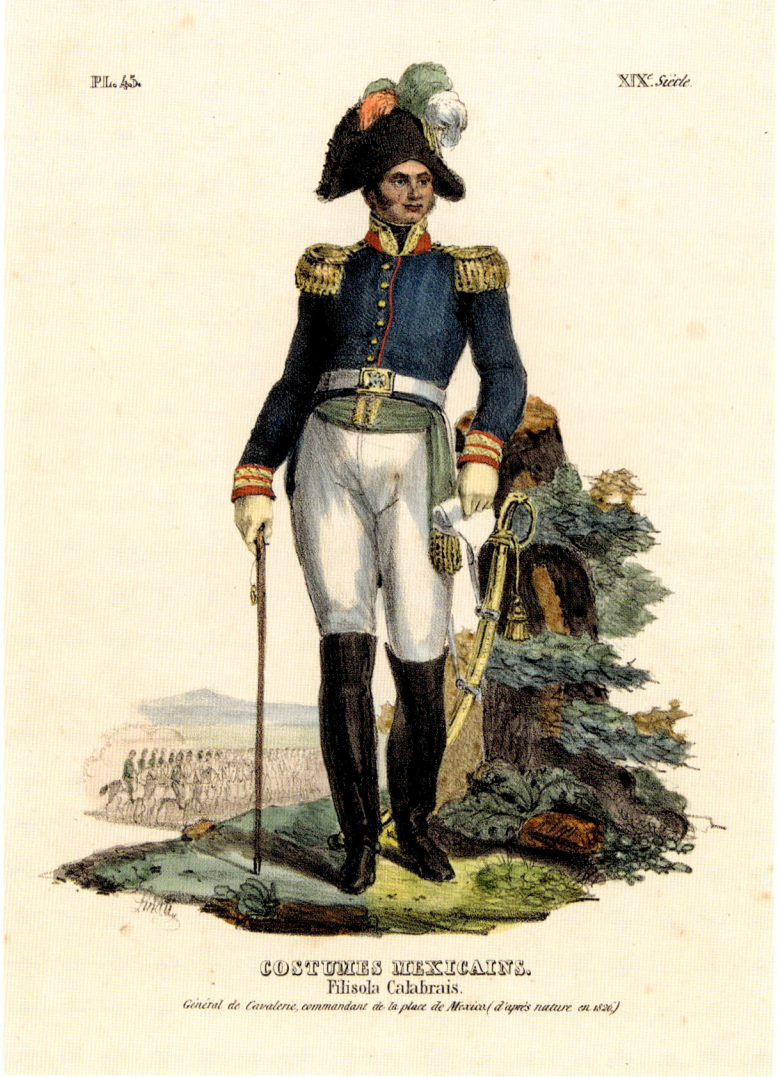

FIGURE 1.11 Claudio Linati, *Cacique Apache des bords du Rio Colorado dans la Californie*, 1828. Hand-colored lithograph, 12.25 × 9.12 in. From Claudio Linati, *Costumes civils, militaires et réligieux du Mexique; dessinés d'après nature* (1828). Courtesy Amon Carter Museum of American Art, Fort Worth.

FIGURE 1.12 Claudio Linati, *Filisola Calabrais. Général de Cavalerie, commandant de la place de Mexico (d'aprés nature en 1826)*, 1828. Hand-colored lithograph, 12.31 × 9.19 in. From Linati, *Costumes civils, militaires et réligieux du Mexique* (1828). Courtesy Amon Carter Museum of American Art, Fort Worth.

last long: he, the mining engineer Fiorenzo Galli, and the Cuban poet José María Heredia established a newspaper, *El Iris*, which included the first political cartoons printed in Mexico and quickly became involved in political squabbles that necessitated Linati's exit from Mexico. He settled for a time in Brussels, where he worked for Jean-Baptiste-Ambroise-Marcellin Jobard, the first important Belgian lithographer. In 1828 Linati and Jobard produced *Costumes civils, militaires et réligieux du Mexique,* based on his collection of original watercolor paintings. He included portraits of various types—laborers, Indians, military men—that document the life and manners of the people.[38] His bold and colorful portrait of the *Cacique Apache des bords du Rio Colorado dans la Californie*, whom he describes as raiding from California to New Mexico, would have been recognizable to many Texians (fig. 1.11).[39] He also included a

portrait of fellow countryman Gen. Vicente Filisola (fig. 1.12), who was serving in the Mexican military as commander of the eastern interior provinces and would claim an *empresario* grant in Texas in 1831, after passage of the Law of April 6, 1830. He would later serve as Gen. Antonio López de Santa Anna's second in command during the Texas rebellion in 1836.[40]

THE COMISIÓN DE LÍMITES: A BELATED WARNING

Stephen F. Austin's growing colony, the land claims of the Cherokee Indians, and the Edwards brothers' Fredonian Rebellion had focused Mexican attention on East Texas and had underscored the fact that the boundary between Mexico and the United States had never been surveyed. The Adams-Onís Treaty of 1819 had declared that the boundary between Spanish Texas and the United States was marked by the Sabine and Red Rivers, but the wilderness between them continued to be disputed territory. Having won its independence from Spain in 1821, the new government of Mexico assigned Gen. Manuel de Mier y Terán, the thirty-eight-year-old head of Mexico's artillery school, the task of marking the boundary (fig. 1.13). In addition, he was to collect information on the natural resources and Indians and observe the number and sentiments of the newly arrived Americans.[41] He carried with him, and annotated throughout the trip, the copy of Stephen F. Austin's 1822 map of Texas that Linati had printed, which shows Texas bounded on the east by the Sabine River, on the north by the Red River, and on the southwest by the Nueces River, with the Gulf of Mexico to the south. Linati's colleague Fiorenzo Galli had drawn it on the stone.

Terán reached Nacogdoches on June 3, 1828, and remained in East Texas until January 1829, when he began his return. He submitted voluminous reports, noting that immigrants from the United States already outnumbered the Tejanos and that cotton, supported by slavery, was now the dominant crop; even some of the Tejanos had begun cultivating it. His recommendations led the Mexican congress to pass the Law of April 6, 1830, which shocked the Texians by prohibiting immigration from the United States and the importation of slaves.[42]

Terán did not publish an official report. Jean Louis Berlandier, the expedition's botanist and zoologist, published his journal in Mexico City's *Registro Oficial* in installments beginning on January 26, 1831; he and Terán collaborated on a pamphlet titled *Memorias de la Comisión de Límites* in 1832; and he and mineralogist Rafael Chovel edited a larger *Diario de viage de la Comisión de Límites* in 1850.[43] This latter work contains a lithographic portrait of Terán that was probably copied from the one in the second edition of Lorenzo de Zavala's *Ensayo histórico de las revoluciones de México*.[44] Berlandier and draftsman José María Sánchez y Tapia also submitted dozens of maps, drawings, and watercolors of villages, Indians, and flora and fauna, but none of them appeared in print until the twentieth century. Publication problems also bedeviled Col. Juan Almonte, who conducted an 1834 inspection of Texas and would have published his map of the region except for the "*difficulty attending engraving or lithography in our country*."[45] Apparently, lithography in Mexico had momentarily lost its champion when Linati departed.[46]

FIGURE 1.13 Unknown artist, *El Exmo. Sr. General D. Manuel de Mier y Terán*, 1845. Lithograph, 13 × 10 cm (comp.), by José Mariano Fernández de Lara, calle de la Palma, México. From Lorenzo de Zavala, *Ensayo histórico de las revoluciones de México* (1845), vol. 2, 277. Courtesy Benson Latin American Collection, UT Austin.

AN AMERICAN "NOBLE SAVAGE"

While Terán was pushing his huge coach through the East Texas mud, an ambitious Sam Houston had just reached the pinnacle in his political career thus far as governor of Tennessee. The man who would become the victorious general at the battle of San Jacinto, the first president of the republic, one of its first US senators, the state's seventh governor, and one of its most celebrated citizens was also a man who clearly loved to be painted, drawn, photographed, and lithographed.[47] Artists had produced two lithographic portraits of him even before he arrived in Texas.

Those portraits were done, however, after Houston experienced a disastrous fall from power resulting from his failed marriage. After a promising political career as a protégé of President Andrew Jackson's—congressman, state's attorney, and governor of Tennessee—Houston in 1829 fled an embarrassing divorce from his bride of only eleven weeks, resigned the Tennessee governorship, and went into exile among his old friends the Cherokees, who by this time had been displaced to Indian Territory. Houston had deplored the treatment of Native Americans ever since he, as a rebellious teenager, had run away from home and happily lived for three years with a band of Cherokees in southeastern Tennessee, where he learned their language and participated in tribal life. Among friends again, Houston regained his energy and in September informed President Jackson that he was in "renewed health." The Cherokees, recognizing his natural abilities as well as his friendship with President Jackson, made him a citizen of their nation and asked him to accompany a delegation to Washington to negotiate various issues.[48]

A reporter saw Houston while he was en route to Washington and described him as wearing a leather hunting shirt, bullet pouch, and scalping knife "in true Indian style."[49] And that is how a miniaturist portrait painter, probably Anson Dickinson, found him—dressed in a turban and a brightly colored cloak lined with fur—when Houston posed for his portrait at the Brown Hotel in Washington (fig. 1.14).[50] A lithographic portrait, showing Houston full-length, might have come from his April 1830 visit to Baltimore, a speculation encouraged by the fact that the firm that produced the print, Endicott & Swett of Baltimore, was in business for only a few months in 1830 and closed shop in December 1831 (fig. 1.15).[51] The artist Dickinson, who worked up and down the East Coast, did not overlook the symbolism of the occasion and pictured his flamboyant subject in a pose similar to that in Chester Harding's full-length portrait of Daniel

FIGURE 1.14 Anson Dickinson (attrib.), *Sam Houston*, 1830. Watercolor on ivory, 13 × 10 cm. Courtesy San Jacinto Museum of History, La Porte, Texas.

Boone (which we know only through J. O. Lewis's contemporary lithograph). Boone is shown standing in front of a tree and leaning on his rifle, a dog at his feet and a river behind him (fig. 1.16). Dressed in Indian style, Houston is shown in the woods standing next to a tree, his rifle in his hand and his dog standing nearby; he is dressed in a fur-collar-trimmed "blanket" coat and sash. A waterfall spills into the river that runs behind him. The head is quite similar to Dickinson's depiction in the miniature portrait done at the Brown Hotel. The fur collar of the blanket coat may also be an iconic reference to the emerging democratic tradition in America that began with Scottish artist Allan Ramsay's portrait of Jean Jacques Rousseau in a fur-collared, plain costume that called to mind the French philosopher's invocation of the Natural Man, and continued with similar

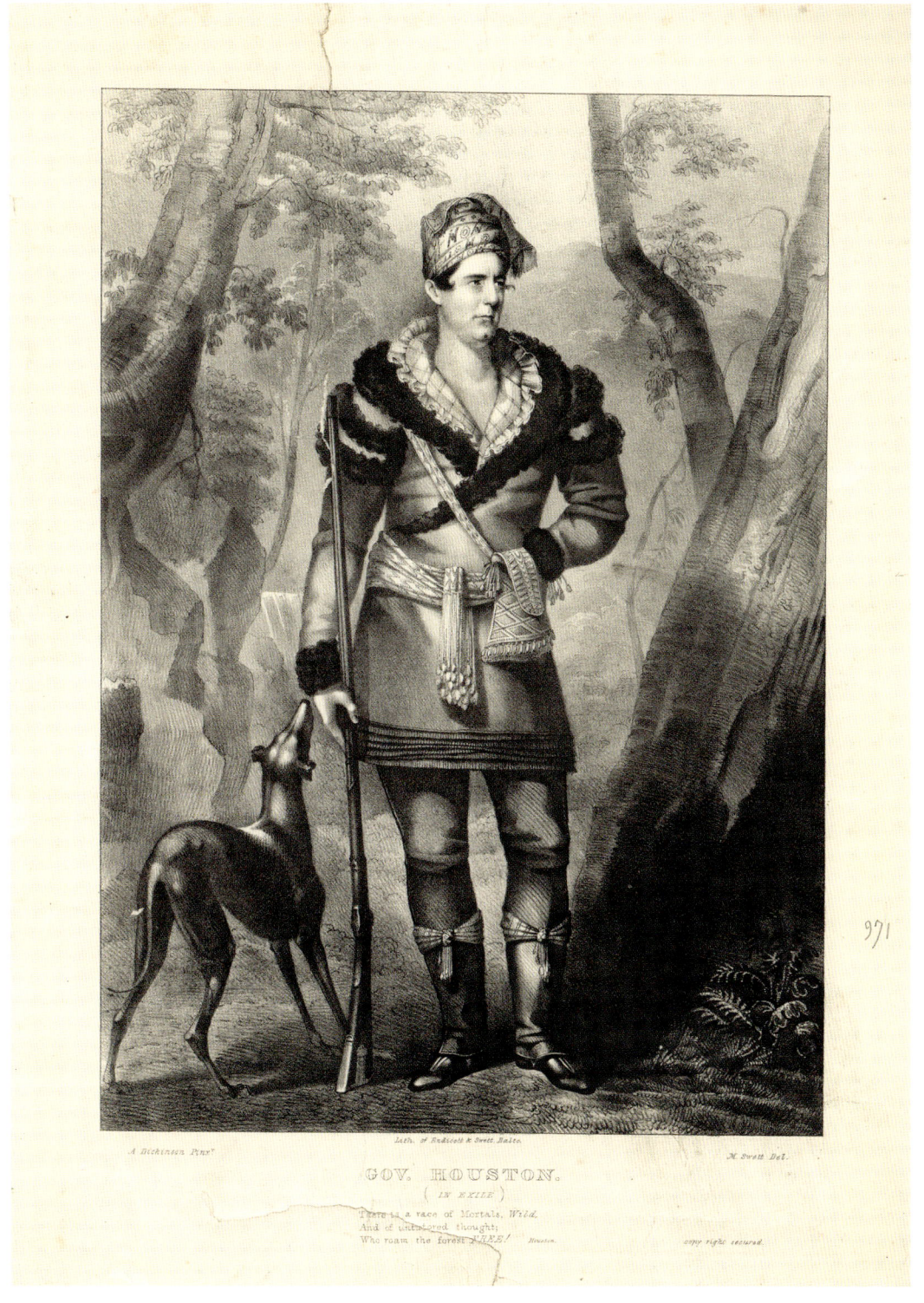

FIGURE 1.15 Moses Swett after A[nson] Dickinson, *Gov. Houston. (In Exile)*, c. 1830. Single sheet. Lithograph, 34.7 × 24.8 cm (image), 38.4 × 24.8 cm (comp.), by Endicott & Swett, Balto. Courtesy Print Collection, New York Public Library.

FIGURE 1.16 James Otto Lewis after Chester Harding, *Col. Daniel Boon*. 1820. Engraving, 11.75 × 8.12 in. Courtesy Saint Louis Art Museum.

"REALLY A KIND OF PARADISE" | 27

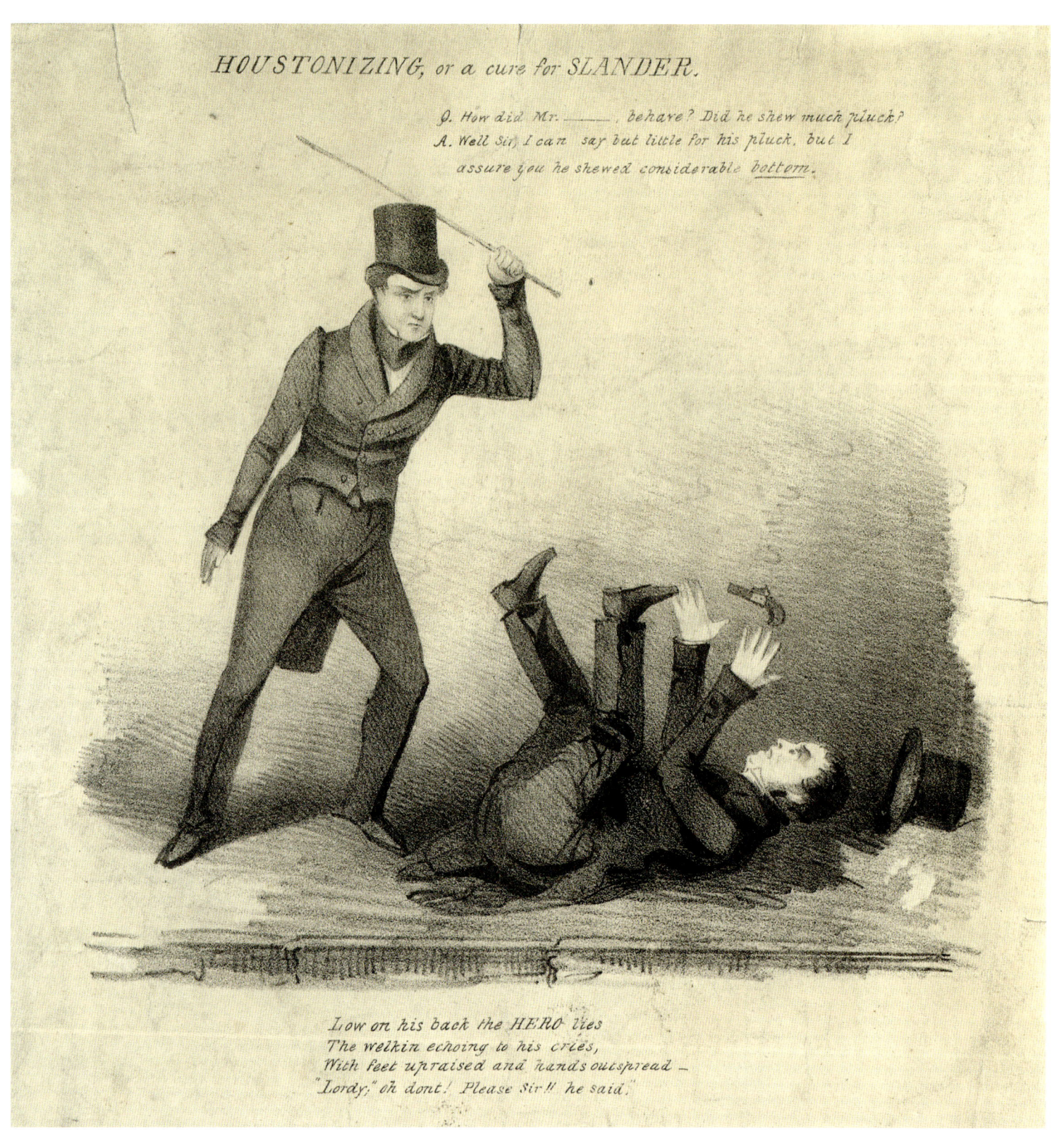

FIGURE 1.17 E. W. Clay (attrib.), *Houstonizing, or a Cure for Slander*, c. 1832. Single sheet. Lithograph, 10.87 × 9.38 in., lithographer unknown. Courtesy Special Collections, University of Houston Libraries.

portraits of Benjamin Franklin, Thomas Jefferson, and Boone.[52] Dickinson shows Houston not just as a man of nature but as a natural man. By June two Washington, DC, retail stores advertised "This novel print" of "GOV. HOUSTON IN EXILE. A full length portrait, with Indian costume, rifle, dog, forest scenery, &c.," and it remained on sale for several months.[53]

Houston's next portrait was an inadvertent caricature that resulted from an infamous April 1832 incident in which he caned a member of the US House of Representatives. Congressman William Stanbery of Ohio had obliquely suggested in a speech that Houston had received an illegal contract for Indian rations while he was living among the Cherokees, and Houston naturally took offense. Encountering the congressman on a Washington street a few days later, Houston struck him with his hickory cane. Trying to defend himself, Stanbery pulled a pistol from his pocket, but it misfired, leading Houston to administer a thorough beating. An injured Stanbery brought the matter before the House of Representatives the following day, resulting in a trial in which lawyer Francis Scott Key represented Houston. The House officially reprimanded and fined Houston, and the incident led to the anonymous creation and publication of *Houstonizing, or a Cure for Slander*, which shows Stanbery on his back with his feet and his derringer in the air (fig. 1.17). The appended verse alludes to the fact that, after Stanbery's pistol misfired, Houston pulled his legs up and thrashed his bottom as well. No artist or publisher is listed, but the caricature resembles the work of Edward W. Clay, a prominent Philadelphia lithographic artist who specialized in biting, satirical prints.[54]

It was almost as if the Stanbery affair reinvigorated Houston. He cut back on his legendary drinking, and a meeting with President Jackson at the Hermitage in August resulted in a commission to treat with the Pawnee and Comanche Indians in Texas to be sure that they were at peace with the eastern tribes that were being displaced to Indian Territory.[55] Houston arrived in Texas in December 1832 and quickly acquired a land grant from Stephen F. Austin (fig. 1.18).[56] Of course there was speculation that such a charismatic character as Houston had no intention of settling down and that, as Huntsville lawyer Henderson Yoakum, his good friend, later wrote, he was in Texas "to examine into the character of the country, with a view to its value to the United States should they purchase it."[57]

FIGURE 1.18 Unknown artist, *Galveston Bay and Texas Land Company*, 1830. Single sheet. Land grant script. Lithograph (stone engraving), 33 × 20 cm, by Edward S. Mesier's Lith. Anthony Dey's certificate, signed by Dey, W. H. Sumner, G. W. Curtis, and W. H. Wilson. Courtesy Cartographic Associates, David Rumsey Collection. Sam Houston was considering coming to Texas as an agent for the company when he attacked Stanbery (Friend, *Sam Houston*, 42–49.)

MANAGING HIS IMAGE

Soon after Houston arrived in Texas, an equally famous Tennessee political colleague toured the East Coast on behalf of the Whig Party. Forty-seven-year-old David Crockett had also served under General Jackson and was elected to the Tennessee Legislature in 1821 and 1823. He was a personable man, charismatic, expressive, and a source of colorful phrases that endeared him to the electorate, and he went on to serve in the twentieth, twenty-first, and twenty-third US Congresses, first as a Jacksonian supporter but then as a Whig after he ran afoul of his fellow Tennessean over his support for the Second Bank of the United States and his opposition to the Indian Removal Bill. Defeated in 1831, Crockett, whom the Jacksonians had portrayed as an ignorant farmer during the last election, decided that he needed to change his image.[58]

Crockett was such a well-known figure that he was the obvious subject of playwright James Kirke Paulding's 1831 play *The Lion of the West*, featuring Col. Nimrod Wildfire, a just-defeated congressman. Two years later, Matthew St. Claire Clarke, clerk of the House of Representatives, published his *Life and Adventures of Colonel David Crockett of West Tennessee*, and when Crockett returned to Congress in the fall of 1833, he undertook an autobiography with his friend Thomas Chilton and sat for his portrait in 1833 and 1834 at least five times.[59]

British-trained artist Samuel Stillman Osgood's portrait of Crockett was drawn on the stone by the prolific lithographic artist Albert Newsam, probably in May or June 1834, and lithographed by the Philadelphia firm of Childs & Lehman (fig. 1.19). Cephas Childs, the firm's principal, had earlier announced a series of portraits of distinguished Americans, which he hoped would take advantage of the growing popular print market, and the portrait was successful enough that Crockett wrote an endorsement for it—the "only correct likeness that has been taken of me"—which was printed beneath

FIGURE 1.19 Albert Newsam (attrib.) after Samuel S. Osgood, *David Crockett*, 1834. Single sheet. Lithograph, 23.2 × 18.2 cm (image), 23.2 × 29.1 cm (comp.), by Childs & Lehman, Philadelphia. Inscription on stone: "I am happy to acknowledge this to be the only correct likeness that has been taken of me. David Crockett." Courtesy Prints and Photographs Division, Library of Congress.

the image.[60] A reporter for the *Boston Transcript* liked it as well, writing, "We have an excellent portrait of the Colonel. The outline of the nose is rather faulty, but the features are well delineated, and the *expression*, which is the life of portraiture, admirable." (Artist William Henry Huddle probably used the Osgood portrait as the model for his 1889 portrait of Crockett that now hangs in the Texas State Capitol.[61]) Later, after traveling to Boston, Crockett had another portrait painted by the prominent portraitist Chester Harding. Then, upon his return to Washington, he consented to sit for artist Anthony Lewis De Rose for a portrait that was published as an engraving.[62]

The life of a traveling author and celebrity offered such appeal to Crockett that he was not as effective a congressman as he might have been. That, plus the fact that Jackson's forces campaigned against him, led to his defeat in 1835. He had promised his constituents that he would continue to serve if reelected, but, as he told the crowd in a Memphis tavern after his defeat, "Since you have chosen to elect a man with a timber toe to succeed me, you may all go to hell, and I will go to Texas."[63]

Arriving at San Augustine early in 1836, Crockett, in a letter to his daughter, called Texas "the garden spot of the world. . . . There is a world of country here to settle." Crockett and his fellow Tennesseans found that Houston was in the field trying to raise an army against an expected Mexican invasion; the men swore allegiance to Texas and left for San Antonio to help defend the Alamo, an act that cut short their brave adventure but forever established their legendary status.[64] Along with James Bowie, Crockett is one of the few Texas participants in the battle of the Alamo for whom a life portrait exists.[65]

LORENZO DE ZAVALA IN EXILE

Another notable who joined the Texas cause as the revolution developed was Lorenzo de Zavala, the best-known and ablest Mexican official to side with Texas. He had a controversial political career in Mexico under both the Spanish and Mexican governments as governor of the state of México, member of the Chamber of Deputies, secretary of the treasury, and minister to France. In 1829 Zavala obtained an *empresario* contract in partnership with David G. Burnet and Joseph Vehlein to settle five hundred families in Texas, which they sold to the Galveston Bay and Texas Land Co. the following year.

Before arriving in Texas, he had published his *Ensayo histórico de las revoluciones de Megico desde 1808 hasta 1830* in two volumes in 1831–1832, the first volume published in Paris and the second in New York. While the first volume is not known to include any illustrations, at least one copy, now in the Stanford University Library, contains a portrait of Zavala done in the shop of the well-known American lithographer Cephas G. Childs, most likely while Zavala was in New York in 1832 (fig. 1.20). (The Mexican artist José Mariano Fernández de Lara copied the portrait for the Mexican edition of the book, which Manuel N. de la Vega published in 1845.)[66] Concluding in 1835 that Santa Anna had no intention of upholding the Constitution of 1824, Zavala resigned his diplomatic assignment and moved to Texas in July, establishing a home on Buffalo Bayou. He participated in the Consultation of 1835 and the Convention of 1836 and signed the Texas Declaration of Independence. He was elected *ad interim* vice president of the republic in March 1836 and served in that capacity until October 22, when he resigned along with the rest of the *ad interim* government. He died of pneumonia the following month.[67]

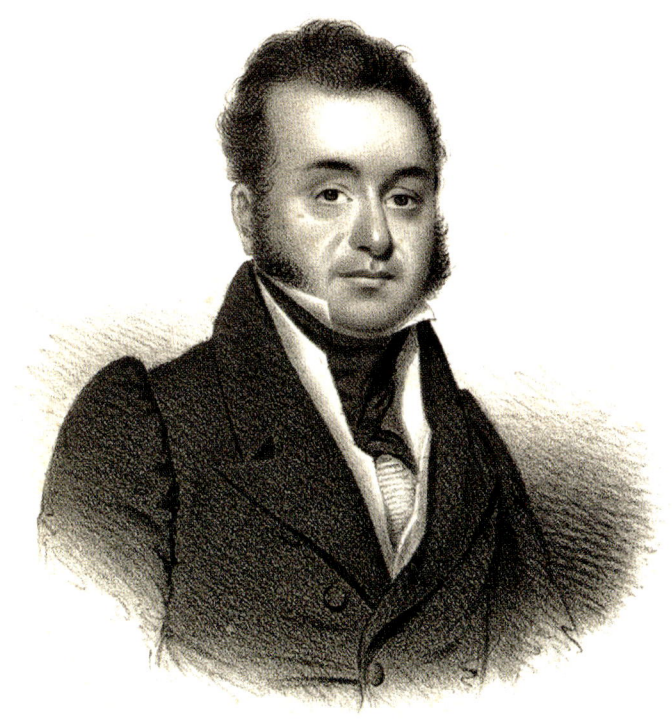

FIGURE 1.20 Cephas G. Childs, [Lorenzo de Zavala], 1831–1832. Lithograph, 20 × 12 cm (page). From Zavala, *Ensayo histórico de las revoluciones de Megico* (1st ed., 1831), 1, facing the *prologo*. Courtesy Department of Special Collections, Stanford University Libraries.

THE TEXAS REVOLUTION

There are no known eyewitness images of the Texas Revolution, but there are several contemporary caricatures and portraits of prominent figures. One map was made by an eyewitness and lithographed; *Fort Defiance Goliad* was made after Joseph M. Chadwick's plan of the fortification that blocked one of the two roads from Mexico into Texas (fig. 1.21). Chadwick was twenty-four years old in 1836, a graduate of Phillips Exeter Academy who had dropped out of West Point and headed west to St. Louis in 1831 to work in his uncle's store. There he met the artist George Catlin, who drew a crayon portrait of young Joe and sent it to the family.[68] In 1835 Chadwick volunteered to help Texas win its independence, arriving at Velasco in December, where he joined William Ward's Georgia Battalion. In February 1836 he reached La Bahía presidio, which Col. James W. Fannin had renamed Fort Defiance, and was appointed acting adjutant general on Fannin's staff. Lewis M. H. Washington, also on Fannin's staff, described Chadwick as having "a native suavity of temper and urbanity of manner, which at once made him the *Pride of the battalion.*" Out of respect for Chadwick's West Point training, Fannin assigned him the task of bolstering the fort's defenses, including mapping the presidio, and Chadwick apparently sent the small drawing, dated March 2, to his mother in what turned out to be his last letter. Chadwick died in the massacre that followed because, according to one of his companions who escaped during the chaos, he refused to desert a friend who had been wounded.[69]

Based on Chadwick's small drawing, New York lithographer Alfred E. Baker produced a bird's-eye view of the fort that shows the church within the walls and the position of the various companies (fig. 1.22). He incorporated Chadwick's detailed explanations in the lithograph, including the arrangement within the walls, how the fort was to be strengthened, where the cannons were to be stationed, where the main gate was located, and, immediately to the north (g), John S. Brooks's primitive battery of sixty-eight mounted musket barrels, all of which could be fired with a single match. Since the drawing lacked details, Baker added verisimilitude—a three-dimensional quality to the image—to the walls, the buildings, and the tents, including several figures and clarifications, some erroneous: P and O indicate where Fannin and some of the prisoners were shot, and R shows Chadwick's position at the head of troops on the parade ground. Perhaps because Chadwick represented the church only by an outline drawing, Baker's added details show it facing east rather

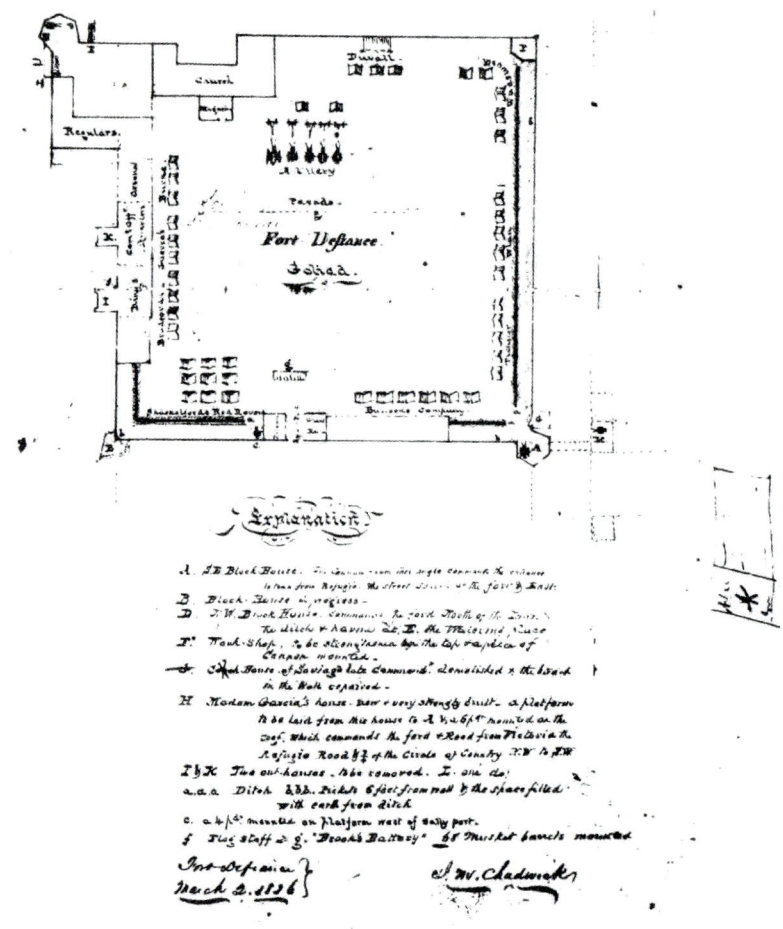

FIGURE 1.21 Joseph M. Chadwick, *Fort Defiance Goliad*, 1836. Photo reproduction of ink drawing on paper. Courtesy Raiford Stripling Associates, Inc., Cushing Memorial Library and Archives, Texas A&M University.

than west. Baker also added several flagpoles and a banner with a single star on a solid field occupying the left one-third, with alternating horizontal stripes on the remainder.[70] Only one copy of the lithograph is known to survive, so Baker probably printed only a few for the Chadwick family members.

The war was over in a little more than six weeks. After overwhelming victories at the Alamo and Goliad, an overconfident Santa Anna blundered into what proved to be an indefensible position at San Jacinto and suffered a crushing defeat on April 21, 1836, that became the determining event in the war when he was captured the following day. Texas emerged as an independent country, free to find its own way in the world or seek annexation to the United States.[71]

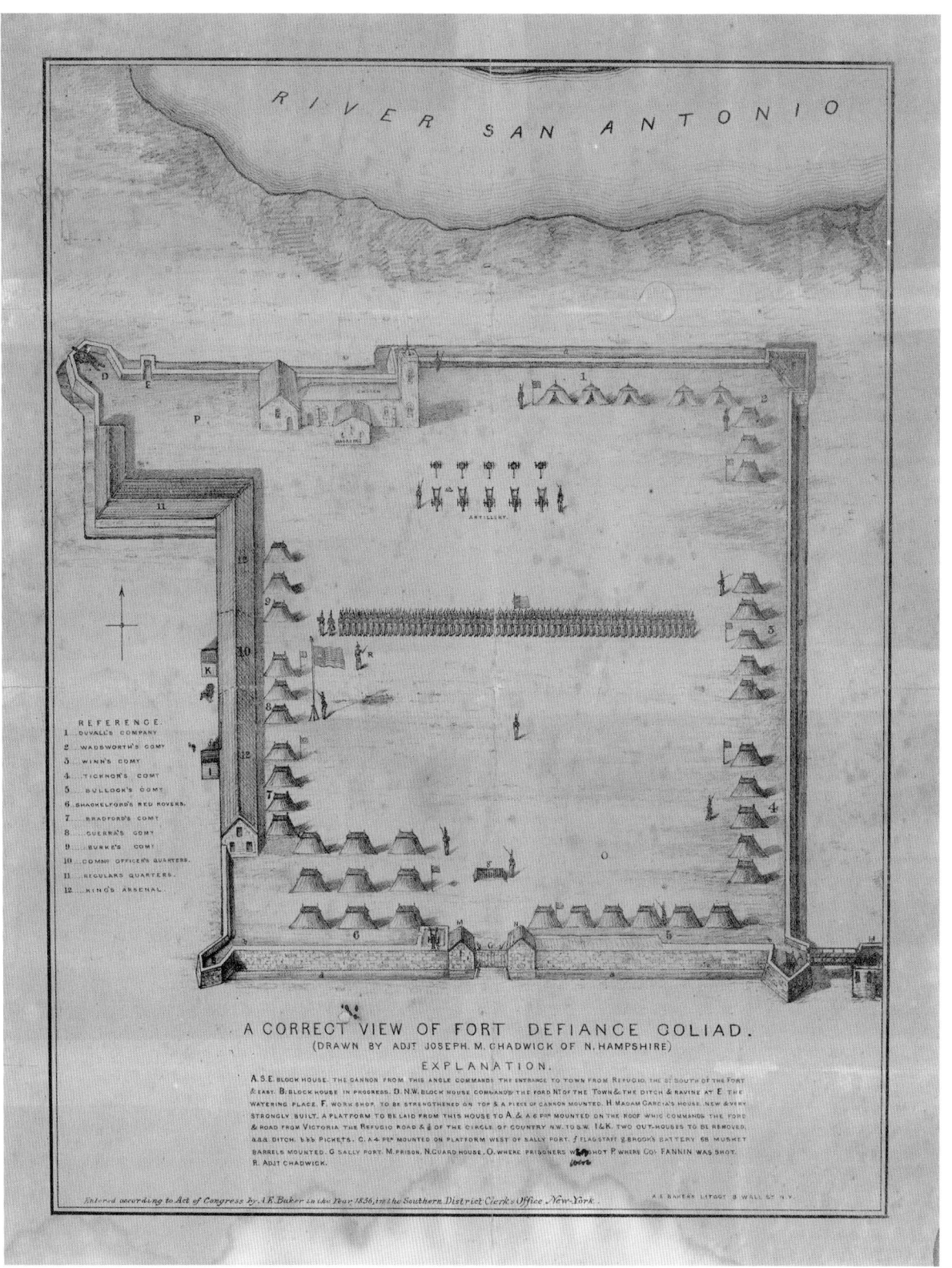

FIGURE 1.22 Alfred E. Baker after Joseph M. Chadwick, *A Correct View of Fort Defiance Goliad*, 1836. Map. Lithograph, 18 × 13.75 in., by Alfred E. Baker, 5 Wall Street, New York. Courtesy the Rees-Jones Collection.

"REALLY A KIND OF PARADISE" | 33

FIGURE 1.23 Currier & Ives after William Ranney, *The Trapper's Last Shot*, after 1857. Single sheet. Hand-colored lithograph, 10.81 × 15.56 in. Courtesy Old Print Shop, New York.

William L. Ranney, a talented Connecticut-born artist, arrived in Texas about three weeks too late to participate in the battle but served for six months in Capt. C. A. W. Fowler's company of the First Regiment Volunteers. His wife later wrote, "He remained in Texas for some time, making sketches for many of his future pictures." Ranney returned to New York in the spring of 1837. The only picture we know of that might relate to the revolution is a now-lost painting entitled *The Wounded Trooper* (c. 1845).[72] Some of his later works that might have been drawn from his Texas sketches include *Hunting Wild Horses* (1846, Autry Museum of the American West), *The Lasso* (1846, Buffalo Bill Center of the West), *Halt on the Prairie* (1850, Blanton Museum of Art), and *The Trapper's Last Shot*. (Two

versions of the latter, both painted in 1850, are now in private collections.) *The Trapper's Last Shot* was lithographed (after an engraving by the Western Art Union in Cincinnati in 1850) by Currier & Ives sometime after 1857 (fig. 1.23).[73]

Texas remained prominent in newspapers throughout the country during 1836, and printers and publishers issued several images relating to incidents from the revolution. John M. Niles included imaginary engravings of the battles of the Alamo and San Jacinto, probably taken from stock images, as well as portraits of Houston and Santa Anna in his *South America and Mexico, with a Complete View of Texas* (1837).[74] Other publishers quickly issued three lithographic illustrations of Santa Anna's surrender to Sam Houston. Wounded in the battle, Houston, who had two horses shot from under him and his left ankle shattered by a rifle ball, painfully reposed under an oak tree in the Texian camp when the captured Santa Anna was brought before him.[75] That scene—which years later was rendered most famously by William Henry Huddle in *Surrender of Santa Anna* (1886), now hanging in the Texas State Capitol—became the subject of two lithographs issued by New York publishing houses.[76] The first is an illustrated sheet music cover for "Texian Grand March" (fig. 1.24), published by Firth & Hall and J. L. Hewitt and composed by a relative unknown, Edwin Meyrick, with lithography by Englishman Anthony Fleetwood, who worked in New York until about 1847, when he moved to Cincinnati to head the firm of Fleetwood & Son. The image erroneously shows the wounded but victorious Houston receiving Santa Anna's surrender while lying on a cot in his tent, rather than under an oak tree, and with a wounded right leg. (Did this print also cause William Huddle to erroneously show Houston

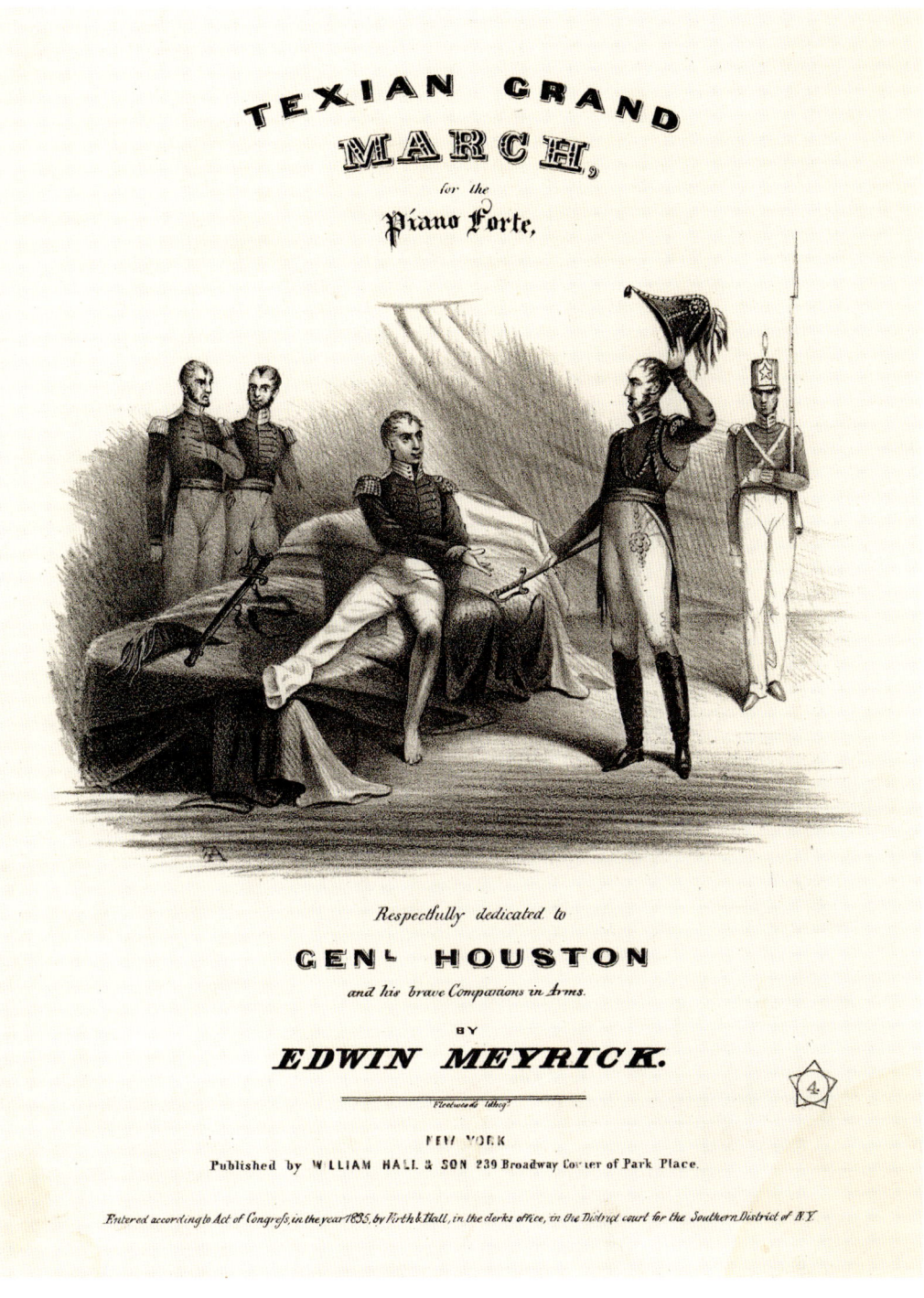

FIGURE 1.24 Anthony Fleetwood after unknown artist, "Texian Grand March for the Piano Forte, Respectfully dedicated to Genl. Houston and his brave Companions in Arms by Edwin Meyrick," 1835 [1836]. Sheet music. Lithograph, 13.7 × 19 cm (image), 25.4 × 19 (comp.), by Fleetwood's Lithog.y. Published by Firth & Hall, no. 1, Franklin Square, J. L. Hewitt & Co., 239 Broadway. Signed in the stone (l.l.) AF [monogram]. Courtesy Anne S. K. Brown Military Collection, Brown University Library.

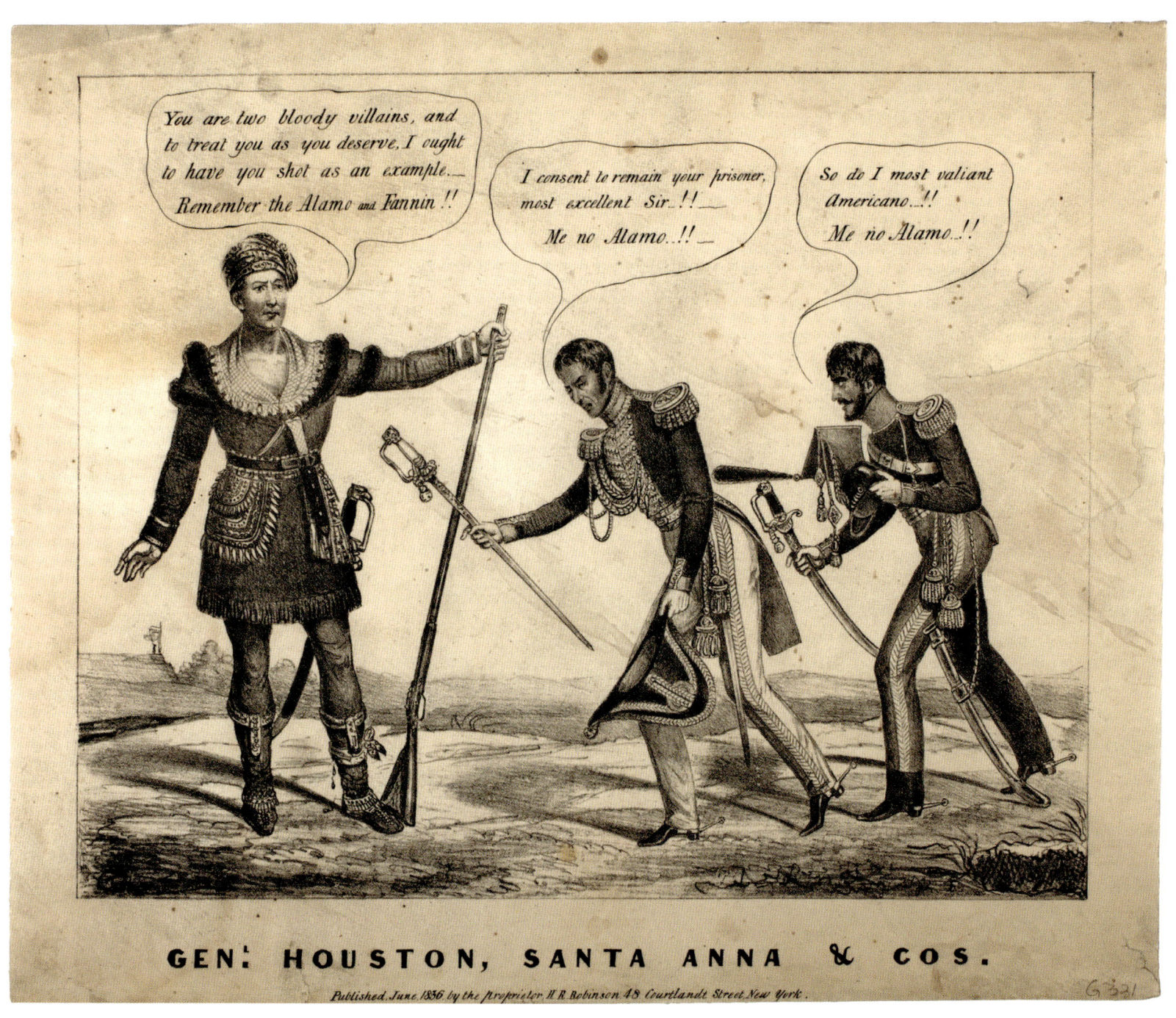

FIGURE 1.25 Edward Williams Clay, *Houston, Santa Anna, and Cos*, 1836. Single sheet. Lithograph, 28.5 × 34.9 cm (image), by Henry R. Robinson, 48 Courtland St., New York. Courtesy Prints and Photographs Division, Library of Congress. This print was so popular that it was reprinted, from different stones, several times.

FIGURE 1.26 Nicolas-Eustache Maurin, *El Eccmo. Señor General de Division D. Antonio Lopez de Santa-Anna*, c. 1840. Single sheet. Hand-colored lithograph, 59 × 43 cm (comp.), by Formentin & Cie. Published in Mexico by Julio Michaud. Courtesy San Jacinto Museum of History, La Porte, Texas.

FIGURE 1.27 Unknown photographer, Antonio López de Santa Anna, c. 1840. Daguerreotype (reversed), 12 × 9.5 cm. Courtesy San Jacinto Museum of History, La Porte, Texas.

with a wounded right leg in his famous painting of *The Surrender of Santa Anna*?) Three other military figures stand nearby. The copyright on the cover is 1835, but it is an obvious mistake and would have had to have been 1836. Bibliographer Thomas W. Streeter cited two other editions of this sheet music, both with almost identical covers. The first one is different only in publisher, William Hall & Son, instead of Firth & Hall and Hewitt. The second one, also published by Firth & Hall and copyrighted in 1836, has a virtually identical image but by a different artist, Moses Swett, who worked in Boston before moving to New York in 1830.[77] This suggests that the sheet sold well enough to be reprinted and that the stone might have worn out or was reused and had to be redrawn. In fact, the print was still on sale as late as 1844.[78]

A caricature of the surrender scene appeared two months after the battle. New York lithographer Henry R. Robinson issued *Houston, Santa Anna & Cos*, which shows Santa Anna and Gen. Martín Perfecto de Cos, also captured at San Jacinto, as Houston's prisoners (fig. 1.25). Houston, dressed in the Cherokee attire that he wore to Washington in 1829 (suggesting that the artist, Edward Williams Clay, used Anson Dickinson's 1830 print of Houston as a

model), charges the pair with villainous behavior in the battle of the Alamo and in the massacre of Fannin's army at Goliad and exclaims, "I ought to have you shot as an example."[79] Santa Anna and Cos maintain their innocence: "Me no Alamo!!" Sometime thereafter, Robinson published a second version of the print that is obviously from a different stone but is similar to the first image. The speech balloons above all three have been cropped, as if the printer had to use a shorter sheet of paper, so the words of each of the figures have been written below or slightly outside of the balloons. Also, in this version blood drips from Houston's left leg to indicate the wound that he sustained in the battle. Most historians, from Marquis James forward, have erroneously stated that his right leg was shattered above the ankle.[80]

The Mexican publisher Julio Michaud y Thomas issued a much more flattering portrait of Santa Anna, probably soon after his return from captivity in Texas in the spring of 1837 (fig. 1.26). The image, by the prominent French artist Nicolas-Eustache Maurín (who was active during the 1830s and 1840s), is similar to a well-known daguerreotype portrait of Santa Anna (fig. 1.27), that is probably contemporary with the lithograph and might have been used as the model. When reversed, the daguerreotype appears to be quite similar to the lithograph. Maurín shows Santa Anna dressed in his uniform as major general: a dark blue coat with a red vest and the light blue sash of his rank. Among the medals on his chest are the crosses of three separate orders. The white-ribboned cross represents independence and was given for his service in the 1810–1811 revolution against Spain. The second, with the tricolor ribbon, was given for his service at the battle of Cordova in 1821, and the third, with the green ribbon, was for his service at Tampico in 1829. The Paris firm of Formentin & Cie. lithographed the image, and Julio Michaud y Thomas, a native of France who established his bookselling and publishing house after his 1837 arrival in Mexico City, distributed it.[81]

Several years later, author and engraver Benson J. Lossing, who would later become one of the country's more successful and popular writers of history, commemorated the upcoming tenth anniversary of the Texian Revolution in a fictional story published in the popular and colorful gift book *The Forget-Me-Not: A Gift for 1846* (1845) (fig. 1.28). His hero, a young man named José Hernanda, left his betrothed to help defend Texas against Santa Anna's legions. Playing fast and loose with historical facts, Lossing has his hero survive the battle of the Alamo only to be taken prisoner. As he was being marched away, a rescue party arrives led by his true love, Mary, disguised as

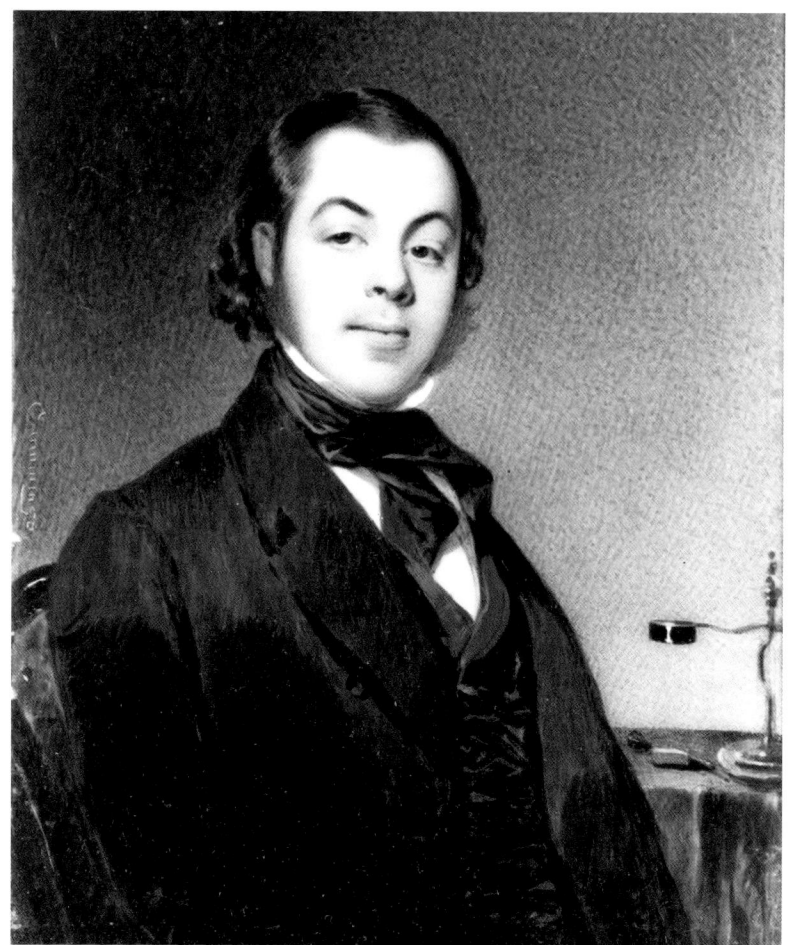

FIGURE 1.28 Thomas Seir Cummings, *Benson John Lossing*, c. 1835. Watercolor on ivory, 3.84 × 2.72 in. Courtesy Metropolitan Museum of Art, New York, Rogers Fund, 1965.

a man, apparently a popular theme in mid-nineteenth-century literature.[82] Unfortunately, the hand-colored lithograph of *The Fall of Bexar* (fig. 1.29), perhaps also by Lossing, who at the time earned his living as an engraver, is as fictional as the story and cannot be said to picture either San Antonio or the Alamo. The unknown artist shows soldiers scaling the wall of a large castle-like fortress. Although the foreground leads one to think of the Alamo barricades, the image seems to represent a much larger structure or structures—perhaps something inspired by an imaginary European battle scene from the publisher's or Lossing's pictorial inventory.[83]

In a little more than two decades, the transformation of the land that Stephen F. Austin had in 1821 called a "wild, howling, interminable, solitude from Sabine to Bexar" had begun. The Spanish/

Mexican province of Texas that had for centuries been the domain of Indians—and later bandits, fleeing outlaws and debtors, would-be revolutionaries, and French exiles—was now seen as a source of almost inexhaustible, inexpensive, and fertile land, "really a kind of paradise," according to an early trader, and had become the westernmost extension of the Southern cotton kingdom with a population of perhaps 52,600, including 5,000 slaves, 3,470 Tejanos, and 14,200 Indians by 1836.[84] The early lithographs began to create an image of Texas for the public, whether as home to a group of French refugees plotting revolution in Mexico; to the sophisticated but idealistic Dunn, whose naiveté led to his execution at the hands of Cherokee warriors; or to individualistic American adventurers like Houston and Crockett, who led a rebellion against Mexico that opened millions of acres of fertile land to Anglo settlement. It was now a fledgling republic with conflicting hopes of statehood and empire and was in the news, on the lips of would-be immigrants, with various aspects visually documented by the growing lithographic press. Absent from this developing image, however, is any hint that the settlers pouring into Austin's and other colonies disagreed with what Stephen F. Austin had confided to his cousin Mary Austin Holley in 1835: *"Texas must be a slave country. It is no longer a matter of doubt."*[85]

FIGURE 1.29 Unknown artist, *The Fall of Bexar*, 1845. Hand-colored lithograph, 9 × 11.5 cm (image), 9.8 × 14.5 cm (comp.), by Lewis & Brown, New York. From Alfred A. Phillips (ed.), *The Forget-Me-Not* (1845). Courtesy private collection.

FIGURE 2.1 Edward Williams Clay, *Major Joe Bunker's Last Parade, or the Fix of a Senator and His 700 Independents*, 1837. Single sheet. Lithograph, 9.06 × 15.2 in. (image), by H. R. Robinson, New York. Courtesy American Antiquarian Society, Worcester, MA.

CHAPTER 2

"A MORE PERFECT FAC-SIMILE OF THINGS"

THE REPUBLIC OF TEXAS

Following the battle of San Jacinto, most of the colonists who had fled their homes during the "runaway scrape" returned, often to find their fields ravaged and houses looted. San Antonio was a desolated village; Gonzales, San Felipe, and Harrisburg were smoldering ruins; and Nacogdoches and San Augustine stood abandoned. The vacuum created by the war seemed only to enhance the region's reputation as a rogue country and "sure asylum" for criminals. The accompanying notoriety and the new republic's presumed annexation to the United States gained the attention of quick-witted American caricaturists, whose creations spread through the major cities along the East Coast as separately printed lithographs.[1] So fixed was the Texas identity that by 1837 the prominent Philadelphia caricaturist Edward Williams Clay was incorporating it into his satires. In *Major Joe Bunker's Last Parade* (fig. 2.1), the foes of President Martin Van Buren's financial plan realize that they have been defeated, one lamenting, "We might as well go to Texas!"[2] The increasingly popular phrase—"Gone to Texas"—was incorporated into the caricatures as the country got acquainted with the new Republic of Texas.[3]

This ravished land soon became a breeding ground for opportunists whose projects are documented in the lithographic maps that they produced to advertise their proposed developments. In August 1836, when the remnant of the Mexican Army had only recently crossed the Rio Grande and Santa Anna was still captive at Orozimbo Plantation, John and Augustus Allen, two New York land speculators who had settled in Nacogdoches, purchased a swampy piece of land on the south side of Buffalo Bayou at its confluence with White Bayou, humble in the extreme but awash with entrepreneurial testosterone. Amid the chaos and uncertainty of the peace, the Allen brothers set out to build a city and a port, which they hoped would become the capital of the new republic and the depot through which East Texas planters would ship their cotton. By fall the brothers were circulating a lithographic map of the townsite, opportunistically named after the republic's first president and most popular citizen, Sam Houston (fig. 2.2). Six weeks after the Allens began advertising their development, the bayou was still a log-choked stream, and the site so resembled virgin land that a young Francis Lubbock, anxious to reserve a place to open a general store, did not realize that he had passed it by until the yawl on which he and his party were traveling got stuck in the encroaching brush farther upstream.[4]

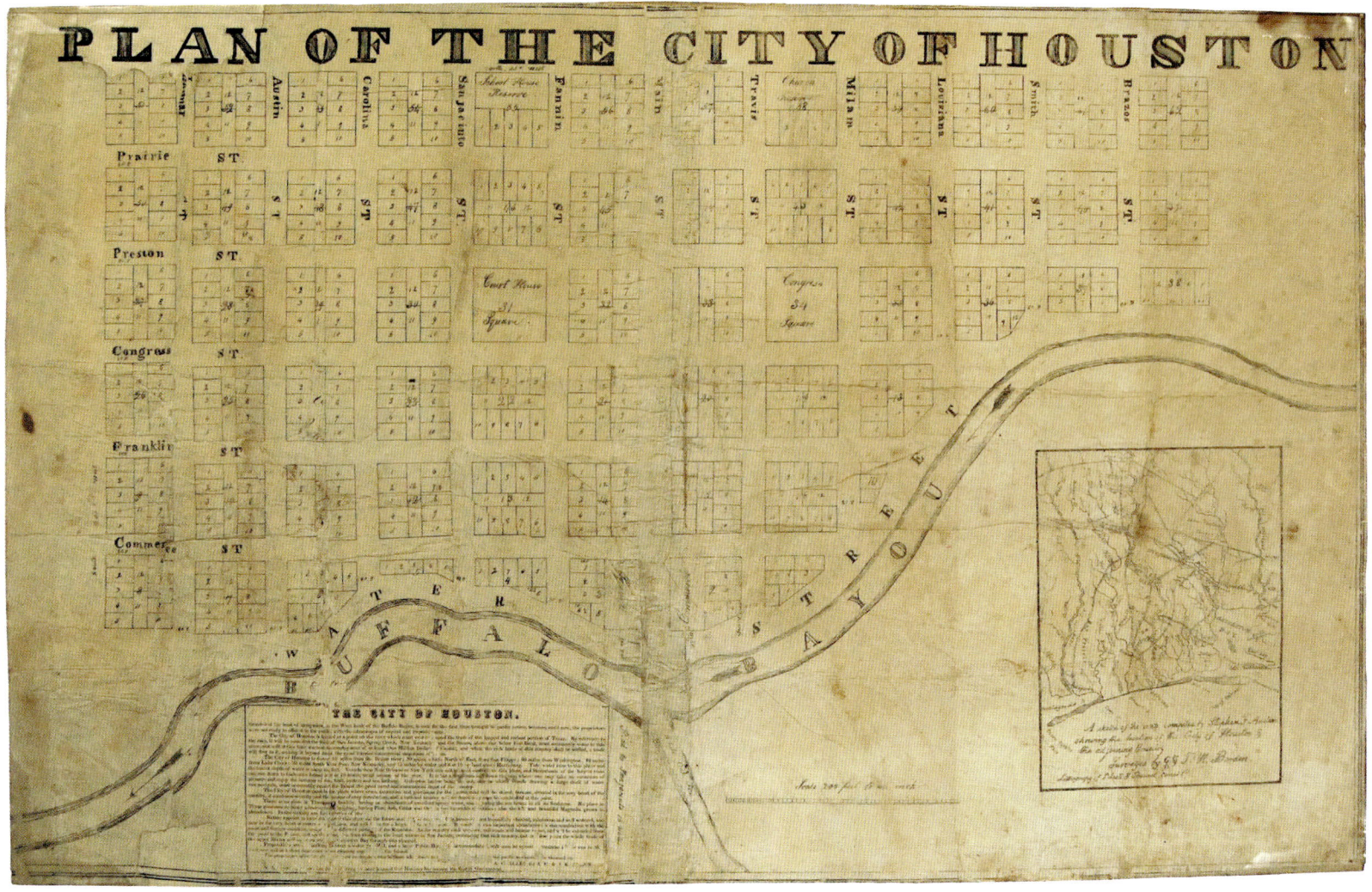

FIGURE 2.2 After G. and T. H. Borden, *Plan of the City of Houston*, 1836. Map. Lithograph, 54 × 74 cm, by P[erez] Snell & [Dominique] Theuret, New Orleans. From the collection of the Bryan Museum, Galveston.

Gail and Thomas Borden and Moses Lapham surveyed for the plat of the planned city and probably created the map as well. What may well be a proof of the map, now in the collection of the Houston Public Library, combines lithography and letterpress with manuscript additions. The city is laid out in a southeasterly direction from the bayou. In the lower right-hand corner is a small copy of Stephen F. Austin's 1835 or 1836 map of Texas, and pasted in the lower left-center is a rectangular piece of paper with twenty-six lines of letterpress describing the new city of Houston, in which the writer declares: "Nature appears to have designated this place as the future seat of Government." The Allens ordered twenty copies of the map from the lithographic firm of Perez Snell and Dominique Theuret on Canal Street in New Orleans. Former deputy constable Edward Stiff recalled several years later that "a splendid map of the city was carried on the wings of the wind to distant places to catch in time the greedy speculator and allure the uninitiated." A spate of lithographic maps of other planned cities followed—Galveston (fig. 2.3), Velasco, Osceola, Swartwout, and Colorado City (fig. 2.4)—as developers prepared for the rush of newcomers.[5]

James Pinckney Henderson, in the meantime, was in Paris attempting to negotiate a treaty with the government of King Louis Philippe I. Appointed minister to England

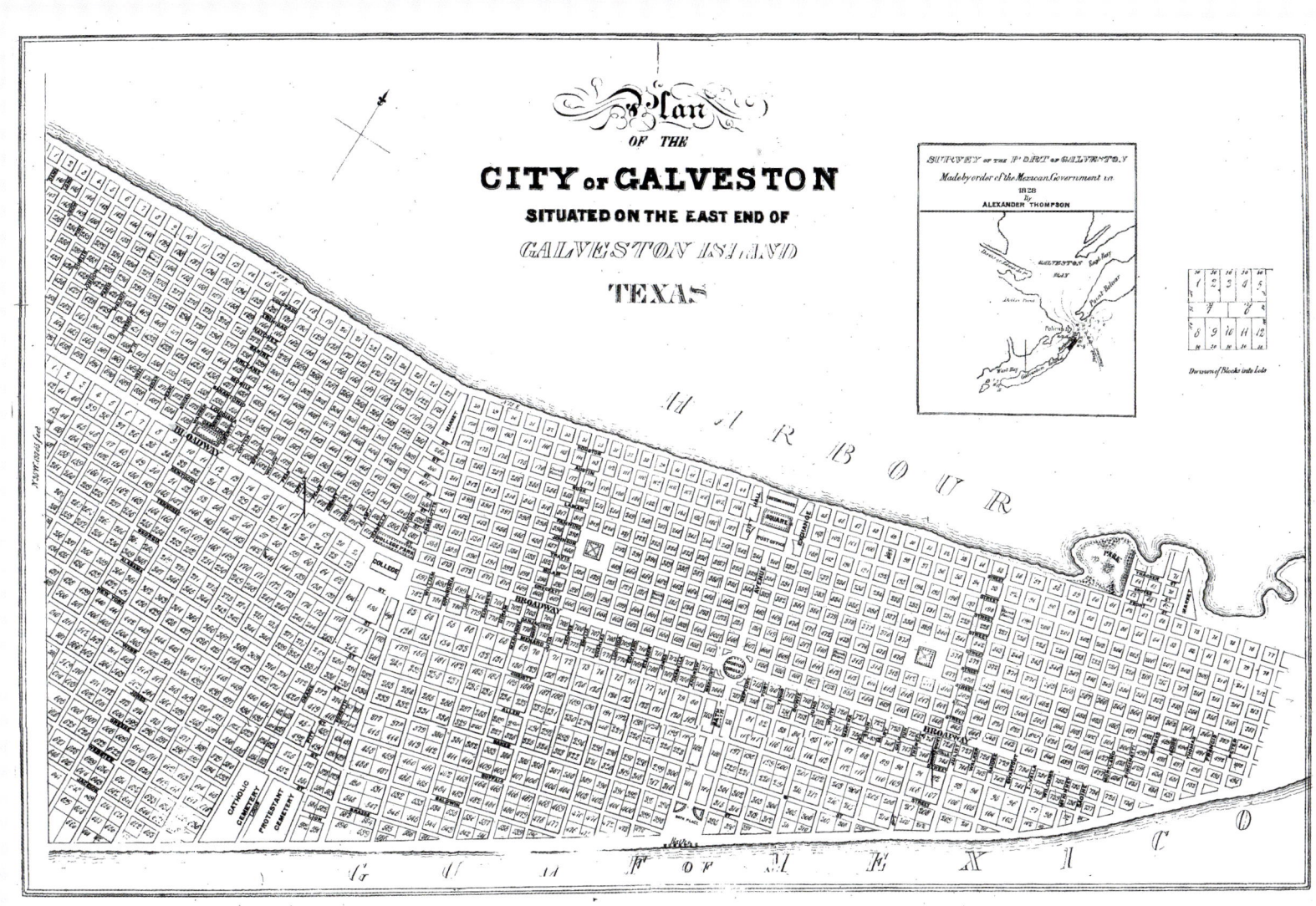

FIGURE 2.3 Anonymous, *Plan of the City of Galveston Situated on the East End of Galveston Island Texas*, 1837. Map. Lithograph, 52 × 81 cm, by Hotchkiss & Co., 53 Magazine St., New Orleans. From *City of Galveston, on Galveston Island, in Texas* (1837). Library of Congress.

and France by President Houston, Henderson, a North Carolina attorney who had arrived in Texas in June 1836 and spent the war recruiting for the Texas army in the United States, had two goals: secure international recognition of Texas independence and negotiate treaties of amity and commerce. Henderson had his portrait made and lithographed by an unnamed artist in Paris, probably as part of his effort to gain recognition from the French court (fig. 2.5). Largely through his efforts, both England and France entered into trade agreements with the new republic and eventually recognized its independence.[6]

At the same time, the French government directed the second secretary of the Washington legation, Jean Pierre Isidore Alphonse

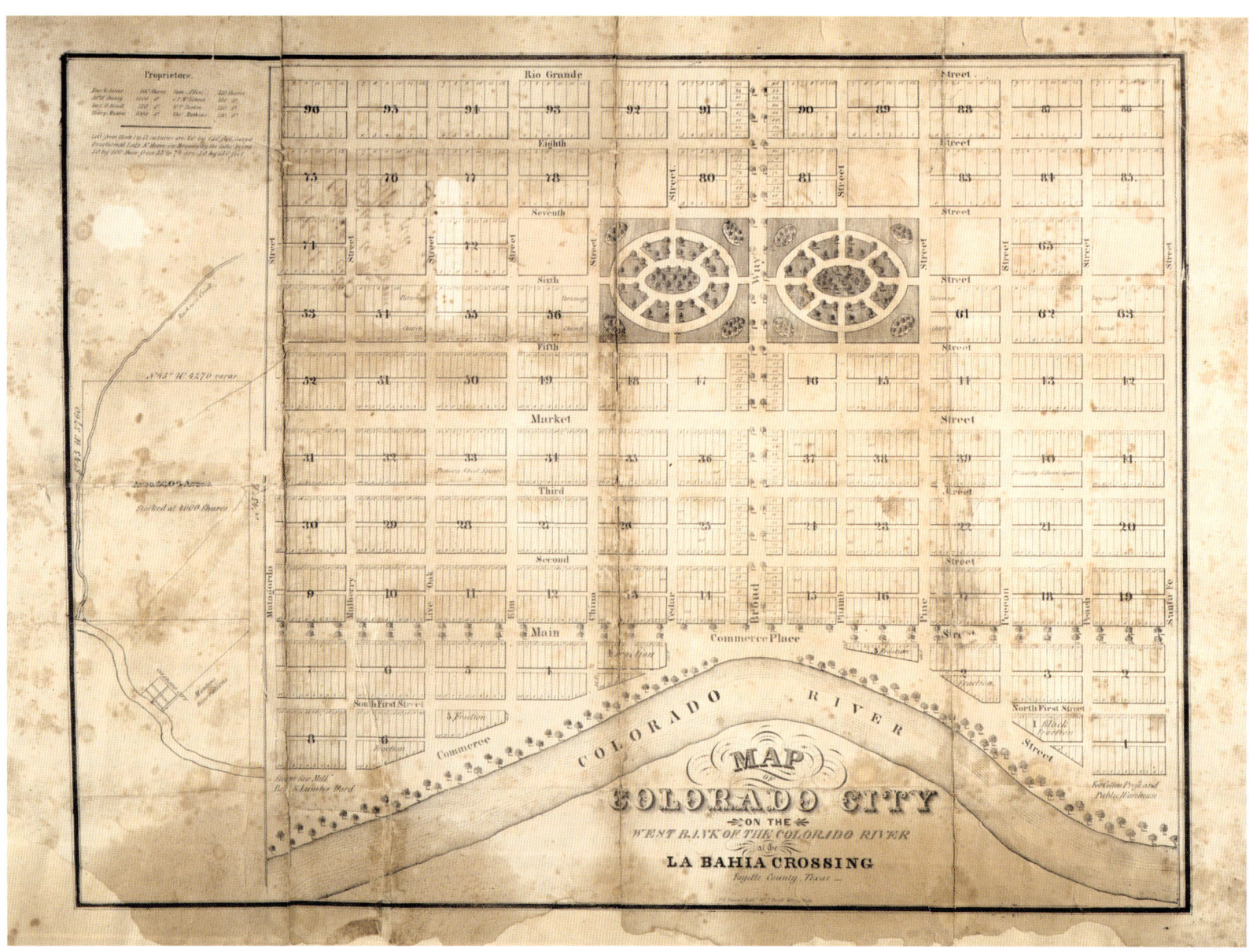

FIGURE 2.4 Unknown artist, *Map of Colorado City on the West Bank of the Colorado River at the La Bahia Crossing Fayette County, Texas*, c. 1838. Lithograph, 19.63 × 26.5 in., by P. S. Duval Lith, No. 7 Bank Alley, Phila. Courtesy Dorothy Sloan—Books. The congress of the republic in fact voted for Colorado City to be the new capital of Texas, but Sam Houston vetoed the bill, and the elaborately designed city never progressed beyond the plat stage.

(LEFT) FIGURE 2.5 Unknown artist, *J. Pinckney Henderson*, c. 1838. Single sheet. Lithograph, 29.6 × 21.4 cm (image), 33.7 × 21.4 (comp.), by Imp Zinco Lith Kaeppelin et Cie 20 r du Croissant, Paris. From the collection of Ted L. and Connie V. Gragg of Conway, South Carolina. Henderson served as President Houston's first attorney general, secretary of state, and minister to England and France. This undated portrait was made while he was in Paris. (RIGHT) FIGURE 2.6 Artist unknown, [Jean Pierre Isidore Alphonse Dubois], c. 1839. Single sheet. Lithograph, 21 × 15 in. Courtesy Briscoe Center for American History, UT Austin.

Dubois, to investigate conditions in Texas, and in 1839 he visited Galveston and Houston on the Gulf Coast and ventured as far west as Matagorda. His reports, which falsely claimed that he surveyed as far inland as San Antonio, influenced the French government to recognize Texas, and Dubois de Saligny, as he styled himself, was sent to Texas in January 1840 as the chargé d'affaires to the new republic. As was apparently customary among diplomats, he had lithographic portraits of himself to distribute to prominent individuals, and the one illustrated here (fig. 2.6), is autographed "To the Honorable Ashbel Smith Token of esteem and friendship." Smith served as chargé d'affaires to England and France from 1842 to 1844.[7]

In February 1838 Francis Moore Jr. of the *Telegraph and Texas Register* reported that "immigration has ushered in a thronging population which is diffused abroad over the country"; and the *New York Spectator* estimated that "the immigration into Texas since March 1st has been about a thousand per week."[8] More would-be settlers headed to Texas than any other western territory until gold was discovered in California in 1848.[9]

"A MORE PERFECT *FAC-SIMILE* OF THINGS" | 45

"MOST BEAUTIFUL & PERFECT SPECIMENS OF THE ART"[10]

No wonder the great ornithologist and artist John James Audubon was curious about the region. Audubon knew that Texas was a great flyway for migrating birds and had been yearning to explore the region for years. As early as March 1821 he had applied for a job as naturalist and draftsman on the team surveying the Louisiana-Texas boundary.[11] Now, he worried to his close friend, the Rev. John Bachman of Charleston, that the "sinister accounts of the Warfare in Texas" seemed about to prevent him from visiting the region before he brought his "great work," the monumental *The Birds of America, from Original Drawings*, which he self-published in London between 1827 and 1838, to a conclusion (fig. 2.7).[12]

When his old friend Col. John James Abert, head of the Corps of Topographical Engineers, made the use of a revenue cutter available to the ornithologist, the fifty-two-year-old Audubon jumped at the chance. He informed friend and patron Edward Harris that "we . . . may proceed towards the Sabine River, all intermediate places, and . . . even to Galveston Bay! . . . [which] abounds with Birds of rare plumage."[13] To Abert, he speculated that this probably would be his last tour "as an ornithologist," but he still had two new projects in mind: a small version of *The Birds of America* and a larger work on the quadrupeds of North America, in which Texas would figure prominently.[14]

Audubon might have seen teacher and author Mary Austin Holley's 1836 observations on Texas. Holley was Stephen F. Austin's cousin and wrote two books on Texas. The first one, published in 1833, was the first book on Texas in English. In her second book, the first history of Texas in English, which reached the market in November 1836, she reported that, at least in the settled portions of the country, "the principal specimens of the feathered tribe . . . are, mostly, such as are well known in the United States."[15] But Audubon wanted to see for himself, and it was now or not at all if the discoveries were to be included in his "great work."

The US revenue schooner *Campbell* deposited Audubon, his son John Woodhouse, and Harris at Galveston Island on April 24, 1837, and the *Telegraph and Texas Register*, in its first issue printed in Houston, noted the famous ornithologist's arrival.[16] There were only a few huts on the island along with the Mexican prisoners ("in a state of apparent inactivity") who were still being held captive more than a year after the battle of San Jacinto.[17] On April 29 John Woodhouse

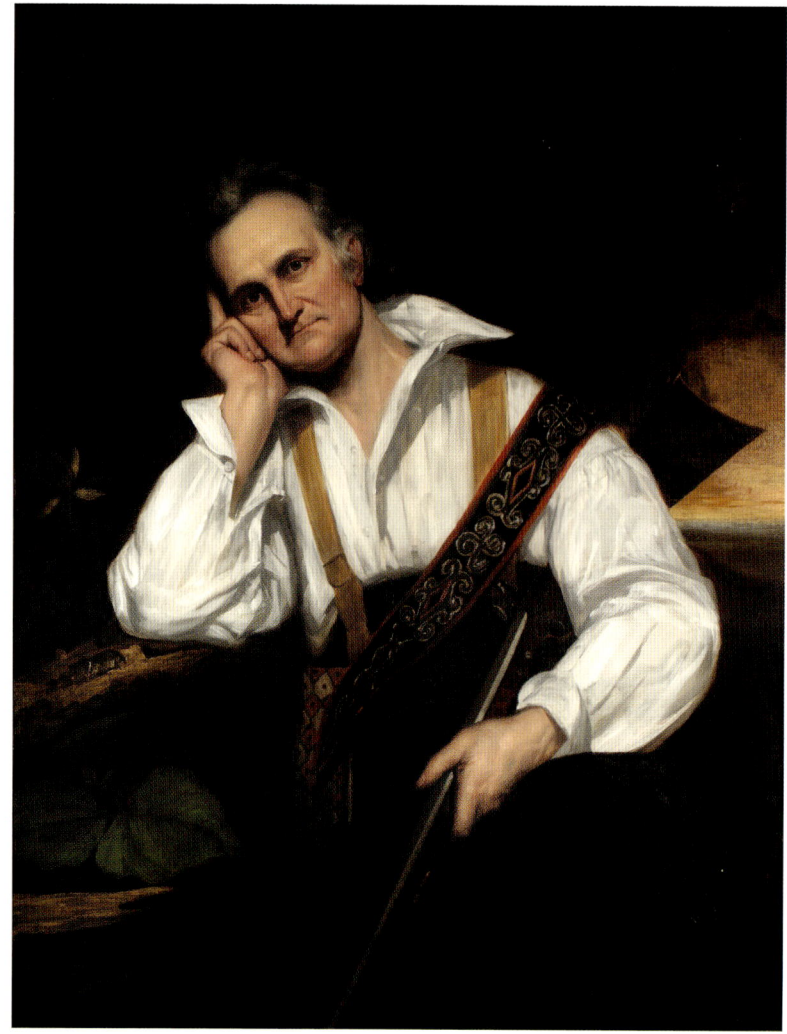

FIGURE 2.7 George P. A. Healy, *John James Audubon*, 1838. Oil on canvas, 27 × 25 in. Courtesy Museum of Science, Boston. According to Stanley Clisby Arthur's 1937 biography (*Audubon: An Intimate Life*, 497), Healy painted Audubon's portrait in London soon after the Texas trip. Audubon would not pose for Healy during the day, so the portrait of Audubon dressed as when he was searching for birds in the field was made by gaslight.

made what might have been the first sketch of the village of Galveston with his camera lucida, an optical device that projects an image onto the artist's paper so that it can be traced, but the drawing is not known to have survived.[18]

Audubon immediately recorded the presence of numerous birds in his journal, including the Ivory-Billed Woodpecker "in abundance."[19] On May 8 he started the trip across the bay to the San Jacinto River and up Buffalo Bayou to Houston, which took several

days as he paused to hunt, survey the recent battleground at San Jacinto, and collect several skulls of Mexican soldiers. He routinely exchanged specimens with different naturalists and sent the skulls to his friend Dr. Samuel George Morton for his crania collection at the University of Pennsylvania.[20] He also gathered a box of eggs of various birds for his friend Thomas M. Brewer, editor of the *Boston Daily Atlas*. Audubon and party arrived at Houston on May 15. By then, he had done most of his birding and discovered no new species. That was not a surprise to Bachman, who urged him: "I do not care much for your finding new birds, but you must try to establish the habits of those already known."[21]

The highlight of his one-day visit in Houston was meeting the city's namesake, Sam Houston.[22] Audubon first saw the president when the latter entered a tavern with "a scowl in the expression of his eyes that was forbidding and disagreeable" to demand that the bartender stop serving liquor to visiting Indians who were already drunk. Later, when Audubon arrived for his official audience with Houston, who had just received a shipment of dress clothes from New Orleans, the president had changed into "a fancy velvet coat, and trousers trimmed with broad gold lace" and a "cravat somewhat in the style of seventy-six." He inquired of Audubon's needs and offered to help however he could. "Our talk was short," Audubon

FIGURE 2.8 John James Audubon, *Havell's Tern Trudeau's Tern*, 1838. Hand-colored, aquatint engraving, 25.5 × 38.25 in., by Robert Havell Jr. Courtesy National Gallery of Art, Washington, DC, gift of Mrs. Walter B. James. Plate 409 in Audubon's *Birds of America, from Original Drawings* (double elephant folio).

recalled, "but the impression which was made on my mind . . . can never be forgotten."[23] His quick survey of the "city in embryo" over, he began his return to Galveston on May 16.[24]

Audubon recognized Texas as one of the best ornithological observation points on the continent: "More than two-thirds of our species occur there," he estimated, but ultimately his findings only echoed those of Holley. "We found not one new species," he wrote Brewer, "but the mass of observations that we gathered connected with the ornithology of our country has, I think, never been surpassed. I feel myself now tolerably competent to give an essay on the geographical distribution of the feathered tribes of our dear country." Audubon's party departed Galveston on May 18, after a little more than three-week stay in Texas.[25]

One of the specimens obtained in Texas permitted Audubon to finally publish *Havell's Tern*, which he had first seen and painted years before, but he had lost the skin. Uncertain of some details, Audubon had waited until he collected another specimen before publishing it. He collected a specimen during his Texas trip and, as soon as he returned to England, made slight amendments to his painting. *Havell's Tern* appeared as plate 409 of *The Birds of America* (fig. 2.8).[26]

The plates in the double elephant folio are hand-colored aquatint engravings and therefore are not a part of this study, but Audubon included them all as lithographs, along with sixty-five additional plates, in the octavo edition of *Birds*, which he began working on as soon as he returned from Britain in 1839. The lithograph of *Havell's Tern* is plate 434. This edition also includes a new specimen from Texas—the *Texan Turtle Dove* (fig. 2.9)—which an unnamed correspondent sent to Audubon's sometime taxidermist John G. Bell, who provided the skin to Audubon. It was Audubon's practice to write extensive notes about the bird's habitat, habits, and territory, but Bell's correspondent had supplied no information, so Audubon only described the skin as he had received it. The *Texan Turtle Dove* is plate 496 in volume seven of the octavo *Birds*, completed in 1844.[27]

Audubon was also collecting for his third massive project, *The Viviparous Quadrupeds of North America*. Viviparous quadrupeds are generally defined as four-footed mammals that bear their young alive, but the grouping also includes whales and bats, for example.[28] He had long dreamed of such a book and had seen—and painted—his first Texas animal while he was in New Orleans preparing for his trip to Texas, "the singular and beautiful little Orange-bellied Squirrel," or the Texas Fox Squirrel, which an Indian hunter told him he had gotten "in the recesses of the forest on the border of an extensive

FIGURE 2.09 John James Audubon, *The Texan Turtle Dove. Male*, 1844. Hand-colored lithograph, 17.4 × 10 cm (image), 22.5 × 12.9 cm (comp.). Lithd. Printed & Cold. by J. T. Bowen, Philada. From Audubon, *Birds of America*, vol. 7, plate 496, opp. 352. Courtesy private collection.

FIGURE 2.10 John James Audubon, *Sciurus Sub-Auratus, Aud. & Bach. Orange-bellied Squirrel. Male & Female. Natural Size*, 1845. Hand-colored lithograph, 56 × 47.8 cm (image), 63.8 × 47.8 cm (comp.), by J. T. Bowen. From John James Audubon and John Bachman, *The Viviparous Quadrupeds of North America* (1845–1848), plate LVIII. Courtesy New York Public Library.

swamp [fig. 2.10]." At Galveston Island he noted that the muskrat was the "only small quadruped found" there, the "common house-rat" having not yet arrived, and he was already collecting and shipping quadruped skins to Bachman while on the trip.[29]

For *Viviparous Quadrupeds* Audubon again envisioned a book on a scale never before produced in the United States, especially in the wake of the panic and depression of 1837. His dear friend, the Revered Bachman, one of the foremost amateur naturalists in the country and soon to be his in-law, had agreed to author the text but cautioned, "Don't flatter yourself that this book is child's play.... The animals are not as numerous [as the birds] but they have never been carefully described, & you will find difficulties at every step."[30] But Audubon's optimism and "holy zeal" prevailed, and he had announced that he was undertaking the work as soon as he returned from Great Britain in 1839.[31]

He turned to lithographer J. T. Bowen of Philadelphia, who was already printing the octavo edition of *The Birds of America*, to lithograph and color the plates of this much larger work, and he announced that *The Viviparous Quadrupeds of North America* would be printed and sold in the same manner as the *Birds*: he would publish the work serially, a fascicule of five plates each month that would sell for $10, and he and his appointed agents would sell it by subscription. It would be a book of 150 plates, each approximately 22 × 28 inches, the whole generally bound in three volumes, for a total of $300 (about $7,350 today), which would include Bachman's three volumes of text.[32] Audubon would not be able to paint all the animals life-size, as he had with the birds, but he did present those animals small

"A MORE PERFECT *FAC-SIMILE* OF THINGS" | 49

FIGURE 2.11 John James Audubon, *Lynx rufus, Common American Wild Cat. ¾ Natural Size. Male*, 1842. Hand-colored lithograph, 28 × 22 in., by J. T. Bowen. From Audubon and Bachman, *Viviparous Quadrupeds*, plate I. Courtesy Amon Carter Museum of American Art, Fort Worth.

FIGURE 2.12 John James Audubon, *Spermophilus ludovicianus, Ord. Prairie Dog—Prairie Marmot Squirrel*, 1846. Hand-colored lithograph, approx. 21 × 27 in., by J. T. Bowen. From Audubon and Bachman, *Viviparous Quadrupeds*, plate XCIX. Courtesy New York Public Library.

enough to fit on the page in life-size. Over the years the book became known as the Imperial Edition because the paper on which the images were printed was called the "imperial folio" in the paper trade.

Bowen completed the first proofs in 1842, which included the *Common American Wildcat*, a Texas mammal, as the first plate (fig. 2.11). The *Civilian and Galveston City Gazette* informed its readers, "The work will include every animal coming within the class it embraces, from Texas, California, and the North west coasts to the British possessions, and to the Arctic region of our continent."[33]

Now that the publication was under way, Audubon had to rush to collect and depict the animals that he was missing, a problem that in 1843 finally provided him with the opportunity for a trip up

FIGURE 2.13 Unknown photographer, John Woodhouse Audubon, 1853. Courtesy of Mill Grove, County of Montgomery, Audubon, PA.

the Missouri River as far as Fort Union (in what is now far western North Dakota). He had longed for a western trip for years and had tried unsuccessfully to gain appointment to several expeditions. Now it became possible when Pierre Chouteau Jr., who had purchased the western division of John Jacob Astor's American Fur Co. and regularly sent steamboats up the Missouri River, offered Audubon free passage.[34] At Fort Union he witnessed a buffalo hunt firsthand and added a "true blue" new species, the black-footed ferret, to his modestly growing portfolio.[35]

Bachman alerted Audubon to another curious animal after sharing a railroad car with George Wilkins Kendall, the well-known editor of the *New Orleans Picayune*, who had spent a great deal of time in Texas and Mexico and whose just-published *Narrative of the Texan Santa Fé Expedition* contained a description of prairie dogs on the southern plains (fig. 2.12). Bachman was fascinated and suggested to Audubon that he send his son John Woodhouse back to Texas to collect more species, especially the prairie dog and the exotic and mysterious armadillo.[36]

John arrived for his second visit to Texas in December 1845, only days before the US Congress accepted Texas as the twenty-eighth state in the Union (fig. 2.13). The ever-observant editor of the *Telegraph and Texas Register*, Dr. Francis Moore Jr., welcomed him, warning that he should avoid those "bipeds whose heads are generally ornamented with owls' feathers" and noting that the senior Audubon had omitted from his *Birds of America* one of the "most singular birds" in the country, birds "that . . . are never known to fly, but run with astonishing velocity"—the Road Runner, or *Geococcyx mexicanus*.[37]

John was not the seasoned naturalist that his father was and had difficulty from the beginning, but with the assistance of several Texas Rangers, Col. William S. Harney of the US Army, and a group of Shawnee Indians in the San Antonio area, he managed to collect several new species, including an ocelot, a ring-tailed cat (fig. 2.14), a jaguar, and a lynx, or Texas Wild Cat. He entertained the Indians with his drawings in an effort to get them to help him, and "in a day or two, I had a beautiful specimen of the Black-tailed Hare"—with the head shot off. The Indians, of course, kept only the pelts and wondered why Audubon wanted anything more. One of John C. Hays's Rangers finally brought in a whole specimen that John could paint.[38] On the road between Houston and LaGrange, John found a large-tailed skunk (fig. 2.15), which he described as being "very common in some parts of Texas" where the animal's "superb tail" was sometimes "used by the country folks by way of plume or feather in their hats."[39] It was his second attempt to obtain the skunk. Earlier he had captured a young specimen alive near the San Jacinto battlefield and placed it in a pack on one of his mules, but when he camped that evening, he discovered that the little skunk had gnawed its way out of his pack during the day, leaving only his scent behind.[40]

The javelina, or collared peccary, was one of the most dangerous animals that he encountered (fig. 2.16). "The Mexican hogs . . . struck terror into the hearts of the settlers," Bachman later reported, "oftentimes pursuing the planter whilst hunting or in search of the lost track of his wandering cattle. . . . They frequently killed his dogs, or even forced him to ascend a tree for safety. . . . [They] would . . . snap their teeth and run about and then lie down at the root of the tree

FIGURE 2.14 John James Audubon, *Bassaris astute, Licht., Ring-Tailed Bassaris. Natural Size. Male*, 1846. Hand-colored lithograph, 27.87 × 21.87 in., by J. T. Bowen. From Audubon and Bachman, *Viviparous Quadrupeds*, plate XCVIII. Courtesy Amon Carter Museum of American Art, Fort Worth.

FIGURE 2.15 John Woodhouse Audubon, *Mephitis Macroura, Licht., Large-Tailed Skunk*, 1846. Hand-colored lithograph, 71 × 55.6 × 71 cm (comp.), by J. T. Bowen. From Audubon and Bachman, *Viviparous Quadrupeds*, plate CII. Courtesy Amon Carter Museum of American Art, Fort Worth.

FIGURE 2.16 John James Audubon, *Dycoteles Torquatus, F. Cuv., Collared Peccary*, 1844. Hand-colored lithograph, 55.7 × 71.7 cm (comp.), by J. T. Bowen. From Audubon and Bachman, *Viviparous Quadrupeds*, plate XXXI. Courtesy Amon Carter Museum of American Art, Fort Worth.

FIGURE 2.17 John Woodhouse Audubon, *Lepus Texianus, Aud. & Bach, Texian Hare*, 1848. Hand-colored lithograph, 21.94 × 27.87 in. (image), by J. T. Bowen. From Audubon and John Bachman, *Viviparous Quadrupeds*, plate CXXXIII. Courtesy Amon Carter Museum of American Art, Fort Worth.

to wait for their enemy to come down." John captured his specimen by setting a trap and dropping a noose around his neck.[41]

John's tour of Texas included San Jacinto, San Antonio, Castroville, Washington-on-the-Brazos, and other places "*not* on the map," the senior Audubon wrote, but he was disappointed with the Texian hare (fig. 2.17), that John had secured, because some American troops en route to Mexico had led him to believe that it was as large as a fox. He also was unhappy that John had not found more of the animals that they needed, but John was unable to go beyond the Medina River because of rumors of unwelcoming Indians and his inability to secure an escort. The armadillo, one of the most desired specimens, eluded him.[42] "Until I went to Texas," John later admitted to Bachman, "I never thought I should have to become to any degree naturalist as well as artist."[43] John spent much of the following year

FIGURE 2.18 John Woodhouse Audubon, *Lasypus Peba, Desm., Nine-Banded Armadillo*, 1848. Hand-colored lithograph, 43.5 × 63 cm (image), 47.3 × 63 cm (comp.), by J. T. Bowen. From Audubon and Bachman, *Viviparous Quadrupeds*, plate CXLVI. Courtesy New York Public Library.

in Britain and Europe painting American quadrupeds from specimens in zoos and museums—specimens that Bachman had suggested that Audubon himself paint before he left England in 1839.[44]

The armadillo, which the Reverend Bachman described as resembling a "small pig saddled with the shell of a turtle," may well be the most sought-after of the Texas quadruped prints today and has become a symbol of popular culture. Victor Audubon, John's brother who was managing the project, held publication until they found a specimen; otherwise their "last numbers will be rather deficient in interest." Bachman attempted to have members of the South Carolina regiment in Mexico send back a specimen but failed.[45] Finally, on June 17, 1848, Victor informed Bachman that he had obtained the skin of an armadillo that had been a pet (fig. 2.18). Bachman cobbled together a description from the few sources available to him,

FIGURE 2.19 John Woodhouse Audubon, *Maphitis Mesoleuca, Licht., Texan Skunk*, 1845. Hand-colored lithograph, 53.2 × 47.9 cm (comp.), by J. T. Bowen. From Audubon and Bachman, *Viviparous Quadrupeds*, plate LIII. Courtesy Amon Carter Museum of American Art, Fort Worth.

explaining that the animal pictured would normally be much darker because in its habitat the critter would take on the color of the earth in its den; the one illustrated was a pet and had been washed and kept clean.[46] The rush to publication probably was responsible for another lapse; Victor included a large clump of *Aloe mitriformis* (family Aloeaceae) in the background, an African rather than an American plant.[47]

Bachman lamented that Audubon's lack of knowledge of the animals combined with damaged specimens resulted in several errors, and was often sharply critical of his work, especially if he thought there were scientific deficiencies. He was especially scolding of the plate of the Texan skunk, which was actually drawn by son John. It was simply a poor composition, he wrote, one that almost makes it appear that there are two animals side by side, one black and one white (fig. 2.19).[48] But, after seeing more of the lithographs, Bachman damped his criticisms: "The last two numbers of the . . . Quadrupeds . . . are most beautiful & perfect specimens of the Art[.] I doubt whether there is anything in the world of Natural history like them."[49]

Diminishing sight forced Audubon to withdraw from the project in 1846, but John, Victor, and Bachman brought it to a successful conclusion, finishing the third volume of plates in 1848. The volume includes several plates by John Woodhouse that have John James's name on them, such as the *Red Texan Wolf* (fig. 2.20), the *Texan Skunk*, and the *Prairie Wolf*. The third volume of text appeared in 1854 and includes six additional octavo plates of animals that had been omitted from the larger volumes.[50] Audubon had painted a number of bats for inclusion, but his sons were so pressed to finish the project that they left them out, along with whales and seals.[51] Victor and John then published an octavo edition containing all 155 plates in three volumes in 1851–1854, with Bowen again serving as the lithographer.[52]

Viviparous Quadrupeds received a warm public reception. There were no scientific reviews, the state of American science being in its infancy, but literary reviewers generally touted them as an achievement on par with *The Birds of America*, although they fall short in that comparison. The lithographs themselves—especially the squirrels and foxes, Audubon's early work—sometimes rise to that level, leading the *U.S. Gazette* to claim, "This is a national work, and we hope a proper national pride will secure ample patronage for it." The *Raleigh Register, and North-Carolina Gazette* recommended it to "those who have taste and feeling for works of genius," and Hamilton Stuart of the *Civilian and Galveston City Gazette* quoted the *New York Courier* that the "great work is . . . such as none other than Audubon could have prepared."[53] Critic and author Charles W. Webber, a former Texas Ranger who had served with John C. Hays, concluded, "We have at last a Great National Work, originated and completed among us—the authors, artists, and artisans of which are our own citizens."[54] With the possible exception of the octavo *Birds*, it is surely the most ambitious and successful color plate book published in nineteenth-century America.

FIGURE 2.20 John Woodhouse Audubon [attrib.], *Canis Lupus, Linn., Var Rufus, Red Texan Wolf*, 1845. Hand-colored lithograph, 55.56 × 70.9 cm (comp.), by J. T. Bowen. From Audubon and Bachman, *Viviparous Quadrupeds*, plate LXXXII. Courtesy Amon Carter Museum of American Art, Fort Worth. John James Audubon is credited with this print in the label, but it is most likely by his son.

"I SHALL ALSO I THINK BUY A LITHOGRAPHIC ESTABLISHMENT"

The first effort to establish a lithographic press in Texas occurred a few months after the elder Audubon's departure in 1837. John Warren J. Niles, a veteran publisher and one of twenty children of Hezekiah Niles, publisher of *Niles Weekly Register* in Baltimore, had established the *Matagorda Bulletin*, the fourth newspaper in the new republic.[55] Although he apparently had not done well in journalism to this point, the young Niles was a friend of Mirabeau B. Lamar, the vice president of the republic, and Lamar, the odds-on favorite to follow Sam Houston as president, probably was one of the silent partners in Niles's company. Niles won a small printing contract from the republic and hoped for more.[56] With the intent of challenging Dr. Moore and Jacob W. Cruger of the *Telegraph and Texas Register* as the republic's official printer, Niles took his advance money and went to New Orleans in December 1837, where he acquired several presses, type, and paper, including a lithographic press, probably the first one brought into the republic. He wrote Lamar: "My Printing Materials will be shipped shortly—consistg of I think 4 Presses—the requisite quantity of type—paper &c.— I shall also I think buy a Lithographic Establishment & Book Bindrs. I shall be prepared for every & any description of work & am determined none shall *under bid* me in prices for work." He then moved from Matagorda to Houston in April 1838 and began publishing the *National Banner* in direct competition with Moore and Cruger; he advertised that he had "the best German and French Stones, and every necessary Material for Drawing [figs. 2.21 and 2.22]."[57] Niles apparently was equipped to print lithographs, but no lithographic artist or pressman has been identified, nor has any production from this press been documented.

Niles's challenge to Moore's and Cruger's hegemony was short lived. By December he had sold the newspaper and all its equipment to a business partner, Samuel Whiting, who changed the name of the *Banner* to the *National Intelligencer* and advertised as late as June 1839 that he was prepared to do all kinds of printing, including "posting bills & show bills for merchants," but without mentioning lithography. When Lamar succeeded Houston in office and moved the capital to Austin in the fall of 1839, Whiting followed and started the *Austin City Gazette*. He and his partner, N. W. Travis, maintained the *Intelligencer* in Houston for a while, but in February 1840 they put all their printing equipment for sale, including "one Lithographic Press, with five superior stones, complete [fig. 2.23]." A. H. Osborn and G. W. Lively purchased the equipment and continued the newspaper from March until July, but no printing from the lithographic press has been identified, nor do we know what happened to it. Niles was reduced to publishing a few issues of the *Texan Emigrant* at Washington-on-the-Brazos before it too failed. He returned to Houston in 1844 where he reportedly ran Niles Coffee House until his death the following year.[58]

Soon after the congress voted to move the capital to Austin, surveyors L. J. Pilie and Charles Schoolfield produced a map of the city ready to be printed (fig. 2.24) but, for lack of a local lithographer, sent it to R. W. Fishbourne and William Greene in New Orleans, who signed the map as the "lithographer to the Republic of Texas."[59]

FIGURE 2.21 J. W. J. Niles ad in the first issue of the *National Banner* (Houston), April 25, 1838, p. 3, col. 2.

FIGURE 2.22 Niles & Co. ad in the *National Banner*, Oct. 5, 1838, p. 4, col. 3.

FIGURE 2.23 "Printing Materials," *Houston Morning Star*, Feb. 19, 1840. Advertising the sale of the lithographic press that John Warren J. Niles brought to Texas in 1838.

Another lithographer, Michael Angelo Welch, immigrated to Texas in 1839, but the only record we have of him is a plea asking for information about him that appeared in the *Telegraph and Texas Register*. We know a bit more about Joshua Lowe of New Orleans, who had a shop at 75 Chartres in New Orleans in 1837 and at 34 Canal in 1838, and who in 1840 lithographed a bird's-eye view of Austin after a drawing by Edward Hall, the Texas purchasing agent, consul, and speculator in New Orleans.[60] In November, after publication of *Texas in 1840*, by the Rev. A. B. Lawrence, Lowe immigrated to Galveston and established a shop at No. 6 22nd Street, near Avenue C.[61]

The hand-colored print appeared as the frontispiece to Lawrence's book, one of the dozens of travel accounts, guides, and promotional pieces published by then but the first to contain an eyewitness lithograph of a Texas city (fig. 2.25).[62] The picture is attributed to Hall in the lower left corner and signed by Lowe as lithographer in the lower right corner. The book probably was the product of Lawrence's entrepreneurship with two other residents of New Orleans and a Philadelphia publisher named Stille, all of whom had more than passing interest in Texas. Since the book was receiving notices and reviews as early as September, in both the United States and England, it probably was published in the spring or summer, before Lowe moved to Texas.[63]

The editor of the *New Orleans Presbyterian*, Lawrence landed at Galveston, then proceeded to Austin, where he arrived on January 12, 1840. He apparently spent some time there, for he penned a lengthy description of the city to accompany the print and delivered a sermon while there. He probably encountered Hall, who spent much of the fall and winter of 1839–1840 in Austin and made the drawing to accompany Lawrence's book.[64] The image shows Austin as of January 1, 1840, from the south and from an imagined perspective dozens of feet above the Colorado River. Congress Avenue stretches northward into the wilderness. "The first object that attracted our attention was a white house, designated the residence of the President," Lawrence recalled. "It commands from its front a fine view of a considerable and beautiful prairie, extending to

FIGURE 2.24 L. J. Pilie, *Plan of the City of Austin*, 1839. Map. Lithograph, 59 × 45 cm, by Greene Lithographer, No. 53 Magazine Street, New Orleans, on stone by Fishbourne. Surveyed by L. J. Pilie & Chas. Schoolfield. Drawn by L. J. Pilie. Courtesy Austin History Center, Austin Public Library.

62 | TEXAS LITHOGRAPHS

the Colorado on the south." Between the president's house and the "neat white building . . . occupied by the two houses of congress" ran "a broad and beautiful street, called Congress Avenue, passing through the whole extent of the contemplated city."[65]

The temporary capitol is the long structure on the hill across Congress Avenue at the upper left, which the colorist has tinted brown, rather than white as Lawrence described. Capitol Hill is the bare spot at the end of Congress Avenue. Two creeks flank the city, Shoal Creek on the west and Waller Creek on the east.[66] Pecan Street runs east-west across the center of the print, and the lithographic artist has included the mountains along the Colorado River in the upper left. One of the houses at the far right may be intended to represent the "humble dwelling" where the French chargé d'affaires Dubois said in November that he was "now camping, rather than living," which was located at about Pecan (Sixth) and Guadalupe Streets. He did not purchase the site for what became known as the Legation House until September, probably months after publication of the print.[67]

Hall made his drawing from street level, and it does not include the river, the creeks, the large two-story structure at the far right, or cabins in the foreground, but it does include an enlarged detail of the president's house, a couple of two-story buildings at the right (which do not appear in the print), and a key that identifies the buildings along Congress Avenue (fig. 2.26). It is apparent that

FIGURE 2.25 Edward Hall, *City of Austin the New Capital of Texas in January 1, 1840*, 1840. Hand-colored lithograph, 10 × 18.2 cm (image), 10.3 × 18.2 cm (comp.). Inscribed: Drawn by Edward Hall. Lithog. By J[oshua]. Lowe. From [A. B. Lawrence], *Texas in 1840, or, the Emigrant's Guide to the New Republic* (1840), frontis. This version of the print, which appears to be from the 1840 edition, is tipped into the 1844 publication of the book. Courtesy Amon Carter Museum of American Art, Fort Worth.

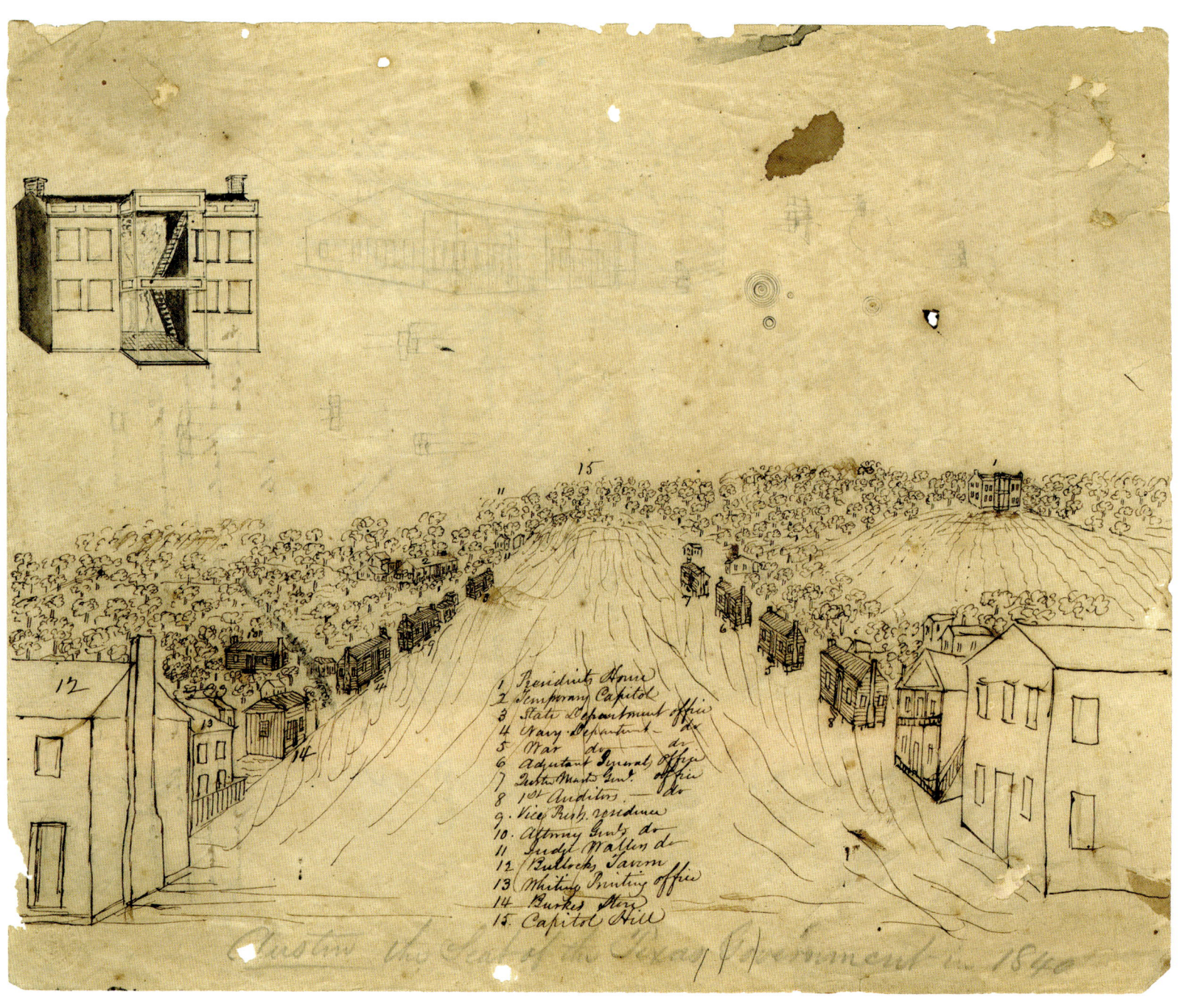

FIGURE 2.26 Edward Hall [attrib.], *Austin the Seat of the Texan Government in 1840*, 1840. Pen and ink with pencil, 8 × 10 in. Courtesy Austin History Center. The buildings are identified in the key in the center of the picture, supposedly in Hall's handwriting.

FIGURE 2.27 Joshua Lowe, *City of Portland Matagorda Co Republic of Texas*, 1841. Engraving, 8.8 × 18.2 cm, by J. Lowe, Galveston. Courtesy Heritage Auctions, Dallas. The only example that I have found of pictorial printing done in Texas during the republic other than the masthead of the *Texas National Register*, published in Washington, Texas, beginning in December 1844; there are also various advertising cuts—clipper ship, steamship, locomotive, horse, tree, runaway slave—but they were acquired from type foundries in the United States.

the lithographic artist (Lowe?) made many changes and additions. But Hall did not sign the drawing, and its provenance has been lost in the passage of time.[68]

The print, no doubt, was an attempt to add visual clarity to Lawrence's comments and to lend credibility to President Mirabeau B. Lamar's controversial decision to move the capital, particularly in the face of widely published complaints by Houston and his friends that Austin was "an inconsiderable hamlet situated on . . . the extreme verge of the northern frontier." It was truly a city set in a wilderness, and the artist showed it surrounded by encroaching trees. Editor Moore of the *Telegraph and Texas Register* in Houston predicted that the seat of government would soon be moved back to Houston because of Indian raids, but George W. Bonnell of the newly established *Texas Sentinel* in Austin refuted reports that "a company of Indians paraded through the streets . . . and gave us a war whoop in the public square at mid-day," while editor Whiting of the *Austin City Gazette*, a Lamar supporter, predicted that the city's "many advantages of location not immediately discernible to the traveller" would prevail. Those advantages were not apparent to one of Dubois's colleagues who visited in 1842 and described the city as "rather like an advanced guard, placed to sound the alarm in case of a surprise attack."[69]

The book received a great deal of publicity and was noticed and reviewed in Eastern as well as English publications. It was reprinted at least three times, once by the original publisher in 1842 and twice by Nafis & Cornish in New York (in 1844 and 1845). A print of Austin appeared in all editions of the book except 1842. Copies of Lowe's lithograph, all known copies hand-colored, were included in the first printing and some copies of the third printing, and an engraved copy of Lowe's lithograph—done as an uncolored, outline drawing and dated 1844—appeared in some copies of the 1844 and 1845 editions.[70] That engraving, titled *City of Austin the New Capital of Texas in 1844*, gives no credit for artist or printer.

Lowe, meanwhile, had little success in Texas. Only an 1841 stock certificate for the would-be city of Portland on the Colorado River survives to document his time in Galveston. It is the only known example of engraving done in the republic (fig. 2.27). The last ad for his services appeared in May 1841, and he disappears from the record.[71]

"A MORE PERFECT *FAC-SIMILE* OF THINGS"

It was, no doubt, such publicity that attracted Englishman Charles Hooton's attention (fig. 2.28). Hooton, a budding essayist, novelist, poet, and passing artist, immigrated to Galveston in 1841. Michel B. Menard and his partners had obtained land on the bay to establish a town and began selling lots in 1838. Galveston was still a small village (but with imperial aspirations as the city "that nature has designed as the New York of Texas") when Hooton arrived with several members of his family on March 29, 1841. The thirty-one-year-old newcomer had read the "golden store of almost unalloyed 'sweet promise'" described in the "various books and pamphlets . . . which happened to fall into my hands," which influenced him to come to Texas rather than some other "paradissical" place. While "the appearance of Galveston is that of a fine city of great extent . . . its glory vanishes gradually in proportion to the nearness of approach," he later wrote. The disappointment was palpable as he and thirty hopeful immigrants passed the wrecks of numerous ships in the shallow waters approaching Galveston Bay. When they landed on so-called Snake Island, which had been the home of Indians for centuries and Laffite's pirate band from 1817 to 1820, they were a bit confounded by the place they had been told was the "head-quarters of modern Texas in population, in commercial importance, in the civilization of its society, in religion, education, morals, and literature."[72]

After landing, Hooton walked the "long, rude, wood projections, called wharfs, which shoot out a quarter of a mile into the shallows of the bay" only to find that the "fine city" that he had seen from a distance was now transformed into "a poor straggling collection of weather-boarded frame-houses, beautifully embellished with white-wash." Regarding continuing threats from Mexico, he observed that an attacker might be put off by this "bold front," with its structures perhaps being mistaken for "white marble" at a distance; but in case of an actual attack, he speculated that the village would succumb to "nothing more formidable than dried peas, instead of grape-shot." It probably wasn't too much hyperbole when he claimed that Galveston bore about the same relationship to a city as does "a pea to a pumpkin."[73] In *Galveston from the Gulf Shore*, he depicted the low, wood-frame buildings of the village huddled against the bay shore, with the masts of ships at anchor visible behind them (fig. 2.29).[74]

Hooton estimated that Galveston was not half the size of an

FIGURE 2.28 A. M'Callum after Robert James, *Charles Hooton*, 1847. Lithograph, 9 × 5.5 in. (page), by Hulmandel & Walton, London. From Charles Hooton, *St. Louis' Isle*, frontis. Courtesy Amon Carter Museum of American Art, Fort Worth.

English village and illustrated, in *Settlers Houses on the Prairie* (fig. 2.30), that the structures were "of the poorest and most temporary nature." They had been "reared here and there, and anywhere, with no more apparent regularity than is displayed by a crop of mushrooms." *Scene on a Bayou* shows why Audubon, despite his difficulties, found the Texas coast to be the bird-hunter's paradise that we know today (fig. 2.31). "Close behind us, the bayou expanded

GALVESTON, FROM THE GULF SHORE.

SETTLERS HOUSES ON THE PRAIRIE.

FIGURE 2.29 Charles Hooton, *Galveston, from the Gulf Shore*, 1847. Lithograph, 8.2 × 12.9 cm (image), 9.7 × 13.1 cm (comp.), by Hullmandel & Walton. From Hooton, *St. Louis' Isle* (1847), opp. 69. Courtesy Amon Carter Museum of American Art, Fort Worth.

FIGURE 2.30 Charles Hooton, *Settlers Houses on the Prairie*, 1847. Lithograph, 9 × 13.5 cm (image), 9.6 × 13.5 cm (comp.), by Hullmandel & Walton. From Hooton, *St. Louis' Isle* (1847), opp. 9. Courtesy Amon Carter Museum of American Art, Fort Worth.

FIGURE 2.31 Charles Hooton, *Scene on a Bayou*, 1847. Lithograph, 9.3 × 12.1 cm (image), 9.7 × 14.2 cm (comp.), by Hullmandel & Walton. From Hooton, *St. Louis' Isle* (1847), opp. 44. Courtesy Amon Carter Museum of American Art, Fort Worth.

FIGURE 2.32 Charles Hooton, *"General Hospital,"* 1847. Lithograph, 9.5 × 13.1 cm (image), 9.5 × 10.5 cm (comp.), by Hullmandel & Walton. From Hooton, *St. Louis' Isle* (1847), opp. 122. Courtesy Amon Carter Museum of American Art, Fort Worth.

into a large shallow pool about two feet deep," Hooton explained, "one foot of mud and one of water—which, morning and night, and frequently throughout the day itself, unless too much disturbed by the sportsman's gun, was the constant resort of hundreds of wading and fishing birds of all sizes."[75]

William Kennedy, who had served as the first Texas consul in London and British consul in Galveston from 1842 until annexation, had mentioned the presence of a hospital at Galveston and claimed that the island was "probably unsurpassed by any place in the world . . . for general healthfulness." But Hooton disagreed and included a rather sad picture of the *"General Hospital,"* a "long and ordinary weather-boarded and shingled house" a mile or so away from the city, where "it stood alone in the desert, dead, silent, and seemingly aloof from all living and active Christian sympathy [fig. 2.32]."

FIGURE 2.33 Charles Hooton, *The "Fever" Burial-Ground*, 1847. Lithograph, 8.7 × 12 cm (image), 9.8 × 12.4 cm (comp.), by Hullmandel & Walton. From Hooton, *St. Louis' Isle* (1847), opp. 142. Courtesy Amon Carter Museum of American Art, Fort Worth.

The lithograph, he said, "calls vividly to recollection . . . that shell of misery, that great coffin of the unburied dead—seen over the prairie from afar." Nearby he sketched *The "Fever" Burial-Ground*: "The remote and barren resting-place of all who fell by the pestilent yellow-fever" epidemic in 1839, the first that Galveston experienced (fig. 2.33).[76] His fellow countrymen Francis Sheridan, a member of the diplomatic service, and Mrs. Matilda Charlotte (Jesse) Fraser Houstoun, a well-born Englishwoman who visited the Republic of Texas with her husband in the winter of 1842–1843, agreed. Sheridan noted the presence of "several large Turkey Buzzards in close consultation round a grave that had just fallen in," while the normally more cheerful Mrs. Houstoun wrote that she "should not have been aware of its [the cemetery's] proximity, had I not perceived a human skull under my horses feet!"[77]

Hooton quickly realized that he had made a mistake and left Galveston in December 1841 after a residence of only a few months,

traveling by way of New Orleans, New York, and Toronto before returning home. He immediately began to memorialize his Galveston sojourn in a series of articles and, ultimately, in a posthumously published book, *St. Louis' Isle, or Texiana* (1847). He included the five lithographs made from his sketches "to convey to the reader a more perfect *fac-simile* of things . . . in the new Republic, than all the laudatory pens of all preceding writers put together." He had in mind such fulsome descriptions as Reverend Lawrence's book or the likes of Chester Newell's *History of the Revolution in Texas, Particularly of the War of 1835 & '36*; Arthur Ikin's *Texas: It's History, Topography, Agriculture, Commerce, and General Statistics . . .*; and Kennedy's *Texas: The Rise, Progress, and Prospects of the Republic of Texas*. The lithographs, he wrote, provide "a just and accurate idea of the nature of the place in which they were made. . . . [and] are offered simply as visible representations of facts stated in the letter-press."[78]

Although Hooton did not visit Austin, he still felt the need to correct the impression that Lawrence's book and illustration might have left on the reader (see fig. 2.25). He probably had the Hall/Lowe print in front of him when he asked:

> What does the reader think of the capital city of a country consisting of at most some fifty or sixty wooden houses *really* built, and some thousands of stately stone erections of the imagination, forming visionary streets, and adorned with splendid public edifices of marble, dug from undug quarries, and not yet existing in embryo even in the brain of an architect? . . . Yet by this rascally kind of castle-building are poor, anxious, and striving emigrants deluded into a wilderness, to live like wild men mayhap, if they live at all.

Hooton went on to charge that the Texas coastal area up to one hundred miles inland was an unhealthy region and that the capital had been located more than two hundred miles from the disease-ridden coast "*just to ensure the perfect safety of the health of its inhabitants*," but that, unfortunately, placed it well within range of the "hostile Camanche Indians."[79]

Hooton reinforced Texas's reputation as a "refuge for rascality and criminality of all kinds" and wrote of an incident similar to the "pig war" that befell Dubois de Saligny, the French chargé d'affaire in Austin, that led the normally mild-mannered Hooton to purchase a brace of pistols and determine "to have the *first* shot" in any encounter.[80] His main purpose in writing the book seems to have been to keep others from following in his "fatal footsteps." Little did he realize the truthfulness of that remark. He had contracted malaria while in Galveston and died in 1847 from an overdose of morphine while treating himself. The London house of Simmonds and Ward published his book later that year.[81]

About a year after Hooton's departure, on December 18, 1842, Mrs. Houstoun arrived with her husband, Capt. William Houstoun of the Tenth Hussars, aboard the 219-ton, hundred-foot yacht *Dolphin* with a crew of fourteen and a physician and fitted for as many as eight Paixhans guns for defense. She was the daughter of Edward Jesse, a writer on natural history and the deputy surveyor-general of the royal parks and palaces, and his wife, Matilda (fig. 2.34).

FIGURE 2.34 Unknown artist, *Mrs. Houstoun*, 1891. From Helen C. Black, *Notable Women Authors of the Day* (1906), opp. 223. Courtesy University of California Libraries. "She is *grande dame* to the tips of her fingers."

William Houstoun was her second husband and the second son of Gen. Sir William Houstoun, who had served as governor of Gibraltar.[82] Mrs. Houstoun claimed that they were traveling primarily in the hopes that the journey would restore her health, and Captain Houstoun told a reporter that he intended to hunt buffaloes, "gaz[e] upon the green bosomed prairies that spread themselves like oceans over the mighty West"—and possibly purchase some land to open a large beef-packing plant. But the luxurious yacht and its firepower, its crew, and their stated reasons for the trip all raised questions as to their intentions. Events that occurred simultaneously with their visit, along with circumstantial evidence, raise the possibility that they were engaged in a larger endeavor that at the time completely overshadowed the fact that this trip produced two lithographs that became virtually synonymous with the Republic of Texas.

While Great Britain and the United States were at peace during these years, there were still areas of tension—especially British opposition to American expansion. An independent Texas under British influence would have been a significant accomplishment for the foreign office and was the goal of the newly appointed British chargé d'affaires to Texas, Charles Elliot. Britain had finally abolished slavery throughout the empire in 1838, and circumstantial evidence suggests that the Houstouns, who were family friends and supporters of William Wilberforce, the British parliamentary leader of the antislavery crusade, might also have favored its abolition in Texas.[83] Dr. Moore, editor of the *Telegraph and Texas Register*, might have had the Houstouns as well as Elliot in mind when he wrote in March, while they were still at Galveston, that "British agents . . . have made propositions to the effect, that the British government will take Texas under its protection, and compel Mexico to acknowledge its independence immediately, provided the citizens of Texas will sell all their slaves to the English subjects, and *abolish* slavery forever in the Republic!" Dr. Moore noted that "this subject has been agitated at Galveston" and copied and commended an article from the short-lived Galveston *Texas Times* that "has treated it with merited reprobation."[84]

Was Captain Houstoun on a mission to find out if Texians would accept compensation for manumission of their slaves? The time seemed right for such a proposal. The republic's very existence was threatened: the price of cotton was low, and planters faced hard times. Mexican armies had twice invaded Texas and captured San Antonio in 1842, the men of the Mier expedition were in prison in Mexico, a Mexican army was rumored to be at Corpus Christi, and Galveston was on the alert for an invasion attempt by sea.[85] Perhaps encouraged by the captain's presence, the well-known Houston attorney and abolitionist Stephen Pearl Andrews suggested just such a plan at a public meeting in Houston in the spring and tried to convene a meeting in Galveston in March, but, according to Britisher William Bollaert, himself in Texas to report for the British Admiralty, "the glorious sovereign mob politely put Mr. Andrews into a boat and sent him across the bay to find his way to Houston."[86]

The Houstouns spent about three months in Texas, aside from a few days spent sailing back and forth to New Orleans. They would have visited Washington-on-the-Brazos (Houston had moved the capital there during his second term as president) had not rainy weather and boggy dirt roads prevented it, and had they not feared another Mexican invasion similar to the one that had recently captured San Antonio.[87] They departed on March 31, 1843.

With talk of annexation on every lip and Mexican invasion a real possibility, and with the United States, Britain, and France carefully watching events, John Murray of London published Mrs. Houstoun's hastily written account as *Texas and the Gulf of Mexico; or Yachting in the New World* in two small, handsome volumes in 1844. The well-known London firm of Day and Haghe, who also printed the lithographs for American artist George Catlin's *North American Indian Portfolio* that year, lithographed the images for the book, which included the second published view of Galveston (fig. 2.35), the first published view that purported to be of Houston (fig. 2.36), and portraits of Mexican president Santa Anna (fig. 2.37) and Texas president Sam Houston (fig. 2.38), among the ten illustrations in the well-publicized work.[88]

The book produced a mild sensation, with the *Times* of London and the *Spectator* among the several journals excerpting it. The *Literary Examiner* judged that "Mrs. Houstoun reports more favourably of Texas and the Texans than any impartial witness that has yet spoken of them," which the reviewer admitted "give[s] us a cold shudder." The *Morning Post* saw the book as "altogether an amusing and somewhat eccentric production" on the "inhabitants of this mock and mongrel republic."[89] In the United States both the *Living Age* and *Smith's Weekly Volume for Town & Country* were among the journals that serialized it the following year, and G. B. Zeiber & Co. of Philadelphia published two pirated editions (containing only a lithographic portrait of Santa Anna). It was Mrs. Houstoun's first book and set her on a minor literary career.[90]

The sources of the Santa Anna and Houston portraits are

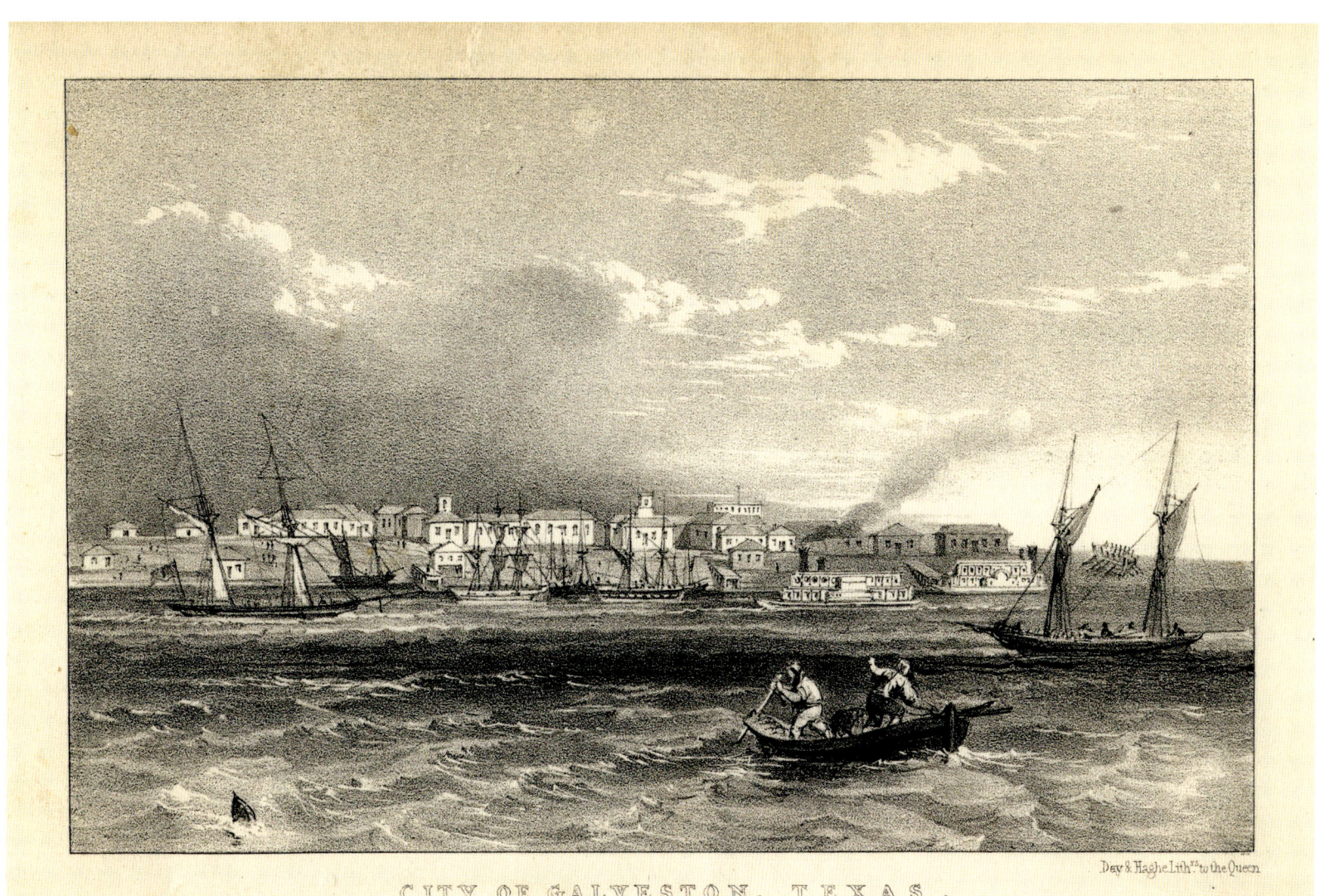

FIGURE 2.35 Unknown artist, *City of Galveston, Texas*, 1844. Lithograph, 9.3 × 14.9 cm (image), 10.3 × 14.9 cm (comp.), by Day and Haghe. From Matilda Charlotte (Jesse) Fraser Houstoun, *Texas and the Gulf of Mexico* (1844), vol. 1, frontis. Courtesy private collection.

unknown, but there are intriguing possibilities. In 1837 the young portrait painter Thomas Jefferson Wright of Kentucky arrived in Houston and announced his services to the public. He quickly became friends with Sam Houston and painted Houston's portrait more than once, perhaps including one that Houston later referenced as being in "military green dress" and called "the best likeness ever taken of me."[91] It was apparently painted soon after Wright arrived in the city as a part of his effort to paint a "gallery of National Portraits" of Texas, perhaps inspired by Charles Willson Peale's gallery of American revolutionary heroes in Philadelphia. Houston left it temporarily with his future father-in-law because his "Palace" was not yet finished.[92] This might have been the source of the portrait published in 1837 in John M. Niles's *History of South America and Mexico*, which Mrs. Houstoun's lithographer then copied.[93] Santa

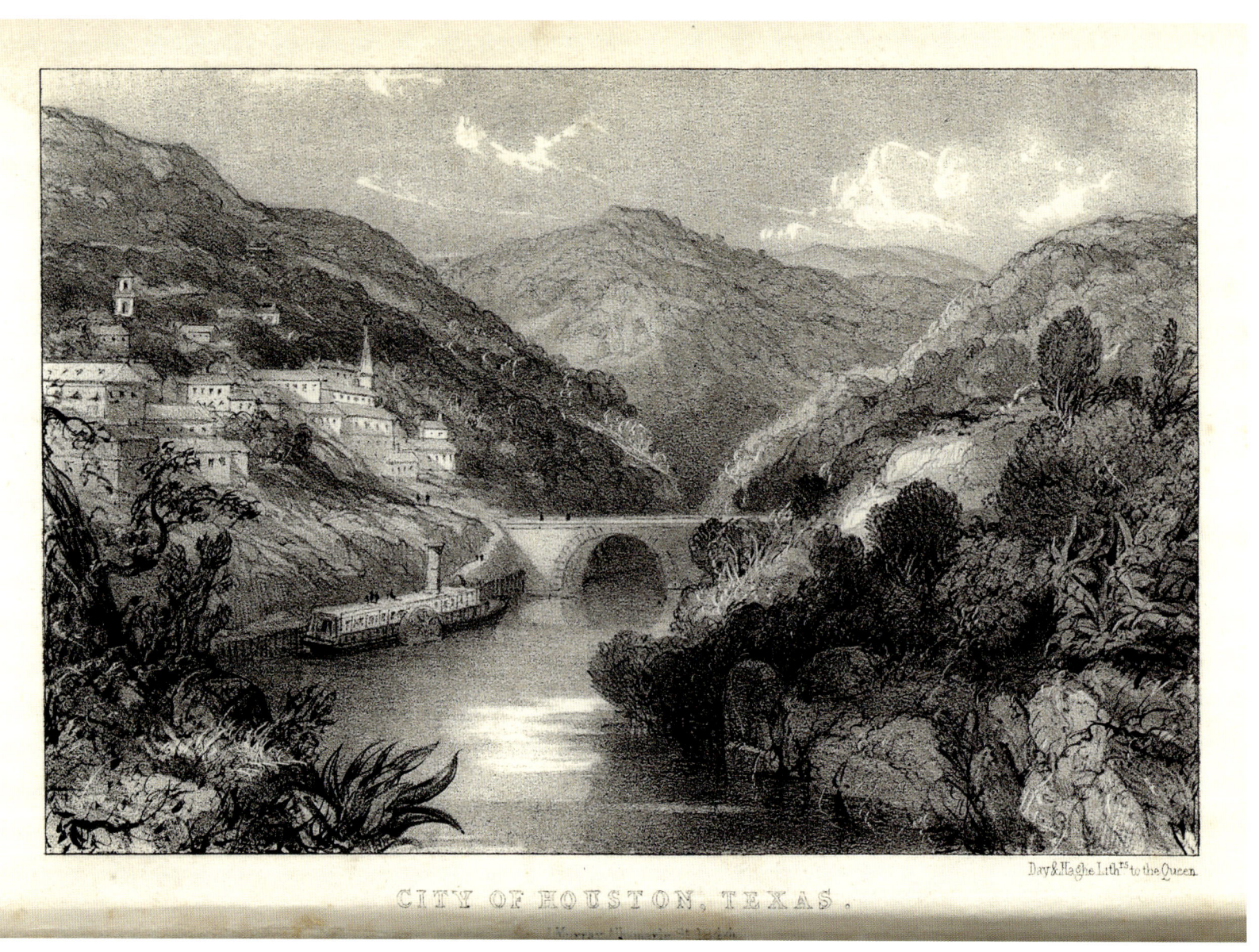

FIGURE 2.36 Unknown artist, *City of Houston, Texas*, 1844. Lithograph, 9.3 × 15 cm (image), 10.2 × 15 cm (comp.), by Day and Haghe. From Houstoun, *Texas and the Gulf of Mexico*, vol. 2, frontis. Courtesy Amon Carter Museum of American Art, Fort Worth.

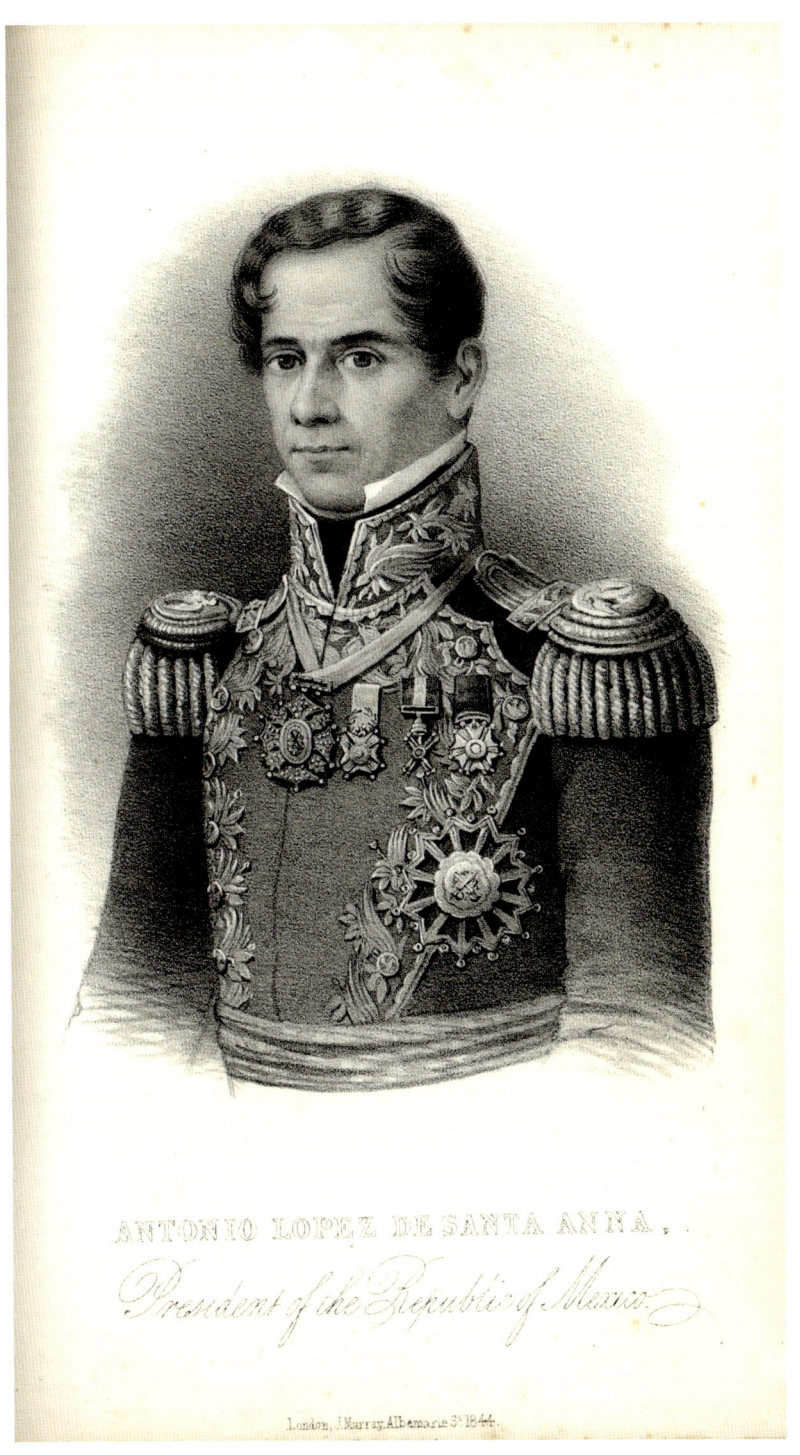

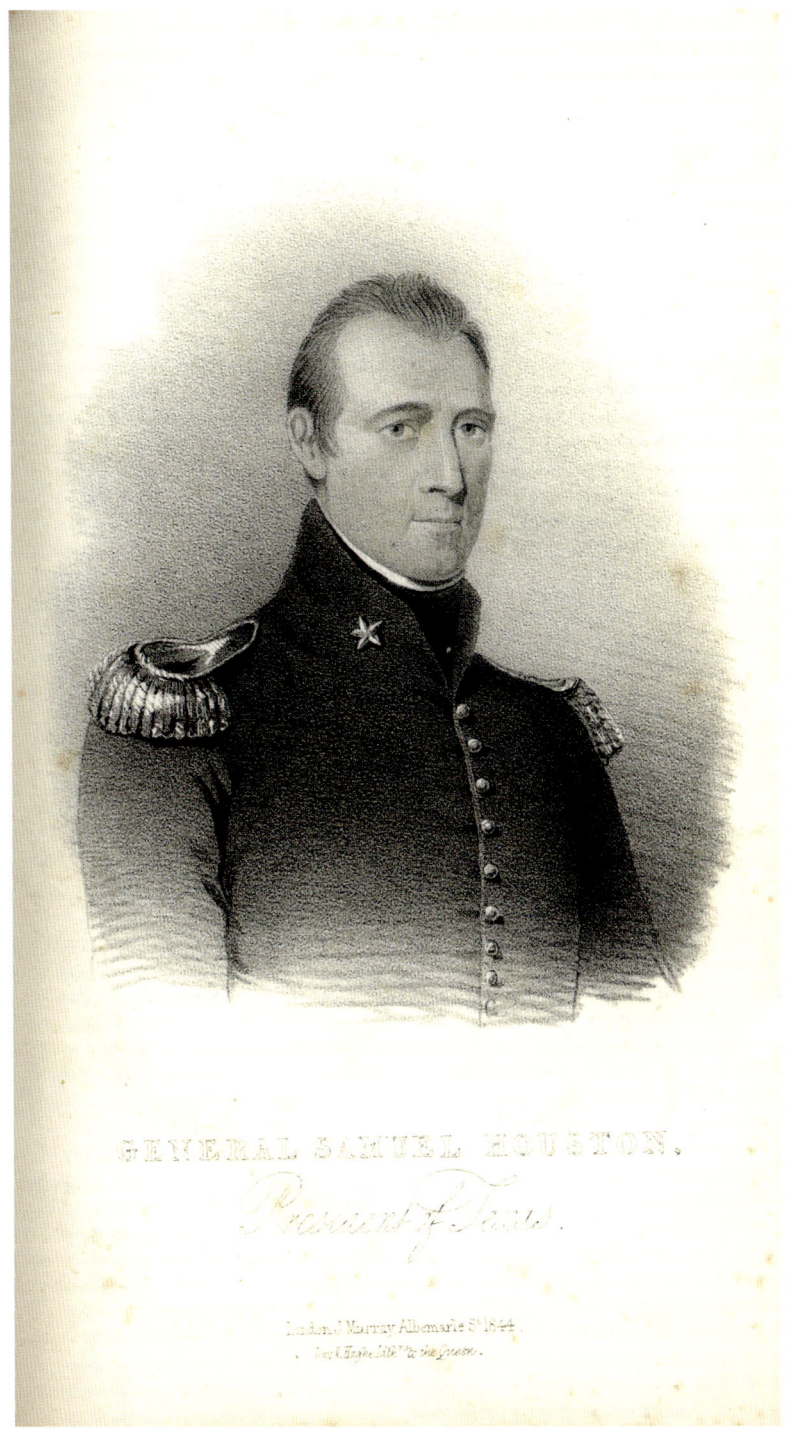

FIGURE 2.37 Unknown artist, *Antonio Lopez de Santa Anna, President of the Republic of Mexico*, 1844. Lithograph, 12.5 × 9.7 cm (image), 17.1 (trimmed) × 9.7 cm (comp.), by Day and Haghe. From Houstoun, *Texas and the Gulf of Mexico*, vol. 1, opp. 244. Courtesy Amon Carter Museum of American Art, Fort Worth.

FIGURE 2.38 Unknown artist, *General Samuel Houston, President of Texas*, 1844. Lithograph, 11.2 × 9.4 cm (image), 15.5 × 9.4 cm (comp.), by Day and Haghe. From Houstoun, *Texas and the Gulf of Mexico*, vol. 2, opp. 166. Courtesy Amon Carter Museum of American Art, Fort Worth.

"A MORE PERFECT *FAC-SIMILE* OF THINGS"

FIGURE 2.39 Robert S. M. Bouchette, *City of Quebec. Taken from the Harbor*, 1831. Hand-colored lithograph [modern color?], approx. 14.5 × 21.5 cm, by Day and Haghe, Lith' to the King. From Joseph Bouchette, *The British Dominions in North America*, vol. 1, opp. 241. Courtesy Toronto Public Library.

Anna's portrait could have been copied from the Maurín portrait published in France and distributed in Mexico or the daguerreotype (see figs. 1.26 and 1.27).

It is possible that Mrs. Houstoun sketched the views of Galveston and Houston that are the frontispieces of her two volumes, for many Victorians dabbled in drawing. But she does not mention sketching in the text, and none of her many other books are illustrated. Or the publisher might have commissioned Day and Haghe to supply the unattributed images based on the author's sketches or descriptions. The reviewers did not comment on the pictures, perhaps because they did not take them seriously, but the images would, in fact, become virtual symbols of the republic.

City of Galveston, Texas (fig. 2.35) shows the village from the bay side with two fishermen and a dog in a rowboat in the center-right foreground, steamboats and sailing ships in the middle distance, and the harbor and city in the background. "The city . . . gives one, on a first view, no very high idea of its importance," Mrs. Houstoun dryly commented. It "contains about three hundred covered buildings, which a bold person would, or might call houses." Anticipating Hooton, but in a polite manner, she continued, "The whole affair has . . . at present rather a fragile appearance, and it will readily be conjectured, that when viewed from the water, any grandeur of effect must be quite out of the question."[94]

This credible view of Galveston, no doubt, benefitted from the Houstouns' long stay in the harbor, but it also might have profited from a picture of the city of Quebec, which bears a striking resemblance to the composition of the Galveston view and which Day and Haghe had in their inventory, having published it a few years before (fig. 2.39). The two prints are similar enough to entertain the possibility that the unnamed lithographic artist might have combined Mrs. Houstoun's description of Galveston with elements from Robert S. M. Bouchette's view of Quebec to produce the final picture of Galveston.[95]

The view of Houston (fig. 2.36), by comparison, seems completely fictitious but might also have been informed, as historian Marilyn McAdams Sibley suggests, by Mrs. Houstoun's description or by some as-yet-undiscovered Day and Haghe print.[96] Mrs. Houstoun got her first look at the city on a bright winter morning after steaming up Buffalo Bayou. As they approached the landing, she noted the "high banks" as the stream narrowed and later commented that Houston "is built on high land, and the banks, which are covered with evergreens, rise abruptly from the river." And, "on leaving Houston, we ascended a hill so steep, as to seem almost impossible for a carriage, however light, to be drawn up it." The lithograph depicts a lush foreground; high, steep banks, particularly in relation to the sleek, double-deck paddle wheeler docked on the south side of what is supposed to be Buffalo Bayou; substantial stone structures on an alpine mountainside; an arched stone bridge across the bayou; and mountains in the distance—clearly not a picture of Houston. But if the lithographer took his cue from her comments, he missed other significant ones. Of the city itself, she wrote, "There is but one brick house in it." And of an excursion out of the city, she observed that "as far as I could see, and I was told it was the same for miles, the horizon was only bounded by the flat, and pathless prairie."[97] Since the Houstouns departed Galveston for Houston on March 31, it is not known whether they would have seen the new Buffalo Bayou bridge built that year (but swept away by a flood in October).[98]

Nevertheless, these small pictures became the most reproduced images of the Texas republic, with outright copies or adaptations of them showing up in several different publications. Perhaps the *Illustrated London News*, January 4, 1845, was the first to copy them, replacing the men in the rowboat in the right-center of the Galveston image with a double-deck paddle wheeler (fig. 2.40, center).[99] In the Houston view the paddle wheeler has been turned into a sailboat, the detailed landscape on both the right- and left-hand sides of the print have been removed, and, somehow, the moon shines brightly through the shadowy form of the mountain at the right-center (bottom). The Houston image was quickly copied in an unidentified German publication (fig. 2.41), which removed the mountain that seemingly obstructed the view of the moon; then, in New York's *Illustrated Sun* (fig. 2.42).[100] Versions of both the Galveston and Houston images appeared in *La Revista Científica y Literaria de México* (figs. 2.43 and 2.44).[101] The Houston lithograph popped up in Robert Sears's *A New and Popular Pictorial Description of the United States . . .* (1848) and in *Gleason's Pictorial Drawing Room Companion* (Boston, 1852).[102] As late as 1859, versions of the Houston view were still in circulation, including *L'Illustration, Journal Universel* (Paris, 1859) (fig. 2.45), the *Illustrated News of the World* (London, 1859), as well as yet another unidentified German publication.[103] The illustrations that originated in Mrs. Houstoun's book were surely the best-known images of Texas in both the United States and Europe prior to the Civil War, and it is fascinating to watch their evolution from one copyist to the next as a double-decker paddle wheeler is added to the Galveston picture and a covered bridge to the Houston view.

FIGURE 2.40 Artist unknown, *Review of "Texan" Troops* (top), *Port of Galveston* (center), and *City of Houston—The Capital of Texas* (bottom), 1845. Wood engravings, 8.5 × 22.3 cm, and 15.1 × 21.9 cm. *Illustrated London News*, Jan. 4, 1845, 4.

Houston, Hauptstadt von Texas.

FIGURE 2.41 Unknown artist, *Houston, Hauptstadt von Texas* [Houston, Capital of Texas], c. 1845. Single sheet. Lithograph, 3.75 × 6 in. (image). Published by Bibliographisches Institut: Brockhaus. Courtesy Museum of Fine Arts, Houston, Bayou Bend Collection, gift of Miss Ima Hogg.

FIGURE 2.42 Artist unknown, *View of the City of Houston*, c. 1845. Engraving, 15.5 × 17.5 cm. From the *New York Illustrated Sun*, exact date unknown. Courtesy Houston Public Library.

View of the City of Houston.

FIGURE 2.43 Hesiquio Iriarte y Zuñiga [attrib.], *Galveston (Tejas)*, 1846. Lithograph, 5.12 × 7 in. (comp.), by Hipólito Salazar. From *Revista Científica y Literaria de México* (1845, serially printed), opp. 144. Courtesy private collection.

(ABOVE) FIGURE 2.44 Hesiquio Iriarte y Zuñiga, *Houston (Capital de Tejas)*, 1846. Lithograph, 5.87 × 7.25 in. (comp.), by Hipólito Salazar. From *Revista Científica y Literaria de México* (1845), opp. 170. Courtesy private collection.

(RIGHT) FIGURE 2.45 E. Therond after L. Regnier, *Vue de la Ville de Houston (Texas, Etats-Unis)*, 1859. Wood engraving, 9 × 12.75 in. From *L'Illustration, Journal Universel* 33 (Jan. 8, 1859), 28. Museum of Fine Arts, Houston, Bayou Bend Collection, gift of Miss Ima Hogg. This image is identical to *The Galveston, Houston, and Henderson Railway (Texas)*, which appeared in *Illustrated News of the World* in February 1859.

"AS FAR FROM TEXAS AS POSSIBLE"[104]

As the variations of the Houston and Galveston views were being reproduced in various publications, *empresario* Henri Castro published Theodore Gentilz's much more accurate view of the frontier village of Castroville as part of an effort to encourage would-be settlers to immigrate to his colony on the Medina River.[105] A former member of the Napoleonic guard with a varied financial background, Castro was a fifty-five-year-old Frenchman who came to Texas in 1842 to look for investment opportunities, and he arrived just in time to successfully apply for a grant himself under the republic's new colonization law. He received two tracts: one west of San Antonio, designed to protect the frontier against Indian raids, and the other along the Rio Grande near Camargo, to guard against a potential Mexican invasion. His contract required that he have one-third of the total number of six hundred families on the land by the end of the first year, so he quickly returned to Europe on a recruiting trip. He added to his grant by purchasing an additional sixteen leagues of land that included access to the Medina River, where he wanted to establish his colony.[106]

News of the Mexican invasion and capture of San Antonio had spread throughout Europe during that summer, hampering his progress, but Castro was successful in convincing a number of French and German settlers to join him in Texas. In September 1844 he led a small band of hopeful but exhausted immigrants to a parklike setting covered with pecan trees along the clear waters of the Medina River about twenty-five miles west of San Antonio. There they established Castroville. Among the colonists was twenty-five-year-old Jean Louis Théodore Gentilz, a French draftsman, painter, and engineer, whom Castro had employed as surveyor, artist, and promotion agent for the colony (fig. 2.46).[107]

Castro published a small booklet, *Le Texas en 1845*, to help him with recruiting during a second trip to Europe in May 1845, only to find that he had to defend himself against several legal charges before he could proceed with his recruiting. Several of the would-be colonists claimed that he had taken money from them but that no land was available because the grant was too exposed on the frontier.[108] *Le Texas*, which contains an account of the establishment of Castroville, a narrative of the troubles Castro had suffered in getting the settlers to the colony, a spirited defense of his conduct, and, folded into the back, Gentilz's view of a string of cabins close by the Medina River, turned out to be part of his successful defense against these suits (fig. 2.47).[109]

The print, made from a Gentilz drawing, is a sweeping Hill Country landscape that shows the settlers' houses strung along the river. The church had been dedicated and the cornerstone laid, but it was not completed at the time the drawing was made, although Gentilz included a small structure with a cross on top in the center. The small, tidy houses, some with fences around them and smoke curling from the chimneys, stretch along the west bank of the Medina River. Gentilz's vantage point is from what he called Mount Gentilz in the print's title, with what may be common grazing grounds reaching down the slope toward the village. When Frederick Law Olmsted visited in 1854, he described the village as being "as far from Texas as possible," wholly un-Texan and comparable to "one of the poorer villages of the upper Rhine valley."[110]

At the same time Castro was recruiting colonists in France, Prince Carl of Solms-Braunfels became the first commissioner-general of

FIGURE 2.46 Jean Louis Théodore Gentilz, *Self-Portrait*, 1864. Watercolor on cream paper, 7 × 5 in. Courtesy Witte Museum, San Antonio.

FIGURE 2.47 Theodore Gentilz, [attrib.], *Vue de Castroville et de ses environs prise du Mont Gentilz*, c. 1845. Lithograph, 16.5 × 37.1 cm (image), 22.2 × 39.1 cm (comp.), by Bertauts r St. Marc, 14 [Paris]. From Henri Castro, *Le Texas en 1845*. Courtesy Briscoe Center for American History, UT Austin.

FIGURE 2.48 J. Kobig after Ferdinand-Karl Klimsch (1812–1890), *Verein zum Schutze deutscher Einwanderer in Texas*, 1844. Folder cover. Lithograph, 24.4 × 19.6 cm, by the Dondorf Establishment, Frankfurt a/M. Courtesy Beinecke Rare Book and Manuscript Library, Yale University.

the Adelsverein, or Verein zum Schutze deutscher Einwanderer in Texas (Society for the Protection of German Immigrants in Texas), and arrived in Texas in July 1844 to help implement the philanthropic and commercial goals of the company: to provide economic relief for poor people who were willing to immigrate and to establish a demand for German goods abroad. The company acquired the contract that Henry F. Fisher and Burchard Miller had received from the republic, and the prince purchased additional land around the site of what is today New Braunfels. German colonists were soon building their homes along the picturesque Comal River.[111]

The society produced a huge number of materials to publicize its venture, including a lithographic illustration for the cover of its stock certificates, which contains several fanciful and idealized scenes of what the industrious immigrant's life in Texas might be like (fig. 2.48). J. Kobig drew the image on the stone after Ferdinand-Karl Klimsch's design, and the Dondorf Establishment in Frankfurt printed it. The image includes rather generic scenes of a priest preaching to Indians and of colonists arriving in a new land, digging the ground, chopping wood and trimming the logs, hunting, fishing, and strolling leisurely in a picturesque setting, all placed in an intricate design of trees, plants, shrubs, leaves, various crops of pumpkins and watermelons, and implements of work and war (or defense). This particular certificate was number seventeen, issued July 1, 1846.

A second society document, a stock certificate printed by an unnamed lithographer, includes various metaphorical scenes: welcoming figures of Indians in a wilderness (one of whom, on the left, exhibits a map and points to it), ships (suggesting overseas travel), a prosperous looking farm scene (bottom), and a family relaxing in a natural setting (top) (fig. 2.49). In the center of the print is what appears to be the seal of Texas, "the Single Star of Texas."

FIGURE 2.49 Unknown artist, *Verein zum Schütze deutscher Auswanderer nach Texas*, c. 1844. Single sheet. Lithograph, 14.7 × 28.5 cm. Courtesy Beinecke Rare Book and Manuscript Library, Yale University.

This certificate, made out to Count August von Leiningen, is dated March 25, 1844.

Olmsted also visited the German villages, which he found to be even more inviting than Castroville. Of his hotel in New Braunfels, he wrote, "I never in my life, except, perhaps in awakening from a dream, met with such a sudden and complete transfer of associations. . . . In short, we were in Germany. . . . A long room, extend[ed] across the whole front of the cottage, the walls pink, with stenciled panels, and scroll ornaments in crimson, and with neatly-framed and glazed pretty lithographic prints hanging on all sides."[112]

"EXPRESSLY FOR THE TEXAS TRADE"[113]

Handsome ship portraits were among the most popular images of the day and constituted another type of immigrant advertising. Ship portraits originated in Europe around the Mediterranean ports, as practiced by the French artist Antoine Roux and his three sons, who kept their studio active for decades by providing souvenir images to ship owners, masters, crew, and passengers.[114] An employee of the lithographic house of Endicott & Co. in New York, one of the largest producers of ship portraits, recalled the delight with which William H. Webb, the country's most prolific shipbuilder, examined a print of one of his ships, then summoned his rigger to scrutinize the rigging and the sail maker to examine the sails. The shipping companies often ordered and distributed lithographic copies for advertising purposes, including images of a number of ships that called at Galveston.[115] Connecticut-born Charles Morgan, who invested in merchant shipping, ironworks, and several sailing and steam packet lines, subscribed to the practice by commissioning a portrait of the *Columbia*, the ship that he used to initiate service between New Orleans and Galveston in 1837.[116] The *Columbia* was a sidewheeler with a single, tall smokestack. An artist named Haswell sketched the ship's portrait, which the young lithographic artist John H. Bufford drew on the stone (fig. 2.50). Morgan probably would have used Mary Austin Holley's review of his ship's service had he known about it. Mrs. Holley was a passenger on the *Columbia* in 1837, calling it "the most perfect boat . . . the best I have ever seen." She wrote that she slept on "the finest and whitest linen," enjoyed the services of "a lady-like chamber maid," dined with "silver forks, or what looks like silver," and "ivory knives" on meals prepared by a "French cook" and served by "White waiters" at the captain's table.[117] The *Columbia* made its first trip from New Orleans to Galveston in three days, arriving on November 28.[118]

While most newcomers to Texas arrived overland, a significant number came by ship as independence brought more communication with the outside world and a significant increase in shipping and immigration. Entrepreneur Henry Austin's loss of the *Ariel* (in an attempt to open the Texas rivers to steamboat traffic in 1830) dampened the enthusiasm of some who might have otherwise invested, but New Orleans businessmen had watched the Texas Revolution closely and followed Morgan into the Texas market.[119] Vessels began to call on ports all along the Texas coast, and Galveston quickly became the gateway. Small paddle wheelers regularly chugged up Buffalo Bayou to the growing town of Houston, where editor Moore of the *Telegraph and Texas Register* reported that "crowds of enterprising emigrants are arriving on every vessel."[120] By March 1838 the *Columbia* had ferried an estimated seven hundred passengers to Texas.[121] Editor Hamilton Stuart of the *Civilian and Galveston Gazette* observed in 1839 that "the number of vessels in our harbor averages from twenty-five to thirty, exclusive of steam ships and steamboats."[122]

With the New Orleans press calling for more transport for the growing Texas trade, Morgan's former associate James Reed and Capt. James Pennoyer partnered on the larger and faster *Neptune*, "a boat of the first class . . . bought expressly for the Texas trade" in 1839 (fig. 2.51). Like the *Columbia*, the *Neptune* was a sidewheeler but boasted double smokestacks. The Texas Emigrant Office in New Orleans offered all "young men of good character and sober habits" free passage to Texas on the *Neptune*, and in January 1840, the New Orleans agent announced that he would accept Texas money for passage at fifty cents on the dollar.[123] New York lithographer H. R. Robinson, who also published many lithographic ship portraits, worked with two experienced artists to produce a print of the *Neptune* for the ship's owners, including James Hamilton Jr., the former governor of South Carolina. Jurgan Frederick Huge provided a watercolor portrait of the vessel, which the versatile Edward W. Clay copied on the stone.[124]

By 1840 Morgan had made his presence felt in the Texas trade. He had moved from part ownership of the *Columbia* to being the dominant commercial shipper along the Texas coast. In 1857 Dunn & Bradstreet, the credit agency, reported that he was "coining money" in the Texas trade, "one of the most profitable lines in the US & prob[ably]. in the world."[125]

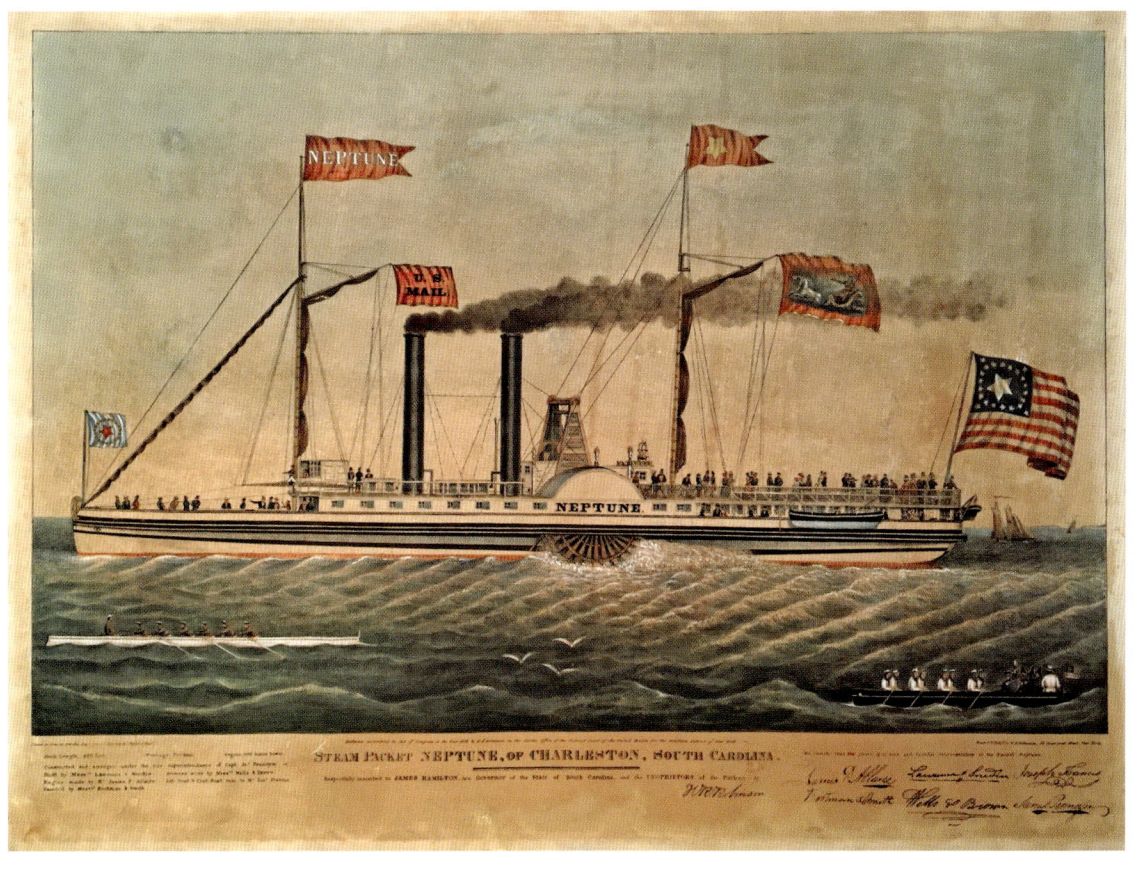

FIGURE 2.50 J. H. Bufford after Haswell, *Steam Packet Columbia*, n.d. Photograph of a single-sheet lithograph (original print unlocated) by Endicott & Co., New York. Courtesy Mariners' Museum, Newport News, Virginia.

FIGURE 2.51 E. W. Clay after Jurgan Frederick Huge, *Steam Packet Neptune, of Charleston, South Carolina*, 1838. Hand-colored lithograph, 65 × 90 cm, by H. R. Robinson. Courtesy Peter Walker Fine Art, Walkerville, South Australia. Signed by, among others, H. R. Robinson.

A MARTIAL IMAGE OF TEXAS

New York and Philadelphia publishers had issued several pieces of Texas-themed sheet music, such as the "Texian Grand March," "Texian Gallopade," "The Flag of Texas," and Mrs. Holley's "The Texan Song of Liberty" and "Brazos Boat Glee" (1838), to take advantage of the fact that the republic was in the news following the revolution. Boston, New York, and Philadelphia publishers picked up the Texas theme again in 1841 with three more illustrated pieces of sheet music for the quickstep, a march step in quick time, such as a fast-paced military march or a spirited dance step. Two pieces were published in 1841, one of them honoring the newly elected vice president of the republic, Edward Burleson (fig. 2.52), and the other celebrating the army. Burleson, a landowner in Austin's second colony, was elected colonel during the revolution and served in both the House and the Senate; he also laid out the town of Waterloo (Austin) in 1838. In 1841 he was elected vice president, and in October his supporters organized a public dinner and ball to celebrate his victory. Perhaps that was the occasion of the publication of "The Texian Quick Step," lithographed by Thayer & Co. in Boston and authored and published by Francis Prentiss, who dedicated it to Burleson. The lithographed scene on the cover shows a bareheaded soldier who might be taken for the frontiersman Burleson in a mounted skirmish firing two pistols at a helmeted soldier with sword drawn, no doubt the unnamed artist's concept of a Mexican cavalryman.[126]

The second 1841 song sheet, with an image by H. Wade, lithographed by Endicott in New York, was probably based on the popular images of local militia companies, such as the "Salem Mechanick Light Infantry Quick Step" and "The New York Light Guards Quick Step." It shows a group of soldiers on parade, apparently marching "TO TEXAS," as a sign in the image indicates. There were several reasons why a military-oriented person might have gone to Texas in 1841. Mexico had not yet accepted Texas independence, and both sides continued to raid across the Rio Grande. Meanwhile, Lamar's disastrous Santa Fe expedition had straggled into Mexican territory and captivity that year in an ill-planned attempt either to take over the territory of what is now New Mexico and Arizona or, at least, to gain a portion of the lucrative Santa Fe trade for the Texas market. Another sheet with the same title carries the illustration of a billowing flag consisting of thirteen horizontal stripes and a single star on a square background in the upper corner nearest the flagpole; the design is similar to the flags in the plan of Fort Defiance (see figs. 1.21, 1.22), but one that Texas apparently never officially employed on one of its flags.[127] The music publishers advertised their publications widely.[128]

As land speculators and colonists rushed in, visual images of Texas—from eyewitness accounts and the imaginations of lithographers and printers who had never seen Galveston, Houston, Castroville, or Austin—helped satisfy public curiosity and supplemented the regular stories of Texas in newspapers, journals, and emigrant guides. Audubon's authentic depictions of birds and animals, as well as maps and portraits of famous persons and ships that connected the faltering republic to the world, fed the world's appetite for information about the new republic. Separately issued satirical prints and idealized illustrations of the German Verein reached niche audiences. Together these prints provided a glimpse of a vast territory populated by a few villages, wild animals, Indians, and a few civilizing influences, such as steamboat connections with New Orleans and New York.

But it is no surprise that John Warren J. Niles failed in his attempt to establish a lithographic press in the sparsely populated republic, only eighteen years after the process was introduced into the United States. American lithographic technology, after all, was still in its infancy, lagging ten to fifteen years behind Europe, and the modest demand for pictures of Texas seemed to come from the East Coast, Great Britain, and Europe rather than Texians themselves. Any pictorial publishing venture that required trained craftsmen, expensive equipment, and an urban clientele was doomed in early Texas, and it would be another decade and a half before the next effort.

FIGURE 2.52 Unknown artist, "The Texian Quick Step, Respectfully Dedicated to Gen. Edward Burleson," 1841. Sheet music. Lithograph, 36 cm (high), by Thayer & Coy Lith., Boston. Published by Henry Prentiss, 33 Court St., Boston. Courtesy Prints, Drawings and Watercolors from the Anne S. K. Brown Military Collection, Brown Digital Repository, Brown University Library.

"A MORE PERFECT *FAC-SIMILE* OF THINGS"

FIGURE 3.1 H. Bucholzer, *Matty Meeting the Texas Question*, 1844. Single sheet bound in book. Hand-colored lithograph, 29.9 × 44.5 cm (image), by James S. Baillie, No. 33 Spruce St., New York. Courtesy Briscoe Center for American History, UT Austin.

CHAPTER 3

"ILLUSTRATIONS OF A CHEAP CHARACTER"

ANNEXATION AND WAR WITH MEXICO

Interest in Texas grew substantially during the 1840s. The presidential election of 1844, the annexation of Texas as the twenty-eighth state, and the subsequent war with Mexico inspired dozens of illustrations in a lithographic industry that by then had honed its production and distribution capabilities and invigorated journalists and artists who had inherited their satirical acumen from their eighteenth-century English ancestors. Supported by a growing consumer base in burgeoning East Coast cities, clever artists revived the sly and rude Anglo pictorial tradition, which began to rival the acidic, partisan commentary of the newspapers.[1] With poison pens and crayons at the ready, James S. Baillie, Henry R. Robinson, Edward Williams Clay, H. Bucholzer, Nathaniel Currier, and other entrepreneurs of the lithographic trade in New York, Boston, Philadelphia, and several other eastern cities reached a pictorial crescendo as the election of 1844 approached, issuing more than eighty different single-sheet political caricatures and cartoons—far more than any other year and at a pace that did not slow when the United States declared war on Mexico in 1846.[2] These years were the heyday of separately issued cartoons, caricatures, and battle prints as changes in the industry had again affected the medium by which information reached the public. Single-sheet lithographs became popular because pictures of current events could be rapidly produced and distributed. Sometimes the artists included a paragraph of information with the image, but most often they provided only a sentence or two of text. These prints kept slavery and the annexation of Texas graphically before the public throughout the 1840s.

Typical was Bucholzer's characterization of the race for the Democratic nomination for president in 1844 in *Matty Meeting the Texas Question* (fig. 3.1). Former president Martin Van Buren was the favorite to claim the Democratic Party's nomination that year, but he vacillated on the issue of Texas statehood, which Bucholzer savagely caricatured as a particularly wild and brutal female with slave shackles and two whips in her left hand, a bloody knife in the other, and two pistols in her sash. She is borne aloft by two of the main protagonists in the conflict: the expansionist-minded senator Thomas Hart Benton on the left and Whig presidential candidate Henry Clay on the right, who disagreed on the Texas issue but wanted to force Van Buren to declare himself. Bucholzer shows former president Andrew Jackson, Van Buren's mentor, who favored Texas annexation, prodding the "Little Magician" with his cane to "stand up to your lick log,

Matty." Van Buren understandably shies away from the crone, but, at the right, James K. Polk, the dark horse candidate who would ultimately claim the nomination and the presidency, turns to his running mate, George M. Dallas, and says, "What say you Dallas? She's not the handsomest Lady I ever saw, but that [presidential salary of] $25,000 a year—Eh! It's worth a little stretching of Conscience!"[3]

The publishers marketed the images, usually printed only in black ink but sometimes hand-colored, to a public already accustomed to the hyperbolic details of political squabbles through the factional newspapers of the day. Words were also important to understanding the images, for the spirit of the satire was usually contained in a pun or an incongruous or ridiculous nickname or predicament, as with the genre paintings of the day, rather than in the sometimes stiff, caricaturish drawings. Athletic events or other sporting motifs provided the tried and trite but continually serviceable themes for political contests: a horse race, a foot race, a boxing match, a cock fight. The characters portrayed were usually well known and recognizably drawn, perhaps based on popular portraits, sitting on a throne, standing stiffly, or taking a grotesque spill. Henry R. Robinson of New York was one of the best known of the publishers, and the *New York American* declared his caricature of *The Great American Steeple Chase for 1844* to be the beginning of the campaign. At a time when good lithographers might print three hundred impressions a day, the publishers sometimes issued thousands of copies, often selling them to political parties at bulk rates for distribution as campaign literature. Those left over would be distributed through bookstores and corner stores and by peddlers who picked them up each day, left a deposit, walked the streets or set up small stands to hawk them to the public, then returned the unsold prints at the end of the day, paid for those they had sold, and reclaimed the day's deposit.[4] The wholesale price of the prints was probably about six cents each, and the peddlers got whatever they could for them, anywhere from fifteen to twenty-five cents each (over $6.62 today based on the Consumer Price Index). Compared to later standards, this was limited distribution, but lithographers Baillie and Robinson, working with artists such as Edward Williams Clay and H. Bucholzer, managed to sell hundreds if not thousands of such prints during these years.[5]

The Texas story made the republic an obvious target of pictorial satire. Texas had been in the news ever since the failed Champ d'Asile settlement and especially after Stephen F. Austin established his colony in 1821. Virtually all American and many European newspapers reported on the successful revolution in 1836, a significant number of them agreeing with abolitionists William Lloyd Garrison and Benjamin Lundy, who tirelessly characterized the Texas revolt as a planter conspiracy to expand slave territory. American president Andrew Jackson finally recognized Texas independence during his last week in office in March 1837, but he left the question of annexation to his successors.[6]

The issue did not seriously resurface until 1844, when Sam Houston, then serving his second term as president of the republic, instructed his minister to Washington to inquire unofficially about the possibility of statehood. That encouraged President John Tyler, who had succeeded to the office upon William H. Harrison's death in 1841, to take matters into his own hands in the hope that annexation of Texas would sweep him into office on his own merits in the upcoming election. He presented an annexation treaty to the Senate for ratification but underestimated both abolitionist sentiment and fear of war with Mexico. The Senate rejected the treaty, foisting the matter into the upcoming presidential election as the main issue.[7]

As the country's first dark-horse candidate, Jackson protégé James K. Polk of Tennessee—a former Speaker of the US House of Representatives and governor of Tennessee—emerged as the Democratic nominee. Artist H. Bucholzer and lithographer James S. Baillie took advantage of the moment to collaborate on at least ten prints focused on or involving Texas annexation and its impact on the election. In *The Little Magician Invoked* (fig. 3.2), Bucholzer depicted candidate Van Buren summoning spirits to divine his fate, while vice presidential candidate Dallas (far right) turns to run: "I'll get out of this scrape as quick as possible[.] Texas wont save us!" In *Sale of Dogs* (fig. 3.3), Bucholzer depicts Van Buren as a fox-like figure on a leash leading Jackson astray while treading between abolitionism on one side and Salt River (a euphemism for trouble) on the other. A Loco Foco Democrat, or, perhaps, Brother Jonathan (depicted in striped trousers), holds up two "well broken" pups (Polk and Dallas) for his consideration. Van Buren counsels that "we must take a middle course," but Jackson complains, "Matty! . . . You are leading me wrong—By the eternal! We shan't find Texas here." Bucholzer also presented Texas as the key issue of the campaign in *The Masked Battery or Loco-Foco Strategy*, with Polk destroying the Whigs (Henry Clay and Daniel Webster) by firing a cannonball labeled "Texas" from behind a shield of veteran candidates (Van Buren, John C. Calhoun, President Tyler). The act of firing (or speaking) from behind a "masked battery" was a common political charge of the day, and the term would have given the caricature resonance with its audience.

FIGURE 3.2 H. Bucholzer, *The Little Magician Invoked*, 1844. Single sheet. Lithograph, 32.5 × 44.3 cm (image), by James S. Baillie, 118 Nassau St., New York. Courtesy American Antiquarian Society, Worcester, MA.

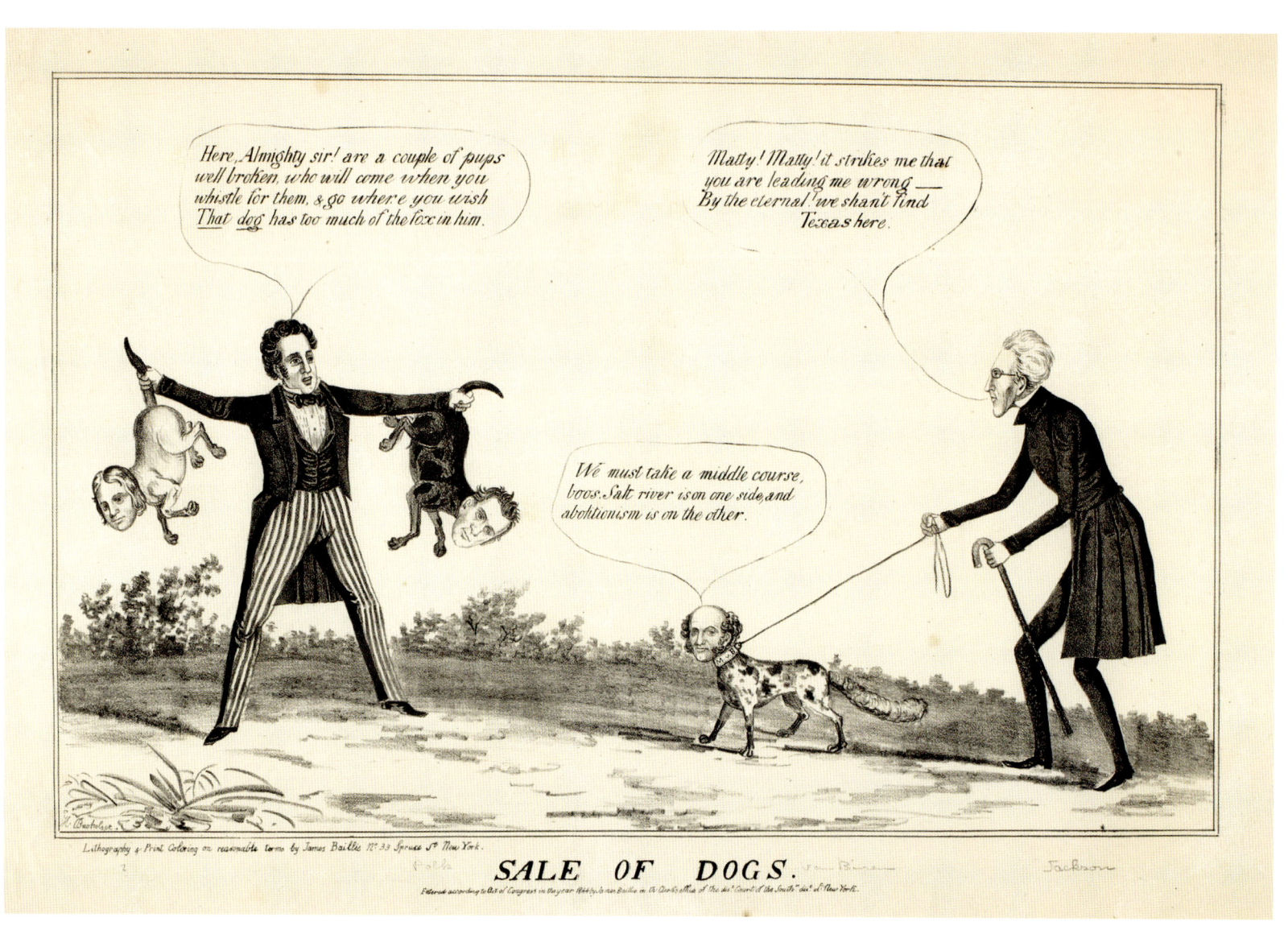

FIGURE 3.3 H. Bucholzer, *Sale of Dogs*, 1844. Single sheet. Lithograph, 30 × 44.1 cm (image), by James S. Baillie, No. 33 Spruce St., New York. Courtesy American Antiquarian Society, Worcester, MA.

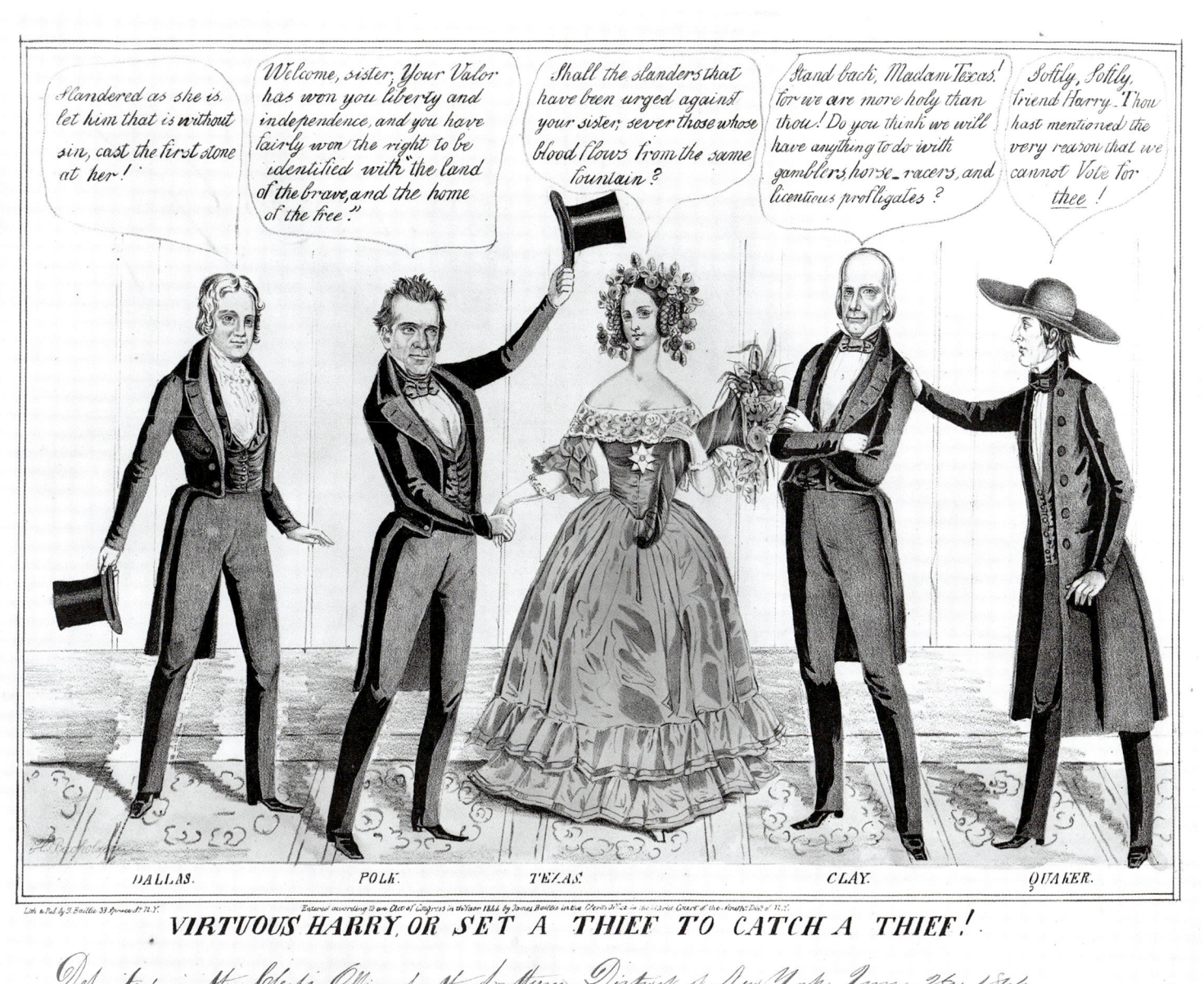

FIGURE 3.4 H. Bucholzer, *Virtuous Harry, or Set a Thief to Catch a Thief!*, 1844. Single sheet. Lithograph, 31.1 × 42 cm (image), by James S. Baillie, No. 33 Spruce St., New York. Courtesy Prints and Photographs Division, Library of Congress.

The *New York Evening Post* concluded that Bucholzer had "ingeniously represented the result of the Baltimore convention."[8]

After Polk and Dallas claimed the nomination, Bucholzer included them in a satire of the Whig Party platform. In *Virtuous Harry, or Set a Thief to Catch a Thief!* (fig. 3.4), Polk and Dallas, on the left, welcome Texas, represented by a beautiful young lady with a bouquet of flowers, into "the land of the brave, and the home of the free," while Clay, standing on her left, demurs that he will have nothing to do "with gamblers, horse-racers, and licentious profligates." But the man at the right, dressed as a Quaker, cautions Clay to be quiet: "Thou hast mentioned the very reason that we cannot Vote for *thee!*" Bucholzer finally predicts Polk's election victory in

"ILLUSTRATIONS OF A CHEAP CHARACTER" | 95

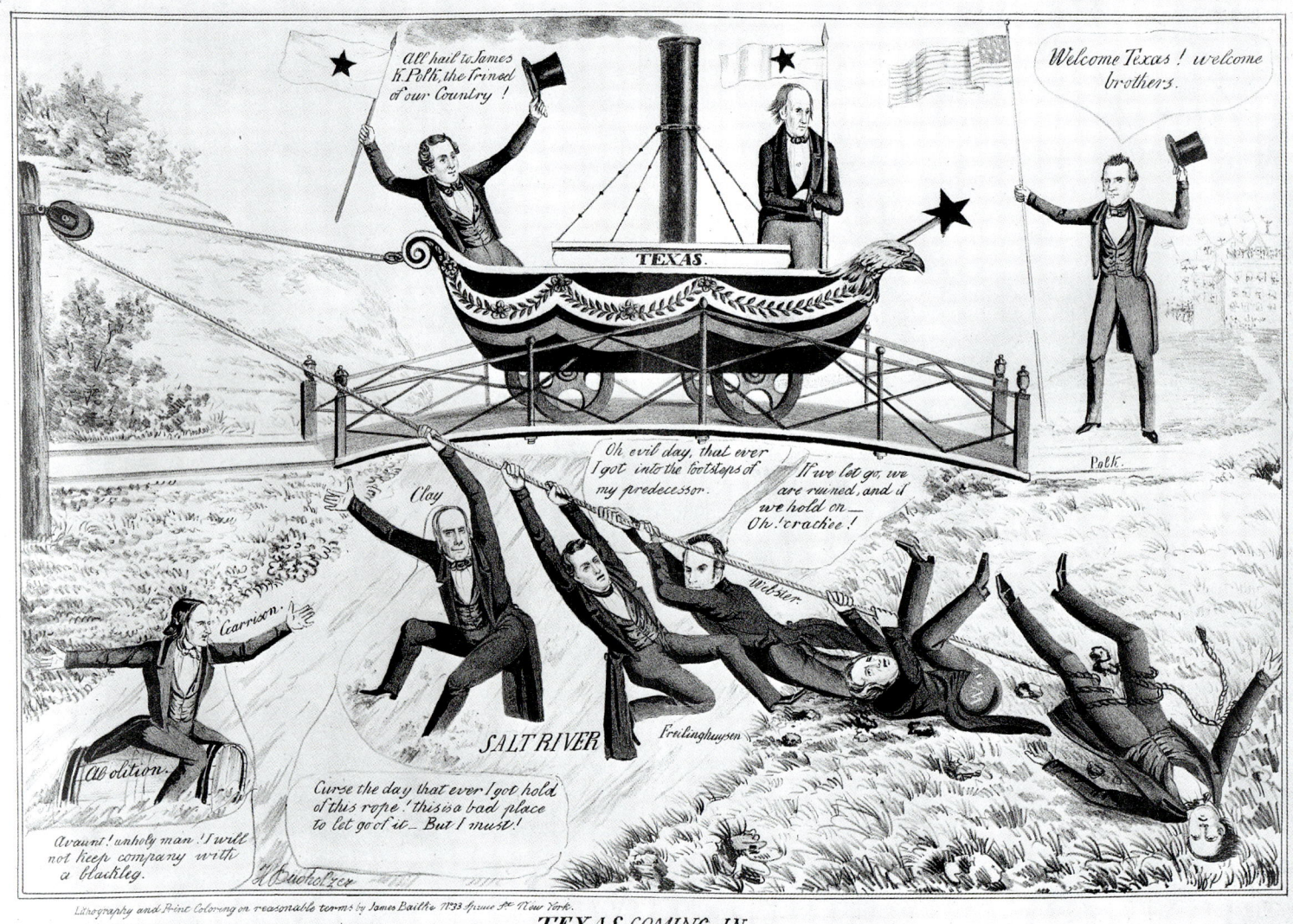

FIGURE 3.5 H. Bucholzer, *Texas Coming In*, 1844. Single sheet. Lithograph, 32 × 44.5 cm (image), by James S. Baillie, No. 33 Spruce St., New York. Courtesy Prints and Photographs Division, Library of Congress.

Texas Coming In, showing Polk at the right with an American flag welcoming Sam Houston and the long-deceased Stephen F. Austin to the United States (fig. 3.5). They are waving Texas flags and riding in a steam-powered carriage ("TEXAS") across the bridge over Salt River while dragging Clay and his supporters into the river.

Lithographer William Dohnert of Philadelphia joined in the fray with *The Coon Party Crossing Cayuga Bridge Novr. 1844, or the Effects of Cassius M. Clay's Political Tour to Western N. York,* by an unnamed artist. Dohnert was a Democrat and was actively involved in the party, including advocating for the annexation of Texas.[9] The print predicts the Whig defeat while, below right, in the distance, a crowd dances around a flag inscribed "Oregon–Texas," a reference to Polk's campaign slogan of "Reannexation of Texas and Reoccupation of Oregon."[10]

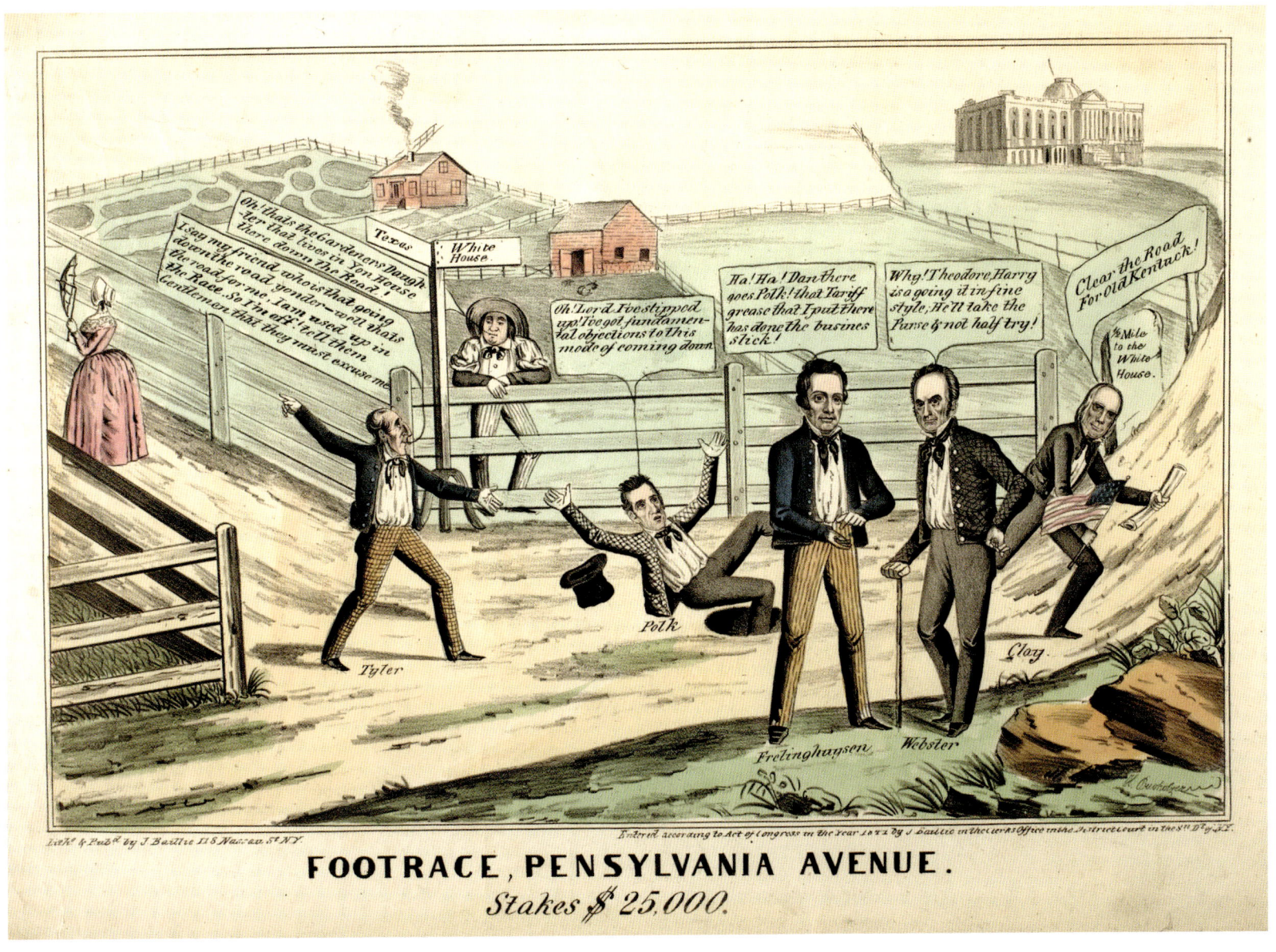

FIGURE 3.6 H. Bucholzer, *Footrace, Pensylvania Avenue. Stakes $25,000*, 1844 (misspelling in orig.). Single sheet. Hand-colored lithograph, 33 × 45 cm (image), by James S. Baillie, 118 Nassau St., New York. Courtesy American Antiquarian Society, Worcester, MA.

As a good satirist, Bucholzer attacked both sides. In *The Two Bridges* he showed Clay and Theodore Frelinghuysen, his running mate, waltzing across "The People's Bridge" to the presidential chair, while the "Loco Foco Bridge" crumbles, throwing Polk and his followers into Salt River. *Footrace, Pensylvania Avenue. Stakes $25,000* (misspelling in original) features Clay leading an uphill race to the White House, with Polk slipping on the "tariff grease" that the handsome Frelinghuysen had placed in his path. Meanwhile, President Tyler is being lured up the wrong road by an attractively dressed female representing Texas (fig. 3.6). Daniel Webster, in the foreground, predicts that Clay will "take the Purse & not half try!" In *Political Cock Fighters*, Bucholzer shows Clay defeating Polk while Jackson concludes, "I doubt the pluck of that Cock from Tenessee, if he does *go for Texas*" (misspelling in original). And, finally,

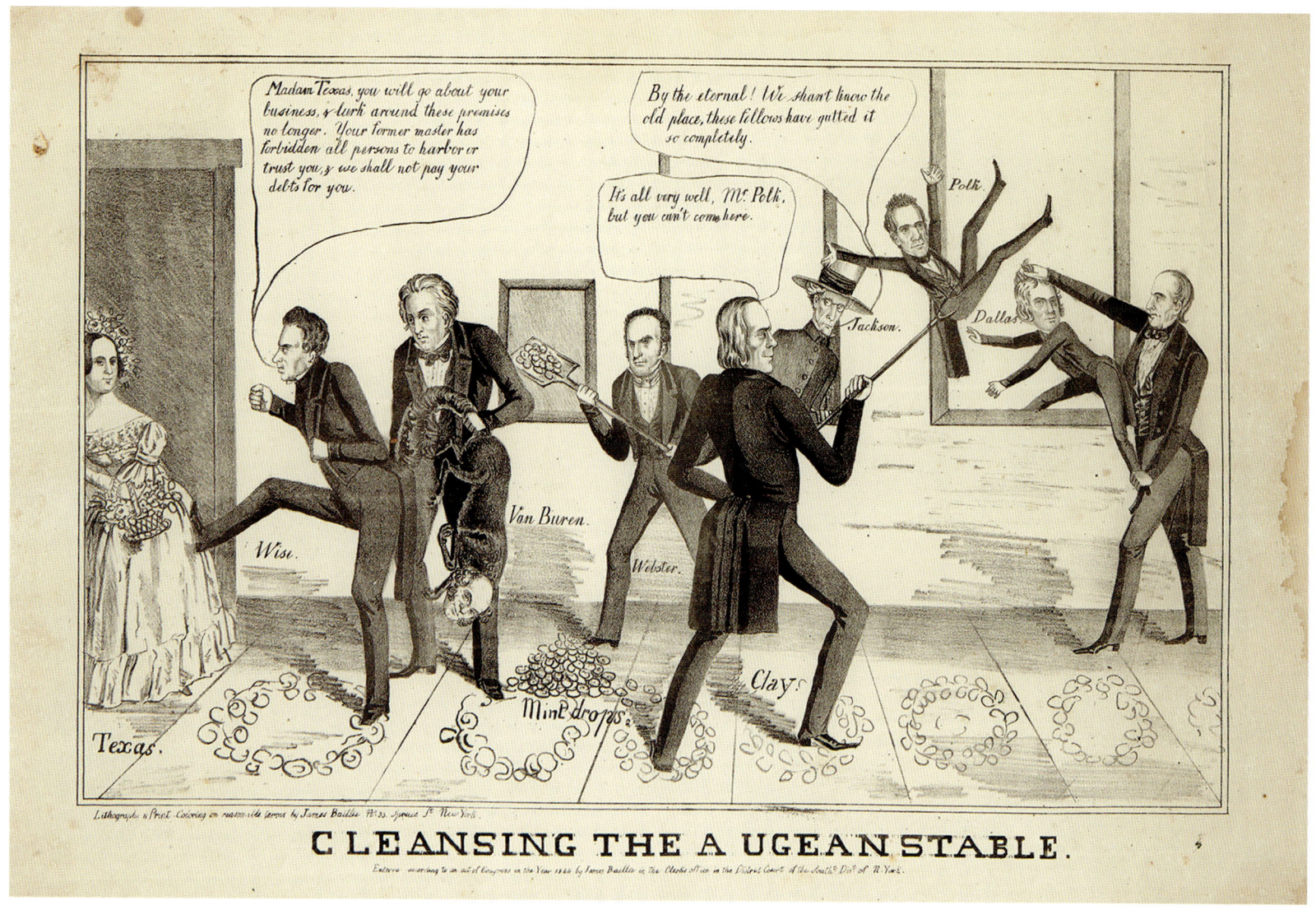

FIGURE 3.7 H. Bucholzer, *Cleansing the Augean Stable*, 1844. Single sheet. Lithograph, 30.1 × 44 cm (image), by James S. Baillie, No. 33 Spruce Street, New York. Courtesy of Swann Auction Galleries.

he showed Clay and his supporters *Cleansing the Augean Stable*, a reference to one of the twelve mythical labors that Hercules had to perform as penance for the murder of his wife and children (fig. 3.7). In this case, King Augeas's stables represent the government after more than a decade of Democratic control, and the cleansing included kicking dame Texas out the door at the left.

Edward Williams Clay (apparently no relation to Henry Clay), perhaps the best known of the satirical artists, generally favored the Whig Party. He gave up a law career in Philadelphia to become a caricaturist, engraver, and lithographer and moved to New York in 1837 to team up with lithographer Robinson. He enjoyed a two-decade career as the preeminent caricaturist of the day until blindness forced him to give up the profession.[11] His *Going to Texas after the Election of 1844* is a prediction of a Whig victory (fig. 3.8). Henry Clay stands on the steps of the White House and bids farewell to Polk and Dallas, who are mounted on a donkey and headed for Texas with other ne'er-do-wells, while Tyler and Jackson stand helplessly by. Jackson laments that he has given all that he can, while Tyler says,

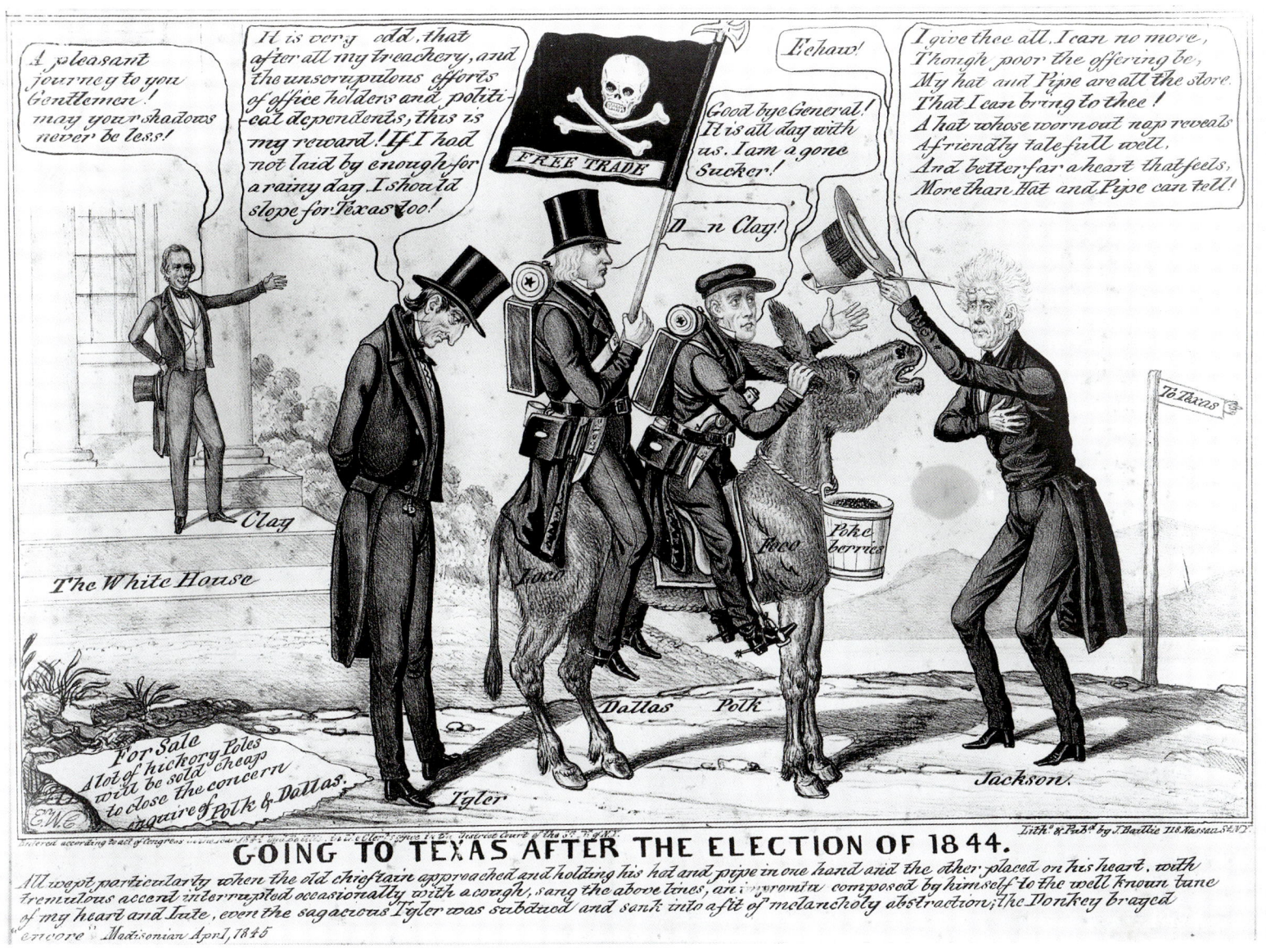

FIGURE 3.8 Edward Williams Clay, *Going to Texas after the Election of 1844*, 1844. Single sheet. Lithograph, 32.5 × 45.4 cm (image), by James S. Baillie. Courtesy Prints and Photographs Division, Library of Congress.

"If I had not laid by enough for a rainy day I should slope for Texas too." In *"Locofocoism" in the Blue Stage of Texian Cholera*, he shows Clay on a white charger headed up the hill to the White House while Tyler and Polk sit astride "Tex-ass," a starving donkey that can go no farther (fig. 3.9). In *The Oregon and Texas Question*, Clay depicts a struggle between Great Britain and American expansionists, represented by Sen. Thomas Hart Benton, with Oregon personified as an Indian woman (fig. 3.10). A statesmanlike Henry Clay, at the left with the American flag at his side, views the chaotic scene, while the Texas dilemma, represented by the Black woman clinging to Andrew Jackson's back, introduces the slavery issue. Santa Anna pursues Jackson, vowing, "You shall never have Texas without a fight for it!" And in *Weighed & Found Wanting* (fig. 3.11), he depicts Clay and Polk on the "Scales of Justice." Each of them has weights representing different parts of their platforms. Clay has tipped the scale, while a shocked Polk slides off, weights labeled Texas and slavery falling with him, saying, "I thought Texas would turn the balance in my favor."

"ILLUSTRATIONS OF A CHEAP CHARACTER" | 99

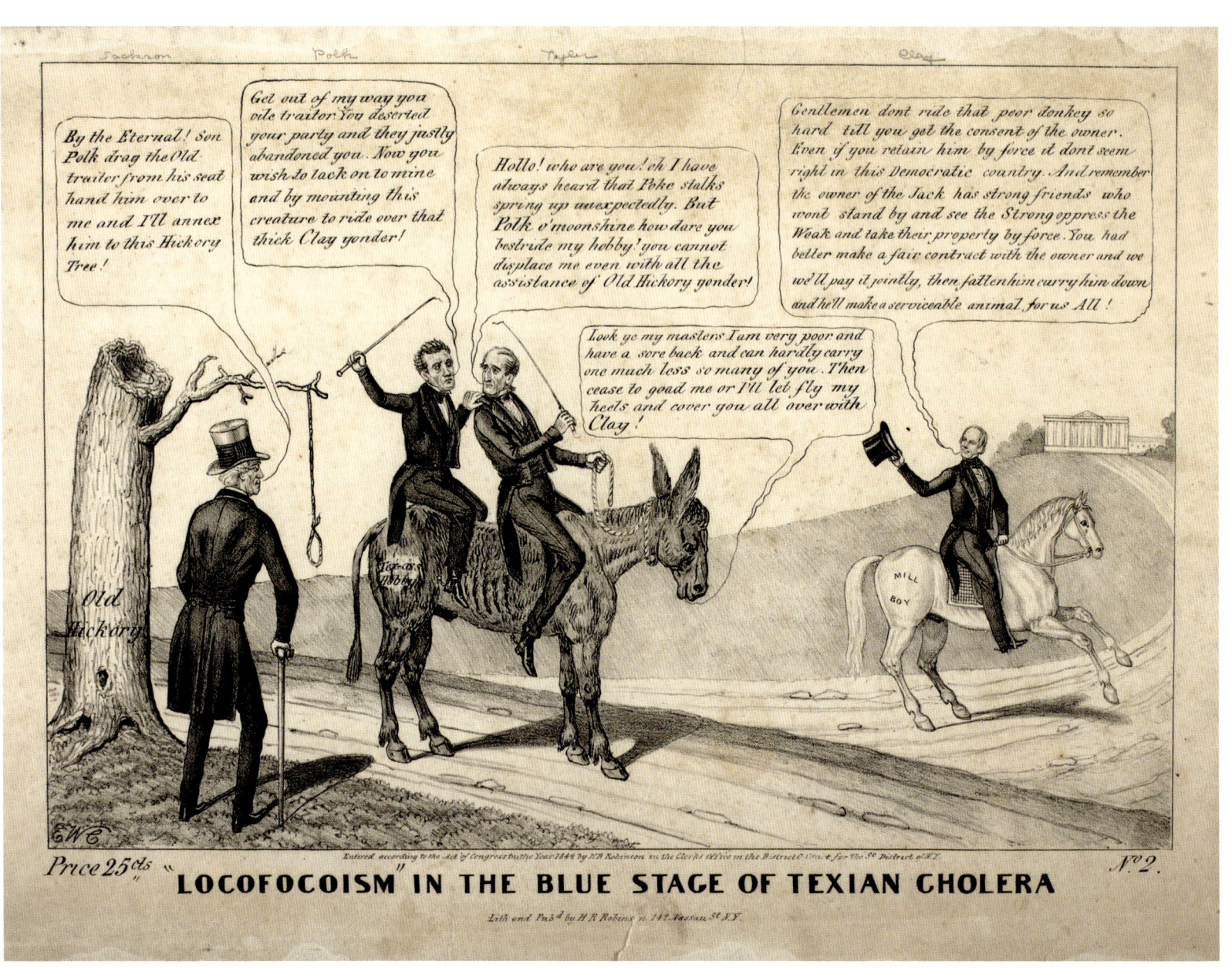

FIGURE 3.9 Edward Williams Clay, *"Locofocoism" in the Blue Stage of Texian Cholera*, 1844. Single sheet. Lithograph, 44 × 32 cm (image), by H. R. Robinson, 142 Nassau St, New York. Courtesy American Antiquarian Society, Worcester, MA.

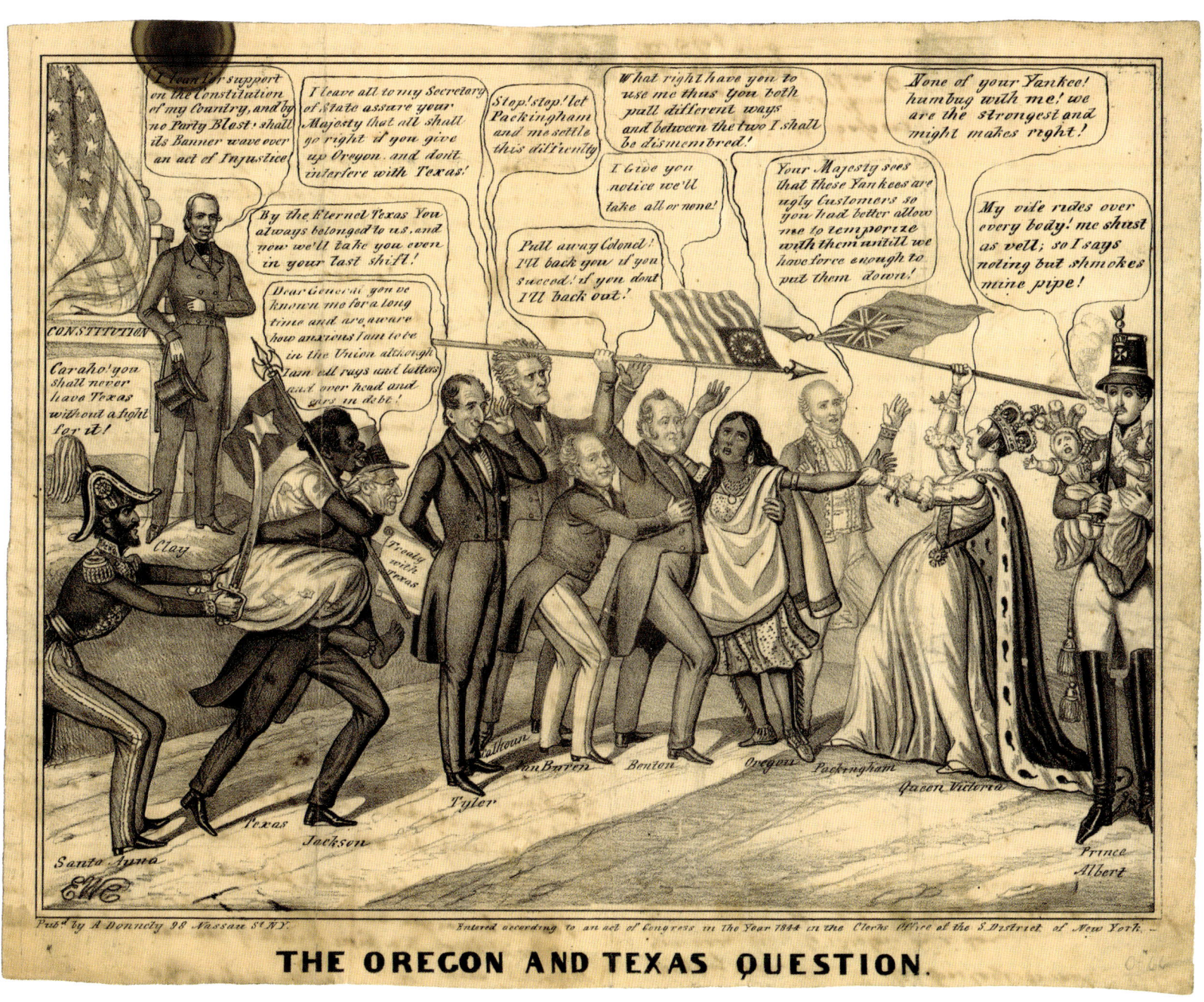

FIGURE 3.10 Edward Williams Clay, *The Oregon and Texas Question*, 1844. Single sheet. Lithograph, 30 × 38 cm (image), by Andrew Donnelly, New York. Courtesy American Antiquarian Society, Worcester, MA.

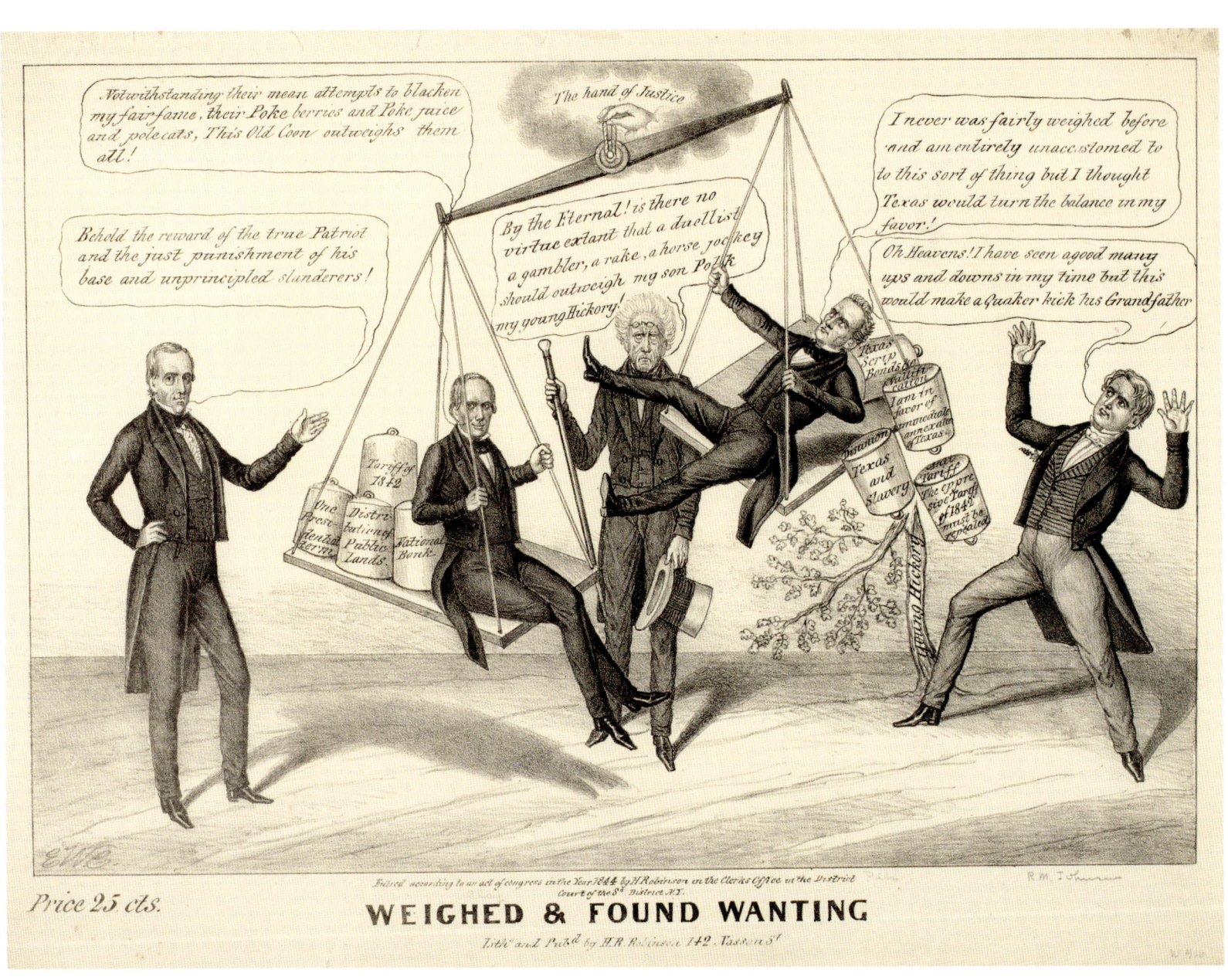

FIGURE 3.11 Edward Williams Clay, *Weighed & Found Wanting*, 1844. Single sheet. Lithograph, 32 × 44 cm, by H. R. Robinson, New York. Courtesy American Antiquarian Society, Worcester, MA.

Edward Clay was also the apparent artist of a far more acerbic caricature, one that speaks directly to slavery, the major issue confronting the country. *Young Texas in Repose* probably appeared in 1845 during the controversy over the admission of Texas to the Union, for that is when Edward Jones, the lithographer, was located at 128 Fulton Street in New York City, the address on the print (fig. 3.12). Playing on the republic's reputation for sheltering shady characters and emphasizing a term—"Young Texas"—often used with reference to it, the image shows a fierce-looking man bristling with weapons and sitting on what at first glance appears to be a bale of cotton but upon examination is clearly a slave in shackles lying on his stomach, a whip on his neck. The image is laden with symbols—tattoos, engraved bracelets and ankle shackles, and various accoutrements, including three muzzle-loading percussion firearms (one with four barrels) and four knives and daggers. The broken shackles on the character's ankles and wrists suggest that he is a fugitive, a notion supported by the engraving on his right foot shackle, which, although only partially shown, appears to be "STATE PRIS[ON]." On the back of his left hand is "GALLEYS," with what may be a brand of some kind, and tattooed on his left arm is a list of evils, including murder, incest, rape, fraud, and swindling, with "slavery" repeated four times. The initials on the shackle on his left ankle are not clear but may be "EWC," perhaps the artist's signature. In addition, the man appears to be of mixed race, a theme that Clay often used in his caricatures: his dress suggests a Mexican peon or a Louisiana creole, and his straight black hair may be a reference to Native Americans. Finally, there is his animalistic, savage look: his fangs, flattened

FIGURE 3.12 Edward W. Clay, *Young Texas in Repose*, c. 1845. Single sheet. Lithograph, 31.4 × 23.8 cm (image), 23.8 × 23.8 cm (comp.), by E. Jones, 128 Fulton St., New York. Signed in the stone on the ankle cuff: EWC. Courtesy Yale Collection of Western Americana, Beinecke Rare Manuscript Library, Yale University.

FIGURE 3.13 J. R. Ames, *Freedom's Wreath*, 1845. Single sheet. Hand-colored lithograph, 21 × 14 in. (image), by John H. Hall, Lith. Courtesy Harry T. Peters "America on Stone" Collection, National Museum of American History, Smithsonian Institution.

nose, slanted eyes, facial scar, ankle shackles, large earrings, rope necklace with an eight-pointed star, the sash (which appears to be a Union Jack) all evoke offensive images of a barbarian, a rogue, a slave owner, an overseer.[12]

Abolitionist Benjamin Lundy's 1836 prediction that the Texas revolt against Mexico was a slaveholder plot to add a slave state to the Union convinced many to oppose the republic's annexation. Despite such vehement opposition, Texas annexation did turn the balance in Polk's favor. He barely won the popular vote but had a comfortable 170 to 105 margin in the Electoral College. Before he left office, President Tyler submitted a joint resolution to Congress (which required only a simple majority of both chambers rather than a two-thirds vote in the Senate required of a treaty) for the annexation of Texas. After it passed, artist J. R. Ames drew a portrait of Charlotte Corday, a heroine of the French Revolution who murdered Jean-Paul Marat, believing that his death would end the violence (fig. 3.13). The portrait is encircled by both a wreath and a tricolor ribbon wound together that incorporates a number of patriotic symbols. She is wearing a Liberty cap in this allegorical print, which honors the members of the House and Senate who voted against annexation "on the 28th of February, 1845, [and] interposed the shield of their vote against the most base and brutal assault ever aimed at the vitals of Liberty."[13] The metaphor is clear: those who thought that admitting Texas as a slave state would end the violence were wrong.[14] These caricatures, crude though they may be, reveal how deeply the Texas issue was embedded in the main American political issue of the day.

THE WAR WITH MEXICO: AMERICA'S FIRST PICTORIAL WAR

Soon after the joint resolution passed, President Polk ordered Gen. Zachary Taylor to move his Army of Observation—which became the Army of Occupation as he moved south—from Fort Jessup, Louisiana, to Corpus Christi, on the Texas Gulf Coast, with orders to protect the new state against a possible Mexican invasion.[15] Taylor established his camp at the mouth of the Nueces River in June 1845, a site that a correspondent for the *Weekly Picayune* described as a "position . . . of extreme beauty." "When the eye first rests upon his camp," he continued, "clustered with a thousand spotless white tents, along the shelly margin of the shore of Corpus Christi Bay, irresistible bursts of admiration follow!" Capt. Daniel P. Whiting of New York, a West Point graduate, veteran of the Seminole Wars in Florida, commander of Company K of the 7th Infantry, and one of more than thirty American artists who documented the war, two-thirds of them in the military, described the location as "covered with scrub" and "infested with rattlesnakes . . . and other vermin." He depicted it in his *Bird's-Eye View of the Camp of the Army of Occupation* (fig. 3.14). It is the first of the images that he later published in his *Army Portfolio No. 1*.[16]

In March 1846 Taylor moved about 150 miles down the coast, well beyond the Nueces River and into territory that had historically been a part of the Mexican state of Tamaulipas. There he began

FIGURE 3.14 Charles Parsons after Daniel Powers Whiting, *Birds-Eye View of the Camp of the Army of Occupation, Commanded by Genl. Taylor, Near Corpus Christi, Texas, (from the North) Oct. 1845*, 1847. Hand-colored toned lithograph, 12.38 × 19.38 in., by G. & W. Endicott, New York. From Whiting, *Army Portfolio No. 1* (1847). Courtesy Amon Carter Museum of American Art, Fort Worth.

"ILLUSTRATIONS OF A CHEAP CHARACTER"

construction of Fort Texas across the Rio Grande from Matamoros. On April 25 one of his dragoon patrols blundered into a Mexican ambush and surrendered following a brief fight in which several men were killed. President Polk had been preparing to ask Congress for a declaration of war when he received Taylor's report of the incident on May 9. Although the clash had occurred in disputed territory, he told the legislators that Mexico had "shed American blood on American soil" and that "war exists . . . by the act of Mexico herself."[17]

As early as March 1846 the *New York Herald* published Samuel Putnam Avery's engravings of the army in South Texas, including scenes of Taylor's army at Corpus Christi, Fort Brown, and just across the river, at Camargo and Matamoros (fig. 3.15). Avery probably engraved the images after sketches by Maj. Joseph H. Eaton, one of Taylor's aides, and/or by Lt. Alfred Sully, the son of Philadelphia portrait artist Thomas Sully. But drawings might also have been available from other West Point–trained soldiers who documented the war for their private journals. The scene of Corpus Christi shows the village from the south, and the tents of the American troops can be seen in the distance at the left center.[18]

Just as publishers quickly copied the images of Galveston and Houston in one journal after another, so the engravings of Corpus Christi and Fort Brown that appeared in the *Herald* quickly spread, beginning with Mexican publishers who lithographed them for two different publications and with Capt. William Seaton Henry, who used them in his book *Campaign Sketches of the War with Mexico*.[19] In Mexico, Plácido Blanco provided a print of Corpus Christi (fig. 3.16) to the *Revista Científica y Literaria de México* to accompany Manuel Payno's brief article on Corpus Christi, the purpose of which was to call attention to Mexico's neglect of its northern borderlands, from Texas to California.[20] The *Revista* was a short-lived production of editor and author José Mariano Fernández de Lara and of a group of writers and artists that succeeded the equally transient *El Museo Mexicano* (1843–1845), both intended to be vehicles for defining the new identity of the Mexican nation. Two of Mexico's most prolific craftsmen, artist Hesiquio Iriarte y Zúñiga and lithographer Plácido Blanco, produced the views, and Lara, who had taken his place among Mexico's foremost lithographers with his production of the *Monumentos de México tomados del natural* in 1841, printed the journal in his shop at Palma 4 in Mexico City. The Corpus Christi article was published in July 1846, shortly after Avery's engraving appeared in the *New York Herald* in March.[21]

A second version of the print appeared in an apparently unfinished translation, or a fragment, of Capt. William Seaton Henry's *Campaign Sketches*, published in Mexico City by La Voz de la Religion in 1848 (fig. 3.17). Henry, a member of the Third US Infantry, who served under General Taylor in the northern campaign, was one of the early participants to write of his experiences in the war. He had been a member of Gen. Edmund P. Gaines's staff when he was ordered to the border of Texas in 1836 and, again, two years later when he conferred with Texas president Sam Houston in Nacogdoches about Indian matters. A regular correspondent for the *Spirit of the Times* (New York) under the pseudonym G**DE L***, Henry gathered his articles and published them in book form with eleven engravings and five maps, including three images from the Texas portion of the campaign: Corpus Christi, Point Isabel, and Fort Brown.[22] La Voz de la Religion translated and began publication of his book, perhaps serially, as *Apuntes de campaña en la guerra con México*. This exceedingly rare imprint is not listed in any bibliography and is known only through a 128-page fragment of Henry's

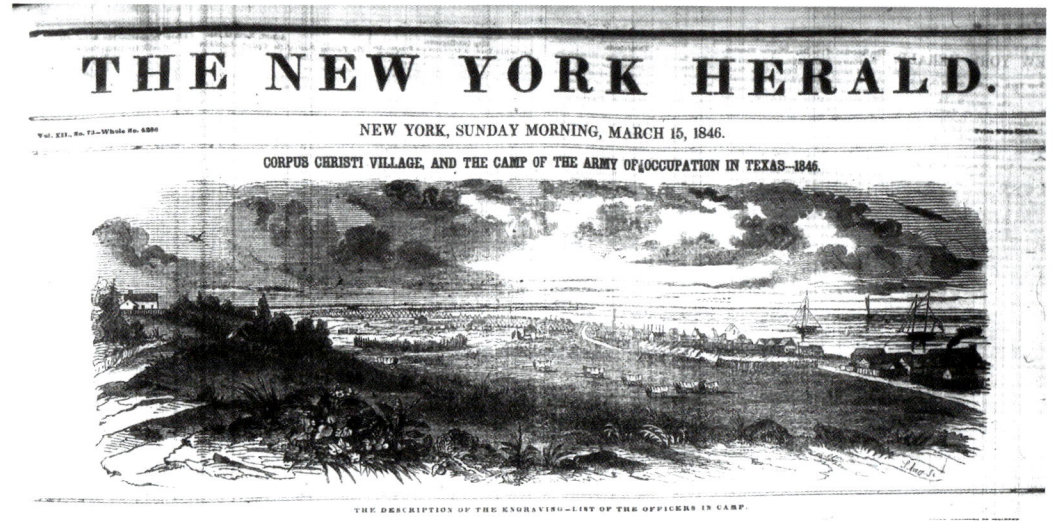

FIGURE 3.15 Samuel Putnam Avery after unknown artist, *Corpus Christi Village, and the Camp of the Army of Occupation in Texas—1846*. Engraving. From *New York Herald*, March 15, 1846, 1.

106 | TEXAS LITHOGRAPHS

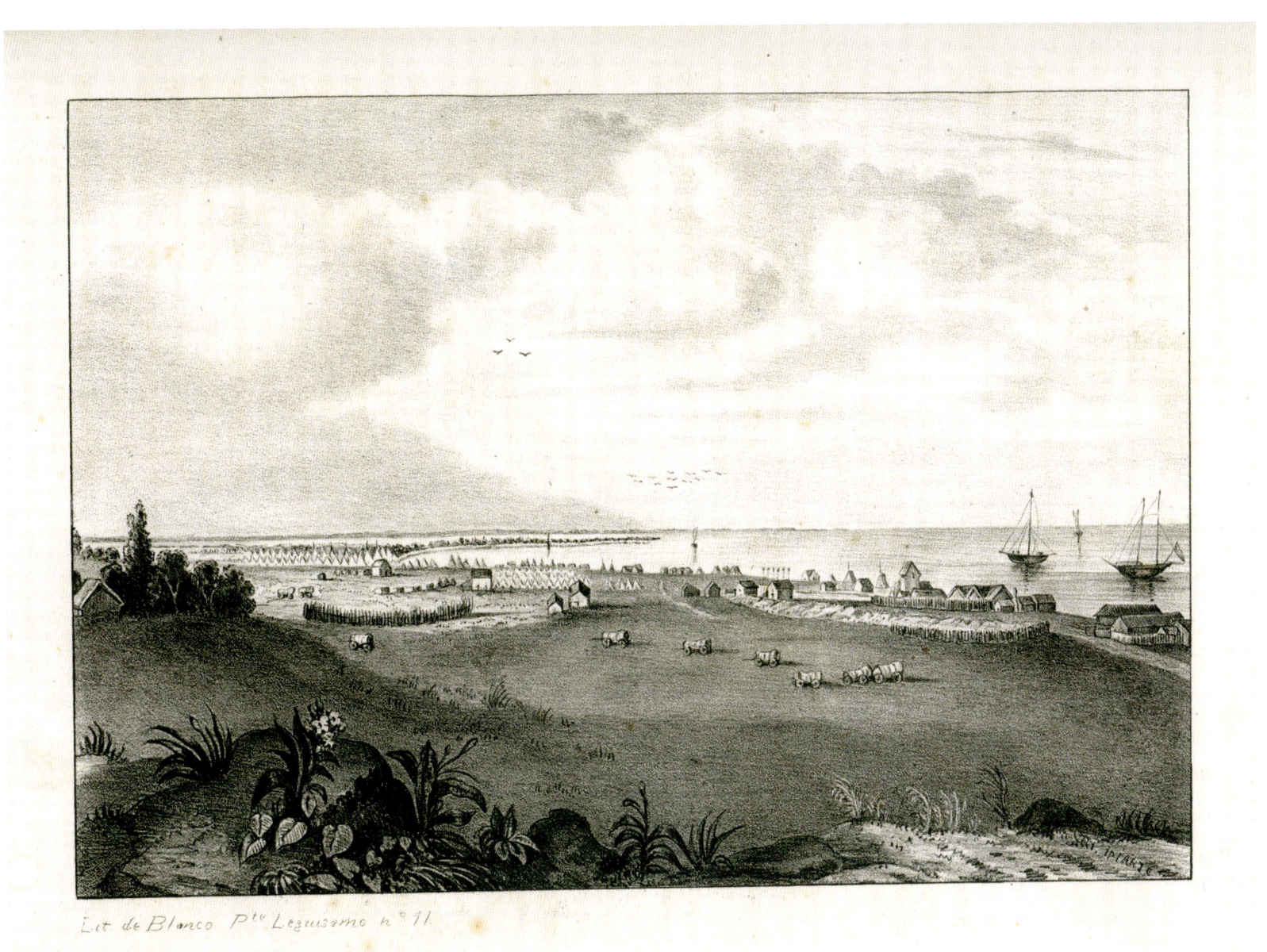

FIGURE 3.16 Hesiquio Iriarte y Zuñiga (signed lower right) after Joseph Horace Eaton (attrib.), *Corpus Christi. (Campamento de Taylor)*, 1846. Lithograph, 9.7 × 14.5 cm (comp.), by Plácido Blanco, Pte. Leguisamo No. 11. From "Corpus-Christi," in *Revista Científica y Literaria de México* (1846), opp. 108. Courtesy private collection.

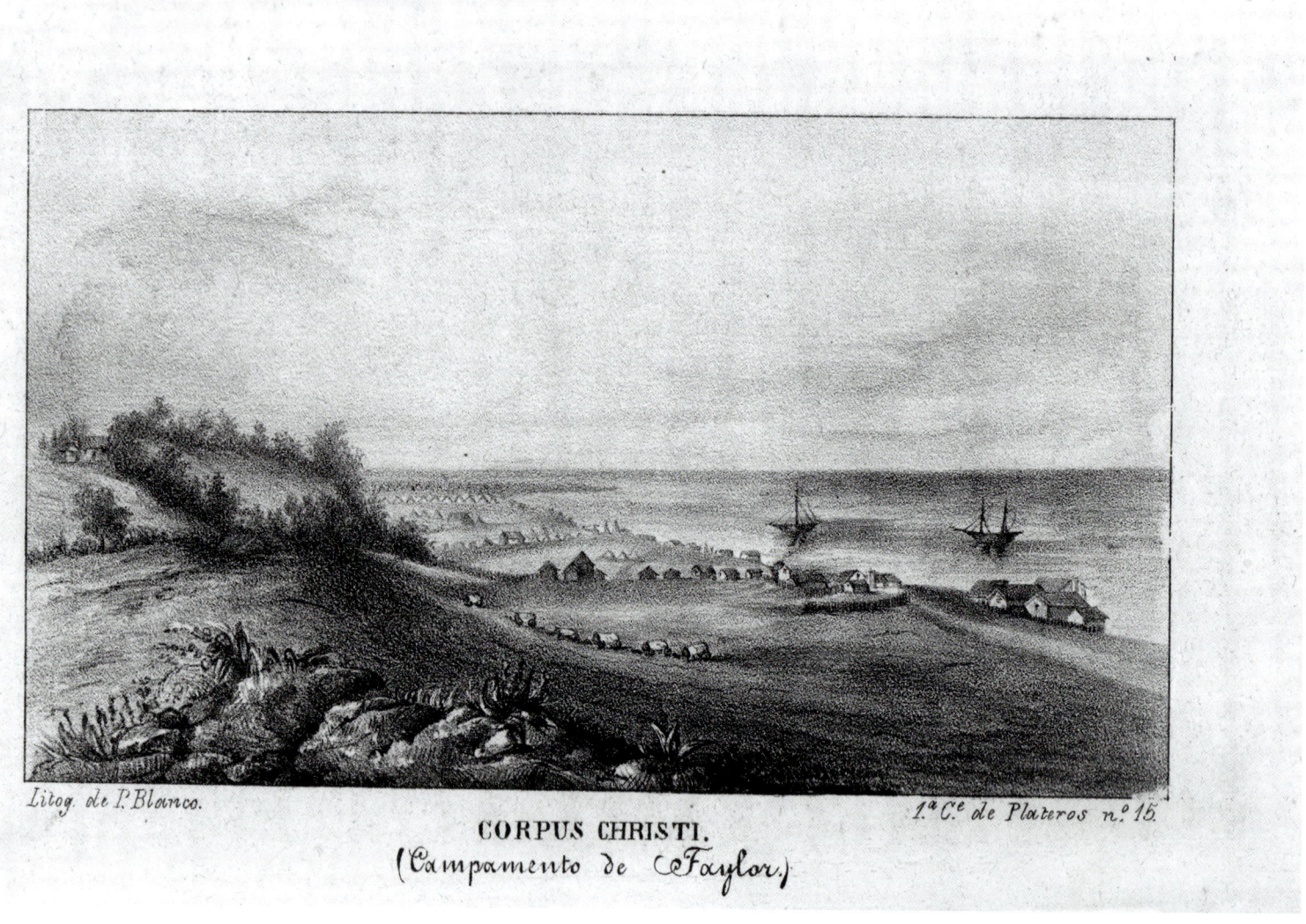

FIGURE 3.17 Plácido Blanco after Joseph Horace Eaton (attrib.), *Corpus Christi. (Campamento de Taylor)*, 1848. Lithograph, approx. 9.7 × 14.5 cm (comp.), by Plácido Blanco, 1.a C.e de Plateros n.o 15. From Capt. W. S. Henry, *Apuntes de campaña en la guerra con México* (1848), a partial translation of his *Campaign Sketches of the War with Mexico* (1847). Courtesy private collection.

more than 300-page book. It contains two lithographic plates—Corpus Christi (fig. 3.17) and Fort Brown—by Plácido Blanco, the same lithographer who did the view of Corpus Christi for the *Revista Científica y Literaria de México*.[23]

Lithographers like Nathaniel Currier, Kellogg & Thayer, C. J. Pollard, James Baillie, and others who had enjoyed popular success during the presidential campaign read the developing "penny press"—and saw the rudimentary engravings—of America's first foreign war and began issuing their own images of war, often accompanied by lengthy captions. Currier had established the model for rapidly issued illustrated news with the publication in New York of the *Extra Sun*, a single-sheet hand-colored lithographic illustration, which was accompanied by the account of the burning of the luxury passenger steamboat *Lexington*, which sank off Long Island on January 13, 1840.[24] The first issue of *Extra Sun* appeared only three days after the accident, an almost revolutionary response, and continued to be reprinted and revised over the next several days. When the war with Mexico began abruptly in mid-May 1846, the lithographic publishers along the East Coast, no doubt remembering Currier's experience, began to depict the war in a form that combined images

and lengthy captions—reminiscent of the political caricatures that had been so popular (fig. 3.18; see also fig. 3.20, for example). They turned out dozens of prints of the war, some of which were done from eyewitness sketches that soldiers sent home, many of which purported to be Texas scenes. Most, however, were the work of artists who had never left their New York shops. They probably took their cues from the lengthy newspaper stories that flowed from the pens of war correspondents such as George Wilkins Kendall of the *New Orleans Picayune* and Thomas Bangs Thorpe of the *New Orleans Tropic*, two of the several journalists who accompanied the troops into Mexico. The lithographers also could have had recourse to numerous European battle prints in their inventories as models. One of the first prints to be noticed in the press was a lithographic portrait of Winfield Scott, the commanding general of the army.[25]

FIGURE 3.18 Unknown artist, *The Battle of Palo Alto. Which was fought by the American & Mexican armies on the 8th May. The Americans proving victorious. Loss of the enemy 300 killed, number of wounded not known. Loss of the Americans, 43 killed, 103 wounded. Duration of the engagement, 5 hours*, 1846. Single sheet. Hand-colored lithograph, 12 × 15.19 in., by Sarony & Major, 88 Nassau near Fulton St., New York. Courtesy Prints and Photographs Division, Library of Congress.

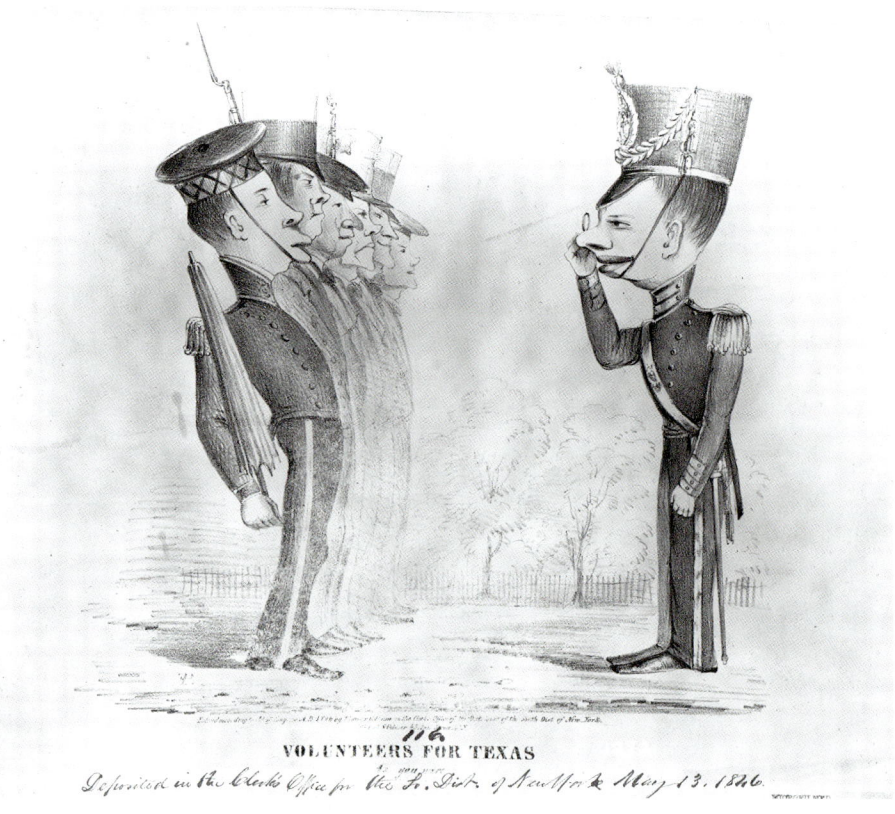

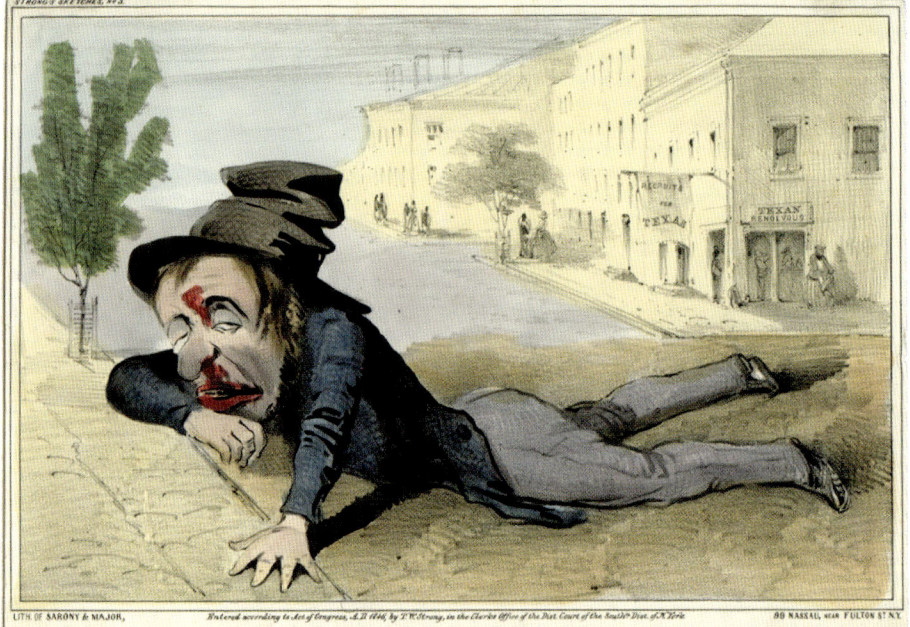

Two of the earlier prints about the war, artist Frances (Fanny) Palmer's *Volunteers for Texas/As You Were* (fig. 3.19), and T. W. Strong's *A Volunteer for the Rio ₲Brandy₤* (fig. 3.20), caricatured the thousands of volunteers who rushed to join the army. Palmer, an English immigrant whose print was registered for copyright on May 13, just four days after Polk's message, appears to be mocking the large number of naïve Irish immigrants who signed up for service, showing a motley group of enlistees standing awkwardly before an immaculately dressed but young officer inspecting them through his monocle. Neat picket fences behind them may represent a cemetery and Palmer's dire prediction of the deaths to come. Strong, a New York engraver and lithographer who worked for a while for the *New York Herald*, shows a drunken volunteer lying in the street, having apparently celebrated at the corner saloon behind him, which bears signs that advertise "Recruits for Texas" and "Texas Rendezvous," with the implication that alcohol played a role in the recruiting of volunteers. A Cincinnati editor might have had such images in mind when he noted that lithographs of "a class peculiar to New York, vulgarly known as the *'b'hoys,'* are being showered upon us like leaves in autumn, and may be seen in most shop windows."[26] Charles Currier offered a more patriotic but nonetheless cheerless image of *The Wounded Dragoon. On the Banks of the Rio Grande*, which shows a lone and injured dragoon, whose horse has been shot from under him, drawing his sword to defend himself from the advancing enemy (fig. 3.21). Perhaps this was Currier's attempt to illustrate the "American blood" that President Polk claimed had been shed on "American soil."[27]

FIGURE 3.19 F[anny] P[almer], *Volunteers for Texas/As You Were*, 1846. Single sheet. Lithograph, 31.3 × 30.7 cm (image), by F. & S. Palmer, 45 Ann St., New York. Published by Thomas Odham. Courtesy Prints and Photographs Division, Library of Congress.

FIGURE 3.20 T. W. Strong, *A Volunteer for the Rio ₲Brandy₤*, 1846. Single sheet. Hand-colored lithograph, 7.94 × 12.25 in. (image), by Sarony & Major, Strong's Sketches No. 5. Courtesy Bowdoin College Museum of Art, Brunswick, ME.

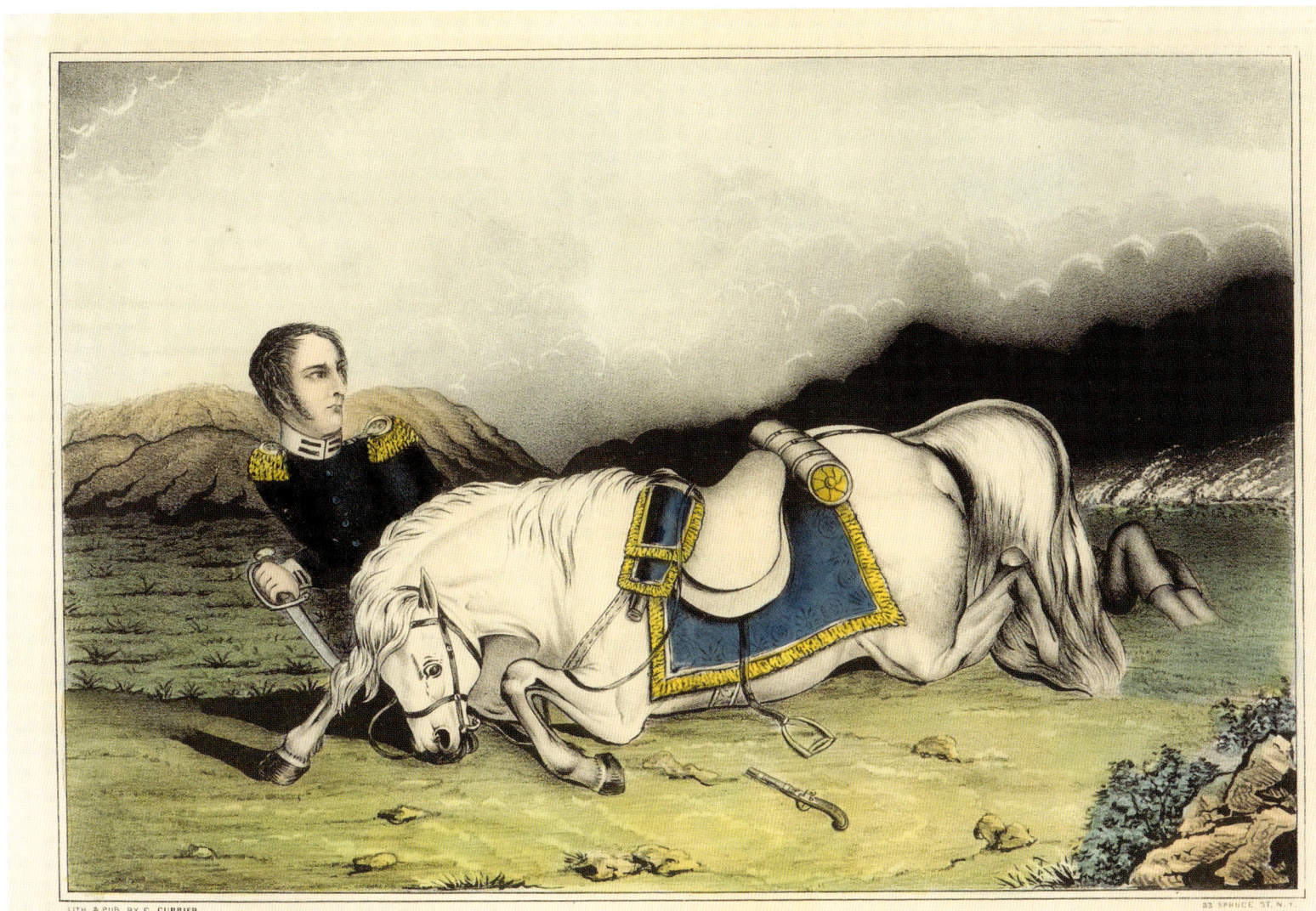

FIGURE 3.21 *The Wounded Dragoon on the Banks of the Rio Grande.* Single sheet. Hand-colored lithograph, 13.87 × 10 in., by Currier & Ives. Courtesy Michele & Donald D'Amour Museum of Fine Arts, Springfield, MA, Gift of Lenore B. and Sidney A. Alpert, supplemented with Museum Acquisitions Funds. Photograph by David Stansbury.

"ILLUSTRATIONS OF A CHEAP CHARACTER" | 111

Sarony & Major and Currier published virtually identical impressions of the siege of Fort Texas, which was renamed Fort Brown in honor of the Major Jacob Brown, who died in its defense. *The Bombardment of Matamoras, May 1847* [*sic*] shows uniformed American troops behind what appears to be a stone wall, rather than the fifteen-foot-thick earthen wall that they constructed, preparing to fire a cannon toward the city, which can be seen across the Rio Grande (fig. 3.22). The American flag flies overhead at the right, while one of the soldiers erects a "Death or Victory" sign at the left.[28]

Meanwhile, Taylor had set out to ensure that his force of some 2,500 men, deep in disputed territory, would not be cut off from the coast and its source of supplies. When a large Mexican contingent

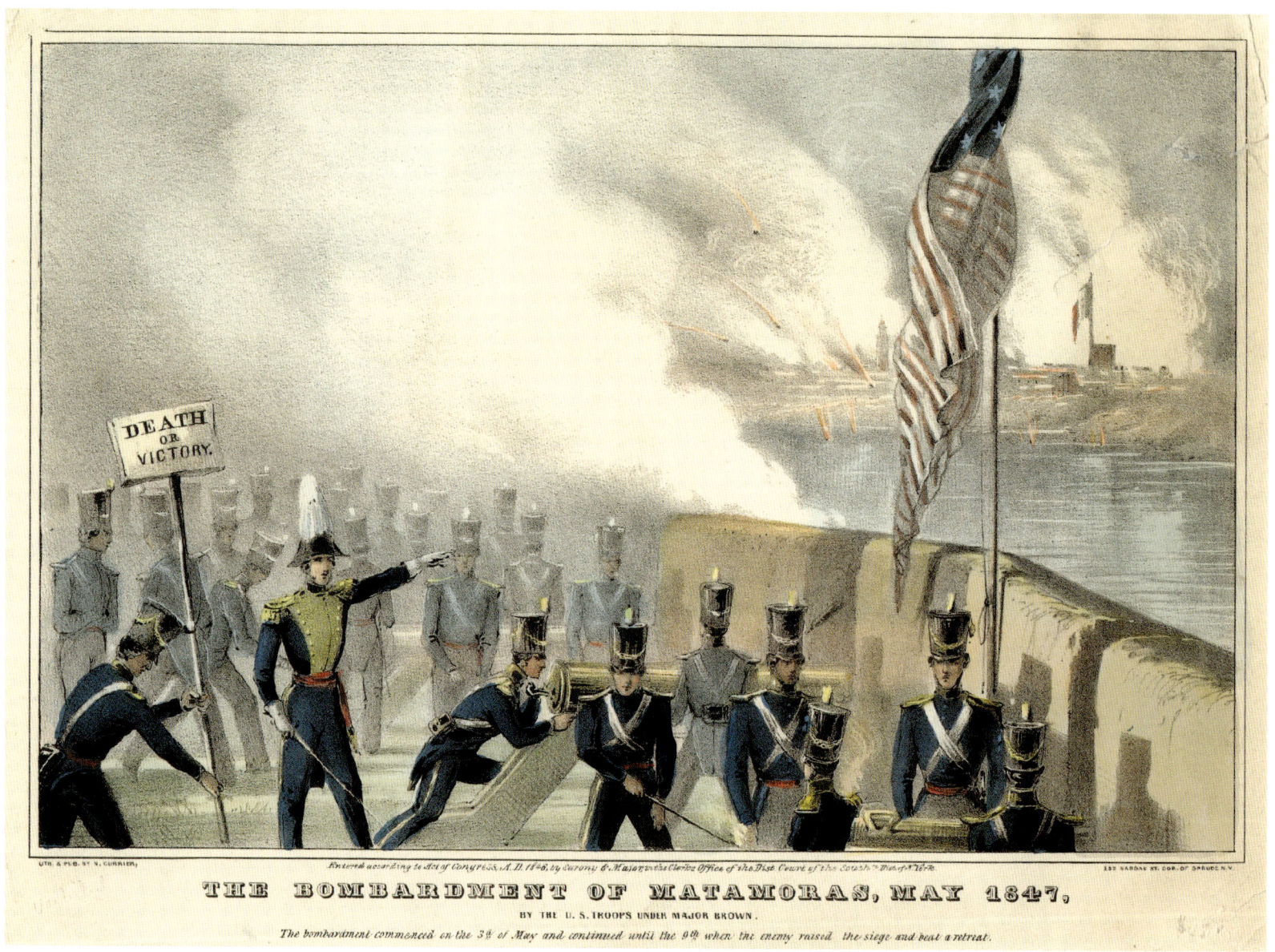

FIGURE 3.22 Unknown artist, *The Bombardment of Matamoros, May 1847. By the U.S. Troops under Major Brown*, 1846. Single sheet. Hand-colored lithograph, 25.2 × 32.5 cm, by Sarony & Major, 33 Nassau near Fulton St., New York. Courtesy Prints, Drawings and Watercolors from the Anne S.K. Brown Military Collection, Brown Digital Repository, Brown University Library. The date in the title is incorrect in both this and the Currier edition; the copyright date is correct.

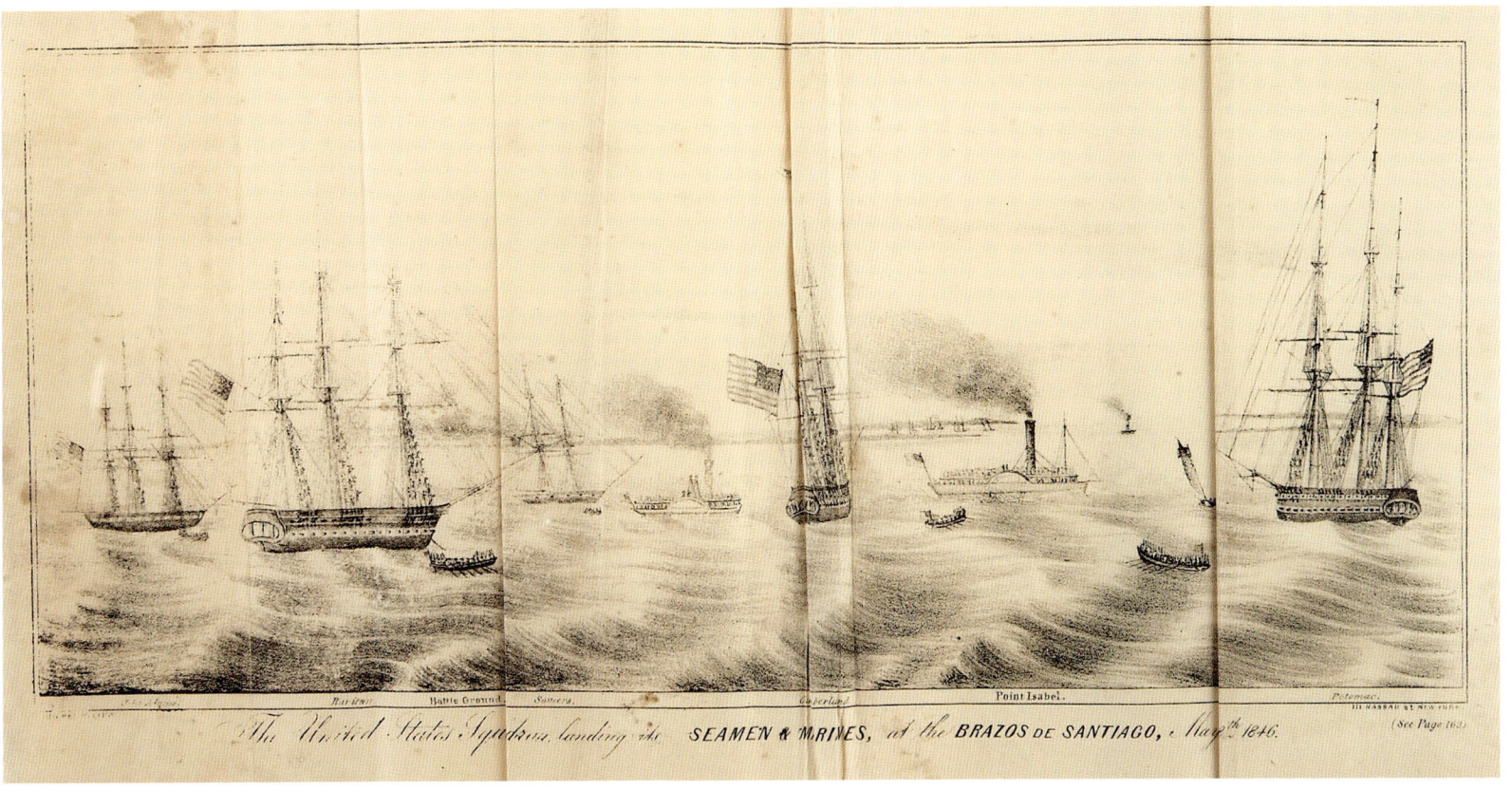

FIGURE 3.23 Unknown artist, *The United States Squadron, Landing Its Seamen & Marines, at the Brazos de Santiago, May 8th 1846*, 1848. Lithograph, 16.5 × 34.8 cm (comp.), by Francis Michelin, 111 Nassau St., New York. From Fitch W. Taylor, *The Broad Pennant* (1848), frontis. Special Collections, University of Texas at Arlington Libraries.

crossed the river on April 30 and took up a position that threatened both Fort Texas and Point Isabel, the port through which Taylor received his supplies, he moved 2,000 of his troops northward to secure the Point and to gather supplies for his upcoming maneuvers.[29] *The United States Squadron Landing Its Seamen & Marines, at the Brazos de Santiago, May 8th 1846* depicts this action (fig. 3.23). Although there is no artist's name on the print, it is probably after a description provided by the Rev. Fitch W. Taylor, whose book the print accompanies and who was a chaplain aboard the USN frigate *Cumberland*, pictured in the center of the print.[30] Perhaps Taylor even provided a sketch for the lithographer. The print depicts five navy frigates and two steam paddle wheelers along with several lesser vessels off Point Isabel and Brazos Santiago.

After securing Point Isabel, Taylor began his return march to a besieged Fort Texas, where Captain Whiting and others anxiously awaited his return. Mexican major general Mariano Arista maneuvered his troops between Taylor and the fort, hoping to destroy the American force along with its two-hundred-wagon supply train, and two 18-pounders (cannon that fired 18-pound balls, but in this battle fired canister, a cylindrical tin box filled with iron shot).[31] The battle began on the afternoon of May 9 as Taylor contemplated a frontal assault. But the American artillery, led by Maj. Samuel Ringgold, was so effective that Taylor continued the bombardment. The Mexicans pulled back, and the battle raged until a burning wad from one of the cannons set a grass fire that produced so much smoke that neither side could see the battleground (fig. 3.24). When the fight resumed, Taylor quickly moved his artillery forward to occupy the abandoned territory. Neither side gained an advantage in what became known as the battle of Palo Alto, and they broke off fighting at dusk. The dawn revealed a Mexican force slowly moving southward.[32]

The American artillerymen had carried the day, but they were

"ILLUSTRATIONS OF A CHEAP CHARACTER" | 113

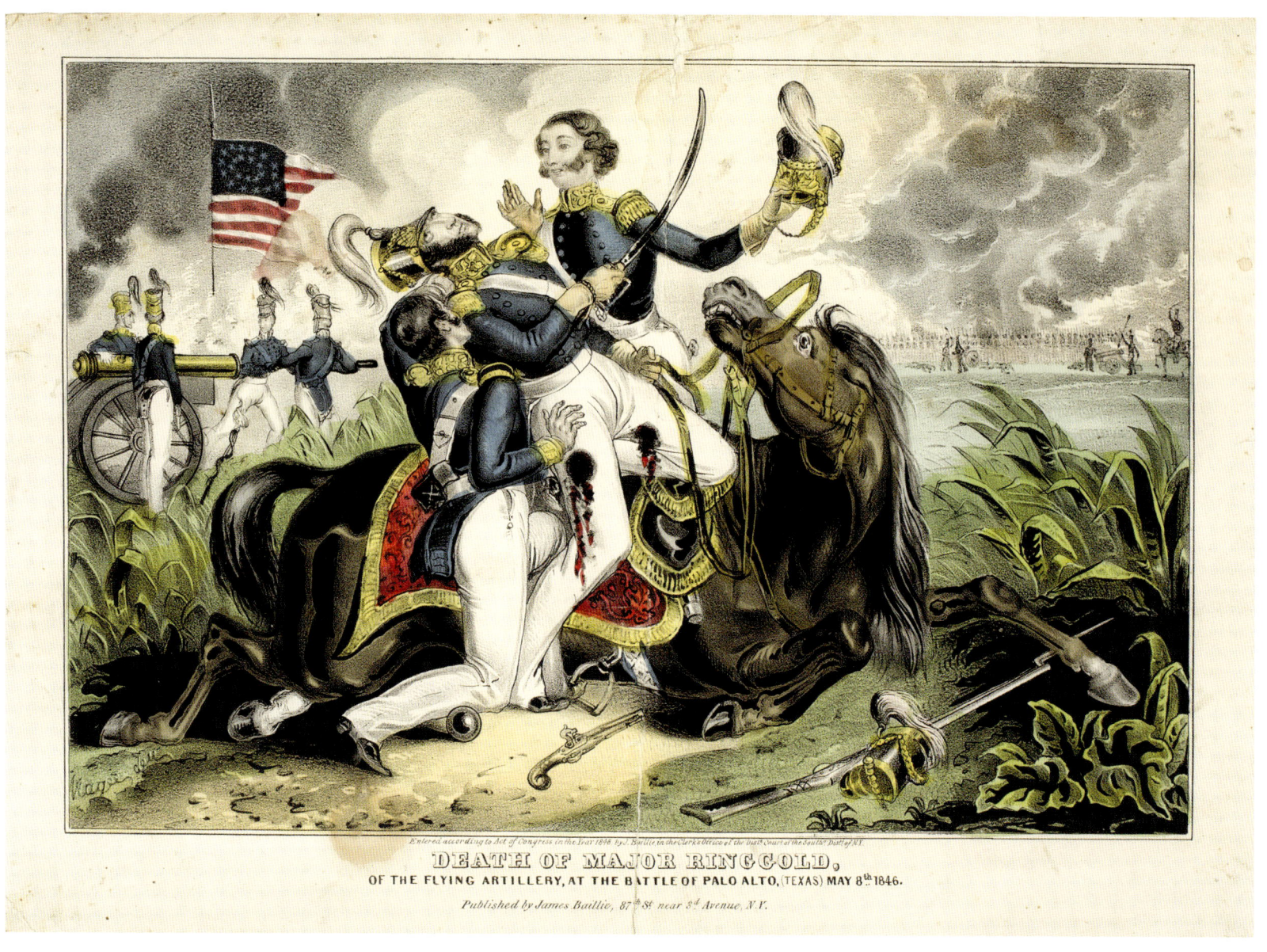

FIGURE 3.24 John L. Magee, *Death of Major Ringgold, of the Flying Artillery, at the Battle of Palo Alto, (Texas) May 8th, 1846*, c. 1848. Single sheet. Hand-colored lithograph, 23 × 31 cm, by James Baillie. Courtesy American Antiquarian Society, Worcester, MA, gift of Charles Henry Taylor.

saddened by the death of Major Ringgold, who had devised the successful "flying" artillery tactics. He became the war's first hero and was celebrated in newspaper stories, sheet music, and at least eight different lithographic prints. Using European prototypes, such as the imaginative Napoleonic battle scenes produced in Epinal, France, American lithographers printed a number of fantasized images of his death.[33] One of the sheet music illustrations, *On to the Charge!*, purports to show his grave in Mexico. Nor are the first prints of the battle of Palo Alto itself any more accurate. In *At the Battle of Palo Alto, the Americans Greatly Distinguished Themselves . . .*, artist John L. Magee satirizes the reports of kind treatment that American soldiers extended to Mexican prisoners during the battle by showing Americans stopping in the middle of battle to feed the prisoners (fig. 3.25).

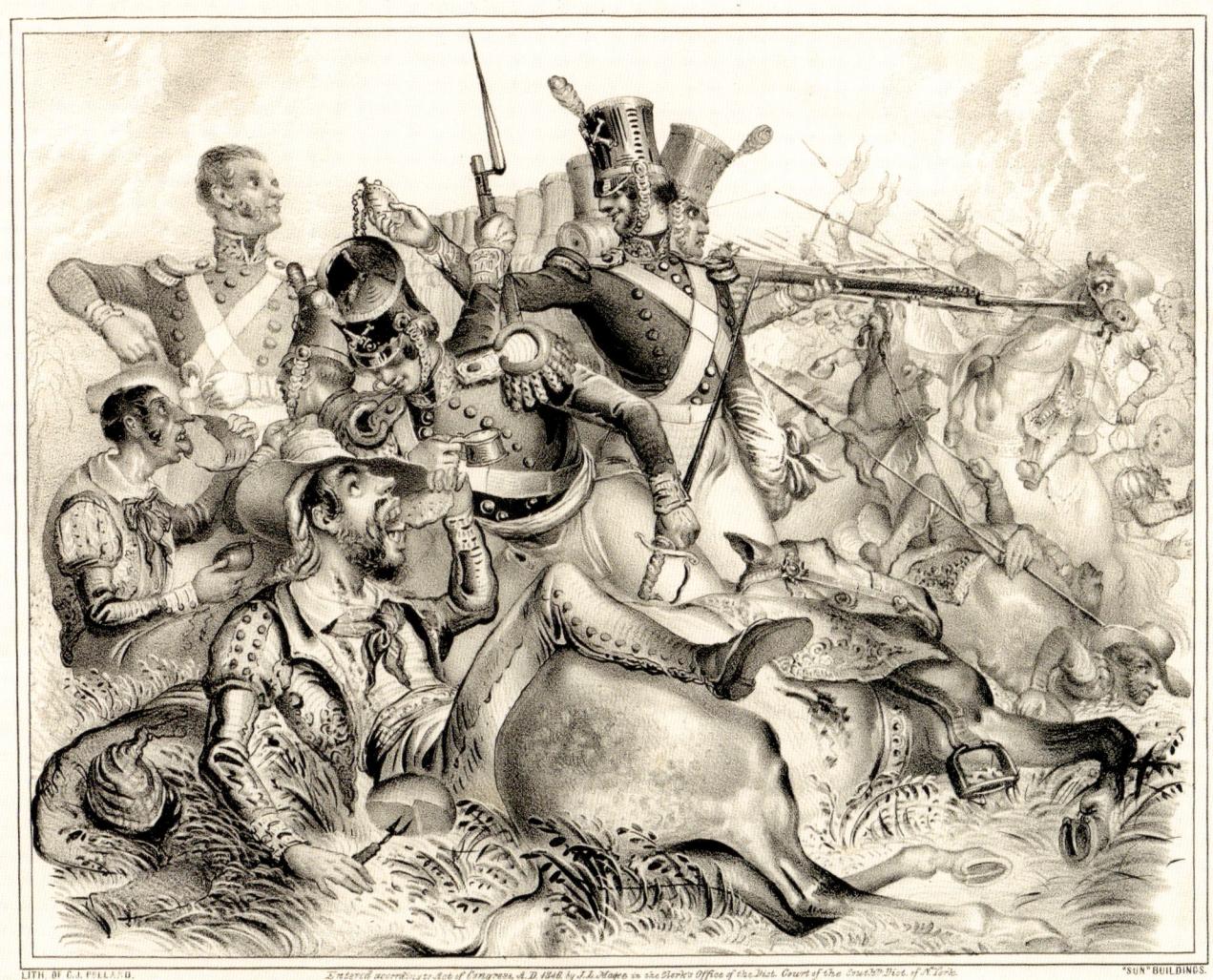

FIGURE 3.25 John L. Magee, *At the Battle of Palo Alto, the Americans Greatly Distinguished Themselves*, 1846. Single sheet. Lithograph, 24.6 × 29.2 cm (image), by C. J. Pollard, "Sun" Buildings, New York. Courtesy Prints and Photographs Division, Library of Congress.

"ILLUSTRATIONS OF A CHEAP CHARACTER"

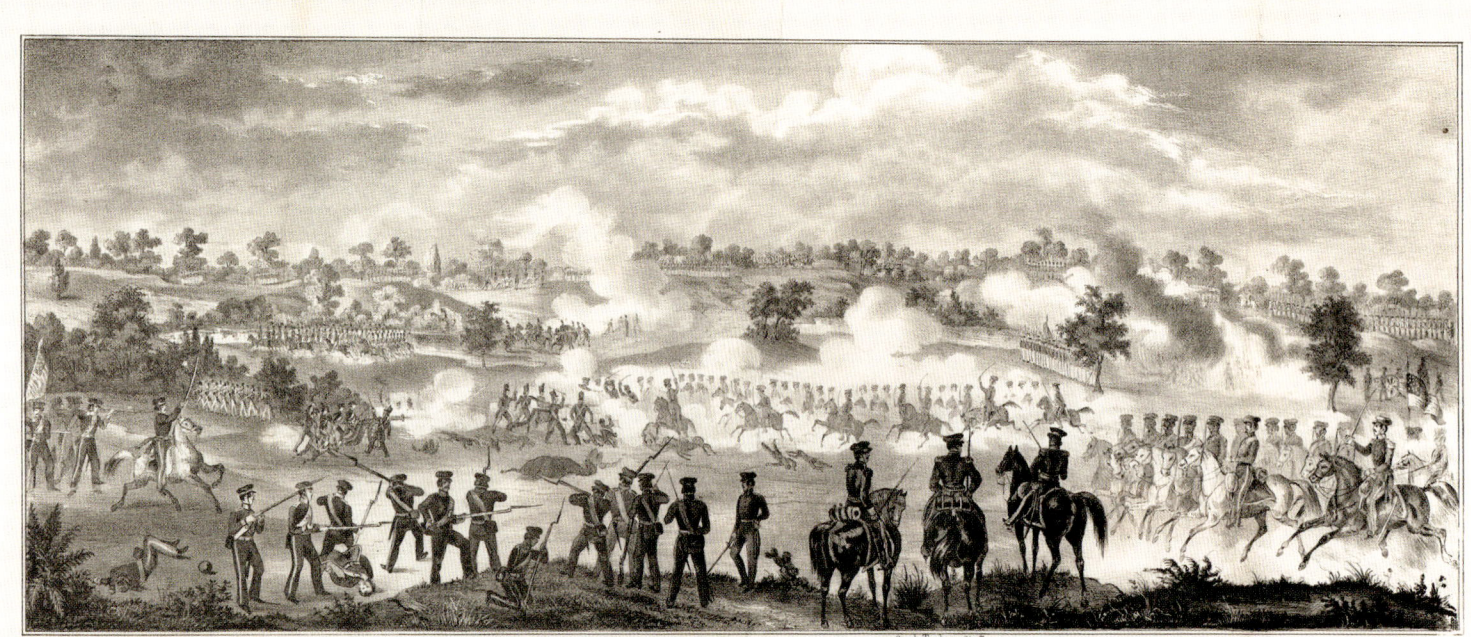
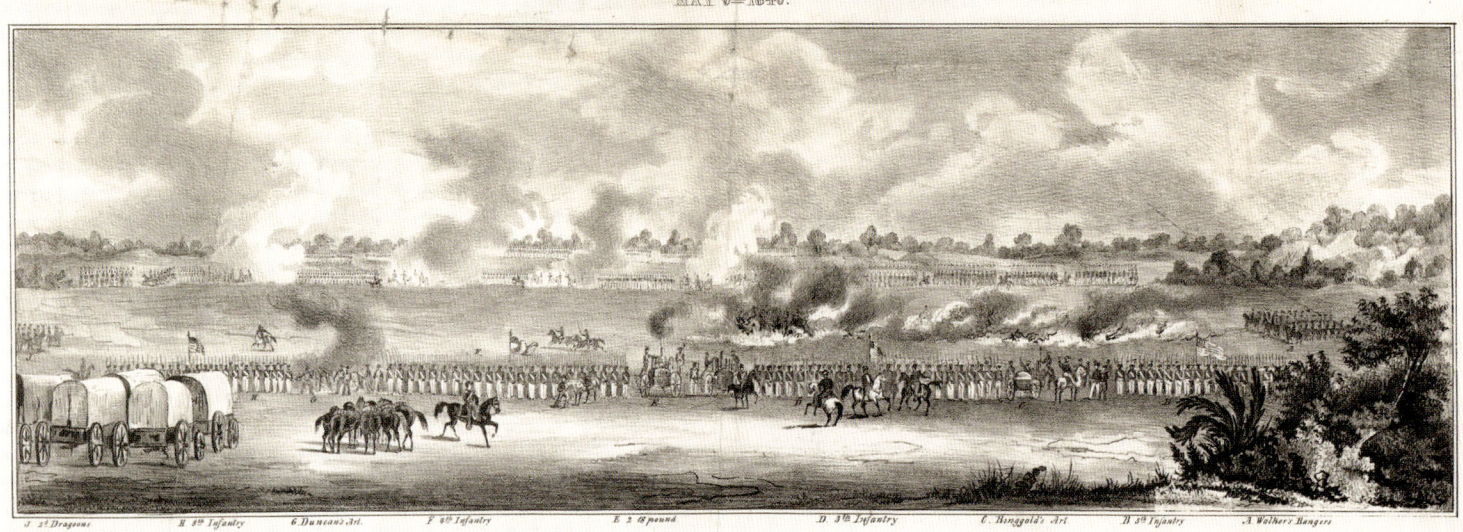

FIGURE 3.26 Emil Klauprecht after Angelo Paldi, *Battle of Resaca de Palma, May 9th 1846* (top); *Battle of Palo Alto, May 9th 1846*, 1846. Single sheet. Lithograph, 14.86 × 19.25 in., by Adolphus Menzel. Published by W. Wiswell, Cincinnati. Courtesy Prints and Photographs Division, Library of Congress.

Emil Klauprecht, editor of the German-language *Fliegende Blätter* in Cincinnati, opened his pictorial coverage of the war by borrowing from Reuben Gilbert and William B. Gihon's engraving of Thomas Bangs Thorpe's *Point Isabel*.[34] Klauprecht and Adolphus Menzel had established the first lithographic press in Cincinnati and continued their coverage of the war with an eyewitness print: Angelo Paldi's *Battle of Palo Alto, May 8th 1846*, in the August 28, 1847, issue of *Fliegende Blätter*. Paldi was a musician in the Fifth US Infantry and was with his regiment on the American right flank during the battle (fig. 3.26, top).

Following the battle the Mexicans withdrew about a half a mile to the shelter of a dense grove of chaparral and trees that extended some seven miles to the Rio Grande and took their position immediately behind one of the old river courses, which the Americans called Resaca de la Palma. Taylor advanced with fewer than two thousand troops, drawing up his forces across the *resaca* from the Mexicans. The battle began sometime after two p.m. and turned when a group of Americans found a trail that skirted the Mexican left flank. The Mexicans fell into a frenzied retreat for Matamoros, and the Fourth Infantry occupied the Mexican camp, capturing General Arista's correspondence and silver service in the process. Realizing that he could not hold Matamoros without thousands more troops, Arista abandoned the city on May 17, and Taylor occupied it the following day, bringing quiet to the Texas front.[35]

The only eyewitness lithograph of the battle of Resaca de la Palma is Paldi's, which Klauprecht published in the *Fliegende Blätter* on September 4, 1847, and later paired with the battle of Palo Alto on a single sheet with captions in English (fig. 3.26, bottom).[36] The progress of the battle is not as easy to follow as his *Palo Alto*, perhaps because it took place on more difficult terrain; nor does Klauprecht provide a descriptive key to help with the interpretation.[37] But the battle produced a second American hero in Capt. Charles May, who, according to initial newspaper accounts, captured Gen. Díaz de la Vega at the height of the battle. This incident received a great deal of publicity at home, leading Mexican War historian Justin Smith to declare May a "newspaper hero." He might well have added a "popular print hero" as well, for lithographers published at least nine prints of May's purported deed and several portraits.[38] (In fact, a bugler had captured the general.) Most of them, like Nathaniel Currier's *Battle of Resaca de la Palma May 9th 1846. Capture of Genl. Vega by the Gallant Capt. May*, depict May as a long-haired, bearded hero or, alternately, as a Roman centurion racing past a Mexican cannon to capture the general (fig. 3.27). All are probably based on the newspaper accounts and the fertile imaginations of the lithographic artists. The following year the *Tri-Weekly Flag & Advertiser* in Montgomery, Alabama, was still advertising a "splendid Lithograph of Col. May" that was available at Pfister's Book Store.[39]

Whiting, meanwhile, had joined Gen. Winfield Scott's forces as they marched inland from Vera Cruz, and, following the battle of Cerro Gordo, Scott granted Whiting's request to return to the United States

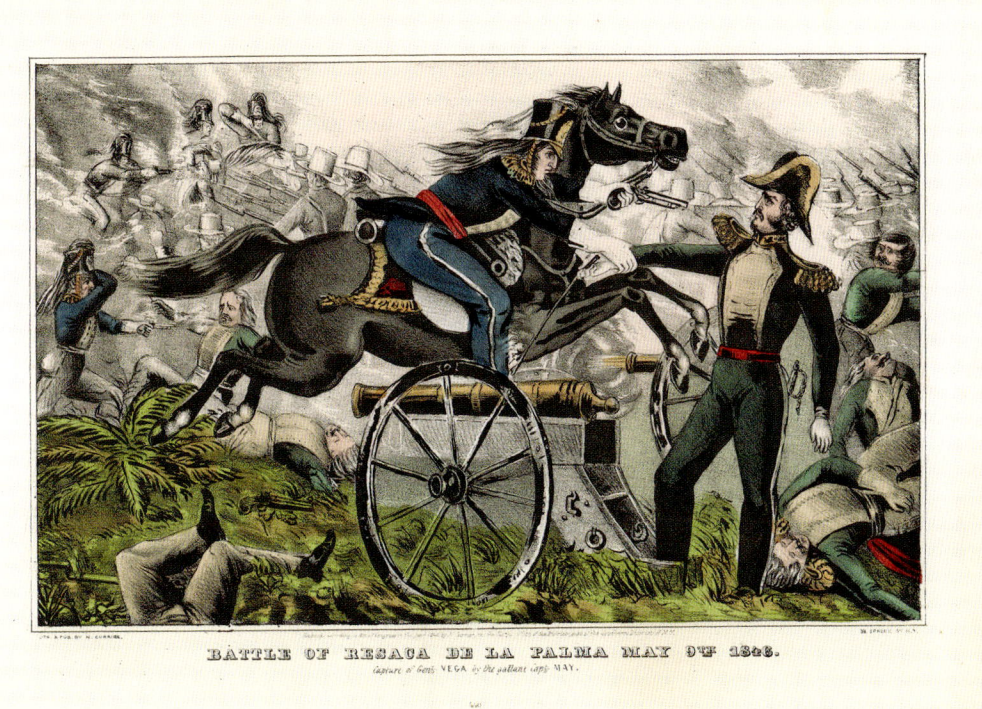

FIGURE 3.27 Unknown artist, *Battle of Resaca de la Palma May 9th 1846. Capture of Genl. Vega by the Gallant Capt. May*, 1846. Single sheet. Hand-colored lithograph, 8 × 12.75 in. (image), 10 × 14 in. (sheet), by N. Currier, New York. Courtesy Prints and Photographs Division, Library of Congress.

to oversee publication of his portfolio of paintings. Back home, and somewhat to his dismay, Whiting saw for the first time "the numerous exaggerated and spurious illustrations of a cheap character" that had "satiated public curiosity" about the war while he was away, and his investment proved to be "a sinking experiment."[40]

His *Army Portfolio No. 1* appeared at about the same time as Captain Henry's *Campaign Sketches*. While still in Mexico, Whiting had sent his sketches to his brother in Baltimore to arrange for publication, and the editor of the *New Orleans Picayune* saw them as they passed through that city, praising them for their "spirit and fidelity."[41] Through his brother, Whiting had employed Edward Weber—the lithographer who had printed the pictures for John Charles Frémont's popular *Report of the Exploring Expedition to the Rocky Mountains in the Year 1842*—to print the picture of Camp Marcy as an experiment. Lithographic artist Charles Fenderich, a German immigrant who had worked with Lehman & Duval in Philadelphia before moving to Baltimore, drew the picture on the stone, and Weber sent the proofs to Whiting in Mexico. But Whiting felt that Fenderich had "not done it justice," hence his request to return home to oversee the publication himself. He had Charles Parsons redraw the Camp Marcy plate on the stone, which G. & W. Endicott and Co. in New York printed. Endicott ultimately printed the entire portfolio of five plates plus text by the summer of 1847.[42] (See fig. 3.14, for example.) The other four plates are scenes of Monterrey and vicinity.

Unfortunately for Whiting, as the reviewer for the Washington, DC, *Daily Union* explained, public demand for images of the conflict had been overwhelmed by the "myriads of prints, hastily gotten up and roughly executed, representing scenes connected with the army in Mexico, [that] are flooding the country, and meet the eye in the windows of every print-shop." Nor did it help that, by the time his portfolio was on the market, General Scott's activities in the heart of Mexico absorbed "all native interest in the war," rather than Taylor's now-forgotten northern campaign. Whiting apparently had planned additional publications—hence the title *Army Portfolio No. 1*—but the commercial failure of the effort (family legend says that only twenty-four copies of this edition were issued), combined with the fact that many of his sketches were lost when the ship carrying them sank in the Gulf of Mexico, led him to abandon the effort. "Satisfied that nothing was to be hoped for from this abortive undertaking," he stopped work on further portfolios and went to visit his parents.[43]

Disappointed though he was, Whiting had produced a work that earned plaudits from many critics. The illustration of Camp Marcy, *Birds-eye View of the Camp of the Army of Occupation* (fig. 3.14), shows the camp and much of its activity, as soldiers drill, visit one another, and return from artillery maneuvers (in the lower right corner). The thin line of troops at the right might be returning from gathering wood, a hunt, or a scout. The two saloons and twenty to thirty houses that made up Corpus Christi when Taylor arrived can be seen stretching perhaps two miles southward along the coast from the left center, past the makeshift wharf, and up the hill in the distance.[44]

By August the portfolio was on sale in at least two New Orleans shops and was receiving good reviews from the editors of both the *Picayune* and the *Bee*. "These sketches are full of merit and are evidently the work of a skillful eye, who has a keen eye for nature and a nimble pencil in portraying the features," wrote the editor of the *Bee*. The *New York Knickerbocker* declared them to be "unmistakably faithful to the scene . . . a *complete* illustration of the military operations of our army in this portion of Mexico." But the greatest praise came from the *Washington Union*:

> It is gratifying to perceive a work like the above, entitled to the name of pictures, of great interest, in being authentic and accurate representations of the scenes they portray, being taken upon the spot, and, for the sake of their beauty, well worthy of a place on the most fashionable centre-table. . . . That there is no exaggeration in these pictures we are assured, not only by Captain Whiting himself, but by all the officers who have been in Mexico, who declare them to be most truthful representations of nature.

The price was one dollar per print, or four dollars for the set of five, including the text that accompanied each of them.[45]

Both the government and commercial publishers continued to issue prints of the war after the Treaty of Guadalupe Hidalgo (1848) ended hostilities. In 1850 the federal government published five much smaller lithographs of San Antonio and its missions from paintings done by Sgt. Edward Everett, a member of the Quincy Riflemen, First Regiment of Illinois Volunteers. Everett had arrived in San Antonio in 1846 with Gen. John E. Wool's Centre Division of Taylor's Army of Occupation. Because of his interest in architecture, he was quickly assigned the task of "making drawings of buildings and objects of interest, particularly . . . of San Antonio," and was given leaves of absence when necessary to accomplish his work.[46]

FIGURE 3.28 Edward Everett, *Ruins of the Church of the Alamo, San Antonio de Béxar*, 1847. Watercolor and ink over graphite on paper, 6 × 9.38 in. Courtesy Amon Carter Museum of American Art, Fort Worth, gift of Anne Burnett Tandy in memory of her father Thomas Lloyd Burnett, 1870–1938.

In September Everett made his first drawings of the now-historic Alamo, which had already been the subject of several other artists (figs. 3.28 and 3.29).[47] Then he turned to Mission Concepción and the more architecturally interesting Mission San José, "remarkable," he noted, "for its façade, which was elaborately carved in stone, scroll work, supporting statues of the Virgin and Saints, surrounding the entrance and the central window."[48] Everett's work was interrupted on September 11, when he was wounded in a *fandango* fracas while on guard duty and spent the next month in bed. Unable to accompany General Wool into Mexico, he was reassigned to the quartermaster department and the following spring participated in the renovation of the Alamo as military storehouse, offices, and workshops. He was honorably discharged in June 1847.[49]

Everett had no expectation that his watercolors would be published, but when he went to Washington to close out his accounts, he met Capt. George W. Hughes, chief topographical engineer for General Wool, who was preparing a report on the army's activities. Hughes liked Everett's watercolors and requested that he make duplicates of them so that he might include them as illustrations in his report. Hughes included lithographs after four of Everett's

FIGURE 3.29 Edward Everett, *Interior View of the Church of the Alamo*, 1847. Watercolor and ink over graphite on paper, 5.5 × 7.63 in. Courtesy Amon Carter Museum of American Art, Fort Worth, gift of Anne Burnett Tandy in memory of her father Thomas Lloyd Burnett, 1870–1938.

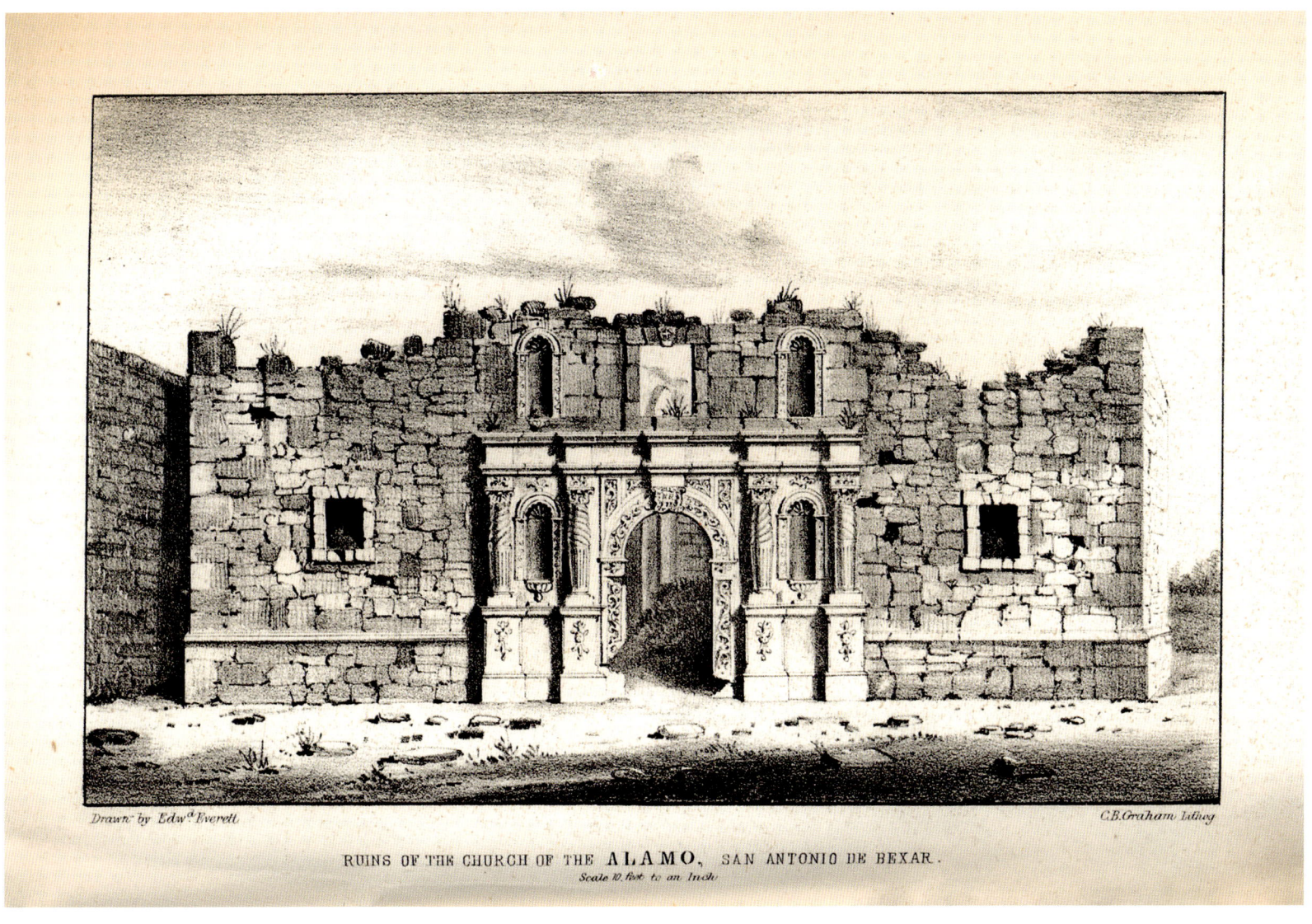

FIGURE 3.30 Edward Everett, *Ruins of the Church of the Alamo, San Antonio de Bexar. Scale 10 feet to an Inch*, 1847. Lithograph, 10.4 × 17 cm (image), 11.5 × 17 cm (comp.). Lithographed by C. B. Graham. From George W. Hughes, "Memoir Descriptive of the March of a Division of the United States Army" (1850). Courtesy Amon Carter Museum of American Art, Fort Worth.

watercolors—*Ruins of the Church of the Alamo* (fig. 3.30), *Interior View of the Church of the Alamo* (fig. 3.31), *Mission Concepción near San Antonio de Bexar* (fig. 3.32), and *Mission of San Jose near San Antonio de Bexar* (fig. 3.33)—among the eight lithographs in his published report. Hughes also included a view of San Antonio (fig. 3.34) by an unidentified artist, two pictures made near Monclova, Coahuila, and Everett's plan of the Alamo. Curtis Burr Graham of Washington printed the lithographs for Hughes's report. In 1848 Graham successfully bid on the lithographic illustrations for James W. Abert's report on New Mexico and William H. Emory's *Notes of a Military Reconnaissance, from Fort Leavenworth, in Missouri, to San Diego, in California*.[50]

The lithograph of the Alamo façade (fig. 3.30), made after Everett's watercolor, was not the first published picture of the famous structure, but it was the first to be lithographed from an eyewitness painting.[51] Drawn on the stone by Graham, the lithograph is

a faithful copy of the watercolor but does have some differences: the bright façade has been darkened and the rocks and foliage rearranged by the lithographic artist.

The interior of the Alamo (fig. 3.31), an unusual perspective drawn from the east looking westward through the nave and over the interior wall of the façade, is a more interesting composition. Perhaps with an eye toward the renovation that would soon be undertaken, Everett recorded some of the details of the interior still intact, despite the poundings of several battles. Most obvious is the extent of the damage and deterioration, but also apparent, as historian Richard E. Ahlborn points out, are significant architectural details, such as the place of each voussoir in the recessed arch of the north transept, recesses for supporting stones for the choir loft, and the doorway to the baptistry. Beyond the wall, Everett showed the dome of San Fernando church as well as the roofs of a few houses around the Main Plaza of old San Antonio across the San Antonio River.[52]

Everett's watercolor of Concepción (fig. 3.32) is interesting because some of the fresco colors are still faintly evident on the towers, color that is lost in the lithograph because it was reproduced only in black. The perspective is quite similar to that in a watercolor done by another soldier-artist, Seth Eastman, who was briefly stationed in San Antonio about a year after Everett left.[53]

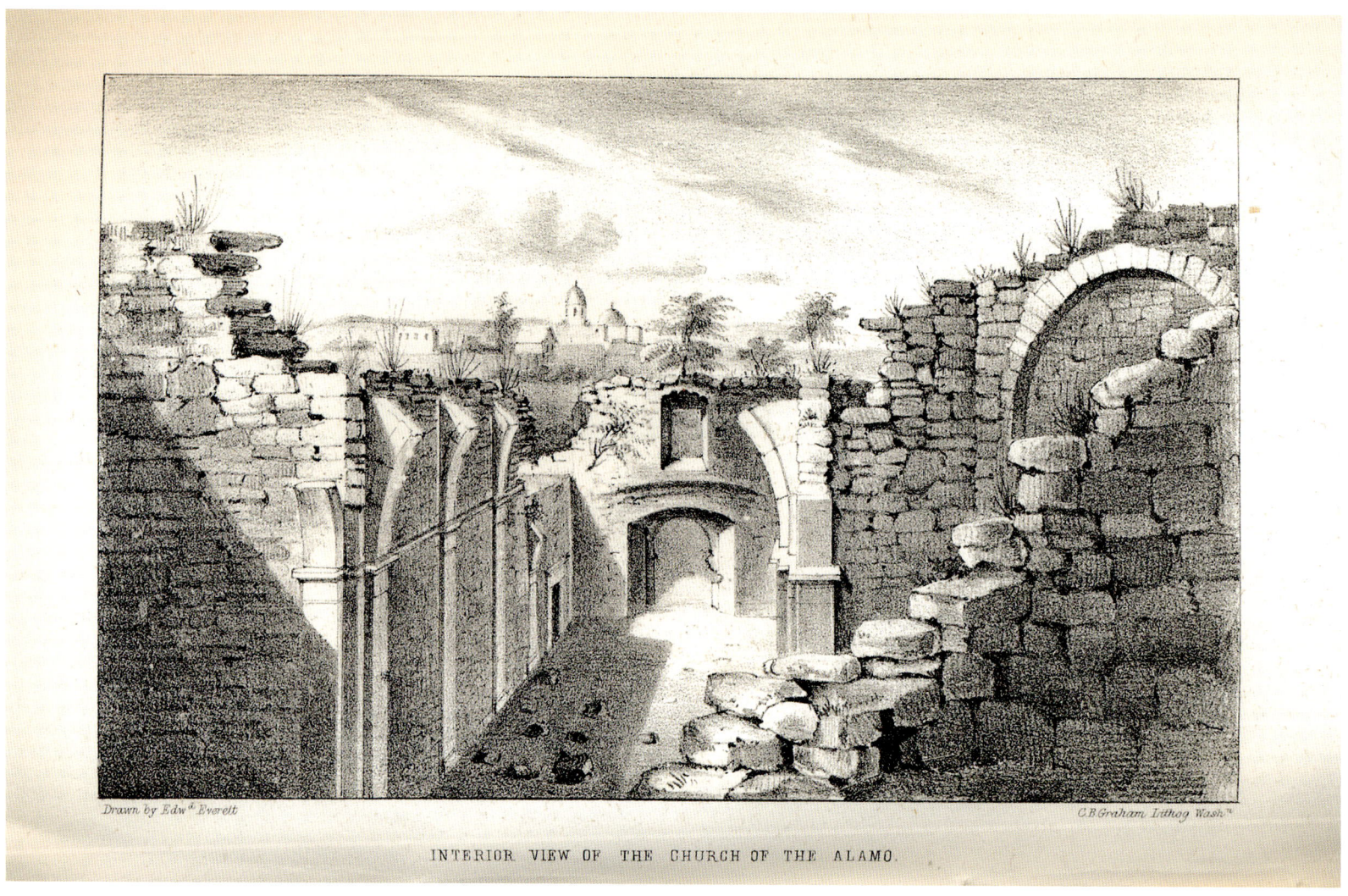

FIGURE 3.31 Edward Everett, *Interior View of the Church of the Alamo*, 1847. Lithograph, 10.4 × 16.9 cm (image), 11.3 × 16.9 cm (comp.). Lithographed by C. B. Graham. From Hughes, "Memoir Descriptive" (1850). Courtesy Amon Carter Museum of American Art, Fort Worth.

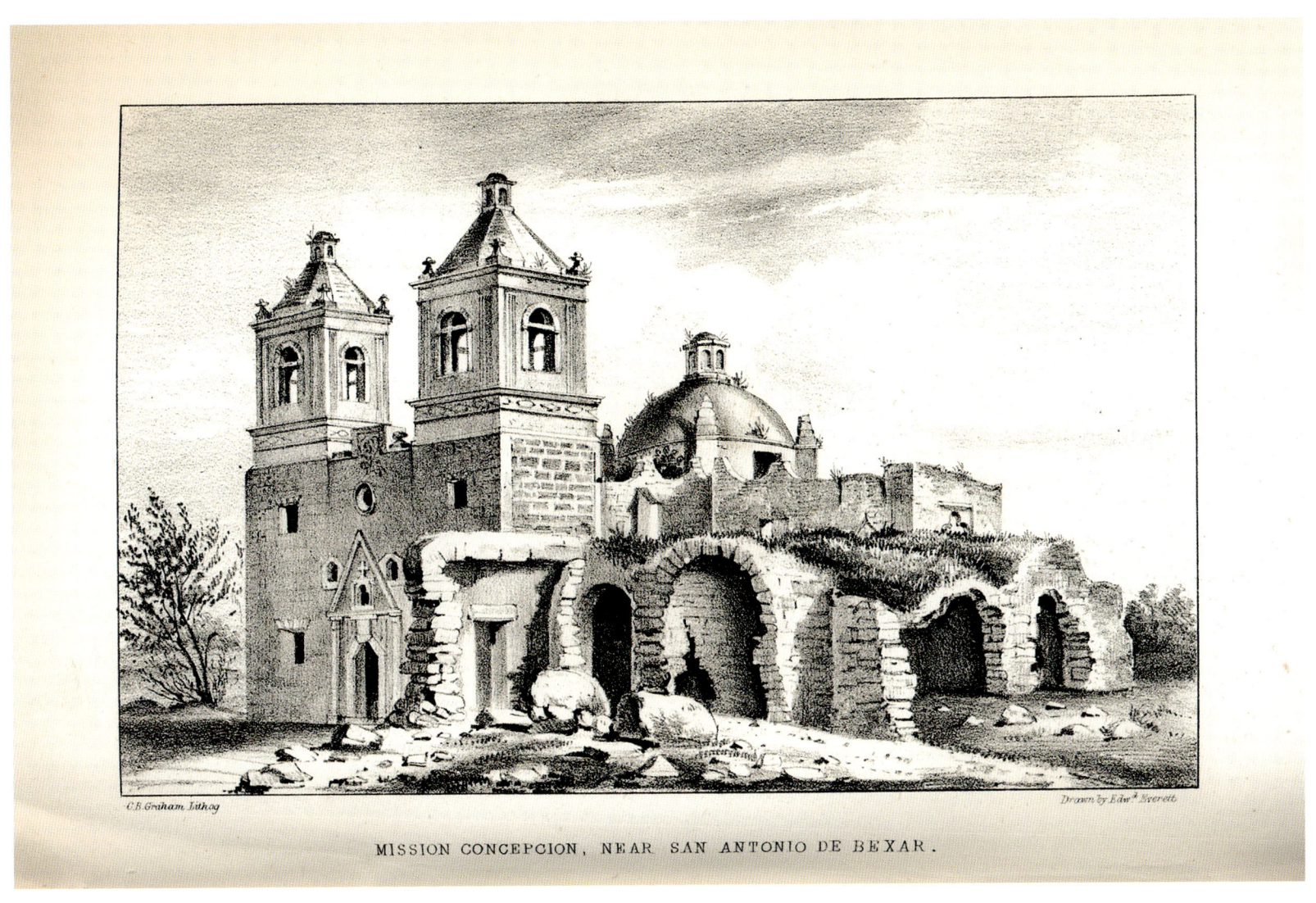

FIGURE 3.32 Edward Everett, *Mission Concepcion, Near San Antonio de Bexar*, 1847. Lithograph, 10.5 × 17 cm (image), 11.4 × 17 cm (comp.). Lithographed by C. B. Graham. From Hughes, "Memoir Descriptive" (1850). Courtesy Amon Carter Museum of American Art, Fort Worth.

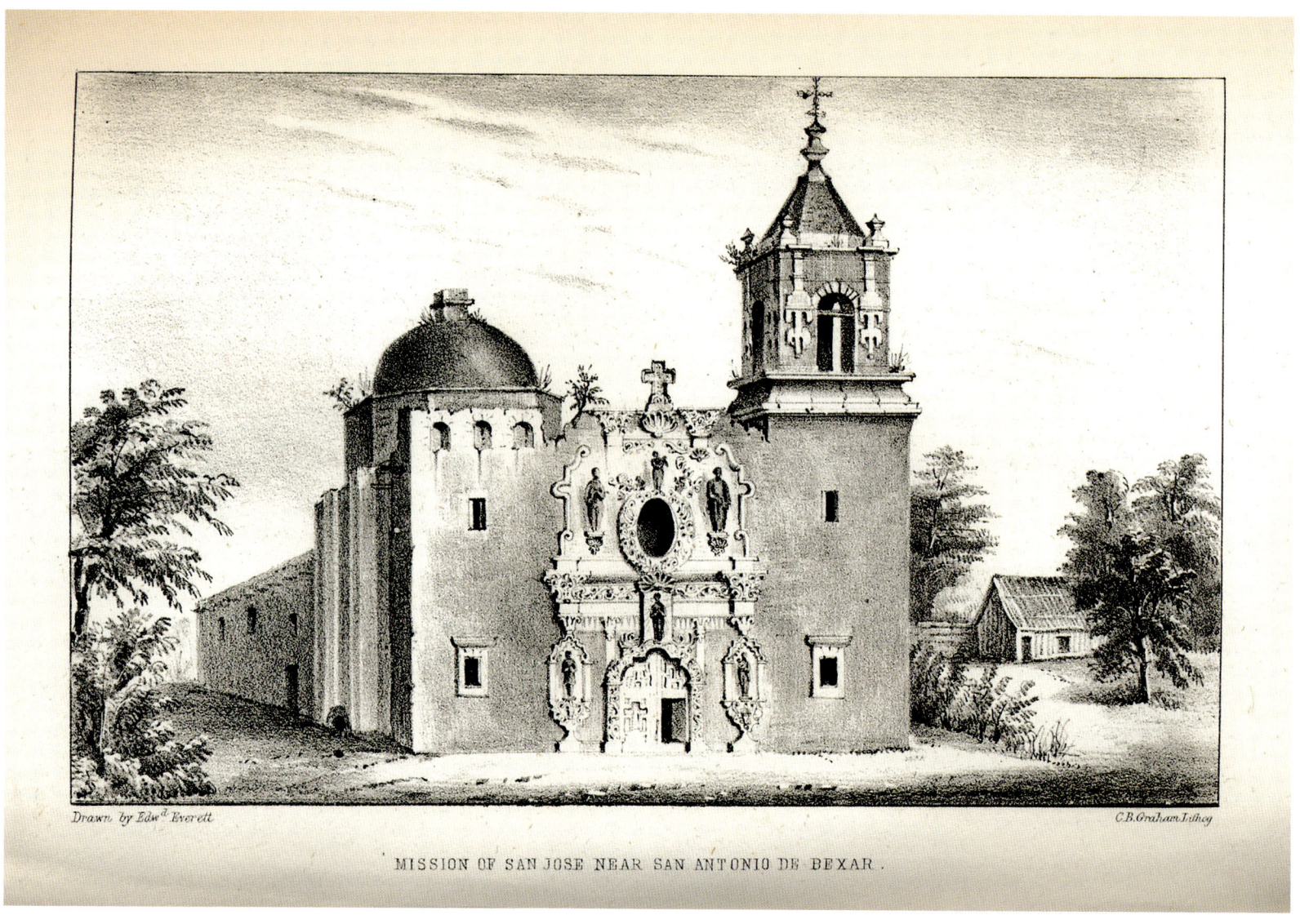

FIGURE 3.33 Edward Everett, *Mission of San Jose Near San Antonio de Bexar*, 1847. Lithograph, 10.4 × 16.9 cm (image), 11.3 × 16.9 cm (comp.). Lithographed by C. B. Graham. From Hughes, "Memoir Descriptive" (1850). Courtesy Amon Carter Museum of American Art, Fort Worth.

The lithograph of San José (fig. 3.33), the most architecturally elaborate of the San Antonio missions, is also rendered darker than Everett's watercolor, making it, in Ahlborn's words, "a ponderous, lonely structure." He pictured the church in the middle of a large courtyard with *jacals* and hovels around it, some occupied by "a few Texans, looking like bandits."[54] The San Antonio River, which runs east of the mission, is seen in the distance between the mission and the structure on the right.

The San Antonio de Bexar lithograph (fig. 3.34)—also perhaps by Everett, though he is not credited with it—shows the city from what appears to be the middle of the San Antonio River as it enters the city. The artist's perspective is from the northern side of the city looking south-southwest toward the Main Plaza and San Fernando church, which dominate the horizon in the distance. The artist was probably situated near the Houston Street crossing of the river, which did not get a bridge until about 1851.[55] This proved to be a

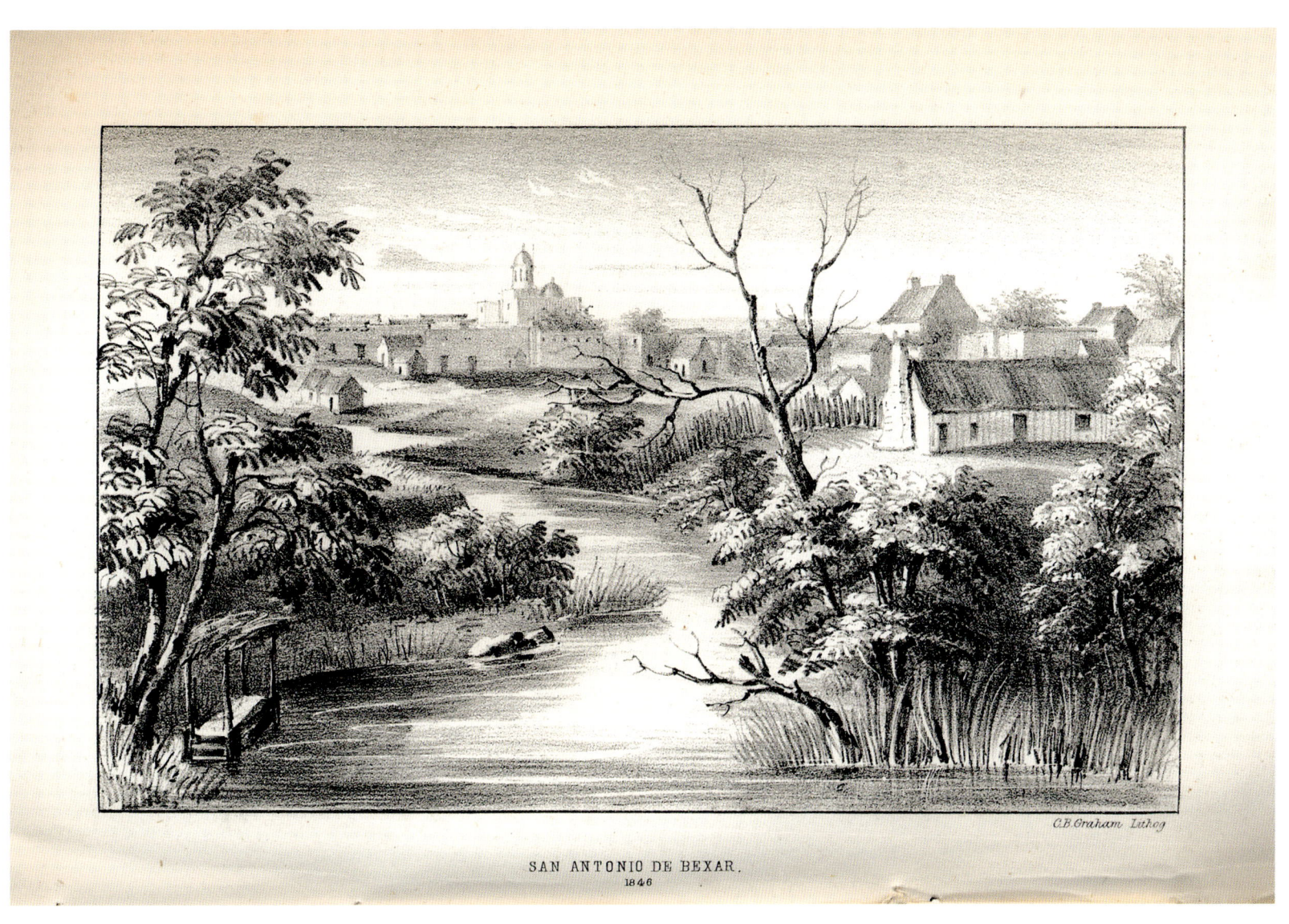

FIGURE 3.34 Unknown artist, *San Antonio de Bexar 1846*, 1846. Lithograph, 10.4 × 16.9 cm (image), 11.6 × 16.9 cm (comp.). Lithographed by C. B. Graham. From Hughes, "Memoir Descriptive" (1850). Courtesy Amon Carter Museum of American Art, Fort Worth.

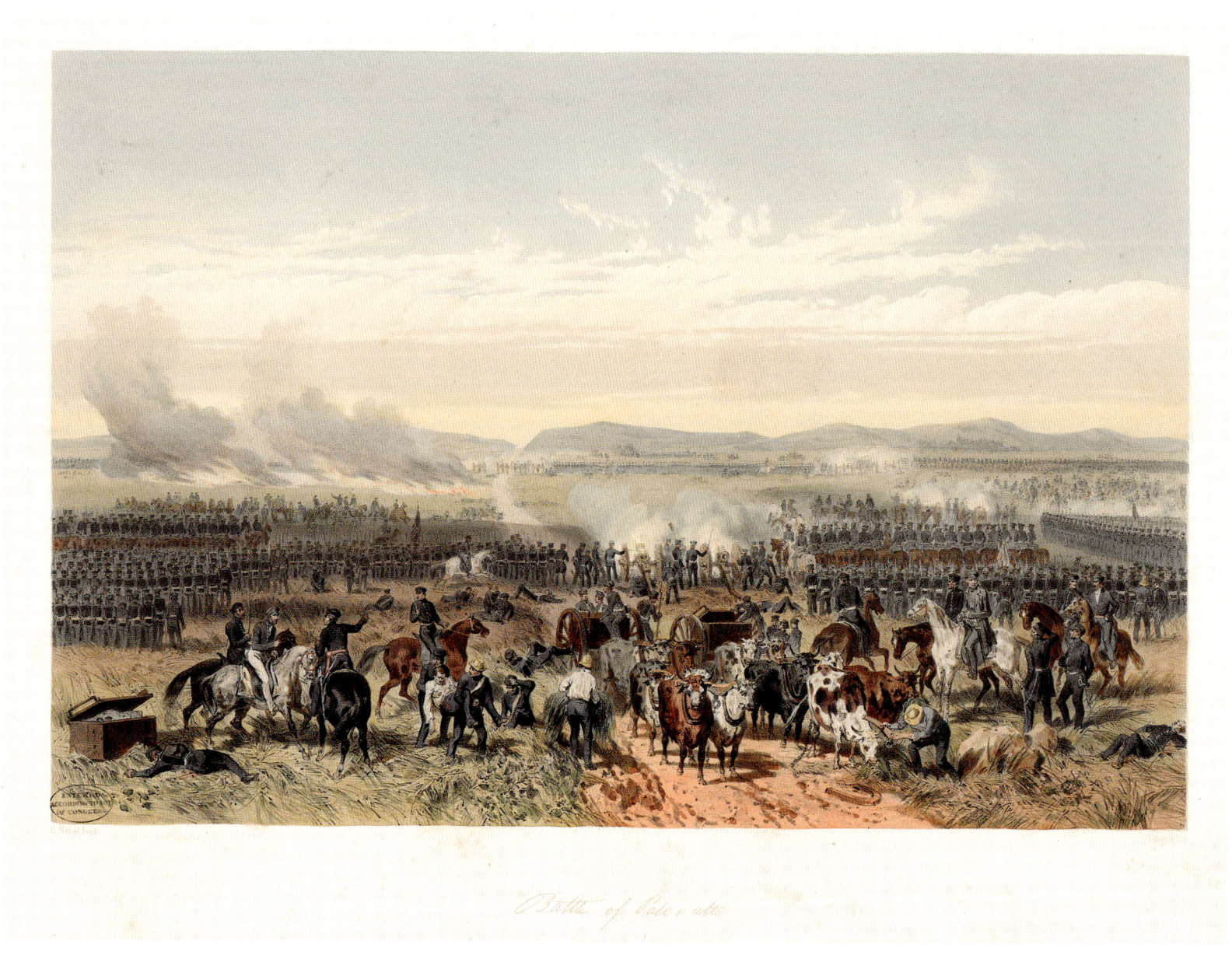

FIGURE 3.35 Carl Nebel, *Battle of Palo-Alto*, 1851. Hand-colored toned lithograph, 27.8 × 42 cm (image), 31.3 × 42 cm (comp.), lithographed by Adolphe-Jean-Baptiste Bayot [Paris]. From Carl Nebel and George Wilkins Kendall, *The War between the United States and Mexico, Illustrated* (1851). Courtesy Amon Carter Museum of American Art, Fort Worth.

popular perspective that several other artists adopted, such as the unnamed creator of the well-known view included in Herman J. Meyer's widely distributed *Universum* almost a decade later.[56]

By far the handsomest prints of the war are contained in George Wilkins Kendall and Carl Nebel's *The War between the United States and Mexico, Illustrated*, published in 1851. Eleven of the dozen scenes by the German artist Carl Nebel are of Mexico, but the first one is a careful depiction of the battle of Palo Alto (fig. 3.35). Kendall, the well-known editor of the *New Orleans Picayune*, was one of several correspondents who covered the war. He reached the Rio Grande on June 6, almost a month after Taylor's victories at Palo Alto and Resaca de la Palma, and spent time scouting with Ben McCulloch's rangers and setting up an express system to get his dispatches to New Orleans. He followed Taylor into northern Mexico and then accompanied General Scott on his march from Veracruz to Mexico City.[57] Within a month of the fall of Mexico City in September 1847, he had entered into an agreement with Nebel, whom he met in Mexico, to illustrate the book that he was already planning.

A university-educated engineer born in Altona, Schleswig-Holstein, on March 18, 1805, Nebel had been inspired by Alexander von Humboldt to travel to Mexico, and he spent the years from 1829 to 1834 sketching for what became his monumental *Voyage pittoresque et archéologique dans la partie la plus intéressante du Mexique*.[58] Nebel painted at least a dozen pictures for Kendall, and when Kendall left Mexico, his friends at the *Daily American Star* reported that he was on his way to Paris to oversee the production of the "splendid illustrations" for his forthcoming book, which they predicted would cost the extraordinary sum of $25.[59]

To reproduce the paintings, Kendall and Nebel chose the Paris firm of Rose-Joseph Lemercier, which had done a number of the lithographs for Nebel's *Voyage pittoresque*. Lemercier was known for new processes and technical innovations, including a method of spreading powdered lithographic crayon on a warm stone, then working it with a brush or a dabber to obtain delicate shadings for skies and water. Lithographers also struggled with how to make a graduated tint, and by the early 1840s Lemercier was experimenting with what he called his *lavis lithographique*, or graded washes on stone. The result was similar to that achieved by aquatint, which, by the time Kendall and Nebel began work on their portfolio, was vanishing as a commercial art.[60] Under the watchful eyes of both Nebel and Kendall, who approved each picture, lithographic artist Adolphe-Jean-Baptiste Bayot copied Nebel's pictures on stone, adding verisimilitude to the landscapes as well as the depictions of the troops and horses.[61] A comparison of Lemercier's work with, for example, the lithographs of C. B. Graham in Hughes's book (figs. 3.30, 3.31, 3.32, 3.33, and 3.34) shows not only Bayot's superior craftsmanship, but also superior lithographic stones, probably Bavarian limestone from the Solnhofen quarries. Kendall later claimed that more than sixty workers were involved in the process of printing and coloring the lithographs, which was so demanding that only 120 prints could be finished each month.[62]

Returning to New York to negotiate a contract for the distribution of his book, Kendall apparently went first to Harper & Brothers, the publisher of his earlier *Narrative of the Texan Santa Fé Expedition*, but ultimately reached an agreement with D. Appleton & Co.: he would supply the book to Appleton on a regular basis, fix the retail price based on the quality of the binding, and pay Appleton a five-dollar-per-copy commission for every book sold. Then he proceeded to New Orleans, where he showed an advance copy to his colleagues and arranged for agents to sell it up and down the Mississippi River.[63]

His editorial friends in New Orleans quickly shared their enthusiasm with their readers:

> We have never seen anything to equal the artistic skill, perfection of design, marvellous beauty of execution, delicacy of truth of coloring, and lifelike animation of figures. . . . They present the most exquisite specimens ever exhibited in this country of the art of colored lithography. . . . Mr. Kendall's pictures, with all their beauty as finished works of consummate art, are exact delineations of the topography and natural scenery . . . and true representations in every point of the military positions and movements. . . . The officers of the army who went through the war assure us that the accuracy of the representation of these famous spots is like daguerreotyping.[64]

Back in Paris in December 1850, Kendall gave the correspondents for the *New York Herald* and the *New York Journal of Commerce* advance looks at the book. It is "one of the most superb works of art ever achieved in Paris," the *Herald* reporter gushed. "The fidelity of the landscapes, and the truthfulness of every point introduced into the pictures, cannot but be at once acknowledged and appreciated by the best connoisseur." The "large folio" contained a superb history of the war with the equivalent of three hundred pages of text, he said. "Nothing of the kind can be more graphic, natural and impressive," the

Journal of Commerce writer agreed. When the first copies reached New Orleans, the *Picayune* advertised it in three different formats: text and plates in paper covers for $34; in "elegant portfolios" for $38; and half bound for $40. That would be the rough equivalent of $600, $675, and $710 today, depending on the scale used—not an inexpensive book and well beyond the $25 that his friends at the *Daily American Star* had predicted. *Spirit of the Times* called it "the most magnificently printed, and illustrated volume, we have ever seen." Even *El Universal* in Mexico City noted its publication.[65]

Kendall claimed accuracy for the prints, writing that "the greater number were drawn on the spot by the artist. So far as regards the general configuration of the ground, fidelity of the landscape, and correctness of the works and buildings introduced, they may be strictly relied upon."[66] With Nebel, of course, Kendall had an artist of considerable reputation whose understanding of Mexico was acknowledged. To inform his pictures, Kendall drew on official reports and memoirs from various field commanders, and on "such advantages . . . as may be derived from having been present at many of the battles, and of having personally examined the ground on which all save that of Buena Vista were fought." Of course, "every reader must be aware of the impossibility, in painting a battle scene, of giving more than one feature or principal incident of the strife," he explained. "The artist has chosen what he deemed the more interesting as well as exciting points of each combat, and trusts that the public may excuse any errors which may be discovered."[67]

The pictures lend themselves to a claim of accuracy, for they look real, especially when compared with the prints that most of the other lithographers were producing. Rather than the traditional history painting or caricature, Nebel created a virtual illustrated map that pictures the armies in such a way that the strategies and events of battle can be followed. The fact that the pictures may be readily interpreted by referring to the official accounts only adds to their credibility and makes them seem a straightforward and comprehensive effort to reconstruct the actual events. Indeed, the "strongest testimony to the correctness of the position of the troops when in 'battle-array'" came from the "participators in the bloody conflicts described," according to the *Knickerbocker*.[68] And, while Nebel supposedly visited most of the battle sites, he probably did not see the only Texas scene in the portfolio, Palo Alto, and likely depended on Kendall for documentation from government reports, eyewitness accounts, and, perhaps, published pictures to reconstruct his *Battle of Palo-Alto*.[69]

The scope of Nebel's picture—encompassing the entire battlefield—means that one must look carefully at the details to appreciate the "realness" of his depiction. Ulysses S. Grant, a young second lieutenant in Taylor's army, noted the Mexican bayonets and lances glistening in the sun as he prepared for his first battle. The tall grass—"very stiff . . . and hard and almost as sharp as a darning-needle" stood shoulder high—and inferior gunpowder slowed down the Mexican cannonballs bounding along, permitting the American troops to dodge most of them—yet the "shot flew thick and fast, doing great execution," including Ringgold, the brilliant artillery tactician. A closer look makes clear the casualties of war.[70]

Much of the Mexican force is obscured by smoke from the wind-whipped wall of flame racing through the tall grass, which suspended action for more than an hour. Beginning at the left center and moving to the right, Nebel depicts five 4-pounders, the First, the Sixth, and the Tenth Infantries, the Fourth Infantry (which joined the battle late with its two 8-pounders), and, in the foreground, General Taylor sits almost casually on Old Whitey. At the far right the Americans repulse Brig. Gen. Anastasio Torrejón's cavalry, which is trying to outflank Taylor and attack the supply train at the rear. On the American side, Nebel shows (from left to right) Col. James Duncan's artillery (which has set the prairie grass on fire), the Fourth Infantry (behind Duncan's battery), the two 18-pounders in the road (with their caissons and oxen behind), and Ringgold's battery and Colonel Twiggs's Fifth Infantry drawn up in a square.[71] The only military aspect of the print that seems inaccurate is the location of the 18-pounders astride the road to the fort, when, apparently, they were a couple of hundred yards to the east (left) of the road.

Nebel adopted a practice in the Palo Alto print that turns up in some of his other prints as well. He pictures the road as it continues behind the Mexican lines through a pass in the hills beyond, suggesting that this segment in the road to Mexico City—the route from Point Isabel to Fort Texas and Matamoros—will be open as soon as the American troops have cleared the way.[72]

Those hills beyond, however, seem to confirm that Nebel did not visit the site. He probably depended on Kendall's description and, perhaps, on several publications that came out soon after the war began, such as Thorpe's book *Our Army on the Rio Grande*, which contains a depiction: *Battle Field, Palo Alto—Mexican Army Drawn Up in Battle Array* (fig. 3.36). Whereas Thorpe and Paldi correctly depicted the tree line on the horizon, Nebel apparently mistook it for mountains and enhanced them in his picture. The Palo Alto battlefield, of course, is a flat, coastal prairie obscured by stands of

BATTLE FIELD, PALO ALTO—MEXICAN ARMY DRAWN UP IN BATTLE ARRAY.

FIGURE 3.36 Thomas Bangs Thorpe, *Battle Field. Palo Alto—Mexican Army Drawn Up in Battle Array*, 1847. Engraving, 9.3 × 15.1 cm. From Thomas Banks Thorpe, *Our Army on the Rio Grande* (1846). Courtesy Special Collections, University of Texas at Arlington.

chaparral and mesquite trees.⁷³ Presumably, Kendall would have noticed this mistake but, perhaps, yielded to its aesthetic contribution.

The forgotten person in the production of these tens of thousands of prints is the colorist, most often young women (usually nameless insofar as the records are concerned) but also including twenty-seven-year-old John Henry Hopkins Jr., an amateur artist and future clergyman, who reacted to the unprecedented deluge of prints in verse, "The Print Colorer's Lament," in 1847:

> *Dame Fortune, that mad, cross-grained wench,*
> *Has fastened me down to a table and bench,*
> *Where, from breakfast time till I go to bed,*
> *Great piles of lithographs, high as your head,*
> *Before me stand;*
> *While, brush in hand,*
> *And surrounded by saucers of various tints,*
> *I must bend to the labor of coloring prints!*

He continued, in a later verse:

> *Our troops, you know,*
> *In Mexico,*
> *Have bravely met and thrashed the foe;*
> *Three days they fought at Monterey,*
> *And, in the fierce and fatal fray,*
> *A thousand Mexicans did slay.*
> *Now I my share of the glory crave,*
> *A soldier steady, true and brave;*
> *For, during this long and desperate fight,*
> *I forsook not my colors, day or night. . . .*
> *Nor is it enough that, day by day,*
> *I lose my flesh and toil away,*
> *With Pocket never fuller'*
> *That close confinement makes me ill,*
> *And with declining health, that still,*
> *My wit grows daily duller:*
> *My vote they mean to take away,*
> *Because that now, the rascals say,*
> *I am a man of color!*⁷⁴

In an age when race was a part of daily discourse, Hopkins obviously intended the double entendre.

Two major issues animated lithographers in the 1840s: the impact of Texas annexation on the 1844 presidential election and the war with Mexico, and they kept the issues of Texas statehood and slavery before the public throughout the decade. Then, out of the cauldron of expansionism and sectionalism in 1848, artists picked up a powerful phrase that had caught the country's attention—"manifest destiny"—and rhetorically motivated American migration westward (a push soon to be helped along by the discovery of gold in California). In *The Modern Gilpins*, caricaturist James Magee parodied the Democratic Party and its annexationist-minded presidential nominee, Lewis Cass, who sits with his allies, Thomas Hart Benton and Levi Woodbury, astride a giant runaway sow headed for Salt River (fig. 3.37). (Magee depicts them as "Modern Gilpins" after the namesake in William Cowper's *Diverting History of John Gilpin* [1785], in which the hero comically loses control of his horse.) Wielding a sword labeled "annexation," Cass orders the road to be cleared because "we are fulfilling our manifest destiny!"

Even in the face of such popular sentiment, however, not everyone took these ubiquitous prints seriously. Several years after Polk's election, E. G. Huston, attorney and editor of the *San Antonio Texan*, expressed his disdain for the faddish caricatures, recalling that a "large lithographic house in New York" had expected Van Buren to be the Democratic nominee in 1844 and printed a huge number of likenesses with the title "Our next President." When Polk won the nomination, the lithographer simply printed "James K. Polk of Tennessee" at the top of the lithographs and quickly disposed of the entire batch to an apparently gullible public.⁷⁵ The story is hearsay—Huston provides no further details—but it represents the opinion of an informed and articulate observer as to the impact, if not the accuracy, of the popular prints.

At the same time, the precision attributed to Nebel's and Whiting's prints of the war represents an altogether new level of concern for rigor and detail that was soon at the service of expansion again. As the country began to explore the prizes of conquest, the more than six hundred thousand square miles of territory that the United States had gained in the war with Mexico and in the Oregon Territory settlement with Great Britain, it turned to the nation's artists and lithographers—and to the accuracy characterizing the early eyewitness prints—to help comprehend, through the many resulting publications, the developing "continental consciousness," including the geographical extremities of Texas.⁷⁶

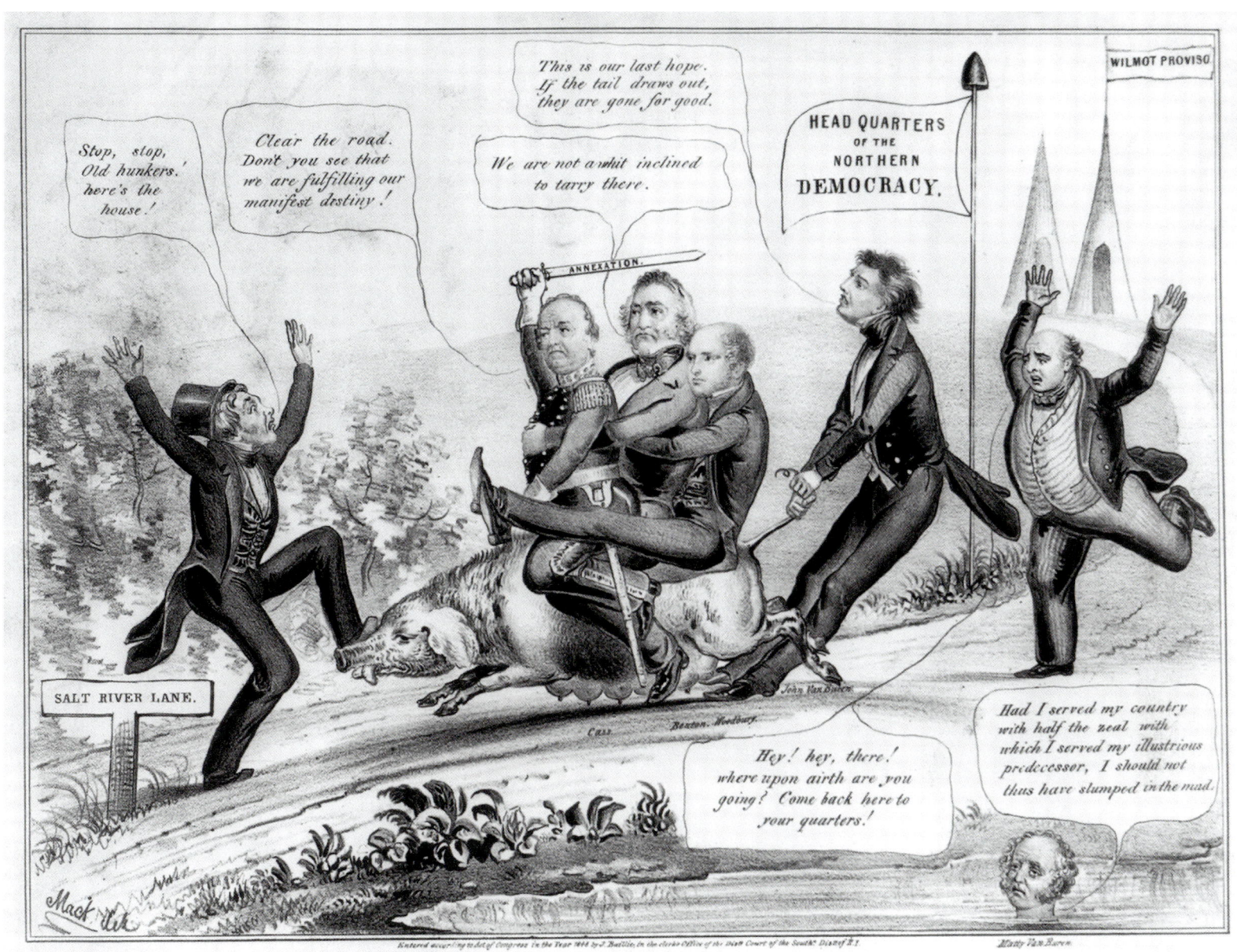

FIGURE 3.37 John Magee (attrib.), *The Modern Gilpins. Love's Labor Lost*, 1848. Single sheet. Lithograph, 31.2 × 39 cm (image), by James Baillie, 87th Street near 3rd Ave., New York. Courtesy Prints and Photographs Division, Library of Congress.

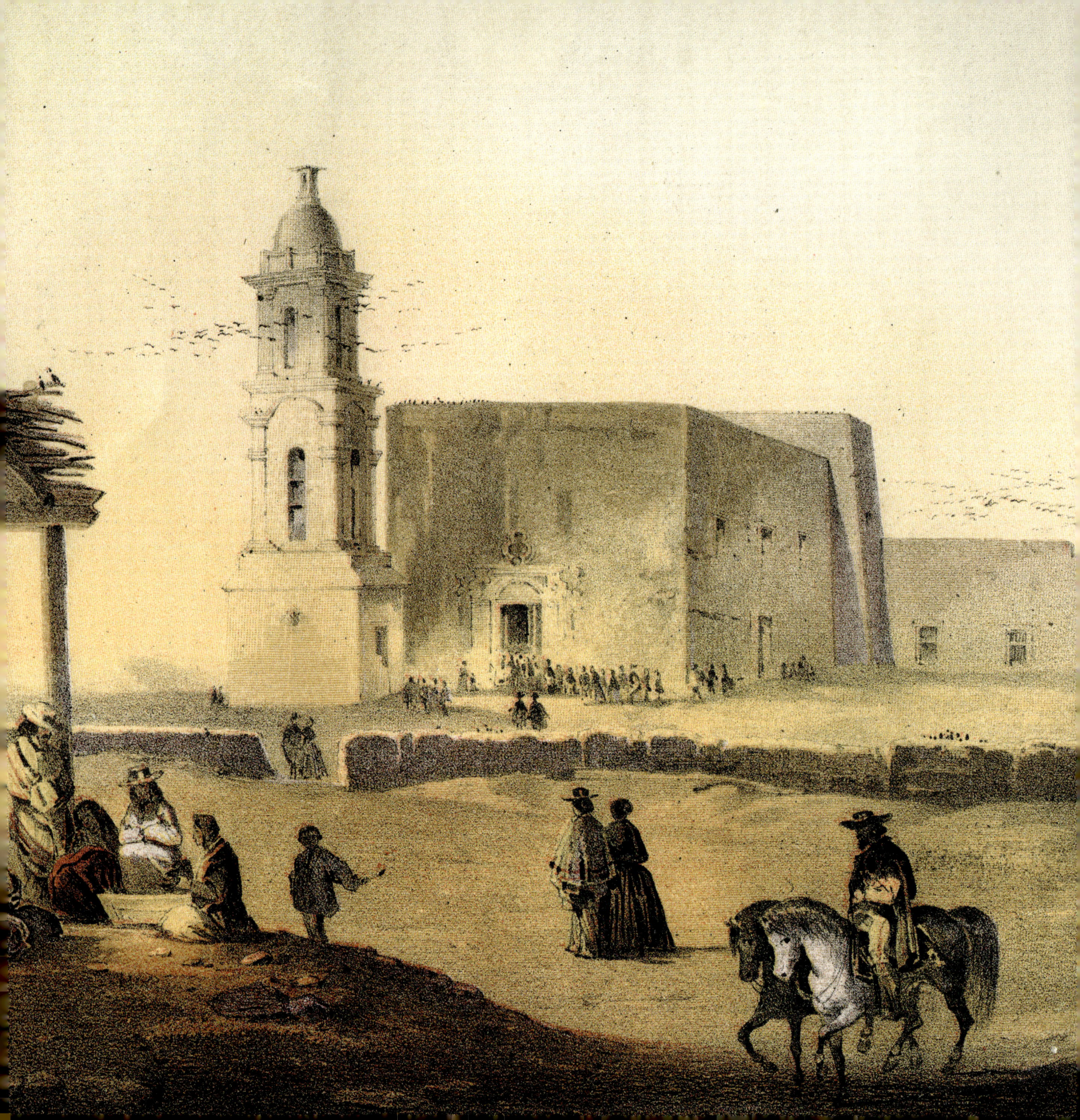

CHAPTER 4

"A PERFECT TERRA INCOGNITA"

SURVEYS OF TEXAS

Americans knew little more of Texas in 1846 than they did of the far West. The many maps, books, newspaper stories, and separately issued prints told the curious public little about the new state except that it had a raucous reputation and lots of fertile, inexpensive land that depended on slavery for successful cultivation. Cartographer Henry S. Tanner suggested in his 1845 map of Texas another unresolved problem when he designated a north-south swath of land west of Austin and San Antonio as the "Range of the Comanches" and showed the trans-Pecos as controlled by the Apaches.[1] That would change in the decade following the war with Mexico, as the federal government established a line of forts along the western edge of settlement and several engineering and scientific expeditions, often accompanied by artists, crisscrossed the state gathering topographical, geographical, natural history, and pictorial data. The lithographs that resulted from these excursions were the first published pictures of what Charles De Morse of the Clarksville (Texas) *Northern Standard* called a "perfect *terra incognita*." But until that moment, as historian Bernard DeVoto memorably wrote, "Manifest Destiny was blindfolded."[2]

The Llano Estacado formed a physical as well as human barrier to travel and settlement. A number of explorers and traders had crossed it via the Canadian River, including the Mallet brothers, Pierre and Paul, in 1739, Col. Stephen H. Long on his return from the Rocky Mountains in 1820, and Santa Fe trader Josiah Gregg in 1840, but there were no reliable maps to guide the men of the ill-fated Texan Santa Fe Expedition who in the summer of 1841 gave themselves up to Mexican forces rather than perish in the desert.[3] In his book on the Great Plains, University of Texas historian Walter Prescott Webb echoed the words of Capt. Randolph B. Marcy, who first traversed the plains in 1849 and pointed out that the climate changed dramatically at the 98th meridian: much less rain; no trees except along the river courses; and a brutal, extreme climate, hot in the summer and cold in the winter. In short, a desert. "It is an ocean of desert prairie, where the voice of man is seldom heard," Marcy wrote, "and where no living being permanently resides." Americans approached it warily. But the Comanche Indians, who in the eighteenth century had migrated southward from what today is the Wyoming area, quickly made it their home. Adapting to the wild mustang to become the ablest mounted warriors on the continent, they carved out their own empire as the "lords of the South Plains."[4]

CREATING THE AMERICAN IDENTITY

By the time the engineers, artists, and surveyors took the field following the war with Mexico, many of their resulting images reflect a major change in American perception. A new coterie of artists had begun to paint the American landscape in the 1820s and 1830s. Heavily influenced by both scientific rigor and Romantic ideals, these artists, following the example of Thomas Cole and the members of what became known as the Hudson River school of painting, sought a distinctive American identity. Along with writers such as Henry David Thoreau and Ralph Waldo Emerson, they concluded that the pristine wilderness was the intrinsic, formative characteristic of the new country. Their paintings emphasized the natural beauty of the Hudson River valley, the Adirondacks, and the Catskills, ranging from scenes of the picturesque (idealized but realistic looking) to the sublime (overwhelming, emotional scenes of nature's power and violence). Later generations of artists—Frederick Church, Albert Bierstadt, W. Worthington Whittredge, and Thomas Moran, among others—painted South America, Mexico, and the American West as landscape painting became the most popular and influential art in America, with patrons usually preferring images made directly from nature rather than the artist's scenic but imaginary compositions.[5]

These ideals entered the curriculum of the United States Military Academy at West Point in 1830s when two young artists, Robert W. Weir and his assistant, Lt. Seth Eastman, joined the faculty. Weir believed that his students should be schooled in the principles of freehand drawing and encouraged them to sketch the scenery up and down the Hudson River. Eastman wrote *Treatise on Topographical Drawing* for use in the classroom, which espoused a precise and systematic form of drawing. The essential skill he wanted to impart, of course, was mapmaking for military purposes, but he also emphasized accuracy in topographical drawing in language that sometimes approached that of the Romantic landscapists of the Hudson River School. When drawing rocks, for example, he proposed that "the best rule that can be given is to imitate nature." The *Treatise* provided the geometrical explanation for converting a topographical plan into a perspective drawing. "The great utility of a topographical drawing, in a military point of view," Eastman explained, "consists in enabling the officer to ascertain with sufficient accuracy what obstacles will be presented to his ascent, and to what extent the ground will admit of manoeuvres."[6]

At the same time, photography, which appeared in 1839 at precisely the right moment to be employed during the government surveys, seemed to offer hope for reliable and easily obtained images that would be more inherently credible than drawings. But photography entailed technical problems such as those experienced by 2nd Lt. John Charles Frémont on his 1842 expedition, when he failed to properly expose any daguerreotype plates. The engineers soon realized that while a photograph was a seemingly accurate document of the scene that appeared before the lens, it might not serve the same purpose as a good topographical drawing.[7] As landscape artist Alfred E. Mathews later argued, "The lens of the instrument must be adjusted to focus on a certain object or objects; and all others more distant, or nearer, will be more or less indistinct." In a topographical drawing the viewer is "situated above, and looking down equally upon every part of" a landscape, according to a contemporary textbook.[8] As a result, for decades exploring parties depended on artists to document the expeditions, even if a camera made up part of their field equipment.

By the time Texas joined the Union, the only American expeditions to include artists had been those of Long, Lt. Charles Wilkes on his circumnavigation of the globe from 1838 to 1842, and Frémont's Rocky Mountain excursions—testifying, perhaps, to the difficulty of obtaining good images under the rudimentary conditions of an exploring party. With such difficulties in mind, Joseph Drayton, a veteran draftsman of the Wilkes expedition, advised artist Edward M. Kern, who was preparing to accompany Frémont on his third expedition, that he needed to take "lots of coloured pencils," a camera lucida, and watercolors. "Make full notes of colours & everything els on the back of the drawings, and . . . always finish your drawings on the spot, as much as possible."[9] These trained artists, both military and civilian, were children of the scientific revolution and the European enlightenment and sought to factually document discoveries as they made them. Schooled in the Baconian tradition of close observation, and aware of Newton's and Locke's demand for accurate description (and depiction), they were heirs of the German tradition of scientific travel—apodemnics—that was taught for generations at the University of Göttingen.[10] They crisscrossed the state of Texas, sketchbooks in hand and lithographers waiting.

Although the art of the surveys was, in a larger sense, a conscious effort by artists to capture and transmit to the viewer their profound impressions of the grand landscapes they beheld, they also catalogued and illustrated fossils, flora and fauna, and the people they encountered. As the nation pushed westward, overwhelming

native populations and foreign governments, Americans accepted that God revealed himself in nature—whether through a pristine, perfectly flat, and treeless plain or a sublime canyon—and that these exotic blessings were uniquely theirs in North America.[11] These convictions were not as evident in pre–Civil War Texas, where many settlers struggled to survive and lived in constant anxiety because of the formidable Native American tribes, but their logical conclusion was to be found everywhere. As editor and soldier John S. "Rip" Ford of the *South Western American* wrote, "Such is the 'manifest destiny' of the American people."[12]

EXCURSION INTO MEXICAN TERRITORY

The first expedition to produce a published lithograph of a Texas scene was that of Lt. James W. Abert in 1845 (fig. 4.1).[13] Educated at Princeton and West Point, Abert had accompanied Captain Frémont on his third expedition into the West in 1845, one of two major expeditions that the federal government sent into Mexican territory as it appeared that war with Mexico might be imminent. Frémont's announced goal was to find the source of the Arkansas River, then the boundary between the United States and the Mexican Southwest. But when they reached Bent's Fort in present-day southeastern Colorado, Frémont headed to California, where he would within a few months help instigate the Bear Flag Revolt, and sent Abert back through the heart of the Comanche empire, one of the most desolate and forbidding regions on the continent, with orders to explore from Bent's Fort southward and eastward along the Canadian River to its junction with the Arkansas.[14] Abert knew that it was a potentially dangerous assignment, for "an Indian who knew well the country, and was a man of great influence, especially among the Comanches" had refused to guide the expedition. Instead, Thomas "Broken Hand" Fitzpatrick, an experienced mountain man and scout, joined Abert.[15]

The son of Col. John James Abert, head of the Topographical Engineers, young Abert, a recent West Point graduate, and his classmates had probably studied topographical drawing with Lieutenant Eastman, an artist of considerable talent, and were among the first to study his brief *Treatise on Topographical Drawing* as they sketched along the Hudson River.[16] A member of the expedition remembered Abert as "a gentleman in every sense of the term. He threw aside the uncondenscion which marked the overbearing exterior of Capt Frémont.—he did not appear like the former to entertain a higher

FIGURE 4.1 Unknown photographer, James W. Abert, c. 1864. From Joshua L. Chamberlain, *Universities and Their Sons* (1900), vol. 5, 334. Courtesy Wellcome Library, London.

opinion of himself than anybody else did, but on the contrary he rode along with, conversed with,—hunted with his men, and even considered it no disrespect toward himself, for anyone to put on a cleaner shirt."[17]

On August 9, 1845, while General Taylor was more than nine hundred miles to the southeast and trying to get his men ashore at Corpus Christi, Abert and his second in command, Lt. William G. Peck, and thirty men set out into territory that Abert knew to be

FIGURE 4.2 Detail from *Map Showing the Route pursued by the Exploring Expedition to New Mexico and the Southern Rocky Mountains . . . conducted by Lieut. J. W. Abert . . . during the year 1845* (1846). Pillar Rock is noted at center.

still claimed by Mexico. Abert was awed by the spectacular scenery of northeastern New Mexico and made numerous sketches that he felt would give "more exact scenographical ideas" than any verbal description. Adjusting to this new landscape, he commented finally that he was "fully satisfied with the wild scene which I have attempted to portray." But he warned, "Should a painter, in sketching the landscape, give it the true tone of color, he likely would be censured for exaggeration"—a common reaction among easterners confronted with the brilliant western sky for the first time.[18]

By September 4 the expedition had crossed the 103rd meridian and entered the southern part of what Major Long had called "The Great American Desert." It was "a country where the utmost precaution became necessary to guard against the surprise or attack of the roving Camanches," Abert wrote. He knew that the frequent fresh

tracks, hours-old campsites, freshly-picked grape vines and plum trees, and phantom-like Indian scouts who constantly shadowed the column and would appear on the distant horizon or a nearby hill as if a mirage, meant that Indians were nearby and watching his every move.[19]

Four days later Abert noted a "singular rock" on the opposite bank of the Canadian, which, he observed, "might be useful as a land-mark to future travellers." He sketched the formation, which he called Pillar Rock, and marked the spot on his map, between the 102nd and 103rd parallels (fig. 4.2). He viewed the column from the north side of the river looking toward the southeast and sketched it for his report. The resulting print shows a promontory at the edge of a broad canyon, with the Canadian River shrouded among the dense line of trees in the valley and a selection of desert plants in the left foreground (fig. 4.3). It was issued uncolored, but in his personal copy of the report Abert added color.[20] It is difficult to locate the promontory today, although there are several formations along the river that, given the erosion that has occurred over the years, might be Abert's Pillar Rock.[21]

Although Abert had returned with dozens of sketches and watercolors, the published report, which the Senate authorized in an edition of 2,100 copies the following year, included only eleven

FIGURE 4.3 James William Abert, *The Pillar Rock on the Canadian*, 1845. Hand-colored lithograph, 12.7 × 17.8 cm (comp.), by E. Weber & C.o Balt.e Hand-colored by Abert. From Abert, *Report of an Expedition . . . on the Upper Arkansas* (1846), opp. 32. Courtesy Beinecke Rare Book and Manuscript Library, Yale University.

lithographs, printed by Edward Weber & Co. of Baltimore, who had produced the plates for Frémont's first two reports. Abert's primary contribution to knowledge of the Texas Panhandle was geographic. His was the first expedition to make astronomical observations and to map the Canadian from its source to its mouth (except for approximately seventy-five miles east of the 101st meridian, when he skipped down to the North Fork of the Red). His written report provided fresh information on the Kiowa and Comanche Indians gained from personal contact as well as from scout Fitzpatrick's vast experience. The data on the location of water holes, timber, and potential settlement areas would be mostly for military use for the next few years, since Anglo-American expansion in this inhospitable domain was not really feasible until the arrival of the railroad and the windmill. Abert also gathered bird and mammal skins, which he preserved with arsenic until he lost his supply, then with cornmeal; he sent Audubon a note describing his collections.[22]

A GERMAN SCIENTIST AMONG THE FOSSILS

Just as Abert reached St. Louis in November 1845, a young German academician arrived in Texas to conduct the first geological survey of Texas. Prince Carl von Solms-Braunfels, who had acquired land north of San Antonio for the German Adelsverein, had encountered a Mexican who promised to guide him to rumored silver mines on the San Saba River, so the prince requested assistance from the Berlin Academy of Sciences in finding a competent young geologist to survey the region. The academy recommended twenty-eight-year-old Carl Ferdinand von Roemer, who had abandoned his study of law and received his PhD in paleontology in Berlin in 1842 (fig. 4.4). His subsequent book on the geology of the mountainous country along the Rhine had caught the attention of the academy, and the great Alexander von Humboldt provided a letter of introduction for the young scientist, who, "like a book, needs only to be opened to yield good answers to all questions."[23] The first lithographs of Texas geological specimens resulted from Roemer's research.

Roemer easily stood out from the crowd when he arrived at Galveston.[24] The young professor—who, according to Mrs. Houstoun, had no teeth, constantly chewed on a cigar, was fond of cognac, and was a poor rider, and whose neglect of personal hygiene was apparent even in Texas— nonetheless kept everyone amused with his "researches

FIGURE 4.4 Unknown photographer, Carl Ferdinand von Roemer in 1855, shortly after he became professor at the University of Breslau and director of the mineralogical cabinet. Courtesy the University of Wrocław, Poland.

amongst the mud of the Texan rivers and his diggings after geological specimens." Anxious to see the new land, Roemer crisscrossed the state for more than seventeen months, exploring as far north as Glen Rose and as far west as Fredericksburg. He quickly passed through the coastal plain, there being few solid rock deposits there to interest him, and paused at the foot of the Balcones Escarpment, near

138 | TEXAS LITHOGRAPHS

FIGURE 4.5 C. Hohe, Plate I. Lithograph, folio, by Henry & Cohen. From Ferdinand Roemer, *Die Kreidebildungen von Texas und ihre organischen Einschlüsse* (1852). Courtesy Harvard University, Museum of Comparative Zoology, Ernst Mayr Library.

New Braunfels, thinking it ironic that the boundary between the modern deposits and the more interesting Cretaceous formations also marked the line between civilization and the wilderness, between the farthest western settlements and "the hunting ground of the Indian." He visited Torrey's Trading Post near Waco and accompanied Baron von Meusebach and Robert S. Neighbors on their treaty-making expedition to the Comanches in 1847. Working virtually without maps, reliable geological information, or colleagues with whom he could discuss his theories, Roemer covered an area of approximately twenty thousand square miles but found no exploitable mineral deposits.[25]

Upon his return to Germany in 1847, young Roemer finished two books at the Royal Academy of Science in Berlin. The first, published in 1849, is a travel narrative that ranks among the most accurate and candid of the accounts of Texas, including a detailed, hand-colored geological map of the state.[26] The second is the first study of Texas geology, *Die kreidebildungen von Texas und ihre organischen Einschlüsse* (The cretaceous formations of Texas and their organic inclusions, 1852), which contains eleven lithographs of a number of fossil specimens that he discovered, drawn on the stone by scientific illustrator Christian Hohe and printed by the Bonn lithographic firm of Henry & Cohen (fig. 4.5).[27] His book set a precedent by demonstrating how the geological survey could encourage the development of unsettled territory and resulted in his steady rise within academia: in 1855 he was appointed professor at the University of Breslau.[28] Some Texans were aware of his travel narrative but few knew of the geological study because he found no precious minerals, and his scientific volume has not been translated.

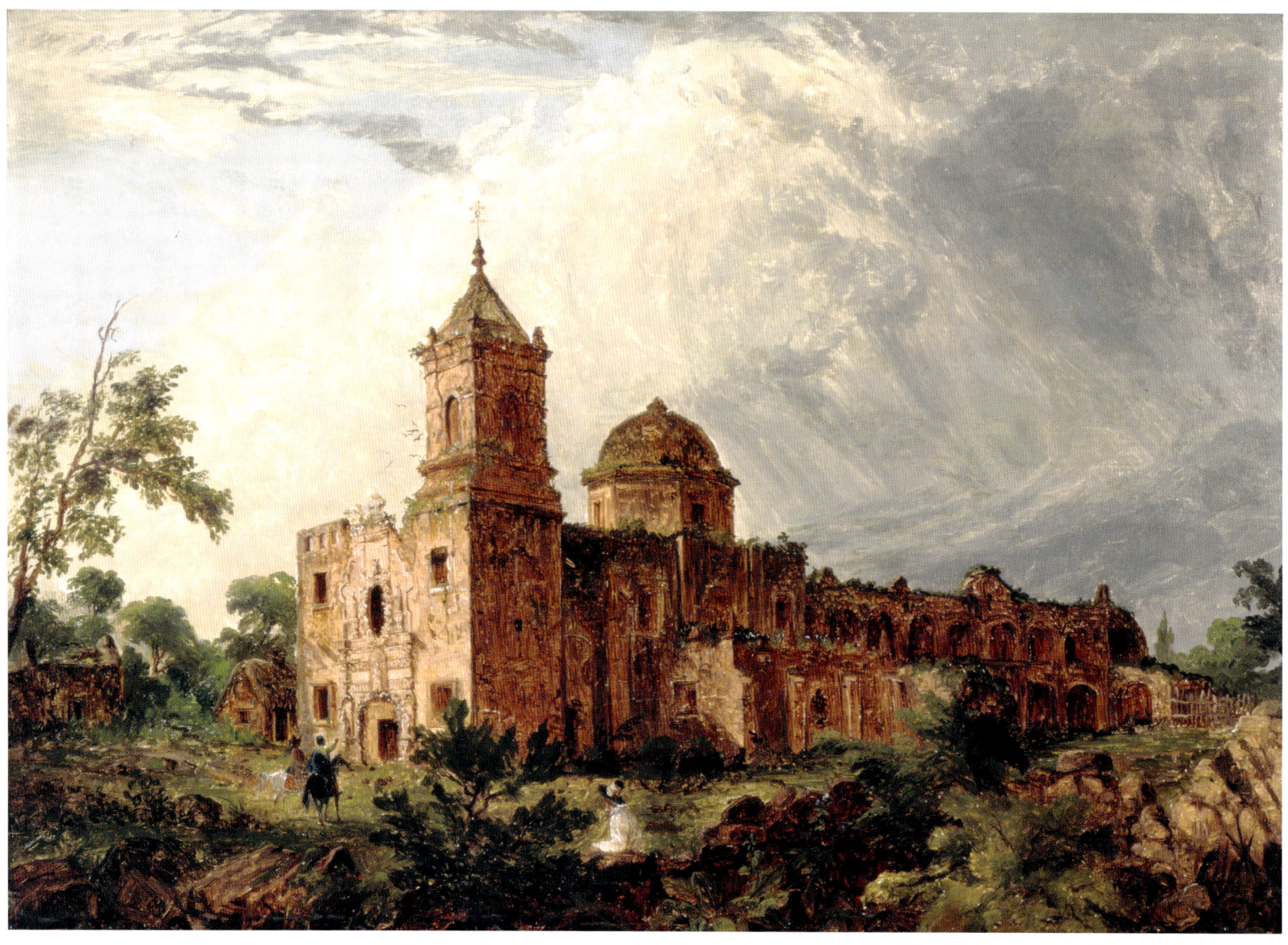

FIGURE 4.6 Seth Eastman, *San José Mission*, 1848–1849. Oil on canvas, 15.5 × 22 in. Courtesy Witte Museum, San Antonio.

A ROMANTIC ARTIST IN SAN ANTONIO

Capt. Seth Eastman, formerly a drawing instructor at West Point, arrived in Texas in November 1848, fresh from service at Fort Snelling on the upper Mississippi River, to help establish the north-south line of federal forts along the western edge of settlement.[29] His stay was brief—from November 1848 to September 1849; he was then ordered to Washington, DC, to provide illustrations for Henry Rowe Schoolcraft's monumental *Historical and Statistical Information Respecting the History, Condition, and Prospects of the Indian Tribes of the United States*, but his academy training led him to keep a journal and visually document his commission in dozens of drawings. One of his Texas drawings—San José Mission—he later worked into an oil painting to be chromolithographed as an illustration for one of his wife's poems (figs. 4.6 and 4.7).[30]

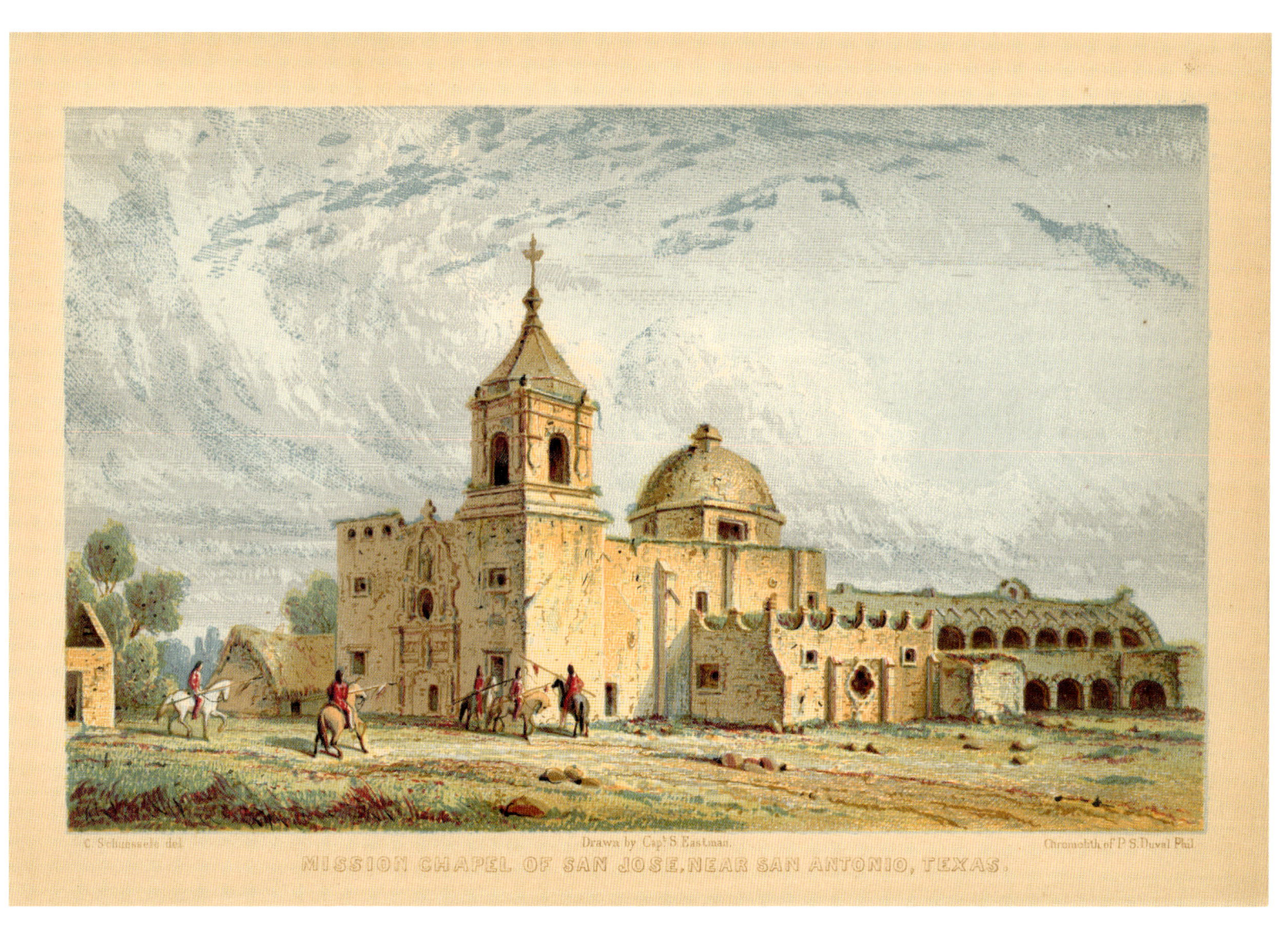

FIGURE 4.7 Christian Schuessele after Seth Eastman, *Mission Chapel of San Jose, Near San Antonio, Texas*, 1851. Chromolithograph, 5.25 × 8 in. (comp.). From John S. Hart, *The Iris: An Illuminated Souvenir for 1852* (1851). Courtesy private collection.

Mary Henderson Eastman was a descendant of one of the first families of Virginia and aspired to a literary career. She had accompanied Eastman to Fort Snelling and wrote *Dahcotah, or Life and Legends of the Sioux around Fort Snelling* (1849), with handsome lithographic illustrations after her husband's paintings. In 1852 she authored what was to be her most popular work, *Aunt Phillis's Cabin, or Southern Life as It Is*, which she intended as a Southern response to Harriet Beecher Stowe's *Uncle Tom's Cabin*. In the meantime she produced eighteen short articles and poems, and Eastman provided a dozen paintings, which editor John Seely Hart secured for his popular annual, *The Iris: An Illuminated Souvenir for 1852*. One of Mrs. Eastman's poems is titled "The Mission Church of San José," which, as she explained in a note, "is the most interesting of the ruins of the mission chapels in Texas . . . but they have become refuges for the bats and owls." Eastman's painting captures the romanticism of a Sunday afternoon sketching trip, with a man on horseback gesturing toward the elaborate carvings on the front of the structure while another, in what may be a self-portrait, sits on a boulder and contemplates this more-than-a-century-old relic of Spanish North America. Grass and weeds grow from the tops of the walls, and a peach tree springs from the bell tower as this slumping but graceful monument seems to be engulfed in vegetation and slowly returning to nature.

To distinguish the volume for 1852, Hart went to the expense of having Eastman's paintings reproduced as ten-color chromolithographs. As he explained, "The happy blending of the colours in these pictures, the disposition of the light and shade, and the skill with which they are printed, give them the appearance of paintings rather than of prints." The effort did not go unnoticed. A reviewer for the *Daily National Intelligencer* complimented Philadelphia printer P. S. Duval, a French immigrant, for his work, calling the oil engravings "the leading novelty" in the book. The reporter continued: "The brilliancy of these pictures and their harmony are truly astonishing, and we cannot but consider Mr. Duval's discoveries and productions in this new art as comprising an era in the history of American art." And the reviewer for the *Art-Journal* in London noted that "the illustrations . . . show that in this, as well as in all other arts, our brethren of the New World are progressing rapidly. The volume is beautifully 'got up,' and the twelve illustrations have a deeper interest than belong to mere 'book-plates,' however requisite they may be, as works of Art."[31]

Whether for better or worse, lithographic artist Christian Schuessele, French-born, like Duval, was not bashful about making changes in the artist's work, and he significantly altered the mood of Eastman's painting. Eastman's dark green and brown palette is gone as Schuessele brightened the image and added a brilliant blue sky. The invading shrubs, bushes, and boulders of Eastman's creation, which seem to surround and almost consume the mission, have been removed in the print, presenting an unimpeded view of the structure. The effect, however, is to see the sunlit mission on an open, gentle slope rather than in the midst of the encroaching wilderness that Eastman, a secondary figure in the romantic Hudson River school of artists, perceived and that Mrs. Eastman described in her accompanying verse: "The long grass twines the arches," while the "vine's dark leaves . . . wave gracefully . . . in the evening air." In Schuessele's version, grass and weeds no longer protrude from the top of the walls or entwine the arches. But the rose window, even then well known, is shown more clearly, and, in what Schuessele must have thought was a change more appropriate to the theme of the book, the casual sightseers have been replaced by Indians mounted on horseback and carrying long feathered lances as they gaze curiously at the large stone structure, which may be seen as symbolic of their dispossession. The entire volume was reissued in 1853 as *The Romance of Indian Life. With Other Tales* under Mary H. Eastman's name.[32]

SEARCH FOR THE SOURCE OF THE RED RIVER

Simultaneous with the appearance of Eastman's view of San José, Capt. Randolph B. Marcy (fig. 4.8), prepared for his second excursion onto the Llano Estacado, which the multitalented Albert B. Pike, who in 1832 had crossed much of it on foot, called a "world of prairie."[33] This time Marcy's goal was to find the elusive source of the main branch of the Red River, a task complicated by the fact that Alexander von Humboldt's 1804 *A Map of New Spain* incorrectly showed the Canadian River joining the Red River (rather than the Arkansas) somewhere in the "Immence Plains, where the Bisons feed."[34] By 1852 the river was no longer an international boundary, but Captain Marcy argued that "one of the largest and most important rivers" in the country, now a part of the boundary between Texas and Indian Territory, was too important for its source to remain "wholly unexplored and unknown." Joining his team were Bvt. Capt. George B. McClellan, who would later become his son-in-law and,

for a short time, his commander during the Civil War, and Dr. George G. Shumard, company surgeon, amateur botanist, and probably the artist of the twelve scenic lithographs that accompanied Marcy's published report, seven of which relate to the Texas Panhandle (figs. 4.9 and 4.10).[35]

Marcy had undertaken a task more complex than he realized, because the Red has several sources, and he was traveling during the dry season. Yet in the process, he provided the initial lithographic images of the unmapped and dramatic topography near Palo Duro Canyon, the first of the great southwestern canyons to be documented and published for a popular audience. A little more than twenty years later, in 1874, troops commanded by Col. Ranald S. Mackenzie would drive out the last resisting bands of Comanches, Kiowas, and Cheyennes encamped there and force them onto reservations.[36]

By mid-June Marcy's expedition had arrived at the source of the North Fork of Red River, in present-day Carson County, Texas. Before turning southward to trace the South or Prairie Dog Town Fork, Marcy took ten men thirty-five miles northward to the Canadian River, which he recognized from his 1849 reconnaissance. The party then rode south, skirting the eastern, mountainous edge of the Caprock, to continue their search for the Red River's main source. To show the rugged character of the edge of the high plains, the unnamed artist, probably the surgeon and geologist Dr. Shumard, sketched *Border of El-Llano Estacado*, an escarpment that stretches for more than 180 miles from the beginning of Palo Duro Canyon to Borden County on the south (fig. 4.11).[37] Shumard usually included people or trees in the picture to give the viewer a way of gauging the scale of the landscape.

On June 26 Marcy encountered a "continuous dog-town," the feature after which the Indians had named the South Fork and the one that Kendall had described to the Reverend Bachman in 1845. Marcy estimated that the village covered 625 square miles and contained an "aggregate population . . . greater than any other city in the universe." Despite the delay caused by observing these curious creatures and circumventing the town, the group arrived the following day at the South Fork of the river, probably below its confluence with Tule Creek in what is today northern Briscoe County, Texas. There, at the edge of the high plains escarpment, the river flows out of "towering and majestic cliffs, which rise almost perpendicularly from the undulating swells of prairie at the base, to the height of eight hundred feet," Marcy wrote. The cliffs "terminate at the

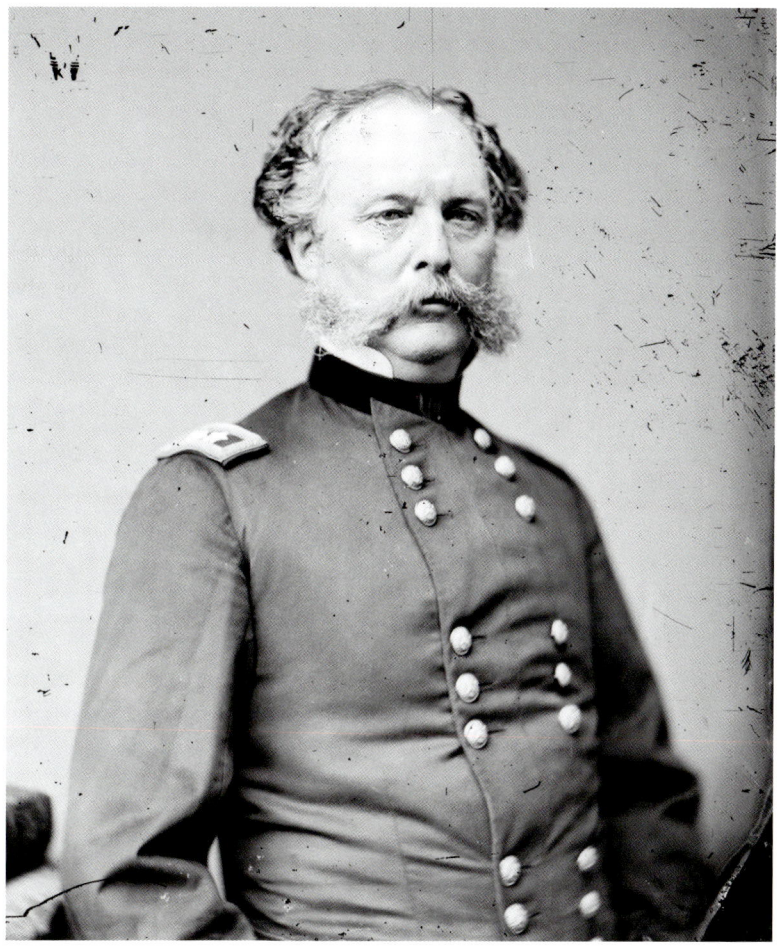

FIGURE 4.8 Mathew Brady, [Gen. Randolph B. Marcy]. Courtesy Brady-Handy Collection, Civil War Photographs, 1861–1865, Prints and Photographs Division, Library of Congress.

summit in a plateau almost as level as the sea." The river was known by the Comanche name of Ke-che-ah-que-ho-no (prairie-dog-town-river), and Shumard documented this point in the print entitled *View Near the Head of the Ke-che-ah-que-ho-no* (fig. 4.12).[38]

As the cliffs closed in on the river and they could go no farther with the wagons, Marcy took ten men along with Captain McClellan and set out to find the river's "head spring." Late in the day of June 30, they reached "a point where the river divided into two forks of about equal dimensions." They followed the left fork, which was probably Tule Creek, rather than the main branch of the river (fig. 4.13). They proceeded across terrain so rough that they had to walk along the edge of the creek, all the while suffering from heat and intense thirst and stomach cramps from drinking the brackish river water.[39]

FIGURE 4.9 George G. Shumard (attrib.), *Gypsum Bluffs on North Branch Red River*, 1852. Toned lithograph, 4.38 × 7.12 in. (comp.), by Ackerman Lith., 379 Broadway, New York. From Randolph B. Marcy, *Exploration of the Red River of Louisiana in the Year 1852*, 32nd Cong., 1st sess., (1854), also Serial 666 (1853), plate 4. Courtesy private collection.

FIGURE 4.10 George G. Shumard (attrib.), *View of Gypsum Bluffs on the Canadian River*, 1852. Toned lithograph, 4.25 × 7.12 in. (comp.), by Ackerman Lith. From Marcy, *Exploration of the Red River* (1854), plate 5. Courtesy private collection.

FIGURE 4.11 George G. Shumard (attrib.), *Border of El-Llano Estacado*, 1852. Toned lithograph, 4.25 × 7.12 in. (comp.), by Ackerman Lith. From Marcy, *Exploration of the Red River* (1854), plate 7. Courtesy private collection. Probably the first published view of Palo Duro Canyon.

FIGURE 4.12 George G. Shumard (attrib.), *View Near the Head of the Ke-che-ah-que-ho-no*, 1852. Toned lithograph, 7.38 × 4 in. (comp.), by Ackerman Lith. From Marcy, *Exploration of the Red River* (1854), plate 8. Courtesy private collection.

FIGURE 4.13 George G. Shumard (attrib.), *View Near Head of Red River*, 1852. Toned lithograph, 4.25 × 7.12 in. (comp.), by Ackerman Lith. From Marcy, *Exploration of the Red River* (1854), plate 9. Courtesy private collection.

On July 1 they reached a point where, according to Marcy, "the gigantic escarpments of sandstone, rising to the giddy height of eight hundred feet on each side, gradually closed in until they were only a few yards apart . . . and finally united overhead, leaving a long, narrow corridor beneath, at the base of which the head spring of the principal or main branch of Red River takes its rise." This probably was the "Narrows" of Tule Creek, which Marcy pronounced to be the source of the main branch of Red River and Shumard pictured in *Head of Ke-che-ah-que-ho-no, or the Main Branch of Red River* (fig. 4.14).

All this—all these scenes—the explorers viewed through the lenses of their own cultural baggage. After drinking from the cool spring water and taking a few minutes to enjoy the Narrows, Marcy soared into rapture: "The magnificence of the views . . . exceeded anything I had ever beheld," he wrote. "It is impossible for me to describe the sensations that came over me, and the exquisite pleasure I experienced, as I gazed upon these grand and novel pictures."[40] McClellan was similarly inspired: "The immense bluffs tower above us on every side, & assume every shape that fancy may suggest," he wrote. "There is an immense fortress, to which Cologne or Schweidnitz is but a plaything—on this side a beautiful East Indian temple."[41] Both men resort to the language of the Picturesque and the Romantic, slippery terms to define but ones that seemed to characterize the mid-nineteenth-century explorers' groping for perspective. The

Picturesque can mean simply to look like a picture; indeed, perhaps the easiest explanation is to see a scene as if it were framed. But the term also involves several philosophical assumptions. A wilderness landscape might be worthy of notice and description because it looks like a work of art, but that perception is also a philosophical and aesthetic construct intended to impose meaning and significance on the scene. Simply put, the Picturesque involved comparing and contrasting the various elements of the landscape—trees, rocks, mountains, meadows, clouds. By the mid-nineteenth century there were certain well-established Picturesque landscapes—Niagara Falls, the Natural Bridge in Virginia, Mount Holyoke in Massachusetts, Catskill Falls, Lake George, and the Hudson, Susquehanna, Schuylkill, and various other rivers. And from this unknown section of the country Marcy and his companions were suggesting new scenes for the American aesthetic canon.[42]

Marcy continued his reverie:

> The stupendous escarpments of solid rock, rising precipitously from the bed of the river to such a height as, for a great portion of the day, to exclude the rays of the sun, were worn away, by the lapse of time and the action of the water and the weather, into the most fantastic forms, that required but little effort of the imagination to convert into works of art, and all united in forming one of the grandest and most picturesque scenes that can be imagined. We all, with one accord, stopped and gazed with wonder and admiration upon a panorama which was now for the first time exhibited to the eyes of civilized man.[43]

Marcy's reaction to the exotic plains scenery also exemplified the Romantic perspective through which European and American explorers viewed the West.

FIGURE 4.14 George G. Shumard (attrib.), *Head of Ke-che-ah-que-ho-no, or the Main Branch of Red-River*, 1852. Toned lithograph, 7.38 × 4 in. (comp.), by Ackerman Lith. From Marcy, *Exploration of the Red River* (1854), plate 10. Courtesy private collection.

As European expeditions sailed the world during the seventeenth and eighteenth centuries encountering exotic cultures and landscapes, explorers frequently compared the natural formations they encountered to ancient and medieval architectural ruins. "The trees of a primeval forest" might be compared to cathedral columns and basalt eruptions to Egyptian pyramids and the temples of the Incas. Artist Samuel Seymour, who accompanied Stephen Long on his trip to the Rocky Mountains in 1820, called one of the formations that he saw near the headwaters of the Arkansas River "Castle Rock" because of its "striking resemblance to a work of art." And Shumard, aided by European-trained lithographers and Marcy's descriptions, showed various rimrock formations "at the borders of the 'Llano estacado'" that appear to be ancient architectural ruins. Of a particular group on the north bank of the river, recalling the famous French military engineer Sébastien Le Prestre de Vauban, Marcy wrote, "Their peculiar formation, and very extraordinary regularity, give them the appearance, in the distance, of gigantic fortifications, capped with battlements of white marble. . . . In many places there are perfect representations of the re-entering angles of a bastion front, with the glacis revetted with turf, and sloping gently to the river." Suffice it to say that Shumard was much more precise in his descriptions of these features, declining to employ phrases such as Marcy's "gigantic fortifications capped with battlements of white marble."[44]

Each of the bluffs in *View of Gypsum Bluffs on the Canadian River* (fig. 4.10) is capped with what appears to be an architectural ruin. Similar structures appear about three-quarters of the way up the large, conical mountain, and a formation in the right center of *Border of El-Llano Estacado* (fig. 4.11) seems to be a multistoried Pueblo-like ruin. The *Border of El-Llano Estacado* (fig. 4.11) also conforms to another romantic proclivity: picturing a pristine wilderness juxtaposed with civilization, represented by the contemplative and rather formally costumed members of the expedition in the left center foreground who provide scale and a path for the eye to follow: from the figures, through the valley in front of them, and up to the Llano, even to the clouds that hover over the peak to make it seem taller. These small figures, also seen in *View Near Head of Red River* (fig. 4.13) and *Head of Ke-che-ah-que-ho-no* (fig. 4.14), demonstrate again the romantic aspirations of the artists in showing man in awe of sublime nature. The lithographers of the plates in Marcy's book probably could not resist adding what they thought would be appropriate alpine-like trees on the tops of what were, in reality, desert mesas.

This is not to say that these images do not faithfully depict the scenes that the artist witnessed. Several historians visited specific sites and found that the lithographs are still today recognizable representations of the landscape.[45]

After pausing to celebrate Independence Day, Marcy and party headed back to Fort Arbuckle, where they received a warm welcome on July 28 and were surprised to learn that during their nearly three-month absence newspapers nationwide had reported that they had been killed by a party of marauding Comanches.[46] Marcy might have realized that he had not found the source of the main branch of Red River, but the publicity created by his supposed massacre and miraculous return ensured that the expedition's published report, *Exploration of the Red River of Louisiana*, would receive attention. There were even rumors that he had discovered gold as pure as that found in California.[47] He dispelled such hearsay in his address before the American Statistical and Geographical Society in 1853, comparing the Panhandle of Texas to the "great Zahara," but he did not admit that he had not discovered the river's main source.[48] The US Senate published 3,450 copies of his report, followed the next year by 2,500 copies of the House version and a second printing of the Senate volume. In addition to the twelve landscape views, Marcy's report includes dozens of scientific illustrations of shells, snakes, lizards, fishes, grasshoppers, scorpions, tarantulas, centipedes, and botanical specimens that the scientists had collected along the route, all drawn by the indefatigable J. H. Richard of the Smithsonian Institution (fig. 4.15).[49] It would not be until 1876 that a party headed by Lt. Ernest H. Ruffner discovered and documented the headwaters of the Prairie Dog Town Fork of Red River.[50]

The government contracted with three different printers and binders and two lithographers for Marcy's report, so there are minor differences between the prints made by Henry Lawrence compared with those of James Ackerman.[51] Reflecting on the volumes, each individually typeset, director Frederick V. Coville of the US National Arboretum described the report as "a good illustration of the wasteful methods pursued in the publication of government reports."[52] It is apparent that the federal government went out of its way to patronize the country's nascent lithographic industry.[53]

Still, William Brown Parker, a New York City businessman and editor who accompanied Marcy on a subsequent expedition into the North Texas wilderness, wanted more. "My wonder has been throughout my journey that so few if any of our artists ever join expeditions to the plains," he wrote.

(LEFT) FIGURE 4.15 J. H. Richard, *Pituophis McClellanii, B. & G.* [Bull snake], 1852. Lithograph, 7.75 × 4.25 in. (comp.), by W. H. Dougal. From Marcy, *Exploration of the Red River*, (1854), plate 5 (zoology series). Courtesy private collection. **(RIGHT) FIGURE 4.16** After Janos Xántus, *Arkanzas folyó főforrása* [Mouth of the Arkansas], 1858. Toned lithograph, approx. 22.5 × 15 cm, by Antal Rohn, Pesten. From Xántus, *Levelei Éjszakamerikából* [Letters from North America, (1858)], opp. [176]. Courtesy University of California Libraries. Xántus, who later served as director of the Zoological Garden of Budapest for thirty years, plagiarized and claimed some of Shumard's illustrations as well as Marcy's text. He also confused the Red River with the Arkansas River.

"A PERFECT *TERRA INCOGNITA*" | 151

A portfolio could soon be filled with novelties, compared with which the hackneyed subjects universally to be found on sale or exhibition sink into mediocrity. Every variety can be found there, hill, dale, lake, valley, mountain, river and plain, whilst color, tint, light and shade are constant in quantity and quality. Let but the experiment be tried, and prairie scenery will become a valued gem in the gallery.[54]

The Marcy report also had the dubious honor of having approximately ninety pages of material plagiarized by Hungarian naturalist Janos Xántus in letters to his family, including lithographic illustrations of Ke-che-ah-que-ho-no, which were eventually published in his *Levelei Éjszakamerikából: Tizenkét eredeti rajzok után készült köés egynehány fametszettel* (Letters from North America, with twelve original drawings and a few woodcuts, [1858]). Xántus also copied images from Richard and Edward Kern and Karl Bodmer, among others (fig. 4.16).[55]

THE "OCEAN PRAIRIE"[56]

The acquisition of Oregon Territory, the Southwest, and California (and the subsequent discovery of gold there) presented the country with a host of new challenges and led to additional lithographs of Texas Panhandle scenes. Since no river connected the newly acquired territories with the rest of the country, Colonel Abert warned Chief Clerk Francis Markoe Jr. of the State Department that a transcontinental railroad was of the highest priority. "The consequences of such a road are immense," he wrote in 1849. "They probably involve the integrity of the Union. Unless some easy, cheap, and rapid means of communicating with these distant provinces be accomplished, there is danger, great danger, that they will not constitute parts of our Union."[57] In response, the federal government spent the next decade establishing forts and dispatching expeditions throughout the West, including the Texas Panhandle and the Texas-Mexico border.

Less than a year after Marcy had ridden from the North Fork of the Red up to the Canadian, and seven years after Lieutenant Abert had filed his report, another government expedition crossed the Llano Estacado, but for a different purpose. Transcontinental railroad fever seemed to sweep the country following acquisition of California and Oregon, and various sections of the country demanded

FIGURE 4.17 Mathew Brady, Amiel Weeks Whipple. From *Photographs and Autographs of Distinguished Civil War Union Generals*, 1864.

that any such road connect their region with the Pacific Ocean. Congress authorized the Pacific Railroad Surveys in March 1853, and Secretary of War Jefferson Davis assigned the Topographical Engineers the task of finding the best railroad route to the Pacific coast. That, of course, was one of the most challenging political and economic issues confronting pre–Civil War America, and government officials hoped that scientific exploration would resolve the political, economic, sectional, and moral issues inherent in choosing a route. While other expeditions scouted routes in the Midwest and along the northern boundary with Canada, Lt. Amiel Weeks Whipple (fig. 4.17) led the survey along the 35th parallel from Fort Smith, Arkansas, to California, which produced additional lithographs of the Texas Panhandle.[58]

Among the specialists in his command was the German artist and

naturalist Heinrich Balduin Möllhausen (fig 4.18). Born in Bonn in 1825, Möllhausen left the Prussian Army in 1848 and, stricken with wanderlust, sailed for the United States early in 1850. A Romantic at heart, he apparently traveled through the Midwest, earning his way as a sign painter, hunter, trapper, and court reporter, until he met Duke Paul of Württemberg, a world traveler and amateur naturalist and collector, who provided the young artist with his own exotic experience. Duke Paul employed Möllhausen as his assistant, taking him to Fort Laramie in the summer of 1851, an expedition that almost cost Möllhausen his life when on their return they were stranded in a snowstorm in southeastern Nebraska, near the Kansas border. The artist returned to Europe in the fall of 1852 when the Prussian consul in St. Louis hired him to accompany a shipment of wild animals to the Berlin zoo.[59]

That errand brought Möllhausen in contact with several important persons in the Berlin scientific community, including Alexander von Humboldt, the famed naturalist and geographer. He spent his time well, studying natural history in the Berlin royal collections, gradually improving his sketches under Humboldt's tutelage, and marrying the daughter of Humboldt's secretary. Under the sponsorship of the Royal Geographic Society of Berlin, Möllhausen was soon on his way back to America to collect natural history specimens.[60]

He arrived in Washington, DC, in May 1853, just in time to apply for one of the positions with the Pacific Railroad Surveys. Presenting his letters of recommendation from Humboldt and others, which obscured the fact that he still lacked artistic talent equal to his peers', he applied for a position with the Isaac Stevens survey of the Northwest. Instead, he was appointed topographer and draughtsman for the 35th parallel survey and in July reported to Fort Smith, Arkansas, where Whipple was organizing his party. Möllhausen's instructions called for him to keep an official journal, to make drawings that might seem of interest or value to the expedition, and to document landscapes along the proposed route. He was also encouraged to record interesting or unusual sites, landmarks, objects, and people, which permitted him a great deal of latitude.[61] Möllhausen further prepared for his task by studying the work of earlier surveyors and artists who had traversed the territory that he was about to enter.[62] Lt. John C. Tidball, a member of the expedition, described Möllhausen as "a brawny, hairy Teuton, full to overflowing with amiability and kindness to everyone."[63]

Whipple generally followed the "California Road," as it became known, that Marcy and Lt. James H. Simpson had documented in

FIGURE 4.18 After W. A. Richter, *Balduin Möllhausen als Trapper*. From *Die Gartenlaube* 29 (No. 29, 1862), 453.

"A PERFECT *TERRA INCOGNITA*" | 153

FIGURE 4.19 Heinrich Bauldin Möllhausen, *Canadian River Near Camp 38*, 1853. Toned lithograph, 18.1 × 23.6 cm (comp.), by Thomas S. Sinclair, Philadelphia. From Whipple and Ives, "Itinerary," in *Reports of Explorations and Surveys* [*Pacific Railroad Surveys*], vol. 3, pt. 1, opp. 30. Courtesy private collection.

FIGURE 4.20 Unknown artist after Heinrich Balduin Möllhausen, *Sand Hills on the Canadian*, 1860. Chromolithograph, 4.81 × 6.94 in. (comp.). From Abbé Emmanuel Domenech, *Seven Years' Residence in the Great Deserts of North America* (1860), vol. 1, between 152–153. Courtesy Amon Carter Museum of American Art, Fort Worth.

1849. Heading east through Indian Territory, they passed the Antelope Hills on the Texas boundary on September 6, then continued up the Canadian River to what is today the northwest portion of Roberts County, Texas, west of the city of Canadian. There, on September 8, as they approached what David S. Stanley, a member of the dragoon escort, described as "the commencement of the Llana Estacado," Möllhausen sketched *Canadian River Near Camp 38* (fig. 4.19), documenting what Whipple described as eroded "remnants of a llano, or prairie, which once covered the whole region. The other parts of the formation have been abraded and swept away, forming undulating prairies, valleys, ravines, and sometimes canyons."[64] Just beyond the hill in the foreground, one can see the men and wagons of the surveying party making their way along the south side of the river. The river must have been on quite a rise when Möllhausen made his drawing, for most of the previous travelers who had passed this way (Edwin James of the

FIGURE 4.21 Heinrich Balduin Möllhausen, *Kaiowa Camp*, 1853. Engraving, 2.75 × 3.81 in. From A. W. Whipple, Thomas Ewbank, and William W. Turner, "Report upon the Indian Tribes," in *Reports of Explorations and Surveys* [*Pacific Railroad Surveys*], vol. 3, pt. 3, p. 20.

Long expedition, for example) described a river about sixty yards wide, only forty yards of which were covered with water about ten inches deep. The other twenty yards were "naked sand-bar." When Abbé Emmanuel Domenech, a French missionary who spent several years in Texas and Mexico, adapted Möllhausen's picture for the English translation of his book, *Seven Years' Residence in the Great Deserts of North America*, he pictured a river that appears to be mostly dry and replaced the surveying party with two men standing on the bank, tiny in comparison to the vast country and typical visual rhetoric of the Romantic era (fig. 4.20).[65]

At about one o'clock the following day, one of the soldiers at the head of the column reached the summit of a hill and quickly spread the word—Comanche camp ahead. "We halted," Lt. John P. Sherburne recalled, and "every one examined his revolver & rifle to see that they were in shooting order . . . [,] knowing we would either be received as friends or be obliged to fight." It turned out to be a Kiowa camp of "about a dozen large conical tents, and as many wigwams," a herd of about five hundred horses, and a few old men as well as women and children. After close examination of the tepees, Whipple described them as being "of well-made poles, fifteen to twenty feet long, interlaced at the top, and intersecting the ground in a circle ten to fifteen feet in diameter. The whole was covered with buffalo hides, beautifully dressed, painted with curious figures, and carefully spread with the hair inside."[66]

Möllhausen sketched the scene for Whipple, but the engraving published in the official report appears to be after a hastily done sketch (fig. 4.21). Möllhausen later made several paintings of the village, one of which was chromolithographed for inclusion in his journal, which was published in German (fig. 4.22), English (fig. 4.23) in 1858, and Danish in 1860 (fig. 4.24).[67] The handsome decorated tepee in the center of the picture, identified by the "splendid plume of eagle's feathers" hanging on a post at the right, apparently belonged to the medicine man or the chief. Whipple said the headdress, which was reserved for "state occasions," was "ornamented with wampum and a buck skin pendant down the back [and] trimmed . . . with a row of stiff feathers . . . standing perpendicularly from the body & tipped with scarlet dye." Whipple tried unsuccessfully to buy the headdress and several other items. At the left, Möllhausen has shown a woman scraping, or "fleshing," a buffalo hide, and, behind the tepee, a buffalo hide has been stretched inside a frame to dry. Möllhausen probably created the rather stagy arrangement of weapons, dog, skulls (buffalo and human), bones, and other accoutrements in front of the tipi.[68]

Publication of several versions of the Kiowa village picture begs an explanation for the differences among them. Möllhausen's later painting, which is preserved in a private collection in Germany, and the chromolithograph, which appeared in the various editions of his journal, show the chief's tipi decorated with a number of human scalps, which are omitted from the American wood engraving. Möllhausen also included a human skull on the ground beneath the headdress.[69] Why were the scalps and human skull left out of the American version of the print? It is true that the southern Comanches, who were much feared in 1845 when Abert crossed the Panhandle, had suffered the loss of hundreds of lives in epidemics of smallpox in 1848 and cholera in 1849 and had recently sought peace with the United States. Simultaneously buffeted by adventurous whites intruding on Indian lands and a dwindling supply of buffaloes, the Comanches had negotiated the Treaty of Fort Atkinson (Kansas) in July 1853.[70] But they had by no means surrendered their right or ability to defend themselves. This fact is acknowledged in the texts of many government publications, but the illustrations invariably depict them, and all other Indians, as lethargic and docile—perhaps,

FIGURE 4.22 Heinrich Balduin Möllhausen, *Lager der Kiowaÿ Indianer*, 1858. Chromolithograph, 6.31 × 9.12 in., by Storch & Kramer, Berlin. From Möllhausen, *Tagebuch einer Reise vom Mississippi nach den Küsten der Südee* (1858), opp. 134. Courtesy Briscoe Center for American History, UT Austin. Note that the prints for Möllhausen's book are much more detailed, and perhaps reversed, than the engravings that appeared in Whipple's report.

FIGURE 4.23 Heinrich Baldwin Möllhausen, *Camp of the Kioway Indians*, 1853. Chromolithograph, 11.7 × 18 cm (image), 12.4 × 18 cm (comp.), by Hanhart. From Möllhausen, *Diary of a Journey from the Mississippi to the Coasts of the Pacific* (1858), vol. 1, opp. 212. Courtesy Amon Carter Museum of American Art, Fort Worth.

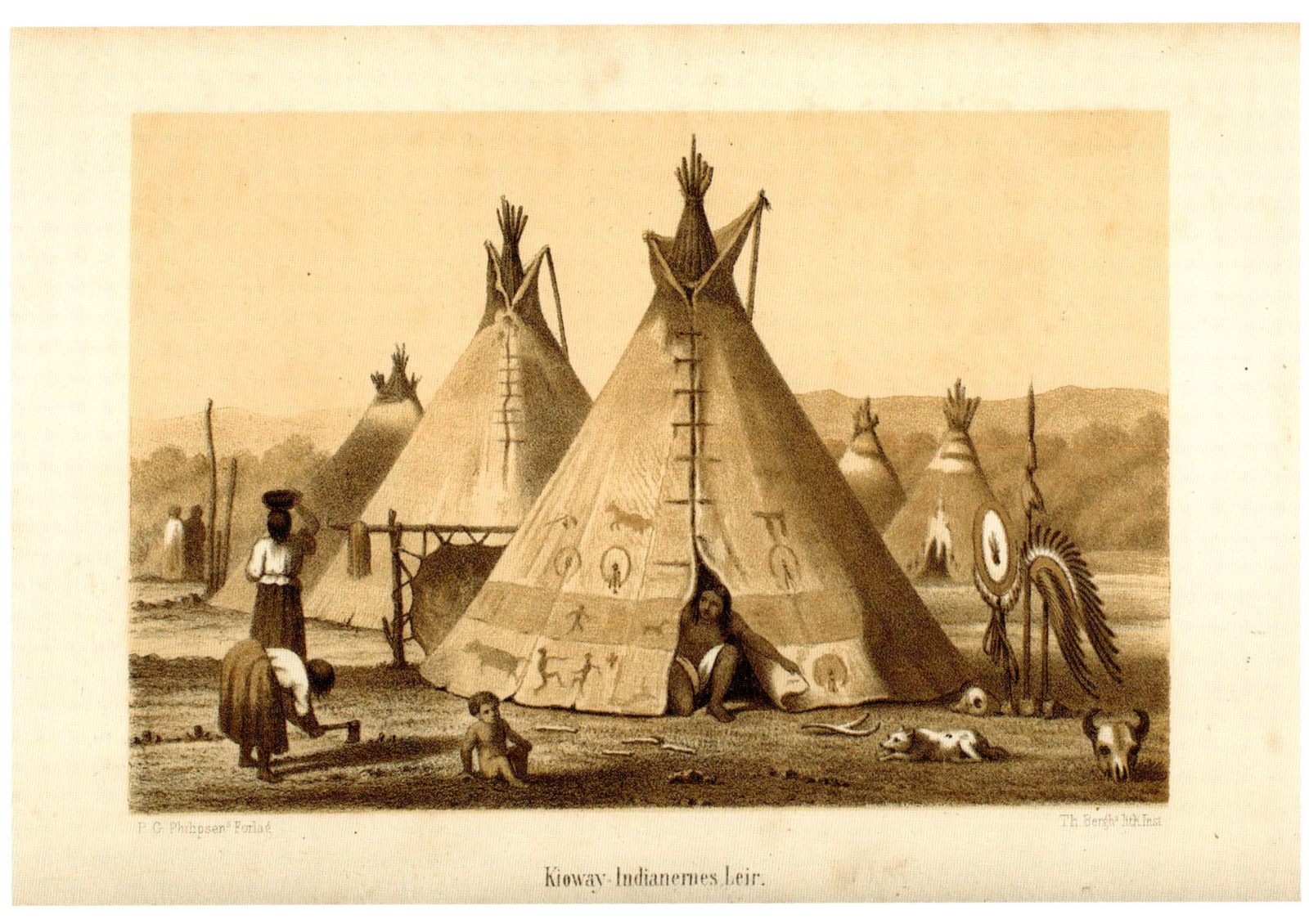

FIGURE 4.24 Heinrich Balduin Möllhausen, *Kioway Indianerues Leir*, 1862. Toned Lithograph, 4.31 × 6 in., by Th. Bergh Lith. Inst. From Möllhausen, *Vandringer gjennem det vestlige Nordamerikas Prairier*, following 130. Courtesy William L. Clements Library, University of Michigan, Ann Arbor.

"A PERFECT *TERRA INCOGNITA*" | 159

it has been suggested, because the government wanted to present an image of peaceful natives who would not resist the westward spread of settlements. Möllhausen's later depiction of well-armed Navajos (whom Whipple describes in the text as enthusiastic and alert, but who appear drowsy and listless in Möllhausen's print) is a case in point.[71] Of course, there is always the possibility that Möllhausen depicted the scalps and human skull to add verisimilitude to his journal.

On September 12, 1853, before they reached the 102nd parallel, Whipple left the Canadian River, apparently bypassing the location of Abert's Pillar Rock. Two days later the surveyors came upon a deserted Comanche camp that covered several acres on both sides of what Whipple called Shady Creek, which is probably present-day Arroyo Bonito north of Amarillo in Potter County (fig. 4.25). Whipple estimated that the camp had been home to more than six hundred Comanche warriors. Möllhausen's sketch looks across the creek toward the escarpment. On the left a dense grove of cedar trees reaches up into the Llano. A group of grass lodges, which Whipple described as "temporary bowers made of branches planted in the ground," dot the area between the trees and the creek. "They appear scattered at random; but, without exception, face the north," he noted. Möllhausen suggested that the large hut in the center of the print was probably a "medicine hut" used for sweat or vapor baths. The mound at the far right appears to be topped with the strata that form the Caprock. In the foreground, on the near side of the stream, Möllhausen sketched a battered cottonwood tree that seems about to fall into the creek, with a dead limb already broken and reaching toward the water. And to the left is a circular formation with four stakes that became the subject of speculation by the members of the team.[72]

Both Sherburne and Möllhausen joined Whipple in pondering the purpose of the site. Sherburne ventured that it represented some kind of offering or maybe even a grave site. Perhaps these were similar to the "circular holes and singular rings" that Abert saw near the Texas boundary with Indian Territory, "which always mark the site of the medicine tent."[73] In another copy of the camp scene, there are streaks running horizontally in the creek, which make it appear to be full of water, an important distinction in such a desolate region.[74]

On September 14 Whipple left the Canadian and ascended about two hundred and fifty feet to the "smooth, level, and boundless . . . ocean prairie" of the Llano Estacado.[75]

Möllhausen apparently did more than 130 sketches and paintings while on the Whipple survey.[76] These pictures show some improvement in his draftsmanship, but overall, when comparisons are possible, it seems that the lithographers who worked from them generally improved his pictures. Whipple, for example, felt that Möllhausen's portraits lacked scientific detail and accuracy—his portraits of Hueco (or Waco) Indians did not show their "high cheek bones, and a wild look"—and it seemed that the reviewer for *Littell's Living Age* only reluctantly granted that "M. Möllhausen is in his own way an artist."[77] Möllhausen might have felt this deficiency, for he referred to himself as a "German naturalist" rather than an artist. He later became much better known in Germany as a novelist of frontier stories based on his American experiences.[78]

As Whipple and the survey team prepared to cross the Texas–New Mexico boundary in September, they paused at Rocky Dell Creek to examine "a sort of cave, which the Indians have converted into a gallery of fine arts." There were "elaborately carved" rocks on the floor, and the walls were covered with an "immense number of carvings, etchings, and paintings," including a "great water-snake," which passing Pueblo Indians from New Mexico described as being "created by Montezuma to give rain and preserve the lives of those who should pray to him." Möllhausen copied a number of the pictographs, which are reproduced as engravings and included in the survey report.[79]

By October 1855 Whipple was back in Washington overseeing production of what became the third and fourth volumes of the *Reports of Explorations and Surveys to Ascertain the Most Practicable and Economic Route for a Railroad from the Mississippi River to the Pacific Ocean made under the Direction of the Secretary of War, in 1853–4* (widely known as the *Pacific Railway Surveys*). Möllhausen quickly returned to Prussia and apparently had no contact or input with the lithographic artists who copied and printed his work, leaving the supervision of the images, including the botanical drawings in volume four, to Whipple. The eminent St. Louis physician and botanist Dr. George Engelmann supervised the finished specimen drawings made from the field artists' sketches, and his correspondence with Whipple provides some insight into the cumbersome task they faced. The survey sketches were sent to Engelmann to be redrawn under his supervision, then submitted to the superintendent of public printing, A. G. Seaman, before being assigned for engraving or lithographing. Engelmann then had to approve the proofs before they could be printed.[80] Whipple also shared another frustration with Engelmann that reflects the huge number of volumes that

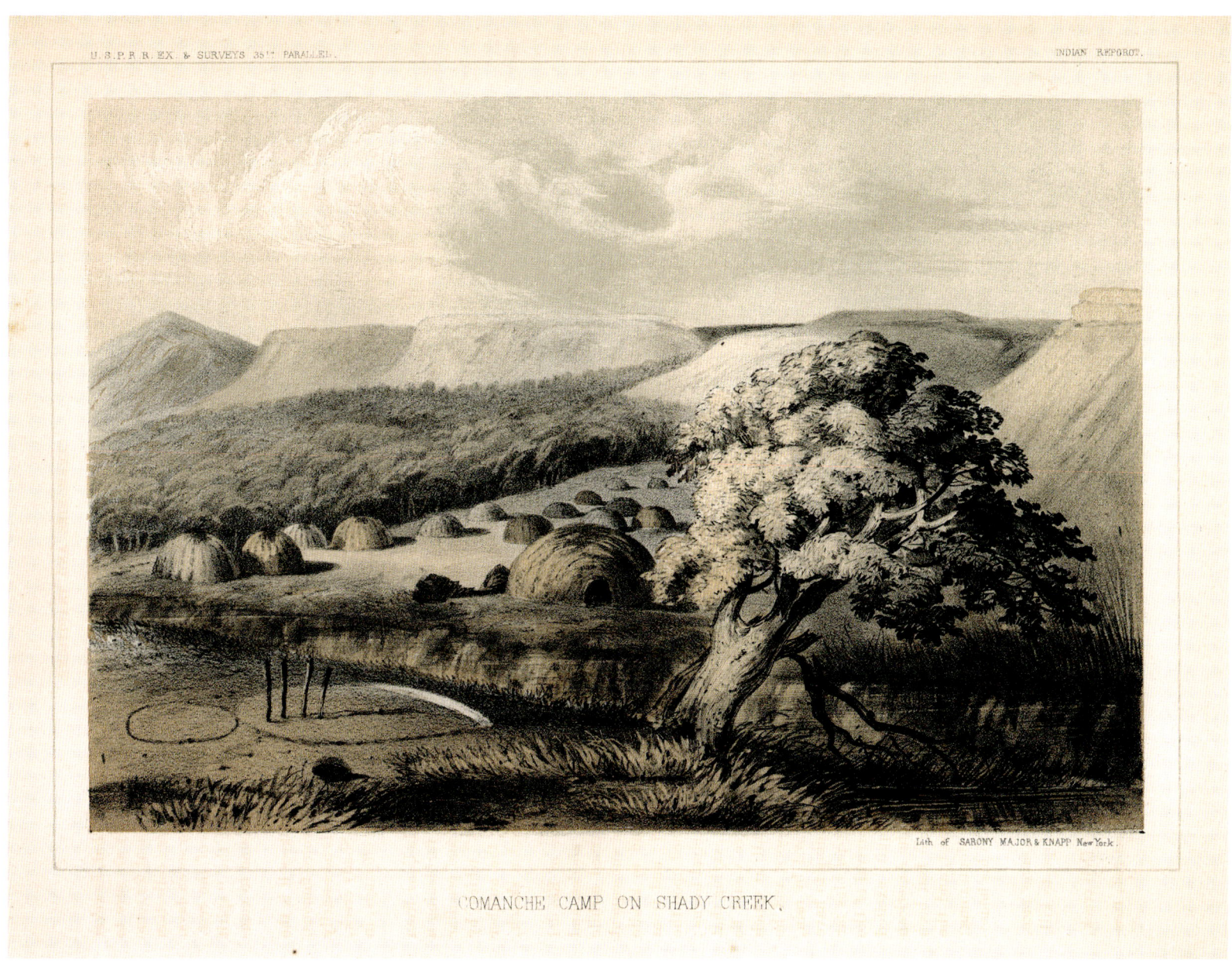

FIGURE 4.25 Heinrich Baldwin Möllhausen, *Comanche Camp on Shady Creek*, 1853. Toned lithograph, 17.4 × 23.9 cm (comp.), by Sarony, Major & Knapp, New York. From Whipple, Ewbank, and Turner, "Report Upon the Indian Tribes," in *Reports of Explorations and Surveys* [*Pacific Railroad Surveys*], vol. 3, pt. 3, opp. 36. Courtesy Amon Carter Museum of American Art, Fort Worth.

the government was printing. "I believe that thousands of copies of valuable public documents are annually sold in this place for waste paper," he disclosed. "I have frequently found at the grocery shops documents [used as wrapping paper?] that had been denied me by members of Congress because, it was pretended, there were not enough to supply their constituents."[81]

Volume 3 of the *Pacific Railway Surveys* contains eighty-seven illustrations, twelve of which are Texas scenes and two of which are chromolithographs. Volume 4 contains fifty-eight engraved plates of cacti and various plants collected along the way.[82] Production of the chromolithographs was shared among Sarony, Major & Knapp of New York City, Thomas Sinclair of Philadelphia, and A. Hoen & Co. of Baltimore. The government ordered 21,000 copies of both volumes, apparently split between House and Senate versions.[83] Some of the natural history plates were engraved on copper, transferred to stone, and lithographed in one color. Others were done as woodcuts and electrotyped for printing.[84]

THE TRANS-PECOS

As Whipple was documenting the 35th parallel, Maj. William H. Emory was conducting a survey of the new boundary between the United States and Mexico. Article 5 of the Treaty of Guadalupe Hidalgo, which concluded the war with Mexico, specified that each country appoint a commissioner and surveyor to establish and mark the new boundary from San Diego to El Paso to the mouth of the Rio Grande. This brought several experienced survey artists to Texas and resulted in a number of lithographic images of the borderlands and native Americans.[85]

Politics—whether slavery would be permitted in the newly acquired territories—complicated the task as one American commissioner after another died, was fired, or resigned with little work accomplished, but Whig president Zachary Taylor finally named bibliophile and amateur ethnologist John Russell Bartlett as the fourth commissioner in May 1850 (fig. 4.26). Co-owner of a bookstore and publishing house on the ground floor of the Astor Hotel in New York City, Bartlett had gained a scholarly reputation for works such as *Progress of Ethnology* (1847), *Dictionary of Americanisms* (1848), and *Reminiscences of Albert Gallatin* (1849). He regularly hosted an unusual literary group in his shop, including eighty-four-year-old Gallatin; Mayan and Egyptian explorer John Lloyd

FIGURE 4.26 Henry Cheever Pratt, *John Russell Bartlett*, 1852. Oil on canvas, 36.25 × 29.25 in. Courtesy Amon Carter Museum of American Art, Fort Worth.

Stephens; writer and art critic Henry Tuckerman; Ephraim Squier, author of *Ancient Monuments of the Mississippi Valley* (1848); ethnologist and geographer Henry Rowe Schoolcraft, who was at work on his monumental, six-volume *History, Condition, and Prospects of the Indian Tribes of the United States* (1851–1857); the reclusive Edgar Allen Poe; and artist Henry Cheever Pratt, among others. Bartlett had kept his political contacts well enough in order that when the Whigs returned to office with Taylor's election in 1848, he sought and received the post of boundary commissioner. He had long relished the opportunity to "be thrown among the wild tribes of the interior," as he put it in a later autobiography, and to join his literary peers as an author of a popular and critically acclaimed

FIGURE 4.27 Mathew Brady, [William H. Emory]. National Archives, Washington, DC.

who were more concerned with technical aspects of topographic drawing. He pressed on through terrible winter weather to reach El Paso del Norte in time for a December rendezvous with Gen. Pedro García Conde, the Mexican commissioner. The goal of the meeting was to agree on the point at which the boundary intersected the Rio Grande, but the task required negotiation because John Disturnell's *Mapa de los Estados Unidos de Méjico* (1847), which the Treaty of Guadalupe Hidalgo specified as the reference, was incorrect. It showed the Rio Grande two degrees farther west than it is and El Paso thirty miles farther north.[87]

Following much discussion, Bartlett and García Conde agreed on a compromise that would have pushed the boundary three degrees west of the Rio Grande before turning north to the first tributary of the Gila River, but the plan called for the line to intersect the Rio Grande at latitude 32°22′ north rather than eight miles north of El Paso (31°45′). In official surveyor Andrew B. Gray's absence, Lieutenant Whipple, now serving as acting surveyor, signed the agreement under protest. When Gray, a Virginian, recovered from an illness and arrived at the camp, he recognized that Bartlett had bargained away what appeared to be the only practicable southern railway route and refused to sign the agreement. Secretary of the Interior Alexander H. H. Stuart replaced Gray with Maj. William H. Emory, but the Southerners in Congress persisted until the United States purchased the disputed territory from Mexico for $10 million in 1853.[88]

During the two-and-a-half hectic and controversial years that Bartlett served as commissioner, he got his adventure, crisscrossing the Southwest from Indianola to San Diego and making side trips as far south as Acapulco and as far north as San Francisco. He replaced the official survey draftsman, Augustus de Vaudricourt, with his friend Henry Pratt. He also employed Harrison Eastman (no relation to Seth), Henry B. Brown of San Francisco, Oscar Bessau, and Seth Eastman to copy some of his sketches as finished paintings for his planned book.[89]

While Bartlett was in California, Major Emory, a graduate of West Point, heir of landed Southern gentry, and a veteran of Kearny's march to California in 1846, returned to the commission (fig. 4.27). "Bold Emory," as he was known among his West Point colleagues, had initially served the survey in a temporary capacity. In September 1851 Secretary of the Interior Stuart reassigned him to the survey as chief astronomer, and he rejoined the team in El Paso the following month, finding an outfit in complete disarray. "Words

adventure book. Unfortunately, neither ambition qualified him for the complicated task he now faced.[86]

Bartlett arrived at Indianola, on the Texas coast, on August 31, 1850. He was a good amateur artist, having received lessons when he was a child, and he kept a journal and regularly sketched as he headed across the well-traveled terrain toward San Antonio, gradually gaining competence to the point that his sepia washes are generally more facile than the work of the official survey artists,

"A PERFECT *TERRA INCOGNITA*" | 163

cannot describe the disorganized and unmanageable condition of this commission," he wrote John Torrey in a private communication. "But you will understand something of the merits of the case when I tell you on the day I arrived here two hundred thousand dollars had been expended and only fifty-eight miles surveyed and one astronomical point determined!" In Bartlett's absence, he focused on the boundary east from El Paso and by the summer of 1852 was ready to chart the unexplored and forbidding canyons of the Big Bend, the most hazardous section of the Rio Grande.[90]

Bartlett left the commissioner's post in 1852 as the Democrats were returning to office and applied to the government to publish his report in a format similar to that of the massive work that Schoolcraft had under way. The Senate tabled the proposal, blaming their inaction on the fact that the survey was not yet completed. Refusing to give up, Bartlett took his idea to D. Appleton & Co. in New York, who advanced him money for two volumes and agreed to split the profits. *Personal Narrative of Explorations and Incidents in Texas, New Mexico, California, Sonora, and Chihuahua, Connected with the United States and Mexican Boundary Commission, During the Years 1850, '51, '52, and '53* appeared to welcome reviews in 1854. The editor of the *San Antonio Ledger*, for example, concluded that "Mr. Bartlett possesses a happy talent for description—his narrative, though simple and unambitious, is never dull—and it abounds in information that is both novel and valuable, and with every internal sign of accuracy."[91]

The two volumes contain ninety-four woodcuts and sixteen lithographs, including a number of Texas views, but none of the chromolithographs that he had envisioned. The only lithograph relating to Texas is of a wash drawing that Bartlett made that first winter along the route to El Paso (fig. 4.28). Acquaintances had warned him of the terrible weather ahead, but the new commissioner felt that the timeliness of his task required that he make the effort, and it resulted in this barren wilderness scene. On November 6 he and his party had camped at Delaware Creek near the Texas–New Mexico border, just sixteen miles from the Pecos River in present-day Culbertson County. There, Bartlett recalled, "The dreaded Norther that I had so much feared when near the Pecos, had now come upon us with all its fury and in its very worst shape, accompanied with snow." The animals suffered more than the men as the blizzard closed in on the camp. Bartlett went hunting as an alternative to "roasting and freezing alternately by the fire," then spent the remainder of the "long day in reading Erman's Travels in Siberia, a proper book for the occasion," and sketching the picture from which this print was made. Bartlett conveys the bitter cold of that evening through his picture, *Camp in Snow Storm on Delaware Creek, Texas* (fig. 4.29), as well as his words: "The sharp wind found its way through the openings in the carriage, which all the blankets I could pile on would not keep out. The young gentlemen crowded themselves in their tents, and lay as close as possible; while the teamsters, laborers, etc., stowed themselves in the wagons." Three members of the expedition volunteered to go ahead to El Paso to get additional provisions, and they are shown in the right side of the picture, mounted and ready to depart.[92]

Henry Hillyard drew *Camp in Snow Storm on Delaware Creek, Texas* on the stone, and Sarony & Co. in New York lithographed it. No doubt Bartlett's book would have been better illustrated if he had received government sponsorship, for this was the era of lavishly produced exploration accounts, and his lively sketches and watercolors were more attractive than most of the work produced by the various survey draftsmen. Bartlett is considered a failure as boundary survey commissioner, but his book is a major contribution, described by bibliographer and collector Thomas W. Streeter as "the first thoroughly scholarly description of the Southwest."[93]

One of Bartlett's woodcuts, *Stampede of the Train by Wild Horses*, marks his ignominious exit from Texas. As his party approached Corpus Christi on the last day of 1852, they encountered a stampede of wild mustangs thrown into a frenzy by a prairie fire that the party only narrowly escaped. Passing through a break in the fire, they came to a chain of lagunas known as "Santa Gertrude," the heart of the ranch that riverman and steamboat entrepreneur Richard King was in the process of purchasing.[94]

Emory, meanwhile, brought the survey to a conclusion in October 1855, and in 1856 the 34th Congress authorized publication of the survey's findings—the book that Bartlett had hoped to do. The resulting volumes constitute one of the great books on Texas and the Southwest borderlands and are comparable to other great government-funded reports, such as Schoolcraft's *History* and the *Pacific Railroad Surveys*. Emory's two-volume *Report on the United States and Mexican Boundary Survey* (usually bound in three) appeared in 1857 and 1859 and includes his narrative, Lt. Nathaniel Michler's account of his surveys, an edited version of surveyor Marine T. W. Chandler's journal of the first scientific exploration of the Big Bend, and various scientific reports. The *Boundary Survey* includes a total of 427 prints in five different media: wood engravings, steel

CAMP IN SNOW STORM ON DELAWARE CREEK, TEXAS.

FIGURE 4.28 John Russell Bartlett, *Camp in Snow Storm on Delaware Creek, Texas*, 1852. Toned lithograph, 10.9 × 17.2 cm (comp.), by Sarony & Co., New York. On Stone by H. Hillyard. From John Russell Bartlett, *Personal Narrative of Explorations and Incidents in Texas* (1854), vol. 1, opp. 112. Courtesy Amon Carter Museum of American Art Library, Fort Worth.

FIGURE 4.29 John Russell Bartlett, *Camp in Snow Storm on Delaware Creek, Texas*, 1850. Pencil and sepia wash on moderately heavy stock, 10.4 × 15.2 in. John Carter Brown Library, Providence, RI.

"A PERFECT *TERRA INCOGNITA*" | 165

engravings, copper engravings, chromolithographs of landscapes and Native Americans, and full-page, hand-colored lithographs of birds.[95]

While Emory claimed that he "shared the fate of everyone who throws a stone into a nest of rotten eggs" and had "become a little splattered by the explosion," the engineering and scientific data accumulated justified his effort, for one of the primary and complicating goals of this survey also was the attempt to locate a transcontinental route to the Pacific.[96] The books also include superb pictorial documentation of the people and some of the most remote parts of the country that places them on a par with other exploration publications of the decade. The multitalented German immigrant Arthur C. V. Schott (fig. 4.30)—naturalist, engineer, physician, geologist, artist, and protégé of Princeton botanist Dr. John Torrey—accompanied Emory and provided most of the portraits and many of the scenic views in the book. John Weyss, newly arrived from Austria and trained as a surveyor, topographer, and illustrator, comes a close second. Dr. Charles C. Parry—botanist, naturalist, medical doctor, and geologist—contributed views of the canyons of the Rio Grande that were published as engravings. The book contains dozens of illustrations that credit no artist. Some of them might be the work of Vaudricourt, who did a number of drawings before he left the survey. Fielding B. Meek, Paulus Roetter in St. Louis, and J. H. Richard of the Smithsonian Institution drew and engraved the dozens of botanical and geological specimens that the surveyors collected. Bartlett kept all of his and Pratt's pictures, but one of them, *The Plaza and Church at El Paso* (fig. 4.34), might have been included in the book, erroneously credited to Vaudricourt.[97]

The *Boundary Survey* contains some of the early chromolithographs of Texas and the Southwest: three landscapes and nine portraits of Indians. Perhaps thinking of Article 11 of the Treaty of Guadalupe Hidalgo, which required that the United States prevent Indians living north of the border from raiding into Mexico, Emory chose to include portraits of three Texas-related Indians who clearly were still conducting raids.[98] The portraits are the work of Schott, who was profoundly influenced by Alexander von Humboldt and would have been familiar with current theories regarding the origin of the different races, a subject of intense discussion during what historian William H. Goetzmann has called "the second great age of discovery." Humboldt and his mentor, Johann Friedrich Blumenbach, professor at the University of Göttingen and the founder of scientific anthropology, trained and influenced a generation of

FIGURE 4.30 Unknown photographer, Arthur C. V. Schott, c. 1860. Courtesy the Smithsonian Institution Archives.

TORO-MUCHO.
CHIEF OF A BAND OF KIOWAYS

exploration artists to produce detailed and accurate images of their subjects, especially portraits. From this information, the stay-at-home savants developed their theories on the scientific questions of the day, such as the origin of the races. But they also interpreted the portraits in the context of the pseudoscience of physiognomy, which enjoyed widespread popularity during the first third of the century.[99] Considered from this perspective, Schott's portraits are far more significant than mere likenesses.

Emory encountered Toro-Mucho in the fall of 1851 at the head of a large party of Comanches and Kiowas at Comanche Springs, near present-day Fort Stockton. He was herding more than a thousand animals from a recent raid into northern Mexico. The warrior visited the surveyors' camp and permitted Schott to sketch his portrait (fig. 4.31). When the work was published, Schott complained that his pictorial interpreter, the lithographic draftsman, "was never out in Texas and can for this reason not be able to finish those sketches as they ought to be done." Yet he pronounced the final product "not bad."[100] Toro-Mucho is shown piously sitting on a rock with his arms folded, a meek countenance, and a large silver cross hanging from his necklace, an unusual portrait for a man who was the leader of a large raiding party. His head is tilted to the right, significantly, toward a cactus in the right background, which seems also to be pointing toward him.

FIGURE 4.31 Arthur C. V. Schott, *Toro-Mucho, Chief of a Band of Kioways*, c. 1852. Chromolithograph, 9 × 5.63 in. (comp.), by Sarony, Major & Knapp, New York. From William H. Emory, *Report of the United States and Mexican Boundary Survey* (1857–1859), vol. 1, pt. 1. Courtesy private collection.

"A PERFECT *TERRA INCOGNITA*" | 167

NOCO-SHIMATT-TASH-TANAKI.
GRIZZLY BEAR.
SEMINOLE CHIEF.

Schott apparently had a special affection for cacti and, as was common among nineteenth-century artists, regarded nature anthropomorphically. He spoke of cacti as "warm sincere friends." He felt that humans, with their "eternal soul imprisoned in a body," were only "one or two grades above vegetables," which, like the cacti, are "fastened to the ground" by their roots. And he suggests this relationship by showing the benign-looking warrior and the cactus leaning toward each other. Major Emory did not share this view of the Indian, who, after all, was returning from a raid in Mexico with more than a thousand animals. Toro-Mucho claimed that he had received the large silver cross from the Bishop of Durango when he was converted to Christianity, but Emory suggested that he had more likely "robbed some church of it" and wrote, "I present him as a type of that class of Mexicans who, by affiliation with the wild Indians, have produced such irreparable ruin to the northern States of Mexico."[101]

Schott probably encountered Grizzly Bear in the vicinity of Fort Duncan, near the home of the well-known Seminole chief Wild Cat and his band of Indians and Blacks (fig. 4.32). Grizzly Bear probably was Crazy Bear, Wild Cat's cousin and lieutenant. Journalist Jane Maria Eliza McManus Storm Cazneau, author of *Eagle Pass, or Life on the Border* (1852) and a resident of Eagle Pass at the time, described Crazy Bear as having "more of the crude, imperfect savage . . . than his

FIGURE 4.32 Arthur C. V. Schott, *Noco-Shimatt-Tash-Tanaki. Grizzly Bear. Seminole Chief*, c. 1852. Chromolithograph, 21.2 × 14 cm (image), 23.2 × 14 cm (comp.), by Sarony & Co. From Emory, *United States and Mexican Boundary Survey* (1857–1859), vol. 1, pt. 1. Courtesy private collection.

chief." "Left to himself," she continued, "the Bear would kill any white man he met alone in the forest with ferocious delight, because he hates the race, and feels that, whether in peace or war, the Red Race is alike dying under his heel." Despite Cazneau's opinion, Schott, who probably met her as the survey proceeded along the river, shows the man standing stoically by shrubs and cacti, again illustrating the relationship between man and nature. The Bear is colorfully dressed in the style of the Seminoles and is holding what may be a Pennsylvania or Kentucky long rifle, highly decorated. Schott clearly felt that this "half primitive half decaying race of Spanish and Indian blood" was inferior to the white race, but he again confirmed their rapport with nature. They "possess ... an almost infinite taste" for nature and "true science is most indebted for a great many acquaintances of most useful plants," he wrote. "It is much, indeed very much, what even most enlightened people can learn from these poor children of the wilderness."[102]

The third portrait came about when Schott accompanied Lieutenant Michler to the Lipan Crossing, about eighty-five miles above the mouth of the Pecos River, and met a number of Lipan Apaches, some of whom served as guides for the surveyors; others conducted regular raids throughout southwest Texas.[103] Schott painted the portrait entitled *Lipan-Warrior*, again showing the man and horse in a close relationship with nature, as represented by the shrubs and cacti at the horse's feet (fig. 4.33).[104]

FIGURE 4.33 Arthur C. V. Schott, *Lipan-Warrior*, c. 1852. Chromolithograph, 23 × 14.1 cm (comp.), by Sarony & Co. From Emory, *United States and Mexican Boundary Survey* (1857–1859), vol. 1, pt. 1. Courtesy private collection.

FIGURE 4.34 Augustus de Vaudricourt, *The Plaza and Church of El Paso*, 1857. Chromolithograph, 6 × 8.25 in. (comp.), by Sarony & Co, New York. From Emory, *United States and Mexican Boundary Survey* (1857–1859), vol. 1, pt. 1. Courtesy private collection.

Of the three chromolithographed landscapes in the *Boundary Survey*, two are of Mexican scenes. Perhaps the best known is *The Plaza and Church of El Paso*, perhaps erroneously credited to Vaudricourt instead of Bartlett, which shows the main plaza of what is today Ciudad Juárez, Chihuahua, with what appears to be a reddish-colored flag flying over the long, low adobe building at the right (fig. 4.34). (There is an almost identical scene among Bartlett's sketches, but no flag is present in his version.) "This town, although built in the sixteenth century, and possessing a very considerable trade, does not contain a single stone, brick, or wooden building," Emory reported. Recent rains had left "several adobe houses . . . washed down, and, with few exceptions, every house in the place was damaged and rendered leaky."[105]

A second landscape, *Falls of the Rio Salado*, drawn by John E.

FIGURE 4.35 John Weyss, *Falls of the Rio Salado*, 1857. Chromolithograph, 6.12 × 8.31 in. (comp.), by Sarony, Major & Knapp, New York. From Emory, *United States and Mexican Boundary Survey* (1857–1859), vol. 1, pt. 1, opp. 67. Courtesy private collection.

Weyss, shows one of the tributaries of the lower Rio Grande, about halfway between Laredo and Roma (fig. 4.35). It, along with the Rio Conchos and winter snowfall in the Rocky Mountains at the headwater of the Rio Grande, provided the annual overflow of the river.[106]

The third chromolithographed landscape, also attributed to Schott, based on circumstantial evidence, is *Prairie of the Antelope* (fig. 4.36). Schott's main assignment for the publication was to draw a series of thirty-five landscape views that would document the positions of the boundary markers, which required purposeful and accurate drawings. Schott always showed the marker in the foreground of these outline drawings; the middle ground usually fell away from the viewer, and the background landscape was intended to help locate the marker should it become displaced. He complemented the drawings with descriptive notes and located the

FIGURE 4.36 Arthur C. V. Schott (attrib.), *Prairie of the Antelope*, c. 1852. Chromolithograph, 15.6 × 12.3 cm (comp.), by Sarony, Major & Knapp, New York. From Emory, *United States and Mexican Boundary Survey* (1857–1859), vol. 1, pt. 1. Courtesy private collection.

sites on an accompanying map.[107] The most obvious characteristic of these views is that the foreground of each image contains a virtual panoply, almost a veil, of carefully selected trees, cacti, and other plants of the region, while the landscape that the survey demanded forms the background. "To make these landscapes more valuable and worthy for science," Schott explained to Dr. Torrey, his Princeton mentor, "I pay particular attention to the execution of the foregrounds"—a creative way for Schott to serve his artistic muse as well as the charge from his employer.[108]

This characteristic may also be seen in *Prairie of the Antelope* (fig. 4.36), a scene from the "Western wastes," as he put it. It may be a West Texas scene, but it is not identified. The artist of *Prairie*

of the Antelope dealt with the scene in the same manner as many of Schott's other landscapes. A mountain range forms the background, while a broad valley stretches across the middle ground; in the foreground, on what appears to be a ledge (or almost a stage) is a virtual congregation of exotic desert plants. Although most of the other illustrations are mentioned in the text, neither the location of the *Prairie of the Antelope* nor the plants are identified.[109]

Schott was concerned that his drawings be properly reproduced and alerted Dr. George Engelmann in St. Louis, the noted botanist in charge of this portion of the publication, that he would be "be very anxious to see them." Working under Engelmann was the St. Louis lithographic artist Paulus Roetter, who copied all of Schott's drawings for publication. In other letters Schott's frustration is apparent as he advises Engelmann of various details and idiosyncrasies of certain cacti. Finally, in desperation, he wrote,

> I think it would be better to have them [the lithographic drawings] done by myself as it is a matter of impossibility to draw anything lifelike, which furnishes so essential features in those Western wilds. No doubt somewhat like can be made by a draftsman according to a good description but the result will unvariably be an artificial plant, whist the real originals having irregularities and deviations from the type, which usually escape before the eye of science.[110]

Engelmann and Roetter, of course, continued with their work.

Scientific illustrators engraved plants, animals, and geology on copper and transferred them to stone, and the pressmen printed them as lithographs. They also printed some of the most striking and well-known views of Texas—San Antonio, Brownsville, various pictures along the Rio Grande—as wood or steel engravings.[111] According to Treasury Department records, the public printer produced 15,000 copies of the first volume (10,000 for the House, 5,000 for the Senate), which might have revived a complaint that had been voiced the previous year in Congress: that the government should publish "useful and not ornamental" material. Perhaps because they did not anticipate as much interest in the botanical and zoological reports, each house of Congress ordered only 1,000 copies of both parts of the second volume from different printers (for a total of 4,000), leading a correspondent for the *New York Herald* to complain in florid prose that this one expedition alone resulted in "at least two quartos, full of gaily colored oyster shells and antipodean roosters, who go to

FIGURE 4.37 Unknown artist, *Chordeiles Texensis* [Texas Night Hawk], c. 1859. Hand-colored lithograph, 12.12 × 8.5 in. (comp.), by Bowen & Co. From Spencer F. Baird, "Birds of the Boundary," in Emory, *United States and Mexican Boundary Survey* (1857–1859), vol. 2, pt. 2, plate 40, 154. Courtesy private collection.

swell Time's wallet for oblivion, and reduce Uncle Sam's auriferous dropsy."[112] Sarony, Major & Knapp printed the chromolithographs for both editions.[113]

Unfortunately, the Mexican government was not able to publish a report comparable to Emory's, but Col. Emilio Langberg, Internal Inspector of the Military Colonies in Chihuahua, had an artist, Enrique Barchesky, with him as he documented the Chihuahua-Coahuila border. Barchesky painted three watercolors that were a part of Langberg's official report.[114]

FIGURE 4.38 George G. White, *The Ground Cuckoo. Geococcyx mexicanus. (Gm)*, 1856. Hand-colored, toned lithograph, 14.6 × 19.8 cm (comp.), On stone by William E. Hitchcock, printed by J. T. Bowen. From John Cassin, *Birds of California, Texas, Oregon* (1856), plate 36. Courtesy private collection.

Volume 2, part 2 of Emory's *United States and Mexican Boundary Survey* (fig. 4.37), the "Zoology of the Boundary," contains twenty-five hand-colored lithographs of birds by an unnamed lithographer, probably the Bowen firm in Philadelphia, accompanied by Spencer Fullerton Baird's essay on "Birds of the Boundary." The prints are, in fact, the product of John Cassin, one of the "closet" naturalists whom Audubon disdained, meaning that he worked more in the laboratory than in the field. Trained as an ornithologist, Cassin grew interested in lithography because he, like Schott and many other artists, realized that it involved an intermediate—and important—step, between the original illustration and the published image.[115]

Through his research Cassin had discovered a number of birds not included in Audubon's work, many of them native to Texas, and in June 1851 he had approached the Audubon brothers about doing a three-volume supplement to the octavo *Birds of America*. The brothers declined, so Cassin undertook his own publication the following year, employing lithographer Lewis N. Rosenthal of Philadelphia. The effort failed due to what even Cassin recognized as "indifferent plates," and he tried again the following year with artist George Gorgas White and lithographer John T. Bowen of Philadelphia, who was Audubon's printer. The finished work, comprising ten parts, contained more than twenty newly discovered Texas birds, including the most famous of them all, the roadrunner (fig. 4.38), or "the *Paisano*, as this bird is called by the Mexicans."[116] The book established Cassin as one of the top ornithologists in the country just in time for him to turn his attention to huge government contracts coming as a result of the western surveys.

Following Bowen's death, Cassin purchased half interest in the company from his widow and became president of the renamed Bowen & Co. He had criticized Bowen's naïveté in "foolishly" relying "on merit or superior ability" in bidding on government contracts and felt that his contacts in the natural history world combined with his newly acquired interest in the Bowen firm would give him an advantage over the competition. His new acquisition also gave him tremendous influence over other scientific publications, ironically including the octavo edition of Audubon's *Birds of America*, which the Bowen firm continued to print until after the Civil War.[117] "Birds of the Boundary," the final part of the *United States and Mexican Boundary Survey* (1859), and *The Birds of North America* (Philadelphia: J. B. Lippincott, 1860) were only two of the jobs that Cassin won for the Bowen firm. The latter volume combines hand-colored lithographs from both the *United States and Mexican Boundary Survey* and the *Pacific Railroad Surveys*.

"A ——— CRAZY DUTCHMAN . . . SURROUNDED BY HIGH WEEDS": THE GRAY SURVEY

Meanwhile, several private investors, led by Robert J. Walker, former secretary of the treasury under President Polk, a stockholder in the Atlantic & Pacific Railroad Co., and Emory's brother-in-law, announced their intention to build a railroad from Vicksburg to El Paso, and from there along the 32nd parallel to California. Walker had a questionable reputation, and many doubted that he was serious about constructing the road. But through another company that he owned, the Texas Western Railroad, he employed former chief surveyor Andrew B. Gray of the US-Mexican Boundary Commission to survey the route. A veteran of the Texas Navy as well as a Republic of Texas surveyor, Gray arrived in San Antonio in December 1853 and organized his party of nineteen men, led by Peter R. Brady, former Navy man and Texas Ranger. Mining engineer Carl Schuchard, a German immigrant who had tried his luck in the California goldfields before migrating to San Antonio, signed on with Gray as topographic artist.[118] Their goal was to prove that the Southern dream of a transcontinental railroad could be built along the route via San Antonio to the Pacific Ocean.

Gray departed on New Year's Day, 1854, just two days after American ambassador to Mexico James Gadsden had secured a large portion of the territory that Gray was to survey in what became known as the Gadsden Purchase. As Gray passed by Fort Chadbourne on the south fork of the Concho River and crossed the Llano Estacado, Schuchard sketched the fort and the nearby Church Mountain Valley (figs. 4.39 and 4.40), territory that seemed "peculiarly adapted in every way to the construction and maintenance of a railroad."[119]

As he approached the fringes of the Llano Estacado, Gray saw possibilities that other travelers might have overlooked: "It is by no means a desert, or barren waste, for with exceptions of narrow belts less prepossessing, there are vast fields of fine grazing lands, where antelope, deer, and other game are seldom out of sight." Schuchard produced a drawing of an antelope to illustrate Gray's comment. Gray admitted that cross-ties for the rails would have to be brought in because there was no ready supply of timber in the region and that

FIGURE 4.39 Carl Schuchard, *Fort Chadbourne, Texas. Latitude 32° 02' N. January 1854*, 1854. Toned lithograph (with modern hand-coloring), 12.1 × 19.9 cm (comp.), by Middleton, Wallace & Co., Cincinnati. From Andrew B. Gray, *Southern Pacific Railroad* (1856). Courtesy private collection.

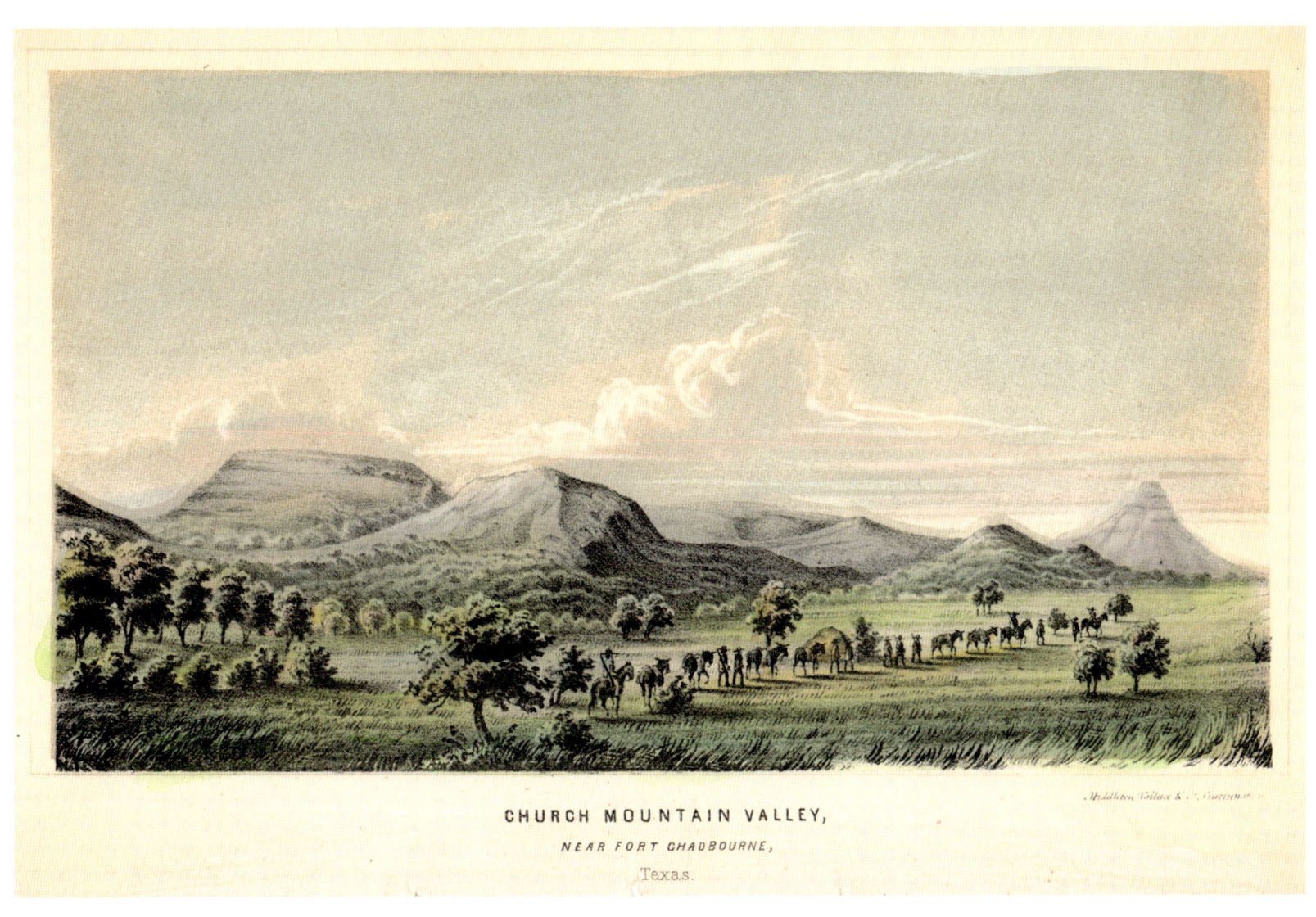

FIGURE 4.40 Carl Schuchard, *Church Mountain Valley, Near Fort Chadbourne, Texas*, 1854, Toned lithograph (with modern hand-coloring), 12.7 × 19.8 cm. (comp.) Lithographed by Middleton, Wallace & Co., Cincinnati. From Gray, *Southern Pacific Railroad* (1856). Courtesy private collection.

the Pecos (fig. 4.41), "a bold, running stream, sixty-five feet wide" that was "tortuous in places," would pose a problem, but he added that their party, nevertheless, had forded it "without difficulty."[120]

Beyond the Pecos the party reached the Guadalupe Mountains, which were "conspicuous" for their "abrupt and precipitous cliff of columnar rock." "The Peak can be seen at a great distance, owing to the clear and rarified atmosphere of the country," Gray reported. Bartlett had called it Guadalupe Mountain; Gray called it Cathedral Rock. Today it goes by the name of El Capitan and is in Guadalupe Mountains National Park.[121] Shown behind El Capitan are four more peaks, known today as Guadalupe Peak, Shumard Peak, Bartlett Peak, and Bush Peak, the four highest mountains in Texas.

An incident that occurred near the Guadalupe Mountains provides some insight into the relationship between surveyor and artist. Brady recorded in his journal that Gray asked Schuchard to make a sketch of the mountains, and, "as usual, Gray had selected the position from which the sketch was to be made, very much against the wish of the artist." Schuchard spent several hours on the drawing, then returned to camp and handed it to Gray. "Gray was furious," Brady recalled, telling Schuchard, "'I cannot see anything but

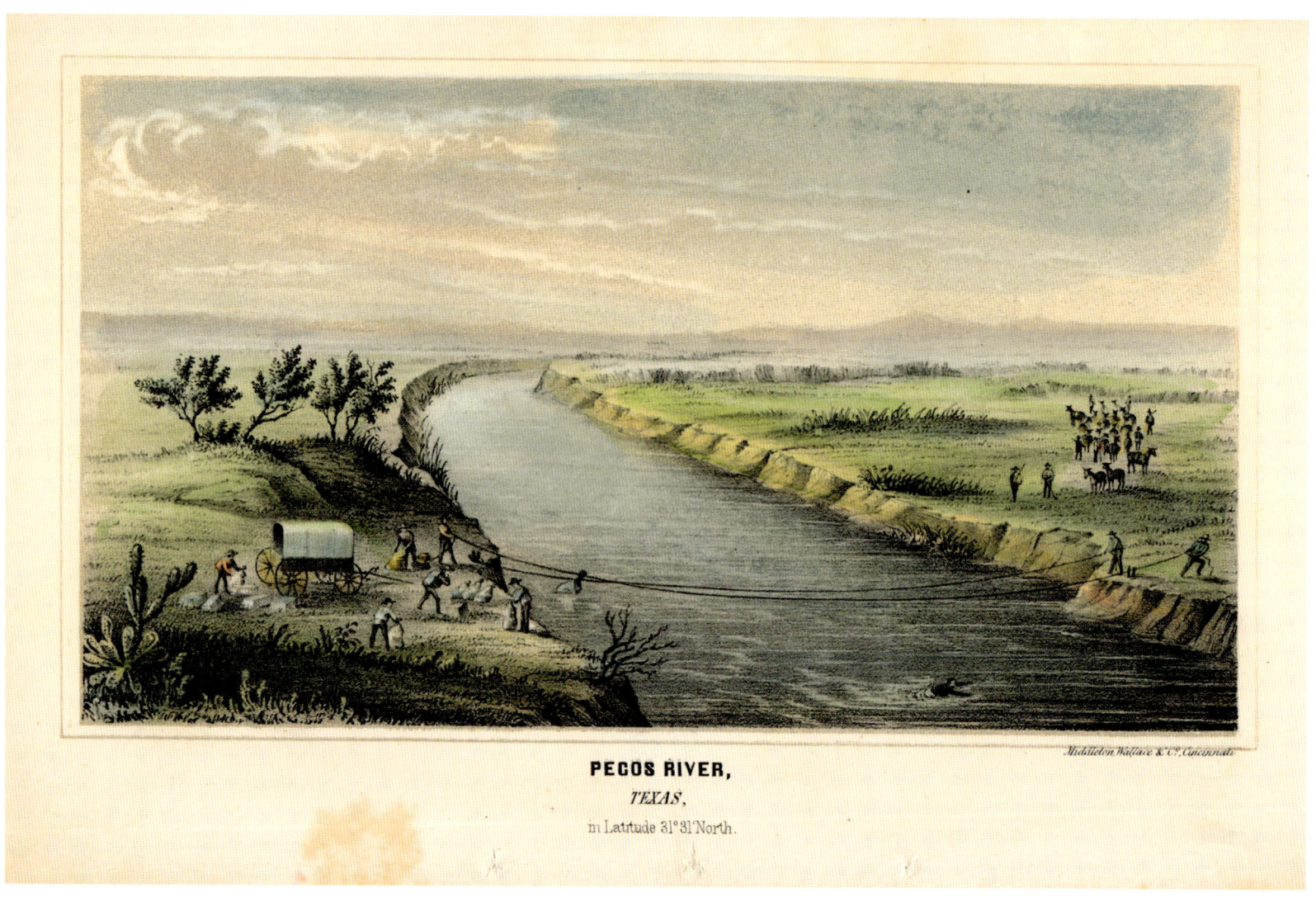

FIGURE 4.41 Carl Schuchard, *Pecos River, Texas, in Latitude 31° 31' North*, 1854. Toned lithograph (with modern hand-coloring), 12.4 × 19.4 cm (comp.), by Middleton, Wallace & Co., Cincinnati. From Gray, *Southern Pacific Railroad* (1856). Courtesy private collection.

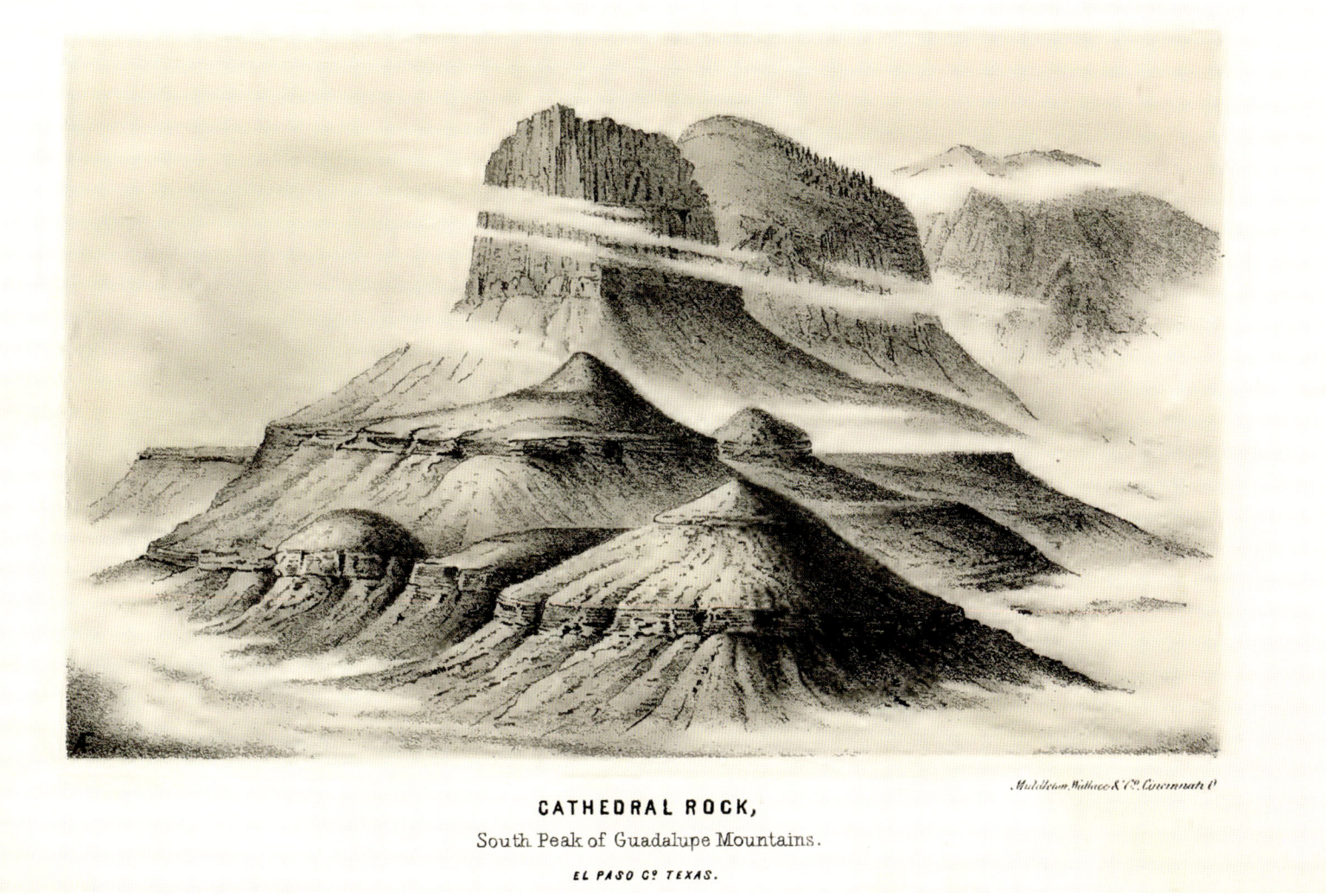

FIGURE 4.42 Carl Schuchard, *Cathedral Rock, South Peak of Guadalupe Mountains*, 1854. Toned lithograph, 11.2 × 16.6 cm (comp.), by Middleton, Wallace & Co., Cincinnati. On stone by A.F. [monogram]. From Gray, *Southern Pacific Railroad* (1856). Courtesy Amon Carter Museum of American Art, Fort Worth.

a ——— crazy Dutchman sitting in a hollow with a pipe in his mouth and surrounded by high weeds and grass on all sides, nothing of the grand mountain to be seen.' 'Well, the next time you want a sketch let me select the place and I will do better,'" Schuchard replied.[122] Gray did, and Schuchard's drawing of Cathedral Rock is included in Gray's report (fig. 4.42).

When he arrived at El Paso (today Ciudad Juárez, fig. 4.43), Gray carefully examined the Rio Grande at Hart's Mill with Capt. John Pope of the Topographical Engineers, who was just beginning his survey of West Texas.[123] Schuchard made two drawings of a possible bridge site that were lithographed for the report (figs. 4.44 and 4.45). *Molino del Norte* was made from the American side of the river, while *Falls of the Rio Grande* is a view from the Mexican side. Schuchard might also have been the artist for the separately issued view of *Falls on Rio Grande at El Paso, Flouring Mills of Simeon Hart Esq.*, which was probably published between 1851 and 1854, when the lithographic firm of J. & D. Major existed in New York (fig. 4.46).[124] Of course, the print could also have been made after a drawing by one of the several other artists who passed through this area in the early 1850s—Pratt, Schott, Vaudricourt, and Harry S. Sindall,

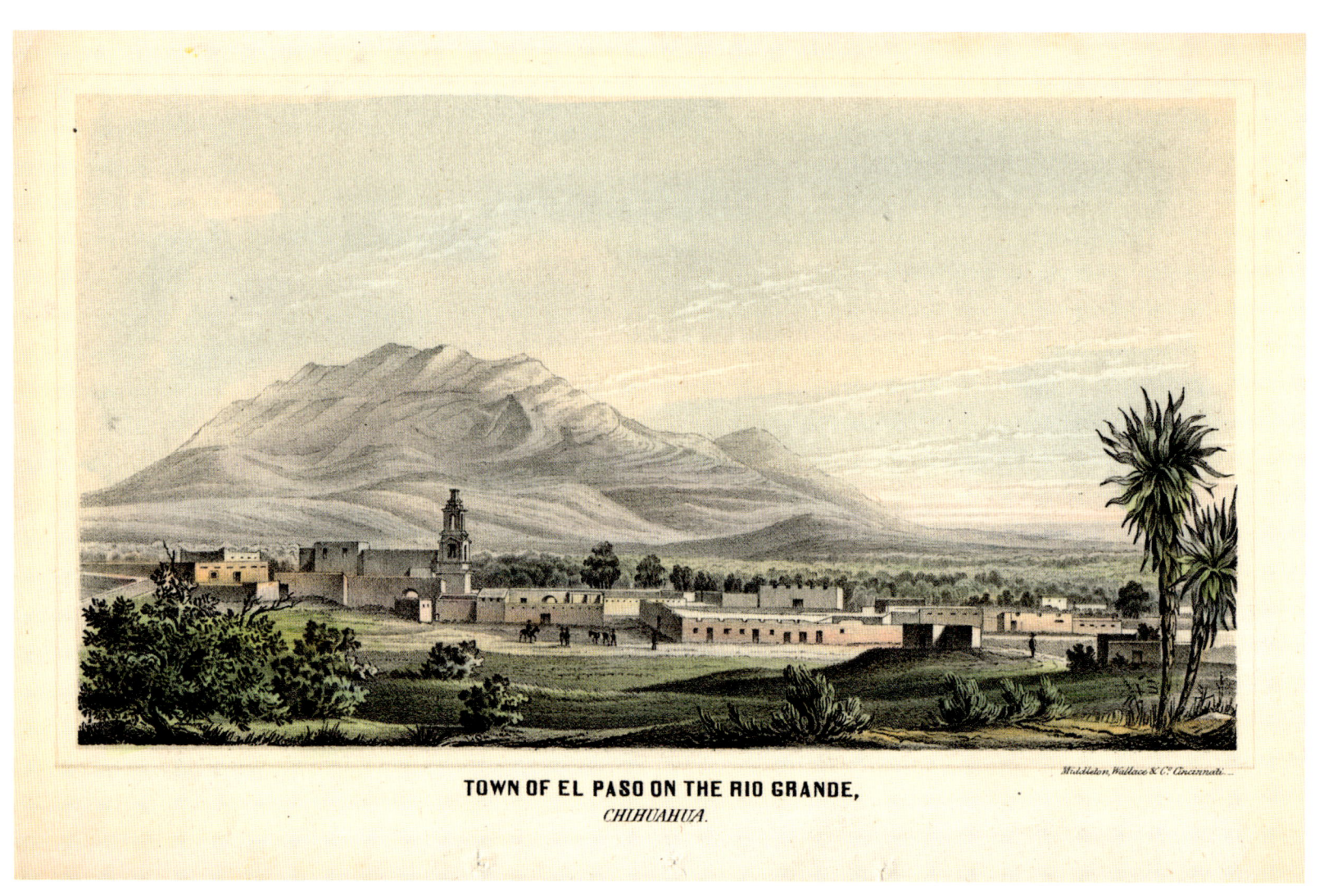

FIGURE 4.43 Carl Schuchard, *Town of El Paso on the Rio Grande, Chihuahua*, 1854. Toned lithograph (with modern hand-coloring), 12 × 19.8 cm (comp.), by Middleton, Wallace & Co., Cincinnati. From Gray, *Southern Pacific Railroad* (1856). Courtesy private collection.

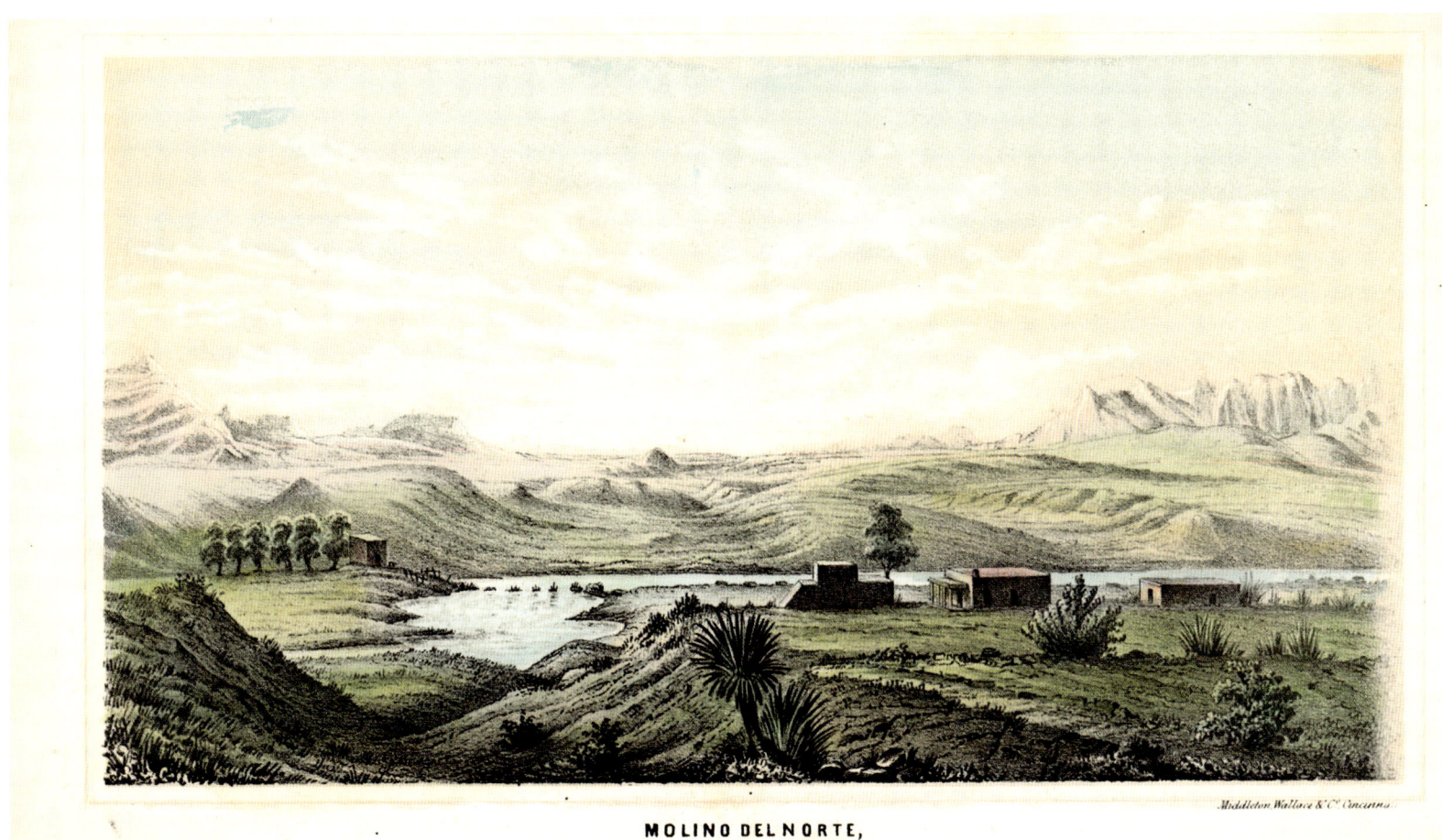

FIGURE 4.44 Carl Schuchard, *Molino del Norte, 2 Miles above El Paso, from the American side Rio Grande, Looking Westward*, 1854. Toned lithograph (with modern hand-coloring), 12.1 × 19.9 cm (comp.), by Middleton, Wallace & Co., Cincinnati. From Gray, *Southern Pacific Railroad* (1856). Courtesy private collection.

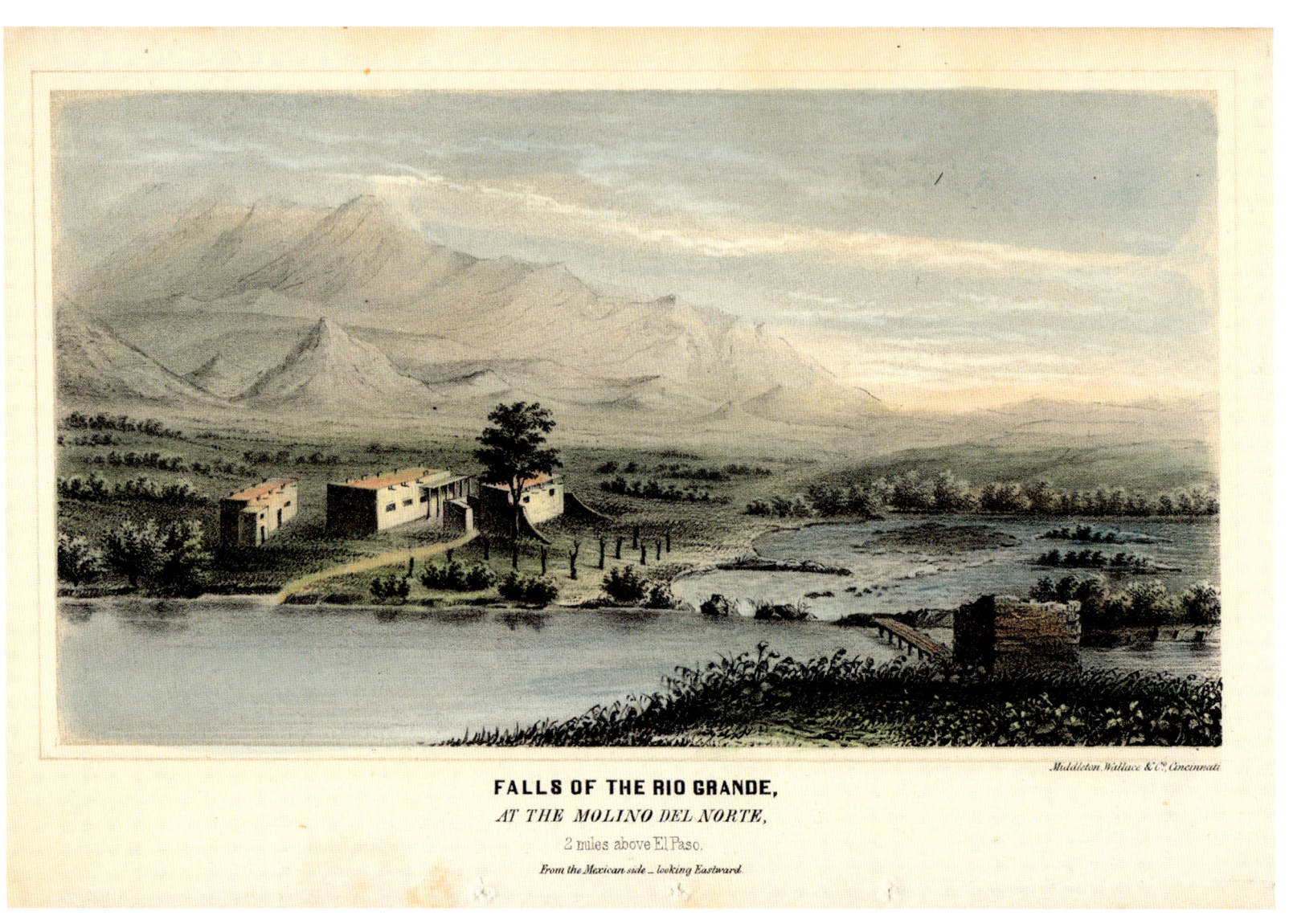

FIGURE 4.45 Carl Schuchard, *Falls of the Rio Grande, at the Molino del Norte, 2 Miles Above El Paso. From the Mountain Side—Looking Eastward*, 1854. Toned lithograph (with modern hand-coloring), 11.2 × 16.6 cm (comp.), by Middleton, Wallace & Co., Cincinnati. On stone by A.F. [monogram]. From Gray, *Southern Pacific Railroad* (1856). Courtesy private collection.

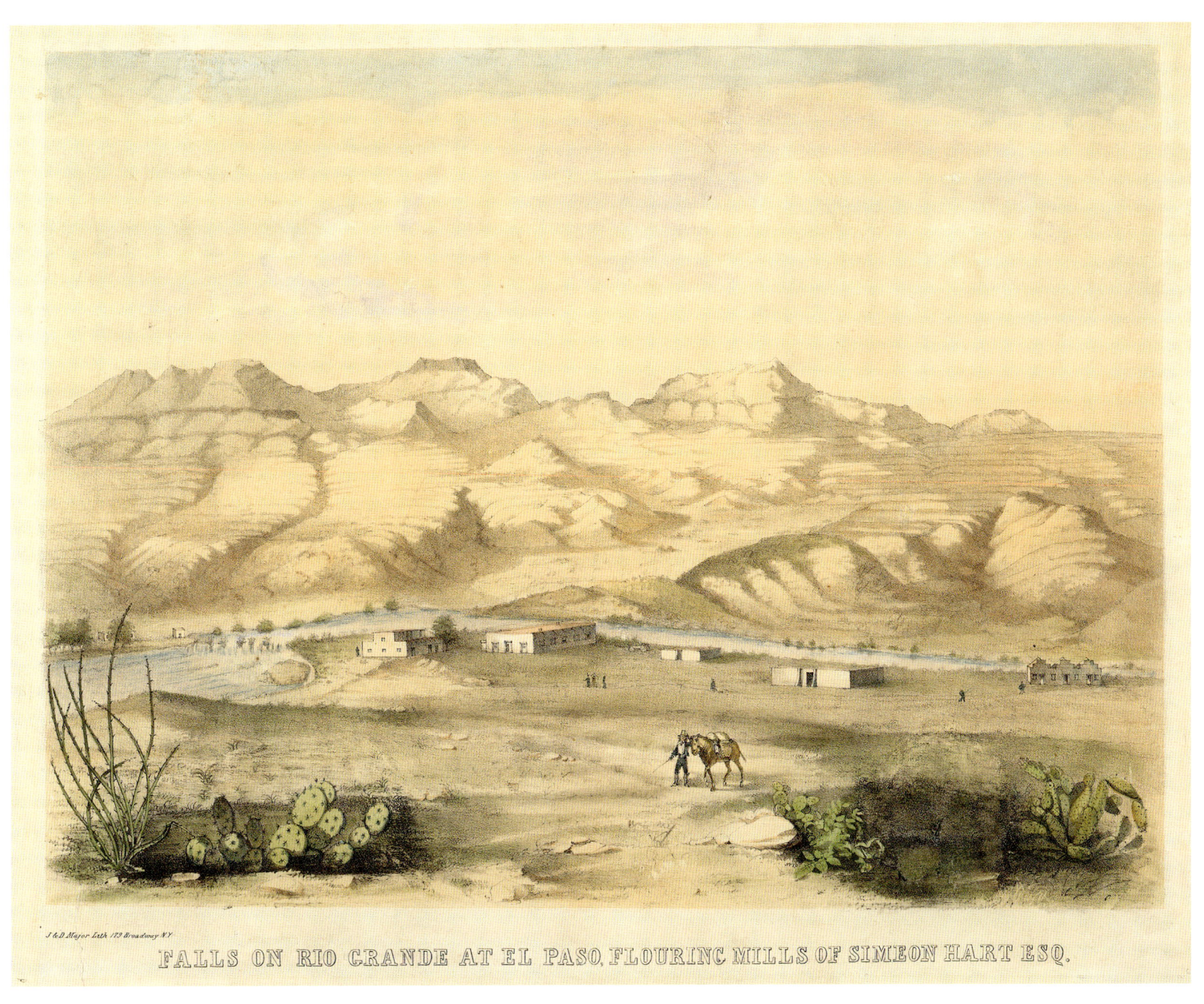

FIGURE 4.46 Unknown artist, *Falls on Rio Grande at El Paso, Flouring Mills of Simeon Hart, Esq.*, c. 1854. Hand-colored lithograph, 37 × 50 cm (image), 39.7 × 50 cm (comp.). Lithographed by J & D Major, 179 Broadway, New York. Courtesy Amon Carter Museum of American Art, Fort Worth.

who accompanied Captain Pope's survey, or even Bartlett, although surely Bartlett would have taken credit for it if it had been his.

Gray surveyed a few miles farther upriver for another bridge site in the event that the company could not negotiate for the use of Mexican territory, and Schuchard produced *Passage of the Rio Grande* and *Break of the Rio Grande, Through the Bluffs Near Frontera* to illustrate a possible crossing point (fig. 4.47). On Easter Sunday, Gray and his party left Texas. Gray sent Brady and a portion of the party on a near-fatal trek across the desert to Lake Guzman, while taking the safer and more familiar El Paso–Chihuahua road himself.[125]

Upon his return, Gray published *Southern Pacific Railroad. Survey of a Route for the Southern Pacific R. R., on the 32nd Parallel*, which contains thirty-three lithographs copied with "thoughtful skill" after Schuchard's sketches, fourteen of them Texas scenes.[126] Like his peers, Gray observed the similarity between classical architectural forms and natural creations: "This stupendous basaltic structure [El Capitan] . . . looks as if it had been shaped by some sudden and powerful convulsion of nature into the form of a large edifice or church," he wrote. More than a year before, John Russell Bartlett had stood in awe of the "dark, gloomy-looking range, with bold and forbidding sides, consisting of huge piles of rocks, their *debris* heaped far above the surrounding hills." Gray, perhaps traveling in better weather than Bartlett experienced, found the peak to be "truly sublime and beautiful."[127]

Southern newspapers noted Gray's publication, but the construction of the Atlantic & Pacific Railroad depended on selling shares and on Texas land grants, and the scheme collapsed when Texas governor Elisha Pease realized how little backing the company had and refused to approve state land grants.[128]

During the first decade of Texas statehood, these systematic surveys beyond the fringes of settlement, into the realms of Native Americans, were directed toward the future: marking the new boundary between Mexico and the United States, identifying any exploitable minerals, and surveying a transcontinental railroad route. These images, for the most part, are accurate enough that historians today can locate the spots where the drawing and paintings were made. As the *Washington Union* reported, "The illustrations, executed on steel and copper, and in colored lithographs, are numerous, and more attention seems to have been paid to their accuracy than to their beauty, and a very good idea of the boundary line may be obtained from a glance at the pictures alone."[129] A backhanded compliment, but one that the topographical artists probably would have considered vindication of their work.

The surveyors and explorers who documented Texas were, for the most part, dedicated scientists and engineers who were committed to unifying a nation that was expanding so rapidly that it would soon fall victim to the inherent conflict at its core. When the rupture came, these men, too, split into factions, as friends, classmates, fathers, sons, and brothers chose different sides. But as acolytes of Romanticism, they believed that the huge volumes of new information that they gathered—narratives, scientific reports and illustrations, astronomical observations, specimens, maps, views—would help in the process of occupying and assimilating the vast territory west of the 100th meridian; they would, in fact, help mold the American character. The rapid growth in the state's population was no doubt due in some measure to the accurate, dependable, and encouraging information now placed in the hands of a democratic and capitalistic society.[130] Boasting chromolithographs of unfamiliar scenery and foreign and curious native cultures, these well-illustrated publications presented not the fertile paradise that stimulated an unprecedented migration westward, but the vastness, beauty, and exoticism of little-known regions of the country. Texans could now see that, instead of constituting the western edge of the country, they would soon become a link between the established, cotton-growing South and the Pacific Ocean. The publications that resulted from these surveys also provided a welcome stimulus for the still fledgling American lithographic industry.

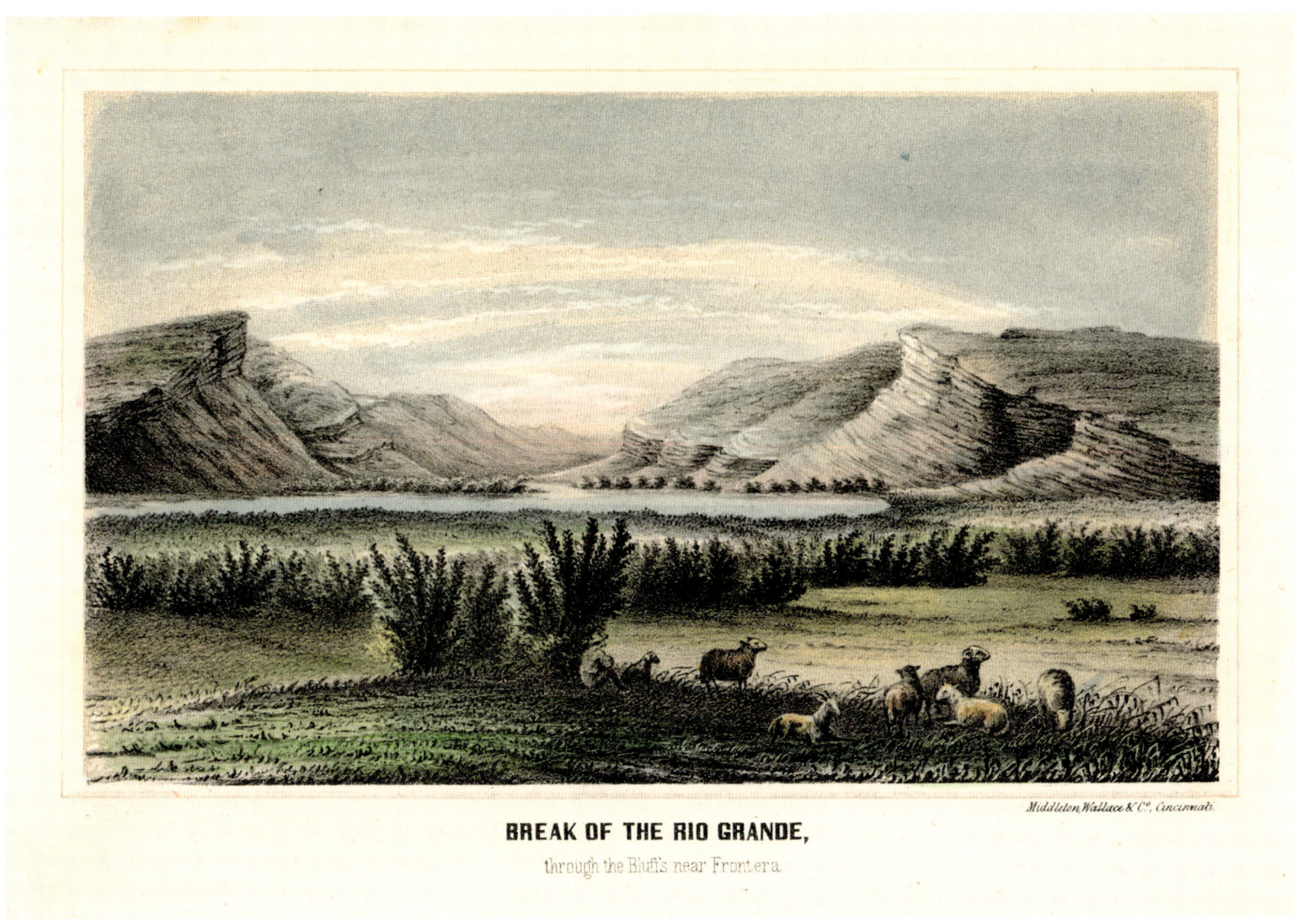

FIGURE 4.47 Carl Schuchard, *Break of the Rio Grande, Through the Bluffs Near Frontera*, 1854. Toned lithograph (with modern hand-coloring), 12.1 × 19.9 cm (comp.), by Middleton, Wallace & Co., Cincinnati. From Gray, *Southern Pacific Railroad* (1856). Courtesy private collection.

FIGURE 5.1 Artist unknown, *Galveston*, 1847. Lithograph, 10.2 × 16 cm (comp.), by Oehme & Müller. From Karl von Sommer, *Bericht über meine Reise nach Texas im Jahre 1846* (1847). Courtesy Dallas Public Library. The name "Hendley & C" is shown above the second-floor windows of the tall structure in the center of the print.

CHAPTER 5

"PRETTY PICTURES . . . 'CANDY' FOR THE IMMIGRANTS"

ILLUSTRATING THE STATE

"Thank God, we are now annexed to the United States, and can hope for home and quiet," Mary A. Maverick of San Antonio confided to her diary in July 1845.[1] Thousands of others agreed, and voters approved annexation 7,664 to 430. Would-be immigrants who might have postponed their departure for the republic because of frontier violence or Mexican incursions now packed their trunks, loaded their wagons, hitched up the oxen, and headed for the new state, confident that the federal government would provide for their security. "Young Texas is no longer a 'lone star,'" proclaimed the editor of the *Public Ledger* in Philadelphia, "but is one of the bright sisterhood whose united splendor and power excite the admiration, astonishment and apprehension of the governments of the old world." War with Mexico had interceded, but during the dozen years that followed, the state's population increased more than fourfold and property values (including slaves) grew more than eightfold as newcomers built their homes in the new state. "The whole west is teeming with life and activity," editor John Salmon "Rip" Ford reported from Austin in 1847, "immigration flowing in from all quarters."[2] Two years later the editor of the *Bonham Argus* declared, "The roads are filled with wagons." These years also saw the establishment and failure of the first lithographic press in the state.

"THE BEAUTIFUL, IMMACULATE WORK OF GOD!"[3]

The number of Texas-related lithographs increased during the decade and a half of statehood prior to the Civil War, primarily because of the significant influx of German immigrants, several of whom were trained artists. Johann Friedrich Ernst, the first German to receive a grant in Stephen F. Austin's colony, wrote a number of letters to friends and family promising that "the sun and air are always bright and clear" and encouraging them to join him.[4] A larger recruiting effort began in 1842 when the Adelsverein (officially the Verein zum Schutze deutscher Einwanderer in Texas, or Society for the Protection of German Emigrants in Texas) acquired a league of land in Fayette County to serve as a base, then purchased land north of San Antonio the following year. German interest in Texas received a significant boost in 1841, when Carl Anton Postl, writing as Charles Sealsfield, published his novel *Das Kajütenbuch* (Zurich, 1841), translated in 1844 as *The Cabin Book*,

an enormously popular novel in which he projects a great future for Texas.[5] (Tellingly, W. G. Webb of the *Houston Telegraph* belatedly criticized the work because Postl "has failed in his attempt to show that bad men are useful in any country.") The *Civilian and Galveston Gazette* reported in 1846 that thirteen ships loaded with immigrants had sailed for Texas from Bremen, Hamburg, and Antwerp in one week.[6] The Adelsverein ultimately failed financially, but, encouraged by Postl's best-selling book and similar publicity, it brought more than 7,380 Germans to Texas before the Civil War, founded the towns of New Braunfels and Fredericksburg, and inspired and created some of the earliest lithographic images of the state that made up part of the effort to entice additional immigration.[7]

Most German immigrants entered Texas through Galveston because it was an established port with regular service to New Orleans and points beyond. It offered a cosmopolitan environment, a community of settled countrymen, and German-language newspapers, such as the *Galveston Zeitung* and *Wöchentliche Union*, the latter of which thirty-five-year-old German native Ferdinand Flake purchased in 1857 and renamed *Die Union* and turned into the largest-circulation newspaper in the city.[8] Karl von Sommer, who arrived in Galveston onboard the *Neptune* on April 17, 1846, with the intent of writing a travel narrative about Texas, was the first to publish an eyewitness view of Galveston after Texas joined the Union. His *Bericht über meine Reise nach Texas im Jahre 1846* (Report on my trip to Texas in 1846) includes a lithographic frontispiece showing Galveston from the bay side (fig. 5.1). The unnamed artist, perhaps Sommer himself, shows a couple of wharves extending out into the water; a sailboat is moored to one, and two rowboats maneuver near the other. Three men casually dealing with freight on one of the wharves do not give the impression of a bustling seaport. The only hint that the city would grow to become the principal port for shipping Texas cotton and importing farming supplies and goods is the two-story Hendley Building in the left center of the image.[9] The lithograph—and the city—gained a wider audience when E. Schossig subsequently copied it, perhaps as a stone engraving, picturing a somewhat busier looking Galveston harbor that C. W. Medau copied and published in Prague (fig. 5.2).[10]

Galveston was also home to the newly completed St. Mary's Cathedral, designed by architect Theodore E. Giraud, the son of François Giraud, who had built St. Mary's and the Ursuline Convent in San Antonio. The church had its beginning in 1841 when the French-born Rt. Rev. Jean Marie Odin constructed the first church building on the island, a frame structure of "starved architectural design" only fifty by twenty-two feet.[11] The European relatives of Father J. M. Paquin, who died while treating victims of a fever outbreak in 1844, sparked construction of the new church when they sent almost half a million bricks from Antwerp to be used in its construction in the priest's memory. Builders laid the cornerstone at the southeast corner of 21st Street and Church Street on March 14, 1847, and Bishop Odin led the dedication on November 26, 1848 (fig. 5.3). Jules Manouvrier and Perez Snell of New Orleans printed the lithograph of the structure, which probably was produced as part of the celebration when the church was completed. Its twin towers, redesigned by architect Nicholas J. Clayton in 1876, still mark the city's mainly horizontal skyline.[12]

St. Mary's Cathedral is prominent at the left-center in C. O. Bähr's c. 1855 view of Galveston, distinctive because of those twin towers. Even in the 1850s the city still occupied only the eastern end of the island, and that is the perspective from which Bähr depicted it (fig. 5.4). By then Galveston was in the midst of an "astonishing" building boom. "Speculation in real estate" was "astronomical," and the city had begun to assume some of the characteristics of a miniature "Manhattan of the Gulf," to which its civic leaders and developers aspired. To the left of St. Mary's is the city square (lined with trees), with the Presbyterian Church behind it. The large, two-story building in the left-center is the Tremont House, and the building with a cupola in the lower left-center is probably a market. The square, two-story building on the street that runs from the lower left-center of the print to the right is probably the Hendley Building, with the custom house on the bay in the center of the print. Several three-story brick buildings with handsome iron fronts had gone up by the late 1850s, but none are depicted in Bähr's view, which may suggest an earlier publication date. By 1857 residents were anticipating the imminent completion of the new federal customs house.[13] Few copies of the print have survived, suggesting that most of them were distributed in Europe to create interest among Germans in joining their countrymen in Texas.

From an imagined, elevated perspective, Bähr looked southwestward across the horizontal city; vacant land occupies both the foreground and the distance. He depicted a compact city center close by the waterfront, which diminishes as it spreads down the island and toward the gulf shore. It is an unpretentious view of a small seaport town occupying a barrier island. Josiah Gregg, who first saw the city in 1841, thought it to be "handsome though too monotonous in

FIGURE 5.2 E. Schossig, *Galveston*, c. 1848. Single sheet (poss. from a book). Hand-colored lithograph (prob. modern color), 4.5 × 6.5 in., by C. W. Medau, Prague. Courtesy private collection.

FIGURE 5.3 Theodore E. Giraud, *St. Mary's Church. Cathedral of Galveston, Texas*, 1847. Single sheet. Lithograph, 23.5 × 28.5 cm (image), 27.5 × 29.2 cm (comp.), by J. Manouvrier and P. Snell, New Orleans. Courtesy Daughters of the Republic of Texas Library.

FIGURE 5.4 Johann Anton Williard after C. O. Bähr [Baehr?], *Ansicht von Galveston*, c. 1855. Single sheet. Hand-colored toned lithograph, 26.3 × 41.1 cm (image), 30.2 × 41.9 cm (comp.). Lithographed and printed by Johann Anton Williard, Dresden. Courtesy New York Public Library.

appearance," an opinion quite at variance with several early English visitors, including Francis Sheridan and Charles Hooton. To them the main commercial street, grandly called the Strand, looked more like a wagon road. In the harbor Bähr showed the US Mail boat *Houston*, which had been running regularly between the two cities since the 1830s. Early arrivals to the city had noted the absence of trees, so the presence of a few of them in this image, including several palm trees, along with several two-story structures, suggests that the residents have begun to improve upon the inhospitable and blighted scene that Hooton had described just a few years prior.[14]

By the late 1850s Galveston was beginning to glimpse its destiny as "Queen of the Mexican Gulf" that surveyor John D. Groesbeck

"PRETTY PICTURES . . . 'CANDY' FOR THE IMMIGRANTS"

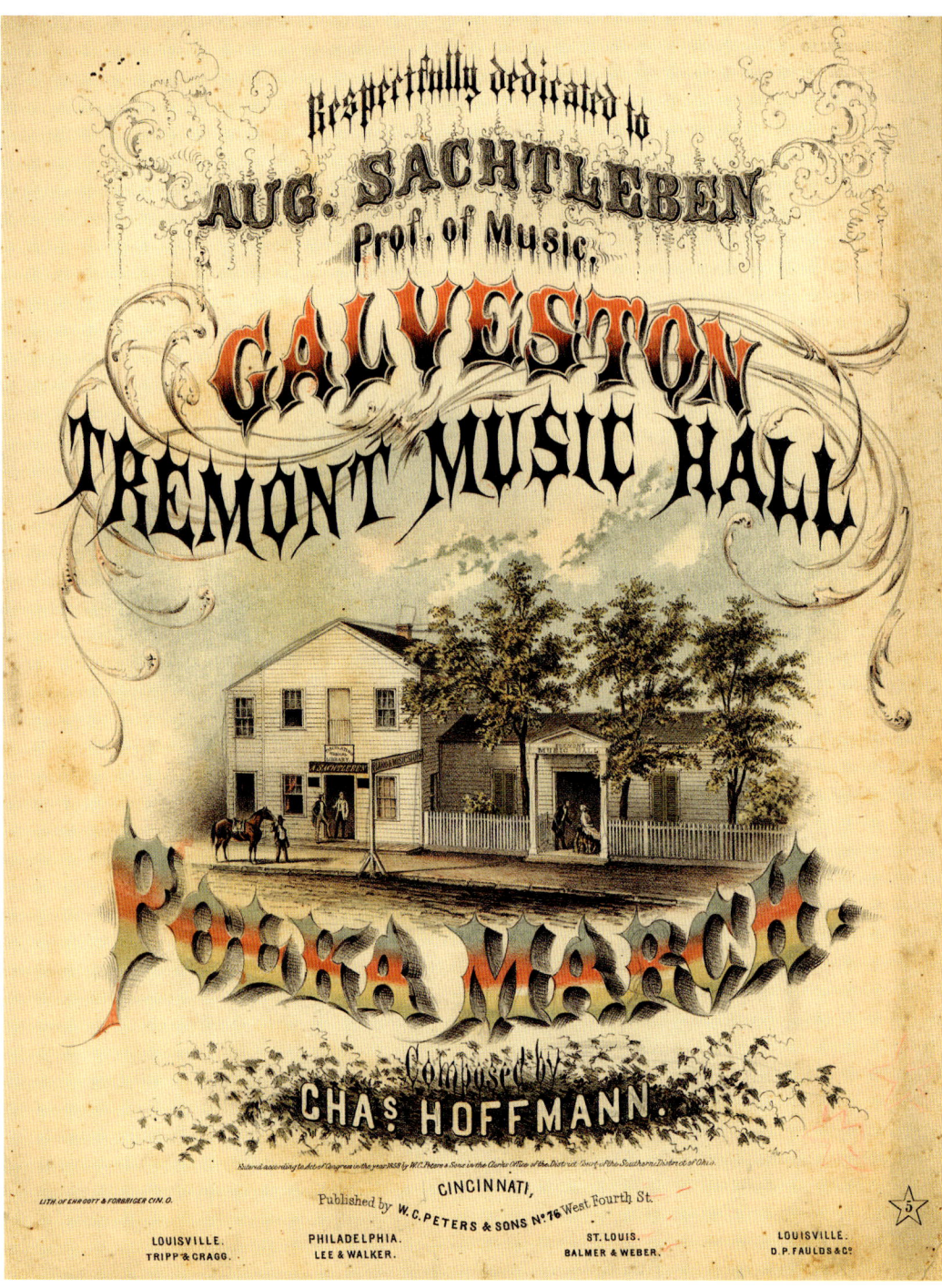

FIGURE 5.5 Unknown artist, "Galveston Tremont Music Hall Polka March," 1858. Sheet music. Hand-colored lithograph, 35.8 × 27.2 cm, by Ehrgott & Forbriger, Cincinnati. Courtesy Special Collections, University of Texas at Arlington Libraries. From this location on Tremont Street, Prof. August Sachtleben, a well-known musician and teacher, offered pianos and other musical instruments, sheet music, and music lessons. Chas. Hoffmann composed the "Polka March" in his honor, and Ehrgott & Forbriger, Cincinnati's leading lithographic firm at the time, printed it.

had envisioned when he platted Broadway as a 150-foot-wide thoroughfare for the Galveston City Co. in 1837–1838. Residents were becoming accustomed to amenities such as August Sachtleben's Tremont Music Hall, the only authorized agent for Steinway pianos in Texas (fig. 5.5). According to one report, twenty-three grand pianos were purchased in 1858, a "typical" year.[15] Bähr shows little or no sign of the mansions that were built along Broadway during the 1850s, but the seven piers, four steamboats, and jumble of masts, sails, and riggings at the foot of the wharves suggest a growing and busy port and a more developed city than the one shown in previous views of the harbor.[16]

Bähr has not been identified with any certainty. C. Baehr is listed as a passenger departing Galveston on the *Weser* in 1858; Chas. Baehr is frequently mentioned in the newspapers as operating a cigar shop at the corner of Centre and Market Streets; and Charles I. Baehr shows up in later Galveston city directories, but none of them is identified in any way as an artist or publisher. If one were to assume that the C. Baehr who departed Galveston in 1858 was the artist, then the print might have been produced c. 1859, and Chas. Baehr might have sold copies from his cigar shop. Bähr could also have been a sailor on one of the many ships that called at Galveston, trying to earn a little extra money by producing and selling city and ship portraits, as did other seamen such as Helmuth Holtz (see figs. 5.7–5.10). The lithographer was Johann Anton Williard of Dresden, who sometimes signed his work "I. Williard," with little distinction between "J" and "I," as was common practice in fraktur, a popular German typeface still used in nineteenth-century German-language newspapers in Texas.[17]

A significant addition to the Galveston skyline at about the same time was the Greek Revival–styled building to house the custom house, federal courthouse, and post office, thought to be the first architect-designed building in the city. The federal government had initiated an expensive building program that spread federal-style architecture beyond Washington, DC, to signify the stability and authority of the nation, and the construction of customs houses was a good investment because customs revenue represented the largest portion of the federal government's income. Congress appropriated $100,000 for construction of the Galveston structure in 1857. Recently appointed supervising architect of the Office of Construction in the Treasury Department, Ammi Burnham Young designed a handsome, three-story Classic Revival building for Galveston, to be surrounded by Doric, Ionic, and Corinthian colonnades and external staircases with three-quarter engaged columns on the shorter north and south sides. The Treasury Department published reproductions of his plans with lithographer Augustus Kollner of Philadelphia in 1856 (fig. 5.6).[18]

Architect Charles B. Cluskey of Washington and Edwin W. Moore, once a commodore in the Republic of Texas Navy, won the contract for construction with a low bid of $69,723.63, and completion was set for March 13, 1859. Unfortunately, the contractors soon discovered problems—the ground was not suitable for a three-story structure, the beams were inappropriate, and the building lacked sufficient space for the custom service and post office—and submitted new plans, which reduced Young's Greek Revival three-story design to two stories. After Congress agreed to the new plans in February 1859, Moore promptly sold the

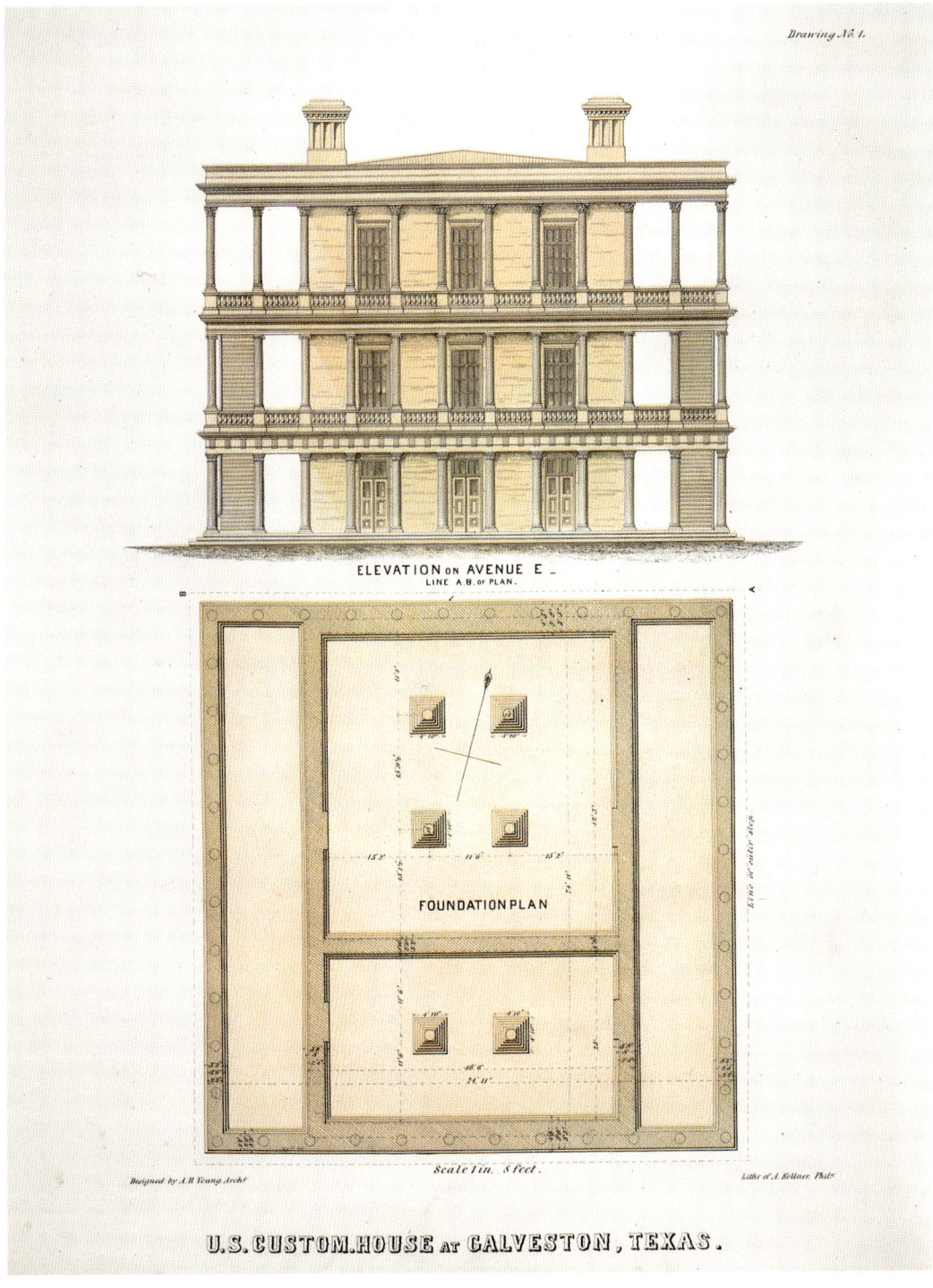

FIGURE 5.6 Augustus Kollner after Ammi Burnham Young, *Plan of Entrance Story. Scale 8 ft. = 1 in. U.S. Custom House at Galveston, Texas*, 1856. Toned lithograph, 46.6 × 30.6 cm (image), 51 × 34.4 cm (comp.), by Augustus Kollner. From *Plans of Public Buildings in Course of Construction* (1855–1856). Courtesy Prints and Photographs Division, Library of Congress.

"PRETTY PICTURES . . . 'CANDY' FOR THE IMMIGRANTS" | 193

job to the Boston firm of Blaisdell and Emerson, who completed the structure in March 1861, just a few weeks before the Confederate attack on Fort Sumter.[19] The government's purpose in having a significant architectural presence in Galveston seemed to be confirmed by a *Harper's Weekly* reporter who noted in 1866 that the "custom-house . . . attracts the attention of the new-comer almost the first thing upon his entrance into the city."[20]

"AN ILLIMITABLE EXPANSE OF WATER AND PRAIRIE"[21]

In 1844 Indianola was little more than a stretch of beach on the southwestern shore of Matagorda Bay about 120 miles southwest of Galveston when Prince Carl designated it as the port of entry for Germans headed to West Texas. Known for a short time as

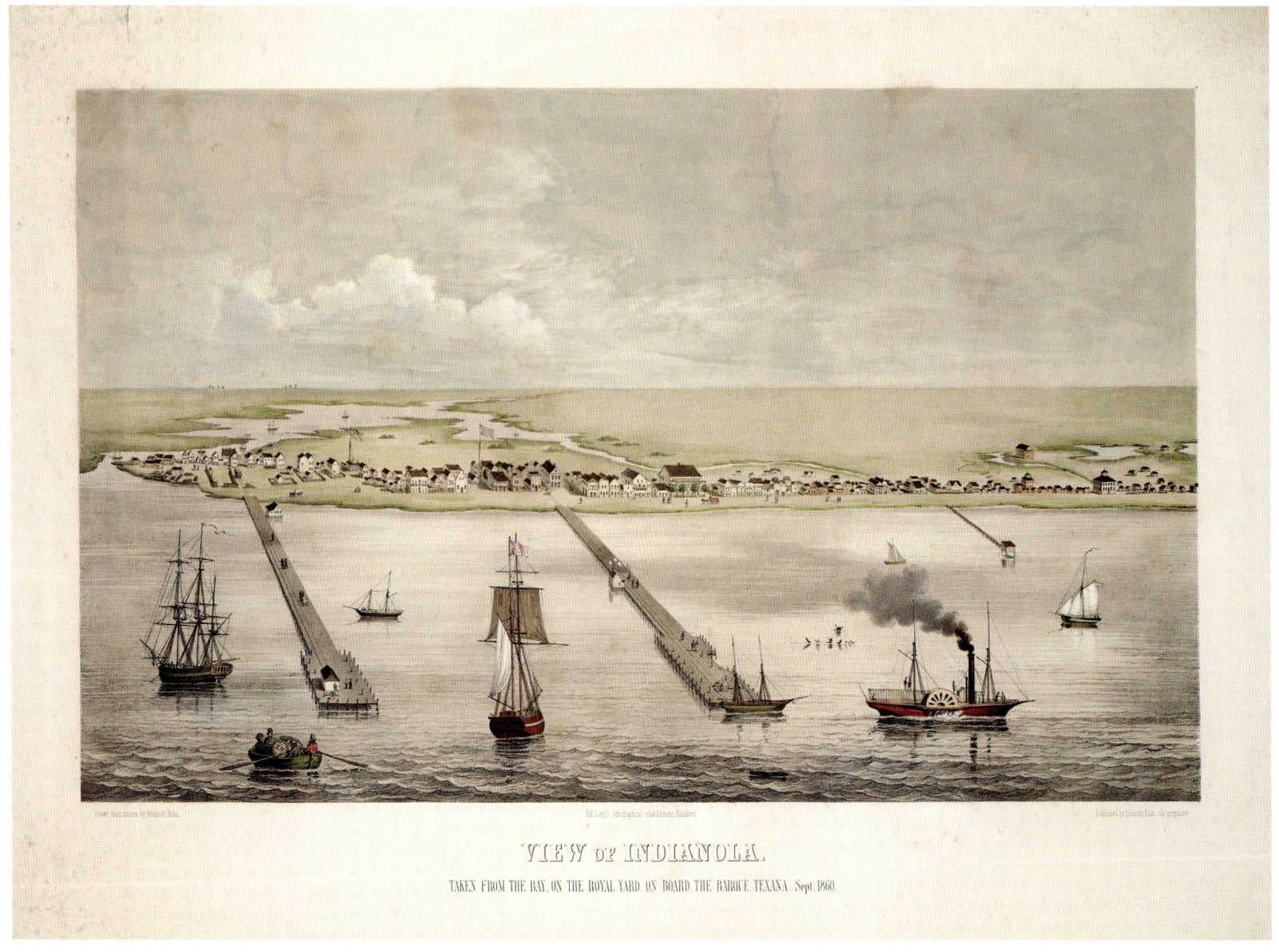

FIGURE 5.7 Helmuth Holtz, *View of Indianola. Taken from the Bay, on the Royal Yard, on board the Barque Texana, Sept. 1860*, 1860. Single sheet. Hand-colored toned lithograph, 36.3 × 58 cm (image), 40.8 × 58 cm (comp.), by Ed. Lang's Lithographical Establishment, Hamburg. Courtesy Beinecke Rare Book and Manuscript Library, Yale University.

194 | TEXAS LITHOGRAPHS

FIGURE 5.8 Detail from Holtz, *View of Indianola*, showing the three flags painted as the Lone Star flag of Texas. Courtesy San Jacinto Museum of History.

Karlshafen, it was closer than Galveston to the Adelsverein land north and west of San Antonio. By the time Helmuth Holtz, a twenty-seven-year-old seaman from Schleswig-Holstein, documented Indianola and Matagorda in 1860, both were small, sleepy ports that had served the US military during the war with Mexico and now catered mostly to goods and travelers headed to San Antonio and beyond (figs. 5.7, 5.8, 5.9, and 5.10).[22]

Holtz was apparently employed on the bark *Texana* when it called at Indianola and Matagorda in September 1860, and he continued the practice of many sailors before him of drawing portraits of port cities. Both cities are located on Matagorda Bay: Matagorda at the mouth of the Colorado River and Indianola about thirty-five miles due west-southwest across the bay. Stephen F. Austin had secured permission from the Mexican authorities to build a port at Matagorda in 1827, and by 1832 more than 1,400 persons lived there, with another 250 outside the town. Charles Morgan, of the Harris & Morgan Line, supplied the commercial impetus in 1849 when he moved the landing for his ships from Port Lavaca to a point three miles below Indianola on Powder Horn Bayou to avoid what he considered the exorbitant fees in Galveston. Prince Carl had planned for Indianola to become a rail and trading center, but the port did not prosper. When Dr. J. D. B. Stillman landed there in May 1855, he noted that "a few frame houses prematurely old, two or three stores, a tavern-stand deserted, a mule with saddle on, and head hanging low and drowsily, half-a-dozen idle men, sitting on boxes—and the whole surrounded by an illimitable expanse of water and prairie, was the sum total of Indianola." Most of the thousands of German settlers who landed there moved on to the interior as rapidly as they could, and little trade came through the port because the hinterland was not yet heavily settled.[23] According to most visitors, Stillman would have found a hospitable reception at Mrs. Angelina Belle Eberly's boarding house had he remained for the night, but he put his baggage back on the boat and proceeded up the bay to Port Lavaca.[24] Indianola survived as a port until it was destroyed by a hurricane in 1894.

Holtz's letter sheet of Matagorda (fig. 5.10) shows Fisher Street, which runs parallel to the shore, with the Colorado House as the large structure in the left-center. The structure to the right, flying the flag and mistakenly labeled "Colonado House," probably was Galen Hodge's home.[25] The street is busy with horsemen, a carriage, couples, and a slave (at the bottom right). Five vignettes decorate the margins of the sheet, including the residence of Robert H. Williams, who came to Texas in 1823 as one of Austin's original three hundred settlers and established himself in Matagorda the following year. The editor of the *Galveston Journal* claimed, "I don't know of a place in Texas where a few weeks can be spent more agreeable" than Galen Hodge's Colorado House, which became a summer retreat for many of the area planters. Also shown are the courthouse, a church, the Masonic hall, and George Burkhart's store. Hodge probably paid Holtz for the letter sheets, which he used as stationery for his hotel, despite the misspelling of the name and possible mislabeling of the structure.[26]

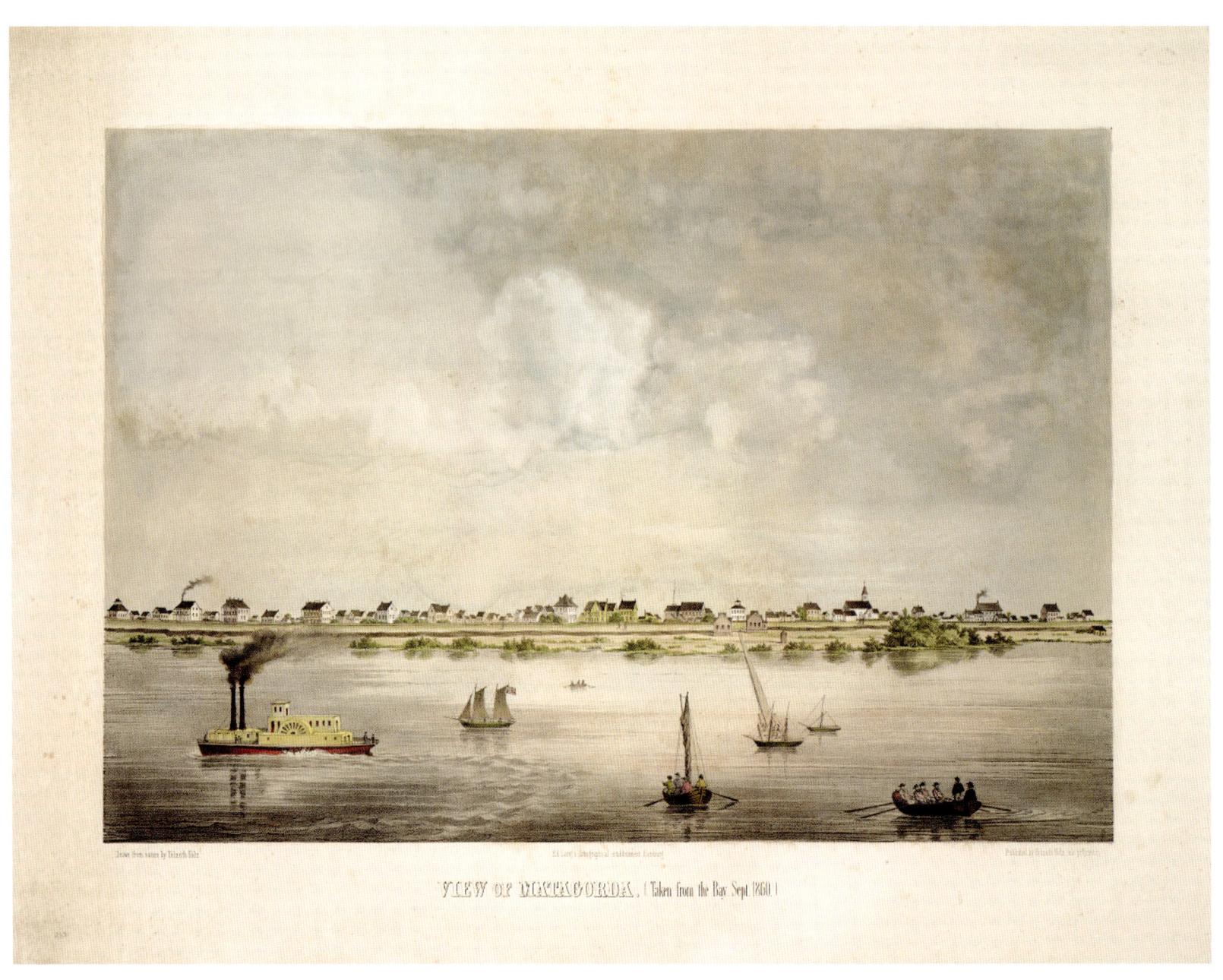

FIGURE 5.9 Helmuth Holtz, *View of Matagorda. (Taken from the Bay, Sept. 1860)*, 1860. Single sheet. Hand-colored toned lithograph, 35.9 × 52 cm (image), 38.6 × 52 cm (comp.), by Ed. Lang, Hamburg. Courtesy Beinecke Rare Book and Manuscript Library, Yale University.

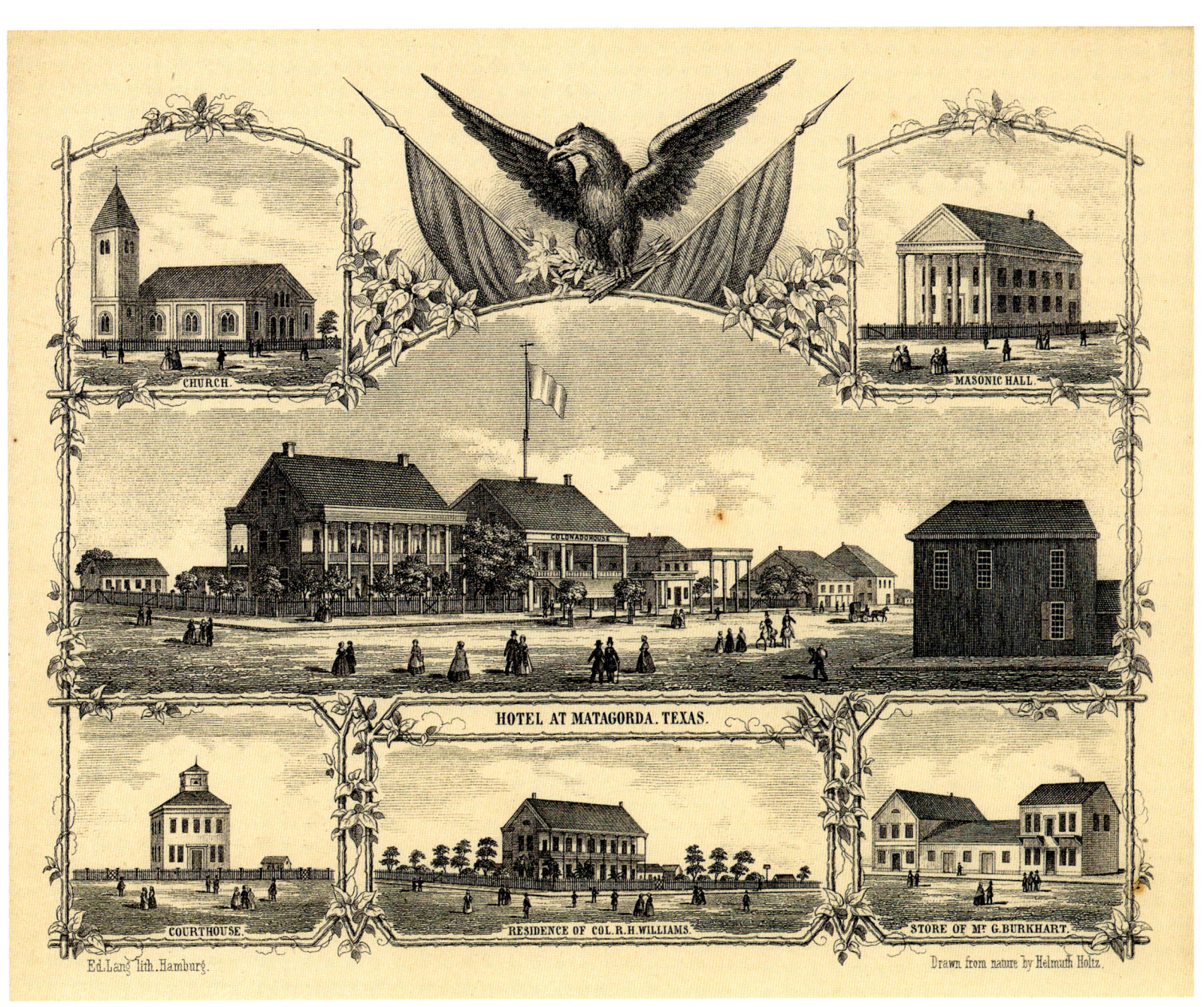

FIGURE 5.10 Helmuth Holtz, *Hotel at Matagorda, Texas*, c. 1860. Letter sheet. Lithograph, 15.1 × 19.1 cm (image), 15.5 × 19.5 cm (comp.), by Ed. Lang, Hamburg. Courtesy private collection.

Some of the structures shown in the letter sheet can also be identified in Holtz's larger view (fig. 5.9). The courthouse is shown at the right-center, easily recognizable because of its bright facade, the two regular rows of windows, and the bell tower. The church is the large, steepled building a bit farther to the right.

Holtz's view of Indianola (fig. 5.7), made from the royal yard of the bark *Texana*, shows the new settlement on Powder Horn Bayou rather than the original Indianola, which was then called Old Town. He shows Powder Horn Bayou at the left, which connects Powder Horn Lake (or Bay) with Matagorda Bay. Stevens Bayou meanders from the lake behind the town. The building with the cupola, at the far right, is the concrete courthouse, which had been completed in 1858.[27] The next large building to the left of the courthouse is the Catholic church; directly behind it is the hospital. After the Civil War started, Confederate general John B. Magruder destroyed the two long wharves stretching out into the bay, where Stillman had landed, for fear that Union troops would capture the city and be able to make use of them.

Holtz included three flags in the composition—one flying from the ship in the lower center of the print and two from flagpoles on land—that are blank, as shown in an uncolored version of the print in the collection of the Amon Carter Museum of American Art in Fort Worth. In a version now in the Beinecke Rare Book and Manuscript Library at Yale, the flags have been colored to represent the American stars and stripes. On a copy in the Library of Congress, the two flags on land appear to be Union Jacks, while the one on the ship resembles the present-day flag of Guatemala. On a copy in the San Jacinto Museum of History, all three flags have been painted as the Lone Star flag, which the republic had adopted in 1839 (fig. 5.8, detail). Perhaps the lithographer left the flags blank so that the purchasers could have them colored according to their taste.[28]

Most of the German immigrants who landed along the Texas coast went on to establish New Braunfels and Fredericksburg between the Fisher-Miller land grant and San Antonio. Some of them, such as Emil Dresel, settled for a short time in Sisterdale, about halfway between San Antonio and Fredericksburg, but moved on to the California goldfields. Like many of his countrymen, Dresel was a trained craftsman, an architect, and probably had some familiarity with lithography. In California he teamed with another German immigrant, Charles Kuchel, to form the partnership of Kuchel & Dresel, which became one of the more prominent lithographic firms in San Francisco and published dozens of his drawings as lithographs of early California and western cities.[29]

"PICTURES WILL DO MORE TO LURE IMMIGRANTS THAN NEWSPAPER ARTICLES."[30]

Less than a year after Sommer's arrival, a professionally trained artist arrived with two companions as members of the Naturforschender Verein (Natural Sciences Society). Conrad Caspar Rordorf, engraver, conservator, colonel in the Swiss Army, and landscape artist, had support from the Adelsverein to research and collect specimens of all natural and historical sciences in Texas, including supplying "true drawings," with the goal of establishing a museum in Germany. The group landed at Galveston on January 11, 1847, and quickly set about collecting and making drawings in the area of Dickinson's Bayou, near where Audubon had hunted almost a decade earlier.[31]

Rordorf was born in Zurich, Switzerland, on November 26, 1800, and studied under Johann Jakob Wetzel, a respected viewmaker and publisher of a series of print portfolios on Swiss and Italian scenery. He had engraved landscapes and town views for several of Wetzel's color-plate books.[32] He left his wife and daughter in 1846 to come to Texas, probably because he was on the losing side in a political struggle and faced the threat of imprisonment.[33]

Rordorf and friends filed only one report with the Adelsverein. According to Alwin Sörgel, who worked as a courier for the society, "Its members avidly accumulated debts, filled up on food, soaked their heads in spirits, bedded down in blankets, preserved their hands and explored the nature of laziness, a subject that they still pursue." But Rordorf quickly abandoned his contract with the society and accepted a position with Sörgel and the Adelsverein. Sörgel later reported that he and Rordorf were planning a book on Texas, with Sörgel providing the text and Rordorf the paintings and drawings—similar to the handsome, hand-colored etchings that he had made of the Sächsische Schweiz (Saxon Switzerland) and Heidelberg Castle. In the meantime, he drew a panorama and several views of Galveston.[34]

Rordorf traveled with Sörgel to New Braunfels and from there accompanied John O. Meusebach, who had succeeded Prince Carl as commissioner general of the Adelsverein, on a survey of the colony.

Rordorf apparently was not present at the treaty signing with the Comanches in March 1847, but he later copied and lettered the formal document. This trip resulted in one of the finest lithographs of pre–Civil War Texas. Working from his headquarters in the society's buildings in New Braunfels, he drew a panorama of the village as well as several views of the company's other settlements. He had soon accumulated forty-five drawings, including engraved copper-plate portraits of some of the Comanche leaders.[35]

On July 20, 1847, Hermann Spiess wrote Prince Carl: "I am sending a panorama of New Braunfels made in exact detail by Mr. C. Rordorf, whom I have engaged, so that he may one after the other execute all towns and settlements that I, that is, the Verein, have established, as well as other interesting sites, since the printing and distribution of such pictures will do more to lure immigrants than newspaper articles [fig. 5.11]." From the perspective of the Vereinsberg—a hill south of town that Dr. Roemer described as offering "a beautiful and commanding view of the whole town, and of the neighboring hills, forests and valleys, for several miles around"—Rordorf showed a village freshly carved out of the surrounding wilderness. Home to perhaps a thousand inhabitants, it would grow to more than 1,700 by 1850. As he sketched, Rordorf looked north toward the town square, located on what Roemer described as "a small, treeless plain, about one-half mile wide and one and one-half miles long." Comal Creek passes through the trees on the horizon along the north side of the city toward its confluence with the Comal River at the right, which then joins the Guadalupe River farther to the right (east).[36]

The drawing of New Braunfels remained unpublished until 1851, when, according to the minutes of the general assembly of the Verein meeting in Wiesbaden on May 12–15, "a happy coincidence led the Committee to a sketch of a panorama of New Braunfels by the famous artist Rordorf." Louis Bene, who had by then succeeded Spiess as general commissioner, agreed but pointed out that four years had elapsed since the drawing had been made and that it should be updated before being printed. Seguin Street should be extended to show the colony's growth, he said, and the new Catholic church should be added. He continued,

> Viewing it [the drawing] unrolled, one takes the position approximately at the wagon in the foreground. The entire terrain, from the watch house on the right to the rather large building (the so-called Klappenbach house), comprises the oft-mentioned *Vereins* mountain, also called the Sophienburg, where the painter Rordorf works.
>
> Since the yucca, a palm-like tree, is native to Texas, it has been planted as a decorative tree. I thought that the front of the *Verein* house ought to have them planted there, as well as along the streets toward town. . . .
>
> Where the changes in the town itself are concerned, many more houses have been built and will be added, especially in the part of town which is to the right of the church. Where I have indicated a pencil line marked with an X, the Catholic Church has been built. One side looks toward the Vereinsburg, a slender tower is on top, and all this is shaded by an immense tree. To the left of the church a street has been built, which is not as yet on the sketch.
>
> What you thought to be the Comal is an area which has not as yet been built upon close to the Comal's banks. Unfortunately, one may not view the river from the hill, since where the Comal and Guadalupe meet, the banks are overgrown with tall trees.[37]

Rordorf's view was revised as Bene suggested and published as a part of the Adelsverein recruiting materials entitled *Instruction für deutsche Auswanderer nach Texas*, published in Berlin in 1851 by D. Reimer. Packaged in a blue-and-yellow folder, the materials included a map of the surveyed portion of the society's land; a map of Texas showing the locations of the land; individual surveys of New Braunfels, Fredericksburg, and Indianola; a copy of the society's 1850 report; two pamphlets; and the print. The map of New Braunfels included in the materials shows Rordorf's position on the Vereinsburg (4) as he drew the panoramic view (fig. 5.12). The revised panorama exists in at least two states: one toned with a second color and the one illustrated here with a third color added, which gives it the general appearance of being a colored print. The view was also offered separately for one thaler.[38]

In the revised New Braunfels panorama, the large two-story house at the extreme left of the print is the Klappenbach house, which a German visitor described in 1849 as an unfinished one-story limestone structure. Its inclusion as a two-story house could either be a nod to what Klappenbach intended the house to look like or another revision by the members of the Verein. To the right of the Klappenbach house, the new Catholic church stands between the two right-hand fronds of the large palm. Rordorf probably saw the original

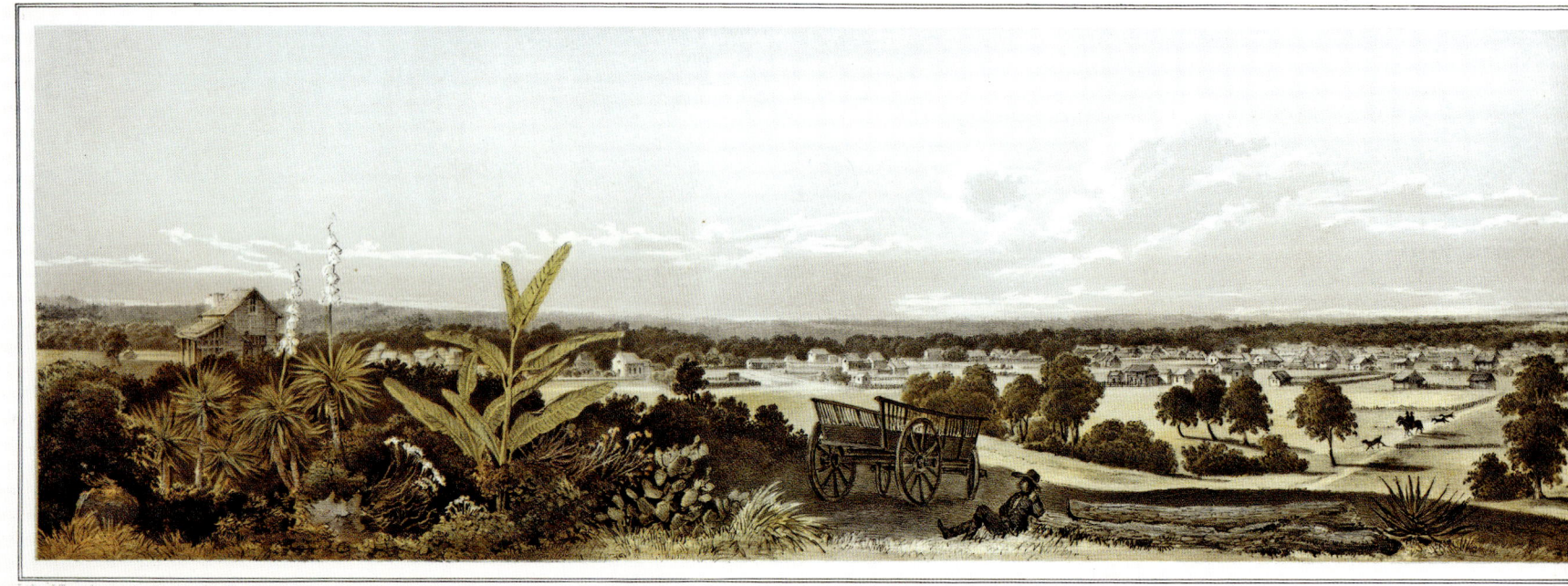

log church, built in 1847, but the Verein members revised the recruitment drawing to show the 1849 church, built of black walnut.[39] The open area farther to the right is the San Antonio Road, and still farther to the right, above the tops of the trees, Rordorf shows the public square, or marketplatz. In the center of the view is the Protestant church, the first church built in New Branufels; Church Street runs by it and continues up the hill in the foreground, and Seguin Street crosses behind it. The road crossing in front of the artist's position is Hill Street. On the extreme right, nestled in the trees, is the Watch House.

Although Rordorf had his critics—one member of the Bonn company accused him of making "pretty pictures of the colonies which were intended as 'candy' for the immigrants in Germany"—the finished print is clearly a joint product of the artist and the members of the Verein and depicts a new village nestled against the banks of the Comal River. A gentleman rests against a log in the left-center

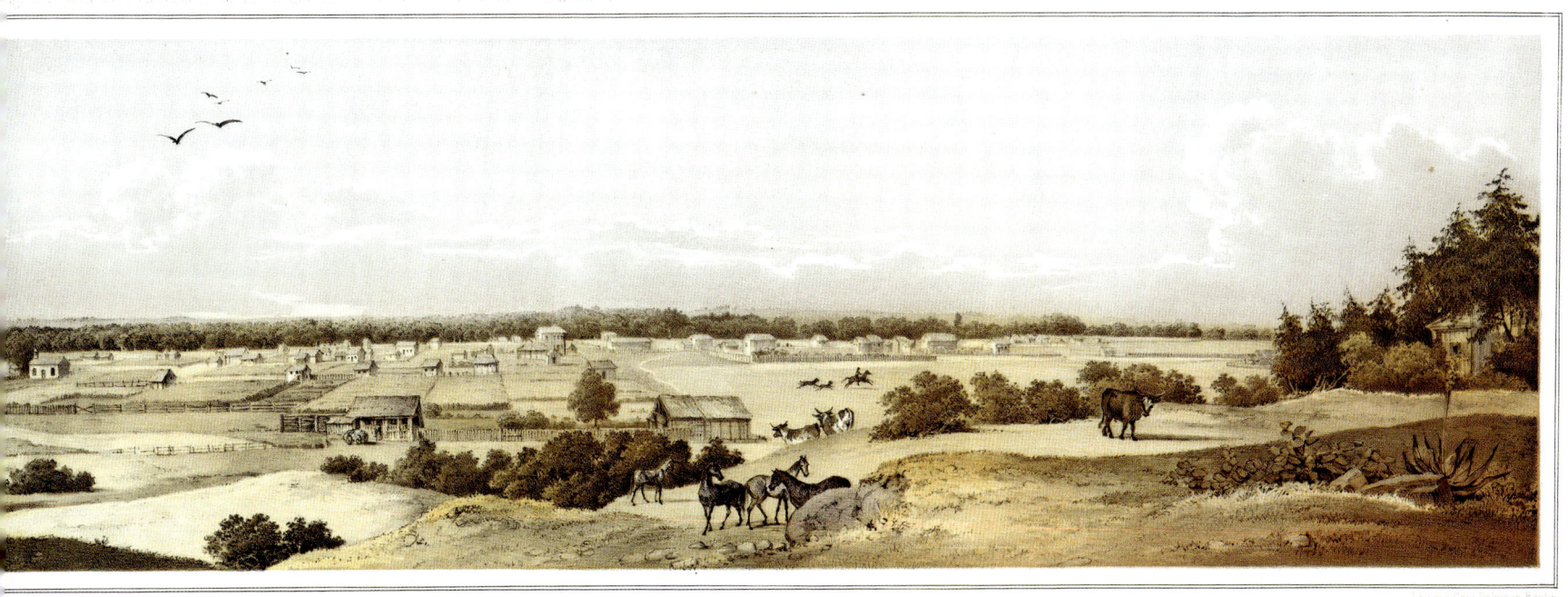

FIGURE 5.11 Julius Tempeltey after Conrad Caspar Rordorf, *Panorama der Stadt Neu-Braunfels in Texas Aufgenommen von der Südwestseite in Sommer 1847*, 1851. Single sheet. Toned lithograph, 15.8 × 96.5 cm (image), 22.8 × 97.9 cm (comp.), by Delius Brothers, Berlin. From *Instruction für deutsche Auswanderer nach Texas* (1851). Courtesy Amon Carter Museum of American Art, Fort Worth.

foreground while horses and cattle gambol at the edge of town, emphasizing the natural setting. Hermann Delius, the printer, seemed pleased with the results, writing, "This original by far surpassed all expectations."[40]

There is no precise count as to how many copies were made, but Verein records indicated that hundreds were printed. Copies of the print were included in Reimer's portfolio and sent to the Verein's noble membership as well as to agents in Germany and Texas, including Meusebach, Bene, and Wilke & Dooly Co. Reimer had exclusive distribution rights in Germany, but sales apparently were disappointing. Only the copy housed at the Dolph Briscoe Center for American History in Austin was known until recently, when several more were discovered in the remaining portion of the Adelsverein archives.[41]

Unfortunately, Rordorf did not live to see his drawing published. Early on the morning of October 28, 1847, he returned with Spiess

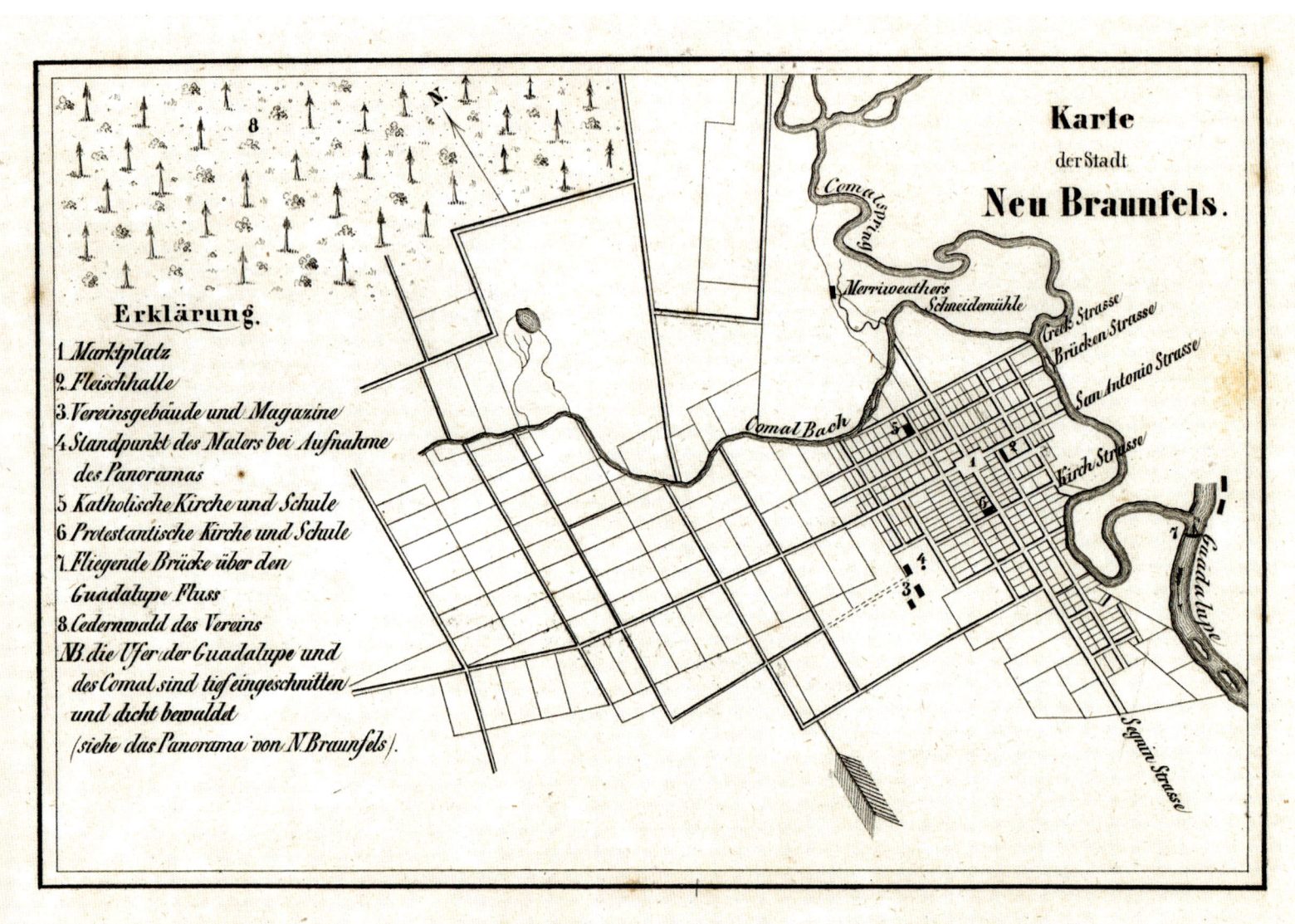

FIGURE 5.12 Unknown artist, *Karte der Stadt Neu Braunfels*, 1851. Map. Lithograph, 9.4 × 14.3 cm, on page with three other maps, 33 × 48 cm (neat line to neat line), by H. Delius, Berlin. From *Instruction für deutsche Auswanderer nach Texas* (Wiesbaden, 1851). Courtesy Special Collections, University of Texas at Arlington Libraries. The map shows the point from which Rordorf drew the view (4).

FIGURE 5.13 Friedrich Armand Strubberg after Conrad Casper Rordorf (attrib.), [Enchanted Rock], 1858. Engraving. From Friedrich Armand Strubberg, *Amerikanische Jagd- und Reise Abenteuer* (1857), opp. 108. Courtesy Texas Collection, Baylor University.

to Nassau Plantation in Fayette County, the Adelsverein's first property in Texas, because it had been taken over by a violent and corrupt gang apparently planning to steal the plantation's slaves. A shootout ensued, and Rordorf was one of two persons killed. His drawings fell into the hands of a "Dr. Schubbert" (real name Friedrich Armand Strubberg), who had been employed by the company but had split with Meusebach. He took them with him to Germany and probably used some of them as the basis for illustrations that appeared in his first book, *Amerikanische Jagd-und Reiseabenteuer: aus meinem Leben in den westlichen Indianergebieten: Mit 24 vom Verfasser nach der Natur entworfenen Skizzen* [American hunting and travelling adventures: From my life in the western Indian areas. With 24 illustrations done by the author himself according to nature] (fig. 5.13). Rordorf might also have been the source of views of Galveston, San Antonio, and New Braunfels that appeared in the German publication *Meyer's Universum* in 1856–1857. His drawings probably survived in Strubberg's family until they were destroyed during World War II.[42] That Rordorf did not live to publish a book of his Texas views and Indian portraits—perhaps something similar to Karl Bodmer's masterful engravings of landscape and portraits of Native Americans along the upper Missouri River—is surely one of the major aesthetic losses of nineteenth-century Texas.

FIGURE 5.14 Karl Wilhelm von Rosenberg (attrib.), *Round-Top in Texas*, c. 1855. Single sheet. Toned lithograph, 15.2 × 29.8 cm (image), 17.3 × 31.6 cm (comp.). Lithographer unknown. Courtesy the James Dick Foundation, Festival Hill, Round Top, gift of Mr. and Mrs. John G. Banik.

FROM ROUND TOP TO THE CAPITOL

Another talented newcomer to Texas was Carl Wilhelm von Rosenberg. Trained at the Royal Academy in Berlin as a surveyor and architect, Rosenberg arrived in Galveston in 1849 and settled on Nassau Plantation, near Round Top. For the next six years, he farmed, learned English, and became an American citizen. He also sketched his surroundings, and a small, unsigned lithograph of *Round Top in Texas* may be his handiwork (fig. 5.14).[43]

The original village derived its name from the "Round Top house" built by Capt. John York during the late 1830s or early 1840s (later sold to Alwin H. Sörgel), which had a cupola-like structure on the roof. In the 1850s, however, another community developed to the southwest, near Cummins Creek, and this is the village pictured in *Round Top in Texas*. The perspective is south to north. The stagecoach, which began running between Houston and Austin sometime in 1849, is shown in the center.[44] The small building near the stagecoach may be the post office, from which this second village finally took its name. The large, two-story building in the center of the picture is the general store, and the small house seemingly under the shade of the large tree at the right is the Wagner house, built about 1856. At the far right is George August Edward Henkel's two-story house, which was built about 1851 and is now one of the more prominent restored buildings in Henkel Square in Round Top. The small

building next to it is the kitchen. The stagecoach and horse tethered near the door suggest a modest amount of activity, but the dominant aspect of the image seems to be the vegetation, which virtually encloses the hamlet. The live oak tree at the right still stands.[45]

Local tradition suggests that the artist for this print might have been Rudolph Melchior, who was born in Burg, Magdeburg, Prussia, in 1835 and came to Texas in 1853, along with Matthais Melchior and at least one other member of his family. Rudolph settled in Latium, Washington County, one of at least five "Latin Settlements" in German Texas (meaning that the residents were mostly educated persons who believed that Latin was essential for higher learning). He earned a local reputation for stencil and freehand wall decorations in the Round Top area, many of which have survived, but the late Lonn Taylor, former Smithsonian Institution historian and director of the Winedale Historical Complex, cautioned that he had never seen any drawings of this nature among Melchior's sketchbooks and doubted that this small view is the work of a man whose only known works are ornamental ceilings and walls.[46] Local lore also suggests that the print was made in Philadelphia, but the view contains no indication as to where it might have been printed or by whom. Perhaps Henkel had the print made to appeal to the new wave of German settlers who were coming into Texas in the 1850s. Rordorf might also have made such a sketch, but a more likely candidate as the creator of the view is Rosenberg (fig. 5.15).

Rosenberg remained in the Round Top area until his design of the Fayette County courthouse in La Grange won him a job as a draftsman in the General Land Office. Shortly after his arrival in Austin in 1856, he produced several drawings of the city, one of which served as the model for a lithograph of the Texas Capitol Building and grounds (fig. 5.16).[47] The voters had only recently confirmed Austin as the capital, and the state authorized the construction of more substantial government buildings. Workmen laid the cornerstone for the new capitol on July 3, 1852, on "a commanding eminence" at the head of Congress Avenue and completed the structure a little over a year later. The building, according to Lancelot Abbotts, editor of the *Texas Monument* in La Grange, was slated "to be 140 feet by 90 feet, and 57 high, two stories," with six large columns of "polished and ornamented rocks, each column 33 feet high," topped off by a tin roof. It became the centerpiece of a modest "capitol complex" that consisted of the treasury building (since demolished), the General Land Office (now the Capitol Visitor's Center), and the Abner Cook–designed-and-constructed Governor's Mansion. The editor

FIGURE 5.15 Unknown photographer, Carl Wilhelm von Rosenberg. Courtesy Jon Todd (JT) Koenig, Austin.

estimated the cost of the capitol at a little more than the $100,000 that the state had appropriated, and it was ready for the inauguration of Gov. Elisha M. Pease in December 1853. An early visitor to the city concluded that it had no "pretentions to architectural beauty" but admitted that the native "soft white stone" gave it a "commanding appearance." Landscape architect and journalist Frederick Law Olmsted, who saw the building just as it was being completed, was a little more complimentary, describing it as a "really imposing building of soft cream limestone."[48]

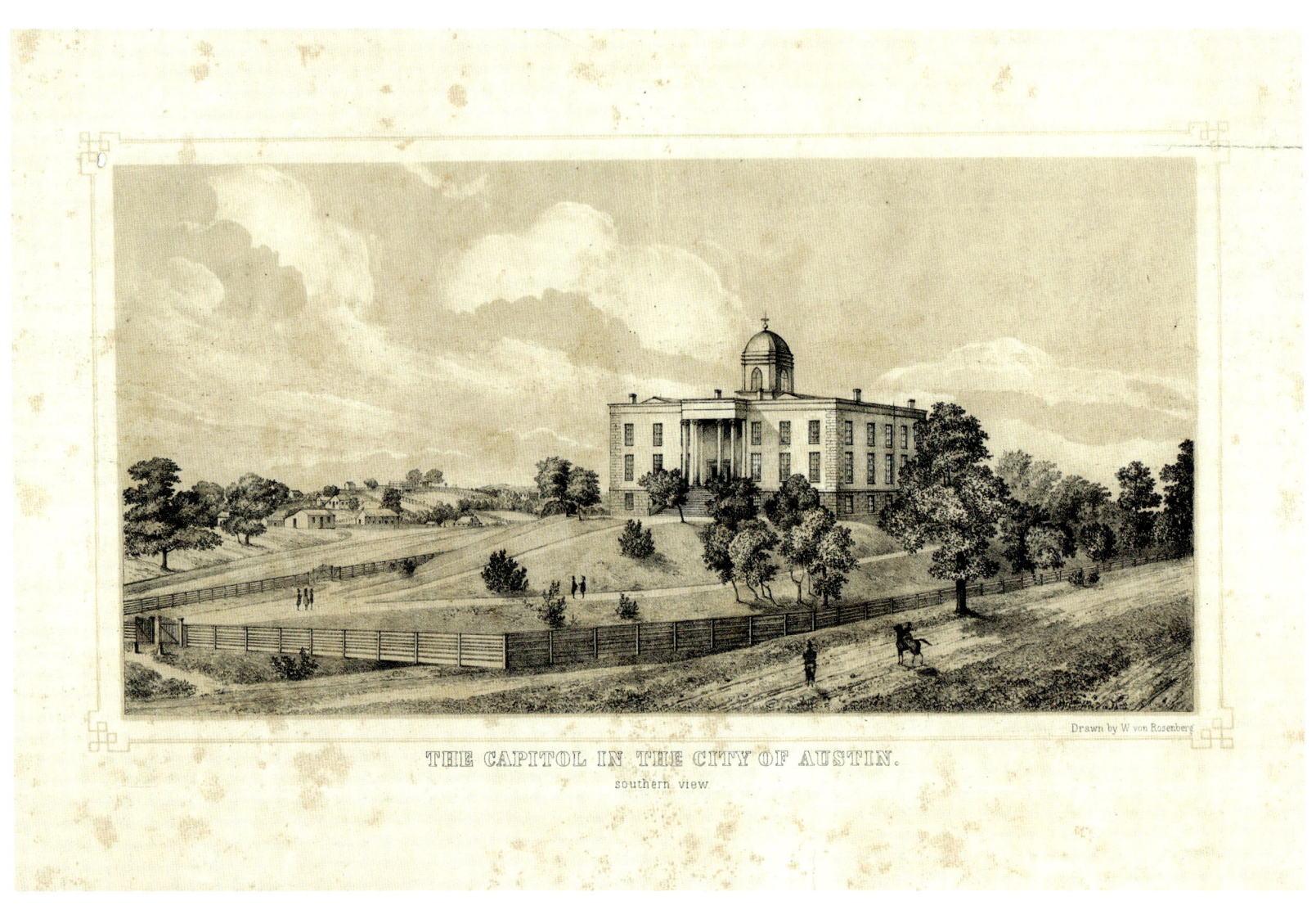

FIGURE 5.16 Carl Wilhelm von Rosenberg, *The Capitol in the City of Austin. Southern View*, 1857. Single sheet. Toned lithograph, 19.7 × 35.2 cm (comp.). Printer unknown. Courtesy Briscoe Center for American History, UT Austin.

FIGURE 5.17　Carl Wilhelm von Rosenberg, *City of Austin Southern View from Hugh Tinnin's Place*, c. 1855. Pencil on paper, size unknown. From a negative photostat (reversed). Courtesy private collection; photostatic copy in the Briscoe Center for American History, UT Austin.

Rosenberg also made drawings of the capitol and buildings up and down Congress Avenue while he was employed at the General Land Office.[49] The editor of the *Texas State Gazette* commented that "a drawing of the Capitol, and surrounding scenery" that Rosenberg had shown him "is perfect, showing a high degree of artistic talent." Rosenberg, he wrote, "is not only an artist but a most skillful and scientific engineer."[50] The drawing chosen for the lithograph shows the building from the southeast side and suggests the growth in both population and political importance that Austin was experiencing.

The unnamed lithographer presented an image of the capitol that dwarfs the few buildings around it, but another Rosenberg drawing, *The City of Austin Southern View from Hugh Tinnin's Place*, shows how thoroughly this modest building dominated the little frontier village on the Colorado River (fig. 5.17). John Marshall, editor of the *State Gazette*, wrote that the lithograph "is well got up" and noted that it was available at Mr. Lehman's store and that discounts were offered for "Booksellers and others at a distance" who might be interested.[51]

"HE PRACTICALLY RE-INVENTED THE ART OF LITHOGRAPHY"[52]

Probably around the same time that the Round Top print appeared, a self-taught German craftsman produced the first lithograph that can be documented to have been printed in Texas. Editor Adolf Douai told the story in the *San Antonio Zeitung* (fig. 5.18). Dr. Douai, a recent immigrant along with his partner J. Martin Reidner, wanted to establish a lithographic press in San Antonio and employed Wilhelm C. A. Thielepape, surveyor, musician, and, later, the "singing mayor" of San Antonio, for the task (fig. 5.19). Little is known of Reidner, but Douai compiled an impressive resume. He had earned a doctoral degree in Leipzig and tutored and taught for several years before immigrating to New Braunfels to escape the political repression brought on by the Revolution of 1848. A fiery four foot eight inches tall, he began his newspaper career in New Braunfels, working with the well-known botanist Ferdinand Lindheimer, editor of the *Neu-Braunfelser Zeitung*. Following an editorial in which he

"PRETTY PICTURES . . . 'CANDY' FOR THE IMMIGRANTS"　|　207

criticized his fellow townspeople, he felt compelled to resign from the newspaper and move to San Antonio, where he and a number of others in the German community established the *San Antonio Zeitung*. He won a contract from the state to print the laws in German; began printing a Spanish-language newspaper, *El Bejareño* for publisher Xavier Blanchard DeBray; and, in December 1854, acquired a used lithographic press and stones. In January 1855 they hired Thielepape, "a distinguished draftsman," as lithographer and announced that they were prepared to produce "every kind of Printing work in all colors [fig. 5.20]."[53]

Thielepape himself had graduated from *gymnasium* in Kassel and pursued university studies before beginning a career as an engineer in Berlin. He emigrated to Indianola in 1850, then to San Antonio four years later. He dabbled in surveying, architecture, and teaching, and, with Douai's encouragement, lithography.[54]

In the meantime, Douai had gotten into considerable trouble

FIGURE 5.18 Unknown photographer, Dr. Adolf Douai. Courtesy Dr. Adolph Carl Daniel Douai (1819–1888)—Find A Grave Memorial.

FIGURE 5.19 Unknown photographer, Wilhelm C. A. Thielepape, c. 1866. Detail of photograph courtesy the General Photographic Collection, University of Texas at San Antonio.

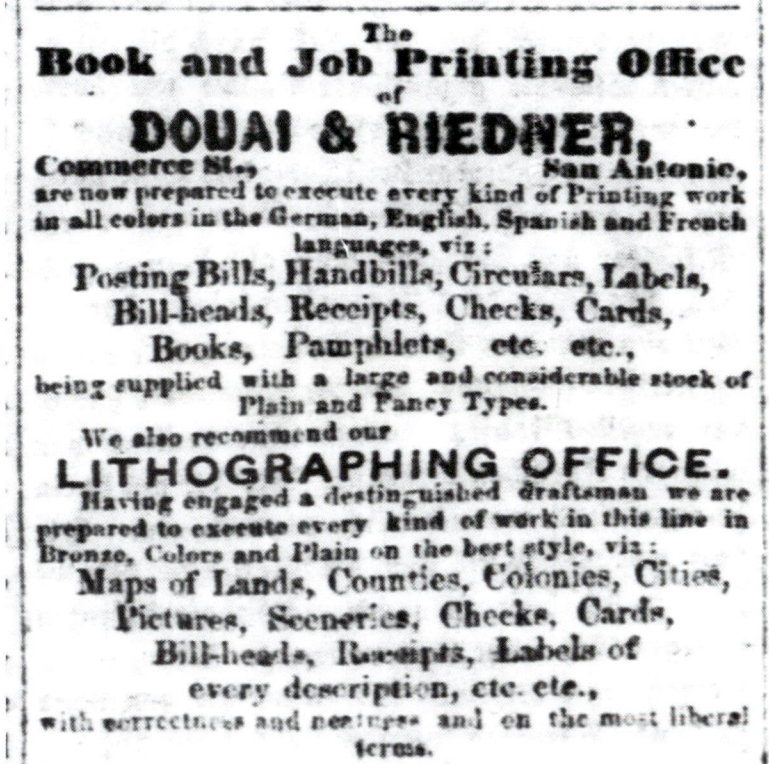

FIGURE 5.20 Advertisement, *San Antonio Zeitung*, Jan. 6, 1855, p. 2. Courtesy Portal to Texas History.

with his newspaper. He and Thielepape were both abolitionists and had participated in the second annual Texanischen Sängerfest in 1854 and assisted in the drafting of a statement of political goals that was subversive as far as most Texans were concerned. They called for the abolition of the Electoral College, the institution of a progressive income tax, and laws so clear and simple that "lawyers be rendered superfluous." They espoused public schools and universities, the abolition of religious teaching in schools, and the repeal of temperance laws as well as capital punishment. They avoided the slavery question, leaving that matter to the individual states, but they harbored a secret plan, which they revealed to only a few people, including Olmsted and his brother John during their tour of the state, to divide Texas and establish the free-soil state of West Texas.[55]

Douai endorsed the platform in editorials in May and June 1854, causing a split among the stockholders of the newspaper. The rift coincided with the arrival in Texas of the Know-Nothing movement, an anti-Catholic, antiforeign secret society called the

FIGURE 5.21 Unknown photographer, John Salmon Ford as a Texas Ranger, c. 1858. Ambrotype with hand-tinted rose to the cheeks and light blue to the pants, approximately 3.5 × 4.75 in. Courtesy Heritage Auctions, Dallas.

American Order that expressed alarm that that there were foreign abolitionists on their own soil.[56] Newspaper editors across the state denounced Douai, who exacerbated the tense situation in February 1855 by revealing his platform. That led to an editorial dispute and fistfight with the equally passionate Rip Ford, former Texas Ranger and now editor of the *Texas State Times* in Austin, whom Douai had accused of lying. The diminutive German claimed in his memoirs to have "beat him up until he bled, even though he was very much stronger and bigger than I was."[57] Ford did not mention the incident in his memoirs (fig. 5.21).

Thielepape, meanwhile, had opened his shop on Galan Street, opposite the San Fernando church, and had been studying and experimenting with the lithographic press. He finally managed to print a crude but complicated caricature of Sam Houston, *Sam Recruiting, after the Injunction of Secrecy had been Removed*, in which he joined Douai in his attack on the senator for his association with the Know-Nothing movement (fig. 5.22).[58] Ford had called Houston the Know-Nothings' "great high priest in the Lone Star State," but Thielepape depicted him as a drunkard carrying a bottle of whiskey—"Not the Battle of Brandywine, but the bottle"—and walking on the Constitution, the Bill of Rights, and the Declaration of Independence. The Democrat editors of the *Texas State Gazette* reveled in Thielepape's caricature, noting that Sam wears a "Transparent Politician Coat that reveals all his Know-Nothing sympathies and carries a long-handled net over his shoulder," to which are attached his "logic or reasoning powers" (a bowie knife and a pistol), hero's medals (for churches burnt or destroyed and riots in various places), his diseased American heart, and a "Mask of [George] Washington." In case the criticisms were not clear, Thielepape listed them along the right-hand side, adding comments such as "Lexington—not the battle, but the horse—lost $50." He also taunted Houston for his multiple marriages in the titles of several pamphlets dangling from the end of his pole: "From Brigham Young about wives," "Marriage Certificate No. 34," and "From Ned Buntline." (Buntline, whose real name was Edward Zane Carroll Judson Sr., would later gain fame as the prolific writer of dime novels and manager of Buffalo Bill's Wild West Show, but in the 1850s he was known as the organizer of the Know-Nothing party in St. Louis, was rumored to be married to half a dozen wives, several of them simultaneously, and was the instigator

FIGURE 5.22 Wilhelm C. A. Thielepape, *Sam Recruiting after the injunction of secrecy had been removed*, July 1855. Single sheet. Lithograph, 49 × 41.5 cm (comp.), by Wilhelm C. A. Thielepape, San Antonio. Courtesy Dorothy Sloan—Books.

of mob violence against the Germans of that city.)[59] The Bible sticking out of Sam's rear pocket is, no doubt, a reference to his recent conversion to the Baptist faith, which many saw as leading to his embrace of Know-Nothingism. The brandy and wine bottles in another pocket bring to mind his legendary drinking habit and put in doubt his rumored reform, represented by the "Temperance Journal" pamphlet under his arm. Finally, Houston's support of slavery is noted by the "N—— Auction" leaflet, also under his arm, and his black right leg and foot on the Bill of Rights. The *Gazette* editors interpreted that as a racial reference, "a genuine n—— color," but Thielepape more likely suggests that, in the parlance of the day, Houston was a "black leg": immoral, a gambler and a card cheat—a grifter. E. G. Huston, editor of the *San Antonio Texan*, concluded that the Know-Nothing "character was very correctly drawn . . . by one of our citizens."[60] Inelegant though Thielepape's print is, as a caricature it communicated visually with the different ethnic and linguistic groups in pre–Civil War Texas. What he lacked in draftsmanship and subtlety he made up in directness and political complexity.

Douai had high hopes that the addition of lithography would increase their cash flow, and Thielepape undertook another large lithograph, a map of San Antonio based on the 1852 survey of the city. It soon became obvious, however, that the equipment and stones were faulty. The large stone on which Thielepape attempted to draw the map proved to be uneven, and Douai had to grind it down a second time. (He drolly remarked in his autobiography that "stone-grinding was my avocation.") But before the map was finished, Douai gave up on the experiment, and he and Thielepape parted as business

FIGURE 5.23 Wilhelm C. A. Thielepape, *Map of the Lands Lying within the Corporation L[imits] of the City of San Antonio as Surveyed and Divided in 1852*, 1855. Lithograph, 23.9 × 18.31 in. Engraved from official sources and pr[inted] by Wilhelm C. A. Thielepape. Courtesy Briscoe Center for American History, UT Austin.

"PRETTY PICTURES . . . 'CANDY' FOR THE IMMIGRANTS"

partners: "It was only just that we entrusted him with the entire ownership of the lithographic equipment," Douai concluded. In August, Thielepape announced that he had "become the sole proprietor of the first lithographic establishment in Texas" and that the map would soon be available for $1 per copy.⁶¹

Map of the lands lying within the Corporation . . . of the City of San Antonio as surveyed and divided in 1852 appeared in September to the praise of the city's editors. The *San Antonio Herald* wrote that "as a matter of reference, it is invaluable" and "as a work of art, [it] will compare favorably with anything of the kind we have seen." The fact that "it was executed in our own city" only heightened the praise. In *El Bejareño*, DeBray described it as "without doubt the best map [of the city] that exists," and the *San Antonio Texan* added that it is "a master piece of the kind [fig. 5.23]."⁶²

Thielepape showed the incorporated city as well as, in the lower right-hand corner, an enlarged map of the downtown area. Just to the right of the large U-shaped twist in the San Antonio River and labeled "A" is the Alamo. In the mouth of the U is the Main Plaza, but the portion of the map that would have shown San Fernando church (and Thielepape's office across Galan Street) is, in this copy, missing. Farther to the left is the Military Plaza.⁶³

Thielepape exhibited his map and several smaller works at the Agricultural Exhibition of Bexar County that fall, but he apparently won no prizes, because Douai, still aggrieved by the unanticipated reaction to his editorials, commented sarcastically that Thielepape, a German, would not be expected to win an award at "a native exhibition." Douai, however, admired Thielepape's accomplishment and explained that Reidner had "brought a lithographic press from New Orleans and soon it became apparent . . . that all of the material that he had bought was more or less unusable." Although Thielepape had known nothing of lithography,

> after months of study, numerous attempts (with the advice of a man who only understood how to draw on the stones) and with great effort and at considerable expense, he discovered the problems with the press and with the materials and improved them so well as to allow for the modest means available in San Antonio for orders. He practically re-invented the art of lithography, and was able to develop it to the point that now, six months after he started, he produces capable work in this field. Truly, only a German could do this, and for that reason, we find it just and reasonable that he did not receive a prize at a native exhibition.⁶⁴

Now on his own, in December Thielelpape produced a "letter paper with the lithographed view of the Main Plaza," an image that others quickly copied (fig. 5.24). It shows the west side of the Main Plaza with the Church of San Fernando in the center. From left to right are the Cassiano house, the Bustillo-García property (which in the early 1840s was a fandango house), Galan Street, the cathedral, Treviño Street, and the José Erasmo Seguin residence, which, at the time Thielepape did the print, was an auction house. A two-wheel Mexican cart is shown at the left, while a horse-drawn coach rattles through the plaza at the center. A contemporary described the scene as "the least business side" of the plaza because of the church. The flag of the headquarters of the US Eighth Military Department can be seen behind the church.⁶⁵

There are at least two editions of the letter sheet, one titled *Main Plaza* and another titled *Main Plaza of San Antonio, Texas* (fig. 5.25), suggesting that the sheet sold moderately well. There are slight differences in the images: several of the figures shown walking or riding through the plaza have been changed, including a slave pushing a wheelbarrow (behind and to the right of the coach). Thielepape's lithographic drawing has also improved to show shading rather than the heavy, dark lines that characterize the first version. This popular scene probably served as a model for the letter sheet that Erhard Pentenrieder produced a year or so later (fig. 5.26), and that the artist Hermann Lungkwitz later used as a vignette in the upper left-hand corner of his San Antonio lithograph (see fig. 5.37).

Based on these few examples, it is apparent that Thielepape's lithographic output was insufficient to earn a living, but he continued his other endeavors, including an 1859 photographic venture with William DeRyee and Hermann Lungkwitz in Austin, surveying the town site of Uvalde, and designing the San Antonio Casino, a social center and four-hundred-seat auditorium. He might also have helped with the Menger Hotel. In 1859 he moved to New Braunfels.⁶⁶

Soon after Thielepape had closed down his lithographic business, Erhard Pentenrieder—an immigrant from Munich, Bavaria, who owned and operated an art supply, stationery, and general merchandise store in San Antonio during the 1850s–1870s with Gustav Blersch (fig. 5.27)—issued his own version of an illustrated letter sheet (fig. 5.26).⁶⁷ The central scene is a view of the Main Plaza quite similar to Thielepape's. Pentenrieder, apparently an amateur artist himself, takes credit for drawing the images "after nature," but no printer is listed. In addition to the familiar view of the Main Plaza, the sheet contains vignettes in the margins on each side: on the left

FIGURE 5.24 Wilhelm C. A. Thielepape, *Main Plaza. San Antonio, Texas*, c. 1855. Letter sheet. Lithograph, 6.3 × 16.2 cm (illustration only). Lower left: "Lith. from Nature and publ. by W. C. A. Thielepape, San Antonio." Courtesy Beinecke Rare Book and Manuscript Library, Yale University.

FIGURE 5.25 Wilhelm C. A. Thielepape, *Main Plaza of San Antonio, Texas*, 1856. Letter sheet. Lithograph, sheet size 27 x 22 cm, image size 7 x 19 cm, lithographed by Thielepape. Courtesy Beinecke Rare Book and Manuscript Library, Yale University.

FIGURE 5.26 Erhard Pentenrieder, *Main Plaza San Antonio, Texas*, c. 1856. Letter sheet. Lithograph, 26 × 22 cm (image). Published by Pentenrieder & Blersch, San Antonio. Courtesy Amon Carter Museum of American Art, Fort Worth.

"PRETTY PICTURES . . . 'CANDY' FOR THE IMMIGRANTS"

FIGURE 5.27 Unknown photographer, Pentenrieder & Blersch's store on Commerce Street, looking east from the balcony of the Plaza House on the north side of Main Plaza, 1860s.

side, views of Mission San José, Mission Concepción, the courthouse, and a man on a burro with a load of hay; on the right side, the Alamo, Mission San Juan, a Mexican *jacal*, and a cowboy roping a steer. There are various embellishments on both sides, including an Indian, a Mexican, a hunter, and a Black man, all in traditional costumes, and various kinds of wild animals. They are identical to those on a sheet issued by St. Louis merchant Conrad Witter during the same decade, suggesting that some enterprising printer—perhaps Witter, who had a large St. Louis publishing company—offered the design to anyone who wanted to add local scenes for their own market (fig. 5.28).[68]

Pentenrieder began advertising his sheet in the *San Antonio Texan* in September 1856 as the "first series of Texas views," for ten cents each or a dollar per dozen (fig. 5.29). J. M. Jones also distributed them from his book and stationery store on the Strand in Galveston. A second printing of this sheet contained two colors, with the views printed in black and the embellishments in green.[69]

A third version of his letter sheet contains a number of changes, including an effort to capitalize on one of the more colorful local events in the city's history. In this version Pentenrieder added a picture of a group of camels in the plaza, a reference to the camel corps that the War Department brought through San Antonio on the way

FIGURE 5.28 Conrad Witter, St. Louis letter sheet, c. 1856. Lithograph, 28 × 23 cm (sheet). Courtesy Broadsides, leaflets, and pamphlets from American and Europe, Rare Book and Special Collections Division, Library of Congress (Printed Ephemera Collection).

"PRETTY PICTURES... 'CANDY' FOR THE IMMIGRANTS"

FIGURE 5.29 "New Goods! Just Received!!," *San Antonio Texan*, Oct. 30, 1856, p. 3, col. 2. Advertising Pentenrieder's letter sheets.

to West Texas between 1856 and 1859 as an experiment in desert transportation. He replaced the old courthouse with the Menger Hotel (opened in January 1859) and added the Freemason's hall on the left side as an additional image. On the right side, he replaced the Mexican *jacal* with the German Casino (opened in 1858) and removed the man on the burro from the left side and placed him at the bottom right, below the image of a cowboy roping a steer.

A fourth version of the letter sheet pictures a remodeled San Fernando church, which was planned by San Antonio architect François P. Giraud in 1868. Pentenrieder included Giraud's planned changes—a Gothic Revival nave, triple entrance portals, a gable roof, and twin bell towers and buttresses—but the church never achieved the grandeur that Pentenrieder anticipated. The New York lithographic firm of Mayer & Merkel printed this version.[70]

"EQUAL TO NAST"[71]

The creative abilities of the German community became even more apparent in the work of a fifteen-year-old, self-taught artist, Carl Gustav von Iwonski, an immigrant from Silesia who arrived in Texas with his parents in 1845 (fig. 5.30). Iwonski soon became acquainted with Rordorf as well as artists Friedrich Richard Petri and Karl Friedrich Hermann Lungkwitz.[72] He produced views of New Braunfels

and San Antonio and a number of portraits, but only two were lithographed: one view of New Braunfels, and his portrait of the founders of the Germania Gesängverein, the first German singing society in Texas (figs. 5.31 and 5.32).

Neu-Braunfels. Deutsche Colonie in West Texas is a splendid print made from the same perspective on the Vereinsberg as Rordorf's drawing, which Iwonski might have seen. By comparing the Rordorf view with Iwonski's, one can see that New Braunfels had grown considerably in the intervening ten years. Just as in Rordorf's

FIGURE 5.30 Unknown photographer, Carl Gustav von Iwonski [Jwonski], c. 1860. Photograph courtesy of the Austin History Center, Austin Public Library.

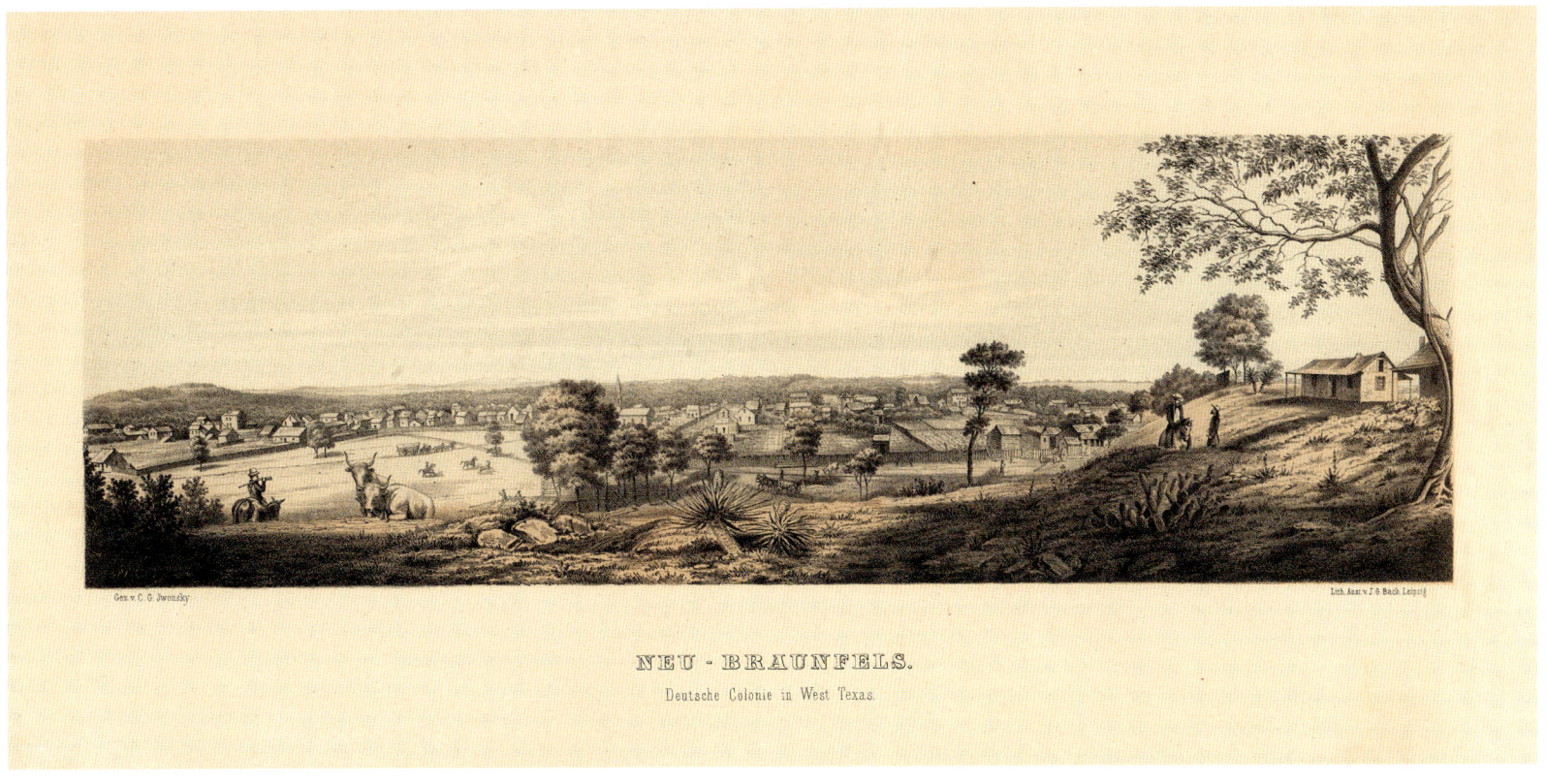

FIGURE 5.31 C. G. Jwonski [Carl Gustav von Iwonski]. *Neu-Braunfels. Deutsche Colonie in West Texas*, 1856. Single sheet. Hand-colored toned lithograph, 15 × 46 cm (image), 18.4 × 45.2 cm (comp.), by J. G. Bach, Leipzig. Courtesy Beinecke Rare Book and Manuscript Library, Yale University.

panorama, the cabin at the right is probably part of the Sophienburg. The road at the left, over which the covered wagon is being drawn, is the San Antonio–Austin Road. Historian James Patrick McGuire, who authored Iwonski's biography, identified the three figures in the foreground of the lithograph as Ernst Dosch (on the left, with his shotgun on his shoulder), a forester from Odenwald and an excellent marksman and hunter, and Dr. Wilhelm Remer from Breslau (on the right, on horseback), the Adelsverein doctor. Remer is talking with Viktor Bracht, a merchant from Dusseldorf and later author of *Texas im Jahre 1848* (*Texas in 1848*).[73]

Iwonski shows the Protestant church beyond the trees at left-center and includes a number of plants and trees in the foreground to illustrate the fertility of the Texas soil. Leipzig printer J. G. Bach rendered Iwonski's name on the print as Jwonski, but, as mentioned above, during the nineteenth century, when the fraktur typeface was commonly used in western Europe, there was little or no distinction between "I" and "J."

Iwonski's lithographic view of New Braunfels might have had its origin with Otto Beyer, who announced in the June 8, 1855, issue of the *Neu-Braunsfelser Zeitung* that he was departing soon for Germany with an "excellent view" of the town, which he intended to have lithographed. For a dollar each he would forward copies to friends or relatives in Germany. While Beyer does not say so, the drawing in his possession could have been the work of the twenty-five-year-old Iwonski, who at that time lived near his family in Hortontown, across the Guadalupe from New Braunfels. In September 1856 Beyer announced that he had returned to New Braunfels and had established a book and art dealership and German loan library on Seguin Street. Among the items he offered for sale was the view of New Braunfels. He also mentioned that he had left two hundred copies of the print with a Leipzig book dealer that could be forwarded to any address for $.75 each.[74]

There are other possible sources for Beyer's print: a little-known German settler—perhaps Wilhme Dammann (the signature is hard

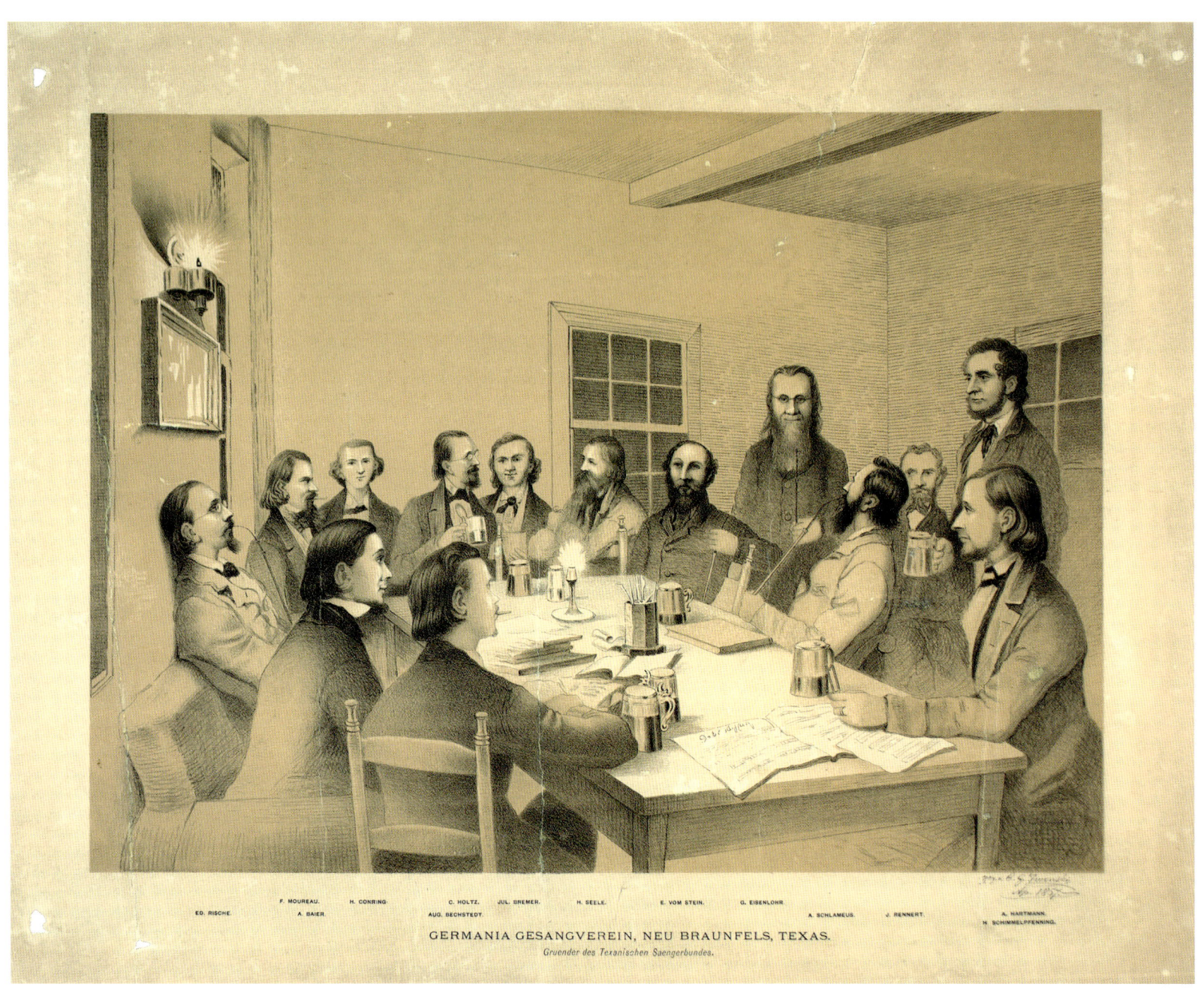

FIGURE 5.32 Carl Gustav von Iwonski, *Germania Gesangverein, Neu Braunfels, Texas. Gruender des Texanischen Saengerbundes*, April 1857. Single sheet. Toned lithograph, 25.9 × 35.3 cm (image), 28.6 × 35.3 cm (comp.). Lithographer unknown. Courtesy Witte Museum, San Antonio.

to read)—made at least one drawing of the village in 1848 (now in the collection of the Bryan Museum in Galveston), and in April 1855 the well-known naturalist and botanist Paul Wilhelm, Duke of Württemberg, visiting New Braunfels on his third trip to North America, obtained several of Iwonski's drawings, including a view of New Braunfels that seems to be the model for the lithograph. The structures and topographical features seem to be the same as in the lithograph, but the drawing lacks the three human figures in the foreground of the print.[75]

Iwonski's second lithograph, the portrait of the members of the New Braunfels Germania Gesängverein, a men's singing club founded in 1850, probably had its origin in the fact that in 1854 and 1855 the club held its rehearsals at his father's saloon in Hortontown (fig. 5.32). It was probably there that he made the drawing that an unnamed lithographer printed in black and brown for Carl A. Jahn, who served as mayor of New Braunfels, to use as gifts for friends. It is possible that the lithograph is a combined effort by Thielepape and Iwonski, since both experimented with lithography and other reproduction processes during the 1850s, but Thielepape would have had to have improved considerably to have produced a toned lithograph of this size and quality, and, if he had done so, surely he would have taken credit for it.[76]

Iwonski moved to San Antonio during the latter part of 1857, where he became friends with many in the German community, including Thielepape, Pentenrieder, and DeRyee, who actively experimented with various photographic processes. By 1858 he and DeRyee had developed a photographic process that they called homeography, by which they reproduced

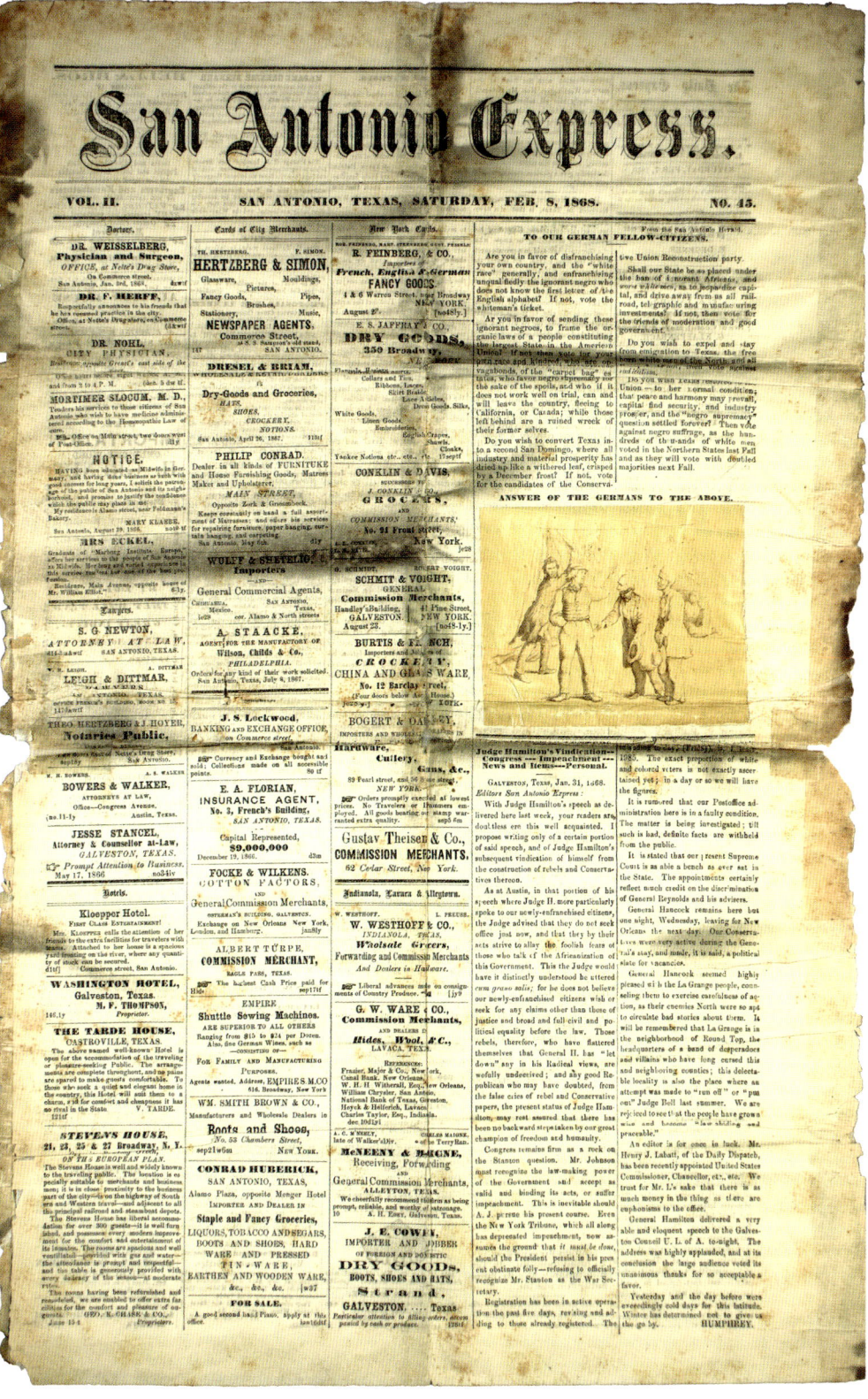

FIGURE 5.33 The Feb. 8, 1868, issue of the *San Antonio Express* with Iwonski's homeographic caricature pasted on the front page. Courtesy Witte Museum, San Antonio.

copies of pencil drawings on glass plates, then printed them on sensitized paper. Iwonski's precise pencil drawings were well suited for DeRyee's process, and the two men collaborated for several years. Iwonski did a portrait drawing of Sam Houston when he was in New Braunfels in 1857 and in 1861 produced a drawing of the governor that was "taken from life during his late Farewell Address at Austin . . . and chemically multiplied by Wm. De Ryee." During the Civil War, DeRyee also printed Texas Cotton Bonds by this process, and after the war Iwonski used the process to create multiple copies of his small caricature, *Answer of the Germans to the Above*. Copies of it were pasted on the front pages of the February 8, 1868, edition of the *San Antonio Express* in support of the Republican effort to adopt a new state constitution. The editors explained:

> On our first page we print a picture, executed by Mr. Iwonski, which is a complete answer to the appeal to the Germans. . . . The picture represents [Judge Thomas J.] Devine appealing to a German to join hands with him in putting down the Union party; old [Samuel A.] Maverick stands by watching the effect of Devine's appeal; [Col. James R.] Sweet of the [San Antonio] Herald is attempting to draw the curtain over the past, but does not succeed. . . . The picture speaks for itself, and needs no more explanation [fig. 5.33].

"The fertility of the artist's brain is equal to Nast, of Harper's Weekly celebrity," claimed the editor of the *Express*.[77] Swante Palm, the Austin collector and bibliophile whose library is one of the foundation donations of the University of Texas at Austin library, recognized the distinctiveness of these images and obtained several for his collection.

"ART—WITHOUT HUMBUG"

The most productive artist of the group was Lungkwitz, and the Texas Hill Country provided the ideal landscape for him to practice the European romanticism in which he and Petri had been schooled during their study in Dresden (fig. 5.34). They arrived in Texas in 1851, via New York and Wheeling, [West] Virginia, settling in 1852 on a farm near Fredericksburg. Lungkwitz had moved to Texas with the impression that one could survive "with his art—without humbug," but soon found that he had to take up farming and cattle raising to

FIGURE 5.34 Unknown photographer, Hermann Lungkwitz, c. 1866. Austin History Center, Austin Public Library.

supplement the meager income from his paintings. Still, he continued to draw and paint, producing hundreds of paintings and drawings before his death in 1891.[78] He had three of his works lithographed.

After spending a few months in New Braunfels, Lungkwitz and his family moved to Fredericksburg in 1852. The village was then only six years old, having been founded in April 1846, when Meusebach led a surveying party about eighty miles northwest of New Braunfels to a suitable site on the Pedernales River. The first settlers arrived in May and named the new village after Prince Frederick of Prussia.

As Fredericksburg began to grow, the US Army established Camp Houston (later Fort Martin Scott) nearby to protect the settlers and in 1849 blazed the road from San Antonio and Austin through Fredericksburg to El Paso. More than twelve hundred persons lived there by 1850.[79]

Lungkwitz produced his first print when Dr. Ernst Kapp, a native of Bavaria and graduate of the University of Bonn who had emigrated to Texas in 1849, asked him to make drawings of his "water-cure" at Sisterdale, a village about forty miles northwest of New Braunfels. Kapp established his water-cure, one of the state's first health spas, in 1852. He called it Badenthal and immediately mounted an advertising campaign proclaiming the benefits of cold-water cures. Lungkwitz visited the sanatorium and became a welcome participant in the discussions at this Latin Settlement. While there, he might have sketched various scenes, which Kapp saw and which led to a commission to do the lithograph of his water-cure.[80]

Gustav Kraetzer in New York City printed *Dr. Kapp's Water-Cure*, probably in 1853 (fig. 5.35).[81] The print includes nine scenes and four decorative drawings. The main view in the center and the one above it show the Kapps' home, with a circular drive in front along with cultivated fields and cattle, while the others show various aspects of the restorative program. The home appears to be a large dogtrot cabin with a small room over the central hallway, situated in a bucolic landscape with well-tended fields and neat fences. A picturesque Hill Country scene rises in the distance. Depictions of the various treatments available at the spa line the margins of the print. Hermann Seele, a New Braunfels attorney and later mayor, recalled an 1860 visit during which Kapp demonstrated the "excellent facilities of his hydropathic health resort" and charmed the several guests with a discourse on hydrotherapy.

Lungkwitz's idyllic view of Fredericksburg, his second lithograph, is one of the best-known images of nineteenth-century Texas (fig. 5.36). Historian McGuire, Lungkwitz's biographer, suggests that the image bears a resemblance to Ludwig Richter's *Hirt und Ziegen in felsigem Tal* [Herdsman and goat in rocky valley] (1823), which Lungkwitz might have seen during his studies. Lungkwitz made the preliminary drawing sometime after 1855 (probably in 1858) and sent it to the lithographic firm of Rau and Son in Dresden to reproduce. Taken from a perspective on Schneider's Hill, south of town, the picture shows Fredericksburg in the middle ground to the north (left-center), with several idyllic scenes of life in the garden—shepherd boys and their flocks, a farmer plowing with oxen, a group of horses grazing in the meadow. The zigzag, or worm, fence, usually made from cedar or oak, was commonly used by the Texas Germans, and examples of it can be seen throughout the middle ground of this print as well as in *Kapp's Water-Cure*. It is also possible to identify the community's first public building, the Vereins Kirche, which served as town hall, school, and multidenominational church, along with the Zion Lutheran church (built 1854) and the Southern Methodist church (built 1855) in the distance.[82]

The print was finished and shipped to Texas, probably in the late summer or fall of 1859, and the editor of the *Neu-Braunfelser Zeitung* announced that "a lithograph of Fredericksburg and vicinity is on display at the drug store of Koester and Tolle; it is a copy of the beautiful original painting by the artist Lungkwitz and is unquestionably the best of the current Texas landscape art." The painting to which the editor referred is apparently lost, for only a preliminary drawing of the scene is known. Family legend claims that the ship bringing the lithographs to Texas was caught in a storm and many of the prints were damaged by salt water, which might explain the rarity of the view as well as the absence of the original painting.[83]

Lungkwitz's handsome *San Antonio de Bexar* is a little more difficult to date (fig. 5.37). Although the single sheet is based on a number of paintings and drawings that he did in 1857, including the main view, he might not have had it lithographed until sometime after the Civil War, when he moved to the city. Along with Galveston, San Antonio was one of the population and cultural centers of the state and, perhaps, the Texas city most frequently portrayed by artists and printmakers. Lungkwitz knew the city well, for he had often been there to conduct business and, from time to time, to exhibit his work.[84] He had been sketching and painting scenes of the city probably since 1852, during his first residence there. The central image in the print is a reproduction of his painting of *Crockett Street Looking West, San Antonio*, which he probably started at that time but did not complete until 1857. There are several sketches among Richard Petri's papers suggesting that the two artists collaborated on the painting.[85] Petri was a better figure painter than Lungkwitz and probably helped his brother-in-law with the figures and the ox team. Of the eight vignettes at the top and bottom of the print, only two can be dated by extant drawings: San Juan in 1856 and San José in 1857. The sketch for *The New Bridge* may be the San Pedro Creek bridge constructed in 1854.[86] The view of the *Main Plaza* in the upper left corner is similar to Thielepape's 1855 lithograph of the same view, even to the stagecoach crossing the plaza. The depiction of the

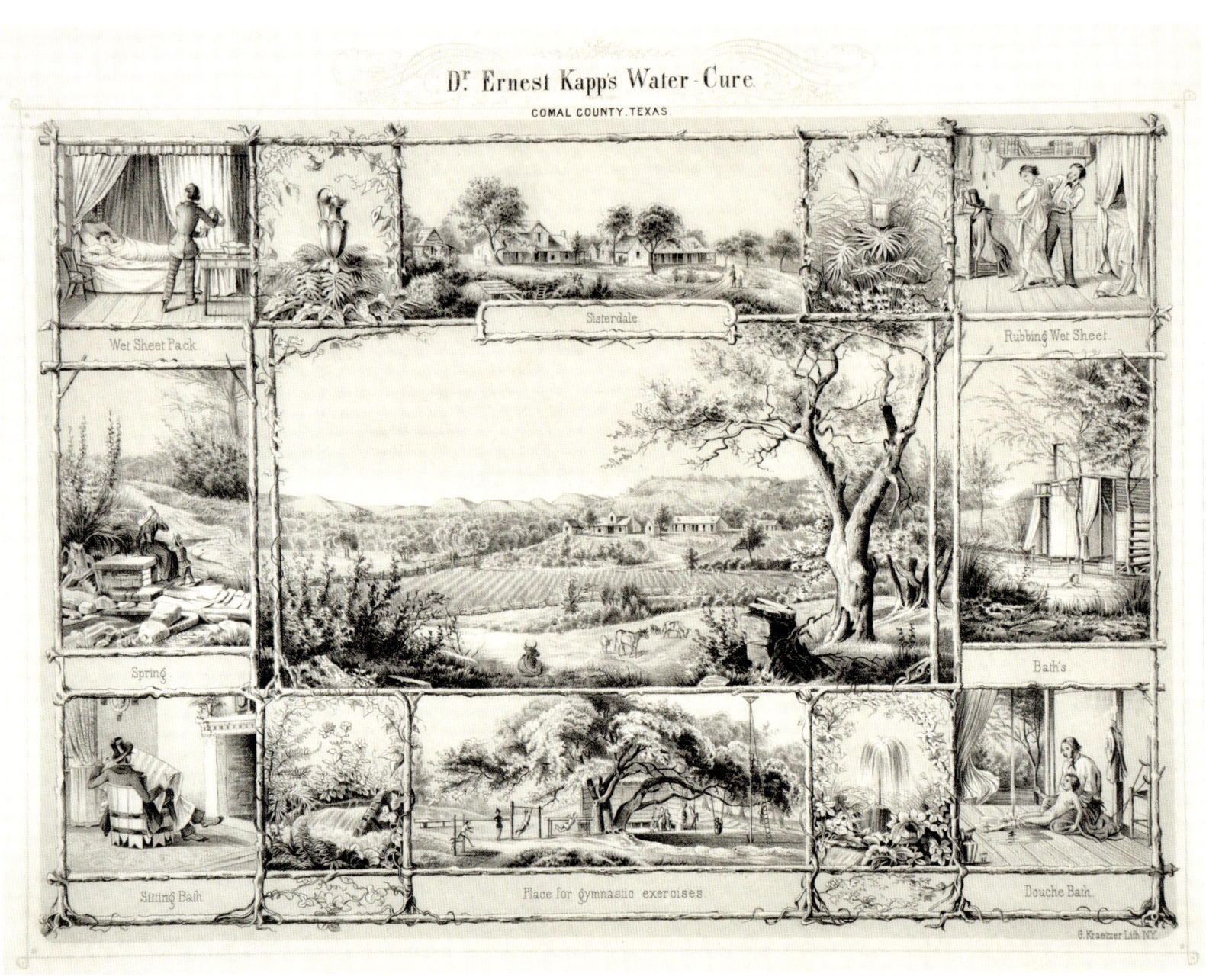

FIGURE 5.35 G. Kraetzer after Hermann Lungkwitz, *Dr. Ernest Kapp's Water-Cure. Comal County. Texas*, c. 1853. Single sheet. Lithograph, 26.7 × 34.9 cm, by G. Kraetzer, New York. Courtesy Ken and Debra Hamlett, Dallas.

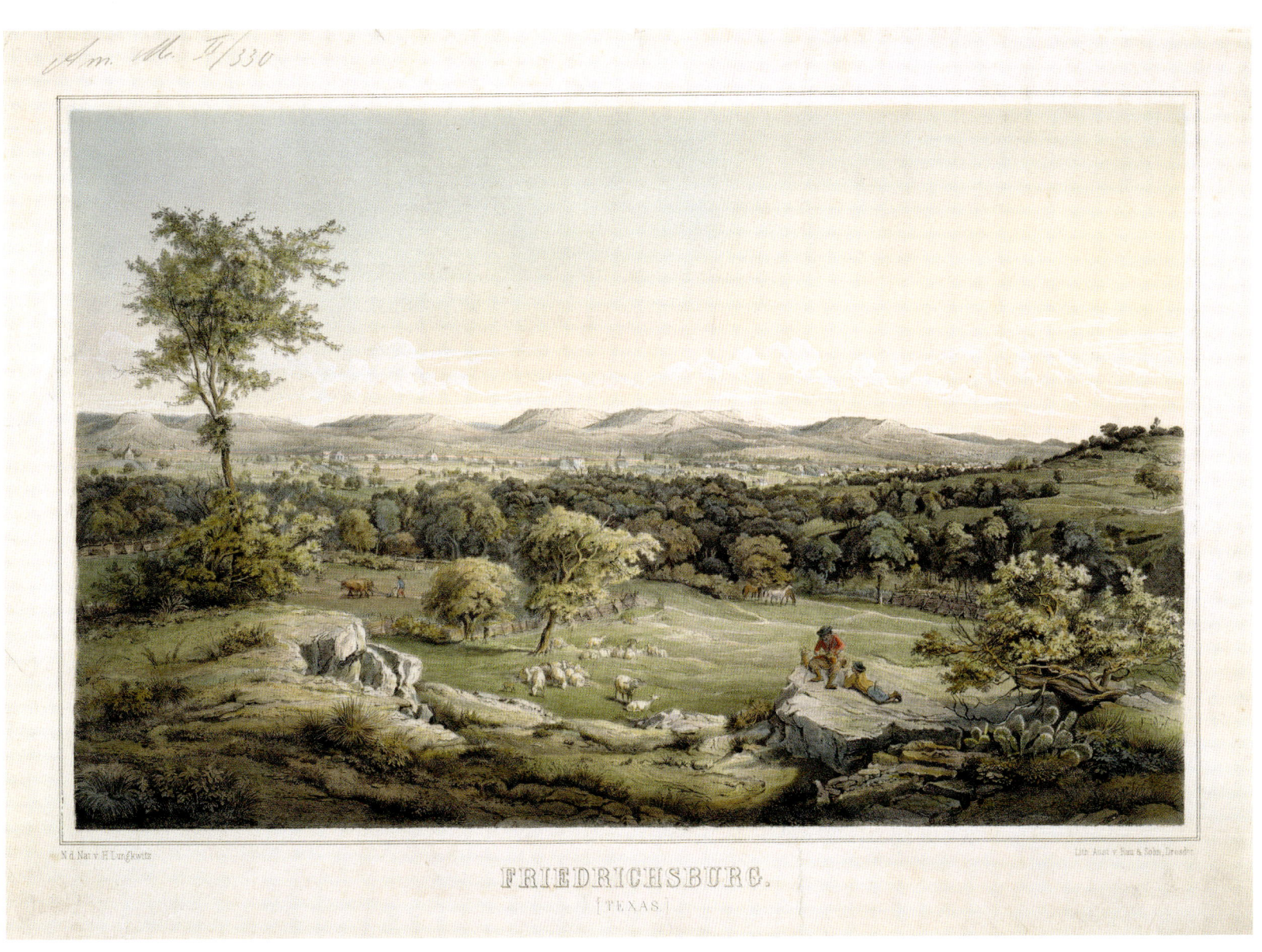

FIGURE 5.36 Hermann Lungkwitz, *Friedrichsburg. [Texas]*, 1859. Single sheet. Hand-colored toned lithograph, 30 × 46.9 cm (image), 33.9 × 48.3 (comp.). Printed by Anst. V. Rau & Son, Dresden. Courtesy Amon Carter Museum of American Art, Fort Worth.

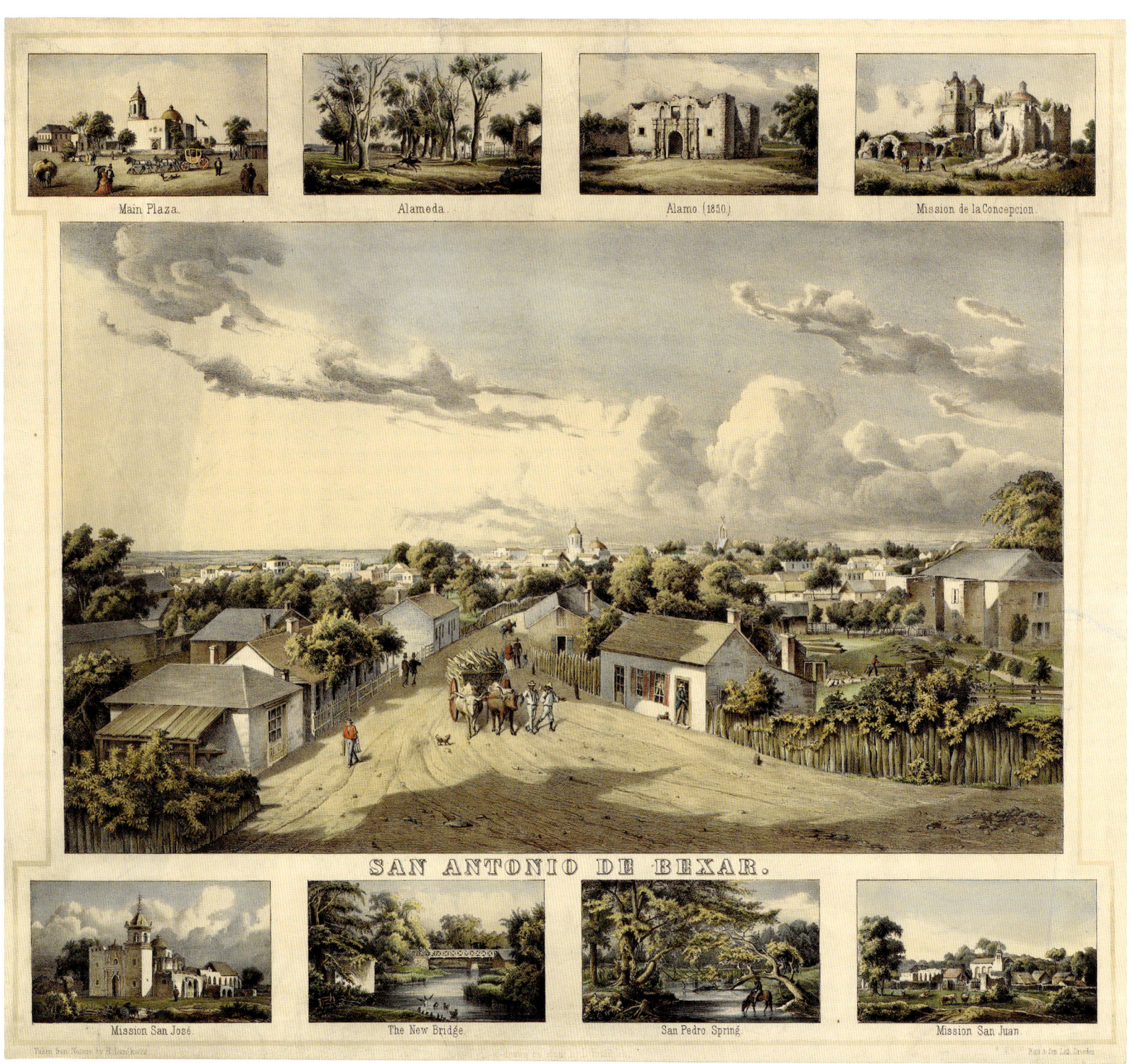

FIGURE 5.37 Ludwig Friedrich after Hermann Lungkwitz, *San Antonio de Bexar*, c. 1859–1868[?]. Single sheet. Hand-colored toned lithograph, 27.6 × 45.1 cm (image), 44.4 × 49.8 cm (comp.), by Rau & Son, Dresden. Courtesy Amon Carter Museum of American Art, Fort Worth.

Alamo from the rear represents the structure after the US Army added a roof and the now-distinctive peak to the façade. Biographer McGuire dates the print to after the Civil War because one of Lungkwitz's former students, Rudolph Menger, claimed to have been with him when he sketched the view from the tower of the Honore Grenet residence on Nacogdoches Street behind the Alamo.[87]

Lungkwitz sent the painting to Louis (Ludwig) Friedrich, his former classmate and Petri's cousin, in Dresden to be lithographed. Friedrich drew the scene on stone for Rau & Son, the lithographers who had previously printed Lungkwitz's view of Fredericksburg. Lungkwitz would have sold the prints in the photographic shop that he, Iwonski, and, by that time, F. Hanzal operated, but no advertising that would clarify the date of publication has been found.[88]

San Antonio de Bexar is one of the handsomest representations of any Texas city. It shows two men walking east on Crockett Street with a team of oxen pulling a cart filled with wood. At the left is the home of Wenzel Friedrich, probably the man walking along the street with the carpenter tools, for he was a well-known furniture maker who later became famous for his horn furniture.[89] At right-center, in the doorway of the adobe house, is Wilhelm Thielepape, the lithographer who also served as Reconstruction mayor of San Antonio from 1867 until 1872. The rear of the Alamo can be seen at the far right, and the tower and dome of San Fernando church, on the Main Plaza, are visible on the horizon at the center of the print. Louis Friedrich apparently added some details to the print, such as the worker in the Alamo yard where Lungkwitz showed only a pile of wood, the dramatic clouds, and the ominous shadow in the foreground.

THE ALAMO MEMORIALIZED

One of the adornments of the new capitol building in Austin was a monument to those who died at the Alamo, which is known today only by the modest lithograph that its owners produced in 1853 in an effort to sell it and by its remaining fire-damaged fragments in the Texas State Library and Archives and the Texas Memorial Museum collection at the Dolph Briscoe Center for American History in Austin (fig. 5.38). A sculptor named William B. Nangle and Joseph Cox, a stonecutter, created the monument in San Antonio in 1841, according to Capt. Reuben M. Potter, a passionate amateur historian who saw the work in progress.[90] At the time, Nangle was carving various mementos—candlesticks, urns, pipes, seals—from the stones of the Alamo to sell to visitors, and he conceived of creating a monument to memorialize those Texans killed in the battle, hoping to sell it to the government. A writer in the *Telegraph and Texas Register* described it as "a small monument about six feet high, consisting of a square column supported on a small square pedestal, and terminated by an urn neatly carved. The four faces of the column are ornamented with beautiful devices of various kinds, and appropriate inscriptions. He has also a portion of the soil containing the ashes of the heroes of the Alamo, which he intends to enclose in the monument." After completing the work, which was modeled on rather common English funerary monuments, Nangle displayed it in the stonecutter Cox's Austin workshop.[91]

Although it received no comment at the time, Nangle may have been the first to use the phrase "Thermoplæ had its messenger of defeat but the Alamo had none" in a public manner, carving it on one side of the monument. A few months later, in April 1842, following a brief Mexican occupation of San Antonio, Edward Burleson, vice president of the republic, gestured toward the battle rubble in front of the Alamo and used the phrase in the stirring conclusion of his address to the volunteers. That seems to be the only public use of the phrase that anyone remembered, even in 1887 when a newspaper debate erupted as to the origin of the famous phrase. Galveston attorney William Pitt Ballinger recalled a discussion among persons who were present for Burleson's now-legendary speech, and all agreed that Burleson, unfamiliar with the classics as he was, could not have composed the sentence and that Thomas Jefferson Green, Burleson's speechwriter during the 1841 presidential campaign, had to have been the author. Green also reportedly suggested the phrase to Nangle for use on the obelisk.[92]

When the republic did not purchase it, Nangle and Cox first solicited subscriptions "for the purchase, and donation to the Republic," then sent it on tour in the United States, eventually having to sell it to cover costs. It fell into the hands of the New Orleans law firm of Leech & Cavanaugh, which in 1853 had a lithograph made showing all four sides of the column. As part of its effort to sell the monument to the state, the firm distributed copies to newspaper editors and, probably, members of the legislature. John Cavanaugh shipped the monument to Austin, where it was displayed on the portico of the capitol and noticed in many of the state's newspapers, most of whom urged the legislature to complete the transaction. Apparently, by May of 1856 it was already the victim of graffiti artists who wrote their names beside "those of the honored dead of the Alamo."

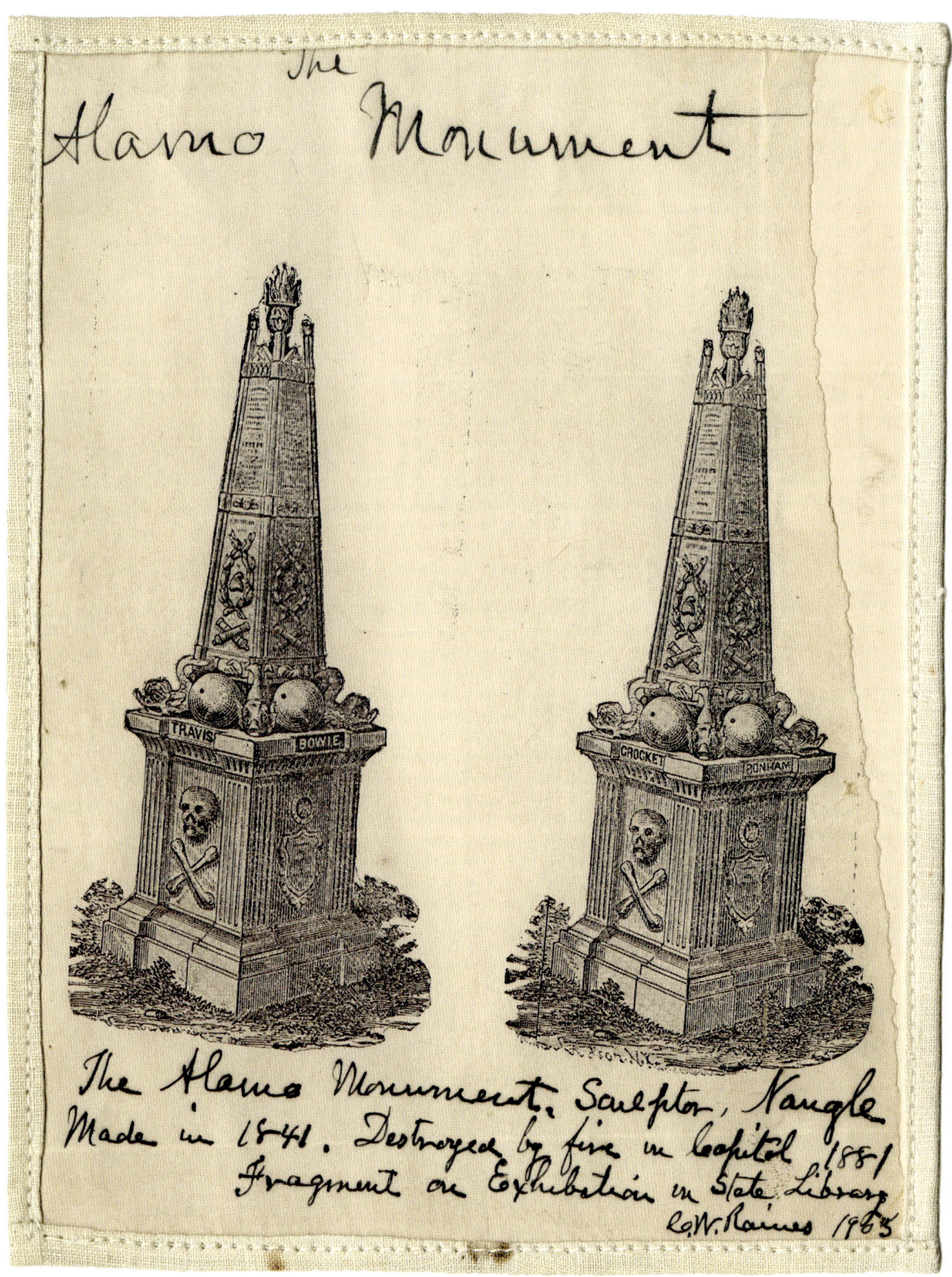

FIGURE 5.38 After William B. Nangle's [Naegle?] Alamo Monument, c. 1853. Single sheet. Lithograph, 6 × 4.5 in. Courtesy Texas State Library and Archives.

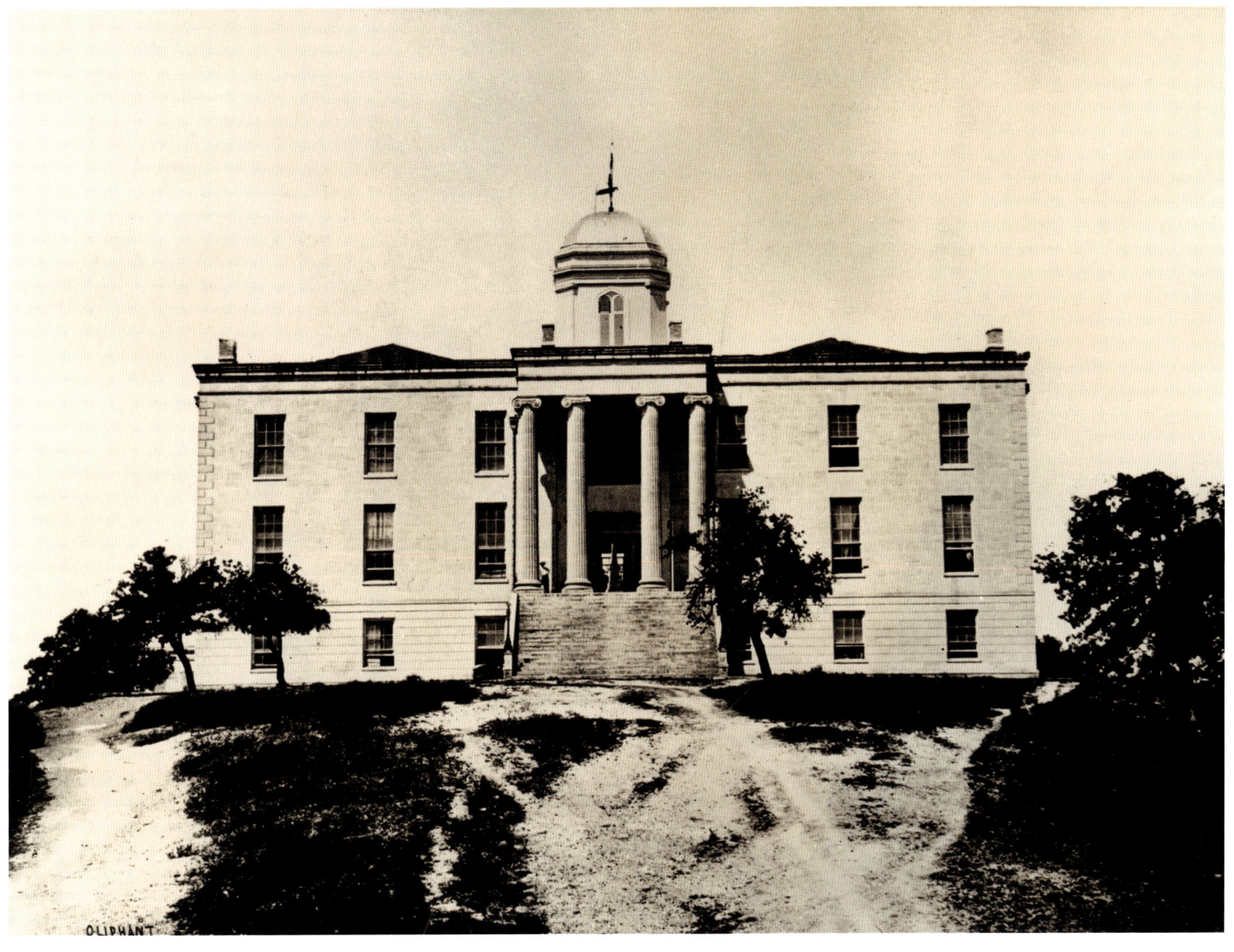

FIGURE 5.39 William J. Oliphant, photographer, Texas State Capitol with Terracing (detail), 1870s, showing the Alamo Monument on the portico. Courtesy Longbow Partners.

The state finally acted in 1858, paying the owners $1,500 and the Nangle family $1,000.[93]

The obelisk shows up in several prints and photographs of the capitol; it even appeared weekly in the *State Gazette*, which, beginning in the late summer or fall of 1855, featured an engraving of the capitol with the monument on its masthead (fig. 5.39). It remained on the capitol portico until 1869, when it had to be repaired because of the effects of the weather. Ferdinand Flake, editor of *Flake's Bulletin*, recommended that it be moved into the hall, where it would be protected from the elements, but the only change apparent upon its reinstallation was a new iron railing. Only fragments of the monument survived the 1881 capitol fire.[94]

"PRETTY PICTURES . . . 'CANDY' FOR THE IMMIGRANTS" | 229

"I SURVIVED THE RUIN OF THIS GLORIOUS UNION"[95]

Sam Houston was an enigma to many of the more than 19,800 Germans who lived in Texas in 1860. He was a Southerner who owned slaves, yet he had supported the Missouri Compromise (which banned slavery north of latitude 36°30′); he had voted for the Compromise of 1850 (in which, for $10 million, Texas ceded its claim to a huge swath of territory from New Mexico to Wyoming, including parts of Indian Territory and Kansas); and in 1855 he endorsed the American Party (the Know-Nothings) because he did not agree with the increasingly sectional views of the Democratic Party. Unfortunately, the Know-Nothings also pledged to vote only for native-born Protestants and advocated raising the residence requirement for citizenship from five years to twenty-one years, which had earned Houston lithographer Thielepape's ire (see fig. 5.22). Houston's prominence and continuing loyalty to the Union placed him among the few to be considered for the Democratic presidential nomination in both 1848 and 1852. His public career—the hero of the battle of San Jacinto, the first president of the Republic of Texas, one of the first US senators for the State of Texas—justified the attention, but, apparently, so did his physical bearing. "Instead of the large and fleshy man he was six years ago," recalled an acquaintance in 1845, Houston was "a spare, tall, and thoughtful looking person, rather pale and more reserved than formerly in his intercourse with the masses."[96] He was also well known for having his portrait made, and there are probably more lithographic portraits of him—both caricatures and formal portraits—than any other figure associated with early Texas.

Suffering a public embarrassment that would have ruined a lesser figure, Houston had overcome a disastrous, brief marriage to Eliza Allen in 1829 and resigned the Tennessee governorship. He sought privacy and support among the Cherokees, who had provided him shelter and sustenance during his younger years, and perhaps his earliest lithographic portrait shows him in Cherokee dress during an 1830 visit to Washington, DC (see fig. 1.15). While in Nashville to attend his dying mother in 1831, he called on the artist Washington Cooper and had himself painted as Caius Marius, the Roman general and consul who was banished from Rome but returned triumphant.[97] He probably knew of John Vanderlyn's 1807 portrait, *Caius Marius amid the Ruins of Carthage* (Fine Art Museums of San Francisco), and being well versed in the classics, he wanted to commemorate his own recovery from disgrace. Houston marked his return to Washington in 1832 by thrashing Congressman William Stanbery of Ohio, who had impugned his reputation in a speech on the floor of the House, and a local caricaturist documented the incident in *Houstonizing, or a Cure for Slander* (see fig. 1.17).

Houston's portrait habit grew as his fame spread. Francis D'Avignon, a European-trained artist and lithographer, copied Bartlett and Fuller's daguerreotype of the senator for an 1848 portrait that master printer Louis Nagel produced (fig. 5.40).[98] And in 1849 Houston asked his friend, storekeeper Thomas M. Bagby in Huntsville, to look after some portraits that he had commissioned, asking, "If you will have the goodness to . . . see what has become of those portraits of mine? . . . One was in Military green dress, and one in citizen dress, Green also." He also wrote Ashbel Smith, apparently regarding the same portrait(s): "If anything should cause you to leave without a visit to us, I want you, if you cannot leave my likeness with some one, (more than safe) do take it to Memphis. I think more of it than all my likenesses."[99]

Caricaturists produced some less-than-flattering likenesses of the senator during the US presidential campaigns of 1848 and 1852. *The Democratic Funeral of 1848*, by Edwin Forrest Durang, correctly predicted the Democrats' demise with Houston (first figure on the left) assisting other party regulars in carrying the bodies of their standard bearers, Van Buren (caricatured as a fox) and Lewis Cass (caricatured as a hot-air balloon), from the field (fig. 5.41). The omnipresent Henry R. Robinson was still at his stand the following year, showing Houston among *Cass & His Cabinet in 1849* as they continue the corrupt practices attributed to the Van Buren era and endorse the Democratic "Platform": "Reward our Friends."[100]

In 1852, when Houston was a legitimate presidential contender, John L. Magee pictured him in *Soliciting a Vote* as one of four candidates competing for the working-man's vote (fig. 5.42). Houston (center left) is depicted as the epitome of Texas swagger, telling the voter, "This is the 'Ticket' for you, my good friend, I am 'Old Sam Houston' if elected I shall not only 'lick all of Europe,' but all 'Creation' to boot." Houston was apparently even more commanding in person. Secretary of the Treasury Thomas Corwin sarcastically reported on a dance that he had attended: "All the candidates were there and acted as if they thought themselves second fiddlers to the *great leader* of the orchestra [Houston] in that *humbug theatre*."[101] The eventual winner, Franklin Pierce, is not included in the print, suggesting that Magee published it before the June convention.

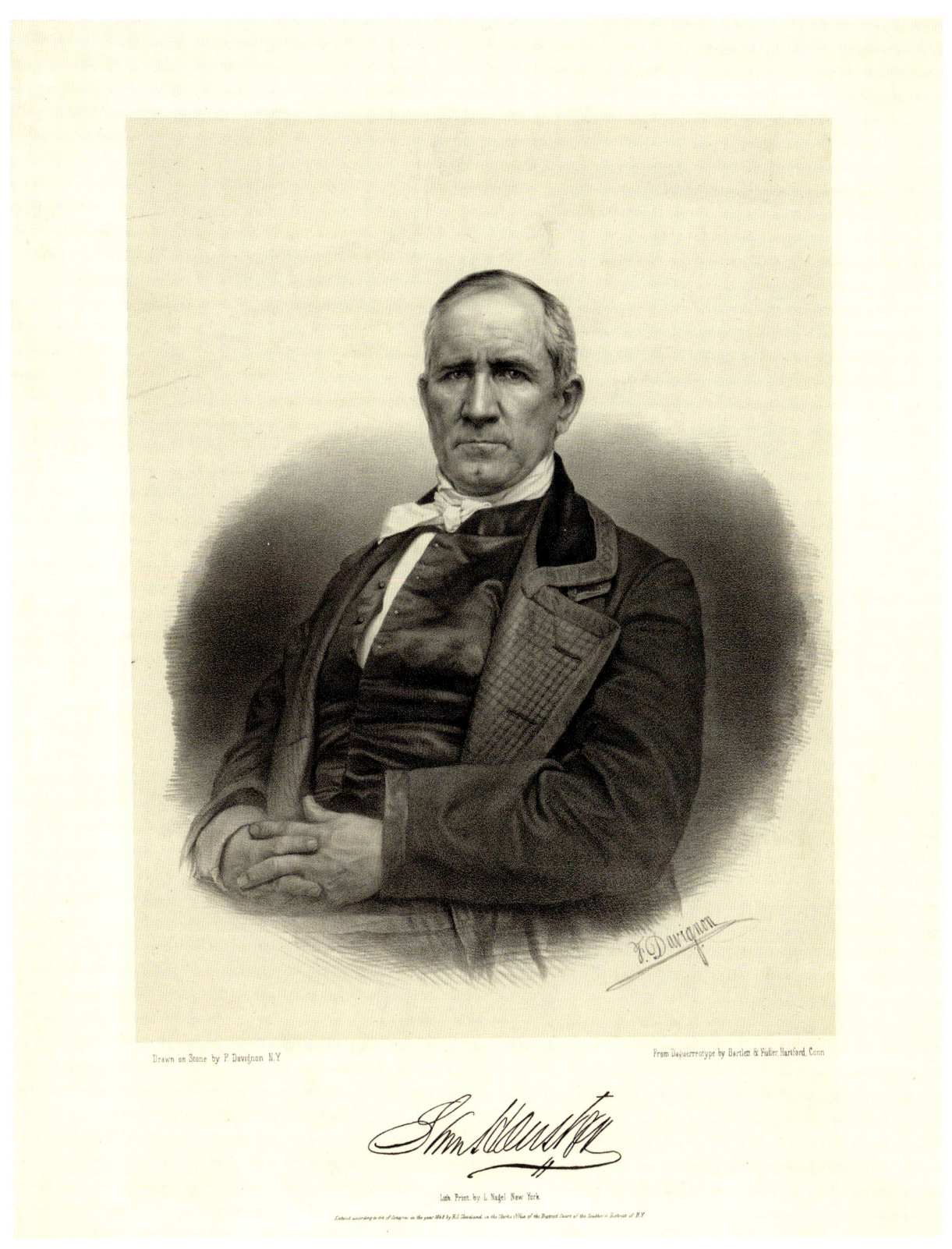

FIGURE 5.40 Francis D'Avignon, *Samuel Houston*, 1848. Single sheet. Toned lithograph, 39 × 30.7 cm (image), 46.6 × 30.7 cm (comp.). Lithographed by L. Nagel, New York, after a daguerreotype by Bartlett & Fuller, Hartford, CT. Courtesy Prints and Photographs Division, Library of Congress.

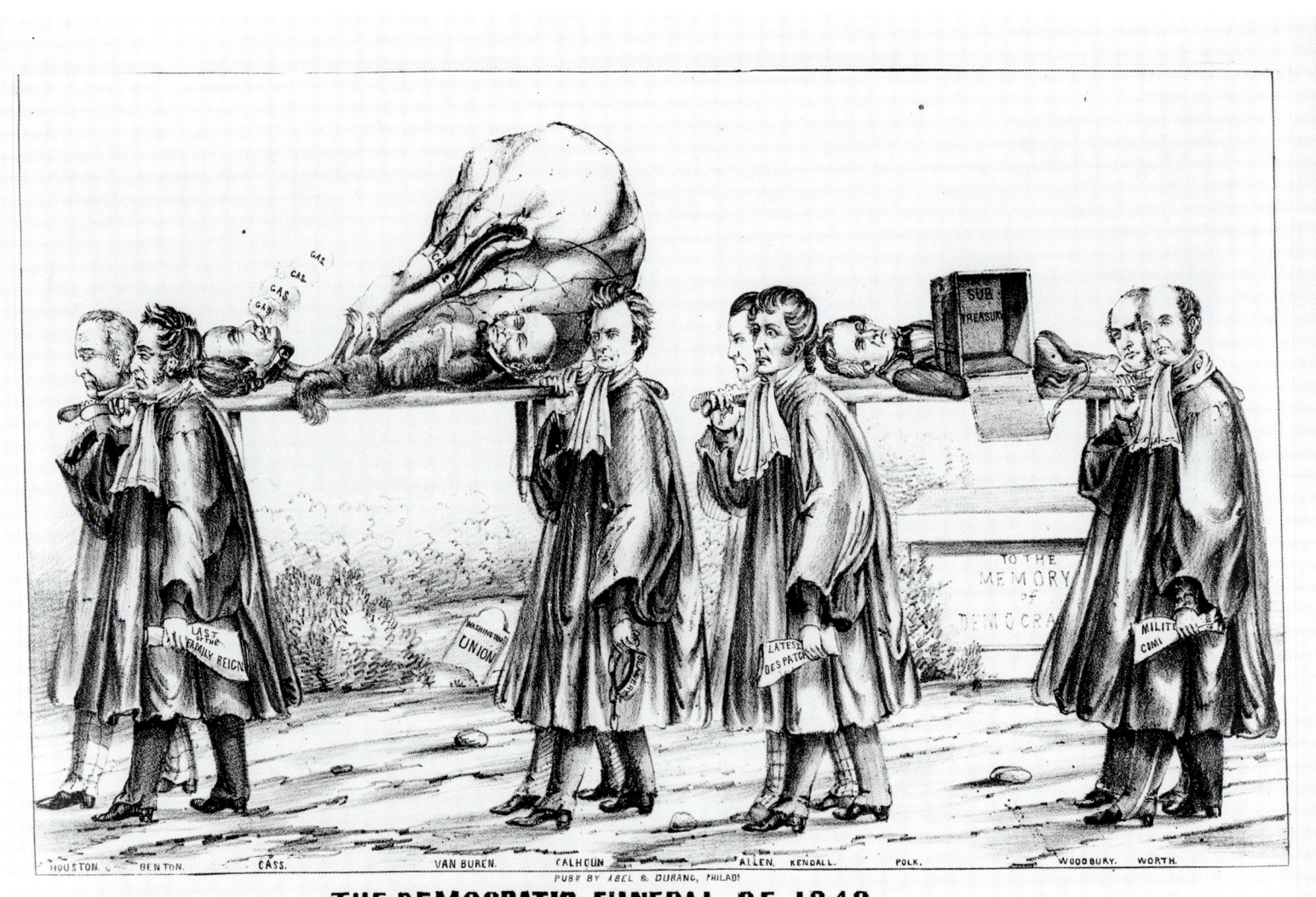

FIGURE 5.41 Edwin Forrest Durang, *The Democratic Funeral of 1848*, 1848. Single sheet. Lithograph, 24.4 × 37.6 cm (image), by Peter E. Abel & Durang, Philada. Courtesy Prints and Photographs Division, Library of Congress.

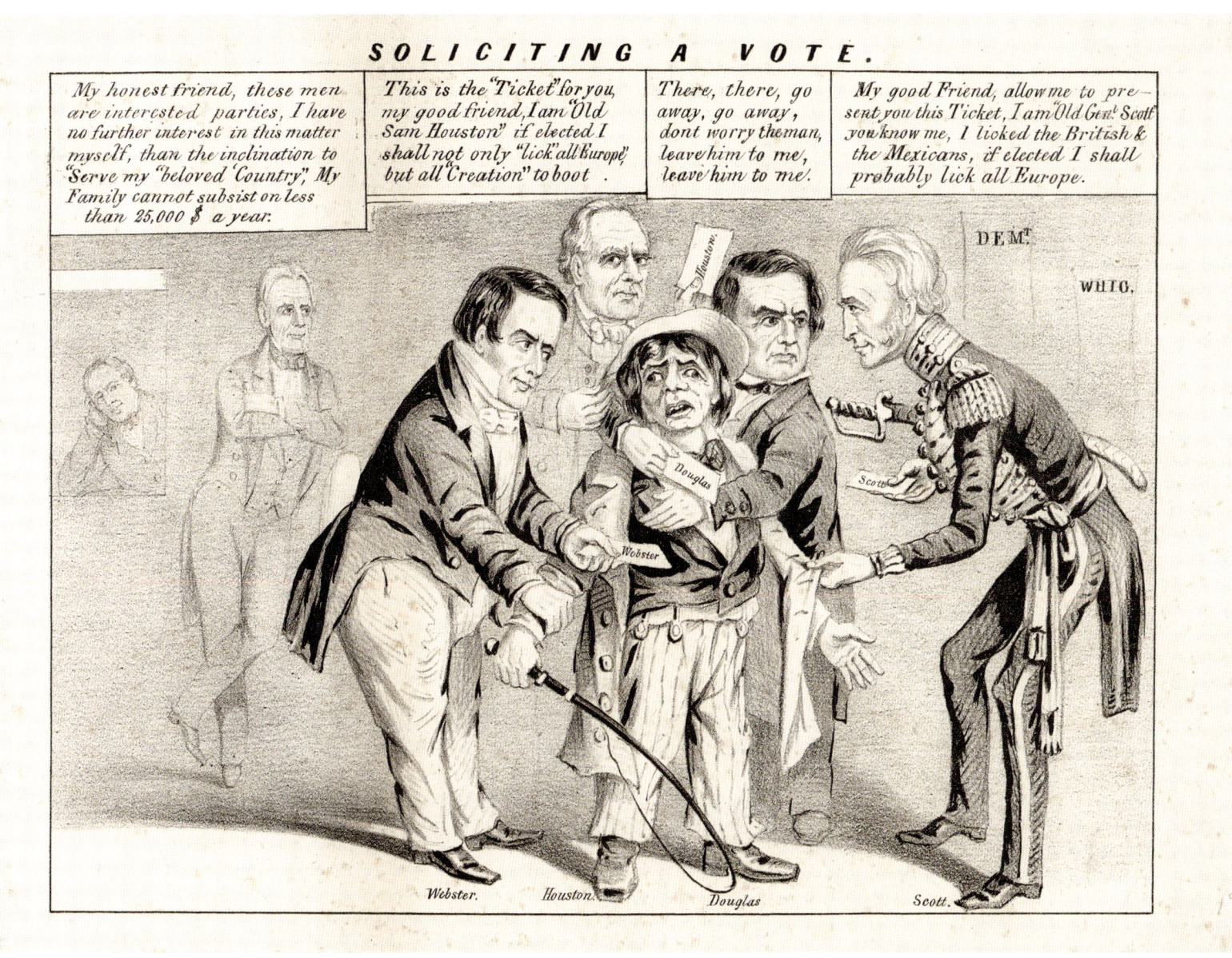

FIGURE 5.42 [John L. Magee], *Soliciting a Vote*, 1852. Single sheet. Lithograph, 16.8 × 22.1 cm (image). Lithographer unknown. Courtesy Prints and Photographs Division, Library of Congress.

As Houston was contemplating the campaign, he posed for several daguerreotypists, which resulted in additional lithographic portraits. In 1851 he posed for the Meade Brothers in Brooklyn, who produced a striking photograph now in the collection of the Museum of Fine Arts, Houston (fig. 5.43). E. C. Kellogg & Co. in New York copied that image to produce a tinted lithograph showing Houston relaxed and standing by a column (fig. 5.44). A short time later, lithographer Ch. Bouvier copied Mathew Brady's daguerreotype of Houston, which was published by Goupil & Co. in New York (fig. 5.45).

As the issues of slavery and secession became more contentious, Houston's firm stand for the Union and his ultimate repudiation of the Know-Nothings cost him his senatorial seat but earned him the support of Ferdinand Flake, editor of *Die Union*, Galveston's largest circulation newspaper, and won him election as governor in 1859.[102]

"PRETTY PICTURES ... 'CANDY' FOR THE IMMIGRANTS" | 233

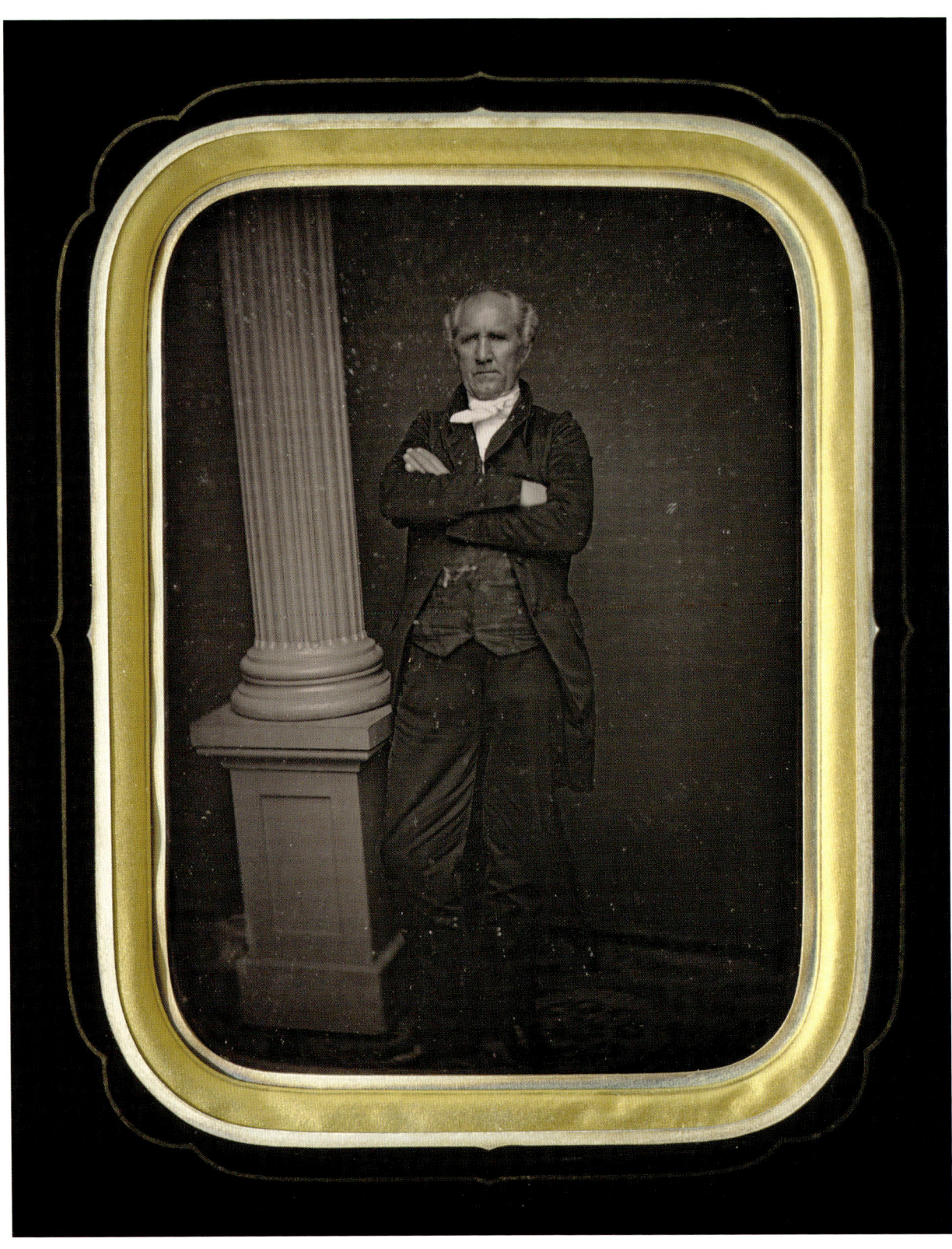

FIGURE 5.43 Meade Brothers Studio, *Sam Houston*, 1851 Daguerreotype, 8 × 5.19 in. Courtesy Museum of Fine Arts, Houston. Museum purchase funded by Vinson & Elkins L.L.P. in honor of the firm's seventy-fifth anniversary.

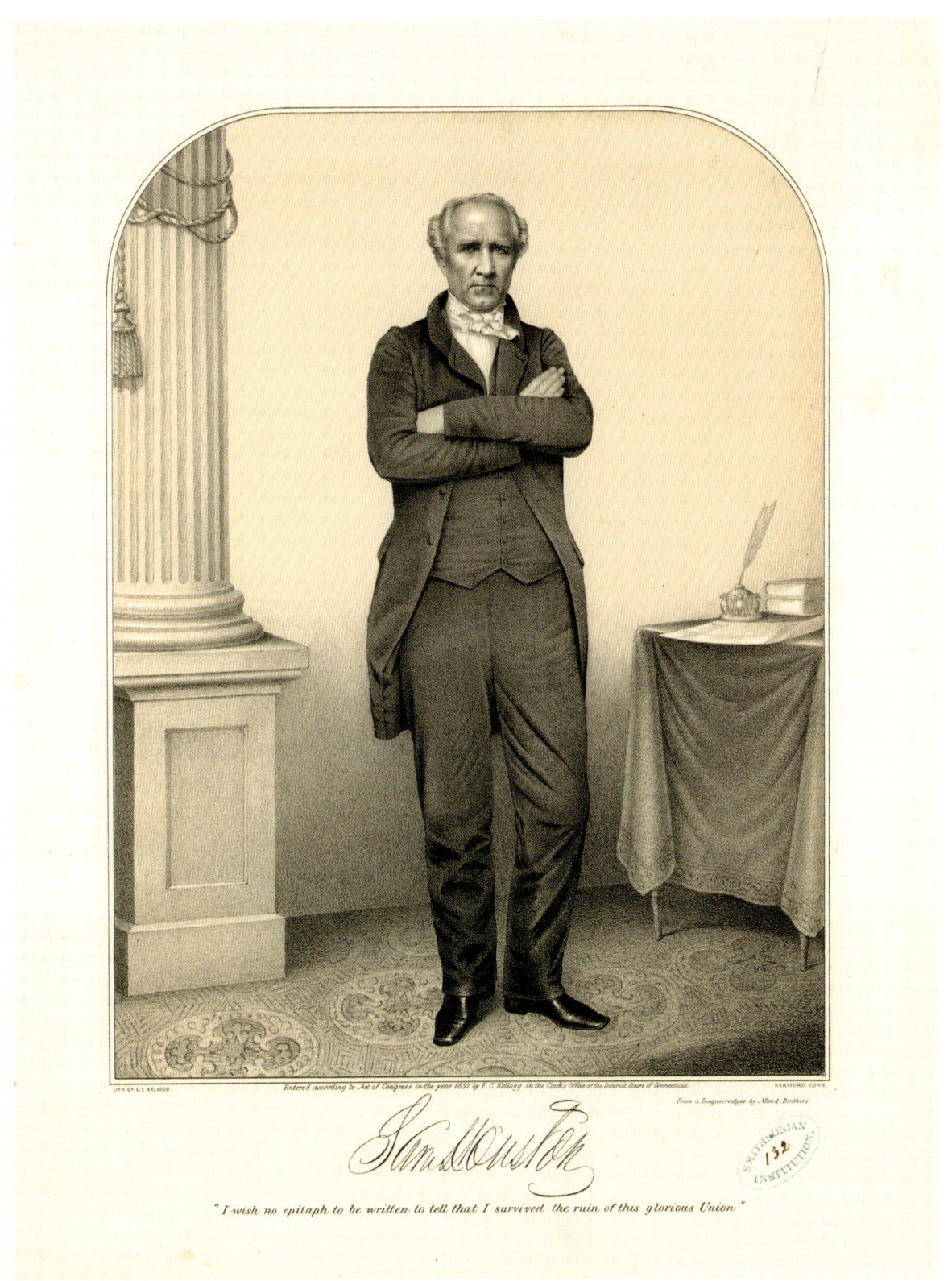

FIGURE 5.44 Unknown artist after Meade Brothers daguerreotype, *Sam Houston "I wish no epitaph to be written to tell that I survived the ruin of this glorious Union,"* 1852. Single sheet. Hand-colored tinted lithograph, 12.63 × 9.75 in., by E. C. Kellogg, Hartford, CT. Courtesy Prints and Photographs Division, Library of Congress.

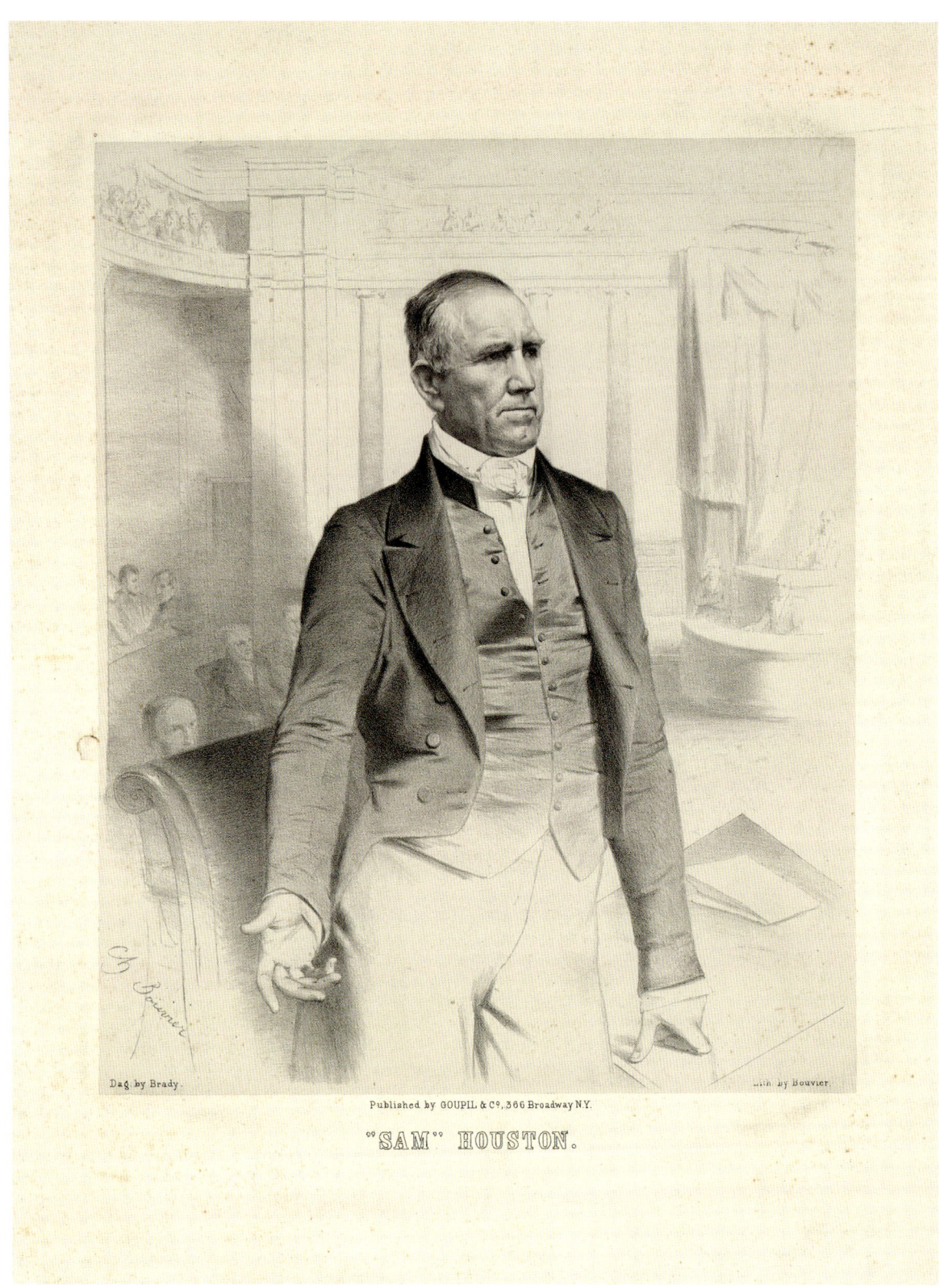

FIGURE 5.45 Ch. Bouvier after Mathew Brady daguerreotype, *"Sam" Houston*, c. 1852. Single sheet. Lithograph, 29 × 24 cm (image), by Ch. Bouvier. Published by Goupil & Co., 366 Broadway, New York. Courtesy Beinecke Rare Book and Manuscript Library, Yale University.

"THE FIRST SCHOLARLY HISTORY OF TEXAS"

Henderson Yoakum was a West Point–educated lawyer and veteran of the war with Mexico who in 1845 settled in Huntsville, near Houston's home, and became Houston's lifelong friend. With the support of attorney Peter W. Gray, about 1850 he began writing what the late rare-book dealer and bibliographer John H. Jenkins called "the first scholarly history of Texas written after annexation." *History of Texas from Its First Settlement in 1685 to Its Annexation to the United States* includes a number of lithographic portraits of significant figures, including Houston (fig. 5.46), Peter Ellis Bean (figs. 5.47 and 5.48), Stephen F. Austin (figs. 5.49, 5.50, and 5.51), and Thomas J. Rusk (fig. 5.52), as well as the frontispiece of volume one, Mission San José (fig. 5.53). The portraits are quite good, because Yoakum secured life portraits and daguerreotypes from the individuals or families for Konrad Huber to use in making the prints. Yoakum wrote Houston on September 24, 1854, asking that his wife "select from your daguerreotypes the one she would prefer to have engraved and send it to me by mail. . . . Redfield [the publisher] I presume will have the first volume before long." The book was originally published in mid-1855, but a fire destroyed most of those copies so that only a few sets of the first edition remain. Redfield reprinted it the following year.[103]

Perhaps the only other lithographic portrait of a Texas figure during these years is that of Thomas William "Peg Leg" Ward, a ubiquitous figure who served as the second commissioner of the General Land Office and three-time mayor of Austin (fig. 5.54). He also built the two-story building in Houston that served as the republic's first capitol. Ward had lost his right leg in the siege of Bexar in 1835, hence his nickname, and his right arm in 1840 when a cannon that he was loading for a Texas Independence Day celebration exploded prematurely. In August 1853 President Franklin Pierce appointed Ward US consul to Panama. Before leaving for Panama, Ward had between three and five hundred copies of his lithographic portrait printed in New York, some of which he placed in cheap gilt frames and hung in American-run hotels and bars in Panama to announce his arrival. His distinctive signature resulted from having to learn to write with his left hand after he lost his right arm in the cannon accident.[104]

FIGURE 5.46 Konrad Huber after Mathew Brady daguerreotype, *Sam Houston*, 1855. Lithograph, 9.6 × 8.8 cm (image), 13.7 × 8.8 cm (comp.). Konrad Huber Lith. From Henderson Yoakum, *History of Texas* (1855), vol. 2, frontis. Courtesy Amon Carter Museum of American Art, Fort Worth.

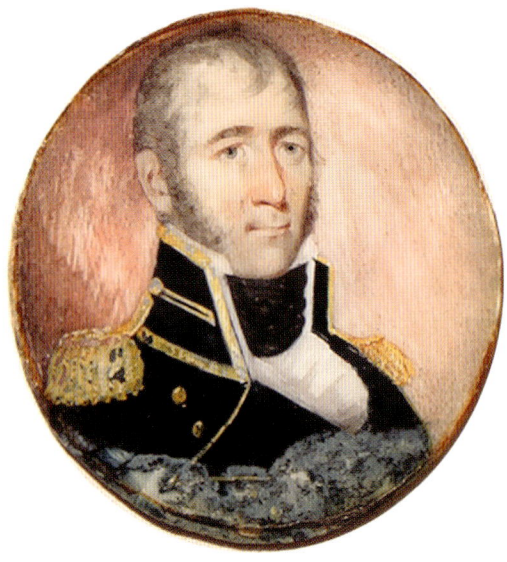

FIGURE 5.48 Unknown artist, perhaps Jacob Marling, *Peter Ellis Bean*, n.d. Watercolor on paper, small, but dimensions unknown. Courtesy private collection.

FIGURE 5.47 Konrad Huber after unknown artist, *Bean*, 1855. Lithograph, 6.7 × 6.6 cm (image), 11.2 × 6.6 cm (comp). From Yoakum, *History of Texas*, vol. 1, opp. 404. Courtesy Amon Carter Museum of American Art, Fort Worth. The print was made from a life portrait in the hands of the family.

FIGURE 5.49 Konrad Huber after unknown artist, *S. F. Austin*, 1855. Lithograph, 11 × 5.2 cm (comp.) From Yoakum, *History of Texas*, vol. 1, opp. 202. Courtesy Amon Carter Museum of American Art, Fort Worth. The portrait probably was made from the painting of Austin that was used on the Republic of Texas $50 note.

FIGURE 5.50 Unknown artist, *Stephen F. Austin*, n.d. Oil on canvas, 22 × 29 in. Courtesy Texas State Library and Archives Commission. 1977/166.

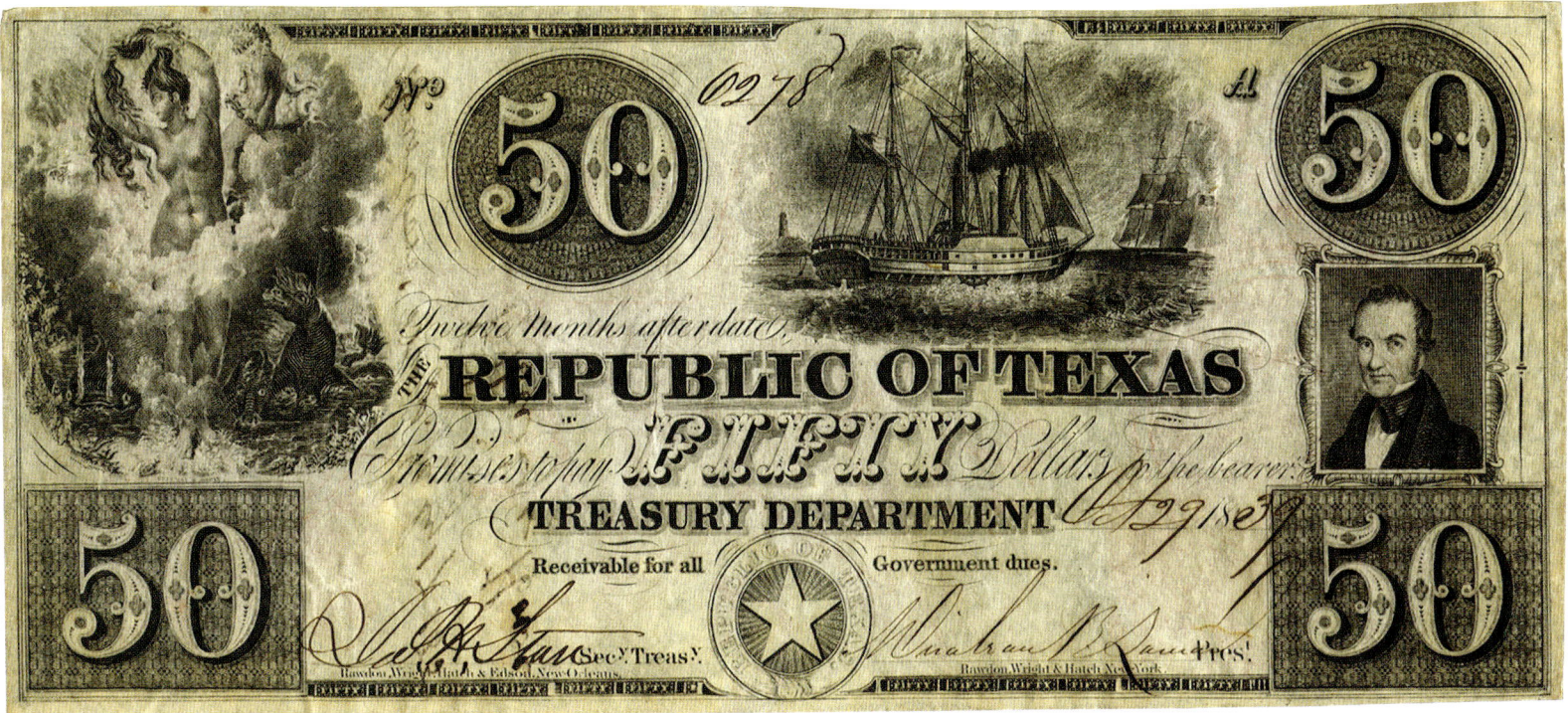

(ABOVE) FIGURE 5.51 "Republic of Texas Fifty Dollars," with portrait of Stephen F. Austin in right margin. Single sheet. Engraving, 7.25 × 3.1 in., by Rowdon, Wright, Hatch & Edson, New Orleans. Issued in 1839 and signed by James H. Starr, Treasurer, and Mirabeau B. Lamar, President, October 29, 1839. Courtesy Heritage Auctions.

(RIGHT) FIGURE 5.52 Konrad Huber after Mathew Brady daguerreotype, *Thomas J. Rusk*, 1855. Lithograph, 8.8 × 8 cm (image), 13 × 8 cm (comp.). From Yoakum, *History of Texas*, vol. 2, opp. 156. Courtesy Amon Carter Museum of American Art, Fort Worth.

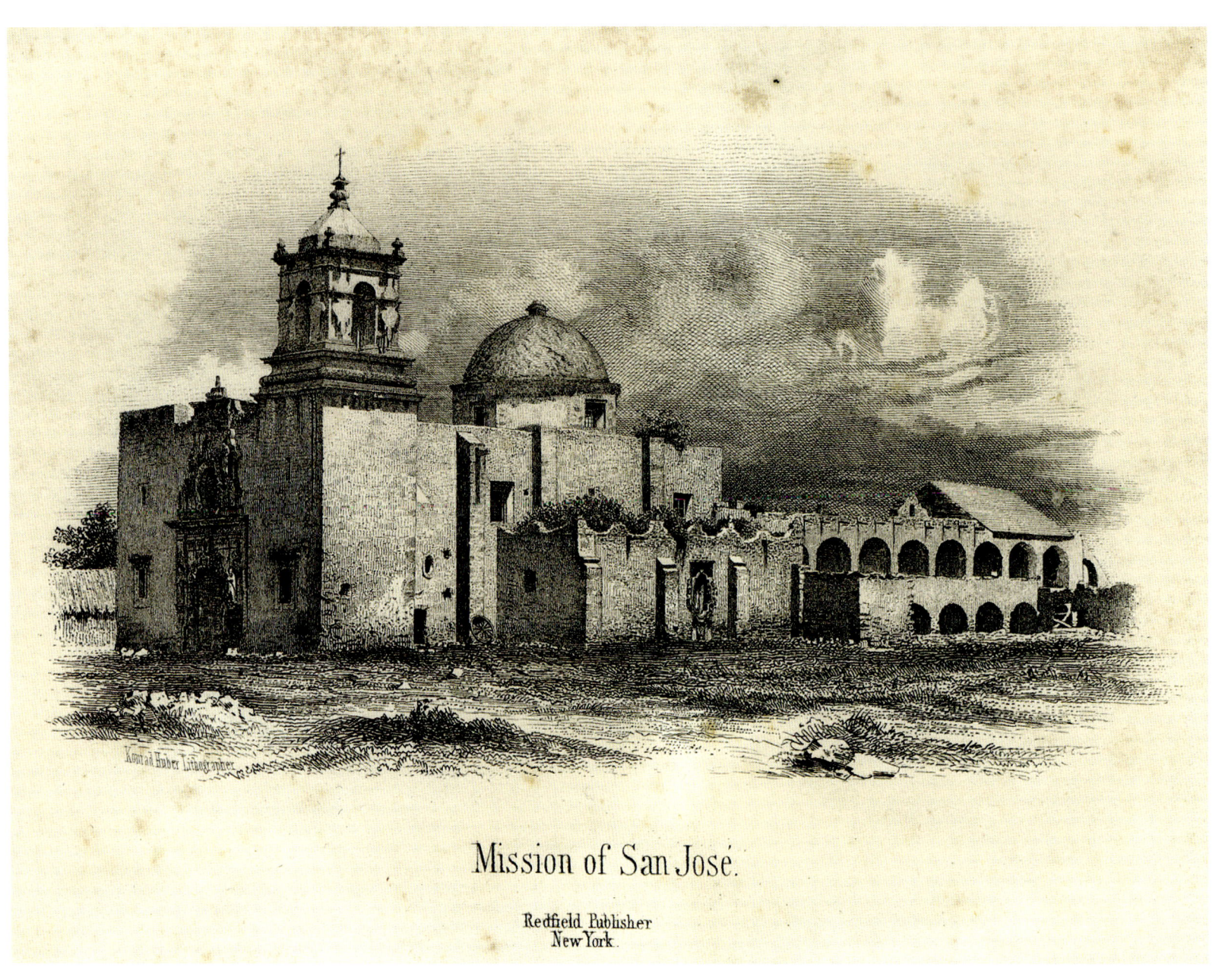

FIGURE 5.53 Konrad Huber after unknown artist, *Mission of San José*, 1855. Lithograph, 3.63 × 4.87 in., by Redfield Publisher, New York. Courtesy private collection.

FIGURE 5.54 Unknown artist, *Col. Thos. Wm. Ward U.S. Consul at Panama*, 1853. Single sheet. Lithograph, 4.94 × 4 in. (image), 7 × 4 in. (comp.). Courtesy Briscoe Center for American History, UT Austin.

THE TEXAS ROSE

Although botanists such as Berlandier, Thomas Drummond, Charles Wright, George Engelmann, Ferdinand Lindheimer, and members of the various government surveys had been sending Texas plants to naturalists in the United States, Britain, and Europe for years—and many of Drummond's specimens had been published as hand-colored engravings in *Curtis's Botanical Magazine*—the first lithographed images of Texas plants did not appear until Louis Van Houtte's monumental, twenty-three-volume *Flore des Serres de des Jardins de l'Europe* (Flora of greenhouses and gardens of Europe) (1845–1880).[105] Van Houtte was a Belgian horticulturist who had explored in Brazil and served as director of the Brussels Botanical Garden before starting his own nursery in 1839. In 1845 he began what turned out to be twenty-three volumes done in three different series: ten volumes from 1845 to 1855, five volumes from 1856 to 1865, and eight volumes from 1865 to 1880, the last of which were continued by associates after his death in 1876. He owned a huge garden and cultivated the plants that appeared in his journal, which also served as a catalogue of his offerings.[106] At a time when many botanical magazines were struggling to survive, he gathered his plants and information from any source available and was not always scrupulous about crediting others with their work, leading Lovell Reeve, editor of the *Botanical Magazine*, to complain to him:

> Not only do you copy the plates in exact detail but you publish them in a dishonest manner and falsify the date. We observe that our beautiful and valuable plate of the Musa Ensete published for the first time in the *Botanical Magazine* of 1 January 1861 appears in facsimile in your *Flore des Serres* dated 1859! Can anything be more dishonest! What can be the object of it except to make the public believe that *yours* is the *original* figure and *ours* a copy.[107]

Van Houtte had been copying at least since 1851, when Walter Hood Fitch illustrated the beautiful *Penstemon wrightii* in the *Botanical Magazine* as a hand-colored engraving.[108] A near copy appeared that same year in Van Houtte's journal. Whatever his ethics, Van Houtte set a high standard for illustrating the plants as hand-colored lithographs, and he beautifully illustrated a number of them from Texas, including the *Pentstemon wrightii*, sometimes called the Texas rose (fig. 5.55).

Following statehood, Texas hosted many more travelers and artists, who often commemorated their visits, and illustrated their books, with prints of eyewitness images—Galveston, Indianola, Matagorda, New Braunfels, Fredericksburg, San Antonio, Round Top, Austin—that conveyed visions of utopia, and portraits of famous men. Coupled with the pictures that the surveyors and explorers produced at the same time, perhaps an image of the state was coming into focus for those who were looking, including a bustling seacoast and a cultured populace. The latter were a minority, of course, but they were building communities, churches, a federal custom house, a new capitol building, Sachtleben's Music Hall, the San Antonio Casino, and a singing club. And fast-growing villages such as Austin, New Braunfels, and Fredericksburg pushed settlement farther west, encouraged by the Gray survey, which presaged a southern transcontinental railroad line running through Texas.

Lithography was another symbol of that sophistication, and it came to Texas in the same manner as it had come to the eastern United States: amid large-scale European immigration and the associated transfer of technology. But one should sympathize with the indomitable Wilhelm Thielepape in San Antonio, struggling with a lithographic manual in hand and a used and decrepit press to work with, virtually, as Douai wrote, reinventing the process. He managed to produce several memorable prints before moving on to the even newer field of photography that he and Iwonski called homeography. None of these images suggested that civil war lay in the immediate future, and it would be several more years before a successful lithograph press would be established in Texas.

FIGURE 5.55 Louis Van Houtte, *Pentstemon wrightii*, 1851. Hand-colored lithograph, octavo, by Severeyns, Stroobant, and De Pannemaker. From Charles Lemaire, Michael Joseph François Scheidweller, and Louis Van Houtte, *Flore des Serres et des Jardins de l'Europe* (1845–1880), vol. 7, plate 685, between 110–111. Courtesy Missouri Botanical Garden, Peter H. Raven Library, St. Louis.

FIGURE 6.1 J. B. Elliott, *Scott's Great Snake*, 1861. Single sheet. Hand-colored lithograph, 35 × 44 cm. Courtesy Geography and Map Division, Library of Congress. Northerners grew restless at early Southern victories, but Scott's "Anaconda Plan" succeeded when Vicksburg fell in July 1863, and Federal forces were soon in control of the Mississippi River.

CHAPTER 6

"THE DARK CORNER OF THE CONFEDERACY"

CIVIL WAR AND RECONSTRUCTION IN TEXAS

As it became apparent that most Southern states would secede from the Union, a former Texas Ranger and sometime artist and gunsmith predicted in 1860 that Texas would lead the secession parade. To deliver his timely message, John J. "Coho" Smith, one of the genuine characters in Texas history, teamed with a French lithographer who in the 1850s had immigrated via New York City to the La Réunion colony west of Dallas.

Smith was born in 1826 to a Dutch family in Pennsylvania. When his father died, he was apprenticed to a cabinetmaker so he could learn English. He arrived in the Dallas area in the early 1840s, in time to assist city founder John Neely Bryan in laying out the original township with surveying instruments that he had made himself. His varied career in Texas and Mexico—merchant, freighter, carpenter, gunsmith, teacher—led him to learn Spanish, German, Comanche, and some French; later he would be one of the persons who talked with former Comanche captive Cynthia Ann Parker after she had been recaptured and returned against her will to her Anglo family.[1]

The lithographer, Joseph Paul Henry (née Henri) of La Réunion, had brought his lithographic press with him from Châtellerault, France, in 1855.[2] He had paused in his migration to work for Endicott & Co. in New York before continuing to Texas; then, after relocating to Lancaster, he became well known for his engraving skills on both metal and ivory. Henry had to put lithography aside while he tried to earn a living for his growing family on the thin and rocky soil in Victor Considerant's poorly organized socialist colony, but he still listed himself as a lithographer in the 1860 census of Dallas County. That year some examples of his work reached the desk of Charles R. Pryor, editor of the *Dallas Herald*. "We have seen some specimens of fine lithography done at Reunion, by Mr. Paul Henry," Pryor wrote in 1860.[3] Unfortunately, none are known to have survived.

By 1860 Coho Smith was back in Dallas, where he produced a cartoon showing a flock of sheep, each one representing a Southern state, in a large rail pen, which Henry lithographed and a *Dallas Herald* reporter described:

> Texas has already jumped over the fence, and South Carolina following suit, and the whole of the others representing the Southern States, are anxious to follow. In the distance is seen Abe Lincoln, with his maul and wedges, exclaiming "Just as I expected." Another figure represents H[enry]. Ward

245

Beecher, who, with Edward Everett, is making tracks for a ship about to sail for England. In the foreground is a representation of Plymouth Rock, behind which crowds the British Lion, and Louis Napoleon is seen concealed behind a bank of earth, taking deliberate aim at the Lion with a rifle.

George W. Baird sold the lithograph, titled the *Disunion Stampede*, in his store on Jefferson Street in Dallas. A Texas friend sent a copy to the editor of Georgia's *Macon Telegraph*, who noted that Smith had predicted that the "great *Ram of Texas*" would be the first to jump the "*Union Fence*." It was announced as one of a series of "unique designs" called "Cohographs" after the artist's nickname, but no others are known to have been printed.[4]

Texas did, of course, secede from the Union and was the fourth state to join the Confederacy, after Alabama, Georgia, and Louisiana. While some residents, such as Governor Houston, refused to swear allegiance to the Confederacy, and others, such as Congressman John H. Reagan, opposed secession but loyally served the Confederacy, most Texans entered the war enthusiastically. On February 1, 1861, the state convention passed the secession ordinance by a vote of 168 to 8, and three weeks later the state's predominantly Southern character became evident as the decision was heartily endorsed by a popular vote of 46,129 to 14,698.[5]

Immediately after the South Carolina militia fired on Fort Sumpter in April 1861, Lincoln declared a blockade of the ports of the seceded states. The following month Gen. Winfield Scott, hero of the war with Mexico and commander of the Union army, proposed adding a huge offensive down the Mississippi River.[6] Critics referred to this strategy as the Anaconda Plan, because the goal was to divide the South, then slowly strangle it, just as the anaconda crushes its prey. Cincinnati publisher J. B. Elliott effectively caricatured the plan as a giant snake encompassing the Southern states with its head in Missouri near the Mississippi River (fig. 6.1). He personified Texas as a slave owner shooting runaway slaves, which he described as "Costly Shooting $1000.00 a Head."

Conditions in Civil War Texas did not permit artists or printers to flourish, for the state shipped most of its manpower and material eastward to the main theater of conflict, while those who remained at home felt the "hard pinch" of the "Lincoln blockade." Several wood engravings of the state appeared in *Harper's Weekly* and *Leslie's Illustrated*, both published in New York City, but printers produced few lithographs *of* Texas and none *in* Texas (so far as we know) during the war. And as the Union navy tightened its grip on Texas ports, essentials such as newsprint became so scarce that some of the state's newspapers had to cancel publication while others resorted to printing small editions and smaller formats on various kinds of scrap paper.[7]

"THE APPREHENSION OF A BLOCKADE"[8]

The first blockading vessels arrived off the coast of Galveston in June 1861, as John Bachmann illustrated in a series of lithographs entitled *Panorama of the Seat of War*, depicting the US coastline from New England to Mexico (fig. 6.2). Bachmann was an established New York lithographic artist and printer who produced more than fifty city views between 1849 and 1885. Born in Switzerland in 1815, he learned lithography in Paris and emigrated to the United States in the 1840s. He first appears in New York City documents in 1849. His distinctive style, employed in this print, was to picture his subjects from an imaginary perspective high in the sky, which he described as "drawn from nature," a specious claim since he had no way of viewing the coastline from such a perspective. He was one of the first artists to popularize the term "bird's-eye view" to describe the technique.[9]

When laid side to side, the seven views in his series constitute a ten- to twelve-foot-long view of the US coastline, which the editor of the *Daily Evening Bulletin* in San Francisco termed "an interesting and instructive study." In a sense, Bachman was illustrating the news of the day; within a month of the battle of Bull Run, the Philadelphia *Press* reported that "with the aid of this Map, which is colored, has the scene of the Battle of Bull Run prominently marked, and represents the whole Seat of War as if it were in *alto relievo*, any one can follow the fortunes of our brave troops." The seventh part in the series, *Birds Eye View of Texas and Part of Mexico*, is a fascinating representation of the state at mid-century, clearly identifying all of the major Texas cities, rivers, roads, and ports and suggesting the terrain. An ad in Virginia's *Richmond Examiner* notes that it "seems to present an accurate view of the whole region embraced," probably a reasonable claim at the time, but the rivers seem much more prominent in his print than in reality, an acknowledgment of their importance in the mid-nineteenth century, a time when few roads existed and Texans were still hoping that the rivers, which were virtually uncrossable during the rainy season, would prove to

FIGURE 6.2 John Bachmann, *Panorama of the Seat of War. Birds Eye View of Texas and Part of Mexico*, 1861. Single sheet. Toned lithograph, 47 × 71.5 cm (image), 57.2 × 71.5 cm (comp.), published by John Bachmann, 115 & 117 Nassau St., New York. Courtesy Amon Carter Museum of American Art, Fort Worth. Part seven of a series of seven.

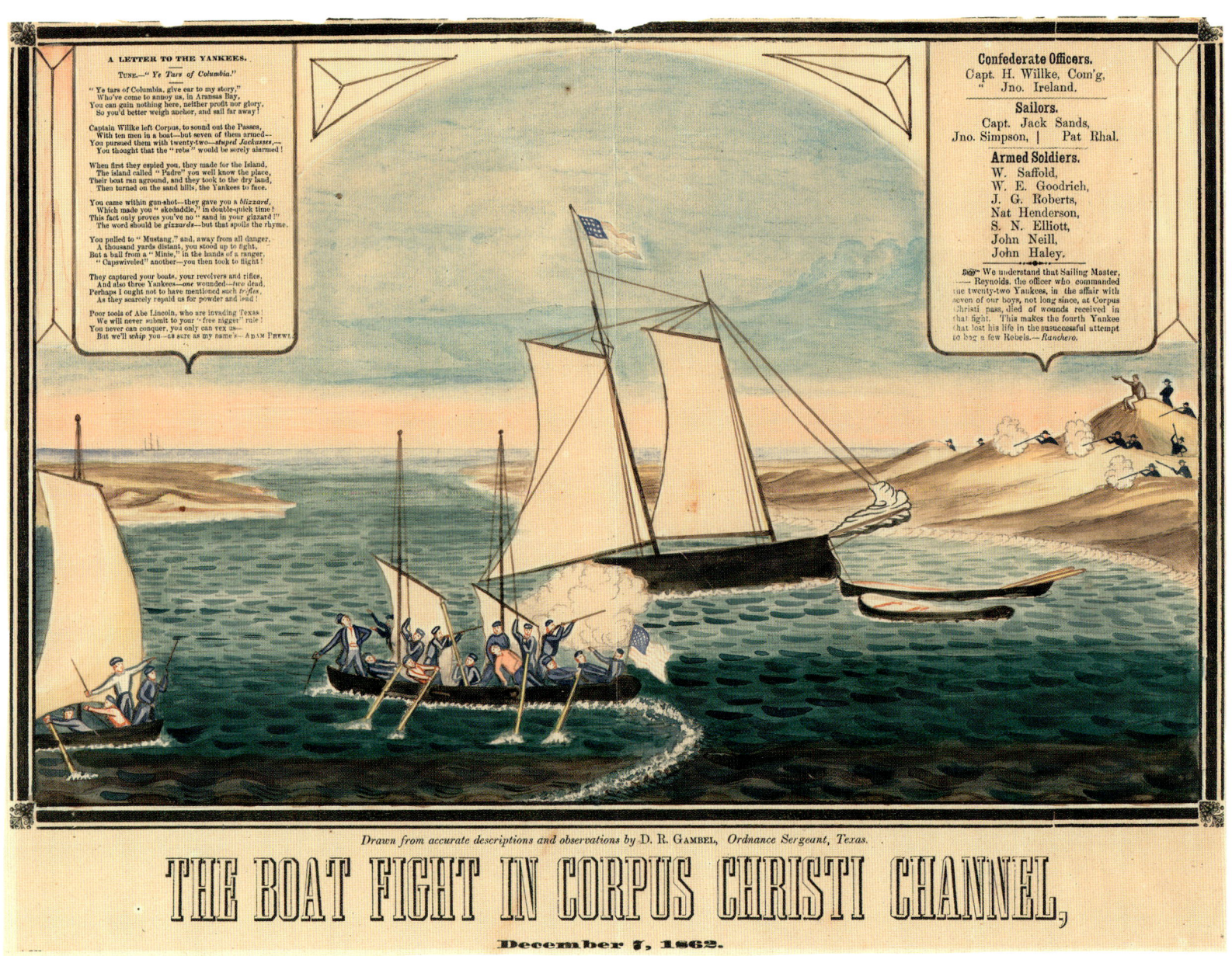

FIGURE 6.3 David R. Gambel, *The Boat Fight in Corpus Christi Channel, December 7, 1862*, c. 1863. Watercolor with letterpress, 11.5 × 15.5 in. (sight). Courtesy Jim Molony, Corpus Christi. Gambel depicts the abandoned Confederate boat in the center while the Confederate troops fire on the approaching Union launches from behind Padre Island sand dunes.

be navigable. There are a few mistakes—Bachmann located "Austin City" on the Guadalupe River rather than the Colorado—but the images of Union ships lurking along the coast quickly make the federal blockade strategy apparent.[10] Since Galveston was "now entirely cut off" from the New Orleans newspapers, the editor of the *Galveston Weekly News* suggested to news-hungry Texans that this would be a good time to subscribe to the *News*.[11] Bachmann reprinted the pictures several times.

As the main port and business center of the state, Galveston is prominent, but exposed, in Bachmann's composition, which illustrates why Gen. Paul O. Hébert, the Confederate commander of the Department of Texas, felt that the state's coastal defenses were inadequate and the city indefensible. He prepared by placing small forts on the eastern end of the island and at Bolivar and on Pelican Spit, but the blockade brought the war home to the city in unexpected ways. The *News* immediately reported a shortage of butter from New Orleans, and when the USS *South Carolina* captured eleven would-be blockade runners in five days, people began to flee to the mainland. "Such a moving as there is now a going on here, you never have seen in all your life," one observer wrote. As the blockaders moved into the harbor to take the city, Hébert called for a truce and ordered an evacuation. "For months it [has] been a foregone conclusion not to defend the place," William Pitt Ballinger, a prominent Galveston attorney and Confederate supply agent, wrote in his diary. "I feel deeply grieved and humiliated—and much of my pride and interest in the place gone."[12] Among the refugees to Houston was Miles Strickland, a young Canadian who had acquired a small bindery in 1858 and was in the process of turning it into a successful business, perhaps even to include lithography.

Tightening the blockade, the Union navy conducted raids on Sabine City and Port Lavaca, and, in August 1862, Acting Vol. Lt. John W. Kittredge ordered a strike on Corpus Christi, where David R. Gambel, a thirty-seven-year-old Confederate ordnance sergeant, was momentarily relieved of his regular duties so he could paint a picture of the action while it was in progress, although his easel was knocked down when a shell landed nearby. The poorly armed Confederates prevented the Union landing party from coming ashore, but the federal navy maintained its blockade of the port. Four months later Gambel depicted another minor skirmish when two launches loaded with twenty-two "abolitionists," as the editor of the *Corpus Christi Ranchero* called them, attacked a party of seven Confederates attempting to sound the bars of Corpus Christi Pass (fig. 6.3). The Texans quickly took refuge behind Padre Island sand dunes and held off the Union troops, killing two and taking a wounded prisoner who had been abandoned in a captured launch. Gambel does not claim to have witnessed this event, but he produced a painting in the format of a lithograph with the title *The Boat Fight in Corpus Christi Channel, December 7, 1862*, which he claimed was painted from "accurate descriptions and observations." In the upper left corner of the watercolor, he includes letterpress lyrics for "A Letter to the Yankees" by Adam Phewl, to be sung to the tune of "Ye Tars of Columbia"; in the right-hand corner, again in letterpress, he listed the names of the Confederate soldiers who were involved in the skirmish.[13] Gamel also had the title and other information printed at the bottom of the painting, mimicking a popular lithographic format.

Meanwhile, Maj. Gen. John Bankhead Magruder had replaced Hébert as department commander, and his decision to retake Galveston resulted in an extraordinary drawing of the harbor. The Union forces had not destroyed the railroad bridge connecting the island to the mainland, and on the night of New Year's Eve 1863, Confederate forces pushing a flatcar loaded with an eight-inch cannon crossed onto the island. They were supported by two "cotton-clad" steamers, the *Bayou City* and the *Neptune*, which attacked the five Union ships anchored in the harbor and captured the USS *Harriet Lane*. The USS *Westfield* ran aground and was blown up, and the other three headed out to sea. George W. Grover, the acting mayor of the city, witnessed the events and produced a detailed pencil-and-ink drawing that he might have intended to be lithographed (fig. 6.4). He shows the *Harriet Lane* at the left center, listing because it had been rammed by the *Bayou City*. The sunken *Neptune* is at the left, and at the right are the USS *Owasco* and the *Westfield*, whose captain died while blowing up his own ship to save it from capture. The careful labeling and captioning in the usual lithographic format suggest that Grover hoped that his drawing would be printed.[14]

Ten days later the blockading fleet suffered another blow when one of the most famous ships of the Civil War, the CSS *Alabama*, which during its brief two-year career destroyed more than sixty Union ships, sank the USS *Hatteras* about twenty miles south of Galveston. John Laird Sons and Co. in England had built the ship in secrecy for the Confederacy in 1862, and it sailed with a British crew before it could be impounded. Perhaps the closest it came to a Southern port was this encounter off the coast of Galveston. The *Hatteras* had captured a number of blockade runners, but Capt.

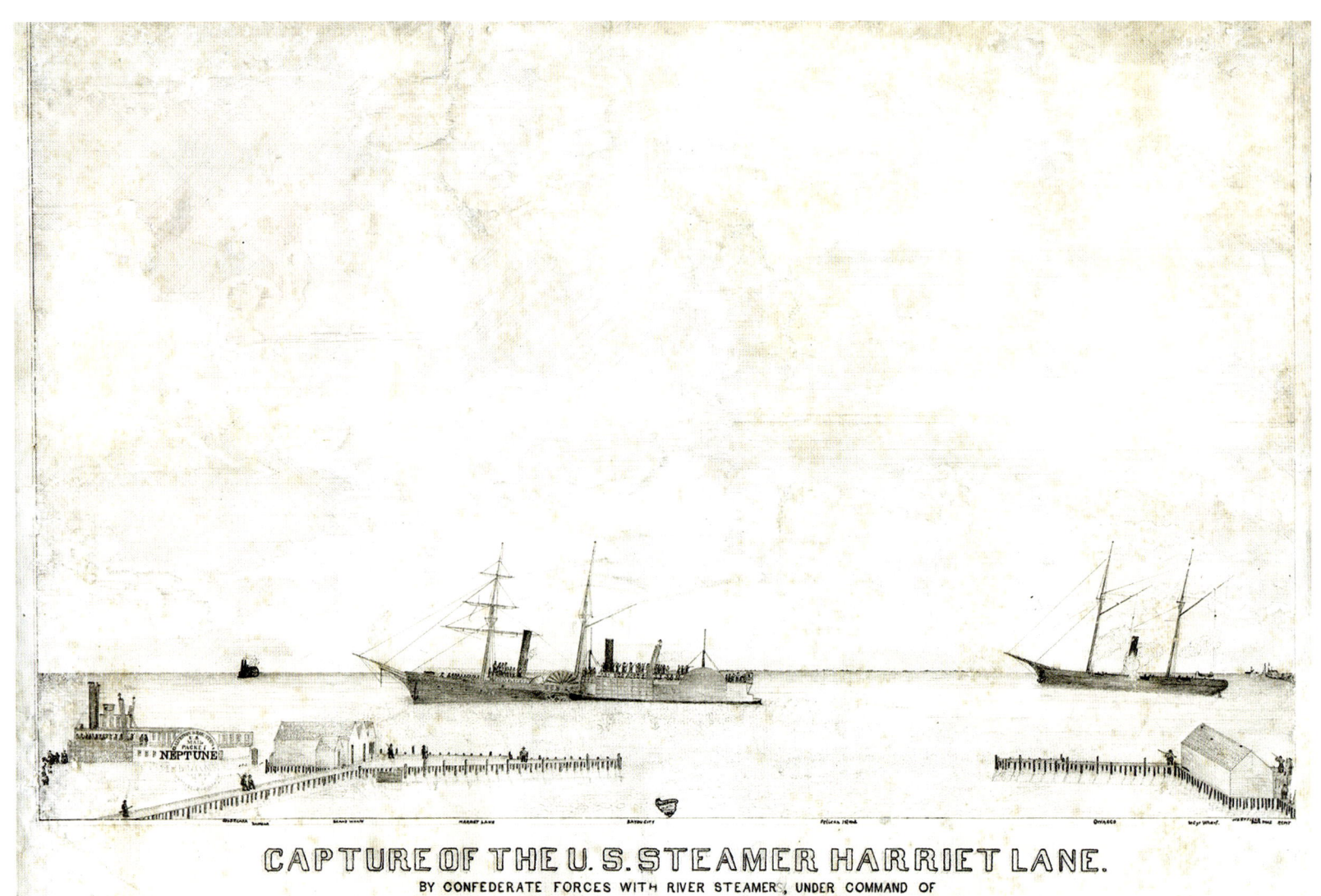

FIGURE 6.4 George W. Grover, *Capture of the U.S. Steamer Harriet Lane. By Confederate Forces with River Steamer[s], under Command of Major General J. Bankhead Magruder Galveston Harbour Texas; Morning of January 1st, 1863*, 1863. Graphite and ink on paper, 25 × 17.5 in. Courtesy Rosenberg Library Museum Collection, Galveston.

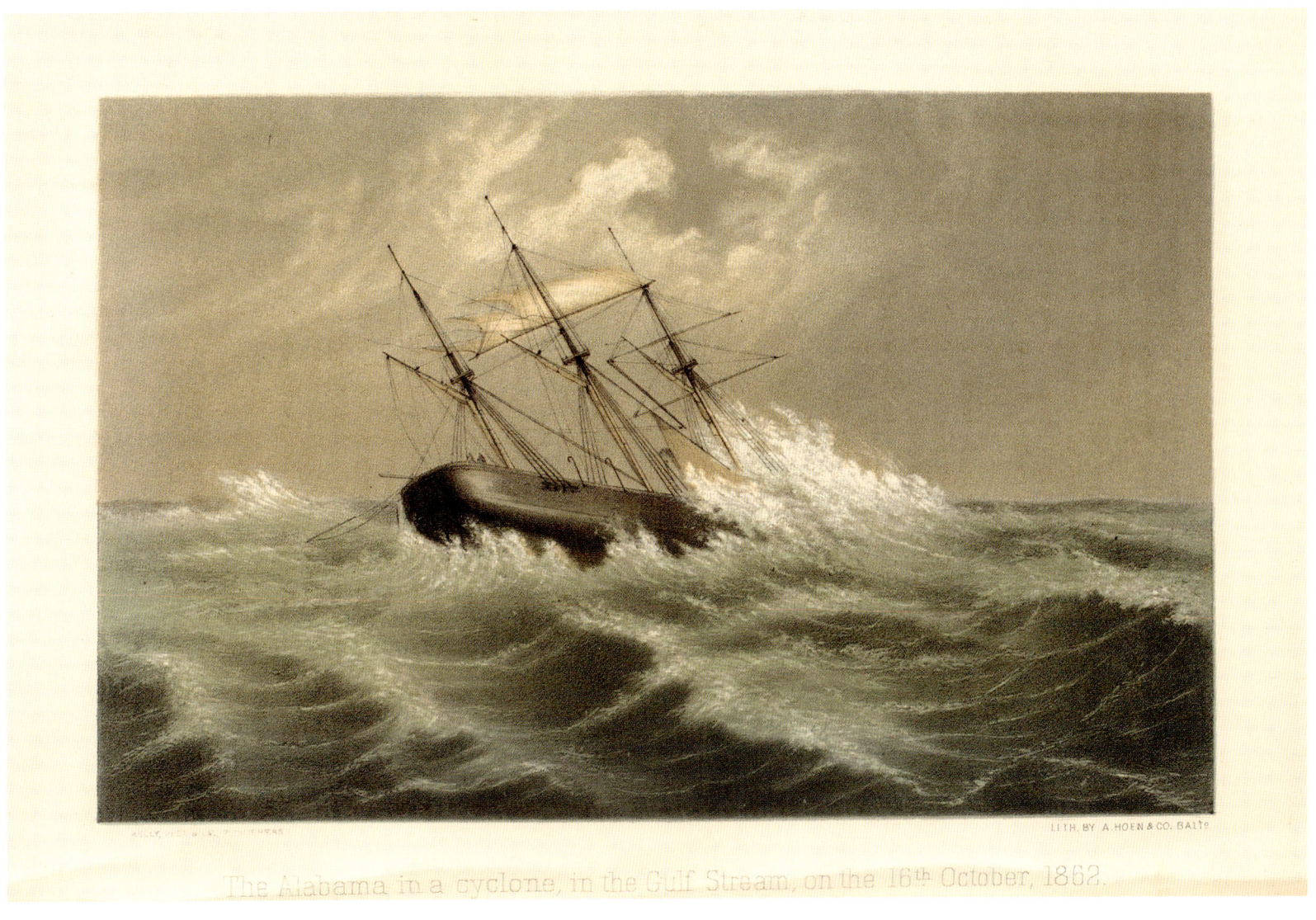

FIGURE 6.5 Unknown artist, *The Alabama in a Cyclone in the Gulf Stream on the 16th October 1862*, 1869. Chromolithograph, 25 cm (book), by A. Hoen & Co., Baltimore. From Raphael Semmes, *Memoirs of Service Afloat* (1869), opp. 464. Courtesy William L. Clements Library, University of Michigan, Ann Arbor.

Raphael Semmes of the *Alabama* lured it away from the fleet on January 11, 1863, sank it in a short engagement, and escaped into the night. When other Union vessels arrived to assist the *Hatteras*, they saw only the masts and pennant above water and fluttering in the breeze. Today the vessel lies in about sixty feet of water and is one of the few wreck sites listed on the National Register of Historic Places.[15] The *Alabama* finally met its fate in June 1864, when the USS *Kearsarge* trapped it in port at Cherbourg, France, where Semmes had put into dry dock for repairs. The *Kearsarge* sank the Confederate ship as Semmes attempted an escape. Semmes himself was spared when he boarded one of the vessels that came to the *Alabama*'s aid, and he lived to write his memoirs, which the Baltimore firm of Kelly, Piet & Co. published in 1869.[16]

A. Hoen & Co. of Baltimore, the successor to E. Weber & Co., printed handsome chromolithographs of the *Alabama* for Semmes's book, *Memoirs of Service Afloat, During the War between the States*. One shows the vessel in a storm in the Gulf (fig. 6.5). The other illustrates the battle with the *Hatteras*, which sits in the center of

"THE DARK CORNER OF THE CONFEDERACY" | 251

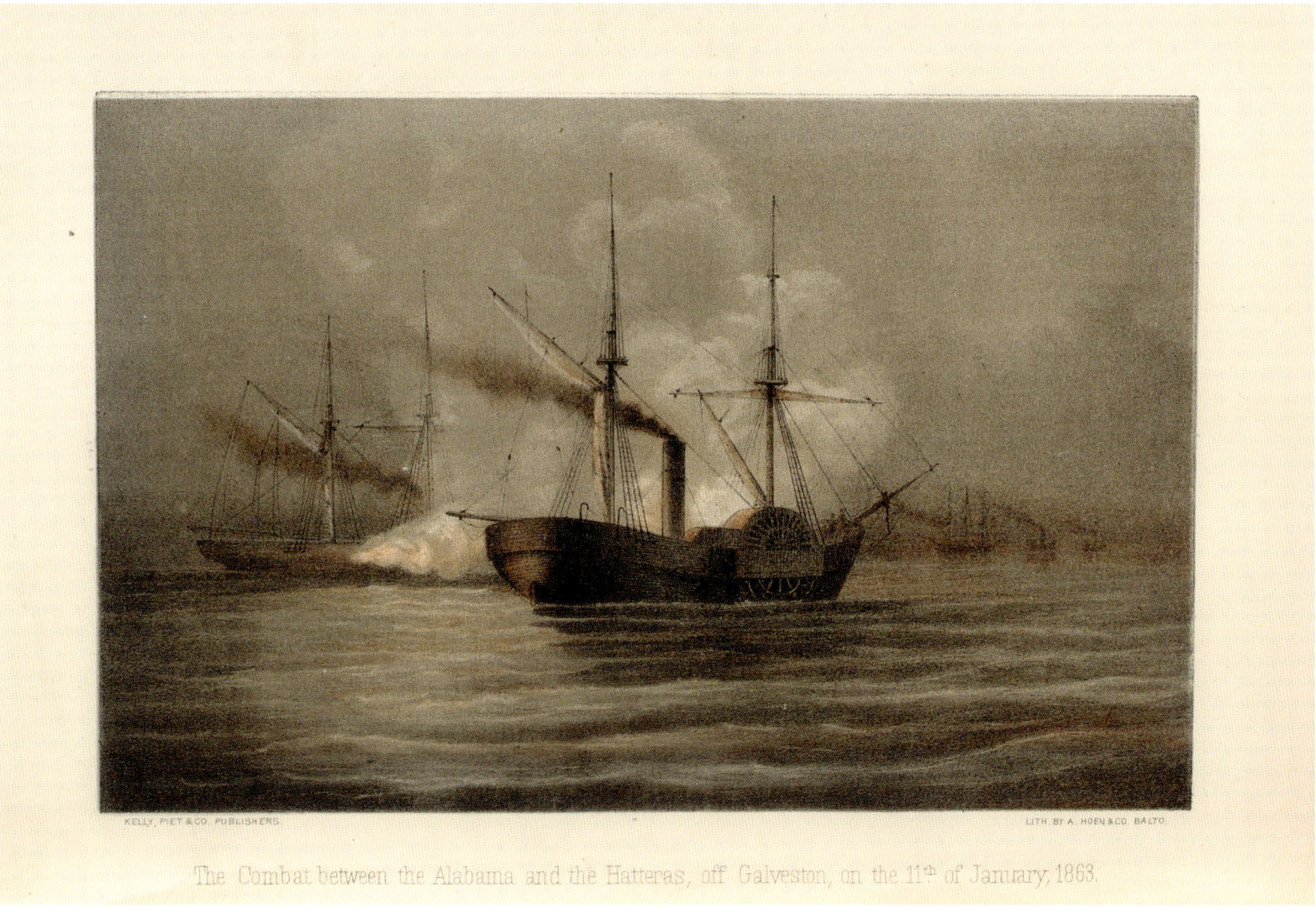

FIGURE 6.6 Unknown artist, *The USS Hatteras in Action with the CSS Alabama, off Galveston, Texas, 11 January 1863*, 1869. Chromolithograph, 25 cm (book), by A. Hoen & Co. From Semmes, *Memoirs of Service Afloat* (1869), opp. 477. Courtesy William L. Clements Library, University of Michigan, Ann Arbor.

the image receiving a broadside from the *Alabama* in the left background (fig. 6.6). Michael J. Kelly and John B. Piet, who owned a large bookstore and publishing house, issued Semmes's book. They were respected in the local business community but apparently harbored Southern sympathies, for the Union provost marshal had arrested them in May 1864 for publishing and selling a large variety of pro-Confederate books, envelopes emblazoned with the Rebel flag, cards bearing portraits of Southern officers, Southern ballads and songs, and even "contraband kindergarten contents."[17]

THE OLD FLAG

Texas harbored pockets of Unionist sentiment in the northern counties, in the German villages, and in deep South Texas, and several other lithographs, published during the war or shortly after it ended, are the products of Texas Unionists and of Union prisoners confined at Camp Ford near Tyler.[18] When Union Leagues (or Loyal Union Leagues) were formed in the north to support President Lincoln's policies, secret groups formed in the German settlements and in

deep South Texas. Little is known of the Loyal National League of Brownsville, but one of the members happened also to be a talented calligrapher and capable lithographer who produced an elegant document certifying that he was a member of the Loyal National League. Leopold Schlinger, a storekeeper in Brownsville who had moved to Matamoros during the war, had received formal training in calligraphy, and probably lithography, at the Normal School of Vienna before immigrating to Texas (fig. 6.7). In May 1864 he marked his membership in the Loyal National League with an intricately drawn certificate, signed by fellow Unionists F. F. Fenn, president, and G. A. Staacke, secretary (fig. 6.8).[19] It is one of the few documents of what was then a secret organization. Schlinger

FIGURE 6.7 Leopold Schlinger, *Preserving Industry Leads to the Desired Point*, 1860s. Single sheet. Lithograph, 12 × 20 in., by Leopold Schlinger. Courtesy Leopold Schlinger Family Papers, 1833–1877, Briscoe Center for American History, UT Austin.

FIGURE 6.8 Leopold Schlinger, "This Certifies," 1864. Single sheet. Lithograph, 11 × 17 in., by Leopold Schlinger. Courtesy Leopold Schlinger Family Papers, 1833–1877, Briscoe Center for American History, UT Austin.

"THE DARK CORNER OF THE CONFEDERACY" | 253

FIGURE 6.9 Louis de Planque, Col. John Salmon Ford, Brownsville, Texas, c. 1865. Photograph, 10 × 6 cm. Courtesy Lawrence T. Jones III Texas Photography Collection, DeGolyer Library, Southern Methodist University.

served as a member of the Brownsville City Council and as city treasurer before moving to Austin, where he opened a grocery store on Congress Avenue.[20]

After the war, Union soldiers who had been held prisoner at Camp Ford in Tyler, one of three Confederate prison camps in Texas (along with Camp Verde in Kerr County and Camp Groce near Hempstead), produced two unusual lithographs related to wartime Texas. Camp Ford began as a conscript camp named for Rip Ford, Superintendent of Conscripts, who established a branch office in Tyler in 1862. Camp Ford received its first prisoners in July 1863 and operated until the close of the war in 1865 (fig. 6.9). It was the largest Confederate prison camp in the Trans-Mississippi Department, incarcerating between 4,500 and 4,600 Union prisoners at its peak in 1864.[21]

Cpl. James S. McClain of Company F, 120th Ohio, who was captured May 3, 1864, and was in the final group of prisoners to leave on May 19, 1865, sketched various aspects of camp life during his imprisonment, and Krebs & Bro. Lithographers in Pittsburgh incorporated a number of his images into a large view probably sometime between 1865, when McClain got out of Camp Ford, and 1870, when the Krebs & Bro. establishment changed its name (fig. 6.10).[22] McClain provides both south and west views of the camp. Three smaller vignettes across the top show the Confederate hospital; the headquarters of camp commander Col. Ruben R. Brown, 35th Texas Cavalry; and the cabin of Capt. Elias Fraunfelter (misspelled on the print as Braunfelter), Company F, 120th Ohio. The stockade was about eighteen feet high, although the lithographer makes it appear that it was only about five feet high. (The guards seem to be a head taller.)[23] On the west side was the main gate, about ten feet wide and hung from heavy, wrought-iron hinges and secured by a wooden bar outside the stockade. The guards' houses and cabins were located just outside the gate. A local resident later recalled that the "general shape of the enclosure" was "an 'irregular square' with a deep ravine along the west side." A spring ran through the southwestern corner of the stockade, supplying water for the entire camp, and there was an open plain to the north, cultivated lands to the east, and wooded hills on the west where the Confederate cavalry and conscripts' camp was located. McClain sketched the hospital that the Confederates permitted the prisoners to build about four hundred yards away from the stockade on the road to Tyler. It initially consisted of a single room, forty-eight feet long by eighteen feet wide, but it was expanded as the prisoners added another room, thirty-six feet long by eight feet wide, then, finally, a "brush

FIGURE 6.10 James S. McClain, *Camp Ford Texas*, c. 1865. Toned lithograph, 18 × 25 in., by Krebs & Bro., Pittsburg. Courtesy Smith County Historical Society, Tyler, Texas.

arbor type shelter" in the summer of 1864, when the crowded conditions were at their worst.[24]

The structures inside the stockade depended on the ingenuity of the prisoners, for the Confederates supplied no shelter. The first prisoners cut down the trees in the compound. Then the guards permitted them to organize parties to go outside the camp to find timber, and McClain shows the nearby hills studded with tree stumps. Construction slowed considerably as the number of prisoners grew, increasing the demand on the few tools available. Nevertheless, the "shebangs," as the prisoners called their rude structures, took shape over a period of months and eventually melded into a "street of log huts." One prisoner recalled that each street was "a small community, every doorway shaded by a broad veranda, thick with evergreens.... Here upright sticks sustain a simple thatch of leaves; there poles fixed slantwise, and overlaid with bark, compose an Indian lodge."[25]

It was in these distinct communities that the prisoners gathered to share Col. A. J. H. Duganne's and Capt. William H. May's hand-lettered newspaper (fig. 6.11). To relieve the monotony of camp life,

FIGURE 6.11 William H. May, *The Old Flag, March 13, 1864*, 1865. Front page of hand-lettered newspaper. Lithograph, 11 x 8.5 in., in J. P. Robens, *The Old Flag* (1865). Courtesy Pearce Museum, Navarro College, Corsicana, TX.

May and Duganne, who was a well-known poet, began editing a camp newspaper in February 1864. May hand-lettered the publication, called *The Old Flag*, with a steel pen using both sides of a sheet of paper that was then folded to make four pages. Duganne later memorialized his experiences: "I must not forget our newspaper," he wrote in *Camps and Prisons*, "not press-printed, but written in minute and legible Roman letters by that general genius, Captain May, who draws with pencil, as with fiddle-bow, to excellent conceit. 'The Old Flag' is a popular sheet, the organ of American opinion at Camp Ford. Its advertising columns show the thrift and progress of this loyal city in extreme Secessia." May and Duganne discussed local news and issues, poetry, art, and chess problems, and they also included advertisements, many of which were legitimate: for camp pipe-makers, barbers, cigar makers, shoe blacks, and "job printing" (by the publisher). As publisher, May sold the single issue of the four-page newspaper to one of the other prisoners—the "subscriber"—for five dollars in gold, who read it and passed it on to his mess-mates and then sold it to another prisoner until it had finally circulated through the entire camp and was returned to May. He produced three issues of the newspaper and, perhaps, one issue of another hand-lettered newspaper titled *Ford City Herald* before he and Duganne were exchanged and the camp destroyed.[26]

In preparation for his exchange, Captain May had sewn the three copies of *The Old Flag* under the epaulets of his uniform and in that way smuggled them out. Reaching New York later that year, he, Duganne, and J. P. Robens (a New York publisher and fellow Camp Ford inmate), had the newspapers lithographed and sent to every man who had been imprisoned at Camp Ford. A portion of the right-hand column is missing in the first issue because, as he explained, "this page got wet and tore off in taking it from under my shoulder straps." The *Boston Daily Advertiser* called the "lithographic *fac-simile* . . . a curious relic of the rebellion, and amusing as well as valuable."[27] The editor of the *Anamosa Eurika* (Iowa) was more expressive:

> Having no command of type or press, they resorted to the all-potent pen. . . . The writing nearly resembles print and the embellishments, also drawn with the pen. . . . The whole affair is very creditable and shows the hand of one who had previously made himself familiar with the use of pen, paste-pot and scissors, and was perfectly at home with the shooting stick [a tool used in hand-setting type] before he took up the shooting iron, and enlisted in Uncle Sam's service.[28]

Although as many as twelve to fifteen thousand Texans fought east of the Mississippi, Texas itself proved to be far from the bloodiest action, experiencing only minor skirmishes at Galveston, Sabine Pass, Brownsville, Brazos Santiago, and Laredo. But when the war began, the line of settlement regressed east as federal troops left the West Texas forts. One of the most unusual incidents resulted in an even more uncommon chromolithograph years after the fact.

George B. Erath, a former legislator who served in the Confederate army, recalled that late in 1864 a large group of Kickapoo Indians crossed Red River on their way to Mexico to escape the violence of the Civil War. They were peaceful, traveling with their families and property, and "had talked to the settlers all along their route." But "their entrance into Texas aroused the frontier at once . . . and . . . a small Confederate troop was started after them."[29] The Indians, perhaps as many as fourteen hundred in all, knew that the Texans were approaching, and on January 8, 1865, they took up a defensive position in a dense thicket and live oaks on the south side of Dove Creek, near present-day San Angelo. The well-armed Kickapoos routed the disorganized Texans, who were armed mostly with shotguns and squirrel rifles, and continued their journey.[30] "I would have allowed them to pass had I been there," Erath concluded, "that is if I could have controlled the frontiersmen, always crazed at the sight of Indians, and determined to kill."[31]

About twenty years after the battle, the successors to the well-known Mexican lithographer Victor Debray in Mexico City printed *La Guerra de los Kikapoos* (fig. 6.12).[32] Designed as a board game, the image is an imaginary depiction of what became known as the battle of Dove Creek. The unnamed artist shows the Kickapoos in the foreground; several of them are fording the creek toward the uniformed Confederates on the other side. Instructions for the game are printed in letterpress below the image. Designed for two participants, it is played on a grid of bright red circles connected by red lines. Each player begins with sixteen pieces aligned on the first two numbered lines and must follow the red lines and cannot move backward. Each player also has two commanders, who start on lines three and four and can move in any direction and jump opposing pieces, as in checkers, from which the game was probably derived. The game is over when one player has gotten the last piece in the enemy camp.

It took a while for news of the Confederate surrender in April 1865 to reach Texas. After Col. Rip Ford defeated Union troops in the battle of Palmito Ranch near Brownsville on May 13, the last battle of the war, he learned from captured prisoners that Robert

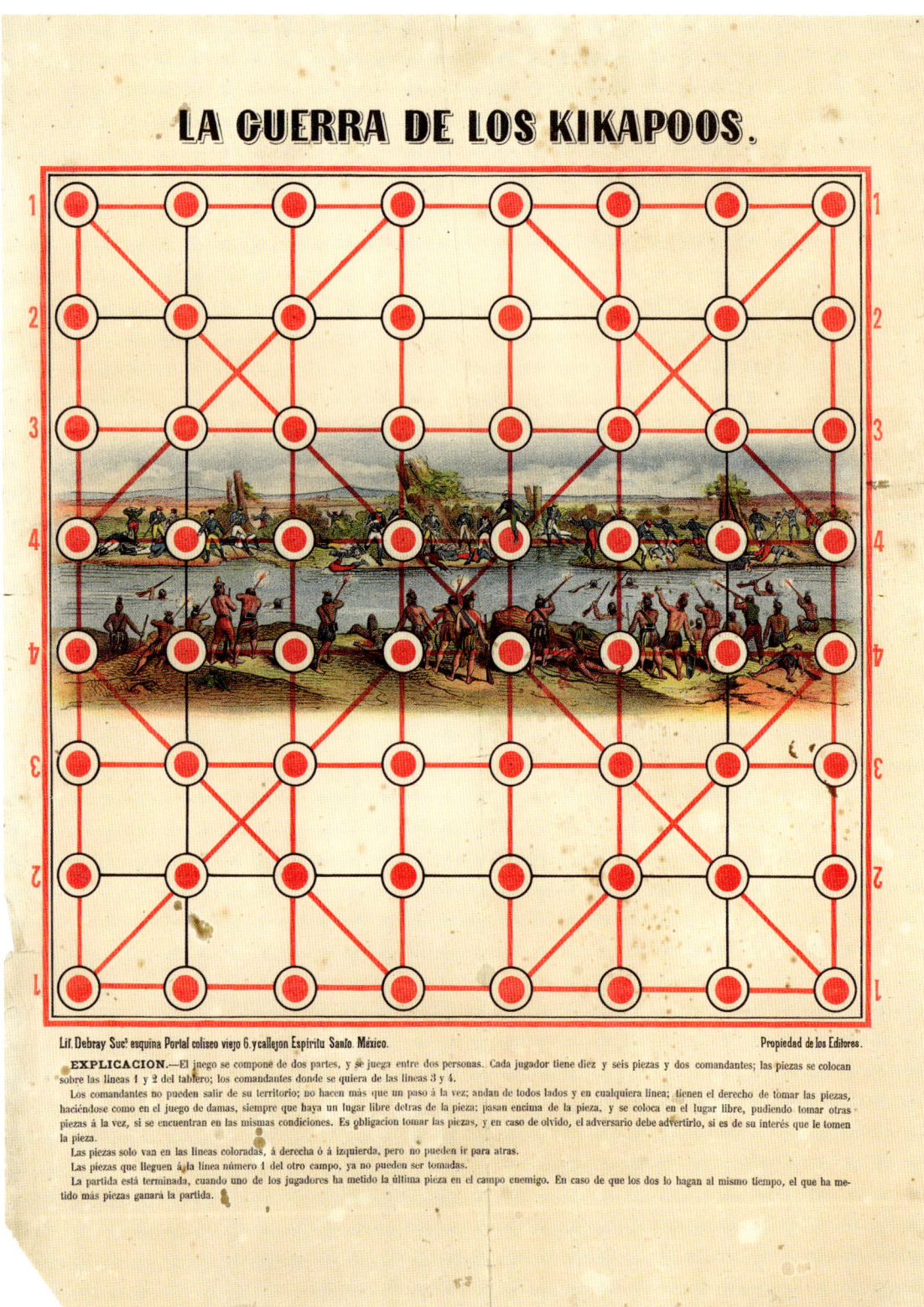

FIGURE 6.12 Unknown artist, *La Guerra de los Kikapoos*, 1880s. Single sheet. Chromolithograph, 29.2 × 29.2 cm (neat line to neat line), 44.6 × 32.8 cm (sheet), by V[ictor] Debray sucesores, Mexico City. Courtesy Dorothy Sloan—Books.

E. Lee had surrendered. Generals Edmund Kirby Smith and John B. Magruder surrendered their commands in Texas on June 2, and Union forces occupied Galveston later that month. On June 19 Union general Gordon Granger issued General Orders No. 3, declaring all slaves to be free.[33]

It was about that time that an unnamed artist produced a lithograph of the village of Bagdad (fig. 6.13), the harbor through which Texas and the Confederacy had, for most of the war, an "unimpeded link to world trade." In 1861 Bagdad was a village of dilapidated fishing huts located on the flat, sandy southern bank of the Rio Grande as it flowed into the Gulf of Mexico, but from 1862 through much of 1865, as the British and French forced the Union to recognize Mexican neutrality, it grew into a "veritable Bable, a Babylon, a whirlpool of business, pleasure, and sin," according to Oblate missionary Pierre Fourrier Parisot. The population reached an estimated 15,000 as the village became the terminus through which merchants, contractors, and Texas and the Confederacy shipped hundreds of thousands of bales of cotton to the New York and London markets. The unnamed artist caught the frenzy of the recently constructed two-story buildings, street activity, and what appear to be dozens of ships just offshore waiting to exchange their cargo for cotton. Melinda Rankin, a Presbyterian missionary to Mexicans, estimated that during her 1863 visit, "it was not infrequently the case that a hundred vessels were lying off the bar" waiting to discharge their goods and load cotton. As the war closed, Bagdad returned to normal. "Almost every shanty, and there are a great many of them, is for sale," a local merchant reported in June 1865. But in that brief time, the cotton trade produced fortunes on both sides of the Rio Grande, including Patricio Milmo, José San Román, Francisco Iturria, and the firm of Richard King, Mifflin Kenedy, and Charles Stillman, among others.[34]

Reconstruction was a shock to many Texans because the state had largely escaped the ravages of war. The Union had not been able to invade the state, and blockade runners and international trade across the Rio Grande had permitted Texas some measure of foreign exchange throughout the conflict. "Texas was never whipped in spirit, only nominally whipped," recalled Thomas North, a northern merchant who turned preacher to avoid the Confederate draft.[35] Texas did, of course, submit to Congressional Reconstruction as a part of the Fifth Military District in 1867. With the Radical Republicans in office in 1870, voters approved the fourteenth and fifteenth amendments to the Constitution, and President Grant signed the formal documents restoring Texas to the Union on March 30.[36] But

FIGURE 6.13 Unknown artist, [Bagdad, Tamaulipas, Mexico], c. 1865. Lithograph, size and publisher unknown. Location unknown.

outlaw gangs still marauded in northeast Texas and the Big Thicket country, harassing and indiscriminately killing Union soldiers and clients and employees of the new Freedman's Bureau. When Bvt. Maj. Gen. Oliver Otis Howard, chief administrator of the bureau, appointed Bvt. Brig. Gen. Edgar M. Gregory as assistant commissioner of the Texas branch, he warned Gregory that Texas was the "post of greatest peril."[37] As Ferdinand Flake, the Unionist editor of *Flake's Bulletin* in Galveston, explained, "The war has educated a class of men into idleness and into a familiarity with deadly weapons, that prompts them to resort to the revolver whenever it suits their drunken vag[a]ries."[38] Thomas North further described them as "a mixed class with very little of the good in the mixture."

> The masses of them wore spurs on their heels, generally the immense wheel-spur, and though they were not born with them on, yet they might as well have been, for they not only rode in them, but walked in them, ate in them, and slept in them. Their clanking as they walked was like a man in chains. They wore belts around the waist, suspending one or two revolvers and a bowie knife; were experts in the saddle, had a reckless dare-*evil* look, and were always ready for whisky and a big chew of tobacco, and the handwriting of passion and appetite was all over them. They were cow-boys from the wild woods and prairies, and sons of the low class planters, with a strong sprinkling of the low white trash, clay-eaters, so plentiful in the Atlantic Southern States.[39]

An unnamed artist and publisher seemed to capture the character of these unrepentant veterans and draft-dodgers, unreconstructed

ruffians who were "never whipped," in *Young Texas* (fig. 6.14). Editorial writers and speakers had used "Young Texas" before, sometimes in admiration, other times in derision. In the caricature, *Young Texas* is shown with a huge bottle of whiskey ("IXL Rotgut"), cards, and a massively large pistol and spurs that recall the stereotypical desperado who had "gone to Texas" to escape his past but, like North's "dare-evil," has not mended his ways. An enormous Bowie knife-cum-sword inscribed "For Reconstruction" adequately expresses the Texan's opinion of the Reconstruction government, whether presidential or the later Congressional plan.[40] A Galveston editor even decried in November 1865 that the country was being "deluged with worthless pictorial publications from the North" and warned his readers to keep the "imperfect wood-cut or the colored lithograph" away from their children lest their "naturally healthy artistic taste . . . be degraded and destroyed."[41]

There is no hint of the artist or publisher of this singular image, but two intriguing *cartes de visite* (fig. 6.15), of what appear to be handmade copies of this image, raise the possibility that it might have been printed in Texas, perhaps at the lithographic press of Paul Henry near Dallas. (Henry was still active, because Coho Smith offered to provide sketches of the races held at the Dallas fairgrounds if Henry, who by then had relocated to Lancaster, would reproduce them as lithographs. The *Herald* editor advised, "We don't know what he will sell the pictures at, but everybody ought to have one.") A close inspection of the images reveals that the photographs feature slight differences and that neither is a photograph of the lithograph, suggesting that the image was more widespread than a single, surviving lithograph would suggest—so the question of who originated and published the picture remains unanswered. One of the photographic prints was made by J. R. Davis, a photographer who had located on Main Street in Dallas as early as 1867. The other was made by A. W. Judd in Jefferson, Texas. A handwritten note on the back of that card is dated June 8, 1878.[42]

"I EXPECT I CAN DO BETTER HERE THAN ANY PLACE ELSE."[43]

The lithographs related to the war offer little comment on what was happening in Texas, primarily because there are so few of them and most of the action was on the eastern side of the Red River. But that absence is suggestive. Not only did printers in Texas suffer from a statewide shortage of paper, but many of them relocated for the duration of the war—Miles Strickland of Galveston, for example, temporarily removed to Houston. And yet the scant record offers hints of reality: blockade-related difficulties, secret Union societies, a huge prisoner-of-war camp rife with continual rumors of a prisoner uprising, resurgent frontier conflict with the Comanches after the departure of federal troops, and, finally, the violence of the Reconstruction era itself, so well represented in the figure of *Young Texas*. Erath added a personal element to the image: "Like many another old Texan I had been careless of accumulating," he recalled, and was "broken financially" by the war. Now, "with ill health, old age, and new times to combat, I had to start again."[44]

A correspondent in Houston elaborated to the editor of the *Cultivator & Country Gentleman* in 1868: "This country is ruined. . . . Cotton planters have lost nearly everything." Still, even amidst Reconstruction, outsiders and newcomers saw something in Texas that attracted their curiosity and inspired their confidence. H. J. Chamberlin of Milam County immediately disputed the Houston correspondent's claim: granting that the slaves were now free, he confidently predicted that "the destiny of the Lone Star State . . . will continue to be, as it now is, a progressive one."[45] In Dallas, thirty-five-year-old attorney John M. McCoy, newly arrived in November 1870, assured his anxious family back in Indiana, "Now about my staying in Texas—you must begin to think about it. . . . If Texas is going to be what all say it is, I expect I can do better here than any place else."[46]

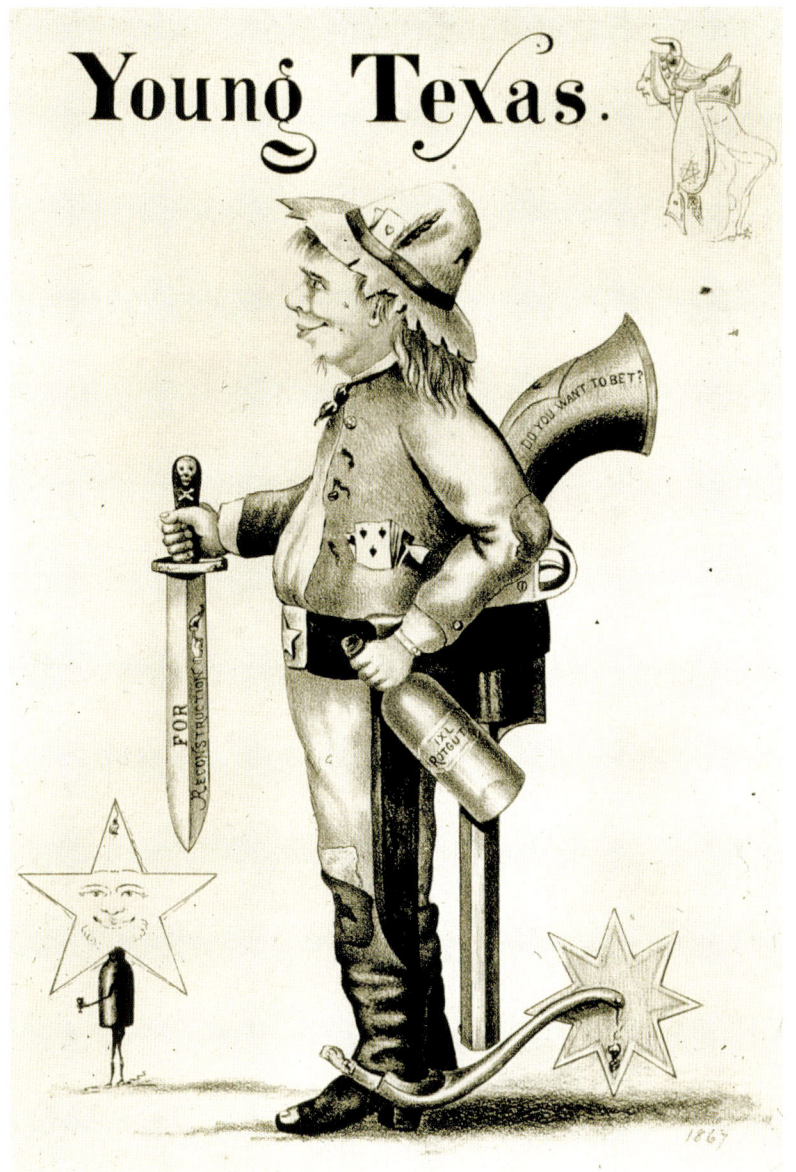

FIGURE 6.14 Unknown artist, *Young Texas*, c. 1867. Single sheet. Lithograph, 34.5 × 24.7 cm (image). Lithographer unknown. Courtesy New-York Historical Society.

FIGURE 6.15 Unknown artist, *Young Texas*, 1867. Carte de visite, by J. R. Davis, Photographer, Main Street, Dallas, TX. Courtesy DeGolyer Library, Southern Methodist University.

"THE DARK CORNER OF THE CONFEDERACY" | 261

CHAPTER 7

"THE ENTERPRISE WAS NOT PROPERLY APPRECIATED"

THE GROWTH OF LITHOGRAPHY IN TEXAS

The last third of the nineteenth century witnessed a tripling of the Texas population, the slaughter of the great southern buffalo herd, the last stand of the Plains Indians, the spread of barbed wire and windmills across the plains, a huge increase in industrial output (primarily lumber), the growth of labor unions, unprecedented expansion in shipping and railroads, and the establishment of a lithographic press as Galveston leaders sought to enhance their city's position as the leading port on the Texas Gulf Coast.[1] Of the former Confederate ports, American-flag carriers returned to Galveston last, because Texas did not surrender to Union forces until June 2, 1865, two months after Lee had surrendered at Appomattox. But within weeks the island was "rapidly regaining its former position as a commercial city, and the marks of war are being obliterated," editor Ferdinand Flake reported. "Old stores are being refitted, and dwellings turned into stores. Hundreds of strangers pass through here every day, and all of our merchants seem busy."[2]

Seizing the moment, Willard Richardson, editor of the *Galveston Daily News*, renewed his prewar vision of a "Galveston Plan" and challenged the city's business community to make Galveston the dominant port on the Gulf, to make it the linchpin between "the Great West" and the world. "It may look extravagant to hold up Galveston as destined, at some future day, to be the sea-port of half a continent," Richardson wrote, "and yet all the premises and existing facts lead precisely to that conclusion." Richardson's intended audience was the community's business leaders, the merchant-elites who remained socially aloof from the working classes and controlled the monopolistic Galveston Wharf & Cotton Press Co., but businessmen like Miles Strickland, stationer and bookbinder, who had moved to Houston during the war, shared Richardson's optimistic view of the city's future and returned to the island in 1866.[3]

Strickland was a twenty-one-year-old Canadian when he immigrated to Texas via Mobile and New Orleans in 1858. He acquired the W. B. Dunning bindery in Galveston and immediately began advertising in several of the local newspapers featuring a cut of an open book on top of what appears to be a large ledger book (fig. 7.1).[4] He had "prospered, and extended the scope of his operations," according to Galveston journalist Charles W. Hayes, but with the coming of the Civil War, the "lucrative trade" that he had built up by "diligent application . . . quickly dissipated," and he, like many other islanders, moved to Houston for the

duration of the war.[5] While in Houston he apparently worked for the *Tri-Weekly Telegraph* before associating with printer A. C. Gray (who seems to have given a number of Texas printers their start) to form Gray, Strickland & Co. Back in Galveston after the war, he partnered with James Owen for a short time in 1866 and located on 22nd Street, two doors north of Market Street.[6] In 1868 he moved to 161 Strand, between 22nd and 23rd Streets, and joined with Samuel B. Burck, a Pennsylvania German, to add lithography to his offerings. This apparently marks the first time, with the possible exception of Joshua Lowe in 1840, that such services had been available in Galveston (fig. 7.2). He began using his signature line, "Sign of the Big Book," and advertised widely.[7]

Lithography had begun as a handicraft, but now it was a corporate industry that required a significant capital investment—in presses, expensive Bavarian stones, and trained craftsmen—that Texas printers, in a rural and sparsely populated state with inadequate transportation and few clients, could ill afford. As the state recovered from the war and the population grew, transportation improved, and by 1888 lithographers were plying their trade in Galveston, Houston, Dallas, Fort Worth, San Antonio, and Corpus Christi.

But Galveston was the business and urban center of the state, and Strickland established his lithographic department more than a decade earlier than any other entrepreneur in Texas. "Being a man of artistic taste, rare judgement, he determined to secure workmen of unquestioned skill in each department, and from the start do work equal to the best lithographic establishments in the country," Hayes wrote. "No new feature or innovation has escaped his notice, while he has originated many new and attractive designs in the lithographic art."[8] Strickland had brought the lithographic age to Texas at a time when there were fewer than 170 lithographic shops nationwide.[9]

In 1872 Burck sold his interest to Robert Clarke, who had recently failed as the copublisher of a freely distributed magazine of Galveston advertising, and Strickland & Clarke moved to 109 Strand, between 22nd and 23rd Streets, and added a state-of-the-art Hoe steam-powered lithographic press in 1873 (figs. 7.3, 7.4, and 7.5).[10] They began advertising as "the only lithographic office in the state," and because locally produced lithography was new to the state, reporters often commented on their productions. Both the *News* and the *Houston Daily Mercury* complimented their Galveston city bonds and invitations.[11] They "have the materials and facilities for executing as artistic lithographic work, plain or colored, as can be had anywhere in the Union," The *Daily Mercury* reported. The reference might have been to the invitation for the Galveston Artillery Ball, which the firm printed in several colors in April 1873, one of the few examples of their work, other than routine business printing, that survived the 1900 storm (fig. 7.6). But, as Galveston historian Hayes explained, "The public were slow in appreciating the fact that work, they heretofore had been having done in New York, could be

FIGURE 7.1 Miles Strickland began advertising in local newspapers—by the sign of the big book—shortly after he opened his store. From the *Civilian and Gazette Weekly*, Jan. 17, 1860, 2.

FIGURE 7.2 Strickland advertises that he has added lithography to his services. *Galveston Daily News*, Oct. 6, 1868. The "Sign of the Big Book" became Strickland's slogan.

FIGURE 7.3 Strickland & Clarke ad from the *Galveston Daily News*, April 23, 1874, 3; it also appeared in *Houston Daily Mercury*, January 4, 1874, 3. Strickland & Clarke changed the slogan to "Sign of the Blank Book." This ad also ran in the *Dallas Weekly Herald* beginning Oct. 18, 1873, 2.

executed here as well, and with as much artistic skill and finish as it could be done in the cities of the North [figs. 7.7A, 7.7B, and 7.8]."[12]

Then came the panic of 1873, one of the worst economic depressions that the country had seen. It was a global recession that began in the United States when Jay Cooke and Co., one of the most respected firms on Wall Street, failed. The New York stock market closed for ten days in September. A month later Texas trail drivers arriving at Kansas railheads had to sell their stock—even "if it takes the hair off"—or they found no market at all.[13] Railroad companies that had been aggressively building across Texas faltered, some declaring bankruptcy. As the shock waves spread, the Texas & Pacific Railway suspended construction just six miles west of Dallas, short-circuiting a nascent economic boom in Fort Worth, thirty miles to the west.[14] And, as Hayes reported, "The prolonged financial crisis" that "hung like a pall over every part of the country for six years . . . fell with staggering effect upon Mr. Strickland . . . crippling business, paralyzing trade of every character and description." In December 1874, Strickland & Clarke placed the steam power lithographic press on sale at "a bargain." But Strickland "met . . . [the crisis] bravely and unflinchingly, averting the impelling blow," Hayes wrote. And when the Galveston elite, "men of years, discretion and sound judgement advised him to yield to the inevitable . . . , he faced the difficulties, and succeeded in placing his affairs upon

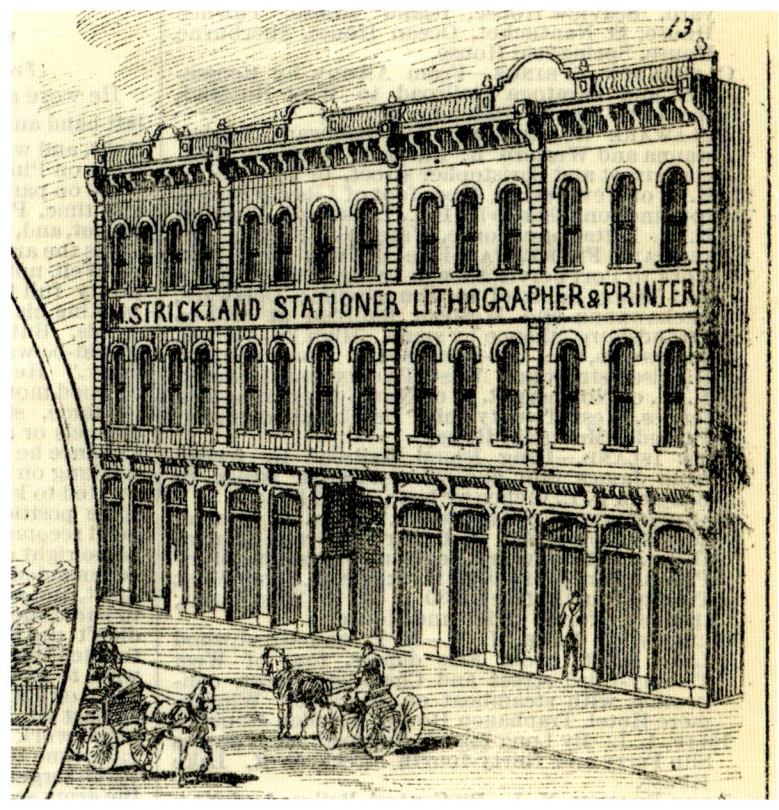

FIGURE 7.4 Detail from "Views of Galveston, Texas," *Daily Graphic* (New York), July 20, 1880. The "Big Book" that became Strickland's brand is shown above the door. By 1880, when this print was made, Clarke had left the partnership.

FIGURE 7.5 R. Hoe & Co. Patent Lithographic Printing Machine. Courtesy Cornell University Library, Ithaca, NY. Perhaps the press that Strickland acquired was similar to this one, advertised in the Hoe & Co. 1873 catalogue. Hoe & Co. regularly advertised their presses in the *Galveston Daily News*. (See May 6, 1874, 4, for example.)

FIGURE 7.6 Artist unknown, *Galveston Artillery Ball*, 1873. Invitation. Lithograph in colors, approx. 7.12 × 4.75 in., by Strickland & Clarke. Courtesy Briscoe Center for American History (Swante Palm Collection), UT Austin.

FIGURE 7.7A AND FIGURE 7.7B Strickland & Clarke's private script (front and back) for the First National Bank of Burgess Business College, Galveston, 1875. Lithograph, 7 × 18 cm. DeGolyer Library, Southern Methodist University.

FIGURE 7.8 Unknown artist, full-page ad for Stationers Lithographers Printers and Blank Book Manufacturers, pairing Robert E. Lee with George Washington. Strickland & Clarke, 109 Strand, Galveston, Tex. Lithograph by Strickland & Clarke. From *Fayman & Reilly's Galveston City Directory for 1875–6*. Courtesy Galveston and Texas History Center, Rosenberg Library.

a more solid basis, and by his fearlessness and concise frankness he won the confidence of the men who held his business life in the hollow of their hands." The 1875–1876 Galveston city directory lists seven lithographers working for Strickland & Clarke—at least four of them Germans. Eleven months later, he and Clarke terminated their partnership.[15]

Galveston rebounded strongly from the depression. While federal troops still prosecuted the Indian wars in North and West Texas, Galveston became the largest city in the state, with concert halls, piano stores, French china, English carpets, restaurants, jewelry stores, fine hotels, and the Galveston Electric Pavilion, the first building in Texas with electric lighting, designed by Nicholas J. Clayton.[16] In 1874 the *New York Daily Herald* reported that Galveston, Texas's "chief commercial port, is already the terminus of over two thousand miles of railway, pervading the great far West from St. Louis to Dakota in the north, Denver in the west and San Antonio in the southwest, and, to all appearances will become the New York of the Gulf."[17] A Louisiana resident looking for a new start found that "there is an air of life and thrift here not visible in any of our towns at home."[18] The enthusiasm seemed to be capped by the visit of former president Ulysses S. Grant in March 1880, a joyous occasion upon which Grant, who was working with Jay Gould to

assemble his western railroad network, declared Texas to be "an empire it itself," and Gen. Phil Sheridan was given the opportunity to "explain" his 1866 remark that if he owned both hell and Texas, he would rent out Texas and live in hell.[19]

Strickland recovered along with the city. When Thomas W. Peirce's Galveston, Harrisburg & San Antonio Railway, which began construction in 1873 and in 1877 became the first line to reach San Antonio, needed a new letterhead, Strickland worked with Galveston artist and professor F. T. Ryan to produce an unusually handsome image (fig. 7.9), which the *Galveston Daily News* reporter recognized as "something decidedly new in this line" that "has suffered nothing from the lithographer."[20] (The comment seems to be damning with faint praise, but it was a common complaint of artists that the lithographic draftsmen who transferred their drawings to the stones made changes in their designs.) Ryan deftly illustrated the importance of the new line by featuring a view of the Galveston harbor on the left and the Alamo and other iconic San Antonio buildings on the right, connected by an image of a train headed due west, from the "ne plus ultra" of Galveston into the setting sun. The route was immediately dubbed the "Sun Set Route."

Strickland soon had an even greater, but unusual, opportunity to publicize his work when some anonymous pen-and-ink sketches of "the bulls and bears in the cotton market" turned up at the Galveston Cotton Exchange in 1876. A reporter described them as drawings "of no ordinary merit" and compared them to the work of the famous Thomas Nast, whose

FIGURE 7.9 F. T. Ryan, Letterhead of the Galveston, Harrisburg & San Antonio Railway Co., 1874. Lithograph, 3.75 × 8.75 in., by Strickland & Clarke. Records Relating to Railroads, Courtesy Texas State Library and Archives Commission.

caricatures appeared regularly in *Harper's Weekly* and the *Daily Graphic* in New York.[21] Speculating that they were the work of a buyer from Philadelphia, the correspondent for the *Galveston Daily News* followed up a few days later to report that the artist still had not revealed his identity. With curiosity remaining high, Strickland lithographed and published the sketches in booklet form and sent them to cotton exchanges throughout the United States as well as abroad and offered them for sale to the public for fifty cents per copy.[22]

The anonymous artist vividly illustrated the ups and downs of the cotton market—which would have been a familiar topic to Galvestonians—by depicting the primordial struggle between bulls and bears.[23] On the cover of the pamphlet Strickland illustrated a female figure draped in an American flag standing amidst tropical trees and shrubs (fig. 7.10). Inside there are twelve pages of rather crudely drawn caricatures of the bulls and bears, humorously contrasting the cotton prices in Galveston (the sellers) with those in New York and Liverpool (the buyers) (fig. 7.11). But the message for the bull is not good, for he winds up skinned and butchered, his carcass suspended from a chain by his rear legs, his hide and head on the floor (fig. 7.12), while the bears fight over his genitals (fig. 7.13). "Alas! Poor Yorick I knew him well," the anonymous artist laments. In the last illustration (fig. 7.14), the bears herd the bulls into the "New York Future Market."

The *News* reporter somewhat generously termed the anonymous drawings "admirably executed," but he was correct that they were "a credit to the publisher." The booklet proved to be so popular that Strickland issued a second edition in May followed by a "supplementary pocket edition," which the *News* correspondent pronounced "decidedly rich."[24] Unfortunately, no copy of the original printing or the pocket edition is known; the DeGolyer Library at Southern Methodist University in Dallas and the Rosenberg Library in Galveston have copies of the second edition.

Strickland followed the *Cotton Exchange Sketches* with one of his most impressive pieces of printing. He had lithographed a number of maps for government entities and the Texas & Pacific Railway Co., including one of Stephens County in the 1870s. But in 1876 he printed and published one of the largest maps yet done in Texas, T. A. Washington and Charles F. White's *Map of Galveston & Vicinity* (fig. 7.15). Approximately 51 × 35.5 inches, the map is printed on two sheets of paper that have been glued together, colored by hand, and ringed with sixty-nine advertisements for various Galveston business such as W. Hendley & Co., Leon & H. Blume Wholesale Dry Goods, Heidenheimer Bros. Wholesale Grocery, and J. S. Brown & Co., Hardware and Liquor; eleven of these ads illustrate the firms' buildings. A twelfth building illustration, at the bottom center, is an advertisement for Nicholas J. Clayton, Galveston's premier architect.

T. A. Washington was a Confederate veteran who had assisted with construction in Galveston during the war and afterward served as engineer and superintendent of streets and vice. Charles White was city tax assessor during the 1880s. The *Galveston Daily News* advertised the map and pointed out that it contained the elevations of all the street corners from Avenue A to Avenue Q½ and from Fourth Street to Thirty-Seventh Street.[25] Strickland printed two additional versions of the map without the ads, one of which was issued in a pocket folder.[26]

With the economic recovery spreading, in the spring of 1877 Strickland added a large Hoe steam press to his printing facilities for a second time, making Strickland & Co. "the only steam lithographing establishment in the South," just in time to help celebrate what became one of the state's main festivals.[27] Many Texas cities organized fairs and festivals to encourage immigration, specific crops, and manufacturers, but the grand event during the last half of the nineteenth century was Galveston's annual Mardi Gras celebration, which gave Strickland an opportunity to demonstrate to an audience used to seeing chromolithographs from out-of-town printers that he could produce images of equal quality.

The event has ancient roots, of course, but in the United States the Gulf Coast cities of Mobile, New Orleans, and Galveston, which were closely associated through shipping lanes, seemed to focus on it. Its inauguration in Galveston occurred with the Jolly Young Bachelors *bal masque* in 1867, probably intended as part of the psychological recovery from the war, or, as a *News* reporter admitted, simply from "the desire for pleasure."[28] But the fact that 75,000 "strangers" had attended Mardi Gras in New Orleans in 1871 was not lost on Galveston business leaders, and they hoped for the "same excitement" from the "surrounding country that now exists all through Texas." *Flake's Daily Galveston Bulletin* reported in 1872 that the islanders had prevailed on the railroads to offer discounted fares for the event and expected three thousand persons from the mainland to attend that year—not a New Orleans–sized crowd, but a beginning.[29] Even Reconstruction governor Edmund J. Davis, who had been subdued by the election of a Democratic legislature the previous fall, took a special train from Austin, along with more than 240 other revelers, to join in the 1873 festivities.[30]

FIGURE 7.10 Unknown artist, *Galveston Cotton Exchange Sketches*, 1876. Lithograph, 23 cm (height). Published by M. Strickland. Courtesy DeGolyer Library, Southern Methodist University. This is the cover of the second edition of the booklet.

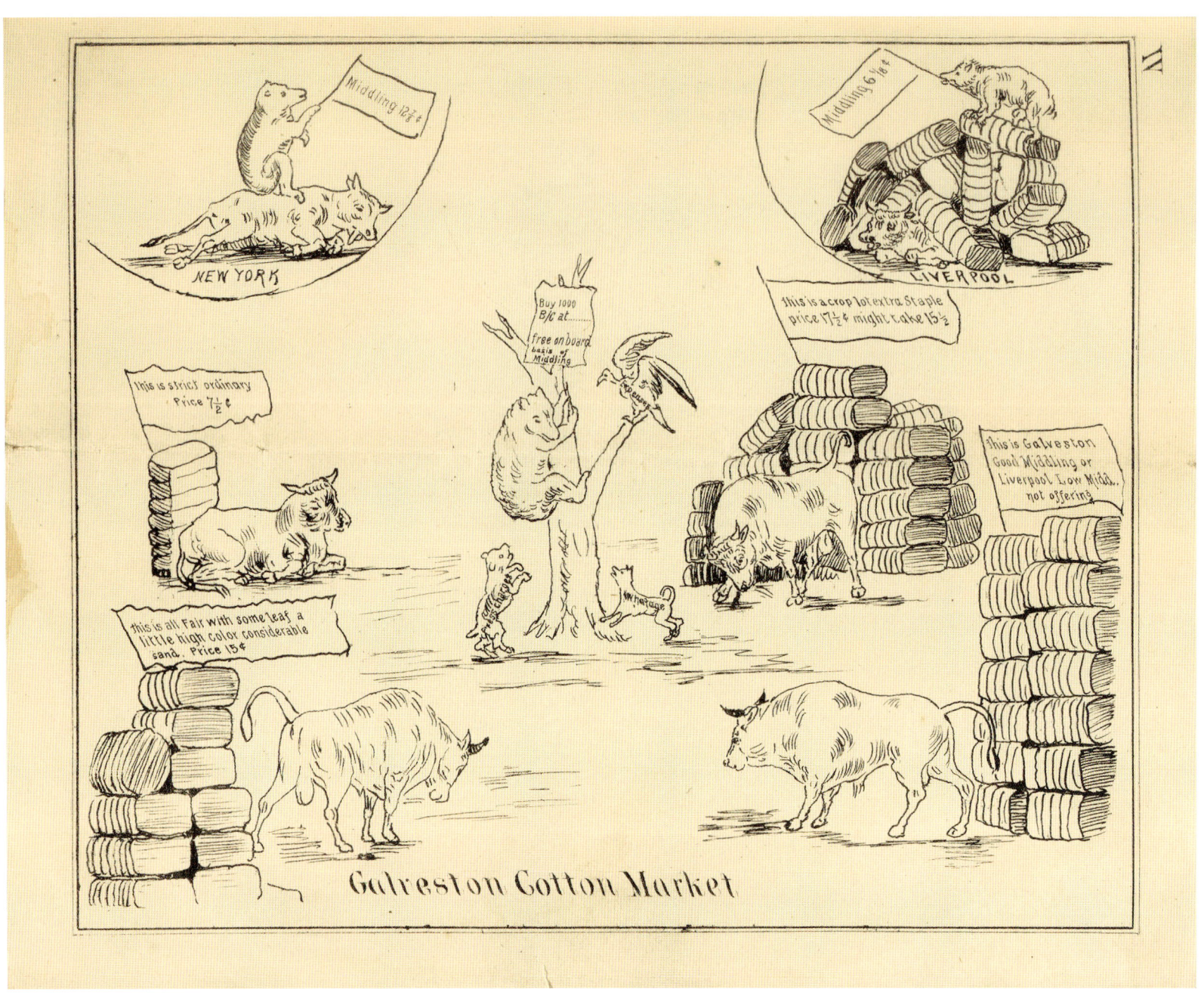

FIGURE 7.11 Unknown artist, *Galveston Cotton Market*. From *Galveston Cotton Exchange Sketches* (1876). Courtesy DeGolyer Library, Southern Methodist University. The bulls seem to remain in control of the Galveston market, while the bears have the upper hand in New York and Liverpool.

FIGURE 7.12 Unknown artist, *To this complexion must we come at last*. From *Galveston Cotton Exchange Sketches* (1876). Courtesy DeGolyer Library, Southern Methodist University.

FIGURE 7.13 Unknown artist, *Donation to the poor*. From *Galveston Cotton Exchange Sketches* (1876). Courtesy DeGolyer Library, Southern Methodist University.

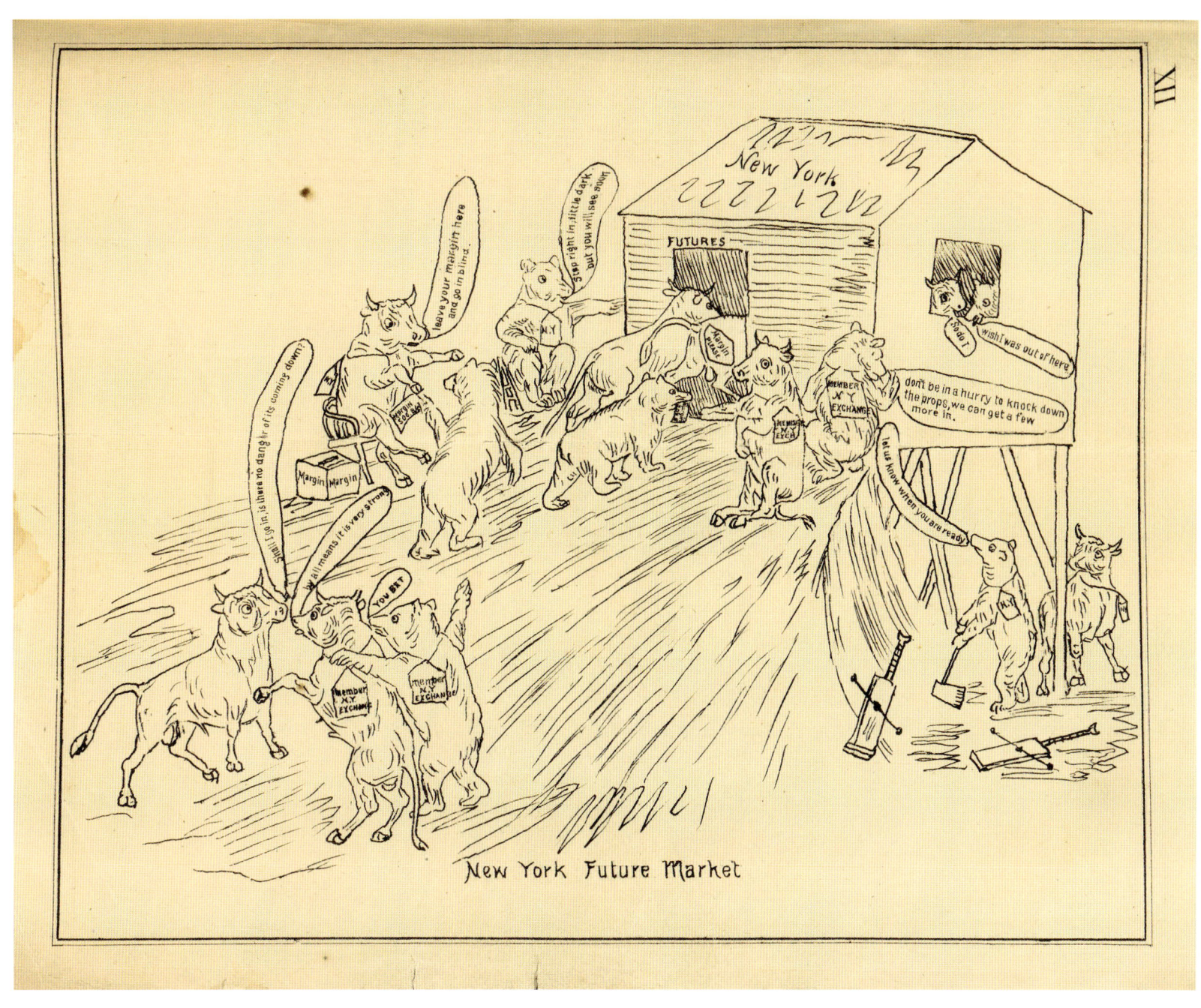

FIGURE 7.14 Unknown artist, *New York Future Market*. From *Galveston Cotton Exchange Sketches* (1876). Courtesy DeGolyer Library, Southern Methodist University.

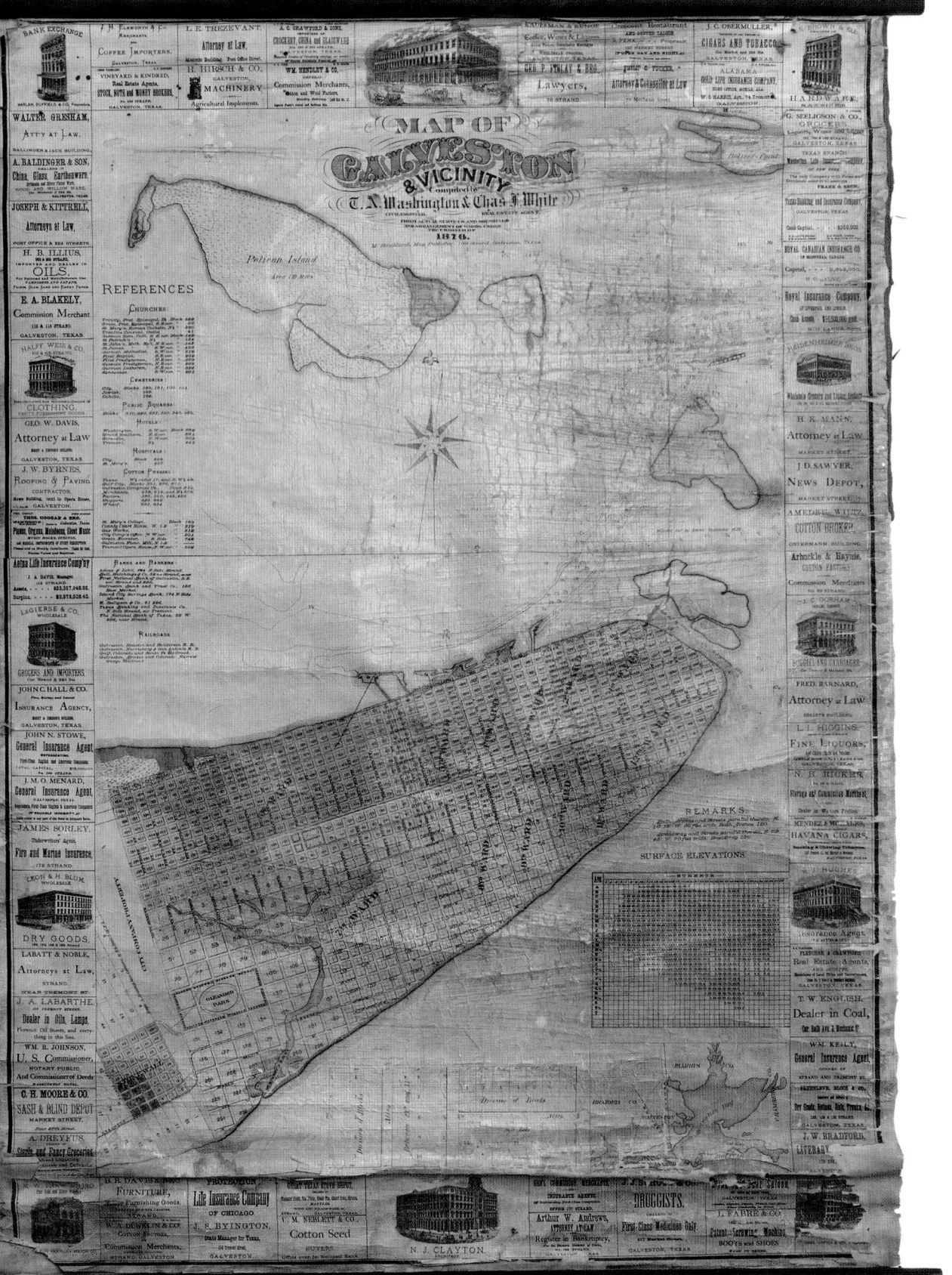

Mardi Gras, it seems, has long been known for its handsomely designed and colorful invitations, a challenge the artists at Strickland & Co. welcomed.[31] An early two-color engraving, printed by the *Galveston News* in 1871, became, as the years progressed, a virtual symbol of the difference between type-metal engraving and chromolithography (fig. 7.16). Inspired by the frivolities of the celebration, lithographic artists created designs that were limited only by the demands of the clients, the size of the stones that they possessed, and the talent of the lithographic artist and printer.[32] These years were the heyday of the "ubiquitous chromo," even in Texas, but Strickland still had to compete with outside firms, such as John Douglas in New Orleans, Chapman & Bloomer in New York, and Michel Charles Fichot and François Appel in Paris, all of whom printed Galveston Mardi Gras invitations in the 1870s (figs. 7.17, 7.18, 7.19, 7.20, 7.21). But the destruction wrought by the storm of 1900 on personal and archival collections likely prevents us from ever knowing the fullness of their creativity.

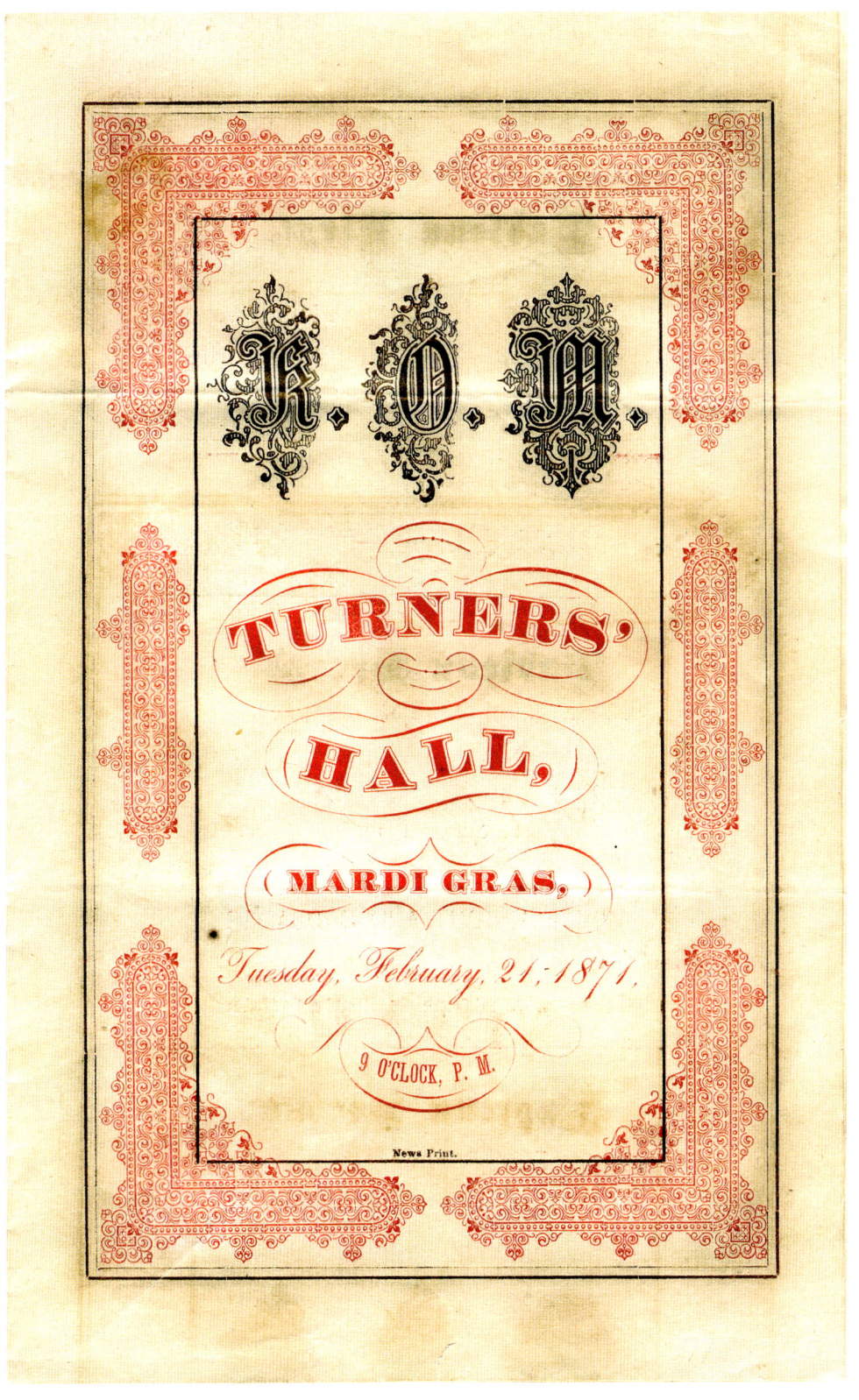

(OPPOSITE PAGE) FIGURE 7.15 T. A. Washington, Charles F. White, and Miles Strickland, *Map of Galveston & Vicinity, Compiled by T. A. Washington & Chas. F. White from Actual Surveys and Soundings, and Arrangement of Wards under the Charter of 1876*, 1876. Hand-colored lithograph, 51 × 35.5 in., printed on two joined sheets and published by M. Strickland. Courtesy Dorothy Sloan—Books.

(RIGHT) FIGURE 7.16 Unknown artist, *Turners' Hall, Mardi Gras, Tuesday, February 21, 1871*. Invitation. Two-color engraving, 10.8 × 8.5 in., by the *Galveston News*. Courtesy Galveston and Texas History Center, Rosenberg Library.

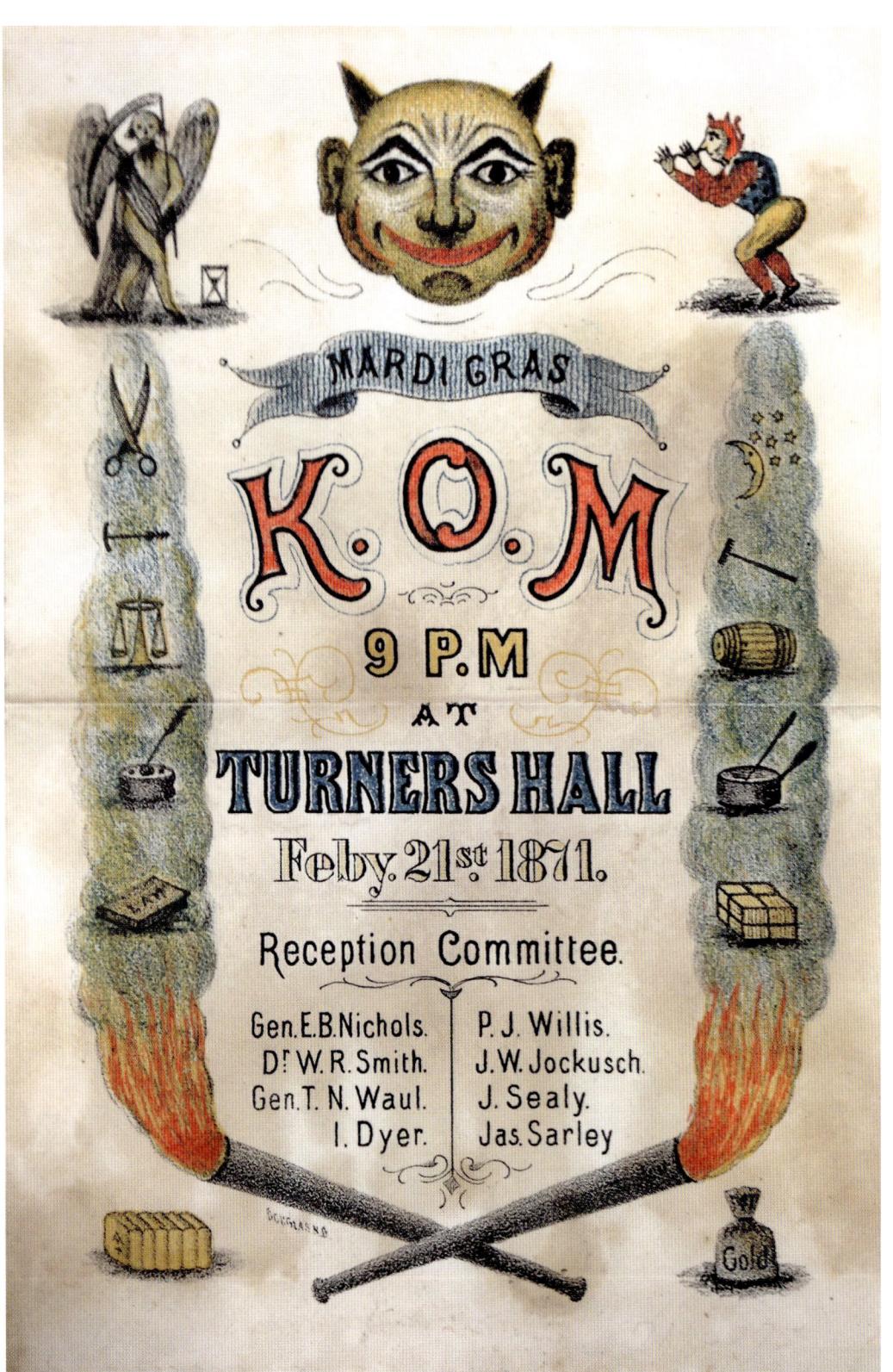

(LEFT) FIGURE 7.17 Unknown artist, *Mardi Gras K.O.M. 9 P.M[.] at Turners Hall, Feby. 21st. 1871.* Invitation. Chromolithograph, 7.12 × 4.75 in., by John Douglas, New Orleans. Courtesy Galveston and Texas History Center, Rosenberg Library.

(OPPOSITE PAGE) FIGURE 7.18 Unknown artist, *Knights of Momus 2d. Anniversary 9. P.M[.] Mardi Gras at Tremont Opera House, Febr. 13th. 1872.* Invitation. Chromolithograph, 6 × 5.19 in., by Chapman & Bloomer, New York. Courtesy Galveston and Texas History Center, Rosenberg Library.

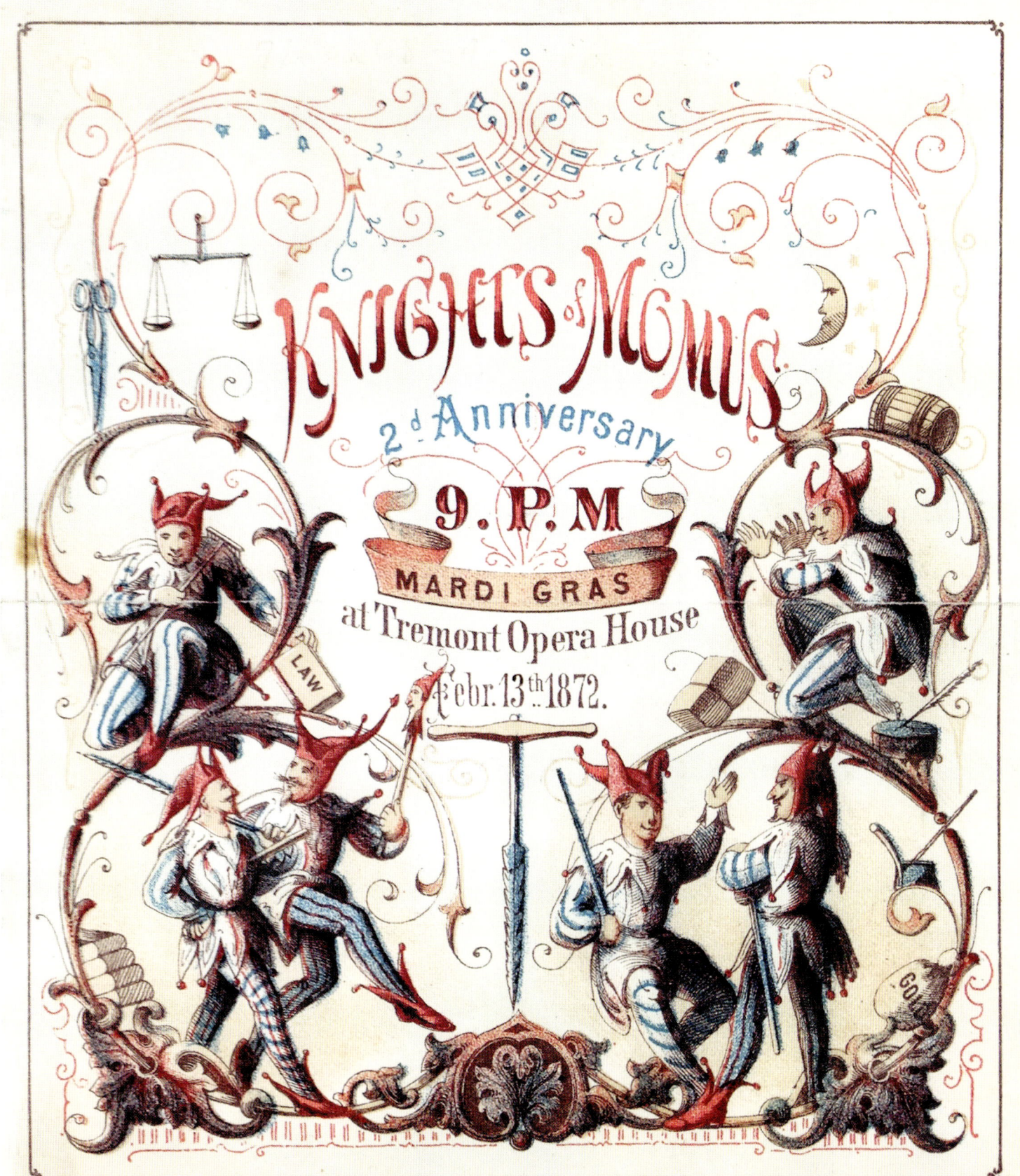

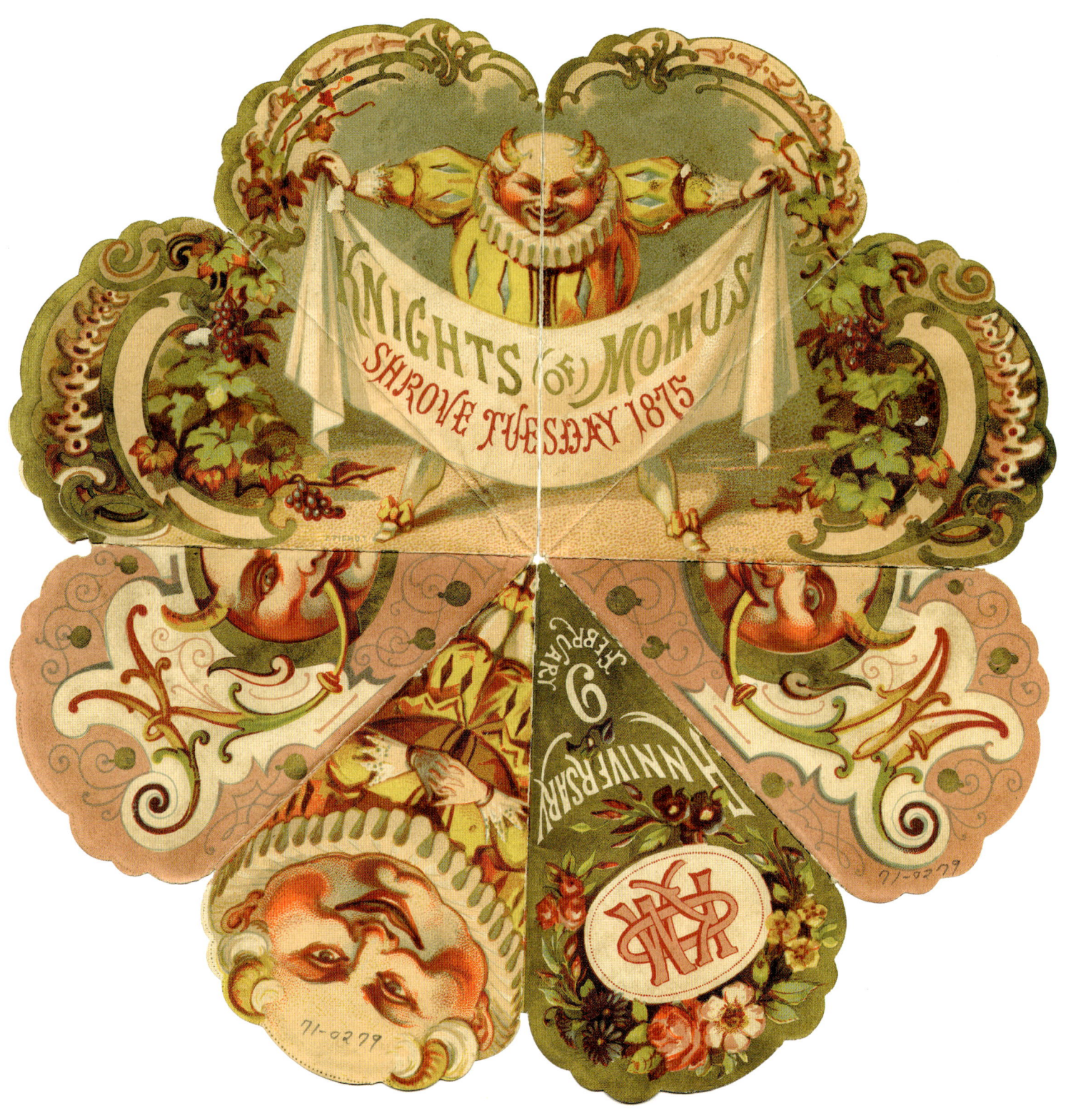

FIGURE 7.19 Unknown artist, *Knights of Momus Shrove Tuesday 1875* [front]. Invitation. Chromolithograph, 10.38 × 10.25 in., by Michel Charles Fichot, Paris. Courtesy Galveston and Texas History Center, Rosenberg Library.

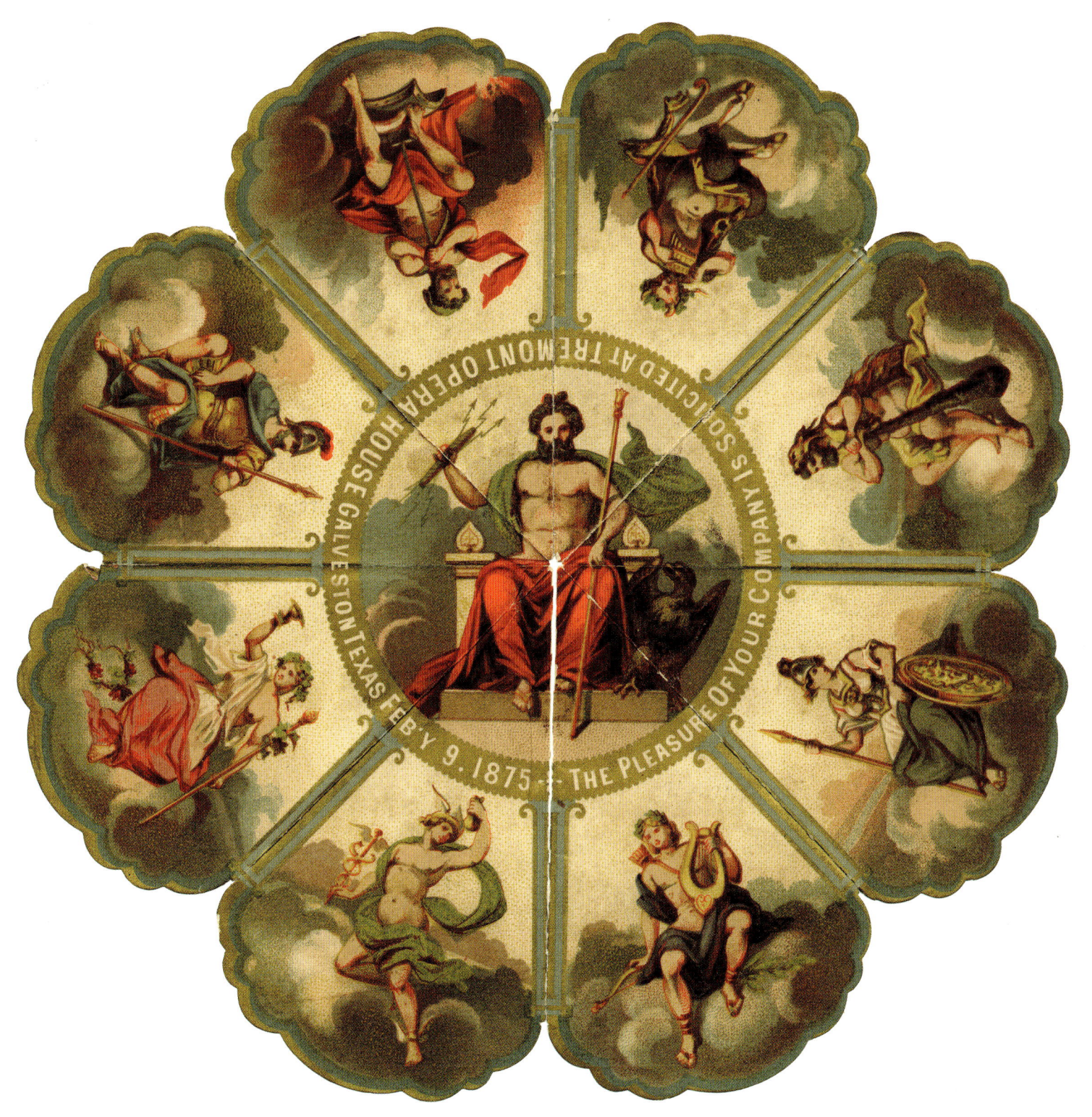

FIGURE 7.20 Unknown artist, *Knights of Momus Shrove Tuesday 1875* (verso).

"THE ENTERPRISE WAS NOT PROPERLY APPRECIATED"

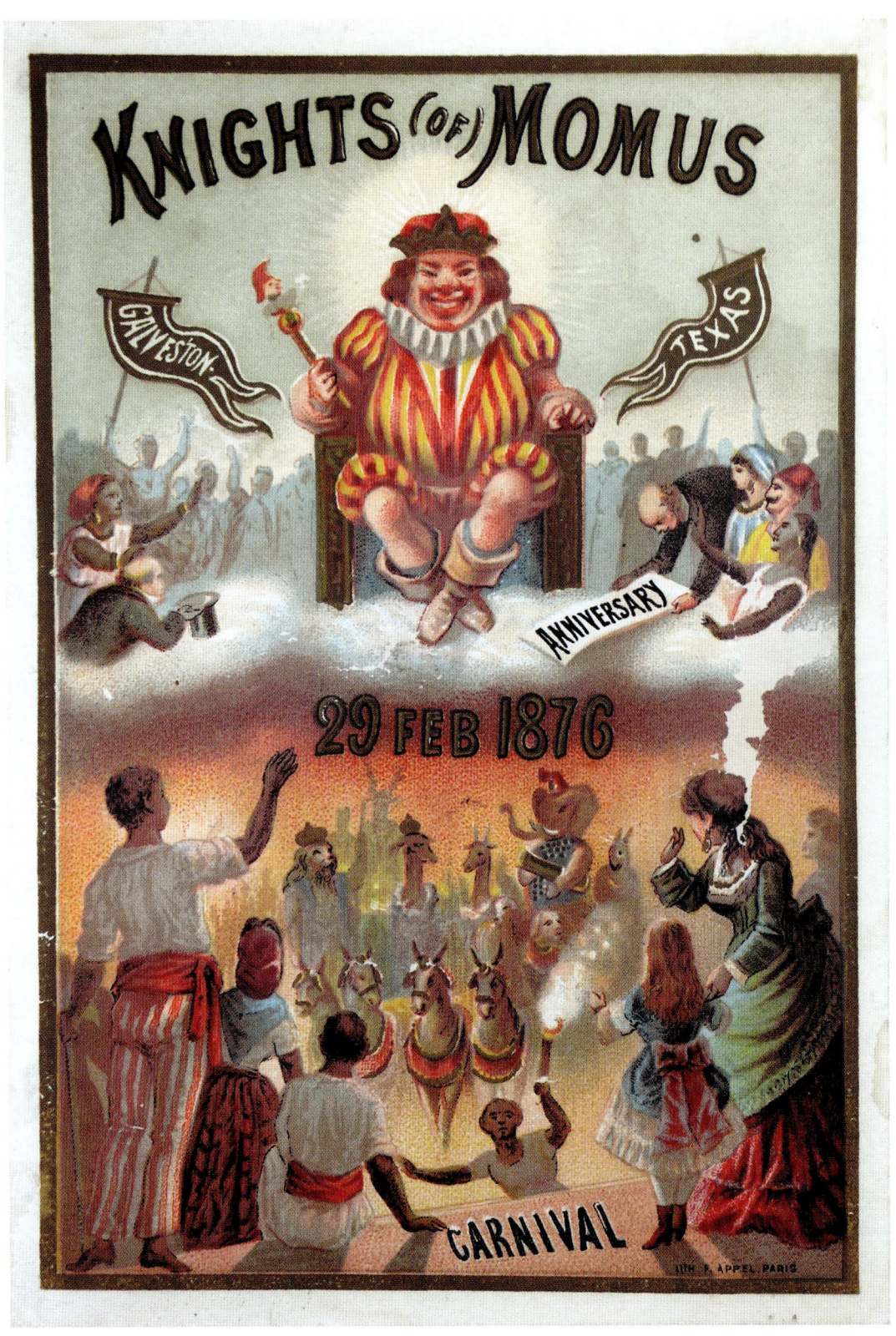

FIGURE 7.21 Unknown artist, *Knights of Momus 29 Feb 1876 Carnival*. Invitation. Chromolithograph, 6.12 × 4.31 in., by François Appel, Paris. Courtesy Galveston and Texas History Center, Rosenberg Library.

FIGURE 7.22 Matthew Whilldin (attrib.), *Delivering the Invitations for the Mardi Gras Festivities at Galveston, Texas*. Half-page lithograph, approx. 10 × 13.5 in. From the *Daily Graphic* (New York), Feb. 26, 1876, 5.

The Mardi Gras invitations set a high standard, and Galveston organizers delivered them "with all the accustomed mystery," ensuring that they were the talk of the city's social set as well as local reporters, who enthusiastically described and explained their symbolism.[33] The new *Daily Graphic* in New York, the country's first illustrated daily newspaper printed entirely by lithography, even included two separate illustrations focusing on the distribution of the invitations and the parade floats (fig. 7.22). According to Matthew Whilldin, the *Graphic* correspondent, the illustration in the center "represents the appearance of the advance envoy extraordinary of the Master of the Revelers, accompanied by his suite, driving from door to door to deliver to the residents of this thriving

"THE ENTERPRISE WAS NOT PROPERLY APPRECIATED" | 283

city invitations to the first annual reception of the Mid-day Revelers. The envoy sat in a gorgeous chariot, and by his side was the bugler, who heralded the movements of his august master by appropriate sounds from his golden horn."[34] The illustrations of the various floats were based on Galveston photographer Frederick W. Bartlett's images (fig. 7.23).

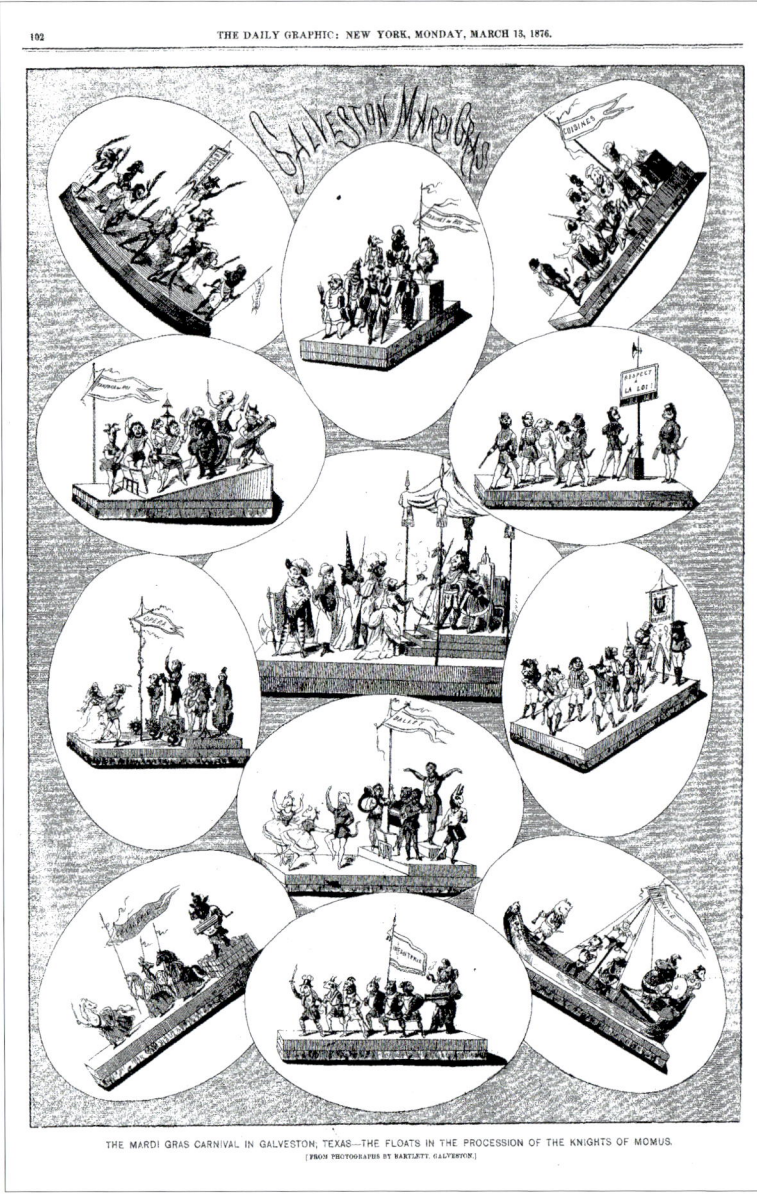

FIGURE 7.23 After photographs by Frederick W. Bartlett, Galveston, *The Mardi Gras Carnival in Galveston, Texas—the Floats in the Procession of the Knights of Momus*. Lithograph, full page. From the *Daily Graphic*, March 13, 1876.

Strickland might have printed his first invitation for the Knights of Momus in 1874, the year that he sold his steam press (fig. 7.24). He is not identified as the printer, but the style of drawing and the one-color printing are similar to his later signed work (fig. 7.25). Momus was the Greek god of mockery, so the Momus parades and floats usually were elaborate efforts at irreverent humor and cutting satire. The unnamed artist, who might well have been Strickland's oldest son, who trained as a lithographic artist, depicts revelers preparing the way for King Momus as he arrives on the back of a mule. Other revelers and angels observe the proceedings, while, at the right, Father Time, hourglass on the floor at his left, leans on his scythe and watches.[35]

As the celebration gained momentum, the Knights went to two well-known French lithographers for their next two invitations. Michel Charles Fichot, one of the foremost lithographers in Paris, designed and printed the 1875 invitations, which were so striking that the *News* reporter devoted almost a column of type to their description—an elegantly folded chromolithograph in the style of what the correspondent called a German valentine printed in thirteen colors (figs. 7.19 and 7.20). The circular card was folded four times to form a small triangle, which displayed the smiling face of Comus, the ancient Greek god of festivity, with his hands folded across his chest. On the opposite side of the small triangle are the initials K.O.M. and the date of the event, set within a bouquet of elegant flowers. Opening the first fold reveals another jocular manifestation of Comus as well as a repeat of the gracefully styled initials. Opening the second and third folds reveals Comus, surrounded by elegant flowers and vines, holding a satin cloth upon which is inscribed "Knights of Momus, Shrove Tuesday 1875." On the verso of the fully opened invitation is the figure of Jupiter, surrounded by eight other mythological figures. The *News* reporter, apparently chosen by the revelers as their contact for disseminating information, called the cards a "most extravagant display." The editor of the *Belton Journal* was even inspired to pronounce them "unique and beautiful in design," and a visitor from Louisiana, where New Orleans Mardi Gras–goers were accustomed to such colorful designs, agreed.[36] The following year, Parisian lithographer François Appel printed a rather more straightforward invitation, perhaps a concession by the Knights that they would have a hard time topping (or, perhaps, paying for) Fichot's work in the midst of a depression (fig. 7.21).

One result of the financial downturn might have been that in 1877 the celebrants returned to Strickland for less expensive invitations

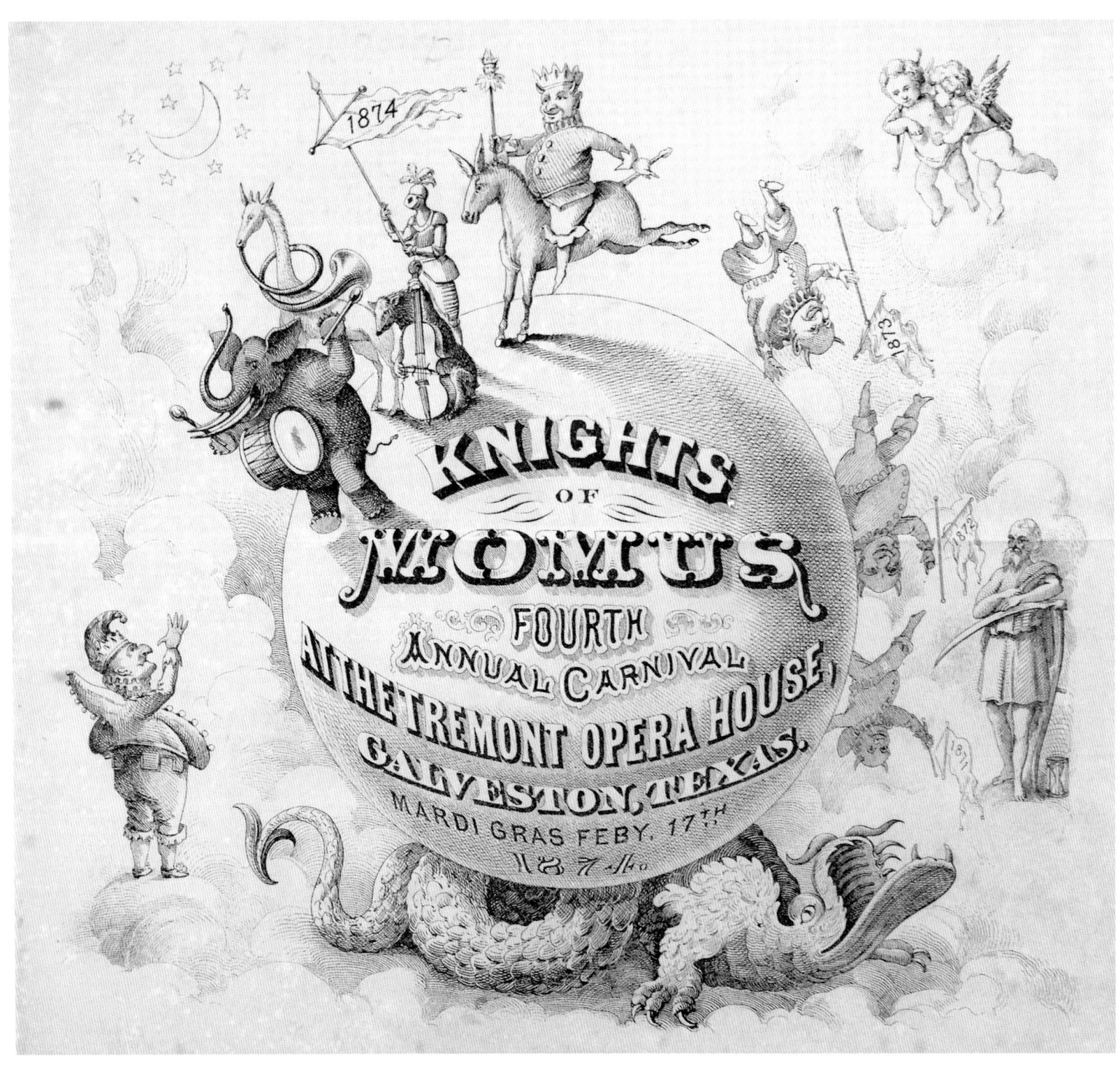

FIGURE 7.24 Unknown artist, *Knights of Momus Fourth Annual Carnival*, 1874. Invitation. Lithograph, 5.38 × 5.87 in., by M. Strickland, Lith., Galveston (attrib.). Courtesy Galveston and Texas History Center, Rosenberg Library.

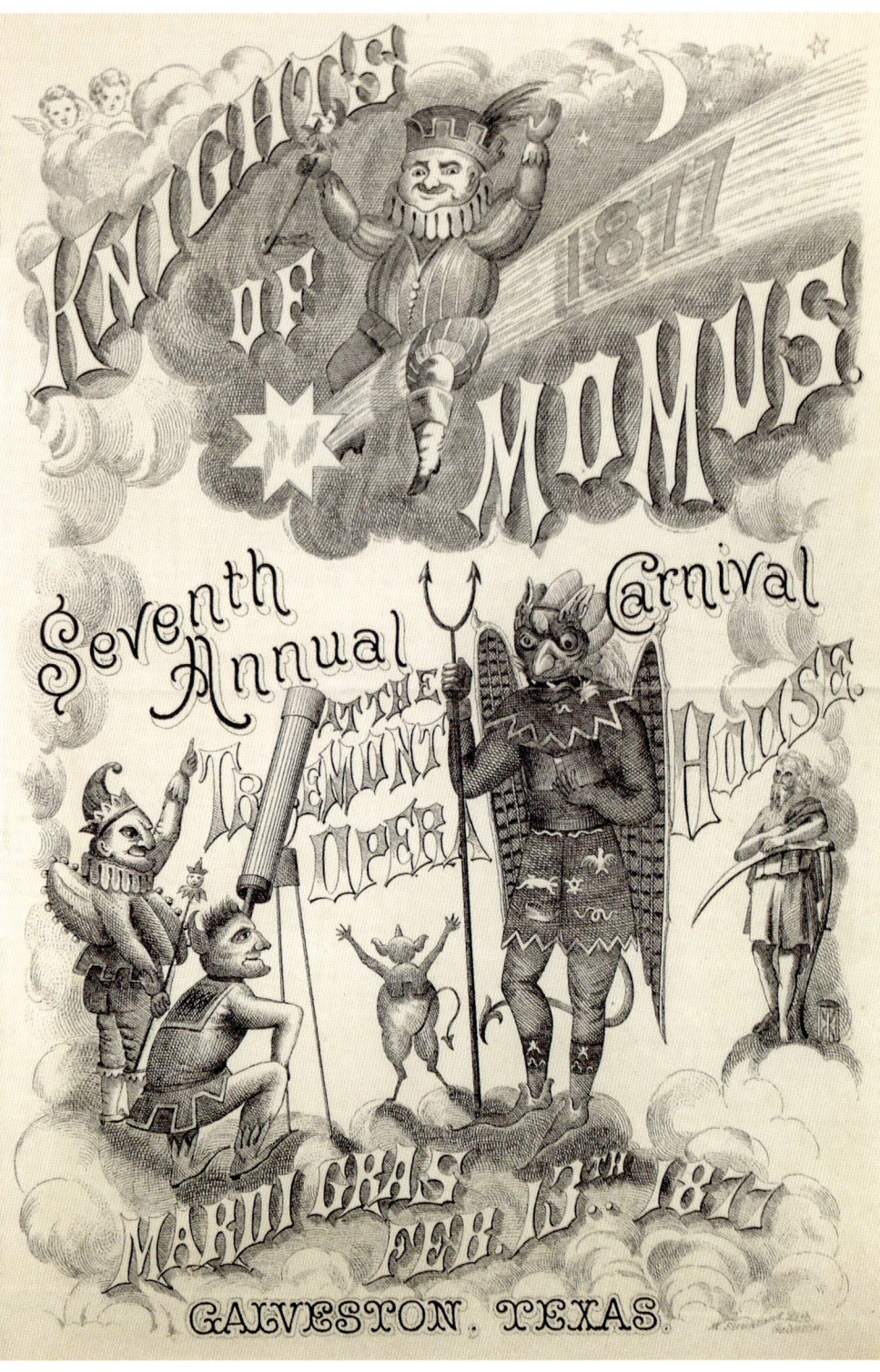

FIGURE 7.25 Unknown artist, *Knights of Momus Seventh Annual Carnival*, 1877. Invitation. Lithograph, 7.06 × 4.69 in., by M. Strickland, Lith., Galveston. Courtesy Galveston and Texas History Center, Rosenberg Library.

printed in black ink on white cards (fig. 7.25). The *News* reporter deciphered the symbols contained in the elaborately drawn Knights of Momus invitation:

> The upper part of the picture shows King Momus dashing through the clouds toward the earth on the tail of a comet, in which also appear the figures 1877. Below stands the Prime Minister Israfel, holding a book in his hand, intently engaged in looking for the time that the King is expected to make his advent. On the left of him a knight sits peering through a telescope toward the heavens, to catch the first glimpse of Momus as he descends. On the left of the royal announcer stands another knight who, with the naked eye, has descried the King advancing on his fiery horse, and gives information of the fact to his companions. A little knight hops about in great glee, with hands uplifted toward Momus, while old Father Time, on the extreme right, surveys the scene with grave composure. Two little angels appear on the upper left-hand corner of the picture, watching Momus from a safe distance.[37]

This is the same figure of Father Time that appeared in the 1874 invitation, seemingly confirming its attribution to Strickland's firm.

The unnamed artist also produced the image for Strickland's invitation to the Mid-Day Revelers Second Annual Reception (fig. 7.26). In the center is a jolly-looking fellow dressed as a clown holding a fishing pole. He has snagged a portrait of William Shakespeare, whose works were honored in the grand parade that year with various floats and representations of his writings.[38] The battered trees, which look dead but boast a few leaves on their extremities, could represent an economically reviving Galveston under the mischievous sun rising on the horizon.

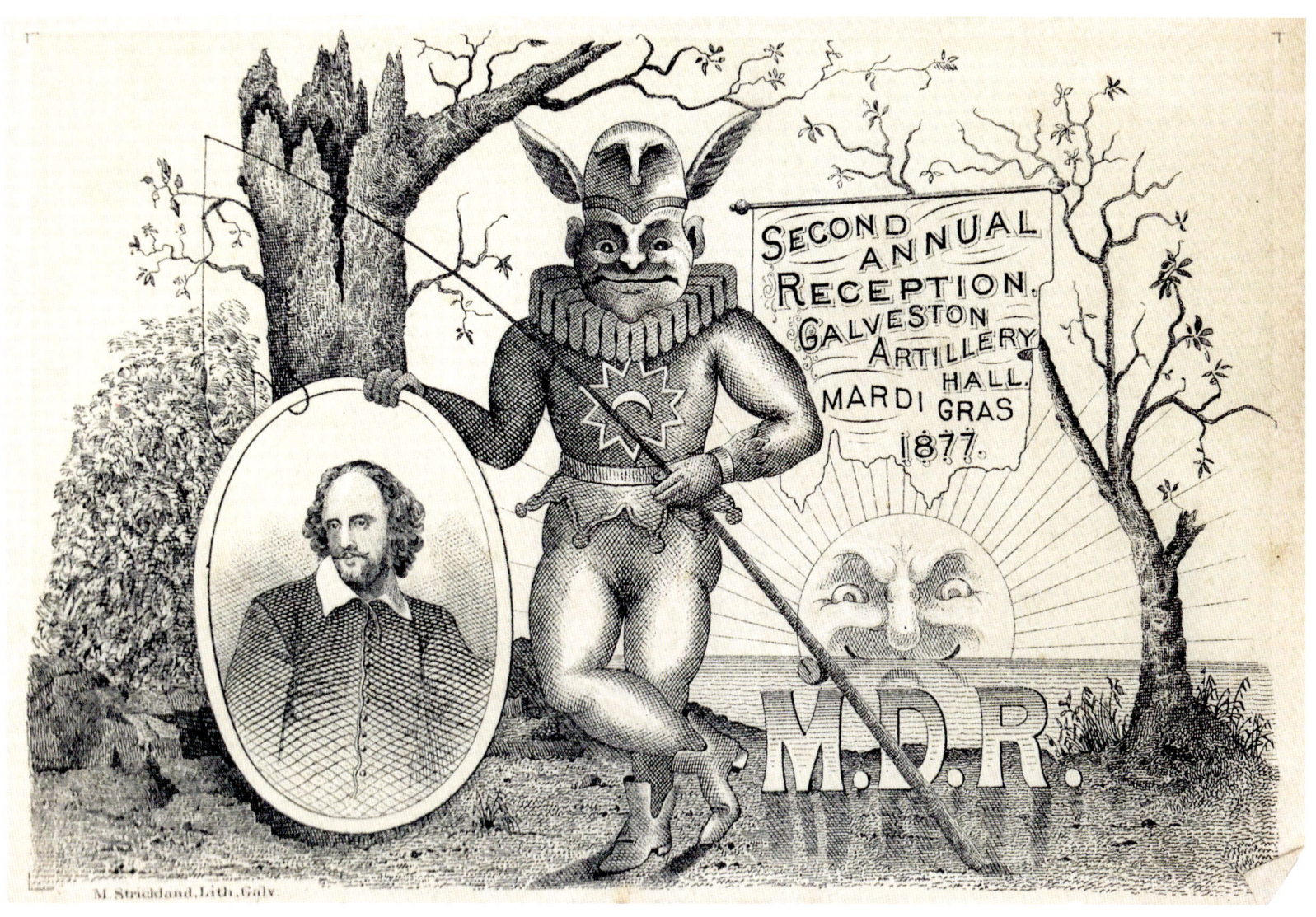

FIGURE 7.26 Unknown artist, *2nd Annual Reception, Galveston Artillery Hall, Mardi Gras 1877*. Invitation. Lithograph, 5.06 × 3.38 in., by M. Strickland, Lith. Courtesy Galveston and Texas History Center, Rosenberg Library.

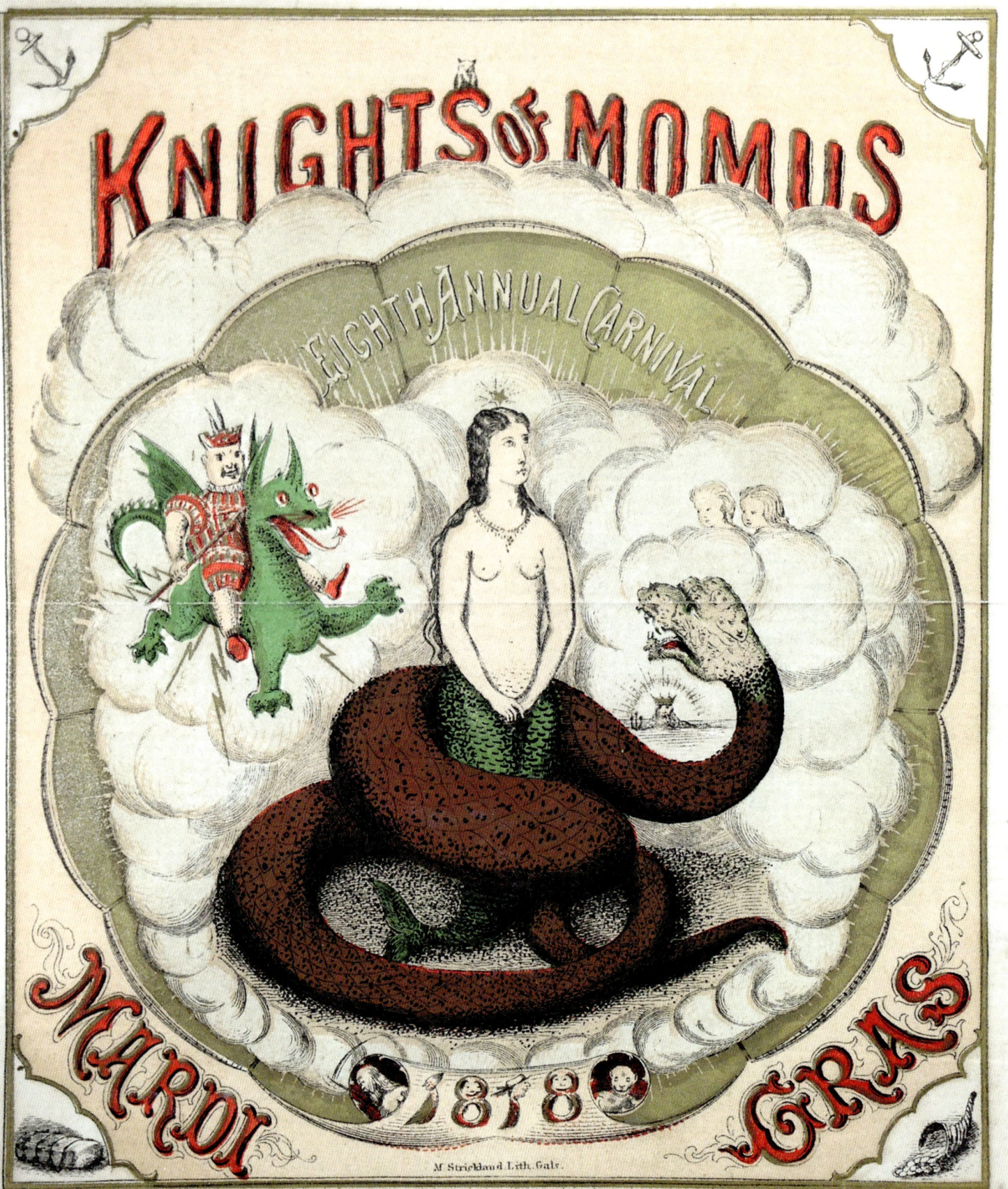

By 1878 Strickland had his new steam press in working order and printed what may be the first chromolithograph produced in Texas: an invitation to the Knights of Momus Eighth Annual Carnival (fig. 7.27).[39] It shows a serpent coiled around a demure mermaid in the center of the composition while "Komus, mounted on his fiery steed, comes charging through the clouds to the rescue." The *News* reporter explained, "The local application of the design[:] Galveston, which is represented by the mermaid, is in the toils of hard times, but the rising sun [at the right center] presages the hope of a brighter future which will follow from increased shipping facilities suggested by the anchors" (in the upper corners) and a bale of cotton and a cornucopia disgorging silver dollars (in the lower corners). The associated tickets and invitations also garnered praise from around the state (fig. 7.28).[40] The editor of the *Fort Worth Standard* called Strickland's diamond-shaped MDR invitation "an exquisite piece of lithographic work."[41] The critics did not mention color as being the distinctive element in these items because, by 1878, they were used to seeing pictures and invitations in bright colors. But for Texas printers, multicolor lithography was a major step, and lithographers around the state would soon follow Strickland's lead.

For the K.O.M. invitation for 1879, Strickland worked with a newly arrived artist to produce perhaps his most challenging chromolithograph. James Henry Moser, a Canadian-born painter who later illustrated for *Harper's Weekly*, *Century*, *Leslie's Illustrated*, and *Atlantic Monthly*, had moved to Galveston with his parents in 1877 (fig. 7.29). His father, John, was the architect for the new cotton exchange building, and James established a studio in the Heidenheimer Building.[42] He provided Strickland's lithographers with an image (fig. 7.30) that the *News* reporter called the "most gorgeous

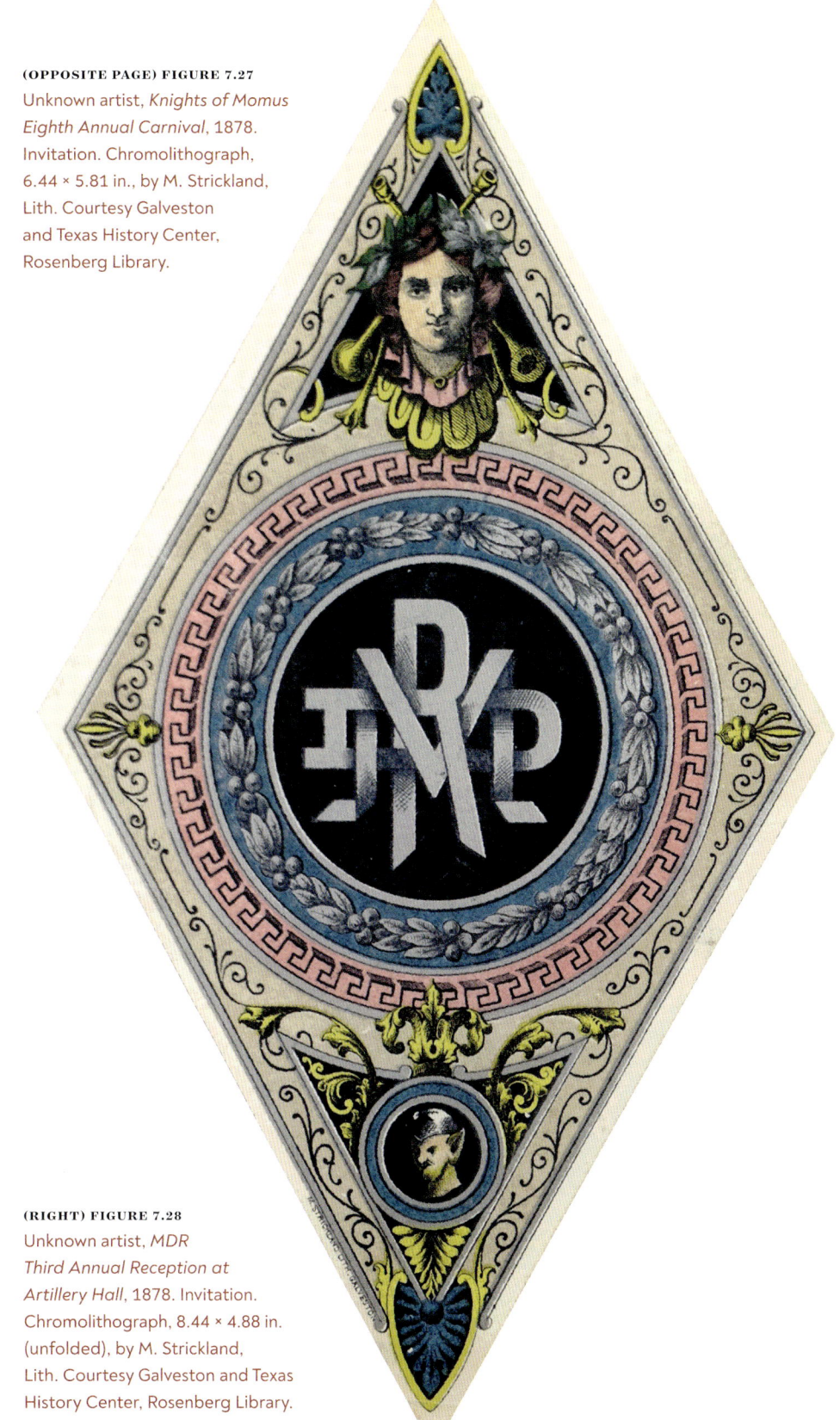

(OPPOSITE PAGE) FIGURE 7.27
Unknown artist, *Knights of Momus Eighth Annual Carnival*, 1878. Invitation. Chromolithograph, 6.44 × 5.81 in., by M. Strickland, Lith. Courtesy Galveston and Texas History Center, Rosenberg Library.

(RIGHT) FIGURE 7.28
Unknown artist, *MDR Third Annual Reception at Artillery Hall*, 1878. Invitation. Chromolithograph, 8.44 × 4.88 in. (unfolded), by M. Strickland, Lith. Courtesy Galveston and Texas History Center, Rosenberg Library.

"THE ENTERPRISE WAS NOT PROPERLY APPRECIATED" | 289

(ABOVE) FIGURE 7.29 Unknown photographer, James Henry Moser, 1878. Courtesy Cornwall Historical Society, Cornwall, CT.

(RIGHT) FIGURE 7.30 James Henry Moser, *Knights of Momus*, 1879. Invitation. Chromolithograph, 8.19 × 6.25 in. Signed lower left "Moser78" and lower right "Strickland Lith." Courtesy Galveston and Texas History Center, Rosenberg Library.

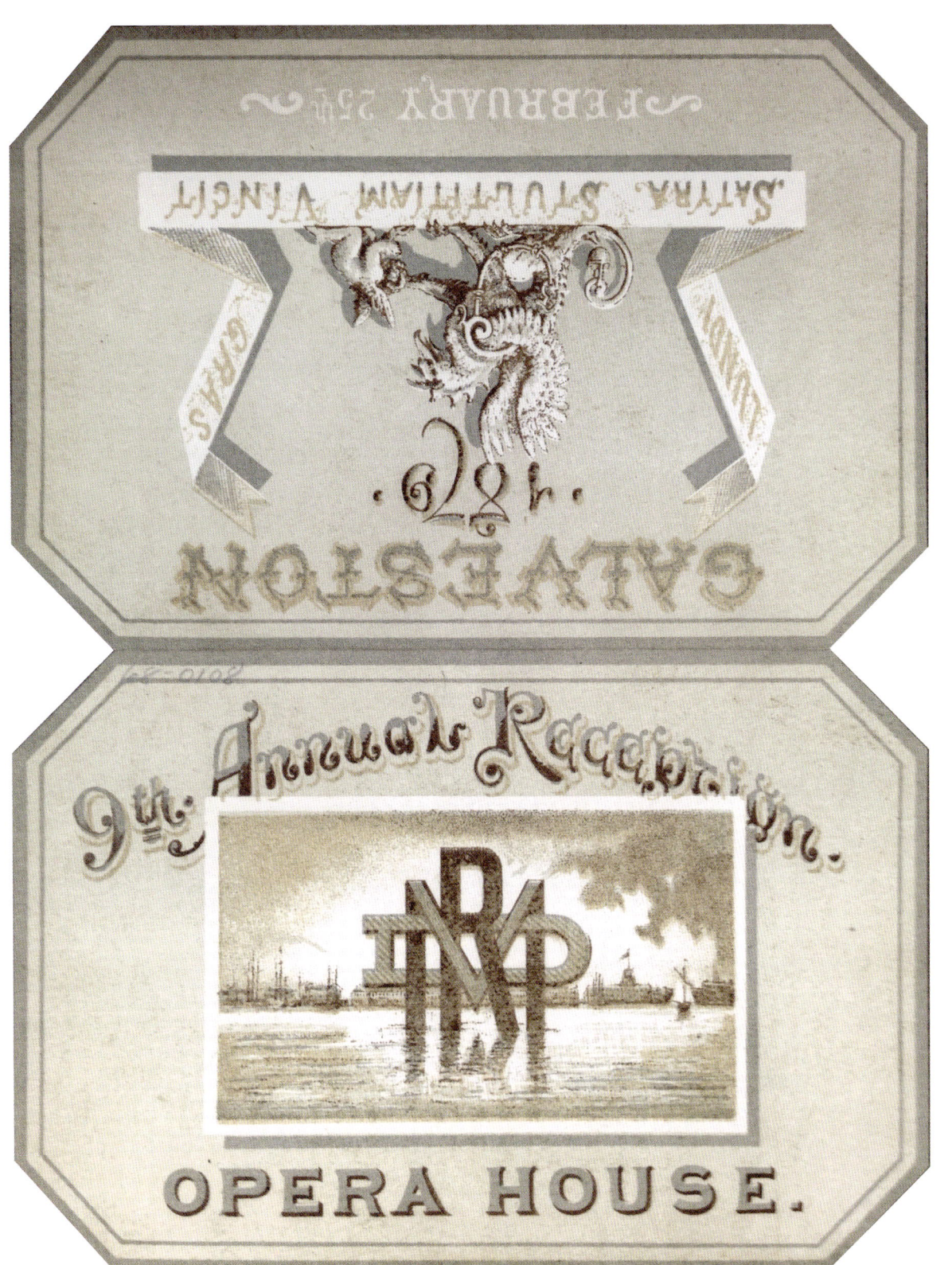

FIGURE 7.31 James Henry Moser (attrib.), *Knights of Momus* (verso), 1879.

"THE ENTERPRISE WAS NOT PROPERLY APPRECIATED"

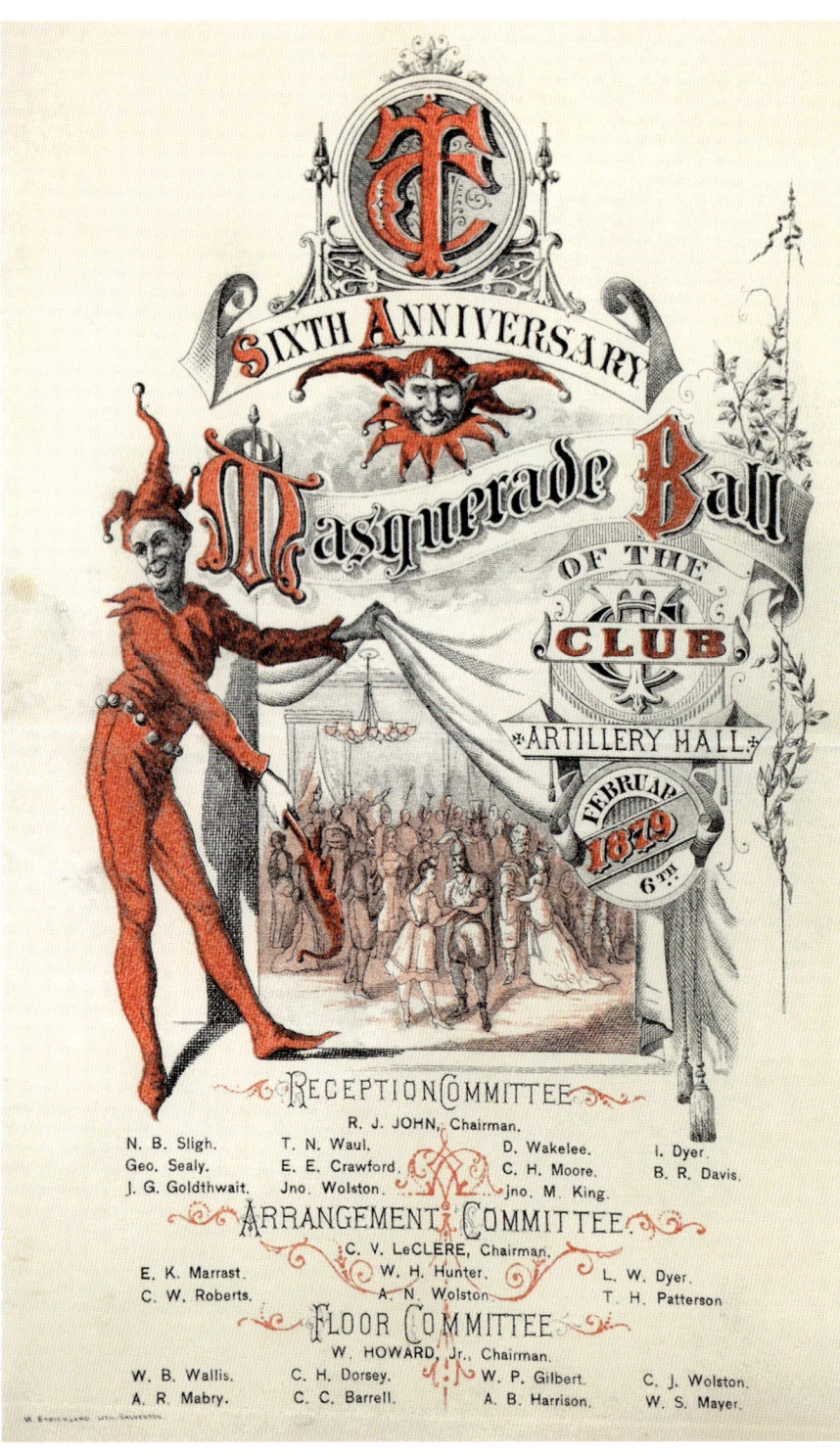

FIGURE 7.32 Unknown artist, *TC Sixth Anniversary Masquerade Ball*, 1879. Invitation. Chromolithograph, 7.31 × 4.36 in., by M. Strickland, Lith. Courtesy Galveston and Texas History Center, Rosenberg Library.

in design, and, when unfolded, open[s] up to the gaze all the delicious fancies of fabled Atlantis." At the top of the invitation is a bust of Pallas, surrounded by "emblems of wisdom, poetry, music and song." A heavy crimson curtain drapes down either side of the card, revealing the "queen of fairy land attired in variegated robes, while behind her dance a number of imps of fun." Behind them the setting sun "throws a gorgeous luster over a valley of full blooming plenty." In case the viewer did not get the point, the back of the invitation displays a view of Galveston harbor (fig. 7.31). The invitations were passed out simultaneously in Galveston, Houston, San Antonio, and Austin.[43] The scene became even more memorable for all who were present at the Opera House on opening night as the players presented "a faithful production of the scene lithographed on the lower half of the invitation cards."[44]

Strickland also printed the *Royal Messenger*, "a lithographed sheet, printed for the Mardi Gras parade," and the invitation to the T.C. Club's sixth anniversary masquerade ball at the Artillery Hall that year (fig. 7.32). The *News* reporter described it as a "tasty lithograph of black, surmounted by crimson, the foreground representing the imp of fun raising a curtain beneath which the gay masqueraders are engaged in the pleasure of the dance." Masquerade balls were common throughout Texas during these years, and the newspapers are littered with announcements and comments about them. But apparently there were some who did not like them. The *News* reporter also noted that the "natural prejudice which exists among many against the masquerade has been a matter of serious consideration with the management of the club" and added that the committee had adopted rules to meet "all objections." Those wearing masks were instructed to enter on Avenue I, while the unmasked were to enter on Twenty-second Street, "where they will meet with due attention from the reception committee."[45]

Strickland's invitations for 1880 were more subdued (fig. 7.33), but in 1881 he returned to full chromolithographic exuberance (fig. 7.34). Momus is shown on his throne, surrounded by his court. In the foreground, an artist dressed as a jester sits at the lower right with his paint palette and tube of paint as he, no doubt, prepares to

(LEFT) FIGURE 7.33 Unknown artist, *Tenth Anniversary Knights of Momus Artillery Hall*, 1880. Invitation. Chromolithograph, 9 × 2.75 in., by M. Strickland, Lith. Courtesy Galveston and Texas History Center, Rosenberg Library. (RIGHT) FIGURE 7.34 Unknown artist, *Knights of Momus 11th Anniversary, Opera House*, 1881. Invitation. Chromolithograph, 8.38 × 6.31 in., by M. Strickland & Co. Lith. Courtesy Galveston and Texas History Center, Rosenberg Library.

"THE ENTERPRISE WAS NOT PROPERLY APPRECIATED" | 293

FIGURE 7.35 John Henry Moser (monogram, lower left corner), *Revelers of Naxos Mardi Gras*, 1882. Invitation. Chromolithograph, 6.38 × 5.19 in., by M. Strickland, Lith. Courtesy Galveston and Texas History Center, Rosenberg Library.

document the festivities. In 1882 Strickland printed, in subtle light blue, pink, and black, an invitation for the Revelers of Naxos depicting the subject of the Revelers' float—the annual return of Bacchus and Ariadne, his wife, to Naxos, one of the Greek islands (fig. 7.35). According to legend, Ariadne's return "dispelled the gloom of winter's snows" and heralded the return of spring. The artist John Henry Moser pictured Bacchus and Ariadne seated in a golden vessel with a blue silk sail and pulled by two swans, her golden crown ascended above them into the stars. The float, according to the *News* correspondent, was "an imitation of the beautiful design which is pictured on the invitation cards."[46] Also that year, the Knights of Momus spoofed the Revelers of Naxos theme of the arrival of Bacchus and Ariadne, which they reenacted on their float (fig. 7.36). Their invitation shows Momus, instead of the royal pair, being escorted

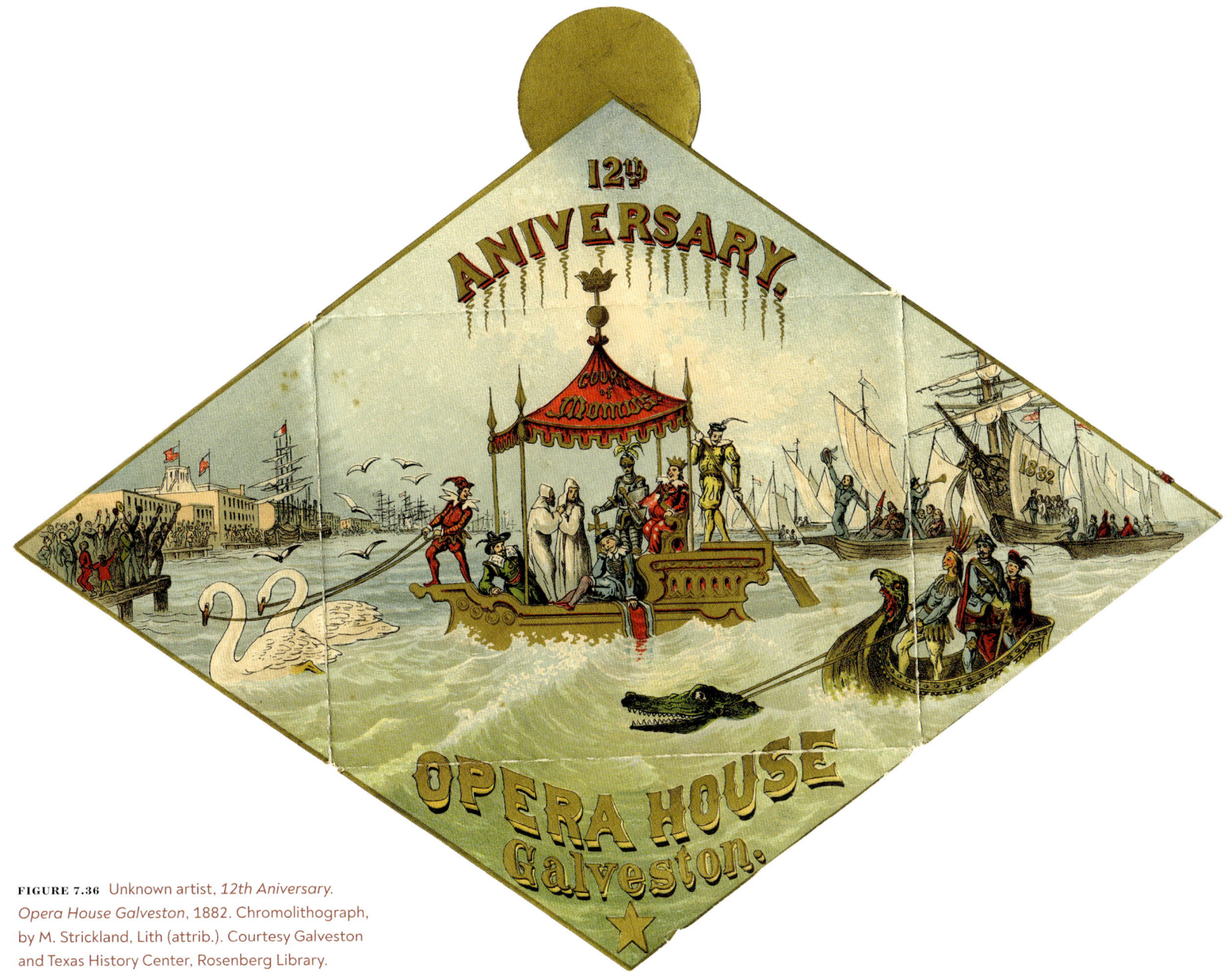

FIGURE 7.36 Unknown artist, *12th Aniversary. Opera House Galveston*, 1882. Chromolithograph, by M. Strickland, Lith (attrib.). Courtesy Galveston and Texas History Center, Rosenberg Library.

FIGURE 7.37 Unknown artist, *Galveston's Grand Mardi-Gras and Inter-State Trades Display Feb. 5th to 10th Inclusive 1891*. Invitation. Chromolithograph, 5.5 × 3.75 in., by Geo. S. Harris & Sons, Lith. Phila. Courtesy Galveston and Texas History Center, Rosenberg Library.

FIGURE 7.38 *Galveston's Grand Mardi-Gras and Inter-State Trades Display*, 1891, with the verso showing through the card. Invitation. Courtesy Galveston and Texas History Center, Rosenberg Library.

to the city in a golden vessel pulled by two swans and accompanied by members of his court. Again, no lithographer or artist is identified.

As Galveston leaders pushed for regional hegemony, the 1891 Mardi Gras celebration shared equal billing with the Inter-State Trades Display, and the invitations were combined with promotion of the port of Galveston and the Deep Water Jubilee. Galveston artist W. A. Caskie depicted "Uncle Sam" standing on the mainland with the White House at his heels, tipping his hat to Galveston harbor (fig. 7.37).[47] Printed in reverse on the back of the card is a drawing of a sack of money (labeled "$6,200,000") beside a circle inscribed "Keep your eye on Galveston $6,200,000 for Deep Water," with the word "eye" represented by the drawing of an eye. Instructions at the bottom of the card invited the viewer to hold the card up to the light. The drawing in reverse on the back of the card shows through the card, which makes it appear that Uncle Sam is presenting the sack of money to Galveston (fig. 7.38). The K.O.M. invitations focused on the port that year as well, with one cut in the shape of a sunburst with ships at its center and the hinterland states named on each of the extending rays (fig. 7.39). When folded, one side shows a garden party with the caption "Fruits and Flowers the Year Round." The other side shows a beach scene and is captioned "Deep Water Jubilee."[48]

Of course, Strickland printed more than just Mardi Gras invitations. His routine lithographic work probably consisted of advertisements, forms, and letterheads, enhanced from time to time with more challenging jobs, such as the Galveston city directory (fig. 7.40).[49] One of his handsomest works was a Galveston Cotton Exchange bond, another collaboration with Moser during his short stay in the city (see fig. 7.45B). Moser provided detailed drawings of the Galveston wharf, the Cotton Exchange Building, which his father had designed, and scrollwork and details, such as a bale of cotton with what appears to be a crown on it.[50]

FIGURE 7.39 Unknown artist, *His Most Royal Highness Momus*, 1891. Invitation. Chromolithograph, 6 × 4 in. folded, 9.25 × 9.25 in. when opened flat, designed by W. P. Pinkston of Pinkston, Paust & Co., St. Louis, and printed by an unnamed Baltimore lithographer. Courtesy DeGolyer Library, Southern Methodist University.

One of the company's handsome letterheads featured Sour Lake, a locally well-known spa in Hardin County about twenty miles west of Beaumont, where John Warren made use of the mineral springs and pitch that had once attracted Sam Houston to "take the waters" to revive its popularity (fig. 7.41).[51]

"THE ENTERPRISE WAS NOT PROPERLY APPRECIATED"

FIGURE 7.40 Strickland's ad in the Galveston City Directory, 1882. Courtesy Galveston and Texas History Center, Rosenberg Library.

FIGURE 7.41 Unknown artist, "Near Sour Lake Station on T.U&R.O.R.R., 63 Miles East of Houston" [Stationary for the Sour Lake Hotel], 1880s. Letter sheet. Lithograph. Courtesy Dorothy Sloan–Books.

Strickland did another letterhead for famed cattleman Abel Head (Shanghai) Pierce. Almost twenty years old when he stowed away on a Texas-bound schooner, Pierce quickly got into the cattle business, and by the time this letter was written, his Rancho Grande made him one of the largest landowners in the state (fig. 7.42). The 1881 two-color lithograph of the new Nicholas J. Clayton–designed Galveston Pavilion is one of Strickland's more ambitious undertakings. Printed as an insert for the short-lived Galveston-based *Texas Journal of Commerce*, the illustration was part of the celebration of the Thirteenth Texas Saengerfest (fig. 7.43). Col. W. H. Sinclair, president of the Galveston City Railway Co., built the picturesque structure, which featured complex, polychromatic details on the façade, to host the Saengerfest, then converted it into a public casino to attract traffic for his streetcar line. A correspondent for the *Dallas Herald* described it as an "immense building" with "electric lights [that] shone with the splendor of noon day." The writer for the *Blanco Star-Vindicator* got carried away, calling it a "magnificent edifice" with an "inimitable view of the blue waters of the Mexico sea, and the glorious beach, so like the lovely vale of flowery Cashmere [Kashmir]."[52] A month before the event, and before the building had been completed, Strickland copied one of Clayton's architectural drawings and added a green tint in the sky. The *Journal* editors boasted that "our picture will be found true to the realities of the building," and the *Colorado Citizen* in Columbus agreed that the print "reflects much credit" on the Strickland firm.[53] The Stricklands might also have printed a slightly different version of the pavilion for the *Sunday Opera Glass* when the building burned in 1883, but no credit is given for the image.[54] In 1881 Strickland advertised his growing prowess with lithographic images (fig. 7.44), announcing in the *Dallas Herald* that he could reproduce anything from "a carte de visite to a mammoth poster, and ... lithograph anything from the tiniest rosebud to a landscape view of Texas."[55]

FIGURE 7.42 Unknown artist, "A. H. & J. E. Pierce Stock Raisers Cattle Dealers," 1884. Letter sheet. Lithograph, 15 cm × 24 cm (sheet), by M. Strickland. Courtesy Briscoe Center for American History, UT Austin.

FIGURE 7.43 After Nicholas J. Clayton, *Thirteenth Texas Saenger Fest, Galveston, April 18th, 19th, 20, 21st, 22d and 23d, 1881. View of Saenger Hall.* Supplement to the *Texas Journal of Commerce*, March 19, 1881. Tinted Lithograph, 25 × 29.75 in. Printed by M. Strickland & Co. Steam Lithographers, Galveston. Courtesy Briscoe Center for American History, UT Austin.

FIGURE 7.44 M. Strickland & Co. ad in Andres Morrison, *The Industries of Dallas* (1887). Printed by Strickland and Co. Courtesy DeGolyer Library, Southern Methodist University.

FIGURE 7.45A AND FIGURE 7.45B
M. Strickland lithographic stone, 10 (height) × 14 (width) × 3 (depth) in., showing (in reverse) the images for printing bonds for the Galveston Cotton Exchange, c. 1890. Courtesy Galveston and Texas History Center, Rosenberg Library, gift of Clarke & Courts Printing Co. On the bottom is the finished impression from the Clarke & Courts specimen books, but the stone is signed by J. H. Moser, artist, and M. Strickland, lithographer. From the private collection of Ben and Christine Andrews. Clarke & Courts acquired the remnants of the Strickland company.

"THE MOST USEFUL AND EXPENSIVE OF ALL THE LIMESTONES"[56]

The growing popularity of lithography made entrepreneurs, even in Texas, aware of another important source of wealth—lithographic stones (figs. 7.45A and 7.45B). As soon they realized that lithography was dependent on the smooth, high-quality stones from the Solenhofen quarries in Bavaria where Senefelder had obtained his, prospectors began to search North America for similar stones along with other geological treasures. In 1845 a geologist with the Canadian Geological Survey reported that he had discovered a "great bed of lithographic stone" in Canada; an English geologist named J. L. Tait reported in 1876 that he had found lithographic-quality stones in three different places along the railroad line east of San Antonio; and the *San Saba News* published a lengthy description of the local limestone in 1880 with special attention to some deposits that the writer thought would be suitable for lithography. The writer explained:

> Lithographic stone . . . the most useful and expensive of all the limestones . . . is sold by the pound, and, like the diamond, its value increases with the increase of its size. From it all lithographic pictures, and all chromos are printed, as well as most of the ornamental blanks, bill heads, maps, etc., etc. Most of the lithographic stone used in the United States is shipped from Europe. It is very rarely found sufficiently free from impurities to work well. The entire mass must be perfectly homogeneous—the least imperfection would spoil the picture. The material for the finest quality has been deposited all over this country in immense quantities, but with very rare exceptions, it has been accompanied with impurities sufficient to destroy its qualities for lithographic purposes. The writer, after years of diligent search, has found in a single locality a limited quantity of lithographic stone of superior quality.[57]

Texas stones were included in the state's exhibit at the World Industrial & Cotton Centennial Exposition in New Orleans in 1885, and, in perhaps the most credible report, the controversial geologist and cartographer Anton R. Roessler claimed that same year to have found in Llano County northwest of Austin "specimens of limestone that present all the appearance and properties of the lithographic stone quarried near Solenhofen, Germany." Texas Spring Palace officials included some of the stones in the exhibit in the "karporamic car" that they sent to different fairs and exhibitions around the country in 1889.[58]

But the most excitement regarding lithographic-quality stones focused on Burnet, near where the stone for the new capitol was quarried. Rancher Harry Peyton, just west of Llano, sent seven stones to Philadelphia, the Smithsonian Institution, and Chicago lithographers for analysis in 1886, and at least one lithographic firm responded that the Burnet stone "ranked with the finest in the world." A man calling himself "Lithograph" Hill reported to the *Austin Weekly Statesman* that he had fifteen men at work in his quarry. "Should this stone prove to be first-class, Mr. Peyton has a fortune secured," the editor reported. Entrepreneurs organized the Texas Lithographic Stone Co. in Burnet to supply the anticipated demand, and others reported "beds of the finest lithographic stones" at Marble Falls. The following year the Dallas Lithograph Co. experimented with the Burnet stone and reported that the results "prove the native stone to be as good as high-priced imported stone for that fine art work." University of Texas geology professor Frederic W. Simonds included reports of lithographic stone in his bibliographic summary for 1896, and state newspapers still held out the possibility that Texas would soon be a major supplier. Had the reports been accurate, the Texas limestone industry would have been even more important; it surely would have given lithography in the state a boost as well.[59]

"THE ONLY LITHOGRAPHIC ESTABLISHMENT IN GALVESTON"[60]

Miles Strickland died of smallpox on March 13, 1882, at the age of forty-four—"in the heyday of his life"—leaving the business to his wife and six sons. The *St. Louis Daily Globe-Democrat* reported that he had contracted smallpox while on a visit to New Orleans. After the smallpox quarantine had expired the following month, a crowd estimated at one thousand gathered on the Strand and marched to Artillery Hall for the "Scottish Rite service . . . of the most imposing character."[61]

Strickland's widow and the firm's manager, Richard E. Koehler, joined with the eldest sons to continue the business, printing the *Texas Midland Review*, a promotional journal that the Gulf, Colorado & Santa Fe Railroad began issuing in 1881; the publication was unusual because, according to the *Brenham Daily Banner*, it

FIGURE 7.46 Louis Glaser, *Clarke & Courts, 66, 68, 70 & 72 Tremont St.*, 1885. Lithograph (detail), 5.8 × 3.7 cm. From *Galveston. Texas* (1885). Courtesy Special Collections, University of Texas at Arlington Libraries. The original Clarke & Courts Building.

was the "first wholly lithographed paper ever printed in Texas." Initially under the editorship of the well-traveled journalist William M. Edwardy, the *Review* was a "spicy little sheet" in a six-column format full of "intelligible and reliable" information, according to the *Galveston Daily News*, "a model of typography or rather of lithography," that received high praise from the state press. The *Dallas Weekly Herald* called it "one of the neatest sheets in the country."[62] Meanwhile, W. H. Coyle had opened a lithographic department in his Houston company in 1880, so the Strickland family changed their advertising claim to M. Strickland & Co., "the Only Lithographic Establishment in Galveston."[63]

Nor did that claim stand for long: several of the talented lithographers that Strickland had brought to Galveston established their own shops. Theodore Pohlmann, a German immigrant who had been the foreman of Strickland's lithographic department, started his own business on the Strand in 1878 before moving on to a notable career in New Orleans, Chicago, and San Francisco.[64] But the main competition came in 1879, when Robert Clarke, who had partnered with Strickland for a short time, joined with George M. Courts, a veteran of the printing and stationery business and formerly with the Thompson Drug Co., to form Clarke & Courts, a printer, stationer, and blank book manufacturer. In place of Strickland's "Big Book" as an advertising symbol, they exhibited a "Big Pencil [fig. 7.46]."[65] They added a lithographic department in late 1884.

Using traveling salesmen and the railroad network to market their products throughout Texas, they soon reached into bordering states as well as into Cuba and Mexico and grew rapidly to become one of the largest printing companies in the South.[66] The recent discovery of the company's printing archive makes clear that Clarke & Courts depended on routine printing for most of their business, such as the letterheads for Winkelmann & Bohne's general merchandise store in Brenham and for cattleman L. H. Ward (figs. 7.47 and 7.48). The specimen books include material printed for companies and individuals throughout Texas and from New Mexico and Arizona to Louisiana and Mississippi, to Mexico to Cuba (fig. 7.49). Stock images include trains, cotton bales, steer heads and longhorns, design elements, bicycles, various products (such as hats, saddles, ammunition, and soap and lard), portraits of historical figures, a cowboy, company logos, many building views in Galveston and other cities, ships, allegorical figures, and much more. Each image bears a number that apparently related to the stone in the company's inventory, and sometimes a note explains the stone's condition (e.g., "broken").

(RIGHT) **FIGURE 7.48** Unknown artist, "L. H. Ward Stock Raiser and Cattle Dealer," 1893. Letterhead. Lithograph, 27.9 × 21.5 cm (sheet), by Clarke & Courts. Courtesy Briscoe Center for American History, University of Texas at Austin.

(BELOW) **FIGURE 7.47** Unknown artist, "Winkelmann & Bohne, Brenham, Texas," c. 1890. Letterhead. Lithograph by Clarke & Courts, Galveston. Courtesy Dorothy Sloan–Books. See *Brenham Weekly Banner*, Feb. 13, 1890, 7, for their advertising.

"THE ENTERPRISE WAS NOT PROPERLY APPRECIATED" | 305

FIGURE 7.49 Unknown artist, "Clarke y Courts Libros en Blanco, Impresores Litografos," c. 1890. Lithograph of a Spanish-language ad from the Clarke & Courts specimen book. Clarke & Courts had customers in Mexico, Central America, and Cuba. From the private collection of Ben and Christine Andrews.

Clarke & Courts's growing prowess can be seen in their cover for the official program of the 1886 Interstate Drill and Encampment held in Galveston (fig. 7.50). Impressive as well is their back-cover image of the *Texas Medical College and Hospital Galveston, Texas. Announcement of Re-Opening Session of 1888–89* (1888), which features the yet-to-be-built John Sealey Hospital (fig. 7.51).[67] And their technical expertise can be judged by the letterhead they printed for the Channing Mercantile & Banking Co., in the Panhandle northwest of Amarillo, in which they improved upon the picture of the cowboy roping a Longhorn on the Clark's O.N.T. Spool Cotton trading card (fig. 7.52; see also fig. 8.19).

As the company grew, the employees joined in community outreach by participating in the 1889 semicentennial of Galveston's founding. Despite rain that ruined their display the day before the parade, the employees managed to repair the large float on which "knights of the art preservative plied their trade," and passed out pictures of the float "printed on a press on the float as it rolled along."[68] By 1890 Clarke & Courts employed between seventy-five and one hundred persons and moved into their own new Clayton-designed five-story office, plant, and warehouse building on Mechanic Street in Galveston, which became known as the Texas House. They actually registered a trademark on their depiction of the Lone Star flag, which was included in their new ads (fig. 7.53).[69] The building, planned more for function than beauty, was the tallest building in Galveston until 1900 and has now been converted into apartments (fig. 7.54).[70]

FIGURE 7.50 Cover of *Official Souvenir Interstate Drill and Encampment. Galveston. Tex. Aug. 5th to 10th Inclusive 1886*. Program. Chromolithograph by Clarke & Courts. Published by Donnaud & Bryan. Courtesy Daughters of the Republic of Texas Library, San Antonio.

"THE ENTERPRISE WAS NOT PROPERLY APPRECIATED"

FIGURE 7.51 Nicolas J. Clayton, Architect, *John Sealy Hospital. Faculty of College and Medical and Surgical Staff*, 1888. Lithograph, 24 cm high, by Clarke & Courts. Back cover of *Texas Medical College and Hospital Galveston* (1888). Courtesy Truman G. Blocker, Jr. History of Medicine Collections, Moody Medical Library, University of Texas Medical Branch, Galveston.

FIGURE 7.52 Unknown artist, [Cowboy roping a Longhorn], "Channing Mercantile & Banking Company, Wholesale and Retail General Merchandise and Banking," 1898. Letterhead. Lithograph by Clarke & Courts. Courtesy XIT Ranch Records, Panhandle-Plains Historical Museum Research Center, Canyon, Texas.

FIGURE 7.53 Ad for the "Texas House Clarke & Courts—Stationers Printers Lithographers Electrotypers & Blank Book Manufacturers . . . Tremont St., Galveston, Texas," 1890. Lithograph, octavo. From *Morrison & Fourmy's General Directory of Waco, 1890–91*, 1. Courtesy Texas Collection, Baylor University.

FIGURE 7.54 A page from the recently discovered sample books from Clarke & Courts, c. 1900. From the private collection of Ben and Christine Andrews. Each image is numbered as a part of the company's cataloging system; the numbers correspond to lithographic stones in their inventory. The samples have been pasted into large ledger books.

"THE ENTERPRISE WAS NOT PROPERLY APPRECIATED" | 309

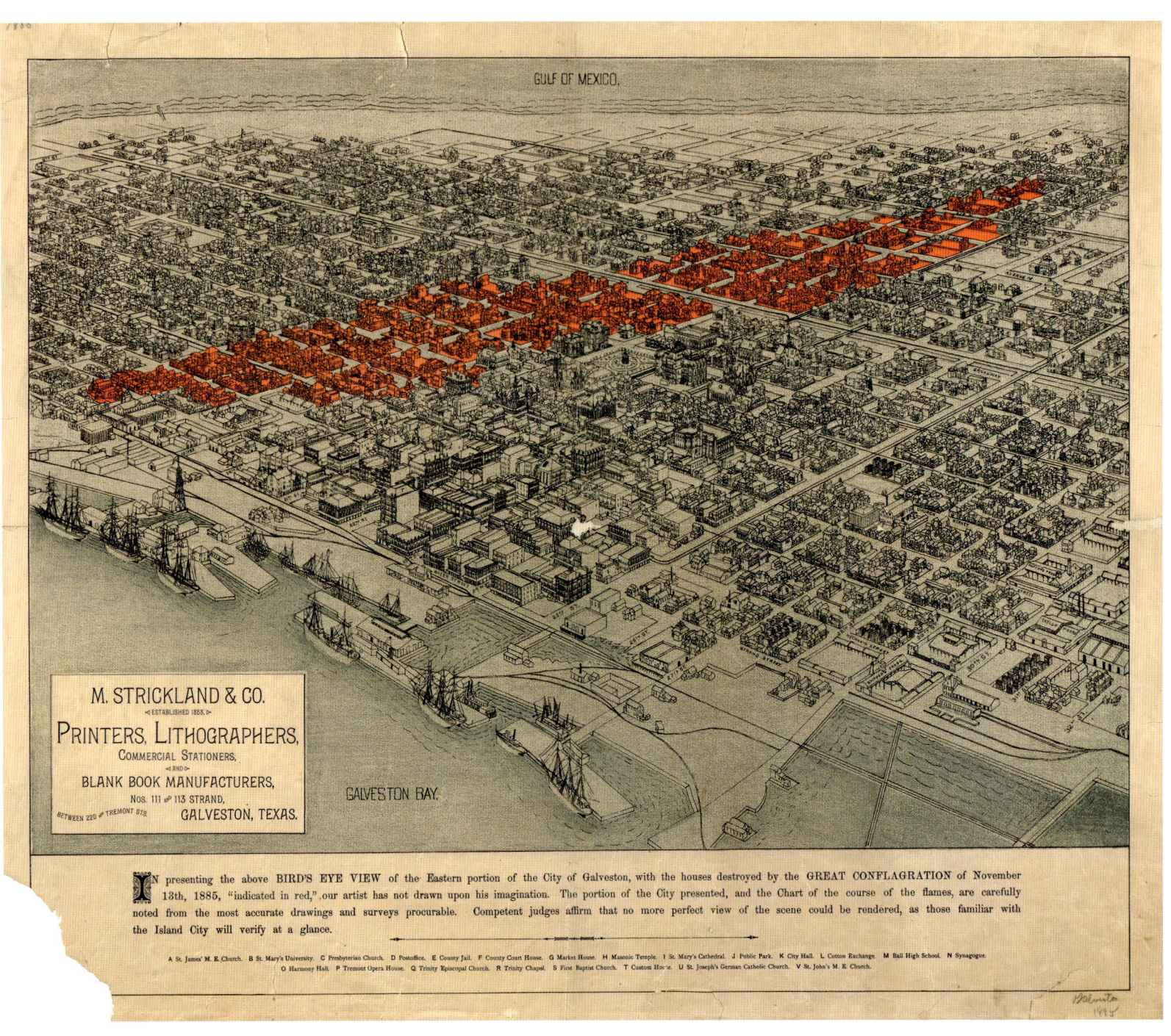

FIGURE 7.55 John Strickland (attrib.) after Augustus Koch, *Bird's Eye View of the Eastern Portion of the City of Galveston, with the homes destroyed by the Great Conflagration of November 13th, 1885*, 1885. Single sheet. Toned lithograph, 47 × 60.5 cm. Printed by M. Strickland & Co., 111 and 113 Strand, Galveston. Courtesy Briscoe Center for American History, UT Austin.

The fire of 1885 gave the lithographers a chance to show their talent as well as provide context for the news of the day and a memento of the disaster. According to contemporary newspaper accounts, the fire began in the rear of a foundry in the early morning hours of November 13 and spread over a fifty-two-block area, destroying many homes, including those of Mrs. Strickland and music store owner Thomas Goggan.[71] The following month Strickland & Co. copied from the bird's-eye view of the city that artist Augustus Koch had just delivered to create their own view showing the burned district (fig. 7.55). The print shows Galveston from the northwest, after Koch, but the Stricklands included a large swath of red that stretches from the left-center across the island toward the Gulf to indicate the path of the fire. If any particular individual were to be credited with the design of the image (other than Koch), it would probably be John Strickland, Miles's son, who is listed in the Galveston City Director for 1886–1887 as the company's "chief litho-engraver." Clarke & Courts also issued a less ambitious print to show the path of the fire, but it was only an outline map of a number of blocks with the path of the fire indicated by the red ink covering them, which music publisher Thomas Goggan used in his much more dramatic scene on the cover of his sheet music, "The Galveston Fire of 85 [fig. 7.56]." The *Galveston Daily News* reporter concluded that Strickland's print provided "a stranger . . . a better idea of the extent of the late fire than from any other map yet published."[72]

Goggan had established his business in Galveston in 1866 when he brought a large

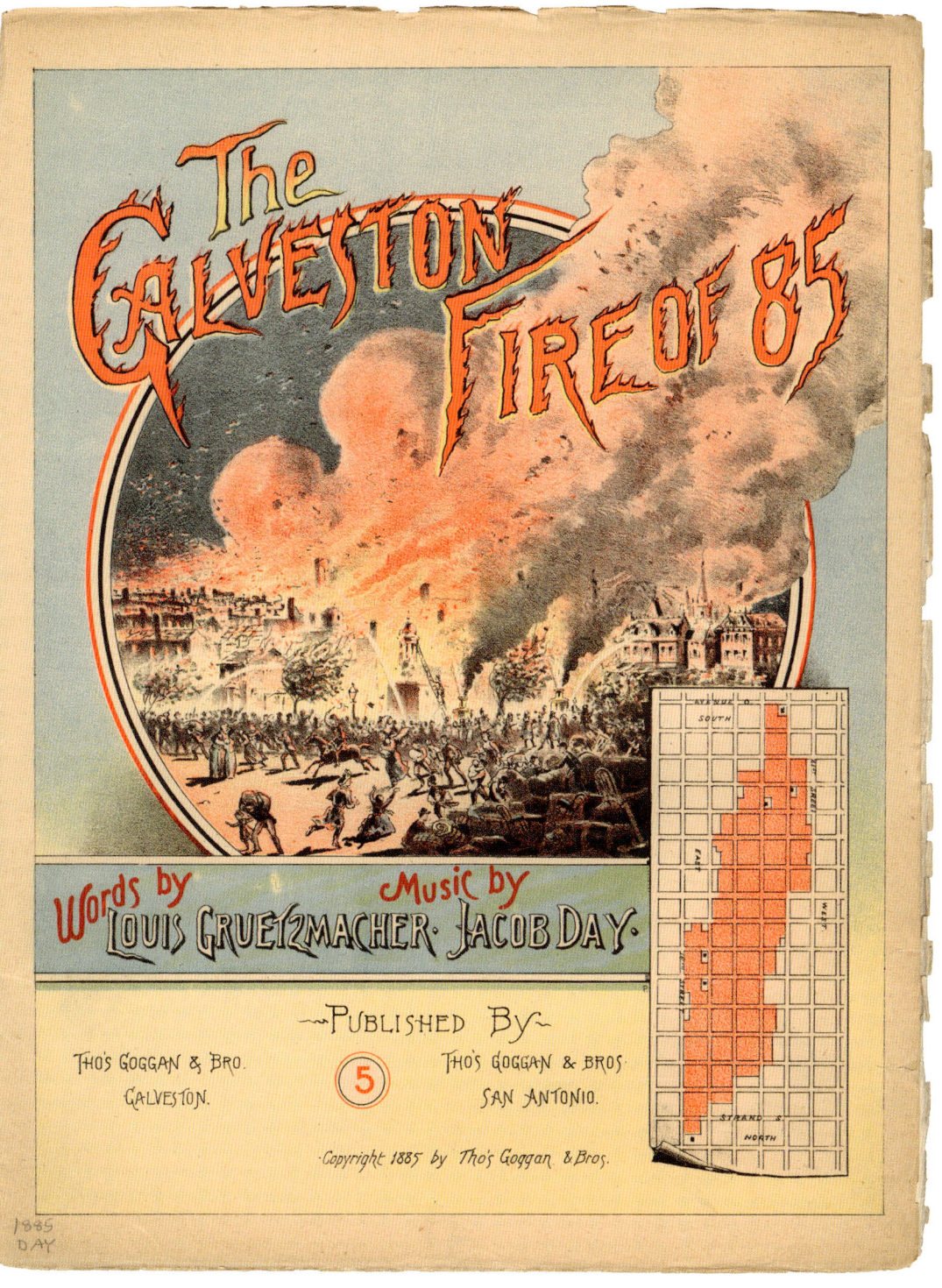

FIGURE 7.56 Unknown artist, "The Galveston Fire of 85," 1885. Sheet music. Chromolithograph, 35 cm high. Published by Tho. Goggan and Bro., Galveston. Words by Louis Gruetzmacher. Music by Jacob Day. Courtesy William L. Clements Library, University of Michigan, Ann Arbor.

"THE ENTERPRISE WAS NOT PROPERLY APPRECIATED"

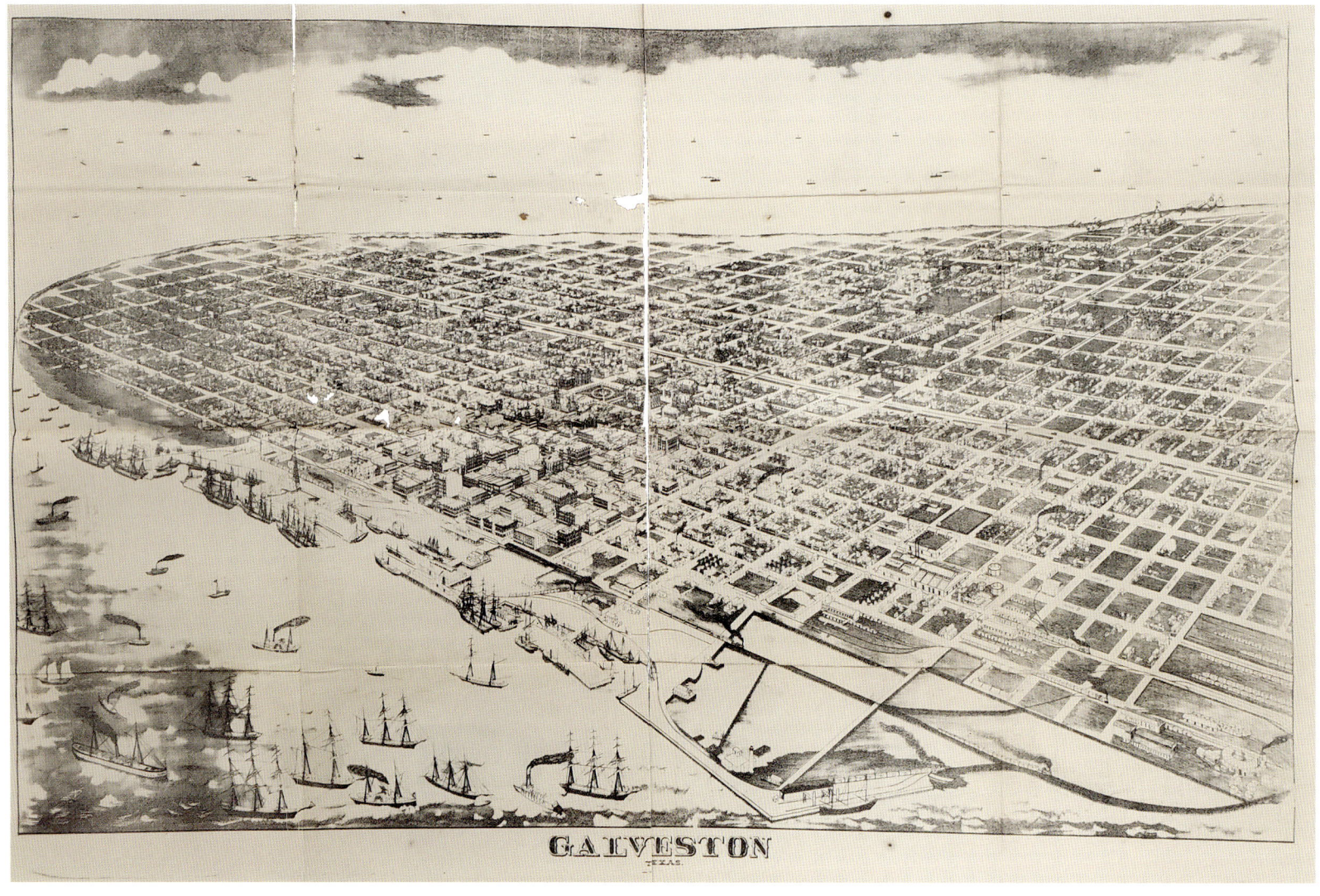

FIGURE 7.57 Unknown artist after Augustus Koch, *Galveston Texas*, 1886. Single sheet. Lithograph, 30 × 44 in., by the *Opera Glass* (Galveston), August 4, 1886. Courtesy Galveston and Texas History Center, Rosenberg Library.

stock of musical instruments from Cincinnati and opened his store. Despite having received advice that in Texas he would do better if he dealt in "Bowie knives, guns, pistols and ammunition," Goggan persisted, and his music business flourished. He established branches in other parts of the state and shipped pianos and other musical instruments by ox team and rail to points as far away as Amarillo and El Paso. His two brothers, John and Mike, joined him in the business, and Mike took over the San Antonio store. Among the sheet music published by the Goggans were several items with interesting cover sheets illustrating events or themes related to Texas, including "The Texas Cowboy," 1886 (fig. 8.38); "Texas State Capitol Grand Waltz," 1888 (fig. 8.34); "The Pirate Isle No More—Semi-Centennial Grand March," 1889 (fig. 8.35); "White Squadron Grand March," 1891 (fig. 8.36); and "The Jetties March and Two-Step," 1898.[73] His colorful cover for "The Galveston Fire of 85" was probably an attempt to capture some of the panic that frantic citizens must have experienced as they fled "the disaster which shook the Island City to its base."[74]

The city gained a third lithographer in 1885 when the *Sunday Opera Glass*, a weekly entertainment newspaper, produced a special edition to welcome the Interstate Drill competition to the city. Begun

in 1879 as an illustrated newspaper dealing with the arts and culture, the *Opera Glass* enjoyed a reputation as a "sprightly paper" that focused primarily on Galveston but also carried news from around the state. It had published an illustrated view of Galveston in June 1882 and a large print of the Galveston Pavilion on August 5, 1883, commemorating the fiery destruction of that building.[75] Its special edition of August 4, 1886, included a 30 × 44-inch lithographic bird's-eye view of the city, which also was pirated from Augustus Koch's view of that same year (fig. 7.57). The *Opera Glass* editor offered the view for five cents a copy and claimed to have sold 25,000 copies by August 7.[76]

Another person who apparently dabbled with lithography in Galveston was E. E. Scherrer of Scherrer's Business College. An expert in calligraphy, he served as a professor of penmanship at St. Mary's University, the first Catholic seminary and college in Texas, and established his business school in 1881. He advertised in the Galveston city directories and produced and apparently lithographed a complicated drawing of a religious message—*Our Father Who Art in Heaven, Hallowed Be Thy Name*—with fine scrollwork and elaborate lettering (fig. 7.58).[77]

In 1890 Theodore G. Rousseau, a former salesman for Clarke & Courts who had also been with T. Fitzwilliam in New Orleans, began

FIGURE 7.58 E. E. Scherrer, *Our Father Who Art in Heaven*, 1881. Lithograph, 8.5 × 14 in., by E. E. Scherrer, Scherrer's Business College, Heidenheimer's Building, Galveston. Courtesy Briscoe Center for American History, UT Austin.

FIGURE 7.59 "To Cotton Men. The Rousseau Company." Ad in the *Galveston Daily News*, Dec. 4, 1890, p. 2, cols. 5–6.

another stationery and printing firm, leading the *Galveston Daily News* to speculate that, despite Clarke & Courts's dominance, "it has left room for the recent establishment of a new house in the same line of business," which was "turning out most artistic work in ball and wedding invitations from stone and copper plates, also bank and merchant's outfits." The Rousseau Co. advertised as "lithographers and paper dealers," but in April 1891, after less than a year in business, it announced that it was in financial trouble and named a trustee to liquidate the business (fig. 7.59).[78]

LITHOGRAPHY COMES TO HOUSTON

Another colleague of A. C. Gray's, William H. Coyle, introduced lithography to Houston in 1880. Coyle, who seemed to be a ubiquitous personality in late nineteenth-century Houston, served as a member of the fire department (elected chief for several years), belonged to several service and fraternal organizations, and was active in politics (fig. 7.60). He was born in Louisville, Kentucky, and lived there until the late 1860s, when he moved to Houston to work as foreman and later superintendent of Gray's printing establishment. He was listed in *Murray's Houston Directory, 1870–71* as "Coyre, W H bookbinder." In 1877 he began his own small business as a steam book and job printer, bookbinder, and blank book manufacturer and in 1880 won the contract to print Morrison & Fourmy's *General Directory of the City of Houston*.[79] Over the next

FIGURE 7.60 Unknown photographer, Ex-Chief W. H. Coyle. Halftone, 12.6 × 10 cm, by Dealy-Adey Co., Houston. From Charles D. Green, *Firefighters of Houston* (1915), 28. Courtesy Special Collections, University of Texas at Arlington Libraries.

few years his business expanded and occupied several locations in the city. A correspondent for the *American Stationer* reported in 1884 that "W. H. Coyle is the giant in the commercial stationery, print and lithographing trade" in Houston "and is perhaps the most enterprising man in the trade in Texas." In that same year, Coyle won the bid to publish the official souvenir for the Grand Inter-State Drill and Encampment held in Houston and produced an appropriate lithograph for the cover (fig. 7.61). In 1886 he also published a seven-color certificate of the Houston Light Guard in full uniform for the drill and encampment, but, unfortunately, no

FIGURE 7.61 Unknown artist, *Grand Inter-State Drill and Encampment, Houston, Texas* (cover), 1884. Chromolithograph, 15 × 10 cm, by W. H. Coyle, Houston. Courtesy Huntington Library, San Marino, CA.

(LEFT) FIGURE 7.62 W. H. Coyle ad in *Industries of Houston* (1887), 93. Courtesy Houston Public Library. In addition to the fancy lettering, the ad features Coyle's building in the center.

(BELOW) FIGURE 7.63 Unknown artist, "Houston East & West Texas R'y. Co.," 1886. Railroad pass. Lithograph by W. H. Coyle. Courtesy Houston East & West Texas Railway Co. Holabird Western Americana Collections (liveauctiongroup.com). An example of Coyle's printing for the railroads.

copy is known to have survived. By 1887 he had moved into a three-story building at 91 and 93 Franklin Street, which, according to an advertisement, was "built and arranged expressly with the view for the accommodation of a large printing establishment." Among other images, Coyle lithographed the cover of J. M. Elstner & Co.'s *The Industries of Houston: Her Relations as a Centre of Trade, Business Houses and Manufacturing Establishments* (1887) (fig. 7.62). When the *Houston Daily Herald* editorialized in favor of placing a statue of Sam Houston in the courthouse yard, Coyle lithographed a blotter with the image of the old hero atop the cotton exchange building.[80] Based on the surviving examples, Coyle (and most other lithographers in Texas) specialized in railroad work, book and commercial printing, and bills, letterheads, and checks with fancy escutcheons, cartouches, and other decorations, rather than the colorful Mardi Gras invitations that Strickland's artists created (figs. 7.63 and 7.64).

Another printer who started with A. C. Gray's firm in Houston and then went on to establish his own lithographic press as a part of a small but profitable company was Joseph J. Pastoriza (fig. 7.65). Pastoriza was born in New Orleans in 1857, orphaned, and then adopted, but he found himself on his own again when his adopted father and brother were killed in the Civil War. At the age of seventeen he started work in a foundry, later working as a printer for both Gray and W. H. Coyle. In his spare time he studied shorthand and bookkeeping and, in 1879, with $350 that he had saved working as manager of the *Houston Age*, the only daily newspaper in the city at the time, purchased a small printing plant and established Pastoriza & Brown with John H.

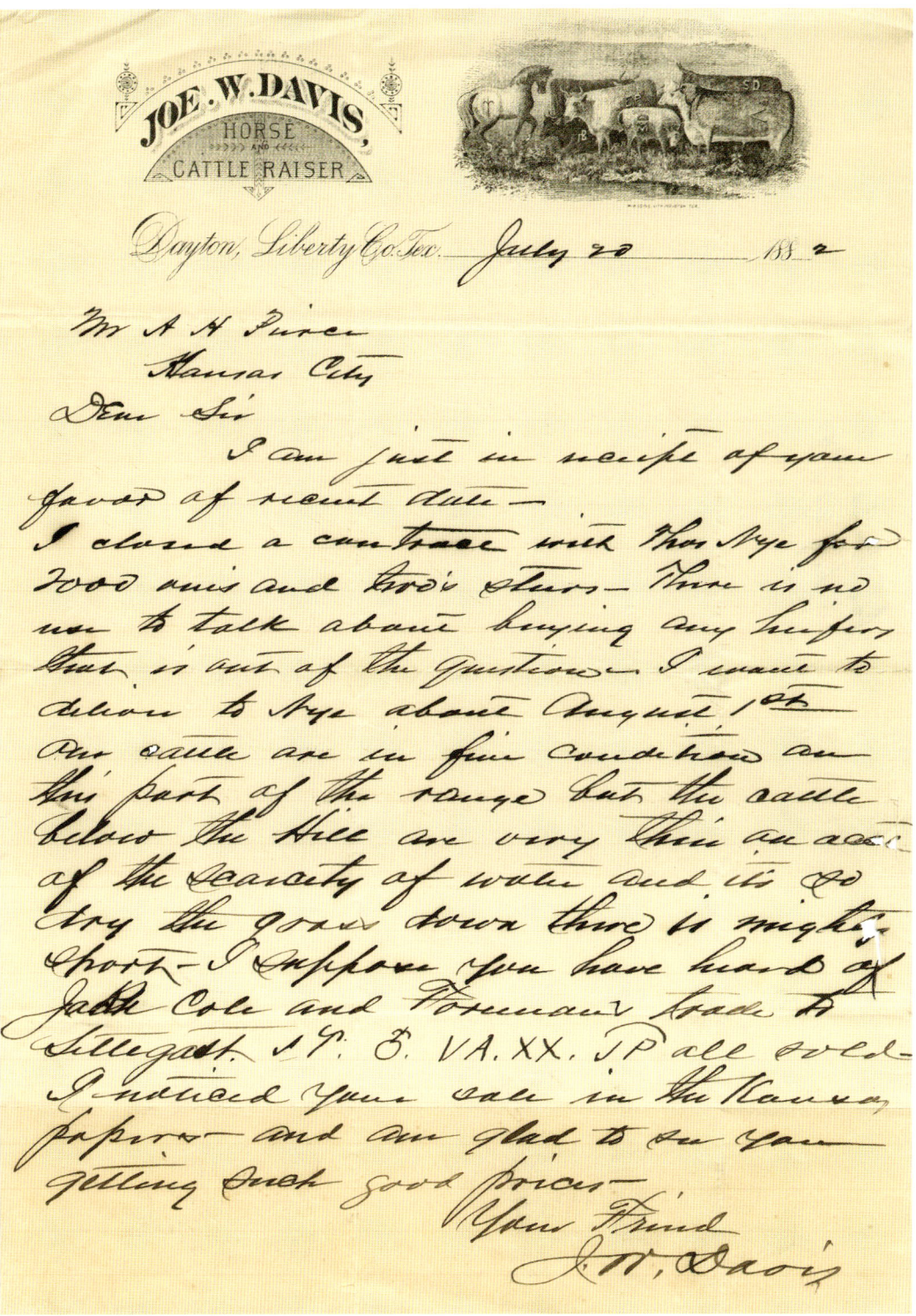

FIGURE 7.64 Unknown artist, "Joe W. Davis, Horse and Cattle Raiser," 1882. Letterhead. Lithograph, 30.2 × 21.7 cm (sheet), by W. H. Coyle. Courtesy Briscoe Center for American History, UT Austin.

Brown. By 1884 Pastoriza was on his own, calling the company simply J. J. Pastoriza. He had added lithography to his offerings by the time he chartered his company in August 1890 (fig. 7.66). Pastoriza continued successfully in business until 1907, when he sold his company and devoted his time to community service, serving as tax commissioner for several years and then as mayor of Houston in 1917.[81]

LITHOGRAPHY REVIVED IN DALLAS

The first lithographer in Dallas was Joseph Paul Henry of the utopian French settlement at nearby La Réunion, who printed Coho Smith's cartoon in 1861, but he found little demand for his talents until the Civil War began. He was conscripted into Confederate service and assigned to the Lancaster Pistol Factory in Texas as an engraver to assist in the production of Colt Dragoon pistols. The first successful lithographic company in the city was the Dallas Lithograph Co., organized in 1884 by Neal Starke, Isaac Mantoux, Jay Booker, and T. L. Townsend, which began modestly by acquiring Henry's lithographic press and stones that he had brought from France. They took a giant step in 1886 when they employed Bernard Gast of the prominent Gast lithographic company in St. Louis to take charge of the printing department (fig. 7.67). The company soon became noted for its "striking illustration[s]," such as a large, 20 × 30-inch lithograph of Reinhardt & Co. that was exhibited at the corner of Elm Street showing the proprietor "demolishing prices in clothing." (Unfortunately, no copies are known.) They also produced posters for the 1887 state fair, and Jay Booker was the artist for the handsome lithographic ads that appeared in the Dallas city directories. A reporter visiting the company's new two-story brick building at the corner of Akard and Commerce Streets in 1889 observed four lithographic presses operated by twenty-two employees, including two artists (one of whom had worked for *Puck*), four stone engravers, two wood engravers, a designer, and a crayon (or lithographic) artist. The company produced illustrations for the short-lived political paper *True Blue* (figs. 7.68 and 7.69), as well as colorful posters (figs. 7.70 and 7.71), job work and well-designed ads (figs. 7.72, 7.73, 7.74A, 7.74B, 7.75, and 7.76), and maps and city views (figs. 7.77 and 7.78).[82] "This company," noted the *Dallas Daily Herald*, "... is climbing to the top of the post."[83] The company moved to 176 Elm Street in 1890 (fig. 7.79).

FIGURE 7.65 Unknown photographer, Joseph Jay Pastoriza, businessman and mayor of Houston. Halftone. From the *Single Tax Review* 17 (July/August 1917), frontis.

FIGURE 7.66 Eugene Baker, compositor, "J. J. Pastoriza," 1886. Engraving of ad, approx. 9 × 26 cm. Published in the *Inland Printer* 3 (April 1886), 437. Courtesy University of Minnesota Library.

FIGURE 7.67 Jay Booker, ad for the Dallas Lithograph Co., 1886. Chromolithograph, 7.25 × 4.5 in., by Dallas Lithographic Co. [or Clark & Courts]. From *Morrison & Fourmy's General Directory of the City of Dallas, 1886–87* (1886). Collections of the Dallas History and Archives Division, Dallas Public Library.

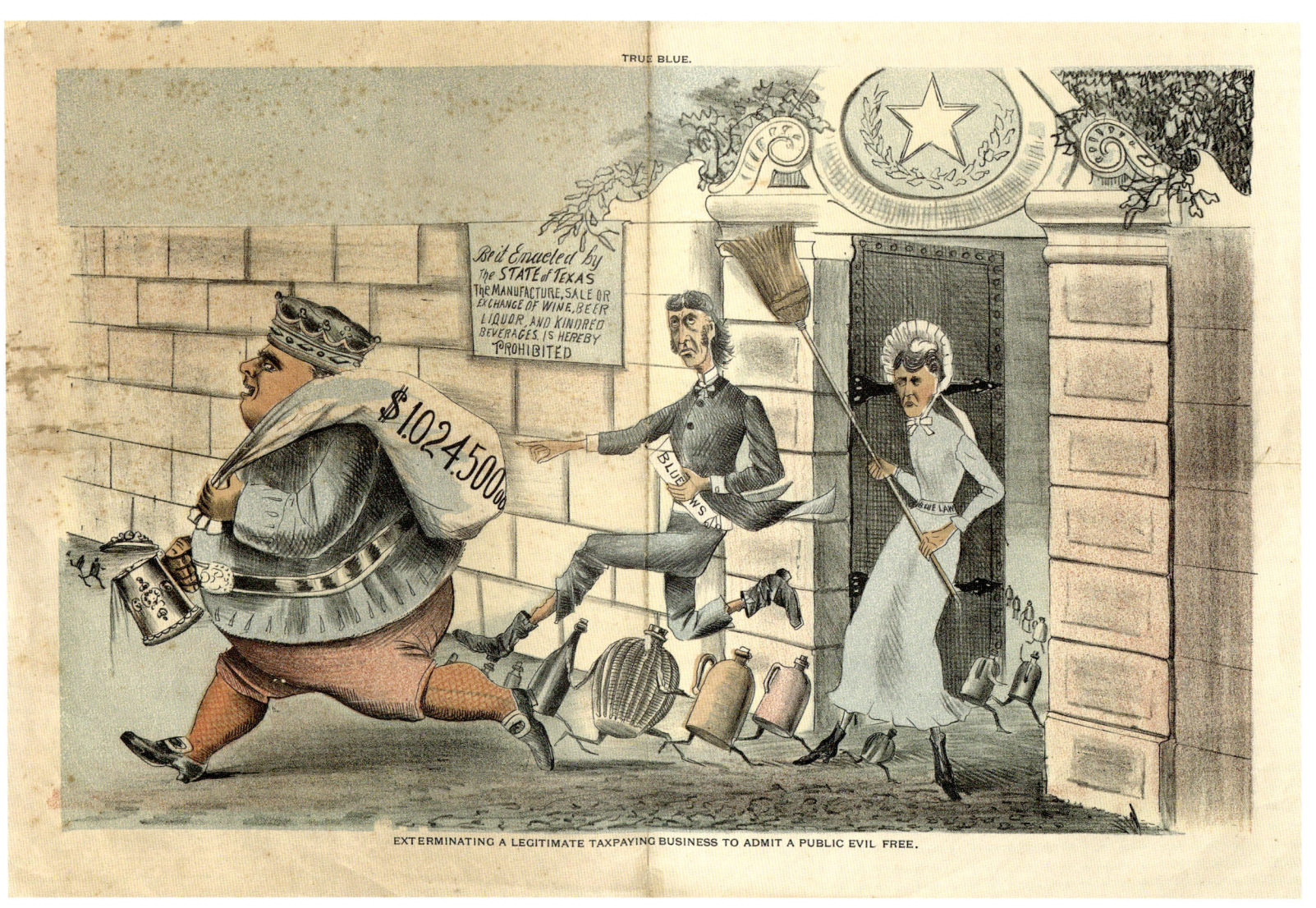

FIGURE 7.68 Unknown artist, *Exterminating a Legitimate Taxpaying Business to Admit a Public Evil Free*, 1887. Chromolithograph, 30 × 47.5 cm (image), by the Dallas Lithographic Co. From *True Blue* (Dallas), June 25, 1887. Courtesy DeGolyer Library, Southern Methodist University. The artist (possibly Joseph A. Bruett, who is listed in the Dallas city directory for 1891 as a "litho. engraver" at Dallas Litho Co.) pictures two skinny prohibitionists driving Gambrinus (European icon of beer and joviality) out of Texas (taking with him the tax money that the state would lose if prohibition were adopted), while unmarked jugs of moonshine scuttle past the dour prohibitionists.

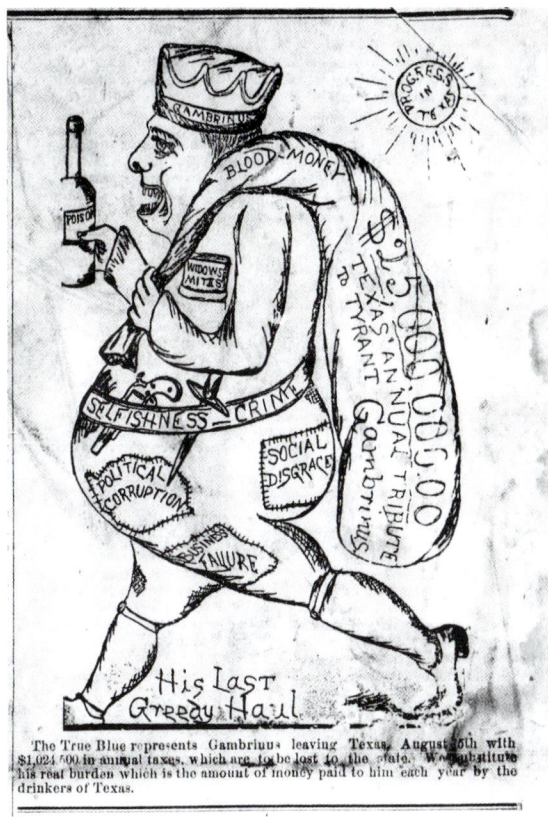

(ABOVE) FIGURE 7.69 Unknown artist, *His Last Greedy Haul*, 1887. Engraving in the *Dallas Daily Herald*, July 1, 1887, 1. The prohibitionist *Herald* responded to the *True Blue* cartoon showing the sun of "Progress in Texas" shining on the brewing icon as he leaves with a $25,000,000 sack of "blood money," the state's "annual tribute to tyrant Gambrinus." He holds a bottle of "poison" in his right hand and carries the "widows' mites" in his shirt pocket, his belt of "selfishness" and "crime" holds a gun and a knife, and his pants are patched with "political corruption," "social disgrace," and "business failure." The referendum lost by ninety thousand votes.

(RIGHT) FIGURE 7.70 Unknown artist [Jay Booker?], *Dallas Brewing Company, Dallas, Texas, U.S.A.*, c. 1887. Single sheet. Chromolithograph, 29.75 × 14.75 in. (sheet), 26.52 × 12 in. (image), by Dallas Lith. Co. Engraving & Printers. Courtesy Dallas Historical Society.

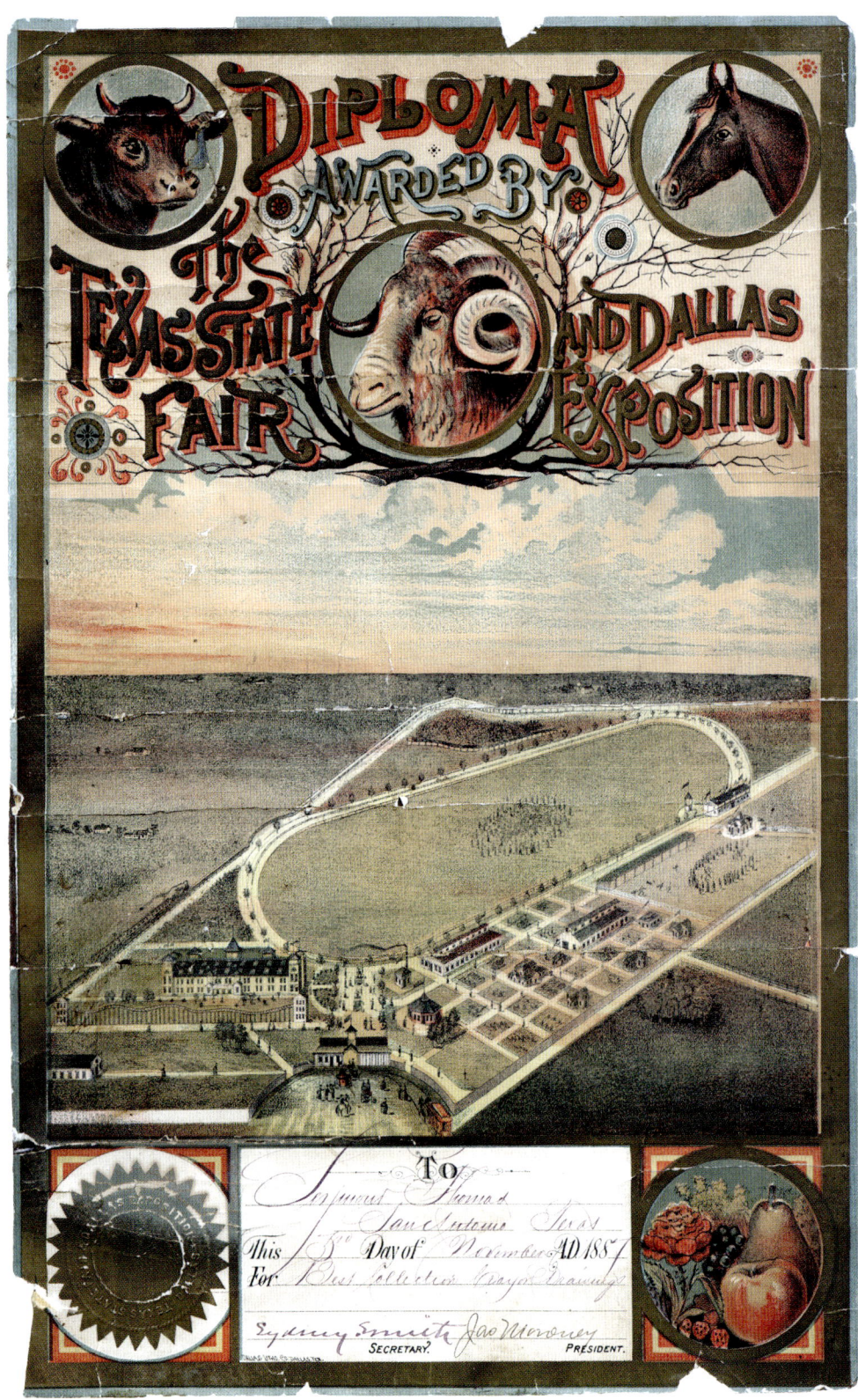

FIGURE 7.71 Unknown artist (possibly Jay Booker), *Diploma Awarded by the Texas State and Dallas Fair Exposition*, 1887. Poster. Chromolithograph, 12.75 × 18.75 in., by the Dallas Lith. Co. Courtesy Dallas Historical Society. Artist Seymour Thomas of San Augustine was only nineteen years old when he won this certificate for the "Best Collection of Crayon Drawings."

(LEFT) FIGURE 7.72 [Jay Booker, attrib.], ad for Dallas Lithograph Co., 1888. Lithograph, full-page. From *Morrison & Fourmy's General Directory of the City of Dallas, 1888–89* (1888), opp. 142. Courtesy Dallas Historical Society. (RIGHT) FIGURE 7.73 Unknown artist, ad for Padgitt Bros. Manufacturers, 1896. Lithograph, 21.2 × 13.3 cm, by Dallas Litho. Co. Courtesy Linda Hall Library, Kansas City, MO.

FIGURE 7.74A AND FIGURE 7.74B Unknown artist, *Visit Oak Cliff, Dallas, Texas*; verso, *View of Oak Cliff from New Courthouse, Dallas, Texas*, 1890. Lithograph, 7 × 14 cm, by Dallas Litho. Co. George W. Cook Collection. Courtesy DeGolyer Library, Southern Methodist University.

FIGURE 7.75 Unknown artist, "Texas State Fair and Dallas Exposition Exhibitors Portrait Ticket 1897." Lithograph and photograph, 2.5 × 4.5 in., by Dallas Lith. Co. Courtesy Frank Reaugh Papers, Briscoe Center for American History, UT Austin.

FIGURE 7.76 Unknown artist [Jay Booker?], *Sanger Bros. Monthly Magazine*, June 1891. Lithograph, 27 × 20 cm, by Dallas Litho. Co. From the collections of the Dallas History and Archives Division, Dallas Public Library. Dallas Lithograph designed a handsome cover for the magazine. Two vignettes on the lower half of the image changed each month: a family reading the *Sanger Bros.* magazine and books, a girl on a porch with a small bouquet, a couple in a boat on the river, two ladies in a garden.

FIGURE 7.77 R. H. Adair, *Map of Alvarado, Texas. Corporate Limits*, 1891. Lithograph, 70.8 × 51.2 cm (neat line to neat line). By Dallas Litho. Co. Courtesy Special Collections, University of Texas at Arlington Libraries.

"THE ENTERPRISE WAS NOT PROPERLY APPRECIATED"

FIGURE 7.78 Paul Giraud, *Dallas, Texas. With the Projected River and Navigation Improvements Viewed from Above the Sister City of Oak Cliff*, 1892. Single sheet. Toned lithograph, 20 × 29 in., by Dallas Litho. Co. Courtesy Geography and Map Division, Library of Congress.

The following year the company gained a talented but short-lived competitor. Floyd Shock was a traveling man who was so well known throughout the state that the local newspapers usually noted his arrival in town. Born in Big Pond Furnace, Pennsylvania, he moved to Texas in 1873 and worked at the US Telegraph office in Denison, then edited the *Graham Leader*, where he also engaged in stock raising and was elected clerk of the Young County District Court. He moved to St. Louis in 1880 to work for the St. Louis book and stationer firm of George D. Barnard & Co. In 1889 he opened his own book and stationer business in Dallas, along with a printing and lithographic shop (fig. 7.80). The *Southern Mercury* of Dallas reported that Shock had ordered book manufacturing and lithographing equipment

FIGURE 7.79 Weatherington Brothers, *Dallas Lithograph Company Building*, 1890. Photograph, 9 × 11 in. Courtesy Dallas Historical Society. As they continued to grow, the company moved to into this building, designed by Albert Ullrich of Dallas, located at 176 Elm Street, between a wholesale grocery and a pub. The company name is carved on the cornice.

FIGURE 7.80 Unknown artist, "Floyd Shock & Co., Dallas," 1889. Letterhead. Lithograph, 2.75 × 8.25 in. (image), 10.75 × 8.25 in. (sheet). Courtesy Panhandle-Plains Historical Museum Research Center, Canyon, Texas.

FIGURE 7.81 Unknown artist, "Tolbert Bros. Real Estate and Loan Agent," 1891. Letterhead. Lithograph, approx. 10.75 × 8.25 in., by Texas Printing and Lithographing Co., Fort Worth. Courtesy Dallas Historical Society.

and expected to employ thirty people, but the effort did not last long because Barnard lured him back to St. Louis, where he continued to call on Texas clients before becoming a director in the company and eventually a vice president of the Central National Bank in St. Louis.[84]

The *Dallas Herald* also reported that W. T. Stewart, manager of the Lithograph and Tin Printing Co., had returned from the East, where he had successfully recruited workmen for his company, but no establishment by this name can be found in the city directories. A few years later, the *Southern Mercury* ordered a "lithographic outfit" to complement its other printing services.[85]

LITHOGRAPHY IN A HAMLET

Apparently, few lithographs printed by the Texas Printing and Lithographing Co. of Fort Worth survive. Proprietor J. K. Milliken established the company in 1888, just in time to provide a "mammoth register" to be placed at the entrance of the Texas Spring Palace, a giant trade festival that the city organized. He claimed that it was the "largest book ever made in Texas," containing 3,000 pages, weighing 106.75 pounds, with room for 45,000 signatures, leading the *Gazette* editor to comment that although Fort Worth was only a "hamlet" when Milliken opened his business, he had achieved "a constant and uninterrupted run ever since."[86] Milliken aggressively sought business, advertised regularly in the *Fort Worth Gazette*, and sent representatives throughout North Texas and as far west as El Paso to recruit business for his new presses. George W. Knott of the *American Stationer* described the company as a "splendid establishment . . . doing a fine business" when he visited in August 1889.[87]

A letterhead for the Tolbert Bros. Real Estate and Loan Agents in Vernon is, perhaps, an example of the salesmanship of Milliken and his agents. The letterhead displays a fine picture of the Wilbarger County courthouse in the center. On the left is a picture showing "My farm before coming to Wilbarger County," a poor scene with a broken-down Dutch-style windmill and wagon, a house with a hole in the roof, a starving mule, and a tree stump in the foreground. The farm "after" arrival in Wilbarger County, on the right, is quite different, with a big house and barn, new windmill, wagons, cattle, and acres of farmland (fig. 7.81).

FIGURE 7.82 Unknown artist, [The Garden of Eden with Hell Below], c. 1889. Chromolithograph attributed to Texas Printing and Lithographing Co. From William W. Dunn, *Evolution and True Light* (1889), frontis. Courtesy DeGolyer Library, Southern Methodist University.

"THE ENTERPRISE WAS NOT PROPERLY APPRECIATED" | 331

FIGURE 7.83 Unknown artist, "The Texas Salt Co., of Colorado, Texas," 1892. Letterhead. Lithograph, 2.75 × 8.25 in. (image), 10.75 × 8.25 in. (sheet), by Texas Printing and Lithographing Co., Fort Worth. Courtesy XIT Ranch Records, Panhandle Plains Historical Museum Research Center, Canyon, Texas.

One of the oddest of their publications surely is a book by sixty-seven-year-old William W. Dunn, a veteran of the war with Mexico, a former Texas Ranger, and an investor and board member of the Spring Palace who arrived in Fort Worth in 1858 when "the moccasin tracks were scarce obliterated." Dunn owned the Mansion Hotel on Rusk (now Commerce) Street, engaged in real estate, and secured patents for several different inventions. But his most lasting contribution may be a book called *Evolution and True Light*, which mixes patriotism and religion and includes, in a biographical sketch, the claim that Dunn was an abolitionist even though he had served as a captain in the Confederate Frontier Regiment in 1861. Perhaps he intended the book to be used for instruction, because he titles some chapters as lessons and follows one with a catechism. But he also ventures into essays on "Bee Culture," "Prairies and Prairie Grass," "Bad Colds," "Sleep," "A Few Hints to Farmer's Wives," some advice "To Young Men," and, finally, an engraving of his hotel.[88] But the most outstanding feature of the book, printed by Texas Printing and Lithographing Co. in 1889, is the untitled four-fold frontispiece, a striking chromolithograph depicting God escorting Adam and Eve out of a highly stylized and colorful Garden of Eden, with the fires of Hell burning below and a star-filled blue sky above (fig. 7.82). No artist or printer is identified on it, but it would have been a sophisticated work for such a young company. In 1892, a correspondent for the *Inland Printer* described the Texas Printing and Lithographing Co. (fig. 7.83) as "one of the largest job-printing establishments in the state."[89]

SAN ANTONIO AND CORPUS CHRISTI

Lithography came to San Antonio about the same time as it appeared in Fort Worth. San Antonio businessman Samuel A. Maverick Jr. had founded Maverick Printing House on East Houston Street in 1879. A veteran of Terry's Texas Rangers (the Eighth Texas Cavalry) during the Civil War and the son of one of the signers of the Texas Declaration of Independence, he owned and operated several businesses, including a lumberyard and grocery store. The new printing company handled all kinds of paper goods and office supplies, forms, and furniture, and in 1888 Maverick enlarged the building and added a lithographic department (fig. 7.84).[90] By 1890 it had moved to Avenue E and a new building just as Maverick's bank failed.[91] Maverick had to dispose of holdings to cover his creditors, which probably led to the sale of the printing company. In 1896 Robert Clarke, former partner with both Strickland and Clarke & Courts in Galveston, along with several San Antonio businessmen, purchased the company and chartered it as the Maverick-Clarke Lithograph Co. (fig. 7.85).[92] The wide range of lithography that the company produced is captured in a lithographic specimen book now in the collection of the Witte Museum in San Antonio—a time capsule, really, and one of the few nineteenth-century printer's specimen books, along with that of Clarke & Courts, to survive (fig. 7.86). The printer's specimen book was used to show the firm's work to potential customers, who could select from the images and ornaments for their own letterheads, booklets, advertising cards, and circulars. This collection was probably compiled shortly after the turn of the century but no doubt contains many lithographs made by Maverick-Clarke during the nineteenth century.

Perhaps the most unusual story associated with lithography in Texas is that of Tito P. Rivera of Corpus Christi. Rivera operated a stationery, blank book, and printing business in Corpus Christi by 1883. Born in 1844 in Sinaloa, Mexico, Rivera, at age nine, secured his father's permission to accompany a pack train into the mountains, where they were ambushed by Comanche Indians, who kidnapped him. He lived with the Indians for two years, becoming proficient in Comanche and serving as translator for the Indians on several occasions. When the Comanches moved back to the reservation on the Clear Fork of the Brazos River, he sent a letter to the US Indian agent, and it fell into the hands of John R. Baylor, who negotiated his release. After Rivera lived with Baylor's family for about two years, Baylor handed him over to Maj. Robert Neighbors, who said that he would return him to his family.

With the coming of the Civil War, Rivera served in the Confederate army, then settled near Victoria, where he earned his living as a cowboy. He worked as a bookkeeper in Galveston before moving to Corpus Christi during the panic of 1873 and securing work as a clerk with the banking firm of Doddridge & Davis. He soon began his own business, opening a stationery, blank book, and printing and lithographic establishment (fig. 7.87). He became active in the business and social life of the city, serving as special postmaster and as a member of committees for the Board of Trade, the abortive Corpus Christi & Nueces Valley Railroad, and the effort to establish a deep-water port, among other activities. Meanwhile, he served as a member of the city council and held positions in various business and civic organizations and was active in his church and several clubs. He also invested in railroad interests and the Corpus Christi Electric Co. in addition to his stationery and printing store.[93]

FIGURE 7.84 Unknown artist, "Souvenir of San Antonio International Fair," 1890. Lithograph on silk, dimensions unknown, by Maverick-Clarke Litho. Co., San Antonio. Courtesy Witte Museum, San Antonio.

FIGURE 7.85 Unknown artist, "John Wharton Maxey, Civil Engineer," 1899. Letterhead. Lithograph by Maverick-Clarke Litho. Co. Courtesy George Fuermann, "Texas and Houston" Collection, Special Collections, University of Houston Libraries.

El Paso did not have a lithographic firm during the nineteenth century, but the *El Paso International Daily Times* served as agent for the Gast firm in St. Louis, and Floyd Shock—representing the Barnard firm—continued to visit, illustrating how deeply St. Louis companies had penetrated the Texas market.[94]

In the meantime, the company begun by Miles Strickland in 1858 had fallen into financial trouble, ironically within a few weeks of being praised by the *Galveston Daily News* for having the "most extensive electric motors used in the city."[95] The sons had installed a nine-horsepower electric engine to run their printing and binding machines and still employed forty to fifty persons, but by 1887 Clarke & Courts had become not only the dominant lithographer in Galveston but perhaps the largest in the South, employing more workers and doing more business than Strickland & Co.[96] In November 1887 one of Miles Strickland's sons, also named Miles, and his partner, Richard E. Koehler, who had joined the company after the founder's death, faced a dilemma: Strickland & Co. had assets valued at $46,750 but liabilities of $20,000.[97] They searched fruitlessly for someone to take over the company, then placed it in an assignee's hands.[98] Thus began a struggle for survival, with attorney and entrepreneur Walter Gresham stepping forward on two occasions to buy the company's assets at auction on behalf of the family. Another

incorporation in 1892 as Strickland Printing Co. seems to have been the last effort to preserve the company.[99] Clarke & Courts traced its history back to Miles Strickland, based on their acquisition of the Strickland company's machinery and lithographic stones.[100] At least one Strickland Co. employee went to work for Clarke & Courts, and it is likely several others did as well.[101]

Texas lithography reached its nineteenth-century peak with Miles Strickland's chromolithographed Mardi Gras invitations, the Dallas Lithograph Co.'s poster for the Dallas Brewing Co., and caricatures for *True Blue*; the form was further enhanced by Clarke & Courts's in-house ads, and, perhaps, the metaphorical view of the Garden of Eden attributed to the Texas Printing and Lithographing Co. in Fort Worth. The growth of lithographic presses in Texas mirrored that of the nation, and by 1890 the federal census counted more than seven hundred lithographic companies nationwide employing more than eight thousand persons.[102] A quick scan of extant Texas city directories and the census yields the names of more than 130 individuals employed in the lithographic industry during the last quarter of the century, including at least three women.[103]

While the improving rail and sea connections between Texas and the rest of the country solved some of the transportation problems that plagued the huge state, they also ensured that Strickland and his colleagues had to compete against older lithographic establishments in New Orleans, St. Louis, and beyond. But they also permitted Clarke & Courts to become by 1900 perhaps the largest lithographic company in the South. The products of these presses document

FIGURE 7.86 Detail of a page from Maverick-Clarke lithographic sample book showing Peacock's School for Boys along with portions of other images. Courtesy Witte Museum, San Antonio. Each of the images are numbered to correspond with the stone.

FIGURE 7.87 T. P. Rivera ad from the *Corpus Christi Caller*, Jan. 21, 1883, 4. He had borrowed Strickland's advertising line: at the "Sign of the Big Book," which was common for stationers in the nineteenth century.

this era of enormous growth, from shipping to railroads to fairs and festivals, and even to the development of the character for which the state is most famous: the cowboy. But the routine jobs—the letterheads, business forms, stock and municipal bond certificates, with their elaborate pictorial designs—may demonstrate the lithographers' development and the state's business growth just as effectively.

"THE ENTERPRISE WAS NOT PROPERLY APPRECIATED"

FIGURE 8.1 After William F. Sparks, *Texas. Cattle Herders Indulging in Revolver Practice on Telegraph Insulators*, 1881. Engraving, 27 × 22 cm (image). From *Frank Leslie's Illustrated Newspaper*, Jan. 29, 1881.

CHAPTER 8

"THE 'IMAGE BREAKERS'"

MENDING THE REPUTATION

If L. C. Butte of Commerce, Texas, is to be believed, constant promotion of Texas by governmental bodies, speculators, developers, merchants, and others since the days of the republic had made little impact on either coast. "The idea that life and property are not safe prevails not only in Washington, but also on the Pacific coast, and it is . . . deep-rooted," he wrote to the *Dallas Morning News* in 1890. Among the difficulties that he could have had in mind, aside from the lasting violence of the Reconstruction period, were continuing border troubles, Indian raids in remote parts of the state that did not end until 1881, fraudulent land deals, and the state's longtime reputation as an "Elysium of rogues."[1] *Young Texas* might well have been the state's poster child, but popular lithographs, which had encouraged the rowdy image for decades, would now become part of the state's effort at redemption.

One of the state's severest critics, and the source of much defamatory publicity, was Joseph B. McCullagh of the *St. Louis Globe-Democrat*. McCullagh was a rabble-rousing editor who realized that as railroads reached into Texas, the state was prime territory for the expansion of St. Louis businesses, including his newspaper, so he sent reporters to the major cities of the Lone Star State to report on what he called a "reign of lawlessness."[2] He regularly ran stories that featured headlines such as "Terrors of Texas" and "A Reign of Terror in Texas," reporting that "the life of a man is held in but little higher esteem than that of an ox or a horse." The caricature of *Young Texas* could have illustrated almost any of McCullagh's stories. (See figs. 6.14 and 6.15, for example.) One of the worst accounts, submitted by the *Globe-Democrat*'s Houston correspondent, detailed the murder of Adolph Schachtrupp of Houston by Richard Coward, who was seeking revenge on behalf of his brother, whom Schachtrupp had accused of stealing his mule. Coward—"dressed in the usual attire of a Texas cowboy, with slouched hat, boots over trowsers, whilst 'long-shanked' Mexican spurs jingled from his boot heels, and a gun rested across the pommel of the saddle"—rode up to Schachtrupp's house, called him out, and shot him. Coward was promptly arrested and sentenced to be hung, but the correspondent wrote that Gov. Oran M. Roberts intervened in what McCullagh called an "unaccountable and inexcusable" fashion, commuting Coward's sentence to life in prison.[3]

Texans did not take these attacks on their character lightly. When will the "image breakers" stop? asked the editor of the *Galveston Daily News* in 1875. After the *Globe-Democrat* ran a series of caricatures titled "Scenes in Austin," one featuring the backside of Alexander Sampson, the clerk

of the Senate, sitting on a railing and titled "The Best Part of Alex. Sampson," Sampson attacked the newspaper's correspondent, Tobias Mitchell, with a "long steel eraser," wounding him severely.[4] The *Austin Sun* editorialized that "the legislature ought to pass a special law making it a capital offense for any Globe-Democrat pictorial artist to visit Texas"; the *Galveston Daily News* noted, "Caricature by means of pictures is one of the main features of libel." Another editor lamented that coverage of the "disgraceful row in the Senate will injure the State" further.[5]

"CRAZED WITH BAD WHISKEY"[6]

Cowboys, "rough men with wild, staring eyes," whom Chester Arthur had described in his first presidential address to a joint session to Congress in 1881 as "a band of armed desperadoes," were the source of much of the state's uncouth reputation.[7] Two years later, a reporter for *Leslie's Illustrated* (fig. 8.1), characterized them as "foul-mouthed, blasphemous, drunken, lecherous, utterly corrupt." They drove huge herds of tick-infested Longhorn cattle through Indian Territory and farmland along the Shawnee and Chisholm Trails, spreading "Texas fever" to the local livestock, and then generally made nuisances of themselves when they arrived at the Kansas cattle towns.[8]

Noting that the "Texas cow-boy" had been exaggerated as "crazed with bad whisky, dashing on horseback through the streets of a village and firing on the citizens right and left," the editor of the *Galveston Daily News* declared, "The demon of ridicule is shattering our finest models of mankind." The editor of the *Stephenville Empire* agreed that some "ignorant scribes" pictured the cowboy as a "black . . . fiend," but in fact he is "a very modest fellow" who has "accomplished more in developing the wealth of Texas than any other class of men [fig. 8.2]."[9] Some popular figures, such as "Texas Jack" Omohundro, a cowboy and frontier scout before his acting days, mitigated the cowboy persona, but the "outlaw cow-boy," such as the murderous Bob Chrystal and his gang near Waco, continued to make headlines.[10] The vast amount of land being opened up by the extension of the railroads and the spread of barbed wire and windmills continued to attract settlers, but the reputation of cowboys—and the state—clearly needed attention.[11]

It helped that men such as Theodore Roosevelt and Theodore A. Dodge came to their defense; William F. "Buffalo Bill" Cody hired cowboys to perform in his Wild West show; popular artists Frederic Remington and Charles M. Russell began to paint them; and Owen Wister began to write about them (fig. 8.3). Editor McCullagh even credited "the *Globe-Democrat*'s denunciation of lawlessness in Texas" as having a "good effect."[12] By the 1880s the cowboy was the state's most recognizable figure (and remains so today), and companies such as Arbuckle Bros. Coffee, Clark's O.N.T. Spool Cotton, Duke's Cigarettes, and *Youth's Companion* magazine—even the Range Canning Co.'s Roast Mutton—used his image to represent the state of Texas and help sell their products. That transformation is apparent in the popular lithographs of the day.

Few early nineteenth-century illustrations of the Texas cowboy exist, probably because the impact of this historic character was not evident until the cattle drives of the last half of the century. But the cowboy was

FIGURE 8.2 "Texas" page from the brochure on the *Star Wind Engine*, 1877. One sheet folded into five pages. Chromolithograph, 14 cm high, by Detroit Lithograph Co. Courtesy Southwest Collection, Special Collections Library, Texas Tech University. The Star windmill dominated in the southern Great Plains until World War I and, along with other windmills, greatly facilitated the settlement of the Panhandle.

FIGURE 8.3 Horace Taylor, *Teddy to the Rescue of Republicanism*, 1899. Magazine cover. Chromolithograph, 23.5 × 21 cm. From *The Verdict*, Oct. 30, 1899. Courtesy of the Theodore Roosevelt Political Cartoon Collection, Houghton Library, Harvard University.

FIGURE 8.4 Unknown artist, "Buck Skin Sam, Song of the Texan Ranger," 1875. Sheet music. Lithograph, by J. H. Bufford's Sons, Boston. Published by White, Smith & Co., Boston. Courtesy Lester S. Levy Sheet Music Collection, Sheridan Libraries, Johns Hopkins University.

well known in nineteenth-century Texas, even though he was still suspected of being "a rough" back East. Many different artists published drawings of the cowboy over the years: the first was perhaps a small engraving, *Lazooing a Horse on the Prairie*, included in an anonymous travel narrative, *A Visit to Texas* (1834), in which the horseback roping skill of the mustangers is illustrated. An editorial in the *Texas Sentinel* in 1840 makes it clear that the term "cow boy" was in use by then, although it carried a taint, equated with cow stealers. William Ranney painted at least two pictures of vaqueros roping a wild horse (*The Lasso* and *Hunting Wild Horses*), both painted in 1846 but probably based on his Texas sketches of a decade earlier. The Longhorn was also becoming a known breed by then and was described in the *Houston Morning Star* as being a "singular breed of wild cattle" that is "fleet and nimble," "of a dark brown color," and equipped with "remarkably large" horns that "stand out straight from the head."[13]

The cowboy did not really begin to catch the popular imagination until decades later, when artists such as William M. Cary, W. A. Rogers, A. R. Waud, Paul Frenzeny, Jules Tavernier, and Rufus F. Zogbaum illustrated cowboy scenes for *Harper's Weekly*. The 1880s saw the spread of Remington's and Russell's illustrations and dime novels. By the turn of the century, Owen Wister's *The Virginian* (1902) established the truly mythic credentials of America's man on horseback and put him well on the road to becoming an icon. By then, the three significant elements of the cowboy legend—ornery Longhorn cattle, drovers and long trail drives, and riotous celebration at the end of the trail—were in place.

Remington had first visited Texas in the summer of 1888, and though he complained of the weather, the insects, the food, and his

hotel room, he came away with the understanding that Texas was a cultural hotbed and that the developing cowboy character was a genuine amalgamation of the Mexican vaquero and southern cowherd, a point of view he shared with Owen Wister when they began working on an article on "The Evolution of the Cow-Puncher."[14]

One of the earliest lithographs of a professional cowboy type must be the sheet music cover for "Buck Skin Sam, Song of the Texan Ranger" (1876), featuring Samuel S. "Buckskin Sam" Hall (fig. 8.4). The publication took advantage of Sam's reputation as a Texas Ranger and spread the word about this bona fide hero who started out as a bullwhacker at age sixteen, fought with Ben McCulloch, rode with William A. A. ("Big-Foot") Wallace, and got his nickname because he always wore a buckskin suit. He was drafted into the Confederate service but later deserted and served as a Union scout. After the war he found his job clerking in a New York City hotel boring and tried his hand at dramas with modest success, which probably led to this piece of illustrated sheet music. He appealed to his old friend Buffalo Bill Cody for a place in his dramas, but Cody and his press agent (and dime novel author) Col. Prentiss Ingraham suggested, instead, that Sam write down some of his adventures. That led to a semisuccessful dime-novel career, especially after he turned to fiction.[15] This sheet music embellishes that image and appeared at a time when a special force of Rangers was making headlines in the Nueces Strip (Juan Cortina's "band" is mentioned in the song) and the Frontier Battalion was battling Comanche and Kiowa Indians ("warriors give their dying whoop").

A contemporary of Sam's, Texas Jack Omohundro traveled and performed with Cody on a number of occasions (fig. 8.5). John B. Omohundro, who had been a soldier, scout, Indian

FIGURE 8.5 V. Arnold, *Texas Jack*, c. 1875. Single sheet. Lithograph, 16.31 × 11.19 in., by Jackson's Printing House, Philadelphia. Courtesy Amon Carter Museum of American Art, Fort Worth.

"THE 'IMAGE BREAKERS'" | 341

FIGURE 8.6 Unknown artist, "'Texas Charlie.' 'Little Bright Eye.' Waltz Song," 1885. Sheet music. Lithograph, 13.5 × 10 in., by Hitchcock's Music Store, New York. Music Division, Library of Congress.

fighter, cowboy, hunter, and actor during the 1870s and 1880s, worked with Buffalo Bill as a scout and guide for the famous hunting party hosted by Grand Duke Alexis of Russia. He was so skilled with a rope that the Indians called him "whirling rope." A handsome and apparently charming figure, he debuted on the Chicago stage in late 1872 with Cody in Ned Buntline's *The Scouts of the Prairie* and married the heroine of the play, an Italian dancer and actress named M'lle Morlacchi, who supposedly introduced the cancan to America.[16]

Artist V. Arnold prepared the poster for Jackson's Printing House in Philadelphia probably about the same time the Buckskin Sam sheet music appeared. Jack is shown dressed for his part in *Scouts of the Prairie*, leaning on his rifle with a big bowie knife and pistol in his fashionable silk sash and a rope over his shoulder. Fringes hang from the sleeves of his buckskin shirt, as does the plume from his oversized cowboy hat, and the loose neckerchief accents his open-throated shirt. Jack performed throughout the 1870s, then, in the 1880s, turned to writing for the *New York Times* and the *New York Herald*. He was only thirty-four-years old when he died of pneumonia in Leadville, Colorado. Little is known of Arnold or Jackson, so the print is difficult to date precisely, but the handwritten notes on the piece in the collection of the Amon Carter Museum of American Art suggest that it might have been produced around 1875.[17]

A character who carried the vaudeville routine even further, and did not help improve the cowboy image, was Texas Charlie Bigelow, a Massachusetts-born showman who fabricated a Bee County, Texas, birthplace for himself as he constructed the frontier character illustrated in an 1885 piece of sheet music, "'Texas Charlie.' 'Little Bright Eye.' Waltz Song [fig. 8.6]." After less than modest success as a liniment entrepreneur, Charlie signed on with John E. Healy, a New Haven, Connecticut, peddler, and Dr. E. H. Flagg of Baltimore, who had been using songs and violin solos to sell Flagg's Instant Relief. Together they turned the elixir, which was largely alcohol, into Kickapoo Indian Oil, which they claimed was created by Kickapoo medicine men who shared it with them only in the cause of public health (including a secret potion that prevented even the best chemist from ascertaining its ingredients). They toured the country with a troupe of Indians—Iroquois, Pawnees, Sioux, but no Kickapoos—much to the consternation of some of the neighborhoods where they appeared, and Charlie was arrested in Harlem for employing underage dancers. But the business became one of the most successful patent-medicine shows in the country, with a number of touring companies. This sheet music was only one of many publications that touted "Texas Charlie" and his Native American miracle cure.[18]

Also appearing in the same year as Texas Charlie's waltz song was an unusual little souvenir album of illustrations of incidents in the life of a cowboy. Printed in Frankfurt, Prussia, by Chas. Frey, the Chisholm Brothers of Portland, Maine, published the album for H. H. Tammen of Denver, who ran a curio company there for more than forty-five years. *Cowboy Life* contains twenty-two views after photographs by the Cheyenne photographer C. A. Hendrick (though he is unacknowledged) printed on one side of twelve panels of coated stock that are fan-folded into the binding. The panels, approximately 4.5 × 5.5 inches, illustrate typical scenes such as *The Mess Wagon*, *Roping a Steer to Inspect Brand*, *Branding on the Prairie*, *Pitching Broncho*, *Cow Ponies Taking a Rest*, and a classic portrait of a cowboy. Cowboys also appeared in some of the souvenir booklets on Texas cities. The images were copied from photographs, and the overall appearance of such booklets is that of a photographic album, but they are, in fact, five-color lithographs (see figs. 9.71–9.77). Under a magnifying glass one can see the grain characteristic of a lithograph as well as the several shades of gray, brown, and black used to imitate the tonal qualities of a photograph.[19] A few years later *Souvenir Album of the Great West* (1889), published by Ward Bros. of Columbus, Ohio, included several more pictures of cowboys—playing cards, riding a bucking horse, wrestling a steer, and gathered around the chuckwagon. All these images, because they appeared to be documentary photographs, added to the cowboy's growing credibility.

In 1885 the citizens of Sherman hosted a ball and banquet for the members of the Cattle Raisers Association of North West Texas (figs. 8.7A and 8.7B). The association had organized in February 1877 in response to a "greatly disorganized and chaotic" livestock industry following the Civil War, and it was so successful that cattle raisers in South Texas formed a similar group.[20] The invitation forms a five-pointed star with the images of different breeds of cattle illustrated on each point of the star under the letters T-E-X-A-S. In the center is a familiar scene: a cowboy throwing a rope amidst a herd of wild cattle. An Indian tipi stands in the background, and the cattle seem to evolve from the wild Longhorns in the background to Herefords in the foreground. On the reverse side is the text of the invitation, with the members of the various committees listed. No printer is named, but the editor of the *Sunday Gazetteer* in Denison considered the invitation the "equal in richness of design and

FIGURE 8.7A AND FIGURE 8.7B Unknown artist, *Texas*, 1885. Invitation (front and verso) to Ball and Banquet of the Cattle Raisers Association of North West Texas. Chromolithograph. Courtesy Dr. John M. Parker, Plano.

"THE 'IMAGE BREAKERS'"

elaborateness of illustration to anything we have seen issued in honor of the annual masquerade festivities in St. Louis and New Orleans."²¹

The following year, two more cowboy images appeared in Charles A. Siringo's *A Texas Cow Boy, or, Fifteen Years on the Hurricane Deck of a Spanish Pony* (1886), the first published cowboy autobiography. Thirty years old in 1885, Siringo had already tried cowboying and storekeeping and still found himself adrift with a wife and child. Some of the accounts that he had read in the *Police Gazette* of others who had gotten rich by telling their stories encouraged him to try his hand at writing—that, combined with an ad that promised "big inducements" to the lad who got into "an untrodden field." He confessed to his readers up front: "My excuse for writing this book is money—and lots of it."²²

Siringo was born in Matagorda County, Texas, in 1855. After some schooling, he worked as a cowboy for several area ranches. He trailed cattle to Kansas for a couple of years, then took a job in the Texas Panhandle until he married and in 1884 moved to Caldwell, Kansas, where he began keeping store. Hoping to launch a successful writing career, Siringo began work on his autobiography during his spare time and moved to Chicago to be near the company that he had selected as his printer, M. Umbdenstock & Co. He contracted for two thousand copies of *A Texas Cow Boy*, half bound in cloth and half in paper, and sold them through subscriptions, newspaper ads, and agents. Umbdenstock probably supplied the artwork for the chromolithographs, which are apparently intended to be portraits of Siringo. The cover of the paperback shows a Siringo-like character sitting astride a horse and looking the viewer in the eye (fig. 8.8). He is stylishly dressed in woolly chaps, cowboy hat, necktie, and red silk sash and is armed to the teeth with a knife, six-shooter, rifle, and ammunition belt draped over his saddle horn. There are cacti and other desert plants on either side of him, and Longhorns and mountains fill the background. The title of the book is displayed against the sky. The second print, titled *Representation of Life in a Cow Camp*, includes the same Siringo-like character at the right,

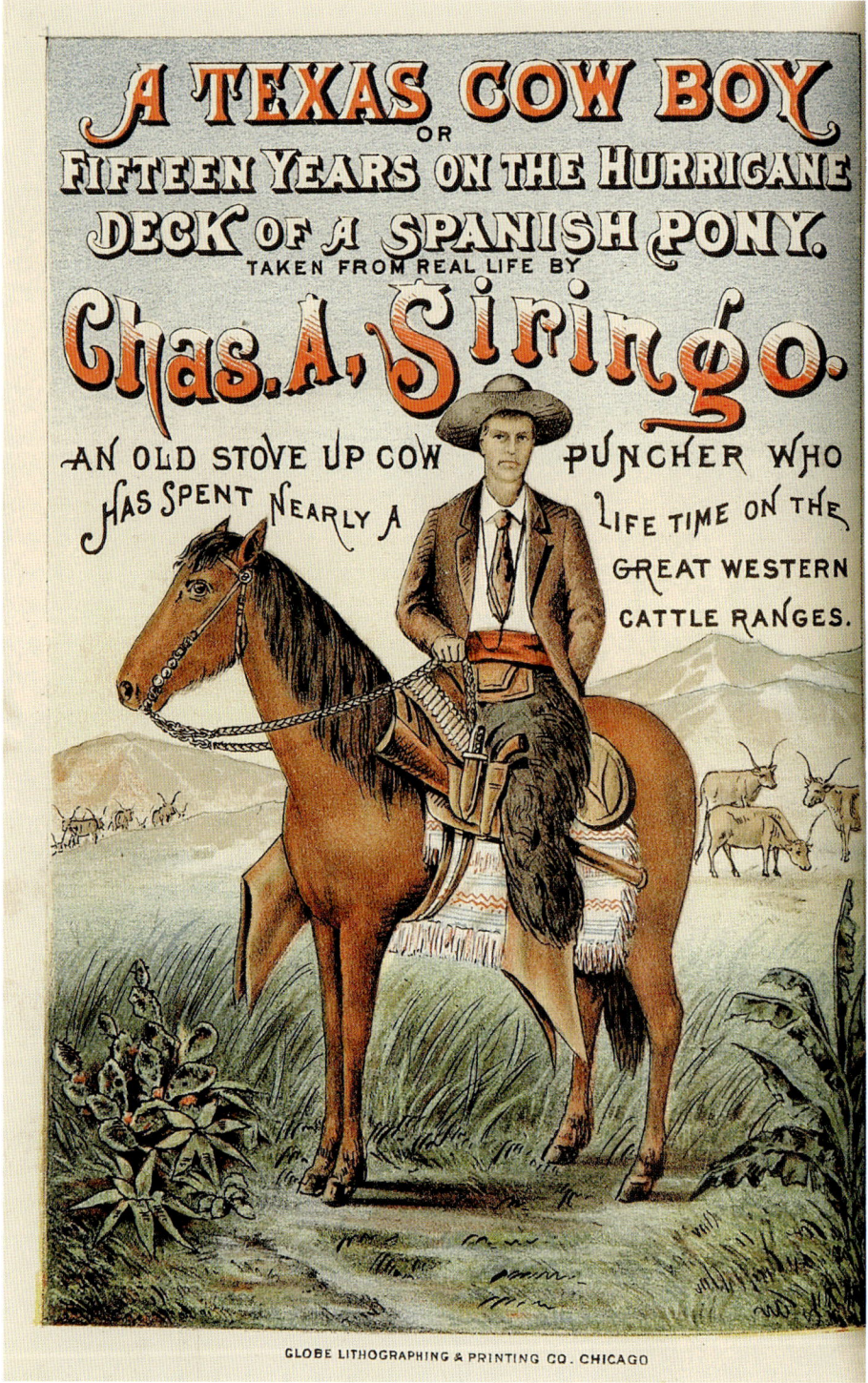

FIGURE 8.8 Unknown artist, *A Texas Cow Boy*, 1886 (cover). Chromolithograph, 16.8 × 11.5 cm, by Globe Lithographing & Printing Co., Chicago. From Chas. A. Siringo, *A Texas Cow Boy* (1886). Amon Carter Museum of American Art, Fort Worth

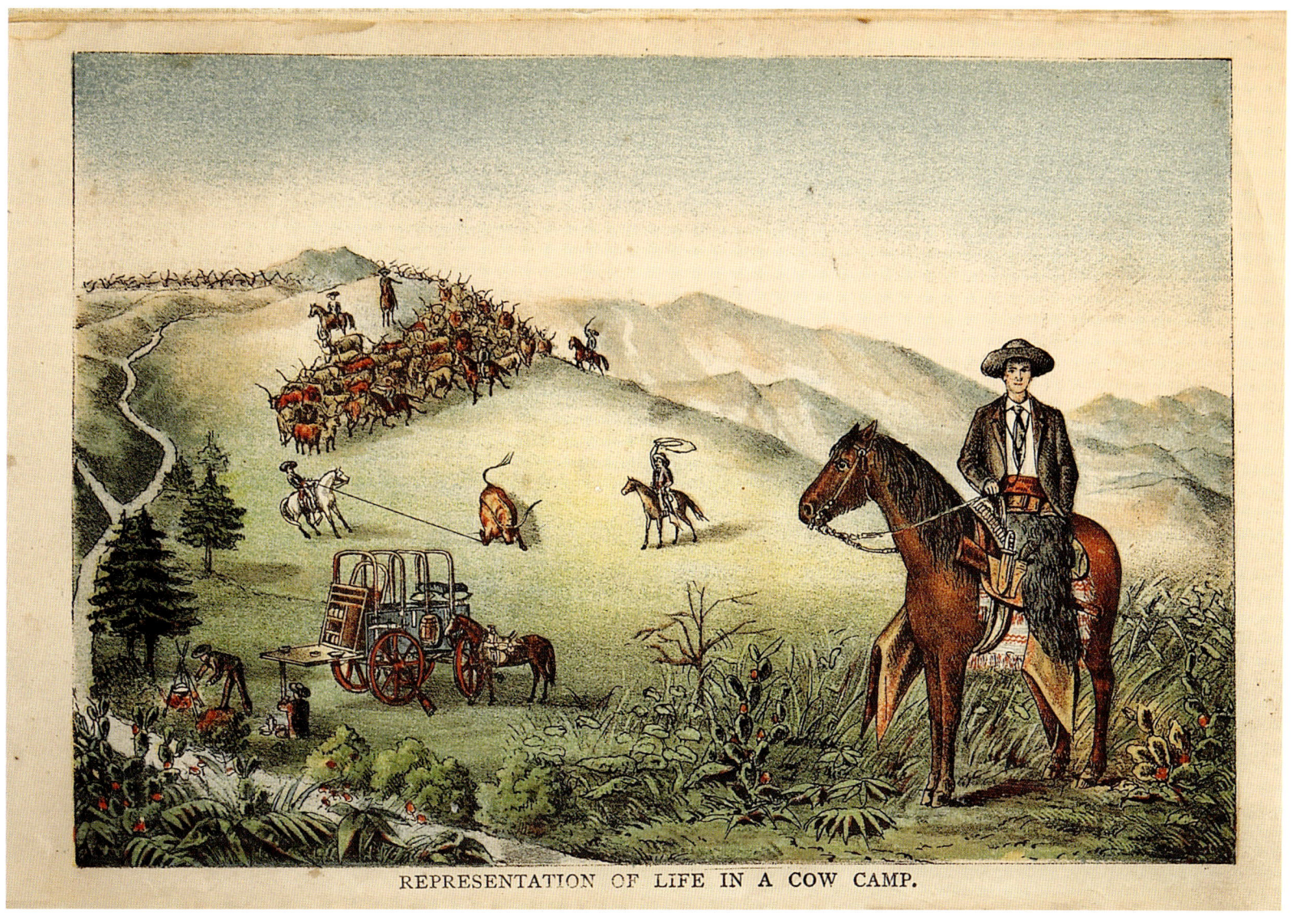

FIGURE 8.9 Unknown artist, *Representation of Life in a Cow Camp*, 1886. Chromolithograph, 11.5 × 16.9 cm (image), 11.9 × 16.9 cm (comp.), by Globe Lithographing & Printing Co., Chicago (attrib.). From Siringo, *A Texas Cow Boy* (1886). Amon Carter Museum of American Art, Fort Worth.

while other important elements of the cowboy's development feature in the background: the roundup and trail drive, with a herd stretching over the hill in the middle distance and the chuckwagon and campfire shown near a stream at the left (fig. 8.9). Globe Lithographing & Printing Co., also owned by Umbdenstock, supplied the chromolithographs.[23]

While Siringo did not earn as much money as he had hoped, the book was successful. The first printing of two thousand copies sold out in a month or two, and, probably with the assistance of an investor named Dobson, he added a thirty-one-page "addenda" and ordered ten thousand copies of a second printing, also split between hardback and paper. The publisher of this edition is listed as Siringo & Dobson. Some copies of this edition contain one color plate, *Representation of Life in a Cow Camp*, which probably was a remainder from the first printing because other copies contain no lithograph. Before the second edition was depleted, Siringo sold the remaining

stock, printing plates, and copyright to the Rand McNally Co. of Chicago, which reprinted the book several times beginning in 1886, albeit with a slightly more garish color plate in later editions, until the copyright expired in 1914. There have been numerous editions since then, but most of the others do not contain the chromolithographs. Bibliographer Ramon F. Adams suggests that the book ultimately sold more than a million copies.[24]

Siringo's story was fresh, original, and "rollicky," in the words of folklorist and candid book critic J. Frank Dobie, and Siringo's hometown newspaper, the *Caldwell Journal*, concurred: "His style of narrative is better than one would expect from the chances he has had. He writes easily, and in language that all can understand." But if Siringo was hoping for a good hometown review in Texas, he was disappointed. The unnamed critic for the *Galveston Daily News*, not far from his birthplace in Matagorda County, ventured that the author's object of "accumulating wealth so absorbed" him "as to obscure his perception of the fact that something better than slang expressions and crude forms of composition was necessary" before he tackled an "'untrodden field in literature.'" Without mentioning any other titles, the reviewer claimed that "the field . . . has been repeatedly trampled by other literary aspirants of experience and talent, and with better results." And the reviewer could not get over Siringo's casual way with the language: "Whether the crudity so apparent in the above work is the result of affectation or unconscious deficiency in literary art is not clear, but if he wishes to 'make money' by wielding the pen, he should learn that to insure success a due observance of recognized literary cannons, together with a fair amount of talent and originality, is indispensable." The elevated standards of the state's most sophisticated city had, perhaps, been upheld and an authentic cowboy shunned, but the amazing thing about the moment is that a book written by a genuine Texas cowboy was being reviewed in the most prestigious newspaper in the state. And history has been kinder to Siringo. Dobie concluded that "his style . . . cannot be called dignified, but it is informed with the innate dignity of honesty. . . . His cowboys and gunmen were not of Hollywood and folklore." Even though much of Siringo's history might be incorrect, Dobie concluded that "he was an honest reporter." Entertainer and columnist Will Rogers, himself a former cowboy, went even further. It was, he wrote, "the Cowboy's Bible." Neither he nor Dobie commented on the caricaturish chromolithographs, but it was apparent that Siringo had contributed significantly to a believable portrait of a figure that was on the cusp of legend.[25]

Two additional lithographs of cowboys were published in 1886: one on the cover of Thomas Goggan's sheet music entitled "The Texas Cowboy," and the other a separately issued print by the Gainesville artist and professor J. R. McFarren in which a *charro*-dressed cowboy illustrates the deep influence of Hispanic culture in Texas. As if the unnamed Goggan artist had read Siringo's narrative, the sheet music cover contains eleven scenes of the various elements of cowboy life within the design of the Texas star: cutting a calf out of the herd, roping, branding, a stampede, the morning roundup, the trail drive, and night camp, among others. The *Taylor County News* in Abilene called it a "beautiful lithograph" (see fig. 8.38).[26]

McFarren's lithograph, on the other hand, is more complicated, with the artist using the now familiar cowboy to promote McFarren's Gainesville Business College (fig. 8.10). The print is a naïve composition that contains images of many of the things for which Texas was known: wild animals, rattlesnakes, Longhorns, two energetic wild horses, turkeys, flocks of birds, squirrels, deer and other game, and a dog ("Nip") chasing a rabbit ("Tuck"). McFarren has concealed human faces in the foliage at the lower left and along the bottom, and figures of animals and humans behind and around the three-dimensional letters that spell out his name at the bottom of the print. There are quails in the grass and a prairie dog looking out at the viewer near the "J" in his name. Behind the two spirited horses are a fence and a cottage. In the left-center of the composition is an elegantly attired cowboy dressed in what appears to be a charro costume, but he is apparently unarmed. At the top of the print, in highly decorative letters, is the word "Cow Boy" above a Texas star. To the right, on a ribbon wrapped around a vine, are the words "nature," "art," and "science." And a ribbon wrapped around a tree in the right border states, "The wonderful border and tree and what can be found there a picture for everybody old & young." The print is signed "Real Penwork by Professor J. R. McFarren Pen Artist Gainesville Texas 1886." Clearly, the professor was ready to share the secrets of penmanship with his students.[27]

In 1893 a book very different from Siringo's appeared. By the 1870s midwestern farmers had realized that a disease that was killing their cattle was associated with the Longhorns being driven north by Texas cattlemen, and, state by state, they passed laws prohibiting Texas cattle drives from settled areas, forcing the drovers farther west. The disease was called Texas fever, or Spanish fever, and in 1885 Kansas prohibited Texas cattle from crossing its borders, essentially ending the two-decades-long tradition of driving Texas

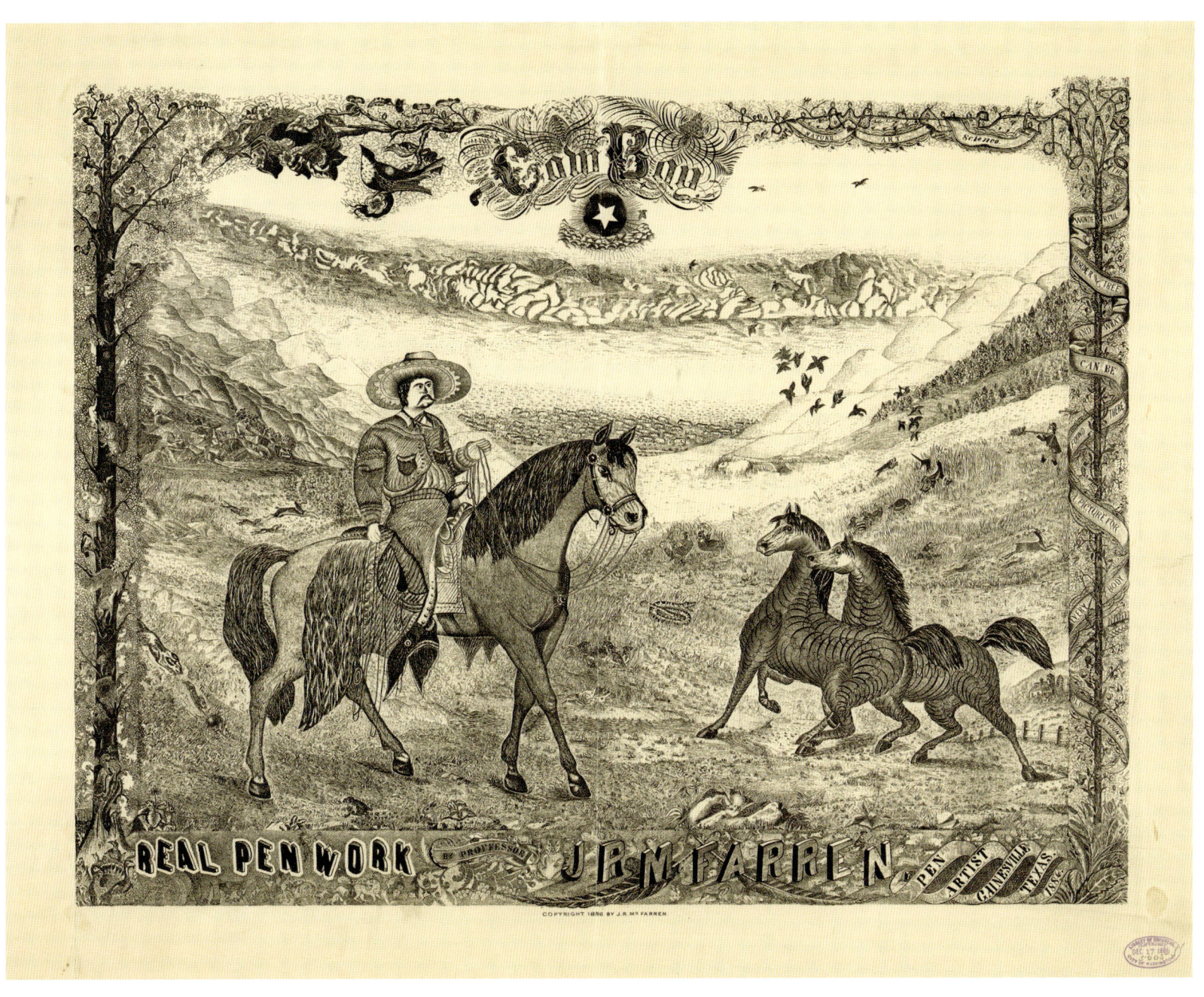

FIGURE 8.10 J. R. McFarren, *Cow Boy*, 1886. Single sheet. Lithograph, 46.3 × 60.5 cm (image), 46.8 × 60.5 cm (comp.), by J. R. McFarren, Gainesville, TX. Courtesy Popular Graphic Arts, Prints and Photographs Division, Library of Congress.

FIGURE 8.11 [?] Haines, *The Cattle Tick—The Carrier of Texas Fever*, 1893. Lithograph, 23 cm (page), by Orcutt Co. Lith., Chicago. From Theobold Smith and F. L. Kilborne, *Investigations into the Nature, Causation, and Prevention of Texas or Southern Cattle Fever* (1893), plate X. Courtesy Wellcome Institute Library, London.

cattle to Kansas railheads.[28] Finally, in 1893, Dr. Theobold Smith, a researcher in the Veterinary Division of the US Department of Agriculture, and veterinarian Fred L. Kilborne discovered the parasite responsible for the malady and published their findings in *Investigations into the Nature, Causation, and Prevention of Texas or Southern Cattle Fever* (1893). The book included chilling portraits of the culprit in its various stages of growth (fig. 8.11).[29] Robert J. Kleberg of the King Ranch is credited with the first program of dipping cattle to rid them of the tick vector, but by then railroads had reached all major Texas cities, rendering long cattle drives unnecessary.[30]

"The career of the renowned long-haired Texas cowboy is fast drawing to a close," noted the *Weekly Democratic Statesman* in Austin in 1880. The cowboy, along with the trail drives, had become the pursuit of historians. One of the first was James Cox, a St. Louis compiler of "mug books" (local biographical histories), who produced the *Historical and Biographical Record of the Cattle Industry and of the Cattlemen of Texas and Adjacent Territory*, published by Woodward & Tiernan in St. Louis. An Englishman who claimed to have graduated from Oxford "with honors in history and jurisprudence," Cox worked as a journalist in St. Louis and seems to have been "a practiced hand with mug and chamber-of-commerce booster books," which Alexander Nicholas DeMenil, editor of the *Hesperian*, described as "mere compilations made to order for subscription companies or advertising firms."[31]

The book contains 449 biographies of Texas cattlemen, compiled by Sylvester D. Barnes, editor of *Outdoor Sports and American Angler* in St. Louis. But it is more than just a mug book, because Cox appended an excellent contemporary account of the Texas cattle trade, though he apparently worked without the knowledge of such books as Siringo's and Kilborne's. Still, according to a usually severe critic, J. Frank Dobie, it was the best analysis of the Texas cattle industry to that date. The book also contains a chromolithographed frontispiece of *A Stampede* by Gean Smith, an artist best known for his paintings of horses, especially trotting horses (fig. 8.12). It was sold by subscription and is today one of the rarest of the cattle trade books.[32] The chromolithograph, copied from the collection of W. H. Woodward (of Woodward & Tiernan), captures a scene that would have been familiar to the cattlemen profiled in the book, at least those who had made the long drive from Texas to Kansas. Smith was a well-known midwestern painter who moved to Galveston in 1924 and spent the remainder of his career there. He died in 1928.[33]

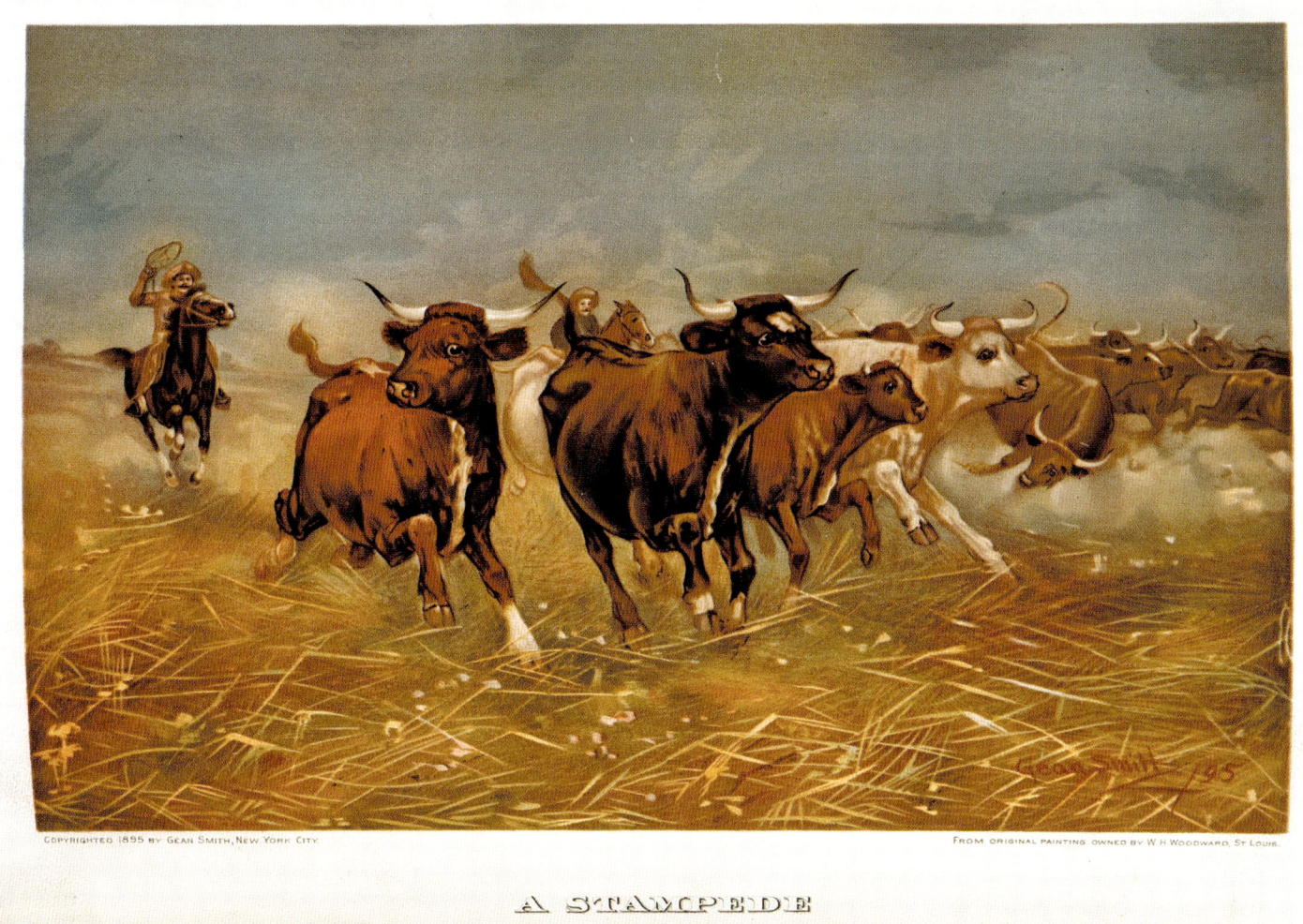

FIGURE 8.12 Gean Smith, *A Stampede*, 1895. Chromolithograph, 6.12 × 9.25 in. (image). From James Cox, *Historical and Biographical Record of the Cattle Industry and of the Cattlemen of Texas and Adjacent Territory* (1895), frontis.

Woodward & Tiernan probably printed between five and six hundred copies of the book and shipped them to subscribers in late 1894 or early 1895 so it would be available when the Texas Cattle Raisers Association held its annual meeting in Fort Worth in March. The *Shiner Gazette* excerpted the biography of L. M. Kokernot in its January 17, 1895, issue.[34] Tradition has held that the book sold for $25 when it was published, but Dobie concluded that it was probably limited to subscribers and advertisers and did not appear on the market. It was surely an expensive book at the time, for when J. W. Fields "refuse[d] to take the book after subscribing for it because it does not come up to the promises of the prospectus," Woodward & Tiernan Printing Co. sued him in a Fort Worth court.[35]

ADVERTISING CARDS POPULARIZE THE COWBOY

The advertising cards that various companies began issuing in the 1880s and 1890s, generally called trading cards today, are an even surer sign that the cowboy had morphed into a positive symbol. Arbuckle Bros. Coffee Co. of Brooklyn, New York, for example, included small (approximately 3 × 5 inch) trading cards in each package of their coffee. In addition to cowboys, the numbered cards illustrated various sports, foods, and historic and satirical scenes, which encouraged customers to collect the whole "set," or, perhaps, to cut them up and create scrapbooks.[36] Donaldson Brothers of New York lithographed for Arbuckle's a montage of historic Texas scenes (fig. 8.13), including Sam Houston in the garb of a Cherokee Indian (see figs. 1.14 and 1.15), a herd of wild horses in the center of the image, LaSalle's ships landing on the coast, and a buckskin-clad figure in a coonskin cap with a rifle in his hand leading troops into battle, perhaps intended to represent the battle of San Jacinto but reminiscent of later images representing David Crockett.[37]

Arbuckle's Ariosa coffee, which was reportedly most popular among Texas cowboys, included various extras, such as coupons redeemable for razors, scissors, and, for enough coupons, a wedding ring, along with a stick of peppermint candy. Then, in 1889, Arbuckle Bros. published one of their most popular advertising premiums, *Arbuckles' Illustrated Atlas of the United States of America*, which combined fifty cards issued separately or in a fourteen-page booklet

FIGURE 8.13 Unknown artist, *Texas*, 1892. Trading card. Chromolithograph, 7.6 × 12.7 cm, by Donaldson Bros., New York. Courtesy William R. Holman, Austin.

FIGURE 8.14 Unknown artist, *Indian Territory, New Mexico, South Dakota, Texas*, 1889. Trading card. Chromolithograph, 18 × 27 cm, by Donaldson Bros. From *Arbuckles' Illustrated Atlas of the United States of America* (1889). Courtesy David Rumsey Map Collection, David Rumsey Map Center, Stanford Libraries. This page from the Arbuckles' atlas could also be cut into four sections for trading cards. Each card measured 7.5 × 12.5 cm.

(including covers) with four images on each of twelve pages with descriptions on the back. The numbered cards encouraged the customer to assemble complete sets by collecting and trading them. The customer could obtain the complete booklet by sending in fifteen signatures cut from one-pound packages of Arbuckles's Ariosa Coffee, along with a two-cent stamp.[38] The page that included the Texas map (along with a cowboy roping a Longhorn) also contained maps of Indian Territory (Oklahoma, with a scene reminiscent of Karl Bodmer's buffalo hunt image), New Mexico, and South Dakota (fig. 8.14).

Other companies pursued the same marketing strategy. In 1888, Allen & Ginter's Cigarettes in Richmond, Virginia, came out with *Flags of the States and Territories* (fig. 8.15). W. Duke & Sons introduced their *Governors Coats of Arms* collectable cards that included a portrait of the governor, the state coat of arms, and various symbols of the state (fig. 8.16). The familiar Longhorn steer is present in both Allen & Ginter's and Duke's Texas cards. Allen & Ginter includes a cowboy and a herd in the background. Inexplicably, the flag is not the Texas flag but one probably more resembling

"THE 'IMAGE BREAKERS'" | 353

FIGURE 8.15 Unknown artist, *Texas*, 1888. Trading card. Chromolithograph, 2.75 × 1.5 in., by George S. Harris & Sons, published by Allen & Ginter, Richmond, VA. Courtesy Metropolitan Museum of Art, New York, Jefferson R. Burdick Collection, gift of Jefferson R. Burdick. The image was published in *Flags of the States and Territories* (1888), with "Texas" emblazoned on the "ribbon" running across the bottom of the flag, and the Allen & Ginter name on the red ribbon at the bottom. The very bottom panel reads "The Lone Star State." From a set of forty-seven cards and one cutout card.

FIGURE 8.16 W. Duke & Sons, *Gov. Ross, Texas*, c. 1888. Trading card. Chromolithograph, 2.75 × 4.31 in. From the series Governors, Arms, Etc. Courtesy Metropolitan Museum of Art, New York, Jefferson R. Burdick Collection, gift of Jefferson R. Burdick. This card was issued in two formats, one printed on thick stock and another on thinner stock, meant to be folded in three parts.

FIGURE 8.17 Unknown artist, *A. H. Belo–A Texas Ranch–Lassoing Cattle*, 1887. Trading card. Chromolithograph, 2.87 × 3.25 in., published by Allen & Ginter, Richmond, VA. Courtesy Metropolitan Museum of Art, New York, Jefferson R. Burdick Collection, gift of Jefferson R. Burdick.

the design that Sam Houston espoused: a blue flag with the Lone Star within the state seal. The Duke cigarettes card includes a portrait of Gov. Lawrence Sullivan Ross, a Longhorn portrait to his right and an image of a cowboy roping a steer to his left. A map of the state along with a brief statistical summary are printed on the back.[39] Allen & Ginter also published a series on American editors, which included A. H. Belo of the *Galveston Daily News* (testifying to the growing prominence of that publication, which Belo acquired in 1879) and the *Dallas Morning News*, which he established in 1885 (fig. 8.17). The coupling of the North Carolina–born Belo with a cowboy roping cattle demonstrates either how tainted the sophisticated Belo had become or the respectability the cowboy had attained in personifying the image of the state alongside one of its most notable publishers.

The Duke company, which introduced machine-made cigarettes to the market in 1885, also published a series of twenty-five cowboy cards to popularize them, with bucking broncos that could have been borrowed from Frederic Remington's action scenes. After interviewing John Orr, a wholesale grocer in Austin, a *Statesman* reporter observed that "the sale of Duke cigarettes has been very much increased through the very handsome and attractive advertising methods they use. . . . [They] find their way into every little store in the state." Simultaneously, a German scientist known for his contributions to agricultural and biological chemistry put Texas cowboys in the background in his image of the desert herb colocynth, which is used in various medicines (fig. 8.18). Recognizing the effectiveness of such advertising, Prof. Justus von Liebig added the by-now-familiar cowboys and a mountainous desert scene reminiscent of the Big

FIGURE 8.18 Unknown artist, *La Flore dans les Déserts*, 1888. Trading card. Chromolithograph, 10.5 × 6.5 cm (image). Published by Compagnie Liebig. Courtesy Albert van den Bosch, www.collectomania.be.

"THE 'IMAGE BREAKERS'" | 357

FIGURE 8.19 Unknown artist, *"Testing" Clark's O.N.T. Spool Cotton*, c. 1890. Trading card. Chromolithograph, 2.6 × 4.3 in. (image), by Prang & Co., Boston. Courtesy private collection.

Bend country to spice up his series on desert plants, one of the many sets of trading cards and calendars that he published to promote his meat extract.[40]

In addition to including cards with the product, salesmen sometimes gave cards to merchants to pass out with purchases. This might have been the case with the Clark Thread Co. of Newark, New Jersey, which also used the cowboy-roping-a-Longhorn image for one of its cards (fig. 8.19), as did Perry Mason & Co., of Boston, in advertising its popular magazine *Youth's Companion* and W. Duke & Sons in its Cowboy Series (fig. 8.20).

Perhaps the most unusual use of the cowboy image was by William L. Black's Range Canning Co. in Fort McKavett. Black was an angora goat raiser who found his land overstocked with goats in the early 1890s. When Armour and Co. declined to buy the animals, he decided to go into the canning business himself, calling his product roast mutton. There is a handsome sheep portrait on one side of the two-pound can, but the dominant image is the familiar depiction of a cowboy roping a beef (fig. 8.21). When even the cowboy label did not sell Black's mutton, he tried to appeal to the Hispanic taste for goat by marketing it under the name of W. G. Tobin's Chili-con-Carne

FIGURE 8.20 Unknown artist, *Texas*, 1891. Trading card. Chromolithograph, 3.1 × 5.5 in. (image), by Perry Mason & Co. Published by the Youth's Companion, Boston. Courtesy private collection.

FIGURE 8.21 Unknown artist, *Roast Mutton. Range Canning Co. Fort McKavett, Texas. U.S.A.*, c. 1893. Label. Chromolithograph, 14.7 × 50.1 cm (comp.), by Pittsburg Label Co. Courtesy private collection.

before giving up the business.⁴¹ Perhaps just as unusual is the Italian card advertising Liebig's popular meat extract with a Longhorn's head in the foreground, lying on a rifle and underneath what appears to be riding gear, while an extraordinarily well-dressed cowboy, presumably the executioner, leans on the barn door while smoking a cigarette. A pleasant ranch scene can be seen in the distance (fig. 8.22).

To market their tobacco products, D. Buchner & Co. of New York issued several different kinds of trading cards—baseball players, police inspectors and captains, and series of sixty cards titled "American Scenes with a Policeman." The cards included such famous scenes as Coney Island, the Zoological Building in Philadelphia, the Exposition Building in St. Louis, and the home of Abraham Lincoln, each one including a policeman, but they seem to have overlooked the cowboy. The Texas card is a scene of Military Plaza in San Antonio, with a policeman walking past a vendor's table. Buchner also published a book, *Defenders and Offenders* (1888), that included a series of chromolithographed portraits and biographical sketches of policemen and offenders, including Maggie Estars [Estes] of Fort Worth, "a keeper of a low resort," who became infamous when she got into an argument with real estate agent A. T. Truett in her room and killed him with a fire shovel.⁴²

Other remnants of the cowboy era are the catalogues that several saddle makers published with lithographed images of their wares. Padgitt Bros. of Dallas,⁴³ L. Frank of San Antonio, Don's Improved Saddle Co. of Houston, and

FIGURE 8.22 Unknown artist, *Il Texas (Stati Uniti d'America)*, c. 1893. Trading card. Chromolithograph, 10.6 × 6.6 cm, published by Liebig. Courtesy private collection. Liebig published his cards in many different countries, and this one appeared in at least four languages: Italian, French, German, and English.

S. D. Myres of Sweetwater, among others, all issued catalogues of their wares. The Dallas Litho Co. catalog for Padgitt Bros. is an example of the work (see fig. 7.73).

While the Texas cowboy did not necessarily recruit immigrants to the cattle country intentionally, the imagined life "seems to have an inexpressible charm for the young men," noted the *Daily Fort Worth Democrat*, and the images that appeared in various journals and trading cards would have encouraged many young men to forsake the shop or farm and head to Texas in its pursuit.[44] As an English visitor to the West wrote in 1887:

> The cowboy has at the present time become a personage; nay, more, he is rapidly becoming a mythical one. Distance is doing for him what lapse of time did for the heroes of antiquity. His admirers are investing him with all manner of romantic qualities; they descant upon his manifold virtues and his pardonable weaknesses as if he were a demi-god, and I have no doubt that before long there will be ample material for any philosophic inquirer who may wish to enlighten the world as to the cause and meaning of the cowboy myth. Meantime, the true character of the cowboy has been obscured, his genuine qualities are lost in fantastic tales of impossible daring and skill, of daring equitations and unexampled endurance.[45]

"SAFE FROM INDIAN RAID"[46]

One of the concerns held by would-be immigrants to western Texas, even as late as the 1880s, was Indians raiding in West and South Texas. The last marked battle with Indians occurred on January 20, 1881, at Sierra Diablo, when a group of Texas Rangers discovered the camp of Indians who had been raiding in the Trans-Pecos. Thereafter, the newspapers regularly assured readers that Texas was now "as safe from Indian raid as the good old city of Boston," but the *Galveston Daily News* reported in 1885 that "raiding warriors had been seen near Kinney," in South Texas. In 1889 the *Mobeetie Panhandle* accused the editor of the *Fort Worth Gazette* of "a willingness to turn the savages loose on the people of the Panhandle" by removing government troops. Perhaps most damaging to the claim that the state was Boston-safe was a letter from Englishman Thomas Wilson written from Luling to the editor of the *Malton Messenger* (in England): The Panhandle "region is (properly) called the barren lands of Texas," he claimed. "It joins the Indian Territory, and is infested by Indian raiders, who drive out nearly all who attempt to settle here."[47]

By then, of course, the Indians had been largely banished to reservations in Indian Territory, and artist Julian Scott's portrait of Quanah Parker was symbolic of that point (fig. 8.23). The son of Peta Nocona of the Quahada Comanches and Cynthia Ann Parker, whom

FIGURE 8.23 Julian Scott, *Quanah Parker. Chief of the Quah-hah-das Comanches—Oklahoma, 1890*, 1894. Chromolithograph, 23 × 17.9 cm (image), 26 × 17.9 cm (comp), by Sackett & Wilhelms Litho. Co., New York. Inscriptions: Eleventh Census of the United States. Robert P. Porter, Superintendent. Indians. [On stone]: JScott '90. From Census Office, *Report on Indians Taxed and Not Taxed in the United States (Except Alaska) at the Eleventh Census: 1890* (1894), opp. 540. Courtesy William L. Clements Library, University of Michigan, Ann Arbor.

the Comanches had captured in a raid on Fort Parker in Central Texas in 1836, Quanah became the last war chief of the Comanches. Provoked by the failure of the government to abide by the provisions outlined in the Treaty of Medicine Lodge (1867) and angered by buffalo hunters who swarmed onto the plains, annihilating the animals on which the Plains Indian cultures were based, Quanah led a multitribal force against a group of hunters at Adobe Walls in the Texas Panhandle in 1874. With their superior weapons, the hunters inflicted a number of casualties, and the US Army ran down the survivors in what became known as the Red River War. The Indians finally gave up and moved to the reservation, where Quanah, again, appeared to be a natural leader.[48]

Julian Scott was working as an artist for the Eleventh US Census in 1890, which was the first to enumerate Native Americans along with the general population. It was also the first census to employ artists and photographers as special agents to gather information about the variety of native lifestyles. Artists Walter Shirlaw, Henry R. Poore, Peter Moran, and Gilbert Gaul joined Scott in verifying the count, providing illustrative material, and submitting written recommendations for future policy.

Scott encountered Parker at Fort Sill, Indian Territory, in mid-August 1890. He photographed the chief and produced a portrait drawing (a conventional three-quarter, head-and-shoulders view) of a strong and dignified leader against a plain background. Scott did not agree with Parker's participation in peyote rituals or his polygamy (he kept seven wives), but the portrait he painted is more intimate and revealing of character than the stereotypical "noble savage." Parker is attired in Anglo-American clothing—a white shirt, brown vest, and black tie, with plaited red watch fob—but he has maintained some of his Comanche appearance as well: braids in his hair, red-painted cheeks and ears (which do not show up as clearly in the chromolithograph), and a decorative star at his throat. From that drawing, Scott did two oil portraits and the chromolithograph that was included in the Eleventh Census.[49] Parker's story soon became "a romantic history," and he himself was noted as "one of the most intelligent of the Indian chiefs."[50]

"LUDICROUS LITHOGRAPHS"[51]

Shortly after election to his second term in office in 1881, sixty-six-year-old governor Oran M. Roberts, who had held public office in Texas for almost four decades, decided to employ his vast experience and the prestige of his office in the effort to bolster the state's image by writing a book, which appeared in fall 1881, along with many other promotional publications, including bird's-eye views, illustrated maps, and railroad pamphlets promoting Texas. The "Old Alcalde," as his law students fondly called him (and the newspapers adopted as "O.A."), drew upon his years of experience—and his old lecture notes—to write chapters on the state's history, geography, crops, natural resources, and transportation. Roberts considered the work to be a condensation of his decades of experience, a primer, a newcomer's guide to life in Texas. It was a well-intentioned effort that was undone by its chromolithographic illustrations.

W. J. Gilbert of the Gilbert Book Co. in St. Louis, a well-known law book publisher, printed and distributed the book, which was titled *A Description of Texas, Its Advantages and Resources, with Some Account of Their Development, Past, Present and Future* (but better known as "Governor Roberts' Texas"); it was dedicated to Texan farmers. It contained 133 pages of text along with five lithographic maps (four with hand-coloring, produced probably with assistance from Prof. C. C. Georgeson of the new Agricultural and Mechanical College on the Brazos River) and eight unsigned chromolithographed illustrations. The volume sold for one dollar.[52]

The editor of the *Houston Age* received one of the prepublication announcements that Gilbert sent out, but he seemed uncertain as to what to expect: "We . . . do not know just what range it may take," the editor admitted, "but it is certain to cover the ground thoroughly as far as it goes."[53] Gilbert followed with advance copies to the press, and the first review was a straightforward summary that appeared in the *St. Louis Globe-Democrat*, a newspaper noted for its (not always positive) coverage of Texas but also for its awareness that the state was an important market for many St. Louis businesses.[54] The review concluded with the seemingly off-hand comment that the text was accompanied by "half a dozen ludicrous lithographs." Charles DeMorse, editor of the *Clarksville Standard*, followed up the remark, observing that the "colored prints, very far removed from true presentation of the scenes and characters they purport to represent," marred "the otherwise clean, nice look of the volume, which is well printed, and on good paper."[55] Faint praise, to be sure.

These chromolithographs by an unnamed artist quickly became the focus of Roberts's political foes and of editorial hilarity throughout the state as would-be critics seemed to vie with each other to fashion the sharpest barbs. The naïve images—an *Indian Chief*

(fig. 8.24), *Mexicans* (fig. 8.25), *Farmer & Negro* (fig. 8.26), *Texian Hare* (fig. 8.27), *Catching Cattle with Lasso* (fig. 8.28), *Looking After Hogs* (fig. 8.29), *Using Mules as a Conveyance* (fig. 8.30), and *Manner of Driving Oxen* (fig. 8.31)—would have been more at home on the lid of a cigar box or in a child's reader. Roberts does not mention the illustrations in the text, nor is there any mention of them in the available correspondence between Roberts and publisher Gilbert. It is possible that Gilbert commissioned them without Roberts's approval, but the unnamed illustrator surely read the manuscript before preparing them, for each print is placed near the discussion of that subject in the text. All feature mountains in the background, however, which is probably evidence enough of the unnamed artist's lack of familiarity with the state.

The pictures seemingly energized Roberts's opponents while leaving his friends bewildered and defensive. Thinking that the book might be part of a campaign to displace Richard Coke in the US Senate or perhaps to run for a third term as governor, Roberts's political foes quickly attacked. The *Waco Examiner* made a snarky assault soon after the review copies had been distributed, quoting the Old Alcalde's opening philosophical assertion that "Civilization . . . begins and ends with the plow," and wondering why he thought that it *ended* with the plow. The *Galveston Daily News* editor went further, questioning the importance or existence of the plow in ancient civilizations. The *News* review appeared several days later, characterizing the book as "a very thin affair." The *Gainesville Register* heightened the rhetoric: the book is "dull and stupid" with "little more than thumb-worn generalities." Finally focusing on the pictures, the editor

FIGURE 8.24 Unknown artist, *Indian Chief*, 1881. Chromolithograph, 9.5 × 16.2 cm (image). From O. M. Roberts, *A Description of Texas* (1881). Courtesy private collection.

FIGURE 8.25 Unknown artist, *Mexicans*, 1881. Chromolithograph, 9.6 × 16.2 cm (image). From Roberts, *Description of Texas* (1881). Courtesy private collection.

continued, "The illustrations are simply abominable, both in design and execution," a charge that was soon picked up by several other state newspapers.[56]

The *Terrell Times* provided more detail: "The rosy pictures . . . , noticeably the Texas hare about the size of a kangaroo [fig. 8.27]; a hog feeder, riding a superb animal, dressed in the glittering costume of the circus ring [fig. 8.29], and other equally unfaithful and ridiculous scenes, detracts rather than adds to whatever little merit the work may have." Suspecting more sinister motives, the editor of the *Crockett Patron* averred that the insertion of those "colored daubs" was a "mean trick" played upon Texas by "those rival States [i.e., Missouri] just above us," and demanded to know "who is responsible for the colored pictures?" He ventured that "if the book had been printed by the [Austin] Statesman or [Houston] Age, it would not have been so disfigured." In Roberts's defense, the *Galveston Daily News* editor suggested, "The St. Louis printers are probably responsible for the pictures."[57]

After following the reactions of his fellow editors for several days, the Crockett editor reconsidered his comments on the illustrations:

> Seeing so much about them, after having had our say, we took another look at them. They have to be seen to be appreciated, and then it will take the eye of an artist to discover all their beauties. They will bear close study. One might think he could take them all in at one glance, but we doubt it. We saw at first examination the negro with high-heeled boots, and lavender pants with the broken handle hoe, cutting up pineapples [fig. 8.26], and also the Texian hare, one

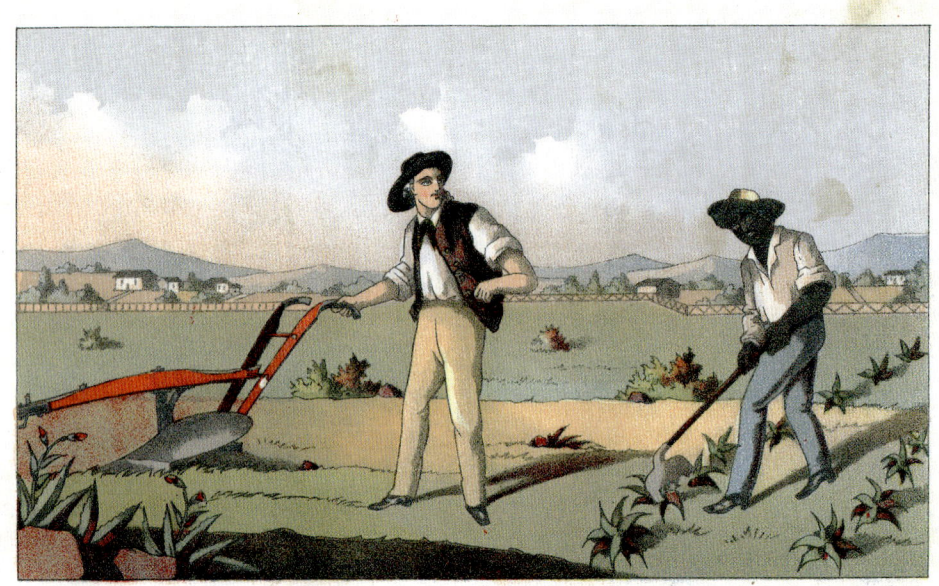

FIGURE 8.26 Unknown artist, *Farmer & Negro*, 1881. Chromolithograph, 9.6 × 16.2 cm (image). From Roberts, *Description of Texas* (1881). Courtesy private collection.

FIGURE 8.27 Unknown artist, *Texian Hare*, 1881. Chromolithograph, 9.6 × 16.2 cm (image). From Roberts, *Description of Texas* (1881). Courtesy private collection.

364 | TEXAS LITHOGRAPHS

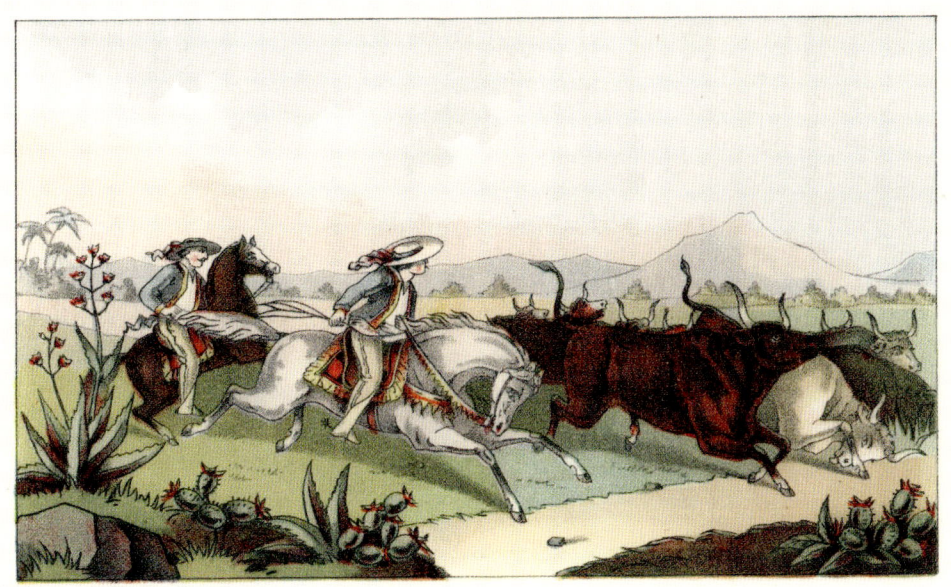

CATCHING CATTLE WITH LASSO.

FIGURE 8.28 Unknown artist, *Catching Cattle with Lasso*, 1881. Chromolithograph, 9.6 × 16.2 cm (image). From Roberts, *Description of Texas* (1881). Courtesy Star of the Republic Museum, Washington, TX.

LOOKING AFTER HOGS.

FIGURE 8.29 Unknown artist, *Looking After Hogs*, 1881. Chromolithograph, 9.5 × 16.2 cm (image). From Roberts, *Description of Texas* (1881). Courtesy private collection.

of whose ears is longer than the man that shot him, and the "big Indian heap," taller than his cone-shaped tent [fig. 8.24], but we honestly confess we did not see the curls in the pigs' tails until the second examination, and possibly would not then, if we had not had a suggestion from another [fig. 8.29]. When you get the book, mark the peculiar harmonious twist given each one; each tail forming a figure 6 with a flourish."[58]

Most of the editors seemed to agree with the *Dallas Herald*, which reported that a small boy was excited about the pictures because he thought they were made by the "same parties who get up the circus show-bills." The *Dallas Times* characterized the "gaudy and different pictures" as "a kind of Humpty Dumpty work," to which the *Corsicana Observer* added that they "would be better appreciated in one of Old Mother Goose's nursery pictorials." An anonymous Austin correspondent considered inclusion of the images "a lucky thought. Without them the book, like many a better one, might have soon been forgotten. With them, we think, it is destined to a permanent place in the family nursery, where it may fairly rival Jack the Giant Killer and Goody Two Shoes."[59] When the editor of the *Waco Telephone* tried to add some sanity to the discussion— "It is simply an entertaining book of Texas, by a Texan and for Texas"—the *Galveston Daily News* replied, "Entertaining is a good word—funny would be better."[60] Austin humorist Alexander E. Sweet, editor of *Texas Siftings*, had the last word, noting that a Boston author was suing his publisher because his book did not sell well, and suggested that Roberts should "be entitled to damages from the publishers of his 'Texas.'"[61]

"THE 'IMAGE BREAKERS'" | 365

FIGURE 8.30 Unknown artist, *Using Mules as a Conveyance*, 1881. Chromolithograph, 9.5 × 16.2 cm (image). From Roberts, *Description of Texas* (1881). Courtesy private collection.

FIGURE 8.31 Unknown artist, *Manner of Driving Oxen*, 1881. Chromolithograph, 9.5 × 16.2 cm (image). From Roberts, *Description of Texas* (1881). Courtesy Star of the Republic Museum, Washington, TX.

Despite the overwhelming consensus, Roberts's friends valiantly defended him, one claiming that "the Old Alcalde and his book are rather benefitted than injured by the laugh of the Texas press," but even they could not accept the pictures.[62] One writer praised Roberts's text as "the best compendium of Texas that has yet been provided for the emigrant," but he could not help but admit a "little chromatic exuberance in the illustrations." "The pictures . . . were probably inserted by the publisher to please the planter's wives and children," claimed R. O. Davidson of Hillsboro. Another reviewer agreed:

> The book is fearfully and wonderfully illustrated, but for the execution of these grotesque decorations the publishers, of course, are responsible. The artist in one startling masterpiece, has displayed to the amazed naturalist a conglomerate structure of jackass and kangaroo and labeled the composition "A Texian Hare," only the text shows that a mule-eared rabbit was intended. If the Old Alcalde is given to the habit of profanity, it must have been interesting to witness his delight at first sight of the pictures with which the publishers have disfigured his book.

The editor of the *Arkansas Gazette* suggested that the poor jackrabbit had already been victimized by cowboys taking target practice, coyotes, and dogs, and now Governor Roberts had added insult to injury with his illustration. In fact, the image that so offended reviewers was copied directly after John Woodhouse Audubon's painting published in John James Audubon and John Bachman's popular *Viviparous Quadrupeds of North America*.[63]

The *Galveston Daily News* finally reported, "There is a general call by the Texas press for the name of the artist who got up the illustrations for the Governor's book. He should come to Texas and start an illustrated comic paper. It would knock the [Texas] Siftings higher than a kite. He beats Nast out of sight as a caricaturist."⁶⁴ Despite such invitations, the name of the artist has not surfaced yet, and Thomas R. Bennett, editor of *Christian Messenger* in Bonham, gracefully concluded that "Gov. Roberts' book on Texas is affording the newspapers a good deal of amusement."⁶⁵

The book nevertheless found a ready audience. A teacher from Alvarado wrote the governor to commend him on his plainspoken summary and reported that she was going to use the book in her school. The A&M College and Sam Houston Normal Institute in Huntsville adopted the book for use in the classroom. Percy V. Pennybacker, superintendent of schools in Bryan, suggested to Roberts that he have the book translated into German, and the International and Great Northern Railroad apparently preordered and distributed two thousand copies at the International Cotton Exposition in Atlanta later that year.⁶⁶ "We hope the sensational colored chromos will be eviscerated" from the "revised, enlarged and improved" edition that both the *Colorado Citizen* and the *Brenham Weekly Independent* reported would be published, but no second edition is known to exist.⁶⁷

A. H. Edwards of Sulphur Springs, president of the Texas Grange, wrote to compliment the governor upon his "clear, plain, concise and philosophical view of Texas," then raised the possibility that Roberts had disavowed the pictures to him: "You explained them to us," he noted, "and I have taken pleasure in so explaining them to others." And John G. James, president of A&M College, suggested that the criticisms were so "ill-natured" because Roberts's political opponents feared that the book was the opening salvo of another political campaign. Instead, it marked the closing of one. Roberts declined to be renominated as candidate for governor in 1882 and accepted a position as professor of law at the newly created University of Texas.⁶⁸ Still, the issue would not go away. When the editor of the *Brenham Daily Banner* learned that Roberts was joining the law school faculty, he urged that he not use his book on Texas "if he has any hopes of the University being a success."⁶⁹ The *San Antonio Express* went further. Claiming that they had thus far maintained silence on the issue "for the credit of the State," the editors considered the proposal "to introduce this ridiculous travesty of a book . . . as a text book into our schools and colleges . . . an unpardonable outrage."⁷⁰

The illustrations so fully occupied the editors of the *Galveston Daily News* that it was Alex Sweet of *Texas Siftings* who finally pointed out several years later that Galveston Island had actually been omitted from Roberts's maps, which showed none of the barrier islands along the coast. The maps located Galveston on the mainland, near Houston. "Here's a pretty howdy-do," Sweet concluded, quoting Ko Ko in the *Mikado* (fig. 8.32). And when the editor of an eastern paper contacted the editor of the *Fort Worth Gazette* asking for a list of one hundred of the worst books ever written, Roberts's book on Texas readily came to mind.⁷¹

FIGURE 8.32 Unknown artist, cover of *Texas Siftings* (New York), April 20, 1889. Chromolithograph. Alex Sweet and John Knox, his partner, moved the publication to New York in 1884, but they continued with their Texas themes.

WALTZES AND MARCHES

More successful than Governor Roberts in mending the Texas image was the Galveston firm of Thomas Goggan & Bro. Goggan did not print lithographs, but he published a number of them as covers for his sheet music. Goggan, an Irish immigrant who attended St. Edwards University in Austin and Springhill College in Mobile, Alabama, worked for the William C. Peters Music Co. in Cincinnati before moving to Galveston with his large stock of musical instruments in 1866. Although he was advised that he would do better in Texas if he dealt in weapons and ammunition, he persisted and did his part to diversify the Texas image. His main business was selling pianos, of course, but in 1869 he became the first firm in Texas to publish sheet music, often illustrated with lithographic covers. In 1889 he published "'Tis Hard to Leave the Old Home," dedicated to Alice S. Coyle, the daughter of Houston stationer and lithographer W. H. Coyle, including "a very correct lithographic picture of the young lady" on the cover.[72] A number of his illustrated music sheets feature Texas scenes, such as "The Galveston Fire of 85"; "Houston's Enterprise Grand Marches" (1887), which features a picture of Main Street in Houston (fig. 8.33); "The Texas State Capitol Grand Waltz" (fig. 8.34), in honor of the opening of the new capitol; "The Pirate Isle No More Semi-Centennial March" (fig. 8.35), on the fiftieth anniversary of the founding of Galveston; the "White Squadron Grand March" (figs. 8.36 and 8.37); and "The Jetties March," featuring a map of the new deep-water entrance to the Port of Galveston. He published one ranching scene on the cover of "The Texas Cowboy" (fig. 8.38), which includes eleven

FIGURE 8.33 Unknown artist, "Houston's Enterprise Grand Marches," 1887. Sheet music. Lithograph, 36 cm. Published by Thos. Goggan & Bro., Galveston. Courtesy Special Collections, University of Houston Libraries.

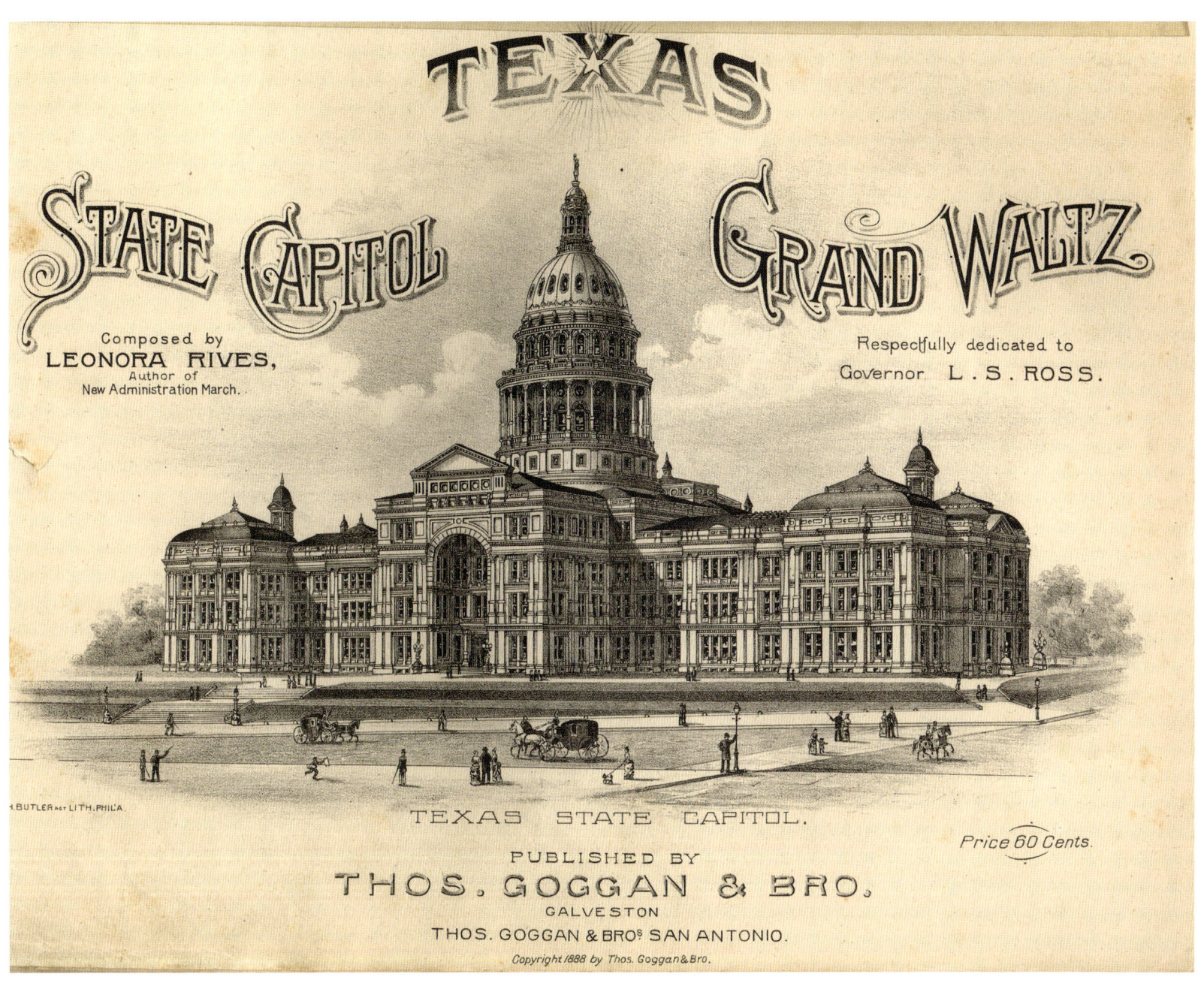

FIGURE 8.34 Unknown artist, "Texas State Capitol Grand Waltz," 1888. Sheet music. Lithograph, 27 × 35.75 cm (comp.), by W. H. Butler, Philadelphia. Leonora Rives (composer). Published by Thos. Goggan & Bro., Galveston. Courtesy Sheridan Libraries, Johns Hopkins University, Levy Sheet Music Collection.

FIGURE 8.35 Unknown artist, "The Pirate Isle No More Semi-Centennial Grand March," 1889. Sheet music. Lithograph, 8.9 × 11.7 in. H. A. Lebermann (composer). Courtesy Sheridan Libraries, Johns Hopkins University, Levy Sheet Music Collection.

(LEFT) FIGURE 8.36 Unknown artist, "White Squadron Grand March," 1891. Sheet music. Lithograph, 18 × 22 cm (image), 35 × 27 cm (comp.). Copyright 1891 by Thos. Goggan & Bro. Mrs. Robert Thomson (composer). Respectfully dedicated to the officers of the White Squadron. The ships are labeled the Boston, Atlanta, Chicago (flagship), Dolphin, and Yorktown. Courtesy DeGolyer Library, Southern Methodist University.

(BELOW) FIGURE 8.37 Unknown artist, engraving of the Great White Fleet from the *Galveston Daily News*, April 26, 1897, 6. Goggan borrowed this scene to feature on the cover of "White Squadron Grand March."

"THE 'IMAGE BREAKERS'" | 371

FIGURE 8.38 Unknown artist, "The Texas Cowboy," 1886. Sheet music. Lithograph, 35.5 × 27 cm. H. F. Fazende (composer). Courtesy Historic Sheet Music Collection, 1800 to 1922 (7.862), Music Division, Library of Congress. One may hear this song played on the piano at "The Texas Cowboy (Polka Mazurka)" at YouTube.

different scenes from cowboy life, among them a covered wagon with "T.G. & Bro." on the canvas cover, and Mrs. Robert Thomson's lyrics show just how far the cowboy's image had evolved from that of the hard-working ranch hand by 1886:

> *I am a Texas Cowboy,*
> *Light hearted, gay and free,*
> *To roam the wide, wide prairie,*
> *Is always a joy to me,*
> *My trusty little pony,*
> *Is my companion true;*
> *O're plain, thro' woods and river,*
> *He's sure to "pull me thro."*[73]

Cowboys also appear on the cover of Ida Louise Overall's "Getting Rich in Texas" (fig. 8.39), alongside rare images of Black people working in the cotton fields and miners digging ore. Mrs. Overall's new composition proved to be popular and was performed at the Texas State Fair in Dallas in 1894, where "it called forth loud applause from the large audience," and at the Grand State Drill and Encampment and Confederate Veterans Reunion in Houston in 1895. Goggan also published songs by the Black minstrel singer, banjo player, comedian, and composer Fred Lyons, such as "Dem Chickens Roost Too High" and "Paint All de Little Black Sinners White."[74]

The "White Squadron Grand March" features one of Goggan's more unusual covers, a lithographic scene of the White Squadron anchored in the Gulf during its 1891 visit to Galveston (see fig. 8.36). The navy had declined following the Civil War, and the White Squadron, six ships built of steel, represented America's return to a competitive navy. The squadron arrived at Galveston in February in time for the Mardi Gras celebration, but the ships had to lie off the coast because they could not enter Galveston's shallow harbor. The *Galveston Daily News* editors were so anxious to get good images of the ships that they sent a photographer out on a tugboat, but the water was too choppy for him to get a good picture. Undeterred, they employed an "aeronaut photographer" who went up in a balloon and photographed the squadron. The engraving after the photograph of the five ships ran in the February 5, 1891, issue of the *News* (see fig. 8.37), and that image inspired Goggan's cover for his "White Squadron Grand March."[75] Goggan identifies few of the lithographers responsible for his sheet music covers, and none of them are Texas lithographers.[76]

FIGURE 8.39 Unknown artist, "Getting Rich in Texas," 1893. Sheet music. Lithograph. Song and chorus composed by Ida Louise Overall. Published by Balmer & Weber Music House Co., St. Louis. Courtesy Texas Collection, Baylor University.

ILLUSTRATED NEWSPAPERS

The trend to deemphasize cowboys and their raucous behavior was never clearer than in the state business community's efforts to seek positive national publicity in the popular illustrated journals of the day. In addition to *Harper's Weekly*, *Ballou's Pictorial*, and *Leslie's Illustrated*, which had been around since the 1850s, the state's civic promoters actively sought coverage in newer northern journals, such as the *Daily Graphic* in New York. Although many Texans still held animosity against the northern publications, their numerous illustrations nevertheless attracted attention. Canadian engravers George-Édouard Desbarats and William Leggo launched what became the first American illustrated daily newspaper in March 1873, which was printed entirely by lithography, including the type; they soon had correspondents in Texas regularly submitting material. Several scenes of Texas appeared in the publication in the 1870s and 1880s.[77]

The *Daily Graphic* fascinated the correspondent for the *Boston Transcript* because it was an unusual newspaper—not only because it was issued daily and was well illustrated but also because it was printed entirely by lithography. The correspondent toured the *Graphic* offices and described the process in an article that was later summarized in other newspapers, including the *Houston Daily Mercury*:

> Some of the sketches which appear in The Graphic are first drawn by hand on paper with a pen and ink. . . . The sketch is then copied upon a glass plate through the instrumentality of a camera. This plate is called a negative, and from it, by the aid of the sun, or a powerful artificial light, a copy of the picture is obtained on transfer paper. The transfer paper is very thin, and so made that it will readily yield ink to a lithographic stone. After having been properly prepared, the transfer paper is placed upon the stone, face down, from which The Graphic is to be printed, and a transfer is made. The result is the picture which was originally drawn with a pen appears upon the smooth surface of the lithographic stone, and is an exact *fac simile* of the original.[78]

The writer answered the obvious question as to why the *Graphic* could not reproduce a photograph: because a photograph "contains no lines, but only light and shade." However, the artists could draw from photographs and often did, as in the case of the Texas illustrations. Nevertheless, the *Graphic* is credited with publishing the first photolithograph that year, an image of Steinway Hall in New York.[79]

The first image of Texas to appear in the *Graphic* was a "spirited rendition" of the distribution of the invitations to the Mardi Gras festivities in Galveston (see fig. 7.22), a collaboration between Matthew Whilldin, a former editor-in-chief of both *Flake's Bulletin* and the *Galveston Daily News*, now serving as the art correspondent for the *Graphic*, and J. C. Evans, a locally known scenic artist who worked at the Galveston Opera House.[80] Whilldin appended an explanation of the illustration:

> The double sheet which encloses the card of invitation bears a picture representing a jolly-looking fellow, dressed as a clown [upper left], with a fishing rod on his shoulder bent with the burden of the letters M. D. R., and hanging to the hook at the end of the line a banner, on which is the following:
> first annual reception,
> galveston artillery hall,
> mardi gras, 1876

The same reveler is shown on the card in the upper-right corner standing on the beach holding a fishing pole, with yet another event announced on the attached banner.[81] Whilldin and Evans followed on March 13 with a full-page illustration of the floats in the Knights of Momus procession (see fig. 7.23).[82]

In between those two stories, the *Graphic* carried a more serious story of how Galvestonians were working to improve the harbor so that larger ships could be accommodated. The half-page image published on March 4 (after photographs by R. B. Talfner, assistant engineer, US Army) touted the construction of gabions for jetties to keep sandbars from forming in the mouth of the harbor, where the San Jacinto and Trinity Rivers meet the waters of the Gulf, but the experiment was a failure.[83]

Whilldin had recently returned from San Antonio, where he had conducted research on the city for a promotional book on the Galveston, Harrisburg & San Antonio Railroad (see chapter 9), and he took advantage of that work to produce a full-page story on the city's missions, with illustrations after San Antonio photographers Henry Doerr & Semmy E. Jacobson (figs. 8.40 and 8.41). He told the story of how Father Antonio Margil de Jesús established the missions, and he submitted stereo-photographic views to be copied

FIGURE 8.40 W. H. C. after Doerr & Jacobson, photographers, *View of Ancient Missions Near San Antonio, Texas*, 1876. Lithograph (with modern color), 8.5 × 12.5 in. From the *Daily Graphic* (New York), March 18, 1876. Courtesy Bradford R. Breuer Collection, San Antonio.

FIGURE 8.41 Henry Doerr, *Mission Concepción, San Antonio*, c. 1875. Right half of a stereograph. DeGolyer Library, Southern Methodist University. The *Daily Graphic* artist copied this photograph for the picture in the center of his illustration (see figure 8.40).

as lithographs in the *Graphic*, complimenting the images as being "of unequalled clearness."[84] The *Daily Graphic* also carried news of the border troubles—cattle rustling and bandits in the area between the Nueces River and the Rio Grande—and of Mexican general Porfirio Díaz's ultimately successful revolt against President Sebastián Lerdo de Tejada.[85]

With its daily publication and timely pictures, the *Daily Graphic* caught the attention of city fathers across the country who were trying to draw the interest of new businesses and immigrants. The *Denison Daily News* sounded a common refrain when it reported in December 1873, and then again in March 1880, that *Daily Graphic* correspondents were in town "for the purpose of illustrating and writing up" the city, but the only picture that appeared was one of the Refrigerator Car Co. building that accompanied a long article on the development of the refrigerator car, an invention vitally important to Texas ranchers.[86] Similarly, the *Galveston Daily News* noted in July that a *Daily Graphic* artist was in town making sketches and inquiring as to the kind of structure Laffite had built on the east end of the island. The resulting illustrations of Austin, Houston, and Galveston, published later that summer (fig. 8.42), did not include Laffite's fort, probably because no one could provide a description of it. Instead, using images by Galveston photographer F. W. Kersting, the *Graphic* artist produced a double-page spread that included twenty-one vignettes of a bustling and prosperous city, including such landmarks as the Strand, the cotton exchange, the Tremont Hotel, the Galveston Pavilion, boats in the harbor, people enjoying the beach, and the Strickland company on the Strand. The Austin view includes ten scenes, including the Colorado River from Mount Bonnell and Bull Creek, copied after photographs by H. B. Hillyer (fig. 8.43).[87]

The *Daily Graphic* followed a similar process with spreads on San Antonio and Galveston in 1881, made after drawings and photographs

FIGURE 8.42 Unknown artist after F. W. Kersting photographs, *Views in Galveston, Texas*, 1880. Lithograph, 20.5 × 29 in. From the *Daily Graphic*, July 20, 1880. Courtesy Rosenberg Library, Galveston.

FIGURE 8.43 Unknown artist after H. B. Hillyer photographs, *Views in Austin, Texas*, 1880. Lithograph (with modern color), 20 × 13.5in. From the *Daily Graphic*, June 30, 1880. Courtesy Briscoe Center for American History, UT Austin.

by their correspondent; Houston (made after Charles J. Wright's photographs); and Fort Worth, Brenham, Corsicana, Laredo, Corpus Christi, and Galveston again in 1882. The opening sentence of the story on Houston probably stoked the competition among ambitious Texas cities by reporting that "Houston is second only to Galveston of all the cities in Texas."[88] The *Graphic* also ran illustrated stories on the rapidly growing city of El Paso in 1883 and 1885, and biographical stories and portraits of Galveston businessman Alfred M. Hobby and Texas governor Richard Coke.[89] Ironically, the *Daily Graphic* apparently skipped over Dallas, the fifth largest city in the state in 1880.

The *Daily Graphic* stories probably had only modest impact, for it did not have the circulation of the large, national journals and ceased publication in 1889.[90] But state leaders were soon presented with an opportunity that they could not pass up: a special edition of *Leslie's Illustrated* all about Texas.

THE TEXAS EDITION

In 1890 *Frank Leslie's Illustrated Newspaper*, one of the most popular illustrated journals in the country and bearing a reputation for accurate illustrations, proposed a "Texas edition" supplement to their publication. They explained that they had done several other special issues and that Texas deserved the attention:

> Texas is the largest State in the Union. It is an empire in itself. Its resources, in their extent and diversity, are wonderful. No State in the Union is attracting a larger stream of emigrants; none offers cheaper lands or lower taxes. No Southern State has had a larger influx of Northern people and of Northern capital within the last five years.[91]

Leslie's sent several advance teams to cities throughout the state to presell the project. The editors of the *San Antonio Daily Light* exemplified the enthusiasm that many felt as they recommended that the city fathers get behind the project: "The part San Antonio will bear in it will be largely dependent upon her wisdom in providing funds to pay the expenses of this edition of Leslie's." Once the project was assured, *Leslie's* sent Russell B. Harrison, co-owner of *Leslie's* and the son of President Benjamin Harrison, along with editors, writers, artists, and reporters from other newspapers, on a tour of the state aboard a special palace car, expenses paid by contributions from Texans anxious to ensure the success of the project. Hosts from Texarkana to El Paso, Gainesville to Laredo, lavishly entertained the visitors, who took photographs, made architectural and portrait drawings, conducted interviews, and wrote many stories. On their stop at Galveston in June 1890, Russell Harrison observed that he was from Montana, "a state that had struggled long for proper recognition—a struggle that Texas was now undergoing," and suggested that "all that was needed was that the present and prospective greatness of Texas be properly presented to the people of the north." Texas business and civic leaders rallied to the cause and gathered enough financial support to publish three special Texas editions instead of just one. Apparently, the El Paso city council was in the minority when it decided not to allocate the $750 requested for 7,500 copies of the proposed issue (ten cents per copy) unless taxpayers requested it—and they did. The *Leslie's* representatives also asked that private citizens match the city's contribution for a total of $1,500. Galvestonians ultimately did not participate, and the editors of the *News*, who had been skeptical of the project from the outset, published a hundred thousand copies of their own seven-page (un-illustrated) "Texas Edition" on September 1.[92]

Leslie's Texas editions appeared on September 27 and October 4 and 18, 1891. They included pages of copy and dozens of sketches of buildings and portraits of civic leaders from almost thirty cities throughout the state. They began with a brief history of the state and its geography, followed by well-illustrated articles on individual cities. *Leslie's*, of course, produced each of the editions as a "copiously illustrated supplement"—*An Empire Illustrated*, with chromolithographed covers, "gorgeous with coloring and gilt [fig. 8.44A and 8.44B]." The new capitol is featured on the front cover, and the back contains a montage of buildings in Sherman. At the top of the page is the scene at the corner of Travis and Houston Streets (which is mislabeled Hamilton Street), but despite such minor errors the *Fort Worth Daily Gazette* was quick to claim, "As an advertisement of Texas this edition cannot be excelled."[93]

Not everyone agreed. Galveston businessmen had to have been a little miffed that their absence from the supplements gave Corpus Christi leaders the opportunity to include a map showing their city as the primary port on the Gulf with railroad lines extending across the United States and into Mexico. The *News* editors eagerly gathered critiques from around the state, including this bit from the *Whitesboro News*:

FIGURES 8.44A AND 8.44B Unknown artist, *An Empire Illustrated*, 1890 (front and back covers). Chromolithograph, 40.7 × 28.4 cm. From *Frank Leslie's Illustrated Newspaper*, Sept. 17, 1890. Courtesy Special Collections, University of Texas at Arlington Libraries.

A universal howl is going up from the town that shelled out liberally to the Frank Leslie Illustrated Newspaper fake that was careering through Texas in palace cars last spring in search of suckers. They complain that the write-ups are the purest slush and that their illustrations make their finest buildings as tumbled down shanties, and their leading citizens look like burglars.

A few weeks later the *News* triumphantly gloated that "the city of El Paso has recovered from the Russell B. Harrison, Frank Leslie and rainmaker sells, and the papers show signs of the return of life and enterprise. The Frank Leslie write-up and the rainmakers came high, but the experience was valuable. . . . All the fish, however, do not seem to have yet been caught by the rainmakers," the editor continued, for after the *Leslie's* entourage visited Aransas Harbor on the coast, Harrison accepted $500,000 in stock to lend his name, along with former Texas lieutenant governor Thomas B. Wheeler's, as heads of the Aransas Harbor and Land Improvement Co., which promoted a deep-water port at Aransas and received two pages of coverage in the Texas edition. When no development had taken place after a year, the company seemed on the verge of collapse, and investors defaulted on their notes and called for the indictment of Harrison and Wheeler. Less than a year after Harrison's visit, his father made the first presidential visit to Texas as a part of his tour of the South and the West, calling, sometimes for only a few minutes, at Texarkana, Palestine, Houston, Galveston, San Antonio, Del Rio, and El Paso (fig. 8.45).[94]

In retrospect, the three *Leslie's* supplements were the most extensive, nationally distributed pictorial coverage of Texas to that date, probably offering more than 250 images of landscapes, cities, buildings, factories, and people. Yet the cowboy—that icon that emerged to represent

FIGURE 8.45 Unknown artist, "President's March through Texas," 1891. Sheet music. Lithograph by J. J. M. Armstrong Co., Engravers, Philadelphia. Published by H. N. Lincoln, Dallas. Courtesy DeGolyer Library, Southern Methodist University.

the state in the popular imagination in the twentieth century, who had already attracted the attention of Charlie Siringo, Frederic Remington, Charles M. Russell, Owen Wister, and Teddy Roosevelt, and of tobacco and coffee companies, among others—was conspicuously absent but for an ad sponsored by Wright & Lenoir. The Fort Worth real estate agents mentioned ranches among the properties that they represented and pictured cowboys watching a herd of cattle along with several other images in a full-page display. State leaders touted the rich farmlands for growing cotton and wheat, and extolled natural resources such as lumber and minerals, but they omitted pictures of cowboys or ranches. In one of their largest efforts to tell the rest of the country about Texas, the state's business and civic leaders apparently wished to shed the troublesome spawn of the vaquero.

But the cowboy would not go away. While the Texas business and civic community pitched growing, modern cities; vast stretches of fertile farmland; and railroad and sea links to larger, industrial markets, a *Galveston Daily News* reporter, noting that the "Texas cowboy is a picturesque and interesting character wherever he goes," quoted a *New York Times* reporter's account of the recent appearance of William F. "Buffalo Bill" Cody's Wild West exhibition in the ancient Roman amphitheater in Verona, Italy, as a case in point:

> The first indication of the rising of the show . . . was a solitary cowboy on a buckskin cayuse, who rode up to the amphitheater and around it with a characteristic ambling gait. With one keen American glance he seemed to take in the whole town, amphitheater, palaces, fortifications, and all. He halted his steed before an ancient archway, through which Diocletian and his suite, and since then Napoleon I, had ridden, and called to the attendant within: "Get a gait on yourself, there, Beardy, and come and open this here iron fence."

And out of a cloud of dust behind him came cowboys, Indians, Mexican vaqueros, buffaloes, Texas steers, and various circus animals. The Galveston editor patronizingly added that the exhibition "is supposed to be a reproduction of what is now taking place throughout the cattle region of Texas."[95] The reporter might have preferred the Goodrich Tire Co.'s portrayal of Mr. Potter of Texas, the leading character in English writer Archibald Clavering Gunter's hit novel *Mr. Potter of Texas* (1888) (fig. 8.46). The subject of this caricature twirls a lasso, presumably in pursuit of the two cattle headed over the horizon, while riding a modern safety bicycle (safer than a highwheeler). The book, loosely based on well-known Texas rancher and stockholder Shanghai Pierce, was translated into several languages and made into a dramatic presentation in 1890 and a silent film in 1922.[96]

L. C. Butte's concern over the "ignorance about Texas" in the rest of the country had, perhaps, helped spur these sincere but uncoordinated efforts to change the state's image. The cowboy did not disappear, but he did get a makeover and was on his way to becoming, even if inadvertently and unofficially, a powerful symbol in the statewide effort to define itself, which reached its apogee during the Texas Centennial of 1936.[97] The state's population was climbing, and the value of its farm products had almost doubled between 1880 and 1890, as had the number of manufacturing establishments.[98] Perhaps more important, there seemed to be a fresh attitude. Following a visit in 1889, George W. Knott, a correspondent for the trade journal The *American Stationer*, reported, "One who visited Texas in 1879 and then made the same trip this summer would scarcely recognize the 'Lone Star' State, so great has its progress been. . . . Texas is the only Southern State which is fully imbued with the spirit of Northern enterprise."[99]

(OPPOSITE PAGE) FIGURE 8.46 Unknown artist, *Goodrich Tires Stand the Wear[.] Ask Mr Potter of Texas*, c. 1895. Poster. Chromolithograph, 82.23 × 59.69 cm, by Werner Co., Akron, OH. Courtesy Jay T. Last Collection of Graphic Arts and Social History, Huntington Digital Library, San Marino, CA.

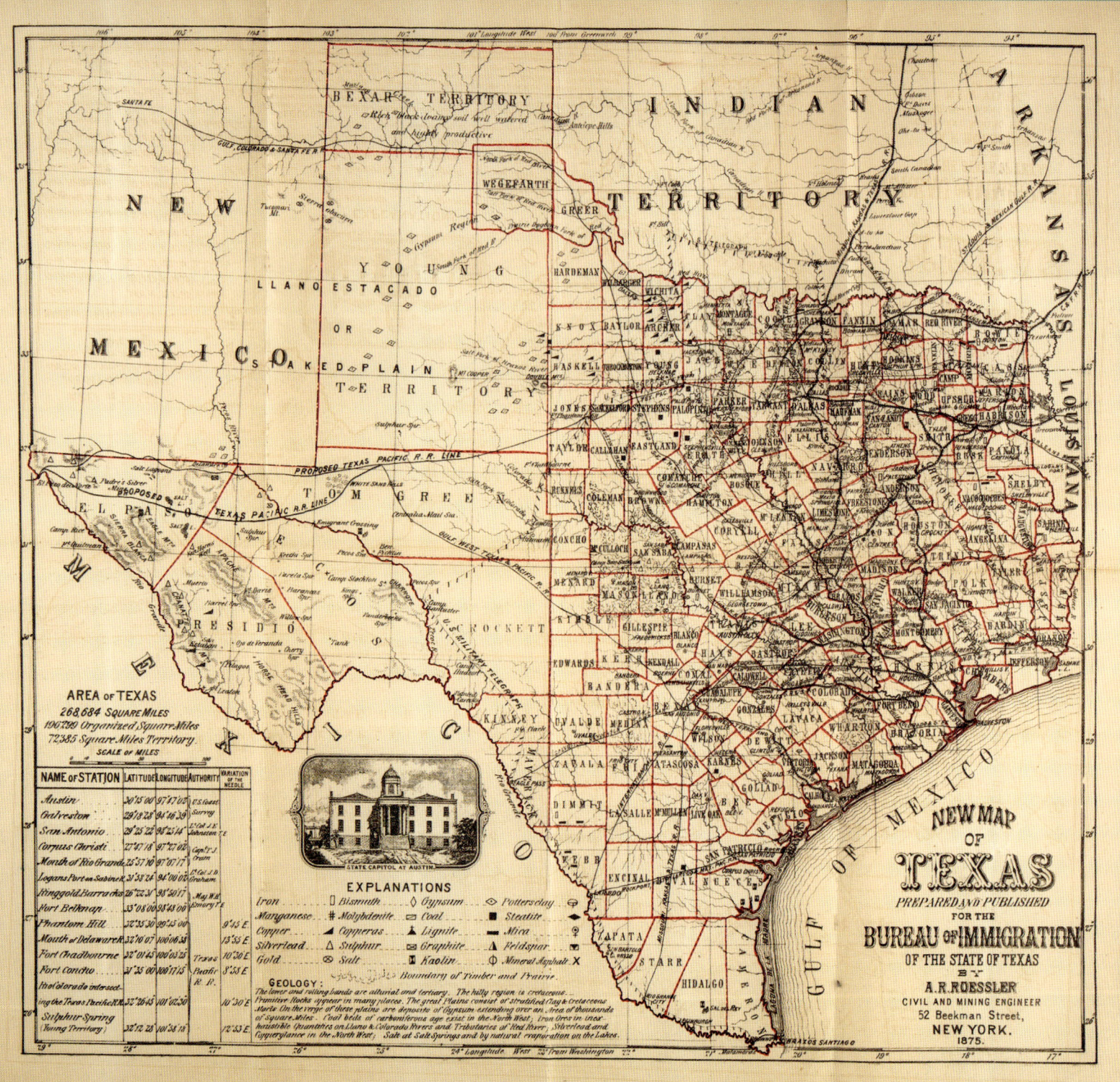

FIGURE 9.1 A. R. Roessler, *New Map of Texas Prepared and Published for the Bureau of Immigration of the State of Texas*, 1875. Color lithograph, 37.6 × 41 cm, lithographer unknown. Courtesy Special Collections, University of Texas at Arlington Libraries.

CHAPTER 9

"THE TRUTH IS TEXAS IS WHAT HER RAILROADS HAVE MADE HER"

By 1897, according to a trade journal, the state was "growing at a most remarkable rate and is an agricultural and commercial empire of steadily increasing proportions," with a "strong rivalry . . . between St. Louis and New York for the business of the Texas merchants."[1] Efforts to recruit more settlers, seriously begun under the Reconstruction government with the poorly funded Bureau of Immigration, had paid dividends. Led by superintendents Gustav Loeffler and Jerome B. Robertson, the bureau had sent agents to St. Louis and New York; Manchester, England; and Bremen, Germany. The bureau also published a number of reports, books, and maps to encourage and assist immigration (fig. 9.1). The Democrats had abolished the bureau in the name of austerity in the 1876 Constitution, lending only moral support through a legislative joint resolution welcoming the "good and industrious immigrant" to the state "*provided*, the same be done without any cost to the State," but creative state officials, individuals, private enterprise, and shipping and railroad companies stepped into the breach, publicizing the state, according to one historian, with "words, words, words." But pictures— engravings and lithographs—also played a largely unheralded role in the effort.[2]

THE "GREAT WEST" BECKONS

With the shipping lanes reestablished after the Civil War, civic leaders had turned their attention to inland transportation and the railroads, which were key to Willard Richardson's plan for making Galveston the transportation hub of the "Great West." As the nation slowly recovered from the panic of 1873, Texas entered its greatest era of railroad building, one of the greatest such efforts in the nation, made possible when the state offered railroad companies sixteen sections of land for every mile of track they built. Railroad mileage in Texas jumped from 711 in 1870 to 9,886 in 1900 and 14,282 in 1910.[3] The huge land bounties meant that the railroads quickly became the largest landholders in the state, and they needed people to buy and settle the land and become customers, to use their facilities both as passengers and shippers.[4] They quickly added their marketing skills to the modest state efforts and to those of developers, land speculators, and community leaders who enthusiastically advertised to attract immigrants.

FIGURES 9.2A AND 9.2B Unknown artist, *Your Too New Young Man* and *A Cabbage Head*, c. 1890. Trading cards. Chromolithographs, approx. 5 × 3 in.

"COME TO TEXAS"[5]

Among the greatest boosters were newspaper editors, who wrote positive stories about the state, published letters from newcomers, and copied articles from other newspapers touting the state's advantages. Most small towns had newspapers, and the larger ones had several. In addition, George H. Sweet, former editor of the *San Antonio Herald*, returned to his home state of New York in 1870 and began publication of the *Texas New Yorker*, a monthly journal targeting would-be immigrants as well as Texas consumers, with the hope of making "capitalists everywhere" aware of the "latent material interests of Texas."[6] Two years later the *St. Louis Texan* began publication with similar goals.[7] Also working in St. Louis, which was rapidly becoming a hotbed of Texas activity, was the "eccentric" John Howard, an agent for the St. Louis, Iron Mountain & Southern Railway, who kept his office in the Southern Hotel. Howard had a long career working with several different rail lines and was "one of the clever men of Texas" who always identified himself as "of and for Texas." According to a Galveston reporter, he "will talk Panhandle country to a lamp-post if he can't do better," and the *Waco Day* wished "that a hustler like Mr. Howard and a hundred others of the same kind were in Waco all the time."[8] Among other efforts, Howard took advantage of a popular fad of the day, chromolithographed trade cards like those distributed by tobacco companies, coffee makers, and others, to advertise the state (figs. 9.2A and 9.2B). Cards featuring anthropomorphic fruits and vegetables, often with humorous captions, were popular during the 1880s, and Howard took advantage of that imagery to advertise the growing climate in Texas.[9] These cards are from a set of six stock cards that Howard purchased and imprinted with his name, address, and slogan. The one with two potatoes shows an older Irish potato man in traditional Irish dress chiding a younger, smartly outfitted Irish potato man: "Your [sic] Too New Young Man." Large printing companies maintained stables of artists to produce the cards, some of which were issued in small print runs and are quite rare today.

An equally extraordinary man published little-known but beautiful images of Texas butterflies just as the state's immigration hype was getting under way. Herman Strecker was a Reading, Pennsylvania, stonecutter and entomologist who specialized in butterflies and moths and maintained a wide correspondence with other scientists, who, as with Audubon, sent him specimens for his collection, which eventually numbered more than two hundred thousand and was acquired by the Field Museum of Natural History in Chicago after his death in 1901. Strecker corresponded with Jacob Boll, among others, a European-trained naturalist who made a collecting trip to Texas in 1870 and supplied him with specimens of Texas butterflies (fig. 9.3).[10]

Like Audubon, Strecker's work was self-financed and published. Not a wealthy man, he realized that his book had to be illustrated in color and saved enough money to purchase a lithographic stone. He drew pictures of the butterflies on it, then carried it to Philadelphia, where he had three hundred copies printed, which he then

FIGURE 9.3 Herman Strecker, [*Catocalal*]. Hand-colored lithograph, 30 cm. From Strecker, *Lepidoptera, Rhopaloceres and Heteroceres* (1872–1877), plate IX (1874).

colored by hand with the assistance of a colorist. Then he cleaned the stone and drew another group of butterflies on it and sent it to Philadelphia—a total of fifteen times for the fifteen hand-colored plates in his book, *Lepidoptera, Rhopaloceres and Heteroceres, Indigenous and Exotic; with Descriptions and Colored Illustrations*, which he issued serially in fifteen parts between 1872 and 1877. He also wrote the text and set the type for each part. Ten of the twelve specimens illustrated in Plate IX are Texas butterflies, most of which Boll sent him, but he also received examples from members of the Pope and Ruffner surveys that are illustrated in other plates. Strecker's book quickly sold out, but he was unable to reprint because of the expense. He added a twenty-two-page pamphlet in 1879, which some have called a second edition.[11] As Strecker's fame spread among lepidopterists on the East Coast and in Europe, the *Brenham Daily Banner* was one of the few newspapers in Texas to acknowledge his work but neglected to mention that his groundbreaking book contained colorful lithographs of Texas butterflies.[12]

THE GREAT LAND RUSH

When the Houston & Texas Central Railway reached Denison in March 1873, it joined the Missouri, Kansas & Texas Railway and linked Texas to St. Louis and markets beyond, inspiring a frenzied battle between St. Louis, New Orleans, and Galveston for northeast Texas trade, especially cotton, which had traditionally gone down the Red River to the Crescent City. St. Louis quickly claimed victory in the match, even topping Galveston. "To put it in its mildest form," wrote a *Daily Missouri Republic* reporter, "there is no doubt that even though St. Louis is nearly twice the distance from Northern Texas that Galveston is, the former is largely sharing the trade with it" and "must gradually . . . encroach upon it and absorb the lion's share."[13] The following year, the editor observed that "no other great commercial centre stands between us and this field, and there is no available point for one to grow up. Thus nature has thrown this priceless treasure into our very hands."[14]

The out-of-state threat pushed the Galveston merchants to respond.[15] The main Texas prize remaining was San Antonio, one of the largest cities in the country not yet included in the rail network. The completion of that line soon led to a southern transcontinental railroad as well as to one of the state's most ambitious lithographic documents.[16] A group of investors led by Boston financier Thomas W. Peirce, who owned a fleet of packet ships operating out of Galveston, acquired the old Buffalo Bayou, Brazos & Colorado Railway Co., the first railroad to operate in Texas, and reorganized it as the Galveston, Harrisburg & San Antonio Railway. At the same time, other Galveston investors organized the Gulf, Colorado & Santa Fe Railway Co. with the goal of building a railroad through Central Texas and on to Santa Fe and Colorado.[17]

To publicize their efforts, Peirce employed Matthew Whilldin, a Galveston journalist and entrepreneur, to describe the "peculiarities and resources of the country." Whilldin was a Union army veteran who had worked as an employee of the Freedman's Bureau in Louisiana and as chief editor for the *New Orleans True Delta*. After moving to Galveston in 1865, he joined *Flake's Daily Galveston Bulletin* as editor. By June of 1871 he was editor in chief of the *Galveston Daily News*, but he was also associated with a series of short-lived newspapers: the *Galveston Commercial* (1871), the *Galveston Advertiser* (1872), and the *Galveston Daily Times* and *Sunday Transcript* (1875). He took a job with the Galveston, Harrisburg & San Antonio Railway sometime in 1875, for in November the *San Antonio Herald* announced that he was "gathering statistics in Western Texas for Pierce's [sic] Railway Company."[18] (Unfortunately, no such effort was made to publicize the Gulf, Colorado & Santa Fe.)

The results of his research appeared in a small book in 1876, a lithographic tour de force titled *Immigrants Guide to Western Texas: Sun Set Route* (alternately titled *A Description of Western Texas: The Sunset Route*), which contains three chromolithographs (front and back covers and a small map, figs. 9.4A and 9.4B, and 9.5) and twenty-nine one-color lithograph images: one page of portraits and twenty-eight views of cities and scenes along the route, ironically printed by the August Gast lithographic firm in St. Louis, perhaps because Strickland was still without a steam press.[19] Some copies also contain a foldout map entitled *Correct Map of Texas Published by Galveston, Harrisburg & San Antonio Railway*, printed by Rand, Avery & Co. in Boston. There is nothing on record to compare to this publication in terms of the number of images of nineteenth-century Texas, unless it is Carl Schuchard's documentation of the scenes along the route of the 1854 Gray survey (see chapter 4). The front cover contains a scene of the railroad heading directly into the setting sun—hence the train's nickname as the "Sun Set Route." The back cover shows the GH&SARR initials flanked by a hunter on the left and a cowboy roping a steer on the right. Below them are symbols of plenty and, at the bottom, the head of a Longhorn.

FIGURES 9.4A AND 9.4B [Matthew Whilldin], *Galveston, Harrisburg and San Antonio R.R. Immigrants Guide to Western Texas, Sun Set Route,* 1876 (front and back covers). Chromolithograph, 20 cm (high), by Aug. Gast Bank Note & Litho. Co., St. Louis. Courtesy Amon Carter Museum of American Art Library, Fort Worth.

FIGURE 9.5 *Map of the rail route from Galveston to San Antonio*. Chromolithograph, 20 cm (wide), by Aug. Gast Bank Note & Litho. Co. From [Whilldin], *Immigrants Guide* (1876). Courtesy Amon Carter Museum of American Art Library, Fort Worth.

The twenty-eight scenic lithographs that follow thoroughly document the approximately two-hundred-mile route from Galveston to the Alamo City. The opening print shows an extremely busy Galveston Harbor, with ships in the bay and others waiting in the Gulf for their turn to dock (fig. 9.6). Conveniently bypassing the rival city of Houston, soon connected by a spur, the unnamed artist, probably Whilldin himself, proceeded westward from Harrisburg (the GH&SA's junction with the Houston & Texas Central), toward San Antonio.[20]

The scenes possess an artistic naiveté that, for example, renders the carriage in the foreground of the Flatonia view (fig. 9.7) abnormally small and the Longhorns waiting on the north side of the Weimar station (fig. 9.8), larger than the locomotive of the approaching train. The heart of the original plan of Gonzales is seen in the slightly elevated view of the courthouse (fig. 9.9). Five open squares in the town center were laid out in a cruciform pattern and reserved for public use. The courthouse, a small brick structure begun in 1849 and finished over the next decade, was located adjacent to the principal plaza, rather than on it. The view shows the church in the left foreground, the Greek Revival style courthouse in the center, and the main square behind it. Some of the images, such as *Military Plaza, Market in the Morning* in San Antonio (fig. 9.10), handle the perspective more realistically and probably were copied from photographs.[21] Several scenic views—such as the *Fall of Comal River, New Braunfels* and *R.R. Bridge Over St. Marcos River* (figs. 9.11 and 9.12)—are included, no doubt to convince the would-be immigrant that there was plenty of water in this part of Texas. The *Galveston News* printed the letterpress for the book.

FIGURE 9.6 Unknown artist, *Galveston*, 1876. Lithograph, 10.8 × 15.6 cm, by Aug. Gast Bank Note & Litho. Co. From [Whilldin], *Immigrants Guide* (1876). Courtesy Amon Carter Museum of American Art, Fort Worth.

FIGURE 9.7 Unknown artist, *Flatonia*, 1876. Lithograph, 9.8 × 15.3 cm (image), 10.4 × 15.4 cm (comp.), by Aug. Gast Bank Note & Litho. Co. From [Whilldin], *Immigrants Guide* (1876). Courtesy Amon Carter Museum of American Art, Fort Worth.

FIGURE 9.8 Unknown artist, *Weimar, North Side*, 1876. Lithograph, 9.9 × 15.3 cm (image), 10.4 × 15.4 cm (comp.), by Aug. Gast Bank Note & Litho. Co. From [Whilldin], *Immigrants Guide* (1876). Courtesy Amon Carter Museum of American Art, Fort Worth.

FIGURE 9.9 Unknown artist, *View of Court House, Gonzales, Texas*, 1876. Lithograph, 9.8 × 15.2 cm (image), 10.5 × 15.4 cm (comp.), by Aug. Gast Bank Note & Litho. Co. From [Whilldin], *Immigrants Guide* (1876). Courtesy New York Public Library.

FIGURE 9.10 Unknown artist, *Military Plaza, Market in the Morning. Commerce Street, San Antonio, Tex.*, 1876. Lithograph, 17.9 × 10.5 cm, by Aug. Gast Bank Note & Litho. Co. From [Whilldin], *Immigrants Guide* (1876). Courtesy Amon Carter Museum of American Art, Fort Worth.

FIGURE 9.11 Unknown artist, *Fall of Comal River, New Braunfels*, 1876. Lithograph, 10 × 17.6 cm, by Aug. Gast Bank Note & Litho. Co. From [Whilldin], *Immigrants Guide* (1876). Courtesy Amon Carter Museum of American Art, Fort Worth.

FIGURE 9.12 Unknown artist, *R.R. Bridge Over St. Marcos River*, 1876. Lithograph, 9.8 × 15.2 cm (image), 10.5 × 15.4 cm (comp.), by Aug. Gast Bank Note & Litho. Co. From [Whilldin], *Immigrants Guide* (1876). Courtesy Amon Carter Museum of American Art, Fort Worth. (San Marcos is incorrectly identified as St. Marcos.)

As one of the largest cities in the state and the destination of the railroad, San Antonio received the most attention, with pictures of Commerce Street, Market Plaza, the Alamo, and the Menger Hotel (fig. 9.13), San Fernando and St. Mary's churches, three of the other four missions, San Pedro Springs, and the head of the San Antonio River (fig. 9.14). The first passenger-bearing train finally arrived in the Alamo City on February 5, 1877, and a celebration ensued (fig. 9.15). The city fathers were already anticipating the extension of the line westward to the Pacific Coast, which occurred only six years later.[22]

Unfortunately, there is no suggestion as to the name of the artist. It probably was Whilldin, who at the time was also serving as the "art correspondent" for the New York *Daily Graphic*, but it could also have been someone like Louis Eyth, who was well established in the city by that time, or, more likely, F. T. Ryan, an artist and professor who designed the railroad's letterhead.[23] While constituting

FIGURE 9.13 A. Gast after unknown artist, *San Antonio*, 1876. Lithograph, 10.8 × 15.4 cm, by Aug. Gast Bank Note & Litho. Co. From [Whilldin], *Immigrants Guide* (1876). Courtesy Amon Carter Museum of American Art, Fort Worth. To get both buildings in the image, the artist has pictured the Alamo and the Menger Hotel closer together than they in fact are.

a visual document of the route, the book was also the opening salvo of the GH&SA's effort to attract immigrants to the almost 1.5 million acres of land along the route that the state of Texas had granted the company.[24]

The importance of these views other than their documentary value is that they provide visual insight into the settlement of Texas, showing many small communities that would not ordinarily be the subject of publication. As works of lithographic art they were drawn by an artist of modest talent and printed from stones of indifferent quality, shown by the coarse grain in each of the images. But their emphasis on water near the San Antonio and New Braunfels areas calls attention to the fact there were no important inland river ports in the state after the destruction of the Red River Raft in 1873 ended Jefferson's tenure as the leading inland port. It was the developing rail network that permitted population to spread into more distant rural areas.[25]

(LEFT) FIGURE 9.14 Unknown artist, *San Antonio River, 3d. Mission in the Distance*, 1876. Lithograph, 15.6 × 10 cm, by Aug. Gast Bank Note & Litho. Co. From [Whilldin], *Immigrants Guide* (1876). Courtesy Amon Carter Museum of American Art, Fort Worth.

(BELOW) FIGURE 9.15 A. A. Babcock, *Celebration, Feb. 19, 1877. Sunset Route G.H.&S.A.R. Welcome!* Lithograph, 24.1 × 15.5 cm, on silk. Courtesy Cowan's, a Hindman Co. Printed to welcome a special train bearing Governor Richard B. Hubbard and other state officials to San Antonio for the commemoration of the completion of the route from Galveston to San Antonio.

"THE TRUTH IS TEXAS IS WHAT HER RAILROADS HAVE MADE HER"

Whilldin was one of the few Texas representatives at the Philadelphia Centennial in 1876. A political dispute had prevented the state from having an official presence, other than a few bales of "very superior cotton," and his book became one of the most sought-after mementos of the state's presence at the event.[26] Apparently, the railroad distributed enough copies that they authorized a second printing.[27] The following summer Whilldin reported from Wilkes-Barre, where he had given a speech, that "Texas fever" had spread to Pennsylvania and, a few days later, that a group of colonists from Elmira, New York, would soon be arriving in Texas.[28] There is no record of how many copies of *Immigrants Guide to Western Texas* the railroad distributed, but it no doubt became the face of Texas for thousands of would-be immigrants.[29]

Promotion of Texas was escalating as Collis P. Huntington visited Galveston in 1882. The owner of the Southern Pacific Railroad, which was then building across the Southwest toward a rendezvous with the Texas & Pacific, encouraged the city's leaders in their quest for a deep-water port. "Galveston . . . is destined to be a city, and command the trade of a part of a continent," he laconically remarked. Although made in a seemingly casual manner, his comment did not pass unnoticed. The *News* reporter pointed out that Huntington was a "practical" man who "realized the profound and vital necessity for securing for his California and Pacific system . . . a deep-water outlet on the gulf." This, he insisted, was Galveston's challenge. When the Texas & Pacific met the Southern Pacific near Sierra Blanca, east of El Paso, the following year, Thomas W. Peirce of the Galveston, Harrisburg & San Antonio Railway drove the ceremonial silver spike on January 12, 1883, to signify completion of the line from New Orleans to California.[30] It would be another dozen years before Galveston's deep-water port became a reality, but Willard Richardson's vision of Galveston and the "Great West" seemed at hand.[31]

Further publicity came from the completion of the link with Denver. Construction on the Fort Worth & Denver Railway began in 1881, just a few years after the Comanches agreed to relocate to Indian Territory; in 1888 the company published *Agricultural Resources of the Pan Handle of Texas* with a handsome lithographed cover of shocks of wheat in the foreground and a large and prosperous-looking two-story farmhouse with outbuildings in the background (fig. 9.16). On the back cover, along with the slogan "From the Summit to the Sea," the editors coupled an illustration of a Rocky Mountain peak with a steamship in the gulf, a visual realization of Richardson's 1866 prediction.[32]

FIGURE 9.16 Unknown artist, *Agricultural Resources in the Pan Handle of Texas on the Line of the Denver, Texas & Fort Worth R.R.* (cover), 1888. Lithograph, 18 cm. Published by Matthews Northrup & Co., Buffalo. Courtesy DeGolyer Library, Southern Methodist University.

Also published in 1888, by Austin promoter John H. Traynham, was *All About Texas: A Hand Book of Information for the Home Seeker, the Capitalist, the Prospector, the Tourist, the Health Hunter . . .* , by John F. Elliott, former editor of the *Dallas Daily Herald* (figs. 9.17A and 9.17B). Elliott served as commissioner-in-chief for Texas at the New Orleans Exposition, as secretary of the State Immigration Committee, and as one of the founders of the Texas Press Association. The chromolithographed covers of his book illustrate many of these activities. Texas is a big state of "'magnificent distances' and cheapest lands," he noted.[33]

FIGURES 9.17A AND 9.17B Unknown artist, *All About Texas* (front and back covers), 1888. Chromolithograph, 23 × 13 cm, by unnamed printer. From John F. Elliott, *All About Texas* (1888). Courtesy Dorothy Sloan–Books. Hutchings Printing House in Austin printed the pamphlet but would have had the covers printed elsewhere, since they did not do lithography.

FIGURE 9.18 Unknown artist, *Roses All the Year Round: Dallas Texas. Ft. Worth, Tex.*, 1891. Calendar. Chromolithograph, 24 × 18 cm. Courtesy Special Collections, University of Texas at Arlington Libraries.

The calendar published by the Texas & Pacific and Missouri Pacific systems set an even higher standard for railroad publications. Titled *Roses All the Year Round*, it included chromolithographic views of Dallas and Fort Worth (fig. 9.18), and San Antonio and Galveston (fig. 9.19), featuring well-known buildings and scenes from each city. It was with only some exaggeration a couple of years later that Alexander Hogg, superintendent of schools in Fort Worth, told an audience at the 1893 Columbian Exposition in Chicago that "the truth is Texas is what her railroads have made her."[34] The railroads soon began advertising directly to Texas residents about travel elsewhere (fig. 9.20).

Of course, not everyone agreed with these exaggerated claims. An English immigrant, N. H. Senelle, who in 1876 founded the settlement of New Philadelphia (now Lissie) in Wharton County, reported that he was one of Whilldin's first recruits and accused him and other agents of "misrepresentations." "I remained in southern Texas nearly two years," he wrote, "quite long enough to prove it is no place for a northern raised man—and as for bringing Englishmen there direct, it is simply murder."[35]

Shipping companies also got involved in the great land rush. Charles Morgan, who was the first to establish regular service between Galveston and New Orleans in 1837, quickly got back into the trade as Harris & Morgan after the Civil War. The Williams & Guion Line established Galveston to New York service followed by the Texas & New York Steamship Line (better known as the Mallory) (figs. 9.21 and 9.22). The newly built *City of Austin* arrived at Galveston in December

FIGURE 9.19 Unknown artist, *Roses All the Year Round: San Antonio, Tex. Galveston, Tex.*, 1891. Calendar. Chromolithograph, 24 × 18 cm. Courtesy Special Collections, University of Texas at Arlington Libraries.

FIGURE 9.20 Unknown artist, *From Summerland to the American Alps*, 1892. Chromolithograph, 20 cm. Woodward & Tiernan Printing Co., St. Louis, for the Union Pacific Railroad Co. Courtesy DeGolyer Library, Southern Methodist University.

(LEFT) FIGURE 9.21 Unknown artist, *Mallory S.S. Lines to Texas and Florida*, 1870–1881. Chromolithograph, 28.5 × 13.5 in. Major & Knapp Lith. Co., New York. Courtesy Jay T. Last Collection of Graphic Arts and Social History, Huntington Library, Prints and Ephemera, San Marino, CA. Major & Knapp were still in business as late as 1881.

(BELOW) FIGURE 9.22 Unknown artist, *Steamship State of Texas, Mallory Line*, 1887. Trading card. Chromolithograph, 2.75 × 2.5 in. From the "Ocean and River Steamers" trading card series printed for Duke cigarettes. Courtesy Metropolitan Museum of Art, New York, Jefferson R. Burdick Collection, gift of Jefferson R. Burdick. One of thirty-six cards in the set.

FIGURE 9.23 Unknown artist after H. W. Finchmann, *Steamer City of Austin Texas Line. New York & Galveston*, c. 1880. Single sheet. Hand-colored toned lithograph, 45.9 × 83.5 cm (image), 52.4 × 83.5 cm (comp.), by Endicott & Co. Lith., 57 Beekman St., New York. Courtesy Amon Carter Museum of American Art, Fort Worth.

1871 on the same day that the last spike was driven in the railroad between Galveston and Austin, a "noteworthy" even if "unintentional" event, according to the reporter for the *Galveston Daily News* (fig. 9.23).[36]

The Liverpool & Texas Steamship Co. inaugurated service between Galveston and Liverpool, England, with the arrival of the *San Jacinto* at Galveston in February 1873 (fig. 9.24).[37] A joint venture of English and Texas investors, the Liverpool & Texas had proposed to the legislature in 1868 that they would bring 12,500 immigrants in five years and transport Texas cotton to the Liverpool market in return for a bonus of 500,000 acres of land.[38] By 1872 C. W. Hurley & Co. had taken over the line, which continued to court Texans by exhibiting a well-made model of the *San Jacinto* at what was billed as the third annual Texas State Fair, held in Houston in May, and in November by publishing a handsome chromolithograph of the *San Jacinto*, which Hurley presented to *News* editor Richardson.[39] The *San Antonio*, the *San Marcus* [sic], the *San Gabriel*, and the *San Bernard* later joined the fleet, and in 1875 Hurley undertook, but was unable to complete, the construction of the Galveston, Brazos & Colorado Narrow Gauge Railroad from Galveston to Austin.[40]

FIGURE 9.24 Unknown artist, *The Liverpool & Texas Steamship Company[.] Steamers San Jacinto—San Antonio—San Marcus—San Gabriel—San Bernard*, c. 1872. Single sheet. Chromolithograph, 47.5 × 76.4 cm (image), 54.1 × 76.4 cm (comp.), by Endicott & Co. Lith. Courtesy Amon Carter Museum of American Art, Fort Worth.

"THE TRUTH IS TEXAS IS WHAT HER RAILROADS HAVE MADE HER" | 405

ILLUSTRATED PROMOTIONAL MAPS

Lithography induced the same kind of revolution in the printing of maps as it did for pictorials. The autographic qualities, the ease of drawing on the stone or transferring to zinc, and the larger print runs led many mapmakers to turn to lithography.[41] It is even more difficult to distinguish between an engraved or lithographed map: a lithographed map, because of its inherent qualities as a line drawing, often does not have any of the shading and grain that readily betray a lithographed picture. In addition, the map might have been engraved first, then transferred to a stone or metal plate to be lithographed. The finished product looks like an engraving but would have been produced by lithography. Added colors might also be a giveaway, because of their flatness or their inconsistencies.

There were several advantages to transferring an engraving to a stone or metal plate. If the stone was large enough, the picture could be duplicated multiple times, increasing the number of images produced with each strike of the stone. In addition, after transferring the engraving to the stone, one could make changes on the stone without affecting the original engraving, which could be used for additional transfers.[42]

Illustrated maps were visual aids to advertise the growth and development of the state, and the state, cities, railroad companies, and developers issued dozens of them.[43] One of the earliest is *Kosse & Scott's Map of the City of Houston and Environs* (1867), a spectacular, hand-colored map of the city, surrounded by an elaborate border and illustrated by ten vignettes of the city and nine portraits, including Sam Houston and Augustus C. Allen, both deceased by the time the map was published (fig. 9.25). Fifty-five-year-old Theodore Kosse was the chief engineer and surveyor for the Houston & Texas Central Railway and had lived in Houston since 1846. He collaborated with Hu T. Scott, a real estate broker who gathered photographs of buildings to accompany the map. The map has all the characteristics of an engraving, but its size (49.25 × 35.87 in.), among other features, raises the possibility that the engravings might have been transferred to stone to be printed, a speculation encouraged by a report in the *Tri-Weekly Telegraph* that its former editor, E. H. Cushing, was hand-carrying the map to New York to be lithographed.[44]

W. E. Wood published an updated Houston map two years later, this one clearly described as a lithograph (fig. 9.26). Wood, a civil engineer and member of the city council, produced *City of Houston, Harris Co. Texas*, and W. H. Rease of Philadelphia lithographed it on four sheets of paper that were glued together to make up the whole, with fifteen vignettes of various Houston buildings and structures plus a portrait of Sam Houston illustrated in the margins. John P. Blessing, of the Blessing & Bro. photography studio, provided the photographs for the vignettes, which include, among others, the old capitol building, which had been converted into the Capitol Hotel.[45] Both the Kosse and Wood maps include outline drawings of the various structures in the city, but the Wood map is much more detailed.

As the Kansas Pacific Railway tracks crept across the state, the number of railroad maps increased. The Kansas Pacific published one of the rarer and more interesting examples in 1871 (and apparently reprinted it annually until 1875). It is a map not of the railroad but of cow trails leading north from Texas to the railheads (fig. 9.27). The railroad wanted to encourage the drovers to bring their cattle to the Kansas towns on their line and gave their map the subtitle *The Best and Shortest Cattle Trail from Texas*, which is printed on a star hanging from the nose ring of a Longhorn, depicted in the lower left-hand corner. The network of trails is marked in red and stretches from Corpus Christi in South Texas northward to Red River Station, where the branch trails converge into the Chisholm Trail, which led to the towns located along the Kansas Pacific line from Denver to Kansas City. This 1873 copy belonged to collectors Thomas W. Streeter and Dr. Alexander Dienst of Temple, who took the opportunity to add details to the Central Texas portion of the map, explaining (in the right margin) that "the *crossing* at Leon River was at same place where wagon bridge spans Leon between Temple & Belton" and was "plainly visible where cattle went down the bank." The 1871 edition of the map used "route" in the title instead of "trail," encased the title in a rectangle instead of a lone star, and did not include the southern tip of Texas.[46]

As more surveys were completed, cartographers and publishers produced several illustrated lithographic maps of the state. One of the first was *Ross's New Connected County and Rail Road Map of Texas and Indian Territory*, which was printed in St. Louis by E. H. Ross, Western Map Emporium, in 1873; it includes a small, anonymous vignette of a train pulling into a busy station. There were at least three editions of the map (in 1871, 1872, and 1873), which appear to be identical except for the date.

The following year, Anton R. Roessler published *A. R. Roessler's Latest Map of the State of Texas*, which was compiled and drawn by M. V. Mittendorfer, a civil engineer in the General Land Office.

FIGURE 9.25 Theodore Kosse, Hu[bert?] T. Scott, et al., *Kosse & Scott's Map of the City of Houston and Environs*, 1867. Engraving, 49.25 × 35.87 in. (image), possibly printed by lithography. Courtesy Dorothy Sloan—Books.

"THE TRUTH IS TEXAS IS WHAT HER RAILROADS HAVE MADE HER" | 407

(OPPOSITE PAGE) FIGURE 9.26 W. E. Wood, *City of Houston, Harris Co. Texas*, 1868. Hand-colored lithograph, 71 × 63.5 in., by W. H. Rease, Philadelphia. "Published from actual Surveys by W. E. Wood, C. E. Jany. 1st. 1869. Scale 350 Ft. to an inch. Entered according to Act of Congress in the Year 1868 by W. E. Wood in the Clerks Office of the District Court for the Eastern District of Texas." Courtesy Beinecke Rare Book and Manuscript Library, Yale University.

(RIGHT) FIGURE 9.27 Unknown artist, *Kansas Pacific Railway. The Best and Shortest Cattle Trail from Texas*, 1873. Map. Lithograph, 56.5 × 40.5 cm, neat line to neat line, by Levison & Blythe, St. Louis. From [William Weston], *Guide Map of the Best and Shortest Cattle Trail to the Kansas Pacific Railway* (1873). Courtesy Dorothy Sloan—Books.

"THE TRUTH IS TEXAS IS WHAT HER RAILROADS HAVE MADE HER"

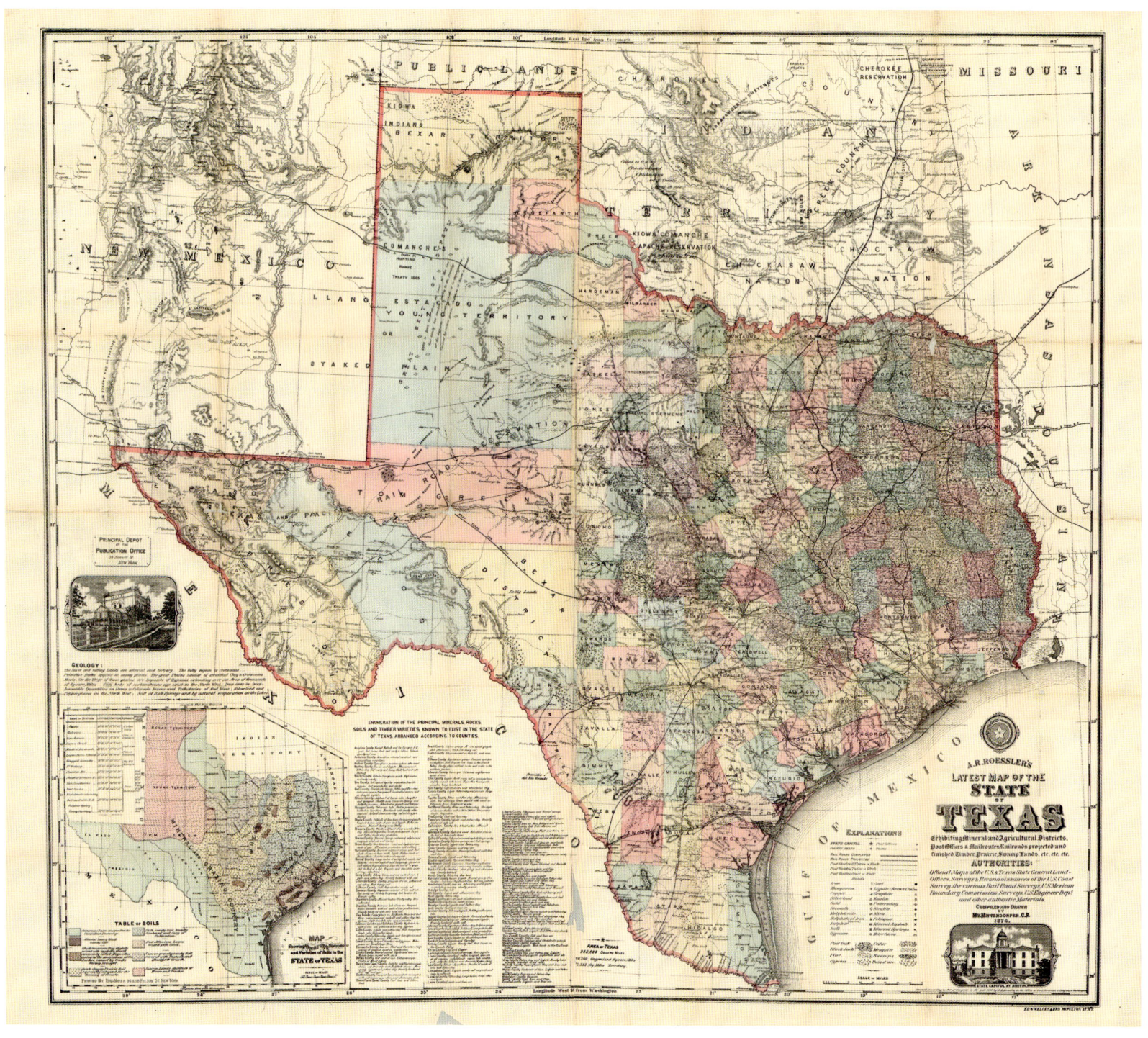

FIGURE 9.28 M. V. Mittendorfer, *A. R. Roessler's Latest Map of the State of Texas*, 1874. Color lithograph or cerograph, 96.8 × 97.7 cm (neat line to neat line, including inscription in lower right corner), by Ferd. Mayer, 96 & 98 Fulton St., New York. Courtesy Special Collections, University of Texas at Arlington Libraries.

It contains two vignettes, one of the capitol building and the other of the General Land Office (fig. 9.28). This historically important map contains information that Roessler salvaged (or stole, depending upon one's perspective) from geologist Benjamin F. Shumard's Texas Geological Survey when the survey rooms in the General Land Office were converted to a percussion-cap factory during the Civil War.⁴⁷ While Roessler shows the counties, towns, military posts, physical features, roads, railroads, and telegraph lines, he also reserved a portion on the western side of the Panhandle as the "Comanches Hunting Range."

Roessler followed, in 1875 and 1876, with a series of sixteen county maps for the Texas Land & Immigration Co. of New York, of which he was secretary (fig. 9.29). Ever since the development of photography in the 1830s and '40s, printers and photographers had struggled to transfer a photographic image to a lithographic stone.⁴⁸ About 1860 John Osborne, an Irishman working on an Australian government survey, developed the process that became known as photolithography. After he immigrated to the United States, the American Photolithographic Co. obtained the rights to his patents and used the process, which became known as Osborne's Process, to print many maps, including Roessler's maps of sixteen Texas counties (fig. 9.30).⁴⁹ Most of them include a vignette in which an unnamed artist has tried to sum up the story of Texas to that point by showing a rising sun, an Indian village, ships arriving on the coast, a farmer plowing behind a mule, another gathering hay or grain, immigrants in covered wagons, a surveyor, a train with smoke billowing from the engine, miners, a hunter, and, near the center of the image, an artist/cartographer sitting with a sketch pad on his lap (fig. 9.31). The Llano County map contains a detail of miners working in the opening of a shaft (fig. 9.32); Marion County has a detailed drawing of the Nash Iron Works (fig. 9.33), the first iron furnace and foundry in Texas; and San Saba County features a miniature panoramic view of *San Saba City Taken from the County College Looking North*, with several businesses and one house identified (fig. 9.34).⁵⁰

The Dallas Lithograph Co. printed a number of city and neighborhood maps, including Paul McCombs's *Map of Rockport, Texas, Aransas County* (1888), the Oak Lane Cemetery in Dallas, and the 1891 map of Alvarado, which includes views of a steam train barreling down the track on one side and on the other a woman sitting in a garden, plucking fruit from a tree while chickens and ducklings gather at her feet (see fig. 7.77). And in that same year, after sixteen years of work, John F. Pope and Reuben Ford produced their map of *Austin and Surrounding Properties*, which Bergen, Daniel, and Gracy published (fig. 9.35). The map identifies numerous property owners and includes a large view of Austin Dam, which failed in 1900, killing dozens of people and leaving Austin without power for months. The view shows the Austin Dam Railroad, which ran 4.75 miles from the city to the dam in 1891 (fig. 9.36). In 1895 it was replaced by the Austin Dam & Suburban Railway, which provided access to a pleasure park near the dam.

FIGURE 9.29 Martin & Troutman, *Dinner Hour, Engineers, Tex. Land and Copper Association*, 1872. Stereograph, right half. Roessler may be the dark figure sitting on the stool at the right. Courtesy DeGolyer Library, Southern Methodist University.

MAP OF BROWN CO.

STATE OF TEXAS

showing the extent of all PUBLIC SURVEYS, Land grants and all other official information, compiled from the Records of the GENERAL LAND OFFICE, AUSTIN

showing also the GEOLOGY, AGRICULTURE and OTHER IMPORTANT DETAILS

Carefully selected from Authentic Sources, revised and corrected up to AUGUST 1876.

A. R. ROESSLER,
CIVIL AND MINING ENGINEER

PUBLISHED BY

The Texas Land & Immigration Co.

H. G. Gilbert, PREST.
A. R. Roessler, SECY.
P.O. Box 4596
35 BROAD ST.
New York.

Area: 1,190 square miles, or 716,800 acres of land.
Population: 2,300.
Geology: Cretaceous and carboniferous, with enough iron and bituminous coal for all practical purposes.
Soil: Yellowish, sandy, alluvial loam, from 18 to 36 inches deep, resting on a clay foundation, yielding from 25 to 40 bushels of wheat, and from 50 to 75 bushels of corn; 1 bale and a half of cotton.
Timber: Oak, pecan, cedar, elm, hackberry, walnut, and cottonwood, well diversified throughout the county, for all fuel and fencing purposes, with large amount of mast for hogs.
General Remarks: The general appearance of the county is beautiful and attractive. Vegetables of nearly every description can be raised with little trouble, and in great profusion, and fruits of various kinds do well. The grape is found wild in many places, and of a superior quality, which shows that vineyards will do as well here, and may be made as profitable as those in California. So great are the inducements held out by the natural resources of this county to immigrants, that though organized but a few years, its population now ranks it among the leading counties of North-western Texas. The county is well adapted to stock-raising, and excellent varieties of grasses, wild oats, and wild rye flourish to feed the cattle.

SCALE OF MILES.

INDEX of COLORS
Carboniferous
Cretaceous

EXPLANATIONS.

Gypsum
Coal
Lignite
Graphite
Kaolin
Iron
Manganese
Copper
Silverlead
Gold
Petroleum
Steatite
Mica
Feldspar
Mineral
Asphalt
Bismuth
Molybdenite
Copperas
Sulphur
Salt

County Seat
Towns
Geological Boundary
Railroads projected
Railroads in operation
Post Offices
Farms
Roads
Boundary of Timber & Prairie
Swamps
Cypress
Mesquite
Post Oak
Pine
Bois d'Arc
Cedar
Black Jack

AM. PHOTO LITHOGRAPHIC CO. N.Y.

MAP OF BROWN CO

STATE OF TEXAS showing the extent of all **PUBLIC SURVEYS** Land grants and all other official information, compiled from the Records of the **GENERAL LAND OFFICE** at **AUSTIN** showing also the GEOLOGY, AGRICULTURE AND OTHER IMPORTANT DETAILS, Carefully selected from Authentic Sources revised and corrected up to AUGUST, 1876. BY A. R. ROESSLER, CIVIL AND MINING ENGINEER PUBLISHED BY The Texas Land and Immigration Co. of N.Y.

H. G. Gilbert, PREST.
A. R. Roessler, SEC'Y.

P.O. Box, 4596.
35 BROAD ST.
New-York.

(LEFT) **FIGURE 9.31** Detail from A. R. Roessler, *Map of Brown Co., State of Texas*, 1876. Photolithograph, 62 × 52 cm. Courtesy Geography and Map Division, Library of Congress.

(BELOW) **FIGURE 9.32** M. V. Mittendorfer, *Map of Llano County Showing Geology, Mineral Localities, Topography etc. Surveys Taken from the Official Map of the General L.O.*, 1875 (detail). Photolithograph, 37.5 × 51 cm (border to border), published by A. R. Roessler, 83 Nassau St., New York. Courtesy Geography and Map Division, Library of Congress.

(OPPOSITE PAGE) **FIGURE 9.30** A. R. Roessler, *Map of Brown Co., State of Texas: Showing the Extent of All Public Surveys, Land Grants and All Other Official Information Compiled from the Records of the General Land Office at Austin*, 1876. Photolithograph, 62 × 52 cm. Published in New York for the Texas Land & Immigration Co. Courtesy Geography and Map Division, Library of Congress.

"THE TRUTH IS TEXAS IS WHAT HER RAILROADS HAVE MADE HER"

FIGURE 9.33 A. R. Roessler, *Iron Furnace and Manufactory (the first established in the State of Texas) Marion County, Known as Nash's Iron Works, as It Appeared in 1857*, detail from *Map of Marion County*, 1876. Photolithograph, 19 × 24 in. Courtesy Heritage Society Map Collection, M. D. Anderson Library, University of Houston.

FIGURE 9.34 A. R. Roessler, *San Saba City Taken from the County College Looking North*, detail from *Map of San Saba County*, 1876. Photolithograph, 58 × 51 cm, by Am. Photolithographic Co., New York. Courtesy Geography and Maps Division, Library of Congress.

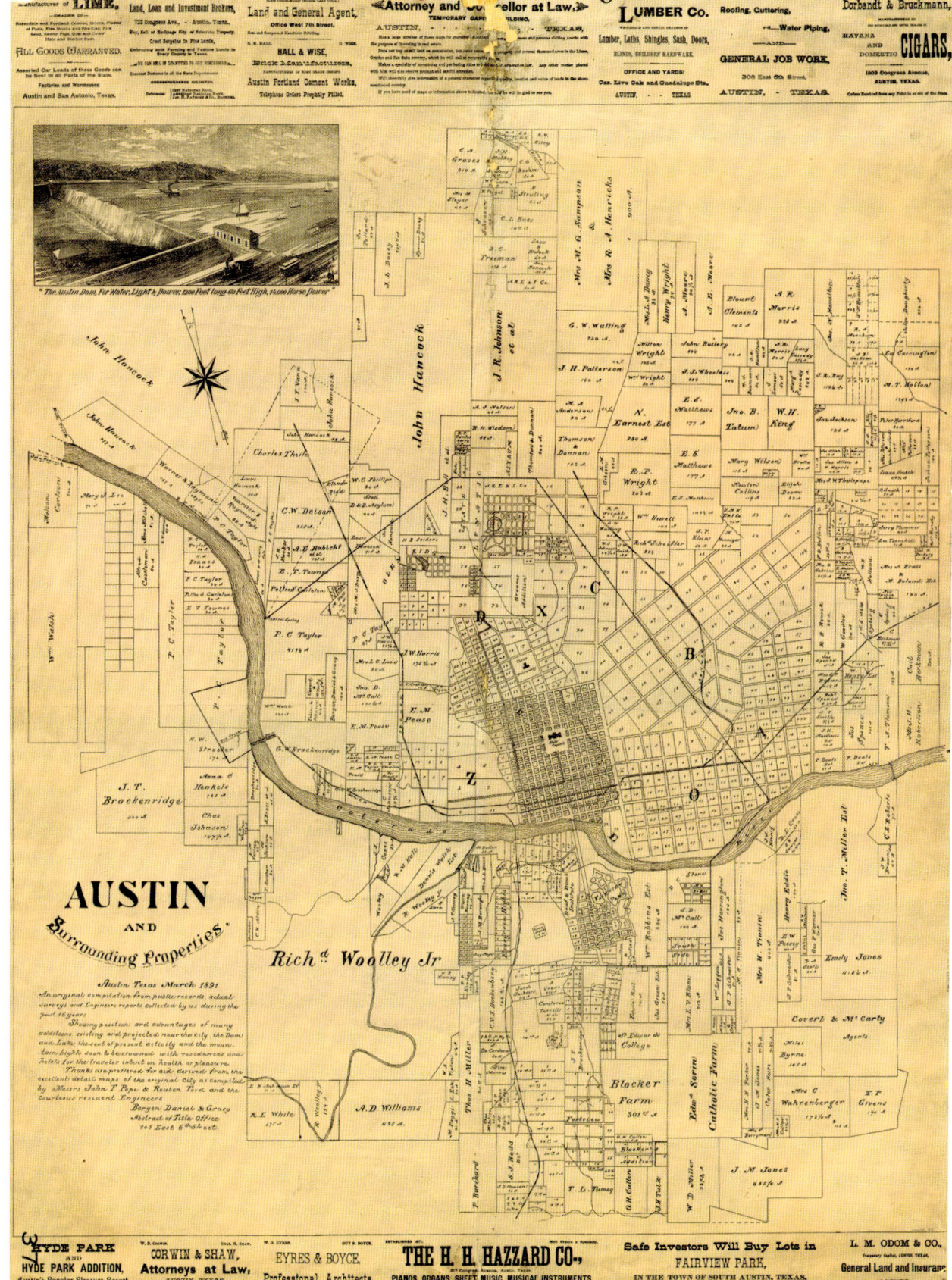

FIGURE 9.35 John F. Pope and Reuben Ford, *Austin and Surrounding Properties*, 1891. Single sheet. Lithograph, 42.9 × 32.1 in., published by Bergen, Daniel, and Gracy Abstract Title Co. Courtesy Texas General Land Office, Austin.

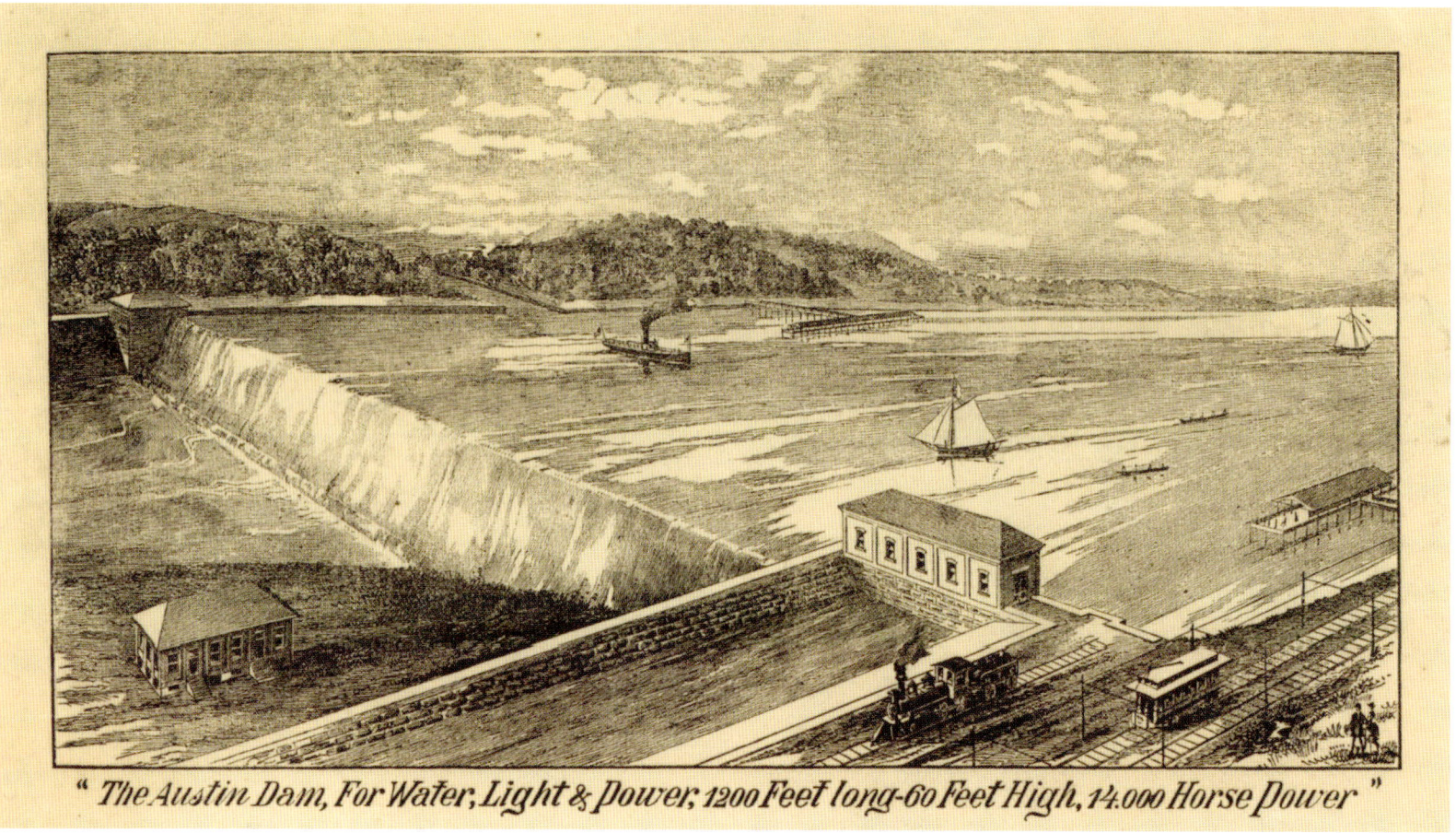

FIGURE 9.36 Unknown artist, *The Austin Dam, for Water, Light & Power; 1200 Feet long–60 Feet High, 14.000 Horse Power*, detail from Pope and Ford, *Austin and Surrounding Properties*. Courtesy Texas General Land Office, Austin.

"A FAIR IDEA OF OUR TOWN"[51]

While Whilldin was gathering information for his book on the GH&SA, several itinerant artists roamed the state via the growing railroad network documenting the young cities in one of the most popular expressions of printmaking in the nineteenth century. As Texans emerged from Reconstruction and the panic of 1873, burgeoning urban areas engaged in commercial and civic regional rivalries—Dallas and Fort Worth, Sherman and Denison, Galveston and Houston—and often expressed their local pride in public architectural monuments, especially imposing and elegant courthouses. But the competition also involved a lesser-known and far more ephemeral manifestation: the publication of dozens of lithographic bird's-eye views of cities.[52] The prints were usually fairly large, 20 × 28 inches or so, and were part of a national fad that emanated from a group of midwestern lithographers in Milwaukee, Madison, Chicago, and Cincinnati. More than eighty Texas images survive, ranging from the largest cities of Galveston, Houston, Dallas, and San Antonio to some of the smallest, such as Flatonia, Ladonia, Wolfe City, and Seymour, and the locations span the state from Texarkana to El Paso and Wichita Falls to Laredo.

The process began in Texas in March 1871, when topographic artist Camille M. Drie (or Dry) called on the *Galveston Daily News* and "exhibited to us some drawings that he is making for a map of Galveston, which will exhibit the buildings on every lot within the city. It is an isometrical projection," the *News* editor explained, "and promises to be a fine picture of the Island City, and will be invaluable to all property holders [fig. 9.37]." Galveston was the

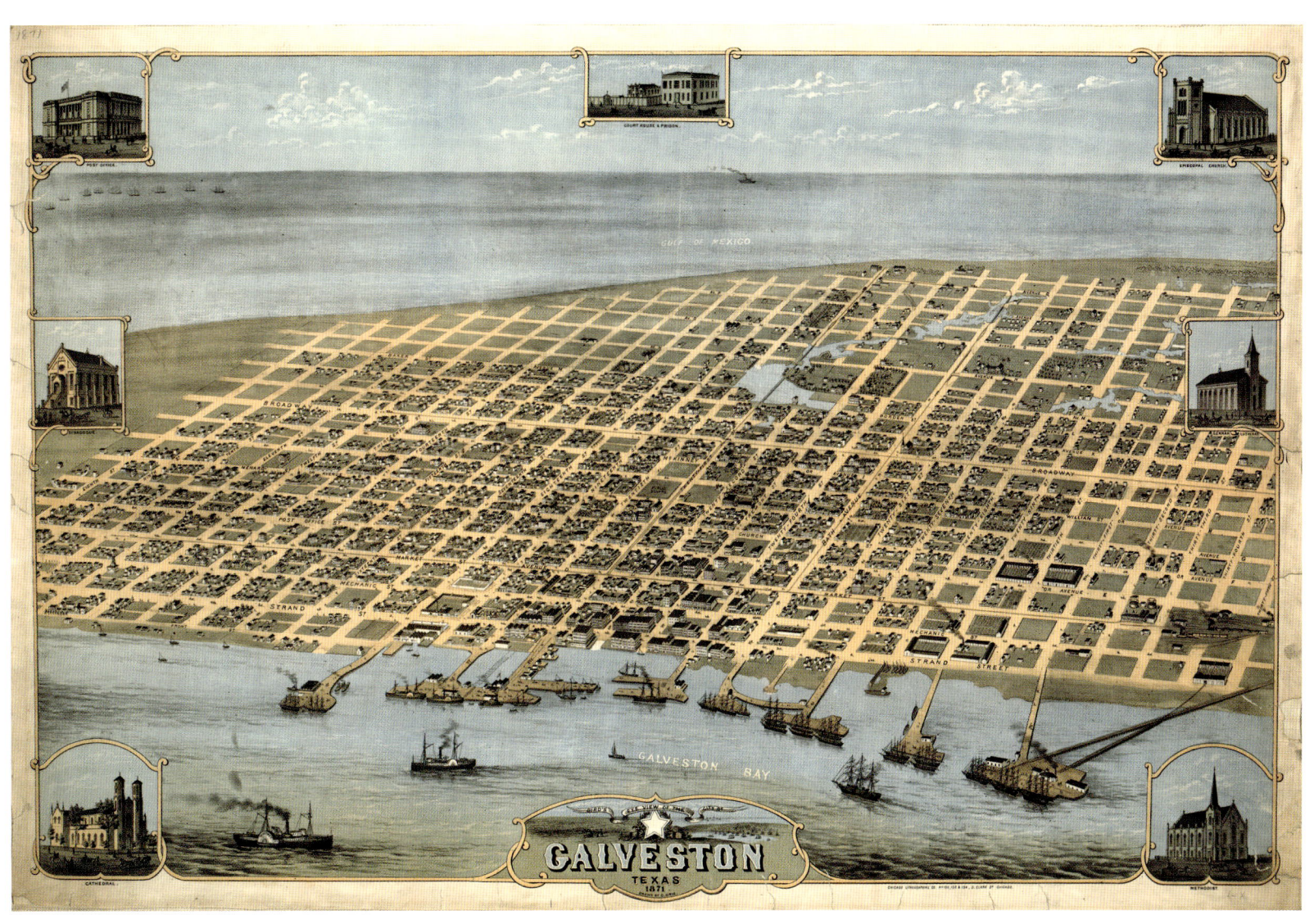

FIGURE 9.37 Unknown artist after Camille N. Drie, *Bird's Eye View of the City of Galveston, Texas*, 1871. Single sheet. Tinted lithograph, 57 × 87 cm, by Chicago Lithographing Co., 150–54 S. Clark. Courtesy Briscoe Center for American History, UT Austin. Drie pictured the city from the northwest.

commercial center of Texas during most of the nineteenth century, and its footprint on the north side of Galveston Island, toward the eastern end, took up less than one-eighth of the small barrier island. But its residents had grand dreams. A writer for *Harper's Weekly* reported in 1866 that there were "few towns in the South where so much Northern energy and the effects of Northern capital are as visible as in Galveston"; the *New York Daily Herald* predicted in 1874 that "Galveston . . . to all appearances, will become the New York of the Gulf."[53]

Little is known about Drie personally. Headquartered in Chicago, he had previously drawn views of the Mississippi towns of Columbus and Vicksburg and began his work on Galveston in the same manner as other bird's-eye-view artists—by showing his previous work to an editor. He would have chosen the perspective from which he would work, in this case from the northwest, and then he would have traversed the town, up and down each street, sketching individual buildings from that direction. What the Galveston editor called an "isometrical projection" resulted in a view made from the imaginary perspective of a forty-five-degree angle hundreds of feet above the city. Drie was not as accomplished as some of the other bird's-eye-view artists, because his work more nearly resembled an axonometric projection: he did not employ vanishing points in his composition—the streets run parallel to each other. Most city-view artists laid out the grid with two vanishing points, one for the vertical axis and one for the horizontal. Drie's work also lacked foreshortening, meaning that the houses in the distance are almost the same size as those in the foreground.[54] But when Drie delivered the finished product in July, the editor of the *News* declared it to be "a splendid map" and claimed never to have seen one "so accurate" or "so beautiful." Ferdinand Flake, editor of *Flake's Bulletin*, agreed that it "is very deserving of patronage."[55]

The comprehensiveness and detail of Drie's view was unlike anything Galvestonians had seen, not to mention that they had never seen their city from such a height (figs. 9.38A and 9.38B). He pictured the eastern end of the island, the main part of the city, from the northwest, with the busy harbor in the foreground and the Gulf of Mexico in the background. The business district, which by 1871 featured several blocks of brick and iron-fronted buildings that had replaced wooden structures destroyed in a December 1869 fire, is shown behind the wharves, while the residential area stretches in a semicircle from the bay toward the Gulf beach. The planned grand avenues in surveyor John D. Groesbeck's 1838 plan, documented in

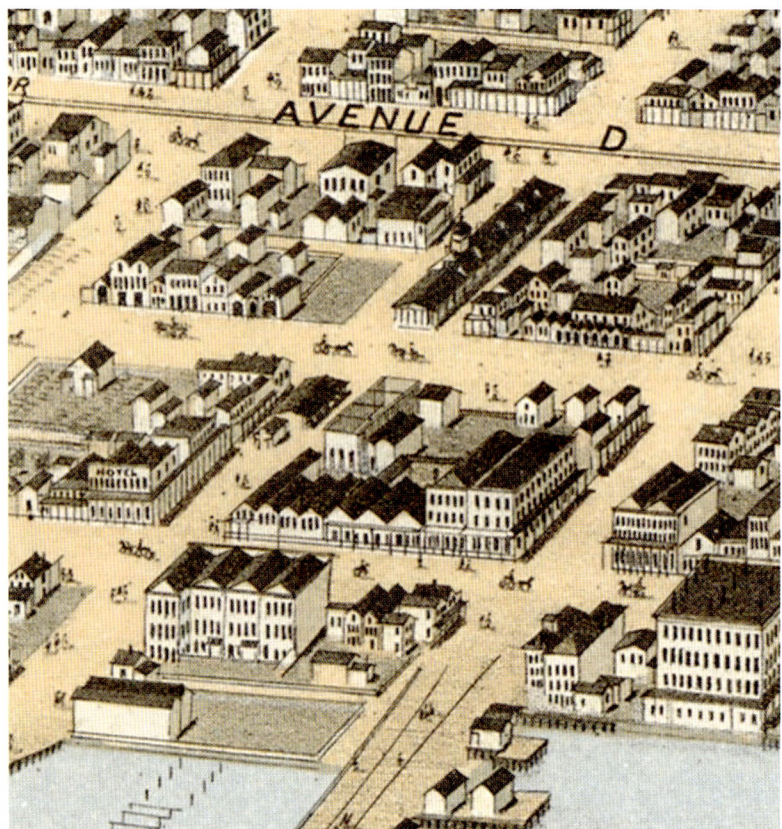

FIGURES 9.38A AND 9.38B Unknown artist after Camille N. Drie, *Bird's Eye View of the City of Galveston*, 1871 (detail). The Hendley Block is shown from the rear, with the Strand in front of the building and 20th Street to the left. One of the buildings of the Market House is shown at the top, in the center of 20th Street. Courtesy Briscoe Center for American History, UT Austin.

418 | TEXAS LITHOGRAPHS

FIGURE 9.39 Unknown artist after Camille N. Drie, *Bird's Eye View of the City of Galveston*, 1871 (detail). Courtesy Briscoe Center for American History, UT Austin.

the first survey of the city, are evident: 25th Street (or Bath Avenue), the main north-south axis, and Broadway, the cross-axis. Groesbeck surveyed both of them to be 150 feet wide and envisioned them lined with the mansions of the city's mercantile class.[56] Hitchcock's Bayou, which served as the city's dumping ground, had become a public health nuisance by the time of Drie's visit; it is pictured in the upper center, bound by 20th Street on the east and Tremont Street on the west and stretching across 24th and 25th Streets toward the Gulf.[57] Ferdinand Flake noted that "the map is relieved of medallions of the finer buildings" around the border—churches, the custom house and post office, and the courthouse and jail. In the cartouche in the foreground are charming landscape scenes of a farmer plowing a field and, on the right side, a self-portrait of the artist leaning against a cotton bale while sketching the city (fig. 9.39).[58] Drie had made good on his promise that the view would "exhibit the buildings on every lot within the city."[59] He announced that the view would be available for $3 per copy (around $65 today, as calculated by the Consumer Price Index, but now valued at much more because of its rarity).[60]

The next artist to come into Texas was twenty-one-year-old Herman Brosius of Milwaukee, representing the Milwaukee Lithographing & Engraving Co.[61] In December 1872 Brosius's agent, William R. Patchen, showed the editor of the *Dallas Herald* both his new drawing of Dallas and the just-completed lithograph of Jefferson, which was a prominent East Texas port on Big Cypress Bayou, larger than Dallas at that time and a competitor in the cotton trade. Dallas was a small town with cotton still farmed within its corporate limits, but its leaders fervently believed that the city was on the rise.[62] The Dallas courthouse had burned in May 1871, but the new one was already under construction when Brosius arrived, and he illustrated the "hard granite" walls of the first floor on the courthouse square, bounded by Main, Commerce, Jefferson, and Houston Streets (fig. 9.40).[63] Diagonally across Main Street was the Crutchfield House, one of the better hotels in the city, and a block and a half to the east was Sarah Cockrell's new toll bridge, which crossed the Trinity River and connected Dallas with major roads south and west.[64] "A sufficient number of subscribers" ordered the print, and Patchen delivered it in March 1873.[65] Attorney John Milton McCoy was not too impressed with the village when he arrived in 1870, but he quickly sent a copy of Brosius's view to his family, claiming that "it will give you a fair idea of our town."[66] The *Herald* journalist reported that the view "shows every house in the corporation limits, together with every street, so accurately drawn that any one acquainted at all with the city can recognize any building."[67]

Bird's-eye views were ideal advertising for a region with lots of vacant land to settle, and other artists were soon combing over the state. In all, eight different artists made views of Texas cities in the years between 1871 and 1892, including Herman Brosius of Milwaukee Lithographing & Engraving; J. W. Pearce, representing

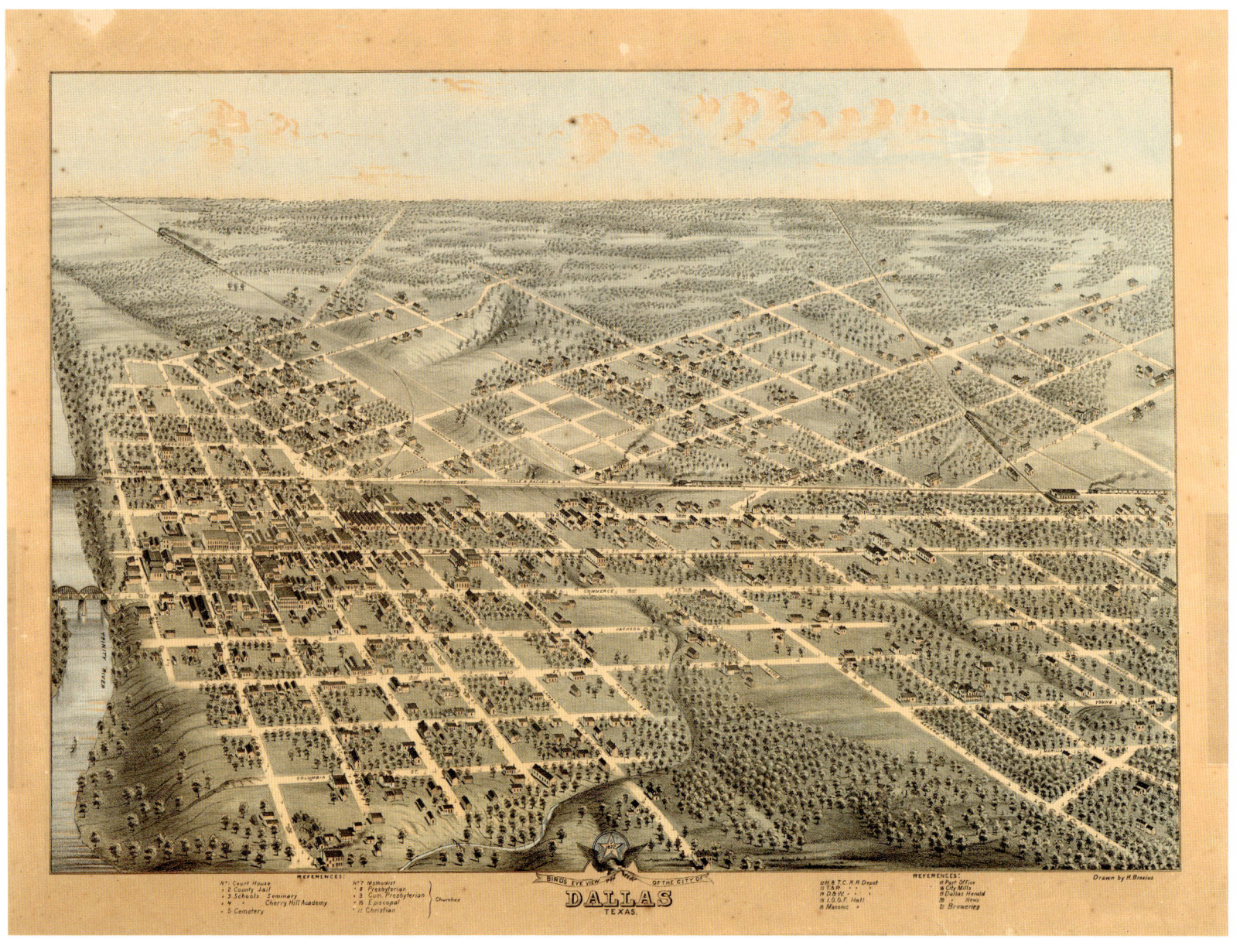

FIGURE 9.40 Unknown artist after Herman Brosius, *Bird's Eye View of the City of Dallas, Texas, 1872*. Single sheet. Hand-colored lithograph, 40.1 × 58.1 cm, lithographer unknown. Courtesy Dallas Historical Society.

the Stoner & Ruger Co. of Madison, Wisconsin; German immigrant and Civil War veteran Augustus Koch, also working with Stoner and W. R. Patchen; D. D. Morse, probably also associated with Stoner; Henry Wellge, who published his views through Beck & Pauli in Milwaukee; Thaddeus M. Fowler, who issued his own views in partnership with James B. Moyer; and A. L. Westyard, who published through D. W. Ensign of Chicago. Three additional artists contributed four twentieth-century views well after the fad had ceased to be popular: E. S. Glover (Amarillo and Port Arthur, 1912), E. E. Motter (Houston, 1912), and A. S. Harris (Fort Worth, 1914).[68]

Their agents resorted to various methods to finance the prints. The most obvious, of course, was subscription, and some Texas

cities were large enough that the lithographers could anticipate sufficient sales to justify a print run with a retail price of between $2 and $5 each (about $44 to $108 today).⁶⁹ If public response was insufficient, the next most obvious method was to find a sponsor. In some instances a local company would support the publication, such as wholesale grocer Joseph H. Brown in Fort Worth, who topped them all in 1885 by ordering eleven hundred copies of Wellge's view of the city, which prominently featured his building in one of the marginal illustrations (fig. 9.41). That, Wellge claimed, was the largest number printed of any city in the South.⁷⁰

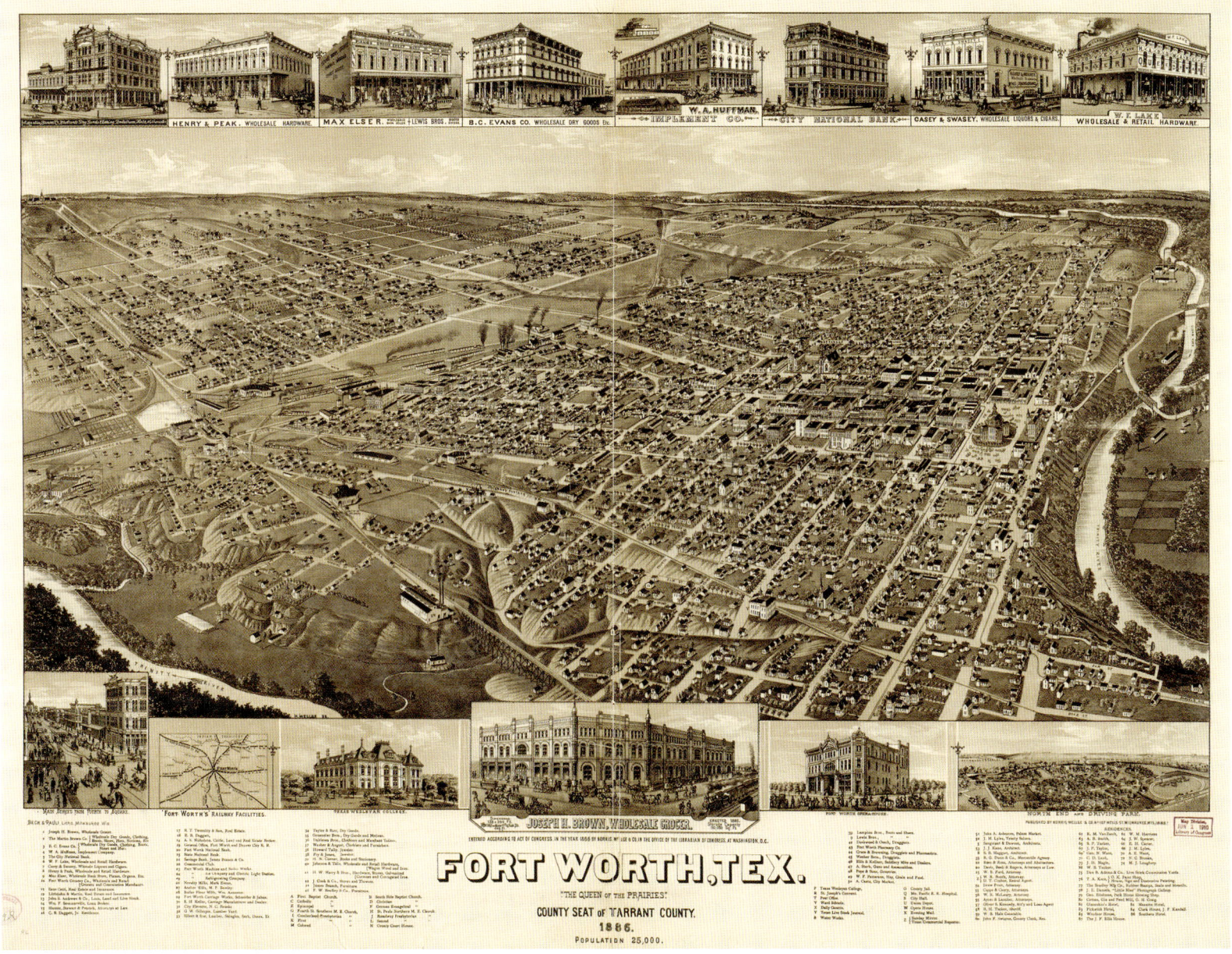

FIGURE 9.41 Unknown artist after Henry Wellge, *Fort Worth, Tex. "The Queen of the Prairies." County Seat of Tarrant County. 1886. Population 25,000.* Single sheet. Lithograph, 23.12 × 33.31 in. (image), by Beck & Pauli, Litho., Milwaukee. Published by Norris, Wellge & Co., No. 107 Wells St., Milwaukee, 1886. Courtesy Amon Carter Museum of American Art, Fort Worth.

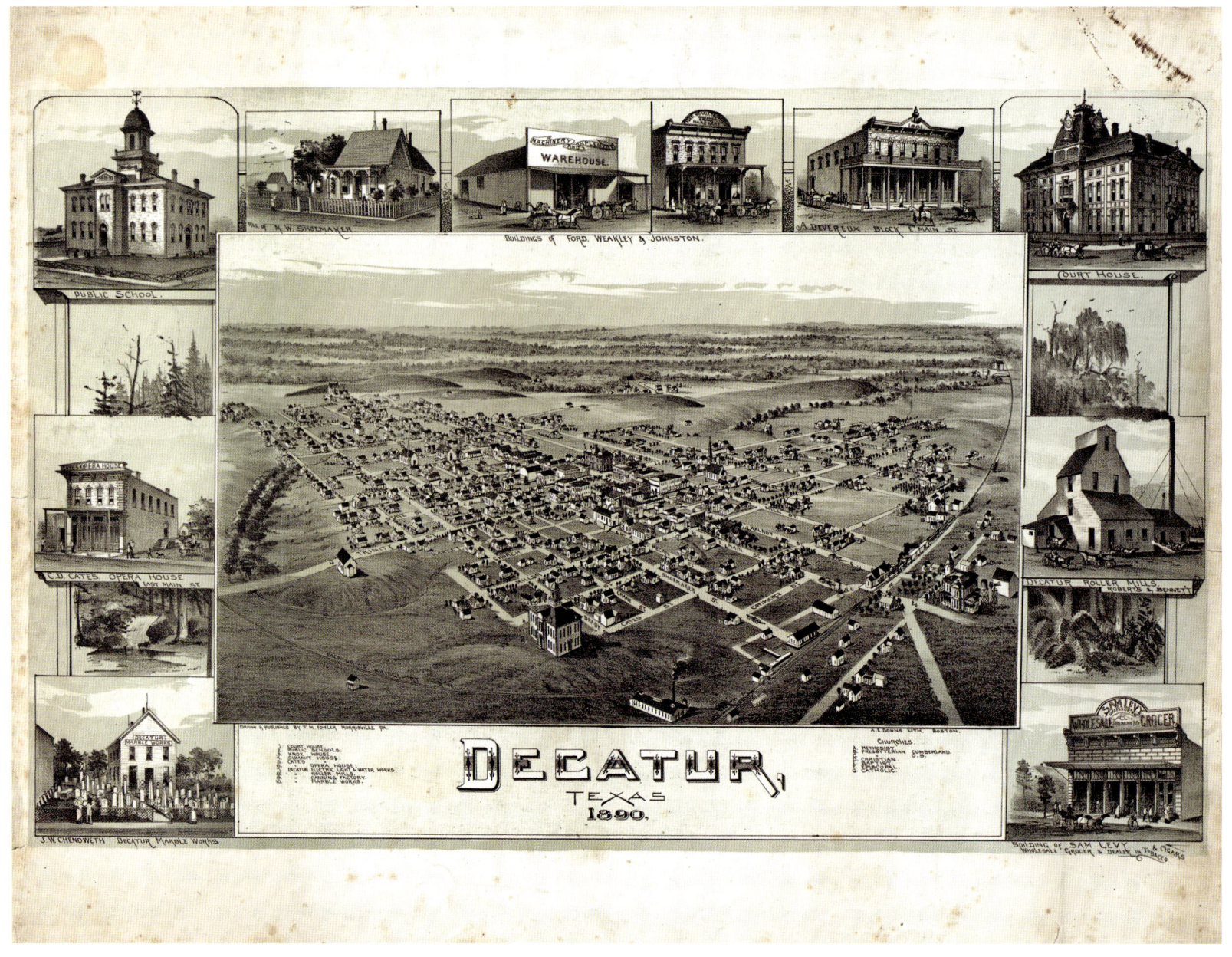

FIGURE 9.42 Unknown artist after Thaddeus Mortimer Fowler, *Decatur, Texas 1890*. Single sheet. Toned lithograph, 56 × 71.2 cm (page). Courtesy Star of the Republic Museum, Washington, Texas.

Although we have no record of it in Texas, the artists and agents surely charged a fee to list or to illustrate businesses, churches, and private homes in the margins of the views, as in the case of Galveston, Fort Worth, and Decatur (fig. 9.42). In two instances while in North Texas, artist Thaddeus Fowler did individual prints of the National Commercial College and the Sherman Oil & Cotton Co. (figs. 9.43 and 9.44). In at least one instance, the city council in Victoria assured publication of the view by purchasing seventy copies, which they marked down from $3 to $1 after it became apparent that they had a surplus on hand.[71]

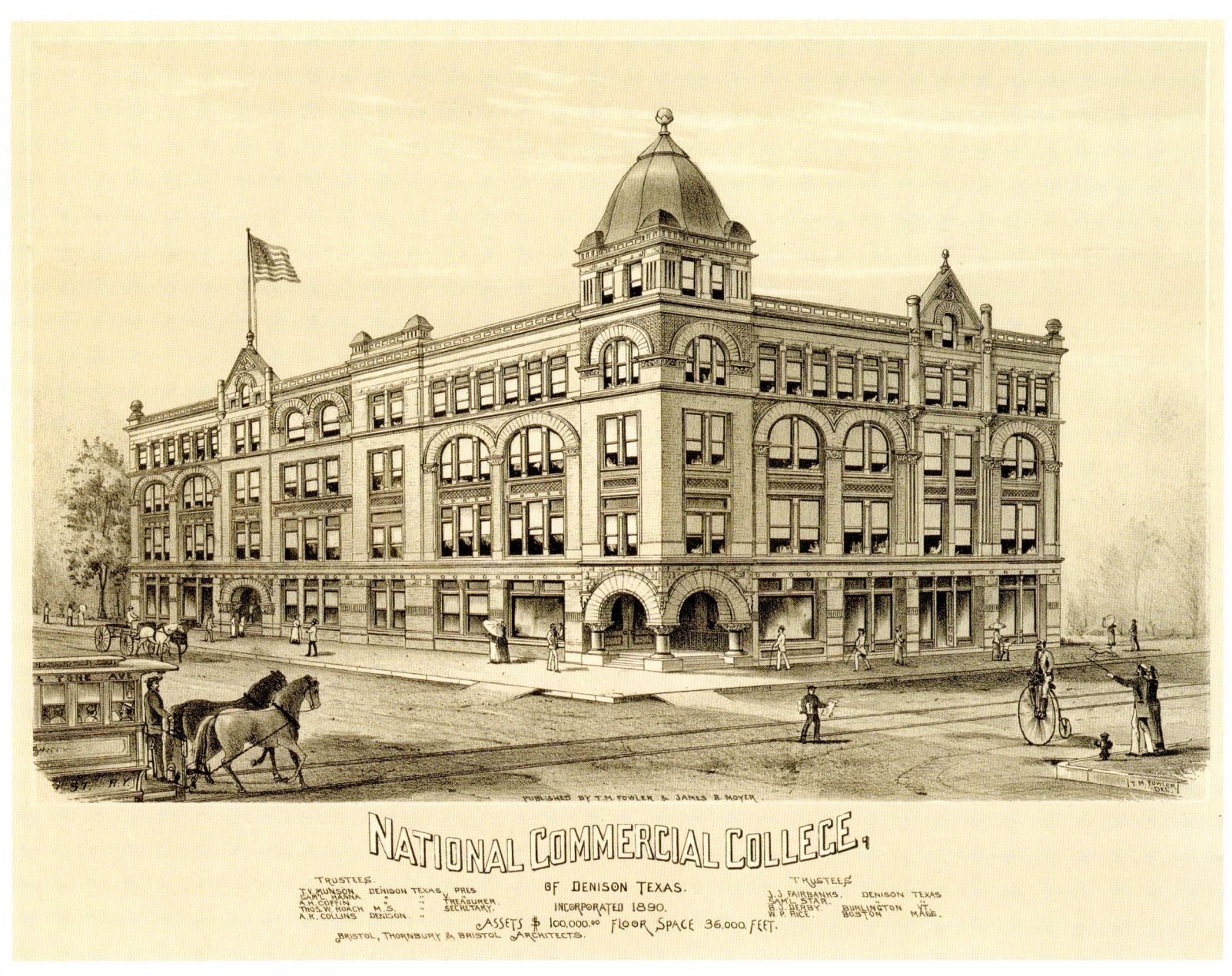

FIGURE 9.43 Unknown artist after Thaddeus Mortimer Fowler, *National Commercial College of Denison, Texas*, c. 1890. Single sheet. Toned lithograph, 10.38 × 16.5 in. Published by T. M. Fowler and James B. Moyer. Courtesy Amon Carter Museum of American Art, Fort Worth.

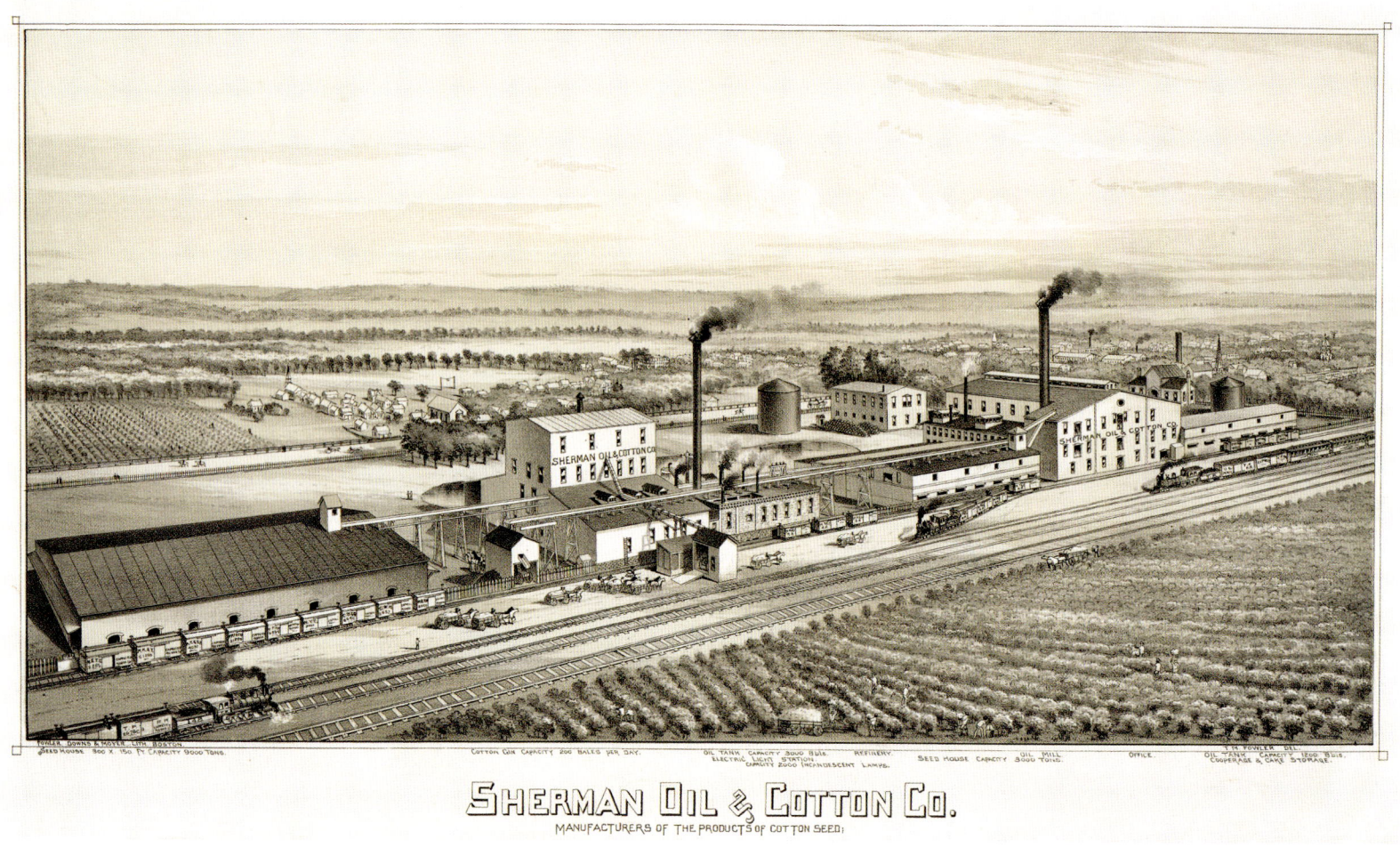

FIGURE 9.44 Unknown artist after Thaddeus Mortimer Fowler, *Sherman Oil & Cotton Co. Manufacturers of the Products of Cotton Seed*, 1890. Single sheet. Toned lithograph, 32.8 × 64.4 cm (image), 39.1 × 65.7 cm (comp.), by Fowler, Downs, & Moyer, Lith., Boston. Courtesy Amon Carter Museum of American Art, Fort Worth.

At the height of the bird's-eye-view popularity in Texas, two Dallas entrepreneurs produced variations on them. In 1876 E. G. Gollner, a civil engineer, published what appears to be a combination map and bird's-eye view of the city with vignettes containing pictures of several important buildings and, on the reverse, a business directory (fig. 9.45).[72] Paul Giraud's 1892 print of Dallas was a promotional effort for the long-dreamed-of improvements to make the Trinity River navigable from Dallas to the Gulf of Mexico (see fig. 7.78). Giraud, a real estate agent and secretary of the Commercial Club of Dallas, made his view from an imaginary perspective over Oak Cliff looking eastward, showing the improvements needed for a river port just south of the Commerce Street bridge. Those improvements included docking facilities and a turning basin, which Giraud optimistically populated with several steamboats, some pulling barges. The effort fell victim to the enormous cost that would have been required to finish the job and was abandoned.[73]

An unusual bird's-eye view of Galveston was supposedly published in 1892 as well. Paul Riecker, a representative of the Galveston Chamber of Commerce, returned from a trip to St. Louis in January and reported that, in addition to several speeches touting the virtues of the Island City, he had ordered two thousand lithographic copies of a bird's-eye view of the city, four by six feet in size, to be "distributed throughout the west."[74] Unfortunately, no copies are known to exist.

FIGURE 9.45 Unknown artist after E. G. Gollner, *Gollner's Map of the City of Dallas, Texas*, 1876. Single sheet. Lithograph, 26 × 34 in., published by S. M. Williams and E. G. Gollner, Dallas. Courtesy Dallas Historical Society.

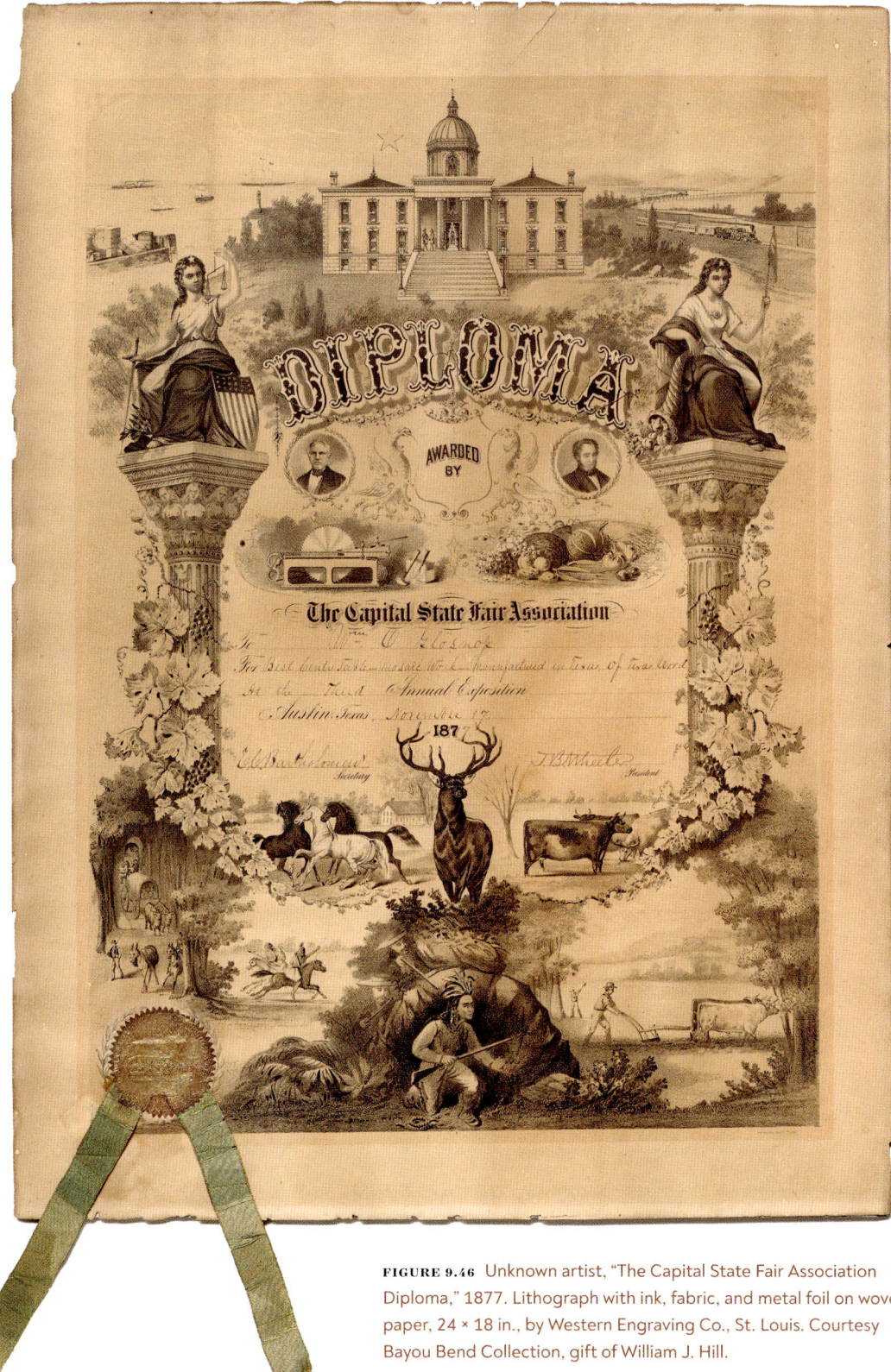

FIGURE 9.46 Unknown artist, "The Capital State Fair Association Diploma," 1877. Lithograph with ink, fabric, and metal foil on wove paper, 24 × 18 in., by Western Engraving Co., St. Louis. Courtesy Bayou Bend Collection, gift of William J. Hill.

The bird's-eye views of Texas cities are among the most desirable nineteenth-century prints for a collector. They appeal to community pride today just as they did then and feed our sense of history. But, more important, they document the growth of Texas cities during a period of rapid expansion, when Texas's population increased 372 percent during the same two decades that the bird's-eye views enjoyed their greatest popularity.

"A NEW ERA IN THE HISTORY OF TEXAS"[75]

With the railroads providing transportation and much of the advertising, great expositions marked the last half of the century. Inspired by London's Crystal Palace in 1851, the trend culminated in the US Centennial Exhibition in Philadelphia in 1876. Seven years after Col. H. L. Kinney presented what might have been the first Lone Star State Fair in Corpus Christi in 1852, Dallas businessmen organized a Dallas fair.[76] Much in the spirit of the New South, it was part of a statewide effort to create "a new era in the history of Texas," according to the editor of the *Texas State Gazette* in Austin, one that would "increase . . . the production of our prosperous State" and bring it to the attention of out-of-state markets. That fall, Sherman, Victoria, Cotton Gin (Freestone County), Ennis, and Dallas, among others, held fairs, but the Civil War interrupted before the Dallas event had achieved any longevity.[77]

Galveston initiated its Mardi Gras celebration in 1867; Houston organized the "first grand State Fair" in 1870; Jefferson produced its "Queen Mab" celebration in 1874;

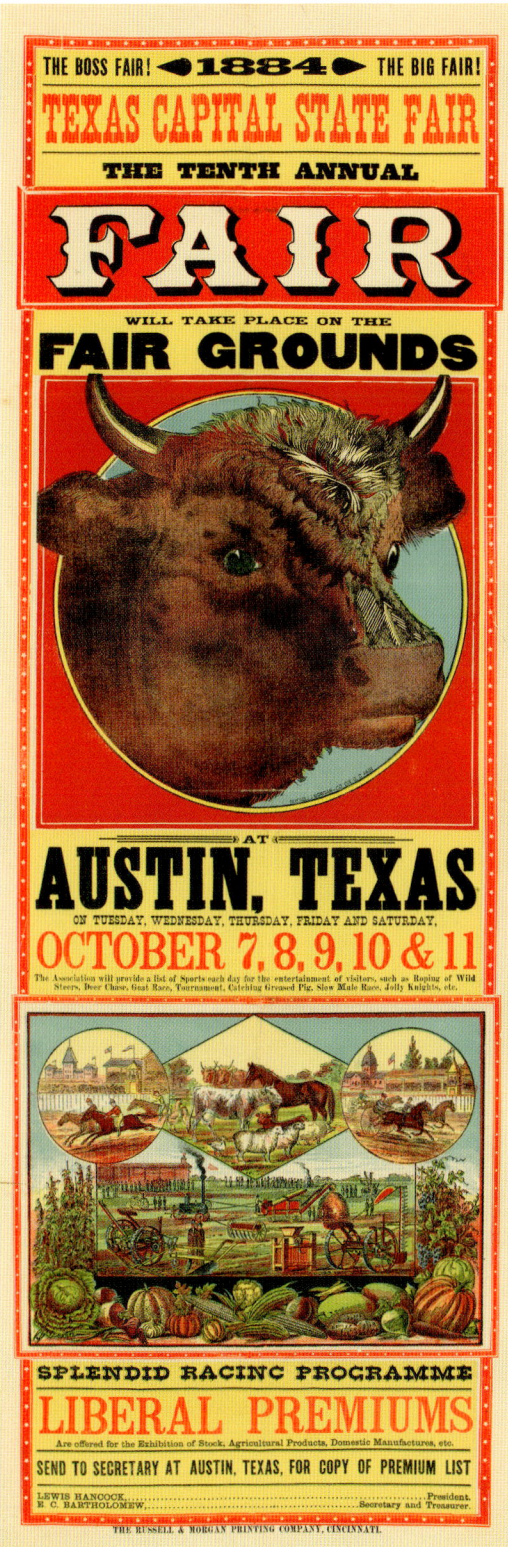

and Austin its Capital State Fair in 1875 (figs. 9.46 and 9.47). In 1876 the *Galveston Daily News* documented some twenty organizations staging fairs around the state (fig. 9.48).[78] Three different organizations staged fairs in Dallas between 1868 and 1877 before the Dallas State Fair and Exposition opened for its first two-week run in 1886, drawing an estimated 100,000 to 250,000 visitors.[79] Rechristened the Texas State Fair and Dallas Exposition the following year, the Dallas fair became a state-wide attraction, offering entertainment and exhibitions of farm stock and machinery (fig. 9.49). Chief among the entertainment was horse racing, and the entire fairground was organized around the racetrack, designed by Judge J. H. Dills of Sherman. The *Waco Daily Examiner* complimented the fair executives for "some of the handsomest work in the lithograph . . . ever seen in Texas [fig. 9.50]."[80]

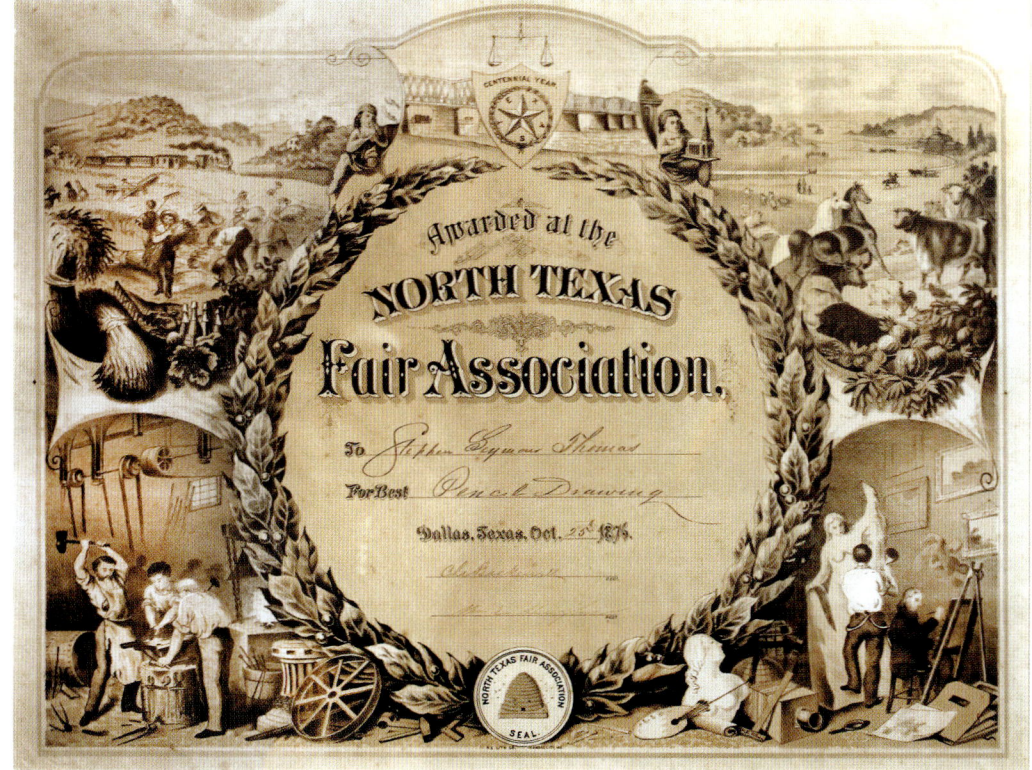

(ABOVE) FIGURE 9.48 Unknown artist, "Awarded at the North Texas Fair Association" [Certificate awarded to Stephen Seymour Thomas for his drawing of *The Hunting Dogs*], 1876. Lithograph, 18.87 × 24.12 in., by K. C. Lith. Co. Kansas City, MO. Courtesy Ezekiel Cullen Chapter, Daughters of the Republic of Texas, San Augustine, gift of Mrs. Jean Haskell.

(LEFT) FIGURE 9.47 Unknown artist, *Texas Capital State Fair: The Tenth Annual Fair*, 1884. Poster. Chromolithograph, approx. 42 × 14.5 in., by Russell & Morgan Printing Co., Cincinnati. Courtesy Briscoe Center for American History, UT Austin.

FIGURE 9.49 Unknown artist, *Great Texas State Fair and Dallas Exposition*, 1890. Poster. Chromolithograph, 24.75 × 19.5 in. (image), 40 × 26 in. (comp.), printed by Woodward & Tiernan PRT'G' Co., St. Louis. Courtesy Dallas Historical Society.

FIGURE 9.50 Unknown artist, *Great Texas State Fair and Dallas Exposition*, 1890. Poster. Chromolithograph, 62.8 x 66.2 cm. Courtesy Dallas Historical Society.

"THE MOST CATCHING THING IN THE WORLD"[81]

Edward J. Smith of Fort Worth managed the telegraph office for Western Union and the Gulf, Colorado & Santa Fe Railway and later worked as a journalist for the *Fort Worth Sunday Mirror*.[82] But in his spare time he was also a talented performer and author and fan of the famous operettas of William S. Gilbert and Arthur Sullivan. Companies all over the United States were producing their plays during the "Mikado craze"—and parodies of them inevitably followed. Smith had one of the starring roles in Fort Worth's 1886 production of Gilbert and Sullivan's *Patience* and was soon at work on a clever adaptation of *The Mikado*. He called it *The Capitalist, or, the City of Fort Worth*, employing rather clumsy puns on Gilbert's character names with the goal of publicizing the advantages of Texas (specifically of Fort Worth) while also spoofing Dallas's efforts (fig. 9.51).[83]

Early in 1888 Smith shared a draft of his work with a local reporter, who called it "one of the best literary efforts that has been made in some time" and suggested that if it were played throughout the country, "it would advertise Texas and Fort Worth as no state and city were every advertised on this earth." A correspondent for the *Austin Statesman* acknowledged that "an advertisement of that kind is the most catching thing in the world." The *Fort Worth Gazette* soon reported that "Mr. Ed Smith's Texas Mikado . . . has been put in print, and it makes a handsome, unique advertisement of Texas and Fort Worth."[84]

An unnamed artist produced the pictures for the booklet, and J. L. Ketterlinus of Philadelphia lithographed it.[85] The front and back covers are chromolithographs. On the front a character with a trumpet holds a sign bearing the name of the production. On the back is a parody of John Gast's famous and widely copied painting and chromolithograph, *American Progress* (fig. 9.52). In Gast's version, a "beautiful and charming female" leads the way westward, carrying a book (representing the common school) in her right hand while she strings telegraph wire, a powerful symbol of modern inventions conquering vast distances, with her left (fig. 9.53). Indians recede before her, helpless in the face of progress. Hunters, miners, farmers—settlers of all kinds—follow in her wake, on foot and via horseback, stagecoach, and train, to possess the now unoccupied fertile land. In the *Texas Mikado* version, a more demurely dressed (but still fashionable) woman beckons would-be immigrants "from

FIGURE 9.51 Unknown artist, *The Capitalist, or, The City of Fort Worth (The Texas Mikado)*, 1888 (front cover). Chromolithograph, 26 × 17.2 cm, by J. L. Ketterlinus, Philadelphia. This parody on the Mikado was published by the Fort Worth Board of Trade. Courtesy Amon Carter Museum of American Art, Fort Worth.

the blizzard region" to the warmer climes of Texas. There are fertile fields at her back, Black people work abundant cotton fields at her feet, and, in the center, cattle graze near a river. The Lone Star hovers over her head to guide the immigrant families who stagger from the snowy north (at right) wrapped in heavy coats toward their new homes in Texas. There are no Indians to be seen, for by 1888 they had been removed to reservations in Indian Territory.

FIGURE 9.52 Unknown artist, *From the Blizzard Region to Texas* (back cover), 1888. Chromolithograph, 17.2 × 26 cm, by J. L. Ketterlinus, Philadelphia. Courtesy Amon Carter Museum of American Art, Fort Worth.

FIGURE 9.53 Unknown artist after John Gast, *American Progress*, 1872. Single sheet. Chromolithograph, 37.6 × 49 cm (sheet), published by George A. Crowfutt. The print was given free to each subscriber of *Crowfutt's Western World*. Courtesy Prints and Photographs Division, Library of Congress. The painting from which the print was made is in the collection of the Autry Museum of the American West, Los Angeles.

432 | TEXAS LITHOGRAPHS

The inside of the book is well illustrated, including a miniature version of what became known as the "tarantula" map, which shows Fort Worth as the rail center of North Texas (fig. 9.54).[86] On the title page is a lithograph of a stack of ten trunks, each of them bearing the name of one of the "trunk" lines serving Fort Worth. There are also small vignette illustrations that suggest a fertile land rich with wildlife. It "is a stunner in its way," concluded the *Gazette*. "It is handsomely printed, beautifully illustrated, full of odd conceit and local hits." A visitor from Denver, presented with a copy by his hosts, called it "a very neatly executed brochure."[87] A copy in the Star of the Republic Museum bears the stamp of R. H. Sellers & Co., Real Estate & Loan Agents, while a copy in the library of the Amon Carter Museum of American Art was distributed by Caswell Bros. Real Estate, showing that Fort Worth businesses adopted the booklet as a part of their advertising.

Smith parodied another Gilbert and Sullivan operetta that same year, *San Antonio, Texas. A Parody on H.M.S. Pinafore*, which he performed in San Antonio and adapted the following year for appearance at the Texas Spring Palace as *The Texas Spring Palace City Fort Worth: A Parody on H.M.S. Pinafore*.[88]

FIGURE 9.54 Unknown artist, *Map Showing the Geographical Location of Fort-Worth, Tex. and Rail-Roads*, 1888. Chromolithograph, 17.2 × 26 cm, by J. L. Ketterlinus, Philadelphia. From *The Capitalist, or, The City of Fort Worth*. Courtesy Amon Carter Museum of American Art, Fort Worth.

"GEMS OF THE PRINTER'S ART"

Fort Worth followed the success of *The Capitalist* with another grand spectacle, at the suggestion of former Union general R. A. Cameron, immigration commissioner for the Fort Worth & Denver Railway. Cameron envisioned "a grand oriental temple" similar to the recent Corn Palace in Sioux City, Iowa, and the Ice Palace in St. Paul, Minnesota, but constructed of and decorated entirely with the products of Fort Worth and Texas.[89] An indefatigable civic booster, *Fort Worth Gazette* editor Boardman "Buckley" Paddock, an Ohio-born former Confederate officer who had moved to Texas in 1872, accepted the role of president of the Texas Spring Palace Co.,[90] and Dallas architects A. J. Armstrong and A. A. Messer, who also had an office in Fort Worth, designed a structure in the shape of a Saint Andrew's cross that was two stories high and 225 feet deep by 375 feet wide; it boasted a 150-foot dome and had eight three-story Moorish-styled towers and two-story double towers to frame the east and west entrances. The lithographed opening invitations earned praise from several journalists: the *Galveston Daily News* described them as "beautifully lithographed . . . and . . . the prettiest work of this kind ever issued in Texas [fig. 9.55]." The *Dallas Morning News* observed that they were the product of "a very skillful hand." The company also produced "something entirely new, having the appearance of a clear black lithograph when laid flat, but when lit from the back, showing the picture [of the palace] in subdued and therefore natural colors." Unfortunately, no copies of this unusual print are known to survive.[91]

Despite a $23,000 loss, the organizers quickly paid off the debt and began planning a second season. Part of Paddock's 1890 promotion was a handsome chromolithographed poster of the building, after a "perspective view" by Fort Worth artist C. H. Morse, which was chromolithographed by Woodward & Tiernan Printing Co. of St. Louis in February 1890 (fig. 9.56). By March 23 the newspaper reported that Paddock had approved the proof and that the final print would be "executed in seven colors, and is a facsimile, even in many of the exterior decorations, of the Palace, as it will appear when completed." A reporter for the *Daily Gazette* described the finished prints as "gems of the printer's art and very fair and correct representations of the Palace."[92] It shows a color representation of the enlarged building with flags flying and people milling about in the fountain gardens at the front of the structure. Paddock mailed the poster far and wide.[93]

The second season opened May 14, but just a few days later, on May 30, tragedy struck. As an estimated seven thousand celebrants crowded into the Palace, a fire of unknown origin broke out and swept through the decorations and dried agricultural products in minutes. Firemen were stationed throughout the building with hoses connected to fire hydrants, but, as Paddock lamented, they "did not have time to turn on the water."[94] One man, Englishman Al Hayne, a civil engineer, helped rescue "fainting women and terrified children" until his clothing caught on fire. He jumped from an upper story window but died three hours later from his injuries.[95] There were numerous calls to rebuild the structure, but the nearest thing to a reconstruction was a large "firework scene" of the Palace, which was set on fire in a bittersweet commemoration by a traveling fireworks company five months after the blaze.[96]

FIGURE 9.55 Unknown artist, *Texas Spring Palace, Fort Worth, Texas*, 1889. Invitation. Lithograph, 16.8 x 25.1 cm, by Homer Lee Bank Note Co., New York. Courtesy Genealogy, History, and Archives Unit, Fort Worth Public Library. Spring Palace Records.

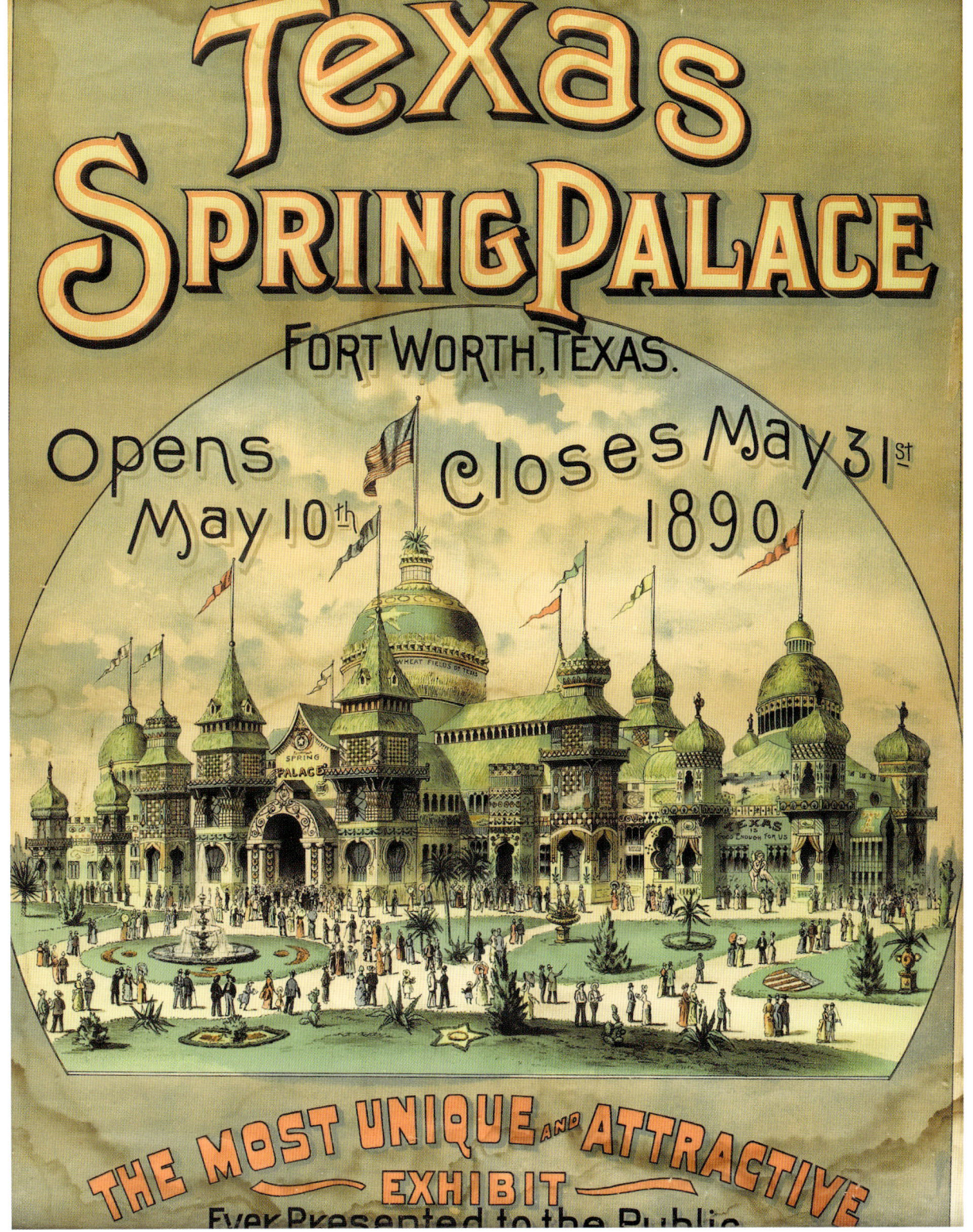

FIGURE 9.56 Unknown artist after C. H. Morse, *Texas Spring Palace. Fort Worth, Texas*, 1890. Poster. Chromolithograph, 69.8 × 45.7 cm (image, sight), by Woodward & Tiernan, St. Louis. From the collection of the Bryan Museum, Galveston. Unfortunately, several inches of the bottom of this copy have been cropped off. The missing text announced that the building was "Constructed, Ornamented, Decorated Entirely with the Products of Texas. Low Rates on All Railroads. Send for Circulars."

DARWIN'S THEORY AND TEXAS HISTORY

As Fort Worth was building the Spring Palace, San Antonio citizens revived their series of public festivals, which had begun in 1869 with the German American community celebrating Alexander von Humboldt's one hundredth birthday. They had held modest celebrations during the ensuing years, but in 1882 they began planning more ambitious events. The first one was built around the theme of "Darwin's Theory," which, appropriately enough, included scenes from Texas history along with participants costumed as bats, butterflies, crabs, fishes, and other members of the animal kingdom. Hoping to generate more trade with Mexico, San Antonio leaders debuted an international fair in November 1888 that was a financial disaster because it rained throughout the month. But they had much better luck in 1889, including the distribution of handsome lithographic posters featuring a female figure representing the United

FIGURE 9.57 Unknown artist after August Nolte, *San Antonio Daily Light Special Edition German-American Day at San Antonio, Texas, Oct. 9th, 10th, and 11th, 1891*. Chromolithograph newspaper page by [Gustave] Koeckert & [John] Walle, 112 Gravier, New Orleans. Courtesy University of Texas at San Antonio Digital Collections/DRT Library.

FIGURE 9.58 After August Nolte, *Special Edition of the First Annual German American Volksfest to be Held at San Antonio, Tex. October 28th, 29th, & 30th. 1892*. Full newspaper page. Chromolithograph, by [Gustave] Koeckert & [John] Walle, 55 Carondelet St., New Orleans. Courtesy University of Texas at San Antonio Digital Collections/ DRT Library.

States sitting on a pedestal and welcoming a woman trailing the red, white, and green colors of Mexico. In their enthusiasm, the printer, Woodward & Tiernan of St. Louis, apparently sent five hundred copies of the poster to the city of Boerne.[97]

In 1890, as a part of the third San Antonio International Exhibition of Texas and Mexico, the German American community renewed its volksfest tradition with a parade. Floats created by Harry Dressel, of New Orleans, who also designed the floats for the New Orleans Mardi Gras celebration, proved to be the highlight of an event so successful that it led to plans for the first German American Volksfest the following year.[98]

Dressel again designed the floats for the 1891 parade, organized around the theme of masterpieces by famous German poets. The floats were so elaborate that the two daily San Antonio newspapers, the *Light* and the *Express*, included a special section that contained chromolithographed illustrations, after the work of New Orleans artist August Nolte, of the sixteen floats and included explanations of the themes of the floats (fig. 9.57).[99]

Despite a deficit of $3,000, the German American Association planned for a parade of twelve floats in 1892, and, instead of employing Dressel, the floats were homemade; nor were there any imported costumes. To commemorate the four-hundredth anniversary of Columbus's voyage to America, the committee chose American historical themes as subjects for the floats. Two of them represented Columbus—his departure from Palos, Spain, and his arrival in America—and four were scenes from Texas history, which would be much more familiar to the viewers: Indians attacking a covered wagon; Crockett, Bowie, Travis, and Bonham at the Alamo; Santa Anna surrendering to Sam Houston; and Texas joining the Union. Nevertheless, the *Daily Light* called it "one of the most brilliant events in the history of the Alamo City [fig. 9.58]."[100] The volksfests continued in 1893 but did not survive the economic depression of that year.[101]

ARCHITECTURAL BOOSTERISM

The same boosterism that fueled production of the city views also motivated production of portraits of new public buildings as the state's population and tax revenue, based on ranching and cotton, increased. Following the Civil War, the Victorian architecture of mainstream America swept through Texas and inspired dozens of new government buildings, including a new capitol in Austin. The framers of the 1876 state constitution had set aside more than three million acres of land in the Panhandle to fund the design and construction of the building. In 1880 the newly appointed Capitol Board invited architects to participate in a design competition and received eleven entries. The board selected Detroit architect Elijah E. Myers, who had already designed capitols in Michigan, Idaho, Colorado, and Utah. Myers had completed plans, detail drawings, full specifications, and a form of contract for the builders when, in November 1881, the old capitol burned, necessitating the rapid construction of a temporary capitol building and inducing some haste in planning the new capitol.[102]

The commissioners reported on their progress in 1883 and included a lithograph of the proposed building as well as plans for each floor. Meanwhile, an 1882 article in the *Austin Daily Statesman* describes an "advertising card—purely the invention of an Austin genius"—that included a picture of the capitol, with a picture of the governor over the dome and portraits of the Capitol Board and commissioners arranged on each side. The whole was "surrounded by business cards, lettered in silver and gold and framed in bronze and glass."[103] The "very latest piece of Texas enterprise," according to the *San Antonio Daily Express*, was a box of "fine cigars called 'Our New Capital' [*sic*] illustrated with a lithograph of the building on the box.[104]

The laying of the cornerstone on March 2, 1885, was done amidst controversy and delay caused when the International Association of Granite Cutters boycotted the job to protest the use of convict laborers. Even so, the event inspired several more lithographs.[105] The peripatetic William M. Edwardy published a *Capitol Souvenir*, which the *Galveston Daily News* editor described as a picture of the capitol surrounded by images of some of the principal buildings of Galveston.[106] Austin printer Charles N. McLaughlin produced a handsome picture of the capitol based on Myers's perspective view of the building, which was lithographed by Charles Sinz and W. P. Morgan of Cleveland, Ohio (fig. 9.59). The unnamed lithographic artist included a portrait of Sam Houston centered over the dome of the capitol, and portraits of state icons David Crockett (after John Gadsby Chapman's 1834 portrait, which was destroyed in the capitol fire), David G. Burnet, Mirabeau B. Lamar, and Stephen F. Austin, along with images of the Alamo and the old capitol in Houston arranged in the left and right borders. There is a brief description of the building at the lower center. The *San Antonio Evening Light* reported, "The new state capital [*sic*] has become a feature in the news-stand landscape."[107]

The building was finally dedicated during the week of May 14, 1888. Participants received gaily decorated and brightly printed invitations and souvenirs (figs. 9.60A and 9.60B). A militia encampment was set up northwest of the city, and a magnificent fireworks display initiated the proceedings. Infantry, artillery, cavalry units, and zouaves in full dress, both professional and volunteer, paraded through Austin and competed in drill competitions. Throughout the week, band concerts, baseball games, rodeo events, shooting exhibitions, German choruses, and a full-scale mock battle entertained the celebrants, while peddlers and "fakirs" plied their trades among the crowd.[108] Inspired by the nation's capitol, the new Texas State Capitol is some 562 feet wide by 287 feet deep. The star that the Goddess of Liberty holds in her hand is 311 feet above the ground.[109]

May 16 was devoted to speeches; the Grand Dedication Ball was held on Friday evening, May 18, in the capitol. Most of the crowd began arriving around nine o'clock. According to the *Austin Daily Statesman*, "The flower of the military of the great state of Texas was there" along with "their . . . distinguished guests in official circles of sister states and from our sister republic."[110] Several groups, including Gilmore's Band of New York, played until eleven o'clock in the Hall of Representatives. One of the musical selections performed that evening might have been "The Texas State Capitol Grand Waltz," composed by Leonora Rives and published that year by Thomas Goggan & Bro. of Galveston with a fine lithographic view of the building on the cover, again copied after architect Myer's perspective rendering (see fig. 8.34). Official acceptance of the building was delayed, however, when the dignitaries were drenched because the roof leaked during a spring rainstorm.[111]

Other lithographs of the capitol copied after Myers's perspective include a chromolithographed trading card published by Allen & Ginter and one by B. J. Kopperl of Austin, who ran a book and stationery store (fig. 9.61). Of course, the building was pictured in many different illustrated magazines and newspapers of the day.[112]

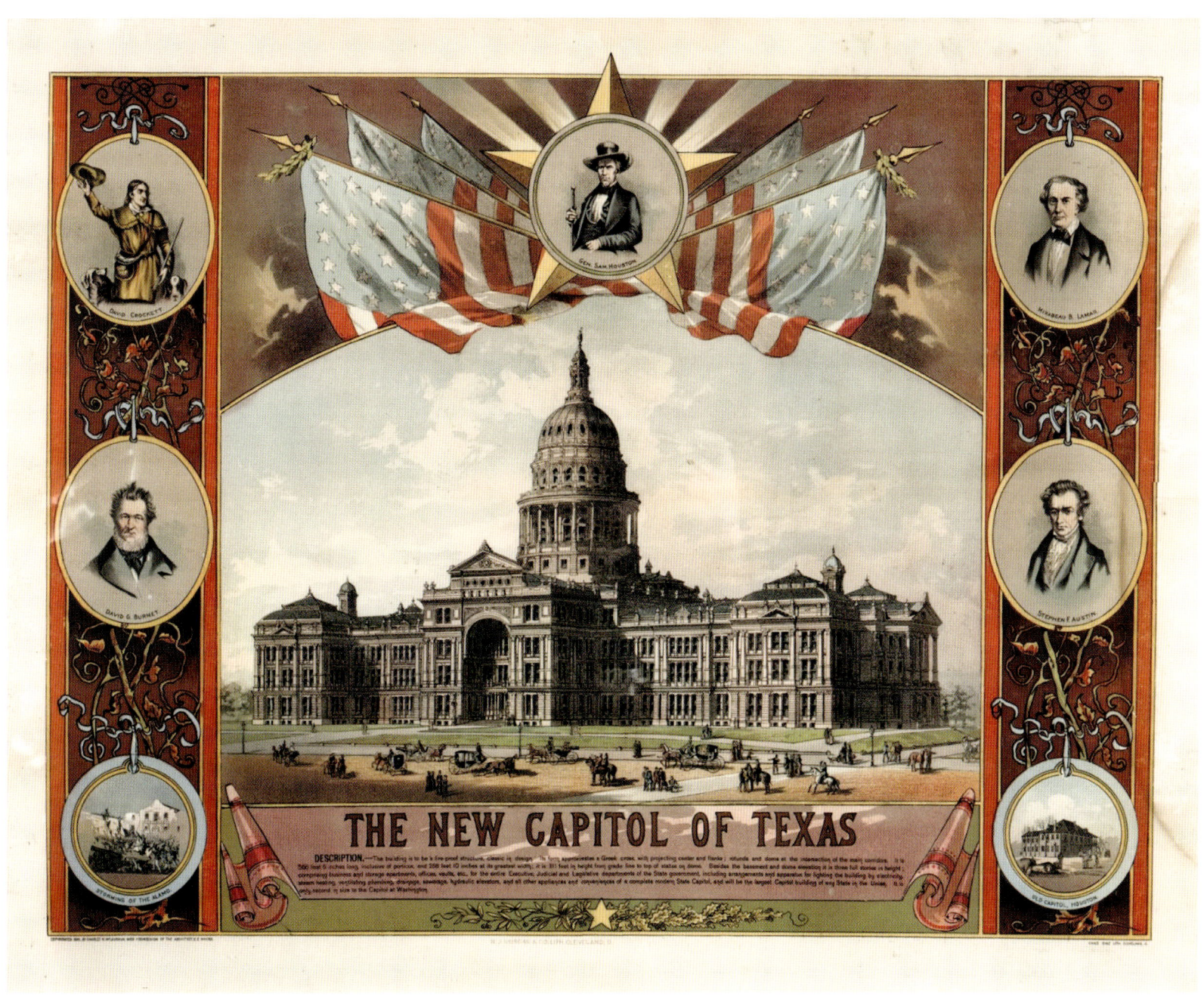

FIGURE 9.59 Unknown artist after Elijah E. Myers, *The New Capitol of Texas*, 1885. Poster. Chromolithograph, 46.7 × 60.7 cm (image), 47.8 × 60.7 cm (comp.). Along the bottom, left to right: Copyrighted 1885 by Charles N. McLaughlin, with permission of the architect, E. E. Myres; W. J. Morgan & Co. Lith., Cleveland, O.; Chas. Sinz Lith. Cleveland O. Courtesy Briscoe Center for American History, UT Austin.

FIGURES 9.60A AND 9.60B Unknown artist, *Souvenir Programme Grand Dedication Ball New State Capitol Building Austin, Texas*, 1888 (front and verso). Invitation. Chromolithograph, 20.6 × 64.5 cm (opened), by Gast, St. Louis. Courtesy Dr. John M. Parker, Plano.

FIGURE 9.61 After Elijah E. Meyer [sic], *Texas State Capitol*, c. 1888. Single sheet. Toned lithograph, 5.9 × 9.4 in., published by B. J. Kopperl, Austin. Courtesy San Jacinto Museum of History, Albert and Ethel Herzstein Library Collection, gift of Mr. and Mrs. George A. Hill, Jr., 1940.

The design of the new capitol probably helped inspire a number of new courthouses, as fires had ripped through many wooden structures and counties outgrew pre–Civil War buildings. The 1890 census certified that Dallas, for example, had become the largest city in the state, with 38,067 residents, and the county commissioners, given the opportunity to build a new courthouse because of yet another fire, decided to build "as fine a court-house as can be found in the State." The city's first courthouse, built in 1844, was a log cabin, ten by ten feet, on the corner of the public square. It burned in 1848 and was replaced two years later by a second log structure that was inadequate by the time the city was incorporated in 1856. The county then built a two-story brick building, surrounded by a grove of trees and a fence to keep livestock off the square. That building, too, burned, in 1860, but was rebuilt and continued in use until 1871, when it burned again.[113] Dallas then built the structure that F. E. Butterfield and C. M. Rundlett illustrated as a vignette on their official map of the city in 1875 (fig. 9.62).[114] The building was under construction when Herman Brosius arrived in 1872 to make his bird's-eye view of the city. Only the walls of the first floor, constructed of "hard granite" quarried east of the city, can be seen on

FIGURE 9.62 Unknown artist, F. E. Butterfield and C. M. Rundlett, *Official Map of Dallas, Texas 1875*, 1874 (detail of the Dallas County Courthouse). Photostat of lithograph, 60 × 55 in., by St. Louis Democrat Lith. & Print Co. Courtesy Heritage Auctions, Dallas. The cartouche of the map contains a drawing of the 1871 courthouse, which burned in 1880.

the square, which is bounded by Main, Commerce, Jefferson, and Houston Streets. The structure was not completed until 1874, when the reporter for the *Dallas Daily Herald* wrote that the new dome "threatens to be high enough to give us a sight of the church spires of Maine."[115] He was referring to the balcony on the roof that the designers had included, which offered residents a majestic view of their growing city. This courthouse, too, burned, in 1880, but the granite walls remained standing and were incorporated into the repaired structure.[116]

Another fire in 1890 cleared the way for Dallas's sixth and most dramatic courthouse. Maximilian A. Orlopp of Little Rock, Arkansas, designed a massive structure that virtually filled the square. Influenced by the work of Henry Hobson Richardson, the Boston architect who gave his name to the Gilded Age–style Richardsonian Romanesque, Orlopp selected the blue Arkansas granite and red sandstone from Pecos, Texas, that gave the structure its contrasting colors. Before the commissioners' court and other officials began moving into the building in the summer of 1892, the Dallas Bar Association reported that it had commissioned a color lithograph of the courthouse from the Dallas Lithograph Co. at a cost of $150 (fig. 9.63).[117] The stately structure soon became known affectionately as "Old Red" and is occupied today by the Old Red Museum of Dallas County History and Culture.

As the century came to a close, developers produced increasingly colorful and handsome maps and brochures advertising their properties and communities (figs. 9.64 and 9.65). The Velasco brochure is especially appealing, apparently produced and designed by Louis Giraud, who was the city engineer of San Antonio from 1877 to 1879. The front of the brochure contains a bird's-eye view of the jetties at the mouth of the Brazos River as well as a picture of the Velasco, a hotel/resort designed by Eugene T. Heiner of Houston. Bookseller Dorothy Sloan described the text on the verso of the print as "an orgy of late nineteenth-century US boosterism."[118]

(OPPOSITE PAGE) FIGURE 9.63 Unknown artist [Jay Booker?] after Maximilian A. Orlopp, *Dallas County Court House*, c. 1892. Poster. Chromolithograph, 29 × 22.25 in., by Dallas Lithograph Co. Courtesy Dallas Historical Society.

FIGURE 9.64 Unknown artist, *Map of Houston Heights, Harris County, Texas. Owned by The Omaha & South Texas Land Co. Houston, Tex.*, 1900. Chromolithograph, 118 × 70 cm (image), 124.5 × 81 cm (comp.), by Forbes Co., Boston. Courtesy General Land Office of Texas, Austin.

FIGURE 9.65 Louis Giraud (attrib.), *Velasco the First & Only Deep Water Port on the Coast of Texas*, 1892. Promotional folder. Chromolithograph, 60.5 × 91.7 cm (sheet), by Aug. Gast Bank Note & Litho. Co., St. Louis. Courtesy Special Collections, University of Texas at Arlington Libraries.

THE GILDED AGE PERSONIFIED

Along with the Democratic resurgence during the post–Civil War years came the revival of the state militias, and they became a fixture at most of the Gilded Age fairs and celebrations. By 1880 forty-seven volunteer companies had organized in Texas, thirty-eight white and nine Black. Inspired by a renewed martial spirit among the post–Civil War generation, these organizations competed vigorously, taking pride in their drills and uniforms.[119] The wealthy and connected and their children filled the militia ranks and made contacts that provided entrées into career and business opportunities. In the case of the Houston Light Guard, the wealthiest men in the community either held positions in the guard or were related to members.[120] Col. Edwin Fairfax Gray, son of Peter W. Gray, one of the founders of the Houston law firm that became Baker Botts, helped establish the Houston Light Guard, the first volunteer company in Texas, in 1873, and James A. Baker Jr., who was later William Marsh Rice's attorney and shepherded Rice Institute (now University) into existence, was also a member.[121] The Austin Greys organized in 1876.[122] The militias spent their duty hours drilling and preparing for celebrations. Companies in Galveston, San Antonio, and Houston formed part of the welcoming receptions for former president Grant when

FIGURE 9.66 Unknown artist, *Houston Light Guard. Capt. Thos. Scurry*, c. 1885. Single sheet. Chromolithograph, 5.75 × 10 in., by T. Fitzwilliam & Co. Lith, New Orleans. Courtesy Briscoe Center for American History, UT Austin.

he visited in 1880. Fifteen companies were expected to attend the Mardi Gras celebration in Galveston in 1882. On occasion they also had to perform more regular duties, such as in 1880 and 1898 when the Houston Light Guard was called out to quell labor strikes.[123]

With private sponsorship, militia drills resumed in 1884. Their activities included scheduling lectures or sometimes breaking up a sham riot or reenacting a battle. Their undertakings became spectator events and were often held in conjunction with the annual celebrations, such as Mardi Gras in Galveston, Houston's Volksfest and San Jacinto Day, July 4th, the various interstate drill competitions, the opening of the new capitol in 1888, and San Antonio's German American festival in 1892, where the Belknap Rifles marched "in full dress costumes."[124] As the popularity of the drill competitions grew, the uniforms became increasingly stylish, as the chromolithographs by the New Orleans firm of T. Fitzwilliam & Co., Lith., of the Houston Light Guard (figs. 9.66 and 9.67) and the Austin Greys (fig. 9.68) illustrate, and participation became increasingly expensive.[125] The Fitzwilliam company printed a number of company portraits for units in several Southern states.

The encampments were bonanzas for local merchants, including the lithographers, who published some of the units' associated materials. W. H. Coyle of Houston lithographed a colorful certificate of honorary membership for the Houston Light Guard as well as the official program for the 1884 Houston Grand Inter-State Drill and Encampment (fig. 7.61). Two years later the Galveston firm of Clarke & Courts printed the official program for the Galveston encampment for publishers Donnaud & Bryan (see fig. 7.50). The *Sunday Opera Glass*, a weekly entertainment newspaper in Galveston, produced a special Inter-State Drill edition, which included a 30-by-44-inch lithographic bird's-eye view of the city (see fig. 7.57) copied from Augustus Koch's 1885 view. The *Opera Glass* editor offered the view for ten cents a copy and claimed to have sold 25,000 copies by August 7. A correspondent estimated that the Houston event drew "more visitors than ever before in her entire history," and two years later a reporter called the Galveston encampment "the grandest gala event in Galveston's history."[126]

FIGURE 9.67 Unknown artist, *Illust'd Sweet Caporal Houston Light Guard, Tex. Militia*, 1888. Trading card. Chromolithograph, 2.75 × 1.5 in., issued by Kinney Brothers Tobacco Co. to promote Sweet Caporal Cigarettes. Courtesy 1888 Kinney Tobacco Military Series N224 Houston Light Guard Tex. Militia, eBay.

FIGURE 9.68 Unknown artist, *Austin Greys Co. A. 2nd Regt. T.V.G.*, c. 1885. Single sheet. Chromolithograph, 6.75 × 10.75 in., by T. Fitzwilliam & Co. Lith., New Orleans. Courtesy Briscoe Center for American History, UT Austin.

FIGURE 9.69 Unknown artist, *U.S.S. Texas*, c. 1893. Trading card. Chromolithograph, 2.5 × 4.19 in., published by W. Duke, Sons & Co. to promote Honest Long Cut Tobacco. Part of the unnumbered transparencies series. Courtesy Metropolitan Museum of Art, New York, the Jefferson R. Burdick Collection, gift of Jefferson R. Burdick.

Adding to the martial flair at the end of the century was the commissioning of the first US battleship to be named after Texas (fig. 9.69). The *Texas* was built at the Norfolk Navy Yard in Virginia and launched on June 28, 1892, as the first American steel-hulled battleship. Miss Madge Houston Williams, the "Maid of Independence" and the granddaughter of Sam Houston, was elected in a competition sponsored by the *Galveston Evening News* to christen the ship. In a sign of the times, the Woman's Christian Temperance Union of Virginia urged her to christen the vessel with pure water instead of wine, and Miss Williams agreed that water, perhaps from the Brazos River, someone added, would be "far more appropriate." But she also noted that she was "not a fanatic on the question."[127] The *Galveston Daily News* reported that as she "broke the bottle of wine across the stately vessel's bow" it "went into the stream without a tremor and sat like a duck when she got there."[128] Miss Williams then led the effort to secure a silver service for the ship.[129] As the *Texas* neared service, the *Brenham Daily Banner* reported it was a ship that "makes only fifteen knots an hour, and was not constructed for running, but for fighting. . . . That's Texas to a dot."[130]

LITHOGRAPHS AS PHOTOGRAPHS

Among the most handsome lithographic products, created during the technological shift from lithography to gravure and other methods of reproducing images, is a series of souvenir books and guidebooks that originated in Germany with the lithographic firms of Louis Glaser in Leipzig and Charles Frey in Frankfurt. Their production served purposes similar to those of the bird's-eye views: to advertise cities to would-be immigrants and tourists.

Glaser and Frey, apparently working independently, developed a multistone lithographic process for printing images, which achieved a striking, monochromatic effect greatly resembling a photograph. Using five or more stones, they laid down a series of separate, oil-based inks ranging from white to light sepia-gray to the darkest sepia-gray and black. Use of multiple stones was common in American chromolithography, but using separate stones with oil-based inks to produce a whole series of shades of the same color seems to be unique to Glaser and Frey. The finished lithograph was varnished to give it an illusion of greater depth than could be achieved in a simple lithograph or toned lithograph. Some historians have called the process black-and-white chromolithography; the *San Antonio Daily Light* called the printed results "litho-photographic views." The ideal vehicle for these images proved to be pocket-sized booklets containing images of cities, natural wonders, various tourist attractions, and popular subjects, such as *Cowboy Life*, published in Portland, Maine, by the Chisholm Bros. in 1897. Most of the pocket-sized books have hard or embossed covers, usually about 5 × 6.25 inches and sometimes featuring attractive and colorful bindings (fig. 9.70). The small albums do not represent as many cities as did the bird's-eye views, but they became almost ubiquitous as tourist souvenirs, and their small size permitted them to be kept and stored much more easily than a framed print.[131]

Perhaps the first of the Glaser/Frey booklets published in the United States was *Centennial Exhibition and Philadelphia* (New York: Wittemann Bros.; Philadelphia: Geo. C. Renkauff, 1876). Adolph Wittemann, who immigrated from Germany to the United States in about 1865 and had established a labels business in New York City by 1874, added publishing to his endeavor two years later. Wittemann worked primarily with Louis Glaser. Meanwhile, the Chisholm Bros. of Portland, Maine, whose primary business was selling newspapers and magazines on trains, copublished a couple of guidebooks with Wittemann before teaming with Charles Frey;

FIGURE 9.70 Cover of *Galveston. Texas*, 1885. Approx. 10 × 15 cm. The first of the Glaser/Frey lithographed souvenir booklets related to Texas was published in New York by Adolph Wittemann in 1885. Courtesy DeGolyer Library, Southern Methodist University.

for a while they advertised themselves as the "sole agents for Chas. Frey's Original Souvenir Albums."[132] Ward Bros. of Columbus, Ohio, joined the competition in 1882. A number of other publishers produced these booklets with Glaser and Frey, but not on the scale of Wittemann, Chisholm, and Ward.[133]

The illustrations were copied after photographs, gathered perhaps by traveling agents employed by the publishers or by local retailers. Adolph Wittemann published the first Texas album, *Galveston. Texas* (1885) (fig. 9.71). Ward Bros. published most of the Texas albums, including *Souvenir of El Paso, Texas & Paso del Norte, Mexico* (1887); *Souvenir of San Antonio Texas* (1886); *Souvenir of Dallas, Texas* (c. 1888); *Souvenir Album of the Great West* (1889); *Souvenir Album of Houston Texas* (1891); and *Souvenir of Galveston, Texas. 70 Views* (1892; reprinted and enlarged to 90 views in 1897). Chisholm Bros. published *Brownsville, Texas. Fort Brown & Matamoros, Mexico* in 1890 (fig. 9.72) and, together with Wittemann, *Souvenir of San Antonio Texas* (1886). Judging from imprints in the albums themselves as well as newspaper advertising, the publishers worked with local retail merchants who would assume or share the production costs, such as J. D. A. Harris (Dallas), Victor Phillips and J. E. Mason (Galveston), W. G. Walz (El Paso), and Nic. Tengg and Paul Wagner (San Antonio) (fig. 9.73). Exactly how many copies of

FIGURE 9.71 Unknown artist, *Interior of Cotton Exchange* and *Cotton Warehouse*. Tinted lithograph, approx. 10 × 15 cm, by Louis Glaser. From *Galveston. Texas* (Adolph Wittemann, 1885). Courtesy DeGolyer Library, Southern Methodist University.

FIGURE 9.72 Unknown artist, *Steamboat Landing, Rio Grande River* [sic] and *Rio Grande Railroad Depot and Repair Shops*, 1899. Tinted lithograph, 13 × 16 cm, by Chas. Frey. From W. H. Chatfield, *Brownsville, Texas. Fort Brown & Matamoros, Mexico* (Chisholm Bros., 1890). Courtesy UTRGV Digital Library, University of Texas–Rio Grande Valley.

FIGURE 9.73 Unknown artist, *The Alamo. Built 1718*, c. 1890. Tinted lithograph, 15 × 24 cm. From *San Antonio Album*, printed by Louis Glaser, Leipzig, Germany and published by Paul Wagner, San Antonio. Courtesy the University of Illinois at Urbana-Champaign, from the Library of William W. R. Woodbury, presented by his family, 1934.

FIGURES 9.74A AND 9.74B After Henry A. Doerr and Semmy E. Jacobson, *Mexican Women Selling Birds*, c. 1890. Tinted lithograph, 16 × 9 cm. From *Souvenir of San Antonio* (imported by Adolph Wittemann, 1890), p. 7, illus. 13. Courtesy Special Collections, University of Texas at San Antonio. Plate 74B: Henry A. Doerr and Semmy E. Jacobson, *"Pagarias" (Mexican Women Selling Birds)*, c. 1890, one frame of a stereograph. Courtesy New York Public Library Digital Collections.

the booklets were printed is unknown, but Paul Wagner advertised in 1886 that he had five thousand copies of the *Souvenir of San Antonio* for sale.[134]

These albums constitute important visual records of the cities they represent. The images are often sharper and more attractive than contemporary photographs, but, as with many other printed images, the lithographic artists added and deleted details and figural staffage as needed—prettifying the images by omitting any discordant elements and including pictorial features that might not have been in the original images. An example of this editing process is the image of two San Antonio women and a child selling birds, which is based on a photograph by Henry A. Doerr of San Antonio (figs. 9.74A and 9.74B). The photograph (right) shows the three figures in a studio setting with a backdrop making it appear that they are on a bridge with the river and a landscape behind them. The lithographic artist dropped the background (left top, circular image), substituting a few strokes of the crayon to suggest a landscape. He also slightly altered the poses and costumes of the three figures. The changes bring more focus to the figures because there is no background or bridge railing to distract.

These booklets often included panoramic or bird's-eye views (fig. 9.75), as well as street scenes and pictures of courthouses, banks, offices, shops, hotels, warehouses, waterworks, railroad depots, military establishments, bridges, churches, schools, parks, and certain

FIGURE 9.75 Unknown artist, *Harris County Court House, City Hall and Market Building, and Looking East and South from City Hall Tower*, 1891. From *Souvenir Album of Houston Texas* (Ward Bros., 1891). Courtesy Special Collections, University of Houston Digital Library.

residences (perhaps chosen either for the renown of the owner or the architectural interest of the house, or, perhaps, because the homeowner paid a fee to have his house included) (fig. 9.76). Among the more unusual images are those of the older battleship *Texas* in Galveston Bay, a steamboat on the Rio Grande (fig. 9.72), and Rio Grande canyons and the Pecos River Bridge (fig. 9.77).

These booklets soon gained credibility beyond their intent. In 1900 Galveston was a city of 38,000 people on a barrier island approximately nine feet above sea level and already subject to periodic flooding. There had been storm warnings, but no one realized that they heralded extraordinary destruction. On September 7 the *Galveston Tribune* forecast "increasing cloudiness and probably rain; slight changes in temperature; brisk to high northerly winds" for the island.[135] But the front edge of an unexpected hurricane had come ashore by the time the *Tribune*, an afternoon newspaper, reached the stands on the 8th. "The Bay too is Boisterous," one headline read. And another, "Considerable Damage along the Beach," hinted at the monster raging in the Gulf. As the *Tribune* went to press that afternoon, another report revealed that water had already reached ten feet deep in some places.[136]

FIGURE 9.76 Unknown artist, *Residence of Jules Schneider, Res. of R. B. Godley, and County Court House*, 1888. Tinted lithograph from *Souvenir of Dallas, Texas* (Ward Bros., published for J. D. A. Harris, Dallas, 1888). Courtesy Library of Congress.

FIGURE 9.77 Unknown artist, *Scenes along the Rio Grande*, 1892. Tinted lithograph, 15.7 × 24.5 cm. From *Souvenir Album of the Great West* (Ward Bros., 1892). Courtesy Bancroft Library, University of California, Berkeley. The second bridge across the Pecos River is shown in the upper right.

The destruction was unimaginable as winds of up to 120 miles per hour battered the island and sent debris hurtling through the air. Fully two-thirds of the city was destroyed; an estimated 10,000 to 12,000 people died. The storm severed all communication with the mainland, and only after a desperate, ten-mile trip across the churning and flotsam-littered bay did the mayor's emissaries reach Houston at three a.m. on September 10 to deliver their message to the world: "Galveston is in ruins."[137]

Many printers and photographers attempted to capture the mass devastation in what is still the deadliest natural disaster known in North American history. Illustrated articles appeared in the major magazines, such as *Harpers Weekly*, and no fewer than five illustrated books were published in less than a year.[138] But the chromolithograph showing the aftermath of the hurricane produced by the Chicago firm of Kurz and Allison is perhaps one of the most horrifying: workers overcome as they searched for survivors among the chaos, gathering corpses, burying them at sea, and burning them when they washed back to shore; and police shooting looters (fig. 9.78). Most of the attempts to document the storm damage might be perceived as more authentic than Louis Kurz's almost ghoulish effort, but the chromolithograph packs a visceral punch. In the wake of the storm, Clarence Ousley, editor of the *Galveston Tribune* and author of *Galveston in Nineteen Hundred*, turned to the lithographed images in the 1885 Galveston album for comparison with photographs of the same scenes after the devastation, testifying to the historical credibility that the little souvenir albums had already assumed.[139]

The state's fledgling lithographic industry was, to a certain extent, caught up in the frenzy as shipping companies, railroads, state agencies, newspaper editors, entrepreneurs, and city fathers touted the advantages of Texas, enthusiastically advertised for new settlers, and organized events tailored to attract them.[140] The bulk of the lithographic printing went to firms outside the state, but Texas lithographers, especially Clarke & Courts and Dallas Lithographic Co., shared in it. Well-illustrated books, maps, pamphlets, calendars, fair mementos and posters, dozens of city views, pictures of the new state capitol, and souvenir booklets poured from the presses.

By 1890 the impact of the immigration drives was evident. The state's population had reached 2,235,527 and was becoming increasingly diverse. According to the "forgotten census" of 1887, which contains ethnic data not available elsewhere, the population was dominantly Anglo-American (65 percent) and African American (20 percent), but there were significant minorities of Germans (6.5 percent) and Hispanics (4 percent), with a scattering of thirteen or fourteen other European nationalities, as well as Chinese, and Native Americans.[141] Texas was still predominantly rural and would be for years to come, but in the decade of the 1890s the urban population grew almost three times faster than that in the rural areas, a trend that would accelerate in the twentieth century.[142] "Farmers and business men are jubilant," the *Stoves and Hardware Reporter* of St. Louis and Chicago declared in 1897, reiterating that "Texas is an empire in itself."[143]

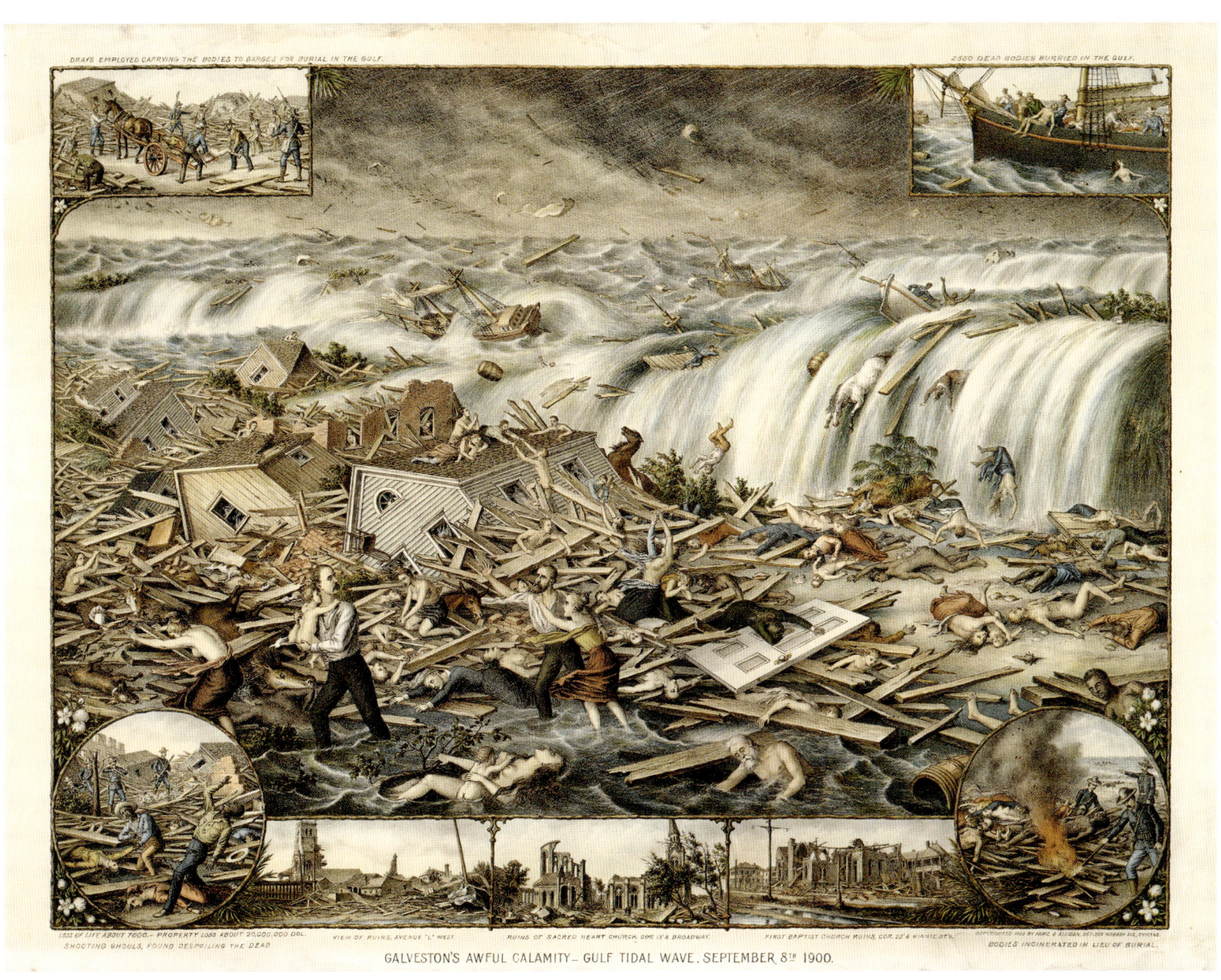

FIGURE 9.78 Louis Kurz, *Galveston's Awful Calamity—Gulf Tidal Wave. September 8th 1900*, 1900. Single sheet. Chromolithograph, 18.63 × 25 in., by Kurz & Allison, Chicago. Courtesy Amon Carter Museum of American Art, Fort Worth.

EPILOGUE

"MISTAKEN . . . FOR LITHOGRAPH WORK"

Many of the visitors to the 1899 San Antonio International Fair and Exposition stopped by the award-winning Maverick-Clarke Lithograph Co. exhibit to marvel at the six-foot-high "monster ledger" displayed next to a tiny cash account book (three by four inches), but their eyes would have quickly drifted to the crisp lithographs displayed in the booth. Nearby, German-born pressman Arthur Lohso demonstrated the printing of a lithograph and passed out "handsome souvenirs fresh from the press" so each guest could admire the company's craftsmanship and take home an example of modern printing technology.[1] Lithographs were now common, noted Dallas editor Anthony B. Norton: "Fifty years ago, how many dwellings were adorned with pictures? How many are there now that do not display a print, engraving, chromo or lithograph?"[2] By the 1890s stone lithography seemed to have reached the pinnacle of its success, leading the *San Antonio Light* to advertise that its "handsome 'copperplate' printing is mistaken by fastidious business men for lithograph work," whereas, years before, lithographers had claimed that their work rivaled copperplate engravings.[3]

Americans had quickly grasped lithography's potential after its introduction in 1819, and dozens of German, French, and English craftsmen immigrated and established and staffed shops in major cities along the East Coast and, after the Civil War, in Texas. A few artists, such as George Catlin, John James Audubon, and Seth Eastman—and, in Texas, Theodore Gentilz, Hermann Lungkwitz, and Carl von Iwonski—had their paintings and drawings reproduced as lithographs, but the presses usually turned out much more common fare such as business and commercial works, maps, cartoons and caricatures, illustrated song sheets, advertisements, trade cards, and the colorful and popular genre views à la Currier & Ives. The addition of steam power after the Civil War—it came to Texas in 1873—improved the output, ensuring lithography's place as the best method of printing pictures but, at the same time, burying the name and reputation of the artists within the team required to operate such a complicated process and machine.[4] Several of Currier & Ives's artists, such as Arthur Fitzwilliam Tait, George Henry Durrie, Louis Maurer, and Fannie Palmer, achieved fame because of the popularity of their pictures, and industry leader Louis Prang of Boston issued impressive chromolithographs after paintings by well-known artists such as Thomas Moran and Winslow Homer. But it is rare for any of Texas's little-known painters and

lithographic artists to be named as the creators of the state's lithographic products.⁵

But by 1900, at its apogee, lithography confronted the same fate that it had forced on etching and engraving: it was being relegated to what the expatriate artist Joseph Pennell described in 1898 as the thoroughly commercialized domain of "the cigar-box maker, the printer of theatrical posters, or the publisher of chromos and comic prints" by a more versatile and less expensive method of reproducing pictures: process halftone engraving.⁶

Halftone engraving, according to Arthur Leslie, head of the Leslie Newspaper Syndicate in New York and grandson of founder Frank Leslie, was the "perfection of illustration," the "crowning triumph of the closing century."⁷ It gained popularity because it enabled printers to reproduce photographs, but Texas newspaper editors and most printers watched from a distance as others worked to overcome its inherent problems. Halftones needed to be printed on hard, smooth paper, for example, rather than newsprint, which soaked up the ink and blurred the images. In 1891 a writer in the *San Saba News* spoke for many, observing that "halftone printing needs the inventor's aid." Some Texas magazines began introducing halftones by 1894: *Texas Farm and Ranch* pioneered halftones in its pages, and the *Texas Industrial Review* followed in 1895. Probably among the first printers in the state to offer the process was Ben C. Jones & Co. of Austin, which advertised that they printed the *Review*, and Austin Photo Engraving Co. also advertised something it called "lithogravures" along with zinc etching.⁸ J. J. Pastoriza of Houston added halftone capability to his shop in 1897 when he purchased the "latest two revolution printing presses, especially adapted for printing fine half-tone catalogues, etc." in New York City.⁹

Lithography never flourished in Texas the way it did in cities of the Northeast and Midwest. One reason, no doubt, was the state's vast space and its largely rural population. Railroads were responsible for the publication of a number of lithographs and enabled the itinerant artists who drew the bird's-eye views to crisscross the state, but there were few other large businesses to patronize the printers. And just as Texas lithographers were getting started, railroads connected the interior of the state to St. Louis and other midwestern cities, forcing them to compete with the larger and established lithographic shops. Galveston's Mardi Gras even patronized the most prestigious lithographers in Paris during the 1870s. Another reason for the tepid reception that lithography met in Texas might have been the "artistic" characteristic that historian Frederick Jackson Turner noted as missing in the frontier intellect.¹⁰ Early settlers were not looking for the sublime paradise of Niagara, the Hudson River, or the Catskills. They were looking for a pastoral paradise—land—where they could "lay a permanent foundation for the future value and usefulness of this country."¹¹ Finally, the state's lithographers had much less time to develop their craft; by the turn of the century the shift to halftone engraving had begun for all but commercial and business printing, such as theatrical posters, letterheads, cards, forms, certificates, and bonds.

What are we to make today of these sometimes crude but often accomplished and highly ephemeral images? How accurate are they, for example? Historians might want to examine those lithographs intended as documents, such as the expeditionary prints, as one would look at photographs. They might interpret them as faithful representations of what was actually there, in front of the "lens," so to speak. That is what San Antonio editor James P. Newcomb expected. He trusted *Harper's Weekly*, the leading national illustrated journal of the day, to provide precision in its images. But in 1861, when the journal published a wood engraving of a scene that he knew well—the familiar west side of San Antonio's Main Plaza, probably after a drawing by the German immigrant Carl von Iwonski—Newcomb declared the picture to be a "miserable cheat" because it showed the Plaza House as a "*frame*" building instead of brick. "If all of *Harper's* pictures are of this stripe what a gulled set of folks *Harper's* subscribers are," he concluded.¹² Galveston editor Ferdinand Flake, a staunch Unionist, considered the truth to be more nuanced; following the Civil War he charged the editors of *Harper's* with a subtler "offence to Southern people" that "consists in the frequency with which it gets up pictures, representing the dark side of Southern Society. While we are forced to believe that these blots on our record are actually there," he admitted, "it is unwise to cast them in our teeth, and untrue to charge them upon all of our people."¹³

While these specific examples did not gain Newcomb's and Flake's approval, others surely would have. Many of the early views of Texas were made by eyewitness draftsmen and artists who were trained, or self-trained, to produce documents for commercial, military, or scientific purposes: mapmakers such as Chadwick; artists such as Audubon, Hooton, Gentilz, Abert, Eastman, Shumard, Möllhausen, Schott, Schuchard, Rordorf, Rosenberg, and Lungkwitz; and, after the Civil War, the illustrated mapmakers and bird's-eye-view artists and architects who documented cities, counties, and civil and business buildings.

Other kinds of visual material that dominated the latter part of the century were not intended to be factual documents. Originating with the city fathers, organizers of fairs and festivals, railroads and shipping companies, and land agents and speculators, these images offered bold, positive, and altogether idealized interpretations—visions, really—of the reality that Texans hoped for. We must also remember that two of the most important historical aspects of the century are not well represented: African American slavery and the racial conflict of the Reconstruction era and the campaign that forced the Indians onto reservations. These omissions diminish the collection somewhat as a historical record, though Texas artists and printers are not unique in their inattention to two of the darkest scars on our national soul. As the humanistic geographer Yi-Fu Tuan reminds us, "Myths and legends are created to give credence to the idea that a place—otherwise unremarkable—is the center of the world."[14] As Philom declared in the *Texas Gazette* in 1829, "The God of nature has scattered choicest blessings in rich profusion" across the Texas landscape. By the time famed author John Steinbeck arrived in Texas in 1960, that feeling had grown to the point that he declared it to be "a state of mind . . . an obsession . . . a nation in every sense of the word."[15]

The lithographic record shows a maturing Texas, developed from Stephen F. Austin's "wild, howling, interminable, solitude" populated by a few distant Spanish outposts and several thousand Native Americans into, for more than a century, the largest state in the Union. An agricultural giant knitted together by a web of almost ten thousand miles of railroad track connecting small but growing cities, Texas hosted a population of more than three million persons, second only to Missouri as the most populous state west of the Mississippi River—even more than California, which had undergone one of the largest gold rushes of the century but still recorded a population of fewer than one and a half million in 1900.[16] The record begins with a handful of fanciful images of a short-lived French settlement on the Trinity River and ends, as the century closed, with a horrifying and violent chromolithograph showing the devastation wrought by a hurricane on the cultural and commercial center of Galveston, the gateway to the "empire in itself."[17] There is little, if any, direct evidence to prove the impact that these pictures had, but it is clear that those who produced them believed in their power to convince. As Hermann Spiess wrote of Rordorf's drawing of New Braunfels, "The printing and distribution of such pictures will do more to lure immigrants than newspaper articles." And attorney McCoy sent the bird's-eye view of Dallas to his Indiana family, hoping to entice them, and his future bride, to join him. The lithographs of Texas played a role in populating the state and nurturing its culture, and these diverse and little-known pictorial remnants deserve attention today as one of the more neglected filters through which a nineteenth-century audience, especially would-be immigrants, clarified their impressions of Texas and were, often, inspired to action.

ACKNOWLEDGMENTS

Texas Lithographs is a book that has been forming for years as we assembled the print collection of the Amon Carter Museum of American Art in Fort Worth, but the immediate inspiration for it came from Barbara and Bill Holman of Austin, who proposed decades ago that we work together on a project that would become one of Bill's elegantly designed books. We began by organizing a small exhibition. My colleague, the late Jan Keene Muhlert, former director of the Carter, suggested that we designate "Texas Lithographs" as the museum's twenty-fifth-anniversary exhibition as well as the museum's first Texas Sesquicentennial exhibition of 1986. Our initial fears that there would not be enough material for an exhibition rapidly dissolved into questions about how we would be able to fit everything into one gallery. We knew of many Texas-related lithographs, but in the course of this project—and with the assistance of scholars, librarians, curators, collectors, and dealers across the country—we have discovered far more than we anticipated, which is a testament to the diversity and richness of Texas history as well as to the region's reputation, which grew exponentially during the nineteenth century. It was a pleasure to anticipate the book with Bill, one of the foremost fine-press designers of the in the country, but I was still in the research stage when he retired.

I put the project on hold in 1986 as I accepted an invitation to join the History Department at the University of Texas at Austin as professor of history and director of the Texas State Historical Association, and then, in 2006, director of the Amon Carter Museum, but I continued to drop research notes into folders during those years and to write a page or two on long weekends and vacations. When I retired from the Carter in 2011, I was finally able to return to the project—only to find that it had grown substantially because the Internet had put so many new resources at our fingertips. One of the most useful sites, especially for this project, is the William J. Hill Texas Artisans & Artists Archive, a project of the Bayou Bend Collection and Gardens, at the Museum of Fine Arts, Houston. Bill Hill was an indefatigable collector of all things Texas, and he recognized the unique resource that an online archive of nineteenth-century material related to artists and artisans would provide. Under the leadership of Bonnie Campbell, Bayou Bend Collection director, and Margaret Culbertson, director of the Kitty King Powell Library, the Hill Archive continues to grow through the spirited efforts of Michelle J. V. Johnson, project manager, and the volunteers and field researchers. The results are updated regularly at texasartisans.mfah.org.

But the Hill Archive is only one of several significant digitizing projects that are now available to researchers and have greatly enlarged the scope of my research. Foremost among them is the Portal to Texas History (texashistory.unt.edu) at the University of North Texas Libraries, which, along with all the other newspaper databases, makes available free of charge hundreds of Texas newspapers, city directories, and other resources. This project would have been considerably reduced in scope but for the Portal and other newspaper sites. Other great web

resources include the Biodiversity Heritage Library (biodiversitylibrary.org) and the Internet Archive, not to mention Google Books. At the same time, many other museums and libraries have established websites that provide easy access to their collections. My research has profited enormously from increased access to ephemeral materials in these collections as well as the growing awareness on the part of many research institutions that access to and use of images in scholarly projects should cost no more than other archival materials.

One of the genuine pleasures of such a long-term project is that, over the decades, I have become acquainted with and received assistance from generations of scholars, friends, librarians, archivists, collectors, and dealers: the late James Patrick McGuire, formerly of the Institute of Texan Cultures in San Antonio, who wrote on three of the artists prominent in this study (Carl Rordorf, Carl G. von Iwonski, and Hermann Lungkwitz); the late Curator of History Cecilia Steinfeldt of the Witte Museum and her husband, Eric, who collected materials related to shipping; Witte Chief Curator Amy Fulkerson; William Elton Green, formerly of the Panhandle-Plains Historical Museum in Canyon; Senior Curator Tom Shelton of the University of Texas at San Antonio; and the late researcher and writer Al Lowman of the Institute of Texan Cultures, whose dedication to the printing arts of Texas is well known. In Austin, Director Don E. Carleton and his staff at the Dolph Briscoe Center for American History, including Head of Reference Services Margaret Schlankey and Lynne Bell, former Curator of Exhibits and Material Culture, have been most helpful, as was former Head of Public Services and Assistant Director Ralph Elder. A succession of librarians and archivists at the Austin History Center (Austin Public Library), the General Land Office of Texas, and the Texas State Archives have also provided ready responses to my pleas for help.

Gathering images during the Covid pandemic has not been easy, and librarians, archivists, and dealers all over the country have been helpful: among them are (at the Amon Carter Museum) former library director Sam Duncan, archivist and Gentling Curator Jon Frembling, and Technical Services Librarian Caroline Clavell, who all fielded numerous calls for help; Russell Martin, Assistant Dean for Collections and Director of the DeGolyer Library at SMU, has been especially helpful; Lauren Martino, Special Collections Manager at the Rosenberg Library in Galveston has been notably important for this study, because Galveston was the center of the state's lithographic industry in the nineteenth century; Karl Chiao, Executive Director, and Kaitlyn Price, Registrar, at the Dallas Historical Society; Lisa Struthers, Library Director at the San Jacinto Museum of History; archivist Vince E. Lee at the University of Houston Libraries; Brenda McClurkin, head of the growing Special Collections Division, University of Texas at Arlington Libraries; Christine Sharbrough and Molly Tepera of the Dallas and Texas History Department of the Dallas Public Library; Mac Woodward Jr., director of the Sam Houston Memorial Museum at Sam Houston State University; Albert L. Peters, Fort Worth bookseller; and Warren Stricker, Director of Research Center at the Panhandle Plains Historical Museum in Canyon.

It is an eccentricity of collecting that much of the best Texas material resides in several great research institutions on the East Coast. Chief among them is the Beinecke Rare Book and Manuscript Library at Yale University, where Western Americana Curator George Miles assisted our effort in every way possible, from making materials readily available and having them scanned to checking his collection against our findings and bringing new materials to my attention. Other fine Texas-related image collections include the Prints and Photographs Division of the Library of Congress, the New York Public Library, the Sheridan Libraries of Johns Hopkins University, Brown University Library, and the American Antiquarian Society.

Generous collectors, including John Rowe of Dallas and Dr. John M. Parker of Plano, have permitted us to study their materials. Bradford R. Breuer of San Antonio, a former student of mine and a trustee of the Amon Carter Museum for more than thirty years, has assisted by making his collections available, locating materials, and offering encouragement at every point. And Jodie Utter, Senior Conservator of Works on Paper at the Amon Carter Museum, and printmaker David Conn, formerly of Texas Christian University, advised me on my descriptions of printing techniques.

This project would have been much more difficult without the excellent Texas materials in the Amon Carter Museum. The late Mitchell A. Wilder, the founding director of the museum, began acquiring printed Americana, including Texas and Western materials, during the 1960s, while they were still relatively available. While engaged in the exhilarating process of building the Carter's collections, I became acquainted with two generations of dealers who are now legendary for the quality of their offerings as well as their personalities, and the Carter collection, and this project, would not be nearly as comprehensive without their help. Foremost among them is the

late William S. Reese of New Haven—whom I first met in 1972 and to whom this volume is dedicated—a dealer, collector, and expert in printed Americana himself whose busy office is located just down the street from the Beinecke Library. He offered his own collection, *Stamped with a National Character: Nineteenth Century American Color Plate Books: An Exhibition* (New York: The Grolier Club, 1999), for exhibition and tour in 2000. I am indebted also to Kenneth M. Newman and his sons Robert and Harry, of the Old Print Shop in New York City; James and Judith Blakeley and James von Reuster, formerly of the Old Print Gallery in Washington, DC, whose store was, for years, across the street from Larry McMurtry's Booked Up; Fred Rosenstock, Denver rare book dealer; Robert Wilson of Dallas; former Fort Worther and raconteur Jake Zeitlin of the famous Red Barn on La Cienega Boulevard in Los Angeles; and Warren Howell of San Francisco, whose shop on Post Street was ideally located about half way between Union Square and the Bohemian Club. Also of great assistance in helping us locate materials for this project were Michael D. Heaston and the late Dorothy Sloan of Austin, to whom this volume is also dedicated. Dorothy publicized the project over the years by including notes in her well-researched catalogues and was quick to share information about any new lithographs that came through her hands. The DeGolyer Library at Southern Methodist University now houses her papers and has kept her website active, which has been an enormous help.

A particular thanks goes to Ben Huseman of Special Collections, University of Texas at Arlington Libraries. Ben was my research assistant at the Carter when this project began, and he contributed substantially to the early research and wrote a superb article on the history of lithography in Texas for the proceedings of the twentieth annual meeting of the North American Print Conference in 1988. Among those who have shared their knowledge and research for various aspects of this study are Betje Klier of Austin, who has channeled a lifetime of research into Champ d'Asile, the short-lived French outpost on the Trinity River; James C. Kearney of the University of Texas at Austin with regard to German immigration, especially the artist Carl Rordorf; Jon Todd (JT) Koenig of Austin and Neale Rabensburg of La Grange, who helped with regard to the Rosenberg family; the late Craig Roell of Georgia Southern University, who helped regarding the Thomas Goggan and Brothers music house; and the late Jack Jackson, whose deeply researched work on early Texas is well known and much appreciated.

I am greatly indebted to Judge David Jackson of the Summerfield G. Roberts Foundation in Dallas and Morris Matson of Fort Worth, who helped fund the publication. The late David J. Weber of Southern Methodist University, former colleague Martha A. Sandweiss of Princeton University, and Don E. Carleton read early portions of this manuscript, and friend and collaborator W. Thomas Taylor of Austin provided a careful and encouraging reading of the entire manuscript that was most helpful. But the only person besides myself who has read it all, multiple times, is my wife, Paula, who, as usual, is my best editor.

RON TYLER
Fort Worth, Texas

NOTES

LIST OF ABBREVIATIONS

BCAH	Dolph Briscoe Center for American History, University of Texas at Austin
CGCG	*Civilian and Galveston City Gazette*
CGG	*Civilian and Galveston Gazette*
CGW	*Civilian and Galveston Weekly*
DDH	*Dallas Daily Herald*
DH	*Dallas Herald*
DMN	*Dallas Morning News*
FB	*Flake's Bulletin* (Galveston)
FDB	*Flake's Daily Bulletin* (Galveston)
FDGB	*Flake's Daily Galveston Bulletin*
FSWGB	*Flake's Semi-Weekly Galveston Bulletin*
FWDG	*Fort Worth Daily Gazette*
FWG	*Fort Worth Gazette*
FWWG	*Fort Worth Weekly Gazette*
GDN	*Galveston Daily News*
GTWN	*Galveston Tri-Weekly News*
GWN	*Galveston Weekly News*
HTO	*Handbook of Texas Online*
NA	National Archives, Washington, DC
NYH	*New York Herald*
SADE	*San Antonio Daily Express*
SAE	*San Antonio Express*
TSG	*Texas State Gazette*
TTR	*Telegraph and Texas Register*

INTRODUCTION

1. Chas. A. Siringo, *A Texas Cow Boy, or Fifteen Years on the Hurricane Deck of a Spanish Pony. Taken from Real Life* (Chicago: M. Umbdenstock, 1885), ix–x. See also Guy Reel, National Police Gazette *and the Making of the Modern American Man, 1879–1906* (New York: Palgrave Macmillan, 2006), 1–4; and Frank Luther Mott, *A History of American Magazines, 1850–1865*, 5 vols. (Cambridge, MA: Harvard University Press, 1970), 2:325–337, who concludes that "the *Gazette*'s art work was doubtless more important than its text" (335).
2. T. H. L., "How Is the Great West Peopled," *Daily Quincy Herald* (IL), May 9, 1872, 4. (Unless otherwise specified, newspapers cited herein were printed in Texas.) This article, sometimes in edited versions, appeared in many midwestern newspapers. Although they are different processes, the popular press frequently used "engraving" and "lithography" interchangeably throughout the nineteenth century.
3. "Art," *The Churchman*, Aug. 22, 1885, 207 (quote).
4. E. L. Godkin, "Chromo-Civilization," *The Nation* 19 (Sept. 24, 1874), 201 (quote). Godkin used the term on several occasions, including, in "The Week" 19 (Aug. 6, 1874), 83, and "The Week" 19 (Sept. 17, 1874), 177. See also "Pictorials," *Galveston Daily News*, Sept. 26, 1865, 2 (quote; hereafter cited as *GDN*). The editor preferred that children be shown "fine engravings" from Europe.
5. Except for Swante Palm. See below, note 33.
6. For the woodcut of the buffalo, see Francisco López de Gómara, *La historia general de las Indias* (Antwerp: En Casa de Juan Steelsio, 1554), 288. See also Richard E. Ahlborn, "American Beginnings: Prints in Sixteenth-Century Mexico," in *Prints in and of America to 1850*, ed. John D. Morse (Charlottesville: University of Virginia Press, 1970); and Richard B. Holman, "Seventeenth-Century American Prints," in *Prints in and of America to 1850*, 6–7, 25–27. There are several images of LaSalle's landing on the coast of Texas and his subsequent murder: see Louis Hennepin, *A New Discovery of a Vast Country in America, Extending above Four Thousand Miles, Between New France and New Mexico* (London: Printed for M. Bentley, J. Tonson, H. Bonwick, T. Goodwin, and S. Manship, 1698). The French edition, which had appeared in Utrecht the previous year, does not contain the illustrations. See also the vignette on Nicholas de Fer's map, *Les Costes aux Environs de la Riviere de Misisipi* . . . in Niclas de Fer, *Atlas Curieux* . . . (Paris, 1700–1704), illustrated in James C. Martin and Robert Sidney Martin, *Maps of Texas and the Southwest, 1513–1900*, 2nd ed. (Austin: Texas State Historical Association, 1999), 49, 90; and Mavis P. Kelsey Sr. and Robin Brandt Hutchison, *Engraved Prints of Texas 1554–1900* (College Station: Texas A&M University Press, 2005), 15–16. The well-known image of María de Jesús de Agreda by Antonio de Castro, "La Ve. Me. Maria de Iesus de Agreda. Predicando a los Chichimecos del Nuebo-mexico," did not appear until 1730 as the frontispiece in Alonso Benavides, *Tanto que se sacó de una carta, que R. padre Fr. Alonso de Benavides, custodio que fue del Nuevo Mexico, embió a los religiosos de la Santa Custodia de la conversion de San Pablo de dicho reyno, desde Madrid, el año de 1631* (México: Joseph Bernardo de Hogal, 1830).
7. For information on the art of Texas Indians, see W. W. Newcomb Jr., *The Rock Art of Texas Indians* (Austin: University of Texas Press, 1967); Carolyn E. Boyd, "Drawing from the Past: Rock Art of the Lower Pecos," in *Painters in Prehistory: Archaeology and Art of the Lower Pecos Canyonlands*, ed. Harry J. Shafer (San Antonio: Witte Museum in association with Trinity University Press, 2013), 171–221; and Carolyn E. Boyd, *The White Shaman Mural: An Enduring Creation Narrative in the Rock Art of the Lower Pecos* (Austin: University of Texas Press, 2016), esp. 29–30. For the number of printers at the battle of San Jacinto, see J[ohn] H[enry] B[rown], "An Old Time Texas Printer," *Dallas Daily Herald*, Dec. 30, 1875, 2 (hereafter cited as *DDH*).
8. Thomas W. Streeter, *Bibliography of Texas, 1795–1845*, rev. and enlarged by Archibald Hanna, 2nd rev. ed. (Woodbridge, CT: Research Publications, Inc., 1983), 328, 383

(entry 1155); John H. Jenkins, *Basic Texas Books: An Annotated Bibliography of Selected Works for a Research Library*, rev. ed. (Austin: Texas State Historical Association, 1988), 551–555; and John H. Jenkins, *Audubon and Texas* (Austin: Pemberton Press, 1965). Marilyn McAdams Sibley, *Travelers in Texas, 1761–1860* (Austin: University of Texas Press, 1967), 181, attributes *A Visit to Texas; Being the Journal of a Traveller through Those Parts Most Interesting to American Settlers. With Descriptions of Scenery, Habits, &c. &c.* (New York: Goodrich & Wiley, 1834) to Asahel Langworthy, whose presence in Texas was documented at about the same time as the anonymous author.

9. For a discussion of this tradition, see Barbara Maria Stafford, *Voyage into Substance: Art, Science, Nature, and the Illustrated Travel Account, 1760–1840* (Cambridge: MIT Press, 1984).

10. "M. Strickland & Co.," *Galveston Daily Civilian*, Aug. 6, 1869, 2; "Railroad, Insurance and Banking Companies of Texas," *Houston Daily Mercury*, Sept. 28, 1873, 5; "Strickland & Clark [*sic*]," *Galveston Daily Civilian*, Sept. 21, 1874, 2; *Waxahachie Enterprise*, Jan. 22, 1876, 5; and "Lithographing and Printing," *GDN*, Dec. 18, 1868, 2; "Attention Merchants!," Apr. 6, 1873, 3; and "Strickland's," Mar. 5, 1878, 4. During the decade after the Civil War, Galveston was the home to so many German-speaking residents that Ferdinand Flake's *Die Union* had a larger circulation than either of the city's English-language newspapers. Earl W. Fornell, "Ferdinand Flake: German Pioneer Journalist of the Southwest," *American-German Review* 21 (Feb.-Mar. 1955), 25.

11. Philip J. Weimerskirch, "The Beginnings of Lithography in America," *Journal of the Printing Historical Society* 27 (1998): 51–53; and Richard Benson's lecture on relief printing, "The Printed Picture," accessed Jan. 2, 2022, https://printedpicture.artgallery.yale.edu/relief-printing.

12. Michael Twyman, *Lithography, 1800–1850: The Techniques of Drawing on Stone in England and France and Their Application in Works of Topography* (London: Oxford University Press, 1970), 11–12, 65, 72.

13. Domenico Porzio, ed., *Lithography: 200 Years of Art, History and Technique*, trans. Geoffrey Culverwell (New York: Harry N. Abrams, 1983), 7; and Worldhistoryproject.org, "1796: Alois Senefelder Invents Lithography."

14. This is a simplified description of lithography taken from Peter C. Marzio, "American Lithographic Technology before the Civil War," in Morse, *Prints in and of America to 1850*, 216–217. For Senefelder's process, see Twyman, *Lithography*, 23, 68–69, and Senefelder, *Vollständiges Lehrbuch der Steindruckerey* (Munich: Karl Thienemann; Vienna: Karl Gerold, 1818), trans. as *A Complete Course of Lithography: Containing Clear and Explicit Instructions in All the Different Branches and Manners of That Art* (London: R. Ackermann, 1819). See also "How a Lithograph Is Made," *Evening Tribune* (Galveston), Sept. 20, 1888, 3. This same principle is employed in offset lithography, the dominant method of commercial printing before digital printing, except that a metal plate and rubber roller are used instead of stone. For an illustrated explanation of how a lithograph is made, see Metmuseum.org, s.v. "The Materials and Techniques of Drawings and Prints / Lithograph," accessed Jan. 2, 2022, https://www.metmuseum.org/about-the-met/curatorial-departments/drawings-and-prints/materials-and-techniques/printmaking/lithograph. By the end of the nineteenth century lithographers were routinely printing thousands of copies of images, even a hundred thousand in the case of a sixteen-color, chromolithographic bird's-eye view of the Chicago World's Columbian Exposition building and grounds. "World's Fair Notes," *Evening Tribune* (Galveston), July 16, 1891, 4.

15. Senefelder, *Complete Course of Lithography*, iii (quote); "Lithography," *United States Literary Gazette* (June 15, 1826), 4: 227 (quote); "New Publication," *Young Mechanic* 1 (June 1832), 94 (quote); and Twyman, *Lithography*, 3–17. For the history of lithography in America, see John Thomas Carey, "The American Lithograph from its Inception to 1865 with Biographical Considerations of Twenty Lithographers and a Check List of Their Works," (PhD diss., Ohio State University, 1954). In *George Caleb Bingham: The Evolution of an Artist* (Berkeley: University of California Press, 1967), E. Maurice Bloch discusses lithography versus engraving with regard to Bingham's prints, pointing out the advantage of speed and economy that lithography offered (122). For the Currier quotation, see *Vermont Phoenix* (Brattleboro), Oct. 22, 1846, 1.

16. A. J. Corrigan, *A Printer and His World* (London: Faber and Faber, 1945), 100 (quote).

17. Carey, "American Lithograph," 26–27, 31, 48–49; Philip J. Weimerskirch, "Lithographic Stone in America," *Printing History: Journal of the American Printing History Association* 11 (1989): 2–16. J. L. Tait, an English geologist and mineralogist, reported the presence of lithographic stones in the Flatonia area, along the railroad route between Galveston and San Antonio. See "Minerals on the Sunset Route," *GDN*, May 5, 1878, 1; and "A Remarkable Find," *El Paso International Daily Times*, Aug. 24, 1892, 7.

18. Peter C. Marzio, *The Democratic Art: Chromolithography, 1840–1900: Pictures for a 19th-Century America* (Boston: David R. Godine, 1979), 69 (quote); J. Luther Ringwalt, *American Encyclopedia of Printing* (Philadelphia: Menamin & Ringwalt, 1871), 285; and "The Zinc Plate in Art," *Waco Evening News*, Nov. 15, 1888, 2 (quoting the *Baltimore American*).

19. John W. Reps, *Views and Viewmakers of Urban America: Lithographs of Towns and Cities in the United States and Canada, Notes on the Artists and Publishers, and a Union Catalog of Their Work, 1825–1925* (Columbia: University of Missouri Press, 1984), 35.

20. Carl Zigrosser and Christa M. Gaehde, *A Guide to the Collecting and Care of Original Prints* (New York: Crown, 1965), 48–49; see also Twyman, *Lithography*, 118.

21. Dr. Karl Adolf Daniel Douai writing in the San Antonio *Staats Zeitung*, Oct. 20, 1855, 2. For a translation, see Ben W. Huseman, "The Beginnings of Lithography in Texas," in Ron Tyler, ed., *Prints and Printmakers of Texas: Proceedings of the Twentieth Annual North American Print Conference* (Austin: Texas State Historical Association, 1997), 24–25.

22. "The Card-Backs," *Flake's Semi-Weekly Galveston Bulletin* (hereafter cited as *FSWGB*), Dec. 11, 1869, 2; Twyman, *Lithography*, 103; and Zigrosser and Gaehde, *Guide*, 49.

23. Twyman, *Lithography*, 64–65, 118–119; see also Estelle Jussim, who wrote in *Visual Communication and the Graphic Arts* (New York: R. R. Bowker, 1974) that "with transfer paper, lithography was capable of transmitting almost all the codes of other media with the exception of photography" (342). See *Daily Picayune* (New Orleans), Mar. 14, 1840, 3, and Sept. 10, 1840, 2, for the Greene & Fishbourne ads, which were courteously supplied to me by Priscilla O'Reilly Lawrence, former executive director of the Historic New Orleans Collection. The process by which the *Daily Graphic* printed its issues is explained in an article, "How 'Graphic' Pictures Are Made," *Houston Daily Mercury*, Dec. 27, 1873, 2. The artist produced a drawing that was photographed to produce a glass-plate negative. A positive print was made from the negative, then transferred by hand press to a lithographic stone for printing.

24. Strickland quoted in "The Hobby Case," *GDN*, Aug. 17, 1877, 4.

25. For a discussion of the various kinds of prints, see Zigrosser and Gaehde, *Guide*, 37–82; Bryan Allen, *Print Collecting* (London: Frederick Muller, 1970), 18–39; and Anthony Dyson, *Pictures to Print: The Nineteenth-Century Engraving Trade* (London: Farrand Press, 1984), 113. Maximilian, Prinz zu Weid, *Reise in das Innere Nord-America in den Jahren 1832 bis 1834* (Coblenz: J. Hölscher, 1839–1841); this work was translated into French (1840–1843) and English (1843). See also George Wilkins Kendall and Carl Nebel, *War Between the United States and Mexico Illustrated, Embracing Pictorial Drawings of All the Principle Conflicts* (New York: D. Appleton & Co., 1851).

26. Michael Twyman, *A History of Chromolithography: Printed Color for All* (London: British Library; New Castle, DE: Oak Knoll Press, 2013), 41–52.

27. Ibid., 25–40; and Marzio, *Democratic Art*, 6–7.

28. It is difficult to determine the number of full sets of the octavo edition Audubon printed. In 1841, Audubon ordered 1,500 copies of numbers 28–30, but he gradually reduced the print order to 1,050 for numbers 57–100. See Ron Tyler, *Audubon's Great National Work: The Royal Octavo Edition of* The Birds of America (Austin: University of Texas Press, 1993), 101–105, 153–154.

29. Charles W. Hayes, *Galveston: History of the Island and the City*, 2 vols. (Austin: Jenkins Garrett Press, 1997), 2:981; and "Strickland's," *GDN*, Mar. 5, 1878, 4.

30. Marzio, *Democratic Art*, 74–75, also illustrates portions of a progressive proof as the frontispiece.

31. C[lifford] K. S[hipton], "Harry Twyford Peters," *Proceedings of the American Antiquarian Society* 58, pt. 2 (Oct. 1948), 207–209; and Harry T. Peters, *Currier & Ives: Printmakers to the American People*, 2 vols. (Garden City, NY: Doubleday, Doran, & Co., 1929–1931); Peters, *America on Stone: The Other Printmakers to the American People. A Chronicle of American Lithography Other Than That of Currier & Ives* (Garden City, NY: Doubleday, Doran & Co., 1931); and Peters, *California on Stone* (Garden City, NY: Doubleday, Doran & Co., 1935).

32. Sally Pierce with Catharina Slautterback and Georgia Brady Barnhill, *Early American Lithography: Images to 1830* (Boston: Boston Athenæum, 1997); Sally Pierce and Catharina Slautterback, *Boston Lithography, 1825–1880* (Boston: Boston Athenæum, 1991); Nicholas B. Wainwright, *Philadelphia in the Romantic Age of Lithography: An Illustrated History of Early Lithography in Philadelphia with a Descriptive List of Philadelphia Scenes Made by Philadelphia Lithographers before 1866* (Philadelphia: Historical Society of Pennsylvania, 1958); Erika Piola, ed., *Philadelphia on Stone: Commercial Lithography in Philadelphia, 1828–1878* (University Park: Pennsylvania State University Press in association with the Library Co. of Philadelphia, 2012); David Tatham, ed., *Prints and Printmakers of New York State, 1825–1940* (Syracuse, NY: Syracuse University Press, 1986); and Jessie J. Poesch, ed., *Printmaking in New Orleans* (Jackson: University Press of Mississippi and the Historic New Orleans Collection, 2006); and Alice M. Cornell, ed., *Art as Image: Prints and Promotion in Cincinnati, Ohio* (Athens: Ohio University Press in association with the University of Cincinnati Digital Press, 2001).

33. Harry Ransom, "A Renaissance Gentleman in Texas: Notes on the Life and Library of Swante Palm," *Southwestern Historical Quarterly* 53 (Jan. 1950): 228, 234; Alan Gribben, *Harry Huntt Ransom: Intellect in Motion* (Austin: University of Texas Press, 2008), 91–125, esp. 91–92; and Handbook of Texas Online (hereafter cited as HTO), s.v. "Jaensson, Swen [Swante Palm]," by Alfred E. Rogers, uploaded June 15, 2010, modified May 1, 2019. The *Handbook of Texas Online* is published and maintained by the Texas State Historical Association.

CHAPTER 1: "REALLY A KIND OF PARADISE"

The chapter title quote is from "Observations on Robin's Travels in Louisiana, &c." (Washington, DC), *National Intelligencer*, April 16, 1811, 1.

1. Andrew J. Torget, *Seeds of Empire: Cotton, Slavery, and the Transformation of the Texas Borderlands, 1800–1850* (Chapel Hill: University of North Carolina Press, 2015), 22, 44 (quotes); C. Norman Guice, "Texas in 1804," *Southwestern Historical Quarterly* 59 (July 1955): 46.

2. Betje Black Klier, "*Champ d'Asile*, Texas," in *The French in Texas: History, Migration, Culture*, ed. François Lagarde, (Austin: University of Texas Press, 2003), 79–97. Dr. Klier, who has done extensive research in the French archives and is working on a full-scale study of Champ d'Asile and its significance in Texas history, has been most helpful in the preparation of this chapter. See also David Murph, "The Search for Champ d'Asile," *Southwestern Historical Quarterly* 121 (Oct. 2017): 199–211.

3. *New-York Columbian*, Apr. 21, 1818, 2; "Napoleon Bonaparte," *Niles Weekly Register*, Dec. 5, 1818, 260; *HTO*, s.v. "Champ d'Asile," by Kent Gardien and Betje Black Klier, accessed June 30, 2011, uploaded June 12, 2010, modified July 12, 2017. See also Jesse S. Reeves, *The Napoleonic Exiles in America: A Study in American Diplomatic History, 1851–1819* (Baltimore: Johns Hopkins University Press, 1905), 9–10; Harris Gaylord Warren, *The Sword Was Their Passport: A History of American Filibustering in the Mexican Revolution* (Baton Rouge: Louisiana State University Press, 1943), ch. 10; Kent Gardien, "Take Pity on Our Glory: Men of Champ d'Asile," *Southwestern Historical Quarterly* 87 (Jan. 1984): 241–268; Jack Autry Dabbs, ed. and trans., "Additional Notes on the Champ d'Asile," *Southwestern Historical Quarterly* 54 (Jan. 1951): 347–358; Betje Black Klier, "The Myth of Champ d'Asile," MLA thesis, Stanford University, 1998, 28. Fannie E. Ratchford, ed., *The Story of Champ d'Asile as Told by Two of the Colonists*, trans. Donald Joseph (Dallas: Book Club of Texas, 1937), 9–24, which includes translations of F. . . . n, G. . . . n, *L'Héroïne du Texas, ou Voyage de Madame *** aux États-Unis et au Mexique* (Paris: Chez Plancher, Éditeur du Manuel des Braves, 1819), and a large portion of L. Hartmann and Millard, *Le Texas, ou Notice Historique suit le Champ d'Asile* (Paris: Chez Béguin, 1819). See also Ines Murat, *Napoleon and the American Dream*, trans. Frances Frenaye (Baton Rouge: Louisiana State University Press, 1981), 139–142; and Rafe Blaufarb, *Bonapartists in the Borderlands: French Exiles and Refugees on the Gulf Coast, 1815–1835* (Tuscaloosa: University of Alabama Press, 2005), 86–116.

4. Honoré de Balzac, *A Bachelor's Establishment*, trans. Clara Bell (New York: Macmillan, 1901), 95 (quote).

5. Blaufarb, *Bonapartists in the Borderlands*, 102–105; Murat, *Napoleon and the American Dream*, 141–142; and Just Girard, *Les aventures d'un capitaine français, planteur au Texas, ancient réfugié du Champ d'Asile* (Tours: Alfred Mame et Fils, 1860), 75.

6. For information on the departure and arrival of the colonists, see Ratchford, *Champ d'Asile*, 16–19; and Gardien, "Men of Champ d'Asile," 256. Gardien also reproduces a recently discovered plan of Champ d'Asile as it appeared when the Spanish troops arrived in October 1818 (248), from the Archivo General de Indias, Sevilla. Dabbs, "Additional Notes on the Champ-d'Asile," makes clear that at least the author of "Notice sur l'expédition des Français dans le Texas" (published in *Journal des Voyages, decouvertes et Navigations moderns* 16 [1822]: 194–204) considered himself to be a private soldier on a military mission (347–358). See also *HTO*, s.v. "Champ d'Asile," by Gardien and Klier.

7. Mattie Austin Hatcher, *The Opening of Texas to Foreign Settlement, 1801–1821* (Austin: University of Texas Bulletin No. 2714, 1927), 260–261; Don Juan de Castañeda to Gov. Antonio Martínez, Nov. 24, 1818, trans. by Sheldon Kindall, Texas A&M University Galveston, Library Special Collections, Marine and Maritime Collection, Laffite Society Collection, 1, accessed Jan. 2, 2022, http://hdl.handle.net/1969.3/28413; and Warren, *Sword was Their Passport*, 222.

8. "Private Correspondence," *The Courier* (London), Dec. 1, 1818, 3 (quote); *Niles' Weekly Register* (Baltimore), Dec. 12, 1818, 265 (quote); Blaufarb, *Bonapartists in the Borderlands*, 107–116, gives the best account from the Spanish perspective; A&M Galveston, Laffite Society Collection, Castañeda to Martínez, Nov. 24, 1818, 6 (quote); and Warren, *Sword Was Their Passport*, 221–226. Gardien, "Men of Champ d'Asile," tells of the men's fate (256–266). See also William C. Davis, *The Pirates Laffite: The Treacherous World of the Corsairs of the Gulf* (New York: Harcourt, 2005), 351–384.

9. E'[variste] D[umoulin], "Le Champ-d'Asile," in *La Minerve Française* 3 (Aug. 1818): 256–263, contains the text of Lallemand's statement. Ratchford, *Champ d'Asile*, 9 (quote), 19–20, 133–134, includes a translation of it. The quotation regarding the code of laws is on p. 19. See also *Niles' Weekly Register* (Baltimore) for the proclamation, Aug. 8, 1818, 193–194; Sept. 26, 1818, 80 (quote); and Dec. 5, 1818, 260 (quote).

10. A banquet in Albi (Tarn) yielded 156 fr. 30 c. for the cause. See *La Minerve Française* 6 (May 1819): 49–52. For the running total of contributions, see ibid., 3 (Aug. 1818), 345–350, 478, 527–528; 4 (Nov. 1818), 46–48, 96, 134–139, 188–192, 241–248, 344–348, 393–395, 493–500, 594–600, 648; 5 (Feb. 1819), 48, 98–104, 153–160, 208, 257–264, 310–312, 360, 409–416, 464, 513–520, 568, 624, 680; 6 (May 1819), 49–52, 100, 148, 196, 291–300; 7 (Aug. 1819), 144; 8 (Nov. 1819), 316–321. See also Anna Elsa Shumway, "A Study of the *Minerve Française* (Feb. 1818–Mar. 1820)," (PhD diss., University of Pennsylvania, 1934), 60; and Ratchford, *Champ d'Asile*, 9 (quote).

11. For information on Engelmann, see Twyman, *Lithography*, 52–54. An announcement of *Le Champ d'Asile Romance* print appears in *La Minerve Française* 4 (Nov. 1818): 139. I am grateful to Dr. Betje Klier for calling my attention to The ARTFL Project: The Image of France, 1795–1880, accessed Jan. 2, 2022, https://artfl-project.uchicago.edu/content/image-france, a website that is an enumeration of the printed imagery—engravings, lithographs, photographs, etc.—that was published in France in accordance with the requirements of legal deposit. A similar print had been dated 1819 by Streeter, *Bibliography of Texas*, entry 1071, p. 354. The print is listed in Henri Beraldi, *Les graveurs du XIXe Siècle: Guide de*

l'amateur d'estampes modernes, 12 vols. (Paris: Librairie L. Conquet, 1892), 12:219, and J. M. Bruzard, *Catalogue de l'oeuvre lithographique de M. J. E. Horace Vernet* (Paris: J. Gratiot, 1826), 8: entry 25: "Sur le devant, un militaire sans habit tient une bèche de la main gauche, l'autre placée sur sa poitrine exprime les regrets que lui cause la patrie; dans le fond, à gauche, d'autres militaires défrichent la terre; à droite, on aperçoit la mer."

12. Betje Black Klier, "The Influence of Jacques-Louis David on the Envisioning of Champ d'Asile in 'The Toast'," *First Empire: The International Magazine for the Napoleonic Enthusiast, Historian and Gamer* 101 (July/Aug. 2008); and Nina Athanassaglou-Kallmyer, "Sad Cincinnatus: *Le Soldat Laboureur* as an Image of the Napoleonic Veteran after the Empire," *Arts Magazine* 60 (May 1986): 65–75.

13. Robert Justin Goldstein, *Censorship of Political Caricature in Nineteenth-Century France* (Kent, OH: Kent State University Press, 1989), 104–105.

14. I am indebted to Dr. Betje Klier for assistance in interpretation of this print. Johann Alois Senefelder had published the first illustration of the soldier-laborer in 1814. See also Athanassaglou-Kallmyer, "Sad Cincinnatus," 65–75.

15. Goldstein, *Censorship of Political Caricature*, 104.

16. Pierre Larousse, *Larousse Grand Dictionnaire universel du XIXème siècle*, 15 vols. (Paris: Administration du Grand Dictionnaire Universel, 1866–1876), 3:888.

17. *La Minerve Française* 4 (Nov. 1818), 248, 572. See also Shumway, "Minerve Française," 30, 58–60.

18. Although Rullmann is not given credit for *Les Lauriers Seuls y Troitront Sans Culture* on the print, he is credited with it in The Image of France, 1795–1880, entry 97957, accessed Jan. 2, 2022, https://artfl-project.uchicago.edu/content/image-france. Rare book dealer Dorothy Sloan included an uncolored version of this image in her Auction 22 that was signed at the l.l. in ink: "Rullmann del." See also Dabbs, "Additional Notes," 355; Gardien, "Men of Champ d'Asile"; Streeter, *Bibliography of Texas*, entries 1069, 1070, 1072, 1072A, 1072B, and 1077, who discusses the book; and Pauline A. Pinckney, *Painting in Texas: The Nineteenth Century* (Austin: University of Texas Press, 1967), 11–13, who mistakenly dates the prints to 1830. For a brief biography of Rullmann, see Emmanuel Bénézit, *Dicionnnaire Critique et Documentaire des Peintres, Dessinateurs, Graveurs et Sculpteurs*, 8 vols. (Paris: Librairie Grund, 1948), 7:430.

19. Athanassaglou-Kallmyer, "Sad Cincinnatus," 72, 86.

20. Maj. Arséne Lacarriere Latour, *Historical Memoir of the War in West Florida and Louisiana in 1814–15*, ed. Gene Allen Smith, trans. H. P. Nugent, (Gainesville: University of Florida Press, 1999).

21. The engravings by Ambrose Louis Garneray are *1ere Vue d'Aigleville, colonie du Texas ou Champ d'Asile* and *2eme Vue d'Aigleville, Colonie du Texas ou Champ*, both in the collection of the Amon Carter Museum of American Art, Fort Worth. Also see Gardien, "Men of Champ d'Asile," cover, 255, and 261 for illustrations. See also Klier, "Myth of Champ d'Asile," 52.

22. *La Minerve Française* carried a continuing list of contributors along with the total amount collected; the editors announced in May 1819 that 95,018 fr. had been collected (445–447). See *The Courier* (London), Jan. 23, 1819, 2, for the student riot. See also Gardien, "Men of Champ d'Asile," who describes the money-raising and dispersal (241, 258); Murat, *Napoleon and the American Dream*, 147–148; and Shumway, "*Minerve Française*," 60.

23. For information on Balzac, see Reeves, *Napoleonic Exiles in America*, 9–10, 87–88; and Dabbs, "Additional Notes," 355. See also the *Arkansas Gazette* (Little Rock), June 3, 1820, 3, which contains a notice requesting that the refugees of Champ D'Asile contact New Orleans attorney Moreau Lislet to claim their portion of the distribution. One of the booksellers collecting subscription money for the colony declared bankruptcy. See *La Minerve Française* 5 (Feb. 1819): 208. For the story of the dispersal of the money, see Gardien, "Men of Champ d'Asile," 258–260.

24. Wright Howes, in *U.S.-iana (1700–1950) a Descriptive Check-List of 11,450 Printed Sources Relating to Those Parts of Continental North American now Comprising the United States* (New York: Bowker, 1954), said that a subsequent novel, [Just J. E. Roy], *Le Adventures d'un Capitaine Francais Planteur au Texas* (Tours: A. Mame et fils, 1879), is "fictionalized, but reasonably authentic" (502). It went through at least six editions, and the engraved frontispiece of the sixth edition, by Carronneau, shows a painted Indian warrior kissing the feet of a French officer. Blaufarb, *Bonapartists in the Borderlands*, 116 (quote).

25. *Civilian and Galveston Gazette*, May 17, 1839, 2 (hereafter cited as *CGG*).

26. *HTO*, s.v. "Champ d'Asile," by Gardien and Klier.

27. Streeter, *Bibliography of Texas*, entry 1077.

28. Richard Drinnon, *White Savage: The Case of John Dunn Hunter* (New York: Schocken Books, 1972), 3–57, 177; *Dictionary of Art Historians*, s.v. "Leslie, Charles Robert," accessed Mar. 12, 2022, https://arthistorians.info.

29. "Literature," *Morning Post* (London), Dec. 31, 1823, 4; "Hunter's *Memoir of His Captivity Among Indians*," *Monthly Review* (London) 102 (Nov. 1823): 243–256, and (Dec. 1823), 368–381; E. Norgate, *Mr. John Dunn Hunter Defended; or, Some Remarks on an Article in the* North American Review, *in which that Gentleman Is Branded as an Imposter* (London: John Miller, 1826); "The Quarterly Review—and Our Indians," *Newburyport Herald* (MA), May 6, 1825, 1; "Hunter's Narrative," *Hampshire Gazette* (Northampton, MA), Apr. 20, 1825, 2 (one of the newspapers that reprinted the *Quarterly Review* article); and "John Dunn Hunter," *National Intelligencer* (Washington, DC), Nov. 9, 1826, 1. See also Henry Rowe Schoolcraft, *The Indian Tribes of the United States: Their History, Antiquities, Customs, Religion, Arts, Language, Traditions, Oral Legends, and Myths*, ed. Francis S. Drake, 2 vols. (Philadelphia: J. B. Lippincott, 1884), 1:168 (quote); [Lewis Cass], "Indians of North America," *North American Review* 22 (Jan. 1826), 54, 101 (quotes). For Cass's identity as the author of the *North American Review* article, see "John Dunn Hunter," *New-York Spectator*, June 5, 1827, 2. George Psalmanazar was an eighteenth-century imposter who made his way around Europe and England claiming to be from a variety of different countries, most notably Formosa, and sharing friendships with a number of literary folk, including Samuel Johnson.

30. "Obituary," *New-York Daily Advertiser*, July 13, 1827, 1; Drinnon, *White Savage*, 59–175; Gary Clayton Anderson, *The Conquest of Texas: Ethnic Cleansing in the Promised Land, 1820–1875* (Norman: University of Oklahoma Press, 2005), 62–64; Dianna Everett, *The Texas Cherokees: A People between Two Fires, 1819–1840* (Norman: University of Oklahoma Press, 1990), 38–41; Henry Stuart Foote, *Texas and the Texans; or, Advance of the Anglo-Americans to the South-West*, 2 vols. (Philadelphia: Thomas, Cowperthwait & Co., 1841), 1:245 (quote).

31. Drinnon, *White Savage*, 177–229; Anderson, *Conquest of Texas*, 50–51; Everett, *Texas Cherokees*, 38–48. Various newspapers noted Hunter's death: "John D. Hunter," *Louisiana Advertiser* (New Orleans), May 1, 1827, 1; "John Dunn Hunter," *New-York Spectator*, June 5, 1827, 2; "Obituary," *New-York Daily Advertiser*, July 13, 1827, 1; and "John Dunn Hunter," *Daily National Journal* (Washington), July 14, 1827, 2 (taken from the *Times* [New York]). See also Jack Jackson, *Indian Agent: Peter Ellis Bean in Mexican Texas* (College Station: Texas A&M University Press, 2005), 64 ff. See also *HTO*, s.v. "Saucedo, Jose Antonio," accessed Sept. 12, 2020.

32. "John Dunn Hunter," *Times* (New York), quoted in *Daily National Journal* (Washington, DC), July 14, 1827, 2.

33. George Catlin, *Adventures of the Ojibbeway and Ioway Indians in England, France, and Belgium; Being Notes of Eight Years' Travels and Residence in Europe with the North American Indian Collection*, 2 vols., 3rd ed. (London: Published by the author, 1852), 1:82–85; Henry R. Wagner and Charles L. Camp, *The Plains and the Rockies: A Critical Bibliography of Exploration, Adventure and Travel in the American West, 1800–1865*, 4th ed., ed. and enlarged by Robert H. Becker (San Francisco: John Howell—Books, 1982), entry 24, pp. 90–94.

34. Annette Kolodny, "Review Essay," *Early American Literature* 14 (Fall 1979): 228.

35. Barbara Hofland, *The Stolen Boy. A Story, Founded on Facts* (London: A. K. Newman, c. 1830). Dennis Butts, *Mistress of Our Tears: A Literary and Bibliographical Study of Barbara Hofland* (Aldershot, UK: Scolar Press, 1992), esp. 83–84; and *Oxford Dictionary of National Biography Online*, s.v. "Hofland, Barbara (*bap*. 1770, *d*. 1844)," by Dennis Butts, accessed Jan. 2, 2022, oxforddnb.com.

36. Streeter, *Bibliography of Texas*, 365–366, entries 1107–1107J. See Hofland, *Der geraubte Knabe. Eine*

amerikanisch-indianische Erzählung (Reutlingen: Joh. Conr. Mäcken Jun., 1842).

37. See Malcolm D. McLean, comp. and ed., *Papers Concerning Robertson's Colony in Texas*, 19 vols. (Fort Worth and Arlington: Texas Christian University Press and UTA Press, 1974–1993), for a reproduction of the map and a translation of the annotations (2:459–465). Bibliographer Thomas W. Streeter described it as the first separately printed map of Texas. Streeter, *Bibliography of Texas*, 240, entry 713. According to Henry R. Wagner, who gave it to the University of Texas at Austin, the map was in the possession of Jean Louis Berlandier, the expedition naturalist, when he died near Matamoros in 1851. In 1853 Darius Nash Couch, a naturalist and an American soldier who had served in the US-Mexican war, purchased the collection from Berlandier's widow, giving part of it to the Smithsonian Institution and selling the rest to recoup his expenditure. See Russell M. Lawson, *Frontier Naturalist: Jean Louis Berlandier and the Exploration of Northern Mexico and Texas* (Albuquerque: University of New Mexico Press, 2012), xviii–16. The Sociedad Mexicana de Geografía y Estadística also tried to buy the collection but did not make an offer until the widow had already sold it to Couch. See *El Constitucional* (Mexico), Apr. 20, 1852, 3; *El Siglo Diez y Nueve* (Mexico), June 3, 1852, 3; *La Sociedad* (Mexico), Oct. 5, 1858, 1, and Apr. 11, 1859, 1. The map subsequently came into the collection of Wagner, who thought the extensive handwritten annotations were by Rafael Chovel, the expedition's mineralogist. University of Texas professor Carlos Castañeda, however, thought them to be in Terán's hand. See Carlos Castañeda and Early Martin Jr., *Three Manuscript Maps of Texas by Stephen F. Austin* (Austin: Privately printed, 1930), 31–32. See also Martin and Martin, *Maps of Texas*, 119; and Jack Jackson, ed., *Texas by Terán*, trans. John Wheat (Austin: University of Texas Press, 2000), 13.

38. Claudio Linati, *Costumes civils, militaires et réligieux du Mexique; dessinés d'après nature* (Bruxelles: C. Sattanino; imprimés à la Lithographie royale de Jobard, [1828]); Magali M. Carrera, *Traveling from New Spain to Mexico: Mapping Practices of Nineteenth-Century Mexico* (Durham: Duke University Press, 2011), 124; Ricardo Pérez Escamilla, "Arriba el Telón. Los litógrafos mexicanos, vanguardia artística y política del siglo XIX," in *Nación de imágenes: La litografía Mexicana del siglo XIX* (Mexico: Museo Nacional de Arte, 1994), 22, 56–61, 163–170, 340–341; María Eugenia Claps Arenas, "*El Iris*. Periódico Crítico y Literario," *Estudios de Historia Moderna y Contemporánea de México* 21 (Jan.–June 2001): 5–29; José N. Iturriaga de la Fuente, *Claudio Linati: Acuarelas y litografías* (Mexico: Inversora Bursatil, S.A. de C.V., 1993); Constance Brooks, *Antonio Panizzi: Scholar and Patriot* (Manchester, UK: Manchester University Press, 1931), 27; Arturo Aguilar Ochoa, "Los inicios de la litografía en México: El periodo oscuro (1827–1837)," *Anales del Instituto de Investigaciones Estéticas* 29 (Spring 2007): 65–100; W. Michael Mathes, *Mexico on Stone: Lithography in Mexico, 1826–1900* (San Francisco: Book Club of California, 1984), 8–14; José N. Iturriaga de la Fuente, *Litografía y grabado en el México del XIX*, 2 vols. (Mexico: Telemex, 1993–94), 1:63–72.

39. The editor of the *Telegraph and Texas Register* (hereafter cited as *TTR*), a newspaper that began publication in San Felipe de Austin that fall, observed that the editor of the *New Orleans Bee* had concluded that the proper name for the people of Texas should be Texians. The San Felipe editor agreed, writing that "we see no reason why this should not be generally adopted." *TTR*, Nov. 7, 1835, 2.

40. Plate 45 in Linati, *Costumes civils, militaires et réligieux du Mexique*; and *HTO*, s.v. "Filisola, Vicente," by A. Wallace Woolsey, accessed Sept. 12, 2020. Filisola's *empresario* grant, like others after the passage of the Law of April 6, 1830, specified that he could not bring Americans into Texas.

41. See Lorenzo de Zavala, *Ensayo histórico de las revoluciones de México, desde 1808 hasta 1830*, 2nd ed., 2 vols. in 1 (Mexico: Manuel N. de la Vega, 1845); Jackson, *Texas by Terán*, 1–5; Ohland Morton, *Terán and Texas: A Chapter in Texas-Mexican Relations* (Austin: Texas State Historical Association, 1948), 52–53. For a description of Mier y Terán's magnificent coach, which made quite a spectacle in wilderness Texas, see "J. C. Clopper's Journal and Book of Memoranda for 1828," *Quarterly of the Texas State Historical Association* 13 (July 1909): 61.

42. Torget, *Seeds of Empire*, 152.

43. Manuel de Terán and Luis Berlandier, *Memorias de la Comisión de Limites a las Ordenes del General Manuel de Terán. Historia Natural Botánica* (Matamoros, 1832); Jean Louis Berlandier and Rafel Chovel, *Diario de viage de la Comisión de Límites que pusó el gobierno de la República, bajo la dirección del Exmo. Sr. General de División D. Manuel de Terán* (Mexico: Tipografía de Juan R. Navarro, 1850); and Russel M. Lawson, *Frontier Naturalist*. For Berlandier's descriptions of his work in Texas, see Berlandier, *Journey to Mexico During the Years 1826 to 1834*, trans. Sheila M. Ohlendorf, Josette M. Bigelow, and Mary M. Standifer, 2 vols. (Austin: Texas State Historical Association, 1980); and Berlandier, *The Indians of Texas in 1830*, ed. John C. Ewers, trans. Patricia Reading Leclercq (Washington: Smithsonian Institution Press, 1969).

44. Lorenzo de Zavala, *Ensayo historico de las revoluciones de México, desde 1808 hasta 1830*, 2 vols. in 1 (Mexico: Manuel N. de la Vega, 1840), vol. 2, opp. 77. This lithograph probably was the source for later portraits of Terán published in Berlandier and in Chovel, *Diario*, frontis; and Julio Zárate, *La Guerra de Independencia*, which is volume 3 of Riva Palacio's magnificent *México á través de los siglos. Historia general y complete del desenvolvimiento social, politico, religioso, military, artístico, científico y literario de México desde la antigüedad más remota hasta la época actual* . . . (Barcelona: Espasa y compañía, [1888–1889]). Mier had plans for a natural history museum in Mexico, which would have exhibited the specimens from his Texas expedition along with those from other parts of Mexico, but most of the specimens wound up in Berlandier's estate. For information on Berlandier's specimens and estate, see the introduction to Berlandier's *Journey to Mexico*, 1, xi–xxxvi. Jackson, *Texas by Terán*, 1–5, 177–188. Terán's observations had convinced him that if Mexico did not take quick action, Texas would break away. Suffering from melancholia, Terán grew increasingly despondent—until, on the morning of July 3, 1832, he dressed in his finest uniform and fell on his sword.

45. William Kennedy, *Texas: The Rise, Progress, and Prospects of the Republic of Texas*, 2 vols. (London: R. Hastings, 1841), 2:80 (quote).

46. Linati returned to Mexico in 1832, after he published his *Costumes civils, militaires et réligieux du Mexique*, but he died in Tampico shortly after his arrival. See Iturriaga de la Fuente, *Claudio Linati*, 14.

47. Sam Houston's earliest known portrait is a miniature painting by Joseph Wood (now in the San Jacinto Museum of History collection) done in 1826. Wood maintained a studio on the north side of Pennsylvania Avenue between Ninth and Tenth Streets, N.W., during the 1820s. See Theodore Bolton, *Early American Portrait Painters in Miniature* (New York: Frederic Fairchild Sherman, 1921), 174–175.

48. Elizabeth Crook, "Sam Houston and Eliza Allen: The Marriage and the Mystery," *Southwestern Historical Quarterly* 94 (July 1990): 1–36; Jack Gregory and Rennard Strickland, *Sam Houston with the Cherokees, 1829–1833* (Austin: University of Texas Press, 1967), 158 (quote); and James L. Haley, *Sam Houston* (Norman: University of Oklahoma Press, 2004), 72.

49. *Philadelphia Inquirer*, Jan. 25, 1830, 2 4; and "The Eccentric Governor," *New Echota Cherokee Phoenix and Indians' Advocate*, Feb. 24, 1830, 3.

50. Llerena B. Friend, *Sam Houston, the Great Designer* (Austin: University of Texas Press, 1954), 27; Gregory and Strickland, *Sam Houston with the Cherokees*, 30, 99–100; Amelia W. Williams and Eugene C. Barker, eds., *The Writings of Sam Houston, 1813–1863*, 8 vols. (Austin: University of Texas Press, 1938–1943), 1: 147.

51. For information on Endicott & Swett, see Georgia Brady Bumgardner, "George and William Endicott: Commercial Lithography in New York, 1831–1851," in Tatham, *Prints and Printmakers of New York State*, 44–45.

52. J. Gray Sweeney, *The Columbus of the Woods: Daniel Boone and the Typology of Manifest Destiny* (St. Louis: Washington University Gallery of Art, 1992), 15. While Chester Harding's portraits depict Boone in a fur-trimmed coat, J. O. Lewis's engraving curiously does not. It shows him in a buckskin jacket, which would become the iconic standard for the frontier.

53. "Gov. Houston in Exile," *National Intelligencer*

(Washington, DC), June 11, 1830, 3 6; "Valuable Prints," *Daily National Journal* (Washington, DC), Sept. 14, 1831, 2.

54. See "Breach of Privilege," *United States' Telegraph* (Washington, DC), Apr. 16, 1832, 2; and Haley, *Sam Houston*, 81–86. See also Nancy R. Davidson, "E. W. Clay and the American Political Caricature Business," in Tatham, *Prints and Printmakers of New York State*, 91–110. The House trial was covered extensively in the newspapers and in *Niles' Weekly Register*, Apr. 28, 1832, 157–163, 171–176, and May 5, 1832, 177–181. The caricature was probably published in May 1832 and is referenced in "Another Breach of Privilege," *Daily National Intelligencer* (Washington, DC), May 16, 1832, 2.

55. Gregory and Strickland, *Sam Houston with the Cherokees*, 132–136; and Haley, *Sam Houston*, 88–89.

56. Founded in New York on October 16, 1830, the Galveston Bay and Texas Land Co. sold script for the purpose of colonizing the lands assigned to *empresarios* Joseph Vehlein, David G. Burnet, and Lorenzo de Zavala, an area of more than three million acres in East Texas between the Sabine and San Jacinto Rivers. (The map in the lower left-hand corner shows north to the left). This script gave the holder the right to locate a specified area of land within the grants but did not convey title. The would-be colonists still had to complete the requirements of Mexican colonization law, which was greatly complicated by the Law of Apr. 6, 1830.

57. Haley, *Sam Houston*, 98–110; Friend, *Sam Houston*, 20–41; and Gregory and Strickland, *Sam Houston with the Cherokees*, 132–154. For information on his marriage to Allen, see Crook, "Sam Houston and Eliza Allen," 1–36. The quote is in Henderson Yoakum, *History of Texas, from Its First Settlement in 1685 to Its Annexation to the United States in 1846*, 2 vols., 2nd ed. (New York: Redfield, 1856), 1, 308 (quote).

58. Biographical information is from *HTO*, s.v. "Crockett, David," by Michael A. Lofaro, Rev. William C. Davis, accessed Sept. 12, 2020. Information regarding his personality is in Curtis Carroll Davis, "A Legend at Full-Length: Mr. Chapman Paints Colonel Crockett—and Tells About It," *Proceedings of the American Antiquarian Society* 69 (1960): 165–174. See also Mark Derr, *The Frontiersman: The Real Life and the Many Legends of Davy Crockett* (New York: Morrow, 1993), 197–198.

59. Frederick S. Voss, "Portraying an American Original: The Likenesses of Davy Crockett," *Southwestern Historical Quarterly* 91 (Apr. 1988): 462–463.

60. Information on Childs and the print trade comes from Wendy Wick Reaves, "Portraits for Every Parlor: Albert Newsam and American Portrait Lithography," in *American Portrait Prints: Proceedings of the Tenth Annual American Print Conference*, ed. Wendy Wick Reaves (Charlottesville: University of Virginia Press, 1984), 89–93; and James C. Kelly and Frederick S. Voss, *Davy Crockett: Gentleman from the Cane: An Exhibition Commemorating Crockett's Life and Legend on the 200th Anniversary of His Birth* (Washington and Nashville: National Portrait Gallery, Smithsonian Institution, and the Tennessee State Museum, 1986), 26. See "S. S. Osgood," *United States' Telegraph* (Washington, DC), Dec. 25, 1833, 3, for an ad for the painter while he was in Washington.

61. "Crockett's Portrait," in *GDN*, Dec. 13, 1891, 13.

62. First quote in Davis, "Legend at Full-Length," 165; second quote in Voss, "Portraying an American Original," 467. For information on Crockett's portraits, see Davis, "Legend at Full-Length," 155–174; *Catalogue of American Portraits in The New-York Historical Society*, 2 vols. (New Haven, CT: Yale University Press, 1974), 1:176–177; and Reaves, "Portraits for Every Parlor," 84–85, 119. James A. Shackford, *David Crockett: The Man and the Legend*, ed. John B. Shackford (Chapel Hill: University of North Carolina Press, 1956), 289, estimated that eight or nine portraits were done in all. For a reproduction of the portrait made from the Chapman painting, see Old Print Shop, Inc., *Portfolio*, 15 (Nov. 1955), cover, and (Mar. 1958), 164. Asher B. Durand produced an engraving from the De Rose portrait.

63. Shackford, *David Crockett*, 212 (quote); Derr, *Frontiersman*, 224, 225.

64. Richard Boyd Hauck, *Crockett: A Bio-Bibliography* (Westport, CT: Greenwood Press, 1982), 50 (quote). Details of Crockett's death are recorded in Enrique de la Peña, *With Santa Anna in Texas: A Personal Narrative of the Revolution*, trans. and ed. Carmen Perry (College Station: Texas A&M University Press, 1975), 53; and elaborated upon in Dan Kilgore, *How Did Davy Die?* (College Station: Texas A&M University Press, 1978); and in James E. Crisp, "The Little Book That Wasn't There: The Myth and Mystery of the De la Peña Diary," *Southwestern Historical Quarterly* 98 (Oct. 1994): 261–296. See also Dan Kilgore and James E. Crisp, *How Did Davy Die? And Why do We Care so Much?* (College Station: Texas A&M University Press, 2010).

65. The Bowie portrait, by American artist George Peter Alexander Healy, is in the collection of the State Preservation Board, Austin. See Joseph Musso, "A Reevaluation of 'The Face Behind the Knife,'" *Southwestern Historical Quarterly* 110 (Jan. 2007): 362–378.

66. Lorenzo de Zavala, *Ensayo histórico de las revoluciones de Megico desde 1808 hasta 1830*, 2 vols. (vol. 1, Paris: Dupont et G.-Laguionie, 1831; vol. 2, New York: Elliott y Palmer, 1832). See Streeter, *Bibliography of Texas*, 374, entries 1128 and 1128A. The only copy of the book that I have found that includes the Childs portrait of Zavala is in the Stanford University Library, a gift of the Pacific-Union Club. Available online at the Internet Archive, accessed Jan. 2, 2022, https://archive.org/details/ensayohistricod02zavagoog. Lara's portrait is the frontispiece in volume one of Zavala, *Ensayo histórico de las revoluciones de México*. For information on Lara, see Mathes, *Mexico on Stone*, 23, 56. See also Margaret Swett Henson, *Lorenzo de Zavala: The Pragmatic Idealist* (Fort Worth: Texas Christian University Press, 1996), 54–55.

67. *HTO*, s.v. "Zavala, Lorenzo de," by Raymond Estep, accessed Sept. 12, 2020.

68. Pinckney reproduced Joe's portrait in *Painting in Texas*, 37. For Catlin's relationship with Chadwick, see Benita Eisler, *The Red Man's Bones: George Catlin, Artist and Showman* (New York: Norton, 2013), 100–102, 154–159, 173–175, 179, 181–183, 187, 191–192, 201–202, 204–205.

69. The *St. Louis Commercial Bulletin and Missouri Literary Register* published eyewitness accounts of the massacre and Chadwick's fate. See issues for May 27, 1836, 1; and "Mr. Joseph M. Chadwick," July 1, 1836, 2. See also "Mr. Joseph M. Chadwick," *New-Hampshire Statesman and State Journal* (Concord), July 23, 1836, 2; and "Fannin and His Command," *Texas State Gazette* (Austin), June 18, 1853, 4 (quote, hereafter cited as *TSG*. See also *HTO*, s.v. "Chadwick, Joseph M.," by Craig H. Roell, accessed Dec. 12, 2014, uploaded June 12, 2010; George Catlin, *Letters and Notes on the Manners, Customs, and Condition of the North American Indians*, 2 vols. (London: Published by the author, 1841), 2:155; Eisler, *Red Man's Bones*, 100–102, 154–156, 158–159, 174–175, 201–202; George C. Groce and David H. Wallace, *The New-York Historical Society's Dictionary of Artists in America, 1654–1860* (New Haven, CT: Yale University Press, 1957), 21. Chadwick's drawing and lithograph were two of the main documents, in addition to extensive archeological evidence that restoration architect Raiford Stripling used in restoring the mission and the fort. See Raiford Stripling Associates, Inc. (2009), Fort Defiance, Cushing Memorial Library and Archives, Texas A&M University, College Station, accessed Jan. 2, 2022, http://hdl.handle.net/1969.1/125995. See also Kathryn Stoner O'Connor, *The Presidio La Bahía del Espíritu Santo de Zuñiga, 1721 to 1846* (Austin: Von Boeckmann-Jones, 1966), 199; and Michael McCullar, *Restoring Texas: Raiford Stripling's Life and Architecture* (College Station: Texas A&M University Press, 1985), 59, 88–91.

70. For a description of this flag, see Robert Maberry Jr., *Texas Flags* (College Station: Texas A&M University Press in association with the Museum of Fine Arts, Houston, 2001), 28–38, esp. 30.

71. See Stephen L. Hardin, *Texian Iliad: A Military History of the Texas Revolution* (Austin: University of Texas Press, 1994).

72. Linda Ayres, "William Ranney," and Bernard F. Reilly, Jr., "Prints of Life in the West, 1840–1860," in *American Frontier Life: Early Western Painting and Prints*, ed. Ron Tyler (New York: Abbeville Press, 1987), 79–107, 167–191; and Linda Bantel, "William Ranney—American Artist," in *Forging an American Identity: The Art of William Ranney, with a Catalogue of His Works*, eds. Linda Bantel, Peter H. Hassrick, Kathleen Luhrs, et al. (Cody, WY: Buffalo Bill Historical Center, 2006), xiv–xvi, 19, 79–107.

73. Reilly, "Prints of Life in the West, 1840–60," 188–190.

74. John M. Niles, *South America and Mexico, with a Complete View of Texas* (Hartford, CT: H. Huntington, Junr., 1837); Susan Prendergast Schoelwer, "The Artist's Alamo: A Reappraisal of Pictorial Evidence, 1836–1850," *Southwestern Historical Quarterly* 91 (Apr. 1988): 412–419; Susan Prendergast Schoelwer with Tom W. Gläser, *Alamo Images: Changing Perceptions of a Texas Experience* (Dallas: DeGolyer Library and Southern Methodist University Press, 1985), 71–73. Two woodcuts of David Crockett at the Alamo appeared in 1837 in *Davy Crockett's Almanack* (Nashville: Published by the heirs of Col. Crockett, 1837; reprinted, San Marino, California: Huntington Library and Art Gallery, 1971), 45, 48; an engraving of the battle was published that same year: see vignette on the title page of John M. Niles, *History of South America and Mexico; Comprising Their Discovery, Geography, Politics, Commerce, and Revolutions* (Hartford, CT: H. Huntington, Jun. 1837), but neither of them are based on eyewitness drawings.

75. Hardin, *Texian Iliad*, 216.

76. Groce and Wallace, *Dictionary of Artists in America*, 230–321. For information on the Huddle painting, see Sam DeShong Ratcliffe, *Painting Texas History to 1900* (Austin: University of Texas Press, 1992), 42–44.

77. See Streeter, *Bibliography of Texas*, entries 1171, 1171A, and 1171B; and Lester S. Levy, *Picture the Songs: Lithographs from the Sheet Music of Nineteenth-Century America* (Baltimore: Johns Hopkins University Press, 1976), 29. Groce and Wallace, *Dictionary of Artists in America*, 616–617. Houston complained in a letter to his wife (My Dear Love), Washington, Jan. 11, 1853, in *The Personal Correspondence of Sam Houston, 1852–1863*, ed. Madge Thornall Roberts, 4 vols. (Denton: University of North Texas Press, 2001), 4:21, that his left leg, the one wounded at the battle of San Jacinto, was giving him trouble.

78. "Music, Music, Music," *Daily National Intelligencer* (Washington, DC), July 18, 1844, 1.

79. Information on Houston in Washington and a portrait painted showing him attired in the Cherokee costume may be found in Gregory and Strickland, *Sam Houston with the Cherokees*, portrait opp. 76, 97–99. See also Peter C. Welsh, "Henry R. Robinson: Printmaker to the Whig Party," *New York History* 53 (Jan. 1972): 25–53.

80. See Friend, *Sam Houston*, 70.

81. According to Julio Romo Michaud, descendant of the publisher, Michaud was born in Paris in 1807 and was about thirty years old when he arrived in Mexico. He was publisher or copublisher of several important lithographic works relating to Mexico, including *Monumentos de México* (Mexico: Julio Michaud y Thomas, 1841), *Album pintoresco de la república méxicana . . .* (Mexico: Julio Michaud y Thomas, c. 1850), and, after he got involved in photography, *Album Fotográfico Mexicano* (Mexico: Julio Michaud é Hijo, 1858). See Peter E. Palmquist and Thomas R. Kailbourn, *Pioneer Photographers from the Mississippi to the Continental Divide: A Biographical Dictionary, 1839–1865* (Stanford: Stanford University Press, 2005), 435; and Dorothy Sloan—Books, Auction 23, accessed Jan. 2, 2022, http://www.dsloan.com/Auctions/A23/item-michaud-album_pintoresco-ca_1850.html. All references to Sloan are courtesy the Dorothy Sloan Papers, DeGolyer Library, Southern Methodist University.

82. B. M. Lossing, "The Fall of Bexar; A Texian Tale," in *The Forget-Me-Not: A Gift for 1846*, ed. Alfred A. Phillips (New York: Nafis & Cornish, 1845), 189-222; Groce and Wallace, *Dictionary of Artists in America*, 404; and Harold E. Mahan, *Benson J. Lossing and Historical Writing in the United States* (Westport, CT: Greenwood Press, 1996).

83. The examples studied are in the New York Public Library and the Texas State Library. For information on the uniform of the Mexican army of the period, see Joseph Hefter, *The Army of the Republic of Texas* (Fort Collins, CO: Old Army Press, 1971), plate 1.

84. Austin to Mary Austin Holley, Nov. 17, 1831, in *The Austin Papers: Annual Report of the American Historical Association for the Year 1922, in Two Volumes and a Supplemental Volume*, ed. Eugene C. Barker (Washington, DC, 1924–1928) 2:705; vol. 4 (Austin: University of Texas, 1927); and William Dunbar, quoting [Pierre] Lefevre, a trader on the Arkansas River, in "Observations on Robin's Travels in Louisiana," *National Intelligencer* (Washington, DC), Apr. 16, 1811, 1.

85. Austin to Holley, New Orleans, Aug. 21, 1835, in Barker, *Austin Papers*, 3:101–102. Emphasis in original.

CHAPTER 2: "A MORE PERFECT *FAC-SIMILE* OF THINGS"

The chapter title quote is from Charles Hooton, *St. Louis' Isle, or Texiana; with Additional Observations Made in the United States and in Canada* (London: Simmonds and Ward, 1847), ix.

1. "Chronicle," *Niles' Weekly Register* 21 (Feb. 16, 1822): 400.

2. Davidson, "E. W. Clay," 104–105; Bernard F. Reilly Jr., *American Political Prints, 1766–1876: A Catalog of the Collections in the Library of Congress* (Boston: G. K. Hall, 1991), 100–101, 107–108.

3. Frederick Law Olmsted, *A Journey through Texas: Or, a Saddle-Trip on the Southwestern Frontier* (New York: Dix, Edwards, 1857), 124. See also Thomas Hughes, ed., *G.T.T. Gone to Texas: Letters from Our Boys* (New York: Macmillan, 1884), v; and *HTO*, s.v. "GTT," accessed Sept. 12, 2020. The earliest use of the term "gone to Texas" that I have found is in the *Louisville Public Advertiser*, Dec. 10, 1825, which compared it to "French leave."

4. Kenneth W. Wheeler, *To Wear a City's Crown: The Beginnings of Urban Growth in Texas, 1836–1865* (Cambridge, MA: Harvard University Press, 1968), 1–3, 47–49; *HTO*, s.v. "Allen, John Kirby," by Amelia W. Williams, accessed Sept. 12, 2020. *HTO*, s.v. "Allen, Augustus Chapman," by Amelia W. Williams, accessed Sept. 12, 2020; and Francis R. Lubbock, *Six Decades in Texas: Or Memoirs of Francis Richard Lubbock*, ed. C. W. Raines (Austin: Ben C. Jones, 1900), 46. For a good description of the rough nature of early Houston, see Stephen L. Hardin, *Texian Macabre: The Melancholy Tale of a Hanging in Early Houston* (Abilene: State House Press, 2007), 78–120.

5. Streeter, *Bibliography of Texas*, entries 244, 1208, 1268, 1283, 1286, and 1324; and Edward Stiff, *The Texan Emigrant: Being a Narration of the Adventures of the Author in Texas . . .* (Cincinnati: George Conclin, 1840), 79 (quote); Snell & Theuret apparently were in business together for only a short time. See John A. Mahé and Rosanne McCaffrey, eds., *Encyclopedia of New Orleans Artists, 1718–1918* (New Orleans: Historic New Orleans Collection, 1987), 359, 372–373.

6. Steven Grady Gamble, "James Pinckney Henderson in Europe: The Diplomacy of the Republic of Texas, 1837–1840," (PhD diss., Texas Tech University, Lubbock, 1976); *HTO*, s.v. "Henderson, James Pinckney," by Claude Elliott, accessed Sept. 12, 2020; Robert Glenn Winchester, *James Pinckney Henderson, Texas' First Governor, U.S. Senator, Statesman, Diplomat, General* (San Antonio: Naylor, 1971), 22, 42. The lithograph of Henderson appears opposite page 1.

7. Dubois apparently added the "de Saligny" to his name to suggest a noble heritage, which he did not have. Nancy Nichols Barker, "Devious Diplomat: Dubois de Saligny and the Republic of Texas," *Southwestern Historical Quarterly* 72 (Jan. 1969), 324–334; and Nancy Nichols Barker, trans. and ed., *The French Legation in Texas*, 2 vols. (Austin: Texas State Historical Association, 1971, 1973), 1:21, 48. Dubois arrived in Austin in the first week of February 1840. "M. de Saligney [*sic*]," *Austin City Gazette*, Feb. 12, 1840, 3.

8. *TTR*, Feb. 17, 1838, 2 (quote); *New York Spectator*, May 4, 1837, 2, (quote).

9. Torget, *Seeds of Empire*, 9–15.

10. Bachman to Audubon, Charleston, Mar. 14, 1844, John Bachman Papers, Charleston Museum, Charleston, SC.

11. Audubon to Governor [James] Miller, Dec. 13, 1820, in Howard Corning, ed., *Journal of John James Audubon Made during His Trip to New Orleans in 1820–1821* (Cambridge: Business Historical Society, 1929), 75–76.

12. Audubon to John Bachman, London, June 12, 1836, in Audubon Typescripts, 2 vols. fMS Am 1265, Houghton Library, Harvard. See also Audubon, *The Birds of America, from Original Drawings*, 4 vols. (London: J. J. Audubon, 1827–1838).

13. "Audubon," *TTR*, May 2, 1837, 2, 3; "From Mexico," *Daily National Intelligencer* (Washington, DC), Apr. 30, 1838, 3; and *People's Press and Wilmington Advertiser* (NC), May 19, 1837, 3. See also Audubon to Bachman, London, June 12 and July 29, New York, Sept. 10, 1836 (quote), in Audubon Typescripts, Houghton Library, Harvard; Audubon to Harris, New Orleans, Mar. 4, 1837, in Audubon-Harris Correspondence, pfMS Am 21, Houghton Library, Harvard. See also Jim Dan Hill, *The Texas Navy: In Forgotten Battles and Shirtsleeve Diplomacy* (Chicago: University of Chicago Press, 1937), 68–73; Stanley

Clisby Arthur, *Audubon: An Intimate Life of the American Woodsman* (New Orleans: Harmanson, 1937).

14. Audubon to Abert, Charleston, Jan. 10, 1837 (B/Au25), Audubon Papers, American Philosophical Society, Philadelphia. See also Waldemar H. Fries, *The Double Elephant Folio: The Story of Audubon's Birds of America* (Chicago: American Library Association, 1973), 100–103; and Alice Ford, *John James Audubon: A Biography* (New York: Abbeville Press, 1988), 346–348.

15. Mary Austin Holley, *Texas* (Lexington, KY: J. Clarke, 1836), 100 (quote); and Samuel Wood Geiser, *Naturalists of the Frontier*, rev. ed. (Dallas: Southern Methodist University Press, 1948), 79–94. See also Mary Austin Holley, *Texas. Observations, Historical, Geographical and Descriptive, in a Series of Letters, Written during a Visit to Austin's Colony . . .* (Baltimore: Armstrong & Plaskitt, 1833).

16. "The City of Houston," *TTR*, May 2, 1837, 2. The newspaper had just moved from Columbia.

17. John James Audubon, *The Life and Adventures of John James Audubon, the Naturalist*, ed. Robert Buchanan from Materials Supplied by His Widow (London: Sampson Low, Son, and Marston, 1868), 329–331, 343 (quote about secret mission); this work contains extensive passages from Audubon's Texas journal, which was among those that a granddaughter apparently destroyed. Geiser, *Naturalists of the Frontier*, 79–94, used Buchanan's work, plus passages from the text that accompanied Audubon's *Ornithological Biography, or an Account of the Habits of the Birds of the United States of America*, 5 vols. (Edinburgh: Adam Black and Charles Black, 1831–1839), to reconstitute insofar as possible Audubon's Texas journals, which his granddaughter had destroyed after publishing a bowdlerized edition: see Maria R. Audubon, ed., *Audubon and His Journals*, notes by Elliott Coues, 2 vols (New York: Charles Scribner's Sons, 1897). Geiser's essay was also published, with notes, in "Naturalist of the Frontier: Audubon in Texas," *Southwest Review* 26 (Autumn 1930): 109–135, 125 (quote). See also Joe B. Frantz, *Gail Borden: Dairyman to a Nation* (Norman: University of Oklahoma Press, 1951), 123–126. Unfortunately, John's sketch of Galveston is not known to exist.

18. The camera lucida is a small sketching aid invented in 1806 by Dr. William Hyde Wollaston in England. By looking through an inclined piece of glass, or a prism, at a sheet of drawing paper on his lap, the artist can see a reflection of the object in front of him so that it might be copied. It was particularly popular among travelers and amateur artists in England in the early nineteenth century and became a staple of topographic art field equipment. John H. Hammond and Jill Austin, *The Camera Lucida in Art and Science* (Bristol: Adam Hilger, 1987).

19. Geiser, "Naturalists of the Frontier," 119–123, 125 (quote).

20. See Samuel George Morton, *Crania Americana: Or a Comparative View of the Skulls of Various Aboriginal Nations of North and South America . . .* (Philadelphia: J. Dobson, 1839). Morton measured the brain size of five human racial groups by filling the cranial cavities: first with white pepper seeds, then, after trying unsuccessfully to duplicate the results, with lead shot. His measurements apparently were accurate, but his conclusion that larger brain size meant superior intelligence was biased and flawed by his racial assumptions. At nearly the same time, German anatomist Friedrich Tiedemann came up with similar data but reached opposite interpretations. Apparently, brain size relates more directly to body size. See University of Pennsylvania, "A New Take on the 19th-century Skull Collection of Samuel Morton," ScienceDaily, Oct. 4, 2018, accessed Jan. 3, 2022, www.sciencedaily.com/releases/2018/10/181004143943.htm; Paul Wolff Mitchell, "The Fault in His Seeds: Lost Notes to the Case of Bias in Samuel George Morton's Cranial Race Science," *PLOS Biology*, 2018, 16 (10): e2007008 DOI: 10.1371/journal.pbio.200708; and Jonathon La Tourelle, "Friedrich Tiedemann (1781–1861)," *Embryo Project Encyclopedia* (2015-07-07), http://embryo.asu.edu/handle/10776/8557. The Morton collection is available to researchers in the Penn Museum of the University of Pennsylvania.

21. Bachman to Audubon, Apr. 24, 1837, Audubon Papers, Box 3, Folder 84, Beinecke Rare Book and Manuscript Library, Yale University; Audubon to Brewer, Charleston, June 12, 1837, Audubon Typescripts, Houghton Library, Harvard.

22. Geiser, "Naturalists of the Frontier," 127; Frantz, *Gail Borden*, 125; and Audubon, *Life and Adventures of Audubon*, 340–341.

23. Geiser, "Naturalists of the Frontier," 126–128 (quotes).

24. Ibid., 128–129; "The City of Houston," *TTR*, May 2, 1837, 2 (quote); "Audubon," *Maryland Gazette* (Annapolis), June 29, 1837, 1, quoting the *TTR*; and Jenkins, *Audubon and Texas*, 5–6.

25. Audubon to Thomas M. Brewer, quoted in Francis Hobart Herrick, *Audubon the Naturalist: A History of His Life and Time*, 2 vols. (New York: D. Appleton, 1917), 2:166; and Geiser, "Naturalists of the Frontier," 129.

26. I am indebted to Bill Steiner, *Audubon Art Prints: A Collector's Guide to Every Edition* (Columbia: University of South Carolina Press, 2003), for bringing this story to my attention. For information on the painting, see Audubon, *The Original Water-Color Paintings by John James Audubon for* The Birds of America, 2 vols. (New York: American Heritage, 1966), 1: plate 181, 2: plate 347.

27. Tyler, *Audubon's Great National Work*, 84, 101; and Audubon, *The Birds of America, from Drawings Made in the United States and Their Territories*, 7 vols. (New York: J. J. Audubon; Philadelphia: J. B. Chevalier, 1840–1844), 7:350–352.

28. For the story of the quadrupeds, see Ron Tyler, "The Publication of *The Viviparous Quadrupeds of North America*," in *John James Audubon in the West: The Last Expedition, Mammals of North America*, ed. Sarah E. Boehme (New York: Harry N. Abrams in association with the Buffalo Bill Historical Center, 2000), 119–182; and Charles T. Butler, ed., *Audubon's Last Wilderness Journey: The Viviparous Quadrupeds of North America* (Auburn, AL: Julie Collins Museum of Art, Auburn University, in association with D Giles Ltd., London, 2018).

29. Jenkins, *Audubon and Texas*, 1, 6; John James Audubon and John Bachman, *The Quadrupeds of North America*, 3 vols. (New York: V. G. Audubon, 1849–1854), 2:69 (first quote); Audubon, *Life and Adventures*, 340 (second and third quotes); and Bachman to Audubon, Charleston (SC), Apr. 8, 1837, Audubon Papers, Box 3, folder 84, Beinecke Rare Book and Manuscript Library, Harvard.

30. Bachman to Audubon, Charleston (SC), Sept. 13, 1839, and Bachman to Audubon, Charleston (SC), Jan. 13, 1840, in Bachman Papers, Charleston Museum; and Jay Shuler, *Had I the Wings: The Friendship of Bachman and Audubon* (Athens: University of Georgia Press, 1995), 168–170. Two of Bachman's daughters had married Audubon's two sons, and Bachman agreed to write the text as a contribution toward the children's welfare.

31. Audubon to Thomas M. Brewer, New York, Sept. 15, 1839, in Audubon Typescripts, Houghton Library, Harvard. The "holy zeal" remark is from George Shattuck to John Woodhouse Audubon, Dec. 9, 1840, in Audubon Papers, Beinecke Rare Book and Manuscript Library, Harvard.

32. Margaret Curzon Welch, "Audubon and His American Audience: Art, Science, and Nature, 1830–1860," (PhD diss., University of Pennsylvania, 1988), 163 (quote); Annette Blaugrund, "The Artist as Entrepreneur," in *The Watercolors for* The Birds of America, by Annette Blaugrund and Theodore E. Stebbens Jr. (New York: New-York Historical Society, 1993), 31–35; Harris to J. J. Audubon, Moorestown, Jan. 9, 1842, Audubon Papers, Missouri Historical Society, St. Louis; and J. Bachman to J. J. Audubon, Charleston (SC), Jan. 26, 1840, Bachman Papers, Charleston Museum; *New York Albion*, Mar. 11, 1843, 128; and Tyler, "Publication of *The Viviparous Quadrupeds*," 151. It is difficult to say how much money is worth from one century to another, much less which index to use. I have relied on EH.net, published by the Economic History Association. Of course, rarity has pushed the price of the *Viviparous Quadrupeds* to more than $350,000 today.

33. "Mr. Audubon," *Civilian and Galveston City Gazette* (hereafter cited as *CGCG*), Apr. 8, 1843, 2, quoting the *New York Courier* and the *Baltimore American*; Jenkins, *Audubon and Texas*, 6–14; Alice Ford, comp. and ed., *Audubon's Animals: The Quadrupeds of North America* (New York: Studio Publications, 1951), 26; Christine E. Jackson, *Bird Etchings: The Illustrators and Their Books, 1655–1855* (Ithaca, NY: Cornell University Press, 1985), 254.

34. Tyler, "Publication of *The Viviparous Quadrupeds*," 126, 151.

35. Ibid., 162.

36. Bachman to Audubon, Charleston (SC), Oct. 31, 1845,

in Bachman Papers, Charleston Museum; George Wilkins Kendall, *Narrative of the Texan Santa Fé Expedition*, 2 vols. (New York: Harper and Brothers, 1844), 1:188–198; Audubon and Bachman, *Quadrupeds*, 2:319–326; *TTR*, Dec. 24, 1845, 3; *Northern Standard* (Clarksville), Mar. 11, 1846, 1; and Larry L. Smith and Robin W. Doughty, *The Amazing Armadillo: Geography of a Folk Critter* (Austin: University of Texas Press, 1984). See also, Jenkins, *Audubon and Texas*, 6–14; Ford, *Audubon's Animals*, 26.

37. *TTR*, Dec. 24, 1845, 3 (quote). The roadrunner was not published until ornithologist John Cassin produced his *Illustrations of the Birds of California, Texas, Oregon, British and Russian America* (Philadelphia: J. B. Lippincott, 1856), 213–220 and plate 36.

38. Audubon and Bachman, *Quadrupeds*, 2:94–99, 98 (quote), 292–296.

39. Ibid., 2:258–262, 3:1–16, quotes on 5 and 13.

40. Ibid., 3:12–13.

41. Ibid., 1:233–241, quote on 238. For reproductions of the quadrupeds painted from Texas specimens, see Mary Bell Hart, *Audubon's Texas Quadrupeds: A Portfolio of Color Prints* (Austin: Hart Graphics, 1979), 53.

42. Audubon to Bachman, Minnie's Land, Mar. 1, 1846, Audubon Papers, bMS AM 1482 (167), Houghton Library, Harvard; Audubon and Bachman, *Quadrupeds*, 2:320–326; *Boston Atlas*, Mar. 25, 1846, 2, which was edited by Thomas M. Brewer, Audubon friend and naturalist. See also Bachman to Audubon, July 5, 1839, Bachman Papers, Charleston (SC) Museum. J. W. Audubon found himself in Texas for the final time in February 1849, en route to the California gold fields. After returning to New York, he produced what is today an exceedingly rare lithographic portfolio, *Illustrated Notes of an Expedition through Mexico and California* (New York: J. W. Audubon, 1852), which contains at least five plates illustrating Mexican scenes. His journal was later published as *Audubon's Western Journal* (Cleveland, OH: Arthur H. Clark, 1906; reprinted, Tucson: University of Arizona Press, 1984). His drawings from the expedition are reproduced in John Woodhouse Audubon, *The Drawings of John Woodhouse Audubon, Illustrating His Adventures through Mexico and California*, notes by Carl Schaefer Dentzel (San Francisco: Book Club of California, 1957).

43. John Woodhouse Audubon to John Bachman, New York, July 20, 1848, Audubon Papers, bMS AM 1482, Houghton Library, Harvard.

44. Bachman to Audubon, New York, July 5, 1839, Bachman Papers, Charleston (SC) Museum; and J. W. Audubon to Audubon, June 5, 1847, in Audubon Papers, Missouri Historical Society.

45. Audubon and Bachman, *Quadrupeds*, 3:221 (quote); John James Audubon and Victor Audubon to John Bachman, Minnie's Land, May 31, 1847, fMS Am 1265; Victor Audubon to John Bachman, New York, Sept. 1, and Oct. 14, 1847 (quote), bMS Am 1265 and bMS Am 1482 (269), all in Audubon Papers, Houghton Library, Harvard.

46. Victor Audubon to John Bachman, New York, Oct. 14, 1847, Audubon Papers, bMS Am 1482 (269), Houghton Library, Harvard. See also Audubon to Bachman, ibid., Nov. 29, 1847, bMS Am 1482 (271); ibid., Jan. 10, 1848, bMS Am 1482 (273); and ibid., June 17, 1848, bMS Am 1482 (279); and Bachman to VGA, Sept. 16, 1848, Bachman Papers, Charleston (SC) Museum. See also Audubon and Bachman, *Quadrupeds*, 3:156–159, first quote on 158, 220–225, quote on 221.

47. Steiner, *Audubon Art Prints*, 242.

48. Audubon to Bachman, Minnie's Land, Jan. 8, 1845, quoted in Herrick, *Audubon the Naturalist*, 2:266.

49. Bachman to Audubon, Charleston (SC), Mar. 14, 1844, Bachman Papers, Charleston Museum.

50. Tyler, "Publication of *The Viviparous Quadrupeds*," 171–177; and Ford, *Audubon*, 448–449. The additional plates were octavo size.

51. Robert McCracken Peck, "Audubon and Bachman: A Collaboration in Science," in Boehme, *John James Audubon in the West*, 107; Roberta J. M. Olson and Alexandra Mazzitelli, "Audubons' Bats: Like Father, Like Son?," *New-York Journal of American History* 66.2 (2003): 68–89.

52. Audubon and Bachman, *Quadrupeds*.

53. Peck, "Audubon and Bachman," 113 (quote); "Quadrupeds of North American," *U.S. Gazette*, quoted in the *Daily Atlas* (Boston), June 18, 1844, 2; *Raleigh Register, and North Carolina Gazette*, Apr. 14, 1846, 2; and "Mr. Audubon," *CGCG*, Apr. 8, 1843, 2, quoting the *New York Courier* and the *Baltimore American*.

54. [Charles Wilkins Webber], "The Quadrupeds of North America," *American Review: A Whig Journal of Politics, Literature, Art and Science* 4 (Dec. 1846): 625 (quote); *HTO*, s.v. "Webber, Charles Wilkins," by Thomas W. Cutrer, accessed Sept. 12, 2020.

55. *TTR*, Aug. 22, 1837, 2; Marilyn McAdams Sibley, *Lone Stars and State Gazettes: Texas Newspapers before the Civil War* (College Station: Texas A&M University Press, 1983), 91.

56. Mott, *American Magazines*, 1:268–270; and Sibley, *Lone Stars and Gazettes*, 97–98.

57. Niles to Lamar, New Orleans, Jan. 1, 1838, in Gulick and Elliott, *Papers of Mirabeau Buonaparte Lamar*, 6 vols. (Austin: A. C. Baldwin Printers, 1920–1927; reprint by Pemberton Press, 1968) 2:13; Sibley, *Lone Stars and State Gazettes*, 95–108; *National Intelligencer* (Houston), June 20, 1839, 4; and *National Banner* (Houston), Apr. 25, 1838, 3, and Oct. 5, 1838, 4 (ad reprinted from the July 5, 1838, edition); Streeter, *Bibliography of Texas*, 21–22 (quoting the *Morning Star*), 195–196; and *HTO*, s.v. "Houston Daily Times," by Diana J. Kleiner, accessed Sept. 12, 2020.

58. "Prospectus for . . . The Times," *Austin City Gazette*, Mar. 25, 1840, 4 (on Osborn and Lively's proposed newspaper in Houston). A lithographic stone offered at auction in Galveston in 1844 by H. A. Cobb might be a remnant of Niles's lithographic office. See *CGG*, Mar. 9, 1844, 3; Streeter, *Bibliography of Texas*, 195–196, 432, entry 1352; and Mahé and McCaffrey, *Encyclopedia of New Orleans Artists*, 135, 165. For more on Niles and Co. and silent partners Moseley Baker, Robert A. Irion, and Sam Whiting, see Sibley, *Lone Stars and State Gazette*, 95–108; and *HTO*, s.v. "Texas Emigrant," by Carole E. Christian, accessed Sept. 12, 2020. William Greene of New Orleans was designated "Lithographer to the Republic of Texas" and printed the *Plan of the City of Austin*, drawn by L. J. Pilie in 1839.

59. Herbert Pickens Gambrell, *Mirabeau Buonaparte Lamar, Troubadour and Crusader* (Dallas: Southwest Press, 1934), 247 (quote); Jeffrey Stuart Kerr, *Seat of Empire: The Embattled Birth of Austin, Texas* (Lubbock: Texas Tech University Press, 2013), 7–8, 9 (quote), 10, 32, 50–58; David C. Humphrey, *Austin: An Illustrated History* (Northridge, CA: Windsor Publications, 1985), 21–24; Philip Graham, *The Life and Poems of Mirabeau B. Lamar* (Chapel Hill: University of North Carolina Press, 1938), 55 (quote); Streeter, *Bibliography of Texas*, entry 1352; Mahé and McCaffrey, *Encyclopedia of New Orleans Artists*, 135, 165.

60. For Welch, see "Information Wanted," *TTR*, Aug. 14, 1839, 3. For Lowe, see Mahé and McCaffrey, *Encyclopedia of New Orleans Artists*, 242; "Marine List—Port of Galveston," *CGG*, Nov. 4, 1840, 2; and "Bank Note Engraving," *Morning Star* (Houston), Nov. 26, 1840, 3. For Hall, see "Texas Land Agency in N. Orleans," *Galveston News*, Nov. 1848, 1; [A. B. Lawrence], *Texas in 1840, or the Emigrant's Guide to the New Republic; Being the Result of Observation, Enquiry and Travel in that Beautiful Country, by an Emigrant, Late of the United States, with an Introduction by the Rev. A. B. Lawrence, of New Orleans* (New York: William W. Allen, 1840), 61ff. A brief sketch of Hall may be found in Williams and Barker, *Writings of Sam Houston*, 2:27. He might have had a home in Marion, Texas, because the *TTR* (Oct. 18, 1837, 2) reported his wife's death there on October 9. See also *Galveston News*, Nov. 11, 1848, 1. [Lanworthy], *A Visit to Texas*, apparently contains the first eyewitness scenes relating to Texas: four engravings by J. T. Hammond. See Streeter, *Bibliography of Texas*, 328, 434–435, and entries 1155, 1155A, and 1363A, which suggests that these engravings may be "the earliest sporting scenes in the West." See also Streeter, *Bibliography of Texas*, 434–435, entries 1361, 1361A, 1361B, and 1361C; Jenkins, *Basic Texas Books*, 318–320, 551–555.

61. Lowe was at 34 Canal Street in New Orleans. See *Gibson's Guide and Directory of the State of Louisiana, and the Cities of New Orleans & Lafayette* (New Orleans: John Gibson, 1838), 131. Lowe moved to Galveston in November 1840, and his arrival on the brig *North* was noted in the *CGG*, Nov. 4, 1840, 2. He advertised in the *TTR*, Feb. 10, 1838, 3, before moving, then advertised extensively from his 22nd Street address in Galveston in the *Texas Sentinel* (Austin), Oct. 24, 1840, 2, and Mar. 18, 1841, 4; the *Morning Star* (Houston), Nov. 26, 1840, 3; *San Luis Advocate*, Nov. 25, 1840, 3, and May 11, 1841; and *Galvestonian*, Apr. 1, 1841, 3. He continued to advertise from Galveston until

at least May 1841. See *Texas Centinel* [*sic*] (Austin), May 27, 1841, 4.

62. The first eyewitness print of a Texas city may be by Edward Stiff, who included a view of Galveston in his *Texan Emigrant*, 151. Stiff spent time in Galveston and might have produced or acquired the drawing that Cincinnati engraver John H. Lovejoy used for the illustration. The earliest notice of the Stiff book that I have found appears in the "New Books" advertisement in the *North American* (Philadelphia), July 21, 1840, 3. Reviews and advertising for Lawrence's book began to appear as early as October 1840. See *Bent's Monthly Literary Advertiser* (London), Oct. 10, 1840, 158. The *TTR* reviewed the book the following month (Nov. 11, 1840, 1). For all practical purposes, the books might have appeared simultaneously, given that it would have taken several weeks for the book to reach London versus Philadelphia.

63. The first notice of the book appeared in *New-York American for the Country*, Sept. 8, 1840, 4; and in the *Morning Chronicle* (London), Sept. 28, 1840, 1. The first review appeared in *Centinel of Freedom* (Newark, NJ), Sept. 29, 1840, 2, and was copied in both the *Morning Star* (Nov. 7, 1840, 3), and the *TTR* (Nov. 11, 1840, 1), but the print is not mentioned. W. Y. Allen says in his reminiscences that Lawrence and Stille wrote the book in a period of four days at his residence in Houston, then Stille left for Philadelphia to publish the manuscript. See William S. Red, ed., "Allen's Reminiscences of Texas, 1838–1842," *Southwestern Historical Quarterly* 17 (Jan. 1913): 298. There were several persons named Stille in Philadelphia at this time: Edmund Stille was associated with the Presbyterian Church and John A. Stille was a printer. See US Presbyterian Church Records, 1701–1970, and the 1860 US Federal Census, both in www.AncestryLibrary.com.

64. A "Mr. Hall" was responsible for preparing a public dinner in honor of Sam Houston in November 1839: see *Austin City Gazette*, Nov. 13, 1839, 2; see also ibid., Jan. 8, 1840, 2. Dr. Alexander Dienst Jr., a dentist, historian, and antiquarian, wrote on the back of the drawing that Hall made the drawing and wrote the names of the buildings in his own hand.

65. Lawrence, *Texas in 1840*, 61–62. Others were equally taken by the view of the president's house. See Kerr, *Seat of Empire*, 85–86. The "neat white building" has been painted brown in this print.

66. A better view of the Capitol may be seen in the reproduction of William Sandusky's *View of Austin* (location unknown), illustrated in Pinckney, *Painting in Texas*, 149; Cora Montgomery [Jane McManus Storm Cazneau], *Texas and Her Presidents: With a Glance at Her Climate and Agricultural Capabilities* (New York: E. Winchester, 1845), 73; and an unknown artist's view of the *First Capitol in Austin*, on the cover of the *Southwestern Historical Quarterly* 88 (Apr. 1985). William Bollaert's drawing of the president's house is a bit different from the one shown in the print, but there are obvious similarities. See W. Eugene Hollon, ed., *William Bollaert's Texas* (Norman: University of Oklahoma Press, 1989 ed.), facing 105. The drawing of Austin is in the collection of the Austin-Travis County Collection, Austin Public Library, *Austin and Travis County: A Pictorial History, 1839–1939*, text by Katherine Hart (Austin: Encino Press, 1975), 3.

67. Barker, *French Legation in Texas*, 1:153, 160, 170–171.

68. Austin-Travis County Collection, *Austin and Travis County*, 3. If the drawing is Hall's original, the lithographic artist would have had to have reversed it on the stone. See Twyman, *Lithography*, 69, 86, 130; and Bamber Gascoigne, *How to Identify Prints: A Complete Guide to Manual and Mechanical Processes from Woodcut to Ink-Jet* (New York: Thames & Hudson, 1986), paragraph 20, for a discussion of the transfer process and its advantages.

69. *TTR*, Apr. 17, 1839, 2; *Texas Sentinel* (Austin), Dec. 12, 1840, 3; *Austin City Gazette*, Oct. 30, 1839, 2; and Barker, *French Legation in Texas*, 1:332.

70. In addition to a review in *Centinel of Freedom* (Newark, NJ), Sept. 29, 1840, 2, one also appeared in "The Literary Examiner," *The Examiner* (London), Nov. 29, 1840, 5, with similar comments in "Texas in 1840," *Newcastle Weekly Courant* (Newcastle upon Tyne, Tyne and Wear, England), Dec. 18, 1840, 7. In the reprints examined, one 1844 edition contained the 1840 plate and one contained the new plate. The 1845 edition cited here also contains the 1840 plate. See Streeter, *Bibliography of Texas*, 434–435, entries 1361, 1361A, 1361B, and 1362C; and Jenkins, *Basic Texas Books*, 318–320. All the copies of the print that I have seen in the first edition are hand-colored, which varies widely. A few of the reviews mention the plate, but none mention that it is colored, which leads me to wonder if the coloring on the plates is modern.

71. Streeter, *Bibliography of Texas*, 144, entry 450. For Lowe's ads, see "J. Lowe, Bank Note Engraver," *TTR*, Feb. 10, 1838, 3; "Bank Note Engraving," *Morning Star* (Houston), Nov. 26, 1840, 3; "Bank Note Engraving, &c.," *San Luis Advocate*, Dec. 3, 1840, 3; *Galvestonian*, Mar. 3, 1841, 3; and "Bank Note Engraving," *Texas Sentinel* (Austin), Mar. 18, 1841, 4, among others.

72. "Notice," *TTR*, July 22, 1837, 3 (quote); Charles Hooton, *St. Louis' Isle, or Texiana* (London: Simmonds & Ward, 1847), viii, 2, 6–7 (quotes). Stiff wrote to confirm Hooton's charges. See "To Correspondents," *London Standard of Freedom*, Mar. 10, 1849, 10. See also Sidney Lee, ed., *Dictionary of National Biography*, 63 vols. (New York: Macmillan, 1891), 27:308; Mary Lee Spence, "British Impressions of Texas and the Texans," *Southwestern Historical Quarterly* 70 (Oct. 1966): 177–178; Davis, *Pirates Laffite*, 307–444; and David G. McComb, *Galveston: A History*, (Austin: University of Texas Press, 1986), 42–43. Hooton's pictures are among the earliest known of Galveston, although they were not published until 1847.

73. Hooton, *St. Louis' Isle*, 7, 11.

74. This is the same perspective as a large oil painting (18.63 × 23.38 in.) now in the collection of the Rosenberg Library in Galveston, which is signed "C. Hooton 1841." The painting was donated to the Rosenberg Library in 1925 by Mrs. A. A. Van Alstyne, the daughter of Abraham Lufkin, who had arrived in Galveston in 1845 at age twenty-eight and later founded the Southern Cotton Press & Manufacturing Co. Mrs. Van Alstyne said that her father had commissioned the painting. The painting was well known in Galveston and used in an illustration on the cover of a Thomas Goggan & Bro. sheet music, "The Pirate Isle No More" (1889), in celebration of Galveston's semicentennial (see figure 8.35).

75. Hooton, *St. Louis' Isle*, 9, 44.

76. Kennedy, *Texas*, 1:78; Larry Wygant, "A Sickly City: Health and Disease in Antebellum Galveston, Texas," *Houston Review: History and Culture of the Gulf Coast* 19, no. 1 (1997): 27–38; Melanie Wiggins, "Combatting Yellow Fever in Galveston, 1839–1905," *Southwestern Historical Quarterly* 119 (Jan. 2016): 235–239; Hooton, *St. Louis' Isle*, ix, 39, 44–45. The hospital was in the section of the island known as "Saccaray" (named after a town in Maine), which the city fathers thought would become the business center of the Galveston. See Hayes, *Galveston*, 1:287.

77. Willis W. Pratt, ed., *Galveston Island, or a Few Months off the Coast of Texas: The Journal of Francis Sheridan, 1839–1840* (Austin: University of Texas Press, 1954), 18–19; Matilda Charlotte (Jesse) Fraser Houstoun, *Texas and the Gulf of Mexico; or, Yachting in the New World*, 2 vols. (London: John Murray, 1844), 2:249.

78. Hooton, *St. Louis' Isle*, ix (quote), 7. Hooton also published a series of articles, "Texiana. Rides, Rambles, and Sketches in Texas," in *Charles Tait's Edinburgh Magazine* 10 (Mar., May, July 1843), 185–192, 288–295, 429–437; A. D. Paterson, ed., "The Emigrants to Texas—A True Story," *Anglo American, a Journal of Literature, News, Politics, the Drama, Fine Arts, Etc.* 1 (Aug. 19, 1843): 398–400; "The Exploit of Moreno the Texan," *New Monthly Magazine and Humorist* 75 (Nov. 1845): 285–292; and "Rides, Rambles, and Sketches in Texas," *Simmonds's Colonial Magazine and Foreign Miscellany* 9 (Sept. 1846): 34–43; ibid. (Oct. 1846), 173–195; ibid. (Dec. 1846), 440–453, prior to the publication of his book.

79. Hooton, *St. Louis' Isle*, 26.

80. Ibid., 15 (quote), 46–50 (quote), 160; see also Sibley, *Travelers in Texas*, 6, 21, 113. For information on Dubois's "pig war," see Barker, *French Legation in Texas*, 2:209n. Hooton was so unrelenting in his criticism that the editor of *Tait's Edinburgh Magazine* felt compelled to take exception when he published a segment of Hooton's essay, "Texiana. Ride, Rambles, and Sketches in Texas," issue 10 (May 1843): 292.

81. "Inquest upon Mr. Charles Hooton," *Morning Post* (London), Feb. 20, 1847, 6; "Sketches of Charles Hooton, Esq.," *New Monthly Magazine and Humorist* (Mar. 1847): 398; and ibid., "The Widow of Charles Hooton" (Apr. 1847): 532.

82. Helen Black, *Notable Women Authors of the Day*

(London: MacLaren, 1906), 223–233. Black interviewed Mrs. Houstoun in 1891. Mrs. Houstoun died in 1892.

83. Sam W. Haynes, *Unfinished Revolution: The Early American Republic in a British World* (Charlottesville: University of Virginia Press, 2010), 185.

84. Marilyn McAdams Sibley, introduction to Matilda Charlotte (Jesse) Fraser Houstoun, *Texas and the Gulf of Mexico; or, Yachting in the New World*, ed. Sibley (Austin: W. Thomas Taylor, 1991), xiv; "Abolition," *TTR*, Mar. 29, 1843, 2.

85. "Mexicans at Corpus Christi," *TTR*, Mar. 29, 1843, 2; "News from the United States," *TTR*, Mar. 22, 1843, 2; "Important from Mexico," *CGCC*, Mar. 29, 1843, 2; and *HTO*, s.v. "Mexican Invasions of 1842," by Sam W. Haynes, accessed May 11, 2020, uploaded June 15, 2010, modified July 10, 2018. Introducing the serialization of Mrs. Houstoun's book, the editor of *Smith's Weekly Volume for Town and Country* (Philadelphia) wrote, "We cannot avoid a belief that Mr. Houstoun's visit . . . had some silent diplomatic squinting towards gaining Texas for a British market" (issue 1 [Feb. 12, 1845]: 98).

86. Madeleine B. Stern, "Stephen Pearl Andrews, Abolitionist, and the Annexation of Texas," *Southwestern Historical Quarterly* 67 (Apr. 1964): 499–504; A. J. Yates to S. Converse, Galveston, Mar. 19, 1843, in *Boston Post*, June 21, 1843, 1–2; Hollon, *William Bollaert's Texas*, 159, 163 (quote). Bollaert, who saw the Houstouns dock at Galveston on December 18, 1842, said that the captain intended to "purchase lands and form a settlement." Ferdinand Roemer, who saw the Houstouns at James Morgan's plantation at New Washington during their second visit to Texas, wrote that the captain was interested in a sugar plantation: see Ferdinand Roemer, *Texas; with Particular Reference to German Immigration and the Physical Appearance of the Country; Described through Personal Observation*, trans. Oswald Mueller (San Antonio: Standard Printing, 1935; reprinted by Eakin Press, Austin, 1983), 58. See also Morgan to Samuel Swartwout, New Washington, Galveston Bay, Texas, Feb. 20, 1846, in Feris A. Bass Jr. and B. R. Brunson, eds., *Fragile Empires: The Texas Correspondence of Samuel Swartwout and James Morgan, 1836–1856* (Austin: Shoal Creek Publishers, 1978), 290.

87. Mrs. Houstoun states that they visited Texas in 1843–1844, but contemporary evidence indicates otherwise, as Jenkins (*Basic Texas Books*, 253) describes. See also Dorman H. Winfrey's introduction to Houstoun, *Texas and the Gulf of Mexico* (Austin: Steck-Warlick, 1968), [iii]. Descriptions of the Houstouns' retinue vary. William R. Hogan, *The Texas Republic: A Social and Economic History* (Norman: University of Oklahoma Press, 1946; reprinted by the University of Texas Press in 1969), 178, estimates the crew at eleven, while Roemer, who saw the Houstouns during their second trip to Texas, reported that Mrs. Houstoun claimed a total of more than twenty in the crew (*Texas*, 54). The yacht was built for pleasure: staterooms and dining room took up half of the below-deck area and were decorated with comfortable furniture, a "beautiful library," and "a small armament of guns and pistols" in the dining room. "The Yacht Dolphin," *TTR*, Dec. 21, 1842, 2. See also Sibley, introduction to Houstoun, *Texas and the Gulf of Mexico*, ix–xv; *CGCC*, Mar. 8, 1843, 2; and "Packing Beef," *TTR*, Mar. 22, 1843, 2. See also *HTO*, "Mexican Invasions of 1842."

88. The first published view of Galveston is probably the wood engraving by John H. Lovejoy, a Cincinnati engraver, that was included in Stiff, *Texan Emigrant*, 151. See Mary Sayre Haverstock, Jennette Mahoney Vance, and Bryan L. Meggitt, comps. and eds., *Artists in Ohio, 1787–1900: A Biographical Dictionary*, 3 vols. (Kent, OH: Kent State University Press, 2000), 539–540. For the Catlin portfolio, see William H. Truettner, "For European Audiences: George Catlin's *North American Indian Portfolio*," in Tyler, *Prints of the American West*, 25–45.

89. "Texas and the Gulf of Mexico," *Literary Examiner* (London), Aug. 3, 1844, 484; "Literature," *Morning Post* (London), Sept. 28, 1844, 6. The book received widespread notice, including "Mrs. Houstoun's Yacht Voyage to Texas and New Orleans," *The Spectator* (London), Aug. 10, 1844, 16–17; "Yacht Voyage to Texas," *The Times* (London), Aug. 22, 1844, 6; "Texas and the Gulf of Mexico," *The Athenæum* (London), Aug. 24, 1844; and "Texas and the Gulf of Mexico," *The Critic* (London), Nov. 1, 1844, 141–142, among others. Ads for the book appeared in many journals in both Britain and the United States.

90. Black, *Notable Women Authors*, 223–233; Jenkins, *Basic Texas Books*, 254; Streeter, *Bibliography of Texas*, entries 1506 and 1506A; and Meredith McGill, "The Role of Government: Copyright," in *A History of the Book in America: The Industrial Book, 1840–1880*, eds. Scott E. Casper, Jeffrey D. Groves, Stephen W. Nissenbaum, and Michael Winship, 5 vols. (Chapel Hill: Published in Association with the American Antiquarian Society by the University of North Carolina Press, 2007), 3:158–159. Thomas Sinclair of Philadelphia lithographed the Santa Anna portrait in the Zieber editions (Philadelphia: G. B. Zieber, 1845). "Mrs. Houstoun's Yacht Voyage to Texas and New Orleans," 476–478; and "Smith's Weekly Volume," *Milwaukee Daily Sentinel*, Jan. 3, 1846, 2. Mrs. Houstoun wrote many other books, including *Hesperos: or, Travels in the West*, 2 vols. (London: J. W. Parker, 1850), which includes her account of her second visit to Texas; and *Twenty Years in the Wild West, or, Life in Connaught* (London: J. Murray, 1879), in addition to thirty novels.

91. Sam Houston to Anna Raguet, Houston, Feb. 1, 1838, in Williamson and Barker, *Writings of Sam Houston*, 2:190 (quote).

92. Pinckney, *Painting in Texas*, 15–17; Houston to Anna Raguet, Houston, Feb. 1, 1838, Williams and Barker, *Writings of Sam Houston*, 2:190; and ibid., Houston to Thomas M. Bagby, Huntsville, May 7, 1849, 5:92; "Portraits," *TTR*, Oct. 7, 1837, 3. The Wright portrait was apparently destroyed in a fire in Kentucky. Mac Woodward Jr. to Ron Tyler, Mar. 27, 2020, pers. comm.

93. Niles, *History of South America and Mexico*, opp. 354. The Sam Houston Memorial Museum in Huntsville has a copy of Wright's portrait of Houston, but it shows a red cloak across his shoulders.

94. *Illustrated London News*, Apr. 13 and June 15, 1844, 226, 379; Houstoun, *Texas and the Gulf of Mexico* (1844), 1:255. William Bollaert's c. 1842 drawing of Galveston also bears some similarity to the print of Galveston in Mrs. Houstoun's book. See Hollon, *William Bollaert's Texas*, opp. 72.

95. For Day and Haghe's view of Quebec, see Joseph Bouchette, *The British Dominions in North America; Topographical and Statistical Descriptions . . .* , 2 vols. (London: Longman, Rees, Orme, Brown, Green, and Longman, 1832), 1: opp. 241. For derivative prints of both Houston and Galveston, see *Illustrated London News*, Jan. 4, 1845, 4; and Manuel Payno, "Tejas," in *Revista Científica y Literaria de Méjico* 1 (1845): 144–145, 169–174. *Gleason's Pictorial Drawing-Room Companion* reproduced a similar view of Galveston in 1852 (illustrated in Glen E. Lich, *The German Texans* [San Antonio: Institute of Texan Cultures, 1981], 46), and Houston was copied, with some notable changes such as a train about to cross the stone bridge in the center, in *L'illustration Journal Universel* 33 (Jan. 9, 1859): 28.

96. Marilyn McAdams Sibley, *The Port of Houston: A History* (Austin: University of Texas Press, 1968), 128.

97. Houstoun, *Texas and the Gulf of Mexico*, 2:175–176, 181, 186, 188, 191.

98. "Freshet," *TTR*, Oct. 11, 1843, 2. The bridge was in place at least by April 13, 1842. See *TTR*, Apr. 13, 1842, 3.

99. *Illustrated London News*, Jan. 4, 1845, 4.

100. Kelsey and Hutchison, *Engraved Prints of Texas*, 55, 71. A subtitle identifies the print as published in the *Illustrated Sun*, and someone has dated it in pencil as February 20, 1845, which was changed to 1847, then to 1846.

101. "Revista," *Diario del Gobierno de la República Mexicana* (Mexico), Nov. 5, 1845, 3; Manuel Payno, "Tejas," in *Revista Científica y Literaria de Méjico* 1 (1845): 144–145, 169–174. See also, Mathes, *Mexico on Stone*, 19–23.

102. Robert Sears, ed., *A New and Popular Pictorial Description of the United States: Containing an Account of the Topography, Settlement, History, Revolutionary and Other Interesting Events . . .* , 3rd ed. (New York: Robert Sears, 1848), 455, 457.

103. *L'Illustration, Journal Universel*, Jan. 8, 1859, 28–29; and *HTO*, s.v. "Galveston, Houston and Henderson Railroad," by George C. Werner, accessed Sept. 12, 2020.

104. Olmsted, *Journey through Texas*, 276 (quote).

105. For the Republic of Texas land policy, see Thomas Lloyd Miller, *The Public Lands of Texas, 1519–1970* (Norman: University of Oklahoma Press, 1972), 27–44, esp. 36–41.

106. For background on these land deals, see *HTO*, s.v.

"Castro's Colony," by Curtis Bishop, accessed Sept. 12, 2020; *HTO*, s.v. "Castroville, TX," by Ruben E. Ochoa, accessed Sept. 26, 2020; Virginia H. Taylor, *The Franco-Texan Land Company* (Austin: University of Texas Press, 1969); and Miller, *Public Lands*, 42.

107. *HTO*, s.v. "Castroville, TX."

108. In fact, Mexico invaded Texas on three occasions in 1842, leading to the disastrous Mier Expedition, in which 261 men invaded Mexico. The Mexican army captured 176 persons and 18 were executed: *HTO*, s.v. "Mexican Invasions of 1842"; and *HTO*, s.v. "Mier Expedition," by Joseph Milton Nance, accessed Mar. 10, 2020. See also Bobby D. Weaver, *Castro's Colony: Empresario Development in Texas, 1842–1865* (College Station: Texas A & M University Press, 1985), 24, 63; Cramayel to Guizot, Galveston, Jan. 26, 1843, in Barker, *French Legation in Texas*, 2:401–402, which summarizes the charges against Castro.

109. Henri Castro, *Le Texas en 1845: Castro-ville colonie Francaise, Fondée par Henry Castro, le Ier Septembre 1844, sur la rivière Medina, 24 milles oueste de San-Antonio de Bexar* (Anvers: J. F. Buschmann, 1845); Streeter, *Bibliography of Texas*, entries 1570, 1570A, 1570B, and 1570C; extract of a telegram from Castro to Louis Huth, Antwerp, Aug. 15, 1845, HM 48842 in the Henri Castro Papers, Huntington Library, San Marino, CA.

110. Weaver, *Castro's Colony*, 50–59; and Olmsted, *Journey through Texas*, 276 (quote).

111. Rudolph Leopold Biesele, *The History of the German Settlements in Texas, 1831–1861* (Austin: Press of Von Boeckmann-Jones, 1930), 1–41, 66–74, 110–119. Prince Carl purchased land from Rafael C. Garza and his wife, Maria Antonio Veramendi Garza. See also Rudolph L. Biesele, "Early Times in New Braunfels and Comal County," *Southwestern Historical Quarterly* 50 (July 1946): 76.

112. Olmsted, *Journey through Texas*, 143–144.

113. "For Galveston—Texas," *Times-Picayune* (New Orleans), Dec. 17, 1839, 3.

114. John Wilmerding, *American Marine Painting*, 2nd ed. (New York: Harry N. Abrams, 1987), 67–73; C. H. Ward-Jackson, *Ship Portrait Painters: Mainly in 19th-Century Britain* (Greenwich, UK: National Maritime Museum, 1978), 3, 5–6, 24.

115. John O. Sands, "American Ship Portraits: The Romantic Fallacy," in *American Maritime Prints: The Proceedings of the Eighth Annual North American Print Conference held at the Whaling Museum, New Bedford, Massachusetts, May 6–7, 1977*, ed. Elton W. Hall (New Bedford, MA: Old Dartmouth Historical Society, 1985), 213–217, 220–222; Bryan Le Beau, *Currier & Ives: America Imagined* (Washington, DC: Smithsonian Institution Press, 2001), 294–299; and Martha R. Wyatt, "Endicott & Co. Lithographs at The Mariner's Museum," *Imprint: Journal of the American Historical Print Collectors Society* 27 (Autumn 2001): 17.

116. The *Columbia* was owned by Morgan and New Orleans agent James Reed & Co. James F. Perry, Stephen F. Austin's brother-in-law, was a silent owner in the ship until he sold his share in 1839. See Perry to James Reed, Peach Point, Aug. 17, 1839, transcript of letter, in Moses and Stephen F. Austin Collection, made available through the Portal to Texas History, accessed Jan. 3, 2022, https://texashistory.unt.edu/ark:/67531/metapth217172/?q=James%20f.%20perry%20to%20james%20reed%201839.

117. James P. Baughman, *Charles Morgan and the Development of Southern Transportation* (Nashville: Vanderbilt University Press, 1968), 22–29; Hogan, *Texas Republic*, 7 (quotes); and Richard V. Francaviglia, *From Sail to Steam: Four Centuries of Texas Maritime History, 1500–1900* (Austin: University of Texas Press, 1998), 128–132.

118. "Port of Galveston," *TTR*, Dec. 2, 1837, 3.

119. Steamboat navigation was still in its infancy in Texas when Austin brought the *Ariel* to the mouth of the Rio Grande to establish regular trade between the mouth of the river and the villages upriver as far as Camargo. When that effort failed, he brought the boat to the mouth of the Brazos but decided that he could not establish a profitable trade there. As he left for New Orleans, the boat was damaged crossing the Brazos bar. Austin finally abandoned it in the San Jacinto River. *HTO*, s.v. "Ariel," by Wesley N. Laing, accessed Sept. 12, 2020.

120. See ads in various newspapers of the day, such as the *Texas Gazette* (San Felipe de Austin), Sept. 25, 1829, 4; *Constitutional Advocate and Texas Public Advertiser* (Brazoria), Sept. 5, 1832, 2; *Texas Republican* (Brazoria), Dec. 20, 1834, 3; and *TTR*, May 16, 1837, 2 (quote). See also Francaviglia, *From Sail to Steam*, 94–105; and Nicholas Doran Maillard, *The History of the Republic of Texas, from the Discovery of the Country to the Present Time; and the Cause of Her Separation from the Republic of Mexico* (London: Smith, Elder, and Co., Cornhill, 1842), 263.

121. Baughman, *Charles Morgan*, 24–25, 27.

122. "First Texas Steamboat," *Dallas Morning News*, Jan. 31, 1893, 6 (hereafter cited as *DMN*); Baughman, *Charles Morgan*, 26–27 (quote); Hogan, *Texas Republic*, 10; and *CGG*, Jan 11, 1839, 2; ibid., May 17, 1839, 3; Samuel May Williams to Anson Jones, Baltimore, Mar. 11, 1839, in *Memoranda and Official Correspondence Relating to the Republic of Texas, Its History and Annexation*, ed. Anson Jones (New York: D. Appleton, 1859), 145–146; Kennedy, *Texas*, 2:345–346; and William J. Phalen, *The Consequences of Cotton in Antebellum America* (Jefferson, NC: McFarland, 2014), 113–114.

123. "From the Galvestonian," *TTR*, Dec. 18, 1839, 3; "Texas—Last Opportunity!" and "For Galveston—Texas," *Daily Picayune* (New Orleans), Dec. 17, 1839, 3 (second quote); "For Galveston—Texas," Jan. 21, 1840, 3 (first quote).

124. For Huge, see National Gallery of Art, accessed Jan. 3, 2022, https://www.nga.gov/collection/artist-info.6533.html.

125. Baughman, *Charles Morgan*, 41 (quote).

126. John H. Jenkins and Kenneth Kesselus, *Edward Burleson: Texas Frontier Leader* (Austin: Jenkins Publishing, 1990), 281–285. "The Texian Quickstep" was still on sale in 1844. See "Music, Music, Music," *Daily National Intelligencer* (Washington, DC), July 18, 1844, 1; and Nancy R. Davidson, "The Grand Triumphal Quick-Step; or, Sheet Music Covers in America" in Morse, ed., *Prints in and of America to 1850*, 274.

127. Streeter, *Bibliography of Texas*, entries 1392, 1402, and 1407; Joseph Milton Nance, *After San Jacinto: The Texas-Mexican Frontier, 1836–1841* (Austin: University of Texas Press, 1963); and Nance, *Attack and Counter-Attack: The Texas-Mexican Frontier, 1842* (Austin: University of Texas Press, 1964); see Sam W. Haynes, *Soldiers of Misfortune: The Somervell and Mier Expeditions* (Austin: University of Texas Press, 1990); and Maberry, *Texas Flags*, 28–38.

128. "New Music," *NYH*, Sept. 17, 1841, 3, advertises "The Texas Quick Step."

CHAPTER 3: "ILLUSTRATIONS OF A CHEAP CHARACTER"

The chapter title quote is from Daniel P. Whiting, *A Soldier's Life: Memoirs of a Veteran of 30 Years of Soldering, Seminole Warfare in Florida, the Mexican War, Mormon Territory and the West*, edited by Murphy Givens (Corpus Christi: Nueces Press, 2011), 120.

1. For example, see Ron Tyler, *The Image of America in Caricature and Cartoon* (Fort Worth: Amon Carter Museum of Western Art, 1975), 4–12, 43–70; and E. P. Richardson, "The Birth of Political Caricature," in *Philadelphia Printmaking: American Prints Before 1860*, ed. Robert F. Looney (West Chester, PA: Tinicum Press, 1976), 71–87.

2. Davison, "E. W. Clay," in Tatham, *Prints and Printmakers of New York State*, 109.

3. The background and interpretations for many of the cartoons in this chapter are based on Reilly, *American Political Prints*. Peter Smith published a similar cartoon during the 1848 election, showing Van Buren being forced into marriage with a Negro woman representing the coalition of the Free Soil and Liberty Parties. See Anne Marie Serio, *Political Cartoons in the 1848 Election Campaign* (Washington, DC: Smithsonian Institution Press, Smithsonian Studies in History and Technology, No. 14, 1972), 11.

4. "First Caricature of the Campaign," *Raleigh Register and North-Carolina Gazette*, June 13, 1843, 2, quoting the *New York American*. See Bumgardner, "George and William Endicott," 49; Reilly, *American Political Prints*; Davison, "E. W. Clay," 260–268. Information on the background of the cartoons as well as the publishers may be found in Stephen Hess and Milton Kaplan, *The Ungentlemanly Art: A History of American Political Cartoons* (New York: Macmillan, 1968), 73–77. For genre painting, see Elizabeth Johns, *American Genre Painting: The Politics of Everyday Life* (New Haven, CT: Yale University Press, 1991).

5. Groce and Wallace. *Dictionary of Artists in America*,

93, provides no other information on an artist named "H. Bucholzer" other than that he was a cartoonist who worked with New York publisher James Baillie during the 1840s. See also Tyler, *Image of America in Caricature and Cartoon*, 11–12; and Le Beau, *Currier & Ives*, 26–27. Estimating the number of prints produced or sold can be only a rough guess because these lithographers apparently left no business records, but see William H. Goetzmann and William N. Goetzmann, *The West of the Imagination*, 2nd. ed. (Norman: University of Oklahoma Press, 2009), 108–109, for an analysis.

6. *HTO*, s.v. "Annexation," by C. T. Neu, accessed Sept. 13, 2020; Paul D. Lack, *The Texas Revolutionary Experience: A Political and Social History, 1835–1836* (College Station: Texas A&M University Press, 1992), 239; and Robert V. Remini, *Andrew Jackson and the Course of American Democracy, 1833–1845*, 3 vols. (New York: Harper & Row, 1977–1984), 3:360–368, 360 (quote).

7. For a good summary of the annexation issues, see Stanley Siegel, *A Political History of the Texas Republic, 1836–1845* (Austin: University of Texas Press, 1956), 231–233; and Remini, *Andrew Jackson*, 3:496, 505.

8. "Washington Correspondence," *North American and Daily Advertiser* (Philadelphia), Apr. 6, 1844, 2; "Pictorial Illustrations of Politics," *Evening Post* (New York), July 2, 1844, 2; Remini, *Andrew Jackson*, 3:492–503. For examples of the early use of the term "masked battery," see the *National Advocate* (New-York), June 1, 1818, 2; and *Louisville Public Advertiser*, Apr. 1, 1826, 3.

9. Dohnert was active in the American Art Union, the Democratic Party, and local issues. See "Local Affairs," *Public Ledger* (Philadelphia), Jan. 25, 1844, 1, and Apr. 23, 1844, 2; "Immense Meeting of the Democracy," *Boston Morning Post*, Oct. 27, 1840, 2; and "Annual Meeting of the American Art Union," *Evening Post* (New York), Dec. 21, 1844, 2.

10. Charles Grier Sellers Jr., *James K. Polk*, in 2 vols. Vol. 1: *Jacksonian, 1795–1843*; vol. 2: *Continentalist, 1843–1846* (Princeton, NJ: Princeton University Press, 1947, 1966), 2:99.

11. Groce and Wallace, *Dictionary of Artists in America*, 131; Davidson, "E. W. Clay," 91–110.

12. My thanks to James T. Bryan, research fellow at McDonald Observatory, College of Natural Sciences, University of Texas at Austin, for his assistance in interpreting this print. For a reference to Edward Jones, see ad in the "Patents, Specifications and Drawings," *New York Herald* (hereafter cited as *NYH*), Apr. 27, 1845, 3, and continuing into May. For references to the use of "Young Texas," see "Texas," *The Radical* (Bowling Green, MO), Apr. 30, 1842, 3; "A New Idea," *The Liberator* (Boston), Dec. 12, 1845, 1, quoting an article from the *New-York News*; "The Young State of Texas," *Public Ledger* (Philadelphia), Dec. 25, 1845, 2; "Progress," *Portage Sentinel* (Ravenna, OH), Aug. 12, 1846, 1; and "Mr. Yancey's Speech," *Montgomery Daily Advertiser* (AL), July 14, 1847, 2.

13. Peters, *America on Stone*, 203.

14. This is one of Joe H. Silbey's main points—that the annexation of Texas was one of the primary causes of the Civil War; see *Storm over Texas: The Annexation Controversy and the Road to Civil War* (New York: Oxford University Press, 2005). See also [Benjamin Lundy], *The War in Texas; Instigated by Slaveholders, Land Speculators, &c. for the Re-establishment of Slavery and the Slave Trade in the Republic of Mexico* (Philadelphia: Merrihew and Gunn, 1836).

15. David M. Pletcher, *The Diplomacy of Annexation: Texas, Oregon, and the Mexican War* (Columbia: University of Missouri Press, 1973), 184; K. Jack Bauer, *The Mexican War, 1846–1848* (New York: Macmillan, 1974), 16–18.

16. This lithograph was published two years later as the first print in Whiting's *Army Portfolio No. 1*, which contains five prints. See Martha A. Sandweiss, Rick Stewart, and Ben W. Huseman, *Eyewitness to War: Prints and Daguerreotypes of the Mexican War, 1846–1848* (Washington, DC: Smithsonian Institution Press, 1989), 8, 101–102, 122–127. The quotations are in *Weekly Picayune* (New Orleans), Sept. 8, 1845; and Whiting, *A Soldier's Life*, 66. In 2002 former *Corpus Christi Caller-Times* publisher Ed Harte offered the city $1 million to install an artwork inspired by the tents in Whiting's view in what is today Artesian Park, the site of Taylor's camp. Harte withdrew the offer when members of the Hispanic community opposed the plan. "Presentation on the proposed development of Artesian Park (Attachment #16)," in "Agenda, City of Corpus Christi, Texas, Regular Council Meeting, Jan. 8, 2002," 6, https://docs.cctexas.com/WebLink/DocView.aspx?id=129&dbid=0&repo=PublicRecords&cr=1; and "Businessman rescinds gift for Corpus park," *Houston Chronicle*, Feb. 2002, 33.

17. Bauer, *The Mexican War*, 48; James D. Richardson, ed., *A Compilation of the Messages and Papers of the Presidents, 1789–1897*, 10 vols. (Washington, DC: Government Printing Office, 1896–1899), 4:442 (quote).

18. "Corpus Christi Village and the Camp of the Army of Occupation in Texas—1846," *NYH*, Mar. 15, 1846, 1; "Fort Brown, Texas, Opposite the City of Matamoros," July 18, 1846, 1. William Seaton Henry, *Campaign Sketches of the War with Mexico* (New York: Harper & Bros., 1847), v–vi, 17 (quote). Henry thanked both men in the preface to his book: Eaton "for a few designs" and Sully for his "spirited embellishments." For Avery, see Groce and Wallace, *Dictionary of American Artists*, 17.

19. See *New York Weekly Herald*, July 18, 1846, 1; and *NYH*, July 21, 1846, 1.

20. Payno had written "Puerta de Monterey, Alta California," the previous year. See *Revista Científica y Literaria de Méjico*, 1:81–84.

21. [Payno], "Corpus Christi," *Revista Científica y Literaria de México* (México: Lito. Calle de la Palma, 1846), 108–109; Ma. Esther Pérez Salas, "*La Revista Científica y Literaria*: Una propuesta editorial novedosa," *Estudios Revista de Investigaciones Literarias y Culturales* 18, no. 36 (July-Dec. 2010); Ricardo Pérez Escamilla, "Arriba el Telón: Los litógrafos mexicanos, vanguardia artística y política del siglo XIX," in *Nación de imágenes: La litografía mexicana del siglo XIX* (Mexico: Museo Nacional de Arte, 1994), 25–26; and *El Monitor Republicano* (Mexico), July 8, 1846, 4, for notice of the publication of the *Revista* no. 5, which contains the image of Corpus Christi.

22. Henry's book was in press at Harper's in October 1847. See *Greenville Mountaineer* (SC), Oct. 29, 1847, 4. The book was issued in parts. The first two sections appeared in November. See also *Boston Daily Atlas*, Nov. 4, 1847, 1. The *Boston Post* had received only no. 2 by Nov. 2, 1847, 1. Sandweiss, Stewart, and Huseman, *Eyewitness to War*, 104.

23. *HTO*, s.v. "Henry, William Seaton," by Thomas A. Munnerlyn, accessed Sept. 13, 2020. The only copy of *Apuntes de campaña* that I have seen is cited in Dorothy Sloan Books, Austin, Catalogue 2 (June 1985), item 294. Dr. Everett Wilkie theorizes that the book might never have been finished because of censorship.

24. James Brust and Wendy Shadwell, "The Many Versions and States of *The Awful Conflagration of the Steam Boat Lexington*," *Imprint: Journal of the American Historical Print Collectors Society* 15 (Autumn 1990): 2–10.

25. "The Life of Gen. Winfield Scott," *Semi-Weekly Raleigh Register* (NC), May 19, 1846, 2.

26. "Local Intelligence," *Cincinnati Daily Enquirer*, July 9, 1846, 3.

27. Charlotte Streifer Rubinstein, *Fanny Palmer: The Life and Works of a Currier & Ives Artist*, ed. Diann Benti (Syracuse, NY: Syracuse University Press, 2018); Reilly, *American Political Prints*, 255 (entry 1846-5); Groce and Wallace, *Dictionary of Artists in America*, 611.

28. The date is an error because the bombardment occurred in 1846. Gale Research Co., *Currier & Ives: A Catalogue Raisonné,* intro. Bernard F. Reilly Jr., 2 vols. (Detroit: Gale Research Co., 1984), 1:73 (entry 668). The Currier version is titled *The Bombardment of Metamoros [sic], May 1847: By the U.S. Troops under Major Brown*.

29. This account of the beginning of the war and the battles of Palo Alto and Resaca de la Palma is found in Bauer, *Mexican War*, 48–63.

30. Fitch W. Taylor, *The Broad Pennant: Or, a Cruise in the United States Flag Ship of the Gulf Squadron, During the Mexican Difficulties; Together with Sketches of the Mexican War, from the Commencement of Hostilities to the Capture of the City of Mexico* (New York: Leavitt, Trow, 1848). The ships are identified (bottom, left to right): *Lawrence*, *John Adams*, *Raritan*, *Battle Ground*, *Somers*, *Cumberland*, *Point Isabel*, *Potomac*.

31. A summary of the battle of Palo Alto may be found in Justin H. Smith, *The War with Mexico*, 2 vols. (New York: Macmillan, 1919), 1:165–169.

32. John Frost, *Pictorial History of Mexico and the Mexican War: Comprising an Account of the Ancient Aztec

Empire, the Conquest by Cortes, Mexico under the Spaniards, the Mexican Revolution, the Republic, the Texan War, and the Recent War with the United States (Philadelphia: Charles Desilver; Claxton, Remsen, and Hafelfinger; J. B. Lippincott & Co., 1871), 229–230; David Nevin and the Editors of Time-Life, *The Mexican War* (Alexandria, VA: Time-Life Books, 1978), 39.

33. Examples of Napoleonic battle prints that might have been used as examples by American lithographers may be seen in Brown University Department of Art, *All the Banners Wave: Art and War in the Romantic Era, 1792–1851* (Providence: Bell Gallery, List Art Center, Brown University, 1982), 23, 24, 82–83.

34. For information on Klauprecht, see Richard F. Askren, "Emil Klauprecht—Ohio Valley German American," in Cornell, ed., *Art as Image*, 160–161. See also the engraving of Point Isabel in Thomas Bangs Thorpe, *Our Army on the Rio Grande* (Philadelphia: Carey and Hart, 1846), opp. 14, in the New York Public Library copy.

35. Bauer, *Mexican War*, 57–63.

36. Sandweiss, Stewart, and Huseman, *Eyewitness to War*, 105–108.

37. Ibid., 106.

38. For a discussion of the publicity relating to this event, see Smith, *War with Mexico*, 1:467; Ronnie C. Tyler, *The Mexican War: A Lithographic Record* (Austin: Texas State Historical Association, 1973), 20–23. (This work also appeared in Tyler, "The Mexican War: A Lithographic Record," *Southwestern Historical Quarterly* 77 [July 1973]: 1–84.) There were at least two portraits of May made after he returned to the US: Ackerman published one by Francis D'Avignon, and Duval published one by H. Dacre. Both are in the Prints and Photographs Division of the Library of Congress. See "Colonel May," *Daily National Intelligencer*, Aug. 6, 1847, 3; "Lieut. Col. May," *New Orleans Daily Picayune*, Aug. 25, 1847, 2.

39. For contemporary coverage of the incident, see "Further from the Battle," *New Orleans Picayune*, May 19, 1846, 4; "The War on the Rio Grande," *NYH*, May 27, 1846, 1. A dinner was held in his honor when he returned to the United States: "Dinner to Lieut. Col. May," *Daily National Intelligencer* (Washington, DC), July 12, 1847, 3; and *Tri-Weekly Flag & Advertiser* (Montgomery, AL), Sept. 4, 1847, 3. May was brevetted to Lt. Col.

40. Bauer, *Mexican War*, 32; and Whiting, *Soldier's Life*, 66, 91, 109, 120 (quote).

41. See Darwin Payne, "Camp Life in the Army of Occupation: Corpus Christi, July 1845 to March 1846," *Southwestern Historical Quarterly* 73 (Jan. 1970), 326–342; and George Winston Smith and Charles Judah, eds., *Chronicles of the Gringos: The U.S. Army in the Mexican War, 1846–1848: Accounts of Eyewitnesses & Combatants* (Albuquerque: University of New Mexico Press, 1968), 56–58, for information on the stay in Corpus Christi. Robert H. Ferrell, ed., *Monterrey Is Ours! The Mexican War Letters of Lieutenant Dana, 1845–1847* (Lexington: University of Kentucky Press, 1990), 148, 149, 153, 182. According to family tradition, Whiting made several more drawings, but they were lost when a steamboat sank en route to New York. See also "Army Portfolio," *New Orleans Daily Picayune*, Aug. 28, 1847, 2.

42. A copy of the Weber version of Whiting's print, drawn on the stone by Charles Fenderich (who immigrated to America in 1830 and worked extensively for Weber and Lehman & Duval in Philadelphia), is in the Prints and Photographs Division, Library of Congress. See Sandweiss, Stewart, and Huseman, *Eyewitness to War*, 7, 13–14 (*Knickerbocker* quote), 102 (first quote), 111–113, 123.

43. Whiting, *Soldier's Life*, 109, 120; *Washington Daily Union* quoted in *Daily National Intelligencer* (Washington, DC), June 24, 1847, 3; and Sandweiss, Stewart, and Huseman, *Eyewitness to War*, 101–102.

44. The other four views in the *Portfolio* are *Monterey, As Seen from a House-Top in the Main Plaza, (To the West.) October, 1846*; *Valley Towards Saltillo, from Near the Base of "Palace Hill," at Montery* [sic]. *(Looking to the S. West.)*; *Heights of Monterey, from the Saltillo Road Looking Towards the City. (From the West.)*; and *Monterey, from Independence Hill, in the Rear of the Bishop's Palace. As it Appeared on 23d. September, 1846. (Looking East.)*

45. "Army Portfolio," *New Orleans Daily Picayune*, Aug. 28, 1847, 2, 3; "Army Portfolio No. 1," *New Orleans Bee*, Aug. 28, 1847, 1 (quote); Sandweiss, Stewart, and Huseman, *Eyewitness to War*, 102 (quote); "Army Portfolio," *Daily Union* (Washington, DC), June 22, 1847, 3 (quote); Whiting, *Soldier's Life*, 109, 120.

46. Richard Eighme Ahlborn, *The San Antonio Missions: Edward Everett and the American Occupation, 1847* (Fort Worth: Amon Carter Museum, 1985), 3–4, 5, 7; Bauer, *Mexican War*, 146.

47. There are at least six earlier drawings of the Alamo: José Juan Sánchez Estrada's was done during the Mier y Terán inspection of the Texas frontier in 1828–1829 (illustrated in Schoelwer, *Alamo Images*, 25–26, and perhaps attributable to José Juan Sánchez Navarro); George W. Fulton's, done in September 1837 and now in the Dolph Briscoe Center for American History, University of Texas at Austin (hereafter cited as BCAH); Mary A. Maverick's, thought to have been done about 1838 (illustrated in Rena Maverick Green, ed., *Samuel Maverick, Texan: 1803–1870* (San Antonio: Privately printed, 1952), opp. 47; one, apparently done by Thomas Falconer in 1841 (and later reproduced in the *Illustrated London News*, July 15, 1844, 380), now in the Falconer Papers, Beinecke Rare Book and Manuscript Library, Yale University; William Bissett's drawing of 1840, now in the collection of the Witte Museum in San Antonio; William Bollaert's, copied after Bissett in Sept. 20, 1843, and now in the Newberry Library, Chicago (see Hollon, *William Bollaert's Texas*, 223–224, and Schoelwer, *Alamo Images*, 44–45); and J. Edmund Blake's, made in 1845 as the Topographical Engineers were surveying the Alamo for possible use by the quartermaster's department. See Amelia Williams, "A Critical Study of the Siege of the Alamo and of the Personnel of Its Defenders" (PhD diss., University of Texas at Austin, 1931), 429–431. The four Everett watercolors from which these prints were made are now in the collection of the Amon Carter Museum of American Art, plus a fifth, a second view of San José, that was not lithographed.

The first published picture, after Bissett's view, "Ruins of the Alamo," appeared in Francis Moore Jr., *Map and Description of Texas, Containing Sketches of Its History, Geology, Geography and Statistics . . . and Some Brief Remarks Upon the Character and Customs of Its Inhabitants* (Philadelphia: H. Tanner, Junr. New York, Tanner & Disturnell, 1840). The book contains eight plates engraved after Bissett's drawings. Arthur Ikin, *Texas: Its History, Topography, Agriculture, Commerce, and General Statistics* (London: Sherwood, Gilbert, and Piper, 1841), illustrates a woodcut of the ruins of the Alamo (on the title page), as does the *Illustrated London News*, July 15, 1844, 380.

48. Edward Everett, "A Narrative of Military Experiences in Several Capacities," in *Transactions of the Illinois State Historical Society for the Year 1905* (Springfield: Illinois State Historical Library, Pub. No. 10, 1906), 204, 205 (quote).

49. Ahlborn, *San Antonio Missions*, 5–20.

50. George W. Hughes, "Memoir Descriptive of the March of a Division of the United States Army, Under the Command of Brigadier General John E. Wool, from San Antonio de Bexar, in Texas, to Saltillo, in Mexico," in *Report of the Secretary of War* (31st Cong., 1st Sess., Ex. Doc. 32); Ahlborn, *San Antonio Missions*, 20–21. See also James W. Abert, *Report of the Secretary of War, Communicating, in Answer to a Resolution of the Senate, a Report and Map of the Examination of New Mexico* (30th Cong., 1st Sess., SD 23); and William H. Emory, *Notes of a Military Reconnoissance* [sic]*, from Fort Leavenworth, in Missouri, to San Diego, in California* (30th Cong., 1st Sess., SD 7).

51. The plate in Moore, *Map and Description of Texas*, was made after a drawing by Bissett.

52. Ahlborn, *San Antonio Missions*, 47–48.

53. Ibid., 49, 51. For a reproduction of Eastman's view of Concepción, see John Francis McDermott, *Seth Eastman: Pictorial Historian of the Indian* (Norman: University of Oklahoma Press, 1961), plate 62.

54. Ahlborn, *San Antonio Missions*, 6.

55. Cecilia Steinfeldt, *San Antonio Was: Seen through a Magic Lantern, Views from the Slide Collection of Albert Steves, Sr.* (San Antonio: San Antonio Museum Association, 1978), 66.

56. Hermann J. Meyer, ed., *Universum; Oder, Abbildung und Beschreibung des Sehenswerthesten und Merkwurdigsten der Natur und Kunst aus der ganzen Erde . . .*, 21 vols. (Hildburghausen: Verlag vom Bibliographischen Institut, 1835–1860), 18 (1857), plate DCCXV, 149–150; and Kelsey and Hutchison, *Engraved Prints of Texas*, 93.

57. "The War in Mexico," *Daily American Star* (Mexico City), Feb. 27, 1848, 2, and Mar. 3, 1848, 2.

58. Fayette Copeland, *Kendall of the* Picayune*, Being His Adventures in New Orleans, on the Texan Santa Fe Expedition, in the Mexican War, and in the Colonization of the Texas Frontier* (Norman: University of Oklahoma Press, 1943), 229; and Arturo Aguilar Ochoa, "La influencia de los artistas viajeros en la litografía Mexicana (1837–1849)," *Anales del Instituto de Investigaciones Estéticas* 22 (Mar./June 2000): 127–135. According to an undated clipping in the Kendall Papers, Special Collections, University of Texas at Arlington Libraries, Nebel was an engineering graduate of a German university who had studied architecture in Paris and Italy. He spent fifteen years in Mexico before returning to Europe, where he died in Paris on June 4, 1855. See Benezit, *Dictionnaire*, 6:323; Ulrich Thieme and Felix Becker, *Allgemeines Lexikon der Bildenden Künstler von Antike bis zur Gegenwart*, 38 vols. (Leipzig: Verlag von E.A. Seeman, 1907–26, 1942, 1947; reprint by F. Ullmann, 1965), 25:370–371. Nebel returned to Europe to see *Viaje pintoresco y arquilógico sobre la parte más interesante de la República mexicana, en los años transcurridos desde 1829 hasta 1834* (Paris: M. Moench, 1836) through publication in Paris, and a second printing (Paris and Mexico: [Impr. de P. Renouard], 1840), but he was back in Mexico in 1840 to bring a lawsuit against lithographer Vicente García Torres, who was publishing prints pirated from Nebel's book. See also Manuel Toussaint, *La litografía en México en el siglo XIX*, with new material by José C. Valadés, 5th ed. [Cuernavaca, 1965], 28–32; Iturriaga, *Litografía y grabado en el México*, 1:95–119; Howard T. Fisher and Marion Hall Fisher, eds., *Life in Mexico: The Letters of Fanny Calderón de la Barca* (New York: Anchor Books, Doubleday, 1970), 357, 748; and Sandweiss, Stewart, and Huseman, *Eyewitness to War*, 110.

59. Copeland, *Kendall*, 228–229; and *Daily American Star* (Mexico), Apr. 8, 1848, 2. See also Ron Tyler, introduction to George Wilkins Kendall and Carl Nebel, *The War between the United States and Mexico, Illustrated* (Austin: Texas State Historical Association, 1994), xvii–xviii.

60. Gascoigne, *How to Identify Prints*, 17d. Lemercier did at least eleven of the fifty plates in Nebel's *Voyage pittoresque et archéologique, dans la partie la plus intéressante du Mexique* (Paris: M. Moench, 1836). Most of them were drawn on the stone by Pierre-Frédéric Lehnert, a watercolorist, engraver, and lithographer who was born in 1811. Benezit, *Dictionnaire*, 5:488. See also Twyman, *Lithography*, 139–143, 150–154.

61. Compare Nebel's painting of *The Battle of Buena Vista, February 22nd-23rd, 1847* (27 × 34 in.)—recently auctioned at Bonhams in London (Bonhams: Carl [Carlos] Nebel [German, 1805–1855] The Battle of Buena Vista, February 22nd-23rd, 1847)—to the finished print (usmw-E404-K46-1851_i03.jpg [1980×1280] [uta.edu]).

62. *Daily Picayune*, July 15, 1850, 2. Bayot (1810–after 1866) was born in Alessandria, Italy, to French parents. He exhibited works at the Paris salons from 1836 to 1866. Louis-Philippe-Alphonse Bichebois (1801–1850), a Parisian lithographer and landscape painter, assisted Bayot with one of the prints. See Benezit, *Dictionnaire*, 1:484, 651; Thieme and Becker, *Allgemeines Lexikon*, 3:104; and Peters, *America on Stone*, 91, who suggests that Bayot might have come to America.

63. The draft contract with Harper & Bros., "G. W. Kendall, Esq. proposes," in the Kendall Papers, UTA, would have required that Kendall pay Harper & Bros. "one-third of the profits." See also "Memorandum of an agreement entered into between D. Appleton & Co. of the city & county of New York, and Geo Wilkins Kendall of New Orleans," July 26, 1850, and copyright for the book on Aug. 3, 1850, copies in Fayette Copeland Jr. Papers, Western History Collections, University of Oklahoma Libraries, Norman. Receipts for binding by Matthews and Rider are in the George Wilkins Kendall Papers, UTA; Kendall to his sister, New Orleans, July 3, 1850, S-1248/K333, Kendall Papers, Western Americana Collection, Beinecke Rare Book and Manuscript Library, Yale University.

64. Copeland, *Kendall*, 251–252; "Illustrations of Mr. Kendall's Work," *New Orleans Daily Picayune*, July 14, 1850, 2 (quote).

65. "Our French Correspondent," *NYH*, Dec. 23, 1850, 1, and reprinted in "The Mexican War," *New Orleans Daily Picayune*, Jan. 1, 1851, 2; "The Mexican War," *New Orleans Daily Picayune*, June 4, 1851, 2; *Journal of Commerce* article reprinted in "Kendall's Work," *Democratic TTR*, Jan. 3, 1851, 2; Prospectus for *The War between the United States and Mexico, Illustrated*, in the Kendall Papers, UTA; *Spirit of the Times* (New York), Feb. 1, 1851, 1; "Historia de la guerra de México," *El Universal* (Mexico City), Feb. 10, 1851, 2; "Historia de la guerra de México," *El Siglo Diez y Nueve*, Feb. 7, 1851, 4; and ibid., "Obra nueva," June 24, 1851, 4. For information on the relative price of the Kendall book, see John H. McCusker, "How Much Is That in Real Money? A Historical Price Index for Use as a Deflator of Money Values in the Economy of the United States," *Proceedings of the American Antiquarian Society: A Journal of American History and Culture through 1876* 101 (Pt. 2, 1991): 328, 332. According to the Consumer Price Index, as calculated by McCusker, each 1851 dollar would be worth approximately $18 as of 2020. See also the ad for *War between the United States and Mexico*, distributed by Mr. Miller, 26, Henrietta Street, Covent Garden, London, pricing the book at £8, 8s, in the Kendall Papers, UTA. According to McCusker's calculations, the list price of the Kendall book would be more than £416 today (about $530), but rarity has driven the price much higher. See also EH.net, published by the Economic History Association, for several different methods of calculating the value.

66. Kendall made this claim in the introduction to the portfolio. See Kendall and Nebel, *War between the United States and Mexico, Illustrated, Embracing Pictorial Drawings of All the Principle Conflicts* (New York: D. Appleton, 1851), [iii]. After viewing the pictures, a correspondent wrote from Paris that "most of them [were] drawn on the spot": "Our French Correspondent," *NYH*, Dec. 23, 1850, 1.

67. Kendall and Nebel, *War between the United States and Mexico* (1851), iii–iv.

68. The *Knickerbocker* is quoted in the prospectus for *War between the United States and Mexico*, 1, in the Kendall Papers, UTA.

69. Dr. Justino Fernández, of the Instituto de Investigaciones Estéticas of the Universidad Nacional Autónoma de México, has suggested that Nebel was not in Mexico during the war and that he used Kendall's notes and his own memory to reconstruct the scenes. See John J. Peck, *The Sign of the Eagle: A View of Mexico—1830 to 1855* (San Diego: A Copley Book, 1970), 165. But Nebel was in Mexico soon after the fighting stopped, at least, for one of Kendall's friends wrote Kendall from Mexico that he had seen Nebel. See Copeland, *Kendall*, 229.

70. U. S. Grant, *Personal Memoirs of U. S. Grant*, 2 vols. (New York: Charles L. Webster, 1885), 1:93–94 (quote); [Thomas Bangs] T[horpe], "Battle of Palo Alto—May 8, 1846, *Weekly Delta* (New Orleans), May 25, 1846, 1 (quote); and Charles M. Haecker, "The Guns of Palo Alto," *Archaeology* 49 (May/June 1996): 48–53.

71. For an excellent map of the battle, see Smith, *War with Mexico*, 1:164–165.

72. This observation is made by Patricia Hills, "Picturing Progress in the Era of Westward Expansion," in William H. Truettner, *The West as America: Reinterpreting Images of the Frontier, 1820–1920* (Washington, DC: Smithsonian Institution Press, 1991), 103.

73. Copeland, *Kendall*, 147 (first quote), 149–150 (second quote), 151 (third quote).

74. Rheyn [John Henry Hopkins, Jr.], "The Print Colorer's Lament," *Columbian Lady's and Gentleman's Magazine* 7 (May 1847): 222. Hopkins helped his father, who was an impoverished Episcopalian bishop in Burlington, VT, color lithographs for instruction books for children, a project that apparently stretched over a couple of years but proved to be a "dead loss." Charles F. Sweet, *A Champion of the Cross; Being the Life of John Henry Hopkins, S.T.D., Including Extracts and Selections from His Writings* (New York: James Pott, 1894), 42–44. Hopkins later attended seminary and became an Episcopalian clergyman. He delivered the eulogy at President Grant's funeral in 1885. Hopkins also published poetry in *The Knickerbocker*, and it is there, in "Literary Notices" (issue 30 [Dec. 1847], 542–543), that his anagrammatic pseudonym of John H. Rheyn is revealed.

75. *San Antonio Texan* quoted in *TSG*, Nov. 22, 1856, 2.

76. Ron Tyler, *Western Art, Western History: Collected Essays* (Norman: University of Oklahoma Press, 2019), 167–189; Davidson, "E. W. Clay," 109; [Jane McManus

Storm Cazneau], "Annexation," *United States and Democratic Review* 17 (July/Aug. 1845): 5 (quote); Linda S. Hudson, *Mistress of Manifest Destiny: A Biography of Jane McManus Storm Cazneau, 1807–1878* (Austin: Texas State Historical Association, 2001), 59–61; and William H. Goetzmann, *New Lands, New Men: America and the Second Great Age of Discovery* (New York: Viking Penguin, 1986), 181 (quote).

CHAPTER 4: "A PERFECT TERRA INCOGNITA"

The chapter title quote is from "Exploration of the Sources of Red River," (Clarksville) *Northern Standard*, Apr. 24, 1852, 2.

1. See Tanner's map in the collection of the University of Texas at Arlington: online at Portal to Texas History, accessed Jan 4, 2022, https://texashistory.unt.edu/ark:/67531/metapth192828/?q=texas. See also Ernest Wallace and E. Adamson Hoebel, *The Comanches: Lords of the South Plains* (Norman: University of Oklahoma Press, 1952); T. R. Fehrenbach, *Comanches: The Destruction of a People* (New York: Knopf, 1974); and two excellent newer works: S. G. Gwyn, *Empire of the Summer Moon: Quanah Parker and the Rise and Fall of the Comanches, the Most Powerful Indian Tribe in American History* (New York: Scribner, 2010); and Pekka Hämäläinen, *The Comanche Empire* (New Haven: Yale University Press, 2008).

2. Bernard DeVoto, *Across the Wide Missouri* (Boston: Houghton Mifflin, 1947), 397.

3. *HTO*, s.v. "Mallet Expeditions," by Morris L. Britton, accessed Sept. 13, 2020; Josiah Gregg, *Commerce of the Prairies; or the Journal of a Santa Fé Trader, During Eight Expeditions across the Great Western Prairies, and a Residence of Nearly Nine Years in Northern Mexico*, 2 vols. (New York: Henry G. Langley, 1844), 2:145–152; "Map of the Prairies," reproduced in Maurice Garland Fulton, ed., *Diary and Letters of Josiah Gregg: Southwestern Enterprises, 1840–1847* (Norman: University of Oklahoma Press, 1941), opp. 94; Edwin James, comp., *Account of an Expedition from Pittsburgh to the Rocky Mountains under the Command of Major Stephen H. Long* (Barre, MA.: Imprint Society, 1972), 370–381; John M. Tucker, "Major Long's Route from the Arkansas to the Canadian River, 1820," *New Mexico Historical Review* 38 (July 1968): 185–219; and *HTO*, s.v. "Texan Santa Fe Expedition," by H. Bailey Carroll, accessed Oct. 1, 2020. See also H. Bailey Carroll, ed., *Guádal P'a: The Journal of Lieutenant J. W. Abert, from Bent's Fort to St. Louis in 1845* (Canyon, TX: Panhandle-Plains Historical Society, 1941), 9, 16; and Frederick W. Rathjen, *The Texas Panhandle Frontier* (Austin: University of Texas Press, 1973), 112–125.

4. Walter Prescott Webb, *The Great Plains* (Boston: Ginn & Co., 1931); Randolph B. Marcy, *Exploration of the Red River of Louisiana* (23rd Cong., 2d Sess., SD 54), 92; Edwin James, comp., *Account of an Expedition from Pittsburgh to the Rocky Mountains, Performed in the Years 1819 and '20*, 2 vols. (Philadelphia: H. C. Cary and I. Lea, 1823), 2:104; and Hämäläinen, *Comanche Empire*, 141–238.

5. Standard works on Romanticism in American art include John K. Howat, *The Hudson River and Its Painters* (New York: Viking, 1972); John K. Howat, ed., *American Paradise: The World of the Hudson River School* (New York: Metropolitan Museum of Art and Harry N. Abrams, 1987); Barbara Novak, *Nature and Culture: American Landscape and Painting, 1825–1875* (New York: Oxford University Press, 1980); and, more recently, Andrew Wilton and Tim Barringer, *American Sublime: Landscape Painting in the United States, 1820–1880* (Princeton, NJ: Princeton University Press, 2002).

6. Seth Eastman, *Treatise on Topographical Drawing* (New York: Wiley & Putnam, 1837), 30 (quote). See also Patricia Trenton and Peter H. Hassrick, *The Rocky Mountains: A Vision for Artists in the Nineteenth Century* (Norman: University of Oklahoma Press, 1983), 44–46; and Ron Tyler, *Prints of the West* (Golden, CO: Fulcrum Publishing, 1994), 75–77.

7. Ron Tyler, "Prints vs. Photographs, 1840–1860," in *Perpetual Mirage: Photographic Narratives of the Desert West*, ed. May Castleberry (New York: Whitney Museum of American Art, 1996), 41–47.

8. Martha A. Sandweiss, *Print the Legend: Photography and the American West* (New Haven: Yale University Press, 2002), 129; "Introductory," in Alfred Edward Mathews, *Pencil Sketches of Montana* (New York: Published the author, 1868), [4] (quote); Tyler, *Prints of the West*, 106.

9. Trenton and Hassrick, *Rocky Mountains*, 49. For information on the camera lucida, see Hammond and Austin, *Camera Lucida*. It was particularly popular among travelers and amateur artists in England in the early nineteenth century and became a staple of topographic art field equipment.

10. Harald Kleinschmidt, *People on the Move: Attitudes Toward and Perceptions of Migration in Medieval and Modern Europe* (Westport, CT: Praeger, 2008), 163–164; Wolf Feuerhahn, "A Theologian's List and an Anthropologist's Prose: Michaelis, Niebuhr, and the Expedition to Felix Arabia," in *Little Tools of Knowledge: Historical Essays on Academic and Bureaucratic Practices*, eds. Peter Becker and William Clark (Ann Arbor: University of Michigan Press, 2001), 146; and Justin Stagl, *A History of Curiosity: The Theory of Travel 1550–1800* (Chur, Switzerland: Harwood Academic Publishers, 1995).

11. Goetzmann, *New Lands, New Men*, 196–197.

12. "The War Question," *South Western American* (Austin), Aug. 6, 1853, 2 (quote).

13. Figure 4.1 is from Joshua L. Chamberlain, ed., *Universities and Their Sons: History, Influence and Characteristics of American Universities . . .*, 5 vols. (Boston: R. Herndon, 1900).

14. Allan Nevins, *Frémont: The West's Greatest Adventurer*, 2 vols. (New York: Harper & Bros., 1928), 1:231–241; Tom Chaffin, *Pathfinder: John Charles Frémont and the Course of American Empire* (New York: Hill and Wang, 2002), 252–260. Abert's official report appeared as "Journal of Lieutenant J. W. Abert, from Bent's Fort to St. Louis, in 1845," in *Message from the President of the United States . . . Communicating a Report of an Expedition Led by Lieutenant Abert, on the Upper Arkansas and through the Country of the Camanche Indians, in the Fall of the Year 1845* (29th Cong., 1st Sess., SD 438), and was published and annotated by H. Bailey Carroll and John Miller Morris. See Carroll, ed., *Guádal P'*; and Abert, *Expedition to the Southwest: An 1845 Reconnaissance of Colorado, New Mexico, Texas, and Oklahoma* (Lincoln: University of Nebraska Press, 1999). Also see John Miller Morris, *El Llano Estacado: Exploration and Imagination on the High Plains of Texas and New Mexico, 1536–1860* (Austin: Texas State Historical Association, 1997), 253–259. John Galvin produced an edited copy of Abert's report, *Through the Country of the Comanche Indians in the Fall of the Year 1845: The Journal of a U.S. Army Expedition Led by Lieutenant James W. Abert* (San Francisco: John Howell—Books, 1970), using Abert's copy of the published report and a government employee's contemporary manuscript copy of the report that is in the National Archives, Washington, DC (hereafter cited as NA).

15. John Charles Frémont, *Memoirs of My Life . . .* , 2 vols. (Chicago: Belford, Clarke, 1887), 1:426 (quote); and LeRoy R. Hafen, *Broken Hand: The Life of Thomas Fitzpatrick: Mountain Man, Guide, and Indian Agent*, rev. ed. (Denver: Old West Publishing, 1973), 218–219. The other expedition was Col. Stephen W. Kearny's march from Fort Leavenworth to South Pass and back.

16. Abert, *Through the Country of the Comanche Indians*, ed. Gavin, xix; Eastman, *Treatise on Topographical Drawing*, 22, 30; Trenton and Hassrick, *Rocky Mountains*, 44–46; Tyler, *Prints of the West*, 75–77; William H. Goetzmann, *Army Exploration in the American West, 1803–1863* (New Haven, CT: Yale University Press, 1959), 117, 123–124; Rathjen, *Texas Panhandle Frontier*, 104–112; and Silbey, *Storm over Texas*. For Abert's instructions, see "Journal of Lieutenant J. W. Abert, from Bent's Fort to St. Louis, in 1845," 2. See also *HTO*, s.v. "Annexation," by C. T. Neu, accessed Sept. 13, 2020.

17. François des Montaignes [Isaac Cooper], *The Plains*, eds. Nancy Alpert Mower and Don Russell (Norman: University of Oklahoma Press, 1972), 75 (quote).

18. Abert, "Journal of Lieutenant J. W. Abert," ii, 2, 25, 46–49, 72, 74. Forty of Abert's sketches and drawings from this expedition are illustrated in Abert, *Through the Country of the Comanche Indians*.

19. "Journal of Lieutenant J. W. Abert," 32 (quote), 35, 38, 46–49, 72, 74. Abert wrote in his personal copy of his report that "I entered on Mexican Soil 9th August & crossed out of their boundaries on the 22d Sept., before the troops sent by Mexico could overtake my forces."

See the comment on the front endpaper of his copy of the report in the Beinecke Rare Book and Manuscript Library at Yale. See also Rupert Norval Richardson, *The Comanche Barrier to South Plains Settlement*, ed. Kenneth R. Jacobs (Abilene: Hardin-Simmons University, 1991), 54–65; Hämäläinen, *Comanche Empire*, 214–219; and Abert, *Guádal P'a*, ed. Carroll, 54n.163. The same month that Abert was leading his survey through the Panhandle, several important Comanche leaders were in council with Texas commissioners at Torrey's Trading House. See "To His Excellency Anson Jones," *Texas National Register* (Washington, Texas), Nov. 15, 1845, 3.

20. "Journal of Lieutenant J. W. Abert," 35–37 (quote). Figure 4.2 shows a detail of "Map Showing the Route pursued by the Exploring Expedition to New Mexico and the Southern Rocky Mountains made under the orders of Captain J. C. Fremont U.S. Topographical Engineers and conducted by Lieut. J. W. Abert, assisted by Lieut. W. G. Peck, U.S.T.E. during the year 1845," from *Report of an Expedition Led by Lieutenant Abert on the Upper Arkansas and through the Country of the Comanche Indians* (29th Cong., 1st Sess., SD 438, 1846). According to Abert's map, Pillar Rock is located between his camps of Sept. 7 and 8, although the journal indicates that they did not see the rock until the 8th. I have seen at least two other copies of the report with the plates hand-colored but there is no documentation as to who colored them. (See *Americana III* [Austin: Michael D. Heaston Co., 1984], item No. 2; and Dorothy Sloan Rare Books, Catalogue 5 [May 1988], item No. 1.) Abert's personal copy of the report in the Beinecke Rare Book and Manuscript Library at Yale has hand-colored plates, is annotated, and has several additional watercolor portraits from the expedition bound in.

21. Historian H. Bailey Carroll was unsuccessful in identifying the peak. He suggested that it might be Chimney Peak, just east of the present-day village of Tascosa, or Torrea Peak southwest of Tascosa. He also suggested that it might have been on the north side of the river, that Abert might have seen it from such a distance that it only appeared to be on the south side. Abert, *Guádal P'a*, ed. Carroll, 60n.183.

22. Abert could have borrowed from Long and Gregg, who made the trip from Van Buren, Arkansas, to Santa Fe via the Canadian River in the spring of 1839 and returned by the same route the following year. See Josiah Gregg, *Commerce of the Prairies* (Norman: University of Oklahoma Press, 1954 [1844]), 225–261, 315–330. See also Goetzmann, *Army Exploration*, 126–127. For settlement of the area, see Rathjen, *Texas Panhandle Frontier*, 228–249; and Hafen, *Broken Hand*, 224–228. Abert brought the bird and mammal skins to Audubon's attention. See Abert to John James Audubon, Apr. 7, 1847, and Jan. 19, 1848, in Audubon Papers, Box 1, folder 3, Beinecke Rare Book and Manuscript Library, Yale. See also Abert, *Western America in 1846–1847: The Original Travel Diary of Lieutenant J. W. Abert. . . .*, ed. John Galvin. (San Francisco: John Howell—Books, 1966), 61; and Cassin, *Illustrations of the Birds of California, Texas, Oregon*, 129.

23. Geiser, *Naturalists of the Frontier*, 17–18, 149–150 (quote); Walter Keene Ferguson, *Geology and Politics in Frontier Texas, 1845–1909* (Austin: University of Texas Press, 1969), 11–12.

24. *Northern Standard*, Feb. 4, 1846, 2, quoting the *Galveston Civilian and Gazette*.

25. Geiser, *Naturalists of the Frontier*, 152–153; Howard, "Geological Preface, 1983," in Roemer, *Texas*, iv; Houstoun, *Hesperos*, 2:121–129, 122 (quote); Nancy Alexander, *Father of Texas Geology: Robert T. Hill* (Dallas: SMU Press, 1976), 48–49; and Ferguson, *Geology and Politics*, 12–13.

26. Ferdinand Roemer, *Texas: Mit besonderer Rücksicht auf deutsche Auswanderung und die physischen Verhältnisse des Landes nach eigener Beobachtung geschildert: Mit einem natuwissenchaftlichen anhange und einer topographisch-geognostischen karte von Texas* (Bonn: Adolph Marcus, 1849), translated by Oswald Mueller as *Texas; With Particular Reference to German Immigration . . .*

27. Roemer, *Die kreidebildungen von Texas und ihre organischen einschlüsse* (Bonn: Adolph Marcus, 1852). Aimé Henry founded the Lithographische Anstalt Henry & Cohen in the early 1830s in Bonn. It was later renamed A. Henry & Co. See also Klaus Hentschel, *Mapping the Spectrum: Techniques of Visual Representation in Research and Teaching* (New York: Oxford University Press, 2002), 127–128; and Denise Steger, "Nicolaus Christian Hohe," Portal Rheinische Geschichte, accessed Mar. 24, 2015, http://www.rheinische-geschichte.lvr.de/persoenlichkeiten/H/Seiten/NicolausChristianHohe.aspx.

28. Geiser, *Naturalists of the Frontier*, 153.

29. McDermott, *Seth Eastman*, 67; see also Brian W. Dippie, *Catlin and His Contemporaries: The Politics of Patronage* (Lincoln: University of Nebraska Press, 1990), 157–208, for the story of Eastman and Schoolcraft; Anderson, *Conquest of Texas*, 182–183; and *HTO*, s.v. "Council House Fight," by Jodye Lynn Dickson Schilz, accessed Sept. 13, 2020.

30. Seth Eastman, *A Seth Eastman Sketchbook, 1848–1849* (Austin: Published for the Marion Koogler McNay Art Institute, San Antonio, by the University of Texas Press, 1961). The print of San José accompanied Mary Eastman's poem, "The Mission Church of San José," in John S. Hart, ed., *The Iris: An Illuminated Souvenir for 1852* (Philadelphia: Lippincott, Grambo, 1851), 151–153.

31. "Indian Legend—The Iris for 1852," *Literary World* 9 (Sept. 20, 1851): 227; and "New Books," *Daily National Intelligencer* (Washington, DC), Nov. 19, 1851, 2.

32. For a study of the relationship between original paintings and their subsequent lithographic reproductions, see David J. Weber, "The Artist, the Lithographer, and the Desert Southwest," *Gateway Heritage* 5 (1984–85): 32–41; and David J. Weber, *Richard H. Kern: Expeditionary Artist in the Far Southwest, 1848–1853* (Albuquerque: Published for the Amon Carter Museum by the University of New Mexico Press, 1985), 254–257. See also Benjamin Rowland Jr., "Popular Romanticism: Art and the Gift Books," *Art Quarterly* 20 (Winter 1957): 365–381, esp. 371.

33. Albert Pike, *Prose Sketches and Poems, Written in the Western Country* (Boston: Light & Horton, 1834), 1 (quote).

34. Alexander von Humboldt, *A Map of New Spain . . . Drawn from Astronomical Observations at Mexico in the Year 1804* (London: Longman, Hurst, Rees, Orme and Browne, 1810). Geography and Map Division, Library of Congress.

35. W. Eugene Hollon, *Beyond the Cross Timbers: The Travels of Randolph B. Marcy, 1812–1887* (Norman: University of Oklahoma Press, 1955), 133 (quotes); Marcy, *Exploration of the Red River*, 1–2; and Keith Young, "The Shumards in Texas," *Earth Sciences History* 13 (1994), 143–153. For figures 4.10–4.15, see Marcy, *Exploration of the Red River* (23rd Cong., 2d Sess., SD 54). (There are two other editions, both printed in Washington: Beverley Tucker, Senate Printer, 1854; and A. O. P. Nicholson, Public Printer, 1854.) See also Pedro Vial who, on his 1788–1789 trip from Santa Fe to Natchitoches, followed the river through Palo Duro Canyon. See Noel M. Loomis and Abraham P. Nasatir, *Pedro Vial and the Roads to Santa Fe* (Norman: University of Oklahoma Press, 1967), 319–327; and Rathjen, *Texas Panhandle Frontier*, 79. For Marcy's summary of his experience, see Randolph B. Marcy, *Thirty Years of Army Life on the Border* (New York: Harper & Bros., 1866), 114–169.

36. Hollon, *Beyond the Cross Timbers*, 126–181, esp. 131–132, and 137; Carl Newton Tyson, *The Red River in Southwestern History* (Norman: University of Oklahoma Press, 1981), 104; Michael Tate, "Randolph B. Marcy, First Explorer of the Wichitas," *Great Plains Journal* 15 (Spring 1976): 88, 91; and Del Weniger, *The Explorers' Texas: The Lands and Waters* (Austin: Eakin Press, 1984), 20–21. *HTO*, s.v. "McClellan, George Brinton," by Thomas W. Cutrer, accessed Sept. 13, 2020.

37. Marcy, *Exploration of the Red River*, 24–25, 38, 42–44; and Hollon, *Beyond the Cross Timbers*, 141. The Canadian River is about a thirty-five-mile march from the North Fork of the Red River. See Grant Foreman, ed., *Adventure on Red River: Report on the Exploration of the Headwaters of the Red River by Captain Randolph B. Marcy and Captain G. B. McClellan* (Norman: University of Oklahoma Press, 1937), 66n; and Young, "Shumards in Texas," 143–150.

38. Marcy, *Exploration of the Red River*, 45–48, 50 (quote), 53, 54–55; Bachman to Victor Audubon, Charleston (SC), Oct. 31, 1845, in Bachman Papers, Charleston Museum. Foreman, *Adventure on Red River*, 77n., points out that there is a mistake in Marcy's calculation of the size of the prairie dog town. See also Kendall, *Narrative of the Texan Santa Fé Expedition*, 1:189–195; and Morris, *El Llano Estacado*, 274–277.

39. Marcy, *Exploration of the Red River*, 53–55 (quotes).

40. Ibid., 55 (quote); Dan Flores, *Caprock Canyonlands: Journeys into the Heart of the Southern Plains* (Austin: University of Texas Press, 1990), 106, 114–124; and Morris, *El Llano Estacado*, 271. José García, a Mexican trader who joined Whipple's later expedition, reported that the Mexicans and Indians referred to the Canadian River as Río Colorado and the Red River as Río Palo Duro, apparently because it flowed out of Palo Duro Canyon. Amiel Weeks Whipple and Joseph Christmas Ives, "Itinerary," in *Reports of Explorations and Surveys to Ascertain the Most Practicable and Economical Route for a Railroad Route From the Mississippi River to the Pacific Ocean*, 13 vols. [33rd Cong., 2nd Sess., HED 91, Serials 791–801; and 36th Cong., 1st Sess., HED 56, Serials 1054–1055] (Washington, DC: A. O. P. Nicholson, Printer, 1855–1861), vol. 3 (1856, Serial 793), pt. 1, p. 33; This set of publications is very confusing, and many published references are incorrect. The Senate version was issued in 12 volumes, the House version in 13. Volume 12 of the Senate version and volumes 12 and 13 of the House version are identical, except the House version is bound in two volumes. I am using the House version here, thus I cite 13 volumes. Each volume has the same title, with parts (with subtitles) and sections (with subtitles) within. For more, See Ron Tyler, "Western American Exploration in the *Serial Set*," in *The Serial Set: Its Make-up and Content*, ed. Andrea Sevetson (Bethesda, MD: ProQuest, 2013), 143–164. See also Goetzmann, *Army Exploration in the American West*, 447–448.

41. Famous German fortifications. See Stephen W. Sears, *George B. McClellan: The Young Napoleon* (New York: Ticknor & Fields, 1988), 34 (quote).

42. Bruce Robertson, "The Picturesque Traveler in America," in *Views and Visions: American Landscape before 1830*, ed. Edward J. Nygren (Washington, DC: Corcoran Gallery of Art, 1986), 189–211; Kris Fresonke, *West of Emerson: The Design of Manifest Destiny* (Berkeley: University of California Press, 2003), 50–56; and Malcolm Andrews, *The Search for the Picturesque* (Stanford, CA: Stanford University Press, 1979).

43. Marcy, *Exploration of the Red River*, 55–56 (quote); and Rathjen, *Texas Panhandle Frontier*, 133–137. Marcy included an engraving of this scene in his book, *Thirty Years of Army Life*, 155.

44. Marcy, *Exploration of the Red River*, 23 (quote), 24; Stafford, *Voyage into Substance*, 9–11, first quote on 10; James, *Account of an Expedition*, Lamar ed., second quote, 340–341. See also Flores, *Caprock Canyonlands*, 122.

45. Goetzmann, *Exploration and Empire*, 562–566, explains the change in geological theory that occurred as a result of John Wesley Powell's writings. Weber studied the pictures of artist Richard Kern in "The Artist, the Lithographer," 32–41. See Robert M. Lindholm, *Karl Bodmer's America Revisited: Landscape Views Across Time* (Norman: University of Oklahoma Press, 2013), for an analysis of Karl Bodmer's landscapes of the upper Missouri River compared with contemporary photographs; and Flores, *Caprock Canyonlands*, 106, 122–123.

46. Marcy, *Exploration of the Red River*, 82; Hollon, *Beyond the Cross Timbers*, 153–158; "Captain Marcy's Expedition," *Northern Standard*, July 24, 1852, 3; "The Late Massacre," *South-Western American* (Austin), July 28, 1852, 2; "The Late Indian Massacre," *Boston Daily Atlas*, July 28, 1852, 2; and *Pittsfield Sun* (MA), July 29, 1852, 3, repeating an article published in the *Fort Smith Herald*.

47. "Gold Region of Texas," *TTR*, Oct. 8, 1852, 2.

48. "Explorations and Discoveries among the Head-Waters of the Red River," *Daily National Intelligencer* (Washington, DC), Apr. 13, 1853, 1.

49. For Marcy quote, see *Route from Fort Smith to Santa Fe* (31st Cong., 1st Sess., HD 45), 42. Neither the reprint of the Senate version of Marcy's report nor the House version bears a document number. See Foreman, *Adventure on Red River*, xv–xvi. Most of the scientific illustrations included in the document relate to Texas.

50. Hollon, *Beyond the Cross Timbers*, 153–158. When he followed the Prairie Dog Town Fork of the Red River to its headwaters in 1876, Lt. Ernest H. Ruffner concluded that Marcy got only as far as Tule Canyon and terminated the search there, probably because of the harsh summer temperatures and lack of good water. T. Lindsay Baker, ed., "The Survey of the Headwaters of the Red River, 1876," *Panhandle-Plains Historical Review* 58 (1985): 13; T. Lindsay Baker, ed., *The Texas Red River Country: The Official Surveys of the Headwaters, 1876* (College Station: Texas A&M University Press, 1998). Flores (*Caprock Canyonlands*, 106) and Morris (*El Llano Estacado*, 259–263) agree with Ruffner. Ruffner had an artist with him, Carl Adolph Hunnius, but none of his drawings were published in the report.

51. New York lithographer James Ackerman produced 3,450 sets of 68 one- and two-color lithographs for both versions of the Senate editions, and Henry Lawrence, also of New York, printed the images for the House publication, so there are at least two versions of each of the scenes in Marcy's report, and sometimes there are minor discrepancies. Account no. 115908, Voucher 295; no. 116473, Voucher 16; no. 117369, Voucher 881, and no. 117451, Vouchers 1 and 8, in Record Group 217, Settled Records, Records of the Accounting Offices of the Department of the Treasury, NA.

52. There are two other editions of Marcy's report: Washington, DC: Beverley Tucker, Senate Printer, 1854; and Washington, DC: A. O. Nicholson, Public Printer, 1854. See Frederick V. Coville, "Three Editions of Marcy's Report on the Red River of Louisiana," *Bulletin of the Torrey Botanical Club* 26 (Jan. 1898): 157 (quote).

53. See my chapter on "'I Am Tired of All This Thing Called Science': Illustrated Government Publications Related to the American West, 1843–1863," in Tyler, *Western Art, Western History*, 167–189.

54. W. B. Parker, *Notes Taken during the Expedition Commanded by Capt. R. B. Marcy, U.S.A., through Unexplored Texas in the Summer and Fall of 1854* (Austin: Texas State Historical Association, 1990 [reprint]), 126.

55. Janos Xántus, *Levelei Éjszakamerikából: Tizenkét eredeti rajzok után készült köés egynehány fametszettel* [Letters from North America, with twelve original drawings and a few woodcuts] (Pesten: Lauffer és Stolp, 1858). See also Henry Miller Madden, *Xántus, Hungarian Naturalist in the Pioneer West* (Linz, Austria: Oberösterreichischer Landesverlag, 1949), 220–221ff. Madden's book was also published in Palo Alto by Books of the West that same year.

56. Whipple, "Itinerary," 36 (quote).

57. Goetzmann, *Army Exploration*, 209 (quote).

58. Ibid., 262–266, 274–277, 288.

59. There are several works on Möllhausen, including Andreas Graf, "Der Tod der Wölfe: Das abenteuerliche und das bürgerliche Leben des Romanschriftstellers und Amerikareisenden Balduin Möllhausen (1825–1905)" (PhD diss., University of Köln, 1990); and Preston Barba, "Balduin Möllhausen, the German Cooper," *Americana Germanica* 17 (University of Pennsylvania, 1914), but I have also relied on Ben W. Huseman, "Romanticism and the Scientific Aesthetic: Balduin Möllhausen's Artistic Development and the Images of the Whipple Expedition" (MA thesis, University of Texas at Austin, 1992). For Möllhausen's early life and his near starvation after being left on the prairie during the winter, see 7–25; David H. Miller, "Balduin Möllhausen, a Prussian's Image of the American West" (PhD diss., University of New Mexico, 1970), 38–80; and Robert Taft, *Artists and Illustrators of the Old West, 1850–1900* (New York: Charles Scribner's Sons, 1953), 23–24.

60. Huseman, "Romanticism and the Scientific Aesthetic," 26–35, mentions the possibility that the secretary's daughter was Humboldt's illegitimate child.

61. Miller, "Prussian on the Plains," 175–193; Taft, *Artists and Illustrators*, 26; and Huseman, "Romanticism and the Scientific Aesthetic," 37–42.

62. Huseman, "Romanticism and the Scientific Aesthetic," 50–54.

63. Eugene C. Tidball, *Soldier-Artist of the Great Reconnaissance: John C. Tidball and the 35th Parallel Pacific Railroad Survey* (Tucson: University of Arizona Press, 2004), 20 (quote).

64. Whipple, "Itinerary," 30 (quote). Simpson's report is published in *Report from the Secretary of War, Communicating, in Compliance with a Resolution of the Senate, the Report and Map of the Route from Fort Smith, Arkansas, to Santa Fe, New Mexico, Made by Lieutenant Simpson, January 14, 1850* (31st Cong., 1st Sess., SD 12). See also David S. Stanley, "Diary of D. S. Stanley, United States, 2nd Dragoons, of a March from Fort Smith, Arkansas, to San Diego, California, made in 1853" (typescript in the Oklahoma Historical Society, Oklahoma City), 9, entry for Sept. 8; Ernest R. Archambeau, ed., "Lieutenant A. W.

Whipple's Railroad Reconnaissance across the Panhandle of Texas in 1853," *Panhandle-Plains Historical Review* 44 (1971): 73; and Grant Foreman, ed., *A Pathfinder in the Southwest: The Itinerary of Lieutenant A. W. Whipple during His Explorations for a Railway Route from Fort Smith to Los Angeles in the Years 1853 and 1854* (Norman: University of Oklahoma Press, 1941), 79.

65. James, *Account of an Expedition*, 2:96 (quote). Domenech served in Castroville and Eagle Pass before returning to France in 1852, where he traveled, wrote, and continued his church duties. He later served with Emperor Maximilian in Mexico. He was not bashful about borrowing images from various sources, including the American artist George Catlin. See Emmanuel Domenech, *Seven Years' Residence in the Great Deserts of North America*, 2 vols. (London: Longman, Green, Longman, and Roberts, 1860); and *HTO*, s.v. "Domenech, Emmanuel Henri Dieudonne," by Ann Lozano, accessed Sept. 13, 2020.

66. Mary McDougall Gordon, ed., *Through the Indian Country to California: John P. Sherburne's Diary of the Whipple Expedition, 1853–1854* (Palo Alto, CA: Stanford University Press, 1988), 83; Whipple, "Itinerary," 31; and Tidball, *Soldier-Artist*, 18.

67. Baldwin Möllhausen, *Diary of a Journey from the Mississippi to the Coasts of the Pacific with a United States Government Expedition*, 2 vols. (London: Longman, Brown, Green, Longman, & Roberts, 1858); in German, *Tagebuch einer Reise vom Mississippi nach den Kusten der Südsee* (Leipzig: Hermann Mendelssohn, 1858); and in Danish, *Vandringer gjennem det vestlige Nordamerikas Prairie rog Udørkener fra Mississippi til Sydhavets* (Kjøbenhavn: P. G. Philipsens forlag, 1862). There is also a Dutch translation, *Reis van den Mississippi naar de kusten van den Grooten Oceaan*, 2 vols. (Te Zutphen, Big: A. E. C. Van Someren, 1858 [1859]), but it does not include the picture of the Kiowa camp.

68. Möllhausen, *Diary*, 1:215. Whipple, "Itinerary," 31–34 (quotes in entries for Sept. 9 and 11, 1853); and Huseman, "Romanticism and the Scientific Aesthetic," 112–113.

69. Möllhausen, *Diary*, 1:213, 215; Foreman, *Pathfinder*, 79–80; Gordon, *Through the Indian Country to California*, 83–87. Huseman, "Romanticism and the Scientific Aesthetic," 113–114.

70. Richardson, *Comanche Barrier*, 78–93.

71. See *Navajos* in Whipple, Thomas Ewbank, and Wm. W. Turner, "Report upon the Indian Tribes," in *Reports of Explorations and Surveys*, pt. 3: opp. 31; and Goetzmann, *Army Exploration*, 211–212, 217, 332, and 360.

72. Whipple, "Itinerary," 34–35; Morris, *El Llano Estacado*, 286.

73. Foreman, *Pathfinder*, 87–88; Gordon, *Through the Indian Country to California*, 90–91, 95–96; Möllhausen, *Diary*, 1:224–225; and Abert, "Journal of Lieutenant J. W. Abert," 56.

74. Tyler, *Western Art, Western History*, 183.

75. Whipple, "Itinerary," 36 (quote).

76. Charles Evans, "Itemized List of the Whipple Collection," *Chronicles of Oklahoma* 28, no. 3 (Autumn 1950): 231–324. Many of the pictures for Möllhausen's *Diary* were in Berlin, but all but six of them were destroyed during World War II, and only two or three of those relate to the Whipple Expedition. Other Möllhausen pictures from this expedition are known only through the prints that appear in the official *Reports of Explorations and Surveys*, vol. 3, and in his *Diary*, published in 1858 after he returned to Prussia.

77. Goetzmann, *Army Exploration*, 287, 332–333, noted that the only thing that Whipple thought Möllhausen drew accurately was a Navajo blanket; Whipple, Ewbank, and Turner, "Report upon the Indian Tribes," in *Reports of Explorations and Surveys*, vol. 3, pt. 3, p. 27; "Möllhausen," *Littell's Living Age* 60 (Jan. 1859): 243 (quote); Huseman, "Romanticism and the Scientific Aesthetic," 44; and Miller, "Prussian on the Plains," 176–177. Apparently, Whipple was criticizing Möllhausen's original drawing, but he could have been referencing the finished lithograph.

78. Huseman, "Romanticism and the Scientific Aesthetic," 42, 97.

79. Whipple, "Itinerary," 37–38; and A. T. Jackson, *Picture-Writing of Texas Indians* (Austin: University of Texas Publication 3809, 1938), 308–312.

80. Whipple to Engelmann, Washington, DC, Oct. 1, 1855, in George Engelmann Papers, Peter H. Raven Library, Missouri Botanical Garden, St. Louis, accessed Jan. 6, 2022, https://www.biodiversitylibrary.org/collection/engelmannpapers.

81. Huseman, "Romanticism and the Scientific Aesthetic," 61–62; and Whipple to Engelmann, Washington, Mar. 22, 1856, in Engelmann Papers, Raven Library, St. Louis.

82. Taft, *Artists and Illustrators*, 254–256. The other eleven pictures in the report are wood engravings: *Canadian River, at the Mouth of Long-Town Creek*; *Table-Hill Three Miles West of Shady Creek*; *Bluffs of the Llano Estacado, One Hour before Sunrise, Sept. 17*; *Kaiowa Camp*; *Kaiowa Indians Removing Camp*; *Kaiowa Buffalo Chase*; *Comanches*; *Governor and Other Indians of the Pueblo of San Domingo*; and three pictures of the pictographs, petroglyphs, and inscriptions at Aqua Piedra, near the New Mexico boundary, which Whipple referred to as Rocky Dell Creek.

83. Account no. 131087, Vouchers 2737, 2739, 2768; no. 132891, Vouchers 663, 668, 684; no. 139907, Vouchers 1339, 1392; no. 139991, Vouchers 853, 901, 961; no. 141294, Vouchers 102, 253, 302, in Settled Records, Accounting Offices of the Department of the Treasury, NA; and Taft, *Artists and Illustrators*, 28.

84. See, for example, the bill that James Ackerman of New York submitted for transferring and printing ten botanical plates on Sept. 4, 1856, in Account no. 126001, Voucher 441, in Settled Records, Accounting Offices of the Department of the Treasury, NA; and Whipple to Engelmann, Washington, DC, Oct. 1, 1855, in the Engelmann Papers, Raven Library, St. Louis.

85. Goetzmann, *Army Exploration*, 157–179. See also Paula Rebert, *La Gran Línea: Mapping the United States-Mexico Boundary, 1849–1857* (Austin: University of Texas Press, 2001); Joseph Richard Werne, *The Imaginary Line: A History of the United States and Mexican Boundary Survey, 1848–1857* (Fort Worth: Texas Christian University Press, 2007); and L. David Norris, James C. Milligan, and Odie B. Faulk, *William H. Emory, Soldier-Scientist* (Tucson: University of Arizona Press, 1998).

86. Goetzmann, *Army Exploration*, 167–168; John Russell Bartlett, *Autobiography of John Russell Bartlett (1805–1886)*, ed. Jerry E. Mueller (Providence, RI: John Carter Brown Library, 2006), 21–40, 37 (quote); Norris, Milligan, and Faulk, *William H. Emory*, 107, 118; and Robert V. Hine, *Bartlett's West: Drawing the Mexican Boundary* (New Haven, CT: Published for the Amon Carter Museum by Yale University Press, 1968), 5–9. Bartlett even claimed to have suggested to Stephens that he go to Central America. See Victor Wolfgang Von Hagen, *Maya Explorer: John Lloyd Stephens and the Lost Cities of Central America and Yucatán* (Norman: University of Oklahoma Press, 1948), 72.

87. Goetzmann, *Army Exploration*, 169–173. Möllhausen thought highly of Bartlett's book. See Möllhausen, *Diary*, 2:11, 78, 134, 140, 274.

88. Goetzmann, *Army Exploration*, 176–178.

89. Hine, *Bartlett's West*, 28–29, 84–85; John Mack Faragher, "North, South, and West: Sectional Controversies and the US-Mexican Boundary Survey," 1–2; and Gray Sweeney, "Drawing Borders: Art and the Cultural Politics of the US-Mexico Boundary Survey, 1850–1853," 31–35, both in Dawn Hall, ed., *Drawing the Borderline: Artist-Explorers of the U.S.-Mexican Boundary Survey* (Albuquerque, NM: Albuquerque Museum, 1996); and Bartlett, *Autobiography*, 42, 178–180.

90. Emory to John Torrey, Frontera near El Paso, Mar. 18, 1852, in William H. Emory and John Torrey Correspondence 1847–1857, Biodiversity Heritage Library, biodiversitylibrary.org; Norris, Milligan, and Faulk, *William H. Emory*, 105–114; Ronnie C. Tyler, ed., "Exploring the Rio Grande: Lt. Duff C. Green's Report of 1852," *Arizona and the West* 10 (Spring 1968): 43–60; and Ron Tyler, *The Big Bend: A History of the Last Texas Frontier* (Washington, DC: National Park Service, 1975; reprinted by Texas A&M University Press, 2003), 75–100.

91. Hine, *Bartlett's West*, 28–29, 84–85; "Personal Narrative," *San Antonio Ledger*, July 6, 1854, 1; and Bartlett, *Autobiography*, 42, 178–180. Bartlett, *Personal Narrative of Explorations and Incidents in Texas, New Mexico, California, Sonora, and Chihuahua, Connected with the United States and Mexican Boundary Commission, during the Years 1850, '51, '52, and '53*, 2 vols. (New York: D. Appleton, 1854). Bartlett's book was also published in London by George Routledge and Co. in 1854 and was reprinted by Appleton in 1856.

92. Bartlett, *Personal Narrative*, 1:111–116; and Jerry E. Mueller, *Boundary Commission Drawings from the Collection of John Russell Bartlett, 1850–1853: At John Carter Brown Library & Rhode Island School of Design, Providence, Rhode Island* (Forsyth, MO: GEM Enterprises, 2014), entry 34. Delaware Creek, now called Delaware River, flows northeastward, finally joining the Pecos just north of the Texas–New Mexico boundary. See *HTO*, s.v. "Delaware River," accessed Sept. 13, 2020.

93. Goetzmann mentions that Congress was becoming concerned over the amount of money being spent for illustrated scientific books (*Army Exploration*, 198). Streeter is quoted in Jenkins, *Basic Texas Books*, 30.

94. Bartlett, *Personal Narrative*, 2:522–525.

95. William H. Emory, *Report on the United States and Mexican Boundary Survey Made under the Direction of the Secretary of the Interior*, 3 vols. (Austin: Texas State Historical Association, 1987), 1:x. (Emory's original report was published in a House version [34th Cong., 1st Sess., HD 135, Serial 861–963] and a Senate version [SD 108, Serial 832–834]. A. O. P. Nicholson printed one and Cornelius Wendell the other.) Goetzmann, *Army Exploration*, 198; Account no. 127113, in Settled Records, Accounting Offices of the Department of the Treasury, NA; Tyler, *Western Art, Western History*, 185; Robin Kelsey, *Archive Style: Photographs and Illustrations for U.S. Surveys, 1850–1890* (Berkeley: University of California Press, 2007), 62–65, quoting *Congressional Globe* (34th Cong., 1st Sess., 1856), 802; and "Our Washington Correspondent," *NYH*, Jan. 17, 1858, 5 (quote); Orville B. Shelburne, *From Presidio to the Pecos River: Surveying the United States–Mexico Boundary along the Rio Grande 1852 and 1853* (Norman: University of Oklahoma Press, 2020).

96. After the line had been drawn, the engineers concluded that the best railroad route remained in Mexico, necessitating the Gadsden Purchase: see Goetzmann, *Army Exploration*, 194.

97. Hine, *Bartlett's West*, 15, 73–74, 89–90, credits *The Plaza and Church of El Paso* (fig. 4.34), to Bartlett based on his sepia sketch now in the John Carter Brown Library, Providence, RI, that is almost identical to Vaudricourt's published work, except for the addition of a couple of riders and the American flag flying over the wall in the distance. See Emory, "Personal Account," 1: opp. 92; and JRB003 - John Russell Bartlett Collection (lunaimaging.com), accessed Jan. 26, 2022. Emory apparently kept some of Vaudricourt's drawings, for as late as Feb. 1, 1853, Bartlett was asking Emory to send them to him: see Hine, *Bartlett's West*, 74n.5. Groce and Wallace, *Dictionary of Artists in America*, 677; Rebert, *La Gran Línea*, 26; Paula Rebert, "A Civilian Surveyor on the United States–Mexico Boundary: The Case of Arthur Schott," *Proceedings of the American Philosophical Society* 155 (Dec. 2011); Alma Durán-Merk and Stephen Merk, "Arthur Schott: A True Renaissance Man in the Americas," *Indiana* 31 (2014): 161–191; and Gretchen Gause Fox, "Arthur Schott, German Immigrant Illustrator of the American West" (MA thesis, George Washington University, 1977). Pratt also did several paintings on his own while on the survey: *View of Smith's West Texas Ranch* (El Paso), 1852, now in the Material Culture Collection of the BCAH; the portrait of James Wiley Magoffin (1852) is a part of the Texas Historical Commission collection, on exhibit in the Magoffin House in El Paso; and the portrait of Benjamin Franklin Coons, in the collection of Philip and Amy Alfeld, Alton, IL.

98. Article 2 of the Gadsden Purchase Treaty, Dec. 30, 1853, abrogated the United States' responsibility under Article 11 of the Treaty of Guadalupe Hidalgo, but most of Emory's work in the Trans-Pecos predated the signing of the Gadsden Treaty. See Yale Law School, Avalon Project, "Gadsden Purchase Treaty: December 30, 1853," accessed Jan. 6, 2022, https://avalon.law.yale.edu/19th_century/mx1853.asp; and Avalon Project, "Treaty of Guadalupe Hidalgo: February 2, 1848," accessed Jan. 6, 2022, https://avalon.law.yale.edu/19th_century/guadhida.asp.

99. Goetzmann, *New Lands, New Men*; David Bindman, *Ape to Apollo: Aesthetics and the Idea of Race in the 18th Century* (London: Reaktion Books, 2002), 12, 17, and ch. 3; Robert E. Bieder, *Science Encounters the Indian, 1820–1880: The Early Years of American Ethnology* (Norman: University of Oklahoma Press, 1986), 6, 61; John C. Greene, *The Death of Adam: Evolution and Its Impact on Western Thought* (Ames: Iowa State University Press, 1959), 221–247; and Tyler, *Western Art, Western History*, 19–20.

100. Quoted in Weber, *Richard H. Kern*, 269.

101. There is some question as to whether this account is from Schott or Emory. See Kelsey, *Archive Style*, 56 (quotes), for a consideration; and Emory, "Personal Account," in *Report on the United States and Mexican Boundary Survey*, vol. 1, pt. 1, p. 43 (quotes), 86, 88.

102. Cora Montgomery [Jane McManus Storm Cazneau], *Eagle Pass; or, Life on the Border* (New York: George P. Putnam, 1852), 74, 76 (quote); Kelsey, *Archival Style*, 51–53 (quote); regarding Grizzly Bear's rifle, interview with David Jackson of Jackson Armory, Dallas, Feb. 10, 2015, in collection of the author. See also Hudson, *Mistress of Manifest Destiny*, 117–143, who describes an illustration of Fort Duncan in Emory ("Personal Account," 1:79) as possibly including images of Cazneau and Wild Cat.

103. Texas governor Elisha M. Pease ordered a Texas Ranger force under James H. Callahan to chastise marauding Indians "wherever they may be found." Callahan invaded Mexico in October 1855 but was defeated and returned to Texas. Governor Santiago Vidaurri of Nuevo León y Coahuila later sent a force to destroy the Lipan Apache settlements in northern Coahuila, and by the 1870s fewer than thirty warriors remained. See Mexico, Comisión pesquisidora de la frontera del norte, *Reports of the Committee of Investigation Sent in 1873 by the Mexican Government to the Frontier of Texas* (New York: Baker & Godwin, 1875), 417–421; Thomas O. McDonald, *Texas Rangers, Ranchers, and Realtors: James Hughes Callahan and the Day Family in the Guadalupe River Basin* (Norman: University of Oklahoma Press, 2021), chs. 12–17; Miguel Ángel González-Quiroga, *War and Peace on the Rio Grande Frontier, 1830–1880* (Norman: University of Oklahoma Press, 2020), 112–113, 118–119; and Alice L. Baumgartner, *South to Freedom: Runaway Slaves to Mexico and the Road to the Civil War* (New York: Basic Books, 2020), 211–213.

104. Emory, "Personal Account," *Report on the United States and Mexican Boundary Survey*, 1:43 (quote), 76–77 (Lipan Warrior).

105. Ibid., 92 (quote); Goetzmann, *Army Exploration*, 154 (quote), 186–195.

106. Emory, "Personal Account," *Report on the United States and Mexican Boundary Survey*, 1:50.

107. Quoted in Paula Rebert, "Views of the Borderlands: The *Report on the United States and Mexican Boundary Survey, 1857–1859*," *Terrae Incognitae* 37 (2005): 79, 81, 89. Both Emory and the Mexican commissioner signed the views along with other documents and intended that they be a part of the official survey. Rebert doubts that the views were ever accepted as legal documents, but they did complement the scientific studies.

108. Kelsey, *Archive Style*, 34 (quote).

109. Schott to Engelmann, Mar. 28, 1856, in Engelmann Papers, Raven Library, St. Louis. My thanks to Orville B. Shelburne, who suggested that the *Prairie of the Antelope* may be of a landscape in eastern Arizona near Antelope Peak (today's Gila Peak), which is noted on Emory's index map no. 4 (1857).

110. Schott to Engelmann, Washington, DC, Mar. 29, 1854, and Mar. 28, 1856 (quote), in Engelmann Papers, Raven Library, St. Louis.

111. Account no. 127113 in Settled Records, Accounting Offices of the Department of the Treasury, NA. Some of the purchase orders for the natural history plates call for "transferring & printing," which probably means that the copper-plate engravings were transferred to stone and printed as lithographs.

112. Goetzmann, *Army Exploration*, 198; Account no. 127113, in Settled Records, Accounting Offices of the Department of the Treasury, NA; Tyler, *Western Art, Western History*, 185; and Kelsey, *Archive Style*, 62–65, quoting *Congressional Globe* (34th Cong., 1st Sess., 1856), 802; and "Our Washington Correspondent," *NYH*, Jan. 17, 1858, 5 (quote).

113. An estimate, based on costs derived from records in the Settled Records and on assigning similar plates similar costs, suggests that the government might have spent as much as $57,834 on the Emory illustrations. The comparison between 1857 dollars and 2020 dollars is based on a calculation described in Samuel H. Williamson, "Seven Ways to Compute the Relative Value of a US Dollar Amount, 1774 to present," Measuring Worth: www

.measuringworth.com/uscompare. See also Tyler, Western Art, Western History, 185.

114. Barchesky's watercolors were not published until late in the twentieth century. See Goetzmann's introduction to Emory, *Report on the United States and Mexican Boundary Survey* (1987), 1:xx; and Bob Cunningham and Harry P. Hewitt, "A 'lovely land full of roses and thorns': Emilio Langberg and Mexico, 1835–1866," *Southwestern Historical Quarterly* 98 (Jan. 1995): 401, 402, 404. The watercolors are *Vista del fortin en la colonia de Monclova el Viejo*, *Vista de la cierra de los Chisos*, and *Vista de la laguna de Jaco* and are in the Western Americana Collection, Beinecke Rare Book and Manuscript Library, Yale.

115. Baird's essay is in Emory, *Report on the United States and Mexican Boundary Survey*, vol. 2, pt. 2 (1859).

116. Tyler, *Audubon's Great National Work*, 109–112; Robert McCracken Peck, introduction to Cassin, *Illustrations of the Birds of California, Texas, Oregon*, I.11–I.21; *TTR*, Dec. 24, 1845, 3 (quote). See also Whitman Bennett, *A Practical Guide to American Nineteenth-Century Color Plate Books* (New York: Bennett Book Studios, 1949), 21.

117. Tyler, *Audubon's Great National Work*, 114–115; and Peck, introduction to Cassin, *Illustrations of the Birds of California, Texas, Oregon*, I.27–I.30.

118. Goetzmann, *Army Explorations*, 269–274; *Galveston Weekly News*, Jan. 3, 1854, 1 (hereafter cited as *GWN*); Andrew B. Gray, *Southern Pacific Railroad: Survey of a Route for the Southern Pacific R. R., on the 23nd Parallel* (Cincinnati: Wrightson & Co.'s ["Railroad Record"] Print, 1856), 1; and Pinckney, *Painting in Texas*, 167. The Gray survey contains thirty-three lithographic plates, which are listed in Wagner and Camp, *Plains and the Rockies*, entry 275, 522–524. Many of Schuchard's drawings were destroyed in the 1865 fire at the Smithsonian Institution and, according to Bailey (ed., *Survey of a Route*, 183), Gray kept several. See also Taft, *Artists and Illustrators*, 269; Norris, Milligan, and Faulk, *William H. Emory*, 152; and *HTO*, s.v. "Schuchard, Carl," by Kathleen Doherty, accessed Nov. 11, 2020.

119. Gray, *Southern Pacific Railroad*, 11, 15; *San Augustine Herald*, Jan. 21, 1854, 2, quoting the *Galveston Civilian*.

120. Gray, *Southern Pacific Railroad*, 18, 23, 33–34.

121. Bartlett had sketched the peak as he passed by. See his *Personal Narrative*, 1:117, where his pencil and sepia wash drawing is reproduced as an engraving. Lt. William H. C. Whiting, who first described the Trans-Pecos as the "Big Bend" in print, had also called the mountain Cathedral Rock when he saw it in 1849. See "Journal of William Henry Chase Whiting, 1849," in *Philip St. George Cooke, William Henry Chase Whiting, Francois Xavier Aubry*, vol. 7 of *Exploring Southwestern Trails, 1846–1854*, ed. Ralph P. Bieber, 12 vols. (Glendale: Arthur H. Clark, 1938), 7:265, 288; Bailey, *Survey of a Route*, 153. See also Gray, *Southern Pacific Railroad*, 25, 27.

122. L. R. Bailey, ed., "The Reminiscences of Peter R. Brady of the A. B. Gray Railroad Survey, 1853–1854," in *Survey of a Route on the 32nd Parallel for the Texas Western Railroad, 1854: The A. B. Gray Report, and Including the Reminiscences of Peter R. Brady, Who Accompanied the Expedition* (Los Angeles: Westernlore Press, 1963), 172, 183 (quote).

123. Gray, *Southern Pacific Railroad*, 52, 59; and *Gonzales Inquirer*, Apr. 8, 1854, 2, quoting the *San Antonio Ledger*. Simeon Hart, a native of Highland, New York, arrived in Texas in 1849 after serving in the Mexican War. He established his mill in December of that year and expanded it in 1854. See Rex W. Strickland, *Six Who Came to El Paso: Pioneers of the 1840s* (El Paso: Texas Western College Press, 1963), 37.

124. Peters, *America on Stone*, 271.

125. Bailey, *Survey of a Route*, 186–196.

126. "VIATOR," writing in *Washington Sentinel* (Washington, DC), Feb. 17, 1854, 2 (quote). Gray touted his forthcoming report when he was in Galveston. "The Pacific Railway," *GWN*, June 17, 1856, 1. Gray's report was translated into Spanish and published as *Ferro-Carril occidental de Tejas. Reconocimiento de la linea: Su costo y producto probable, entroncado en el camino de hierro del Pacifico. Naturaleza del pais, clima, recursos, minerales, y agricoles*, trans. del ingles por A. Guridi (New York: T. Wrightson & Co., Cincinnati, OH, 1856), but this work contains no illustrations.

127. Gray, *Southern Pacific Railroad*, 19 (quote); and Bartlett, *Personal Narrative*, 1:117 (quote).

128. See "Stateburg, S.C.," *GWN*, Nov. 13, 1855, 1; "Southern Pacific Railroad," *Galveston Commercial and Weekly Prices Current*, Nov. 22, 1855, 1; "The Texas Route," Dec. 20, 1855, 1; and Goetzmann, *Army Exploration*, 271.

129. "Mexican Boundary Commission," *Washington Union*, reprinted in *San Antonio Ledger*, July 11, 1857, 1.

130. Sweeney, "Drawing Borders," 31–35; and Susana Delano McKelvey, *Botanical Exploration of the Trans-Mississippi West, 1790–1850* (Jamaica Plain, MA: Arnold Arboretum of Harvard University, 1955), 932–940, 981–989, 990–1018.

CHAPTER 5: "PRETTY PICTURES . . . 'CANDY' FOR THE IMMIGRANTS"

The chapter title quote is from James Patrick McGuire, "Carl Rordorf, Artist to the *Adelsverein*," unpublished manuscript in author's possession, 2.

1. Mary A. Maverick and George Madison Maverick (arr.), *Memoirs of Mary A. Maverick*, ed. Rena Maverick Green (San Antonio: Alamo Printing, 1921), 89. Texas did not legally enter the Union until December 29, 1845; Mary Maverick was reacting to the Convention of 1845, which accepted the US offer of annexation on July 4, 1845.

2. "The Young State of Texas," *Public Ledger* (Philadelphia), Dec. 25, 1845, 2; "Immigration," *Bonham Argus*, quoted in *Texas Democrat* (Austin), Feb. 3, 1849, 4; and "Improvement in the West," *Texas Democrat* (Austin), quoted in *CGG*, Aug. 14, 1847, 2.

3. Charles Sealsfield [Carl Anton Postl], *Frontier Life, or Scenes and Adventures in the South West*, ed. Francis Hardman (New York: Miller, Orton & Mulligan, 1855), 77 (quote).

4. One of Ernst's letters is reproduced in "Report of a Letter from an Oldenburg Man in Texas," in Detlef Dunt [Detlef Thomas Friedrich Jordt], *Journey to Texas, 1833*, eds. James C. Kearney and Geir Bentzen, trans. Anders Saustrup (Austin: University of Texas Press, 2015), 30–37.

5. *HTO*, s.v. "Postl, Carl Anton," by Glen E. Lich, accessed June 20, 2020, uploaded June 15, 2010, modified May 6, 2019.

6. "German Emigration to Texas," *CGG*, Feb. 21, 1846, 1; *Houston Telegraph*, Jan. 11, 1872, 7.

7. *HTO*, s.v. "Germans," by Terry Jordan, accessed Aug. 18, 2011; Terry G. Jordan, "The German Settlement of Texas after 1865," *Southwestern Historical Quarterly* 73 (Oct. 1969): 194; and Lich, *German Texans*, 7.

8. More than 7,600 emigrants from Bremen entered Texas through Galveston during the 1840s: see Jordan, "German Settlement of Texas," 196. See also Earl W. Fornell, "Ferdinand Flake: German Pioneer Journalist of the Southwest," *American-German Review* 21 (Feb.–Mar. 1955): 25; Hayes, *Galveston*, 2:699, 943–946; and Sibley, *Lone Stars and State Gazettes*, 226–227.

9. Brothers William and J. J. Hendley established Hendley & Co. in Galveston in 1844 and built and ran the first line of packet ships between New York and Galveston. The much larger Hendley Building on the Strand, which was built between 1855 and 1858, is a monument to the company and, according to architectural historian Howard Barnstone, "enjoys the distinction . . . of being the first pretentious business building in Galveston," *The Galveston That Was* (New York: Macmillan and Museum of Fine Arts, Houston, 1966), 29, 35.

10. Karl von Sommer, *Bericht über meine Reise nach Texas im Jahre 1846* (Bremen: Johann Georg Heyse, 1847), 5; Earl Wesley Fornell, *The Galveston Era: The Texas Crescent on the Eve of Secession* (Austin: University of Texas Press, 1961), 4; and Jeffrey T. Leigh, *Austrian Imperial Censorship and the Bohemian Periodical Press, 1848–71: The Baneful Work of the Opposition Press Is Fearsome* (Cham, Switzerland: Palgrave Macmillan, 2017), 30. For a translation of Sommer's trip outside Houston, see Dan M. Worrall, *Pleasant Bend: Upper Buffalo Bayou and the San Felipe Trail in the Nineteenth Century* (Fulshear, TX: Concertina Press, 2016), 84–86. Medau was also publisher of *Prague Zeitung*.

11. Ralph Bayard, *Lone-Star Vanguard: The Catholic Re-Occupation of Texas (1838–1848)* (St. Louis: Vincentian Press, 1945), 190 (quote).

12. "Catholic Church," *Democratic TTR*, Mar. 29, 1847, 2, quoting the *Galveston News*; Fornell, *Galveston Era*, 78–79; W. & D. Richardson, *Galveston Directory for 1859–60: With a Brief History of the Island, Prior to the Foundation of the City* (Galveston: "News" Book and Job Office,

1859), 64; and *Cohen's New Orleans and Lafayette Directory, Including Algiers, Gretna and McDonoghville, for 1849* (New Orleans: D. Davies & Son, 1849), 74. See also Priscilla Lawrence, "A New Plane: Pre–Civil War Lithography in New Orleans," in Poesch, *Printmaking in New Orleans*, 124; and Mahé and McCaffrey, *Encyclopedia of New Orleans Artists*, 252. Charles G. Bryant, a self-trained architect from Bangor, Maine, who came to Texas in 1839, also claimed to be the architect of the church, but Willard B. Robinson attributes the church's design to Giraud based on correspondence between Giraud and Bishop Odin in the Catholic Archives of Texas: see Robinson, "Houses of Worship in Nineteenth-Century Texas," *Southwestern Historical Quarterly* 85 (Jan. 1982): 261; and *HTO*, s.v. "St. Mary's Cathedral, Galveston," by Roberta Buescher Christensen, accessed Oct. 5, 2020.

13. Fulton, *Diary and Letters of Josiah Gregg*, 100; Fornell, *Galveston Era*, 33 (quotes).

14. Quote in I. N. Phelps Stokes and Daniel C. Haskell, *American Historical Prints: Early Views of American Cities, Etc., From the Phelps Stokes and Other Collections* (New York: New York Public Library, 1933), 119–120.

15. Fornell, *Galveston Era*, 90; and *Flake's Bulletin* (Galveston), Aug. 4, 1866, 4 (hereafter cited as *FB*).

16. Barrie Scardino and Drexel Turner, *Clayton's Galveston: The Architecture of Nicholas J. Clayton and His Contemporaries* (College Station: Texas A&M University Press, 2000), 9; "The Post Office and Mails," *Morrison & Fourmy's General Directory of the City of Galveston* (Galveston: Morrison & Fourmy, 1859), 57; and Stephen Fox, "Broadway, Galveston, Texas," in *The Grand American Avenue, 1850–1920*, eds. Jan Cigliano and Sarah Bradford Landau (San Francisco: Pomegranate Artbooks, 1994), 207–211.

17. "Triumphant Return," *Flake's Daily Galveston Bulletin*, May 19, 1870, 5 (hereafter cited as *FDGB*); Ethel Hander Geue, *New Homes in a New Land: German Immigration to Texas, 1847–1861* (Waco: Texian Press, 1970), 50; and Johann Friedrich Hoff, *Adrian Ludwig Richter Maler und Radierer* (Dresden: J. Heinrich Richter, 1877), 480. Fraktur, or blackletter, typeface was based on the calligraphic style of the sixteenth-century German monk Leonhard Wagner and became the "national typographic style." See Peter M. Van Wingen, "*Die geuerlicheiten vnd eins teils derr geschichten des loblichen streytparen vnd hochberümbten helds vnd ritters herr Tewrdannckhs*," in *Vision of a Collector: The Lessing J. Rosenwald Collection in the Library of Congress*, Rare Book and Special Collections Division (Washington, DC: Library of Congress, 1991), 31.

18. See *Plans of Public Buildings in Course of Construction for the United States of America under the Direction of the Secretary of the Treasury Including the Specifications Thereof*, 5. vols. (Washington, DC: n.p., 1855–1856). *Plans of Public Buildings* includes reproductions of about forty-seven of Young's designs. See Lawrence Wodehouse, "The Custom House, Galveston, Texas, 1857–1861, by Ammi Burnham Young," *Journal of the Society of Architectural Historians* 25 (Mar. 1966): 64–65. For information on Young, see Daniel Bluestone, "Civic and Aesthetic Reserve: Ammi Burnham Young's 1850s Federal Customhouse Designs," *Winterthur Portfolio* 25 (Summer–Autumn, 1990): 131–156; and for information on Kollner, see Nicholas B. Wainwright, "Augustus Kollner, Artist," *Pennsylvania Magazine of History and Biography* 84 (July 1960): 325–351.

19. Wodehouse, "Custom House, Galveston," 64–67; *New Georgia Encyclopedia Online*, s.v. "Charles B. Cluskey (ca. 1808–1871)," by Stephen H. Moffson, accessed Jan. 7, 2022, https://www.georgiaencyclopedia.org; Willard B. Robinson, *Texas Public Buildings of the Nineteenth Century* (Austin: University of Texas Press for the Amon Carter Museum of Western Art, 1974), 36–38; Scardino and Turner, *Clayton's Galveston*, 16; and Barnstone, *The Galveston That Was*, 36–43, quote on 43.

20. Wodehouse, "Custom House, Galveston," 67; "Galveston, Texas," in *Harper's Weekly*, Oct. 27, 1866, 686; and Hayes, *Galveston*, 1:491.

21. J. D. B. Stillman, "Texas, May 18, 1855," in Stillman, *Wanderings in the Southwest in 1855*, ed. Ron Tyler (Spokane, WA: Arthur H. Clark, 1990), 23 (quote).

22. Biesele, *German Settlements in Texas*, 112. *HTO*, s.v. "Indianola, TX," by Brownson Malsch, accessed Sept. 13, 2020.

23. Stillman, *Wanderings in the Southwest*, 23 (quote); and *HTO*, s.v. "Matagorda, TX," by Diana J. Kleiner, accessed Sept. 13, 2020.

24. The Eberly House, whether in Houston, Austin, Port Lavaca, or Indianola, won praise from its guests. Cora Montgomery [Jane Storms Cazneau] called it the "epitome of Texas history" (*Eagle Pass*, 16–17). Sibley noted that Mrs. Eberly "enjoyed a reputation for fine foods" (*Travelers in Texas*, 42). See also Malsch, *Indianola*, 5–13, 39–43.

25. Extant photographs of the Colorado House document Holtz's mistaken identity. The Colorado House regularly advertised. See, for example, "Colorado House," *Matagorda Gazette*, May 23, 1860, 1, 2. For information on Holtz, see *HTO*, s.v. "Holtz, Helmuth Heinrich Diedrich," by Ben W. Huseman, accessed Sept. 13, 2020. Holtz also made a print entitled *18 Miles from the Mississippi*, from the Atchafalaya River in Louisiana (NA, No. 54, 1735). See Pinckney, *Painting in Texas*, 152–153; *Texas Centennial Exhibition* (Washington, DC: Government Printing Office, 1946), 22, entry 91. See also Ward-Jackson, *Ship Portrait Painters*, 3, 5–6, for comments on sailors as artists.

26. Williams is listed in Gifford White, *1830 Citizens of Texas* (Austin: Eakin Press, 1983), 197, as having arrived in Matagorda in 1825. See *TSG* (Austin), July 29, 1854, 4, quoting the *Galveston Journal*; and "The 'Fashionable' Colorado House and the Family of Galen and Amelia Luddington Mckinstry Hodges," Colorado House (usgenwebsites.org), accessed Jan. 26, 2022.

27. White, *1830 Citizens of Texas*, 84, 90, 113–114, 170–171. The bark *Texana* was a 588-ton vessel built in 1859 at Mystic by George Greenman & Co. for John A. McGaw and others of New York City. The *Texana* sailed for the Oakley and Keating line between New York and Mobile for a while. The Confederates captured it near the mouth of the Mississippi River on June 10, 1863. See John Faunce Leavitt, "Cradle of Ships: Chronological List of Vessels Built in the Stonington-Groton Area," unpublished manuscript, Mystic Seaport Museum Library, RF 244, Mystic, CT.

28. The accession number of the Indianola print in the Amon Carter Museum collection is 84.75. The Library of Congress copy is illustrated in John W. Reps, *Cities of the American West: A History of Frontier Urban Planning* (Princeton, NJ: Princeton University Press, 1979), 147. Some of the coloring on these prints may be modern color.

29. Albert Bernhardt Faust, *The German Element in the United States. . . .* , 2 vols. (Boston: Houghton Mifflin, 1909), 2:48; Gustav Dresel, *Gustav Dresel's Houston Journal: Adventures in North America and Texas, 1837–1841*, trans. and ed. Max Freund (Austin: University of Texas Press, 1954), xxvi; John W. Reps, *Views and Viewmakers of Urban America: Lithographs of Towns and Cities in the United States and Canada, Notes on the Artists and Publishers, and a Union Catalog of Their Work, 1825–1925* (Columbia: University of Missouri Press, 1984), 187. Dresel was trained as an architect in Wiesbaden. By 1856 he had joined with Charles Conrad Kuchel to establish a successful lithography shop in San Francisco that printed lithographic copies of Dresel's drawings of northern California and Oregon: see Groce and Wallace, *Dictionary of Artists in America*, 189; and Jeanne Van Nostrand, *The First Hundred Years of Painting in California, 1775–1875: With Biographical Information and References Relating to Artists* (San Francisco: John Howell—Books, 1980), 97. Dresel soon turned to growing grapes and became one of the most successful viticulturists in California. When phylloxera struck the California vineyards in the 1880s, his brother, Julius, returned to Texas and obtained the same rootstocks that had been used to save the French wine industry a few years before. See "Sudden Death of Emil Dresel," *Daily Evening Bulletin* (San Francisco), July 28, 1869, 3; and Jim Wood, "Estate of the Art," *San Francisco Examiner Image*, Oct. 10, 1993, 14–16.

30. See McGuire, "Carl Rordorf," 4, quoting Spiess to Your Highness, New Braunfels, Texas, July 20, 1847, in the Solms-Braunfels Archives, XL, 237–38, BCAH.

31. McGuire, "Carl Rordorf"; and James C. Kearney, "The Murder of Conrad Caspar Rordorf: Art, Violence, and Intrigue on the Texas Frontier," *Southwestern Historical Quarterly* 123 (July 2019): 1–28.

32. Rordorf assisted Johann Jakob Wetzel with *Voyages pittoresques aux lacs suisses*, 2 vols. (Zurich: Orell et Fussli, 1820–28), which contains 137 colored engravings.

33. Kearney, "Murder of Caspar Rordorf," 1–6.

34. Sörgel to Professor [Karl Biedermann], Galveston,

June 30, 1847, in Alwin H. Sörgel, *A Sojourn in Texas, 1846–47: Alwin H. Sörgel's Texas Writings*, trans. and ed. W. M. Von-Maszewski (San Marcos: German-Texan Heritage Society, Southwest Texas State University, 1992), 124–125; and James C. Kearney, *Nassau Plantation: The Evolution of a Texas German Slave Plantation* (Denton: University of North Texas Press, 2010), 138. See also Johann Metzger, *Beschreibung des Heidelberger Schlosses und Gartens: Nach gründlichen Untersuchungen und den vorzüglichsten Nachrichten. Mit 24 in Aquatinta, von C. Rordorf gestochenen Kupfertafeln* (Heidelberg: August Osswald, 1829), available online at http://digi.ub.uni-heidelberg.de/diglit/metzger1829/0133/thumbs. An English edition followed: Metzger, *An Historical Description of the Castle of Heidelberg and Its Gardens* (Heidelberg: L. Meder, 1830). See also Rordorf's hand-colored aquatint etching *Heidelberg: Gesamtansicht vom Schlangenweg über den Neckar gesehen*, artnet, accessed Jan. 7, 2022, http://www.artnet.com/artists/conrad-caspar-rordorf/heidelberg-gesamtansicht-vom-schlangenweg-über-BpTIxdDZEdlPXCADKJqGfA2. One of Rordorf's views of Galveston might have been published as an engraving in Meyer's *Universum*, plate 775 (73–79); see also the cover of the *Southwestern Historical Quarterly* 123 (July 2019).

35. For information on the Bonn Company of Naturalists, see *Statutes of the Natural Sciences Verein of Texas (Statauten des naturforschenden Vereins in Texas)*, in the Solms-Braunfels Archives. See also Kearney, *Nassau Plantation*, 138–139. The Meusebach treaty with the Comanches apparently was a part of the original Solms-Braunfels Archives, which were housed in the Solms castle in Germany. Irene Marschall King, Meusebach's granddaughter, purchased it and placed it on permanent loan to the Texas State Library and Archives in Austin in 1972. Baron Otfried Hans Freiherr von Meusebach dropped his German title of nobility and adopted John O. Meusebach.

36. The inscription (fig. 5.11) at the top reads "Special-Karten der Besitzungen des Texas Vereines nebst einer Generalkarte des Staates Texas nach den durch Congressbeschluss vom Sept 1850 in Washington neuerdings festgestellten Grenzen und einer Instruction für deusche Ausanderer." See McGuire, "Carl Rordorf," 4, quoting Spiess or Meusebach to Your Highness, New Braunfels, Texas, July 20, 1847, in the Solms-Braunfels Archives, XL, 237–238; for the Roemer quotes, see Roemer, *Texas*, 92; see also *TTR*, Mar. 4, 1846, 2. For information on the founding of New Braunfels, see Carl, Prince of Solms-Braunfels, *Texas, 1844–1845* (Houston: Anson Jones Press, 1936), 33 (a translation of his *Texas: Geschildert in Beziehung auf Sein Geographischen, Sozialen und üebrigen Verhältnisse mit besonderer Rücksicht auf die deutsche Colonisation . . .* (Frankfurt am Main: Johann David Sauerlander's Verlag, 1846); Beisele, "Early Times in New Braunfels," 75–78; Beisele, *German Settlements in Texas*, 139–140, 148–149; and map of New Braunfels, entitled "Kaarte der Stadt Neu Braunfels," in H. Wilke, *Verein zum Schütze Deutscher Auswanderer nach Texas* (Berlin: Lithographed and printed by H. Delius, ca. 1850). Prince Carl had intended that Sophienburg, which he named for his fiancé, Lady Sophia, Princess of Salm-Salm, be the beginning of a fort, which he considered necessary for the protection of New Braunfels. It was never finished, and the cabin was destroyed by a hurricane in 1886. The citizens of New Braunfels built the Sophienburg Memorial Museum on the site. Oscar Haas, *The History of New Braunfels and Comal County, Texas; 1844–1946* (Austin: Privately printed, 1968), 27–28. See *TTR*, Mar. 4, 1846, 2, for a contemporary description of the town.

37. McGuire, "Carl Rordorf," 5–7, quoting the Minutes of the General Assembly of the Texas Verein, Wiesbaden, May 12–15, 1851, in the Solms-Braunfels Archives; and Louis Bene, Wiesbaden, to Baron von Bibra, Mar. 22, 1851, in the Maximilian Prinz zu Wied Archives, BCAH.

38. McGuire, "Carl Rordorf," 7. See also *Instructionen für deutsche Auswanderer nach Texas: Nebst der neuesten Karte dieses Staates, nach den Grenzbestimmungen durch Congress-Beschluss vom September 1850* (Wiesbaden, 1851; reprinted Berlin: Dietrich Reimer Verlag, 1983), original materials in the Wied Archives, BCAH. The maps are also reproduced in Reps, *Cities of the American West*, 144. The thaler was a silver coin used throughout Europe, with the value being set by each principality, kingdom, duchy, or region. In 1875 the thaler weighed approximately 37 grains compared to 26 grains for the American silver dollar.

39. Gilbert J. Jordan, trans. and ed., "W. Steinert's View of Texas in 1849," *Southwestern Historical Quarterly* 80 (Oct. 1976): 178. Wilhelm Steinert's book was later published as *North America, Particularly Texas in the Year 1849: A Travel Account; A Book for Emigrants, Especially for Persons Enthusiastic about Emigration*, trans. Gilbert J. Jordan, ed. Terry G. Jordan-Bychkov (Dallas: DeGolyer Library & William P. Clements Center for Southwest Studies, SMU, 1999), esp. 52. See also Haas, *New Braunfels*, 110; and Ben W. Huseman, *Charting Chartered Companies: Concessions to Companies as Mirrored in Maps, 1600–1900* (Arlington: University of Texas at Arlington Library, 2010), 32–34.

40. McGuire, "Carl Rordorf," 2 (quote); see also *Instructionen für deutsche Auswanderer nach Texas*, 3.

41. McGuire, "Carl Rordorf," 2, 7; *Instruction für deutsche Auswanderer*, 3. The William S. Reese Co. in New Haven, CT, acquired the remainder of the Adelsverein archives, which are now in the Beinecke Rare Book and Manuscript Library at Yale.

42. McGuire, "Carl Rordorf," 2–3, cites *Galveston Zeitung*, Nov. 10, 1847; Kearney, "Murder of Caspar Rordorf," 1–28; Kearney, *Nassau Plantation*, 138–141, 150–151; and Friedrich Armand Strubberg, *Friedrichsburg, A Novel: Colony of the German Füstenverein*, trans. and ed. James C. Kearney (Austin: University of Texas Press, 2012), 1–25.

43. *HTO*, s.v. "Rosenberg, Carl Wilhelm von," by Louis E. Brister, accessed Mar. 18, 2020, uploaded June 15, 2010, modified May 4, 2016.

44. *Texas Democrat* (Austin), Mar. 3, 1849, 2; for Sörghel's comments, see Sörgel, *Sojourn in Texas*, 124–125. For a while there were two villages of Round Top, one on Sörgel Hill and a newer one on Cummins Creek, to the southwest.

45. Personal correspondence with Jon Todd (JT) Koenig of Austin and Neale Rabensburg of La Grange.

46. R. Henderson Shuffler, "Winedale Inn at Texas' Cultural Crossroad," *Texas Quarterly* 8 (Summer 1965), 135–136; Geue lists M., R., and W. Melchior as coming from Burg in 1853 and settling in Fayette County (*New Homes in a New Land*, 106). See also James Dick to Ron Tyler, Round Top, Nov. 7, 1985 (author's collection); interview with Mrs. Faith Bybee, Round Top, (author's collection); interview with former Winedale curator Lonn Taylor, Fort Davis, Texas (author's collection); *HTO*, s.v. "Winedale Historical Center," by Drury Blake Alexander, accessed Sept. 13, 2020; *Wikipedia*, s.v. "Rudolph Melchior," accessed Jan. 7, 2022; and Beisele, *German Settlements in Texas*, 171–172.

47. Lich, *German Texans*, 103; *HTO*, s.v. "Rosenberg, Carl Wilhelm von," by Louis E. Brister.

48. "The Inauguration," *TSG* (Austin), Dec. 27, 1853, 2; Sara Clark, *The Capitols of Texas: A Visual History* (Austin: Encino Press, 1975), 32–33 (quotes); Olmsted, *Journey through Texas*, 110 (quote); and Humphrey, *Austin*, 36.

49. Humphrey reproduces one of Rosenberg's drawings in *Austin*, 37, as does Kerr in *Seat of Empire*, 10.

50. *TSG* (Austin), May 3, 1856, 2. Rosenberg later advertised his services in teaching landscape drawing, architectural plans, civil engineering, and similar branches of science. See *TSG*, Aug. 23, 1856, 4.

51. *TSG*, Mar. 21, 1857, 2.

52. *San Antonio Zeitung*, October 10, 1855, 2.

53. See Huseman, "Beginnings of Lithography in Texas," 21–47; *San Antonio Zeitung*, Dec. 9, 1854, 3, and Jan. 6, 1855, 2; and Sibley, *Lone Stars and State Gazettes*, 230–237.

54. *HTO*, s.v. "Thielepape, Wilhelm Carl August," by Theodore Albrecht, accessed Sept. 13, 2020.

55. The *Sängerfest* platform was published in the *Neu Braunfelser Zeitung*, May 19, 1854, and in the *San Antonio Zeitung*. It also is included in Ernest William Winkler, ed., *Platforms of Political Parties in Texas* (Austin: Bulletin of the University of Texas No. 53, 1916), 58–61. See also Olmsted, *Journey through Texas*, 187–188. For background on the effort, see Ernest Wallace, *The Howling of the Coyotes: Reconstruction Efforts to Divide Texas* (College Station: Texas A&M University Press, 1979), 15–16.

56. The American Party began as a secret organization and earned the nickname because members responded that they "Know Nothing" about the party when asked: *HTO*, s.v. "Houston, Sam," by Thomas H. Kreneck, accessed Mar. 21, 2020, uploaded June 15, 2010, modified Nov. 1, 2019.

57. "Germans in Texas," *Texas State Times* (Austin), Oct. 6, 1855, 2; Sibley, *Lone Stars and State Gazettes*, 230–237 (quote); Richard B. McCaslin, *Fighting Stock: John S. "Rip" Ford of Texas* (Fort Worth: TCU Press, 2011), 61 (quote); and *San Antonio Staats Zeitung*, Mar. 30, 1855, 2.

58. Douai announced that the caricature was available for sale for fifty cents each or four dollars per dozen. "A Caricature," *San Antonio Zeitung*, July 28, 1855, 3.

59. John Salmon Ford, *Rip Ford's Texas*, ed. Stephen B. Oates (Austin: University of Texas Press, 1963), 211–212 (quote); Jay Monaghan, *The Great Rascal: The Life and Adventures of Ned Buntline* (Boston: Little, Brown, 1952), 192–203.

60. "'Sam Recruiting,'" *TSG*, Aug. 1, 1855, 2 (quote); "The Inquiry," *San Antonio Texan*, Oct. 4, 1855, 2 (quote); and David S. Heidler and Jeanne T. Heidler, *Henry Clay: The Essential American* (New York: Random House, 2011), 197, for the meaning of "blackleg." The term was used so often during the nineteenth century that the editor of the *Richmond Whig and Public Advertiser* suggested that it be stereotyped to save typesetters the trouble of setting each letter every time it was used (Sept. 29, 1826, 3).

61. "Lithographische Unstalt," *San Antonio Zeitung*, Aug. 11, 1855, 3. All the information from the *Zeitung* is based on research done and translations made by Ben Huseman, "Beginnings of Lithography in Texas," 21–34. Another account of the establishment of Texas's first lithographic press may be found in Theodore Albrecht, "San Antonio's Singing Mayor: Wilhelm Carl August Thielepape, 1814–1904," unpublished manuscript, 1976, photocopy of typescript at University of Texas at San Antonio Library, 8. An article on "Lithography," in *Scientific American* 7 (July 25, 1852): 357, explained that "all lithographic presses are worked by hand; not one has been made, so far as we know, self-acting, to be driven by steam power."

62. "Map of the City," *San Antonio Herald*, Sept. 4, 1855, 2 (quote); *El Bejareño*, Sept. 1, 1855, 2 (quote); and *San Antonio Texan*, Aug. 30, 1855, 2 (quote).

63. The only known copy of the map is in the Briscoe Center for American History, UT Austin. A portion of it is reproduced in Kent Keeth, "Sankt Antonius: Germans in the Alamo City in the 1850s," *Southwestern Historical Quarterly* 76 (Oct. 1972): 192. Keeth also states that Douai and Thielepape hoped to print a thousand copies of the map but were unable to do so (191). The discovery of Thielepape as a fledgling lithographer would have been made long before now had not Ernest William Winkler misread the inscription on the caricature of Sam Houston as "W. J. Leth" instead of W[ilhelm]. T[hielepape]. Lith[ographer]: see Winkler's *Check List of Texas Imprints, 1846–1860* (Austin: Texas State Historical Association, 1949), 117, entry 531.

64. *San Antonio Zeitung*, Oct. 20, 1855, 2, quote in Huseman, "Beginnings of Lithography in Texas," 24–25.

65. *Neu Braunfelser Zeitung*, Aug. 11, 1855, 3; "Map of the City," *San Antonio Herald*, Sept. 4, 1855, 2; *San Antonio Zeitung*, Dec. 8, 1855, 2; Martha Utterback, comp., *Early Texas Art in the Witte Museum* (San Antonio: Witte Memorial Museum, 1968), 4.

66. *HTO*, s.v. "Thielepape, Wilhelm Carl August," by Theodore Albrecht. See *The Latest News*, in which Thielepape, DeRyee, and Lungkwitz announce their photographic services: broadside BC_0323, BCAH.

67. Perhaps Pentenrieder and Blersch opened their store sometime in 1855, for one of their first ads appeared in *El Bejareño*, May 26, 1855, 4.

68. "Views of St. Louis, upon letter paper, with marginal decorations Ret. 10c," *Publishers' Uniform Trade List Directory: Comprising all the Books, Old and New, of Upwards of Two Hundred Publishers. Also, Trade Lists, Cards, &c., of Wholesale Stationers* (Philadelphia: Howard Challen, 1868), 16. For a reproduction of Witter's letter sheet, see John W. Reps, *St. Louis Illustrated: Nineteenth-Century Engravings and Lithographs of a Mississippi River Metropolis* (Columbia: University of Missouri Press, 1989), 105. See also Utterback, *Early Texas Art*, 44. Pentenrieder and Blersch were in business during the 1850s, 1860s, and 1870s. Blersch went to Europe during the Civil War but returned to San Antonio in 1869 and to a partnership with Pentenrieder. See *San Antonio Express*, Oct. 16, 1869, 5, and Nov. 2, 1869, 4 (hereafter cited as *SAE*). See also *Texas, County Tax Rolls*. The two-color lithographs of Pentenrieder's letter sheet are in the collections of the Witte Museum in San Antonio and the Beinecke Rare Book and Manuscript Library, Yale.

69. "New Goods," *San Antonio Texan*, Sept. 18, 1856, 2; "First Series of Texas Views," *GWN*, Mar. 3, 1857, 4.

70. *HTO*, s.v. "San Fernando Cathedral," by Ann Graham Gaines, accessed Sept. 13, 2020.

71. "Our Platform—Another Campaign Document," *SAE*, Feb. 12, 1868, 2 (quote).

72. James Patrick McGuire, *Iwonski in Texas: Painter and Citizen* (San Antonio: San Antonio Museum Association, 1976), 11–13.

73. McGuire names the figures in the print apparently based on a copy of the print in the collection of the Sophienburg Museum in New Braunfels (*Iwonski*, 71). See Cecilia Steinfeldt, *Art for History's Sake: The Texas Collection of the Witte Museum* (Austin: Texas State Historical Association for the Witte Museum, 1993), 138–139. The Witte Museum in San Antonio owns a copy of the print on which someone, probably a previous owner, has identified the men as Dosch, Dr. Roemer (rather than Remer), and Ferdinand Lindheimer, the botanist and newspaper editor, rather than Bracht. The figure on horseback probably was not intended to be Dr. Roemer, because he had left Texas by the time Iwonski made the drawing. Viktor Bracht's book, *Texas in 1848*, trans. Charles Frank Schmidt (San Antonio: Naylor Printing, 1931) was published in Elberfeld u. Iserlohn by J. Badeker in 1849.

74. *Neu-Braunfelser Zeitung*, June 1, p. 4; June 8, p. 3; and June 22, 1855, p. 3; and Sept. 19, 1856. For information on Iwonski, see McGuire, *Iwonski*, 14–16.

75. The Dammann drawing came out of Germany recently. Personal communication, Harry Halff to the author, May 26, 2020. Dammann arrived in Texas in 1846: see Chester William Geue and Ethel Hander Geue, *A New Land Beckoned to Texas, 1844–1847* (Baltimore: Clearfield Co., Genealogical Publishing Co., 2002), 87. Iwonski's pencil drawing was a part of Prince Paul's collection in the Württembergische Landsbibliotek in Stuttgart, where it was discovered and photographed in 1935 by Dr. Charles L. Camp of the University of California. The original sketches and accompanying documents were destroyed during a bombing raid in World War II, but Dr. Camp's photographs have been preserved in the Lovejoy Library, Southern Illinois University at Edwardsville: see McGuire, *Iwonski*, 61; see also *Neu-Braunfelser Zeitung*, Apr. 20, 1855, 2; Paul Wilhelm, Duke of Wurttemberg, *Travels in North America, 1822–1824*, trans. W. Robert Nitske, ed. Savoie Lottinville (Norman: University of Oklahoma Press, 1973), xiii, xxiv.

About the same time Iwonski's view was published in Leipzig, views of New Braunfels and San Antonio were published in Meyer's *Universum*: New Braunfels, 18 (1857), plate 773 (55–57); San Antonio, 18 (1857), plate 715 (149–150). These engravings have been reproduced frequently and are subject to much misstatement and confusion. (See Pinckney, *Painting in Texas*, 153, for example, where Ms. Pinckney credits them to an artist named "Eigenthum d. Verleger," which, in fact, translates as "property of the publisher.") The inclusion of the New Braunfels print in the translation of Prince Carl's *Texas*, 12, has led some, who probably have mistaken the citation of a map of New Braunfels for a reference to a view, to speculate that this image might have been included in a second issue of the Solms-Braunfels book. These views could have been the work of any one of several German artists active in Texas at that time, especially Dammann, Iwonski, and/or Rordorf. See Colton Storm, comp., *A Catalogue of the Everett D. Graff Collection of Western Americana* (Chicago: University of Chicago Press, 1968), 584, entry no. 3889, for citation of the map of New Braunfels.

76. McGuire, *Iwonski*, 15, 19–20, 71. Haas has identified the individuals as (*left to right*): Ed. Rische, F. Moureau, H. Conring, A. Baier, Aug. Bechstedt, C. H. Holtz, Jul. Bremer, H. Seele, E. vom Stein, G. Eisenlohr, A. Schlameus, J. Rennert, H. Schimmelpfennig, and A. Hartmann (*New Braunfels*, 106). See also Albrecht, "San Antonio's Singing Mayor," 8; and Steinfeldt, *Art for History's Sake*, 138.

77. "Our Platform—Another Campaign Document," *SAE*, Feb. 12, 1868, 2 (quote); McGuire, *Iwonski*, 17–21, 71, 82, 84, 88; "Gen Sam Houston's Picture!!," *Tri-Weekly Alamo Express* (San Antonio), Apr. 24, 1861, 1; McGuire and Haynes, "William DeRyee, Carl G. von Iwonski, and Homeography," 49–79; *SAE*, Feb. 8, 1868, 1 (in the collection of the Witte Museum, San Antonio). Swante Palm's collection of DeRyee and Iwonski's homeographs is in the Harry Ransom Center at the University of Texas at Austin, 79.338.1–4.

78. James Patrick McGuire, *Hermann Lungkwitz: Romantic Landscapist on the Texas Frontier* (Austin: University of Texas Press, 1983), 10. McGuire catalogued 341 Lungkwitz drawings, prints, and paintings, 167–195.

79. "Expedition to the Perdinales [*sic*]," *TTR*, Feb. 18, 1846, 2; Beisele, *German Settlements in Texas*, 139–140, 148–149; *HTO*, s.v. "Fredericksburg, TX," by Martin Donell Kohout, accessed Sept. 13, 2020.

80. Hermann Seele, *The Cypress and Other Writings of a German Pioneer in Texas*, trans. Edward C. Breitenkamp (Austin: University of Texas Press, 1979), 157. Kapp returned to Germany for a visit in 1865 and, due to illness, remained there the rest of his life. He published several important works in the fields of philosophy of science and geography during these years. For a reproduction of the *Sketch for the Bath House*, see McGuire, *Lungkwitz*, 11–12, 112. See p. 180 for comments on the print.

81. Samuel Wood Geiser, "Chronology of Dr. Ernst Kapp (1808–1896), Geographer of Early Texas (1849–1865)," *Southwestern Historical Quarterly* 50 (Oct. 1946): 299. For advertisements, see *Neu-Braunfelser Zeitung*, Dec. 2, 1853, 3, and Dec. 9, 1853, 3, in English; *San Antonio Zeitung*, Aug. 13, 1853, 3. The ad ran for several months. See also "Water-Cure Establishment," *Texan Mercury* (Seguin), Mar. 11, 1854, 2, for a long article accompanied by an ad (p. 3); *HTO*, s.v. "Kapp, Ernst," by Terry G. Jordan, accessed Sept. 13, 2020; and Groce and Wallace, *Dictionary of Artists in America*, 376.

82. See McGuire, *Lungkwitz*, 20, 183, for information on the lithograph. Entries 218, 219, and 220 are studies for the lithograph. For information on the fences used by Texas Germans in the Hill Country, see Terry Jordan, *German Seed in Texas Soil: Immigrant Farmers in Nineteenth-Century Texas* (Austin: University of Texas Press, 1966), 163–166.

83. McGuire, *Lungkwitz*, 20 (quoting the *Neu-Braunfelser Zeitung*, Oct. 14, 1859), reproduction of the drawing on 119; and Steinfeldt, *Art for History's Sake*, 159.

84. The first published view of San Antonio appeared in 1840 in Moore, *Map and Description of Texas*. Subsequent views appeared in Hughes, "Memoir Descriptive of the March . . . of Brigadier General John E. Wool," in 1850; Meyer, *Universum*, in 1857; and Emory, *United States and Mexican Boundary Survey*, 1: frontis., in 1857. See also McGuire, *Lungkwitz*, 24.

85. McGuire, *Lungkwitz*, 185; W. W. Newcomb Jr., with Mary S. Carnahan, *German Artist on the Texas Frontier: Friedrich Richard Petri* (Austin: University of Texas Press, 1978), 74–75, 77.

86. Interview with William Green, former Associate Curator of History, Witte Museum, San Antonio, Sept. 28, 1985 (author's collection). The bridge shown in the vignette is the same bridge illustrated in Charles Ramsdel, *San Antonio: A Historical and Pictorial Guide*, ed. Carmen Perry, 2nd rev. ed. (Austin: University of Texas Press, 1985), 15, 32. See also McGuire, *Lungkwitz*, 31, 184–187, and entries 226, 228–231, 233, 243, 244 in the *catalogue raisonné* for the studies and finished paintings for *San Antonio de Bexar*. *San Antonio Zeitung*, Feb. 18, 1854, 3, announces that the "new bridge over the San Antonio River" is ready for pedestrians and would soon be ready for wagons. A comparison with contemporary photographs suggests that the bridge shown in the print is not the bridge over Commerce Street, which was completed in 1859. See also Ahlborn, *Edward Everett*, 57. The painting remained in Germany until a San Antonio collector bought it in Hanover and returned it to Texas.

87. McGuire, *Lungkwitz*, 31; In *Texas: Nature Observations and Reminiscences* (San Antonio: Guessaz and Ferlet Co., 1913), 213, 276–277, Rudolph Menger tells of taking drawing lessons from Lungkwitz after the Civil War and describes Lungkwitz making the drawings for the print, saying that they are "true to nature to a fault." Menger wrote that Lungkwitz drew the central scene from the tower of the Honore Grenet residence, which was located where the Crockett Hotel now stands.

88. "Photographic Gallery," *SAE*, Oct. 18, 1865, 5, and May 16, 1869, 3.

89. McGuire interview, July 31, 1985; Cecilia Steinfeldt and Donald Lewis Stover, *Early Texas Furniture and Decorative Arts* (San Antonio: Trinity University Press for the San Antonio Museum Association, 1973), 136–141.

90. The records disagree on how Nangle's name is spelled. The newspapers of the day and Hollon (*William Bollaert's Texas*, 222) spell it "Nangle," while records in the Texas State Archives, spell it "Naegele" (Secretary of State, Deeds, Abstracts and Cessions of Jurisdictions, State Historical Parks and Monuments, Box 2-10/294). State officials apparently were in contact with the family when the legislature appropriated a thousand dollars to be paid to the family in 1858. Potter's letter to the *New Orleans Crescent*, Mar. 28, 1851, is quoted in C. W. Raines, "The Alamo Monument," *Quarterly of the Texas State Historical Association* 6 (Apr. 1903): 306.

91. *Daily Bulletin* (Austin), Jan. 4, 1842, 3; "Monument of the Alamo," *TTR*, Jan. 26, 1842, 2 (quote), and July 26, 1843, 3; and Nelson, *The Alamo*, 65. For comments on similarly styled monuments, see Kenneth Lindley, *Of Graves and Epitaphs* (London: Hutchison, 1965), 42, 72–73; and James Scott Rawlins, *Virginia's Colonial Churches: An Architectural Guide* (Richmond: Garrett and Massie, 1963), 79. Interview with Dr. Patrick H. Butler III, San Antonio. See his "Knowing the Uncertainties of This Life: Death and Society in Colonial Tidewater Virginia" (PhD diss., Johns Hopkins University, Baltimore, 1998), 275–278.

92. The four sides of the monument, with their inscriptions intact, are preserved in the Texas State Library in Austin. See also Burleson's speech, *TTR*, Apr. 20, 1842, 1; "Disputed Authorship," *GDN*, June 5, 1887, 4; and Raines, "The Alamo Monument," 309n.1. Raines wrote that Guy M. Bryan, nephew of Stephen F. Austin and former Speaker of the Texas House of Representatives, told him in 1898 that Green had also suggested the phrase to Nangle.

93. The image looks more like a woodcut, but it is described in the contemporary literature as a lithograph. Nangle apparently died shortly after the Congress declined to purchase the monument, but no death date is known. "Monument to the Heroes of the Alamo," *Austin City Gazette*, Feb. 16, 1842, 4; "The Alamo Monument," *TSG* (Austin), Jan. 29, 1853, 3; "The Heroes of the Alamo," *Weekly Journal* (Galveston), Feb. 11, 1853, 4; "From Our Austin Correspondent," *Washington American* (Washington, TX), Dec. 14, 1855, 2; J., "'Thermopylae had Her Messenger of Defeat, But the Alamo Had None,'" *State Gazette* (Austin), Dec. 15, 1855, 4; "Editorial Correspondence," *GWN*, Dec. 18, 1855, 1; [Illegible], *San Antonio Ledger*, Dec. 22, 1855, 1; *Texas State Times* (Austin), Jan. 5, 1856, 2, and May 10, 1856, 2 (quote); and Raines, "The Alamo Monument," 308. See Deed of Purchase, Feb. 6, 1858, in Secretary of State, Deeds, Abstracts and Cessions of Jurisdictions, State Historical Parks and Monuments, Folder 1, Alamo Monument, Texas State Library and Archives, Austin.

94. "Texas Items," *FDGB*, May 22, 1869, 8; "Military Appointments," May 26, 1869, 5; "Lee on Gettysburg," *FSWGB*, Sept. 8, 1869, 4; "Not an Isolated Case," Sept. 25, 1869, 2; "Texas News," *GDN*, June 8, 1869, 2. See Raines's inscription on copy of the lithograph in the Texas State Library and Archives collection (fig. 5.38).

95. Sam Houston, *Speech of Hon. Sam Houston, of Texas, on the Subject of Compromise. In the Senate of the United States, February 8, 1850* [Washington, DC: Towers, 1850], 16 (quote).

96. Geiser, *Naturalists of the Frontier*, 91–92 (quote); J. George Harris to James K. Polk, June 12, 1845, quoted in Friend, *Sam Houston*, 157.

97. Crook, "Sam Houston and Eliza Allen," 1–36. The portrait, which is in the collection of the Harry Ransom Center at UT Austin, has long been attributed to Cooper, but there is no compelling evidence of his authorship. See Friend, *Sam Houston*, opp. 18 and opp. 50.

98. In "The Intellectual Climate of Houston during the Period of the Republic," *Southwestern Historical Quarterly* 62 (Jan. 1959): 318, Andrew Forest Muir, describes Houston as having his portrait painted by both Jefferson Wright and Ambrose Andrews in 1837. See William F. Stapp, "Daguerreotypes onto Stone," in Reaves, *American Portrait Prints*, 201, 220. Information on Plumbe may be found in Alan Fern, "John Plumbe and the 'Plumbeotype,'" in Looney, *Philadelphia Printmaking*, 149–163.

99. Houston to Thomas M. Bagby, Huntsville, May 7, 1849, and Houston to Ashbel Smith, Huntsville, May 31, 1849, in Williams and Barker, *Writings of Sam Houston*, 5:92, 94.

100. *Cass & His Cabinet in 1849*, Prints and Photographs online catalog, Library of Congress, accessed Dec. 20, 2021, http://www.loc.gov/pictures/item/2008661495. Houston is shown second from the right.

101. Corwin to J. J. Crittenden, Jan. 10, 1852, in Mrs. Chapman Coleman, ed., *The Life of John J. Crittenden, with Selections from His Correspondence and Speeches*, 2 vols. (Philadelphia: J. B. Lippincott, 1871), 2:38.
102. Walter L. Buenger, "Secession and the Texas German Community: Editor Lindheimer vs. Editor Flake," *Southwestern Historical Quarterly* 82 (Apr. 1979): 383–384.
103. *HTO*, s.v. "Gray, Peter W.," by Thomas W. Cutrer, accessed Sept. 13, 2020; and Jenkins, *Basic Texas Books*, 590–593, quotes on 591. For Huber, see Groce and Wallace, *Dictionary of Artists in America*, 332. For the Bean miniature, see Jackson, *Indian Agent*.
104. David C. Humphrey, *Peg Leg: The Improbable Life of a Texas Hero, Thomas William Ward, 1807–1872* (Denton: Texas State Historical Association, 2009), 157.
105. McKelvey, *Botanical Exploration of the Trans-Mississippi West*, 365–382, 486–507, 890–913.
106. Van Houtte's nursery and publication were known in Texas. See "Hyacinths in the Garden," *GDN*, Aug. 18, 1883, 4.
107. Quoted in Ray Desmond, "Victorian Gardening Magazines," *Garden History* 5, no. 3 (Winter 1977): 64.
108. "Pentstemon Wrightii. Mr. Wright's Pentstemmon," *Curtis's Botanical Magazine* 77 (1851), Tab. 4601.

CHAPTER 6: "THE DARK CORNER OF THE CONFEDERACY"

The chapter title quote is from Kate Stone, *Brokenburn: The Journal of Kate Stone, 1861–1868*, ed. John Q. Anderson (Baton Rouge: Louisiana State University Press, 1955), 237.

1. *HTO*, s.v. "Smith, John Jeremiah [Coho]," by William S. Warren, accessed Sept. 13, 2020; see also Smith, *Cohographs*.
2. For the history of the La Réunion community, see James Pratt, *Sabotaged: Dreams of Utopia in Texas* (Lincoln: University of Nebraska Press, 2020); George H. Santerre, *White Cliffs of Dallas: The Story of La Reunion, the Old French Colony* (Dallas: Book Craft, 1955); and William J. Hammond and Margaret F. Hammond, *La Réunion, a French Settlement in Texas* (Dallas: Royal Publishing Co., 1958).
3. *Dallas Herald*, May 23, 1860, 3 (hereafter cited as *DH*); *GWN*, June 5, 1860, 1; "Rene Paul Henry," in Philip Lindsley, *A History of Greater Dallas and Vicinity*, ed. L. B. Hill, 2 vols. (Chicago: Lewis Publishing, 1909), 2:369; and Huseman, "Beginnings of Lithography in Texas," 35–38.
4. *DH*, Nov. 28, 1860, 3; "A Texas Caricature," *Macon Daily Telegraph* (Georgia), Dec. 24, 1860, 2. Also cited in Winkler, *Check List of Texas Imprints*, 273–274, entry 1385.
5. *HTO*, s.v. "Secession," by Walter L. Buenger, accessed Sept. 13, 2020.
6. Theodore Ropp, "Anacondas Anyone?," *Military Affairs* 27 (Summer 1963): 71–76; and Alwyn Barr, "Texas Coastal Defense, 1861–1865," *Southwestern Historical Quarterly* 65 (July 1961): 1.
7. Quote in B. P. Gallaway, ed., *The Dark Corner of the Confederacy: Accounts of Civil War Texas as Told by Contemporaries*, 2nd ed. (Dubuque, IA: Kendall/Hunt Publishing, 1972), 180; and "Letter from Corpus Christi," *GWN*, June 11, 1861, 3 (quote). For examples of wartime printing on "brown straw paper" and "green paper," see Winkler and Friend, *Check List of Texas Imprints*, 147, entries 938–940.
8. *CGW*, June 11, 1861, 3 (quote).
9. McComb, *Galveston*, 78; Reps, *Views and Viewmakers*, 160–161; and Nat Case, "John Bachmann and the American Bird's-Eye View Print," *Imprint: Journal of the American Historical Print Collectors Society* 33 (Autumn 2008): 19–35. The earliest use of the term "bird's-eye view" (meaning an elevated perspective of the landscape) that I have found is John Joshua Kirby, *Dr. Brook Taylor's Method of Perspective Made Easy, Both in Theory and Practice . . .*, 2 vols., 2nd ed. (Ipswich: W. Craighton, for the author, 1755), 2: app. 5.
10. "Panorama of the Seat of War," *The Press* (Philadelphia), Aug. 9, 1861, 1; "Bird's-Eye Views of the Seat of War," *Daily Evening Bulletin* (San Francisco), Mar. 1, 1862, 3. Bachman distributed his prints widely. See ads in *NYH*, June 8, 1861, 8; *Boston Daily Advertiser*, May 27, 1861, 1; *Boston Evening Transcript*, Aug. 6, 1861, 3; *Chicago Daily Tribune*, Oct. 12, 1861, 2; *Cincinnati Daily Commercial*, Jan. 18, 1862, 2; and even in the *Richmond Examiner* (VA), Dec. 10, 1861, 5.
11. "To Subscribers," *GWN*, June 11, 1861, 1 (quote).
12. "Butter," *GWN*, June 25, 1861, 2; McComb, *Galveston*, 73–75 (quotes).
13. Gambel was born in Baltimore and followed his brother to Texas in 1855. *The Ranchero* (Corpus Christi), Dec. 25, 1862, 2; "Private," "Letter from Corpus Christi," *Weekly Telegraph* (Houston), Dec. 24, 1862, 1; Norman C. Delaney, "Searching for Sergeant Gambel: David Reed Gambel, Soldier and Painter, 1825–1874," *Southwestern Historical Quarterly* 108 (Jan. 2005): 301; and Thomas W. Cutrer, *Theater of a Separate War: The Civil War West of the Mississippi River, 1861–1865* (Chapel Hill: University of North Carolina Press, 2017), 171. Phewl later published a poem in the *New Orleans Republican*, May 17, 1870, 1. For "Ye Tars of Columbia," see Arabkitsch.com, Tars of Columbia, accessed Jan. 7, 2022, https://arabkitsch.com/song-directory-2/990/tars-of-columbia/.
14. *HTO*, s.v. "Grover, George Washington," by Thomas W. Cutrer, accessed Oct. 9, 2020.
15. *HTO*, s.v. "Hatteras," by J. Barto Arnold III, accessed Sept. 13, 2020; Raphael Semmes, *Memoirs of Service Afloat during the War between the States* (Baltimore: Kelly, Piet, 1869), 548–550; James M. McPherson, *War on the Waters: The Union and Confederate Navies, 1861–1865* (Chapel Hill: University of North Carolina Press, 2012), 130; and Edward T. Cotham Jr., *Battle on the Bay: The Civil War Struggle for Galveston* (Austin: University of Texas Press, 1998), 143–147.
16. Frederick Milnes Edge, *An Englishman's View of the Battle Between the* Alabama *and the* Kearsarge . . . (New York: Anson D. F. Randolph, 1864), 99; William Marvel, *The Alabama and the Kearsarge: The Sailor's Civil War* (Chapel Hill: University of North Carolina Press, 1996); and Semmes, *Memoirs of Service Afloat*.
17. "Arrest of Booksellers," *Adams Sentinal* (Gettysburg, PA), May 31, 1864, 1; David W. Bulla, "The Suppression of the Mid-Atlantic Copperhead Press," in *A Press Divided: Newspaper Coverage of the Civil War*, ed. David B. Sachsman (New Brunswick, NJ: Transaction Publishers, 2014); Timothy L. Wesley, *The Politics of Faith During the Civil War* (Baton Rouge: Louisiana State University Press, 2013), ch. 5; Henry Bascom Smith, *Between the Lines: Secret Service Stories Told Fifty Years After* (New York: J. J. Little & Ives, 1911), 109 (quote), 115; and Lois B. McCauley, *A. Hoen on Stone: Lithographs of E. Weber & Co., and A. Hoen & Co., Baltimore, 1835–1969* (Baltimore: Maryland Historical Society, 1969), 2–6.
18. Richard B. McCaslin, *Tainted Breeze: The Great Hanging at Gainesville, Texas, 1862* (Baton Rouge: Louisiana State University Press, 1997).
19. *HTO*, s.v. "Union League," by Carl H. Moneyhon, accessed Sept. 13, 2020; and Carl H. Moneyhon, *The Union League and Biracial Politics in Reconstruction Texas* (College Station: Texas A&M University Press, 2021), 14–15, 68–69. Fenn served as postmaster in Brownsville for a time (*Southern Intelligencer* [Austin], Dec. 22, 1858, 1), and G. A. Staacke was a well-known abolitionist in the Laredo area. A man named Staacke reportedly assisted a slave in crossing the Rio Grande in 1861: *Weekly Telegraph* (Houston), Dec. 4, 1861, 1.
20. "Official. City Council Proceedings," *Daily Ranchero* (Brownsville), July 26, 1870, 2, and Aug. 2, 1870, 2; and S. A. Gray and W. D. Moore, *Mercantile and General City Directory of Austin Texas—1872–73* (Austin: S. A. Gray, Book and Job Printer, 1872), 96. Schlinger died of influenza in Galveston. "Mortuary Report," *GDN*, Jan. 17, 1892, 12.
21. F. Lee Lawrence and Robert W. Glover, *Camp Ford C.S.A.: The Story of Union Prisoners in Texas* (Austin: Texas Civil War Centennial Advisory Committee, 1964), 1, 3, 29. See also Leon Mitchell Jr., "Camp Ford: Confederate Military Prison," *Southwestern Historical Quarterly* 66 (July 1962): 1–16; and *HTO*, s.v. "Camp Ford," by F. Lee Lawrence, accessed Sept. 13, 2020.
22. The Krebs family operated a lithographic company in Pittsburgh for years, changing the name in 1870, when Otto Krebs became the successor to Krebs & Bro. See ad for Otto Krebs Lithographic, Engraving and Printing Establishment in George H. Thurston, *Directory of Pittsburgh & Allegheny Cities, the Adjacent Boroughs, and Parts of the Adjacent Townships for 1870–71* (Pittsburgh: Geo. H. Thurston, 1870), unnumbered advertising page before the title page.
23. Gallaway, *Dark Corner*, 186.
24. Lawrence and Glover, *Camp Ford*, 5–8, 26; Arthur E.

Gilligan, "Yankee Prisoner in Texas, 1865," in Gallaway, *Dark Corner*, 187–188.

25. Lawrence and Glover, *Camp Ford*, 11–12.

26. Ibid., 8. The Confederates captured Duganne and May, among 1,300 others, in June 1863 in the Bayou Teche Campaign in southern Louisiana. See W. A. Croffut and John M. Morris, *The Military and Civil History of Connecticut during the War of 1861–65...*, 3rd ed. (New York: Ledyard Bill, 1869), 430–432; A. J. H. Duganne, *Camps and Prisons: Twenty Months in the Department of the Gulf* (New York: J. P. Robens, 1865), 335. See also "The Old Flag (TX, 1864)," The Handwritten Newspapers Project, accessed Jan. 7, 2022, http://handwrittennews.com/2011/07/16/the-old-flag-tx-1864.

27. Robert W. Glover, "Camp Ford: Largest Confederate Prison Camp West of the Mississippi, Tyler, Texas," MS in possession of the author; Handwritten Newspapers Project; J. P. Robens, *The Old Flag: First Published by Union Prisoners at Camp Ford, Tyler, Texas* (N.P.: J. P. Robens, [1865]). Robens apparently sent a copy of his publication to the editor of the *Boston Daily Advertiser*, who noticed it on Aug. 23, 1865, 1. After May had been exchanged, Capt. Lewis Burger hand-lettered one issue of the *Camp Ford News* in 1865. According to an article ("The Old Flag," *St. Louis Republic*, Mar. 15, 1896, pt. 4, 34), a Chicago newspaper had recently published a facsimile of *The Old Flag*.

28. "The Old Flag," *Anamosa Eurika* (Iowa), Jan. 13, 1870, 3.

29. George Bernard Erath, "Memoirs of Major George Bernard Erath," comp. Lucy A. Erath, *Southwestern Historical Quarterly* 28 (Oct. 1923): 160.

30. *HTO*, s.v. "Dove Creek, Battle of," by Elmer Kelton, accessed Sept. 13, 2020; William C. Pool, "The Battle of Dove Creek," *Southwestern Historical Quarterly* 53 (Apr. 1950): 367–385; David Paul Smith, *Frontier Defense in the Civil War: Texas' Rangers and Rebels* (College Station: Texas A&M University Press, 1992), 151–155; and Anderson, *Conquest of Texas*, 342.

31. Erath, "Memoirs of Major Erath," 161.

32. Victor Debray sold the firm in 1881 and his successors made the print. See "Victor Debray et Cie," *Le Trait d'Union* (Mexico), Apr. 24, 1881, 3. See also Mathes, *Mexico on Stone*, 35.

33. General Orders No. 3, declaring that "all slaves are free," was published in both the *Galveston Tri-Weekly News*, June 20, 1865, 1 (hereafter cited as *GTWN*), and *Flake's Tri-Weekly Bulletin*, June 20, 1865, 2. See also *HTO*, s.v. "Civil War," by Ralph A. Wooster, rev. Brett J. Derbes, accessed Sept. 13, 2020.

34. Rev. P. F. Parisot, *The Reminiscences of a Texas Missionary* (San Antonio: St. Mary's Church, 1899), 56 (quote); Manuel Humberto González Ramos, *Historia del puerto de Bagdad* (Matamoros: Published by the author, 2005), contains a drawing after the lithograph; James A. Irby, *Backdoor at Bagdad: The Civil War on the Rio Grande* (El Paso: Texas Western Press at the University of Texas at El Paso, 1977); and Melinda Rankin, *Twenty Years among the Mexicans: A Narrative of Missionary Labor* (Cincinnati: Chase & Hall, Publishers, 1875), 99 (quote); "From Matamoros," *Houston Tri-Weekly Telegraph*, June 2, 1865, 2 (quote).

35. Gallaway, *Dark Corner*, 14; Thomas North, *Five Years in Texas* (Cincinnati: Elm Street Printing, 1871), 102 (quote); and E. Merton Coulter, *Travels in the Confederate States: A Bibliography* (Norman: University of Oklahoma Press, 1948), 346. For a good summary of Civil War conflicts in Texas, see Frank H. Smyrl, *Texas in Gray: The Civil War Years, 1861–1865* (Boston: American Press, 1983), 16–23, 36–37. For the trade with Mexico during the war, see Ronnie C. Tyler, *Santiago Vidaurri and the Southern Confederacy* (Austin: Texas State Historical Association, 1973), esp. chs. 3 and 4.

36. Carl H. Moneyhon, *HTO*, s.v. "Reconstruction," by Carl H. Moneyhon, accessed Sept. 13, 2020. See also William Curtis Nunn, *Texas Under the Carpetbaggers* (Austin: University of Texas Press, 1962), 117–119, 121–132; Carl Moneyhon, *Republicanism in Reconstruction Texas* (Austin: University of Texas Press, 1980; reprint College Station: Texas A&M University Press, 2000); and Randolph B. Campbell, *Grass-Roots Reconstruction in Texas, 1865–1880* (Baton Rouge: Louisiana State University Press, 1997).

37. Christopher B. Bean, *Too Great a Burden to Bear: The Struggle and Failure of the Freedman's Bureau in Texas* (New York: Fordham University Press, 2017), 31 (quote). See also James Marten, *Texas Divided: Loyalty & Dissent in the Lone Star State, 1856–1874* (Lexington: University of Kentucky Press, 1984).

38. "Lawlessness," *Southern Intelligencer* (Austin), Oct. 4, 1866, 4, quoting *FB*.

39. North, *Five Years in Texas*, 104.

40. Ibid., 105; Cary D. Wintz, *Reconstruction in Texas* (Boston: American Press, 1983), 12–14, 14–15 (quote). See also David Pickering and Judy Falls, *Brush Men and Vigilantes: Civil War Dissent in Texas* (College Station: Texas A&M University Press, 2000). For examples of the term "Young Texas" in the contemporary press, see "A New Idea," *The Liberator* (Boston), Dec. 12, 1845, 1; "On The Philosophy of Life," *Spirit of the Times* (New York), Feb. 1, 1848, 599; "Texas," *Tri-Weekly Telegraph* (Houston), Nov. 24, 1862, 1; "Our Next State Officials," *Houston Daily Mercury*, Aug. 9, 1873, 2; and "Young Texas," *GDN*, June 9, 1875, 4.

41. O. O. Howard, *Autobiography of Oliver Otis Howard, Major General, United States Army*, 2 vols. (New York: Baker & Taylor, 1907–1908), 2:218. William L. Richter, *Overreached on All Sides: The Freedman's Bureau Administration in Texas, 1865–1868* (College Station: Texas A&M University Press, 1991), 3, 166–167, 194, 281–282, 285, 302; "Pictorials," *GDN*, Sept. 26, 1865, 2.

42. "Coho Smith," *DH*, Oct. 16, 1869, 3; and J. R. Davis ad in "Look Here," *DH*, Oct. 19, 1867, 2. There is no evidence that Smith's drawings were ever printed.

43. McCoy to his parents, undated, late 1870 or early 1871, in Elizabeth York Enstam, ed., *When Dallas Became a City: Letters of John Milton McCoy, 1870–1881* (Dallas: Dallas Historical Society, 1982), 21.

44. Erath, "Memoirs of Major Erath," 161.

45. P.J.M., "Texas," *Cultivator & Country Gentleman* 31 (Jan. 30, 1868): 84, and ibid., H. J. Chamberlin, "Letter from Texas," (Apr. 9, 1868): 262.

46. McCoy to his parents, undated, late 1870 or early 1871, in Enstam, *When Dallas Became a City*, 21.

CHAPTER 7: "THE ENTERPRISE WAS NOT PROPERLY APPRECIATED"

The chapter title quote is from "Strickland's," *GDN*, Mar. 5, 1878, 4.

1. Carl Moneyhon, *Texas after the Civil War: The Struggle of Reconstruction* (College Station: Texas A&M University Press, 2004), 77–86, 115, 174–176, 182–183, 164; Barbara J. Rozek, *Come to Texas: Enticing Immigrants, 1865–1915* (College Station: Texas A&M University Press, 2003), 16–17, 79, 102–104; David La Vere, *The Texas Indians* (College Station: Texas A&M University Press, 2004), 202–216; Anderson, *Conquest of Texas*, 345–361; and E. T. Miller, "A Financial History of Texas," *Bulletin of The University of Texas*, no. 37 (July 1, 1916). See also Harry Williams, "The Development of a Market Economy in Texas: The Establishment of the Railway Network, 1836–1890" (PhD diss., University of Texas, Austin, 1957), 324; and Edwin L. Caldwell, "Highlights of the Development of Manufacturing in Texas, 1900–1960," *Southwestern Historical Quarterly* 68 (Apr. 1965): 1.

2. "Local Intelligence," *Flake's Daily Bulletin*, Aug. 29, 1865, 3 (quote, hereafter cited as *FDB*). See also numerous ads in the latter months of 1865 (e.g., Dec. 28, 1865).

3. Fornell, *Galveston Era*, 144–145; Wheeler, *To Wear a City's Crown*, 94–96; "Galveston and the Great West," *GDN*, May 3, 1866, 2 (quote); and Earle B. Young, *Galveston and the Great West* (College Station: Texas A&M University Press, 1997), 3–9. Richardson's prewar suggestion had failed when the city's leaders insisted on private rather than public financing. See also "M. Strickland," *GDN*, June 1, 1866, 2; and *FDGB*, June 2, 1866, 4; "M. Strickland," June 4, 1866, 4; and "Mr. Strickland," *Tri-Weekly Telegraph* (Houston), June 13, 1866, 2, and Nov. 7, 1866, 4.

4. Of English descent, Strickland was born in Ontario, Canada, in about 1838: see 1880 US Federal Census, Galveston, TX, https://www.ancestrylibrary.com, 9; Hayes, *Galveston*, 2:980–981. Strickland apparently purchased the bindery from A. A. Durnett (who had purchased it from Dunning's estate) in 1859 and partnered with James Owen. See Richardson, *Galveston Directory for 1859–60*, 23; "Book Binding," *CGW*, May 3, 1859, 2; "Book Binding," *CGW*, Jan. 17, 1860, 2, and "Book Bindery and Blank Book Manufactory," Jan. 1, 1861, 1; and *Hempstead Courier*, May 26, 1860, 4.

5. Hayes, *Galveston*, 2:980. Charles W. Hayes, a Union

veteran and Galveston journalist, wrote his history of Galveston over a period of five years shortly after his arrival on the island, and Strickland intended to print it in 1879 or 1880. Strickland had sent the manuscript to Cincinnati to be typeset and electrotyped and had received a proof copy. It contains many typos, which he intended to correct, but he then learned that a fire at the Cincinnati printer had destroyed the original manuscript and all the plates and that his proof copy was the only remaining copy. His son, John, brought the proof copy before the Texas Historical Society in Galveston in 1896, but it was referred to committee. "Lovers of History," *GDN*, Mar. 17, 1896, 7. The *GDN* printed much of the book serially in 1942 and 1943, but the full manuscript was not issued until the Jenkins Garrett Press published it in two volumes in 1974 from the hand-corrected galleys that had somehow survived the Galveston flood of 1900.

6. "Hospital Contributions," *Tri-Weekly Telegraph*, Dec. 19, 1862, 2; "Strickland & Owen," *FDGB*, Oct. 5, 1866, 4; "New Advertisements," *GDN*, Dec. 26, 1866, 5. In 1867 Strickland split with Owen and moved to new quarters at 112 Tremont Street. "New Advertisements," *FDGB*, Dec. 26, 1866, 5; *FDGB*, "New Advertisements," Jan. 5, 1867, 4, and Jan. 26, 1868, 5; and "Dissolution," *GDN*, Jan. 25, 1867, 6.

7. Hayes, *Galveston*, 2:980; Richardson, *Galveston Directory for 1859–60*, 23; "Lithographing and Printing," *GDN*, Dec. 18, 1868, 2; *GDN*, Apr. 21, 1869, 3 (Sign of the Big Book); "M. Strickland & Co.," *Galveston Daily Civilian*, Aug. 6, 1869, 2; "M. Strickland & Co.," *Jasper News-Boy*, June 24, 1871, 2; *Lampasas Dispatch*, Dec. 14, 1872, 3; *Beaumont News-Beacon*, June 7, 1873, 3; and *Texas New Yorker* (New York), June 1, 1877, 8. Strickland changed the name of the company to M. Strickland & Co.: see John H. Heller, *Galveston City Directory for 1870* (Galveston: John H. Heller, 1870), 24, 29, 30, 57, and 114.

8. Hayes, *Galveston*, 2:980–981 (quotes); "The Commercial," *GDN*, May 31, 1871, 2; and *GDN*, "Victorious Once More," July 2, 1871, 3.

9. Marzio, *Democratic Art*, 3 quoting the 1870 census.

10. "Special Notices," *GDN*, Oct. 12, 1871, 2. Strickland and Burck announced that they had dissolved their partnership in "Copartnership," *FDB*, June 5, 1872, 8. "The Eternal Fitness of Things," *GDN*, June 9, 1872, 3; "Still Growing in Popularity," *GDN*, Sept. 1, 1872, 3; and "A Neat and Handsome Piece of Job Printing," *GTWN*, Dec. 2, 1872, 3, and June 9, 1873, 3; *GDN*, Apr. 6, 1873, 3, and Jan. 11, 1874, 4. For Clarke's previous business with Joseph Smallwood, see *FDB*, Mar. 28, 1869, 4. See also Peter C. Marzio, "Lithography as a Democratic Art: A Reappraisal," *Leonardo* 4 (Winter 1971): 46; Marzio says that by the 1870s and '80s, Richard Hoe offered at least five powered presses. The largest weighed 12.5 tons, was powered by a one-horsepower engine, and cost $7,200.

11. *GTWN*, Dec. 2, 1872, 3, and June 9, 1873, 3; "Railroads, Insurance and Banking Companies of Texas," *Houston Daily Mercury*, Sept. 28, 1873, 3, and 5; "The Only Lithographic Office in the State," *GDN*, Aug. 17, 1873, 2, and Jan. 11, 1874, 4. Strickland often had to look outside of Texas for trained lithographers. When he added steam printing in 1873, one of the seven new lithographers that joined the firm came from Germany.

12. "Strickland & Clarke," *Houston Daily Mercury*, Nov. 30, 1873, 5 (quote); Hayes, *Galveston*, 2:981 (quote); "A Bargain," *GDN*, Sept. 20, 1874, 2; "Commercial," *GDN*, Dec. 31, 1874, 3 (quote).

13. "Correspondence of the Junction City Tribune from Wichita," *Wichita City Eagle* (KS), Nov. 27, 1873 (quote).

14. Julia Kathryn Garrett, *Fort Worth: A Frontier Triumph*, 2nd ed. (Fort Worth: Texas Christian University Press, 1996), 258–260, 266–269, 283–285, 288–289, 311–318, 329–337; *Dallas Weekly Herald*, Nov. 15, 1873, 3.

15. Hayes, *Galveston*, 2:981; "A Bargain," *GDN*, Sept. 20, 1874, 2; "Commercial," *GDN*, Dec. 31, 1874, 3 (quote); and "Notice," *GDN*, Aug. 27, 1875, 3.

16. The *GDN* carried frequent accounts of Indian raids and incidents. See, for example, "Texas Items," Jan. 3, 1874, 2, and "From San Antonio," Jan. 4, 1874, 1.

17. "The Finances and Future of Texas," *New York Daily Herald*, Mar. 2, 1874, 7. See also Gary Cartwright, *Galveston: A History of the Island* (New York: Atheneum, 1991), 114–115. The railroad to San Antonio was not completed until 1877.

18. James P. Baughman, "Letters from the Texas Coast, 1875," *Southwestern Historical Quarterly* 69 (Apr. 1966): 499.

19. "Gen. Grant and Party," *GDN*, Mar. 25, 1880, 4; "Speech," in John Y. Simon, ed., *The Papers of Ulysses S. Grant*, 32 vols. (Carbondale: Southern Illinois University Press, 1967–2009), 29:369; Earle B. Young, *Tracks to the Sea: Galveston and Western Railroad Development, 1866–1900* (College Station: Texas A&M University Press, 1999), 56–57; and Edward T. Cotham Jr., *A Busy Week in Texas: Ulysses S. Grant's 1880 Visit to the Lone Star State* (Austin: Texas State Historical Association, 2021). Sheridan said that he only meant to convey his disgust with the newspaperman who put the question to him.

20. "Mr. F. T. Ryan," *GDN*, June 2, 1874, 2 (quote).

21. "Rival of Nast," *GDN*, Mar. 5, 1876, 4.

22. "The Cotton Exchange Pen and Ink Sketches," *GDN*, Apr. 2, 1876, 4.

23. *Galveston Cotton Exchange Sketches*, 2nd ed. (Galveston: M. Strickland, 1876). Bearbaiting, usually with dogs but often with other animals, was popular in England and other countries until the nineteenth century. In the early nineteenth century the Spanish garrison at San Francisco arranged bull and bear fights to entertain visitors. See G. H. Von Langsdorff, *Voyages and Travels in Various Parts of the World, during the Years 1803, 1804, 1805, 1806, and 1807*, 2 vols. (London: Henry Colburn, 1813–14), 2:181; Otto Von Kotzebue, *A Voyage of Discovery, into the South Sea and Beering's Straits, for the Purpose of Exploring a North-East Passage, Undertaken in the years 1815–1818 . . . ,* 3 vols. (London: Longman, Hurst, Rees, Orme, and Brown, 1821), 1:287–288; and Adelbert von Chamisso, *A Voyage around the World with the Romanzov Exploring Expedition in the Years 1815–1818, in the Brig Rurik, Captain Otto Von Kotzebue*, trans. and ed. Henry Kratz (Honolulu: University of Hawaii Press, 1986), 106.

24. "The Cotton Exchange Sketches," *GDN*, May 25, 1876, 4.

25. "New Map of Galveston," *GDN*, Oct. 15, 1876, 2; and "New Map—Surface Elevations," 4. For a full description of the map, see Dorothy Sloan—Books, accessed Jan. 7, 2022, https://www.dsloan.com/Auctions/A23/item-map-washington-galveston-1876.html. According to Henry G. Taliaferro, this is the first edition of the map (see *Cartographic Sources in the Rosenberg Library* [College Station: Texas A&M University Press, 1988], 356A). A second edition did not contain the ads or illustrations around the margins, and a third edition was issued folded into cloth pocket covers.

26. Dorothy Sloan—Books, Auction 23, Item 385, dsloan.com.

27. "Stricklands," *GDN*, Mar. 5, 1878, 4 (quote).

28. *GTWN*, Feb. 15, 1871, 1; "Mardi Gras," *GTWN*, Feb. 17, 1871, 3; "Mardi Gras," *GTWN*, Feb. 22, 1871, 3; and "Jolly Young Bachelors," *FDGB*, Mar. 1, 1867, 5.

29. "The Bal Masque," *FDGB*, Mar. 7, 1867, 1 (quote); "The Bal Masque," *FDGB*, Feb. 6, 1872, 5; "K.O.M.," *FDGB*, Feb. 25, 1868, 5, reported that "there appears a greater disposition to celebrate the day than we have ever observed in Galveston" and that a permit had been granted for a Mardi Gras parade. A summary of the history of the event to date appears in "Mardi Gras Parades and Spectacles," *GWN*, Mar. 3, 1879, 5. See also "The Bal Masque," *Flake's Weekly Galveston Bulletin*, Mar. 13, 1867, 13.

30. "Art," *The Churchman*, Aug. 22, 1885, 207 (quote); "From Houston," *GDN*, Feb. 25, 1873, 2.

31. See, for example, Henri Schindler, *Mardi Gras Treasures: Invitations of the Golden Age* (Gretna, LA: Pelican Publishing, 2000). A reporter claiming to have been chosen by the Knights of Momus, who organized the celebration beginning in 1871, to "make their communications with the public, knows no more than he writes." See "Mystic Societies," *GDN*, Feb. 4, 1872, 2. Several readers accused the columnist who wrote "Mardi Gras Siftings" *GWN*, Feb. 12, 1880, 8, of exaggerating, of "impart[ing] unhealthy swelling to the truth," in his coverage of the Mardi Gras events. The reporter agreed that he was guilty of "the truth, as it is, but not too much of it at a time."

32. Marzio, *Democratic Art*, 191.

33. "Mardi Gras," *GTWN*, Feb. 22, 1871, 3; Baughman, ""Letters from the Texas Coast, 1875," 504; "Engraving and Lithographing," *Times-Picayune* (New Orleans), Jan. 7, 1872, 2; Mahé and McCaffrey, *Encyclopedia of New Orleans Artists*, 112–113; Twyman, *History of Chromolithography*, 131.

34. "Mystical," *Galveston Tri-Weekly Civilian*, Feb. 11, 1873, 3; *Daily Graphic*, Feb. 26, 1876, 5.

35. There are a number of persons, both men and women, who listed themselves in the newspapers, the census, and the city directories as artists residing in Galveston during the last four decades of the nineteenth century, but none of them identified as working for Strickland.

36. "Texas Press," *GDN*, Feb. 4, 1875, 2 (quoting the *Belton Journal*); "K.O.M.," *GDN*, Jan. 29, 1875, 4 (quote); and Schindler, *Mardi Gras Treasures*.

37. "K.O.M.," *GDN*, Jan. 28, 1877, 4.

38. "The Mid Day Revelers," *GDN*, Feb. 14, 1877, 4.

39. *Waxahachie Enterprise*, Jan. 27, 1876, 5; "Rival of Nast," Mar. 5, 1876, 7; "The Cotton Exchange Pen and Ink Sketches," Apr. 2, 1876, 4 (quote); "The Cotton Exchange Sketches," May 25, 1876, 4 (quote); and "An Indignant Celestial," Aug. 16, 1877, 4, all from *GDN*; "Strickland's," *GDN*, Mar. 5, 1878, 4. Whether Strickland sold his Hoe press is unclear. If he did, he acquired another one in 1877 or 1878.

40. "Fine Printing," *GDN*, Jan. 31, 1878, 4; and "Arrived," *GDN*, Feb. 19, 1878, 3. The editor of the *Brenham Weekly Banner* (Jan. 11, 1878, 2) acknowledged receiving a "handsome lithographic poster announcing Mardi Gras festivities to take place in Galveston," but it probably was not the print issued by the *News* because of the disparity in the dates of the news stories. See also "The Coming Mardi Gras," *GDN*, Jan. 27, 1891, 8; and "Local Railroad Notes," *GDN*, Feb. 22, 1891, 4.

41. *Fort Worth Standard*, Feb. 6, 1878, 4.

42. "Personal," *GDN*, Dec. 7, 1878, 1, "Creations of Art," Jan. 5, p. 4, "Matters and Things," Feb. 2, p. 4, and "Galveston Art," Mar. 23, 1879, 4. Moser was one of the illustrators for Joel Chandler Harris, *Uncle Remus: His Songs and His Sayings; the Folk-Lore of the Old Plantation* (New York: D. Appleton, 1881 [©1880]).

43. "The City," *GDN*, Feb. 5, 1879, 4; and Grace Moser Fetherolf, *James Henry Moser, His Brush and His Pen* (Phoenix: Fetherolf Publishing, 1982), 10–12.

44. "Momus!" *GDN*, Feb. 26, 1879, 4.

45. *GDN*, Mar. 1, 1879, 1; and "The T. C. Masquerade," *GDN*, Jan. 12, 1879, 4. See "The Mask Ball," *Fort Worth Daily Democrat*, May 15, 1879, 4, for example.

46. "The King's Rule," *GDN*, Feb. 22, 1882, 4. The various Mardi Gras groups sent out approximately thirty thousand invitations in 1882, three to four thousand distributed in Galveston. "The Merry King of Carnival," *GDN*, Feb. 2, 1882, 4.

47. "The Coming Mardi Gras," *GDN*, Jan. 27, 1891, 8, says that "the picture of Uncle Sam tendering Galveston the $6,200,000 which forms the central figure on the Mardi Gras advertising matter, was originated and first designed by Maj. W. A. Caskie, a well-known artist of this city, and formed an attractive street sign for a real estate firm during the recent November jubilee."

48. The *El Paso International Daily Times*, Jan. 23, 1891, 4, offered compliments on the "beautiful and unique" invitation. See also "The Waco Wagon," *GDN*, Jan. 28, 1891, 3; "The Mardi Gras Invitations," *GDN*, Jan. 27, p. 8; and "The State Press," *GDN*, Jan. 28, p. 3.

49. The Strickland firm printed the Galveston city directory in 1874, 1875, 1876, 1878, 1880, 1881, and 1884.

50. Shortly after John H. Moser finished the Cotton Exchange building, he and his family moved to Vicksburg, Mississippi. Fetherolf, *James Henry Moser*, 14.

51. "Sour Lake," *Evening Tribune* (Galveston), July 20, 1885, 1; and *HTO*, s.v. "Sour Lake, TX," Diana J. Kleiner, accessed May 04, 2021.

52. "Galveston Saengerfest," *DDH*, Apr. 20, 1881, 4; "State Press," *GDN*, Mar. 29, 1881, 2. See also Scardino and Turner, *Clayton's Galveston*, 49–50, 212.

53. "The Saenger-Fest Pavilion," *Texas Journal of Commerce* (Galveston), Mar. 19, 1881, 2; and "The Texas Journal of Commerce," *Colorado Citizen* (Columbus, TX), Mar. 24, 1881, 2 (quote).

54. *Sunday Opera Glass* (Galveston), Aug. 5, 1883, issue not known to exist, but the large picture of the pavilion does exist in the collection of the BCAH.

55. "Abreast with the Times," *DDH*, June 15, 1881, 3. The ad appeared in Andres Morrison, *The Industries of Dallas: Her Relations as a Center of Trade* (Dallas: Metropolitan Publishing, 1887).

56. "Description of San Saba County," *San Saba News*, Dec. 25, 1880, 1 (quote).

57. "Discovery of Lithographic Stone," *Voice of Freedom* (Brandon, VT), Mar. 6, 1845, 4; "Minerals on the Sunset Route," *GDN*, May 5, 1878, 1; "Description of San Saba County," *San Saba News*, Dec. 25, 1880, 1 (quote); and J. L. Tait, *A Six Months Exploration of the State of Texas; Giving an Account of Its Climate, Soil, Productions, and Mineral Resources* (London: "Anglo-American" Times Press, 1876), 30.

58. *San Marcos Free Press*, June 22, 1882, 4; "Texas at the Exposition," *Standard* (Clarksville), June 19, 1885, 2; "Natural Products of Texas," *GDN*, Apr. 29, 1885, 2; and "Texas Abroad," *San Saba News*, Nov. 22, 1889, 1.

59. "Burnet, September 17," *Austin Weekly Statesman*, Sept. 23, 1886, 2 (second quote); ibid., "Personal Mention," Oct. 28, 1886, 1; "Burnet," *DMN*, Sept. 30, 1886, 5; *DMN*, "The Burnet Quarries," Oct. 6, 1886, 5 (first quote); "Natural Resources," *Fort Worth Daily Gazette*, Jan. 2, 1887, 4 (third quote); ibid., "A Valuable Product," Nov. 14, 1887, 8; *DH*, Nov. 14, 1887, 4 (fourth quote); "The Dallas Lithographic Co.," *Dallas Weekly Herald*, Nov. 19, 1887, 2; "Mines," *GDN*, July 5, 1885, 2; "Burnet," *GDN*, Sept. 30, 1886, 3; "Texas Lithographic Stone," *GDN*, Oct. 6, 1886, 3; A. R. Johnson, *Homes in Texas. 200,000 Acres of Valuable Land for Sale* ([Burnet, TX]: [A. R. Johnson], c. 1890), 2; Frederick W. Simonds, *A Record of the Geology of Texas for the Decade Ending December 31, 1896* (Austin: Von Boeckmann, Schutze, 1900), 39, 55, 66; Department of the Interior, Census Office, *Preliminary Results as Contained in the Eleventh Census Bulletins* 3, no. 75 (June 8, 1891): 36–37; and Weimerskirch, "Lithographic Stone in America," 2–15.

60. "The Only Lithographic Establishment," *GDN*, June 24, 1883, 4.

61. "An Unfortunate Visit," *St. Louis Daily Globe-Democrat*, Mar. 9, 1882, 6; and ibid., "Death of Mr. Strickland," Mar. 14, 1882, 4. "The City. In Memoriam. Funeral Ceremonies of the Late Miles Strickland," *GDN*, Apr. 4, 1882, 4; "Galveston," *Fort Worth Daily Democrat-Advance*, Apr. 4, 1882, 1; and "Galveston," *DDH*, 1.

62. "The Galveston News," *GDN*, Nov. 25, 1881, 1; "State Press," *GDN*, Feb. 19, 1882, 2; "Texas Midland Review," *GDN*, Sept. 6, 1882, 4 (quote); "State Press," *GDN*, Feb. 13, 1883, 2 (quote); *Dallas Weekly Herald*, Nov. 23, 1882 (2nd ed.), 6; *Brenham Daily Banner*, Feb. 15, 1883, 2 (quote). Edwardy was a minor notorious character and apparently charming individual. See Larry D. Ball, "William Edwardy: Frontier Journalist and Adventurer," *Journal of Arizona History* 56 (Autumn 2015): 247. After a brief suspension, the *Review* resumed under the editorship of a former *News* staff member, Al. Donaud. It was lithographed on fifty-pound book paper. "The Midland Review," *GDN*, Nov. 11, 1883, 4. Unfortunately, no copies are known today.

63. "The Only Lithographic Establishment," *GDN*, June 17, 1883, 3. Coyle advertised lithography in *Morrison & Fourmy's General Directory of the City of Houston for 1880–81* (Houston: Morrison & Fourmy, 1880). He printed the directory and listed himself as the lithographer on the title page. He also had an ad on the back cover, which is missing from the microfilmed copy of the directory.

64. "Likeness of Pope Leo XIII," *GDN*, Mar. 1, 1878, 4; Mar. 3, 1878, 1; "Strickland's," *GDN*, Mar. 5, 1878, 4 (quote), and May 2, 1882, 4; "Our Exposition Letter," *Daily Cosmopolitan* (Brownsville), Jan. 19, 1885, 1; *The Visitor's Guide to the World's Exposition: Compact, Accurate, Comprehensive: December 16th 1884 to May 31, 1885* (New Orleans: Pub. by Theo. Pohlmann, 1884). Pohlmann worked for a time in Chicago (C. N. Caspar, *Caspar's Directory of the American Book, News and Stationery Trade, Wholesale and Retail* (Milwaukee: C. N. Caspar, 1889), 272) then moved to California, where he worked with Crocker's Printing Establishment before moving to the United States Printing Co.'s west coast branch. See *Fifty Years of Odd Fellowship in California* (San Francisco: Executive Committee Golden Jubilee Celebration, I.O.O.F. of California, 1889), 338; and "U.S. Printing Company Sends Out New Manager," *California Fruit Grower* 48 (Nov. 15, 1913): 14.

65. "Copartnership Notice," *GDN*, July 1, 1879, 2; "Clarke & Courts," *GDN*, Aug. 6, 1879, 1. See also *HTO*, s.v. "Clarke and Courts Printing," by Diana J. Kleiner, accessed Jan. 24, 2022.

66. Clarke & Courts began advertising lithography in November 1884. See *GDN*, Nov. 19, 1884, 3, and Nov. 26, 1884, 3. The *News* reported seeing some "fine Lithography executed by Clarke & Courts" in December. See "Special to the News," *GDN*, Dec. 7, 1884, 5.

67. Thanks to Ben and Christine Andrews, who rescued the Clarke & Courts specimen books and made them available for study and use. The catalogue featured in figure 7.51, for the forerunner of the University of Texas Medical Branch, has lithographs on the front and back covers featuring two of the city's prominent buildings designed by architect Nicholas J. Clayton: City Hospital (front cover) and the much more interesting John Sealy Hospital on the back.

68. "Clarke & Courts," *GDN*, June 12, 1889, 2. The "art preservative" refers to the art of printing. See William S. Walsh, *Handy-Book of Curious Information* (Philadelphia: J. B. Lippincott, 1912), 68.

69. See [Trademark registration by Clarke & Courts for (Texas Flag Logo) brand Blank Books, Calendars, Blotter Covers for Writing Pads, and Printed Stationery], digital file from original, Library of Congress.

70. Clarke & Courts partnership notice in "Copartnership Notice," *GDN*, July 3, 1879, 2. See also "Other Galveston Industries," *GDN*, Sept. 11, 1887, 10; *HTO*, s.v. "Clarke and Courts Printing," by Kleiner; Chester R. Burns, *Saving Lives, Training Caregivers, Making Discoveries: A Centennial History of the University of Texas Medical Branch at Galveston* (Austin: Texas State Historical Association, 2003), 11–12; Scardino and Turner, *Clayton's Galveston*, 83–87, 90, 228–229, 235; "From Galveston," *Inland Printer* 7 (Mar. 1890): 519; ibid., "'The Texas House,' of Galveston," 8 (Sept. 1891): 1089; and ibid., "Of Interest to the Craft," 10 (Feb. 1893): 427. Clarke & Courts closed its business in 1989, and the building has been converted into lofts.

71. *GDN*, Nov. 14, 1885, 1; *SAE*, Nov. 14, 1885, 1. Goggan & Bros. was the first music house in Texas to publish extensively. *HTO*, s.v. "Thomas Goggan and Brothers," by Craig H. Roell, accessed Sept. 14, 2020.

72. Newspaper clipping in M. D. Hinkley, manager, Clarke & Courts, to Ben Huseman, Nov. 20, 1985; *Morrison & Fourmy's General Directory of the City of Galveston, 1886–87* (Galveston: Morrison & Fourmy, 1886), 364. Koch was in Galveston, probably to deliver his finished view, in November, and the fire broke out later that week. "Hotel Arrivals," *GDN*, Nov. 9, 1885, 4; "A Great Holocaust," *GDN*, Nov. 14, 1885, 1; and "Where Those Burned Out Are Now Located," *GDN*, Nov. 20, 1885, 5. See also *Arkansas Gazette* (Little Rock), Nov. 20, 1885, 5, for a comment on what is probably Clarke & Courts's print. "The City," *GDN*, Dec. 6, 1885, 5. For Augustus Koch's view of Galveston, see Galveston Texas—Augustus Koch—Google Arts & Culture online.

73. "The Great Fire," *GDN*, Nov. 15, 1885, 1; "Correct Diagram of the Late Galveston Conflagration," *Evening Tribune* (Galveston), Nov. 16, 1885, 1. For Goggan, see Ellis A. Davis and Edwin H. Grobe, comps. and eds., *The New Encyclopedia of Texas*, 4 vols. (Dallas: Texas Development Bureau, 1920–1930), 2:1138.

74. "The Fire in Galveston," *San Antonio Light*, Dec. 12, 1885, 4 (quote); and *La Grange Journal*, Dec. 17, 1885, 3.

75. *Pettingill's Newspaper Directory and Gazetteer* (Boston: Pettingill, 1903), 578; quote in *Daily Democrat* (Fort Worth), Feb. 3, 1883, 1; *The Standard* (Clarksville), Apr. 25, 1884, 3; and *Opera Glass*, Dec. 31, 1898, 8.

76. "From Houston," *GDN*, Mar. 21, 1884, 2; "The Eve of the Great Event," *GDN*, Aug. 4, 1886, 8; "Special Notice," *GDN*, June 30, 1886, 8; "It Will Catch 'Em All," *GDN*, Aug. 1, 1886, 12; and "New Out," *GDN*, Aug. 7, 1886, 1, announcing the *Opera Glass* view, which the *Opera Glass* (Galveston), Aug. 7, 1886, 1, published as a double-page spread. See also Michael Robert Green, "Houston Light Guard, 1873–1898," *Military History of Texas and the Southwest* 14 (1978): 95–97; and Bruce Allen Olson, "The Houston Light Guards: Elite Cohesion and Social Order in the New South, 1873–1940" (PhD diss., University of Houston, 1989).

77. See Scherrer's ads in *Morrison & Fourmy's General Directory of the City of Galveston, 1882–83* (Galveston: Clarke & Courts, 1882), xxvi; and *Morrison & Fourmy's General Directory of the City of Galveston, 1884–85* (Galveston: M. Strickland & Co., 1884), 26; *Texas State Gazetteer and Business Directory, 1884–5*, 2 vols. (St. Louis: R. L. Polk, 1884), 2:383, 543, 1143, 1245; and *HTO*, s.v. "St. Mary's University, Galveston," by Aníbal A. González, accessed Sept. 14, 2020.

78. "The Rousseau Company," *GDN*, Dec. 9, 1890, 8; and "Trade Gossip," *American Stationer* 13 (June 28, 1883): 906; ibid., "Trade Items," 28 (July 10, 1890): 75; ibid., (Aug. 14, 1890): 325; ibid., "In Financial Trouble," (Apr. 23, 1891): 8; ibid., "For Sale. A Stationery Business," (Apr. 30, 1891): 3; and ibid., "Trustee's Sale," (May 5, 1891): 3.

79. The *GDN* reporter in Houston filed regular summaries of events in the Bayou City, and W. H. Coyle is prominent among the persons regularly mentioned in this column in the 1880s and 1890s. See also William Murray, *Murray's City Directory for 1870–71; Containing a Full and Complete Directory of the Names, Residences, Trades, Callings, Professions, Institutions, Etc.* (Houston: W. Murray, 1870), 32; *Mooney & Morrison's Directory of the City of Houston, for 1877–78 . . .* (Houston: W. M. Hamilton, Book and Job Printer, 1877), 82; and *Morrison & Fourmy's General Directory of the City of Houston, for 1880–81*, 107.

80. "Crescent," "'Lone Star' Scintillations," *American Stationer* 16 (Sept. 18, 1884): 376; "Interstate Drill and Encampment," *GDN*, Apr. 30, 1884, 5; "Bayou City Locals," *GDN*, June 25, 1885, 3; and "Beautiful Certificate," *GDN*, Dec. 20, 1886, 5.

81. "A New Company," *Houston Post*, Jan. 4, 1906, 2; "Mayor Pastoriza Is Dead from Heart Stroke," *Houston Chronicle*, July 9, 1917, 1; *Morrison & Fourmy's General Directory of the City of Houston for 1880–81*, 232; and "Charters Filed, Political Gossip and Other Notes," *Dallas Weekly Times Herald*, Aug. 2, 1890, 3. A supporter of Henry George's single-tax theories, Pastoriza died after only eighty-three days in office.

82. *True Blue* was a short-lived antiprohibitionist journal published by Dallas lawyer and former lieutenant governor Barnett Gibbs. The *Dallas Morning News* noted: "The Texas *True Blue*, enlarged and improved, begins its regular issue to-day. True Blue is a colored cartoon, satirical paper, lithographed, engraved and printed by our own corps of artists and lithographers in Dallas, Texas. For sale everywhere" (Sept. 3, 1887, 8). See also James D. Ivy, *No Saloon in the Valley: The Southern Strategy of Texas Prohibitionists in the 1880s* (Waco: Baylor University Press, 2003), 66; and Worth Robert Miller, HTO, s.v. "Gibbs, Barnett," accessed Nov. 23, 2014, uploaded June 15, 2010.

83. "The State Capital," *DMN*, Nov. 27, 1886, 7; "'A Phenomenally Large Transaction,'" *DMN*, Jan. 7, 1887, 8; "Fair Notes," *DMN*, Aug. 12, 1887, 8; "The San Antonio Fair," *DMN*, Nov. 30, 1888, 2; "Dallas Enterprises," *DMN*, Feb. 14, 1889, 3; *DDH*, Jan. 4, 1887, 4 (quote); *DDH*, Jan. 15, 3; and "Mayor's Court," *DDH*, Mar. 15, 3 (quote); and *Morrison & Fourmy's General Directory of the City of Dallas, 1886–87* (Galveston: Morrison & Fourmy, 1886), 86, 174, 348.

84. "State Press," *GDN*, Aug. 19, 1876, 2; *Denison Daily News*, Jan. 16, 1878, 4; *Frontier Echo* (Jacksboro), Jan. 25, 1878, 3; "Personal," *Fort Worth Daily Gazette*, Mar. 21, 1886, 8 (hereafter cited as *FWDG*); "Personal," Mar. 5, 1892, 2; "Governmental," *Weekly Statesman* (Austin), Mar. 14, 1889, 7; "Texas Progress," *Southern Mercury* (Dallas), Mar. 28, 1889, 4; "Searching the Records," *Houston Post*, Jan. 14, 1906, 6; "To My Texas and Other Friends," *Daily Express* (San Antonio), May 14, 1909, 3; John W. Leonard, *The Book of St. Louisans: A Biographical Dictionary of Leading Living Men of the City of St. Louis* (St. Louis: St. Louis Republic, 1906), 37, 528–529.

85. "Personal," *DH*, Jan. 5, 1887, 5; and "Trade Notes," *Inland Printer* 10 (Oct. 1892): 62.

86. "Trade Items," *American Stationer* 23 (June 28, 1888): 1281; "Trade News," *Inland Printer* 5 (July 1888): 783; "Local Notes," *DMN*, Sept. 22, 1888, 5; [Ad], *FWDG*, Jan. 1, 1889, 15; "Their Labors Finished," *FWDG*, Sept. 12, 1889, 5; "Localities," *FWDG*, Sept. 28, 1889, 8; "Fort Worth City Directory," *FWDG*, Sept. 29, 1889, 3; "The Palace," *FWDG*, May 21, 1890, 2 (quote); "Fort Worth's Way," *FWDG*, May 20, 1890, 4, and 12 (quote).

87. The editor of the "The City," *Gainesville Daly Hesperian*, Dec. 18, 1888, 3, noted the presence of a Texas Printing and Lithographing Co. salesman in Gainesville. See ad in *FWDG*, Feb. 22, 1889, 3. "Mentions," *El Paso International Daily Times*, Dec. 18, 1889, 3, and "Mentions," Apr. 24, 1890, 7, which noted the presence of salesmen from Fort Worth on two occasions; and George W. Knott, "Texas," *American Stationer* 26 (Aug. 22, 1889): 524.

88. "Texas Patents," *San Antonio Light*, Sept. 18, 1883, 4; "W. W. Dunn," in *Indian Wars and Pioneers of Texas*, by John Henry Brown (Austin: L. E. Daniell, 1896), 556–558; W. W. Dunn, *Evolution and True Light* (Fort Worth: Texas Printing and Lithographing, 1889), 149 (quote); and Garrett, *Fort Worth*, 153.

89. "From Texas," *Inland Printer* 10 (Dec. 1892): 228–229

(quote). The company also had to deal with a printers' strike and several fires. "Fire at Fort Worth," *Austin Weekly Statesman*, Apr. 15, 1897, 1; "A Day's Fire Record," *Houston Daily Post*, Oct. 9, 1897, 5; and "In the Courts," *FWG*, June 6, 1894, 6 (hereafter cited as *FWG*).

90. "City News," *San Antonio Daily Express*, Feb. 21, 1888, 5 (hereafter cited as *SADE*); "City News," *SADE*, Apr. 21, 1888, 5; "The Maverick Printing House," *San Antonio Daily Light*, June 8, 1888, 1; and George W. Knott, "Texas," *American Stationer* 26 (Aug. 22, 1889): 522.

91. See *Fort Worth Weekly Gazette*, Dec. 25, 1890, 1 (hereafter cited as *FWWG*); "Editorial Summary," *SADE*, Dec. 26, 1890, 4; "Suspended," *FWDG*, Dec. 27, 1890, 4.

92. "Chartered," *GDN*, Jan. 30, 1896, 2; and "Clarke to Go to San Antonio," Jan. 31, 1896, 3.

93. "An Ex-Indian Captive," *GDN*, Oct. 19, 1881, 3; "Deep Water Delegates," *GDN*, Aug. 5, 1888, 2; "Local Intelligence," *Austin Weekly Statesman*, Apr. 19, 1883, 4; ibid., "An Important Letter," July 21, 1887, 2; "Texas," *Daily Picayune* (New Orleans), June 30, 1884, 6; "Corpus Christi Callings," *SADE*, Mar. 20, 1889, 7; "A Delightful Time," *DMN*, Apr. 29, 1889, 4; Ad, *Corpus Christi Caller*, Jan. 21, 1883, 4; Frank Wagner, "A Biographical Sketch of Tito Rivera of Corpus Christi" (MS in the Corpus Christi Museum); *Texas State Gazetteer and Business Directory, 1884–5*, vol. 2, pt. 1, pp. 23, 237; and *Texas State Gazetteer and Business Directory, 1890–91*, 3 vols. (St. Louis: R. L. Polk, 1890), vol. 3, pt. 3, pp. 31, 305.

94. "How to Make Money," *El Paso International Daily Times*, Oct. 10, 1895, 3; ibid., "Blanks to Order," Oct. 16, 1895, 2.

95. "M. Strickland & Co.," *GDN*, Sept. 11, 1887, 10; and "Science of Electricity," *GDN*, Oct. 15, 1887, 5.

96. "Other Galveston Industries," *GDN*, Sept. 11, 1887, 10; "Science of Electricity," *GDN*, Oct. 15, 1887, 5; and "Chained Lightning," *Evening Tribune* (Galveston), Apr. 13, 1887, 1. The *Tribune* reporter described the motor as "a queer-looking little affair, perhaps four feet long and three feet in height."

97. These figures are always hard to calculate, but $20,000 in 1887 might have the purchasing power of $519,000 in 2021. See Economic History Association, https://eh.net.

98. "An Assignment," *GDN*, Nov. 19, 1887, 8. Edwin Ketchum, the assignee, began advertising the "entire stock of Stationery, Fixtures, Lithographic Printing and Binding Machinery of M. Strickland & Co." for sale. See "For Sale," *GDN*, Dec. 18, 1887, 12, and Feb. 13, 1888, 5; and "Trade Items," *American Stationer* 22 (Dec. 1, 1887): 1114. Clarke & Courts traces its origin to the Strickland company, so it is likely that they purchased much of Strickland's machinery from bankruptcy. See "The Story of Clarke & Courts," *GDN*, July 4, 1976, 12-C, and "The Story of Clarke & Courts," typescript on the letterhead of Clarke & Courts, in Clarke & Courts Vertical File, 1, Amon Carter Museum of American Art Library.

99. See "Assignee Sale," *Evening News* (Galveston), Feb. 3, 1888, 4; ibid., "Stationery Stock Sold," Feb. 21, 1888, 1; ibid., "Sold by the Sheriff," Aug. 3, 1888, 1; ibid., "Another Picture," Jan. 14, 1889, 1; "Galveston," *FWDG*, Feb. 22, 1888, 8; "Suing Out an Injunction," *GDN*, Feb. 22, 1888, 8; "Notice," *GDN*, Feb. 23, 1888, 1; "Special Notice," *GDN*, July 26, 1888, 3; "Auction Sale," *GDN*, Oct. 28, 1888, 3; "Continuation of Sale," *GDN*, Nov. 1, 1888, 3, and June 27, 1889, 1; and "A New Enterprise," *GDN*, Feb. 21, 1892, 5.

100. Huseman, "Beginnings of Lithography in Texas," 43. A number of lithographs in the Clarke & Courts specimen books have Strickland's imprint on them.

101. *HTO*, s.v. "Clarke and Courts Printing," by Diana J. Kleiner, accessed July 30, 2021. Thomas J. Cordray Jr. was an apprentice pressman at Strickland's who, in 1890, worked at Clarke & Courts. See *Morrison & Fourmy's General Directory of the City of Galveston, 1890–91* (Galveston: Morrison & Fourmy, 1890), 147.

102. Marzio, *Democratic Art*, 3.

103. The women were Ella M. Carter, ruler, lithograph department at Clarke & Courts; Lula A. Woodward, lithographer (no employer mentioned); and Minnie L. Gregory, lithograph press feeder, Clarke & Courts.

CHAPTER 8: "THE 'IMAGE BREAKERS'"

The chapter title quote is from "The Humorous Iconoclast," *GDN*, Mar. 12, 1875, 1.

1. "To Advertise Texas," *DMN*, May 9, 1890, 2 (quoting L. C. Butte, a Californian of some twenty years' experience living in Commerce); "Fort Davis," *GDN*, Sept. 2, 1881, 1; "The Great Land Fraud," *Texas Siftings* 2 (May 5, 1883): 2; and Timothy Flint, ed., *The Personal Narrative of James O. Pattie of Kentucky . . .* (Cincinnati: John H. Wood, 1831), 289 (quote).

2. *St. Louis Globe-Democrat*, July 16, 1879, 4 (quote); and Ellen M. Mrja, "Joseph B. McCullagh," in *American Newspaper Journalists, 1873–1900*, ed. Perry J. Ashley (Detroit: Gale, 1983), vol. 23, Dictionary of Literary Biography, Literature Resource Center, https://link.gale.com/apps/doc/H1200005774/LitRC?u=txshracd2573&sid=LitRC&xid=12f11bbe, accessed Dec. 2, 2019. Boosters in St. Louis felt that their city was positioned and primed to dominate southwestern trade. See Thomas Lee Charlton, "The Development of St. Louis as a Southwestern Commercial Depot, 1870–1920 (PhD diss., University of Texas at Austin, 1969), 19–14, 26. St. Louis newspapers had a larger circulation in North Texas in the 1880s than any other newspapers. See *HTO*, s.v. "Dallas Morning News," by Judith M. Garrett and Michael V. Hazel, accessed May 12, 2020, uploaded June 12, 2010, modified June 26, 2019.

3. "Texas Tragedies," *St. Louis Globe-Democrat*, Nov. 23, 1878, 2; ibid., "Terrors of Texas," Jan. 25, 1879, 1; ibid., "A Reign of Terror in Texas," Feb. 18, 1879, 5; ibid., "Shot in a Hotel," Feb. 22, 1879, 1; ibid., "Tales from Texas," Feb. 24, 1879, 4; ibid., "Twin Tragedies," Mar. 26, 1879, 1; ibid., June 20, 1879, 4 (quote); "Houston Happenings," *GDN*, May 4, 1879, 1; "Houston Happenings," *GDN*, June 19, 1879, 1; "Executive Clemency," *GDN*, June 22, 1879, 1; and "Governor vs. Gallows," *Panola Watchman* (Carthage), June 25, 1879, 2. Roberts apparently commuted Coward's sentence because one of the witnesses confused Coward with his brother William. "Houston Local Items," *GDN*, Sept. 14, 1876, 4.

4. A steel eraser, about six inches long, was a tool for erasing ink.

5. "Scenes in Austin," *St. Louis Globe-Democrat*, Mar. 25 and 30, 1885, 3; "Grew Out of a Caricature," *GDN*, Mar. 28, 1885, 2; "State Press," *GDN*, Mar. 30, 1885, 4 (quotes); and "Cutting to Kill," *Austin Weekly Statesman*, Apr. 2, 1885, 4.

6. "The Humorous Iconoclast," *GDN*, Mar. 12, 1875, 1 (quote).

7. Laura Winthrop Johnson, "Eight Hundred Miles in an Ambulance," pt. 1, *Lippincott's Magazine* 15 (June 1875): 695 (quote); Chester A. Arthur, First Annual Message, Dec. 6, 1881, American Presidency Project, accessed Jan. 6, 2018, http://www.presidency.ucsb.edu/ws/index.php?pid=29522.

8. "The Texas Cow-boy," *Leslie's Illustrated*, Dec. 1, 1883, 229; *Denison Daily News*, Feb. 19, 1876, 1; and "Stock Cattle and Texas Ticks," *Fort Griffin Echo*, Oct. 11, 1879, 2, quoting *Drover's Journal*; "A Wild Texas Boy Killed," *SADE*, July 8, 1875, 1.

9. For more on the Star windmills featured in fig. 8.2, see T. Lindsay Baker, *A Field Guide to American Windmills* (Norman: University of Oklahoma Press, 1985), 67–68, 232–233.

10. "The Humorous Iconoclast," *GDN*, Mar. 12, 1875, 1 (quote); "The Texas Cowboy," *Stephenville Empire*, Jan. 6, 1883, 7 (quote); "By Telegraph," *Houston Daily Mercury*, July 29, 1873, 2; ibid., "State Items," Aug. 21, 1873, 3 (quote); "The Waco Murder," *Dallas Weekly Herald*, Aug. 2, 1873, 1.

11. "Murdered by a Cowboy," *FWDG*, Dec. 30, 1884, 3.

12. Col. Theodore Ayrault Dodge, "Some American Riders," *Harper's New Monthly Magazine* 83 (June 1891): 204–214; "Mr. Roosevelt among the Cowboys," *New York Tribune*, July 28, 1884, 8; *St. Louis Globe-Democrat*, June 12, 1879, 4 (quote); and Owen Wister, "The Evolution of the Cow-Puncher," *Harper's New Monthly Magazine* 91 (Sept. 1895): 602–617.

13. "The Texas Cowboy," *Stephenville Empire*, Jan. 6, 1883, 7; [Langworthy], *A Visit to Texas*, following p. 60; *Texas Sentinel* (Austin), May 23, 1840, 2; *Morning Star* (Houston), Nov. 1, 1845. The earliest use of the word cowboy, or cow-boy, that I have found is in the *Newport Mercury*, Aug. 19, 1776, 3, grouping "cow-boys" with "rabble" such as pickpockets. See also Kelsey and Hutchison, *Engraved Prints of Texas*, 26.

14. See Lonn Taylor, "The Cowboy Hero: An American Myth Examined," in *The American Cowboy*, by Lonn Taylor and Ingrid Maar (Washington, DC: American Folklife Center, Library of Congress, 1983), 62–79; "Mode of Catching Wild Horses on the Prairies, Texas," *Gleason's*

Pictorial, June 16, 1852, 401; Peggy and Harold Samuels, *Frederic Remington: A Biography* (Garden City, NY: Doubleday, 1982), 218; Claudine Chalmers's *Chronicling the West for Harper's: Coast to Coast with Frenzeny and Tavernier in 1873–1874* (Norman: University of Oklahoma Press, 2013) contains reproductions of work by Remington and Frenzeny and Tavernier; Wister, "Evolution of the Cow-Puncher," 602–617, esp. 608. See *A Running Bucker*, in *Drawings*, by Frederic Remington (New York: R. H. Russell, 1897); Remington, *A "Sunfisher"* (New York: Davis & Stanford, c. 1895); and Remington, *The Cowpuncher, a.k.a. No More He Rides*, *Collier's Weekly*, Sept. 14, 1901, as examples. The black-and-white, oil on canvas (28.87 × 19 in.) version of the *The Cowpuncher* is in the collection of the Sid Richardson Museum in Fort Worth.

15. William F. Cody to Buckskin Sam Hall, North Platte, NE, July 5, 1879, in William F. Cody Archive, accessed Jan. 8, 2022, http://codyarchive.org/texts/wfc.css00046.html; "Amusements," in *Inter Ocean* (Chicago), July 14, 1887, 10; "Monthly Bulletin of New Music," *Folio: A Journal of Music, Drama, Art and Literature* 14 (Jan. 1876): 73; J. C. Dykes, "Buckskin Sam, Ranger and Writer; or, The Life and Sub-Literary Labors of Samuel Stone Hall," *American Book Collector* 10 (Mar. 1960): 8–18, and "Dime Novel Texas; or, the Sub-Literature of the Lone Star State," *Southwestern Historical Quarterly* 49 (Jan. 1946): 327–340; Lester S. Levy, *Grace Notes in American History: Popular Sheet Music from 1820 to 1900* (Norman: University of Oklahoma Press, 1967), 355–361; and Albert Johannsen, *The House of Beadle and Adams and Its Dime and Nickel Novels: The Story of a Vanished Literature* (Norman: University of Oklahoma Press, 1950), 124–127.

16. "Buffalo Bill and Texas Jack," *St. Albans Messenger* (VT), Sept. 24, 1875, 1; *HTO*, s.v. "Omohundro, John Burwell, Jr.," by Edgar P. Sneed, accessed Sept. 14, 2020; Barbara Barker. "Morlacchi, Giuseppina," American National Biography, http://www.anb.org; and Louis S. Warren, *Buffalo Bill's America: William Cody and the Wild West Show* (New York: Knopf, 2005), 165–166.

17. September 17 fell on a Friday that year, and Cody, Jack, and Morlacchi were performing at the Academy of Music in Auburn, New York, that week. See ad, *Auburn Daily Bulletin*, Sept. 16, 1875, 1; "Cohoes and Vicinity," *Daily Albany Argus*, Sept. 15, 1875, 4; Herschel C. Logan, *Buckskin and Satin: The Life of Texas Jack (J. B. Omohundro) Buckskin Clad Scout, Indian Fighter, Plainsman, Cowboy, Hunter, Guide and Actor, and His Wife Mlle. Morlacchi, Premiere Danseuse in Satin Slippers* (Harrisburg, PA: Stackpole, [1954]), 99, 205–207; and Thadd Turner, "'Texas Jack' Omohundro," Buffalo Bill Center of the West, accessed Jan. 8, 2022, http://centerofthewest.org/explore/buffalo-bill/reearch/texas-jack. Perhaps Jackson Bros. Printing at 402 Library in Philadelphia was the printer. See *Gopsill's Philadelphia City Directory for 1880* (Philadelphia: James Gopsill, 1880), 856.

18. "Annoyed by the Show," *NYH*, May 26, 1884, 8; "Notes," *New Haven Register* (CT), Oct. 1, 1883, 4; "Chicopee," *Springfield Republican* (MA), Jan. 1, 1884, 6; Brooks McNamara, *Step Right Up* (Garden City, NY: Doubleday, 1976), 73–83; Ann Anderson, *Snake Oil, Hustlers, and Hambones: The American Medicine Show* (Jefferson, NC: McFarland, 2000), 61–64. Indian agents tried to prevent what they considered the exploitation of the Indians, to no avail. See L. G. Moses, *Wild West Shows and the Images of American Indians, 1883–1933* (Albuquerque: University of New Mexico Press, 1996), 71. For Bigelow's birthplace, see "Col. Charles Bigelow 'Texas Charley,'" Bigelow Society, accessed Jan. 8, 2022, http://bigelowsociety.com/rod2001/kicapoo2.htm.

19. *Cowboy Life* (Portland, ME: Chisholm Bros., published by H. H. Tammen, Denver, 1885); and *Souvenir Album of the Great West* (Columbus, OH: Ward Bros., 1889). There are at least two editions of *The Great West*, one with twenty-five pages of illustrations and the other with thirty-seven pages. See also David Brodherson, "Souvenir Books in Stone: Lithographic Miniatures for the Masses," *Imprint: Journal of the American Historical Print Collectors Society* 12 (Autumn, 1987): 21–28; and Gascoigne, *How to Identify Prints*, entry 56, 258.

20. B. B. Paddock, *History of Texas: Fort Worth and the Texas Northwest Edition*, 4 vols. (Chicago: Lewis Publishing, 1922), 2:540 (quote); and *HTO*, s.v. "Texas and Southwestern Cattle Raisers Association," by Larry Marshall, T. C. Richardson, and Dick Wilson, accessed July 21, 2021. The two groups merged in 1893.

21. *Sunday Gazetteer* (Denison), Mar. 8, 1885, 4.

22. Siringo, *Texas Cow Boy*, ix–xi.

23. "Texas Cow-boy," *Golden Era* (Lincoln, NM), Nov. 5, 1885, 1, 4, and Nov. 12, 1885, 1; *Weekly Inter Ocean* (Chicago), Apr. 1, 1886, 3, for an ad; *The Bad Lands Cow Boy* (Mendora, Dakota), Apr. 15, 1886, 1; Ben E. Pingenot, *Siringo: The True Story of Charles A. Siringo, Texas Cowboy, Longhorn Trail Driver, Private Detective, Rancher, New Mexico Ranger, and Author . . .* (College Station: Texas A&M University Press, 1989), xvii–xviii, 167–168. For information on Michael Umbdenstock, see the *Daily Inter Ocean* (Chicago), Mar. 27, 1888, 4; ibid., "Candidate for Assessor," 6; ibid., "Umbdenstock Accepts," Mar. 29, 1888, 3, 4, and Sept. 17, 1890, section 1, 1. Umbdenstock was a well-known member of the business community and was nominated on the Republican ticket for assessor.

24. Pingenot, *Siringo*, 168; Jenkins, *Basic Texas Books*, entry 185; and Ramon F. Adams, *Burs under the Saddle: A Second Look at Books and Histories of the West* (Norman: University of Oklahoma Press, 1964), 473.

25. Quoted in "Charlie Siringo, Writer and Man," by J. Frank Dobie, introduction to Siringo, *A Texas Cowboy; or, Fifteen Years on the Hurricane Deck of a Spanish Pony—Taken from Real Life* (New York: William Sloane Associates, 1950), x, xvii, xxxi, xxxv; "Book Notice," *GDN*, Jan. 12, 1886, 4; and Howard R. Lamar, *Charlie Siringo's West: An Interpretive Biography* (Albuquerque: University of New Mexico Press, 2005), 298 (quote). Ramon Adams severely criticizes Siringo for his account of Billy the Kid (*Burs under the Saddle*, 473–475).

26. *Taylor County News* (Abilene), Dec. 17, 1886, 5.

27. "Gainesville," *FWDG*, Dec. 3, 1884, 5, announced the formation of the school. See also *Report of the Secretary of the Interior; Being Part of the Message and Documents Communicated to the Two Houses of Congress at the Beginning of the Second Session of the Fifty-Fourth Congress* (HD 5, vol. 5, pt. 2, 2078); and Taylor and Maar, *American Cowboy*, 81.

28. *HTO*, s.v. "Texas Fever," by Tamara Miner Haygood, accessed Jan. 24, 2022.

29. Theobold Smith and F. L. Kilborne, *Investigations into the Nature, Causation, and Prevention of Texas or Southern Cattle Fever* (Washington, DC: USDA, Bulletin No. 1, 1893).

30. *HTO*, s.v. "Texas Fever," by Haygood.

31. "Dobie, "Charlie Siringo," 2, 6 (quotes); Alexander Nicholas DeMenil, "A Century of Missouri Literature," *Missouri Historical Review* 15 (Oct. 1920): 114 (quote). Cox later wrote articles, mainly on the St. Louis area, for *Leslie's Illustrated*, *Lippincott's*, and other magazines and served as secretary of the Louisiana Purchase Exposition Co. and the Bureau of Information for St. Louis Autumnal Festivities Association. William Marion Reedy, editor of the feisty St. Louis literary journal *The Mirror*, chided him as the "grass widow of the Writers Club." See "Cox, James," in *Encyclopedia of the History of Missouri: A Compendium of History and Biography for Ready Reference*, ed. Howard L. Conard, 4 vols. (New York: Southern History Co., 1899–1901), 2:174.

32. Jenkins, *Basic Texas Books*, 91–93; J. Frank Dobie, introduction to *Historical and Biographical Record of the Cattle Industry and the Cattlemen of Texas and Adjacent Territory*, 2 vols. (New York: Antiquarian Press, 1959 [reprint]) 1:3.

33. "A Great Picture," *Daily Inter Ocean* (Chicago), Nov. 6, 1886, 3; "One of the Most Famous Animal Painters of America Is in Galveston Doing Some Work," *GDN*, July 27, 1924, 4; and Texas Death Certificates, 1903–1982, ancestrylibrary.com, for Gean N. Smith. One of the most famous trotters in the 1890s was a black gelding named Gean Smith: "Gean Smith's Great Speed," *Daily Inter Ocean*, Aug. 31, 1889, 7.

34. "L. M. Kokernot," *Shiner Gazette*, Jan. 17, 1895, 5; "Cattlemen of Texas," *GDN*, Mar. 11, 1895, 6.

35. "The Cattlemen's Book," *FWG*, Mar. 25, 1896, 6. Apparently the newspaper did not report on the outcome of the case.

36. One such scrapbook, "Galveston Merchants Advertising Cards Compiled by William J. Frederich 1887 for his Niece Louise Erhard," may be seen in the William J. Hill Texas Artisans and Artists Archive, accessed Jan. 8, 2022, http://texasartisans.mfah.org/cdm/compoundobject/collection/p15939coll3/id/2404/rec/1. Either Galveston merchants

avoided entirely images of cowboys, or Frederich might have thought them inappropriate for his niece.

37. For information on Arbuckle Bros. trading cards and atlas, see collector Jeff Buck's "Arbuckles' Ariosa Coffee Trade Cards," Arbuckle Trade Cards, About This Site, arbycards.info. See also Lisa Jacobson, *Raising Consumers: Children and the American Mass Market in the Early Twentieth Century* (New York: Columbia University Press, 2004), 18–21; and Jay T. Last, *The Color Explosion: Nineteenth-Century American Lithography* (Santa Ana, CA: Hillcrest Press, 2005), 244–245.

38. "Coffee Kings of the Old West: Folger Was First, Then Arbuckle," historynet.com.

39. Janet Katelyn Hammond, "Capitalizing on Taboos in Advertising: The Cigarette Card Series of W. Duke, Sons & Company" (Honors thesis, Appalachian State University, Boone, NC, 2018).

40. Liebig began publishing his colorful trade cards in 1872, and by the 1880s they had developed a devoted following. Liebig distributed more than seven thousand different cards in eleven hundred series in Germany and thirteen other countries. Mark R. Finlay, "Quackery and Cookery: Justus von Liebig's Extract of Meat and the Theory of Nutrition in the Victorian Age," *Bulletin of the History of Medicine* 66 (Fall 1992): 415. See also "In Business Circles," *Austin Weekly Statesman*, Sept. 20, 1888, 4.

41. See Paul H. Carlson, *Texas Woollybacks: The Range Sheep and Goat Industry* (College Station: Texas A&M University Press, 1982), 127–128; and Douglas E. Barnett, "Angora Goats in Texas: Agricultural Innovation on the Edwards Plateau, 1858–1900," *Southwestern Historical Quarterly* 90 (Apr. 1987): 361–362.

42. "Admitted to Bail," *Austin Weekly Statesman*, Mar. 15, 1888, 9. Maggie later committed suicide: "Maggie Estes Dead," *FWDG*, Sept. 6, 1889, 2.

43. "Waco's First Mai Fest," *GDN*, May 11, 1877, 1.

44. "How the Texas Cow-Boy Lives," *Daily Fort Worth Democrat*, Dec. 27, 1877, 3 (quote). Aside from the testimony of cowboys like E. C. "Teddy Blue" Abbott in Abbott and Helena Huntington Smith, *We Pointed Them North: Recollections of a Cowpuncher* (New York: Farrar & Rinehart, 1939; reprint, Norman: University of Oklahoma Press, 1955), see "Embryo Terrors," *GDN*, Jan. 8, 1887, 5; and "Charmed by Cowboy Life," *Daily Inter Ocean* (Chicago), Jan. 8, 1887, 4.

45. "On a Western Cattle Ranch," *Fortnightly Review* 47 (1887): 516, quoted in Taylor and Maar, *American Cowboy*, 17.

46. Frank W. Calkins, "Saved by a Jack," *DDH*, Oct. 14, 1887, 6 (quote).

47. "The Warpath," *Austin American-Statesman*, Feb. 4, 1881, 4; Calkins, "Saved by a Jack," 6 (quote), reprinting what appears to be a firsthand story by a popular writer that appeared in the *Atlanta Constitution*. See also "Indian Warriors on the War Path," *GDN*, July 21, 1885, 1 (quote); *FWDG*, Feb. 5, 1889, 4 (quote); and "Texas News in England," *FWDG*, Mar. 22, 1888, 2 (quote).

48. *HTO*, s.v. "Parker, Quanah," by Brian C. Hosmer; and *HTO*, s.v. "Red River War," by James L. Haley, both accessed Sept. 14, 2020.

49. Robert J. Titterton, *Julian Scott: Artist of the Civil War and Native America: With 97 Illustrations* (Jefferson, NC: McFarland, 1997), 201–202, 209; and B. Byron Price, "Indian Territory, 1861–1907: Turmoil and Transition," in *Picturing Indian Territory: Portraits of the Land That Became Oklahoma, 1819–1907*, ed. B. Byron Price (Norman: University of Oklahoma Press, 2016), 52.

50. "Chief Quanah Parker," *Daily Herald* (Brownsville), May 12, 1897, 1 (quotes); Price, "Indian Territory," 52–53.

51. "Texas for Settlers," *St. Louis Globe-Democrat*, Oct. 10, 1881, 2 (quote).

52. For Gilbert, see J. Thomas Scharf, *History of Saint Louis City and County, From the Earliest Periods to the Present Day . . .* , 2 vols. (Philadelphia: Louis H. Everts, 1883), 2:1608; and *Pen and Sunlight Sketches of Saint Louis: The Commercial Gateway to the South* (Chicago: Phoenix Publishing, 1892), 117. C. C. Georgeson to Oran M. Roberts, Mar. 30, 1881 (215d), in the Oran M. Roberts Papers, BCAH. See also *DMN*, Jan. 27, 1886, 6, for news of Georgeson's departure for a teaching appointment in Japan.

53. *St. Louis Globe-Democrat*, Aug. 26, 1881, 2; *Houston Age* quoted in "State Press," *GDN*, Oct. 7, 1881, 5.

54. See "The Manufacturers and Merchants of St. Louis," *FWG*, Jan. 22, 1893, 4; and "At San Antonio," *Lampasas Leader*, May 17, 1901, 3, for insight into the overtures that St. Louis business leaders made in Texas.

55. "Texas for Settlers," *St. Louis Globe-Democrat*, Oct. 10, 1881, 2; and "Gov. Robert's Texas," *The Standard* (Clarksville), Oct. 21, 1881, 2.

56. Oran M. Roberts, *A Description of Texas, Its Advantages and Resources, with Some Account of Their Development, Past, Present and Future* (St. Louis: Gilbert Book Co., 1881), [i]; *Waco Examiner* quoted in "State Press," *GDN*, Oct. 8, 1881, 2; "State Press," *GDN*, Oct. 22, 1881, 2; *Gainesville Register* quoted in both "State Press," *GDN*, Oct. 26, 1881, 2, and *The Standard* (Clarksville), Oct. 28, 1881, 4. The press coverage was dominated by the *GDN*, whose editors offered their own opinions and summarized those from other state newspapers. See *Texas Siftings* 3 (Apr. 26, 1884): 8, and ibid., 5 (Sept. 5, 1885): 4, for continuing concerns that Roberts would reenter politics.

57. *Terrell Times* quoted in "State Press," *GDN*, Oct. 22, 1881, 2; *Crockett Patron* quoted in "State Press," *GDN*, Oct. 25, 1881, 2.

58. "State Press," *GDN*, Oct. 25, 1881, 2 (quote); "State Press," *GDN*, Oct. 30, 1881, 2 (quote).

59. *DH* quoted in *Brenham Daily Banner*, Oct. 20, 1881, 2; *Dallas Times* quoted in "State Press," *GDN*, Oct. 21, 1881, 2 (quote); *Corsicana Observer* quoted in "State Press," *GDN*, Oct. 23, 1881, 2; "Governor Roberts's Texas," *GDN*, Oct. 28, 1881, 2 (quote); *Terrell Times* quoted in the "State Press," *GDN*, Oct. 22, 1881, 2; and *Crockett Patron* quoted in the *GDN*, Oct. 30, 1881, 2.

60. "The Old Alcalde's Book," *GDN*, Oct. 15, 1881, 2.

61. *Texas Siftings* 3 (June 16, 1883): 1.

62. "State Press," *GDN*, Nov. 2, 1881, 5.

63. Undated clipping from *The Journal*, in W. J. Gilbert to Roberts, St. Louis, Oct. 1881 (215b); R. O. Davidson review, undated clipping (Box 2M 406); W. J. Gilbert to Roberts, St. Louis, Oct. 10, 1881 (214a); undated clipping from the *San Marcos Free Press* (1881) (quote), in Box 2M 406; and J. W. Delaney to Roberts, Springfield, IL, Oct. 10, 1881, (216a), all in Roberts Papers, BCAH; *St. Louis Globe-Democrat*, Oct. 10, 1881, 2; *Corsicana Observer* quoted in "State Press," *GDN*, Oct. 23, 1881, 2; *The Standard* (Clarksville), Oct. 21, 1881, 2; John James Audubon and John Bachman, *The Viviparous Quadrupeds of North America*, most often bound in 3 vols. (New York: V. G. Audubon, 1845–1846), plate CXXXIII; and "The Jack-Rabbit of Texas," *Arkansas Gazette* (Little Rock), Dec. 28, 1881, 4.

64. "State Press," *GDN*, Nov. 3, 1881, 5.

65. "Texas Items," *Christian Messenger* (Bonham, TX), Nov. 16, 1881, 8 (quote).

66. Mrs. E. L. Smith, Alvarado, to Roberts, Apr. 6, 1882, (206b); John G. James, President of A&M College, to Roberts, Oct. 25, 1881 (234a1–2), and Nov. 10, 1881 (218b); W. J. Gilbert to Roberts, St. Louis, Oct. 1881 (215b); Percy V. Pennybacker to Roberts, Bryan, Apr. 8, 1882 (204a); H. M. Lawson, Rusk County, to Roberts, Apr. 14, 1882 (205a), all in Roberts Papers, BCAH; *San Marcos Free Press*, Oct. 20, 1881, 2; *Dallas Weekly Herald*, Feb. 16, 1882, 3; and the *Caldwell Register* reprinted in "State Press," *GDN*, Dec. 14, 1881, 2: "It is eclectic in its character, and may serve as a text on almost any subject. Its strong points, however, are razor-back hogs and jack rabbits." A correspondent for the *News* found a voucher in the comptroller's office in Austin for 150 copies of Roberts's book for Sam Houston Normal Institute at $.60 each: "Austin," *GDN*, Feb. 12, 1882, 1.

67. *Colorado Citizen* (Columbus), Mar. 30, 1882, 2 (quote); and *Brenham Weekly Independent*, Apr. 6, 1882, 4.

68. A. H. Edwards to Roberts, Sulphur Springs, Dec. 13, 1881 (213d1–3); and James to Roberts, College Station, Oct. 25, 1881 (234a1–2), in Roberts Papers, BCAH; Alwyn Barr, *Reconstruction to Reform: Texas Politics, 1876–1906* (Austin: University of Texas Press, 1971), 65–66; *HTO*, s.v. "Roberts, Oran Milo," by Ford Dixon, accessed Sept. 14, 2020.

69. "State Press," *Brenham Daily Banner*, May 31, 1883, 2.

70. *SAE* quoted in "State Press," *GDN*, Dec. 23, 1881, 2.

71. "Galveston's Comforters," *Texas Siftings* 5 (Dec. 19, 1885): 4; and *FWDG*, Feb. 13, 1888, 2.

72. "Little Locals," *GDN*, Dec. 22, 1889, 2.

73. *HTO*, s.v. "Goggan, Thomas," by Erica Gish and Laurie E. Jasinski, accessed Sept. 14, 2020; "Thos. Goggan & Bro. Incorporate," *Music Trade Review* 42 (Feb. 10, 1906): 5. See also "They Say," *Evening Tribune* (Galveston), Dec. 6, 1886, 4; *Jacksboro Gazette*, Sept. 29, 1887, 2; "Now in Press," *Evening Tribune* (Galveston), May 10, 1889, 1, and

ibid., "The Pirate Isle—No More," June 20, 1889, 2. *Taylor County News*, Sept. 30, 1887, 5; and Leslie C. Gay Jr., "Before the Deluge: The Technoculture of Song-Sheet Publishing Viewed from Late Nineteenth-Century Galveston," *American Music* 17 (Winter 1999): 396–421. For Goggan's obituary, see *Music Trade Review* 36 (June 27, 1903): 15.

74. "Getting Rich in Texas," *San Antonio Light*, Dec. 6, 1893, 1; *DMN*, Oct. 31, 1894, 2; and "The Big Reunion," *GDN*, May 19, 1895, 4; *Evening Tribune* (Galveston), Jan. 14, 1887, 3; Gay, "Before the Deluge," 405–407. See examples of Lyons's songs in the Texas Collection at Baylor University and the Lester Levy collection at Johns Hopkins University.

75. "The White Squadron," *GDN*, Feb. 5, 1891, 8; "The White Squadron at Galveston," *New York Times*, Feb. 4, 1891, 1. A few years later photographers were employing kites to take bird's-eye view photographs of cities. "Takes Pictures 24 Miles Away," *GDN*, Mar. 1, 1897, 3.

76. Butler did Goggan's "When Shall We Meet Again Love" (1888), example in the Library of Congress.

77. "The Metropolitan Daily Press: The Graphic," *American Stationer* 14 (Sept. 13, 1883): 425.

78. Kelsey and Hutchison, *Engraved Prints of Texas*, 158; "Our Enterprise," *Daily Graphic* (New York), June 28, 1873, 11; "How 'Graphic' Pictures Are Made," *Houston Daily Mercury*, Dec. 27, 1873, 2; and "New York Gossip," *Omaha Daily Bee* (NE), Aug. 22, 1883, 2.

79. See Stephen H. Horgan, *Horgan's Half-Tone and Photomechanical Processes* (Chicago: Inland Printer, 1913), 12–14.

80. "Pictures of the Day," *Daily Graphic*, Feb. 26, 1876, 922 (quote).

81. M[atthew] W[hilldin], "Delivery of Mardi Gras Invitations," *Daily Graphic*, Feb. 26, 1876, 919. Whilldin's name is sometimes spelled "Whilden."

82. "Pictures of the Day," *Daily Graphic*, Mar. 13, 1876, 101.

83. [Matthew] W[hilldin], "Galveston Harbor," *Daily Graphic*, Mar. 4, 1876, 40. The *Daily Graphic* story and images were copied in "The Jetty Works of Galveston Harbor, Texas," 245.

84. [Matthew] W[hilldin], "San Antonio Missions," *Daily Graphic*, Mar. 18, 1876, 146–147.

85. Jerry D. Thompson, *Cortina: Defending the Mexican Name in Texas* (College Station: Texas A&M University Press, 2007), ch. 9.

86. "Personal," *Denison Daily News*, Dec. 31, 1873, 3; ibid., Mar. 27, 1880, 4; Anna S. Dimock, "Down in Texas," *Daily Graphic*, Feb. 19, 1874, 3, 8.

87. "Views in Galveston, Texas," *Daily Graphic*, July 20, 1880, 136–137; and ibid., "Views in Austin, Texas," June 30, 1880, 1001; David Haynes, *Catching Shadows: A Directory of 19th-Century Texas Photographers* (Austin: Texas State Historical Association, 1993), 62, 123.

88. In the *Daily Graphic*: "Views in San Antonio, Texas," Nov. 17, 1881, 127; "Views in Houston, Texas," June 2, 1882, 659; "Fort Worth, Texas," Feb. 28, 1882, 821; "Laredo, Texas," May 23, 1882, 590; "Corpus Christi, Texas," June 9, 1882, 711; "Corsicana, Texas," May 12, 1882, 517; and "El Paso, Texas," Apr. 10, 1883, 287, and Jan. 23, 1885, 601.

89. "Alfred M. Hobby," *Daily Graphic*, Apr. 12, 1876, 6, 8 (portrait); and ibid., "Richard Coke," May 22, 1876, 4.

90. "The Metropolitan Daily Press: The Graphic," *American Stationer* 14 (Sept. 13, 1883): 425; and Joshua Brown, *Beyond the Lines: Pictorial Reporting, Everyday Life, and the Crisis of Gilded Age America* (Berkeley: University of California Press, 2002), 267.

91. "Our Texas Trip," *Frank Leslie's Illustrated Newspaper* (New York), June 21, 1890, 414. By the time *Leslie's* used the phrase "an empire in itself," it was virtually a cliché. The earliest use that I have found is "Texas," *Gonzales Inquirer*, Oct. 8, 1853, 2, quoting the *New Orleans Southern Organ*. It was used regularly in the Texas press afterward. Even President Grant used the phrase when he visited Galveston in 1880. See Grant's speech of Mar. 24, 1880, in Simon, ed., *Papers of Ulysses S. Grant*, 29:369. On the accuracy of *Leslie's* illustrations, see Andrea G. Pearson, "*Frank Leslie's Illustrated Newspaper* and *Harper's Weekly*: Innovation and Imitation in Nineteenth-Century American Pictorial Reporting," *Journal of Popular Culture* 23 (Spring 1990): 87.

92. "State Press," *GDN*, Feb. 15, 1890, 4; "Personals," *GDN*, Mar. 20, 1890, 2; "Knights of the Faber," *GDN*, May 27, 1890, 4; "Entertaining the Visitors," *GDN*, June 13, 1890, 8 (quote); "The Resources of Texas," *GDN*, June 23, 1890, 7; "To Advertise Texas," *San Antonio Daily Light*, Mar. 20, 1890, 1; "Beeville Wants a Write-Up," *SADE*, Mar. 21, 1890, 3; "Coming This Way," *El Paso International Daily Times*, June 10, 1890, 4.

93. *FWDG*, Sept. 29, 1890, 4 (quote).

94. During Harrison's whistle-stop tour through the South and West, the *Galveston Daily News* commented that "President Harrison's ready tongue swung easily on its well oiled pivot at Galveston Saturday," as he reminded his listeners of the federal governments support of the city's deep-water port (Apr. 27, 1891, 4). "State Press," *GDN*, Nov. 11, 1890, 4 (quote); "State Press," *GDN*, Dec. 18, 1891, 4 (quote); "In Hot Water," *Boston Daily Globe*, Sept. 21, 1891, 26; *HTO*, s.v. "Aransas Pass, TX," by Keith Guthrie, accessed Sept. 14, 2020. Aransas Pass finally became a deep-water port in 1907; Benjamin Harrison, *Through the South and West with the President, April 14–May 15, 1891*, comp. John S. Shriver (New York: Mail and Express, 1891), 25–40.

95. "State Press," *GDN*, May 23, 1890, 4.

96. *HTO*, s.v. "Pierce, Abel Head [Shanghai]," by Chris Emmett, accessed July 19, 2021. "Gunter, Archibald Clavering," in *Men and Women of the Time: A Dictionary of Contemporaries*, by George Washington Moon (London: Routledge, 1891), 402; Chris Emmett, *Shanghai Pierce: A Fair Likeness* (Norman: University of Oklahoma Press, 1953), 297. Apparently, *Mr. Potter* was a brisk-seller at the newsstands: see Stewart H. Holbrook, *The Story of American Railroads: From the Iron Horse to the Diesel Locomotive* (Mineola, NY: Dover, 2015), 406.

97. See Kenneth Baxter Ragsdale, *The Year America Discovered Texas: Centennial '36* (College Station: Texas A&M University Press, 1987).

98. John S. Spratt, *The Road to Spindletop: Economic Change in Texas, 1875–1901* (Dallas: SMU Press, 1955), 290–291, 299; "To Advertise Texas," *Salt Lake Tribune*, Jan. 10, 1889, 4 (quote); "To Advertise Texas," *DMN*, May 9, 1890, 2 (quote). By comparison, the artist Frederic Remington wrote in 1896, after a visit to the state, that "Texas is to-day the only State in the Union where pistol-carrying is attended with great chances of arrest and fine." See Remington, "How the Law Got into the Chaparral," *Harper's Monthly* 94 (Dec. 1896), 60–69.

99. George W. Knott, "Texas," *American Stationer* 26 (Aug. 15, 1889): 400.

CHAPTER 9: "THE TRUTH IS TEXAS IS WHAT HER RAILROADS HAVE MADE HER"

The chapter title quote is from Alexander Hogg, the first superintendent of schools in Fort Worth, who made the statement at the 1893 Columbian Exposition in Chicago. See "Texas a Great State," (Chicago) *Daily Inter Ocean*, Aug. 12, 1893, 9.

1. "A Friendly Contest," *Stoves and Hardware Reporter* 29 (July 15, 1897): 14 (quotes); and ""Facts about Texas," *Stoves and Hardware Reporter* 29 (Aug. 12, 1897): 39.

2. *Constitution of the State of Texas* . . . (Austin: Daily Republican Office, 1869), 33 (article 11); Rozek, *Come to Texas*, 57, 59–78 (quote).

3. US Department of Commerce, *Statistical Abstract of the United States, 1950* (Washington, DC: Government Printing Office, 1950), 498; Miller, *Public Lands of Texas*, 100; *HTO*, s.v. "Railroad Construction, Public Aid to," by Stephen G. Wilson, accessed Sept. 16, 2020; Spratt, *Road to Spindletop*, 32–33; James P. Baughman, "The Evolution of Rail-Water Systems of Transportation in the Gulf Southwest, 1836–1890," *Journal of Southern History* 34 (Aug. 1968), 372–373; James P. Baughman, *The Mallorys of Mystic: Six Generations in American Maritime Enterprise* (Middletown, CT: Published for the Marine Historical Association, Mystic Seaport, by Wesleyan University Press), 146–160; Sibley, *Port of Houston*, 99–100.

4. The Texas Pacific land trust is still one of the largest landholders in the state. See Texas Pacific Land Corporation, accessed Jan. 10, 2022, https://www.texaspacific.com.

5. "Come to Texas," *SAE*, May 27, 1868, 2.

6. "The Texas New Yorker," *Evening Telegraph* (Houston), Sept. 8, 1870, 2; "The Texas New Yorker," *FSWGB*, Sept. 10, 1870, 4; and *HTO*, s.v. "Sweet, George Henry," by Bruce Allardice, accessed Sept. 16, 2020.

7. *GTWN*, Nov. 8, 1872, 1; "The St. Louis Texan," *St. Joseph Standard* (MO), Nov. 7, 1872, 3.

8. Rozek, *Come to Texas*, 21–39, 57, 154–155; Charlton, "Development of St. Louis," 45–55; and Barbara J. Rozek's

introduction to *Forgotten Texas Census: First Annual Report of the Agricultural Bureau of the Department of Agriculture, Insurance, Statistics, and History, 1887–88*, by L. L. Foster (Austin: Texas State Historical Association, 2001), viii (quote). For information on Howard, see "Railway News," *St. Louis Globe-Democrat*, Sept. 13, 1881, 7; "From Dallas," *GDN*, Feb. 24, 1884, 1; "A Walk-a-Way," *GDN*, Sept. 20, 1884, 8 (quote); and "State Press," *GDN*, Jan. 11, 1891, 8 (quoting the *Waco Day*); "Of and for Texas," *FWDG*, Feb. 29, 1888, 2; "John Howard's Work," *FWDG*, Mar. 15, 2 (quote); "As Others See Us," *Houston Daily Post*, Dec. 1, 1893, 6; "John Howard," *Canadian Free Press*, Mar. 7, 1888, 4; ibid., "John Howard Endorsed," May 2, 1888, 4; and *Fort Worth Democrat*, June 17, 1876.

9. William Woys Weaver, *Culinary Ephemera: An Illustrated History* (Berkeley: University of California Press, 2010), 223–225.

10. Geiser, "Naturalists of the Frontier," 184–198. Boll later settled in Dallas.

11. Herman Strecker, *Lepidoptera, Rhopaloceres and Heteroceres, Indigenous and Exotic; with Descriptions and Colored Illustrations* (Reading, PA: Owen's Steam Book and Job Printing Office, 1872–1877); W. B. Weiss and Herman Strecker, "An Interview with Herman Strecker in 1887," *Journal of the New York Entomological Society* 61 (Dec. 1953): 201–210; Bennett, *Practical Guide*, 102; and William Leach, *Butterfly People: An American Encounter with the Beauty of the World* (New York: Pantheon, 2012), 52–66.

12. *Brenham Daily Banner*, June 16, 1885, 4.

13. "Commercial," *Daily Missouri Republican* (St. Louis), Apr. 9, 1873, 6.

14. Ibid., "Mexican Annexation," Aug. 9, 1874, 4.

15. Baughman, "Evolution of Rail-Water Systems," 372–373. See Baughman, *Mallorys of Mystic*, 146–160; Sibley, *Port of Houston*, 99–100.

16. *HTO*, s.v. "Indianola Railroad," by Brownson Malsch, accessed Sept. 14, 2020; Donald J. Everett, "San Antonio Welcomes the 'Sunset'—1877," *Southwestern Historical Quarterly* 65 (July 1961): 48, 51; "On the Wing," *GDN*, Feb. 6, 1876, 1 (quote).

17. "San Antonio," *GDN*, Dec. 5, 1875, 1; "San Antonio," *GDN*, Dec. 11, 1875, 1. For information on the Sunset Route, which eventually reached the Pacific Ocean, see S. G. Reed, *A History of the Texas Railroads and of Transportation Conditions under Spain and Mexico and the Republic and the State* (Houston: St. Clair Publishing, 1941), 191–207. See also *HTO*, s.v. "Peirce, Thomas Wentworth," by John Mason Hart, accessed Sept. 14, 2020; Fornell, *Galveston Era*, 145; and *HTO*, s.v. "Gulf, Colorado and Santa Fe Railway," by George C. Werner, accessed July 20, 2021.

18. Information on Whilldin [spelled Whillden] is contained in Heller, *Galveston City Directory for 1870*, 61, 96; Heller, comp., *Galveston City Directory 1872* (Galveston: John D. Heller, 1872) [spelled correctly], 136; and W. A. Fayman & T. W. Reilly's *Fayman & Reilly's Galveston City Directory for 1875–6* (Galveston: Strickland & Clarke, 1875), 282. See also the "Report of Brig. Gen. Stephen G. Burbridge, U.S. Army, Commanding First Brigade," Jan. 14, 1863, in *The War of the Rebellion: A Compilation of the Official Records of the Union and Confederate Armies*, Series 1, vol. 17 (2 parts), pt. 1, "Reports" (Washington, DC: GPO, 1886), 731; "Roster of Civilians Employed as Assistants, Agents, Inspectors &c. by Thomas W. Conway Assistant Commissioner &c., Bureau of Refugees, Freedmen and A. Lands, State of Louisiana, September 1865," in *Records of the Assistant Commissioner for the State of Louisiana, Bureau of Refugees, Freedmen and Abandoned Lands, 1865–1869*, NA, Microfilm Publication M1027, Roll 34; "Salutatory," *FDB*, Nov. 18, 1865, 2; *GDN*, Sept. 10, 1871, 2; "The Advertiser," *GDN*, Oct. 8, 1872, 2; June 1, 1875, 1; "Guide to Western Texas," Feb. 5, 1876, 2; "State News," *GDN*, Mar. 21, 1876, 3; "Texas—Facts and Fancies," *Weekly Democratic Statesman* (Austin), Nov. 4, 1875, 2, quoting the *San Antonio Herald*; and "Obituary," *GDN*, July 23, 1888, 1.

19. Brothers Leopold and August Gast arrived in St. Louis in 1852 from the principality of Lippe Detmold and established their business with the one lithographic press that Leopold had brought with him. In 1866 Leopold sold his share of the business to August; the firm became the August Gast & Co. and was well established by 1876 when it printed the lithographic covers and illustrations for Whilldin's book. See Ernst D. Kragau, *The German Element in St. Louis*, trans. William G. Bek (Baltimore: Genealogical Publishing, 2000), 323–325.

20. David G. McComb, *Houston: A History* (Austin: University of Texas Press, 1981), 65; [Matthew Whilldin], *A Description of Western Texas, Published by the Galveston, Harrisburg & San Antonio Railway Company, the Sunset Route* (Galveston: "News" Steam Book & Job Office, 1876), 12–21.

21. See Willard B. Robinson, *The People's Architecture: Texas Courthouses, Jails, and Municipal Buildings* (Austin: Texas State Historical Association, 1983), 5–36, for a comment on this unusual arrangement in Gonzales. In fig. 9.9 Robinson illustrates a c. 1858 photograph of the courthouse that shows the structure from the opposite direction of the print.

22. [Whilldin], *Description of Western Texas*, 85; "San Antonio," *GDN*, Feb. 21, 1877, 1; Everett, "San Antonio Welcomes the 'Sunset'—1877," 48, 51–52; and Young, *Tracks to the Sea*, 4, 102, 107.

23. Louis Eyth was established in Galveston by at least 1869 when he taught drawing and painting at the Young Ladies' Institute ("Young Ladies' Institute," *GDN*, Aug. 29, 1869, 5). In 1877 he opened his own school of design ("School of Design," *GDN*, Aug. 19, 1877, 3). He caught the editor's attention again when he produced a cartoon of Governor Roberts ("An Amusing Cartoon," *GDN*, Aug. 25, 1880, 4) and undertook to publish a satirical Sunday paper entitled *The Lash* ("A New Paper," *GDN*, Dec. 3, 1883, 8). In 1884 Eyth painted a historical scene of William B. Travis addressing the Alamo garrison the evening before Santa Anna's attack, which recently surfaced in a private collection. "A Historical Picture," *GDN*, June 6, 1884, 8; and "Mr. Eyth's Painting," *GDN*, June 9, 1884, 8; "The Galveston Correspondent," *San Antonio Light*, June 28, 1884, 1. Apparently he had moved to Waco by 1892 when he produced another cartoon showing a third-party candidate as an "immense porker galloping toward the gubernatorial mansion." "Waco Budget," *GDN*, Aug. 25, 1892, 6. He later provided illustrations for James T. DeShields, *The Border Wars of Texas . . .* (Tioga, TX: Herald Co., 1912). F. T. Ryan advertised as a professor of drawing and painting in Dallas in 1873 ("F. T. Ryan," *DDH*, May 28, 1873, 4) and won prizes at the fair that fall for best watercolor and best painting ("Third Day of the Fair," *DDH*, Oct. 3, 1873, 4). By 1874 he was advertising his talents in Galveston (*GDN*, Apr. 5, 1874, 3, and "F. T. Ryan," 2) and later that year designed and illustrated the letterhead that the *GDN* (June 2, 1874, 2) noticed. See "State Press," *GDN*, May 28, 1876, 3, for Whilldin's association with the New York *Daily Graphic*. See the *Daily Graphic* (Feb. 26, 1876, 5, Mar. 4, 1876, 5, and May 26, 1876, 921) for sketches by the Galveston "art correspondent."

24. [Whilldin], preface to *Description of Western Texas*; *GDN*, Feb. 5, 1876, 2.

25. *HTO*, s.v. "River Navagation," by Seymour V. Connor, accessed Jan. 29, 2022. That did not mean that municipalities and entrepreneurs did not continue searching for a navigable river. See Jackie McElhaney, "Navigating the Trinity: A Dream that Endured for 130 Years," *Legacies: A History Journal for Dallas and North Central Texas* 3 (Spring 1991), 4–13; and Baughman, "Evolution of Rail-Water Systems," 357–381.

26. Jack Noe, "Representative Men: The Post-Civil War Political Struggle over Texas's Commissioners to the 1876 Centennial Exhibition," *Southwestern Historical Quarterly* 120 (Oct. 2016): 162–187. The Texas exhibit fell victim to politics, as the two Texas commissioners—former Confederate general turned Radical Republican William Henry Parsons and former *Houston Telegraph* editor John C. Chew, a Democrat and former slave owner, nominated by Governor Davis and appointed by President Grant—refused to resign their positions, and the Democrat-controlled state legislature refused to fund it. See also "Philadelphia," *GDN*, July 6, 1876, 4; "Texas and the Centennial," *Emmetsburg Palo Alto Pilot* (Iowa), Oct. 28, 1876, 6; "Local Personals," *GDN*, Dec. 15, 1876, 4.

27. The second edition, apparently also done in 1876, contained several corrections.

28. The company issued at least two editions: a first printing and a corrected printing. See Dorothy Sloan—Books, Auction 23, accessed Jan. 10, 2022, http://www.dsloan.com/Auctions/A23/item-galveston-whilldin-description-1876.html. The editors made corrections to pages 112–113 in the second printing. See also "Texas," *Luzerne Union* (Wilkes-Barre, PA), July 18, 1877, 3; and M. Whilldin, "The

Immigration Cause," *GDN*, Aug. 3, 1877, 4, and Aug. 30, 1877, 1; "The Texas Ho," *SADE*, Aug. 19, 1877, 4; *Waxahachie Enterprise*, Jan. 29, 1876, 1; and *GDN*, Apr. 13, 1877, 2.

29. After leaving Philadelphia, Whilldin made a presentation in Wilkes-Barre, and in 1881 he was in London as agent for the British American Line. See "Texas," *Luzerne Union* (Wilkes-Barre, PA), July 18, 1877, 4; and "British American Line," *Liverpool Mercury* (England), Nov. 21, 1881, 8. Whilldin died in Dallas in 1888. "Obituary. Matthew Whilldin," *GDN*, July 23, 1888, 1.

30. "Distinguished Visitors," *GDN*, Mar. 21, 1882, 4 (quote); "The Railroad Problem and the Deep-Water Problem," *GDN*, Mar. 21, 1882, 2; "San Antonio," *GDN*, Jan. 13, 1883, 1; and Young, *Galveston and the Great West*, 75–78.

31. Bernard Axelrod, "Galveston: Denver's Deep-Water Port," *Southwestern Historical Quarterly* 70 (Oct. 1966): 217–228; and McComb, *Galveston*, 58–61. Richardson died in 1875.

32. Wilson served as a member of Congress until his election was successfully challenged; he later served as secretary of agriculture under presidents McKinley, Roosevelt, and Taft. See Biographical Dictionary of the United States Congress, accessed Jan. 10, 2022, http://bioguide.congress.gov/scripts/biodisplay.pl?index=W00059. Rozek, *Come to Texas*, 158, 165–166; [James Wilson], *Agricultural Resources in the Pan Handle of Texas on the Line of the Denver, Texas & Ft. Worth R.R.* (Denver[?]: The Railroad [?], 1888); John F. Elliott, *All About Texas: A Hand Book of Information for the Home Seeker, the Capitalist, the Prospector, the Tourist, the Health Hunter, Containing a Description of the State . . .* (Austin: published for John H. Traynham by Hutchings Printing, 1888); and Lewis Publishing Co., *Memorial and Biographical History of Ellis County, Texas . . .* (Chicago: Lewis Publishing, 1892), 822–824.

33. Elliott, *All About Texas*, 16; "All About Texas," *Austin Weekly Statesman*, Feb. 16, 1888, 5; and "Colonel John F. Elliott," in Lewis Publishing, *Memorial and Biographical History of Ellis County*, 822–823. See also Jan Blodgett, *Land of Bright Promise: Advertising the Texas Panhandle and South Plains, 1870–1917* (Austin: University of Texas Press, 1988), 26–42.

34. "A Thing of Beauty," *Evening Tribune* (Galveston), Jan. 19, 1891, 1; *El Paso International Daily Times*, Jan. 16, 1891, 4; and "Texas a Great State," *The Inter Ocean* (Chicago), Aug. 12, 1893, 9 (quote).

35. "State Press," *GDN*, Oct. 17, 1879, 3 (quote).

36. "Galveston," *FDB*, Sept. 26, 1865, 2; "Galveston," *FDB*, Oct. 5, 1865, 2; *Houston Tri-Weekly Telegraph*, Sept. 25, 1864, 4; "The Steamship City of Austin," *GDN*, Dec. 28, 1871, 3 (quote); and "Steamer Ashore," *Dallas Weekly Herald*, Apr. 28, 1881, 1.

37. "Immigrants to Texas," *GDN*, Dec. 8, 1868, 2; *London Daily Times*, Nov. 3, 1868, 5; *FDB*, Oct. 25, 1868, 15; and "Pioneer Line Emigration to Texas," *Anglo-American Times* (London), Jan. 16, 1869, 24. When the *San Jacinto* arrived at Galveston, the *News* published a lengthy description of the vessel. See "Steamer San Jacinto," *GDN*, Feb. 11, 1873, 2. The best information on Mallory & Co. is in Baughman, *Mallorys of Mystic*: see pp. 135–143 for the beginning of the Mallorys's Texas trade after the Civil War. See also John H. Morrison, *A History of American Steam Navigation* (New York: Argosy-Antiquarian, 1967), 466–467; Francaviglia, *From Sail to Steam*, 221–237; and Hayes, *Galveston*, 2:678–680.

38. "Synopsis of Mr. Degener's Speech," *FSWGB*, Feb. 3, 1869, 4; *FSWGB*, Mar. 13, 1869, 2, quoting the *Cincinnati Times*; "Immigration to Texas," *GDN*, Dec. 8, 1868, 2.

39. "Messrs. C. W. Hurley & Co.," *GTWN*, Nov. 13, 1872, 3 (quote); Oct. 16, 1872, 2; "Steamer San Jacinto," *GDN*, Feb. 11, 1873, 3.

40. "Black Star Line," *GDN*, Jan. 1, 1874; Francaviglia, *From Sail to Steam*, 221; and Rozek, *Come to Texas*, 172–189; "Col. C. W. Hurley," *GDN*, May 19, 1877, 2; and "Interview with Mr. Hurley," *GDN*, May 30, 1877, 4. The notice of the company's scheduled liquidation on June 30, 1877, first appeared in the "Liverpool and Texas Steamship Co., Limited," *GDN* on May 18, 1877, 1.

41. Walter W. Ristow, *American Maps and Mapmakers: Commercial Cartography in the Nineteenth Century* (Detroit: Wayne State University Press, 1985), 281–301.

42. See Black, *Maps and History*, 49.

43. See *Fort Worth Democrat*, Jan. 25, 1873, 2, and Apr. 4, 1874, 2; ibid., "Texas & Pacific Railway Lands," Aug. 21, 1875, 2, and Jan. 29, 1876, 3; ibid., "Texas Homestead and Banking Company of St. Louis," May 20, 1876, 4; and "Free," *Daily Fort Worth Standard*, Oct. 7, 1876, 4, for examples of how maps were used in the promotion of available land.

44. Kosse apparently made the map at the behest of the city. *Tri-Weekly Telegraph* (Houston), May 7, 1866, 16, and "The City," June 20, 1866, 11.

45. There is a contradiction in the information provided on the map: Wood lists 1868 as the publication date but says that it was made from surveys done on Jan. 1, 1869. The Blessing Brothers had established their first Texas studio in Galveston, then moved to Houston when the Civil War threatened the island city. They reopened the Galveston location after the war and maintained studios in both cities. See *HTO*, s.v. "Blessing Brothers," by Ben W. Huseman, accessed Sept. 14, 2020; W. A. Leonard, comp., *Houston City Directory for 1867–8* (Houston: W. A. Leonard, 1867), xix, in the advertisements. On the old capitol, see "The Capitol Hotel," *Weekly Telegraph* (Houston), Sept. 17, 1868, 4.

46. Taylor and Maar, *American Cowboy*, 50–51.

47. *HTO*, s.v. "Roessler, Anton R.," by Keith Young, accessed Sept. 14, 2020.

48. Lemercier began experimenting with reproducing a photograph by lithography in 1849 and printed *Lithographie ou impressions obtenus sur pierre à l'aide de la photographie* (Paris, 1853). See Twyman, *Lithography*, 253. The first large-scale use of photolithography in America is generally considered to be A. A. Turner, *Villas on the Hudson: A Collection of Photo-Lithographs of Thirty-One Country Residences* (New York: D. Appleton, 1860). David A. Hanson, "A. A. Turner, American Photolithographer," *History of Photography* 10 (Issue 3, 1986); Twyman, *History of Chromolithography*, 60, 179; and Porzio, "Invention and Technical Evolution," in Porzio, *Lithography*, 32–35.

49. "Photozincography, Photolithography, &c.," *Boston Daily Advertiser*, Aug. 31, 1861, 2; and ibid., "Photolithography," Aug. 16, 1864, 2. Joseph Dixon is also given credit for developing photolithography. See "The Death of a Remarkable Inventor," *Milwaukee Daily Sentinel*, June 26, 1869, 2.

50. These maps are in the Geography and Map Division of the Library of Congress.

51. McCoy to Dearest Parents, Dec. 6, 1870, and May 17, 1873, in Enstam, *When Dallas Became a City*, 106 (quote).

52. Witness the municipal rivalry between Dallas and Fort Worth than began when the *DDH* reported that Fort Worth was so deserted that a panther wandered up from the Trinity River bottom and slept in the street through the night. "Fort Worth in a Cold Sweat," *DDH*, Feb. 2, 1875, 4.

53. "New Map," *GDN*, Mar. 10, 1871, 3; "Galveston, Texas," *Harper's Weekly* 10 (Oct. 27, 1866): 686; "The Finances and Future of Texas," *New York Daily Herald*, Mar. 2, 1874, 7. Drie later changed the spelling of his name to Dry.

54. John W. Reps has published a number of books on this subject, but the most important is *Views and Viewmakers*, 20, 172.

55. "A Splendid Map," *GDN*, July 11, 1871, 2 (quote). The ad also appears in the paper on Mar. 15, 16, 17, and 18. See also "New City Map," *FB*, July 18, 1871, 3.

56. "The Galveston Fire," *San Antonio Weekly Star*, Dec. 11, 1869, 3 (quoting *FB*); Fox, "Broadway, Galveston, Texas," 210; and *HTO*, s.v. "Groesbeeck, John D.," by G. E. Baker, accessed Dec. 11, 2019.

57. Casey Edward Greene, "Yellow Fever Led to the Filling of Hitchcock's Bayou," *Galveston County Daily News*, Mar. 16, 2008, C1, C8.

58. "New City Map," *FB*, July 18, 1871, 3.

59. "New Map," *GDN*, Mar. 10, 1871, 3 (quote), and Mar. 14, 1871, 2; and "A Splendid Map," *GTWN*, July 12, 1871, 1.

60. "New Map," *GDN*, Mar. 10, 1871, 3.

61. Brosius was born April 8, 1851. Karen Brosius to Ron Tyler, Dec. 3, 2010, letter in possession of the author; and "Bird's-Eye View of Dallas," *DH*, Dec. 28, 1872, 2, in which his name is misspelled as "Brasieus." See also Reps, *Views and Viewmakers*, 165.

62. *DH*, Aug. 5, 1871, 2.

63. *DH*, May 20, 1871, 3.

64. *HTO*, s.v. "Cockrell, Sarah Horton," by Elizabeth York Enstam, accessed Mar. 24, 2020, uploaded June 12, 2010.

65. "Bird's Eye View of Dallas," *DDH*, Mar. 12, 1873, 2.

66. McCoy to Dearest Parents, Dec. 6, 1870, and May 17, 1873, in Enstam, *When Dallas Became a City*, 16, 106.

67. "Bird's-Eye View of Dallas," *DH*, Dec. 28, 1872, 2 (quote).

68. For biographies of all these artists except Pearce, Patchen, and Westyard, see Reps, *Views and Viewmakers*, 7–16, 172, 174–177, 184–186. D. D. Morse published *D. D. Morse's Manual of Art: A Self Teacher of All Branches of Decorative Art, Embracing almost Every Variety of Painting and Drawing, on China, Glass, Velvet, Canvas, Paper and* (Chicago, 1884).

69. These amounts are derived from the Consumer Price Index tables at www.MeasuringWorth.com. "Bird's-Eye View of San Antonio," *San Antonio Daily Herald*, Apr. 12, 1873, 3. Drie's Galveston view was offered for $3 each; Koch's 1873 Austin view, $5; his 1873 view of Brenham initially for $2, then for $3; Wellge's 1886 Waco view, $3. See "Bird's-Eye View of Galveston," *GDN*, Mar. 14, 1871, 2; "A Bird's-Eye View," *Austin Daily Democratic Statesman*, Apr. 9, 1873, 3; *Brenham Banner*, Apr. 12, 16, 19 and May 3, 10, 17, 24, 1873; "Waco, the Queen City," *The Day* (Waco), Jan. 25, 1886, 1.

70. "Waco, the Queen City," *The Day* (Waco), Jan. 25, 1886, 1; "A Complete Picture," *Daily Examiner* (Waco), Jan. 24, 1886, 4; and Reps, *Views and Viewmakers*, 56. The Laredo Real Estate & Abstract Co., R. West Starr and B. B. Paddock (Paddock was the editor of the *Fort Worth Democrat* and also business partner with Starr), the Texas Land & Investment Co., and Caswell Bros. Loan all added their names to copies of views.

71. Reps, *Views and Viewmakers*, 53–55; Minutes of the Victoria City Council, Feb. 8, 15, Apr. 26, and Sept. 20, 1873. The council appointed a committee to name all the streets of the city so that Brosius could include them on his map. For information on courthouses, see Robinson, *People's Architecture*. I have counted at least eighty-one bird's-eye views of Texas cities published between 1871 and 1900 and four after 1900. In addition, there are several copies and smaller views published in various souvenir booklets. See also Enstam, *When Dallas Became a City*, 106, 110, 119.

72. *DDH*, Dec. 30, 1875, 4; "Map of Dallas," *DDH*, Feb. 15, 1876, 4. Both sides of Gollner's print are shown as endpapers in A. C. Greene, *A Place Called Dallas: The Pioneering Years of a Continuing Metropolis* (Dallas: Dallas County Heritage Society, 1975). Gollner also published *Gollner's Pocket Guide of Saratoga Springs, New York, U.S.A.* (Trenton, NJ: W. S. Sharp, 1881).

73. "Dallas Budget," *GDN*, Mar. 7, 1893, 6; "Galveston and Dallas," *GDN*, May 1, 1893, 7; "A Visit to the Harvey," *GDN*, May 16, 1893, 6; and "Dallas Swells in Glory," *GDN*, May 25, 1893, 2; "Opening Up the Trinity," *DMN*, Nov. 4, 1892, 8; "Commercial Club," Feb. 14, 1894, 8 (quote). At this time, Alfred H. Belo owned both the *Galveston Daily News* and the *Dallas News*, which were connected by telegraph and usually ran many of the same stories on the same day. "Of Interest to the Craft," *Inland Printer* 3 (May 1886): 505. See also E. H. Brown, *Trinity River Canalization* (Dallas: C. H. Plyer, 1930), 39–45; Jackie McElhaney, "Navigating the Trinity," *Legacies: A History Journal for Dallas and North Central Texas* 3 (Spring 1991): 6–13. The idea of making the Trinity navigable by barge traffic resurfaced over the years, and Congressman Jim Wright of Fort Worth actively pushed the plan during the 1960s. A favorable Corps of Engineers report led to modest appropriations to begin the effort, but when Dallas–Fort Worth voters turned down a bond issue that would have provided start-up money, the federal government dropped the idea. See *HTO*, s.v. "Trinity River Navigation Projects," by Wayne Gard, accessed Dec. 13, 2013.

74. "An Interesting Meeting," *GDN*, Jan. 16, 1892, 8. A trained civil and mining engineer, Riecker cut quite a figure through the nineteenth-century West from Tucson to Los Angeles to Washington Territory to Galveston and back to California. Having deserted his wife and family in Arizona, he was at one point described as a "fortune-hunter" in Los Angeles for his attempt to marry the daughter of a local millionaire. "Personal News," *Los Angeles Times*, Oct. 13, 1887, 8. He was apparently in Galveston for only a short time but took a leading role in promotion of the city and was mentioned frequently in news articles in both the *News* and the *Evening Tribune*.

75. "Fairs," *TSG* (Austin), Oct. 15, 1859, 2 (quote).

76. Some have claimed that Colonel Kinney's Lone Star State Fair was more of a land speculating scheme than a fair. See *Corpus Christi: 100 Years* (Corpus Christi: Corpus Christi Caller-Times, 1952), 58.

77. "Fairs," *TSG* (Austin), Oct. 15, 1859, 2 (quote). For the Dallas editor's summary of the Dallas fair, see "County Agricultural and Mechanical Association," *DH*, Nov. 2, 1859, 2. See also Edward Hake Phillips, "Texas and the World Fairs, 1851–1935," *East Texas Historical Journal* 23 (Issue 2): 5; Nancy Wiley, *The Great State Fair of Texas: An Illustrated History* (Dallas: Taylor Publishing, 1985), 4.

78. *Weekly State Gazette*, Mar. 26, 1870, 1; "Our Fair," *Houston Telegraph*, Mar. 24, 1870, 4; Jeff Large, "Queen Mab and the Mastodon: The Late Entertainment Network," *Texas Historian* 42 (Sept. 1981): 12–18. The organizers of the Austin event changed the name to the Texas Capital State Fair and incorporated in 1878. "The First Annual Exhibition of the Capital State Fair Association," *GDN*, Oct. 28, 1875, 2; "State Press," *GDN*, Feb. 24, 1876, 2; "Tyler Tap—Narrow Gauge," *GDN*, Sept. 15, 1878, 8; "The Coming Fair," *Weekly Democratic Statesman* (Austin), Aug. 26, 1875, 3.

79. Societies in Austin," *GDN*, Sept. 15, 1878, 3, published a notice of the incorporation of the Capital State Fair Association as well as the San Antonio Fair Association (July 3, 1888, 1). Two fairs opened in Dallas in 1886—the Dallas State Fair and Exposition and the Texas State Fair and Exposition—because the sponsors could not agree on a site. After both events lost money, the sponsors willingly collaborated the following year to form the Texas State Fair and Dallas Exposition, the forerunner to the State Fair of Texas. Attendance had to be estimated because accurate records were not kept during the fair's early days. See Wiley, *Great State Fair*, 4–13.

80. "Street Notes," *Waco Daily Examiner*, Oct. 18, 1887, 7 (quote).

81. "A Clever Parody," *FWDG*, Jan. 25, 1888, 2; "The Texas Mikado," *FWDG*, Jan. 30, 2 (quote).

82. "Personal," *FWDG*, Jan. 9, 1883, 5; "Rail and Wire," *FWDG*, Sept. 19, 1884, 8; "Localettes," *FWDG*, Feb. 17, 1885, 8; "Jo: A Telegrapher's Tale," *FWDG*, Apr. 27, 1885, 8; "The Newspapers," *FWDG*, May 25, 1887, 6; and "East Lynne," *FWDG*, May 30, 1888, 8.

83. Edward J. Smith, *The Capitalist; or, The City of Fort Worth (The Texas Mikado)* (Fort Worth: Fort Worth Board of Trade, 1888), 7, 14; and "Emma Abbott Opera Festival," *FWDG*, Dec. 16, 1885, 3 (quote). See also Jan L. Jones, *Renegades, Showmen, and Angels: A Theatrical History of Fort Worth from 1873–2001* (Fort Worth: TCU Press, 2006), 76–78; Laura K. Bennett, "Rural and Urban Boosterism in Texas, 1880s–1930s" (MA thesis, University of Texas at Arlington, 2008), 18–26; and Harold Rich, *Fort Worth: Outpost, Cowtown, Boomtown* (Norman: University of Oklahoma Press, 2014), 53.

84. "A Clever Parody," *FWDG*, Jan. 25, 1888, 2; "The Texas Mikado," *FWDG*, Jan. 30, 2 (quote); "Localities," *FWDG*, Jan. 31 and Apr. 29, 1888, 2. The books were delivered on June 1. *FWDG*, June 1, 1888, 2, and "The Capitalist," 8.

85. Ketterlinus entry in Groce and Wallace, *Dictionary of Artists in America, 1564–1860*, 368.

86. In 1873 the Fort Worth real estate firm of Brewer & Waterman created and had engraved a map of the city showing nine railroad lines extending in every direction from the city. The map ran first in the *North Texas Epitomist*, then, a few days later, in the *Fort Worth Democrat*, July 26 through August 23, 1873. Because the rail lines seemed to mimic the legs of a spider, the map soon became known as the "tarantula map," and the city used it for decades to advertise its reputation as the railroad center of North and West Texas.

87. "To a Stranger," *FWDG*, Dec. 12, 1888, 7. Following his success with the parodies of Gilbert and Sullivan operettas, Smith moved to New Jersey to reenter the postal telegraph service. "General and Personal," *FWDG*, Oct. 22, 1890, 5.

88. Edward J. Smith, *San Antonio, Texas: A Parody on the H.M.S. Pinafore* (N.P.: E. J. Smith and A. R. Keele, 1888); "A Move in the Right Direction," *San Antonio Daily Light*, June 13, 1888, 1; ibid., "Pinafore Advertising," June 18, 1888, 4; ibid., "A Parody on Pinafore," Sept. 19, 1888, 1; "Fort Worth News," *GDN*, Mar. 9, 1889, 6.

89. "The Palace," *FWDG*, May 21, 1890, 2; Fred Frank Blalock, "Texas Beautiful Fire Trap," *True West* 21 (June 1974): 32ff; John R. Rose, *The Texas Spring Palace: A Complete and Illustrated Description . . . Its Origin and the Causes Leading up to Its Grand Success* (Fort Worth: Self-published, 1890); Richard Selcer, "People's Palaces," *American History* 49 (Apr. 2014): 58–65; and, for context,

Pamela H. Simpson, *Corn Palaces and Butter Queens: A History of Crop Art and Dairy Sculpture* (Minneapolis: University of Minnesota Press, 2012), 30–31.

90. "Texas Spring Palace," *FWDG*, Feb. 12, 1889, 5. See also Patricia Leonora Duncan, "B. B. Paddock and Fort Worth: A Case Study of Late Nineteenth-Century American Boosterism" (MA thesis, University of Texas at Arlington, 1982); E. D. Allen, *The Texas Spring Palace, a Complete and Categorical Description of this Marvelous Temple* (Fort Worth: Texas Printing and Lithographing Co., 1889), copy in Box 10,108-4 through 110-4, Works Progress Administration, National Writers' Project, "Fort Worth City Guide Draft and Records," Special Collections, University of Texas at Arlington Libraries.

91. 111–114, Box 2, No. 2–7, Works Progress Administration, National Writers' Project, "Fort Worth City Guide and Draft Records," Special Collections, UTA; "Texas Spring Palace," *FWDG*, Feb. 21, 1889, 5; "Six O'Clock," *FWDG*, Feb. 27, 1889, 5; and "The Palace," *FWDG*, May 21, 1890, 3. Weekly summaries appeared in the *Gazette* on May 2, May 23, May 30, and June 6, 1889. "Texas Spring Palace," *GDN*, May 18, 1889, 8 (quote); "Texas Spring Palace," *DMN*, May 15, 1889, 4 (quote); and "Notes," *San Antonio Daily News*, May 9, 1889, 7 (quote). See also *Jacksboro Gazette*, May 16, 1889, 2; Leonard Sanders, *How Fort Worth Became the Texasmost City* (Fort Worth: Amon Carter Museum of Western Art, 1973), 103, quoting Paddock; and Edward J. Smith, *Texas Spring Palace City, Fort Worth. A Parody on H.M.S. Pinafore* (Fort Worth: Texas Spring Palace, 1889).

92. Paddock paid $2,217.25 to Woodward & Tiernan for printing lithographs, hangers, tickets, etc. See "Statement of Receipts and Expenditures, (Texas Spring Palace)," Feb. 1 to Sept. 19, 1890, B. B. Paddock Papers (Box 2F172), BCAH, which shows that Morse was paid $40 on Feb. 17, 1890, for "making [a] perspective view of the new building." See also Sanders, *How Fort Worth Became the Texasmost City*, 103–104; "Where They Came From," *FWWG*, July 4, 1889, 4; "Unexcelled as an Advertisement," *FWWG*, July 11, 1889, 1, quoting the *Tascosa Pioneer*, 2, 7; "New Texas Spring Palace," *FWDG*, Mar. 23, 1890, 3; and "Spring Palace Notes," *FWDG*, Mar. 29, 1890, 4 (quote).

93. "The Palace," *FWDG*, May 21, 1890, 2 (quote).

94. "Surging Masses," *FWDG*, May 12, 1890, 1; "Increasing Crowd," *FWDG*, May 14, 1890, 2; "Crowding In," *FWDG*, May 16, 1890, 2; "A Great Calamity," *FWDG*, June 5, 1890, 3; Blalock, "Texas Beautiful Fire Trap," 32ff; Sanders, *How Fort Worth Became the Texasmost City*, 104 (quote); and Rich, *Fort Worth*, 56–60.

95. "Burning of the Great Texas Spring Palace," *Frank Leslie's Illustrated Newspaper* (New York), June 14, 1890, 401; ibid., "The Hero of the Texas Fire," June 28, 439. See also "A Permanent Palace," *FWWG*, June 9, 1890, 4. There is a monument to Al Hayne located in a small bit of parkland across Lancaster Street from the Fort Worth Water Garden, near the original site of the Spring Palace, in downtown Fort Worth. It contains a bust of Hayne by sculptor Evaline Sellors, which in 1934 replaced the original likeness that had become worn by age. See Richard F. Selcer, *Fort Worth Characters* (Denton: University of North Texas Press, 2009), 88–160; Rich, *Fort Worth*, 69–71; and "The Hayne Fund," *FWDG*, June 9, 1890, 8.

96. "A Grander Palace," *FWDG*, June 5, 1890, 3; "Rebuild the Palace," *FWDG*, June 14, 1890, 10; "A Texan Phoenix," *FWDG*, June 23, 1890, 3; "Realty and Building," *FWDG*, June 25, 1890, 4; "Pompeiian Inclosure," *FWDG*, Oct. 8, 1890, 6; and "The Spring Palace," *FWDG*, Oct. 31, 1890, 8.

97. "The Great and Exposition," *San Antonio Light*, Nov. 20, 1888, 2; ibid., "Fair Notes," Oct. 16, 1888, 4; "Mexican Exhibits at the Fair," *SADE*, Oct. 1, 1889, 8.

98. Judith Berg-Sobré, *San Antonio on Parade: Six Historic Festivals* (College Station: Texas A&M University Press, 2003), 132–137.

99. Ibid., 137–143; "August Nolte," in Mahé and McCaffrey, *Encyclopedia of New Orleans Artists*, 284; and "German Folk Lore," *San Antonio Daily Light*, Apr. 28, 1891, 2.

100. "German Day," *San Antonio Daily Light*, Oct. 28, 1892, 1 (quote).

101. Berg-Sobré, *San Antonio on Parade*, 143–153.

102. For accounts of the building of the capitol, see Clark, *Capitols of Texas*; Frederick W. Rathjen, "The Texas State House," in *The Texas State Capitol*, ed. Robert C. Cotner (Austin: Pemberton Press, 1968), 1–5; *HTO*, s.v. "Capitol," by William Elton Green, accessed Dec. 19, 2019, uploaded June 12, 2010, modified Feb. 13, 2019; and Texas Legislative Council, *The Texas Capitol: Symbol of Accomplishment*, 4th ed. (Austin: Texas Legislative Council, 1986), 29–52.

103. "Matters Briefly Noted," *Austin Daily Statesman*, June 18, 1882, 4. I have not seen a copy of this print.

104. "State News," *San Antonio Daily Express*, Mar. 3, 1882.

105. Clark, *Capitols of Texas*, 62; Rathjen, "Texas State House," 10–12, 21; Legislative Council, *Texas Capitol*, 42–43; "A Valuable Report," *Weekly Democratic Statesman* (Austin), Jan. 18, 1883, 5; and *Report of the Capitol Building Commissioners to the Governor of Texas, Austin, January 1, 1883* (Austin: E. W. Swindells, 1883). See also Ruth Alice Allen, "The Capitol Boycott: A Study in Peaceful Labor Tactics," in Cotner, *Texas State Capitol*, 31–57; John G. Johnson, *HTO*, s.v. "Capitol Boycott," by John G. Johnson, accessed Mar. 07, 2012.

106. "Capitol Souvenir," *GDN*, Mar. 1, 1885, 8. I have not seen a copy of this print.

107. "Local Dots," *San Antonio Evening Light*, Mar. 31, 1882, 1.

108. For a mention of the lithograph, see "Finished" and "Around Austin," *Austin Daily Statesman*, Mar. 1, 1885, 4. A thorough description of these activities may be found in the *Austin Daily Statesman*, May 14–19, 1888; and Clark, *Capitols of Texas*, 62–64.

109. Willard B. Robinson, "Pride of Texas: The State Capitol," *Southwestern Historical Quarterly* 92 (Oct. 1988): 236.

110. "The Ball," *Austin Daily Statesman*, May 19, 1888, 4.

111. "A Native Production," *Evening Tribune* (Galveston), Mar. 9, 1888, 1. See also Rathjen, "Texas State House," 16–20, 25, 29–30; and Robert C. Cotner, "Attorney General Hogg and the Acceptance of the State Capitol: A Reappraisal," in Cotner, *Texas State Capitol*, 58–81.

112. Kopperl avoided bankruptcy just in time to publish the view of the capitol. "Trade Gossip," *American Stationer* 15 (Jan. 3, 1884): 12; and Geo. W. Knott, "Clippings from Dixie," *American Stationer* 24 (July 19, 1888): 108. The Austin humor publication *Texas Siftings* (Jan. 26, 1884, 8) observed, "It is only when some over-zealous and enterprising merchant advertises a book, a lithograph or a chromo to be given away free, that we fully realize how near he is approaching bankruptcy." The new capitol was also illustrated in the *Chicago Illustrated Graphic News*, Nov. 1, 1887, 1; and *Harper's Weekly* (May 12, 1888), 341.

113. *DH*, May 20, 1871, 3.

114. *DH*, July 15, 1871, 3; *DDH*, Mar. 30, 1875, 4.

115. *DDH*, Jan. 9, 1874, 4 (quote).

116. "Court House Burned," *DDH*, Feb. 4, 1880, 5; and Ron Emrich, "Old Red: Celebrating the Centennial of a Dallas Landmark," *Legacies: A History Journal for Dallas and North Central Texas* 4 (Fall 1992): 4.

117. "Dallas Bar Meeting," *DMN*, Nov. 3, 1891, 10; "Dallas," *FWDG*, Nov. 3, 1891, 5; and Emrich, "Old Red," 5–7.

118. Dorothy Sloan—Books, Auction 21, Item 17, dsloan.com.

119. "Military," *Austin Weekly Statesman*, Mar. 27, 1884, 2; ibid., "Around Austin," Apr. 2, 1885, 6; "Inter-State Military Match," *GDN*, Mar. 17, 1877, 1; S. O. Young, *Thumb-Nail History of the City of Houston Texas: From Its Founding in 1836 to the Year 1912* (Houston: Press of Rein & Sons, 1912), 120–124; and *HTO*, s.v. "Houston Light Guards," by Bruce A. Olson, accessed Sept. 14, 2020.

120. *HTO*, s.v. "Houston Light Guards," by Olson, 70–95.

121. Kate Sayen Kirkland, *Captain James A. Baker of Houston, 1857–1941* (College Station: Texas A&M University Press, 2012), 57–58, 128–176.

122. *HTO*, s.v. "Texas National Guard," by Bruce A. Olson, accessed Sept. 14, 2020.

123. Cotham, *A Busy Week in Texas*, 23, 59, and 73; "Stray Notes," *GDN*, Feb. 10, 1882, 4; "German Day," *San Antonio Daily Light*, Oct. 28, 1892, 1 (quote); Allan Robert Purcell, "The History of the Texas Militia, 1835–1903" (PhD diss., University of Texas at Austin, 1981), 262–263; Bruce A. Olson and Jack L. Howard, "Armed Elites Confront Labor: The Texas Militia and the Houston Strikes of 1880 and 1898," *Labor's Heritage* 7 (Sept. 1, 1995): 52–63; and "Texas Military Forces Historical Sketch, 1880 to 1897," Texas Military Forces Museum, accessed Jan. 10, 2022, http://www.texasmilitaryforcesmuseum.org/tnghist14.htm.

124. Purcell, "History of the Texas Militia," 277–279; *Daily Banner* (Brenham), Nov. 18, 1877, 1.

125. See, for example, "The Big Day at Austin," *GDN*, Nov. 18, 1876, 1; "The Big Day at Austin," *GDN*, Nov. 17, 1877, 1; "The Houston Drill," *St. Louis Globe-Democrat*, May 11, 1884, 5. Even San Francisco's *Daily Evening Bulletin*

("Telegraphic Notes," May 12, 1884, 1) carried stories on the drill competition. See "Of Military Moment," *GDN*, May 22, 1886, 8; ad for Galveston Interstate Drill and Encampment, *GDN*, Aug. 1, 1886, 4; and "The Eve of the Great Event," *GDN*, Aug. 4, 1886, 8. For information on Fitzwilliam, see Mahé and McCaffrey, *Encyclopedia of New Orleans Artists*, 137.

126. "Beautiful Certificate," *GDN*, Dec. 20, 1886, 5; "Interstate Drill and Encampment," *GDN*, Apr. 30, 1884, 5; "From Houston," *GDN*, Mar. 21, 1884, 2; "The Eve of the Great Event," *GDN*, Aug. 4, 1886, 8; "Special Notice," *GDN*, June 30, 1886, 8; "It Will Catch 'Em All," *GDN*, Aug. 1, 1886, 23. "New Out," *GDN*, Aug. 7, 1886, 1, 8, announces the *Opera Glass* view, which the *Opera Glass* (Galveston, Aug. 7, 1886, 1), published as a double-page spread. See also Green, "Houston Light Guard," 95–97; and *HTO*, s.v. "Houston Light Guards," by Olson.

127. "Miss Madge Williams," *Evening Tribune*, Mar. 11, 1892, 1; "She Would Use Water," *Brenham Daily Banner*, Apr. 29, 1892, 3 (quotes); "The New Warship," *Velasco Daily Times*, June 10, 1892, 3 (quote).

128. "The Battle Ship Texas," *GDN*, June 29, 1892, 1.

129. "Silver Service for the Texas," *Post-Mirror* (Pilot Point), July 7, 1893, 6.

130. *Brenham Daily Banner*, Mar. 9, 1894, 2.

131. Herman H. Henkle, with Herbert Mitchell, "American View Books Printed by the Glaser/Frey Lithographic Process" (Chicago, 1985), 7, 89–96 (copy in Amon Carter Museum of American Art Library); Herbert Gottfried, *Landscape in American Guides and View Books: Visual History of Touring and Travel* (Lanham, MD: Lexington Books, 2013), 28–37; and *San Antonio Daily Light*, Nov. 20, 1886, 4. Brodherson, "Souvenir Books in Stone," 21–28; Gascoigne, *How to Identify Prints*, entry 56 (258); and Richard Benson, *The Printed Picture* (New York: Museum of Modern Art, 2008), 62, 242–243.

132. "New England Railroad News Agents," *Bookseller and Newsman* 14 (Dec. 1897): 13–14.

133. Henkle and Mitchell, "American View Books," 97–106.

134. Some of the Brownsville views were published in W. H. Chatfield, comp., *The Twin Cities of the Border and the Country of the Lower Rio Grande* (New Orleans: E. Brando, 1893), with photographs by Chatfield. See *San Antonio Daily Light*, Nov. 20, 1886, 4, for notice of Wagner's *Souvenir of San Antonio, Texas* (Columbus, Ohio: Ward Bros., 1886); and "Souvenir Albums," *GDN*, Apr. 3, 1892, 6, for *Souvenir of Galveston*. See also city directories for Galveston and San Antonio and "Crescent," "'Lone Star' Scintillations," 376. Similar books were published on Austin (1888) and Fort Worth (1890), but they were printed by the Albertype Co. of New York as collotypes rather than lithographs.

135. "The Weather," *Galveston Tribune*, Sept. 7, 1900, 2.

136. "Wind and Wave from Shore and Sea," *Galveston Tribune*, Sept. 8, 1900, 1; ibid., "Ten Feet Deep," 7.

137. Galveston Is in Dire Distress," *Houston Daily Post*, Sept. 10, 1900, 5; "President Tendered Aid," *San Antonio Daily Express*, Sept. 11, 1900, 3 (quote); and Patricia Bellis Bixel and Elizabeth Hayes Turner, *Galveston and the 1900 Storm: Catastrophe and Catalyst* (Austin: University of Texas Press, 2000), 17–43, 45. Perhaps the best description of the storm and the aftermath is Erik Larson, *Isaac's Storm: A Man, a Time, and the Deadliest Hurricane in History* (New York: Crown, 1999). See also John Edward Weems, *A Weekend in September* (New York: Holt, 1957).

138. John Gilmer Speed, "The Galveston Calamity," *Harper's Weekly* 44 (Sept. 22, 1900): 886, illustration on 883. See books by Paul Lester, *The Great Galveston Disaster* (Philadelphia: Globe, 1900); John Coulter, ed., *The Complete Story of the Galveston Horror, Written by the Survivors* (Chicago: United Publishers of America, 1900); Nathan C. Greene, ed., *"Story of the Galveston Flood": Complete, Graphic, Authentic* (Baltimore: R. H. Woodward, 1900); Murat Halstead, *Galveston: The Horrors of a Stricken City* (Chicago: American Publishers' Association, 1900); and Clarence Ousley, comp. and ed., *Galveston in Nineteen Hundred* (Atlanta: William C. Chase, 1900).

139. Ousley, *Galveston in Nineteen Hundred*, 212–213, 229, 233, for example.

140. The huge grants to railroads have been criticized, but Miller concludes that the policy achieved its goals (*Public Lands of Texas*, 102–105).

141. Terry G. Jordan, "The Forgotten Texas State Census of 1887," *Southwestern Historical Quarterly* 85 (Apr. 1982): 401–408; and Foster, *Forgotten Texas Census*.

142. Spratt, *Road to Spindletop*, 281.

143. "Signs of the Times," *Stoves and Hardware Reporter* 29 (July 22, 1897): 11 (quote).

EPILOGUE

The chapter title quote is from *San Antonio Light*, Apr. 12, 1896, 7.

1. "Exposition Notes," *San Antonio Light*, Oct. 31, 1899, 5; and ibid., "Maverick-Clarke," Nov. 5, 1899, 5.

2. "Old Times," *Norton's Daily Union Intelligencer* (Dallas), Mar. 31, 1882, 1.

3. *San Antonio Light*, Apr. 12, 1896, 7.

4. Exceptions, of course, are those lithographs intended to be sold as works of art, such as some of Lungkwitz's prints. As Marzio (*Democratic Art*, 79–90) discusses, the record is unclear as to when the first steam-powered press was added to an American lithographic shop.

5. Louis Eyth and Julius Stockfleth are two of the better-known Galveston-based artists during these years, but neither is known to have had his paintings reproduced lithographically. *HTO*, s.v. "Eyth, Louis," by Pauline A. Pinckney, accessed Sept. 15, 2020; *HTO*, s.v. "Stockfleth, Julius," by James Patrick McGuire, accessed Sept. 15, 2020; and James Patrick McGuire, *Julius Stockfleth: Gulf Coast Marine and Landscape Painter* (San Antonio: Trinity University Press and the Rosenberg Library, Galveston, 1976). Several of Eyth's drawings were reproduced by halftone in James T. DeShields books. See also David Tatham, "The Lithographic Workshop, 1825–50," *Proceedings of the American Antiquarian Society* 105 (pt. 1, 1995) 77.

6. Joseph Pennell and Elizabeth Robins Pennell, *Lithography and Lithographers* (London: T. Fisher Unwin, 1898), 217 (quote).

7. Arthur Leslie, "The Secret of Half-Tone Revealed," *DMN*, Apr. 16, 1899, 15; and "An Important Advance in Newspaper Illustration," June 4, 1899, 19.

8. "Book Illustration," *Brenham Daily Banner*, Feb. 6, 1892, 2; "Popular Illustration," *Halletsville Herald*, Mar. 28, 1895, 2; *San Saba News*, June 19, 1891, 4. See Jones's ad in Charles A. Newning, ed., *Texas Industrial Review* 1, no. 3 (Oct. 1895): 68, 75; and Austin Photo Engraving Co. ad in *Morrison & Fourmy's General Directory of the City of Austin, 1897–98* (Galveston: Morrison & Fourmy, 1897), 75, 78, opp. 322. Magazines were able to begin using halftone engraving before newspapers because they printed on superior paper stock.

9. "Fifty Texas Notabilities," *DMN*, Dec. 4, 1891, 5; *GDN*, Sept. 4, 1894, 4, quoting the *Bryan Pilot*; "Association Notes," *FWG*, Feb. 21, 1895, 2; *Sunday Gazetteer* (Denison), July 7, 1895, 1; *Caldwell News-Chronicle*, Jan. 21, 1898, 4; and *Houston Daily Post*, June 9, 1897, 6.

10. Frederick Jackson Turner, "The Significance of the Frontier in American History," *Proceedings of the State Historical Society of Wisconsin at Its Forty-First Annual Meeting, Held December 14, 1893* (Madison: Democrat Printing, 1894), 111 (quote).

11. Philom, "Education," *Texas Gazette*, Nov. 7, 1829, 1. "Philom" was a common pseudonym of the day, an abbreviation for philomath, meaning one who studies philosophy and mathematics. The author might have been Austin himself.

12. *Tri-Weekly Alamo Express* (San Antonio), Mar. 29, 1861, 3. The offending image appeared in *Harper's Weekly*, Mar. 23, 1861, 184. Although the image is credited to a government artist, the work is similar to other Iwonski drawings of the same scene on the same day. There is reason to believe that he got the image right, and that an engraver at *Harper's* simplified it, because another Iwonski picture of the building shows it to be a brick building. The original drawing of the published image is not known to exist. McGuire, *Iwonski in Texas*, 75–76.

13. "Harper's Weekly," *FDGB*, Jan. 10, 1867, 4.

14. Yi-Fu Tuan, *Man and Nature* (Washington, DC: Association of American Geographers, 1971), 18 (quote).

15. John Steinbeck, *Travels with Charley in Search of America* (New York: Penguin, 1997), 174.

16. Austin to Mary Austin Holley, Nov. 17, 1831, in Barker, *The Austin Papers*, 2:705; and "Table 16. Population: 1790–1990," US Census, https://www.census.gov/population/www/censusdata/files/table-16.pdf.

17. "Texas Railroads," *Railroad Gazette* 6 (Aug. 1, 1874): 294 (quote).

INDEX

Note: Italic page numbers refer to figures.

Abert, James W.: and John James Audubon, 138, 483n22; expedition into Mexican territory, 135–138, *136*, 152, 156, 482n14, 482–483n19, 483n20; on New Mexico, 121, 136; photograph of, *135*; *The Pillar Rock on the Canadian*, 137, *137*, 160, 483n20, 483n21; on Texas Panhandle, 138, 152, 156, 160
Abert, John James, 46, 135
abolitionism, 92, 104, 209, 332, 492n19
Ackerman, James, 150, 480n38, 484n51
Adair, R. H., *Map of Alvarado, Texas. Corporate Limits*, 318, *327*, 411
Adams, Ramon F., 348, 498n25
Adams-Onís Treaty of 1819, 20, 25
Adelsverein, 187–188, 195, 198–199, 201, 203, 489n41
Advertisement, *San Antonio Zeitung*, 208, *209*
Agricultural Resources in the Pan Handle of Texas on the Line of the Denver, Texas & Fort Worth R.R. (cover) (unknown artist), 398, *398*
"A. H. & J. E. Pierce Stock Raisers Cattle Dealers." Letter sheet (unknown artist), 299, *299*
A. H. Belo—A Texas Ranch—Lassoing Cattle Trading card (unknown artist), 8, *356*, 357
Ahlborn, Richard E., 122, 124
A. Hoen & Co., Baltimore, 162, 251
The Alabama in a Cyclone in the Gulf Stream (unknown artist), 251, *251*

Alamo: battle of, 31, 32, 35, 38, 473n74; as subject of artists, 119, 121–122, 395, 438, 480n47
Albrecht, Theodore, 490n61
All About Texas (unknown artist), 398, *399*
Allen, Augustus C., 41–42, 406
Allen, John, 41–42
Allen & Ginter's Cigarettes, 353, 357
American Party (Know-Nothings), 209, 210–211, 230, 233, 489n56
American Photolithographic Co., 411
American West, 1, 134, 149
Ames, J. R., *Freedom's Wreath*, 104, *104*
An Empire Illustrated (front and back covers) (unknown artist), *380*
annexation of Texas: as cause of Civil War, 479n14; interest in, 41, 72; lithographic images of, 91–92, 95–99, 103–104, 130; Mary A. Maverick on, 187, 487n1; and slavery, 91, 99, 103–104, 130, 162; and US presidential election of 1844, 91–92, 130
Antonio Lopez de Santa Anna (unknown artist), 72, *75*
Antonio López de Santa Anna (unknown photographer), *37*, 77
Apache Indians, 133
Apodaca y Eliza, Juan José Ruiz de, 13
Appel, François, 277, 284
Aransas Pass, Texas, 381, 500n94
Arbuckle Bros. Coffee, 338, 352–353
Ariel (ship), 86, 478n119
Arista, Mariano, 113, 117
Armour and Co., 358
Arnold, V., *Texas Jack*, *341*, 343

Arthur C. V. Schott (unknown photographer), 166, *166*
Audubon, John James: and James W. Abert, 138, 483n22; and John Bachman, 46, 47, 49, 52, 58, 366, 474n30; *Bassaris astute, Licht., Ring-Tailed Bassaris. Natural Size. Male*, 52, *53*; *The Birds of America*, 3, 7, 46, 48, 49, 52, 58, 175, 468n28; on John Cassin, 175; *Dycoteles Torquatus, F. Cuv., Collared Peccary*, *55*; *Havell's Tern Trudeau's Tern*, *47*, 48; *Lynx rufus, Common American Wild Cat*, *50*, 51; and Missouri River, 52; paintings reproduced as lithographs, 459; portrait of, *46*; *Sciurus Sub-Auratus, Aud. & Bach. Orange-bellied Squirrel. Male & Female. Natural Size*, 48–49, *49*, 52; *Spermophilus ludovicianus, Ord. Prairie Dog—Prairie Marmot Squirrel*, *51*; and Herman Strecker, 387; *The Texan Turtle Dove. Male*, 48, *48*; in Texas, 3, 46–49, 51, 60, 66, 198, 474n17; *Viviparous Quadrupeds of North America*, 7, 46, 48–49, 51–52, 56, 58, 366, 474n32
Audubon, John Woodhouse: and James Bachman, 56–58; John Cassin and, 175; *Lasypus Peba, Desm., Nine-Banded Armadillo*, 57–58, *57*; *Lepus Texianus, Aud. & Bach, Texian Hare*, *56*, 366; *Maphitis Mesoleuca, Licht., Texan Skunk*, 58, *58*; *Mephitis Macroura, Licht., Large-Tailed Skunk*, *54*; photograph of, *52*; in Texas, 46, 52, 56, 475n42

Audubon, John Woodhouse (attrib.), *Canis Lupus, Linn., Var Rufus, Red Texan Wolf*, 58, *59*
Audubon, Victor, 57–58, 175
Auguste D., "Le Champ d'Asile Romance Tirée de la Minerve française," 16, *16*
Austin, Henry, 86, 478n119
Austin, Stephen F.: caricatures of, 96; colony of, 25, 38–39, 92, 187, 461; and Mary Austin Holley, 46; and Sam Houston, 29; and John Dunn Hunter, 21–22; and port of Matagorda, 195; portraits of, 237, *238*, *239*, 438; Texas map of, *23*, 25, 42, 471n37
Austin, Texas: and Edward Burleson, 88; as capitol of Texas, 61, 63, 65, 71, 205, 476n65; Governor's Mansion, 205; Charles Hooton on, 71, 476n80; lithographs of, 7, 60, 61, 63, 65, 71, 205, 476n64, 476n66, 476n70; Texas Capital State Fair, *426*, 427, *427*, 503n78; Texas State Capitol Building, 205, 438, *439*, *440*, *441*
The Austin Dam, for Water, Light & Power (unknown artist), 411, *416*
Austin Dam & Suburban Railway, 411
Austin Greys, 446, 447, *448*
Austin Greys Co. A. 2nd Regt. T.V.G. (unknown artist), 447, *448*
Austin Photo Engraving Co., 460
Avery, Samuel Putnam after unknown artist, *Corpus Christi Village, and the Camp of the Army of Occupation in Texas—1846*, 106, *106*
"Awarded at the North Texas Fair Association" (unknown artist), 427, *427*

507

Babcock, A. A., *Celebration, Feb. 19, 1877. Sunset Route G.H.&S.A.R. Welcome!*, 395, *397*
Bach, J. G., 219
Bachman, John, 46–47, 49, 52, 56–58, 143, 366, 474n30
Bachmann, John: *Birds Eye View of Texas and Part of Mexico* series, 246, 249; *Panorama of the Seat of War*, 246, *247*
[Bagdad, Tamaulipas, Mexico] (unknown artist), 259, *259*
Bähr, C. O., 188, *191*, 192
Bailey, L. R., 487n118
Baillie, James S., 91–92, 108, 479n5
Baird, George W., 246
Baker, Alfred E. after Joseph M. Chadwick, *A Correct View of Fort Defiance Goliad*, 32, *33*, 88
Baker, Eugene, compositor, "J.J. Pastoriza," 318, *318*
Ballinger, William Pitt, 227, 249
Balzac, Honoré de, 12, 19
Barchesky, Enrique, 173, 487n114
Bartlett, Frederick W. after photographs by, *The Mardi Gras Carnival in Galveston, Texas—the Floats in the Procession of the Knights of Momus*, 284, *284*, 374
Bartlett, John Russell: boundary commission and, 162–164, 166, 170, 184, 485n86, 485n91; *Camp in Snow Storm on Delaware Creek, Texas*, 1850, 164, *165*, 486n92; *Camp in Snow Storm on Delaware Creek, Texas*, 1852, 164, *165*; on Guadalupe Mountain, 178, 184, 487n121; Robert V. Hine on, 486n97; and Sam Houston, 230; portrait of, *162*
The Battle of Palo Alto (unknown artist), 109, *109*
Battle of Resaca de la Palma May 9th 1846. Capture of Genl. Vega by the Gallant Capt. May (unknown artist), 117, *117*
Bavaria, Solenhofen quarries in, 4, 6, 127, 264, 303
Baylor, John R., 333
Bayot, Adolphe-Jean-Baptiste, 127, 481n62
Bean, Peter Ellis, 237, *238*
Beck & Pauli, Milwaukee, 421
Belo, A. H., 8, *356*, 357, 503n73
Bene, Louis, 199, 201
Benton, Thomas Hart, 91, 99, 130
Bent's Fort, Colorado, 135
Béranger, Pierre-Jean de, 14

Berlandier, Jean Louis, 25, 242, 471n37, 471n44
Beyer, Otto, 219, 221
Bichebois, Louis-Philippe-Alphonse, 481n62
Bierstadt, Albert, 134
Big Bend, 164, 357–358, 487n121
Bigelow, Texas Charlie, 343
Bingham, George Caleb, 468n15
bird's-eye-views (elevated perspective): John Bachmann on, 246; of cities, 362, 416, 418–422, 424, 426, 441, 447, 450, 460, 461, 503n71; John Joshua Kirby on, 492n9; kites used for, 500n75; and Oran M. Roberts, 362
Bissett, William, 480n47, 480n51
Black, William L., 358, 360
blackleg, 211, 490n60
Blanco, Plácido after Joseph Horace Eaton (attrib.), *Corpus Christi. (Campamento de Taylor)*, 106, 108, *108*
Blersch, Gustav, 212, *216*, 490n67, 490n68
Bloch, E. Maurice, 468n15
Blumenbach, Johann Friedrich, 166–167
Bodmer, Karl, 7, 152, 203, 353
Boll, Jacob, 387–388
Bollaert, William, 72, 476n66, 477n86, 477n94, 480n47
The Bombardment of Matamoros, May 1847 (unknown artist), 112, *112*, 479n28
Bonapartists, 12–14, 19
Bonham, James, 437
Bonnell, George W., 65
Booker, Jay, ad for Dallas Lithograph Co., 8, 317, 318, *319*
Booker, Jay (attr.), ad for Dallas Lithograph Co., 8, 318, *323*
Boone, Daniel, 26, *27*, 29, 30–31, 471n52
Borden, G. and T. H., after, *Plan of the City of Houston*, 42, *42*
Borney, E. [*sic*, should be Burney], "Bis die eilfte ihm in die Wade fuhr," 22
Bouchette, Robert S. M., *City of Quebec*, 76, 77
Bouvier, Ch. after Mathew Brady daguerreotype, "Sam" Houston, 233, *236*
Bowen, John T., 7, 49, 51, 58, 175
Bowie, James, 31, 437, 472n65
Bowl (Cherokee chief), 21
Bracht, Viktor, 219, 490n73
Brady, Mathew: Amiel Weeks Whipple, *152*; [Gen. Randolph B. Marcy], *143*; [William H. Emory], *163*
Brady, Peter R., 175, 178, 184
Brewer, Thomas M., 47–48

Brosius, Herman, 419, 441, 502n61, 503n71
Brosius, Herman, unknown artist after, *Bird's Eye View of the City of Dallas Texas*, 419, *420*, 441
Brown, Henry B., 163
Brown, John H., 317–318
Brown, Ruben R., 254
Bryan, John Neely, 245
Bucholzer, H.: as artist, 91–92, 479n5; *Cleansing the Augean Stable*, 98, *98*; *Footrace, Pensylvania Avenue. Stakes $25,000*, 97, *97*; *The Little Magician Invoked*, 92, *93*; *The Masked Battery or Loco-Foco Strategy*, 92; *Matty Meeting the Texas Question*, 90, 91; *Political Cock Fighters*, 97; *Sale of Dogs*, 92, *94*; *Texas Coming In*, 95–96, *96*; *The Two Bridges*, 97; *Virtuous Harry, or Set a Thief to Catch a Thief!*, 95, *95*
"Buck Skin Sam, Song of the Texan Ranger" Sheet music (unknown artist), *340*, 341, 343
Buffalo Bayou, Brazos & Colorado Railway Co., 388
[Buffalo] (unknown artist), *2*
Bufford, J. H. after Haswell, *Steam Packet Columbia*, 86, *87*
Buntline, Ned, 210, 343
Burck, Samuel B., 264, 494n10
Burleson, Edward, 88, 227
Burnet, David G., 31, 438
Butte, L. C., 337, 382
Butterfield, F. E. and C. M. Rundlett, *Official Map of Dallas Texas 1875* (detail of Dallas County Courthouse), 441, *442*

camera lucida, 46, 134, 474n18, 482n9
Camp Ford, 252, 254–255, *255*, 257
The Capitalist, or, The City of Fort Worth (The Texas Mikado) (front cover) (unknown artist), 430, *430*, 434
"The Capital State Fair Association Diploma" (unknown artist), *426*, 427
Carl, Prince of Solms-Braunfels, 82, 85, 138, 194–195, 198–199, 478n111, 489n36, 490n75
Carl Ferdinand von Roemer (unknown photographer), *138*
Carl Gustav von Iwonski [Jwonski] (unknown photographer), *218*
Carl Wilhelm von Rosenberg (unknown photographer), *205*
Caskie, W. A., 297, 495n47
Cass, Lewis, 21, 130, 230
Cassin, John, 175, 475n37

Castañeda, Carlos, 471n37
Castañeda, Juan de, 13
Castroville, Texas, 82, 86, 485n65
Catching Cattle with Lasso (unknown artist), 363, *365*
Catlin, George, 22, 32, 72, 459, 485n65
Cattle Raisers Association of North West Texas, 343, 346
Cazneau, Jane Maria Eliza McManus Storm, 168–169, 486n102, 488n24
Centennial Exhibition and Philadelphia (Glaser/Frey booklet), 450
Chadwick, Joseph M., *Fort Defiance Goliad*, 32, *32*, 88, 472n68, 472n69
Champ d'Asile (French settlement on Trinity River), 3, 11–14, 16, 19–21, 92, 461, 469n6, 470nn22–24
Chapman, John Gadsby, 438, 472n62
Charlet, Nicolas Toussaint, *Le marchand de dessins lithographiques* [The seller of lithographic drawings], 14, *15*
Cherokee Indians, 21–22, 25, 26, 29, 230, 352
Cheyenne Indians, 143
Childs, Cephas G. [Lorenzo de Zavala], 31, *31*
Chisholm Brothers, 343, 450
Chordeiles Texensis [Texas Night Hawk] (unknown artist), *173*, 175
Chovel, Rafael, 25, 471n37, 471n44
City of Austin (steamer), 400, 404, *404*
City of Galveston, Texas (unknown artist), *73*, 77, 477n88
City of Houston, Texas (unknown artist), *74*, 77
Civil War: and blockade of Texas, 246, 249, 251–252, 259, 260; and Samuel S. "Buckskin Sam" Hall, 341; Indianola and, 198; Mexican neutrality in, 259; secession of Texas and, 4, 233, 245, 246; surrender of Texas, 263; Unionist sentiment in Texas, 252–255, 257, 259–260
Clarke, Matthew St. Claire, 30
Clarke, Robert, 264, 268, 304, 333
Clarke & Courts: closing of, 496n70; dominance of, 314, 334, 335, 456; and fire of 1885, 311; formation of, 304; in-house ads of, 335; and state militias, 447; and Miles Strickland, 304, 333, 335, 497n98, 497n100, 497n101; technical expertise of, 306
Clarke & Courts sample books, 306, *309*, 333
"Clarke y Courts Libros en Blanco, Impresores Litografos" (unknown artist), 304, *306*

508 | INDEX

Clark's O.N.T. Spool Cotton, 8, 306, 338, 358, *358*
Clay, Edward Williams: caricatures of, 103–104; *Going to Texas after the Election of 1844*, 98, *99*; *Houston, Santa Anna, and Cos*, *36*, 37–38; as lithographer, 86, 91, 92, 98; *"Locofocoism" in the Blue Stage of Texian Cholera*, 99, *100*; *Major Joe Bunker's Last Parade, or the Fix of a Senator and His 700 Independents*, *40*, 41; *The Oregon and Texas Question*, 99, *101*; satirical prints of, 29, 98; *Weighed & Found Wanting*, 99, *102*; *Young Texas in Repose*, 103–104, *103*
Clay, E. W. (attrib.), *Houstonizing, or a Cure for Slander*, *28*, 29, 230, 472n54
Clay, E. W. after Jurgan Frederick Huge, *Steam Packet Neptune, of Charleston, South Carolina*, 86, *87*
Clay, Henry, 91, 92, 95–99
Clayton, Nicholas J.: advertisement for, 270; and Galveston Electric Pavilion, 268, 299; *John Sealy Hospital*, 306, *308*, 496n67; and St. Mary's Cathedral, 188
Clayton, Nicholas J., after, *Thirteenth Texas Saenger Fest, Galveston*, 299, *300*
Cody, William F. "Buffalo Bill," 210, 338, 341, 343, 382, 498n17
Coke, Richard, 363, 379
Cole, Thomas, 134
Colorado City, Texas, 42, *44*
Col. Thos. Wm. Ward U.S. Consul at Panama (unknown artist), 237, *241*
Columbia (steam packet), 86, *87*, 478n116
Columbia Exposition of 1893, Chicago, 400
Columbus, Christopher, 437
Comanche Indians: and James W. Abert, 135, 136–137, 138; and William H. Emory, 167; and Frontier Battalion, 341; and Sam Houston, 29; and Indian Territory, 398; and Ranald S. Mackenzie, 143; and Randolph B. Marcy, 150; Heinrich Balduin Möllhausen on, 160, *161*; and Cynthia Ann Parker, 245; and Quanah Parker, 361–362; and Manuel del Perez, 22; range of, 71, 411; and Tito P. Rivera, 333; and Carl Ferdinand von Roemer, 139; Conrad Caspar Rordorf's portraits of, 199, 203; and South Plains, 133, 156
Comisión de Límites, 25
Compromise of 1850, 230
Compte Rendu (unknown artist), 19, *20*

Constant, Benjamin, 13
Constitution of 1824, 31
Constitution of 1876, 385, 438
Consultation of 1835, 31
Convention of 1836, 31
Coons, Benjamin Franklin, 486n97
Cooper, Washington, 230, 491n97
Corday, Charlotte, 104, *104*
Cordray, Thomas J., Jr., 497n101
Coronado, Francisco Vázquez de, 2
Corpus Christi, Texas: and Civil War, 249; *Frank Leslie's Illustrated Newspaper* on, 379; lithography of, 106, *106*, *107*, 108, *108*, 333; Lone Star State Fair in, 426, 503n76; and Mexican invasion, 72; and Mexican War, 104, 106; and Zachary Taylor, 106, 135
Cos, Martín Perfecto de, 37–38
Courts, George M., 304
Coward, Richard, 337, 497n3
[Cowboy roping a Longhorn], "Channing Mercantile & Banking Company" Letterhead (unknown artist), 306, *308*
Cox, James, 350, 498n31
Coyle, Alice S., 368
Coyle, William H.: ad in *Industries of Houston*, *316*, 317; *Grand Inter-State Drill and Encampment, Houston, Texas* (cover), 8, 314, *315*; in Houston, 304, 314, 317, 495n63, 496n79; and Houston Light Guard, 447; photograph of, 314, *314*; sheet music and, 368
Crazy Bear (Seminole chief), 168–169
Crockett, David: death of, 472n64; and German American Volksfest in San Antonio, 437; portraits of, 30–31, *30*, *39*, 438, 472n62; trading cards of, 352; woodcuts of, 473n74
Cumberland (USN frigate), 113
Cummings, Thomas Seir, *Benson John Lossing*, 38, *38*
Currier, Charles, 110, 112
Currier, Nathaniel, 4, 91, 108, 117
Currier and Ives, 1, 4, 8, 459
Currier and Ives after William Ranney, *The Trappers Last Shot*, 34–35, *34*

Daily Graphic, 283–284, 374, 376, 379
Dallas, George M., 92, 95, 98
Dallas, Texas: *Bird's Eye View of the City of Dallas Texas*, 419, *420*, 461; Dallas County Courthouse, 441–442, *442*, *443*; fairs in, 426, 427, *428*, *429*, 503n79; and Fort Worth rivalry, 416, 502n52; *Gollner's Map of the City*

of Dallas Texas, 424, *425*, 503n72; lithography revived in, 318, 329, 331; and Trinity River navigation projects, 318, *328*, 424, 503n73
Dallas Brewing Company, Dallas, Texas, U.S.A. (unknown artist [Jay Booker?]), 8, 318, *321*, 335
Dallas Lithograph Co.: and advertising, 8, 317, 318, *319*, 323, 324, *325*, *326*, 361; and Burnet stone, 303; chromolithography of, 7, 8, *320*, *321*, *322*, *442*, 443; competitors of, 329, 456; *Dallas Lithography Company Building*, 318, *329*; and maps and city views, *327*, *328*, 411; posters of, 335
Dallas State Fair and Exposition, 503n79
Dammann, Wilhme, 219, 221, 490n75
David, Jacques-Louis, 14, 16, 23
D'Avignon, Francis: and Charles May, 480n38; *Samuel Houston*, 230, *231*
Davis, Edmund J., 270, 501n26
Davis, Jefferson, 152
Day and Haghe, 72, 77
D. Buchner & Co., New York, 360
Debray, Victor, *La Guerra de los Kikapoos*, 257, *258*, 493n32
DeBray, Xavier Blanchard, 208, 212
DeMenil, Alexander Nicholas, 350
Demopolis, Alabama, 12, 16, 19
DeMorse, Charles, 133, 362
Denison, Texas, 416
DeRyee, William, 212, 221–222, 490n77
Devine, Thomas J., 222
Díaz, Porfirio, 376
Dickinson, Anson, 37
Dickinson, Anson (attrib.), *Sam Houston*, 26, *26*, 29, 37, 352
Dienst, Alexander, 406
Dienst, Alexander, Jr., 476n64
Diploma Awarded by the Texas State and Dallas Fair Exposition (unknown artist, possibly Jay Booker), 7, 8, 318, *322*
Dixon, Joseph, 502n48
Dobie, J. Frank, 348, 350–351
Doerr, Henry, *Mission Concepción, San Antonio*, 374, *376*
Doerr, Henry A., 453
Doerr, Henry A. and Semmy E. Jacobson, after: *Mexican Women Selling Birds*, 343, 453, *453*; *"Pagarias" (Mexican Women Selling Birds)*, 343, 453, *453*
Dohnert, William, 96, 479n9
Domenech, Emmanuel, 156, 485n65
Donation to the poor. From *Galveston Cotton Exchange Sketches*, 270, *274*
Don's Improved Saddle Co., Houston, 360

Dosch, Ernst, 219, 490n73
Douai, Adolph, 207–209, *208*, *209*, 211–212, 490n58, 490n63
Dr. Adolf Douai (unknown photographer), *208*
Drayton, Joseph, 134
Dresel, Emil, 198, 488n29
Dressel, Harry, 437
Drie, Camille M., 416, 418–419
Drie, Camille M., unknown artist after: *Bird's Eye View of the City of Galveston Texas*, 416, *417*, 418–419, 424; *Bird's Eye View of the City of Galveston Texas* (detail), 418, *418*; *Bird's Eye View of the City of Galveston Texas* (detail of cartouche), 419, *419*
Dubois, Jean Pierre Isidore Alphonse (Dubois de Saligny), 44–45, *45*, 63, 65, 71, 473n7
Duganne, A. J. H., 255, 257, 493n26
Dunn, William W., *Evolution and True Light*, 8, *331*, 332
Dunning, W. B., 263, 493n4
Duponceau, Peter Stephen, 21
Durang, Edwin Forrest, *The Democratic Funeral of 1848*, 230, *232*
Duval, P. S., 142, 480n38

Eastman, Harrison, 163
Eastman, Mary Henderson, 140, 142, 483n30
Eastman, Seth: and John Russell Bartlett, 163; at Fort Snelling, 140, 142; *Mission Chapel of San Jose*, 8, *141*, 142, 483n30; on Mission Concepción, 122; prints reproduced as lithographs, 459; *San José Mission*, 140, 142; *Treatise on Topographical Drawing*, 134, 135
Eaton, Joseph H., 106, 479n18
Eberly, Angelina Belle, 195, 488n24
Edwards, A. H., 367
Edwards, Benjamin, 22, 25
Edwards, Haden, 22, 25
Edward Weber & Co., Baltimore, 138
Edwardy, William M., 304, 438, 495n62
Eleventh US Census, 362
El Exmo. Sr. General D. Manuel de Mier y Terán (unknown artist), 25, *25*, 471n44
Elliott, J. B., *Scott's Great Snake*, 244, 246
Elliott, John F., *All About Texas*, 398, *399*
El Paso, Texas, 334, 379, 381
Emerson, Ralph Waldo, 134
Emory, William H.: and John Russell Bartlett, 486n97; *Notes of a Military*

INDEX | 509

Reconnaissance, 121; portrait of, *163*; *Report on the United States and Mexican Boundary Survey*, 164, 166–167, 170, 173, 175, 486n95, 486n101, 486n107, 486n109, 486n111, 486n113; and Trans-Pecos, 162, 163–164, 166–168, 170, 173, 175, 486n98
Endicott & Co., New York, 86, 88, 118, 245
Endicott & Swett of Baltimore, 26
Engelmann, George, 160, 162, 173, 242
Engelmann, Godefroy, 7, 11, 14, 16
engraving, 4, 6–7, 35, 406, 459–460, 467n2, 505n8
Erath, George B., 257, 260
Ernst, Johann Friedrich, 187
Estars [Estes], Maggie, 360
etching, 4, 6–7, 459, 460
Everett, Edward: *Interior View of the Church of the Alamo*, 119, *120*, 121, 122, *122*, 127; *Mission Concepcion, Near San Antonio de Bexar*, 121, 122, *123*, 127; *Mission of San Jose Near San Antonio de Bexar*, 121, 124, *124*, 127; *Ruins of the Church of the Alamo, San Antonio de Béxar*, 118–119, *119*, 121, *121*, 127
Ex-Chief W. H. Coyle (unknown photographer), 314, *314*
Exterminating a Legitimate Taxpaying Business to Admit a Public Evil Free (unknown artist), 8, 318, *320*
Eyth, Louis, 395, 501n23, 505n5

The Fall of Bexar (unknown artist), 39, *39*
Fall of Comal River, New Braunfels (unknown artist), 390, *394*
Falls on Rio Grande at El Paso, Flouring Mills of Simeon Hart, Esq. (unknown artist), 179, *183*
Fannin, James W., 32, 38
Farmer & Negro (unknown artist), 363, 364, *364*
Fenderich, Charles, 118, 480n42
Fenn, F. F., 253, 492n19
Ferdinand VII (king of Spain), 12
Fernández, Justino, 481n69
Fernández de Lara, José Mariano, 31, 106
Fichot, Michel Charles, 277, 284
Filisola, Vicente, *24*, 25, 471n40
Finchmann, H. W., unknown artist after, *Steamer City of Austin Texas Line. New York & Galveston*, 400, 404, *404*
Firth & Hall, 35, 37
Fitzpatrick, Thomas "Broken Hand," 135, 138
Flake, Ferdinand: on Civil War recovery, 263; *Die Union* published by, 188, 468n10; on Galveston bird's-eye-view, 418–419; and Sam Houston, 233; on lithography, 6; on William B. Nangle's Alamo Monument, 229; on northern representations of South, 460; on Reconstruction, 259
Flatonia (unknown artist), 390, *391*
Fleetwood, Anthony after unknown artist, "Texian Grand March for the Piano Forte" Sheet music, 35, *35*, 37
La Flore dans les Déserts Trading card (unknown artist), 8, 357, *357*
Flores, Dan, 484n50
"Floyd Shock & Co., Dallas" (unknown artist), 329, *329*
Ford, John Salmon "Rip," 135, 187, 209–210, *209*, 254, *254*, 257
Fort Brown, 106, 108
Fort Chadbourne, 175
Fort Defiance Goliad, 32, *32*, *33*, 88, 472n68, 472n69
Fort Duncan, 168, 486n102
Fort Sill, Indian Territory, 362
Fort Stockton, 167
Fort Texas, 113
Fort Worth, Texas: and Dallas rivalry, 416, 502n52; lithography in, 331–332; Edward J. Smith's *The Capitalist* operetta in, 430, *430*, 434; "tarantula" map, 433, *433*, 503n86; Texas Spring Palace, 8, 303, 331, 332, 434, *434*, *435*, 436
Fort Worth & Denver Railway, 398, 434
Fowler, Thaddeus M., 420, 422
Fowler, Thaddeus Mortimer, unknown artist after: *Decatur, Texas 1890*, *422*; *National Commercial College of Denison, Texas*, 422, *423*; *Sherman Oil & Cotton Co.*, 422, *424*
fraktur (blackletter) typeface, 192, 219, 488n17
Frank Leslie's Illustrated Newspaper, 379, 381–382, 500n91
Frederich, William J., 498–499n36
Frederick, Prince of Prussia, 222
Fredericksburg, Texas, 188, 198, 199, 222–223
Fredonian Rebellion, 22, 25
Free Soil Party, 478n3
Frémont, John Charles: *Report of the Exploring Expedition to the Rocky Mountains in the Year 1842*, 118, 138; Rocky Mountain excursions of, 134, 135
Frenzeny, Paul, 340, 498n14
Frey, Charles, 343, 450
Friedrich, Ludwig after Hermann Lungkwitz, *San Antonio de Bexar*, 212, 223, *226*, 227

From Summerland to the American Alps (unknown artist), 400, *402*
From the Blizzard Region to Texas (back cover) (unknown artist), 430, *431*

Gadsden Purchase Treaty, 175, 486n96, 486n98
Gaines, George Strother, 16, 19
Gallatin, Albert, 162
Galli, Fiorenzo, 24
Galli, Fiorenzo after Stephen F. Austin, *Texas*, 23, 25, 42, 471n37
Galveston, Brazos & Colorado Narrow Gauge Railroad, 404
Galveston, Harrisburg & San Antonio Railway, 374, 388, 395–396, 398
Galveston, Texas: John Woodhouse Audubon on, 46, 48; *Bird's Eye View of City of Galveston*, 416, *417*, 418–419, *418*, 424; and British protection of Texas, 72; building boom of, 188; Civil War blockade of, 246, 249; custom house of, 193–194; Deep Water Jubilee, 297, 495n47; and fire of 1885, 311, 312, 496n72; *Frank Leslie's Illustrated Newspaper* on, 379; Galveston Electric Pavilion, 268, 299; Galveston Plan, 263, 493n3; German immigration and, 188, 487n8; Ulysses S. Grant's visit, 268–269; John D. Groesbeck on, 191–192; John D. Groesbeck's plan and survey of, 418–419; Hendley Building of, 188, 487n9; Hitchcock's Bayou, 419; and Charles Hooton, 66, 69–71, 476n72, 476n74, 476n76; and Houston rivalry, 416; and hurricane of 1900, 277, 454, 456, *457*, 461; Inter-State Trades Display, 297; lithographic presses of, 4, 263, 304; lithographs of, 42, *43*, *67*, *68*, *69*, *70*, *73*, 77, *78*, *80*, 82, 106, 477n84, 477n95; Mardi Gras celebrations, 270, 277, 283, 284, 286, 289, 292, 295, 297, 373, 374, 426, 447, 460, 494n29, 494n31, 495n46; and Mexican invasion attempts, 72; newspapers of, 468n10; and panic of 1873, 265, 268, 269; port fees of, 195; railroads of, 299, 385, 398; Conrad Caspar Rordorf's view of, 489n34; semicentennial of founding, 306; state militias of, 446–447; *Sunday Opera Glass*, 312–313; and trade, 388; Tremont Music Hall, 192; Union occupation of, 259; yellow fever epidemic of 1839, 70
Galveston (unknown artist), *186*, 188, 390, *391*

Galveston Artillery Ball (unknown artist), *266*
Galveston Bay and Texas Land Company, 31
Galveston Bay and Texas Land Company (unknown artist), 29, *29*
Galveston City Directory, Strickland's ad in, 297, *298*, 495n49
Galveston City Railway Co., 299
Galveston Cotton Exchange Sketches (unknown artist), 270, *271*
Galveston Cotton Market. From *Galveston Cotton Exchange Sketches*, 270, *272*
"The Galveston Fire of 85" Sheet music (unknown artist), 311, *311*, 312
Galveston Island, 13, 20, 46, 49, 367
Galveston's Grand Mardi-Gras and Inter-State Trades Display, 1891 with verso showing. Invitation, *296*, 297
Galveston's Grand Mardi-Gras and Inter-State Trades Display Feb. 5th to 10th Inclusive 1891. Invitation (unknown artist), *296*, 297
Galveston. Texas, Cover of, 450, *450*
"Galveston Tremont Music Hall Polka March" (unknown artist), 192, *192*
Galveston Wharf & Cotton Press Co., 263
Gambel, David R., *The Boat Fight in Corpus Christi Channel*, *248*, 249, 492n13
[The Garden of Eden with Hell Below] (unknown artist), *331*, 332, 335
Garneray, Ambrose Louis, 19, 470n21
Garrison, William Lloyd, 92
Garza, Maria Antonio Veramendi, 478n111
Gast, A. after unknown artist, *San Antonio*, 395, *396*
Gast, August, 388
Gast, Bernard, 318
Gast, John, unknown artist after, *American Progress*, 430, *432*
Gast lithographic company, St. Louis, 318, 334
General Samuel Houston, President of Texas (unknown artist), 72, *75*
Gentilz, Jean Louis Théodore: paintings reproduced as lithographs, 82, 459, 460; *Self-Portrait*, *82*
Gentilz, Jean Louis Théodore (attrib.), *Vue de Castroville et de ses environs prise du Mont Gentilz*, 82, *83*
George D. Barnard & Co., 329, 331, 334
Georgeson, C. C., 362
"Getting Rich in Texas" Sheet music (unknown artist), 372, *373*
Gibbs, Barnett, 496n82
Gihon, William B., 117
Gilbert, Reuben, 117

510 | INDEX

Gilbert, William S., 430, 433
Gilbert, W. J., 362–363
Gilbert Book Co., St. Louis, 362, 363
Gilded Age, 442, 446–447, 449
Giraud, François P., 188, 218
Giraud, Louis (attrib.), *Velasco the First & Only Deep Water Port on the Coast of Texas*, 442, *445*
Giraud, Paul, *Dallas, Texas. With the Projected River and Navigation Improvements*, 318, *328*, 424
Giraud, Theodore E., *St. Mary's Church. Cathedral of Galveston, Texas*, 188, *190*, 488n12
Glaser, Louis: *Clarke & Courts* (detail), 304, *304*; souvenir and guidebooks of, 450, 453
Gleason's Pictorial Drawing Room Companion, 77
Globe Lithographing & Printing Co., 347
Glover, E. S., 420
Godkin, E. L., 2, 467n4
Goetzmann, William H., 166, 484n45, 485n77, 486n93
Goggan, John, 312
Goggan, Mike, 312
Goggan, Thomas, 311–312, 348, 368, 372, 373, 438
Goggin & Bros., 496n71
Goliad, battle of, 32
Gollner, E. G., 424
Gollner, E. G., unknown artist after, *Gollner's Map of the City of Dallas Texas*, 424, *425*, 503n72
Goodrich Tires Stand the Wear[.] Ask Mr Potter of Texas Poster (unknown artist), 382, *383*
Gould, Jay, 268–269
Graham, Curtis Burr, 121–122, 127
Grand Inter-State Drill and Encampment, Houston, Texas cover (unknown artist), 8, 314, *315*
Granger, Gordon, 259
Grant, Ulysses S., 128, 259, 268–269, 446–447, 481n74, 500n91, 501n26
Gray, A. C., 264, 314, 317, 494n5
Gray, Andrew B., 163, 175, 178–179, 184, 242, 388, 487n118, 487n126
Gray, Edwin Fairfax, 446
Gray, Peter W., 237, 242, 446
Gray, Strickland & Co., 264
Great Britain, 72, 99, 130, 477n85
Great Texas State Fair and Dallas Exposition Poster (unknown artist), 427, *428*, 429
Great White Fleet engraving (unknown artist), 368, *371*, 373

Green, Thomas Jefferson, 227, 491n92
Greene, William, 60
Greene & Fishbourne, 7, 468n23
Gregg, Josiah, 133, 188, 191, 483n22
Gregory, Edgar M., 259
Gregory, Minnie L., 497n103
Grenet, Honore, 227
Gresham, Walter, 334
Grizzly Bear (Seminole chief), 168–169, *168*
Groce, George C., 478–479n5
Groesbeck, John D., 191–192, 418–419
Grouchy, Marshal Emmanuel, 19
Grouchy, Victor, 19
Grover, George W., *Capture of the U.S. Steamer Harriet Lane*, 249, *250*
Guadalupe Mountains National Park, 178
La Guerra de los Kikapoos (unknown artist), 257, *258*, 493n32
Gulf, Colorado & Santa Fe Railway Co., 388, 430
Gunter, Archibald Clavering, 382, 500n96

Haines, *The Cattle Tick—The Carrier of Texas Fever*, 350
Hall, Edward: *City of Austin the New Capital of Texas in January 1, 1840*, 7, 61, 63, *63*, 65, 71, 476n64, 476n66; and Sam Houston, 476n64
Hall, Edward (attrib.), *Austin the Seat of the Texan Government in 1840*, 63, *64*, 65, 476n68
Hall, Samuel S. "Buckskin Sam," *340*, 341, 343
Hamilton, James, Jr., 86
Hammond, J. T., 475n60
Hanzal, F., 227
Harding, Chester, 26, 29, 31, 471n52
Harney, William S., 52
Harriet Lane (U.S. steamer), 249, *250*
Harris, A. S., 420
Harris, Edward, 46
Harris, J. D. A., 450
Harris, Joel Chandler, 495n42
Harris & Morgan Line, 195, 400
Harris County Court House, City Hall and Market Building, and Looking East and South from City Hall Tower (unknown artist), 343, 453, *454*
Harrison, Benjamin, 379, 381, 500n94
Harrison, Russell B., 379, 381
Harrison, William H., 92
Hart, John Seely, 142
Hart, Simeon, 487n123
Harte, Ed, 479n16
Hart's Mill, 179, 487n123
Hayes, Charles W., 263–265, 268, 493–494n5

Hayne, Al, 434, 504n95
Hays, John C., 52, 58
Healy, George Peter Alexander: *John James Audubon*, *46*; portrait of James Bowie, 472n65
Healy, John E., 343
Hébert, Paul O., 249
Heiner, Eugene T., 442
Henderson, James Pinckney, 42, 44, *45*
Hendley & Co., 487n9
Hendrick, C. A., 343
Henkel, George August Edward, 204–205
Hennepin, Louis, 2
Henry, Aimé, 483n27
Henry, Joseph Paul, 4, 245, 246, 318
Henry, Paul, 245, 260
Henry, William Seaton, *Campaign Sketches of the War with Mexico*, 106, 108, 118, 479n18, 479n22, 479n23
Henry & Cohen, 139, 483n27
Heredia, José María, 24
Hermann Lungkwitz (unknown photographer), *222*
Hewitt, J. L., 35, 37
Hill, "Lithograph," 303
Hillyard, Henry, 164
Hillyer, H. B., 376
Hine, Robert V., 486n97
His Last Greedy Haul (unknown artist), 318, *321*
His Most Royal Highness Momus. Invitation (unknown artist), 297, *297*
Hispanic culture, 341, 343, 348, 363, 382, 453, *453*
Hobby, Alfred M., 379
Hodge, Galen, 195, 488n26
Hodges, Amelia Luddington Mckinstry, 488n26
Hoe, Richard, steam presses of, 265, 270, 494n10
Hofland, Barbara, 22
Hogan, William R., 477n87
Hogg, Alexander, 400
Hohe, Christian, Plate I. Lithograph from Ferdinand Roemer, 139, *139*
Holley, Mary Austin, 39, 46, 48, 86, 88
Holtz, Helmuth: *Hotel at Matagorda, Texas*, 195, *197*, 198, 488n25; ship portraits of, 192; *View of Indianola*, detail, 195, *195*, 198; *View of Indianola. Taken from the Bay*, *194*, 195, 198, 488n28; *View of Matagorda. (Taken from the Bay, Sept. 1860)*, 195, *196*, 198
Homer, Winslow, 459
Hooton, Charles: on Austin, 71, 476n80; *The "Fever" Burial-Ground*, 70, *70*;

on Galveston, 66, 69–71, 77, 191, 476n72, 476n74; *Galveston, from the Gulf Shore*, 66, *67*; "General Hospital," 69–70, *69*, 476n76; portrait of, *66*; *St. Louis' Isle, or Texiana*, 71; *Scene on a Bayou*, 66, *68*; *Settlers Houses on the Prairie*, 66, *67*
Hopkins, John Henry, Jr., 130, 481n74
Houston, Hauptstadt von Texas [Houston, Capital of Texas] (unknown artist), 77, *79*
Houston, Sam: and annexation of Texas, 92, 96; and John James Audubon, 47; caricatures of, 4, *28*, 29, 210–211, *210*, 230, *233*, 472n54, 490n63, 491n100; and William H. Coyle, 317; as governor of Tennessee, 26, 230; as governor of Texas, 26, 31; and Edward Hall, 476n64; Houston named for, 41; and Carl Gustav von Iwonski, 222; and Know-Nothing movement, 210, 230, 233; portraits of, 26, *26*, *28*, 35, 39, 72, 74, *75*, 230, *231*, 233, *234*, *235*, *236*, 237, *237*, 406, 438, 471n47, 477n92, 477n93, 491n97, 491n98; as president of Republic of Texas, 26, 42, 44, 60, 65, 72, 92, 106; Antonio López de Santa Anna's surrender to, 35, *35*, 37, 437; on secession, 246; and Texas flag design, 357; trading cards of, 352; as US senator from Texas, 26, 230; and John Warren, 297; wounds of, 35, 37, 38, 473n77
Houston, Texas: John James Audubon in, 46–48; William H. Coyle in, 304, 314, 317, 495n63, 496n79; and Galveston rivalry, 416; lithographic maps of, 41–42, *42*, 406; lithographs of, *74*, 77, *78*, *79*, *81*, 82, 106, 477n95; State Fair in, 426; state militias of, 446–447, *446*, *447*; Miles Strickland in, 249, 260, 263–264
Houston & Texas Central Railway, 388, 390, 406
"Houston East & West Texas R'y. Co." Railroad pass, *316*, 317
Houston Light Guard, 446–447
Houston Light Guard. Capt. Thos. Scurry (unknown artist), *446*, 447
"Houston's Enterprise Grand Marches" Sheet music (unknown artist), 368, *368*
Houstoun, Matilda Charlotte (Jesse) Fraser, 70–72, *71*, 77, 138, 477n85, 477n86, 477n87, 477n89
Houstoun, William, 71–72, 77, 477n85, 477n86

INDEX | 511

Howard, John, 387
Howard, Oliver Otis, 259
Howes, Wright, 470n24
Huber, Konrad, 237
Huber, Konrad after Mathew Brady daguerreotype: *Sam Houston*, 237, *237*; *Thomas J. Rusk*, 237, *239*
Huber, Konrad after unknown artist: *Bean*, 237, *238*; *Mission of San José*, 237, *240*; *S. F. Austin*, 237, *238*
Huddle, William Henry, 31, 35, 37
Hudson, Linda S., 486n102
Huge, Jurgan Frederick, 86, *87*
Hughes, George W., 119, 121, 127, 491n84
Hullmandel, Charles, 7
Humboldt, Alexander von, 127, 138, 142, 153, 166, 436, 484n60
Hunnius, Carl Adolph, 484n50
Hunter, John Dunn, 21–22, *21*, 39
Huntington, Collis P., 398
Hurley, C. W., 404
Huseman, Ben W., 484n60, 490n61
Huston, E. G., 130, 211
Hutchison, Robin Brandt, 2

Ikin, Arthur, 71
Illust'd Sweet Caporal Houston Light Guard Tex. Militia Trading card (unknown artist), 447, *447*
immigration: German immigrants, 187, 188, 194–195, 204–205, 207, 230, 436–437, 487n8; and Mexican War of 1846–1848, 187; promotion of, 385, 387–388, 396, 398, 430, 456, 461, 502n29
Indian Chief (unknown artist), 362–363, *363*, 365
Indianola, Texas, 194–195, *194*, *195*, 198, 199
Indian Removal Bill, 30
Indian Territory, 8, 142, 160, 353, 361, 430, 461
Indian Territory, New Mexico, South Dakota, Texas Trading card (unknown artist), 8, 353, *353*
Indian wars, 268, 494n16
Ingraham, Prentiss, 341
Interior of Cotton Exchange and Cotton Warehouse (unknown artist), 343, 450, *451*
International and Great Northern Railroad, 367
International Association of Granite Cutters, 438
International Cotton Exposition, 367
Iriarte y Zuñiga, Hesiquio, *Houston (Capital de Tejas)*, *81*

Iriarte y Zuñiga, Hesiquio (attrib.), *Galveston (Tejas)*, 77, *80*
Iriarte y Zuñiga, Hesiquio after Joseph Horace Eaton, *Corpus Christi (Campamento de Taylor)*, 106, *107*
Isabey, Jean-Baptiste, 14
Iturria, Francisco, 259
Ives, James Merritt, 4
Iwonski, Carl Gustav von: *Answer of the Germans to the Above*, 221, 222; drawings reproduced as wood engravings, 460, 505n12; *Germania Gesangverein, Neu Braunfels, Texas. Gruender des Texanischen Saengerbundes*, 218, *220*, 221; and homeography, 221–222, 242, 490n77; and Karl Friedrich Hermann Lungkwitz, 218, 227; *Neu-Braunfels. Deutsche Colonie in West Texas*, 218–219, *219*, 221, 490n73, 490n75; paintings reproduced as lithographs, 459; photograph of, *218*

Jackson, Andrew, 19, 26, 29–31, 91, 92, 97–99
Jacobson, Semmy E., 374
Jaensson, Swen (Swante Palm), 8, 222, 490n77
James, Edwin, 155–156
James Henry Moser (unknown photographer), 289, *290*
James W. Abert (unknown photographer), *135*
[Jean Pierre Isidore Alphonse Dubois] (artist unknown), *45*
Jefferson, Texas, 419, 426
Jefferson, Thomas, 21, 29
Jenkins, John H., 237, 477n87
Jenkins Garrett Press, 494n5
J. L. Ketterlinus, Philadelphia, 430
"Joe W. Davis, Horse and Cattle Raiser" Letterhead (unknown artist), 317, *317*
John Laird Sons and Co., England, 249
John Salmon Ford as a Texas Ranger (unknown photographer), *209*
"John Wharton Maxey, Civil Engineer" Letterhead (unknown artist), 333, *334*
John Woodhouse Audubon (unknown photographer), *52*
Joseph Bonaparte, King of Spain, 12, 14
Joseph Jay Pastoriza (unknown photographer), *318*
J. Pinckney Henderson (unknown artist), 44, *45*
Judson, Edward Zane Carroll, Sr., 210–211
Jwonski, C. G. [Carl Gustav von Iwonski], *Neu-Braunfels. Deutsche Colonie in West Texas*, *219*

Kansas Pacific Railway (unknown artist), 406, *409*
Kapp, Ernst, 223, 491n80
Karte der Stadt Neu Braunfels (unknown artist), 199, *202*
Kearny, Stephen W., 163, 482n15
Kendall, George Wilkins: and John Bachman, 143; on Mexican War, 109, 127; *Narrative of the Texan Santa Fé Expedition*, 52, 127; *The War between the United States and Mexico, Illustrated*, 7, 127–128, 130, 481n66, 481n69
Kennedy, William, 69, 71
Kern, Edward M., 134, 152
Kern, Richard, 152, 484n45
Key, Francis Scott, 29
Kickapoo Indians, 257
King, Richard, 164, 259
Kinney, H. L., 426, 503n76
Kiowa Indians, 138, 143, 156, 341
Kittredge, John W., 249
Klauprecht, Emil after Angelo Paldi, *Battle of Resaca de Palma, May 9th 1846; Battle of Palo Alto, May 9th 1846*, *116*, 117
Kleberg, Robert J., 350
Klier, Betje, 16, 19
Klimsch, Ferdinand-Karl, *84*, 85–86
Knights of Momus 2d. Anniversary 9. P.M[.] Mardi Gras at Tremont Opera House, Febr. 13th. 1872. Invitation (unknown artist), 277, *279*
Knights of Momus 11th Anniversary, Opera House (unknown artist), 8, 292, *293*
Knights of Momus 29 Feb 1876 Carnival. Invitation (unknown artist), 277, *282*, 284
Knights of Momus Eighth Annual Carnival (unknown artist), 8, *288*, 289
Knights of Momus Fourth Annual Carnival. Invitation (unknown artist), 8, 284, *285*
Knights of Momus Seventh Annual Carnival. Invitation (unknown artist), 8, 284, 286, *286*
Knights of Momus Shrove Tuesday 1875 (verso) (unknown artist), 277, *281*, 284
Knights of Momus Shrove Tuesday 1875 [front]. Invitation (unknown artist), 277, *280*, 284
Knott, George W., 331, 382, 496n87
Know-Nothing movement, 209, 210–211, 230, 233, 489n56
Kobig, J. after Ferdinand-Karl Klimsch, *Verein zum Schutze deutscher Einwanderer in Texas*, *84*, 85–86
Koch, Augustus, 311, 313, 420, 447, 496n72
Koch, Augustus unknown artist after, *Galveston Texas*, *312*, 313, 447
Koehler, Richard E., 303, 334
Kollner, Augustus after Ammi Burnham Young, *Plan of Entrance Story. Scale 8 ft. = 1 in. U.S. Custom House at Galveston, Texas*, 193, *193*
Kopperl, B. J., 438, 504n112
Kosse, Theodore, 406, 502n44
Kosse, Theodore, Hu T. Scott, et al., *Kosse & Scott's Map of the City of Houston and Environs*, 406, *407*
Kraetzer, Gustav, 22
Kraetzer, Gustav after Hermann Lungkwitz, *Dr. Ernest Kapp's Water-Cure. Comal County. Texas*, 223, *224*
Krebs & Bro. Lithographers, Pittsburgh, 254, 492n22
Kuchel, Charles, 198, 488n29
Kurz, Louis, *Galveston's Awful Calamity—Gulf Tidal Wave. September 8th 1900*, 456, *457*

Lacarrière-Latour, Arsène, 19
Laffite, Jean, 13, 20, 66, 376
La Grange, Texas, 205
Lallemand, Charles-François Antoine, 11–14, *12*, 19
Lallemand, Henri Dominique, 13
Lamar, Mirabeau B., 60, 65, 88, 438
Langberg, Emilio, 173
Langworthy, Asahel, 468n8
La Réunion, Texas, 3, 4, 245, 318
La Salle, René Robert, Sieur de, 2, *3*, 352
Latin Settlements, 205, 223
Law of April 6, 1830, 25, 471n40
Lawrence, A. B., 61, 63, 65, 71, 476n63
Lawrence, Henry, 150, 484n51
Lee, Robert E., 257, 259, 263
Lefebvre-Desnouëttes, Charles, 16, 19
Lehnert, Pierre-Frédéric, 481n60
Lemercier, Rose-Joseph, 127, 481n60, 502n48
Lerdo de Tejada, Sebastián, 376
Leslie, Arthur, 460
Leslie, Charles Robert, *John D. Hunter*, 21, *21*
Leslie, Frank, 381, 460
Lewis, James Otto after Chester Harding, *Col. Daniel Boon*, 26, *27*, 471n52
Lexington (steamboat), 108
L. Frank, San Antonio, 360
"L. H. Ward Stock Raiser and Cattle

Dealer" Letterhead (unknown artist), 304, *305*
Liberty Party, 478n3
Liebig, Justus von, 357–358, 360, 499n40
Linati de Prévost, Claudio: *Cacique Apache des bords du Rio Colorado dans la Californie*, 24, *24*; *Filisola Calabrais. Général de Cavalerie, commandant de la place de Mexico (d'aprés nature en 1826)*, 24–25, *24*; as lithographer, 23–25, 471n48
Lincoln, Abraham, 245, 246, 252, 360
Lindheimer, Ferdinand, 207, 242
Lipan Apaches, 169, 486n103
Lithograph and Tin Printing Co., 331
Lithographer (unknown artist), *5*
lithography: chromolithography, 5, 7–8, 166, 277, 450, 459; coloring for, 6, 7–8, 130, 388, 481n74; development of, 1–5, 8, 91; engravings and etchings compared to, 6–7, 459; and engraving transferred to stone, 406; engraving used interchangeably with, 6, 467n2; graded washes on stone, 127; intaglio prints compared to, 7; lithographs as photographs, 450, 453–454, 456; multistone lithographic process, 450; offset lithography, 468n14; photographic images transferred to stone, 343, 411, 502n48, 502n49; as planographic medium, 4, 6; process of, 4–8, *5*, 468n14, 468n23; relief printing compared to, 7; reproductions of images, 4, 173, 175, 468n14, 468n15; reverse image of, 6; steam lithographic presses, 4, *265*, 270, 459, 490n61, 494n11, 505n4; stones for, 4–7, 127, 264, 297, *302*, 303, 304, 396, 450, 468n17; toned lithographs, 8. *See also* Texas lithography
Liverpool & Texas Steamship Co., 404, 502n40
The Liverpool & Texas Steamship Company[.] Steamers San Jacinto—San Antonio—San Marcos—San Gabriel—San Bernard (unknown artist), 404, *405*
Llano Estacado, 133, 160, 175, 178
Long, Stephen H., 133, 134, 136, 150, 156, 483n22
Looking After Hogs (unknown artist), 363, 364, 365, *365*
Louis Philippe I (king of France), 42, 44
Louis XVIII (king of France), 12
Lowe, Joshua: *City of Portland Matagorda Co Republic of Texas*, 65, *65*; as lithographer, 61, 65, 264, 475–476n61

Lowe, Joshua, after Edward Hall, *City of Austin the New Capital of Texas in January 1, 1840*, 7, 61, *63*, 65, 71, 476n70
Lubbock, Francis, 41
Lufkin, Abraham, 476n74
Lundy, Benjamin, 92, 104
Lungkwitz, Karl Friedrich Hermann: *Crockett Street Looking West, San Antonio*, 223; in Fredericksburg, 222–223; *Friedrichsburg. [Texas]*, 223, *225*, 227; and Carl Gustav von Iwonski, 218, 227; *The New Bridge*, 223, 491n86; paintings reproduced as lithographs, 459, 505n4; photograph of, *222*; and Romanticism, 222; and San Antonio, 212, 223; *San Antonio de Bexar*, 212, 223, *226*, 227

M'Callum, A. after Robert James, *Charles Hooton*, *66*
McClain, James S., *Camp Ford Texas*, 254–255, *255*
McClellan, George B., 142–143, 148
McCombs, Paul, *Map of Rockport, Texas, Aransas County*, 411
McCoy, John Milton, 260, 419, 461
McCullagh, Joseph B., 337–338
McCulloch, Ben, 127, 341
McFarren, J. R., *Cow Boy*, 348, *349*
McGuire, James Patrick, 219, 223, 227, 490n73
Mackenzie, Ranald S., 143
McLaughlin, Charles N., 438
Madden, Henry Miller, 484n55
Magee, James, 130
Magee, John L.: *At the Battle of Palo Alto*, 114, *115*; *Death of Major Ringgold, of the Flying Artillery*, 113, *114*; *Soliciting a Vote*, 230, *233*
Magee, John L. (attrib.), *The Modern Gilpins. Love's Labor Lost*, 130, *131*
Magoffin, James Wiley, 486n97
Magruder, John Bankhead, 198, 249, 259
Mallet, Paul, 133
Mallet, Pierre, 133
Mallory S.S. Lines to Texas and Florida (unknown artist), *403*
manifest destiny, 130, 133, 135
Manner of Driving Oxen (unknown artist), 363, *366*
Map of Colorado City on the West Bank of the Colorado River at the La Bahia Crossing Fayette County, Texas (unknown artist), *44*
Map of Houston Heights Harris County, Texas (unknown artist), 442, *444*

Map of the rail route from Galveston to San Antonio, 388, 390, *390*
Map Showing the Geographical Location of Fort-Worth Tex. And Rail-Roads (unknown artist), 433, *433*, 503n86
Map Showing the Route pursued by the Exploring Expedition to New Mexico and the Southern Rocky Mountains . . . conducted by Lieut. J. W. Abert detail, *136*, 137, 483n20
Marble Falls, Texas, 303
Marcy, Randolph B., 133, 142–143, *143*, 148–150, 152–153, 155, 483n38, 484n50, 484n51
Mardi Gras K.O.M. 9 P.M[.] at Turners Hall, Feby. 21st. 1871. Invitation, 277, *278*
Margil de Jesús, Antonio, 374
Martin & Troutman, *Dinner Hour, Engineers, Tex. Land and Copper Association*, 411, *411*
Matagorda, Texas, 195, 198
Maurín, Nicolas-Eustache, *El Eccmo. Señor General de División D. Antonio Lopez de Santa-Anna*, *37*, 38, 77
Maverick, Mary A., 187, 480n47, 487n1
Maverick, Samuel A., Jr., 222, 333
Maverick-Clarke Lithograph Co., 333, *333*, *334*, *335*, 459
Maverick-Clarke lithographic sample book, 333, *335*
Maverick Printing House, 333
May, Charles, 117, 480n38, 480n39
May, William H., *The Old Flag, March 13, 1864*, 255, *256*, 257, 493n26, 493n27
MDR Third Annual Reception at Artillery Hall (unknown artist), 8, 289, *289*
Meade Brothers Studio, *Sam Houston*, 233, *234*
Meade Brothers Studio, after, *Sam Houston "I wish no epitaph to be written to tell that I survived the ruin of this glorious Union,"* 233, *235*
Medau, C. W., 188
Meek, Fielding B., 166
Melchior, Matthais, 205
Melchior, Rudolph, 205
Menger, Rudolph, 227, 491n87
Meusebach, John O., 139, 198, 201, 203, 222
Mexicans (unknown artist), 363, *363*
Mexican War of 1846–1848: fears of, 92; immigration following, 187; lithographic images of, 91, 104, 106, 108–109, 110, 112–114, 117–119, 121–122, 124, 127–128, 130; and survey expeditions, 135

Mexico: boundary with US, 25, 152, 162–164, 166, 184, 486n96; Civil War neutrality of, 259; invasions of Texas, 72, 82, 88, 104, 478n108; lithography in, 23–25; and survey expeditions, 135–138
Meyer [sic], Elijah E., after, *Texas State Capitol*, 438, *441*
Meyer's Universum, 203, 490n75
Michaud, Julio Romo, 473n81
Michaud y Thomas, Julio, 38, 473n81
Michler, Nathaniel, 164, 169
Mier Expedition, 72, 478n108
Mier y Terán, Manuel de, 23, 25, *25*, 26, 471n44, 480n47
Military Plaza, Market in the Morning. Commerce Street, San Antonio, Tex. (unknown artist), 390, *393*
Milwaukee Lithographing & Engraving Co., 419
Mission Concepción, 119
Mission San José, 119, 237, *240*
Missouri, Kansas & Texas Railway, 388
Missouri Compromise, 230
Mitchell, Tobias, 338
Mittendorfer, M. V.: *A. R. Roessler's Latest Map of the State of Texas*, 406, *410*, 411; *Map of Llano County* (detail), *413*
Möllhausen, Heinrich Balduin: *Camp of the Kioway Indians*, 156, *158*; *Canadian River Near Camp 38*, *154*, 155–156; *Comanche Camp on Shady Creek*, 160, *161*; *Kaiowa Camp*, 156, *156*; *Kioway Indianerues Leir*, 156, *159*; *Lager der Kiowaÿ Indianer*, 156, *157*; on Navajos, 160; and Pacific Railroad Surveys, 153, 155, 156, 160, 485n76; portrait of, *153*
Möllhausen, Heinrich Balduin unknown artist after, *Sand Hills on the Canadian*, *155*, 156
Montezuma, 160
Montgomery, Cora. *See* Cazneau, Jane Maria Eliza McManus Storm
Moore, Edwin W., 193–194
Moore, Francis, Jr., 45, 52, 60, 65, 72, 86, 480n51, 491n84
Moran, Peter, 362
Moran, Thomas, 134, 459
Morgan, Charles, 86, 195, 400, 478n116
Morgan, James, 477n86
Morgan, W. P., 438
Morlacchi, Giuseppina, 343, 498n17
Morris, John Miller, 484n50
Morse, C. H., 434, 504n92
Morse, C. H., unknown artist after,

INDEX | 513

Texas Spring Palace. Fort Worth, Texas Poster, 8, 434, *435*
Morton, Samuel George, 47, 474n20
Moser, James Henry: Cotton Exchange bond, 297, *302*; drawings of Cotton Exchange Building, 297; as illustrator for Joel Chandler Harris, 495n42; *Knights of Momus.* Invitation, 8, 289, *290*, 292; photograph of, 289, *290*
Moser, James Henry (attrib.), *Knights of Momus* (verso), 8, *291*, 292
Moser, John H., 289, 495n50
Moser, John Henry, *Revelers of Naxos Mardi Gras*. Invitation, 8, *294*, 295
Mott, Frank Luther, 467n1
Motter, E. E., 420
Moyer, James B., 420
Mrs. Houstoun (unknown artist), 71, *71*
M. Strickland lithographic stone, showing (in reverse) the images for printing bonds for the Galveston Cotton Exchange, 297, *302*
Muir, Andrew Forest, 491n98
Mullard, François-Henry, *Général Charles Lallemand*, 11, *12*
Murray, John, 72
Myers, Elijah E., 438
Myers, Elijah E., unknown artist after, *The New Capitol of Texas*, 8, 438, *439*

Nangle, William B., after, Alamo Monument, 227, *228*, 229, 491n90, 491n92, 491n93
Napoleon I, Emperor of the French, 4, 11–14, 19, 382
Napoleonic battle prints, 114
Nassau Plantation, 203, 204
Nast, Thomas, 222, 269–270
Native Americans: and Austin as capitol of Texas, 65, 71; Karl Bodmer's portraits of, 203; caricatures of, 103–104; census of, 362; and William H. Emory, 167–168; and Sam Houston, 26, 29, 47; and John Dunn Hunter, 21–22; and Indian wars, 268, 494n16; lithographic images of, 162, 166; and patent-medicine shows, 343, 498n18; raids of, 54, 82, 166, 169, 337, 361–362; and settlers, 135; and Snake Island, 66; and surveys, 184; and Texas Panhandle, 361, 362, 411. See also Indian Territory; *and specific tribes*
Navajos, 160, 485n77
"Near Sour Lake Station on T.U&R.O.R.R., 63 Miles East of Houston" (unknown artist), 297, *298*

Nebel, Carl: *Battle of Palo-Alto*, *126*, 127, 128, 130, 481n69; *Battle of Palo-Alto* detail, *6*; *Voyage pittoresque*, 127, 481n58, 481n60; *The War between the United States and Mexico, Illustrated*, 7, 127–128, 130, 481n66
Neighbors, Robert S., 139, 333
Neptune (steam packet), 86, *87*
New Braunfels, Texas, 85–86, 188, 198–201, *200–201*, 218–219, 396, 461, 490n73
"New Goods! Just Received!!," *San Antonio Texan*, 216, *218*
New Orleans, Louisiana: and cotton trade, 388; lithography in, 6, 7, 8, 19, 42, 60–61, 86, 188, 212, 277, 335, 447; Mardi Gras celebrations of, 270, 284, 346, 437; World Industrial & Cotton Centennial Exposition, 303, 398
Newsam, Albert (attrib.) after Samuel S. Osgood, *David Crockett*, 30–31, *30*
New York Future Market. From *Galveston Cotton Exchange Sketches*, 270, *275*
Nicholson, A. O. P., 486n95
Niles, Hezekiah, 13, 60
Niles, John M., 35, 74
Niles, John Warren J., 60, *60*, *61*, 88, 475n58
Nocona, Peta, 361
Nolte, August, 437
Nolte, August, after, *Special Edition of the First Annual German American Volksfest to be Held at San Antonio, Tex. October 28th, 29th, & 30th. 1892*, 437, *437*
Nolte, August, unknown artist after, *San Antonio Daily Light Special Edition German-American Day at San Antonio, Texas, Oct. 9th, 10th, and 11th, 1891*, *436*, 437
North, Thomas, 259

Odin, Jean Marie, 188, 488n12
Official Souvenir Interstate Drill and Encampment Program Cover, 306, *307*, 447
Oliphant, William J., Texas State Capitol with Terracing (detail), showing Alamo Monument, 229, *229*
Olmsted, Frederick Law, 82, 86, 205, 209
Olmsted, John, 209
Omohundro, John B. ("Texas Jack"), 338, 341, *341*, 343, 498n17
Oregon Territory, 130, 152
Orlopp, Maximilian A., unknown artist [Jay Booker?] after, *Dallas County Courthouse*, 442, *443*

Osgood, Samuel Stillman, 30–31
Ousley, Clarence, 456
Overall, Ida Louise, 372
Owen, James, 264, 493n4, 494n6

Paddock, Boardman "Buckley," 434, 504n92
Padgitt Bros., Dallas, 360–361
Padgitt Bros. Manufacturers ad (unknown artist), 8, 318, *323*, 361
Paldi, Angelo, 117, 128
Palm, Swante (Swen Jaensson), 8, 222, 490n77
Palmer, Frances (Fanny): popularity of, 459; *Volunteers for Texas. As You Were*, 110, *110*
Palo Duro Canyon, 143, 483n35, 484n40
panic of 1873, 265, 268, 269, 333, 385, 416
Paquin, J. M., 188
Parisot, Pierre Fourrier, 259
Parker, Cynthia Ann, 245, 361–362
Parker, Quanah, 361–362, *361*
Parker, William Brown, 150
Parry, Charles C., 166
Parsons, Charles, 118
Parsons, Charles after Daniel Power Whiting, *Birds-Eye View of the Camp of the Army of Occupation, Commanded by Genl. Taylor, Near Corpus Christi, Texas, (from the North) Oct. 1845*, 104, *105*, 118, 479n16
Parsons, William Henry, 501n26
Pastoriza, Joseph J., 317–318, *318*, 460, 496n81
Pastoriza & Brown, 317–318
Patchen, William R., 419, 420
Paul Wilhelm, Duke of Württemberg, 153, 221, 490n75
Pawnee Indians, 29
Payno, Manuel, 106, 479n20
Peale, Charles Willson, 74
Pearce, J. W., 419–420
Pease, Elisha M., 184, 205, 486n103
Peck, William G., 135
Peirce, Thomas W., 269, 388, 398
Peña, Enrique de la, 472n64
Pennell, Joseph, 460
Pennoyer, James, 86
Pennybacker, Percy V., 367
Pentenrieder, Erhard: and Gustav Blersch, 212, *216*, 490n67, 490n68; and Carl Gustav von Iwonski, 221; *Main Plaza San Antonio, Texas*, 212, *215*, 216, 218, 490n68
Pentenrieder & Blersch's store on Commerce Street (unknown photographer), 212, *216*

Perez, Manuel del, 22
Perry, James F., 478n116
Perry Mason & Co., 358
Peta Nocona, 361
Peter Ellis Bean (unknown artist, perhaps Jacob Marling), 237, *238*
Peters, Harry T., 8
Petri, Friedrich Richard, 218, 222, 223, 227
Peyton, Harry, 303
Phewl, Adam, 249
Philadelphia, Pennsylvania, US Centennial Exhibition of 1876, 398, 426, 501n26
Phillips, Victor, 450
photography: and government surveys, 134; and halftone engraving, 460; lithographs as photographs, 450, 453–454, 456; photographic images transferred to stone, 343, 411, 502n48, 502n49
photolithography, 411, 502n48
Pierce, Abel Head (Shanghai), 299, 382
Pierce, Franklin, 230, 237
Pierce, Sally, 8
Pierce, Shanghai, 382
Piet, John B., 252
Pike, Albert B., 142
Pilie, L. J., *Plan of the City of Austin*, 60, *62*
Pinckney, Pauline A., 470n18, 472n68, 476n66
Piola, Erika, 8
"The Pirate Isle No More Semi-Centennial Grand March" Sheet music (unknown artist), 312, 368, *370*, 476n74
Plains Indians, 263, 362
Plan of the City of Galveston Situated on the East End of Galveston Island Texas (anonymous), 42, *43*
Planque, Louis de, Col. John Salmon Ford, *254*
Poe, Edgar Allen, 162
Pohlmann, Theodore, 304, 495n64
Police Gazette, 1, 467n1
Polk, James K., 92, 95–99, 104, 106, 110, 130
Pollard, C. J., 108
Poore, Henry R., 362
Pope, John, 179, 184, 388
Pope, John F. and Reuben Ford, *Austin and Surrounding Properties*, 411, *415*
Port Lavaca, Texas, 195
Postl, Carl Anton, 187–188
Potter, Reuben M., 227, 491n90
Powder Horn Bayou, 195, 198
Powell, John Wesley, 484n45
Prang, Louis, 1, 459

514 | INDEX

Pratt, Henry Cheever: John Russell Bartlett and, 166; *John Russell Bartlett*, 162, *162*; and boundary survey, 163, 179; *View of Smith's West Texas Ranch*, 486n97

Prentiss, Francis, 88

"President's March through Texas" Sheet music (unknown artist), *381*

Pryor, Charles R., 245

Psalmanazar, George, 21, 470n29

Pueblo Indians, 160

racial theories, 166–167, 169, 474n20

railroads: and bird's eye views of cities, 316, 416, 418–422, 424, 426, 441, 447, 450, 460, 461, 503n71; and boundary survey, 163, 166, 184, 486n96; and cattle transport, 350; and William H. Coyle, 317; expansion of, 263, 268–269, 337, 385, 387, 400, 461; and Gadsden Purchase, 486n96; and Galveston, 268, 269; and Gray Survey, 175, 178–179, 184, 242; and illustrated promotional maps, 362, 406, 411, 460; land grants for, 385, 388, 390, 395–396, 398, 400, 404, 500n4, 505n140; Pacific Railroad Surveys, 152–153, 155–156, 160, 162, 164, 175; and panic of 1873, 265; and San Antonio, 269, 388, 494n17; and southern transcontinental railroad, 388; Sun Set Route, 269, 388, 390, 395–396, 398. *See also specific railroads*

Raines, C. W., 491n90, 491n92

Ramsay, Allan, 26, 29

Ramsdel, Charles, 491n86

Range Canning Co., 338, 358

Rankin, Melinda, 259

Ranney, William L., 34, 340

Ransom, Harry, 8

Reagan, John H., 246

Rease, W. H., 406

Rebert, Paula, 486n107

Red River Raft, 396

Red River War, 362

Reed, James, 86

Reedy, William Marion, 498n31

Reeve, Lovell, 242

Reidner, J. Martin, 207, 212

Reilly, Bernard F., Jr., 478n3

Reimer, D., 199, 201

Reinhardt & Co., 318

Remer, Wilhelm, 219

Remington, Frederic, 338, 340–341, 357, 382, 498n14, 500n98

Representation of Life in a Cow Camp (unknown artist), 346–347, *347*

Reps, John W., 502n54

Republic of Texas: and Great Britain, 72, 477n85; Sam Houston as president of, 26, 42, 44, 60, 65, 72, 92, 106; Matilda Houstoun on, 72, 477n89, 477n90; international recognition of independence, 20, 44; John James Audubon's exploration of, 46–49, 51–52, 56–58; lithographs associated with, 72; martial image of, 88; reputation of, 103; settlements of, 82, 85–86; settlers of, 45; slavery in, 39, 72; and Texas identity, 41; Texas-themed sheet music, 88; and trade, 86, 88. *See also* annexation of Texas

"Republic of Texas Fifty Dollars," with portrait of Stephen F. Austin in right margin, 237, *239*

Residence of Jules Schneider, Res. of R. B. Godley, and County Court House (unknown artist), 343, 454, *455*

Review of "Texan" Troops, Port of Galveston, and *City of Houston—The Capital of Texas* (artist unknown), 77, *78*

Rice, William Marsh, 446

Rice Institute (now University), 446

Richard, J. H.: and boundary survey, 166; *Pituophis McClellanii, B. & G.* [Bull snake], 150, *151*

Richardson, Henry Hobson, 442

Richardson, Willard, 263, 385, 398, 404, 493n3

Richter, Ludwig, *Hirt und Ziegen in felsigem Tal*, 223

Richter, W. A., after, *Balduin Möllhausen als Trapper*, 153

Riecker, Paul, 424, 503n74

Rigaud, Antoine, 13, 19

Rigaud, Antonia, 13

Rigaud, Narcisse, 13

Ringgold, Samuel, 113–114, 128

Riva Palacio, Vicente, 471n44

Rivera, Tito P., 333, *335*

Rives, Leonora, 438

Roast Mutton. Range Canning Co. Fort McKavett, Texas. U.S.A. Label (unknown artist), 358, *359*

Robens, J. P., 257, 493n27

Roberts, Oran M.: and Richard Coward, 337, 497n3; *A Description of Texas*, 362–368, *363*, *364*, *365*, *366*, 499n56, 499n66; and Louis Eyth, 501n23

Robertson, Jerome B., 385

Robinson, Henry R., 37–38, 86, 91, 92, 98, 230

Robinson, Willard B., 488n12, 501n21

Roemer, Carl Ferdinand von, 138–139, *138*, *139*, 199, 477n86, 477n87, 490n73

Roessler, Anton R.: *A. R. Roessler's Latest Map of the State of Texas*, 406, *410*, 411; *Iron Furnace and Manufactory (the first established in the State of Texas) Marion County*, 411, *414*; on limestone, 303; *Map of Brown Co., State of Texas*, 411, *412*; *Map of Brown Co., State of Texas*, detail from, 411, *413*; *New Map of Texas Prepared and Published for the Bureau of Immigration of the State of Texas*, *384*, 385; *San Saba City Taken from the County College Looking North*, 411, *414*

Roetter, Paulus, 166, 173

Rogers, W. A., 340

Rogers, Will, 348

Romagnesi, A., 14

Romanticism, 19–21, 134, 148–149, 153, 156, 184, 222

Roosevelt, Theodore, 338, 382

Rordorf, Conrad Caspar: Comanche Indian portraits of, 199, 203; Galveston view of, 489n35; and Nassau Plantation, 203; in New Braunfels, 198–199; New Braunfels panorama of, 199–201, *200–201*, 218–219, 461, 489n36, 490n75; and Round Top sketch, 205; and Johann Jakob Wetzel, 488n32

Rosenberg, Carl Wilhelm von: in Austin, 205, 207; *The Capitol in the City of Austin. Southern View*, 205, *206*; *City of Austin Southern View from Hugh Tinnin's Place*, 207, *207*; as engineer, 207, 489n50; photograph of, *205*; in Round Top, 204–205

Rosenberg, Karl Wilhelm von (attrib.), *Round-Top in Texas*, 204–205, *204*, 207

Rosenthal, Lewis N., 175

Roses All the Year Round: Dallas Texas. Ft. Worth, Tex. Calendar (unknown artist), 400, *400*

Roses All the Year Round: San Antonio, Tex. Galveston, Tex. Calendar (unknown artist), 400, *401*

Ross, E. H., 406

Ross, Lawrence Sullivan, 353, *355*, 357

Ross's New Connected County and Rail Road Map of Texas and Indian Territory, 406

Round Top, Texas, 204–205

Rousseau, Jean Jacques, 21, 26

Rousseau, Theodore G., 313–314

Rousseau Company, "To Cotton Men. The Rousseau Company," 314, *314*

Roux, Antoine, 86

R.R. Bridge Over St. Marcos River (unknown artist), 390, *395*

Ruffner, Ernest H., 150, 388, 484n50

Rullmann, Ludwig after Arsène Lacarrièr-Latour (attrib.): *Colonie du Texas*, 16, *18*, 19; *Les Lauriers Seuls y Croitront Sans Culture*, 16, *17*, 19, 470n18

Rundlett, C. M., 441, *442*

Rusk, Thomas J., 237, *239*

Russell, Charles M., 338, 340, 382

Ryan, F. T.: in Dallas, 501n23; Letterhead of the Galveston, Harrisburg & San Antonio Railway Co., 269, *269*, 395

Sachtleben, August, 192, 242

St. Louis, Iron Mountain & Southern Railway, 387

St. Louis, Missouri, 337, 362, 387, 388, 460, 497n2

Sampson, Alexander, 337–338

San Antonio, Texas: *Frank Leslie's Illustrated Newspaper* on, 379; German American Association of, 437; German Casino, 218; lithographic presses in, 207, 212, 333; Main Plaza of, 212, *213*, *214*, *215*, 216, 218, 223, 460, 490n68, 505n12; Menger Hotel, 212, 218, 395; Mexican armies' capture of, 72, 82; public festivals of, 436–437, *436*, 447, 459; and railroads, 269, 388, 494n17; St. Mary's Church, 395; San Fernando church, 122, 124, 210, 212, 218, 227, 395; state militias of, 446–447; Ursuline Convent of, 188; water near, 396

San Antonio Casino, 212, 242

San Antonio de Bexar 1846 (unknown artist), 121, 124, *125*, 127

San Antonio Fair Association, 503n79

San Antonio International Exhibition of Texas and Mexico of 1890, 437

San Antonio International Fair and Exposition of 1899, 459

San Antonio River, 3d. Mission in the Distance (unknown artist), 395, *397*

Sánchez Estrada, José Juan, 480n47

Sánchez Navarro, José Juan, 480n47

Sánchez y Tapia, José María, 25

Sandusky, William, 476n66

Sanger Bros. Monthly Magazine (unknown artist [Jay Booker?]), 318, *326*

San Jacinto, battle of, 3, 26, 32, 35, 41, 46–47

San Román, José, 259

Santa Anna, Antonio López de: and Constitution of 1824, 31; and Vicente

INDEX | 515

Filisola, 25; portraits of, 35, *36*, 37–38, *37*, 72, 74, *75*, 77, 477n90; at San Jacinto, 32, 41; surrender of, 35, *35*, 37, 437
Sarony, Major & Knapp, New York City, 162, 173
Sarony & Co., New York, 164
Sarony & Major, 112
Scenes along the Rio Grande (unknown artist), 343, 454, *456*
Schachtrupp, Adolph, 337
Scherrer, E. E., *Our Father Who Art in Heaven*, 313, *313*
Schlinger, Leopold: and Loyal National League, 253–254; *Preserving Industry Leads to the Desired Point*, 253, *253*; "This Certifies," 253, *253*
Schoolcraft, Henry Rowe, 21, 140, 162, 164
Schoolfield, Charles, 60
Schossig, E., *Galveston*, 188, *189*
Schott, Arthur C. V.: and boundary survey, 179; and William H. Emory, 166; *Lipan-Warrior*, 169, *169*; on lithography, 173, 175; *Noco-Shimatt-Tash-Tanaki. Grizzly Bear. Seminole Chief*, 168–169, *168*; photograph of, *166*; *Toro-Mucho, Chief of a Band of Kioways*, 167–168, *167*
Schott, Arthur C. V. (attrib.), *Prairie of the Antelope*, 171–173, *172*, 486n109
Schuchard, Carl: *Break of the Rio Grande, Through the Bluffs Near Frontera*, 184, *185*; *Cathedral Rock, South Peak of Guadalupe Mountains*, 179, *179*; *Church Mountain Valley, Near Fort Chadbourne, Texas*, 175, *177*; *Falls of the Rio Grande*, 179, *182*; *Fort Chadbourne, Texas*, 175, *176*; and Gray survey, 388; *Molino del Norte*, 179, *181*; *Passage of the Rio Grande*, 184; *Pecos River, Texas, in Latitude 31° 31' North*, 178, *178*; sketches destroyed in Smithsonian Institution fire, 487n118; *Town of El Paso on the Rio Grande, Chihuahua*, 179, *180*
Schuessele, Christian after Seth Eastman, *Mission Chapel of San Jose, Near San Antonio, Texas*, *141*, 142, 483n30
Scott, Hu T., 406
Scott, Julian, *Quanah Parker. Chief of the Quah-hah-das Comanches—Oklahoma, 1890*, 361–362, *361*
Scott, Winfield, 109, 117–118, 127, 246
S. D. Myres, Sweetwater, 361
Sealsfield, Charles, 187–188
Seaman, A. G., 160
Sears, Robert, 77

2nd Annual Reception, Galveston Artillery Hall, Mardi Gras (unknown artist), 8, 286, *287*
Second Bank of the United States, 30
Seele, Hermann, 223
Seguin, José Erasmo, 212
Sellors, Evaline, 504n95
Semmes, Raphael, 249, 251–252
Senefelder, Alois, 4, 5–8, 12, 303, 470n14
Senelle, N. H., 400
Seymour, Samuel, 150
Shakespeare, William, 286, *287*
Sharp, William, 7
Shawnee Indians, 52
Sherburne, John P., 156, 160
Sheridan, Francis, 70, 191
Sheridan, Phil, 269, 494n19
Sherman, Texas, 343, 379, 416, 426
Shirlaw, Walter, 362
Shock, Floyd, 329, 331, 334
Shumard, Benjamin F., 411
Shumard, George G., 143, 148, 150
Shumard, George G. (attrib.): *Border of El-Llano Estacado*, 143, *146*, 150; *Gypsum Bluffs on North Branch Red River*, *144*; *Head of Ke-che-ah-que-ho-no, or the Main Branch of Red-River*, 148, *149*, 150; *View Near Head of Red River*, *148*, 150; *View Near the Head of the Ke-che-ah-que-ho-no*, 143, *147*; *View of Gypsum Bluffs on the Canadian River*, *145*, 150
Sibley, Marilyn McAdams, 77, 468n8, 488n24
Silbey, Joe H., 479n14
Simonds, Frederic W., 303
Simpson, James H., 153, 155
Sinclair, Thomas, 162
Sinclair, W. H., 299
Sindall, Harry S., 179, 184
Sinz, Charles, 438
Siringo, Charles A.: and mass-produced images, 1; *A Texas Cow Boy*, 8, 346–348, *346*, *347*, 350, 382, 498n25
Sisterdale, Texas, 198, 223
Slautterback, Catharina, 8
slavery: and annexation of Texas, 91, 99, 103–104, 130, 162; and Albert Douai, 209; Gordon Granger's General Orders No. 3 declaring freedom, 259, 493n33; and Sam Houston, 211, 230, 233; and Law of April 6, 1830, 25; lithographic images of, 91, 99, 103–104, 461, 478n3; and Reconstruction, 260; in Republic of Texas, 39, 72; in state of Texas, 187, 195; and Texas Revolution, 92, 104

Sloan, Dorothy, 442, 470n18
Smith, Ashbel, 45, 230
Smith, Edmund Kirby, 259
Smith, Edward J., 430, 433, 503n87
Smith, Gean, *A Stampede*, 350–351, *351*
Smith, John J. "Coho," 245–246, 260, 318, 493n42
Smith, Justin, 117
Smith, Peter, 478n3
Smith, Theobold, 350
Snake Island, 66
Snell, Perez, 42, 188
Snell & Theuret, 42, 473n5
Sommer, Karl von, 188, 198
Sophienburg, 199, 219, 489n36
Sophienburg Memorial Museum, New Braunfels, 489n36, 490n73
Sörgel, Alwin, 198
Sörgel, Alwin H., 204
Southern Pacific Railroad, 398
souvenir albums, 343, 450, *450–452*, 453–454, *453–455*, 456, *456*
"Souvenir of San Antonio International Fair" (unknown artist), 333, *333*
Souvenir Programme Grand Dedication Ball New State Capitol Building Austin, Texas (unknown artist), 8, 438, *440*
Spanish Texas, 11–14
Sparks, William F., after, *Cattle Herders Indulging in Revolver Practice on Telegraph Insulators*, *336*, 338
Spiess, Hermann, 199, 201, 203, 461
Squier, Ephraim, 162
Staacke, G. A., 253, 492n19
Stanbery, William, *28*, 29, 230
Stanley, David S., 155
Starke, Neal, 318
Stationers Lithographers Printers and Blank Book Manufacturers, pairing Robert E. Lee with George Washington. Strickland & Clarke ad (unknown artist), *268*
Steamboat Landing, Rio Grande River [sic] and Rio Grande Railroad Depot and Repair Shops (unknown artist), 343, 450, *451*, 454
Steamship State of Texas, Mallory Line Trading card (unknown artist), *403*
steel erasers, 338, 497n4
Steinbeck, John, 461
Steinert, Wilhelm, 489n39
Stephen F. Austin (unknown artist), 237, *238*
Stephens, John Lloyd, 162, 485n86
Stevens, Isaac, 153
Stevens Bayou, 198

Stewart, W. T., 331
Stiff, Edward, 42, 476n62, 476n72, 477n88
Stille, John A., 61, 476n63
Stillman, Charles, 259
Stillman, J. D. B., 195, 198
Stockfleth, Julius, 505n5
Stoner & Ruger Co., 420
Stowe, Harriet Beecher, 142
Strecker, Herman [*Catocalal*], 387–388, *387*
Streeter, Thomas W., 20, 37, 164, 406, 471n37
Strickland, John (son), 311, 494n5
Strickland, John (attrib.) after Augustus Koch, *Bird's Eye View of the Eastern Portion of the City of Galveston*, 310
Strickland, Miles (Strickland & Co.): ad for Stationers Lithographers Printers and Blank Book Manufacturers, 265, *268*; ad in Andres Morrison, *The Industries of Dallas*, 299, *301*; advertising in local newspapers, 263, 264, *264*, 265, 494n7; death of, 303, 334; and electric motors, 334, 497n96; financial trouble of, 334, 335, 497n97; in Galveston, 264; and Galveston Artillery Ball, 264, *266*; Galveston city directory ad, 297, *298*, 495n49; Galveston Cotton Exchange bond, 297, *302*; and *Galveston Cotton Exchange Sketches*, 269–270, *271*, *272*, *273*, *274*, *275*; and A. C. Gray's history of Galveston, 494n5; in Houston, 249, 260, 263–264; lithographic stones, 30, 297, *302*, 335; and lithography, 4, 7–8, 264, 304, 494n11; *Map of Galveston & Vicinity*, 270, *276*, 494n25; Mardi Gras chromolithographs of, 270, *288*, 289, *289*, *290*, 292, *292*, *293*, *294*, 295, *295*, 297; Mardi Gras invitations of, 8, 277, 284, *285*, 286, *286*, *287*, *288*, 289, *289*, 292, *292*, *293*, 295, 297, 317, 335, 495n35, 495n40; and James Owen, 264, 493n4, 494n6; and panic of 1873, 265, 268, 269; private script (front and back) for the First National Bank of Burgess Business College, 265, *267*; steam press of, 270, 284, 289, 495n39
Strickland, Miles (son), 284, 334
Strickland, Mrs., 311
Stripling, Raiford, 472n69
Strong, T. W., *A Volunteer for the Rio ⟨Brandy⟩*, 109, 110, *110*
Strubberg, Friedrich Armand, after

Conrad Caspar Rordorf (attrib.), [Enchanted Rock], 203, *203*
Stuart, Alexander H. H., 163
Stuart, Hamilton, 58, 86
Sullivan, Arthur, 430, 433
Sully, Alfred, 106, 479n18
Sully, Thomas, 106
surveys: flora and fauna recorded in, 134–135, 138, 150, 153, 160, 162, 166, 171–173, 175, 242, 388, 483n22; Gray Survey, 175, 178–179, 184, 242, 388, 487n118, 487n126; and Mexican territory, 135–138; Pacific Railroad Surveys, 152–153, 155–156, 160, 162, 164, 175; photography used for, 134; and source of Red River, 142–143, 148–150, 152, 484n40; topographical drawings used for, 134, 135, 153, 163, 166, 175, 179, 184, 460; and Trans-Pecos, 162–164, 166–173, 175, 486n98
Sweet, Alexander E., 365, 367
Sweet, George H., 387
Swett, Moses, 37
Swett, Moses after A[nson] Dickinson, *Gov. Houston. (In Exile)*, 26, *27*, 29, 230, 352
Szarkowski, John, 4

Tait, Fitzwilliam, 459
Tait, J. L., 303, 468n17
Talfner, R. B., 374
Taliaferro, Henry G., 494n25
Tammen, H. H.: *Cowboy Life*, 343, 498n19; *Souvenir Album of the Great West*, 343, 498n19
Tanner, Henry S., 133
Tatham, David, 8
Tavernier, Jules, 340, 498n14
Taylor, Fitch W., 113
Taylor, Horace, *Teddy to the Rescue of Republicanism*, 338, *339*
Taylor, Lonn, 205
Taylor, Zachary, 104, 106, 112–113, 117–118, 127–128, 135, 162, 479n16
TC Sixth Anniversary Masquerade Ball (unknown artist), 8, 292, *292*
Teas Geological Survey, 411
Tempeltey, Julius after Conrad Caspar Rordorf, *Panorama der Stadt Neu-Braunfels in Texas Aufgenommen von der Südwestseite in Sommer 1847*, *200–201*, 218, 489n36
Tengg, Nic., 450
Tenth Anniversary Knights of Momus Artillery Hall (unknown artist), 8, 292, *293*
"Testing" Clark's O.N.T. Spool Cotton Trading card (unknown artist), 8, 306, 358, *358*
Texana (bark), 195, 198, 488n27
Texanischen Sängerfest, 209
Texan Santa Fe expedition, 52, 88, 127, 133
Texas & New York Steamship Line (Mallory), 400
Texas & Pacific Railway, 265, 270, 398, 400
Texas: architectural boosterism, 438, 441–442; boundaries of, 25, 152; caricatures of, 337–338; Civil War blockade of, 246, 249, 251–252, 259, 260; Civil War surrender of, 263; Civil War Unionist sentiment in, 252–255, 257, 259–260; cowboy persona of, 338, 340–341, 343, 346–348, 350–351, 374, 381–382, 497n13; economic growth of, 385, 426; ethnicities in, 456; forts of, 133; *Frank Leslie's Illustrated Newspaper* on, 379, 381–382, 500n91; "Gone to Texas" phrase, 41, 473n3; identity of, 41, 71; illustrated newspapers of, 374, 376, 379; independence from Mexico, 20, 25, 31, 32, 34–35, 38–39, 44; and Longhorn cattle, 340, 343, 348, 350, 353, 360; population growth of, 184, 263, 382, 385, 426, 456, 461; promotion of, 337, 398, 426–427, 430, 433, 434, 436–437, 502n29; Reconstruction in, 259–260, 270, 337, 385, 416, 461; reputation of, 133, 337–338; rivers of, 396, 501n25; secession of, 4, 233, 245, 246; sheet music of, 368, *368*, *369*, *370*, *371*, 372–373, *372*, *373*; Spanish Texas, 11–14; statehood of, 91, 184, 437; and state militias, 446–447; surveys of, 134, 184; US battleship named for, 449, *449*. *See also* annexation of Texas; Republic of Texas; Texas Revolution
Il Texas (Stati Uniti d'America) Trading card (unknown artist), 8, 360, *360*
Texas Capital State Fair: The Tenth Annual Fair (unknown artist), 8, 427, *427*
Texas Cattle Raisers Association, 352
Texas Centennial of 1936, 382
"'Texas Charlie.' 'Little Bright Eye.' Waltz Song" Sheet music (unknown artist), *342*, 343
"The Texas Cowboy" Sheet music (unknown artist), 312, 348, 368, 372, *372*
Texas Declaration of Independence, 31
Texas fever, 338, 348, 398
Texas Grange, 367
"Texas House Clarke & Courts—Stationers" Ad, *309*
Texas Invitation (front and verso) to Ball and Banquet of the Cattle Raisers Association of North West Texas (unknown artist), 343, *344*, *345*, 346
Texas Land & Immigration Co. of New York, 411
Texas Lithographic Stone Co., 303
Texas lithography: and caricatures, 4, 29, 91, 92, 103–104, 110, 130, 472n54; characteristics of, 2, 3, 6; context of, 2, 3; distribution of, 92, 479n5; and eyewitness images, 3; history documented by, 2–3, 8; presses of, 60–61, *60*, *61*, 63, 65, 88, 187, 207, 242, 263, 264, 456, 460; and satirical prints, 29, 91, 92, 97, 114; and sporting motifs, 92
Texas Pacific land trust, 500n4
"Texas" page from *Star Wind Engine* brochure, 338, *338*
Texas Panhandle, 138, 150, 152, 156, 160, 361–362, 387, 411
Texas Printing and Lithographing Co. of Fort Worth, 331–332, 335, 496n87, 497n89
Texas Revolution, 20, 25, 31–32, 34–35, 38–39, 88, 92, 104
"The Texas Salt Co., of Colorado, Texas" (unknown artist), 332, *332*
Texas Siftings, 367, 504n112
Texas Siftings cover (unknown artist), 367, *367*
Texas Spring Palace, 8, 303, 331, 332, 434, *434*, *435*
Texas Spring Palace, Fort Worth, Texas Invitation (unknown artist), 434, *434*
"Texas State Capitol Grand Waltz" Sheet music (unknown artist), 8, 312, 368, *369*, 438
Texas State Fair, 372, 404, 427, *428*, *429*
Texas State Fair and Dallas Exposition, 7, 8, 318, *322*, *325*, 503n79
"Texas State Fair and Dallas Exposition Exhibitors Portrait Ticket 1897" (unknown artist), 318, *325*
Texas Trading card (unknown artist), 8, 352, *352*, 353, *354*, 358, *359*
Texian Hare (unknown artist), 363, 364–365, *364*, 366
"The Texian Quick Step, Respectfully Dedicated to Gen. Edward Burleson" Sheet music (unknown artist), 88, *89*
Texians, people of Texas known as, 471n39

T. Fitzwilliam & Co., Lith., 447
thaler (silver coin), 199, 489n38
Thayer & Co., 88
The Alamo. Built 1718 (unknown artist), 343, 450, *452*
Therond, E. after L. Regnier, *Vue de la Ville de Houston (Texas, Etats-Unis)*, *81*
Theuret, Dominique, 42
Thielepape, Wilhelm C. A.: as abolitionist, 209; Galan Street shop of, 210, 212; and Carl Gustav von Iwonski, 221; as lithographer, 208, 210, 212, 221, 227; lithographic manual of, 6, 242; *Main Plaza of San Antonio, Texas*, 212, *214*, 223; *Main Plaza. San Antonio, Texas*, 212, *213*; *Map of the Lands Lying within the Corporation L[imits] of the City of San Antonio as Surveyed and Divided in 1852*, 211–212, *211*, 490n63; photograph of, *208*; *Sam Recruiting after the injunction of secrecy had been removed*, 4, 210–211, *210*, 230, 490n63
Thomson, Mrs. Robert, 372
Thoreau, Henry David, 134
Thorpe, Thomas Bangs: *Battle Field. Palo Alto—Mexican Army Drawn Up in Battle Array*, 128, *129*; on Mexican War, 109; *Point Isabel*, 117
Tidball, John C., 153
Tiedemann, Friedrich, 474n20
"Tolbert Bros. Real Estate and Loan Agent" (unknown artist), *330*, 331
Toro-Mucho (Kiowa chief), 167–168, *167*
Torrejón, Anastasio, 128
Torrey, John, 164, 166, 172
To this complexion must we come at last. From Galveston Cotton Exchange Sketches (unknown artist), 270, *273*
Townsend, T. L., 318
T. P. Rivera ad, *335*
Trans-Pecos: and Indian raids, 361; and surveys, 162–164, 166–173, 175, 486n98; William H. C. Whiting on, 487n121
Travis, N. W., 60
Travis, William B., 437, 501n23
Traynham, John H., 398
Treaty of Fort Atkinson (Kansas), 156
Treaty of Guadalupe Hidalgo (1848), 118, 162, 163, 166, 486n98
Treaty of Medicine Lodge (1867), 362
True Blue, 318, *320*, *321*, 335, 496n82
Truett, A. T., 360
Tuan, Yi-Fu, 461
Tuckerman, Henry, 162

Turner, A. A., 502n48
Turner, Frederick Jackson, 460
Turners' Hall, Mardi Gras, Tuesday, February 21, 1871 (unknown artist), 277, *277*
12th Aniversary. Opera House Galveston (unknown artist), 8, 295, *295*, 297
Twiggs, David E., 128
Tyler, John, 92, 97–99, 104

Umbdenstock, M., 346, 347, 498n23
Union Leagues, 252–253
US Army, 362
US Centennial Exhibition of 1876, 398, 426, 501n26
US-Mexican Boundary Commission, 175
United States Military Academy at West Point, 134, 140, 163
The USS Hatteras in Action with the CSS Alabama, off Galveston, Texas, 11 January 1863 (unknown artist), 252, *252*
The United States Squadron, Landing Its Seamen & Marines, at the Brazos de Santiago, May 8th 1846 (unknown artist), 113, *113*
US Treasury Department, 173
Using Mules as a Conveyance (unknown artist), 363, *366*
U.S.S. Texas Trading card (unknown artist), 449, *449*
Uvalde, Texas, 212

Van Alstyne, Mrs. A. A., 476n74
Van Buren, Martin, 41, 91–92, 130, 230, 478n3
Vander Gucht, M., *The Unfortunate Adventures of Monsr. de la Salle*, 3
Vanderlyn, John, 230
Van Houtte, Louis, *Pentstemon wrightii*, 242, *243*
Vauban, Sébastien Le Prestre de, 150
Vaudricourt, Augustus de: and boundary survey, 163, 166, 179; *The Plaza and Church of El Paso*, 166, 170, *170*, 486n97
Vega, Manuel N. de la, 31
Vehlein, Joseph, 31
Verein zum Schütze deutscher Auswanderer nach Texas (unknown artist), 85, *85*
Vernet, Horace, "Le Champ d'Asile Romance" Sheet music, 3, *10*, 11, 14
Vial, Pedro, 483n35
Victoria, Texas, 422, 426, 503n71
Vidaurri, Santiago, 486n103
View of Court House, Gonzales, Texas (unknown artist), 390, *392*, 501n21

View of Oak Cliff from New Courthouse, Dallas, Texas (unknown artist), 318, *324*
View of the City of Houston (artist unknown), 77, *79*
Views in Austin, Texas (unknown artist after H. B. Hillyer photographs), 376, *378*
Views in Galveston, Texas (unknown artist after F. W. Kersting photographs), 376, *377*
Visit Oak Cliff, Dallas, Texas verso (unknown artist), 318, *324*
A Visit to Texas, 3, 468n8

Waco Indians, 160
Wade, H., 88
Wagner, Henry R., 471n37
Wagner, Leonhard, 488n17
Wagner, Paul, 450, 453
Wainwright, Nicholas B., 8
Walker, Robert J., 175
Wallace, David H., 478–479n5
Wallace, William A. A. ("Big-Foot"), 341
Walz, W. G., 450
Ward, L. H., 304
Ward, Thomas William "Peg Leg," 237
Ward, William, 32
Ward Bros., 450
Warren, John, 297
Washington, George, 210
Washington, Lewis M. H., 32
Washington, T. A., Charles F. White, and Miles Strickland, *Map of Galveston & Vicinity*, 270, *276*, 494n25
Washington-on-the-Brazos, Texas, 72
Waud, A. R., 340
W. Duke & Sons: Cowboy Series, 358; *Gov. Ross, Texas* Trading card, 353, *355*, 357
Weatherington Brothers, *Dallas Lithograph Company Building*, 318, *329*
Webb, Walter Prescott, 133
Webb, W. G., 188
Webb, William H., 86
Webber, Charles W., 58
Weber, David J., 484n45
Weber, Edward, 118, 480n42
Webster, Daniel, 92, 97
Weimar, North Side (unknown artist), 390, *392*
Weir, Robert W., 134
Welch, Michael Angelo, 61
Wellge, Henry, 420–421
Wellge, Henry, unknown artist after, *Fort Worth, Tex. "The Queen of the Prairies."*, 421, *421*

Wendell, Cornelius, 486n95
Westyard, A. L., 420
Wetzel, Johann Jakob, 198, 488n32
Weyss, John E.: *Falls of the Rio Salado*, 170–171, *171*; and surveys, 166
W. G. Tobin's Chili-con-Carne, 358, 360
W. H. C. after Doerr & Jacobson, photographers, *View of Ancient Missions Near San Antonio, Texas*, 374, *375*
Wheeler, Thomas B., 381
Whig Party, 30, 95, 98, 162
Whilldin, Matthew: criticism of, 400; and *Daily Graphic*, 283–284, 374, 376, 395; *Galveston, Harrisburg and San Antonio R.R. Immigrants Guide to Western Texas, Sun Set Route*, 388, *389*, 390, 395–396, 398, 416
Whilldin, Matthew (attrib.), *Delivering the Invitations for the Mardi Gras Festivities at Galveston, Texas*, 283, *283*, 374
Whipple, Amiel Weeks: boundary with Mexico, 163; and Pacific Railroad Surveys, 152–153, 155–156, 160, 162, 164, 175, 484n40, 485n76, 485n77, 485n82; photograph of, *152*
White, Charles F., 270, *276*
White, George G., *The Ground Cuckoo. Geococcyx mexicanus. (Gm)*, *174*, 175
White, Gifford, 488n26
"White Squadron Grand March" Sheet music (unknown artist), 312, 368, *371*, 373
Whiting, Daniel P.: *Army Portfolio No. 1*, 104, 118, 130, 479n16, 480n41, 480n44; and Mexican War, 113, 117–118
Whiting, Samuel, 60, 65
Whiting, William H. C., 487n121
Whittredge, W. Worthington, 134
Wilberforce, William, 72
Wild Cat (Seminole chief), 168, 486n102
Wilhelm C. A. Thielepape (unknown photographer), *208*
Wilke & Dooly Co., 201
Wilkes, Charles, 134
Wilkie, Everett, 479n23
William C. Peters Music Co., 368
William Hall & Son, 37
Williams, Madge Houston, 449
Williams, Robert H., 195, 488n26
Williams & Guion Line, 400
Williamson, Samuel H., 486n113
Williard, Johann Anton, 192
Williard, Johann Anton after C. O. Bähr, *Ansicht von Galveston*, 191
Wilson, Thomas, 361

Winedale Historical Complex, 205
"Winkelmann & Bohne, Brenham, Texas" Letterhead (unknown artist), 304, *305*
Winkler, Ernest William, 490n63
Wister, Owen, 338, 340–341, 382
Wittemann, Adolph, 450
Witter, Conrad, St. Louis letter sheet, 216, *217*
Wollaston, William Hyde, 474n18
Woman's Christian Temperance Union of Virginia, 449
women, in lithographic industry, 335, 497n103
Wood, Joseph, 471n47
Wood, W. E., *City of Houston, Harris Co. Texas*, 406, *408*, 502n45
Woodbury, Levi, 130
Woodward, Lula A., 497n103
Woodward, W. H., 350
Woodward & Tiernan Printing Co., 350–351, 434, 437, 504n92
Wool, John E., 118–119
Woolsey, A. Wallace, 471n40
World Industrial & Cotton Centennial Exposition (New Orleans, 1885), 303, 398
The Wounded Dragoon. On the Banks of the Rio Grande (unknown artist), 110, *111*
Wright, Charles, 242
Wright, Charles J., 379
Wright, Jefferson, 491n98
Wright, Jim, 503n73
Wright, Thomas Jefferson, 74, 477n92, 477n93

Xántus, Janos, 152
Xántus, Janos, after, *Arkanzas folyó főforrása* [Mouth of the Arkansas], *151*, 152

Yoakum, Henderson, 29, 237
York, John, 204
Young, Ammi Burnham, 193
Young, Brigham, 210
Young Texas Carte de visite (unknown artist), *261*, 337
Young Texas Single sheet (unknown artist), *261*, 337
Your Too New Young Man and *A Cabbage Head* Trading cards (unknown artist), *386*, 387
Youth's Companion, 338, 358

Zavala, Lorenzo de, 25, 31, *31*
Zúñiga, Hesiquio Iriarte y, 106